Furniture

Furniture

FROM ROCOCO TO ART DECO

Adriana Boidi Sassone · Elisabetta Cozzi · Andrea Disertori
Massimo Griffo · Andreina Griseri · Anna M. Necchi Disertori
Alessandra Ponte · Gianni Carlo Sciolla · Ornella Selvafolta

EVERGREEN

This work is based on the
Grande enciclopedia dell'Antiquariato
in collaboration with *Sotheby's, London*

We wish to thank Jonathan Meyer of Sotheby's Institute, London,
for his help with the preparation of the English translation on
furniture of the 19th century, and Elisabeth Darby, Raymond Notley
and Adriana Turpin of Sotheby's Institute, London, for their expert
advice and editorial assistance.

EVERGREEN is an imprint of
Benedikt Taschen Verlag GmbH

English translation by J. Bainbridge's Editorial and
Translation Services, Poulton, Gloucestershire (pp. 14–319);
Isabel Varea, London (pp. 322–455);
Simon Knight, Bishop's Stortford (pp. 456–605);
George Giles Watson, Udine (pp. 606–769)
Edited by Yvonne Havertz, Cologne

Printed in Hungary
ISBN 3–8228–6517–6

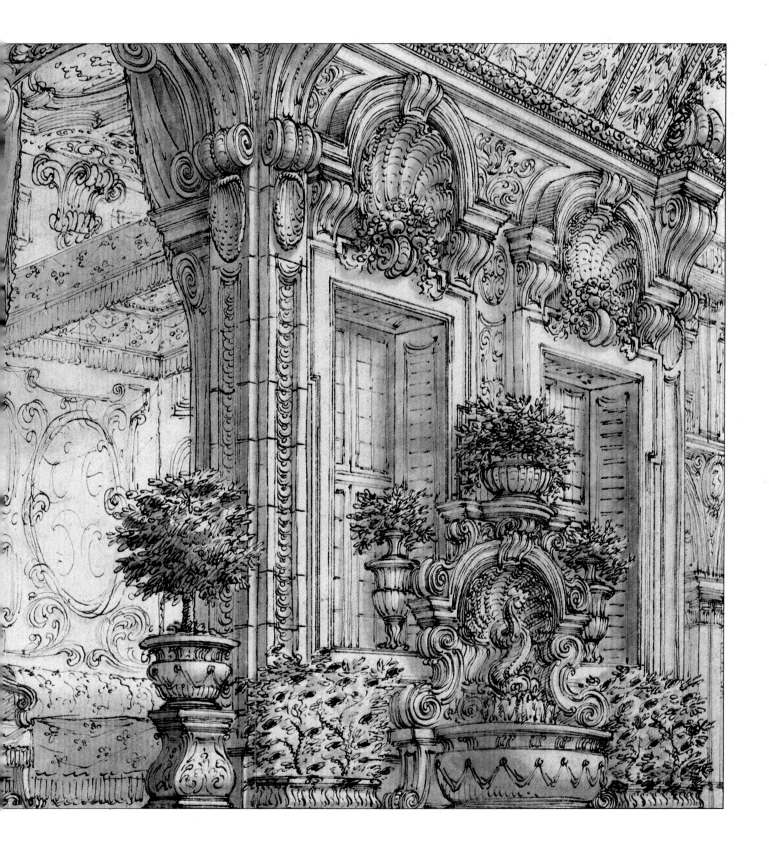

Contents

FURNITURE OF THE 18TH CENTURY

Contents

Furniture of the 19th Century

OTHER EUROPEAN
COUNTRIES
by Massimo Griffo

INTERIORS
by Gianni Carlo Sciolla

Contents

Furniture of the 20th Century

Art Nouveau
by Ornella Selvafolta

ART DECO
by Ornella Selvafolta

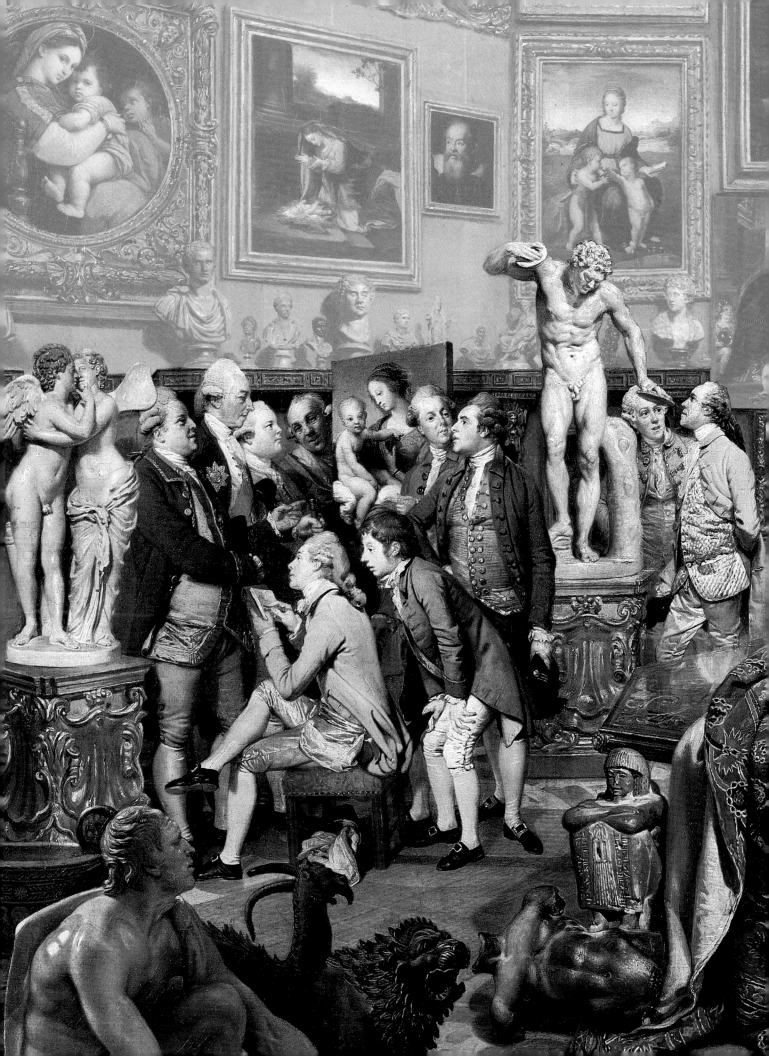

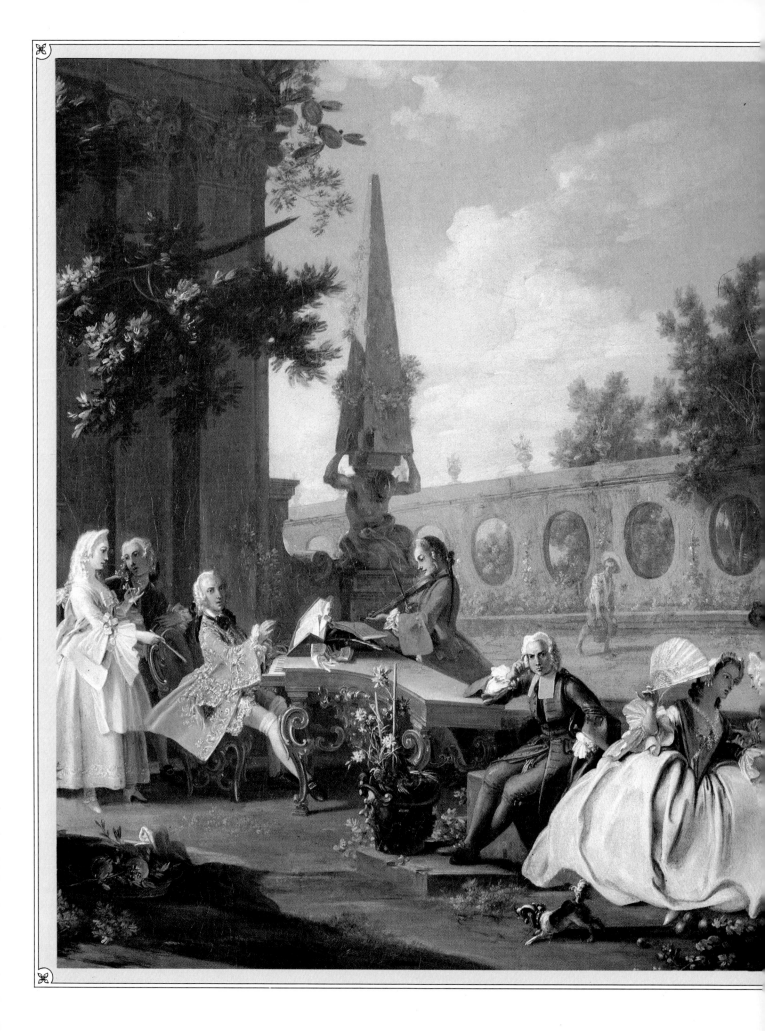

FURNITURE OF THE 18TH CENTURY

ITALY

by Andrea Disertori and
Anna Maria Necchi Disertori

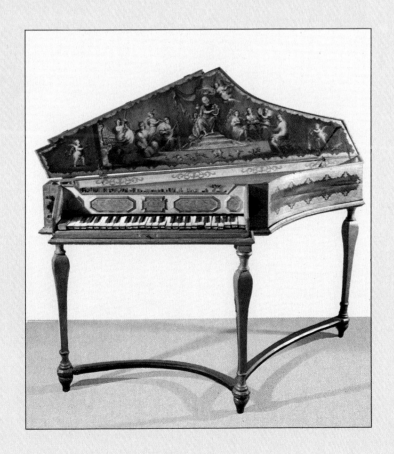

Italian furniture of the 18th century

The origins of Rococo

The 18th century is like an arch spanning the void between the pillars of the ancient and modern worlds. It begins at the height of the "absolutism" of Louis XIV and the aristocracy and ends with the French Revolution and the triumph of the bourgeoisie. Taken as a whole it is a century marked by continual political upheaval and enormous cultural and creative vitality.

During the first decades of the 18th century, the creative ebullience of the Baroque began to fade. Forms became more cumbersome as attempts to achieve ever greater splendour became empty show. When the Sun King died in 1715, his court seemed to reject the atmosphere of grandiose severity that he had imposed in favour of a pursuit of unrestrained luxury, in a more liberal cultural climate in which art and science became subjects of discussion.

As the state's economy grew stronger, so too did the interest of the Regent, Philippe d'Orléans, and his successors Louis XV and Madame de Pompadour in such enlightened thinkers as Diderot, D'Alembert and Helvetius, and they did not conceal their preference for elegance in both fashion and the design and comfort of their apartments. No longer did Europe look to Florence or Rome as capitals of the visual arts, taste and fashion but instead turned to Versailles, where, in the Regency years and later under Louis XV, culture based on Horatian aesthetics began to develop into a new lifestyle.

Giovan Mario Crescimbeni (1663–1728), first keeper of the Arcadian Academy in Rome

(1690), stated in *Bellezza della Volgare Poesia* (1700): "A good poet combines the useful with the sweet." The tendency during the century was in fact to reject the idea of art as something weighty and imposing and instead perceive it as an expression of lightness and delicacy. Contemporary expressions such as *style moderne, style nouveau* or *nouvelle manière* were used to describe this newly emerging artistic manner which the later Neoclassical period derogatorily classified as Rococo. The *Diction-naire* of the Académie française states: "Rococo se dit trivialement du genre d'ornement, de style et de dessin qui appartient à l'école de Louis XV et du commencement de Louis XVI." Reference is made to the work of the *rocailleurs,* who from the end of the 16th century decorated grottoes and fountains in French gardens with *rocailles,* decorative conceits made with stones, small rocks and shell incrustations.

Early 19th-century academics treated both Baroque and Rococo styles with the dismissive attitude expressed by Italian art critic Francesco Milizia in the *Dizionario delle Belle Arti del Disegno* (1787): "the superlative of the bizarre, an excess of the ridiculous". It is impossible to consider Rococo style and ignore the Baroque. Leading art critics like Jacob Burckhardt and August Schmarsow believed Rococo to be the decadent last gasp of the Baroque itself, a notion opposed by the American Sidney Fiske Kimball who, in *The Creation of Rococo* (1943), considered the Rococo style to be creatively

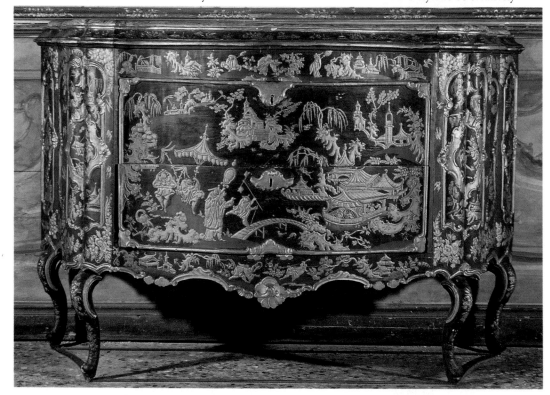

Venetian commode (c. 1750) carved and lacquered with *chinoiseries* and floral compositions in gold relief, within *rocaille* cartouches, detail opposite. Ca' Rezzonico, Venice.
PRECEDING PAGES: detail of the painting *Garden Entertainment,* by the 18th century Neapolitan painter Filippo Falciatore; and a spinet (1735) in pine and walnut, the interior with an allegory of music. Institute of Arts, Detroit, and Musei del Castello Sforzesco, Milan.

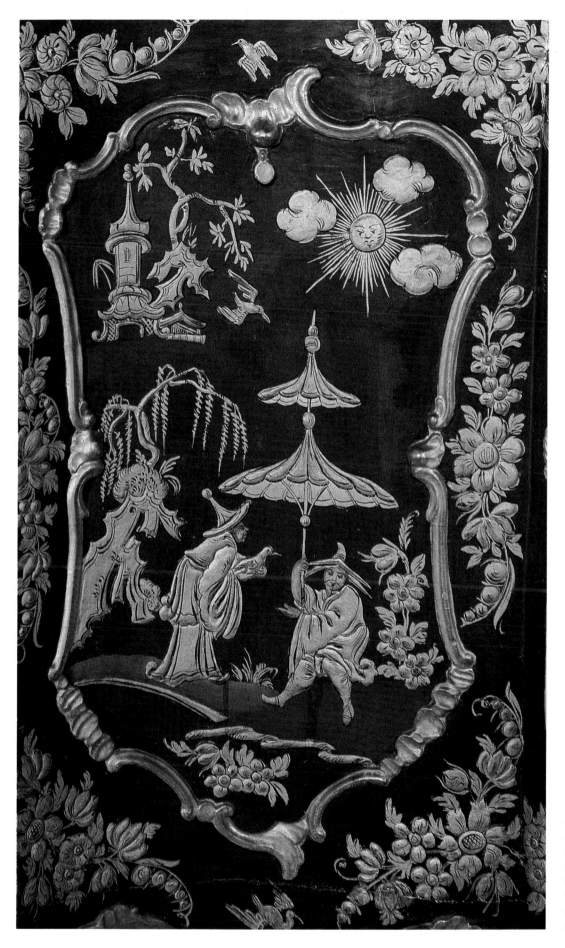

independent of both the Baroque style which came before it and the Neoclassicism which followed it. A less convincing view is that of Gottfried Semper, who believed the origins of Rococo were linked with the discovery of the secret of Chinese porcelain in 1708 by the German chemist Johann Friedrich Böttger.

The first signs of the Rococo were already discernible in Louis XIV's France. Engraver and interior decorator Jean Bérain the Elder (1637–1711) framed tableaux and theatrical sets with contours that were indented with delicate and fanciful decoration. Similar sinuous lines were favoured by Pierre Lepautre (1648–1744), another engraver and interior decorator who worked with the architect Jules Hardouin-Mansart (1646–1708) in the royal workshops. He was to inspire Gilles Marie Oppenordt (1672–1742), chief architect to Philippe d' Orléans, whose designs engraved by Jacques-Gabriel Huquier (1695–1772), along with those of Juste-Aurèle Meissonnier (1695–1750), would diffuse this style throughout Europe.

In an albeit cursory and sweeping attempt to compare the architectural and decorative aspects of the Baroque and Rococo styles, we may note in the former a desire to explore spatial values with clear-cut volumetric statements and strong sculptural contrasts and contrasts of light and shade, in both exterior and interior decoration; whereas the latter is characterized by a predilection for less movemented exterior surfaces highlighted by two-dimensional decorative motifs, while the decorative effect in the interiors – the architect's responsibility – is achieved through the

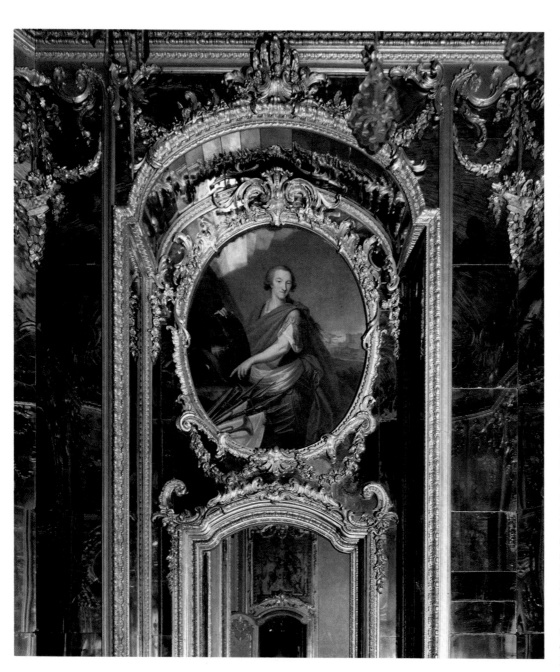

The Rococo in Italy

By the 18th century, Italy had finally lost its status as cultural leader and arbiter of taste. Rococo in Italy, also called *barocchetto*, which appeared quite late in comparison with other countries in central Europe, was essentially influenced by the style of Louis XV (1722–74) but also, in part, by the preceding Régence period (1715–22). The influence of Italy's heavy Spanish heritage delayed the introduction of the French *nouvelle manière,* especially in those regions that had developed more grandiose architecture and interiors during the Baroque period.

In the aristocratic palaces of the time, grand but somewhat austere reception rooms were only occasionally thrown open for parties and official occasions, while domestic life, even in noble households, remained frugal. Families lived in small, scantily furnished rooms, using makeshift areas and mezzanines. During the 18th century, these small apartments were improved and refurbished and turned into comfortable and elegant spaces, including accommodation for guests, a new breed of gentleman for whom luxury and comfort was paramount at all times of the day.

This was the century that took pleasure in conversation and enjoyed showing off its culture. It heralded the birth of drawing rooms large and small, parlours and rooms specially for music, games and reading. The introduction of the *boudoir* and the delicacy and gracefulness of furniture took particular account of the requirements of female lives. Following the French example of *bagatelles, sans-soucis, ermitages,*

application of stucco and the use of delicately carved *boiseries,* reflections in mirrors and delicate colour schemes, dominated by the use of white with subtle pastel shades in combination with gold detailing. Also, architects in the Rococo period tended to lavish particular care on the layout of individual rooms, proportioning each one in accordance with its specific function and blending architecture, decorative paintwork and the use of the minor arts into a unique and perfect whole.

THIS PAGE: detail of the decoration (c. 1760) by Benedetto Alfieri (1700–67) from the *Salotto Ottagonale* in the Palazzo Isnardi di Caroglio in Turin. The chief civil architect of the court of Savoy was inspired by the French Rococo style and used large mirrors to complete the opulent ornamentation of the walls, made of stuccoed, painted, carved and gilded panelling.

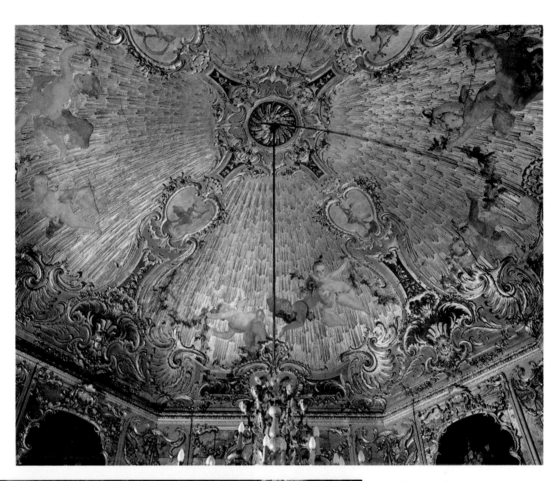

– frivolous but graceful terms evocative of a thoroughly 18th-century architectural genre comprising small and graceful buildings where the aristocratic classes lived out superficial Arcadian lives far removed from reality, Italian parks and gardens, too, began to fill up with *casini,* small lodges decorated in a pretty and dainty manner. In the 18th century, contemporaneously with the large royal palaces at Caserta and Stupinigi and other princely dwellings, mansions of more modest proportions were built by the minor aristocracy and the well-to-do bourgeoisie. Their smaller size made it important to subdivide and exploit fully their smaller internal spaces and to furnish them elegantly but more informally than during the Baroque period.

These new requirements for living gave birth to a new type of furniture. Certain types of Renaissance and Baroque styles completely disappeared, making

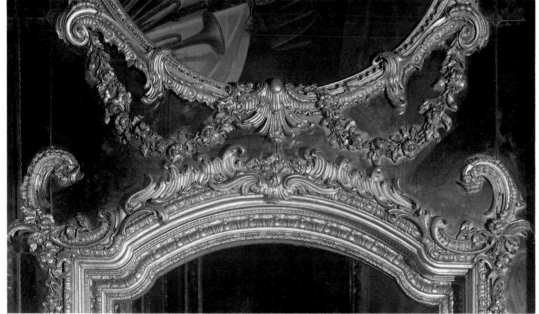

way for more graceful shapes. As Nino Barbantini (*Scritti d'arte,* 1932) pertinently observed: "There were two main reasons for the look and style of 18th-century furniture. First, there was a determination to ensure that each item fulfilled its practical function of giving maximum comfort, while the visual and structural design of the piece was often inspired by its usefulness and practicality: with comfortable sofas and armchairs, slender tables, which took up little space and were easily movable, and bureau-cabinets designed in such a way as to be used simultaneously as writing desk, chest of drawers and bookshelves. Second, there was the desire that each item of furniture should be

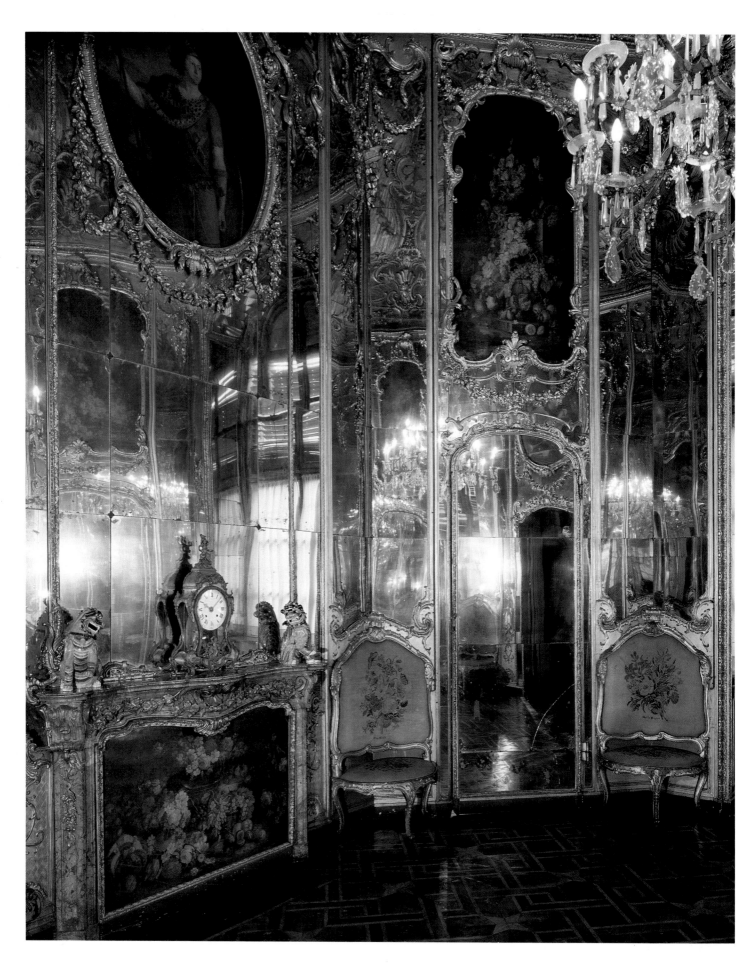

beautiful not only in the order and proportion of its component parts and in its sculpted and applied decoration but also, and more especially, in the modulation of its forms, the modelling of its surfaces and compact unity of the parts within the whole, where the combined sculptural and light and shade effects prevail over the tangible reality of the construction."

The new styles

Among the great variety of styles and shapes that characterized Rococo furnishings there were some decorative and structural features in common. Asymmetrical ornamentation, which was rare in the late Baroque period, was a constant theme of the Rococo. Ornamental decoration became less imposing, and masks, putti, grotesques, caryatids and acanthus leaves sculpted in the round were replaced by more graceful subjects such as flowers, rosebuds, garlands and the ubiquitous scallop-shell that were carved in less pronounced relief. The stocky supports and stretchers of monumental Baroque tables and chairs, with legs which were either columnar, spiralled or carved with animal-shapes, became slim and graceful S-shaped cabriole legs, just strong enough to support the light and dainty Rococo furniture. Stretchers joining the supports continued to be used only during the brief Regency transition period and were then discarded.

The main visible sign of the 18th-century pursuit of greater comfort was in the shape of chairs. Chairs called *chaises meublantes* or *chaises à la reine*

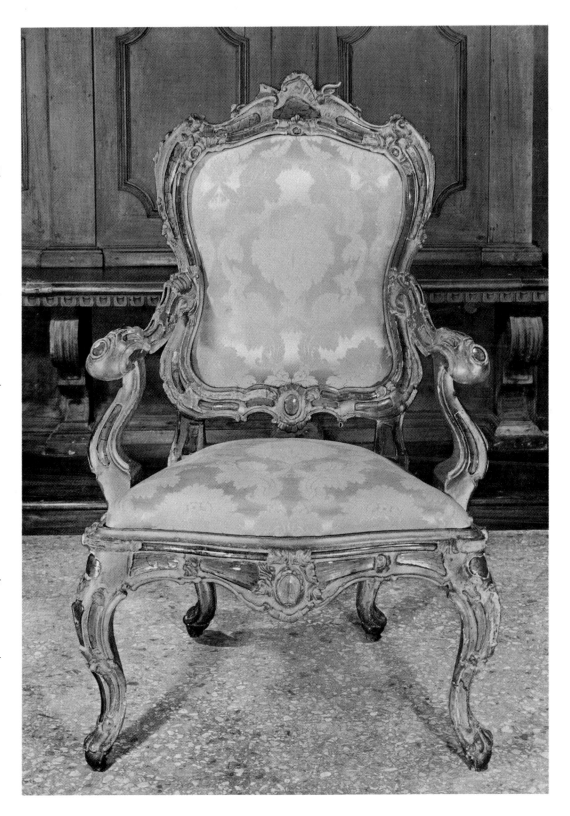

The delicacy and grace of Rococo furniture

A new style was developing in Paris, fuelled by a desire for a more relaxed and gayer life, which influenced the decoration and style of interiors. The ponderous, austere and, until that moment, heavy decoration of the Baroque was rejected in favour of lightness, sinuosity of line and delicate carvings in shallow relief. While rooms were decorated with delicate stucco-work and pale panelling, gilding and mirrors, Rococo furniture reduced its dimensions, assumed elegant flowing lines, softened its corners, curved its supports, arms and outlines; its surfaces were graced with carved decorations of scrolls, cartouches, latticework and flowers, in an imaginative profusion of new designs. Corner cupboards, night tables, centre tables, dressing tables, games tables, different kinds of writing table and desk found their place beside traditional furniture, while chairs and sofas took into account the shape of the human body with a new consideration for the comfort of the sitter. Carved furniture was still *de rigeur* in formal drawing rooms but it was accompanied by pieces inlaid with exotic woods and lacquered pieces. The Rococo style, which reached its greatest popularity between 1730 and 1750, was adopted in all the regions of Italy but displayed distinctly different regional features. In Lombardy, for example, furniture tended to have more severe lines; in Piedmont, with craftsmen like Luigi Prinotto and Pietro Piffetti, decoration was more ornate; in Genoa, quatrefoil motifs decorated the front, sides and top of pieces in a skilful interplay of veneers; and finally, in Venice, furniture was whimsical and fanciful, with a use of colour that would also find echoes in Sicilian pieces.

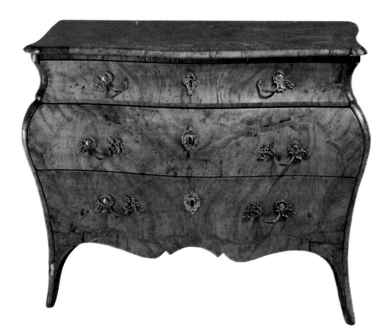

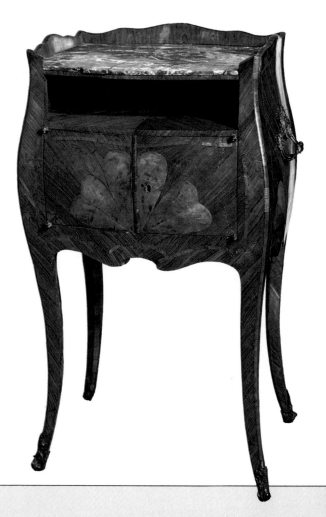

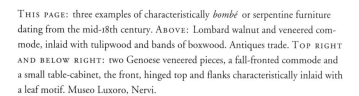

THIS PAGE: three examples of characteristically *bombé* or serpentine furniture dating from the mid-18th century. ABOVE: Lombard walnut and veneered commode, inlaid with tulipwood and bands of boxwood. Antiques trade. TOP RIGHT AND BELOW RIGHT: two Genoese veneered pieces, a fall-fronted commode and a small table-cabinet, the front, hinged top and flanks characteristically inlaid with a leaf motif. Museo Luxoro, Nervi.

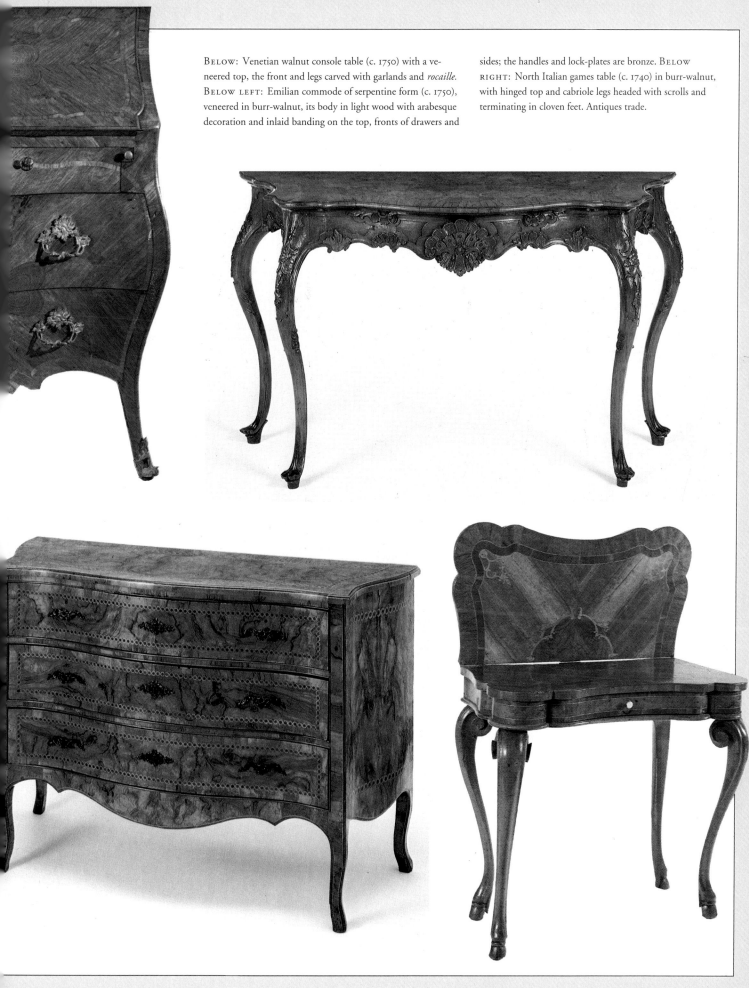

BELOW: Venetian walnut console table (c. 1750) with a veneered top, the front and legs carved with garlands and *rocaille*. BELOW LEFT: Emilian commode of serpentine form (c. 1750), veneered in burr-walnut, its body in light wood with arabesque decoration and inlaid banding on the top, fronts of drawers and sides; the handles and lock-plates are bronze. BELOW RIGHT: North Italian games table (c. 1740) in burr-walnut, with hinged top and cabriole legs headed with scrolls and terminating in cloven feet. Antiques trade.

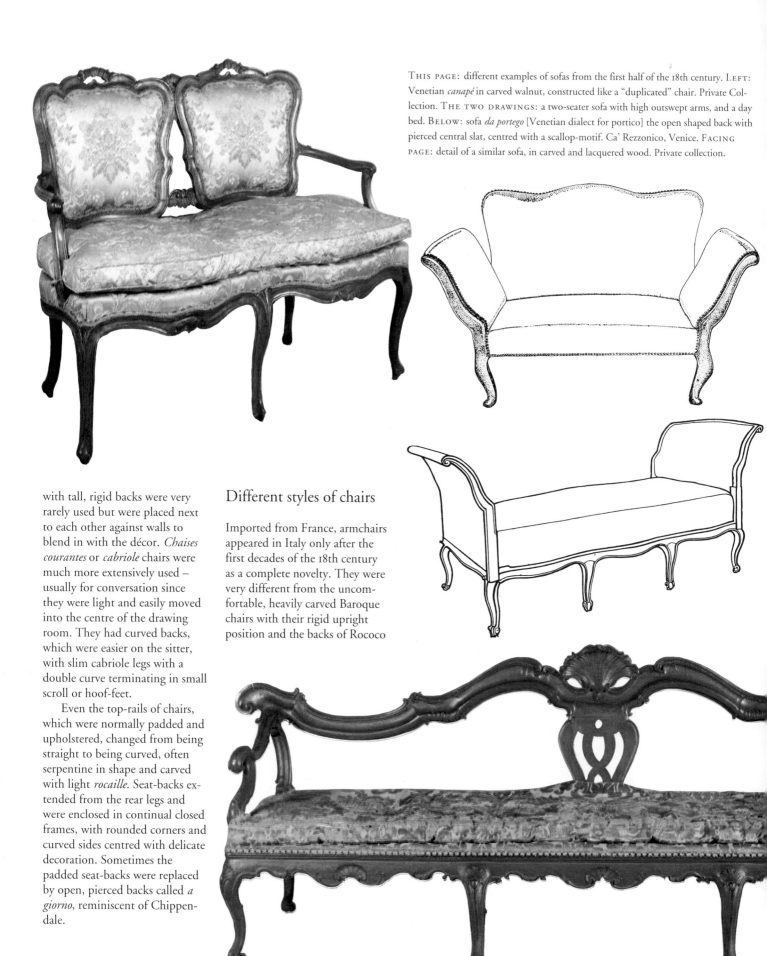

THIS PAGE: different examples of sofas from the first half of the 18th century. LEFT: Venetian *canapé* in carved walnut, constructed like a "duplicated" chair. Private Collection. THE TWO DRAWINGS: a two-seater sofa with high outswept arms, and a day bed. BELOW: sofa *da portego* [Venetian dialect for portico] the open shaped back with pierced central slat, centred with a scallop-motif. Ca' Rezzonico, Venice. FACING PAGE: detail of a similar sofa, in carved and lacquered wood. Private collection.

with tall, rigid backs were very rarely used but were placed next to each other against walls to blend in with the décor. *Chaises courantes* or *cabriole* chairs were much more extensively used – usually for conversation since they were light and easily moved into the centre of the drawing room. They had curved backs, which were easier on the sitter, with slim cabriole legs with a double curve terminating in small scroll or hoof-feet.

Even the top-rails of chairs, which were normally padded and upholstered, changed from being straight to being curved, often serpentine in shape and carved with light *rocaille*. Seat-backs extended from the rear legs and were enclosed in continual closed frames, with rounded corners and curved sides centred with delicate decoration. Sometimes the padded seat-backs were replaced by open, pierced backs called *a giorno*, reminiscent of Chippendale.

Different styles of chairs

Imported from France, armchairs appeared in Italy only after the first decades of the 18th century as a complete novelty. They were very different from the uncomfortable, heavily carved Baroque chairs with their rigid upright position and the backs of Rococo

armchairs have the same characteristics as contemporary chairs without arms, whereas the seats, often covered by a loose cushion, were lower and consequently the cabriole legs were shorter. The most common type of armchair was in carved parcel-gilt or lacquered wood, or in natural walnut with an enclosed padded or pierced back. Chair arms were set back in a curve at the front of the chair to accommodate the ladies' wide-hooped dresses. The *a pozzetto* armchair had a moulded back support continuing directly to form the arms.

The confessional chair already appeared in France in Louis XIV's reign. It had a high back with wings, which fulfilled the dual purpose of providing a head-rest and a screen for the face. This was a forerunner of the Louis XV *bergére*; because of its wings it became known in Italy as *a orecchioni*. If it had a reclining back it was known as a chair *de commodité* or *fauteuil de malade*, like the one in which Voltaire died. The *chaise longue* had a longer seat so one could

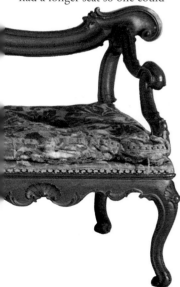

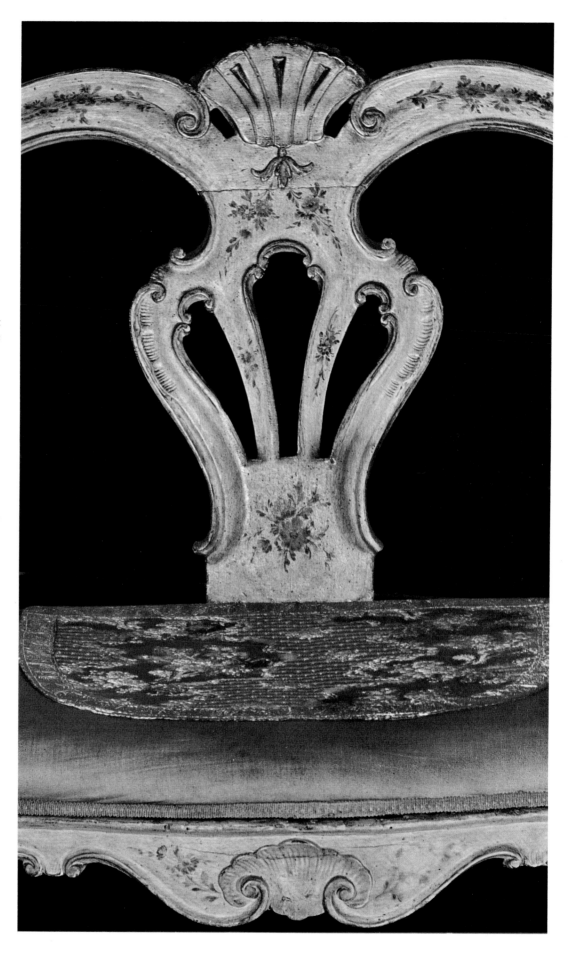

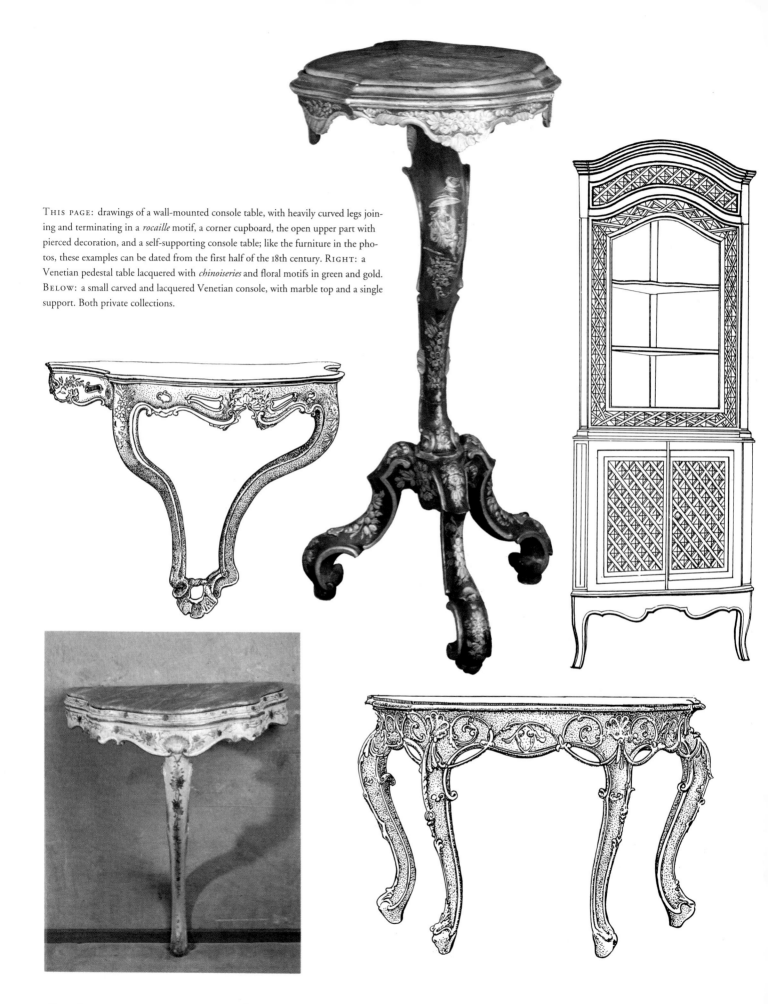

THIS PAGE: drawings of a wall-mounted console table, with heavily curved legs joining and terminating in a *rocaille* motif, a corner cupboard, the open upper part with pierced decoration, and a self-supporting console table; like the furniture in the photos, these examples can be dated from the first half of the 18th century. RIGHT: a Venetian pedestal table lacquered with *chinoiseries* and floral motifs in green and gold. BELOW: a small carved and lacquered Venetian console, with marble top and a single support. Both private collections.

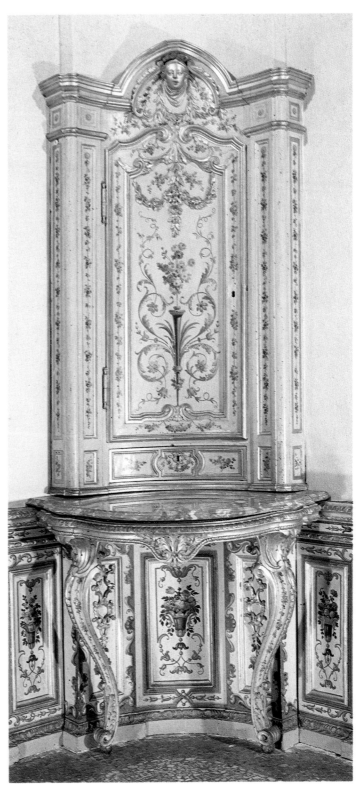

recline full-length on it; the addition of a padded stool and of a smaller chair to rest one's feet for greater comfort turned it into a *duchesse brisée.* If these three elements, however, were combined into one piece, then the *chaise longue* became known as a *duchesse.* A purely French invention was the *marquise,* also enclosed like the *a pozzetto* armchair but large enough to seat two people. There would often be a loose cushion upholstered in the same fabric. The *voyeuse* had a padded elbow rest on the top rail to allow standing spectators to follow a card game. There were office chairs, toilet chairs and *siéges percées,* also known as commodes, with apertures beneath. Placed as a pair on either side of a fireplace, *veilleuses* had only one armrest, which was a continuation of the padded back.

The sofa followed a similar evolution to the armchair, appearing beside it in the drawing rooms of the 18th century. Generally its shape was similar to that of the various types of armchair,

merely being bigger in order to provide more seats. In Italy the first examples of sofas were to be found at the end of the 17th century. They had vertical backs with arms supported by the extensions of turned front legs and joined by stretchers. Distinguishing features were the lightly padded upholstery of the seat, back and arms.

Rococo sofas and *canapés* underwent a complete transformation, the legs dispensing with strechers and becoming slimmer and curved. Six legs were used on two-seater sofas, eight on three-seater versions. The most usual model had down-scrolled arms, and the padded backs were often subdivided into cartouche-shaped sections corresponding with the number of seats. Where seat-backs were pierced in the English manner, they were not divided. With the fan-shaped sofa *(a ventaglio),* whose name derived from the shape of its padded back, the arms were scrolled outwards. The two-seater sofa *à corbeille* had the same features as the armchair *a pozzetto.*

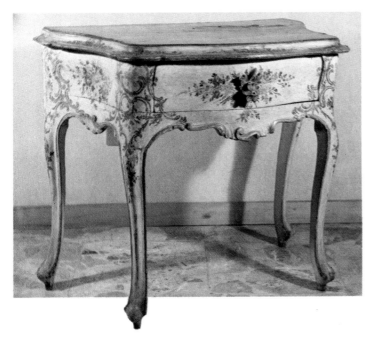

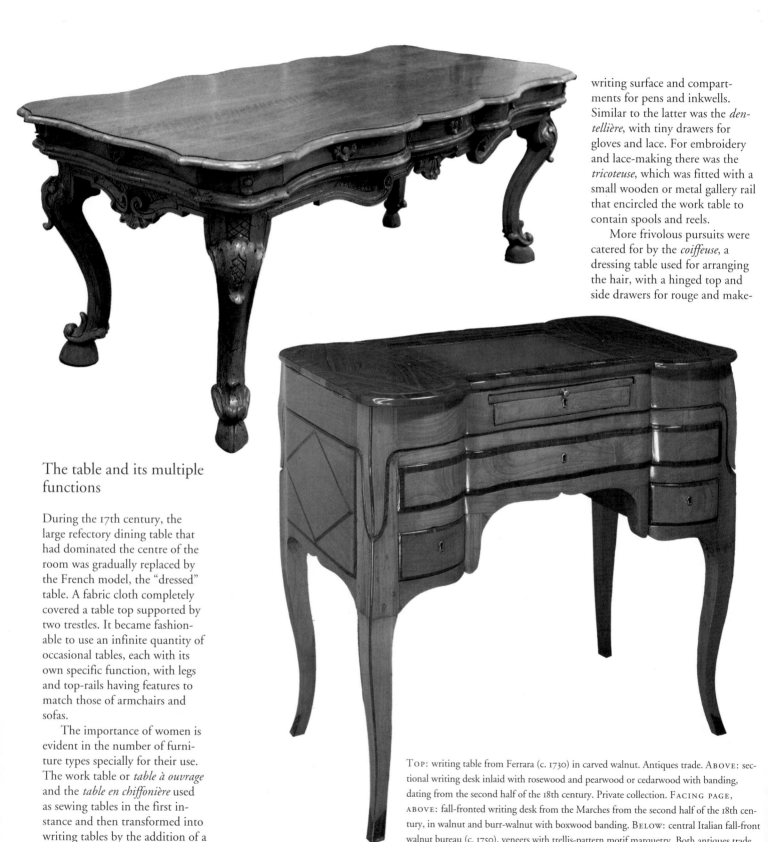

writing surface and compartments for pens and inkwells. Similar to the latter was the *dentellière*, with tiny drawers for gloves and lace. For embroidery and lace-making there was the *tricoteuse*, which was fitted with a small wooden or metal gallery rail that encircled the work table to contain spools and reels.

More frivolous pursuits were catered for by the *coiffeuse*, a dressing table used for arranging the hair, with a hinged top and side drawers for rouge and make-

The table and its multiple functions

During the 17th century, the large refectory dining table that had dominated the centre of the room was gradually replaced by the French model, the "dressed" table. A fabric cloth completely covered a table top supported by two trestles. It became fashionable to use an infinite quantity of occasional tables, each with its own specific function, with legs and top-rails having features to match those of armchairs and sofas.

The importance of women is evident in the number of furniture types specially for their use. The work table or *table à ouvrage* and the *table en chiffonière* used as sewing tables in the first instance and then transformed into writing tables by the addition of a

TOP: writing table from Ferrara (c. 1730) in carved walnut. Antiques trade. ABOVE: sectional writing desk inlaid with rosewood and pearwood or cedarwood with banding, dating from the second half of the 18th century. Private collection. FACING PAGE, ABOVE: fall-fronted writing desk from the Marches from the second half of the 18th century, in walnut and burr-walnut with boxwood banding. BELOW: central Italian fall-front walnut bureau (c. 1750), veneers with trellis-pattern motif marquetry. Both antiques trade.

up, and the *poudreuse* used for powdering wigs and faces. The top was divided into three compartments, the central panel having a hinged lid enclosing a mirror that was flanked by two hinged outer flaps, which opened outwards to reveal shelves fitted for toiletries.

The *bonheur-du-jour* was another small, predominantly feminine piece of furniture with a writing surface and a little cabinet of shelves and pigeon holes above. Another small table light enough to be lifted with one hand was the *guéridon* table or *servidor*, i.e. a dumb waiter. Its generally tripod base supported a slender curved column or pedestal surmounted by a shaped tray on which could be placed any small items such as gloves, fans or snuffboxes. Similar to the *guéridon,* the *table-servante* had two or more overlapping leaves for serving coffee or hot chocolate. The same function was served by the *table à cabaret,* or tray table, whose top was formed by a removable tray.

The night table or *table de chevet* makes its appearance in the bedroom and was a miniature replica of the commode. In the 18th century, besides a love of gossip there was a passion for gambling. To indulge this pastime numerous styles of convertible gaming tables were made. One of the most popular was the "book table", so-called because the table top was divided into two rectangular panels folded like a book, which opened out to form a square top. Table tops were often inlaid with boards for chess and draughts.

The *bureau plat*, or flat-topped writing table, was the forerunner of the writing desk

proper, though it was rectangular and had grander proportions. The writing surface was of tooled leather and beneath it were parallel drawers. In some examples leaves could be pulled out laterally for books, enabling two people to read at the same time.

After many transformations, the console table, which appeared towards the end of the 17th century, became very important in the 18th. Barbantini writes: "In order to appreciate this we need only compare the Roman console table – which was heavily carved with foliage and embossed with sculpted figures in the round and could not disguise its basic framework as that of the large rectangular refectory table on four massive supports – with a Venetian console table of fifty years later, all sensuous curves, poised daintily on slender legs." While the tops of centre tables were typically undulated and carved with *rocailles*, with console tables the side placed against the wall was absolutely straight. The latter could have two, three or four legs connected by supporting stretchers and a central decoration. Console tables with mirrors above blended with the panelling and became integral parts of the design of the interior walls.

The Rococo bed

In the late 17th century the most popular types of beds in Italy made full use of fine locally produced textiles. Sides and headboards were completely upholstered in brocade and damask with applied decoration. The same drapery was used for the sumptuous rectangular canopy, which was supported from the

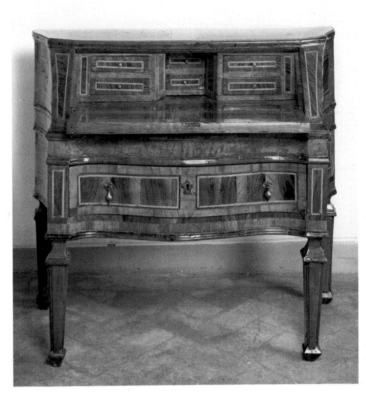

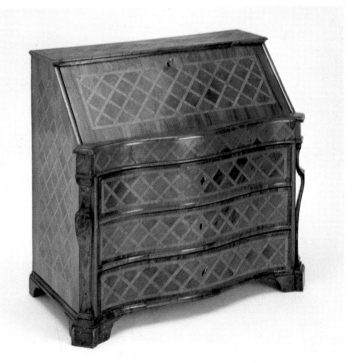

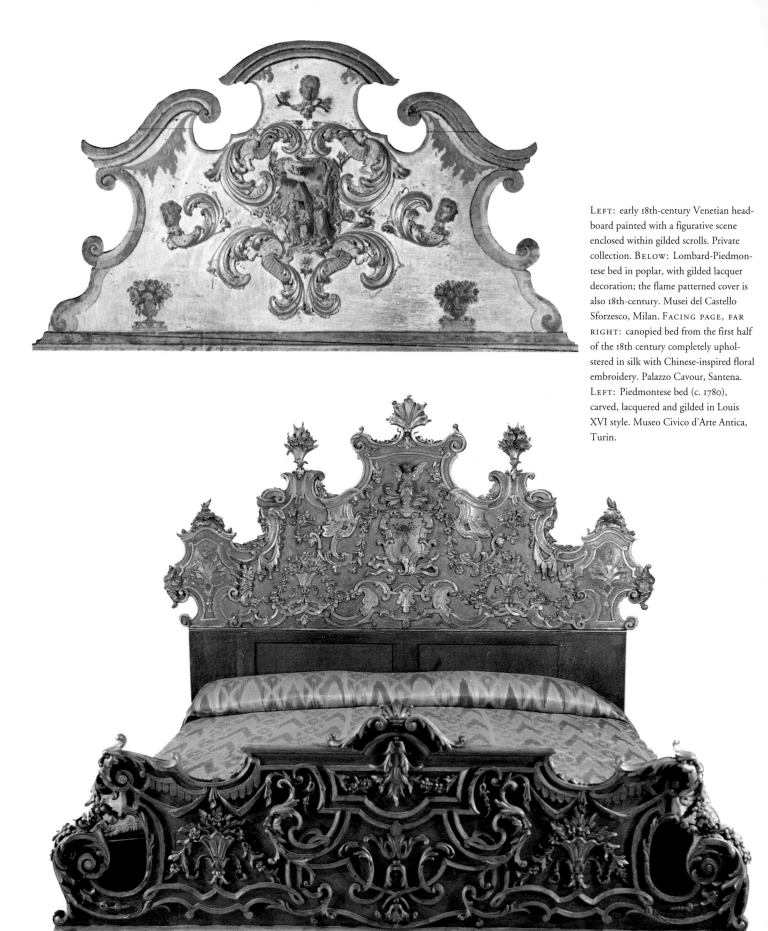

LEFT: early 18th-century Venetian head-board painted with a figurative scene enclosed within gilded scrolls. Private collection. BELOW: Lombard-Piedmontese bed in poplar, with gilded lacquer decoration; the flame patterned cover is also 18th-century. Musei del Castello Sforzesco, Milan. FACING PAGE, FAR RIGHT: canopied bed from the first half of the 18th century completely upholstered in silk with Chinese-inspired floral embroidery. Palazzo Cavour, Santena. LEFT: Piedmontese bed (c. 1780), carved, lacquered and gilded in Louis XVI style. Museo Civico d'Arte Antica, Turin.

wall or ceiling and extended the entire length of the bed, and from which fell the fabric hangings that enclosed it. No wooden part was visible, and the upholsterer's art completely replaced that of the cabinet-maker and the carver. The late Baroque period saw the introduction of the *lit d'ange,* or angel bed, which had a shorter canopy often forming the shape of a dome. These models would remain in use throughout the 18th century, alongside newer types. While the Baroque bed was completely swathed in drapery, the Rococo type used fabric on padded headboards, enclosed in a fancifully carved gilt-wood or lacquer frame. The headboards

recalled the lines of the "fan-shaped" sofas. The circular or oval canopy of the angel bed was often held by four curved iron supports at the four corners of the bed and covered by hangings, instead of being supported from the ceiling. It became fashionable to place the bed with one side against the wall *à la polonaise,* instead of the head-board being against the wall *à la française.* The whole concept behind Rococo furnishings was the harmonious relationship between furniture and its practical setting, as illustrated by the fashion of fitting a bed into its own alcove or niche in the wall.

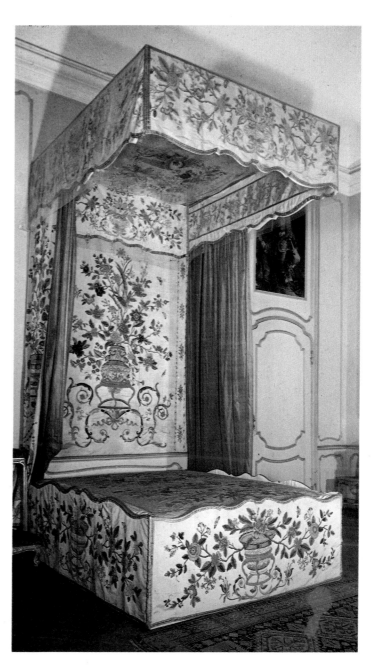

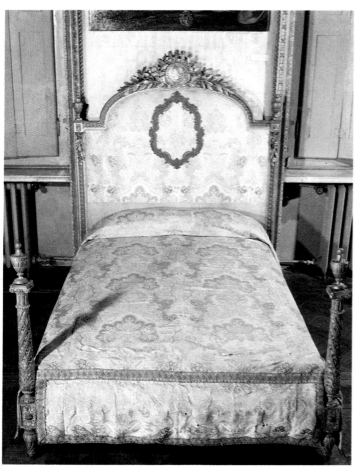

Commodes and corner cupboards

The structure of a monumental Baroque chest of drawers or commode must be interpreted with an architectural key. The front, flanked by two vertical pilasters

or caryatids, was defined above by a moulded frieze supporting the top, which displayed the divisions between the drawers. The spirit of the Rococo commode was diametrically opposed to that of its Baroque predecessor. It gradually shook off the structural

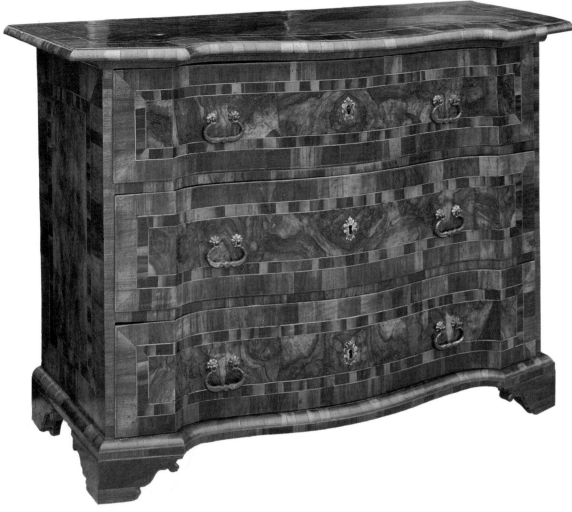

of the new style of writing desk and was replaced as the most imposing piece of furniture in a room by the multi-purpose *trumeau* or bureau-cabinet. This was the only large piece of furniture to be found during the Rococo period, and it consisted of two separate pieces with differing functions placed one above the other. The lower part was usually a writing desk, consisting of drawers, generally three, and a bureau section, with a sloping writing flap behind which were enclosed small drawers and secret compartments. The upper part was shallower, with shelves intended for china, glass or books. This section could be open-fronted or could have two doors with painted or inlaid panels, a bevelled mirror or clear glass. Given the weight of the piece, it needed to be supported on feet that were sturdier than the slender versions so typical of the period. Vertical pieces such as these achieved their carved *rocaille* effect by the curved moulding of the crests and pediments.

The bureau without an upper portion was a simpler piece of furniture with a more specific function. A central flap opened out between the drawers to create a knee-hole recess for the writer. In more delicate versions, beneath the *à dos d'âne* (ogee-shaped) flap there would be a single drawer supported by four long curved legs.

In the quest for usefulness and the practical organization of space in 18th-century interiors, certain areas were turned into closets and linen rooms, and wardrobes were built out from the walls and disguised by wall-coverings and panelling. The large Baroque *armoire* thus be-

constraints of its constituent parts. The commode's body stretched, contracted and swelled in a perfect equilibrium of curves and hollows, giving the impression of a single fusion within a mould rather than a piece constructed from separate components. The wood seemed modelled as a malleable material rather than hewn, carved and fitted together. Rococo pieces were smaller than their Baroque counterparts, the line of their generally curved legs being the continuation of the line of the corners formed by the intersection of the front and the side panels. Sometimes the front was convex with straight sides, sometimes the entire piece was

bombé on all sides. If the commode had two drawers, the legs were longer. If there were more than two drawers, then the piece seemed heavier and the legs were shorter.

In 18th-century interiors, the ideal of perfect harmony between furniture and decoration, upholstery, stucco, panelling and mirrors was achieved not solely by the actual arrangement of the furniture itself but often by the creation of *en suite* pieces. Often a wall would have a commode in the centre with two small side cabinets placed in the corners of the room. These corner cupboards would be a one- or two-door cupboard on a triangular

base supported by two or three legs. Earlier versions would have an upper section of shelving which gradually sloped nearer the top and was entirely independent of its base. In later versions this section was no longer included.

From the cabinet to the *trumeau*

One of the pieces of furniture that lost its appeal halfway through the 18th century was the tall Baroque cabinet with a hinged lid in the upper section concealing drawers and pigeon holes. It was made redundant as a writing table by the appearance

came superfluous and was confined to the servants quarters and used as a linen cupboard. However, simpler examples of *armoires* were to be found in more modest homes. They were rather rustic and linear in shape, sometimes made of walnut but more often of untreated softwood. Their slightly wavy pedestals and the rather timid curved decoration on the doors revealed their Rococo origins.

Neoclassicism

The end of the Rococo period is usually considered to coincide with the death of Louis XV (1774). However, as with all artistic periods, there was always a transition period where old and new ideas co-existed, and by the 1760s, Neoclassicism had emerged as a fully developed style, while early signs of Neoclassical influence were already present during the Rococo period. Interest in classical art, which appeared with varying intensity at different historical times, was more scientific in character in the 18th century as its foundations had been laid by the ideas of the Enlightenment. In 1711 the first excavations at Herculaneum began, with those on the Palatine Hill in Rome following between 1720 and 1727, and at the Hadrian's Villa at Tivoli between 1724 and 1742. The ruins at Herculaneum were discovered in 1738 and those in Pompeii in 1749. On-the-spot *vedute* (views) of Greek and Roman monuments by artists like Richard Dalton, James Stuart, Nicholas Revett and Piranesi fuelled the growing interest in classical art. The two series of

etchings by Giovanni Battista Piranesi (1720–78) entitled *Diverse maniere d'adornare i camini ed ogni altra parte degli edifici* (1769) and *Vasi, candelabri, cippi, sarcophagi, tripodi, lucerne ed ornamenti antichi* (1768–78) became style handbooks providing inspiration for the decorative arts. Madame de Pompadour herself, and later Madame Dubarry, who were both inspirational muses of Rococo taste, also favoured the new *goût grec,* as the return to antiquity was called in France.

The emergence of Neoclassicism was possibly the result of cultural changes, but people were also beginning to tire of the graceful but by now rather sugary

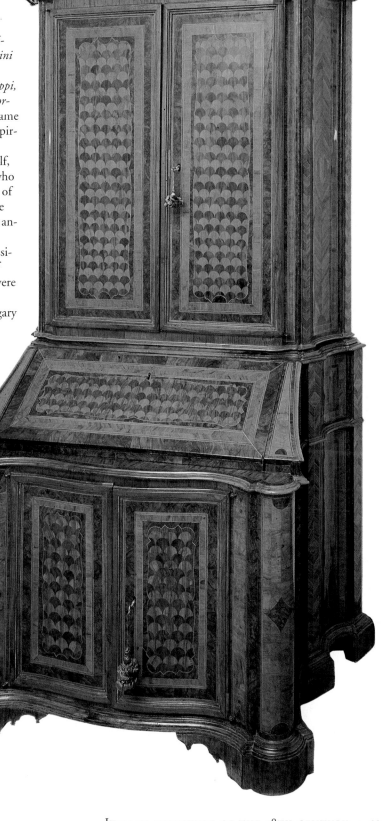

Rococo taste. One cannot rule out the possibility that the new aesthetic approach to interior decoration may also have provided a pretext for the newly formed court of Louis XVI to assert itself. The Marquis de Marigny, Madame de Pompadour's brother, was replaced as superintendent of the *beaux arts* by the Comte d'Angivillier. However, while Louis XV participated vigorously in the artistic trends that flourished during his reign, the same could not be said for his nephew Louis XVI, who seemed entirely insensible to aesthetic considerations of any kind and certainly to the style that took his name. The very most

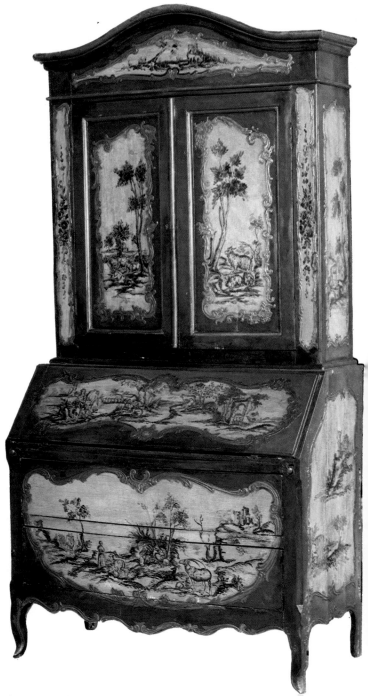

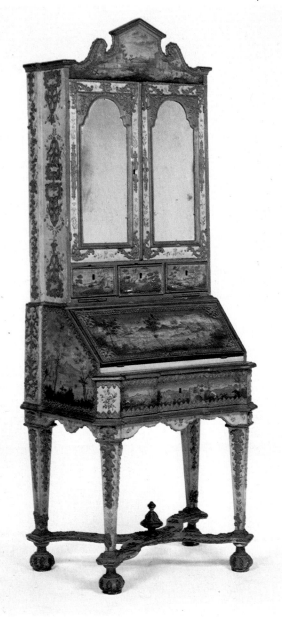

that captured his attention was the mechanical furniture created for the court by Jean-Henri Riesener (1734–1806), a German cabinet-maker working in Paris.

Just as the Louis XV style had inspired the Italian Rococo, so again the stylistic changes that were taking place in France were felt in Italy. Valentino Brosio defines as Louis XVI style all Italian furniture between 1775 and 1795, and reserves the term "Neoclassical" for the successive Directoire, Empire and Restauration periods. Giuseppe Morazzoni, however, after pointing out various differences between the French and Italian styles, defines early Neoclassicism as the style that was developed in Italy during the time of Louis XVI.

Typologies

While the transition from Baroque to Rococo had seen radical changes in the structure and function of furniture, the differences between Louis XV and Louis XVI styles were chiefly a matter of decorative and formal detail. The styles and general principles of comfort and rationality characterizing the furniture of the previous period remained unchanged.

Classical mouldings and sparing ornamentation, the use of Greek friezes, husks, beads, paterae, ovules and rosettes were in clear contrast to the last displays of Rococo decorative expressions. Legs discarded their curves in favour of tapered columns with vertical or spiral fluting, or square tapering versions on block feet, headed by a carved rosette which extended from the equally straight sides.

Most typical of the Louis XVI period were chairs, with or without arms, with circular, oval or medallion-shaped moulded backs. Also popular during this time were chairs with pierced backs, often in the shape of a lyre in the style of Hepplewhite.

Each type of armchair had its corresponding sofa, just as it had during the Rococo period. The sofas had straighter backs contained in a rectangular or ovoid frame. A new type emerged – the *méridienne* or day bed – which was to achieve great popularity during the Empire period. Day beds had no back, and their massive side arms splayed outwards with a double curve connected to the seat. The great variety of occasional tables and small pieces of feminine furniture were still evi-

dent, but Neoclassical versions were simpler and straighter with "Grecian" decorations.

One new feature towards the end of the 18th century was the round *brazier* table, derived from the Roman tripod table. The dining table came back into fashion, either oval or circular with four, six or even eight legs. These

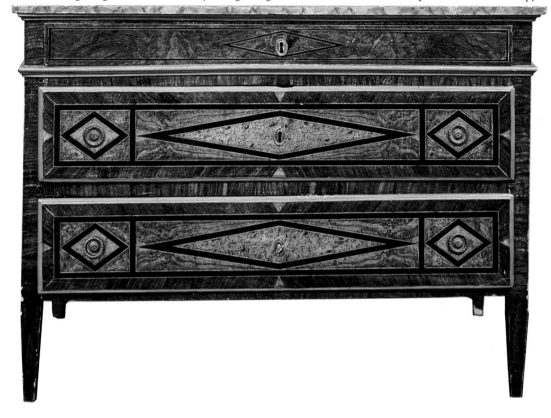

tables were still quite small but could be enlarged by the insertion of one or more leaves between the two main sections. Owing to its straighter legs and its rectangular top, the console table had the appearance of a normal side table whereas the semicircular version was new.

The item of furniture that probably underwent the greatest transformation during the Neoclassical period was the com-

mode. Curves on the sides and front were discarded and the whole piece became straight. One exception was the demilune commode, where the front and the sides merged in a single curved surface. The flat surfaces of such pieces with drawers or with doors inspired the revival of marquetry. By disregarding divisions for

drawers and compartments the craftsman executing the inlay found he had a background on which he could create real landscapes, still lifes or figurative scenes. The Lombard cabinet-maker Giuseppe Maggiolini was famous for his naturalistic compositions, while Ignazio Revelli, and his son Luigi from Vercelli were renowned for their marquetry of classical architectural perspectives.

By the end of the century, the habit of placing a bed with one side against the wall became more frequent. One example was the *lit à la polonaise* with its small canopy supported from the bed on four columns or supports, from which hung the heavy drapery. The *lit en bateau* or boat-shaped bed, with its canopy

attached to the wall, appeared around this time, and remained popular throughout the Empire period.

Although French influence on Italian furniture created certain universal common features, these emerged at different times in different regions. Existing local artistic and socio-historical traditions, along with different regional tastes, toned down the Louis XV and Louis XVI styles

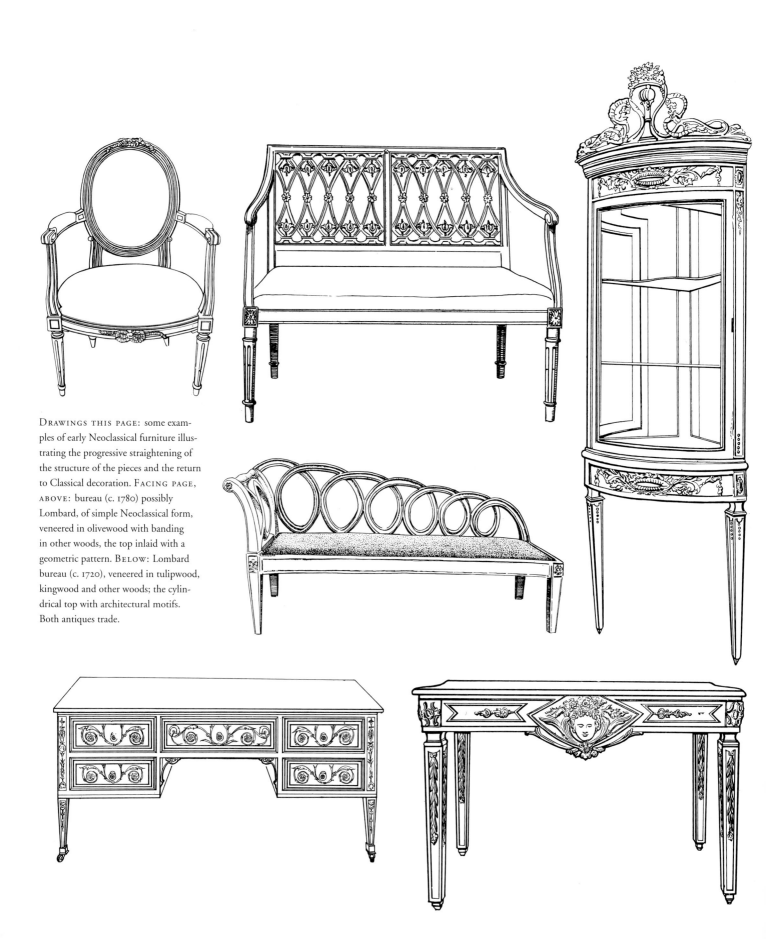

DRAWINGS THIS PAGE: some examples of early Neoclassical furniture illustrating the progressive straightening of the structure of the pieces and the return to Classical decoration. FACING PAGE, ABOVE: bureau (c. 1780) possibly Lombard, of simple Neoclassical form, veneered in olivewood with banding in other woods, the top inlaid with a geometric pattern. BELOW: Lombard bureau (c. 1720), veneered in tulipwood, kingwood and other woods; the cylindrical top with architectural motifs. Both antiques trade.

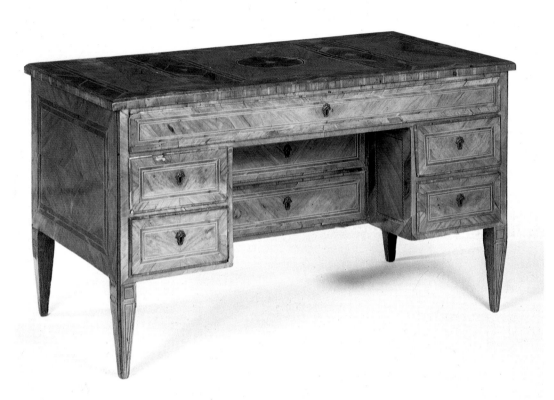

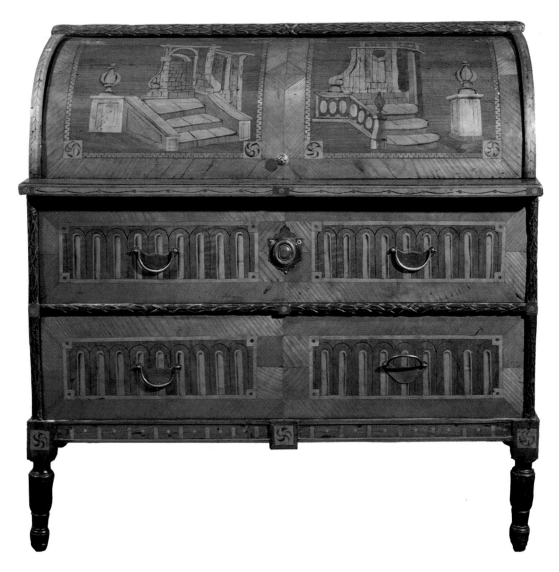

and redefined them. When attempting to define the specific nature of the output of each individual Italian city or region, it is not possible to establish a fixed pattern since there was no limit to the imagination and personality of individual artists and artisans.

In 1751 a French law made the stamping of the craftsman's name on each piece he constructed compulsory, thereby making attribution possible. On the other hand in Italy, before the Empire period, it was virtually impossible to determine the maker of a piece, and attribution could only be achieved indirectly through the discovery of a contemporary inventory or bill of sale.

The great centres of production

Turin and Piedmont

Throughout the 18th century there was a gradual increase in the pace of the movement that was to lead to the establishment of Piedmont – thanks to the political acumen shown by members of its reigning house of Savoy – as a solid, albeit small, independent state which was soon to become the arbiter of future events in Italy. Culturally, however, its proximity to France (Savoy, home of the ruling house, extended into French territory) undoubtedly influenced the court and the aristocracy.

In the 17th century the work of Guarino Guarini (1624–83) had already accustomed Turin and the other main cities of Piedmont to the Baroque style. Although in terms of urban design first Filippo Juvarra (1678–1736) and after him Benedetto Alfieri (1700–67) and Bernardo Antonio Vittore (1705–70) were clearly influenced by their French neighbours, this was tempered by the lack of ostentatiousness which was a distinguishing feature of the Piedmontese tradition.

Political stability and the subsequent economic well-being that it created made Piedmont more immediately receptive than other regions to the new ideas coming from Paris. Under Vittorio Amadeo II (1675–1730) and Carlo Emanuele III (1730–73) work was undertaken to restore the Palazzo Reale in Turin and the castles of Rivoli, Moncalieri and Venaria, and to create the jewel in the crown of Piedmontese Rococo, the hunting lodge at Stupinigi. This brought about not only a genuine need but also a keenness to design new furniture and to renew existing furnishings in the austere 17th-century palaces, along the delicate and elegant lines required by new tastes. Juvarra himself, as court architect, was not above designing furniture and furnishings that he would then integrate into his interiors.

His successor, Count Benedetto Alfieri also took great interest in interior decoration. In the Chiablese and Caroglio palaces, he and his colleagues architect and decorator Giovan Battista Borra (active 1747–1786) and cabinet-maker Francesco Bolgieri created a harmonious and imaginative marriage between architecture and interior design.

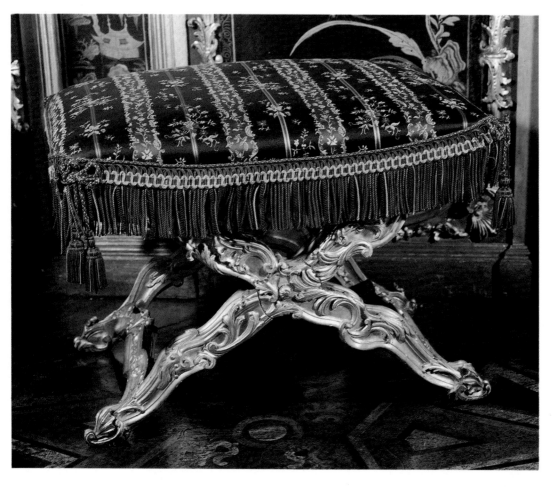

Example of a stool (c. 1740), with X-shaped legs, carved and gilded with foliate motifs from the *Gabinetto Cinese*. FACING PAGE: an interior from the Palazzo Reale in Turin, designed by Filippo Juvarra, embellished with fine Chinese lacquerwork, enclosed in carved gilt-wood frames of different shapes and incorporated into the ornate *boiserie*, illustrating one of the best examples of *rocaille* decoration. Completing the furnishing of the room are a gilt-wood side console table carved with medallions and palmettes, a centre table also in carved gilt wood but of a later date, and a sumptuous sofa, upholstered in silk like the stools.

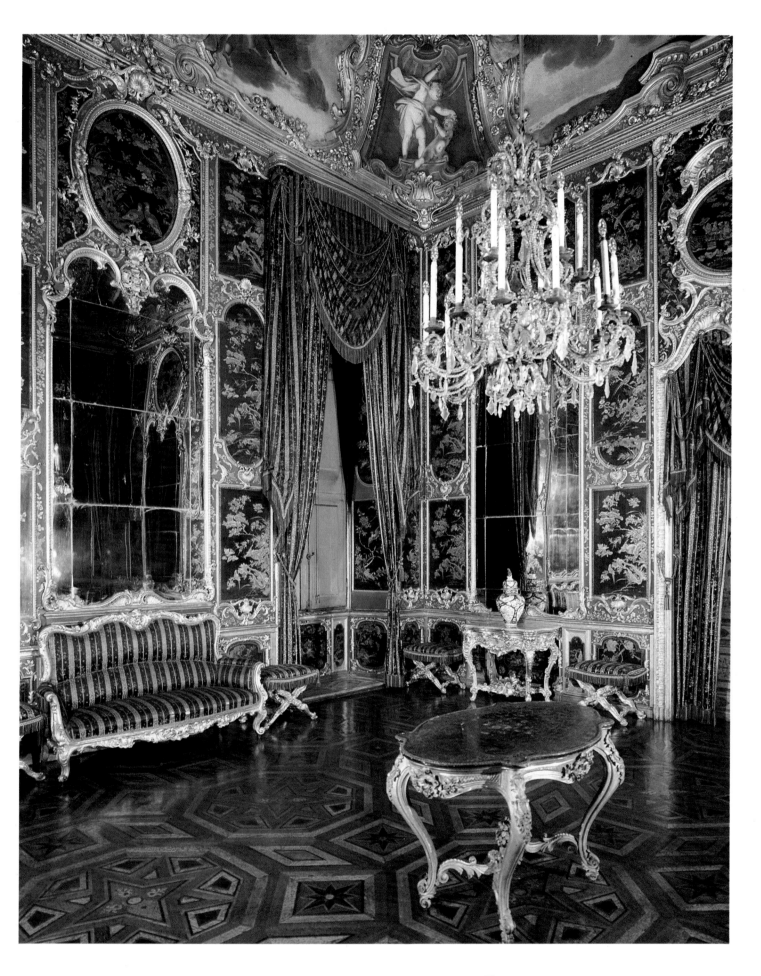

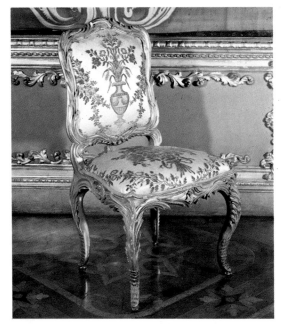

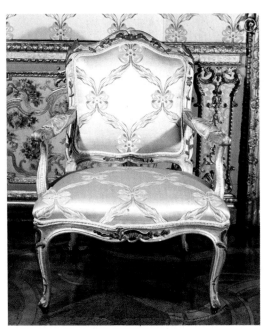

This page: examples of seat furniture from the Palazzo Reale in Turin, all dating from the mid-18th century. Left: one of twenty-four gilt-wood chairs from the dining room, carved with foliate decoration and upholstered in velvet with floral and foliate motifs. Right: arm-chair from the *Sala del Caffè* in carved gilt-wood with cartouches and lacquered foliate motifs, upholstered in silk.

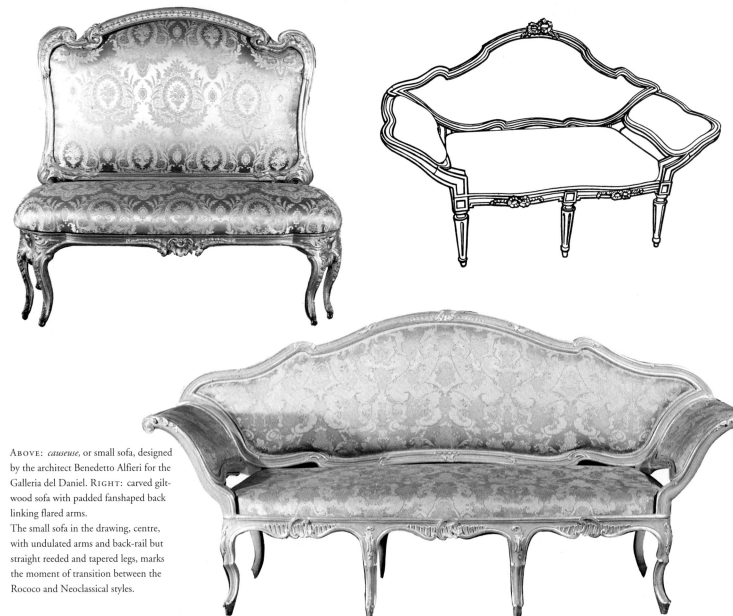

Above: *causeuse,* or small sofa, designed by the architect Benedetto Alfieri for the Galleria del Daniel. Right: carved gilt-wood sofa with padded fanshaped back linking flared arms.
The small sofa in the drawing, centre, with undulated arms and back-rail but straight reeded and tapered legs, marks the moment of transition between the Rococo and Neoclassical styles.

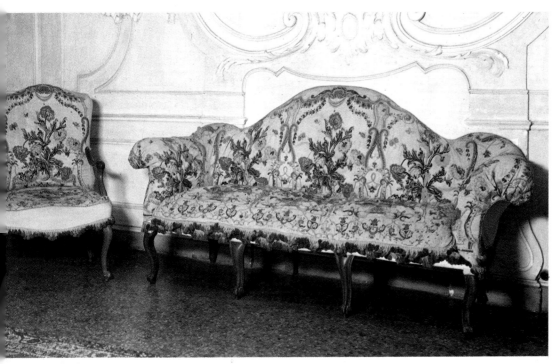

Quality craftsmanship

Piedmontese furniture was all too often incorrectly considered to be a provincial version of its French counterpart. It should not be forgotten that the design books by Juste-Aurèle Meissonnier (1695–1750), published in Paris in 1734 and considered to be the "Rococo Bible", were the work of a Piedmontese emigrant who became designer, silversmith and decorator to the court of Louis XV. Turinese craftsmanship was not only imaginative but also skilfully executed, thanks to a rigorous training programme in Turin from the Università dei Minusieri. It differed from the work of Venetian craftsmen, which was more fanciful but less precise in its finish.

Piedmontese furniture, which in the 17th century was rather ponderous in its form and decoration, became more elegant in the 18th century. The two main reasons for this change were the influence of French style and the architecture of Juvarra, who was educated in Rome during the late Baroque period. These influences were tempered by the moderation and balance of the local furniture-makers. In the 17th century Piedmontese craftsmen used natural walnut, but the 18th century saw the introduction of exotic woods. Their contrasting colours would stand out against delicate inlays, which were often embellished with sheets of tortoiseshell, mother-of-pearl or ivory, fine enough to be perfectly affixed to the multiple curves of the surface of the furniture.

In the more stately drawing rooms used for entertaining, gilded furniture was preferred, made from soft woods like poplar

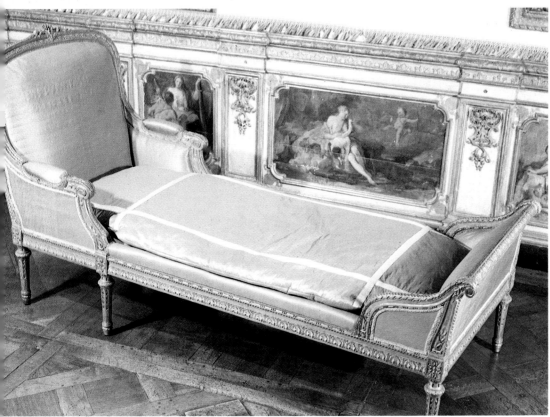

Pietro Piffetti: the controversial origins of a great cabinet-maker

The birthplace of one of the chief exponents of Italian 18th-century furniture, in terms of creative inspiration, imaginative design and technical mastery, has occasioned much debate: his use of tortoiseshell and mother-of-pearl inlay is typically Neapolitan, say advocates of a southern origin; but supporters of a Piedmontese birth maintain that such materials were much in evidence in the Kingdom of Savoy and, to back their argument, they can produce details of the census of 1705 which registered a Pietro Piffetti, four years of age, resident of the Turinese "island" of S. Maria Maddalena. But the mystery surrounding his life continues: his activity is documented in Rome in 1730, where he is thought to have learned the techniques of floral marquetry from the Parisian cabinet-maker Pierre Daneau the Younger. In Rome the high quality of his work was noticed by the remarkable talent scout the Marquess of Ormea who promptly sent him to the King of Sardinia, thereby securing Piedmont one of the most important cabinet-makers in Italy.

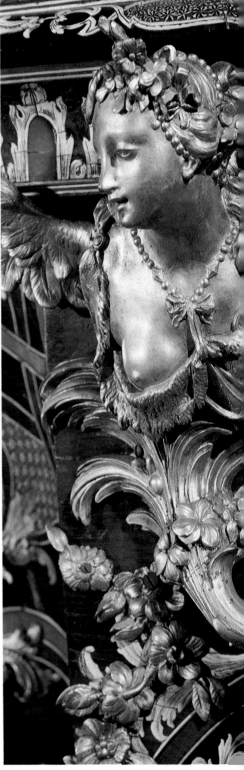

LEFT: detail of a marquetry table-top with *trompe-l'œil* playing cards by Piffetti. Museo Civico d'Arte Antica, Turin. ABOVE: details of a cabinet in two sections (1731–33) by Piffetti, veneered in Indian walnut, mother-of-pearl and ivory with ormolu mounts by Francesco Ladatte. Palazzo Reale, Turin. FACING PAGE, ABOVE: detail of a frieze of a bookcase, in the form of shelved panelling made by Piffetti in 1731 and

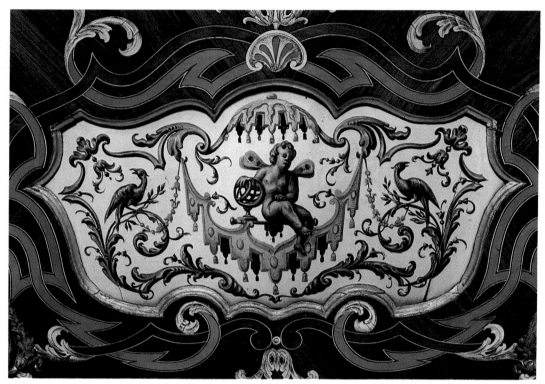

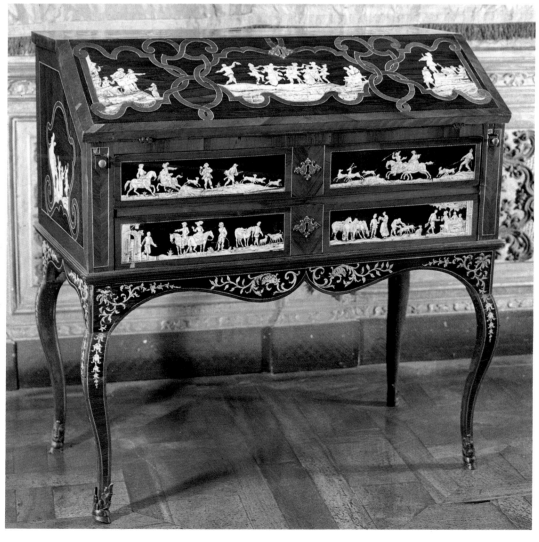

originally destined for the Palazzo Reale in Turin. Quirinal Library, Rome. BELOW: fall-front writing desk with hunting scenes in ivory, attributed to Luigi Prinotto. Museo Civico d'Arte Antica, Turin.

BELOW: Ebony and rosewood *Bureau Mazarin* by Luigi Prinotto, with a central recessed knee-hole cupboard, on eight square tapering legs, joined four-by-four by an H-shaped stretcher, in typically French Louis XIV style, with vine and palmette motifs enclosing narrative scenes inlaid in ivory, depicting the life of a young couple from their first meeting to their wedding day, based on drawings attributed to Pietro Domenico Olivero. DETAIL ABOVE: scene of a "family quarrel". Stupinigi Hunting Lodge, Turin.

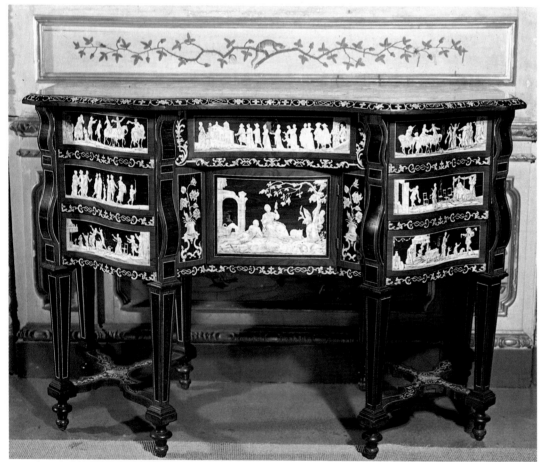

Handles, keyholes, lock-plates, sabots and *chutes*, which were mounts applied to the corners of furniture, were crafted with a skill rarely seen in other Italian regions. The undisputed master of this craft was the Turinese Francesco Ladatte (1706–87) who, on his numerous trips to Paris, not only acquired these skills but was even able to compete with French master craftsmen.

Rococo examples

Piedmontese Rococo chairs had typically shaped legs but with only quite moderate curves terminating in hoof feet or sabots. Grander seating was totally or partially gilded, whereas chairs for everyday use were left in natural wood. Armchairs followed French shape and design, but the shape of sofas was more original. These were upholstered and had very wide swept arms flanking a fan-shaped back. Models with pierced and gilded backs did not lose any decorative richness by the use of unnecessarily heavy lines.

During the first half of the 18th century the gently serpentine front and the moulded tops of commodes, with three drawers and hoof feet, revealed the Rococo spirit of these pieces. Towards the second half of the century two-drawer versions usually had lengthened supports and achieved a greater delicacy. The first half of the century also saw the great success of a version with just a slight swell to the front and with flat sides, in the style of Piffetti. However, these types of commode were enriched by inlays of fine woods, ivory, tortoiseshell,

or lime. In less formal rooms the use of gilding was confined to highlighting the pale shades of the lacquers. Lacquered furniture in Piedmont was less fanciful than in Venice but was more carefully worked. Delicate floral decoration would alternate on

pale cream or light-blue grounds with raised gilt gesso motifs.

Interest in *chinoiseries* penetrated the ideas of even the most sombre Piedmontese craftsman. Examples of this genre were used by Juvarra for the study in the Palazzo Reale in Turin, where

authentic black and red oriental lacquer was highlighted in gold.

A natural connection between French and Piedmontese furniture of the highest quality was the presence of gilt bronze mounts, which were applied to the fronts and sides of pieces.

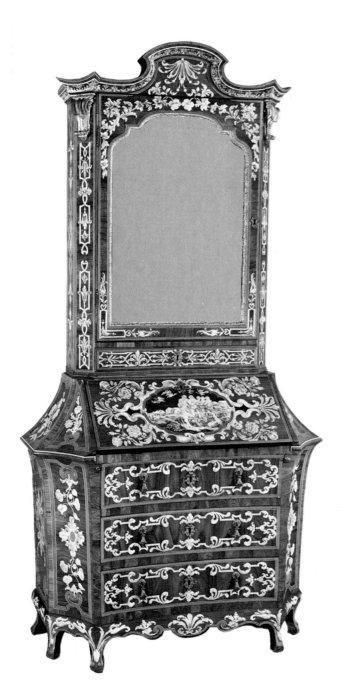

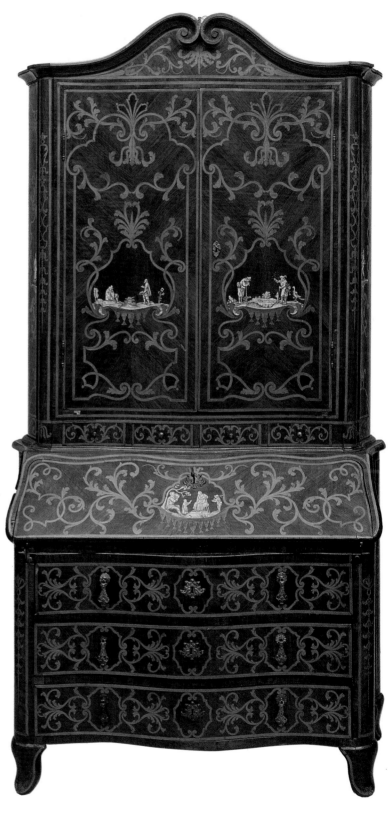

ABOVE: Piedmontese bureau-cabinet (c. 1735) of the Piffetti school, with ivory marquetry on a background of kingwood and rosewood, the fall-front centred with a large cartouche enclosing a scene depicting Noah's Ark. Stupingi Hunting Lodge, Turin. RIGHT: 18th-century fall-fronted bureau-cabinet, Piedmontese, veneered in walnut with marquetry of fruitwoods and ivory. Antiques trade.

Piedmontese walnut credenza, its small raised superstructure with four drawers, early 18th century; the panels on the doors are carved in a spider-web motif, while the medley of lines carved on the drawers recalls, albeit with more curving outline and a reduced overhang, typical 17th-century Piedmontese decoration. Private collection.

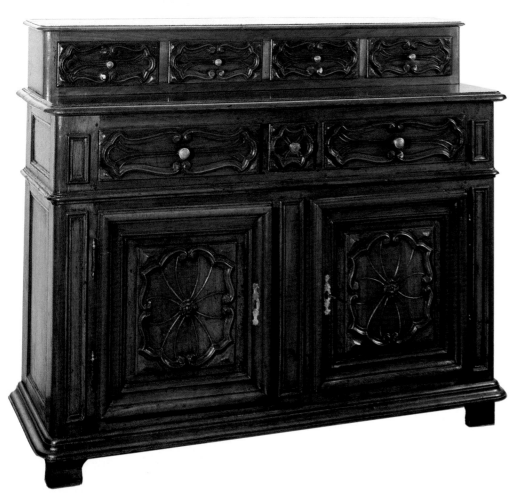

mother-of-pearl and bone, with no need for the addition of any metals.

Less important and provincial commodes continued to be made in walnut, which was coated with a layer of oil, with carved or inlaid decoration. In these, one still encounters the 18th century in full bloom, as they bore the typical panel within a carved frame that in previous centuries, thanks to differences expressed in the central motif, had characterized the various regions of Piedmont. However, the silhouette of these panels now took on a more pronounced sinuosity, while the whole was carved in much lighter

relief and decoration tended increasingly towards *rocaille*. The most interesting examples of pieces made in two parts were small writing tables whose upper section, intended for books with either doors or open shelves, seemed quite detached from the hinged flap beneath, to which it would be linked by a double-scrolled *rocaille*.

Court cabinet-makers

Through the demands for royal commissions, Piedmont became an area of production of prestigious pieces for the court, which

made cabinet-makers like Piffetti and Prinotto famous.

Pietro Piffetti was cabinet-maker to the royal household from July 1731. He was probably born in Piedmont about 1700 but was brought up in Rome, and it was from this Roman background that the craftsman, who for forty years worked for the House of Savoy, drew his incredible decorative exuberance. Although he respected French examples, he was able to impose his own personal imprint on his work. To veneer his pieces, he only used exotic woods, and in his early period he used the black of ebony as his base colour. In

later years, however, he preferred the warmer tones of burr-walnut and rosewood, against which he created marquetery of amazing technical virtuosity which with one single motif covered completely, almost obsessively, the entire surface of the piece of furniture. Hunting scenes, landscapes and dancing figures emerged from a network of ribbons, garlands, flower-heads and leaves inlaid in ivory, bone and mother-of-pearl. Often these decorations were completed by keyholes, gilt leg covers, handles and bronze mounts made by Francesco Ladatte and Giovanni Venosta.

Apart from a brief period in Rome a little before 1750, Piffetti's activities were centred almost exclusively in Turin, where he made an incredible number of high quality pieces: *prie-dieus*, cabinets, bookcases and medal cabinets of vast proportions, numerous commodes, footstools and various smaller objects like frames and mirrors, clock cases and even 24 spittoons for the castle of Moncalieri. Piffetti's most important pieces are easily datable, as he would often insert the date in the inlaid cartouche that would bear his signature and sometimes the destination of the piece.

Though Luigi Prinotto's date of birth is uncertain, he was definitely working in Turin between 1722 and 1733. Nothing is known of his formative years, but the first pieces he created for the House of Savoy revealed his maturity and his amazing skills in the techniques of marquetery. Showing less imagination than Piffetti, his over-decorative style never went as far as to traduce his furniture designs, which were

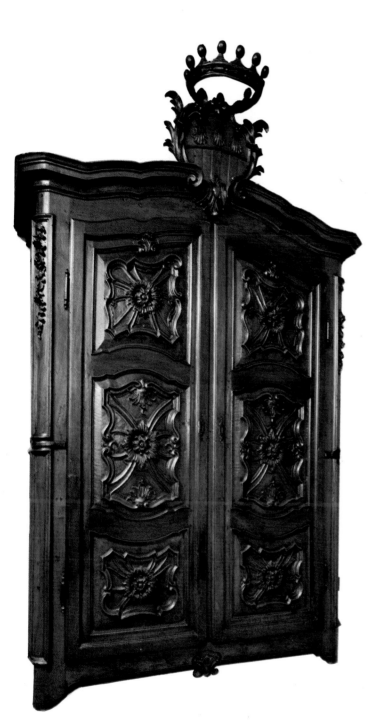

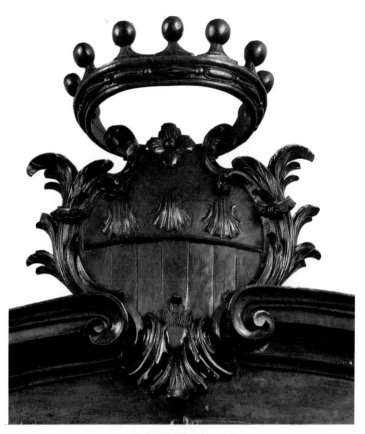

Carved walnut cupboard, made in Turin in 1729, the top centred with the crest of the counts of Cavour (detail top right). RIGHT: the typically Rococo carving of the panels is attributed to the circle of Filippo Juvarra. Private collection.

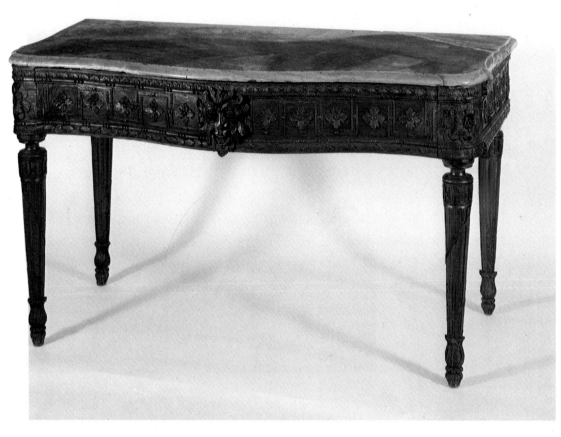

Neoclassical style

Ever alert to changes of taste in Versailles, Turin embraced Neoclassicism early but re-elaborated it. The taste for the antique, relieved of the "burden" of archeology, retained some traces of Rococo frivolity; and Greek friezes and carved gesso beading against Rococo-inspired cream, pale green and blue lacquered grounds would soon replace *rocaille* carving.

A typical Piedmontese feature for the sofa was the medallion motif, which would be positioned in the centre of the seatback. More popular in Piedmont than in any other region was the

initially inspired by Louis XIV but subsequently evolved into the more curving and delicate shapes of the Rococo, like the "hunting desk" in Turin (Museo Civico d'Arte Antica) or the desk with scenes from the siege of Turin (Palazzo Reale, Turin). By his use of marquetry, with exotic materials, mother-of-pearl, ivory and brass banding, he achieved chromatic harmony, and his decorations always seemed in proportion with the surface space. For his figurative scenes, enclosed within oval or multilinear cartouches, he often used drawings by the artist Pietro Domenico Oliviero (1679–1755) or Francesco Beaumont (1694–1766). His decorations of entwined leaves and branches, of flowers and latticework were more personal. Like Piffetti, Prinotto worked under the supervision of Juvarra, who seemed to know how to use their individual talents to the full.

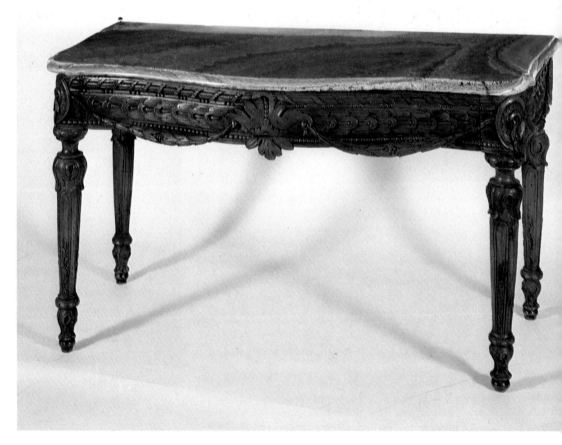

FACING PAGE: two Piedmontese console tables (c. 1780), in carved walnut with ala-
baster tops, which reflect the French style of Louis XVI in their fluted tapering legs on
spindle feet and the classical decorations on the frieze with medallions, rosettes, gar-
lands and laurel leaves. THIS PAGE, BELOW: oval Genoese table (c. 1750), in carved
walnut sculpted and highlighted in gold, the undulated frieze beneath the top merging
with the six cabriole legs joined by a similar X-shaped stretcher centred with a carved
cabbage-shaped finial. Both antiques trade.

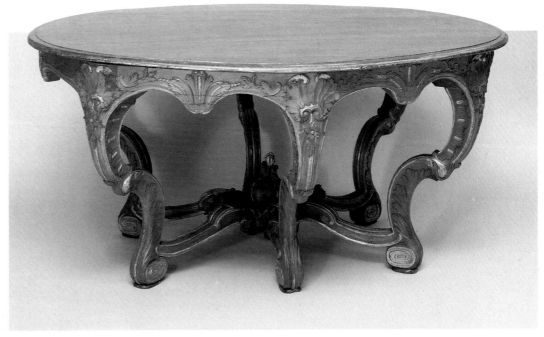

demilune commode, which was embellished with veneers of precious woods and inlay. By disregarding the subdivisions for drawers and compartments, figurative scenes or geometric marquetery could be freely developed.

The flat surfaces of the Neo-classical style inspired cabinet-makers like Ignazio Revelli (1756–1836) and his son Luigi (1776–1856) to create real "mar-quetry paintings" of landscapes, scenic ruins and architectural per-spectives, taken from their own drawings, or, more frequently, from watercolours or prints of notable artists of the time such as Piranesi. Revelli's efforts, similar to Giuseppe Maggiolini's (1738–1814) in Lombardy, repre-sented a period of transition from Louis XVI to the 19th century.

Just as Pietro Piffetti was the chief exponent of the Piedmon-tese Rococo style, so Giuseppe Maria Bonzanigo (1745–1820), of-ficial wood carver and designer to the crown, played an important role in defining the Louis XVI style in Piedmont. Nevertheless, his classicism was expressed in the clarity of his furniture's archi-tectural structure, enhanced by the rich decorative apparel with its *al antica* motifs. His skill and precision in carving placed him squarely in line with the expres-sive vocabulary of the next century.

Genoa and Liguria

A particularly lively cultural cli-mate characterized 18th-century Genoa. The wealthy middle classes aspired to positions in the higher echelons of the magistra-ture and, in attempts to compete with the aristocracy, flaunted their elegance and remained alert to all the artistic and cultural cur-rents of the times. Between 1650 and 1790, the Strada Nuova (now Via Garibaldi) and Nuovissima (now Via Balbi) and the two river banks were full of palaces and vil-las built by the notable Genoese families such as the Dorias, the Brignoles and the Sales. The furnishings and interiors of the Palazzo Ducale were also re-stored. Relations with France, which had been quite tense at the end of the 17th century after the city fell to Louis XIV in 1684, be-gan to normalize. The city was still effectively under French pat-ronage, and so diplomatic and cultural exchanges with Versailles continued and were frequent throughout the century.

One should not underesti-mate the influence of Francesco Maria Barzone in the propaga-tion of French taste in Genoa. Barzone was nominated *peintre ordinaire du roi* by Louis XIV, and was given the task of taking Ligurian marble to Versailles. The revocation of the Edict of Nantes (1685) by Louis XIV, which had caused an exodus from France of groups of Protestant craftsmen, further encouraged contact. Among these émigrés were a great number of cabinet-makers who chose to go to Liguria where they had previ-ously worked. For this reason late 17th-century and 18th-cen-tury Genoese furniture greatly resembled the French style and, as in France itself, the Genoese preferred exotic woods like kingwood, tulipwood, rosewood and Indian walnut, which thanks to maritime trade were easily obtainable, along with local Ligurian woods such as walnut, oak, bay oak, olive and cherry.

Bancalari, carvers and decorators

Genoese furniture was known for being technically very skil-fully made and finished to the smallest detail, by the *bancalari*. This precision of execution meant that pieces from Liguria were often thought to be French or even English. The figure of the *bancalaro* or Ligurian cabi-net-maker was similar in terms of serious preparation to that of the Piedmontese *minusiere*. In order to protect this heritage, Genoese patricians formed the Accademia Ligustica in 1751, where technical and formal in-struction was entrusted to the most important artists of the time such as Agostino Ratti (1699–1755) and Andrea Taglia-ficchi (1729–1811).

The technical and creative skills of the Genoese cabinet-makers is apparent in veneered chests, bureaux and writing desks. To obtain colour shading, different sheets of exotic wood veneer would be applied in a herringbone pattern, which created the background for the recurrent quatrefoil motif often found on the fronts and sides of Ligurian furniture, and which

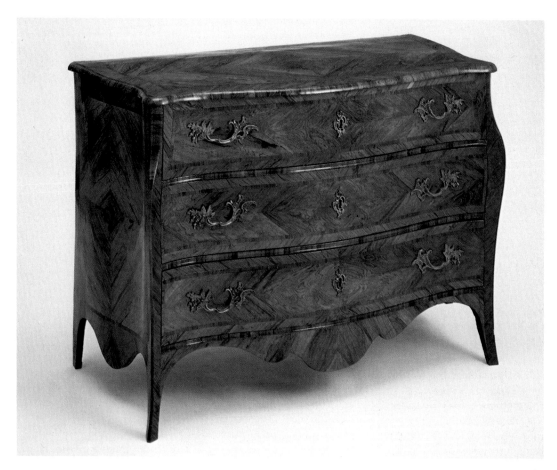

furniture, destined for seaside villas and women's drawing rooms, was made in soft woods with the same precision as marquetry pieces. The most dominant decorative features were flowers, either on their own or in small sprigs, which stood out in pale but vivid colours. The same brightness was re-echoed in fruit and bird motifs, while the classic intense Genoese blue found in Savona ceramics was used for small monochrome views.

There was no shortage of exotic subject matter, however. Pagodas and mandarins were given a home-spun treatment. In this type of Genoese furniture the use of lacquer was different from that used in Venice. In Genoa only a few layers of varnish (not like the fifteen layers used in Venice) protected the base, painted in tempera; if the surfaces seemed less smooth, the decorations nonetheless appeared less crystallized.

allowed the tone of each different colour to stand out.

Although they were used sparingly, finely carved ormolu mounts reflected French taste and required significant technical skill to produce. For the tops of commodes, different types of marble were used: Spanish breccia, green Valpolcevera, Alpine green and peach-coloured marble.

In the field of furnishings the wood sculptor took his place alongside the cabinet-maker, creating elaborately carved pieces which still reflected traces of Baroque sumptuousness through the gracefulness of the Rococo styles.

To add further delicacy to their carving, skilled gilders would apply a very fine layer of gesso and glue; an applied thin sheet of gold would then be lightly burnished to prevent it being too vulgar and bright. The Ligurian woodcarver, sculptor and painter was no mere craftsman but an artist of ancient and continually renewed tradition, with exponents as such Filippo Parodi (1630–1702), Domenico Parodi, Anton Maria Maragliano (1644–1749), Bernardo Schiaffino (1678–1725), il Navone and Lorenzo de Ferrari (1680–1744).

The passion for lacquered furniture did not hit Genoa until well into the 18th century. This

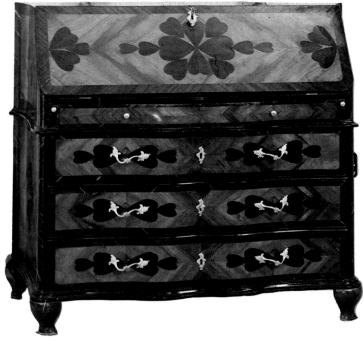

Typologies

Elegance and sobriety connected the Genoese Rococo chair, with its barely curved, quite high back, to its Piedmontese counterpart. Equally restrained, and of clear French inspiration, was the commode, whose three drawers, the shallower one beneath the top, formed one body with no subdivisions. The use of ormolu decoration was sparing, and used most on the *scussà,* or apron, with a *rocaille* motif in the centre of the shaped lower section; on small sabots, with scrolled or foliate decoration adorning the feet; on handles carved with scrolls and indentation; and sometimes on the corners, in the form of cascades of garlands. In the bureau-cabinet, constructed as case furniture, the curved top was almost always gently curved, with no apex, and only occasionally interrupted in the middle by a restrained carved gilt decoration in the form of an urn or a shell.

The first signs of Neoclassicism, which in Genoa perhaps appeared sooner than in other cities, could be linked to the presence in 1776 of the French architect Charles de Wailly (1729–98), who, in collaboration with the Ligurian Andrea Tagliaficchi, was employed to restore the Palazzo Spinola. One year later, the fire at the Palazzo Ducale led to the total renovation of all the interiors and furnishings, which Marcello Durazzo, Doge from 1767 to 1769, in partnership with the supervisor of the restoration work, Simone Cantoni (or Cantone, 1736–1818), steered towards the new classical taste of Louis XVI. The more serious and formal nature of this style was enthusiastically received in Liguria where severe classical lines were reworked to give gentler shapes.

Chairs were always elegantly proportioned. Most typical were versions with tapering fluted legs, the recurrent lion-head motif on the legs at the frame, and caned

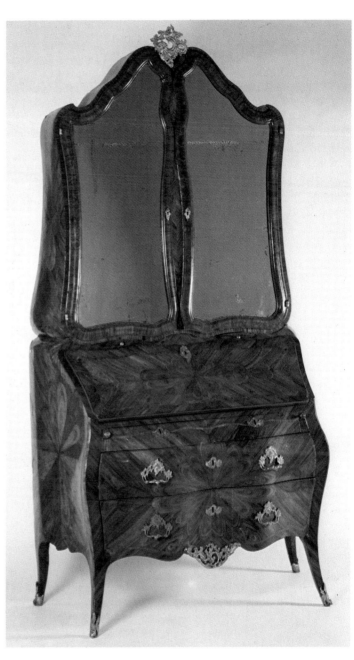

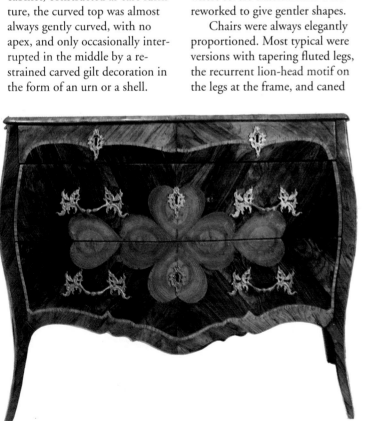

LEFT: Genoese mid-18th-century commode in kingwood, with tulipwood and boxwood stringing, the front centred with a typical quatrefoil motif with further foils on each side, ormolu handles and lock-plates. Musei del Castello Sforzesco, Milan.
ABOVE: Genoese, late 18th-century bureau-cabinet with quatrefoil veneer to the front and sides and with fine bronze mounts on the handles, apron and crest. Antiques trade.

backs and seats. The tradition of refined rationality typical of the Genoese chair was to lead eventually to the highly individualistic output of Gaetano Descalzi in Chiavari.

Applied bronze decoration was less important on Neoclassical commodes and was limited to lock-plates and simple handles.

The Genoese interpretation of Classicism was most evident in console tables, however, whether rectangular or semicircular. The top, in fine real, or painted *faux* marble or imitation *pietre dure*, sat on a classical linear frieze and supports. Grander versions had different shades of gilding. In lacquered or painted versions the intensity of the base colour contrasted with paler decoration. A tall mirror in like style always featured above the console.

The Republic of Venice

In the 18th century the Serene Republic, which had managed to remain independent during the Spanish domination of Italy, had its final period of cultural vitality and prosperity, despite the fact that its maritime supremacy had been already seriously undermined by increased Turkish power in the Mediterranean and by the transfer of maritime trade from the Mediterranean to the Atlantic. By the end of the century, the Venice that Napoleon bequeathed to Austria (1797) was impoverished and exhausted.

The Baroque period in Venice came to an end during the first thirty years of the 18th century with the termination of the activities of the sublime sculptors in wood, Andrea Brus-

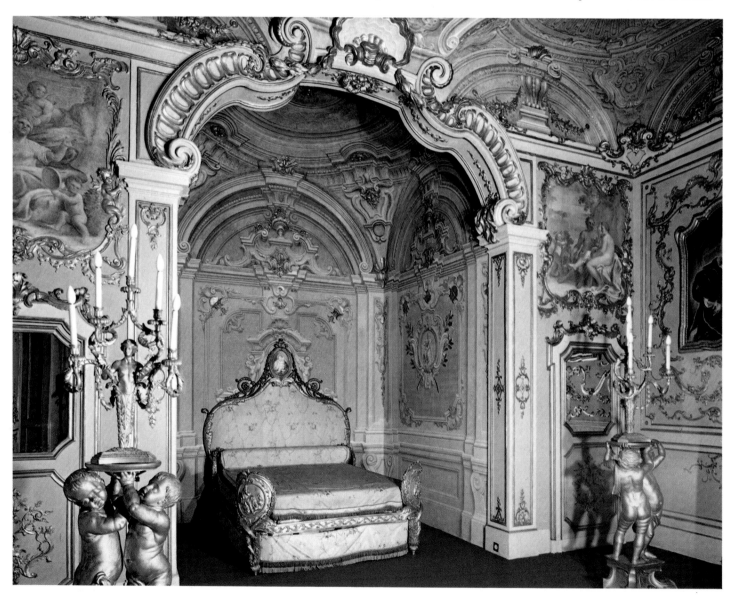

FACING PAGE: alcoved bed chamber in the Palazzo Rosso in Genoa; the majestic
high-backed bed with a carved and gilded headboard is surmounted by a medallion
enclosing a painting of the Madonna and Child; the same subject is also used on the
medallions surmounting the two sculpted columns at the foot of the bed.

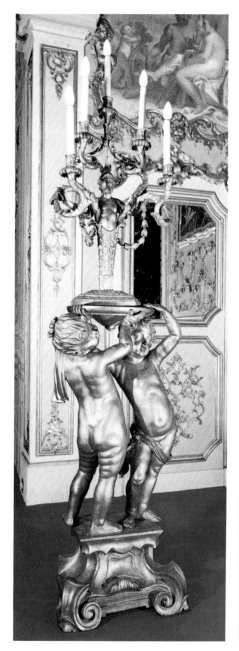

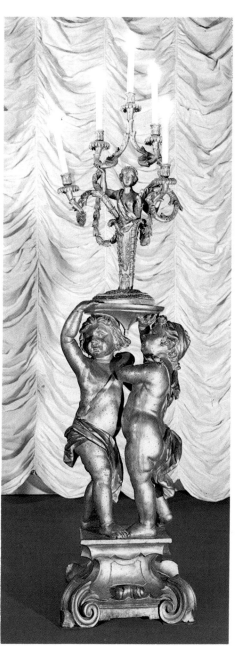

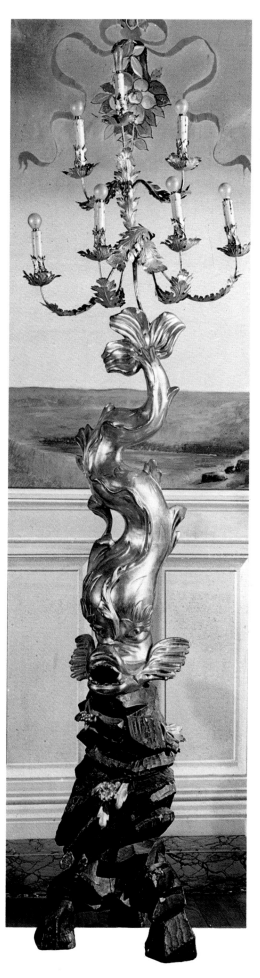

Completing the furnishings of the alcoved bed-chamber. ABOVE: two gilt-wood
torchères sculpted in the round, each with two putti on shaped pedestals with scrolls
and cartouches, supporting a five-branch candelabrum. Palazzo Rosso, Genoa. RIGHT:
gilt-wood *torchère* in the form of a dolphin on a rock-shaped pedestal, the dolphin's
tail supporting a gilt-metal candelabrum. Museo Luxoro, Nervi.

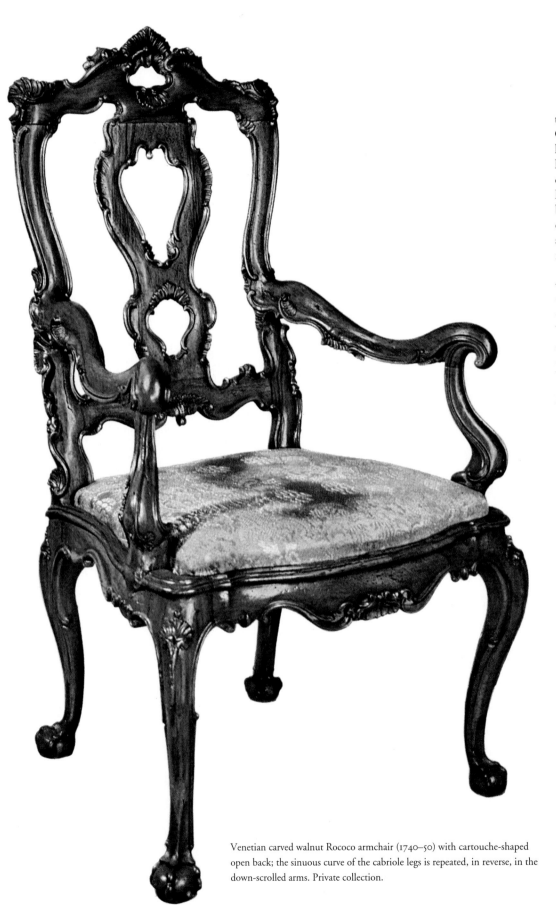

Venetian carved walnut Rococo armchair (1740–50) with cartouche-shaped open back; the sinuous curve of the cabriole legs is repeated, in reverse, in the down-scrolled arms. Private collection.

tolan (1662–1732) and Antonio Corradini (1688–1752). A new lighter-hearted and more frivolous age dawned in which Rococo furniture, which was more lightly carved and mannered, became the prerogative not just of the *intaiadori* (carvers) but also of the *marangoni* (cabinet-makers).

In Venice, Rococo furniture was utterly original and, more than in any other region, distanced itself from French taste. Vincenzio Golzio observes quite correctly: "A characteristic aspect of the 18th century was found in Venice and for us this city is identified with that century." The reasons are manifold. First of all, Venetian palaces, which were built on poles in muddy depths, could not compete in size with the massive Roman or Tuscan palaces. Consequently, well before the 18th century, these smaller interiors already required furniture of reduced proportions and thus anticipated that particular feature of Rococo style.

Although the Republic of San Marco had an affluent middle class as well as a large aristocracy, craftsmen could not count on court patronage as they could in Paris or Turin or the Papacy in Rome. Therefore, even before the Renaissance, the various craftsmen and artists had organized themselves into efficient corporations. Unlike those in Turin, they were not only there to look after the training and to monitor the skills of their members but more especially to safeguard their interests, helping them in cases of illness and other difficulties.

The *marangoni* were divided into four categories, three of which were dedicated to the construction of furniture. The

THIS PAGE: examples of Venetian chairs. ABOVE: two armchairs of curving design, with cabriole arms and legs, the one on the left with a cartouche-shaped open back in lacquered and painted wood, early 18th century; the other, on the right, in yellow lacquer and polychrome flowers, the seat and back upholstered in satin. Ca' Rezzonico, Venice. BELOW LEFT: lacquered chair (1750–60), highlighted in green and decorated with polychrome flowers on a pale ground. Private collection. BELOW RIGHT: late 18th-century armchair in the Neoclassical style with fluted tapering legs and square seat-back. Ca' Rezzonico, Venice.

marangoni da noghera concentrated on the manufacture of furnishings in unveneered wood; the *remesseri* were more skilled than the first group and were given the sole task of veneering and inlaying; the *marangoni di soaze* specialized in the making of frames and even windows for gondolas.

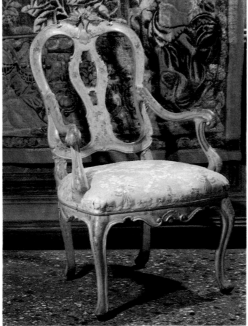

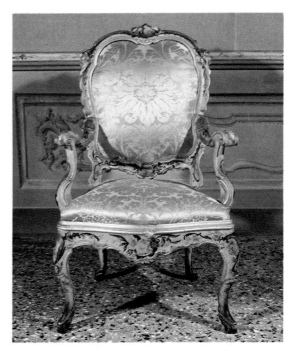

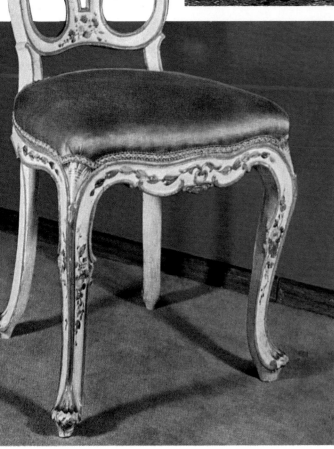

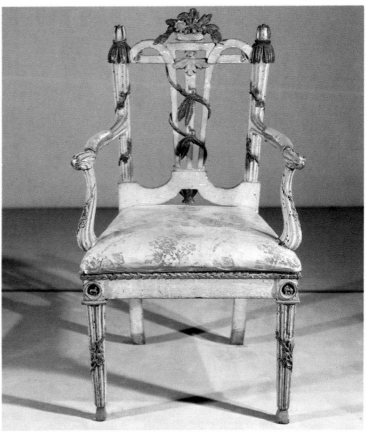

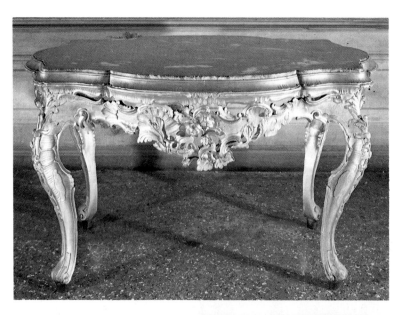

The guilds

Venetian furniture would never be as opulent or as intrinsically valuable as the extremely costly pieces produced by the likes of Piffetti or Prinotto, in some measure because of the use made by the latter of precious materials. However, because of much higher consumer demand, output was greater.

To satisfy the strong demand for refined furniture, while trying to keep costs down and work faster, craftsmen decided to spezialze, dividing up the tasks involved in the manufacture of each piece of furniture according to their various skills. Thus, after the *intaiadori* there would be other specialists to complete the work such as the upholsterers, the *bolzeri*, who took care of the engraving and piercing, the gilders, the glassworkers, the mirror-makers, and, above all, the *depentori* or japanners. This collective effort explains why nearly all 18th-century Venetian furniture, even of the finest quality, remains unattributed.

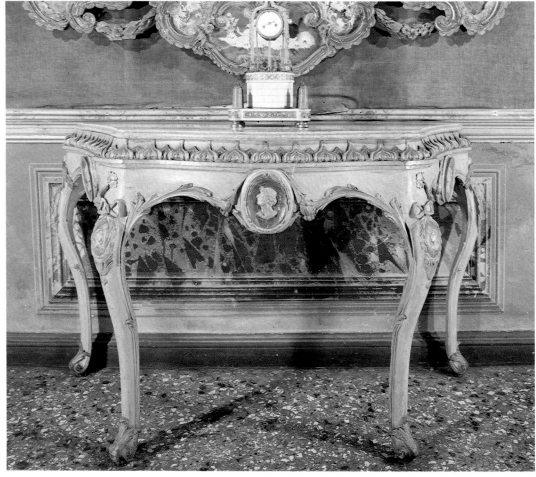

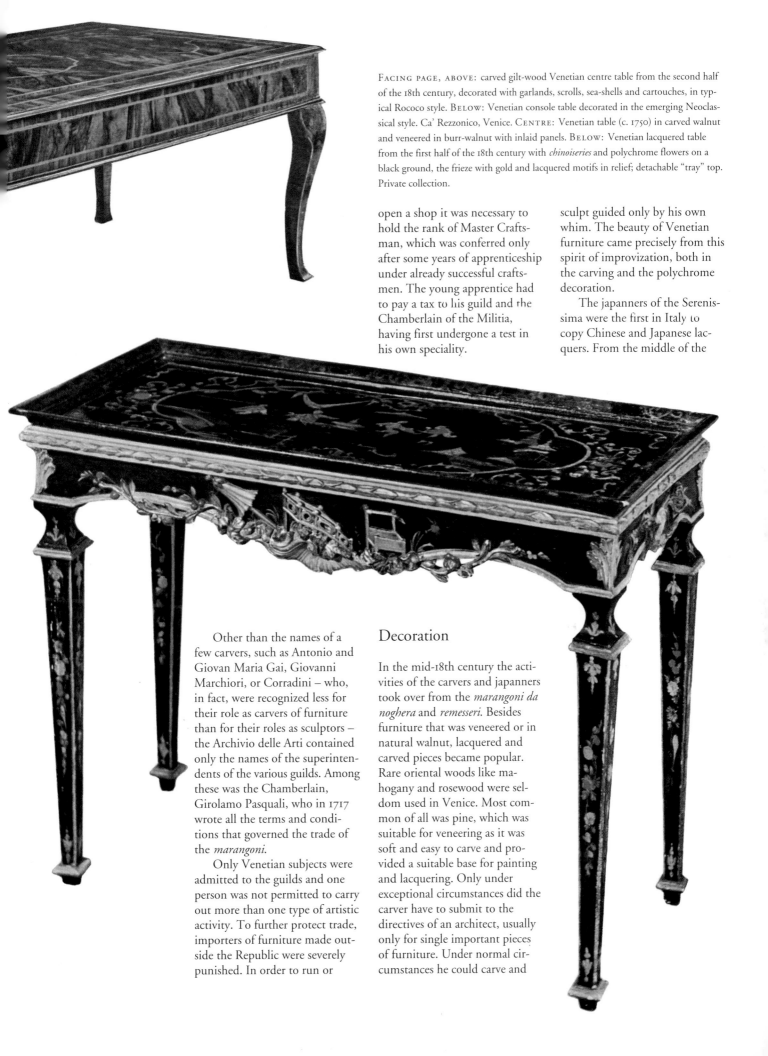

FACING PAGE, ABOVE: carved gilt-wood Venetian centre table from the second half of the 18th century, decorated with garlands, scrolls, sea-shells and cartouches, in typical Rococo style. BELOW: Venetian console table decorated in the emerging Neoclassical style. Ca' Rezzonico, Venice. CENTRE: Venetian table (c. 1750) in carved walnut and veneered in burr-walnut with inlaid panels. BELOW: Venetian lacquered table from the first half of the 18th century with *chinoiseries* and polychrome flowers on a black ground, the frieze with gold and lacquered motifs in relief; detachable "tray" top. Private collection.

open a shop it was necessary to hold the rank of Master Craftsman, which was conferred only after some years of apprenticeship under already successful craftsmen. The young apprentice had to pay a tax to his guild and the Chamberlain of the Militia, having first undergone a test in his own speciality.

Other than the names of a few carvers, such as Antonio and Giovan Maria Gai, Giovanni Marchiori, or Corradini – who, in fact, were recognized less for their role as carvers of furniture than for their roles as sculptors – the Archivio delle Arti contained only the names of the superintendents of the various guilds. Among these was the Chamberlain, Girolamo Pasquali, who in 1717 wrote all the terms and conditions that governed the trade of the *marangoni*.

Only Venetian subjects were admitted to the guilds and one person was not permitted to carry out more than one type of artistic activity. To further protect trade, importers of furniture made outside the Republic were severely punished. In order to run or

sculpt guided only by his own whim. The beauty of Venetian furniture came precisely from this spirit of improvization, both in the carving and the polychrome decoration.

The japanners of the Serenissima were the first in Italy to copy Chinese and Japanese lacquers. From the middle of the

Decoration

In the mid-18th century the activities of the carvers and japanners took over from the *marangoni da noghera* and *remesseri*. Besides furniture that was veneered or in natural walnut, lacquered and carved pieces became popular. Rare oriental woods like mahogany and rosewood were seldom used in Venice. Most common of all was pine, which was suitable for veneering as it was soft and easy to carve and provided a suitable base for painting and lacquering. Only under exceptional circumstances did the carver have to submit to the directives of an architect, usually only for single important pieces of furniture. Under normal circumstances he could carve and

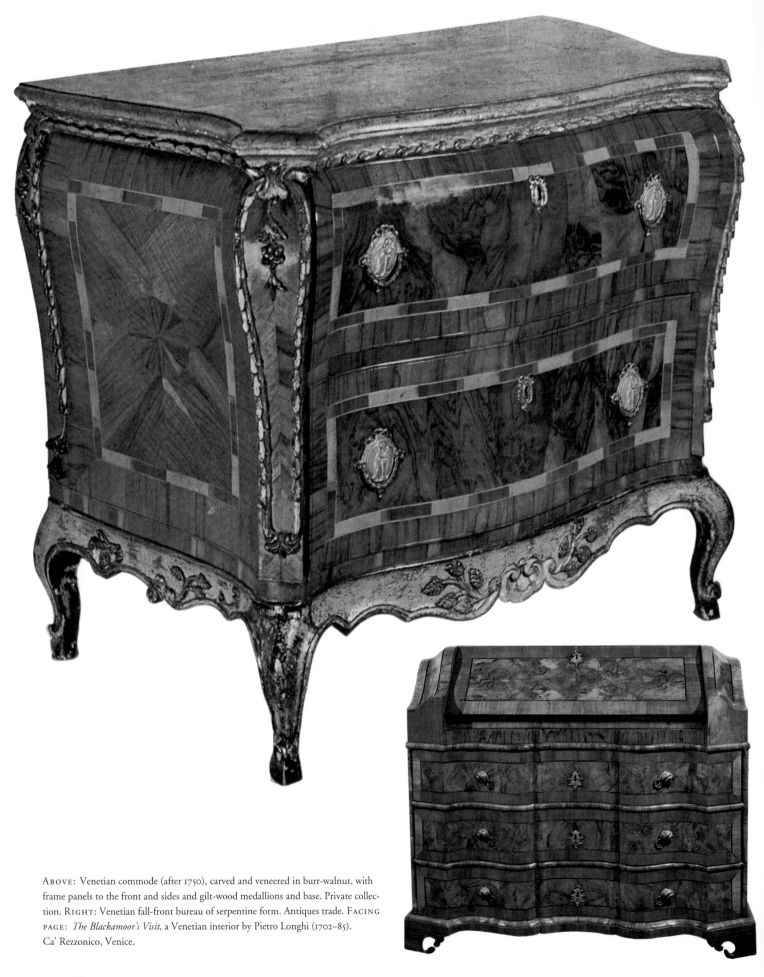

ABOVE: Venetian commode (after 1750), carved and veneered in burr-walnut, with frame panels to the front and sides and gilt-wood medallions and base. Private collection. RIGHT: Venetian fall-front bureau of serpentine form. Antiques trade. FACING PAGE: *The Blackamoor's Visit,* a Venetian interior by Pietro Longhi (1702–85). Ca' Rezzonico, Venice.

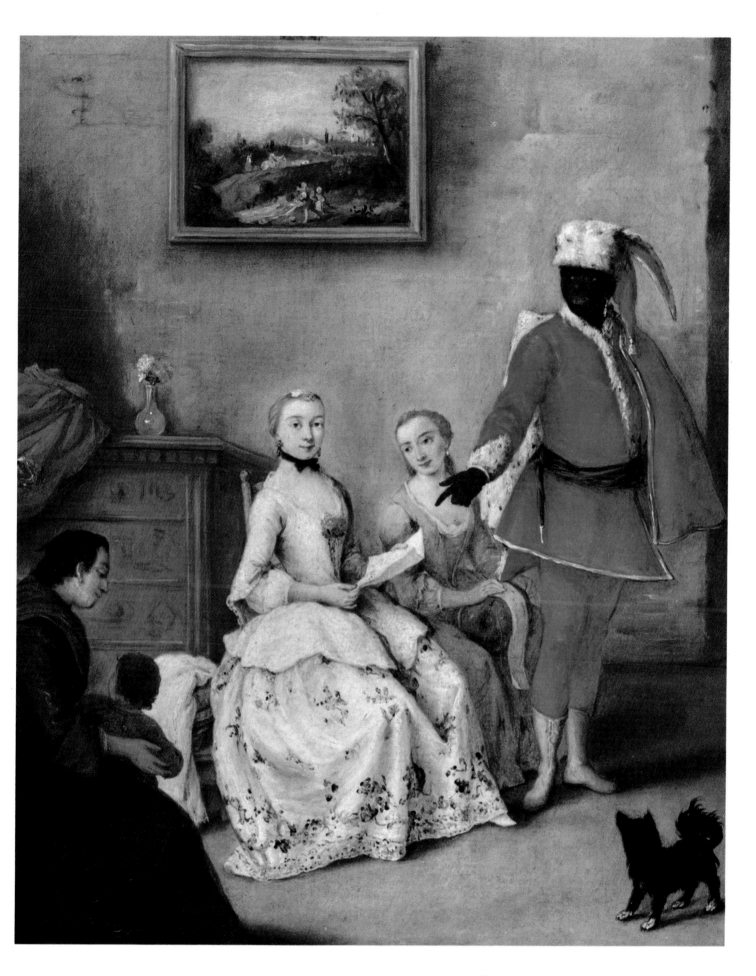

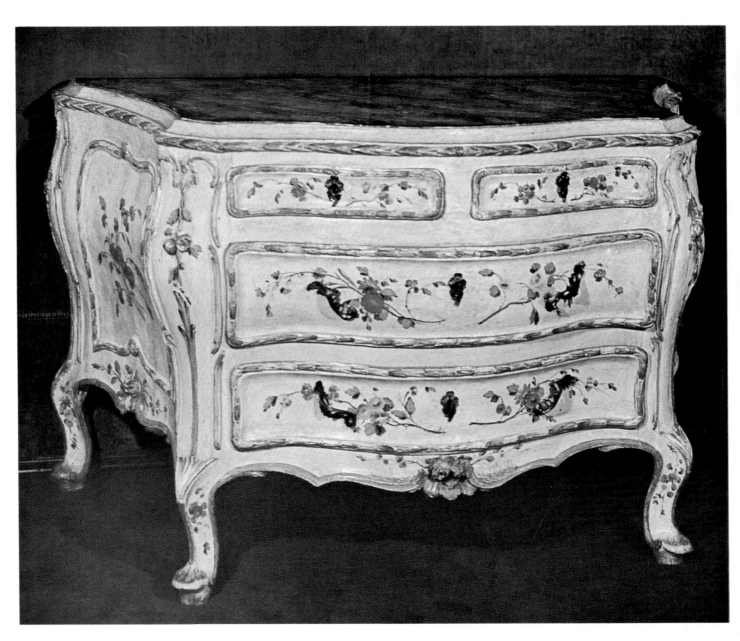

18th century, they threw off the constraints of making faithful copies of oriental decoration, and developed their own style, guided purely by their own imaginations. Pagodas, mandarins, warriors, Tartar princesses, dragons and exotic beasts painted against black, red and green backgrounds were replaced by Venetian subjects in softer shades, intimate landscapes and country scenes inspired by Bernardo Bellotto (1720–80), Canaletto and Francesco Guardi (1712–93), and delicate floral motifs and foliate arabesques taken from wall decorations in domestic rooms and salons.

Father Filippo Bonanni (*Trattato sopra la vernice detta comunemente cinese*, Rome, 1720) described the process of lacquering. The carver delivered the polished and stuccoed piece in pine to the japanner, who applied the base colour, then drew and painted the ground and details of the decoration, skilfully setting them out over flat and curved surfaces, hollows and reliefs. Then between fifteen and eighteen layers of transparent protective varnish would be applied. The varnish was sandarac, made in a variety of ways. For less expensive furniture a typically Venetian technique was used called *a lacca povera* that consisted of decorative designs being printed on very fine sheets of paper, which were cut out and

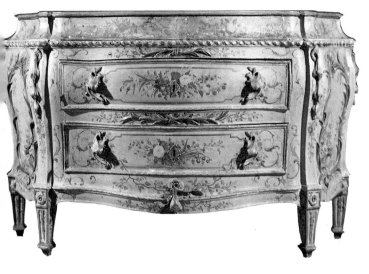
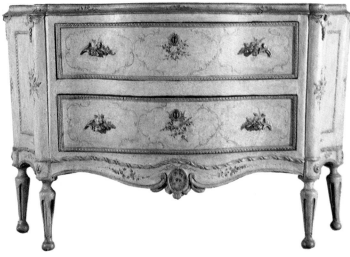

glued on to the surfaces of the furniture and painted. The whole piece of furniture would then be coated with varnish to level off the surfaces. The decorations were supplied by the Remondini printers from Bassano or taken from engravings of the most popular artists of the time such as Ricci, Zaiss, Zuccarelli, Amigoni, Wagner and Dall'Acqua. Gilding in pure gold or inlay of Murano glass adorned the most opulent pieces.

Types of furniture

Venice provided the greatest variety in chairs and seating. The most common model was the *pozzetto,* which was produced not only in lacquered and upholstered versions but also in a summer model in natural walnut with caned back and seat. The frequently lacquered Venetian armchair usually had a shaped top-rail and seat rail centred with a decoration that was more ornately carved than its Piedmontese counterpart. Even the cabriole legs were carved with *rocaille* forms and usually terminated in cloven feet.

Commodes with double or triple swells, narrowing at the bottom and supported by very curved legs, were quite new. In the most popular lacquered examples, even the tops and scrolled handles were made of painted wood. Only rare walnut or veneered examples had bronze drop handles. The fronts of the commodes were outlined in darker-coloured gesso fantastically carved in *rocaille* decoration. Many small versions had two doors concealing drawers from the partially open front, and the upper part had an elegant undulating and broken pediment. Although great care was taken to make these external features appealing and graceful, the same attention was not extended to the interiors, which were quite neglected.

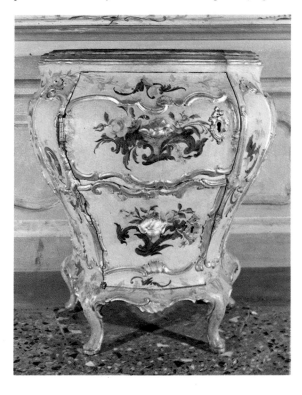
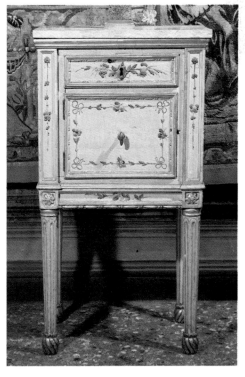

Lacca povera: an ingenious technique

Lacquered furniture satisfied all the desires for grace and daintiness, the love of pale and bright colours, and a taste for the exotic that were so much a part of the 18th century. Venice found a special formula to incorporate all of these, thanks to the imaginative ingenuity and refined artistic taste of its craftsmen. The imagination of the *depentore* (painter or japanner), inspired by the lacquers of China, created a technique of infinite creative expression, and, although the subject matter of the decoration originally derived from oriental prototypes, the motifs used gradually became more Westernized. The laborious preparation of the lacquer and the high costs of working with these traditional techniques forced craftsmen to invent a more speedy and less costly method. Instead of drawing and painting decoration and figures on furniture consigned to them by the *intaiador,* they glued them on. This method, called *a lacca povera,* consisted of applying to the furniture engravings, taken from popular catalogues, then printed on paper and cut out. These would then be covered by layers of varnish to level and finish off the surfaces.

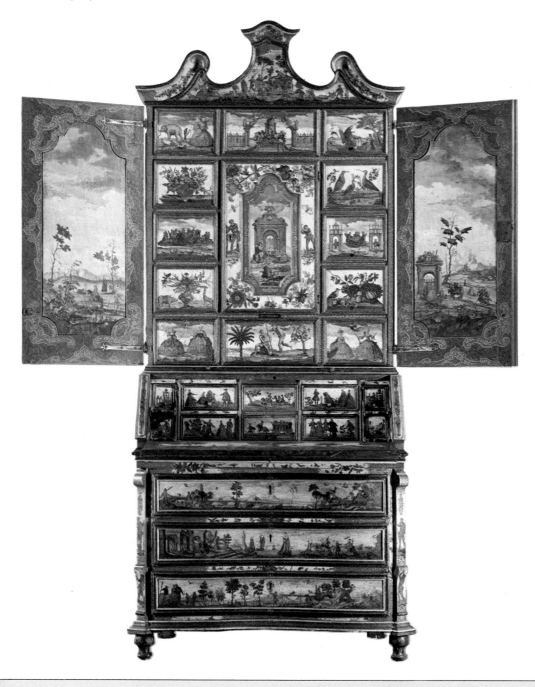

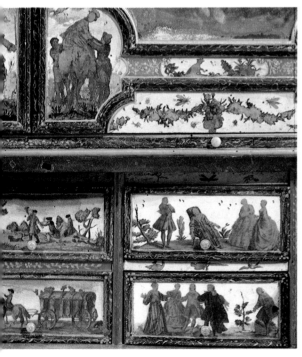

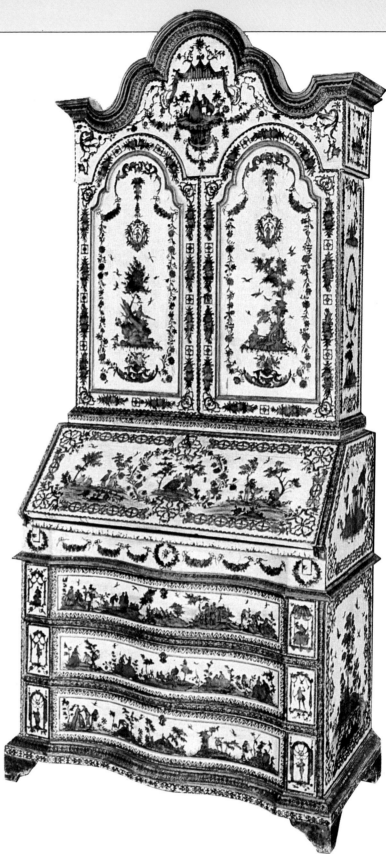

BOTH PAGES: two Venetian bureau-cabinets decorated in *lacca povera,* the one opposite, with open doors, early 18th-century, in pine and poplar, decorated with amusing genre scenes, as shown by the detail of the interior of the hinged top and the cornices of the doors (left). Musei del Castello Sforzesco, Milan. ABOVE: This example above is datable to the early 18th century by its serpentine lower part and curvilinear cornice above. CENTRE, ABOVE: detail showing love scene and floral motifs.

Below left: Venetian burr-walnut bureau-cabinet (c. 1750) , the lower section of serpentine form with concave sides, supported on cabriole legs, the upper section with a single door enclosing a glass panel, terminating in a broken crest of curved outline. Antiques trade. Right: veneered burr-walnut Venetian bureau-cabinet (c. 1750), the lower section similar to the former example, supported on bun feet, the upper section with four doors, two at the front, and one at each side, terminating in an arched

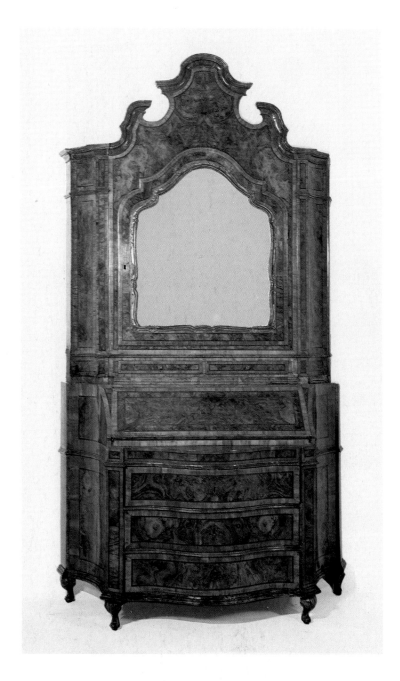

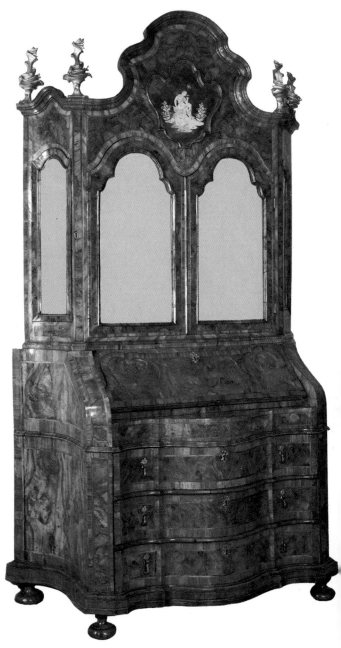

Bureau-cabinets were much squarer in shape. They often had polychrome decoration and were supported on bun or bracket feet. The door panels of the upper section frequently contained polished glass, while in more splendid examples the doors were decorated both externally and internally with painting. The cymatium traced a very busy curve, broken into several parts and often surmounted by a typically Baroque fastigium.

Rococo taste remained fashionable in Venice even when other regions began to turn towards the style of Louis XVI. The only tentative signs of Venetian furniture succumbing to a brief period of Neoclassicism were in the appearance of columnar legs and medallion backs in chairs and seating.

pediment enclosing a cartouche with an engraved glass panel and embellished with carved finials. Private collection. THIS PAGE, BELOW: Lombard or Venetian early 18th-century bureau-cabinet, frame in poplar, veneered in burr-walnut with burr-olive and burr-box inlay, the ovoid-shaped crest enclosing an engraved glass panel. Musei del Castello Sforzesco, Milan.

Milan and Lombardy

"Spanish domination had found in Milan 300,000 souls and after seventy-seven years left only 100,000; it had found seventy wool factories and left a mere five." Thus the Italian author and economist Pietro Verri (1728–97) describes the dark age of Spanish domination of Lombardy. But when Lombardy fell to Austria (1714) the situation changed radically. In a relatively short time life was breathed back into those industries that, in previous centuries, had once represented the wealth of the region. As always, renewed economic prosperity, brought an artistic revival with it.

Its position in the centre of regions that expressed their stylistic ideas in such diverse ways – between Piedmont which was influenced by French taste, Liguria with its precise joinery and the Veneto with its fanciful and unique style – made Lombardy, in terms of furniture, subject to many disparate influences. Given the more reticent character and the more serious lifestyle of the Milanese, these influences were toned down to create an independent, more severe style. At the beginning of the 18th century, the influence of the previous century was still evident in the cumbersome furniture and moulded decorations in dark stained wood, which in drawer furniture, whether on a commode, a bureau-bookcase or a fall-fronted piece, stood out against the paler, warm surfaces of walnut or burr-walnut. The patterns made by this type of banding often extended over the entire surface of the front of the piece, either in a single line disregarding any sub-

divisions for apertures, shelves or drawers or, alternatively, delineating each single drawer.

Marquetry was the pride of Renaissance Lombardy, and it assumed equal importance in the 18th century, culminating towards the end of the century in the work of Giuseppe Maggiolini. On the veneered façades of pieces made out of pine and poplar would appear cartouche motifs, creating colour contrasts by juxtaposing local woods with exotic timbers like rosewood, kingwood and boxwood. These often naturalistic designs covered whole surfaces and were uninterrupted by the subdivisions for drawers.

Carving and gilding, when compared with their vogue in other regions in Italy, were less important. The recurrent motif typical of Rococo carving of a slightly frayed curl was called by the prosaic Milanese *pel de rava*, because it resembled turnip peel. For handles, lock-plates and knobs wood was preferred and metals were rarely used. Milanese Rococo triumphed in the Salon of the Palazzo Casati, which was frescoed in 1731 by Giovan Battista Tiepolo. The ceiling frescoes, full of sky and light, blended perfectly with the wall decoration made by Angelo Cavanna or Cavagna, from Lodi, in gilded lapis-lazuli blue lacquered wood and inlaid with glass from Murano.

Typologies

Falling somewhere between Piedmontese and Venetian models, the Lombard chair had difficulty reaching a harmonious composition of its separate parts. Its

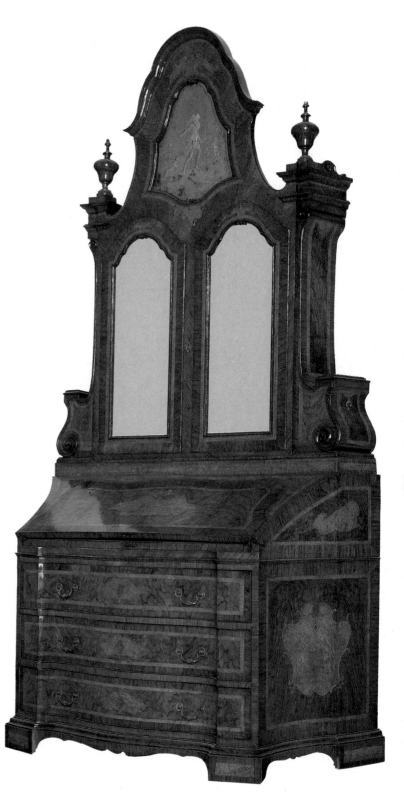

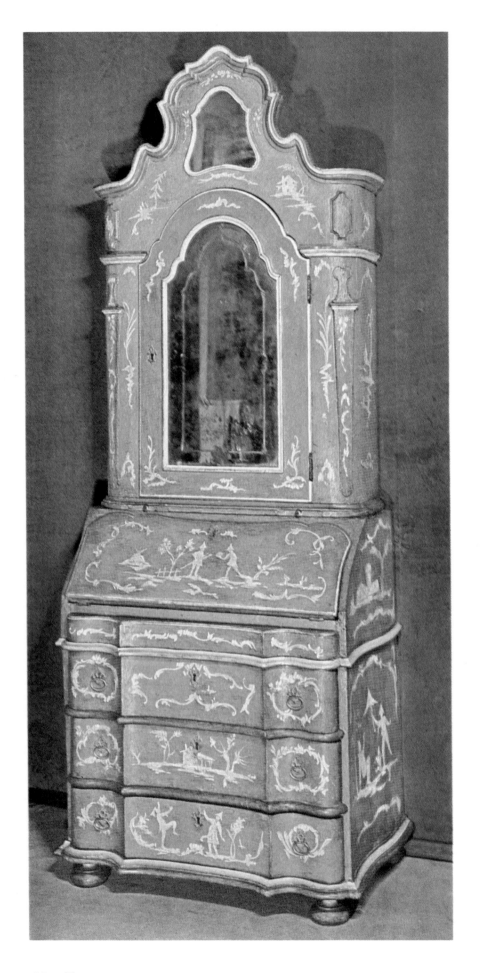

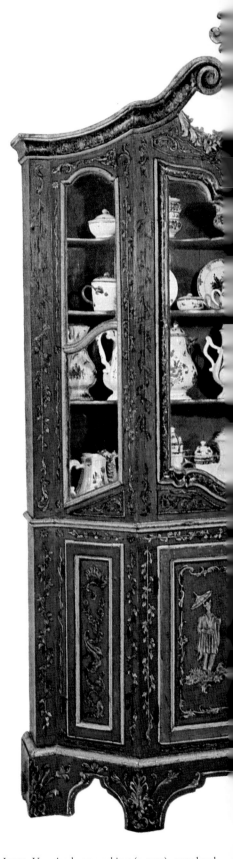

LEFT: Venetian bureau-cabinet (c. 1740), carved and lacquered in blue, decorated in pale lacquer with *chinoiseries* and garlands enclosing the ormolu handles on the drawers. CENTRE: cabinet pre-1750, the upper section with glass panels, carved and lacquered with

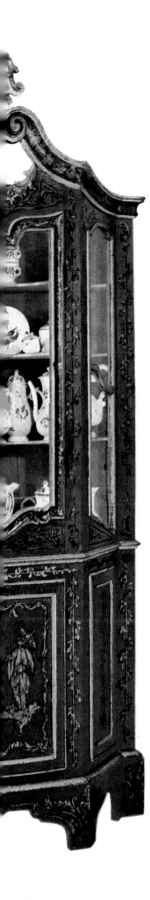

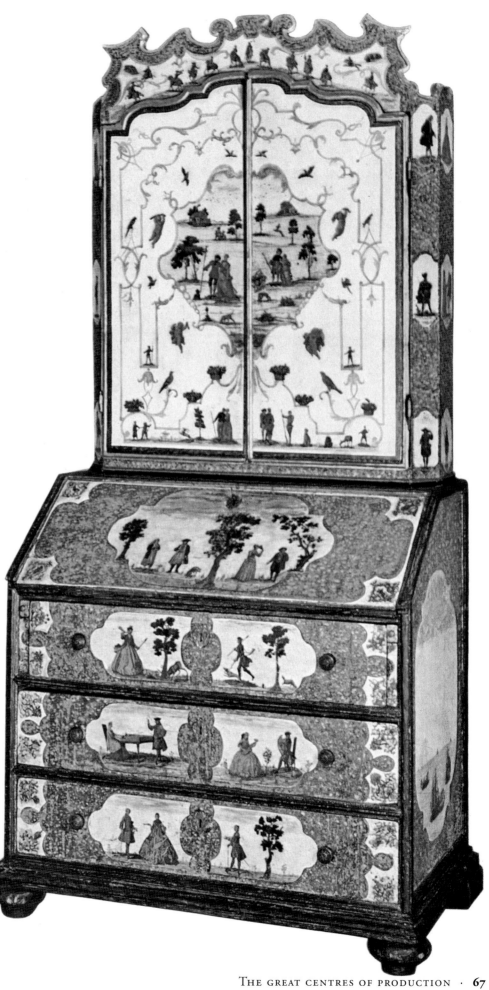

gilded scrolling foliate and *chinoiserie* decoration on a blue ground. RIGHT: Venetian bureau-cabinet pre-1750, carved and lacquered with polychrome amorous scenes, scrolls and naturalistic motifs. Private collections.

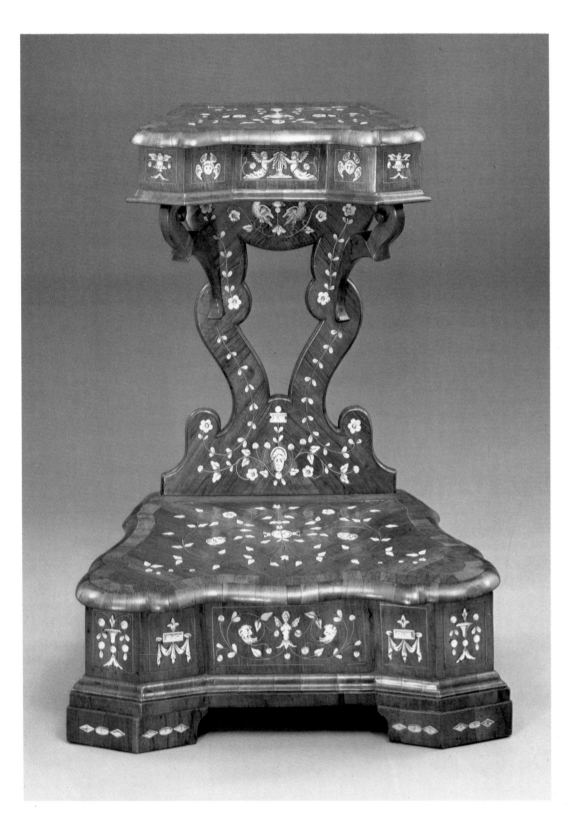

scrolled or cloven feet and its heavily prominent back, falling away at the shoulders, were perhaps its most prominent features. A carved and pierced scroll would often be centred on the back rail and seat rail, beneath the seat.

The *cumò*, the Lombard translation of the French *commode*, had triple swells to the front and sides and somewhat heavy proportions. In better quality versions drawer divisions disappeared so that decoration could be spread over the entire surface. The frame in pine or poplar was veneered in walnut, and lacquered examples were rare. Towards 1740 this furniture achieved greater delicacy by the lengthening and curving of its legs and by a less ponderous body with more accentuated curves. The same changes that took place in commodes applied to writing desks.

Even in Lombardy the Neoclassical trend came early. Giuseppe Piermarini (1734–1808), who was in charge of the restoration of the palazzo Reale in Milan from 1769, his colleague Giocondo Albertolli (1742–1839), the artist Giuseppe Levati (1738–1828) and many other minor artists and intellectuals were the protagonists of the classical revival that affected architecture and the applied arts in the second half of the 18th century. In this fervour for renewal, the furnishings of numerous stately palaces were revamped and the many Neoclassical pieces produced in Lombard workshops achieved a restrained formality not seen in the Rococo era. Carving, lacquer and gilding, rarely used before, now began to equal the refined skills evident in Liguria and Piedmont. Even *chi-*

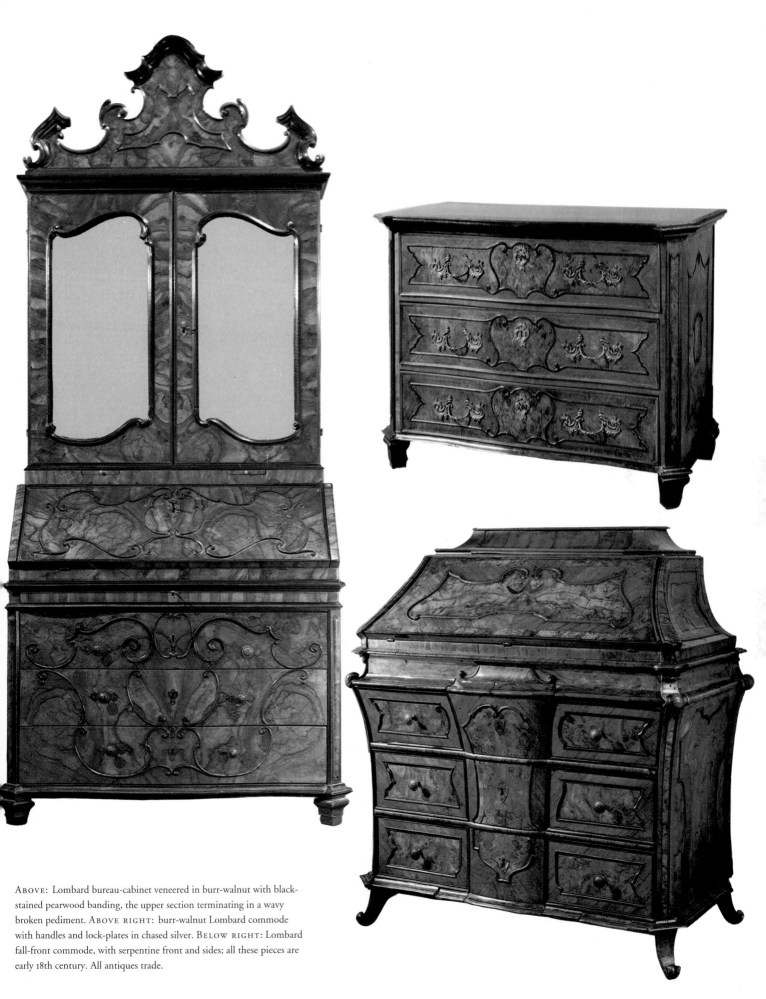

ABOVE: Lombard bureau-cabinet veneered in burr-walnut with black-stained pearwood banding, the upper section terminating in a wavy broken pediment. ABOVE RIGHT: burr-walnut Lombard commode with handles and lock-plates in chased silver. BELOW RIGHT: Lombard fall-front commode, with serpentine front and sides; all these pieces are early 18th century. All antiques trade.

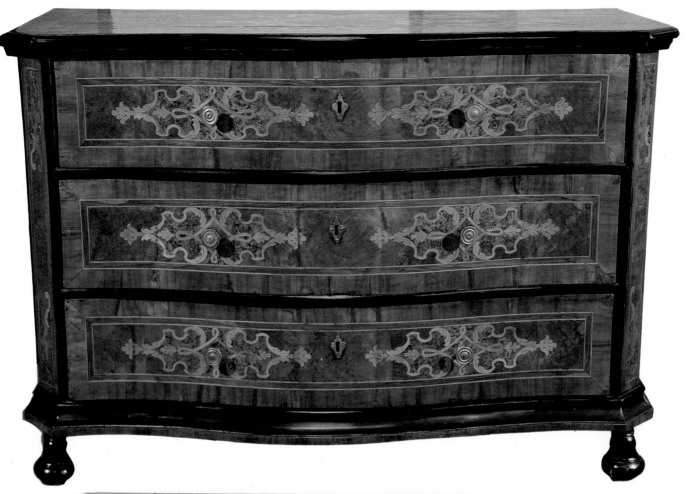

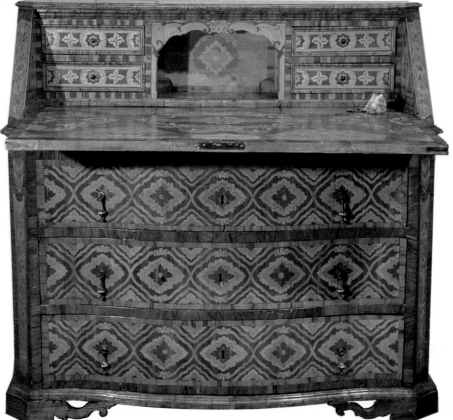

noiseries, which became popular in Milan later than in neighbouring states, was redefined by Neoclassical interpretation. China and the classical world blended in a bizarre mix, with incredible pieces like the table supported by figures of mandarins exhibited in 1963 at the exhibition of Piedmontese Baroque in Turin, or the sofa in painted wood, which was already part of the furnishings in the Villa Silva at Cinisello.

It was, however, with marquetry that Lombard Neoclassicism found its most typical expression, particularly in the works of Maggiolini, the craftsman who elevated this art to a national level and who was described by the historian Melchiore Gioia (1767–1829) as a "painter in wood". Giuseppe Maggiolini (1738–1814), who did produce Rococo pieces, albeit with measured and modestly sinuous forms, reached the peak of his artistic career by taking advantage

FACING PAGE, ABOVE: Lombard commode, possibly made in Brescia in the early 18th century in burr-olivewood with boxwood inlay. BELOW: early 18th-century fall-front commode, Lombardy or Veneto, entirely veneered with geometric motifs, with bronze drawer handles. Antiques trade. THIS PAGE, BELOW: Lombard early 18th-century fall-front bureau, veneered in precious woods on the front, the sides and in the interior section; the same scene within a medallion on the front and on the hinged writing surface, detail above. Private collection. RIGHT: 18th-century Lombard corner cabinet in walnut. Antiques trade.

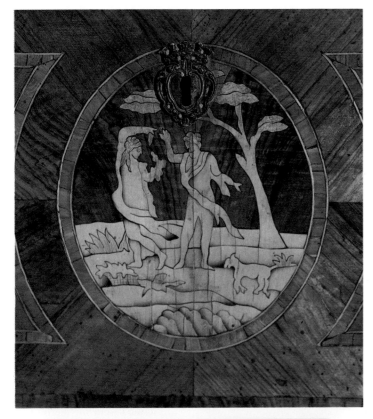

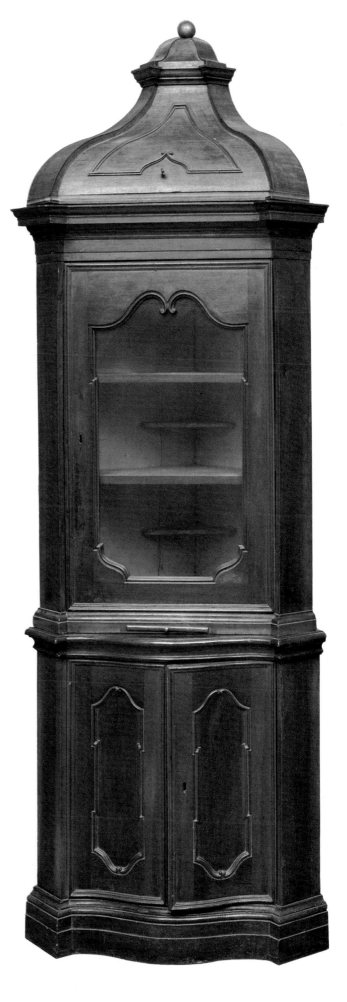

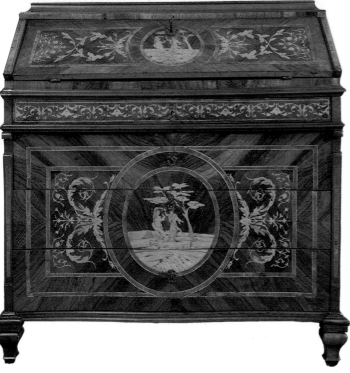

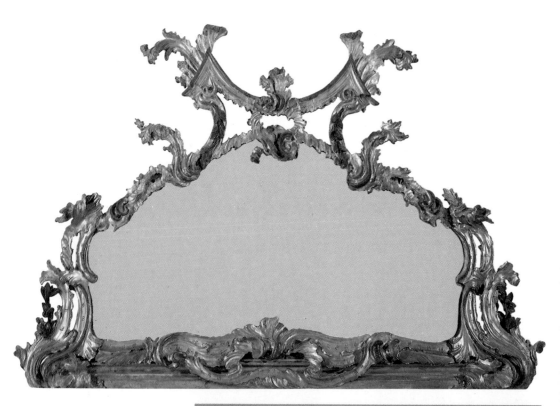

rial couple, installed himself in Florence surrounded by capable ministers and technicians, did Tuscan institutions and lifestyle revive.

Florentine Rococo was of scant importance, and even the floral festoons and *rocaille* decoration seemed reminiscent of the Renaissance. 18th-century furniture with its monumental tendencies resembled that of the preceding era. In decoration, an interesting novelty was the "bat" mask with fluid lines. A greater creative impetus occurred when Leopold renovated the furnishings in the Palazzo Pitti in Neoclassical style. The numerous pieces of furniture made during this time appear to be constructed with great skill, and reveal an understanding of French and English models. The fleur-de-lys, symbol from the city's arms, was a recurring motif in pierced seat-backs, as was the feather.

The *Opificio delle Pietre dure*, founded by Grand Duke Ferdinand I in 1588, continued to produce small doors and table tops on commission using either *pietre dure* or fine marble, mostly for export rather than local use. The high cost of these luxury pieces soon encouraged copies made in scagliola. This new material was developed by the Abbot of Vallombrosa, Enrico Hugford (1695–1771), assisted by his pupils Torello Mannini, Pietro Belloni and the most talented, Lamberto Cristiano Gori (1730–1801). The polychrome table tops, made possible by this extraordinary technique, were often difficult to distinguish from those commissioned in authentic marble, and were sometimes even more beautiful.

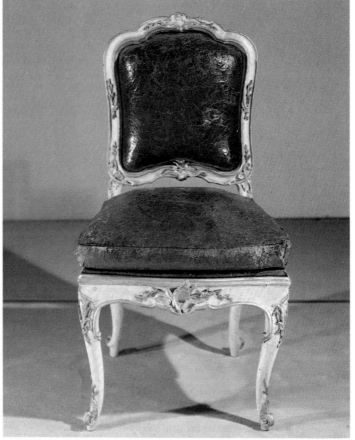

of the linear structure of Neoclassical furniture, which lent itself so well to the development of marquetry over large surfaces. His work is examined in the volume dedicated to the 19th century.

Florence and Tuscany

With the death of Gian Gaetano, the last of the Medici, in 1737, the Grand Duchy of Tuscany was assigned – following the terms of the Treaty of Vienna in 1735 which ended the Polish War of Succession and which were confirmed in the treaty of 1738 – to Francis Stephen II of Lorraine, consort of Archduchess Maria Theresa of Austria, and later emperor Francis I. They both continued to maintain their residence in Vienna, thereby neglecting the interests of the Grand Duchy, so they entrusted it to Prince Marco di Craon. Only in 1765, when Leopold (1747–92), third son of the impe-

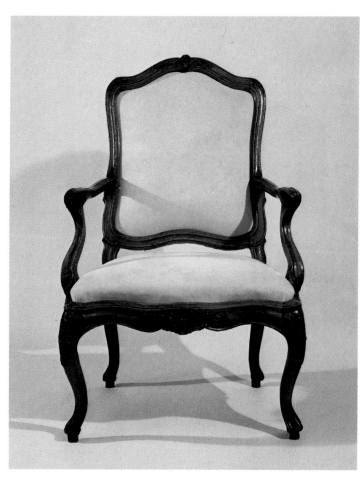

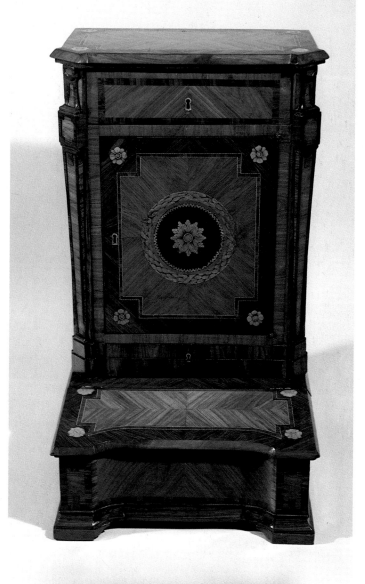

FACING PAGE, ABOVE: Lombard overmantel mirror. The "saddle" motif of the part-gilt and part-bronzed poplar frame, carved with foliate motifs, was made to accommodate an ornamental painting on the crest. BELOW: carved, painted and gilded Lombard chair, the seat and back upholstered in embossed leather. Musei del Castello Sforzesco, Milan.

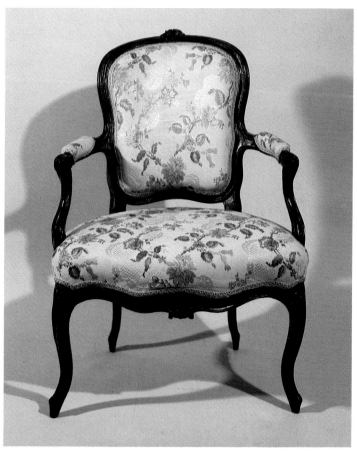

THIS PAGE LEFT, ABOVE AND BELOW: two Lombard walnut armchairs in Louis XV style, the curves of their cabriole legs repeated in the undulated movement of the arms. RIGHT: Lombard *prie-dieu* from the second half of the 18th century, veneered and inlaid in tulipwood, violetwood and boxwood. Both antiques trade.

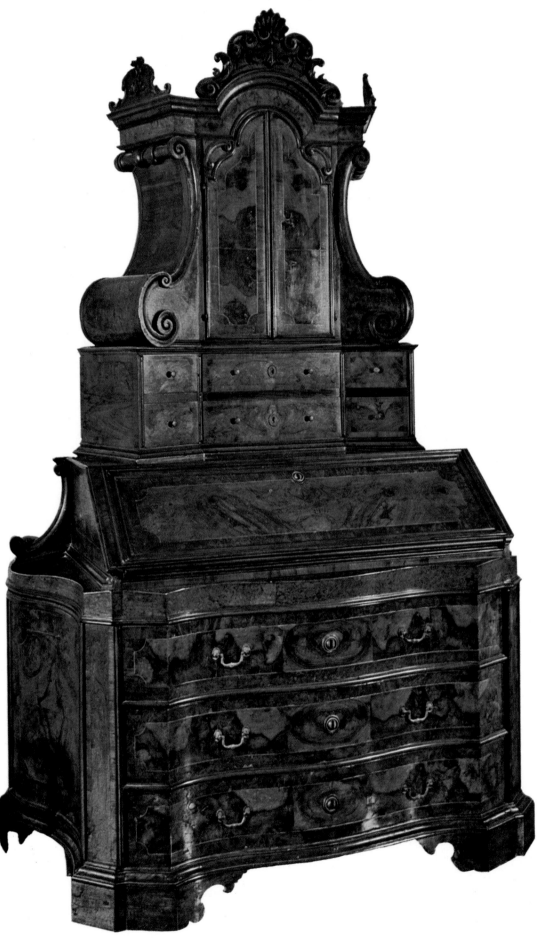

Rome and the Vatican State

The victory of Pope Innocent XI over Louis XIV when he succeeded in thwarting the French king's attempt to create a Gallic Church (1682), which would have subjugated the clergy to the crown, was the last manifestation of papal power. In the 18th century, Rome was not the city from which Bernini had promoted the Baroque style throughout Europe.

Then, with the powerful grandiosity of its antique architecture, 17th-century Rome offered its artists the most fitting setting for such a style, but now it seemed to find it difficult to absorb the Rococo style, where delicacy prevailed over grandiosity. Even if one could glimpse those first manifestations of a Rococo style in the fanciful sinuosity of the work of Francesco Borromini (1599–1661), it was a style that otherwise seemed not to exist in Rome. It was not a style indigenous to that city, and the gay frivolity that was its principal feature was never fully appreciated.

More than in any other Italian city, the 18th century began in a Rome that was still influenced by its stylistic past. In fact the entire century was steeped in the remnants of a Baroque style that was still able to produce elegant pieces, but which was by then lacking in any real creative force. Roman furniture of the first half of the century continued to be heavily and elaborately carved. Its most spectacular successes were in supports for musical instruments: for example the organ in the Casa Verospi, made by Michele Todino in the 1820s. Sculptor-carvers like Nicola Car-

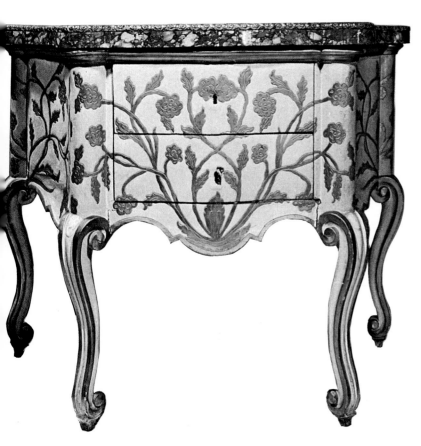

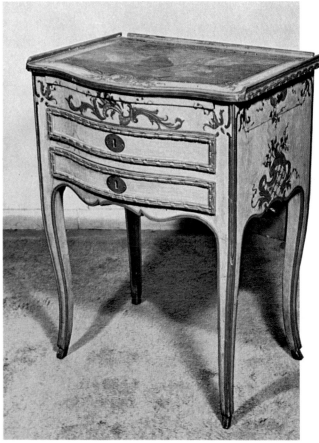

Facing page: burr-walnut bureau-cabinet from the Marches from the first half of the 18th century, the lower fall-front section with serpentine front, rounded corners, concave sides, supported by bracket feet; the upper section with two levels, the lower with drawers, the upper with doors and waisted scrolled flanks, terminating in a carved arch pediment. This page, Above left: Roman lacquered two-drawer commode (1740–50), carved with gilded floral motifs with ormolu banding. Above right: Roman bedside table (1760–70) with two drawers and sliding writing surface, carved and lacquered, with opaque gilding, a painted landscape on the top. Right: Roman lacquered commode (1730–40) with three drawers, decorated with polychrome *chinoiseries* with red-gold gilding on the gently *bombé* front and concave sides, applied with bronze mounts on the corners, and with gilded banding around the drawers and following the lines of the lower section, with the barest hint of an apron, and continuing along the cabriole legs. All private collections.

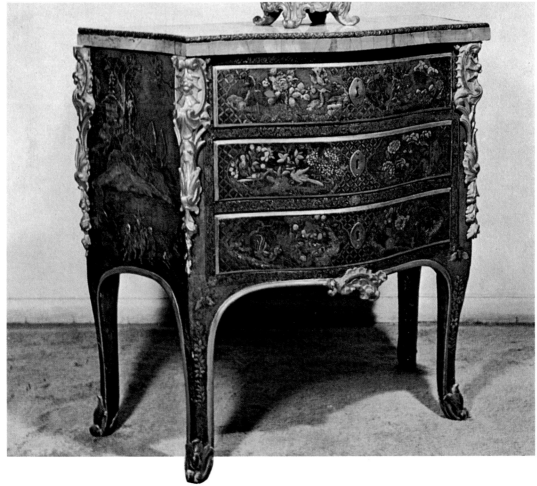

letti and Tommaso Righi (1727–1802) embellished massive and heavily gilded pieces of furniture with garlands, grotesques and "bat" masks.

Exotic woods were used for cabinet-making and rare woods for marquetry, often on a background of rosewood which, because of its warm tones, was popular in Rome during this period. On marquetry pieces there was no shortage of decoration in chased and gilt bronze, i.e. handles, key-plates and other decorative detail which made them more desirable.

Dutch influence can be observed in the marquetry at which cabinet-maker Andrea Mimmi excelled. He made the splendid inlaid floor in the *Salone d'oro* in Palazzo Chigi between 1765 and 1767.

Even in 18th-century Rome the fashion for lacquered furniture flourished. This had already existed in Rome in the 17th century ever since *chinoiseries* became popular. One chronicler of the time confirmed that the city street Via dei Coronari was reserved entirely for master lacquerists. The oily consistency of Roman lacquer meant that it could never match the delicacy of Genoese lacquerwork or the fantasy of the Venetians.

In the first decades of the 18th century, Italian and foreign artists and intellectuals flocked to Rome to see its artistic and

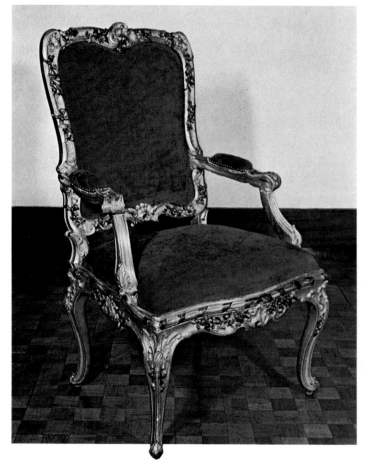

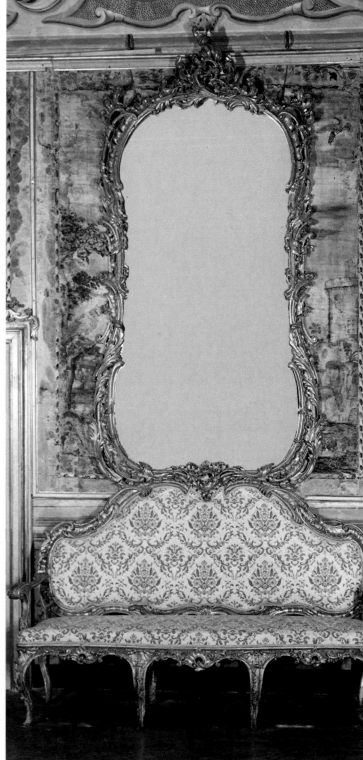

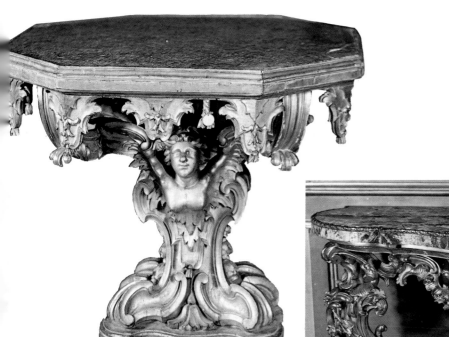

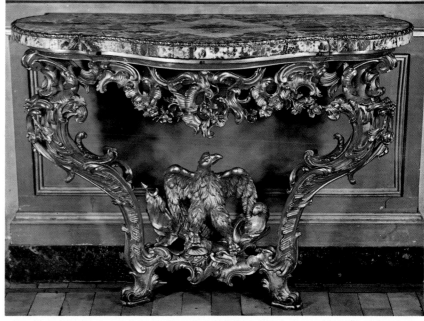

Facing page, left: carved and painted gilt-wood Roman armchair (1772–74). Private collection. Right: sofa and mirror made for the Salone in the Palazzo Barberini, the gilded and silvered frames of each piece, with Rococo carvings of sprigs, ribbons and sea-shells, joining at a point along the top-rail of the sofa. Museo delle Arti Decorative, Rome. This page, above: small octagonal table. Right and below: console table and side table (below), all Roman, dated around 1760 and with strong links to the Baroque. Palazzo Doria-Pamphili, Rome.

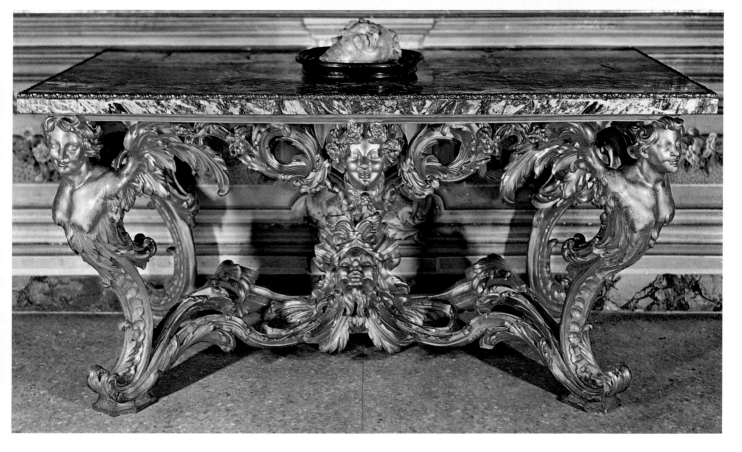

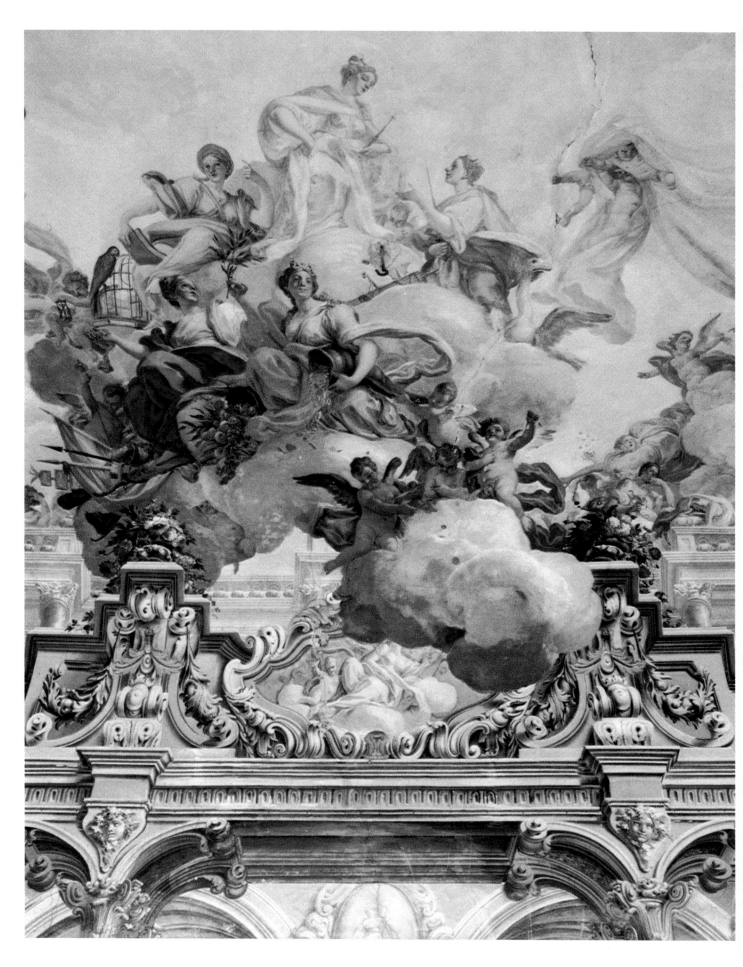

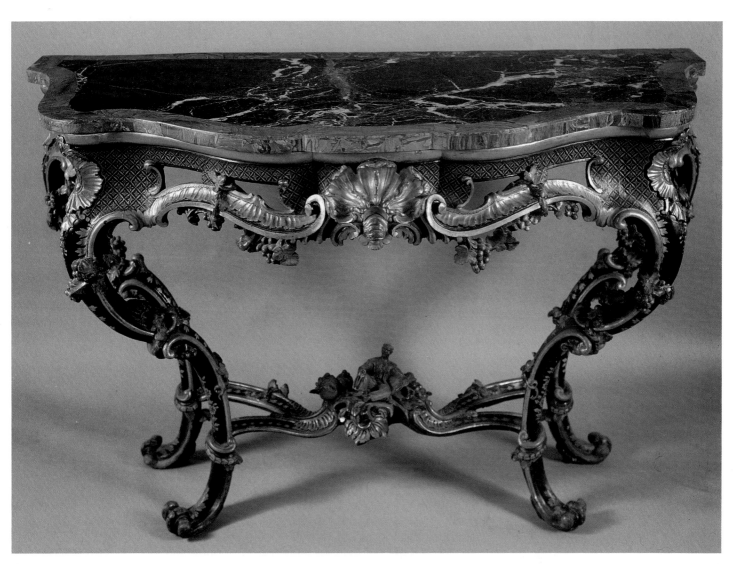

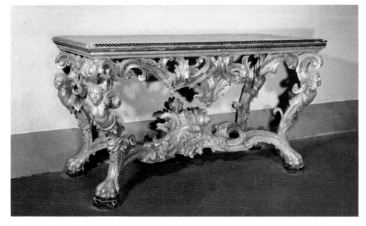

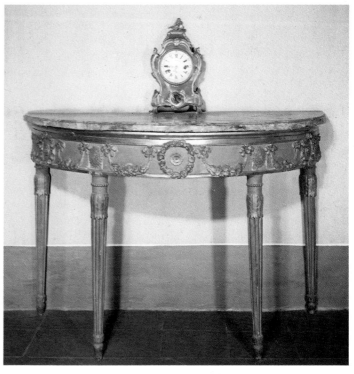

FACING PAGE: detail of the vaulted ceiling of the antichamber of the sea wing in the Palazzo Reale di Portice, with the *Allegory of Truth*, painted by Crescenzo Gamba. ABOVE: carved gilt-wood Neapolitan console table (1760–70), the black marble top veined with white and set within a border of alabaster, the stretchers centred with a painted terracotta figure. Museo Nazionale di Capodimonte, Naples. ABOVE: Neapolitan carved and sculpted gilt-wood side table, its curved form applied with decorative motifs still in the Baroque style. RIGHT: painted and gilded Neapolitan console table. Museo Correale di Terranova, Sorrento.

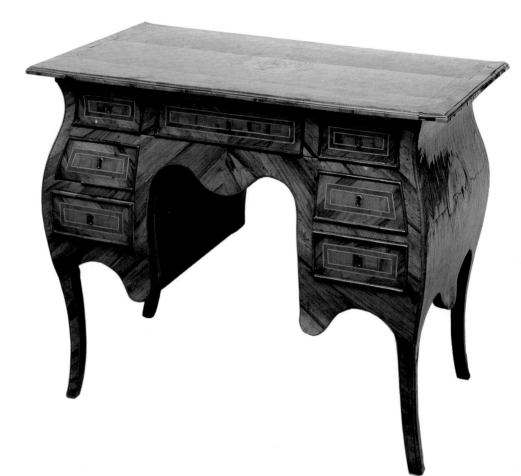

RIGHT: Neapolitan writing desk from the second half of the 18th century; the rectangular top, placed on to an exaggerated *bombé* body, is decorated with marquetry of banding and medallions.
BELOW: Neapolitan commode (c. 1750), veneered in walnut and inlaid overall in a herringbone pattern of tulipwood, with gently *bombé* sides, medallions inlaid with geometric motifs enclosing the lock-plates, which are in bronze, as are the handles and sabots. Antiques trade.

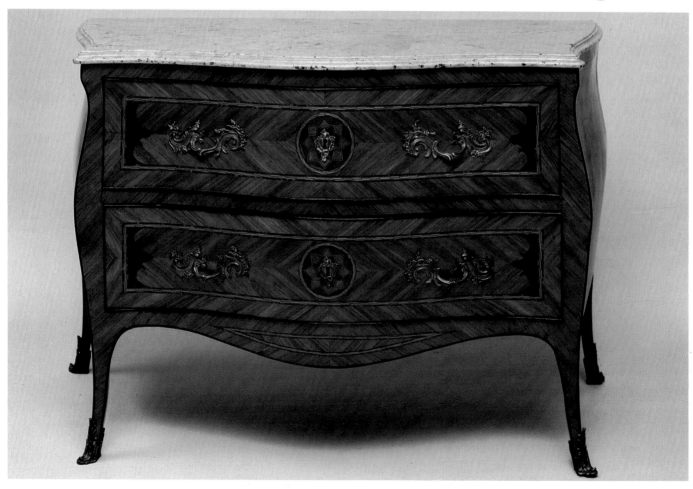

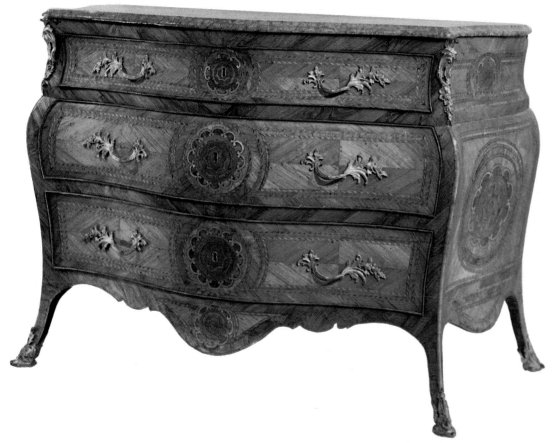

LEFT: Neapolitan chest-of-drawers
(c. 1730) with veneered banding and in-
laid rosettes, the serpentine front with
three drawers, shaped apron, bronze
handles and trimmings, the top in pink
marble, and the *bombé* sides also with a
shaped apron. BELOW: small Neapoli-
tan chest, from the second half of the
18th century, inlaid with various woods
in a geometric motif, typical of this
southern region. Both Museo Correale
di Terranova, Sorrento.

archaeological glories at first
hand. This made the city the first
in Italy to accept the new Neo-
classical trend. The presence in
Rome of French artists at the
Academia de St Luca and of Eng-
lish architects such as Robert
Adam (1728–92), and the diffu-
sion of engravings by Giovanni
Battista Piranesi (1720–78) all
contributed to a stylistic renewal
which extended to furniture.

Towards the end of the 1750s,
the architect Carlo Marchioni
(1702–86) built a villa for Cardi-
nal Albani where Anton Raphael
Mengs (1728–79) and other
artists created, in a triumph of
marble, rooms in which antique
pieces were placed side by side
with contemporary furniture.
The winged lions that support
the marble tops of the tables in
the galleries of the Villa Borghese
illustrate the persistent Roman
passion for sculptural supports.
This is made evident by the eight
statues of Hercules modelled in
1789 by Vincenzo Pacetti
(1746–1820), which served as sup-
ports for the monumental tables

designed by Giuseppe Valadier
(1762–1839) and were made for
the Biblioteca Vaticana. In
Rome, even in the Neoclassical
era, the tradition of marquetry
continued but mainly on large,
lavishly decorated pieces of
stately furniture.

Naples

Poverty and the wealth of the
aristocracy were never more
starkly juxtaposed than in Naples
in the 17th and 18th centuries. Of
a population of nearly 220,000,
only three thousand had any
wealth, and those came from
three hundred noble households.
Half of the affluent few had a
title, while the remaining half
were merchants, craftsmen, doc-
tors, pharmacists, lawyers or pro-
fessors. There were also a signific-
ant number of wealthy clerics of
noble descent living in monaster-
ies. Only these minorities could
afford fine furniture – apart from,
of course, the Royal family, the
Bourbons of Spain who, except

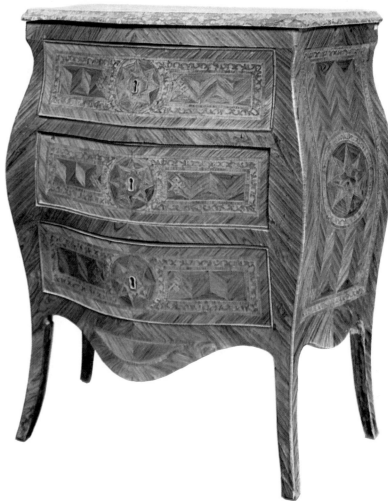

The apotheosis of the curved silhouette: *bombé* furniture

The curving silhouette, the hallmark of 18th-century furniture, reaches its zenith in the *bombé* chests of drawers that were typical of North Italian output, particularly in Lombardy and the Veneto. A development of the 15th-century *cassone* in terms of its use as a container for linen, clothing and toiletry articles, the chest was already a permanent feature in 16th-century bedrooms, and the more richly decorated version was to be found in more public apartments. The commode as it developed in France, is thought to have its origins in the bureau, with drawers underneath the flat top. It combines the chest of drawers as known outside France with the *cassetone*, as it is called in Italy. As the contours of its geometric structure gradually softened, it broadened out and began to "swell", adopting a sinuous silhouette while retaining elegant and balanced proportions. The first part of the commode to embrace this new sinuous linearity was the front, which began to take on a serpentine or bow shape, but very soon the curving spread to all sides in a medley of lines, meandering twice or even thrice – no longer only along the length of the commode but also crosswise. The decorative detail, consisting of a more or less substantial trim, of *rocaille*-edged scrolling, or simply of the natural surface decoration provided by the use of burr-walnut, or again, of the moulded dark-stained edging typical of Lombard furniture, followed and highlighted this sinuosity, moulding itself to the extreme swelling of the sides and front of the piece where the division into drawers gradually faded and disappeared in an attempt to leave the surface movement unbroken and intact. Even when the commode was enriched by the addition of a hinged, fall-fronted top section, this too would follow the line and decoration of the body of the piece, giving rise to the classic sarcophagus style.

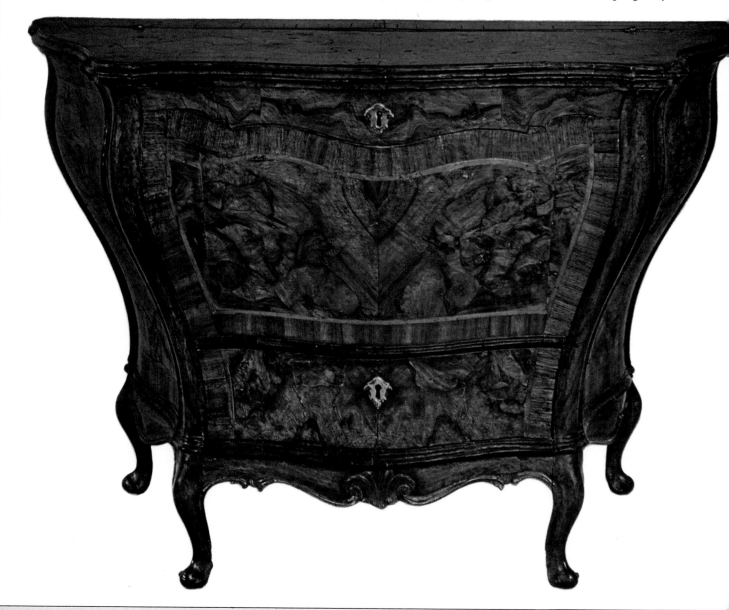

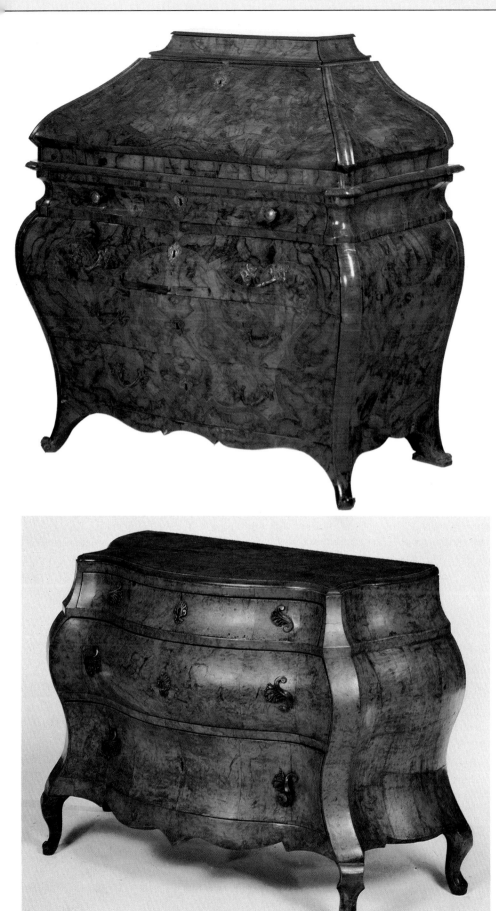

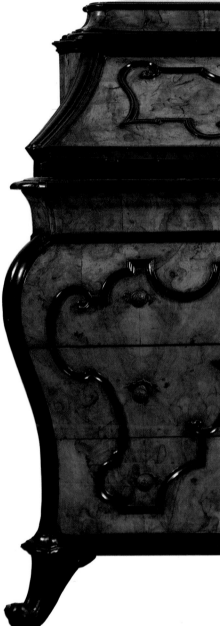

FACING PAGE: Venetian walnut commode
(1740–50), carved and veneered in burr-walnut,
with tulip-wood banding. Private collection. LEFT:
Lombard burr-walnut fall-front commode (c. 1750)
of characteristic "sarcophagus" shape, with scrolled
front feet. Antiques trade.

LEFT: walnut commode from the Veneto region
(c. 1760), of exaggerated *bombé* shape, terminating
in short cabriole legs. Antiques trade. ABOVE: de-
tail of a commode with a fall-fronted upper section,
veneered in burr-walnut, with black-stained band-
ing and decorative motifs, highlighted by the *bombé*
outlines, typical of the furniture of Lombardy.
Musei del Castello Sforzesco, Milan.

This page, above: Neapolitan serpentine commode (c. 1750) with carved ormolu mounts and banding applied to the corners, sabots, lock-plates, sides and apron. Below: late 18th-century Neapolitan commode, veneered all over with various woods in a herringbone pattern, with marquetry rosettes on the front and sides. Facing page: Neapolitan Neoclassical commode, veneered in various woods and inlaid all over in a geometric pattern with two rosettes enclosing the lock-plates. Museo Correale di Terranova, Sorrento.

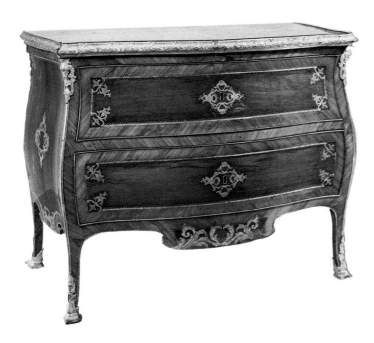

for the period of Austrian control (1707–34), ruled Naples for the entire century.

In Naples too, guilds were formed of cabinet-makers, carvers, inlayers and gilders. The guild of "masters of inlay in ebony, ivory, wood, gold, silver and other metals" dated back to 1621, and in 1736 they established an association with the "seat-makers and trimmers". Charles IV, the Bourbon King (1734–59; then as Charles III, King of Spain from 1759–1788), personally founded the tapestry factory in 1738 and the royal porcelain factory of Capodimonte in 1743 in order to increase the prestige of his state in the eyes of other European monarchies.

Baroque furniture, produced in the first twenty years of the 18th century for the luxurious homes of the aristocracy, revealed a varied lineage in the designs it featured. The lasting influence of Spanish taste was apparent in the recurrent use of a black ground for commodes and "sideboards",

obtained by using ebony and, in lesser pieces, by staining black more common woods like poplar or pear. Flemish influence was also evident in rare marquetry in

pale woods, ivory and mother-of-pearl against dark grounds of vases, foliate sprays, flowers, butterflies and birds. Antonella Putaturo Muraro (*Il mobile napoletano del Settecento*, 1977) attributes this influence to the fact that out of the thirty-five craftsmen who underwrote the statute of the *scrittoriari,* eleven were Dutchmen who had moved to Naples along with merchants and commercial agents.

Gilded consoles and centre tables, with fine marble or tortoiseshell tops and supported by caryatids, telamons or winged figures with lions' feet represented the taste of the Neapolitan nobility during the first decades of the 18th century. Churchmen preferred lecterns and episcopal thrones carved with a profusion of acanthus leaves and, given their particular function, with

backs and arms terminating in cherubs' heads.

French influence

In the second quarter of the century even names like *console, tremò, commode* and *boffette,* which appeared on inventories of furniture, revealed a distinct determination to return to the French models in vogue under Louis XV, who was the Bourbon King Charles's cousin, rejecting the heavy anthropomorphic supports and funereal ebony surfaces. It was not only the nobility and members of the aspirant bourgeoisie who were particularly keen to conform to the new trends but also the convents, which housed many daughters of the nobility. There were writing tables and chests that were very similar to French Rococo furni-

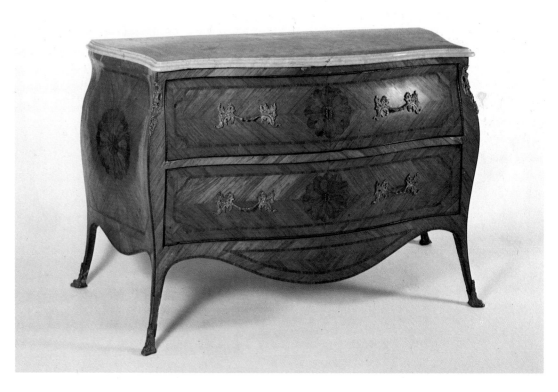

ture, differing only in that they were made of pine and poplar rather than oak and had slightly heavier lines.

This similarity was evident in the sinuous contoured outline of the pieces, in the chased bronze adornments such as handles, the corners of the drawers, the sabot feet and the apron in the centre of the lower frieze. The marquetry of rosewood, kingwood and tulipwood and Spanish yellow-wood was interspersed with basket-weave motifs and geometric designs created by intricate patterns of lozenges, circles, squares and cubes and herringbone banding. Sometimes applied bronze decorations were replaced by carved gilt wood, like the furnishings in the Farmacia degli Incurabili. In addition to the ubiquitous scallop-motif carved in *rocaille* in the centre of seat rails and gilt-lacquered console tables, more typically Neapolitan decorative motifs were employed such as the oval medallion framed by an aureole of acanthus leaves found on the tops of pieces, and on the corners and flanks of Rococo cabriole legs. These terminated in either scrolled or cloven feet, or often English-inspired claw and ball feet. Two festive garlands of flowers cascaded from each side of the central decorative motif or from the sinuous friezes of tables and consoles. After 1750, together with the lion mask, one of the most utilized decorative motifs was the female head crowned by a halo of garlands, reminiscent of the Baroque.

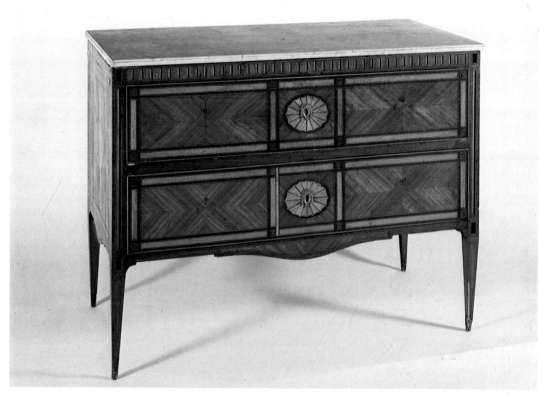

Decoration between the Baroque and the Rococo

The persistence of Baroque decoration, with its mannered naturalism, was a theme that was to characterize Neapolitan output throughout the 18th century. It took as its models the stucco decoration with which the architect Domenico Antonio Vaccaro (1681–1750) had filled the churches of Naples between 1720 and 1730, just as Cosimo Fanzago (1593–1678), who was the first to put forward the idea of a fusion between architecture and decoration, had done in earlier years.

This principle seemed to be the inspiration behind the cabinet in the palace of the Duke of Corigliano. In this square room, the extraordinary wood panels of the walls carved with garlands,

foliate branches and wreaths blended well with the arabesque-inlaid decoration and the French breccia and white marble floor. Painted *chinoiseries* made their first appearance here, although such decoration was not widespread. Artists worthy of mention, who worked closely with Vaccaro, are the carver Giovanni Sisto and the inlayer Mario Pagano from Castellammare di Stabia, who around 1750 worked on the interior design in the abbatial palace of Loreto Mercogliano.

The master carver Giuseppe Postiglione worked under the auspices of Vaccaro in the Palazzo Spinelli di Tarsia and of Filippo Bonocore in the Palazzo Corigliano. The carvers Biagio Calisano, Giulio Gatto and Francesco Lerca worked mostly

for ecclesiastical clients. Clients from the aristocracy, before refurbishing the interiors of their palaces, insisted that architects show them the working designs, which clearly demonstrated the proposed stucco decoration of the walls and ceilings, the floors, the upholstery and the furniture. Antonella Putaturo Muraro (op. cit.) surmises that craftsmen would submit to their middle-class clients more modest copies of furniture already made for the nobility, using models in miniature as samples. The miniature armchair, commode and the fall-fronted cabinet in the Museo Diocesano at Pompeii are examples of these.

The publication of the *Antichità di Ercolano* by Piranesi (1757) did not diminish the enduring taste for *rocaille* carving

among furniture-makers and their clients. In 1775–80 the young Queen Maria Carolina insisted that the architect Carlo Vanvitelli (1739–1821), who took over his father's commissions, use mirrors from Venice and Rococo-style furniture made by Gaetano Salamone, the *sigiolaro* Emanuele Giraldi, and the inlayer Gennaro Fiore for her private quarters in the Reggia di Caserta.

Ferdinand IV, King of Naples and Sicily (1759–99), was however a convinced disciple of the style of Louis XVI, which became known in Naples as *stile Ferdinandeo*. For his study at Caserta, decorated in about 1778 by the stucco decorators Gaetano Magrì and Carlo Brunelli, he ordered

furniture made in the Neoclassical style in Frankfurt in Germany.

Neoclassical forms were only universally accepted by the furniture-makers and their clients after 1785, when Domenico Venuti took over as director of the royal porcelain factory at Capodimonte. Ornamentation on the new designs of Louis XVI-style furniture was initially reminiscent of the Rococo style and was only gradually replaced by Neoclassical motifs. Garlands and female heads encircled by wreaths of carved acanthus leaves survived these changes and remained. The inlaid rosette changed into the eight- or ten-rayed star typical of Neapolitan

furniture decoration and which was named "rose of the winds".

Sicily

Political events in Sicily could not fail to have repercussions in artistic life. With the Treaty of Utrecht (1713), marking the end of the Spanish War of Succession, the island's government passed from the Spanish Viceroy to Vittorio Amadeo II of Savoy, whose presence on the island was, however, of brief duration since in 1718 it came under the rule of Austria. Only in 1734, when, united with Naples, it could claim its own sovereign with Charles of Bourbon as King

Charles IV, did the region undergo relative economic improvement and open up both culturally and commercially towards Europe.

Palermo was therefore open to a variety of outside influences, from France in the form of furniture, from England in the details of the trimmings and from Liguria mainly in lacquerwork, thanks to the importation of Genoese furniture at the end of Spanish rule.

Compared with Ligurian lacquerwork, however, Sicilian lacquer was much more colourful and its ornamentation more vigorously fanciful, as Sicilian craftsmen revealed their Moorish and Spanish roots through their predilection for gilded pastiglia decoration, in which gold with silver was used.

Commodes were flat-sided, with fronts that were lightly bowed in the centre; the lower frieze was usually serpentine, while the handles, which were mainly in bronze, were carved with light *rocaille*. Legs were often stumpier than on Piedmontese or Ligurian examples, uncarved and supported by relatively tall cloven feet. Some pieces were completely gilded, others were decorated with floral motifs in pastiglia in very light relief. Sometimes a fine layer of brown applied over the ivory-coloured ground produced a particularly decorative effect.

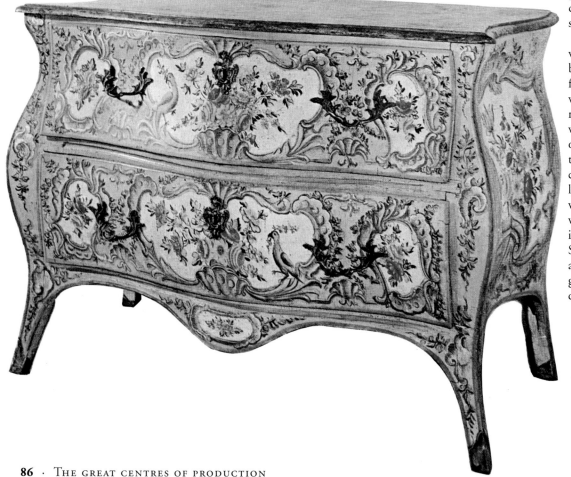

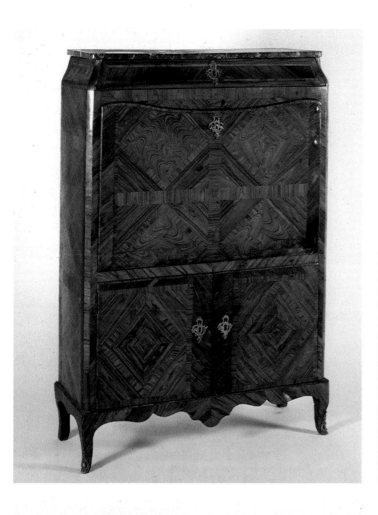

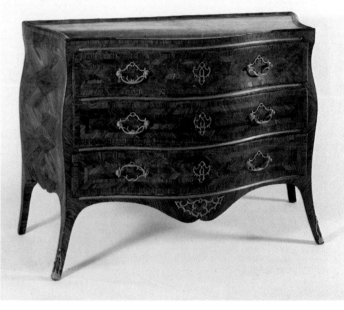

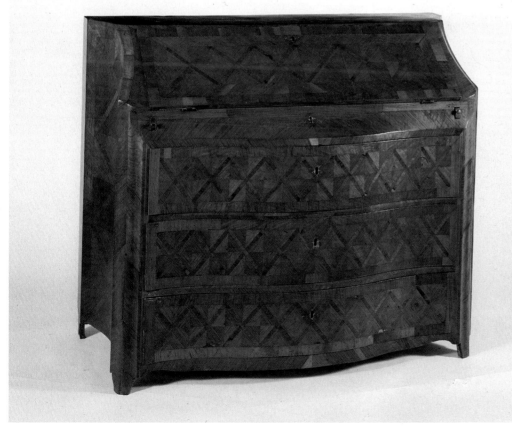

Facing page: Sicilian Rococo com-
mode painted with flowers and birds
within asymmetrical cartouches, with
ormolu trimmings and marble top.
Private collection. This page, top
left: South Italian secretaire (1760–80),
veneered in rosewood, the front with two
doors and a fall-front and a heavily
scrolled apron, on curved legs. Right:
Sicilian veneered commode, with serpen-
tine front and brass banding between the
drawers. Below: fall-front Sicilian
commode (c. 1750) veneered and inlaid
all over in walnut with a geometric motif
and faceted with lozenges, with a serpen-
tine front and concave sides. Antiques
trade.

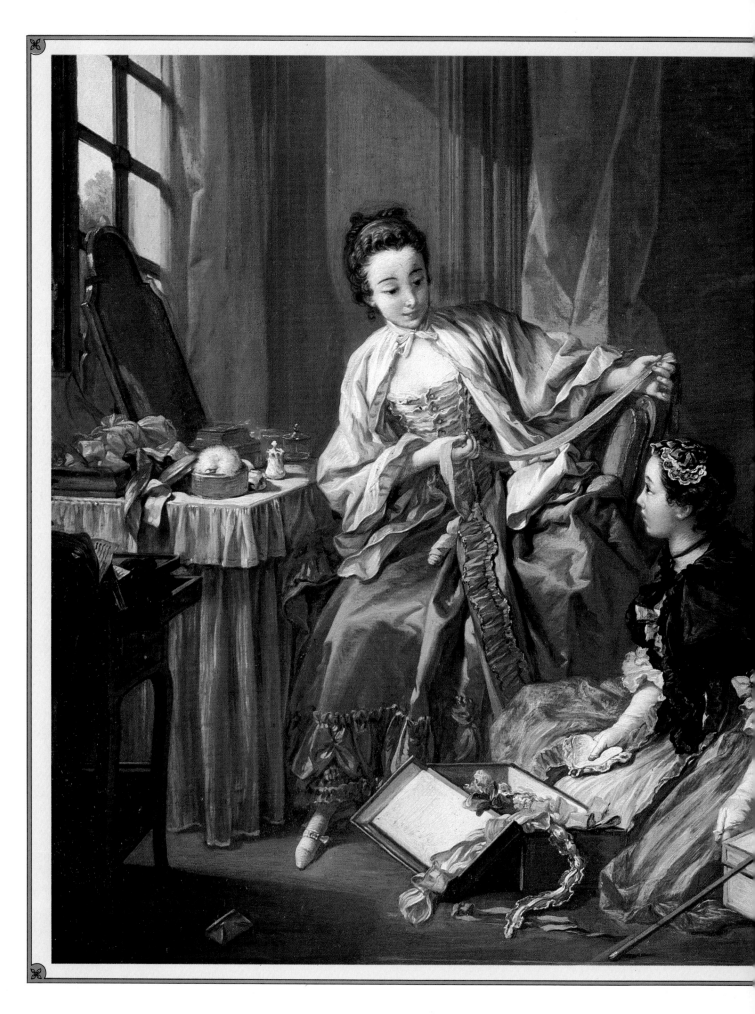

FURNITURE OF THE 18TH CENTURY

FRANCE

by Alessandra Ponte

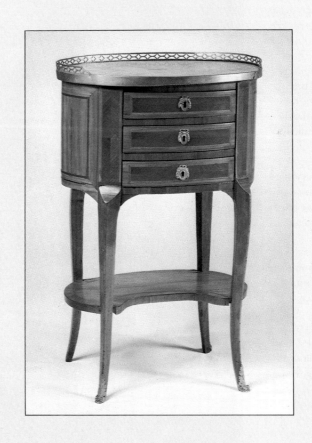

French furniture of the 18th century

Introduction

"In the 17th century, an ostentatious style could still be regarded as a way for royal or noble families to display their "charisma"; whereas in the 18th century an article of luxury simply represents the embodiment of wealth, its beauty no longer echoing any spiritual antecedents; it no longer expresses reflected authority in a purely material world. The luxurious style of the 18th century exploits and modifies the many different forms through which authority used to express itself but does not adopt any of their substance. Form becomes an end in itself. The artist can make fanciful use of form to satisfy the taste for variety." This is how Jean Starobinski describes the Rococo style in his book *The Invention of Liberty 1700–89* (Geneva 1964), elegantly summing up the moment of transition from the style of Louis XIV to that of Louis XV. In the decorative arts, the cartouche, or scroll-like feature, came to symbolize this transition. What once framed a coat of arms or a family motto now became purely decorative, with no emblematic significance.

The godlike figure of the absolute monarch, the Sun King, dwindled and retreated into the background of the immense perspectives that he himself had created. The rigid rituals with which the courtiers whiled away their time in the vast salons of Versailles, the protocol governing every detail of their life and behaviour, and the endless allegorical references to the power of the monarch in architecture, painting and decor, all made way for a more cheerful and intimate atmosphere favoured by a sophis-

ticated society that sought amusement rather than responsibility.

The pioneers of this brilliant, scintillating and "dancing" style were Bérain and Lepautre. Developed by Oppenordt, it reached its real apogee in the asymmetrical exuberance of Pineau, Meissonnier and Cuvilliés. They

decorated walls, panelled furniture, ceramics and fabrics with floral patterns, bouquets in vases and baskets, arrows and quivers, garlands, cupids, smiling Chinese goddesses resembling Parisian *cocottes*, elegant mandarins, shepherdesses, harlequins, pierrots and, above all, scallop

shells. The pearly intimacy of the insides of these shells perfectly matched the taste of certain boudoirs and the accommodating curves of their armchairs. The contours are full of serpentine convexities and concavities; they are detached and appear to float freely. The curved line reigns

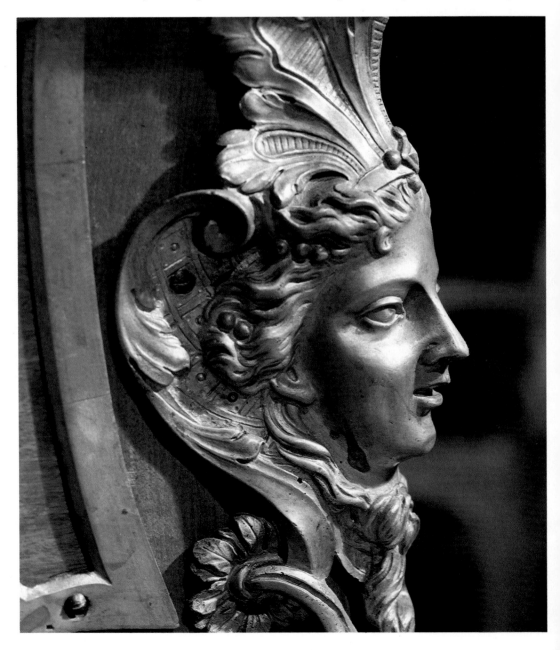

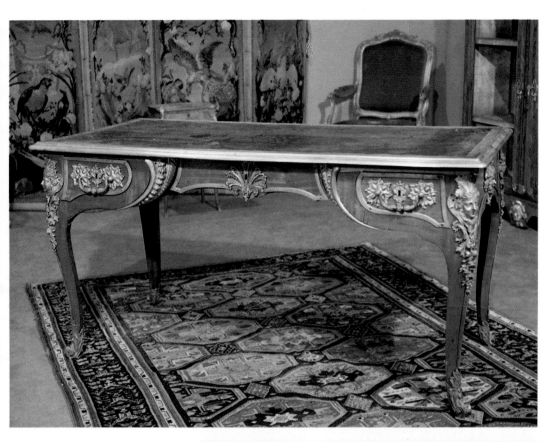

an ardent advocate of Neoclassicism, which began to gain popularity in France in the 1750s, when the first pieces of furniture in the *goût grec* appeared. Linear and symmetrical structures decorated with forms borrowed from antiquity gradually displaced Rococo fantasy. This was the age of the palmette and meander pattern, chapiters, laurel and acanthus leaves. But alongside lions, griffins, satyrs and nymphs we still find *chinoiseries*, floral motifs and pastoral idylls. Not until the post-Revolutionary Directoire and Empire periods did designers

supreme. As the French painter Dufresnoy wrote in 1688: "The outlines of the different parts begin to resemble waves, flames or the writhing coils of a snake. These contours tend to be large, fluid and seemingly intangible."

From 1750 critical opinion began to react against the unbridled licence and decorative whimsicality of the Rococo.

The most devastating verdict came from Le Camus in 1780: "Any shape whatsoever was permitted: as long as it billowed or took flight, people were happy. There was no harmony, no order, no symmetry. [...] What we have here are transient afflictions and a corruption of taste against which one can never be too vigilant."

Those words were written by

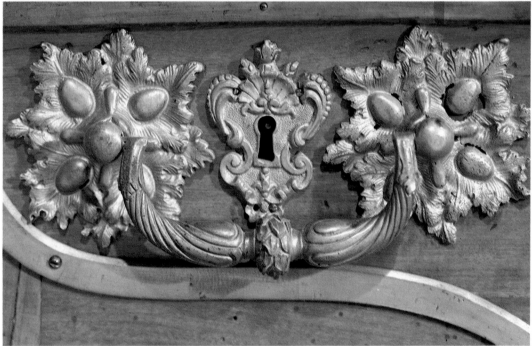

THESE PAGES: overall view and details of a *bureau plat* from the Régence period. This desk, veneered in purplewood and *bois satiné*, is decorated with ormolu mounts, lock-plates, scroll-like curled bronze foot-mountings and the characteristic *espagnolettes*, small female heads in the Spanish tradition. Antiques trade. PREVIOUS PAGES: In his painting *La Modiste* (The Milliner), François Boucher (1703–70) represents a typical day in the life of an 18th-century lady of fashion. On the right is a *chiffonière* (c. 1780), a small piece of furniture with drawers for fabrics and accessories, made by Jean-Pierre Dusetoy. National Museum, Stockholm, and antiques trade.

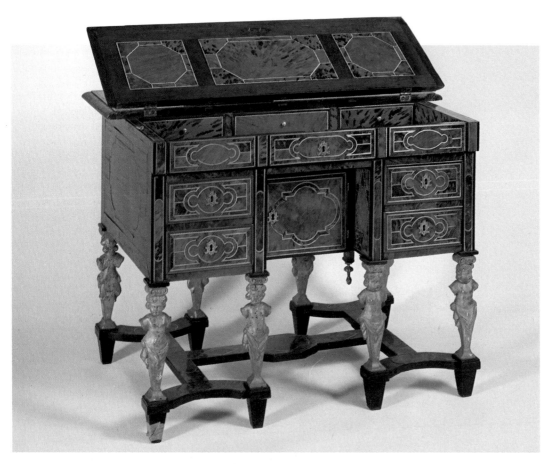

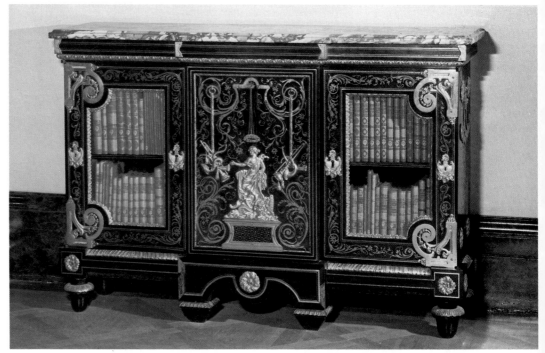

BELOW LEFT: *Bureau Mazarin* (1680–90) with ebony and tortoiseshell veneers and brass inlays. The legs in the form of busts with the heads of youths are in carved, gilt wood. Antiques trade. BOTTOM RIGHT: bookcase with Boulle-style marquetry by Jean-Louis Faizelot Delorme, who is known to have been active from 1748 to 1768. Wallace Collection, London.

sovereign. Indeed the artisans and artists in royal service were to create a sumptuous setting at Versailles for the king in which all of the architecture, every decorative motif and every painting was intended to exalt his power and glory.

Initially, this programme was directed and choreographed by the painter and designer Charles Le Brun (1619–90). After studying painting with Simon Vouet, Le Brun was sent to Rome by his patron, Chancellor Séguier. He remained in the Eternal City for about three years (1642–46), where he came into contact with Nicolas Poussin and Pietro da Cortona, who helped to influence the classically inspired Baroque style that came to characterize his work.

On his return to France Colbert recommended him to the king, who first appointed him (in 1658) director of the Maincy start copying classical models in precise detail.

The Louis XIV style

The dominant and centralizing influence of Louis XIV, the Sun King, was fundamental in developing the style which takes his name. In collaboration with his Chief Minister, Jean-Baptiste Colbert (1619–83), he created a system of manufacture and *ateliers* (workshops) dependent on the crown. Not only did these workshops raise French art and craftsmanship to a high level of perfection, an example to the whole of Europe in the 17th and 18th centuries, but they were also instrumental in the self-aggrandizement and glorification of the

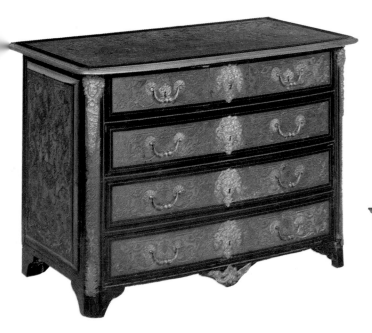

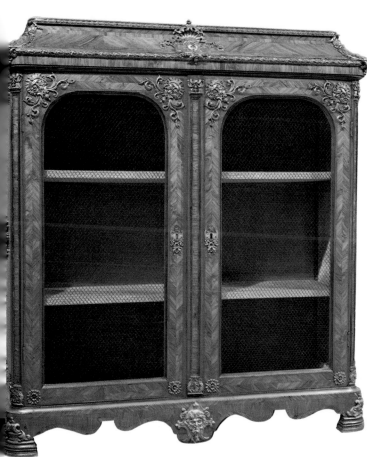

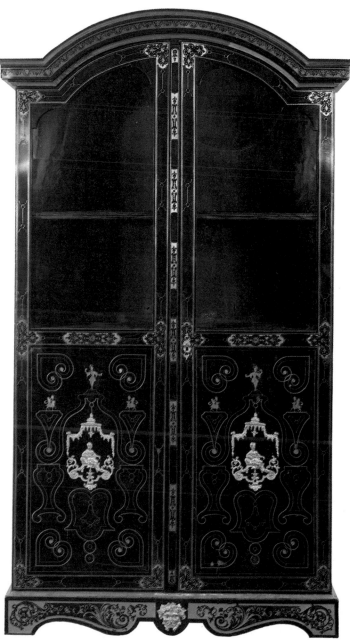

LEFT: a Boulle commode with decorations *à la Bérain,* in brass and tin on red tortoiseshell. BELOW LEFT: a small bookcase in kingwood with ormolu mounts. BELOW RIGHT: an ebony wardrobe (c. 1700) with copper incrustations. The figures below the *lambrequins* are ormolu. All antiques trade.

carpet factory. Later he managed the *Manufacture des Meubles de la Couronne,* the royal workshops established by Colbert at the Gobelins in Paris in 1662. In the various *ateliers* of the Gobelins and those of the Louvre, also under Le Brun's control, some

250 craftsmen – carpet-weavers, painters, bronze-casters, cabinet-makers, gold- and silversmiths – produced most of the furnishing for the royal residences. After the death of Colbert, Le Brun fell out of favour and the *Manufacture* closed in 1684 because of financial

problems caused by successive wars. Its gates remained shut until 1699, after which it concentrated entirely on tapestries.

Le Brun not only drew the sketches for the tapestries but also designed models for all kinds of artisanate production. He con-

trolled the quality of workmanship and the elegance of ornamentation with a rod of iron, and imposed on the decoration a classically influenced character, which restrained the inclination to ostentation, and the bizarre and decorative excess typical of

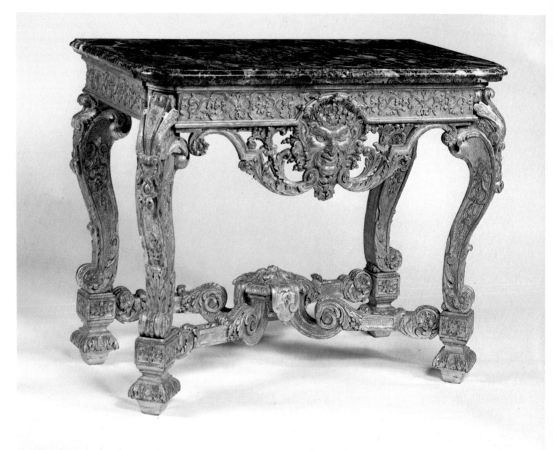

the Baroque. Le Brun reinforced the Italian influence that was already present when Louis XIV came to the throne, thanks chiefly to Cardinal Mazarin. This man brought numerous artists and craftsmen from Italy to France, one of the most famous Italians at the Gobelins being the cabinet-maker and goldsmith Domenico Cucci (before 1640–1705), who came to France about 1660. In addition Le Brun used classical subjects as allegories of the power of his monarch.

Decorative motifs and materials

The furniture of this period, whose architectural appearance is still essentially early 17th century, was decorated with antique motifs such as the breastplate, shield, cornucopia, sphinx, griffin, winged horse, eagle, dolphin, lion, lyre and cithara. But these were combined with symbols of the French royal house: crown, sceptre, fleurs-de-lis framed with palm leaves, scallop shells and laurel wreaths. In addition, cornices and pillars were decorated with elements of classical architecture in use since the Renaissance such as balusters, busts, medallions and pilasters.

The materials were extraordinarily costly: veneers and inlays of rare hardwoods, combined with marquetry of semiprecious stones, ivory or mother-of-pearl and appliquéd metals, mainly bronze and silver. Entire suites of solid silver were created, for example for the Hall of Mir-

FACING PAGE, ABOVE: console table (c. 1700) in carved, gilt wood with a top made from green and white marble, and satyr masks framed by scrolls in the centre of the front. The curved legs decorated with plant-like motifs are connected near the base by double-curved stretchers. BELOW: a Régence console table in carved, gilt wood. In the centre of the front is a characteristic scallop motif surrounded by tendrils. THIS PAGE, BELOW: Régence table with the scallop shell motif set in pierced tendril-work. BOTTOM LEFT: Régence console table in carved oak, decorated with shell motifs, foliage and a bearded mask, with cloven feet and red marble top. BOTTOM RIGHT: a Louis XV console table in carved, gilt wood with *rocaille* motifs. The feet are joined by baskets of flowers. All antiques trade.

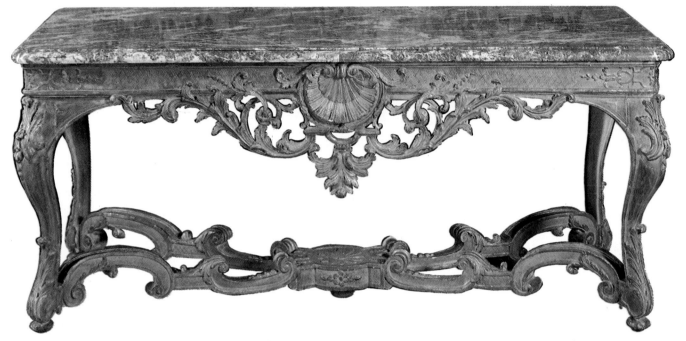

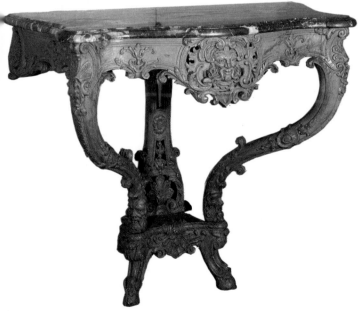

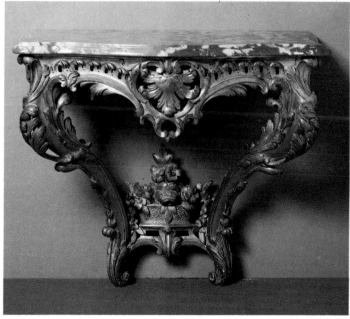

rors at Versailles; in 1689, when the high cost of waging war had created an economic crisis, the pieces were melted down and replaced by replicas in gilded, silvered or lacquered wood.

In the *Manufacture des Gobelins,* designs were produced for furniture and other articles *à la façon de la Chine* copied from oriental lacquered furniture and decorated with motifs borrowed from Chinese and other eastern art. In those days very little was known about these countries, and so many pieces of "Chinese" furniture must have looked anything but exotic. Contemporary descriptions confirm that these figurative elements and ornamentation were very freely interpreted and combined with structures still closely based on classical models. A typical example is the decor of the *Trianon de Porcelaine,* which Louis XIV had built in winter 1670/71 for his current mistress, Madame de Montespan. This miniature palace, designed by Louis Le Vau (1612–70), became the prototype for countless pavilions and garden temples in

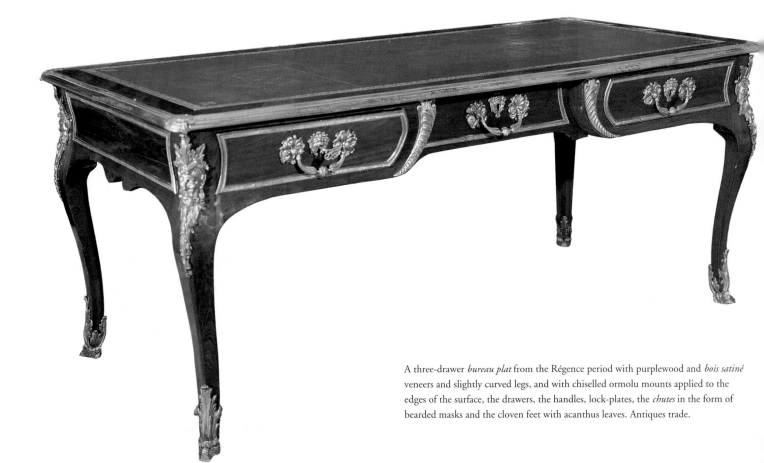

A three-drawer *bureau plat* from the Régence period with purplewood and *bois satiné* veneers and slightly curved legs, and with chiselled ormolu mounts applied to the edges of the surface, the drawers, the handles, lock-plates, the *chutes* in the form of bearded masks and the cloven feet with acanthus leaves. Antiques trade.

the Chinese style. The building was decorated with faience tiles whose dominant colours were blue and white, considered at the time "thoroughly Chinese". The *Chambre des Amours* had "Chinese" chairs upholstered either in blue and white or gold and silver. The bed in the *Chambre de Diane* was decorated with putti, clearly in European taste, though a dash of "Chinese flair" was provided by curtains in blue, gold and silver taffeta. Tables of various sizes were blue and white to match the tiles.

Architects and designers

In France as elsewhere, there was a growing fashion for porcelain and lacquerwork imported from

China and Japan. Vases and cabinets – generally on bases of gilded bronze or carved wood painted in the contemporary manner – replaced the very much more expensive items of furniture made from silver. One artist who contributed to the development of the Louis XIV style was Jean Lepautre (1618–82), brother of architect Antoine Lepautre (1621–91), and like him trained during the reign of Louis XIII. Some 2,000 engravings of his designs survive, showing fireplace consoles, urns, beds and other furniture.

The designs from Jean Lepautre's early creative period may seem over-opulent and heavy, incorporating a wealth of putti, flowers and foliage, nymphs and satyrs, but his later

drawings show more maturity and elegance. His son Pierre Lepautre (1660–1716) worked as a draughtsman under the architect Jules Hardouin-Mansart (1646–1708) at Versailles. His style is typical early Rococo.

The great importance of the architect, designer and decorator Jean Bérain the Elder (1637–1711) lies in the fact that at the turn of the 17th and 18th centuries he brought about a change in decorative style. It was he who promoted the use of "grotesques", imaginative decorations of small, stylized plant motifs with human figures or animals, as well as other ornamentation, which display not only Italian and Flemish influences but also a leaning toward the ancient world. The son of a gunsmith,

his family moved to Paris, and in 1674 he was appointed *Dessinateur de la Chambre et du Cabinet du Roi* (designer of the king's bed-chamber and study). His duties included organizing ballet performances, festivities and other events. In 1691 he gained the title *Maître dessinateur* and succeeded Le Brun as the principal designer of furniture for the court. Bérain's drawings anticipated the Rococo: his elegant and imaginative decoration was so unmistakable that it henceforth set a style known as *à la Bérain*. It is characterized by exceptionally charming grotesques, which are often surmounted by canopies with drapery of light material supported by busts in the form of pillars. He portrayed elegant

BELOW LEFT: one of a pair of corner cupboards from the Régence period with purplewood veneer, a red marble top and ormolu decorations. BELOW RIGHT: one of a pair of Louis XV corner cupboards (c. 1750) in tulipwood veneer; the top made from speckled marble, above a serpentine front with two doors, the panels bordered in kingwood, supported on bracket feet. BOTTOM: Louis XV corner cupboards with marquetry composed of flower and bird motifs and bronze mounts. All antiques trade.

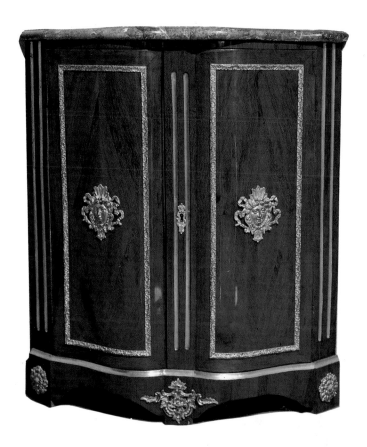

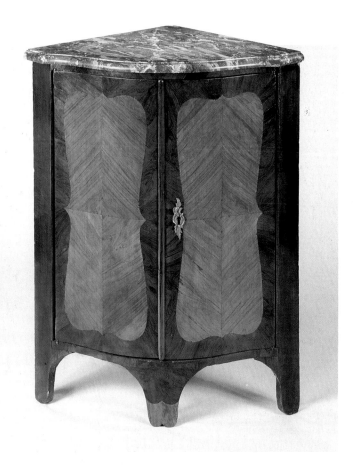

gods and goddesses framed with acanthus leaves, and had a penchant for both musical instruments and *singeries* – representations of monkeys in human situations – and scenes with oriental figures. The arrangement of ornamental motifs is always symmetrical and harmonious. His engravings were published in Paris between 1710 and 1711, reprinted after his death by his son-in-law as *Œuvres de Jean Bérain, recueillies par les soins du sieur Thuret* (Works of Jean Bérain collected by Mr Thuret). In the Louvre, where most royal cabinetmakers' workshops were situated, Bérain collaborated with the leading French *ébéniste* of the period, André-Charles Boulle.

The last great designer of the age of Louis XIV was Claude

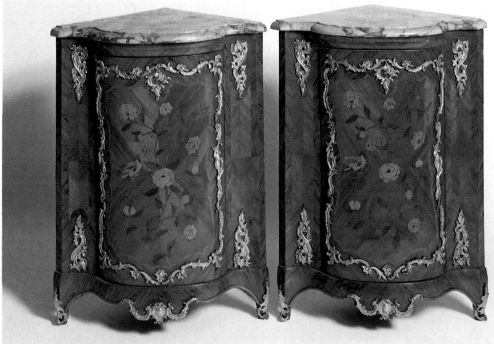

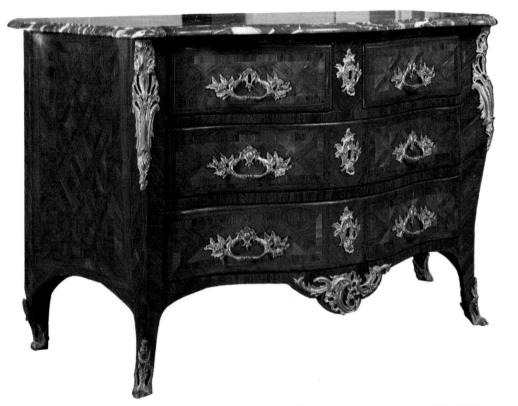

BELOW: a Louis XV commode in kingwood with serpentine front, concave sides and decorations in ormulu. BOTTOM: commode (c. 1725) in kingwood with marquetry, serpentine front and applied with ormulu mounts, the *chutes* with *espagnolette* busts, inspired by the paintings of Watteau. The piece bears the stamp "F.F". Antiques trade.

The Régence style

In some ways the Régence (Regency, 1715–23) was a transition between Louis XIV and Louis XV styles, since it shows features common to both. This has led to confusion in the classification of individual pieces of furniture. During the last years of Louis XIV's reign, several artists and craftsmen discussed elsewhere in this book had already begun laying the foundations for developments in the Régence period. Among the most important of these is the architect Robert de Cotte (1656–1735), a pupil of Jules Hardouin-Mansart and his successor (in 1709) as *Premier Architecte du Roi* (The King's Chief Architect). Among other things, Cotte designed the

Audran III (1658–1734), from Lyons, who continued Bérain's tradition. Audran settled in Paris in 1692 and was working for the royal palace by 1693. Though classical elements are still present in his work, they no longer possess the symbolic and allegorical slant of previous decades. The delicate, flowing lines of his designs herald the beginnings of Rococo. Towards the end of the 17th century both the ornamentation and shape of furniture became lighter and more graceful. Once freed of the architectural rigidity that had characterized it throughout the century, it took on softer shapes and more sinuous outlines.

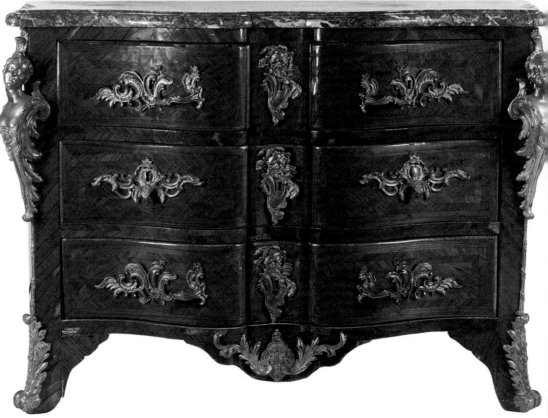

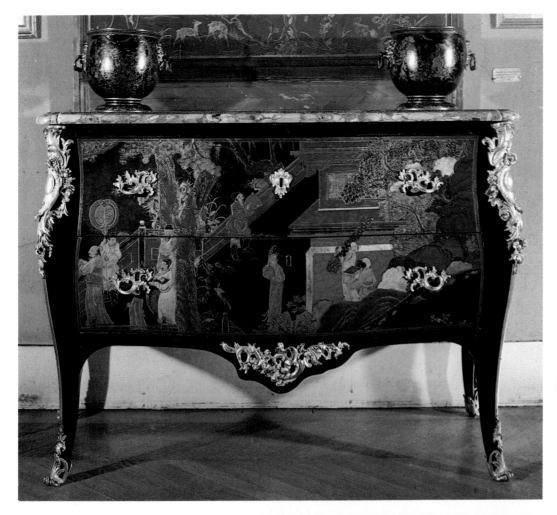

Though of Dutch extraction, Oppenordt was born in Paris and educated at the French Academy in Rome. His work was clearly influenced by Bernini, Borromini and other architects of the Italian Baroque. After his death, three volumes of his collected drawings were published in 1748, with the titles *Petit, Moyen* and *Grand Oppenordt*, and containing designs for *boiseries* (decorative woodwork), panelling, furniture, consoles, lamps and cartouches. In spite of the curves and counter-curves, whims and oddities of his designs, the balance and symmetry of late-17th-century decorative motifs were to some extent preserved. From 1715 onwards Oppenordt was court architect to the Regent.

Chapel Royal at Versailles and the Hôtel de Toulouse, the building in Paris that now houses the Banque de France. Among the *ménusiers* who worked under his direction and were influenced by him were Du Goullon, who created the choir-stalls in Notre-Dame, François Potain the Elder, who made a number of wardrobes and sideboards for Versailles, Nicolas Foliot the Elder who made several pieces of furniture for the Prince de Condé and Jean-Baptiste Tilliard, supplier of furniture to the court.

Beside André-Charles Boulle and Jean Bérain the Elder, who had a decisive influence on the decorative arts of the age, the name of Charles Cressent deserves mention. He created elegant and sumptuous furniture for the Regent, the Duc d'Orléans, which was in keeping with the interiors designed by Gilles-Marie Oppenordt (1672–1742).

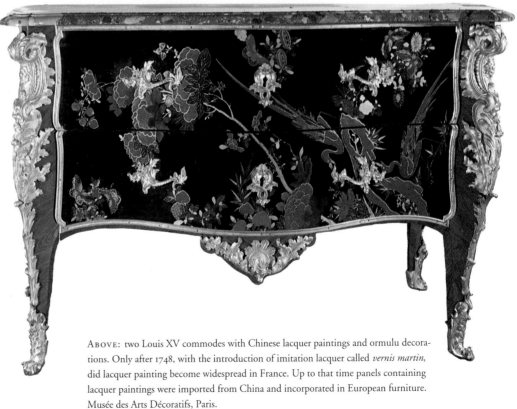

ABOVE: two Louis XV commodes with Chinese lacquer paintings and ormulu decorations. Only after 1748, with the introduction of imitation lacquer called *vernis martin*, did lacquer painting become widespread in France. Up to that time panels containing lacquer paintings were imported from China and incorporated in European furniture. Musée des Arts Décoratifs, Paris.

BELOW LEFT: a *bureau plat* in the Louis XV style, made from *bois satiné* veneer with ormulu mounts. BELOW RIGHT: a small Louis XV writing-table with tulipwood and *bois satiné* veneer in a "butterfly-wing" design. The piece bears the stamp of Delorme. BOTTOM: a *bureau en pente* in the Louis XV style, with inlay in kingwood and *bois satiné*, and lock-plates and other decorations in bronze. Antiques trade.

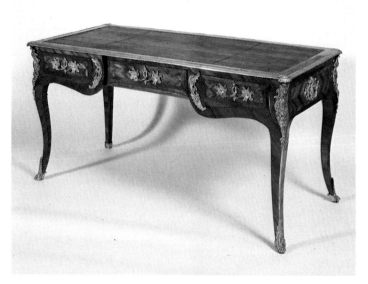

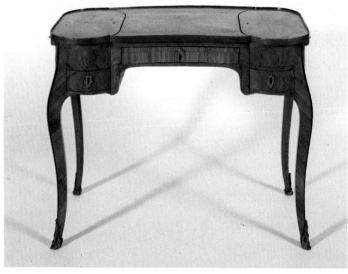

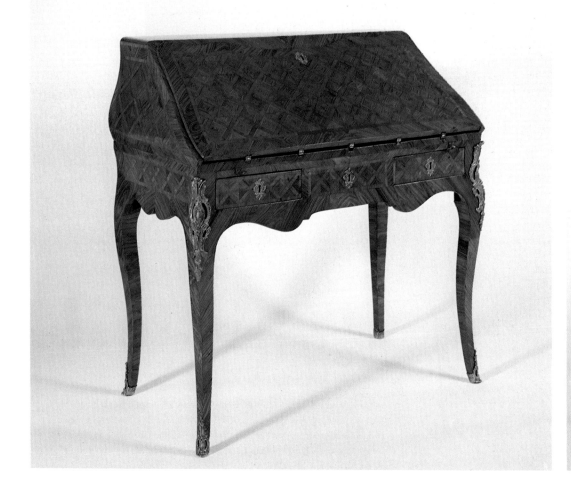

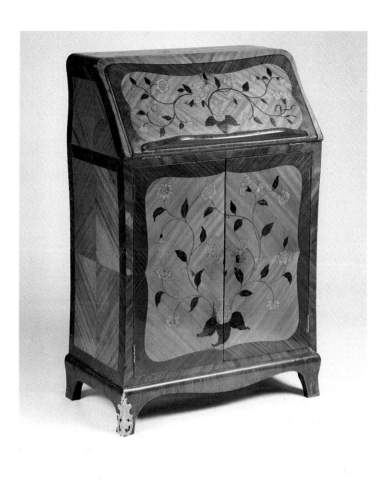

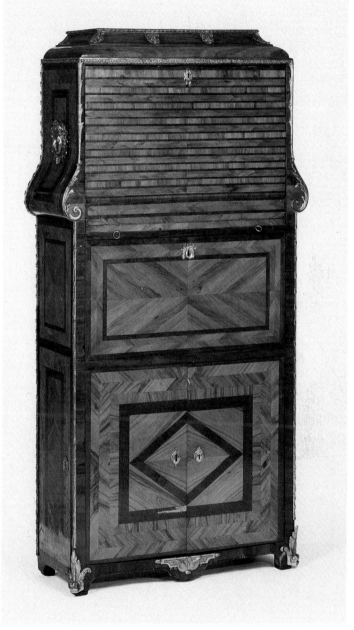

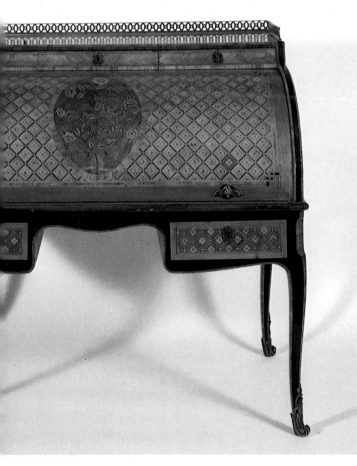

LEFT: a Louis XV *bureau à cylindre* with an inlaid floral medallion in tulipwood.
ABOVE LEFT: secretaire (c. 1750) with veneer in tulipwood and other woods. The
bordered door-panels and lid are inlaid with floral motifs. ABOVE: a *secrétaire
cartonnier* (c. 1740) with marquetry in various woods and ormulu mounts. The upper
sliding panel conceals a row of pigeon-holes. Antiques trade.

Function and comfort: the 18th-century armchair

For obvious functional reasons, seating has always played an important role in furniture. Throughout every stylistic epoch craftsmen have sought new solutions to the problems of structure, decoration and accessories that not only appealed to contemporary taste but were also better adapted to changes in lifestyle. In the 18th century, especially in France, the trend was toward wider and more comfortable designs, whose structure and shape was primarily aimed at meeting the need for comfort. Seating became increasingly light and attractive, and upholstery was used more and more. Various different types of seating were developed to suit specific activities: lying down, relaxing, holding conversations, reading, studying, playing cards or gambling. Two categories enjoyed particular popularity: placed against the wall was the *siège meublant* or *chaise à la reine*, which had a wide, flat back-rest, often covered with velvet, damask or silk decorated with floral patterns or *petit-point* embroidery. Smaller, lighter, portable and comfortable chairs, placed singly or in groups in a room, were for relaxing or conversing; these were called *sièges courants* or *chaises en cabriolet* and had curved, concave backs. The "classics" of the 18th century are all a further development of the *siège courant:* the *bergère*, with seat, back and arms all upholstered, often has loose seat-cushions and a curved back-rest extending beyond the arms; the very low *chauffeuse* was placed near the fireplace; the wing-chair protected the occupant from prying eyes; the *voyeuse* had padding on top of the back-rest so that the user could sit astride it or kneel on it and watch a gambling game; the *causeuse*, finally, was designed for discreet conversations *à deux*, and was therefore also known as the *confident* or *téte-à-téte*.

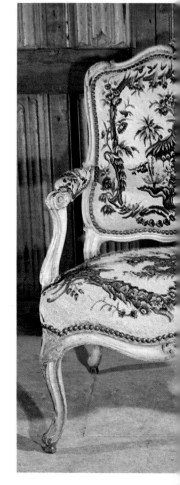

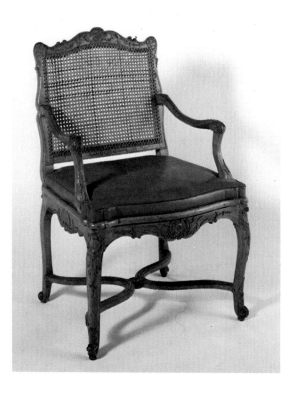

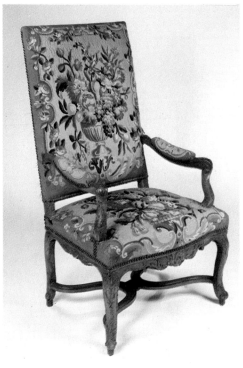

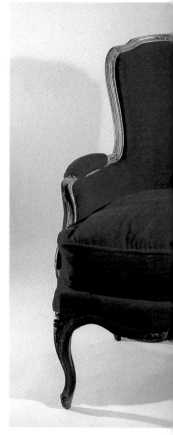

Above: two chairs whose legs and stretchers place them clearly in the Régence period. The example on the left has a woven cane back and decorative top-rail, the decoration consisting of carved plant motifs and shells. The chair on the right (c. 1720), like the one previously described, is made of carved walnut and upholstered with an Aubusson fabric. The legs of both chairs are joined by curved stretchers. Antiques trade.

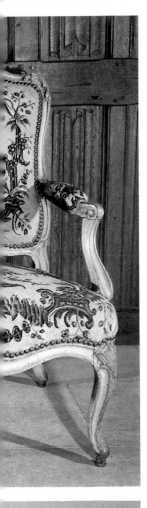

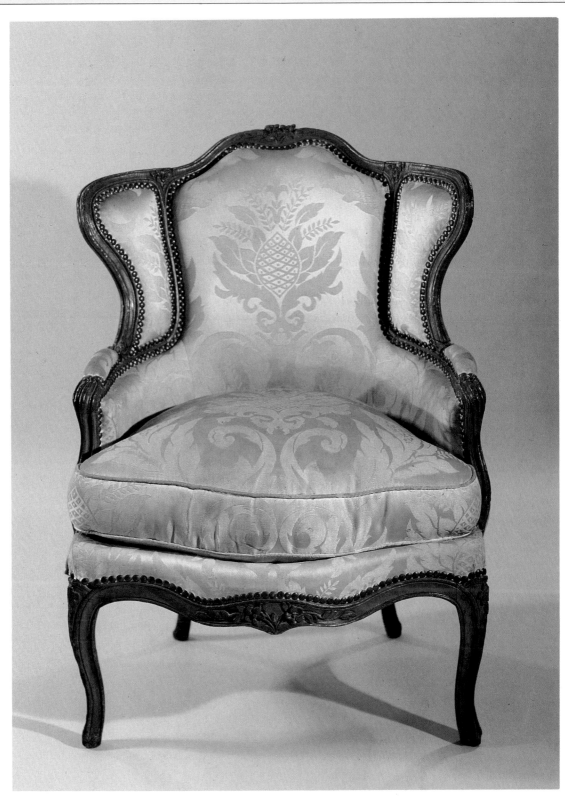

ABOVE LEFT: a Louis XV *chaise à la reine* in painted wood; the covering fabric features *petit-point* embroidery. The tall, straight back is typical of this style. Musée des Arts Décoratifs, Paris. BELOW LEFT: a Louis XV *bergère en gondole* in natural moulded wood with small floral carvings. It is fully upholstered, with a deep seat-cushion. ABOVE: a Louis XV *bergère à oreilles* in moulded oak with small floral carvings. Antiques trade.

BELOW: armchair and *chaise en cabriolet* of the Louis XV period in carved, gilt wood. Both examples shown are part of a twenty-piece suite made by Pierre Nogaret. They are covered with a fabric from the Manufacture des Gobelins, featuring bird motifs on the back-rests and themes from the fables of La Fontaine on the seats. Antiques trade. BOTTOM: This settee (c. 1750) is made of carved walnut with a satin finish and is also the work of Nogaret. Musée Nissim de Camondo, Paris. FACING PAGE: *Le Bénédicité* (The Grace) by Jean-Baptiste-Siméon Chardin (1699–1779). Musée du Louvre, Paris.

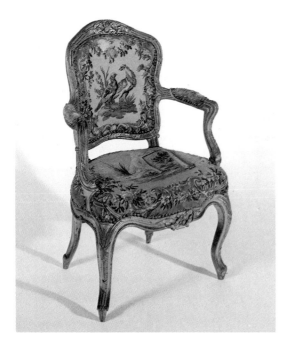

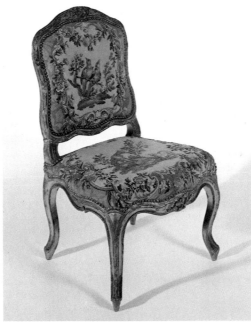

were beginning to emerge. The first examples of *pieds de biche* (hoof feet) and curved console-style legs can be found in chairs made about 1690; chair-backs became semicircular and the seats more rounded. All types of furniture are notable for their vigorous outlines. Wardrobes acquired curved pediments and their legs became longer and less compressed, so that the furniture appeared slimmer and lighter. During the Régence fabric covering mattered less, carved wood assumed an increasingly important role and the stretchers between the legs disappeared. Chairs made from 1718 onward had shorter armrests, in order to accommodate women's hooped skirts more comfortably. During this period multicoloured ornamentation and gilding remained as popular as ever, and cabinet-makers continued the tradition of marquetry and bronze appliqué. Decorative motifs did

Probably the most lasting influence on the decorative arts of this era was that of the painter Jean-Antoine Watteau (1684–1721). Reproductions of his slender, imaginative little figures and ethereal landscapes, and decorative motifs from his paintings, drawings and posthumous engravings are found on tapestries, porcelain, glassware and furniture. Watteau composed paintings inspired by the fabled Cathay (China) – frivolous fantasies featuring idols and goddesses, priests, courtiers, temples and awnings shaped like baldachins – all in exquisite taste. Sometimes figures from the *commedia dell'arte* peer out from behind scrollwork or foliage. He was probably the first artist to incorporate *espagnolettes* (Spanish girls) into his paintings; these were female heads with the high, stiff lace collars popular in Spain. By contrast, Claude Audran III invented *singeries*, which enjoyed great popularity during the Rococo period. These strange little scenes in which

monkeys behave like humans were adopted by Jean Bérain and Christophe Huet.

Characteristics of the Régence style

The furniture of the Régence retains some of the heavy monumentality of the previous age but the flowing lines of the Rococo

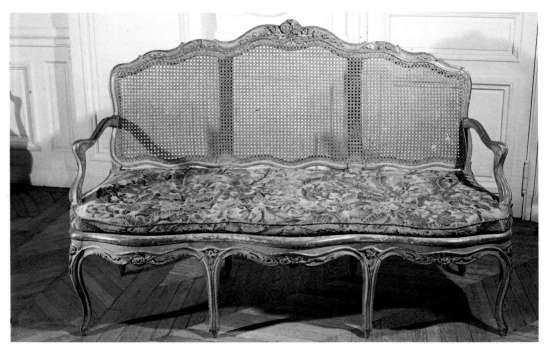

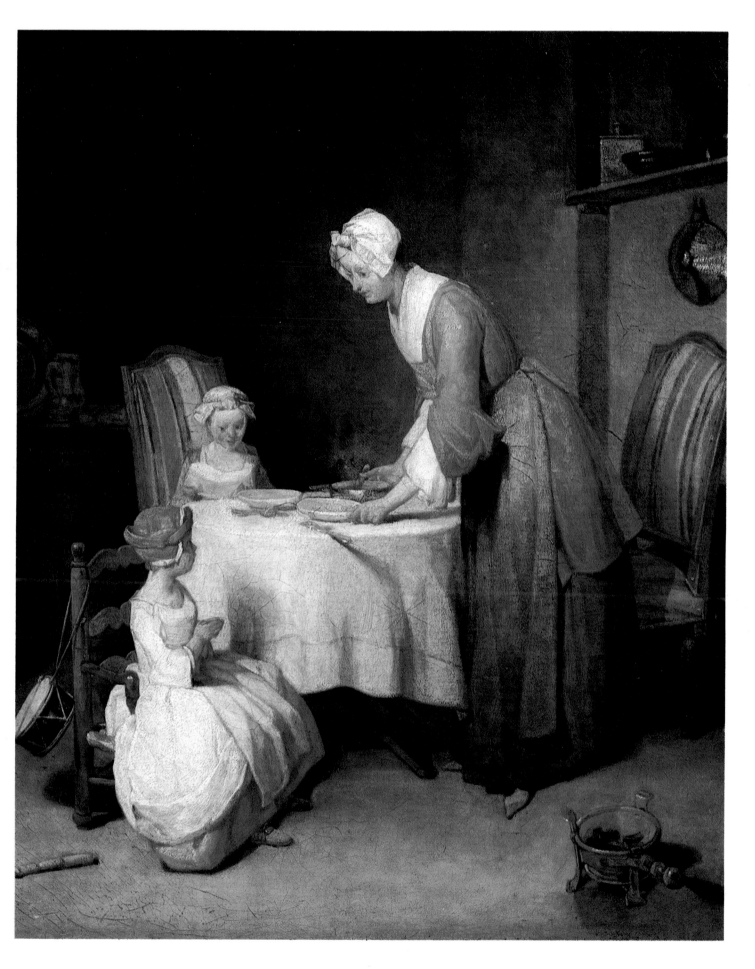

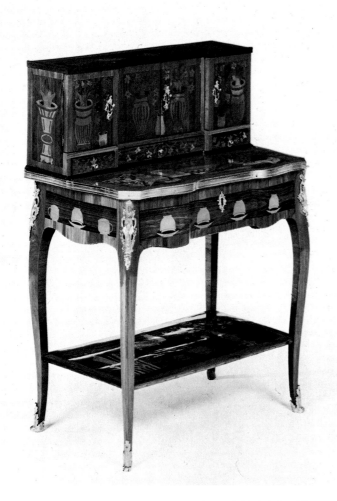

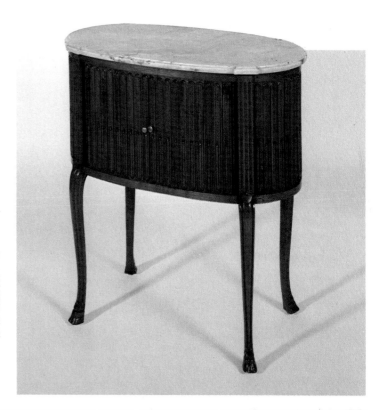

LEFT: A *bonheur-du-jour* (c. 1775) with a small cabinet on the table-top, in tulipwood with inlaid flowers, playing cards and tea-cups. BELOW: a Transition *table d'en cas* in fluted mahogany. BOTTOM: a commode of the Transition period. Although the legs are still curved, the body of the piece has been given a more rectangular shape. Antiques trade.

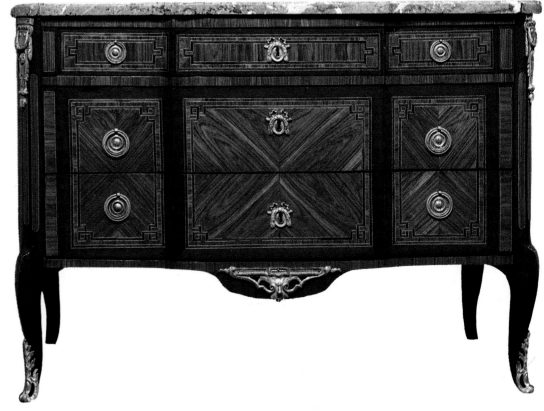

not differ greatly from those of the previous age. However, the work of Boulle and other craftsmen shows the influence of Bérain's design-books in their grotesques, *singeries*, tendril-like arabesques and floral decorations. Simple, geometric, lozenge-shaped marquetry in tulipwood or purple-coloured wood also enjoyed great popularity. *Ebénistes* very quickly developed new items of furniture, especially commodes and large writing tables known as *bureaux plats*.

The Louis XV style

During the reign of Louis XV (1715–74) furniture was intended to suit smaller, more intimate rooms, and it assumed greater importance in the context of interior decor as a whole. Items of furniture were designed for a wide variety of specific purposes:

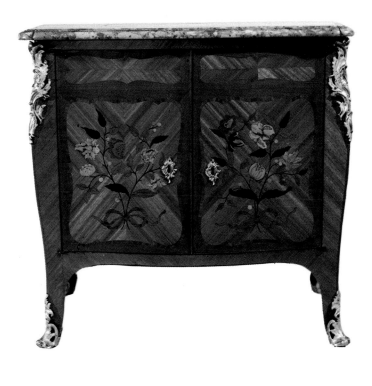

small tables for day use and others for the bedside, tables for sewing and playing cards or gambling, as well as serving tables, corner cupboards, bench-seats, armchairs, *canapés* or settees and sofas in the most unusual shapes began to appear in bedrooms, reception rooms and boudoirs. The flowing curve reigned supreme: every outline, moulding and ornament assumed a sinuous, serpentine shape, enlivened with curlicues, cartouches, cascade-like motifs and features reminiscent of fountains. The Rococo, a style that had begun to emerge in the last few decades, was now enjoying its heyday. Charm, elegance and fantasy replaced pomp and overwrought emotion. The dominance of classicism was finally past and artists were adopting very different exemplars.

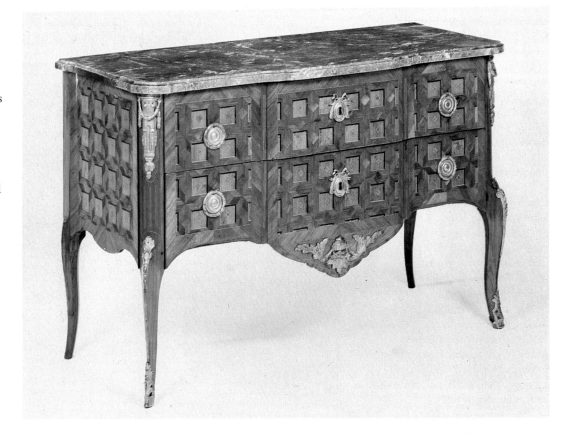

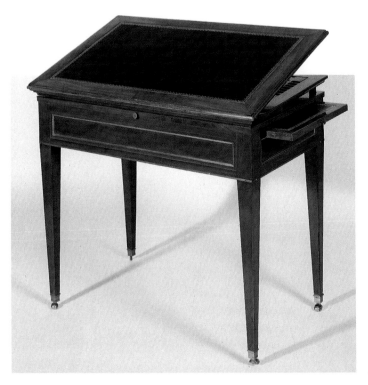

The sensual, optimistic, elegant, carefree and playful society of the first half of the 18th century continued to show a preference for *chinoiseries,* which reached perfection in the work of François Boucher (1703–70), Christophe Huet (d. 1759) and Jean-Baptiste Pillement (1728–1808). The direct contribution that the successful painter Boucher made to the applied arts consisted primarily of drawings for tapestries, but motifs from his paintings and engravings can be found in marquetry and on fabrics and porcelain.

Boucher portrayed Chinese fairs, mandarins and grand moguls, ladies with parrots and noblemen fishing in baggy clothes and strange pointed headgear. He created genre scenes (shepherds and shepherdesses) and classically inspired scenes of gods and goddesses. He was the favourite painter of Madame de Pompadour, Louis XV's mistress and an important patron of the arts. Both Huet and Pillement

continued to cater for this penchant for *chinoiseries* until the end of the 18th century.

Decoration

The ornamentation of furniture now passed through a period of incredibly rapid change. Within

ten years everything had altered. References to architecture and classical and Baroque forms disappeared completely, and two motifs dominated, viz. flowers,

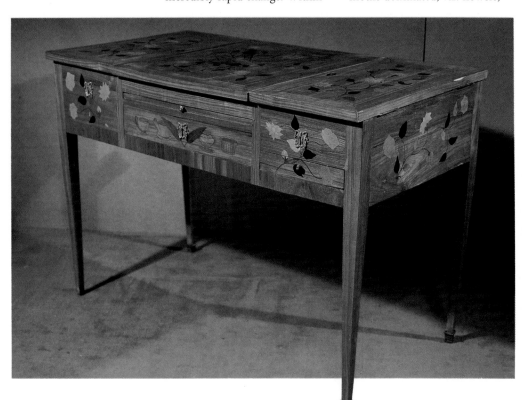

marquetry in various woods, depicting flowers, musical instruments, small tea-pots and cups, the central panel in the surface concealing a mirror and small pigeon-holes with drawers. This page: a Louis XVI centre piece veneered in mahogany which bears the stamp of Godefroy Dester. On one side it serves as a *commode à vantaux*, while the other is a desk with three drawers and cupboards on each side. Antiques trade.

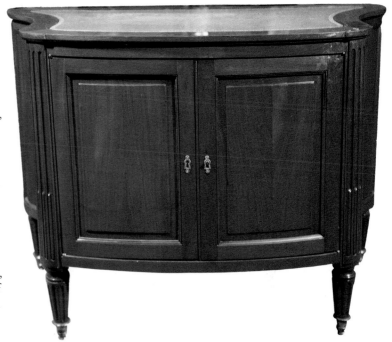

often stylized, individually or in bunches and baskets or as blossoms on a branch and *rocailles*, imaginative designs based on sea-shells and rock-like shapes with jagged outlines which might resemble leaves, assymetrical scrolls, wave crests, fountains or cascades.

Wood carving became more important, especially in *menusier* pieces. Many pieces of this period were decorated with urns, masks, cartouches and other motifs that had "survived" from the classical repertoire. Colours tended towards complementary shades harmonizing with the furnishings, upholstery and wall-coverings. The most common combinations were yellow/silver, blue/white, green/blue or green/lilac. Bronzes on furniture work resembled wood carving, i.e. were asymmetrical and fanciful, running along edges, winding around legs or decorating the fronts, where they bore no relation to the arrangement of the drawers.

The geometric and symmetrical veneering was usually in the form of lozenges or quatrefoils, while polychrome inlays repeated the motifs of bronze work, or depicted other scenes. The still popular lacquered furniture bore landscapes, figures and decorations drawn from paintings and engravings of the most famous artists of the day.

Among important cabinet-makers in the Louis XV style were Cressent, the Vanrisamburghs, Pierre Migeon II and his son Pierre III and the Roussels. The most influential decorators were Juste-Aurèle Meissonnier (1695–1750) and Nicolas Pineau (1684–1754), creators of the *genre pittoresque* with its complex curves, C-shaped scrolls and

asymmetrical motifs. Their portfolios of designs were sold widely.

The Transitional style

The style known as "transitional" or late Rococo, is in some ways comparable to the *Régence*, and, like the *Régence*, shows similarities to both preceding styles and those that followed. In his book *Early Neoclassicism in France* (1974) Svend Eriksen lists the "emotional" reasons that led to the advance of classicism in France: the desire for innovation, the reaction to the exuberance of the Rococo, and the new fashion inspired by antiquity, which was known as the *goût grec* (although it drew its inspiration more from the Roman excavations at Pompeii and Herculaneum), plus a nostalgia for the *grand style* of Louis XIV. Indeed, the earliest pieces that indicate a change in taste with their reticent and symmetrical ornamentation are mainly based on the Louis XIV style.

In the work of ordinary *ménusiers* curves became less pronounced, arm-supports thinner and chair-backs oval or round. The restless shapes of the Rococo disappeared. New features included straight legs, which, in furniture made from the 1770s onward, even took the form of balusters or quivers. The top cabinet-makers, the *ébénistes*, strove for simplicity, but their pieces still made use of curved legs, though the corner-supports and bodies of the pieces usually featured straight lines and severe shapes, resulting in a rather heavy overall appearance. Once again, decorative motifs were clearly

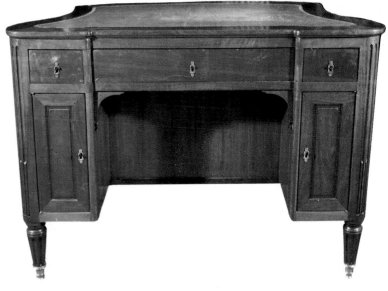

derived from antiquity and included ovules, palmettes, mascarons and ribbon-work. The covings were simpler and more rectangular, and colouring was more restrained. In this period the use of colour declined and white was used more and more,

until in the following decades it became the colour of choice.

The interest in antiquity

In 1749 Madame de Pompadour dispatched a fact-finding team to

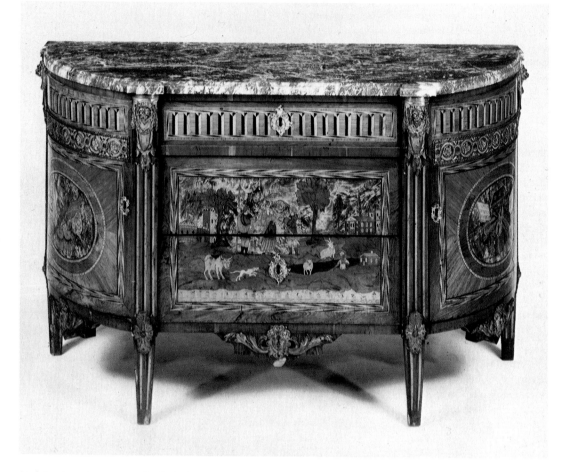

Italy. The party consisted of her brother, the Comte de Vandières (who later became the Marquis de Marigny, Superintendent of Royal Buildings), the architect Soufflot, the engraver Charles-Nicolas Cochin (1715–90) and the Abbé le Blanc. Their task was to gather information about stylistic trends in Italy. At the end of two years – during which they visited the latest excavations at Pompeii and Herculaneum – they returned with innovative ideas and fashions that aroused lively interest in the French capital.

The enthusiasm for antiquities at that time is also shown by the numerous publications on the theme. When the Comte de Caylus (1692–1765) returned

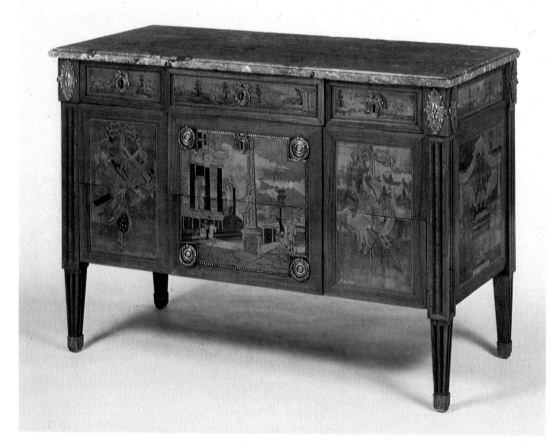

from a journey through Asia Minor, where he had attempted to locate the site of ancient Troy, he made a collection of ancient objects and published the results of his archaeological studies in the *Recueil d'Antiquités* (1752–67). In 1756 one of his protégés, the painter Louis-Joseph Le Lorrain (1715–59), made several pieces of furniture in ebony with bronze mounts in the *goût grec*, which were much praised by his contemporaries. They were commissioned by the Master of Court Ceremonies Ange-Laurent Lalive de Jully, author of a *Catalogue Historique* (1764), in which he describes his collection. Even in Le Lorrain's work one notices the heaviness so characteristic of furniture made in those years, more reminiscent of Louis XIV than the ancient world.

Among the *ébénistes* of this period, Jean-François Oeben, Madame de Pompadour's favourite cabinet-maker, should be mentioned: the first man to

FACING PAGE, ABOVE: a demilune commode (c. 1775) with genre scenes inlaid on the drawers and martial and musical trophies on the curved side doors. BELOW: a marquetry commode (c. 1775). In the centre of the two large drawers is a landscape with ruins, and at each side, trophies; the side-panels are fitted with incense-burners (thuribles). THIS PAGE, ABOVE: a marquetry *console-desserte* (sideboard, c. 1775), with trelliswork of stylized flowers set in lozenges. BELOW: a Louis XVI *duchesse brisée*. Antiques trade.

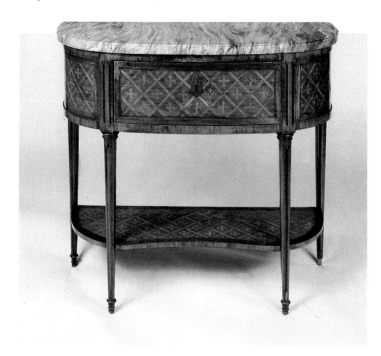

production" of Roman, Greek and even Etruscan styles. However, in the context of Louis XVI, it would not yet be correct to talk of "reproduction", since designers of this period drew inspiration from rather than copied classical art. Thus the legs of chairs are straight in profile, but generally rounded and spindle-shaped, spiral, lathe-turned or fluted. On either side of the backs, which assume a wide variety of forms, slender columns are sometimes found, and the arms rest on vertical supports.

Even sophisticated cabinet-makers strove for simple, rigid forms. The bodies of their furniture rested on straight, sometimes rather over-slender supports, and took the form of a horizontal parallel whose accentuated covings emphasized the shape. Marble was used for flat surfaces. Carved decoration drew on the classical repertoire – palm leaves and acanthus leaves, ovules, rosettes, pilasters, capitals, lions' heads and paws, chimaeras and genii – combined with motifs taken over from wall-coverings: ribbons, drapery, bands of rosettes and ropes. As in earlier epochs, exotic subjects enjoyed great popularity – the *chinoiseries* of Boucher and Pillement had lost none of their attraction. But the Louis XV period also brought in a fashion for *turqueries*, inspired by the now relatively benign Ottoman empire. For

return to a rectilinear design for the bodies of his furniture. *Ebénistes* used exotic wood such as rosewood or tulipwood as a veneer and sometimes relieved the severe shape of their furniture with multicoloured inlays. Popular motifs included latticework, urns, rosettes, sprays of flowers, lozenges and meanders. In ormolu mounts as well, *rocailles* declined in importance. Laurel wreaths, rams' and lions' heads, rosettes and meanders were preferred, all borrowed from ancient sources.

The Louis XVI style

The reign of Louis XVI (1774–93) saw a consolidation of the tendencies of the previous period. The relationship with ancient art evolved continuously, from the approximate copying of Baroque classicism in the Louis XIV period through the rediscovery of Italy and the Renaissance to the "re-

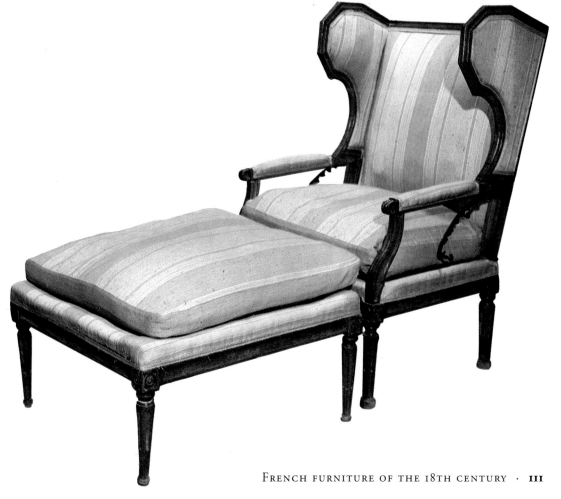

A Neoclassical demilune console table from the late 18th century, with kingwood marquetry and applied with engraved ormolu mounts. The two back legs take the form of tapered tetragons with *chutes* of ormolu plaquettes; the front leg is a fluted spindle. The table-top is of porphyry with a border of green marble and rests on a deep dentellated frieze decorated with classically inspired rosettes. Antiques trade.

example, Marie-Antoinette, the king's consort, commissioned complete furnishings in the Turkish style for her *boudoir* in the palace of Fontainebleau. English influences were also felt in the use of mahogany for chair-backs and veneers, which generally came to be preferred to inlays.

White was the preferred colour for lacquered furniture and even other furnishings, and multiple colouring fell out of favour. Gilding, however, remained in vogue, in shades of yellow, green or reddish gold. The wonderful chiselled ormolu work in the shape of flowers, fruit, scrolls, draperies, festoons, ropes, lions, palmettes and urns provides examples of exquisite craftsmanship.

Many leading cabinet-makers of this period – Benneman, Carlin, Oeben, Riesener, Roentgen and Weisweiler – came from Germany or Holland. Some had been summoned to France by the Austrian-born queen, Marie-Antoinette, and their French contemporaries – Topino, Cressent, Migeon and Leleu – were simply no match for them. The role of the workers in carved wood, the *menuisiers*, changed over the years. Previously more conservative than the creative *ébénistes*, their number now included bold innovators like Jacob, Boulard, Foliot, Lelarge and Sené.

Designers and ornamentalists

During the Louis XVI period, countless collections of engraved furniture designs were published. An important furniture designer and decorator of this generation was Jean-Démosthène Dugourc (1749–1825), who with Jacob developed the late Louis XVI and the "Etruscan" style. Dugourc was first appointed *Dessinateur de la Chambre et du Cabinet de Monsieur* (1780), "Monsieur" being the king's younger brother. Then in 1784 he became *Dessinateur du Garde-Meuble de la Couronne* (Designer of the Crown Furniture Depository). He married the sister of his mentor, architect François-Joseph Bélanger (1744–1818), who was not so much a pioneer of classicism as a creator of architectural fashions. Bélanger worked mainly in Paris and Versailles. He designed the famous Pavillon de Bagatelle built in Paris in 1777 for the Comte d'Artois, and supervised its decoration and furnishing.

Another leading architect and designer, Jacques Gondouin (1737–1818), whose design for the Ecole de chirurgie (School of Surgery) in Paris is one of the most interesting Neoclassical

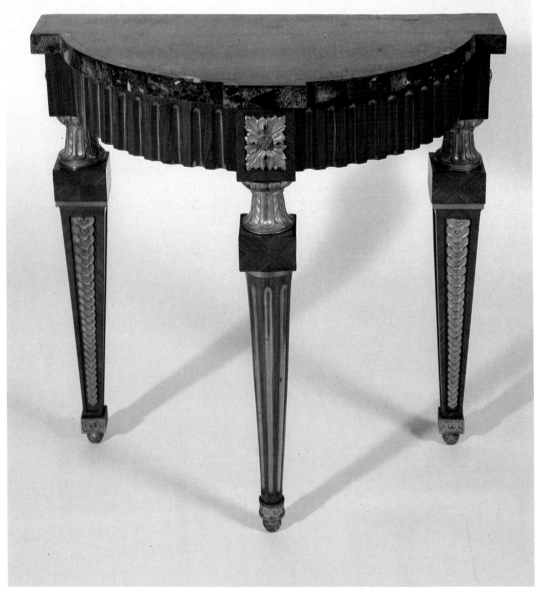

BELOW: a Louis XVI *console-desserte* with veneers of satinwood and purplewood. The side-panels curve inwards, the fluted legs taper to spindle feet and the blue marble top is enclosed by a delicate pierced bronze gallery, which is repeated around the bottom of the body. In the middle of the wide drawer is a plaquette of *biscuit* porcelain (Sèvres) depicting a pastoral scene (detail above) which folds out to reveal a lock. The coving and knobs are of ormolu. Antiques trade.

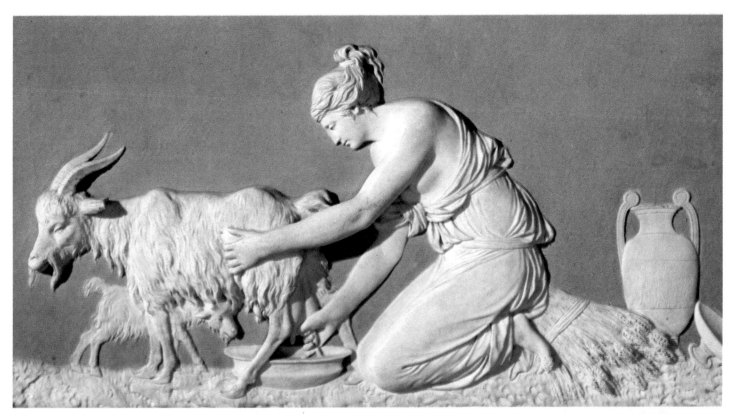

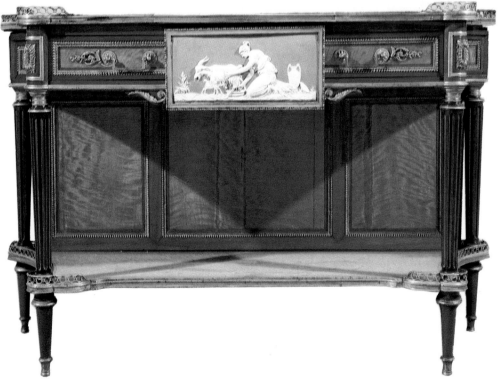

buildings of the 18th century, was appointed *Dessinateur du Mobilier de la Couronne* (Designer of the Royal Furniture) in 1769. He designed furniture for Marie-Antoinette, including chairs for the Petit Trianon.

Antoine Rousseau's sons (1710–82) Pierre and Jacques-Pierre-Jean worked for Marie-Antoinette at Fontainebleau and Versailles. A decorator in the Louis XVI style with much influence on contemporary taste was Richard de Lalonde, active 1780–1790. In his notebooks, the *Cahiers d'Ameublement* (1780), Lalonde assembled designs for chairs, fireplaces, door-frames and commodes. Besides decorative details, he provided plans, sectional drawings and overall views for each piece – i.e. all the instructions for production.

Woods and decorative techniques

Specialized craftsmen

In several early 17th-century documents the distinction is made for the first time between *ébénistes*, i.e. artistic or creative cabinet-makers, and *menuisiers*, ordinary furniture-makers. This distinction was to have a decisive impact on the future development of furniture-making in France. As early as 1608 one Laurent Stabre was given the appellation *Menuisier en ébène, Faiseur des Cabinets du Roi* (carpenter in ebony, maker of the royal cabinets) and granted permission by Henri IV to set up his own workshop in the palace of the Louvre.

Under a similar decree, the *Maître menuisier* Van Opstal (in 1627) and the *tourneur et Menuisier du Roi en Cabinets d'ébène* Pierre Boulle (in 1631) also established their workshops in the Louvre. From the terminology used in these documents, we learn that the distinction between *ébénistes* and other cabinet-makers was initially based on the materials in which they worked. The former used ebony, which in the early 17th century was a rare and therefore very costly hardwood. Later they added other hardwoods, precious metals, semi-precious stones, tortoiseshell, ivory and horn. The use of ebony led to two further differences between *ébénistes* and other cabinet-makers. First the types of furniture made from this wood were naturally the most luxurious pieces, namely cabinets, wardrobes and tables for ceremonial rooms. The second difference was one of technique: ebony was not used for the basic framework but always cut into sheets – usually around 8mm thick – which were worked in various ways, then glued or nailed on to less expensive

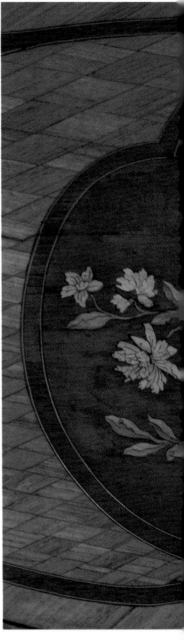

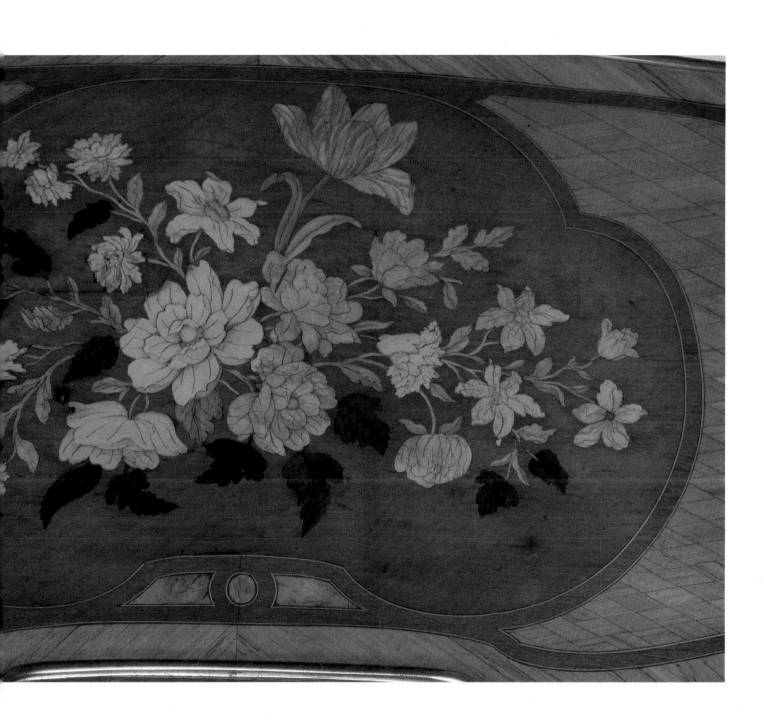

FACING PAGE: marquetry depicting a basket of flowers, part of an Louis XVI secretaire in *bois satiné* and purplewood made by the German-born cabinet-maker Jean-Henri Riesener. Having settled in Paris as a young man, Riesener was one of Marie-Antoinette's favourite *ébénistes*. Antiques trade. ABOVE: these floral motifs decorate the top of a small dressing-table (c. 1760) which bears the stamp of Jean-François Oeben. Also of German origin, Oeben specialized in marquetry. He was one of the most important *ébénistes* working in France in the Transition period between the styles of Louis XV and Louis XVI. Victoria and Albert Museum, London.

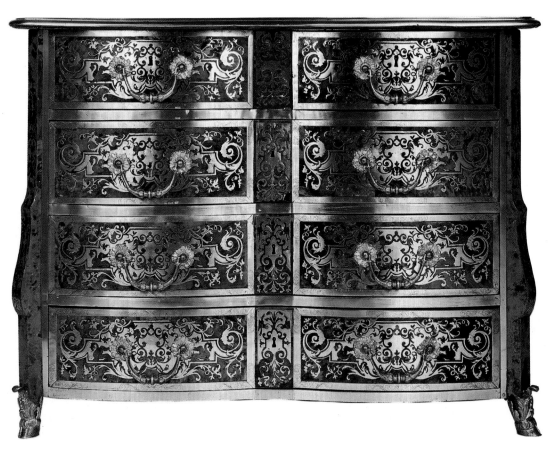

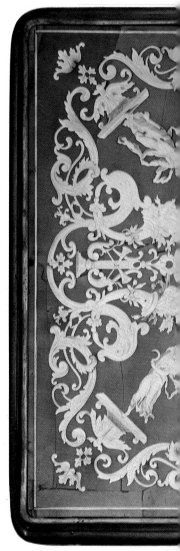

contre partie, where the tortoise-shell design is set in brass. Paired pieces of furniture could thus be decorated, one with the *première* and the other with the *contre partie,* as could the inner and outer panels of doors. Boulle usually scored the brass with small marks to achieve a "shaded" effect which further enhanced the design. The parts of his furniture that were not inlaid were veneered in ebony. Boulle's pupils and imitators, wishing to

timber. This technique, known as *placage d'ébène,* cannot strictly be described as veneering because of the thickness of the sheets and different ways they were handled. During the reign of Louis XIV *placage* fell increasingly into disuse, thinner foils being applied to a *bâti,* or oak frame. Other types of hardwood were also now used for prestigious furniture. There are many examples of pieces made from heavily grained walnut, olive and cedarwood, English burr-woods and walnut German.

The veneer was applied either in plain sheets over the whole piece, or in geometrical patterns – e.g. lozenges, squares or quatre-foils – generally framed with narrow inlaid lines in contrasting

colours of rosewood, ebony, copper and ivory.

This technique was employed in luxury furniture intended for everyday use such as desks, cabinets, tables and commodes. For even more expensive pieces there was a preference for decorative marquetry. This type of work was more complex and in many cases reaches such a level of perfection that it can give the impression of a painting. The craftsmen made use of numerous motifs: sprays of flowers, birds, arabesques, trelliswork and tendrils. In addition to precious metals and animal products such as ivory, horn and tortoiseshell, the range of hardwoods widened to include almond, box, pear and holly.

Boulle marquetry

It was during the reign of Louis XIV that André-Charles Boulle perfected the technique that bears his name: marquetry in brass and tortoiseshell. The technique was brought to France by Italian craftsmen in the service of Maria de' Medici, and consisted of gluing together a sheet of brass and a sheet of tortoiseshell and then sawing out a shape to a predetermined design. The sheets were then separated and fitted together so that the convex and concave curves matched perfectly. In this way two effects were produced: *première partie,* in which the brighter brass shape stands out against the dark tortoiseshell background; and

achieve even more impressive effects, would dye the tortoise-shell or combine it with inlays of tin, mother-of-pearl and horn dyed red, green or blue. Boulle himself tried further variations, for example by laminating brass, silver, tortoiseshell or other materials and cutting out the patterns, thus creating a *troisième effet*.

Decoration in bronze

Under Louis XIV *ébénistes* introduced a decorative element that became very widespread and remained in use throughout the 18th century, namely gilded and engraved bronze mounts. These served to protect the most delicate parts of the furniture, i.e. locks, edges and legs. Some furniture dating from this period is also decorated with inlaid bronze, and occasionally even

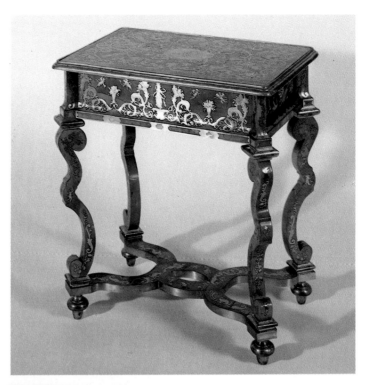

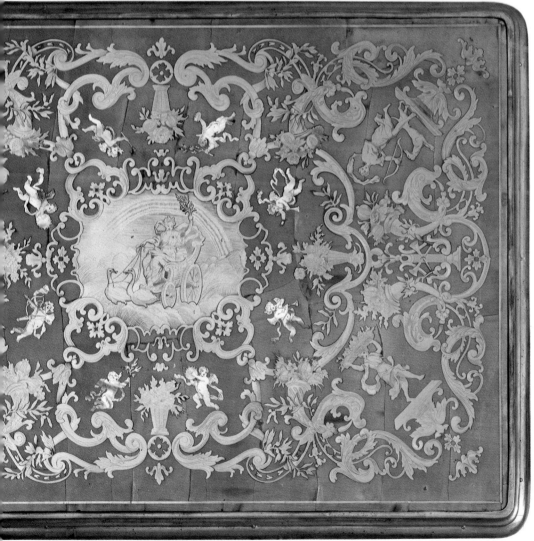

wood carving was replaced by chased and gilded bronze classical motifs such as medallions and mascarons.

Although this decoration was typical of furniture made by *ébénistes*, it was carried out not by them but by specialist *fondeurs-ciseleurs*, who worked the metals before they were gilded. Only rarely, and then by royal licence, did *ébénistes* make bronze embellishments for their own furniture. It contravened guild rules and led to countless disputes and court cases between members of different craft guilds, the case of *ébéniste* Charles Cressent being the most famous. However, *ébénistes* did under-take decoration in *pietre dure*, either flat or in relief. This is a technique developed in Florence for laying pieces of short stones in patterns, with no joints visible between the pieces.

The role of the ordinary cabinet-maker

During the second half of the 17th century, *menuisiers* con-tinued to produce furniture for daily use, which had been their

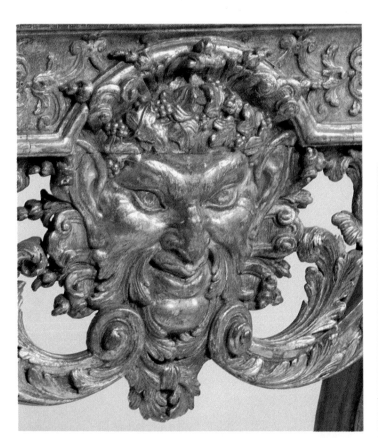

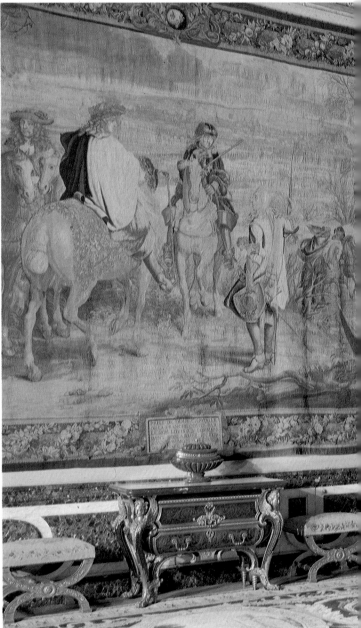

ABOVE LEFT: this satyr mask surrounded by scrollwork decorates the front of a console table (c. 1700) in carved gilt-wood. BELOW: detail of a gilt-wood Régence mirror frame carved with scrolls, shells and small roses. Antiques trade.

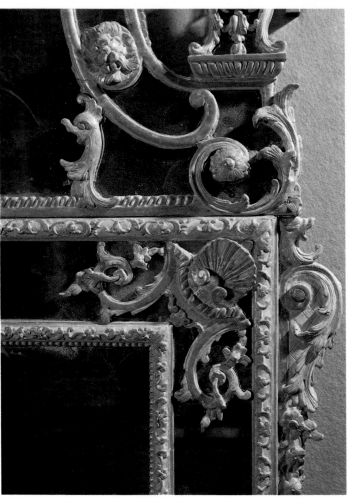

sphere of responsibility since the beginning of the century: chairs, beds, armchairs, console tables, mirror frames and simple decorative objects for the bourgeoisie and more modest households. The tasks of the journeyman furniture-maker were restricted to selecting woods, designing and constructing furniture, and minor wood-carving work such as rosettes, *agraffes* and ornaments in the form of cornices or mascarons, to conceal the join between crown and coving. The *menuisiers* generally used local

Foreshortened view of the *Salon de Mercure*, Louis XIV's bed-chamber. The commode in *première partie* (1708/09) was made for the Sun King by André-Charles Boulle. The walls are hung with tapestries from the *Manufacture des Gobelins*, based on designs by Charles Le Brun.

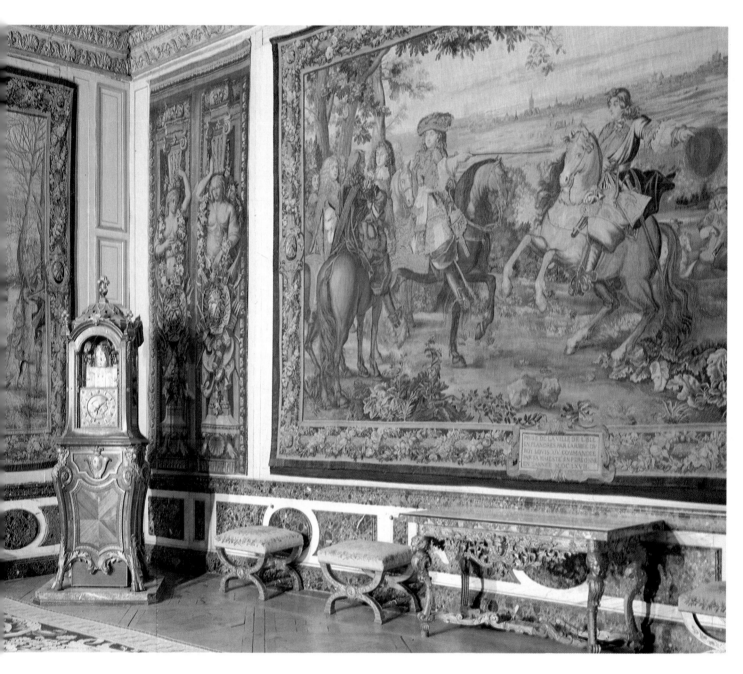

woods, i.e. pear, walnut, beech, oak and pine according to the region.

About the middle of the 17th century the wood was often painted in two or more glowing and contrasting colours, so that there are surviving pieces in colour combinations of red, green and pale blue, or yellow and pale blue. In the period that followed, designers restricted themselves to a single colour with narrow lines of gilded inlay. By 1680 gilded and silvered items of furniture began to enjoy great popularity, and the gilders even had a craft guild of their own.

Unlike the *ébénistes*, all the 17th-century *menuisiers* were Parisians working in their family businesses, which meant that sons carried on their fathers' traditional skills. This led to a rather conservative attitude and mistrust of innovation and new fashions. By contrast, the *ébénistes*, though members of the same guild, were often foreigners; they had long been in competition with the *menuisiers*, and took great interest in the change.

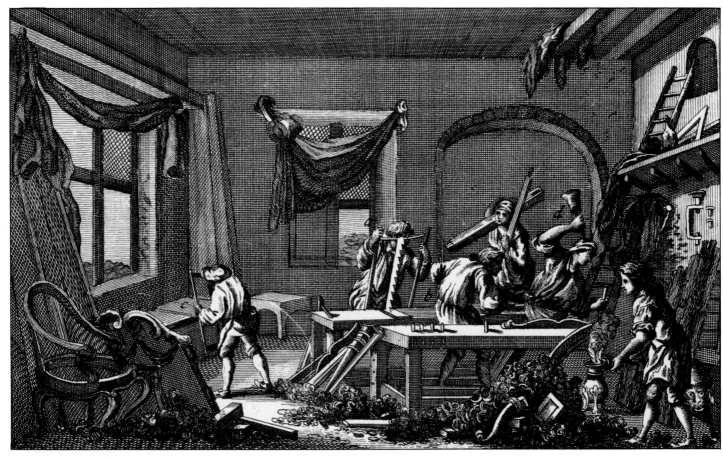

It is well known that throughout the entire 17th century, and much of the 18th, traditional cabinet-makers continued to use medieval mortice-and-tenon, tongue-and-groove or dovetail joints. In the 18th century, it is true, they began using wooden dowels and screws, but only for beds.

This conservatism persisted over a long period, as is shown by the notes on the subject written by Roubo, a *Menuisier en bâtiments* or joiner, who worked as an editor on the *Encyclopédie* of Diderot and d'Alembert, and wrote a number of interesting publications on the work of the *menuisiers* towards the end of Louis XV's reign. The latter

contain superb illustrations of tools, woodworking techniques and furniture components. Roubo claimed that in their work the *menuisiers* adhered blindly to outmoded practices, produced mediocre pieces and allowed themselves to be exploited by dealers. Furthermore, the author drew attention to the fact that most of them were incapable of drafting designs.

The most common woods

Thanks to Roubo, we also know that throughout the 18th century, the *menuisiers* used local woods, except for special commissions. The most popular woods were

beech and walnut; beech, usually painted or gilded, was chiefly used for chairs and walnut for other items of furniture. There is evidence that many furniture-makers made their commodes and sideboards from oak, even though Roubo advised against using this wood, which he considered only suitable for drawers and other parts hidden from view.

For the legs and other parts requiring reinforcement, the preference was for a wood known as whitebeam. In Normandy, Brittany and the Low Countries, as well as Gascony, Lorraine, Artois and Picardy, the most commonly used wood was oak, while furniture-makers in

Provence, the Dauphiné and the Auvergne preferred to work in walnut. However, there are still pieces of walnut furniture to be found originating from Lorraine, Brittany and the Low Countries. In other regions chestnut and ash were the dominant woods. In Provence olive-wood and in the Auvergne pine were also used. Not until the closing years of Louis XIV's reign did mahogany begin to be used in Paris for making chairs, although this wood was employed much earlier in France's major Atlantic ports of Bordeaux, Nantes and St Malo.

Before measuring and cutting out the components *menuisiers* had to take great care in selecting the wood. If they were found

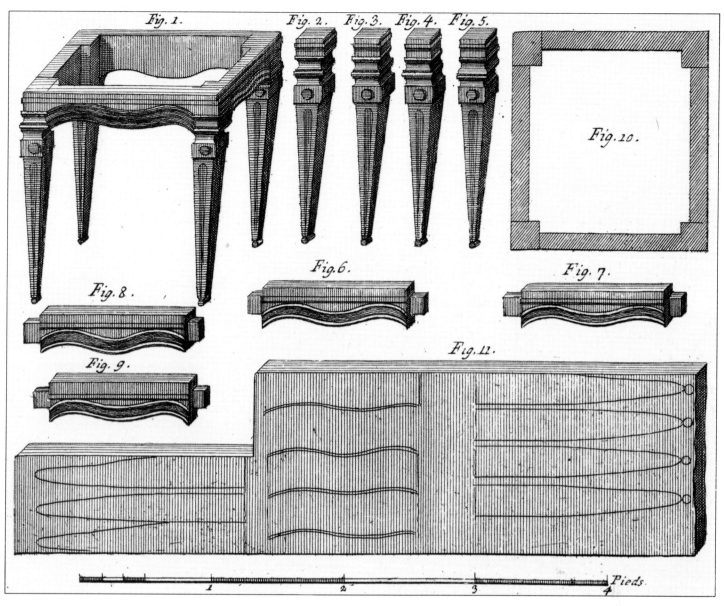

using faulty wood, they were heavily fined by their guild.

The function of the sculpteurs

It has already been mentioned that *menuisiers* were not permitted to add complex wood carving to their furniture. Once assembled and its covings given simple decorations, the piece was handed to a *sculpteur* or wood-carver, most often called in when the item was of a high value or was designed for a particular room. In this case, the carver would first make a maquette in wax, clay or softwood, which he then showed to the client,

architect or cabinet-maker. To provide alternatives, the carver usually gave the two halves of the maquette different shapes. It was even permissible to plagiarize or copy existing decorations, so that different pieces often had similar or identical embellishments. Having finished the carvings, the *sculpteur* added his own mark beside the *menuisier's*. It is not always easy to identify these marks or *estampilles*, since there were families of craftsmen who included both joiners and wood-carvers. The *estampilles* were not burnt on, but were the signatures of master *ébénistes* or *menuisiers* impressed into the wood with a metal stamp. As a result of changes to guild statutes in 1743,

these stamps became obligatory in 1751, until abolished in 1791 with the dissolution of the guilds. During that time, however, only craftsmen employed by the king were exempt from using the marks. On delicate pieces, where a stamp would be unsuitable, signatures in ink are found – either the maker's full name or his initials or monogram.

Polishing and gilding

When the piece had been assembled it was either polished with wax, painted in one or more colours or gilded. Throughout the 18th century, painting and gilding were far more widespread

than might be presumed from today's evidence. On many items from that period, whose wood now appears in its natural state, the original paint or lacquer was either removed in a later period or else has worn off completely. Wax polishing was the job of the *menuisier*. For simple pieces a mixture of yellow wax and talc was used, but the more valuable items were treated with white wax. The examples where the wood was most often left in its natural state are those of walnut and beech, though beech was often treated to make it resemble walnut.

Where painting or gilding was required, the piece of furniture was passed to a *peintre-*

The guild of the *fondeurs-ciseleurs*

Ormolu mounts were very common on furniture even under Louis XIV, but this type of decoration reached its heyday during the Rococo period, only to decline again in the Louis XVI age, when ornamentation became simpler and more classical. This type of metal-working was the prerogative of the *fondeurs-ciseleurs* (caster and chasers), whose guild is first mentioned in the 13th-century *Livres des Métiers* (Books of Trades) by Etienne Boileau *(c. 1200–1270)*. In the 16th century and again in 1651 the statutes of the guild were revised and improved. Only in exceptional cases, and then only by special licence, were the *ébénistes* permitted to produce their own bronze mounts. As with other guild crafts, foundrymen who wished to obtain their *maîtrise* had to undergo five years' training and then demonstrate their capabilities by submitting a 'masterpiece'. Only then could they pursue their vocation as self-employed craftsmen. As 'sub-contractors' they produced scrollwork, botanical and animal motifs, and bronze foot-mountings in the form of acanthus leaves or animal hooves, which they then passed on to a *maître-doreur* (gilder). The guild of the gilders was amalgamated with that of the bronze-founders and chasers in 1776. Once these craftsmen had completed their combined work on a project, the *ébéniste* would then fix the bronze appliqué to his furniture, often with so little care that the screw-heads remained visible. Among the leading *fondeurs-ciseleurs* of the 18th century was the Italian-born Jacques Caffieri (1673–1755), who worked for the court from 1736 until his death. With his enthusiasm for *rocaille* motifs he influenced the decorative art of the Louis XV period to a significant degree. Also noteworthy was Etienne Forestier (1712–68), who supplied bronze decoration to Boulle, Joubert and Oeben.

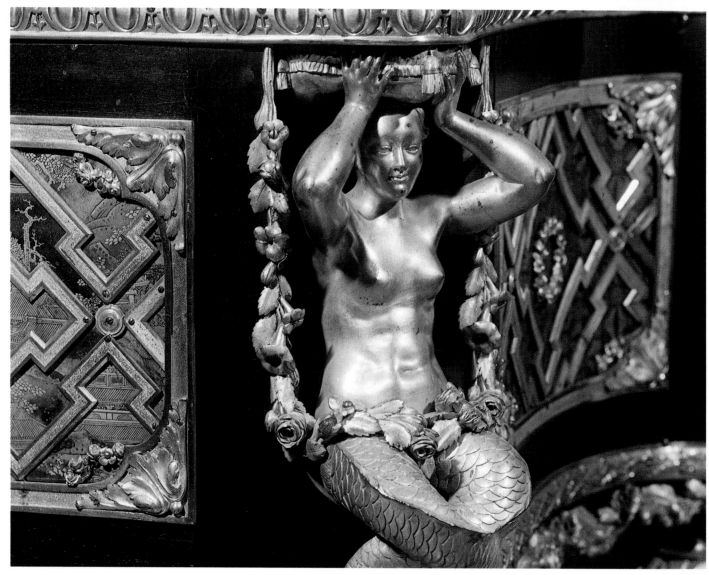

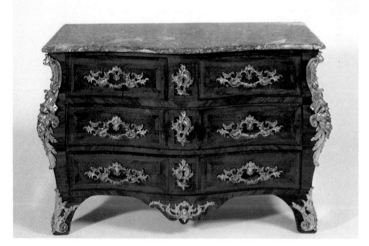

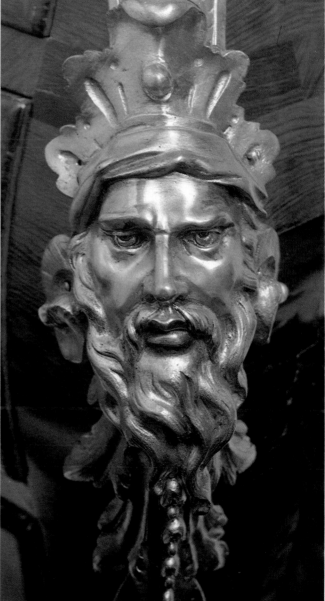

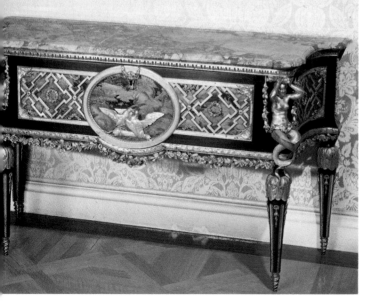

LEFT: the *commode enconiste* for Marie-Antoinette by René Dubois. For the decoration, Japanese and European lacquer paintings were combined with bronze mounts – for example the caryatids in the form of sirens, one of which is shown in the detail opposite, attributed to the *sculpteur* Maurice Falconet. Wallace Collection, London.

doreur (painter-japanner). In *Les meubles français du XVIIIe siècle* (French 18th-century Furniture, 1982), Pierre Verlet shows how the complexity of this treatment varied according to the type of furniture. In certain cases a single colour was used – for example blue, particularly for pieces made from ash – or white, which was especially popular toward the end of the century. However, there are examples painted in various lively colour combinations, sometimes even with strings of gold inlay. Occasionally the paint would be mixed with gold and the lacquer – made up of shellac, sandarac, alcohol and turpentine – was applied in layers by the *peintre-doreur*, who polished each coating with the utmost care.

Gilding was a complicated task using costly material. One of two techniques was used: oil gilding or water gilding. In the former the item was first covered in several coats of white lead and yellow ochre dissolved in oil. When this base coating was dry, it was polished with dried horse-tail plants, a natural abrasive, and finally covered with gold leaf. However, water-gilding was preferred because it allowed greater relief in the wood carvings. Even so, it still consisted of seventeen separate stages, the most important of which was the *reparure*: surfaces that had been treated with a kind of stucco had to be reworked so finely that every detail of the wood carving emerged clearly. Only then was the gold leaf applied.

The upholsterers belonged to a different guild. Their work was important for items of furniture that contained a large element of fabric such as chairs, settees, sofas and beds. They selected the woven fabrics, silks, wall-coverings, carpets and different kinds of leather, plus various trims which were used to conceal the structure of a piece.

Imported woods

A list of the different types of wood used by *ébénistes* during the 18th century raises as many questions as it answers. Roubo drew up an extensive list of forty-eight woods, but because of his imprecise definitions and vague terminology these are not easy to identify. Verlet has summarized this catalogue and established the types most frequently mentioned. Tulipwood (a yellow wood with a red grain) was among the most popular materials of that period. However, this has no connection with what we call rosewood (or 'palisander') from the *dalbergia*

tree, which was imported from Brazil and Peru in the 18th century. The origin of the wood that Roubo calls *bois violet,* or sometimes kingwood, is not clear. Roubo distinguishes two species: the *violet* (known commonly as kingwood) imported from the East Indies, and the *violet palissandre* from the Caribbean (often called rosewood). The latter, often confused with purplewood (amarynth), was also widely used in the later 18th century. Possibly several types of *satiné* in France were included under the general term *citronnier*. However, Roubo again distinguishes *citronnier* from *bois de citron* (lemonwood), which was imported from Bermuda, Jamaica and Santo Domingo. Other woods of a bright red colouring, whose identity is obscure, are *cayenne, bois de Chine, corail, amourette* and *Brésil.* Two more

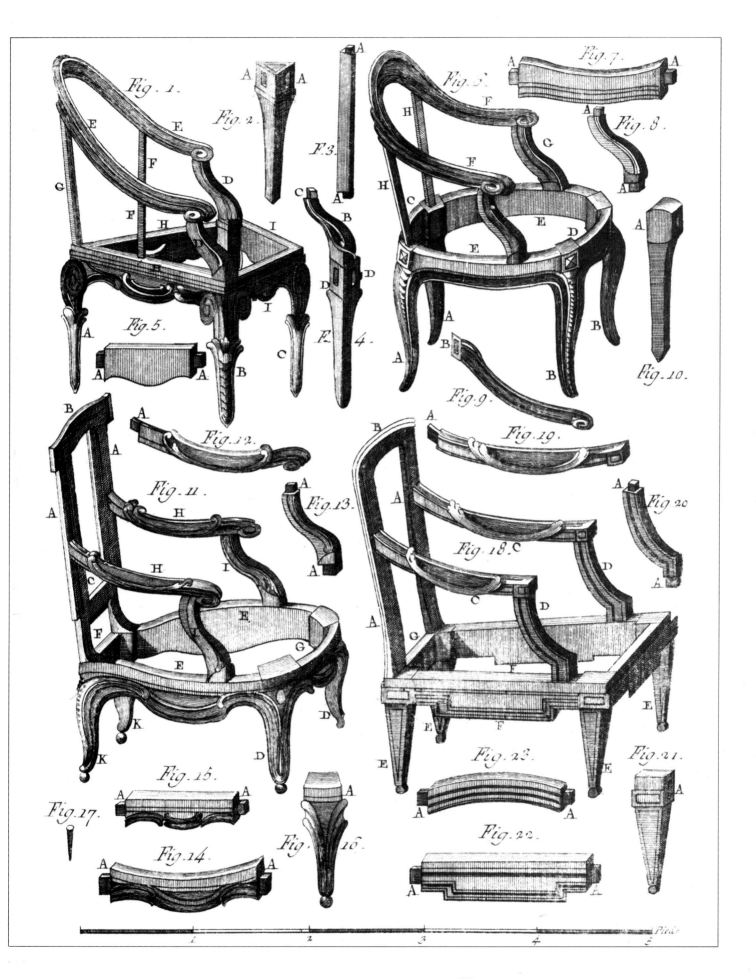

Below left: *lit à la Polonaise* (c. 1780) in gilt wood, probably commissioned by Marie-Antoinette. The head and foot are still covered with their original brocade fabric. Right: a Louis XVI *secrétaire à abattant* in black lacquer with ormolu decorations, made by Etienne Lavasseur. Antiques trade. Facing page: a Louis XVI *commode d'appui* made for Marie-Antoinette by Etienne Avril in mahogany and ebony with simple decorative motifs. The centres of the two doors are decorated with white and pale blue ovals of Sèvres porcelain with figures in relief, modelled on English Wedgwood cameos. Musée National du Château de Fontainebleau.

hardwoods used by the *ébénistes* were *bois aurore* and *amboine*.

Beside the exotic woods mentioned above, French craftsmen also worked with a large number of native woods, some of which were used almost exclusively for panelled pieces, while others such as walnut and cherry were used for solid furniture. Most 18th-century furniture is made from oak, pine or lime. It may be surprising to find the latter two woods, which are not particularly dense, being used even for very expensive furniture, but this can be explained by the fact that many *ébénistes* subcontracted the construction of their pieces to poorly paid furniture-makers who were anxious to cut costs by using cheaper types of wood.

Veneers and marquetry

When *ébénistes* had drawn out the relevant designs, they applied marquetry or veneers to the body of the piece. Veneering usually involved only one kind of wood; the sheets of veneer were assembled according to grain, thickness and colour and then arranged over a wooden base. Thus, depending on how the grain ran, various effects and patterns could be achieved – lozenges, rays, hearts, quatrefoils or motifs reminiscent of faceted diamonds or multifoils. In general, a veneer with reverse grain was used to frame the panels, which were often of a different wood. Fine thread-inlays of hollywood or willow divide the border from the panel.

Marquetry was very much more labour-intensive and extravagant. As in painting, the decorative motifs achieved effects of colour and light. The woods were dyed red, blue, grey, green and yellow, treated with acid or dipped in hot sand, in order to create the deep tones and appropriate tints required for parts that were in shade. Nowadays it is difficult to imagine the brilliance and ingenuity of these multi-coloured inlays, since the effects of light and the ageing of the wood have caused the original colours to fade. Only on the inside of the furniture and under areas of bronze appliqués have parts been preserved. To prevent this kind of problem developing, some *ébénistes* used where possible the natural colours of woods to create their sprigs of blossom, bouquets of flowers in baskets and vases, landscapes, *chinoiseries*, geometric motifs and architectural façades. Costly materials like mother-of-pearl and horn remained in use throughout the 18th century. The furniture was polished with wax or other substances, including

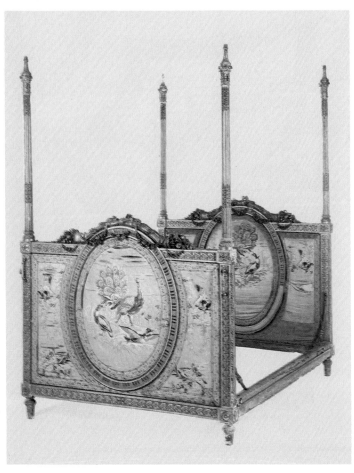

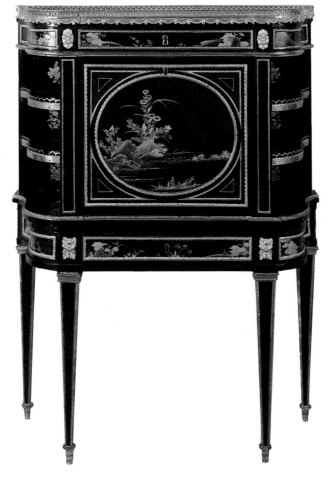

very often *vernis de Venise*, a mixture of alcohol, sandarac, oil, mastic and latex gum.

Bronze-founders and engravers

As we have already seen, it was members of a different guild who were responsible for producing the *chutes* (bronze corner-pieces), *sabots* (bronze feet), *tabliers*, which was an apron-like decoration hanging down in the centre of the frame, lock-plates and other bronze decorative elements. For a period, three different guilds ope-rated side by side: the *fondeurs* (foundrymen), the *ciseleurs* (engravers) and the *doreurs*, who carried out the gilding. In 1776 the three craft societies merged into one.

One of the gilding techniques most widely used in 18th-century France was that of hot-gilding (ormolu), in which the craftsman was exposed to the toxic fumes of mercury oxide. The articles were coated with an amalgam of mercury and gold and then heated in a moderate oven. The mercury evaporated, leaving a thin gold film. It was in France that ormolu work reached a peak of perfection. The metal was given a brown tint, and either a high polish or a matt finish. Among the masters of this trade was a man of Italian extraction, Jacques Caffieri (1673–1755), whose father, the sculptor Philippe Caffieri, had been summoned to France by Cardinal Mazarin. Jacques became a *maître* in about 1715 and was one of the most talented *fondeurs-ciseleurs* of the Rococo age. From 1736 he was employed by the court, where he collaborated principally with the *ébéniste* Gaudreaux.

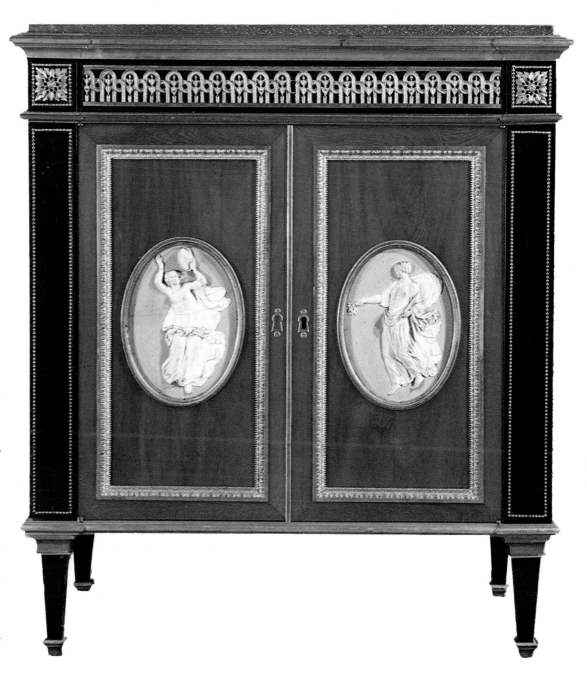

Another significant figure during the reign of Louis XVI was Pierre Gouthière (1732–c. 1814), who gained the title of *maître* in 1758. It is probable that he invented a new technique of hot-gilding, which he used to create matt surfaces which harmonized splendidly with the burnished areas, and which he usually chose to decorate with leaves, flowers and other motifs from nature. Gouthière worked for Madame Dubarry, Marie-Antoinette and the Duc d'Aumont, and supplied the *ébéniste* Adam Weisweiler with bronze mounts. Some work formerly attributed to Gouthière has now being identified as being by the gilder Rémond, who also worked for the cabinet-makers, among them Weisweiler and David Roentgen.

An important foundry was es-

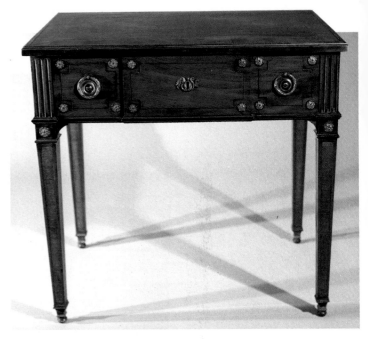

tablished by Etienne Forestier (c. 1712–68), and carried on by his sons Etienne-Jean and Pierre-Auguste (1755–1838). Forestier *père* worked for Boulle, Joubert and Oeben, while his two sons supplied bronze to the *ébénistes* at the court of Louis XVI. Finally, mention must be made of Pierre-Philippe Thomire (1751–1843), who, in the early part of his career at least, worked in the Louis XVI style and supplied the *ébénistes* Benneman and Weisweiler. As will be seen later, he went on to become the most gifted *fondeur-doreur* of the Empire period.

Designs in bronze were re-exploited with astonishing frequency, which means that identical motifs can be found on pieces made by very different *ébénistes*. However, if a *fondeur* did not rely on his own imagination but "made use of" designs borrowed from colleagues, this very often resulted in indictments and lawsuits. *Ebénistes* who had the right to apply bronze mountings to their work generally did so without a great deal of care, i.e. the heads of the screws that fixed the mountings remained visible. Not until the very end of the 18th century were sensible solutions found for this problem.

Vernis Martin

During the 18th century, lacquered furniture enjoyed great popularity. Either genuine lacquer painting was used, or else imitations developed by French craftsmen. These substitutes included a mixture of shellac and alcohol or a preparation based on amber. Several coats were applied to light and dense woods – usually lime, box, maple or pear.

When a lacquer-painting workshop had been opened in the *Manufacture des Gobelins* in 1713, the Martin brothers perfected this imitation and developed a special lacquer which was named after them: *vernis Martin*. Of the four brothers, Etienne-Simon (d. 1770), Julien (d. 1783), Robert (1706–66) and Guillaume

(d. 1794), the last named was probably the most famous. Together with his brother Etienne-Simon, he obtained a patent in 1730 for the production of imitation lacquer articles in relief, and this was renewed fourteen years later.

The brightly shining *vernis Martin*, a further development of the well-known garlic-based lacquer known as *chipolin*, was produced in pearl grey, light green, mauve and blue. Painting on the lacquer – either monochrome or with gold dust – was not without its complications. Roughly forty coats were needed, each of which had to dry before the next one could be applied. Jean-Alexandre Martin, the son of Robert, who carried on his uncle's craft, received the title of *Vernisseur du Roi* from Frederick II the Great, king of Prussia, in 1760.

If original oriental lacquer paintings were required, suitable panels were taken from large Chinese or Japanese screens, or else cabinets imported from those countries were dismantled, the panels cut up and then fixed to important pieces of furniture. This presented no problem when the examples were rectangular, but complications arose if the paintings were required to decorate curved surfaces. A pamphlet entitled *Art du peintre doreur vernisseur* (1773/74) by *peintre-doreur* Watin provides valuable clues to 18th-century methods, and introduces the techniques of mother-of-pearl incrustation on lacquer, gold and silver decorations, and the use of aventurine, similar in colour to mica quartz, as a background to sparkling colour effects in yellow, green or red.

Porcelain, glass and metal

Porcelain plaques from the Sèvres factory were sometimes used to ornament furniture. These are generally small plaques made especially for the furniture by the factory and were commissioned by the *merchand merciers* or Parisian furniture dealers, who probably created the vogue for this form of decorative furniture. Majolica and small panels of painted glass were sometimes substituted for the porcelain plaques, and after 1750 black lacquer was applied to the glass panels. Ornaments or figures were left unlacquered and then metal foil or gilded bronze was placed behind the glass. This particular form of glass-painting was developed by the Parisian frame-maker Jean-Baptiste Glomy (d. 1786), after whom the technique was named – *verre églomisé*. Such porcelain and glass paintings include flowers, arabesques, coloured *chinoiseries* and other motifs based on the miniatures of de Gault, painted *en grisaille* (in various shades of grey).

During Louis XIV's reign metal plates were sometimes used for the design and decoration of furniture. These might be table-tops, a base for lacquering, or reinforcements for drawers or for other parts of furniture which were used for storing valuables. In addition, steel plates became widely employed as a base for gilded bronze appliqué. Sometimes metal was also used for the legs of certain types of furniture. Such "mechanical" furniture gained increasing popularity, and so the *ébénistes* began working more closely with *serruriers,* i.e. locksmiths and blacksmiths.

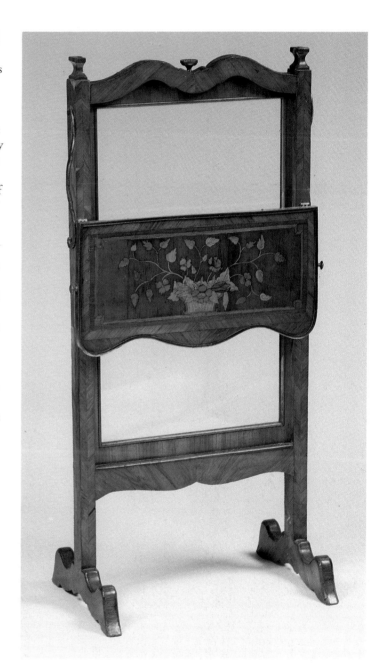

Many pieces made by *ébénistes* of this period have tops made from marble of greater or lesser value, imported from Italy, the Pyrenees, the Low Countries or Brittany. In certain cases the marble had originally been used by the ancient Greeks or Romans.

Some furniture incorporated slabs of porphyry. In the second half of the 18th century, *pietre dure* inlay – a mosaic technique which had become popular under Louis XIV – came back into fashion again.

A short dictionary of cabinet- and furniture makers

Benneman, Guillaume

One of the numerous German *ébénistes* who worked in Paris in the second half of the 18th century, Benneman (d. 1811) received his first royal commision in 1784.

In the following year he became a *Maître ébéniste* and shortly afterward succeeded Riesener as court cabinet-maker. To some extent he basked in borrowed glory, by cleverly copying or varying the work of his fellow-countryman,

Stöckel. Benneman collaborated with the wood-carver Hauré, who after 1785 was responsible for all furniture supplied to the royal palaces, and the bronze-founders, Forestier, Galle and Thomire. His work commissioned by the court

was conservative in style. However, several of his pieces, despite their somewhat clumsy appearance, anticipate the Empire style in their simplicity, their severe outlines and the bronze caryatids on their edges.

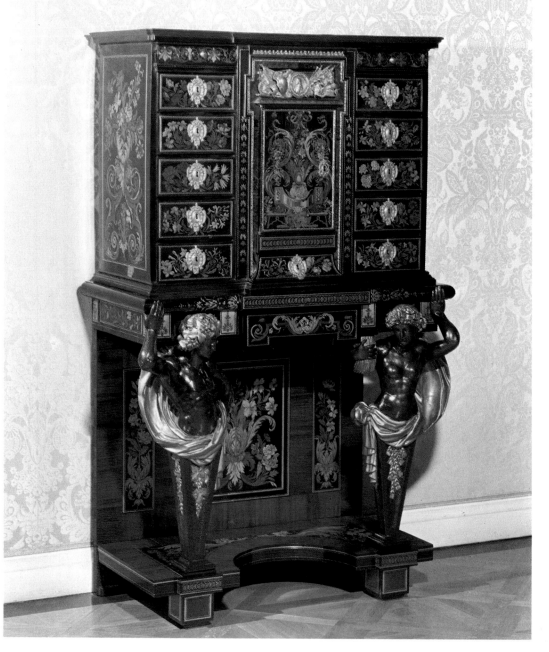

Boulard, Jean-Baptiste

One of the most important *menuisiers* of the Louis XVI period, Boulard (c. 1725–89) became a *maître* in 1754 but did not begin supplying the royal *Garde-Meuble* until 1777. His pieces show the reticence typical of the period just before the French Revolution. This is evident in his famous *lit à la polonaise* (1785) which can be seen today in the Petit Trianon, as well as the set of chairs made in 1786 for the Palace of Fontainebleau, which are now distributed between the Louvre, the Wallace Collection in London and New York's Metropolitan Museum.

Boulle, André-Charles

Boulle was the leading *ébéniste* of the Louis XIV era and perhaps the greatest of all French furniture designers. Born in Paris in 1642, he died in 1732 and provides a personal link between the 17th and 18th centuries. His work was continued by his sons, André-Charles II (1685–1745), also known as Boulle-de-Sève, and Charles-Joseph (d. 1745). Boulle's style and technique were to influence furniture design throughout the 18th century and part of the 19th. Boulle, who was the son of Jean Bolt, *Maître menuisier en ébène,* and began his career as a painter at the Académie de Saint-Luc. By the 1660s Boulle had al-

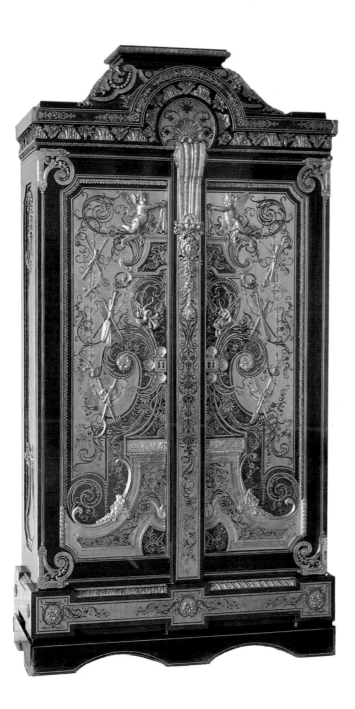

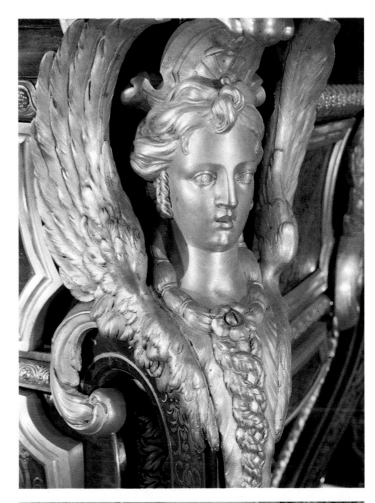

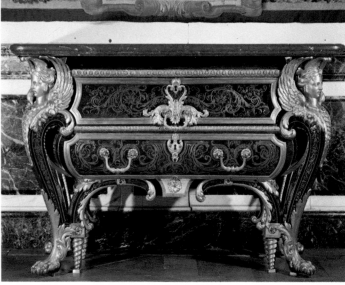

FACING PAGE: an ebony-veneered cabinet attributed to Boulle, veneered with tulip-wood, tortoiseshell and pewter. Wallace Collection, London. THIS PAGE, ABOVE: a Boulle wardrobe with ebony veneer, decorated with brass and tortoiseshell, and applied with ormolu mounts. Musée National du Château de Versailles. RIGHT: a commode made by Boulle for Louis XIV's apartment at Versailles (c. 1708/09). ABOVE RIGHT: one of the ormulu corner mounts in the form of a winged sphinx which decorate this commode. Musée National du Château de Versailles.

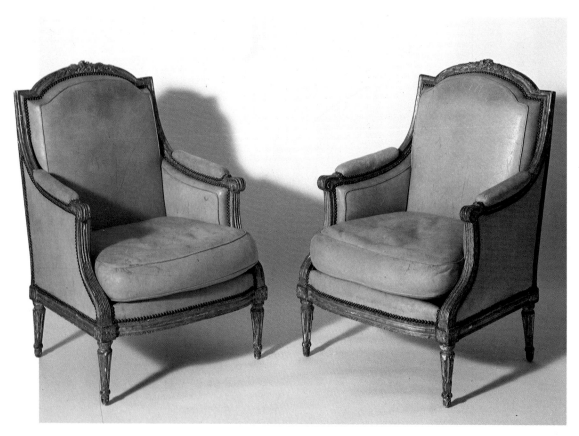

Two Louis XVI *bergères* in gilt-wood carved with interlaced ribbons, rosettes and fluting. The chairs are stamped as the work of Jean-Baptiste Boulard, a *menuisier* in the service of the crown from 1777 onwards. Among other things he made a series of chairs for Fontainebleau which today are dispersed among various collections. Antiques trade.

ready achieved such eminence that Bernini visited him and offered him advice while in Paris in 1665. The king's minister Colbert recommended him to His Majesty as the best *ébéniste* in Paris, and saw to it that he was appointed *ébéniste du roi* in 1672.

As a specialist in inlay work, Boulle was most important for perfecting the already familiar technique of marquetry using brass and tortoiseshell, which from then on bore his name. His style is characterized by a symmetrical and monumental arrangement of architectural elements, as well as original, carefully worked decorative mounts in engraved bronze, often featuring mythological figures. His position as court *ébéniste* enabled him to work in metal as

well as wood. Boulle was one of the first craftsmen to use purple-wood for geometric inlay work (c. 1715).

In the early 18th century – the precise year is not known – a series of engravings of Boulle's designs was published in Paris under the title: *Nouveaux dessins de meubles et ouvrages de bronze et de menuiserie inventés et gravés par A.C. Boulle.* His furniture designs show affinities with those of Bérain and Gilles Marie Oppenordt, who seems to have worked as a designer to the Boulle workshop towards the end of Boulle's career. Boulle supplied the Bâtiments du Roi with marquetry for floors and architectural fittings. However, most of his pre-1700 furniture was made not for the king but for

other members of the Royal Family, in particular the Grand Dauphin. He also made furniture for Philip V of Spain and the Electors of Bavaria and Cologne, as well as for several noblemen and wealthy commoners. He had no stamp to identify his works, and few surviving pieces can be attributed to him with certainty; the most important are a pair of commodes designed for the Grand Trianon and supplied in 1708, which are now at Versailles.

B.V.R.B.

This is the stamp used to identify the works of the three generations of *ébénistes*, Bernard I, Bernard II and Bernard III

Vanrisamburgh. For a long time the works could not be attributed, even though the family created some of the most beautiful and valuable French furniture of the 18th century. Bernard I came from Holland and settled in Paris before 1696, where he obtained his *maîtrise.* When he died in 1738 he was survived by five sons. The eldest, Bernard II (c. 1700–65), became a *maître* as early as 1730. One of his six sons Bernard III (d. 1799) continued to run his father's workshop until the death of his mother – it was required by law that women inherited their husbands' *maîtrise.* Oddly enough, Bernard III was the only member of the family never to become a *maître,* possibly because he had a strong interest in wood-carving. After his mother's death he established a workshop for carving. His impressive bronze decorations also suggest that he secretly worked as a *fondeur-ciseleur.*

The most important representative of the family, Bernard II, worked for one or two *marchands-merciers* (probably Lazare Duvaux or Poirier). Presumably they ordered him to sign his pieces simply with The dealers not only obtained commissions for him but also influenced his designs. Typical features of Bernard II's highly prized pieces are the elegant linking elements, delicate feet, flowing outlines of the commodes and *secrétaires en pente*, with bronze *agraffes* in the centre of the curves, floral branches in kingwod (cut across the grain) overlaid on tulipwood, veners of japanning and imitation lacquer, and decorative Sèvres porcelain.

RIGHT: a small example of Louis XVI furniture by Carlin, with Sèvres porcelain decorations. Wallace Collection, London. BELOW, LEFT: chair with an oval back, by Jacques Cheneaux (c. 1775). BELOW, RIGHT: *bureau plat* (c. 1780) by Carlin, in mahogany and ebony with ormolu decorative motifs. Antiques trade.

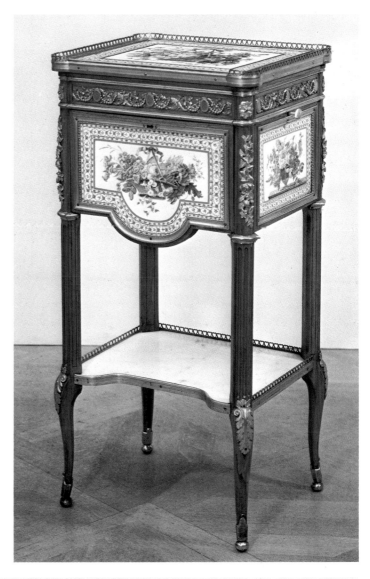

Carlin, Martin

Originally from Germany, Carlin (c. 1730–1785) came to Paris in 1759 and was trained by Oeben, whose sister he married. He obtained his *maître* in 1766, after which he worked mainly for the *marchands-merciers* (Poirier, Daguerre and the Darnaul brothers), who commissioned small pieces from him such as *bonheurs-du-jour,* cabinets, secretaires and tables. Probably at their request Carlin made use of lacquer panels and porcelain plaques but he himself preferred ebony, purplewood and tulipwood, woods that he frequently used in threadinlays of contrasting colours. The furniture he built, probably to designs by G.-P. Cauvet, Gondouin and J-D. Dugourc et al., is decorated with draperies, fluted columns, laurel wreaths and other classical motifs, and festooned with tassels.

Cressent, Charles

The son of an *ébéniste* and grandson of a wood-carver, Cressent (1685–1758) used both skills. He was trained in his native town of Amiens, but soon settled in Paris, where he became a member of the Académie de Saint-Luc in 1714. Some years later he married the widow of Joseph Poitou, with whom Cressent had worked and whose father had been a rival of Boulle. Cressent inherited Poitou's workshop as well as his title as *Ebéniste du Duc d'Orléans*, in other words court cabinetmaker to the Regent. His name appears frequently in 18th-century auction catalogues, which makes it possible to identify some of his pieces with absolute certainty. Cressent was working at a time when it was still not compulsory to mark furniture with a stamp, and it is normally very difficult to distinguish his pieces

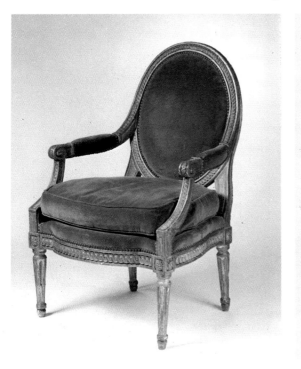

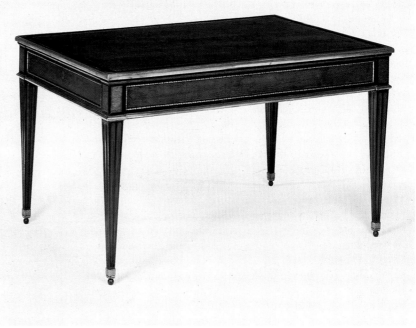

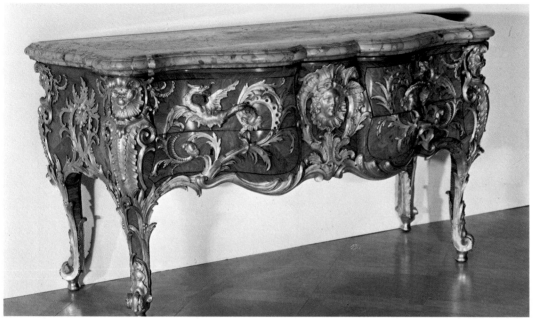

Cucci, Domenico

Born in Italy, Cucci (c. 1635–1705) settled in Paris c. 1660. As a wood-carver, stone-carver and *ébéniste*, he decorated the panels of his cabinets with semi-precious stones. Besides jasper and lapis lazuli he used silver, tin, tortoiseshell and other costly materials which gave his furniture the sumptuous appearance typical of

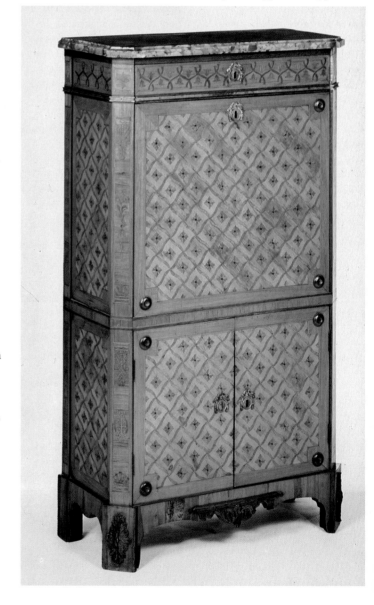

from those by Doirat or Gaudreaux. Numerous pieces of furniture have been attributed to him on the basis of inadequate documentation.

His sculptural training is evident in the bronze mounts – Cressent's favourite decorative elements – which are set off particularly well by the various exotic hardwoods in which he worked. Cressent mainly used *bois satiné* and purplewood which, in his early work, he arranged in large lozenges and rectangles, and later in designs that harmonized with the bronze decorations. His passion for bronze mountings embroiled him in disputes with the guild of bronze-founders and engravers, who refused him the right to work in this metal. Cressent borrowed decorative motifs from both the Rococo and the Régence style promoted by the architect Robert de Cotte and the Duchess of Burgundy. Watteau's influence is also clearly visible in his small female figures, *singeries* and portrayals of young people, seasons and flowers surrounded by *espagnolettes* and *chinoiseries*, palmettes, floral motifs and vine leaves. Of particular interest are Cressent's lock-plates embellished with chimaeras.

It was either Cressent or perhaps Gaudreaux who defined the appearance of the Louis XV commode: curved front, central *tablier*, embellished edges and rather tall legs. Typical commodes attributed to Cressent are at Waddesdon Manor and in the Residenzmuseum, Munich. He often used a veneer of *bois satiné* and purplewood to give a frame to the ormolu mounts. The mounts are also exceptional, with sculpted figures such as children or young ladies on the corners and masks of Apollo in the centre.

Criaerd, Mathieu

Flemish-born Criaerd (1689–1787), gained his *maîtrise* in 1738 and created valuable furniture in the Louis XV style, which he probably sold to the trade through the *merciers*. His Rococo-inspired style featured inlays with floral motifs and real and imitation lacquers. When he retired in 1767, his youngest son Sébastien-Mathieu (1732–96) inherited his *atelier*, his eldest, Antoine-Mathieu (1724–87), a *maître* since 1747, already having a workshop. An important *encoignure* or corner cupboard painted in blue and white and made in 1743 for Mlle. de Mailly at Choisy is now in the Louvre.

the Louis XIV style. Next to Golle and Boulle he is one of the most important *ébénistes* of his age, and he too created articles designed to furnish the royal residences. However, most of his pieces have been either lost or destroyed. In fact, many of Cucci's works were later dismantled so that the valuable components could be re-used. Two pieces to survive are cabinets in ebony veneer with areas of *pietre dure* and ormolu decorations (now in Alnwick Castle, Northumberland).

Delanois, Louis

This *menuisier* (1731–92), who obtained his *maîtrise* in 1761, numbered among his patrons Madame Dubarry, the King of Poland, the Prince de Condé, the Comte d'Artois and the Dukes of Chartres and Choiseul. He left an unmistakable mark on the Transitional style. His early settees and sofas have rounded profiles and are decorated with floral carving. Typical features of these pieces are the heart-shaped embellishments on the side-panels and backs, and the Y-shaped decorations on the upper parts of the legs. Later in his career Delanois fully embraced the Louis XVI style, as is evident from a set of chairs – one of the first in the Neoclassical style – which the king gave to his mistress Madame Dubarry for her pavilion at Louveciennes.

The Dubois family

The founder of the family, Jacques (1693–1763), *maître* from 1742, and his son René (1737–99),

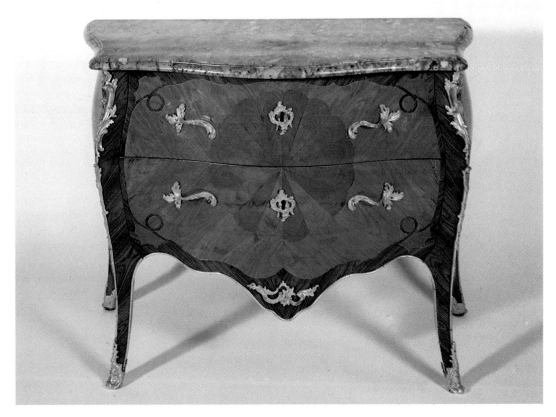

maître from 1755, both evolved from the Louis XV to the Louis XVI style and have similarities with the work of the Vanrisamburgh family, though their designs have greater force and originality. The luxurious and imaginative works of Dubois père et fils may sometimes appear a little over-elaborate and lacking in elegance, which reflects the fact that much of their work was done for foreign clients. Like the Vanrisamburghs, they used real and imitation lacquer, floral marquetry in *bois de bout,* ormolu mounts with swirling, asymmetrical *rocailles,* and *chinoiseries* and other exotic decorations.

René, the most important member of this great cabinet-making family, took over his father's workshop from his mother in

1772. He is decribed in 1779 as *Ebéniste de la Reine.* He worked in a variety of techniques, including Boulle marquetry and lacquer panels; he is most famous for furniture painted in *vernis Martin* or *en camaieux,* shades of beige on a green ground. A typical piece by him is a commode veneered with Japanese lacquer, with ormolu mounts in the shapes of sirens (c. 1775; Wallace Collection, London). He also worked for foreign clients, and the so-called *Tilsit Table* was in the collection of the Russian Prince Kourakin (now Wallace Collecion, London).

The Foliot family

The founder of this dynasty of

ménusiers, which served the royal *Garde-Meuble* for nearly 40 years, was Nicolas, who died in 1745. He was followed by his two sons Nicolas-Quinibert (1706–76) and François I (d. 1761), and later François-Toussaint, known as François II (b. 1748, probably the son of François I). Nicolas-Quinibert was one of the most significant furniture-makers of the late Louis XV period. He created a large number of upholstered and textile-covered pieces for Versailles whose simplicity and quiet elegance already foreshadow Neoclassicism. His collaborators were the wood-carvers Babel and Dupré and the gilders Bordon and Chatard. With the latter he produced in 1770 the suite of furniture known as the *Mobilier des Dieux* ("furni-

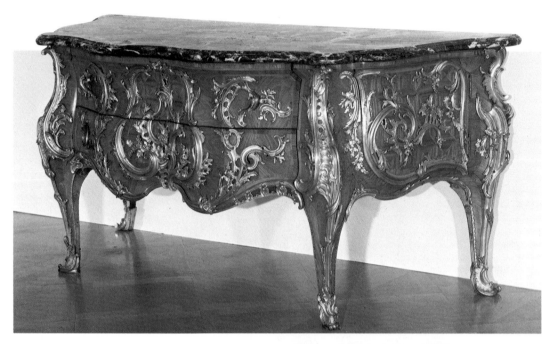

the interior furnishing of the Bibliothèque Royale and the Tuileries. His early pieces feature rectangular veneering and thread-inlays of olivewood or rosewood, and he often worked in patterns of small squares, lozenges or mosaic, or large surfaces in king-woood, for which he had a great preference, with *rocaille* embellishments in bronze. He made a coin-cabinet (1738), and a commode (1739) to a design by the Slodtz brothers for the king's apartment in Versailles, with mounts by Jacques Caffieri (now Wallace Collection, London).

ture of the gods"), parts of which can be seen today in the Louvre.

Garnier, Pierre

The son of *ébéniste* François Garnier, Pierre (1720–c. 1800) gained his *maîtrise* in 1742 and worked for the Duchesse de Mazarin, the Maréchal de Contades, the Marquis de Marigny and probably several Paris furniture-dealers. Though not as famous as Oeben, his pieces, often lacquered, show superb craftsmanship. His style is somewhat ponderous but full of invention and marks the transition from Rococo to *goût grec*.

Gaudreaux, Antoine

The work of this *ébéniste*, like that of Cressent, bears no stamp and very little is known about it. What we can be sure of is that between 1726 and 1751 he supplied many pieces to the *Garde-Meuble de la Couronne* and was involved with

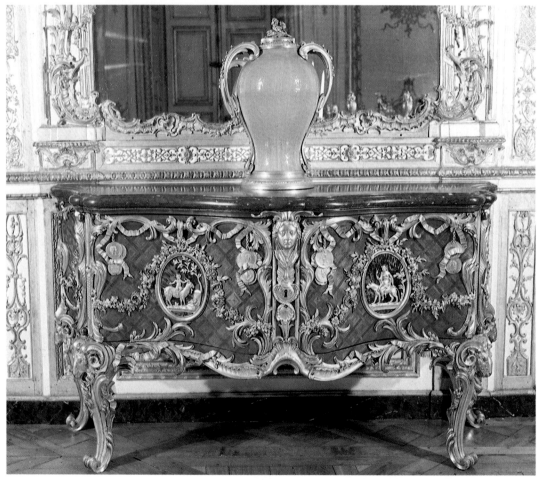

FACING PAGE: two commodes by Gaudreaux to designs by the Slodtz brothers. The upper example is in kingwood and *bois satiné* and decorated with ormulu *rocaille* motifs by Jacques Caffieri. Wallace Collection, London. The lower piece, made as a coin-case for the *Cabinet du Roi* at Versailles, is applied with magnificent bronze decoration designed by the Slodtz brothers. THIS PAGE: The same motifs can be found, as the detail (below) shows, on the corner cupboard by Joubert, which was made at the same time for the *Cabinet du Roi*. Musée National du Château de Versailles.

Golle, Pierre

Dutch-born, Pierre Golle (d. 1684) was a major *ébéniste* of the Louis XIV period. Cardinal Mazarin, who may have invited him to France, commissioned two ebony cabinets from him. Until recently none of his work could be identified, but now a small ivory cabinet in the Victoria and Albert Museum, a writing desk in pewter marquetry on a brass ground at Boughton House and a small table at the Getty Museum, Los Angeles, have been linked to items he supplied to the royal palaces. He was apparently one of the first to work in both floral and metal marquetry.

Gourdin, Jean-Baptiste and Michel

The Gourdin brothers, sons of Jean Gourdin, a cabinet-maker active in the mid-18th century, were talented *menuisiers*, who gained their *maîtrises* in 1748 and 1752 respectively and made chairs, settees and sofas, initially with floral motifs and *rocaille* decorations, in the Louis XV style. Later (c. 1770–75) they tended more towards the Louis XVI style. Michel made numerous pieces for patrons at court. Some of his chairs are now in the Wallace Collection in London.

Heurtaut, Nicolas

There is evidence that Heurtaut, who came from a family of cabinet-makers, was born in 1720, gained his *maîtrise* in 1755 and was still active in 1771. He chiefly made beds, settees and chairs, often covered with Gobe-

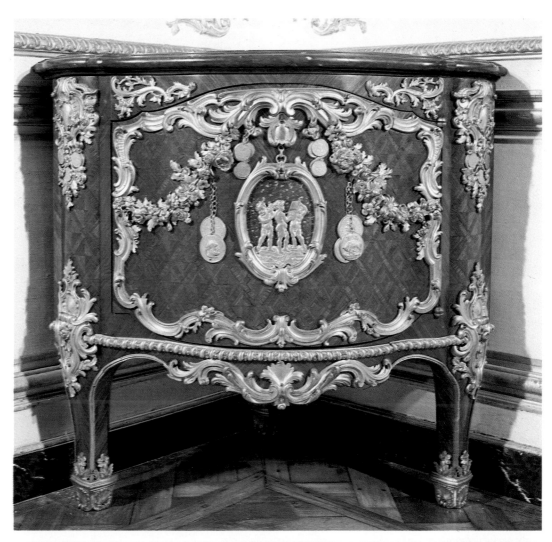

A chair and settee by *menuisier* Georges Jacob. BELOW: A *chaise à la reine* (1780–90) in carved gilt wood. Musée Nissim de Camondo, Paris. BOTTOM: a Louis XVI settee with a curved oval back-rest and sides. Antiques trade. FACING PAGE, ABOVE: Louis XVI commode by Joseph, inlaid with ebony, tortoiseshell and various metals. Wallace Collection, London. BELOW: two simply designed Louis XVI corner cupboards with restrained decoration by Lacroix. Antiques trade.

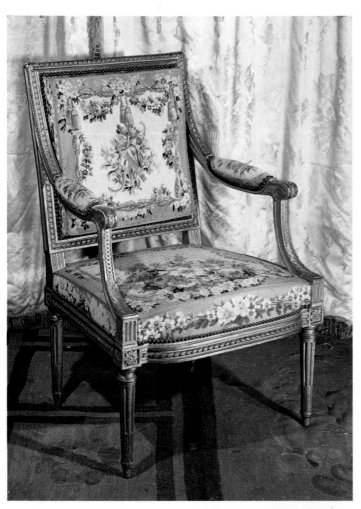

stock and obtained his *maîtrise* in 1765, probably after being trained by Delanois. Jacob's early work reflects the Louis XV style, but he soon changed to that of the Louis XVI period. It is chiefly the furniture he made in the later style, especially chairs, that demonstrates his inventiveness. The motifs most associated with him are triangles decorated with rosettes at the joins between the arms and backs of his chairs and, in pieces dating from the late Louis XVI period, the cube-shaped section of the legs on which daisies or small suns are carved. Inspired by English examples, he was also one of the first French cabinet-makers to use mahogany for chairs with pierced carving on the back.

It is probable that even before the abolition of the guilds he himself executed the carvings on his furniture. For the side-panels, legs and arm-rests of his seating he continued to create new variations: he "invented" the circular seat-frame, and both the sloping and the baluster-shaped, spiral-fluted arm-rests. The planed-off inside angles of the seat-frames of chairs and settees gave these a lighter appearance, without sacrificing any of their stability. His patrons included Marie-Antoinette, the Comte d'Artois, the Duc de Chartres and the Prince of Wales. However, he also worked for the *marchands-merciers* (especially Daguerre), who obtained commissions for him in England. Jacob made not only seating but also other furniture such as *canapés, pliants*, fire-screens, beds of various designs, tables and consoles.

Joseph (Joseph Baumhauer)

The German-born *ébéniste* Joseph Baumhauer (d. 1772) used to stamp his pieces simply with his first name, and it is under this name that he usually appears in the literature. Thanks to special permission from the king, he received his *maîtrise* in 1767, and it is likely that he also worked for the leading *marchands-merciers*. Joseph worked in both the Louis

lin fabrics. Generous proportions, richly detailed *rocaille* carvings and great attention to workmanship are the main features of his work.

Jacob, Georges

The career of Georges Jacob (1739–1814), one of the most important names in the history of 18th-century French furniture, is closely bound up with the Directoire, the Empire and the furniture design of the early 19th century. In contrast to the other *menuisiers*, he came from peasant

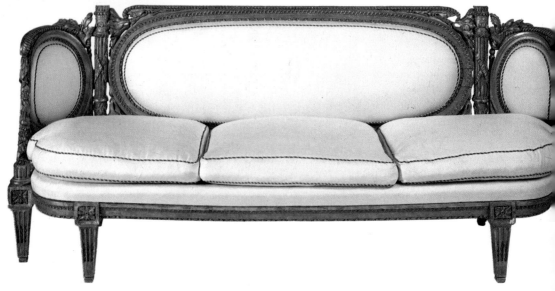

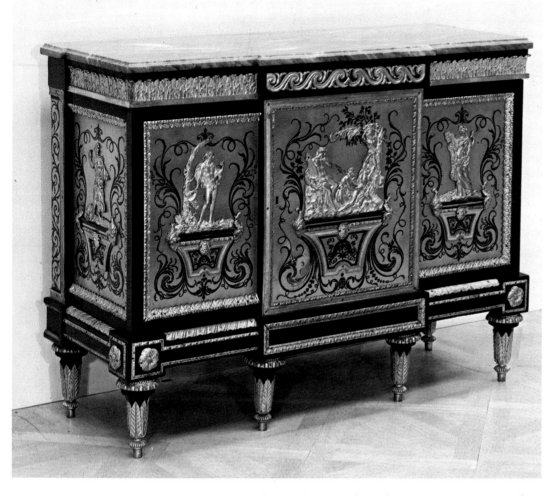

inet-makers, especially Criaerd and Marchand. Furthermore, he rarely stamped his own pieces, initially because at that time *estampilles* were not obligatory, and later because he was working on royal commissions, to which the new law did not apply. For these reasons it is difficult to identify Joubert's work. He worked predominantly in the Louis XV style, although some of his early pieces feature less pronounced curves. During the last years of his life Joubert developed a decorative motif – small pieces of bronze appliqué in the form of rosettes on lozenges of inlay work – which makes the attribution of his work easier. In addition to this, his use of acanthus leaves and rosettes demonstrates his interest in the new *goût grec*.

XV and Louis XVI styles. The different types of furniture he made are all notable for the masterly placing of bronze mounts with a matt or satin finish. Also typical of his work are marquetry in the Boulle technique and *pietre dure* inlays.

Joubert, Gilles

Joubert (1689–1775) married a cousin of Pierre Migeon II, who was one of Madame de Pompadour's favourite *ébénistes*. Doubtless this facilitated his own entrée to the royal court, for which he worked from 1748 onward. Ten years later he was appointed *Ebéniste ordinaire du Garde-Meuble de la Couronne*, and on Oeben's death in 1763 he was promoted to *Ebéniste du Roi*. A large quantity of the furniture he supplied to the Crown came from the workshops of other cab-

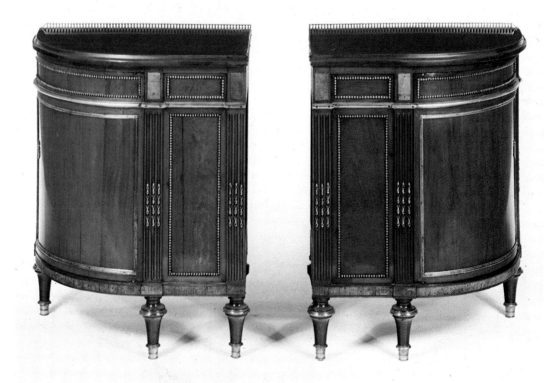

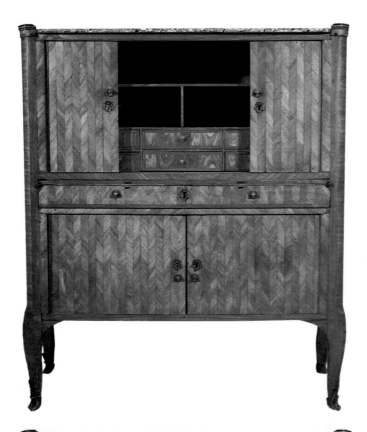

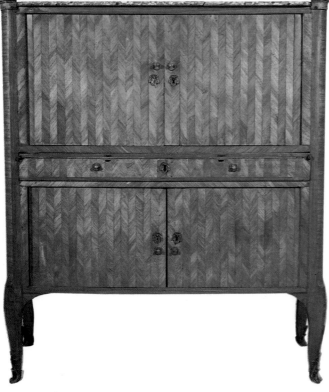

Lacroix (Roger van der Cruse)

The Flemish *ébéniste* Roger van der Cruse (1728–99) used to sign his work with the name "Lacroix" and the initials R.V.L.C. After training under Pierre Migeon he obtained his *maîtrise* in 1755. The Lacroix style, characteristic of the final years of Louis XV's reign, can without hesitation be ascribed to the Transition period. In fact he created several pieces which anticipated elements of the Louis XVI style. Thanks to a relationship by marriage to Oeben he gained access to the royal court and worked for Madame Dubarry among others. However, he also worked for the *marchands-merciers,* and it was probably at their urging that he concentrated on making small pieces – *bonheurs-du-jour* (writing-tables), *guéridons* (occasional tables) and other small tables with decorations in genuine lacquer, imitation lacquer and plaques of Sèvres porcelain. Typical features of Lacroix's pieces are slender, double-curved legs and pale wood veneers. The influence of Oeben is very clear in his marquetry – chiefly lozenge shapes, latticework, baskets of flowers and rosettes. The floral motifs in *bois de bout* and the *chinoiseries* bear his personal signature. "Lacroix" bronze mountings were initially dominated by *rocailles,* but these later gave way to other motifs more in keeping with the new enthusiasm for the ancient world. His son Pierre (d. 1789), also a cabinet-maker, worked mainly as a restorer.

Latz, Jean-Pierre

Originally from Cologne in Germany, Latz (c. 1691–1754) moved to Paris in about 1719 and after a long apprenticeship was appointed in 1741 to the position of *Ebéniste privilégé du Roi suivant la Cour,* which meant that he no longer had to worry about gaining his *maîtrise.* In addition, he served the courts in Berlin, Dresden and Parma. Latz decorated his furniture with sumptuous bronze mounts made in his own workshop. This infringement of the guild regulations led to a lawsuit in 1749. Latz achieved fame through his clocks, such as the one preserved in the Cleveland Museum of Art in the USA. It is decorated with Boulle marquetry and ormolu Rococo embellishments.

Lelarge, Jean-Baptiste III

The work of Lelarge (1743–1802), who came from a Parisian family of cabinet-makers and gained his *maîtrise* in 1775, is strongly influenced by Sené and Jacob. Our knowledge of Lelarge is very incomplete. Although he doubtless made other types of furniture, he is only known for his chairs. These have medallion-shaped backs adorned at the top with knots or other motifs *à la Artois.* His pieces can be seen in the Louvre, the Wallace Collection and New York's Metropolitan Museum.

Leleu, Jean-François

A pupil of Oeben, born in Paris, Leleu (1729–1807) gained his *maîtrise* in 1764 and worked for

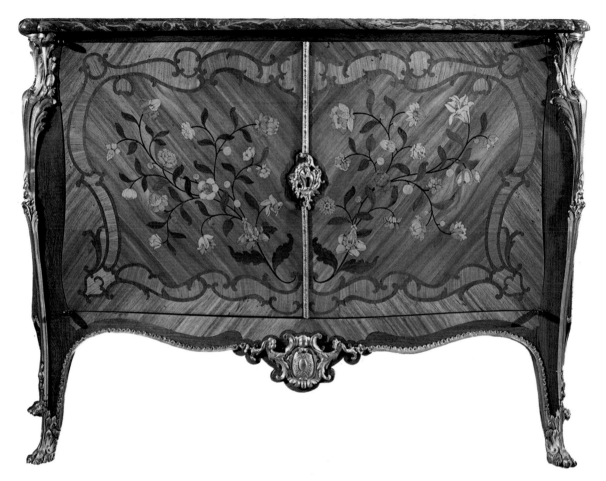

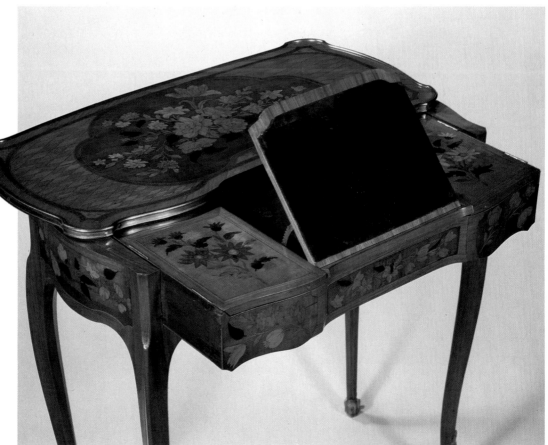

the Prince de Condé, Madame Dubarry and Marie-Antoinette. His early works are very much in the Transitional style. However, Leleu quickly adopted the Louis XVI idiom and came to be one of its most important exponents. His furniture sometimes looks rather squat and heavy but often has a lightly curved profile which relieves the four-square design. Some of his pieces lack legs and instead stand directly on the floor. Leleu had a penchant for marquetry: lozenge patterns, rosettes, bouquets of flowers and delicate tracery in the style of wrought iron known as *ferronnerie*. He used tulipwood, purplewood and mahogany, and framed his inlay-work with black and white stringing. In 1792 he retired and handed over his *atelier* to his brother-in-law Charles-Antoine Stadler, his partner since 1780, who ran it until 1811.

An important *ébéniste:* Jean-Henri Riesener

Born in Gladbeck, a small town eight miles (13 km) from Essen in Germany, Jean-Henri Riesener was just 20 when, like many of his fellow-countrymen, he made his home in Paris. He realized that he would find the best surroundings for his artistic development in the French capital, which at that time played a leading role in the art of furniture-making. Riesener produced a large number of pieces of different kinds, but his career can be divided into three phases: in the heavy and formal Louis XV furniture of his first phase, the influence of Oeben is very apparent. During the second phase, which began in about 1775, Riesener's lines became straighter and his ornamentation – skilful inlay-work and delicate bronze appliqués, provided for him by Duplessis, Hervieu and Forestier among others – increased in elegance. In the third phase, from 1784 onward, these tendencies became more pronounced and he created slender pieces of great charm. The range of his production ran from small, ingenious and costly caskets to grand and opulent pieces of furniture. For example, there is the famous *Bureau du Roi* made for Louis XV, which later spawned many other versions. The desk was begun by Oeben and completed and signed by Riesener. It contained a system of springs by which the cylinder front could be raised or lowered at the touch of a button. Riesener had a particular love of such mechanisms and, often in collaboration with the German locksmith Merklein, produced various pieces that, with the aid of specially designed apparatus, could be altered and adapted for different functions. Notable among these was the bedside table designed for Marie-Antoinette, whose height could be adjusted so that it could be also be used for eating meals. If other knobs were pressed, the table would become a desk or a dressing-table. Characteristic of Riesener's furniture is the charm and variety of the decorative motifs: mother-of-pearl incrustation, like that on the magnificent *bureau à cylindre* made in 1785 for Marie-Antoinette, porcelain plaques and oriental lacquer paintings. But above all Riesener's furniture is recognizable by a special type of lozenge-patterned marquetry, which he "inherited" from Oeben, and which he modified and perfected. Riesener was well known as the most expensive *ébéniste* of his age, but he also produced simple furniture, almost devoid of embellishment, which is among the first French furniture to be made mahogany.

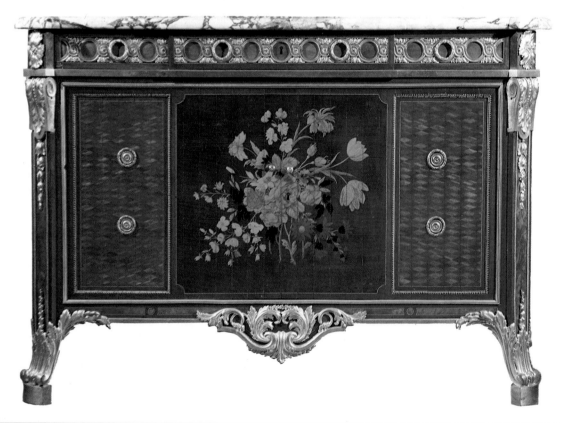

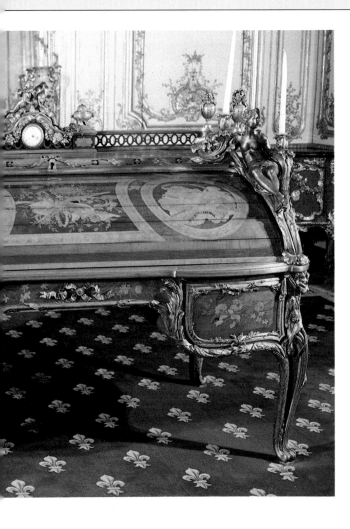

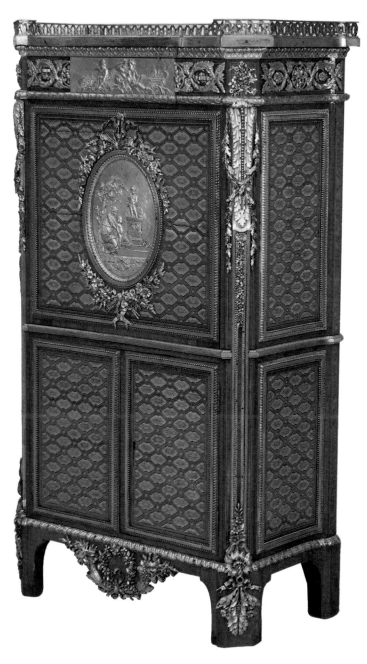

FACING PAGE: commode with three-panelled front and sliding doors. The two doors at the sides are decorated with lozenge patterns in exotic woods, while the central panel has a spray of flowers. The corners, apron and feet are enhanced with bronze scrollwork and acanthus leaves. The ormolu frieze at the front conceals three drawers. Musée Nissim de Camondo, Paris. LEFT: Louis XV's famous *Bureau du Roi*, commissioned from Oeben in 1760 and completed and signed by Riesener. Musée National du Château de Versailles.

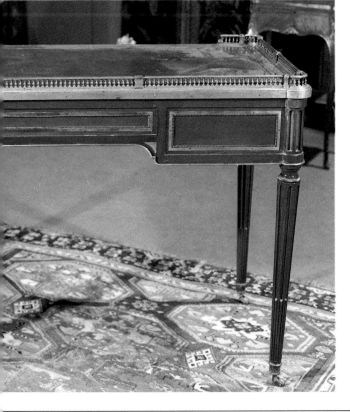

ABOVE: a *secrétaire à abattant* made for Marie-Antoinette (c. 1790) with marquetry of geometric patterns and trelliswork. The bronze decoration of the cornices, corners and apron were designed and made by Riesener, while the plaques with their classically inspired subjects are taken from the work of the sculptor Claude Michel Clodion. Wallace Collection, London. BOTTOM LEFT: a *bureau plat* in mahogany veneer with inlaid stringing and a delicate ormolu gallery. The turned, fluted and tapered legs are typical of the Louis XVI style. Antiques trade.

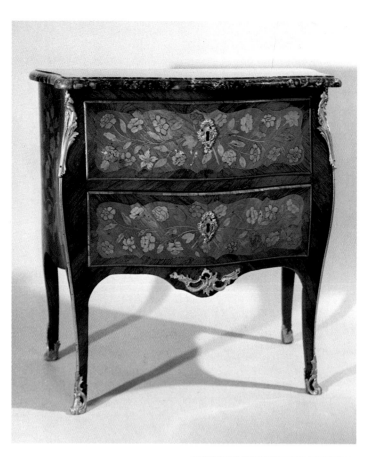

of multifoliate veneering which gives an impression of tiles. The latter motif was relatively common among the *ébénistes* of the age. In addition Pierre II used *bois de bout*, and in 1740 was one of the first furniture-makers to work in mahogany. From 1740 onwards he worked in the service of the court and in particular for Madame de Pompadour. He specialized in small pieces – travelling dressing-tables and collapsible *secrétaires*, to which he added various devices to extend their usefulness. His son Pierre III (1733–75), a *maître* after 1761, was really more of a dealer than an *ébéniste*.

Oeben, Jean-François

Not much is known about the early years of Oeben (c. 1721–63), who was German by birth. Nonetheless, he was probably the most important and talented *ébéniste* active in the mid-18th century.

In 1751 he was working as an independent in the *atelier* of the sons of André-Charles Boulle, and three years later, possibly at the instigation of Madame de Pompadour, he was appointed *Ebéniste du Roi*.

His family relationships with other cabinet-makers must certainly have contributed to his

The Migeon family

The best-known of this "dynasty" of Paris furniture-makers was Pierre II (1701–58), who succeeded his father Pierre I in 1739 (born c. 1670) as head of the family workshop. The Migeons were not only *ébénistes* but also dealers. On some pieces attributed to them we find not only their stamp but also the signatures of other craftsmen who supplied them with furniture of all kinds. These suppliers included Dautriche, Gérard Péridiez, Bon Durand, Criaerd, Lacroix, Boudin and Macret. It is said that Pierre II never obtained his *maîtrise* because, as a Calvinist, he would have had to petition for a special licence. He built chiefly low-standing, heavy pieces with curved drawer-fronts and cupboard doors, and recesses in the centre of the framework. He worked mainly with rather simple veneers of *bois satiné* or tulipwood further applied with kingwood and purplewood. However, there are also examples

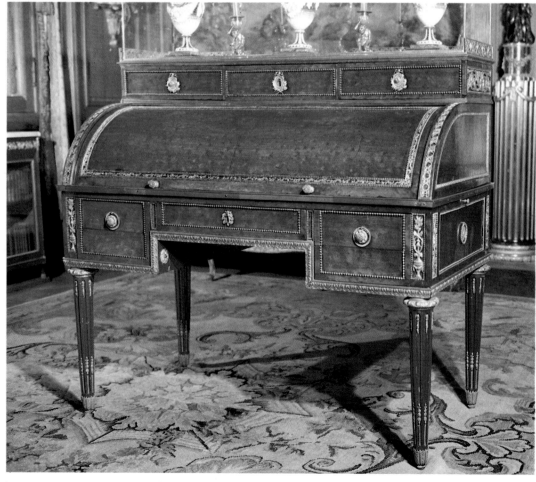

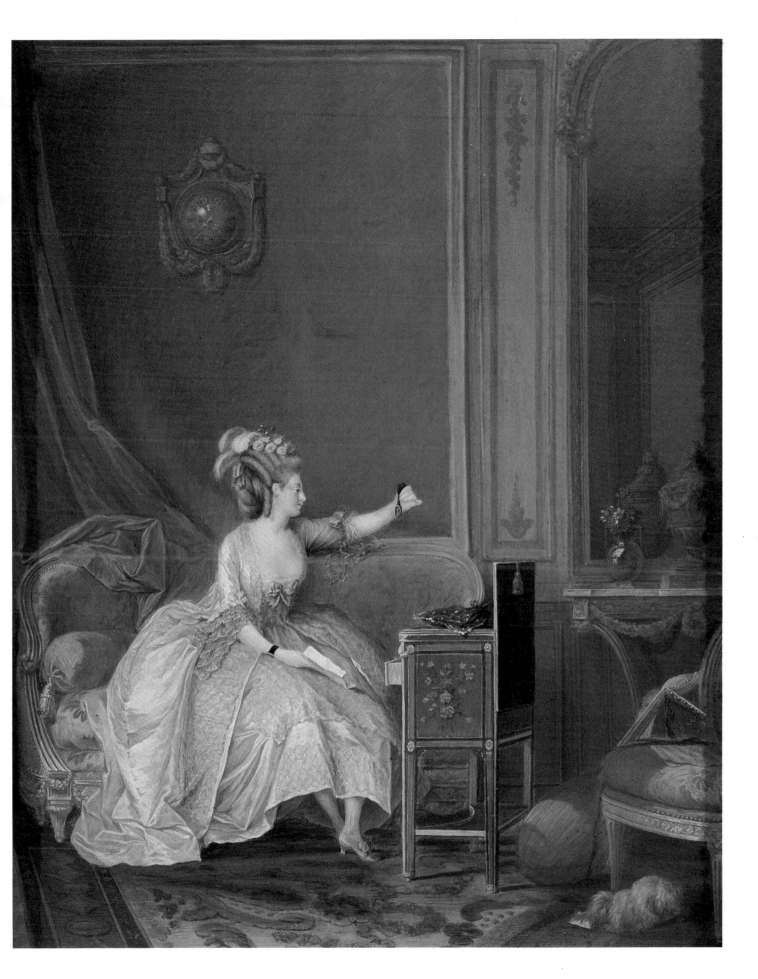

BELOW: a Louis XVI cabinet-bookcase by Saunier veneered in tulipwood and purple-wood, with restrained ormolu decoration. Antiques trade. FACING PAGE, ABOVE LEFT: a Louis XV *voyeuse* by Tilliard in carved gilt wood. ABOVE RIGHT: a *bonheur-du-jour* of the Transition period made by Topino, an *ébéniste* who specialized in small items of furniture. Musée des Arts Décoratifs, Paris. BELOW: a *veilleuse* (c. 1750) by Tilliard. The fine carving of the frame-cartouches and floral motifs is characteristic of the *menuisiers* of the Louis XV period. Victoria and Albert Museum, London.

estampille is rare, and in fact most of those were probably made by his pupil Jean-Henri Riesener.

Jean-François Oeben worked in the Transitional Style between Louis XV and Louis XVI. He specialized in what were called *meubles à secrets et à surprises*: with the aid of springs and crank-handles he created a large variety of mechanisms by which the doors, lids and other moving parts of his furniture could be made to disappear and reappear. His style is characterized by geometric marquetry. The surfaces of his later pieces are embellished with lozenge or rosette patterns, or wonderful marquetry in the form of sprays or baskets of flowers surrounded by interwoven ribbons.

According to Pierre Verlet, other typical Oeben features were areas framed with black and white string-inlay and marquetry separated by small inlays made from burr-sycamore. Oeben was entitled to cast his own bronze mounts, and here too it is evident that he worked with the utmost care. Very early in his career he was already using classical motifs such as acanthus leaves, laurel leaves and rams' heads. His most famous work is the *Bureau du Roi*, an imposing, painstakingly crafted and luxurious cylindrical desk for Louis XV, which can be seen today in Versailles and which was commissioned from Oeben in 1760. It was completed by Riesener after the death of his master.

Riesener, Jean-Henri

German-born Riesener (1734–1806) settled in Paris as a young man, and in 1754 became a pupil of Oeben. At the wish of Oeben's widow, whom he married in 1767, he continued to run his master's workshop. Once he had acquired his *maîtrise* in 1768, he was able to sign his own furniture.

Two years later he completed the *Bureau du Roi*, which had been commissioned from Oeben, and in 1774 he was appointed *Premier ébéniste* to Louis XVI. He was one of Marie-Antoinette's favourite furniture-makers, but also worked for the Duc de Penthièvre, the Duc de la Rochefoucault, the Duc de Biron and other royalty and nobility. Pierre Verlet divides Riesener's stylistic development into several phases. Even in his early work (c. 1769–75) Louis XVI features can be detected: severe outlines, rectangular or trapezoid motifs projecting from the centre of commodes, marquetry which, although clearly influenced by Oeben, has novel elements which bring its appearance ever closer to painting, and finally subdued bronze mounts. Between 1775 and 1784 Riesener developed a more personal style. In these years the lines were even simpler, almost crude. He often did marquetry in floral patterns and for his mounts, too, he used classical floral motifs. In the third phase and high point of his career (1784–1789) Riesener worked with costly, exotic materials such as mahogany (various kinds were imported from Santo Domingo and elsewhere), *bois satiné*, tulip-wood, and for Marie-Antoinette's cabinet at Fontainebleau in mother-of-pearl. He also invented a marquetry of lozenges outlined by black and white filets on a sycamore ground called *satiné gris*.

fame. Oeben married the sister of Lacroix in 1749 and one of his sisters became the wife of Martin Carlin. His younger brother Simon-François (d. 1786) also rose to be *Ebéniste du Roi*.

Oeben trained both Leleu and Riesener, the latter continu-ing to run the *atelier* after Oeben's death and marrying his widow. Although as an *Ebéniste du Roi* he needed no *maîtrise*, Oeben nevertheless gained it two years before his death and there-after was obliged to sign his pieces. This explains why his

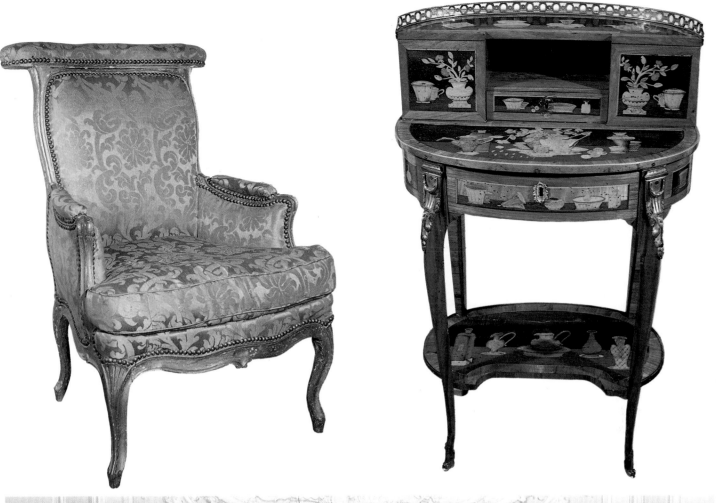

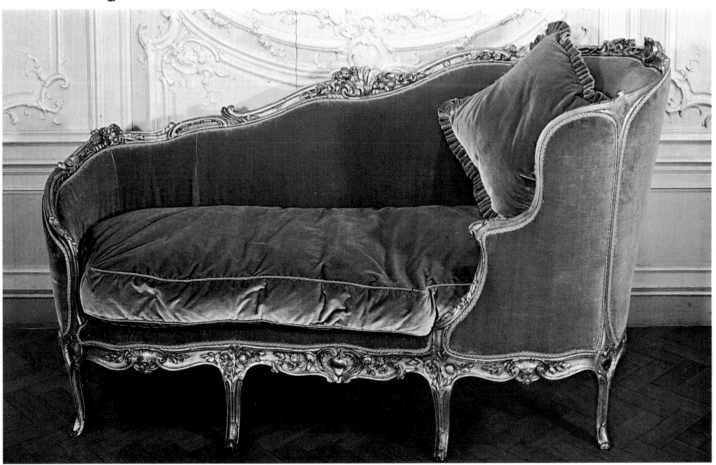

A *secrétaire à abattant* (c. 1780, in open and closed positions) attributed to Adam Weisweiler and intended for the *Cabinet du Roi* at Versailles. A frieze of arabesques, small putti and roebuck runs round below the marble top; the three areas of lacquer paintings on the front are surrounded by mother-of-pearl inlay, and the front corners are decorated with ormolu busts. The drawers in the lower part are decorated with lacquer paintings framed in ormolu. The body rests on turned and fluted legs, which terminate in spiral-turned ormolu feet. Antiques trade. FACING PAGE: Louis XVI *commode d'appui* by Weisweiler in ebony, with an oval panel containing a japanned lacquer painting. Musée Nissim de Camondo, Paris.

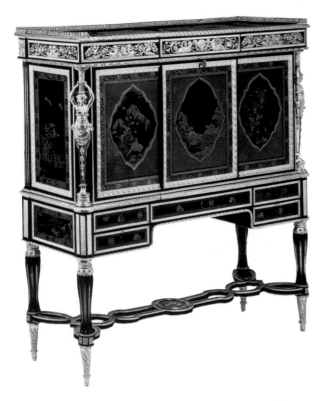

Riesener's exceptional technical skill is seen in the furniture incorporating special mechanisms. Several of these pieces were built in collaboration with a metal-worker of German origin named Merklein. An example of these is the table which can be converted either into a secretaire, a dressing-table or a dining table (Metropolitan Museum, New York). Among other well-known pieces by Riesener are those commissioned by Marie-Antoinette for Fontainebleau, and the secretaire with lacquer appliqué made in 1787 for Saint-Cloud.

Roussel, Pierre

Roussel (1723–82) obtained his *maîtrise* in 1745 and was already famous by the middle of the century, though his pieces are less original than those of leading contemporaries. The influence of Migeon is clear in the rather heavy lines and deeply descending aprons of his commodes. Roussel seldom used *bois de bout* or lozenge patterns, preferring painted colours, lacquer paintings and multicoloured marquetry. During the Transition period his style became more severe, angular shapes predominate and the inlays include sprays of flowers, urns and ancient ruins. In his final period Roussel turned to geometric motifs for decoration.

The Saunier family

The best-known member of this family of *ébénistes*, Claude-Charles (1735–1807), worked initially in Louis XV, but then changed to Louis XVI. Saunier made commodes, tables and bureaux, but seems to have specialized in console tables and cylinder front desks. His pieces are notable for elegant combinations of pale and dark woods. His bronze work sports scrolls and tendrils, rosettes and latticework. He also worked with lacquer and imitation lacquer.

Sené, Jean-Baptiste-Claude

Sené (1748–1803) was a contemporary and competitor of Jacob, but as a designer lacked Jacob's ability and inventiveness. Born of a family of *menuisiers* (his father, Claude I, was quite well known), he obtained his *maîtrise* in 1769 and, together with Foliot and Boulard. In 1785 he was appointed *Fournisseur de la Couronne*. Many of the designs for Sené's pieces were by Gondouin and Dugourc; in his commissions for the king, the wood-carvings were usually done by Vallois, Laurent, Alexandre Régnier or Guérin. Typical features of his chairs are the small, slender columns on each side of the back and spiral-fluted legs. The carvings that connect the arms and backs of the chairs often include the classical cornucopia motif. In one instance we can be certain that Sené directly copied one of Jacob's designs, and elsewhere the influence of Jacob can be seen in the pierced mahogany backs.

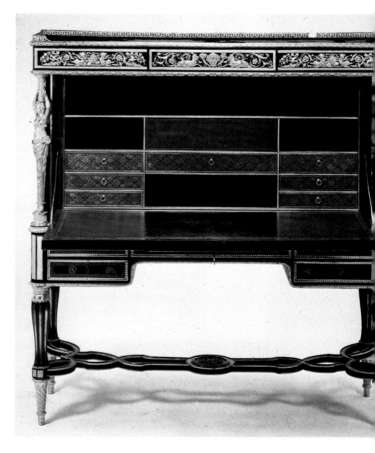

Stöckel, Joseph

Stöckel (1743–1800) is an interesting but still little-known exponent of Louis XVI. Originally from Germany, he came to Paris in 1769, obtaining his *maîtrise* six years later. He worked for both the crown and the *marchands-merciers*. His furniture is typically veneered in mahogany or tulipwood, and features clustered columns on the corners, round, semi-circular or rectangular bronze inlays and motifs in the classical idiom such as lions' paws, urns and mascarons.

Tilliard, Jean-Baptiste

Tilliard (1685–1766) was a *menuisier* who played a major part in establishing and popularizing the Louis XV style. Between 1737 and 1739 he made furniture for the queen's apartments and Louis XV's bedroom and study, and also for the Prince de Soubise and Fermier-Général, Fontaine de Cramayel. His luxurious and usually imposing furniture – chiefly chairs, beds and settees – often feature heart-shaped cartouches in the centre of the rail and back. In addition he decorated the base of the legs with the idiosyncratic motif of a half-closed fan. Tilliard's collaborators included for the carvings Roumier and for the gilding and silvering, Bardou.

When Tilliard retired in 1764, the workshop was taken over by his son Jean-Baptiste II, who had gained his *maîtrise* in 1752. Although father and son used the same stamp and both had a preference for beechwood, differences in their style enable their work to be distinguished. Jean-Baptiste II

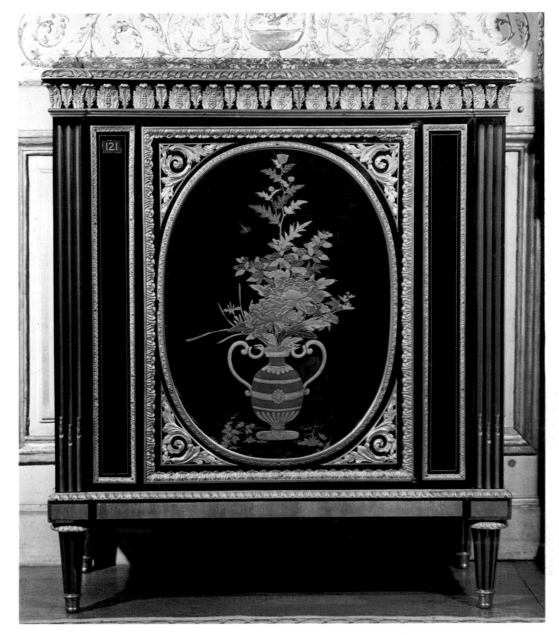

began in the Transitional style and then went over to Louis XVI. Though somewhat clumsy in proportions and ornamentation, thanks to the collaboration of skilled wood-carvers and gilders, his furniture is of very high quality.

Topino, Charles

Topino was a *maître* from 1773. He was one of the few important French-born *ébénistes* at a time when German craftsmen dominated the market. Conforming to the taste of the age, his pieces of furniture are extremely elegant, with elements both of Louis XVI

and of the Directoire and Empire. His inlay-work, usually on a light background, consists of floral motifs, rosettes and scrolls. His bronze decoration work is not particularly original.

Weisweiler, Adam

Trained in Roentgen's workshop in Neuwied near Koblenz, Weisweiler (c. 1750–1810) settled in Paris, obtaining his *maîtrise* in 1778. The elegance of his Louis XVI style is typified by extremely slender legs, which sometimes give his furniture an oddly ill-proportioned look. Legs are usually

tapered and either decorated with inlay or shaped like spinning-tops. Weisweiler worked mainly in mahogany and ebony. Marquetry is found only rarely, and he preferred lacquer, Sèvres porcelain and mahogany veneer. Weisweiler produced numerous three-doored commodes whose lower edging is enhanced by small copper plaques and whose fronts are framed by tapering columns. The bronze work includes cupids, caryatids, sphinxes, satyrs, *canephori* and floral motifs. Weisweiler worked on into the Empire period, producing a few pieces of very high quality. His patrons included the Bonaparte family.

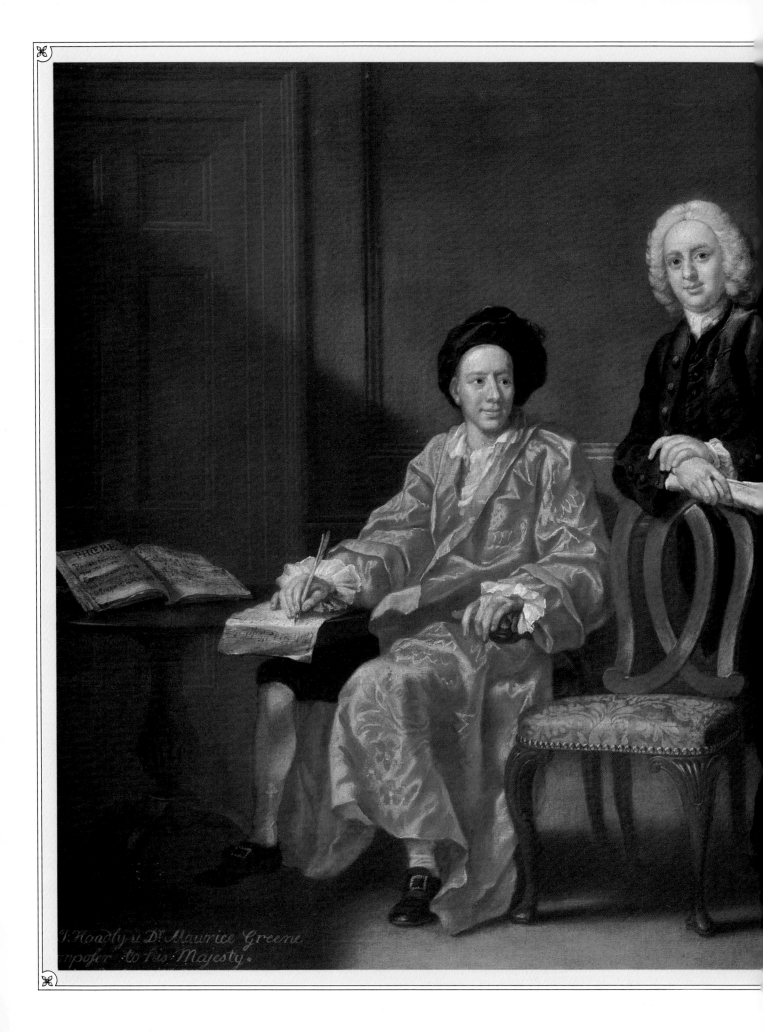

B. Hoadly & Dr. Maurice Greene.
...mpofer to his Majesty.

Furniture of the 18th Century

England

by Alessandra Ponte

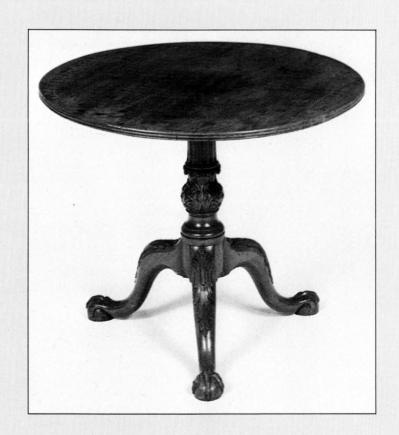

The Legacy of the 17th century and the Queen Anne Style

Introduction

The 18th century was the golden age of English furniture. The wealthy and educated aristocracy of the Enlightenment decorated their great country houses with a sumptuous and refined elegance. This was the era of magnificent

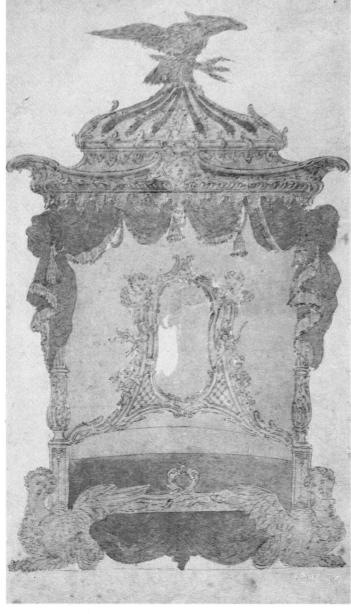

Palladian villas which, with their classical façades, white cupolas and long colonnades, rose magically from the verdant pastures of the English countryside. The houses were enclosed by great tracts of parkland, and the architecture and design of the buildings and gardens were discussed

at length by the nobility – dilettantes, whose minds had been broadened by the experiences of the Grand Tour in France, Germany and Italy. The aristocrat who took pleasure in the arts required a setting fit for the display of the treasure he had acquired abroad, and the traditional interior format had to be changed to accommodate his collections. Galleries were left unaltered, but now, alongside ancestral portraits, landscapes and paintings of various genres appeared (history paintings, still lifes, flower paintings and interiors). Cabinets, where assiduous collectors of the previous century had displayed their coins, scientific curiosities, *objets de vertu*, archives and rare books, became studies where rare objects, travel diaries, souvenirs and sentimental items could be kept. Libraries, too, now became rooms for social intercourse, and their books were instruments of entertainment rather than rare objects.

Pliny the Elder's *Naturalis Historia*, the bizarre rock formations of Chinese gardens with their delicate little bridges, aquatic displays, Gothic ruins surrounded and half-hidden by man-made imitations of "untamed" Nature, temples, obelisks, pyramids, pagodas, grotesques and Pompeiian frescoes – these were all topics for intense philosophical discussion, the parameters of which were taste, style and elegance. From time to time a conclusion would be reached and the supremacy of one stylistic principle over another would be declared: the serpentine outline was to be preferred to the linear, the irregular and asymmetrical to regularity and symmetry.

The virtues of Rococo flamboyance and the untamed picturesque were extolled; what was beautiful, sublime, dreadful was all matter for discussion and debate, in which every aspect of sensibility was called into play to determine what was preferable aesthetically. The origins of pleasure were disputed, and poets and painters alike aimed their satire at these fashionable new pastimes. William Hogarth, for instance, poked fun at fashionable couples and other "types" in contemporary society – both aristocratic and bourgeois – in his series of paintings *Modern Moral Subjects*, which depict in minute detail the interiors of upper-class houses in the first half of the 18th century. Alexander Pope ridiculed the taste for the exotic with the dying words of the unfortunate Narcissa, who appears in his *Moral Essays* (1773): "Odious! In woollen! 'Twould a saint provoke/ (Were the last words that poor Narcissa spoke)/: No, let a charming chintz and Brussels lace / Wrap my cold limbs, and shade my lifeless face". Then, speaking of Lady Mary Wortley Montagu, he adds: "She, while her lover pants upon her breast, / Can mark the figures on an Indian chest". To which the lady, offended, replied, ridiculing Pope's own taste, which had found expression in the famous grotto that linked the front garden to the rear gardens of his villa at Twickenham overlooking the Thames: "Decorated within with worthless sea-shells, symbols of bad verse and trifles, the sacred cave is choked in perpetual mist, and the fragrant odours of nearby drains waft around it."

The cabinet-makers faithfully followed the vagaries of taste and

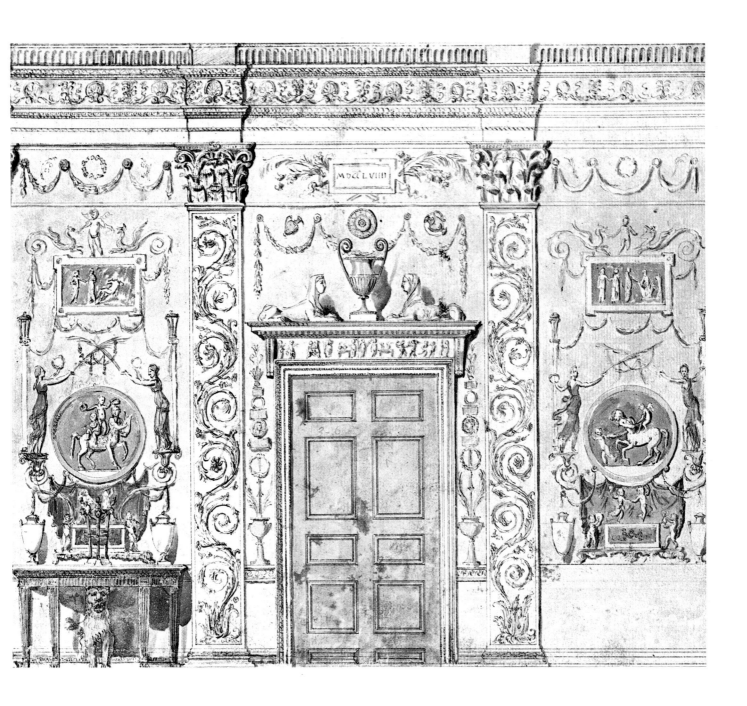

FACING PAGE: watercolour design for a Rococo bed by John Linnell (c. 1755). Victoria and Albert Museum, London. ABOVE: watercolour design by James Stuart (1759) for the Painted Room at Spencer House, one of the earliest examples of an interior design based on classical antiquity. British Museum, London. PREVIOUS PAGES: *Dr J. Hoadly and Dr Maurice Greene* (1747), a painting by Francis Hayman (1708–76), showing a Georgian interior; tripod table with a circular top and three cabriole legs terminating in claw and ball feet. Such tables were very popular during this period, and were still produced in the centuries that followed. National Portrait Gallery, London, and antiques trade.

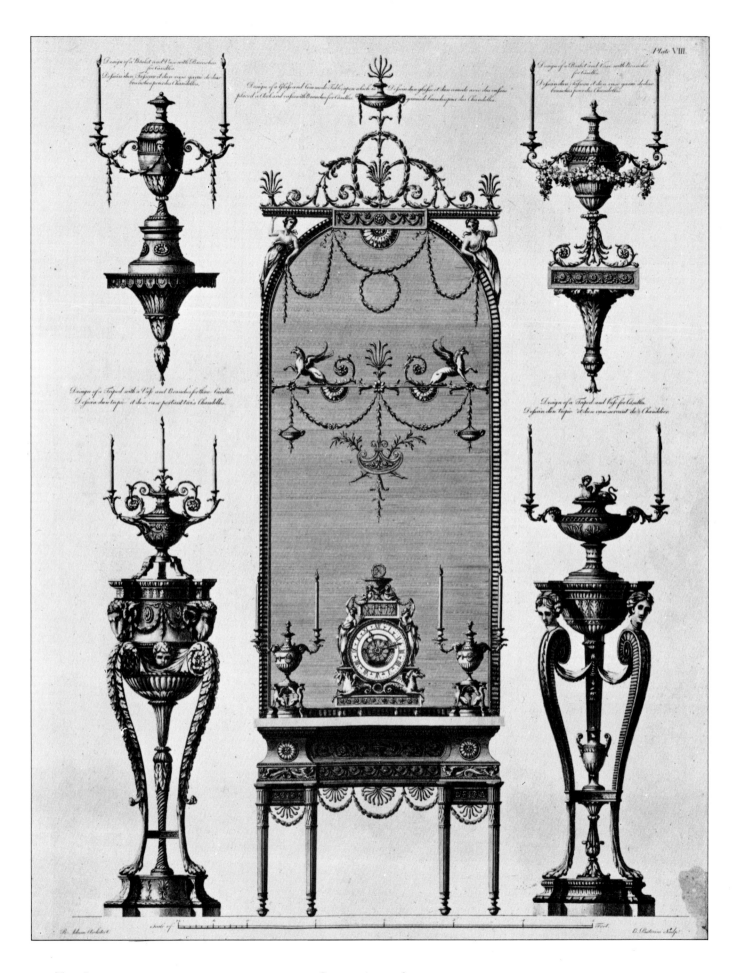

FACING PAGE: drawings of decorative elements (1772) by Robert Adam (1728–92), illustrating the classical themes from which the Neoclassical architect drew his inspiration. BELOW: drawings by Thomas Chippendale (1718–79) from his book of designs, *The Gentleman and Cabinet-Maker's Director*, published in 1754.

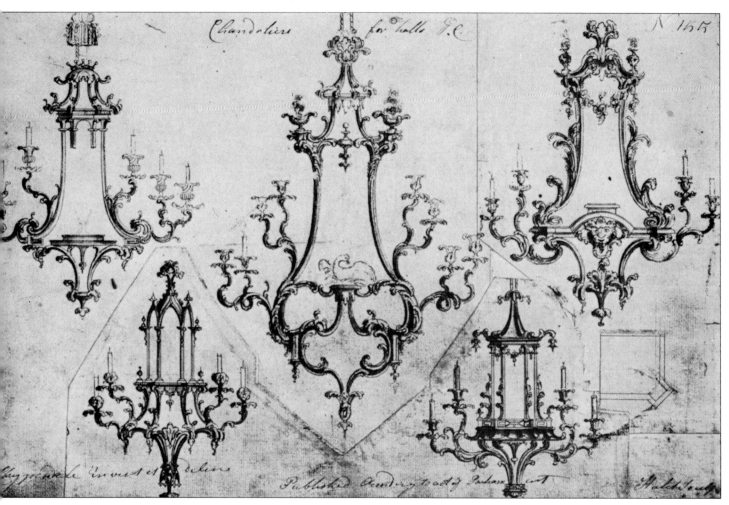

fashion, employing as decorative motifs sometimes tympana and classical columns, sometimes Rococo flourishes. Cabinets and chests of drawers were adorned with brilliant lacquerwork, the mirror frames and mantelpieces with little bells, pagoda roofs and dragons, while chairs, bookcases and armchairs were surmounted with pinnacles and finials, and the "Etruscan" furniture popular at the end of the century was painted in delicate colours.

Despite the whims of fashion, cabinet-makers none the less maintained a quality and elegance in their work that has made the furniture of the 18th century unique in the history of English cabinet-making. At the pinnacle of this epoch stands the great triumvirate of the second half of the century: Chippendale, Hepplewhite and Sheraton.

Such was the perfection of some of their creations that two centuries later, in 1929, the Viennese architect Adolf Loos asserted: "to design a new chair for the dining room is in my opinion ridiculous [...] Chippendale's dining chair was perfect. It answered every requirement. The design could not be improved upon. [...] The Chippendale chair is so utterly perfect that it blends in with any setting that came after it, even with a modern decor." Loos's enthusiastic words of praise can be accepted, but it should also be remembered that there was not just one "Chippendale dining chair" but a series of designs that were the end result of decades of technical and formal experimentation and invention. The workshops of the English furniture-makers of the period achieved the highest-quality craftsmanship in wood, particularly in mahogany, which was the principal wood used in the second half of the 18th century. These craftsmen devised a whole series of gadgets, joints and mechanisms which, together with the comfort of the chairs, the ingenuity of some of the designs for tables, sideboards and bookcases, and the elegant shapes of the furniture, resulted in pieces of unsurpassable quality. Chippendale did not, of course, personally produce every piece of quality. He and Hepplewhite should be considered rather as symbolic representatives, thanks above all to the renown and influence of their pattern books: *The Gentleman and Cabinet-Maker's Directory* and *The Cabinet-Maker and*

Upholsterer's Guide. The role of continuing this tradition during the first decades of the 19th century fell to Sheraton.

From oak to walnut

Queen Anne reigned from 1702 to 1714, but the style that bears her name embraces a longer period that takes in the years up to about 1720, while most of the techniques, the decorative motifs, materials and types of furniture in fashion at this time relied on models of the preceding years. It will therefore be useful to summarize, albeit briefly, the main developments in the evolution of English furniture from the second half of the 17th century onwards.

During the reign of Charles II (1660–85), which corresponds to the Restoration style, as a result of increasing general affluence England began to enjoy a more refined and luxurious style of living, which, in the field of furniture and in interior decoration in general, resulted in changes influenced notably by continental Europe, and in particular by Holland.

A decisive role was played by the fact that walnut replaced oak as the chief wood in furniture-making. Until now oak had been used almost exclusively, and the intrinsic characteristics of the wood itself were reflected in the solid and ponderous appearance of the furniture. The adoption of walnut as a medium resulted in significant changes both to construction techniques and to design.

During this same period the distinction between cabinet-makers and chair-makers – one that

had developed in the early years of the 17th century – became quite clearly defined. The responsibilities of the former included particularly the technique of veneering – a technique most probably imported from Holland during the 1660s. The craftsmen who made chairs worked in solid walnut and specialized in the art of turning.

Walnut had been known in England for about a hundred years, and seems to have been planted for the first time in 1550; but locally produced walnut was of poor quality, and when walnut was employed in the manufacture of furniture, imported wood was used. The varieties grown in England were *Junglas regia*, which was light brown in colour and smooth or with a dark grain, and *Junglas nigra*, grey-brown in colour, perhaps with surface markings or speckling and known as "black wood", characteristics reminiscent of mahogany.

Veneering and marquetry

In the beginning at least, English cabinet-makers seldom used solid wood in the manufacture of furniture – with the exception of chairs, as has already been mentioned. They preferred to use the technique of veneering – covering a carcass of oak or other wood with thin layers of walnut.

As has already been explained in the discussion of 17th-century English furniture, the veneers, that is to say the leaves of wood used in the process of veneering, were cut from near the root and from the thickest sections of the trunk. The leaves were cut obliquely or in the direction of the grain, and were then applied to

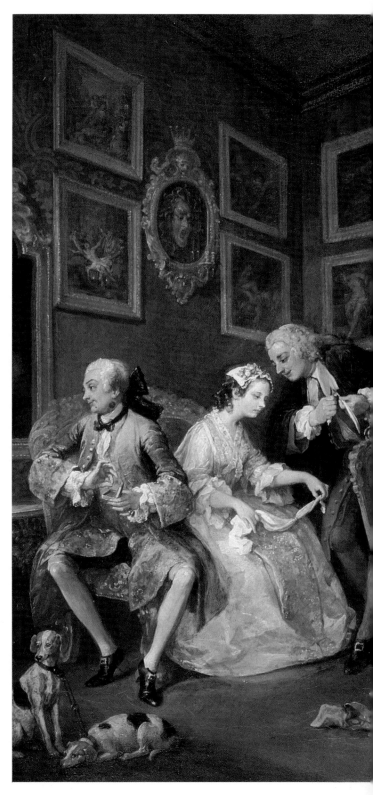

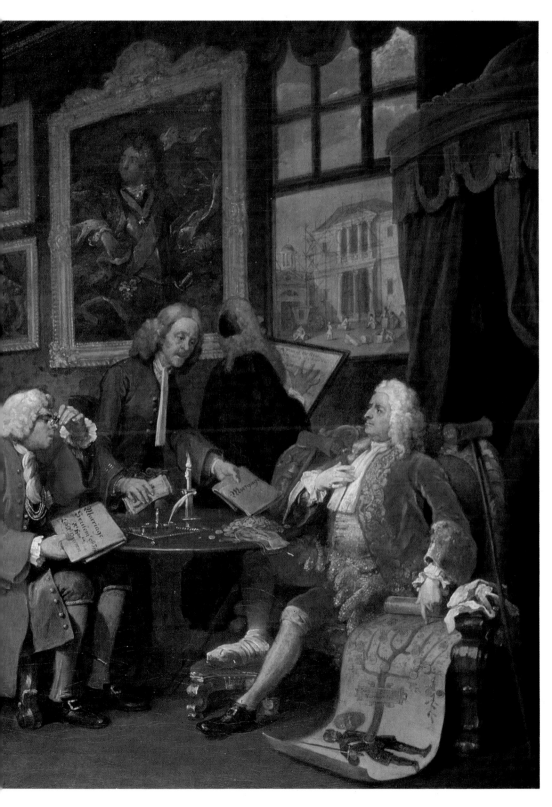

The Marriage Contract, part of the series *Marriage à la Mode*, completed in 1745, by William Hogarth (1697–64). In a series of genre scenes the artist depicted with biting satire various aspects of 18th-century London society. National Gallery, London.

the carcass to form symmetrical decorative motifs. Veneers with distinct, regular markings and others of a more complex pattern cut from the cross-section of branches of irregular shape, were used together to produce the effect known as "oyster-shell" veneer, so-called because it resembled the shell of an oyster in its irregular grain and variegated colouring.

The technique of marquetry – the English equivalent of the French term *marqueterie* – was also introduced into England during the Restoration period. This was different from the traditional inlay previously used; inlay was executed by inserting the wood tesserae of various kinds into the base wood of the piece of furniture, in spaces hollowed out to match the insert exactly; while in marquetry the veneers, cut out to a chosen design, were applied in sequence to the surface of the piece of furniture.

The most frequently used decorative motifs were flowers or compositions of flowers with birds. On early pieces displaying this technique, the colours of the woods used were vivid, and some of the most frequently used types of wood such as orange, lemon, cedar, sycamore, holly, yew and box were dyed in order to introduce more intense shades of colour. The use of marquetry was very often limited to panels, sometimes oval in shape.

From the late 17th century "seaweed" or "arabesque" marquetry was very fashionable. This was a decorative device usually composed of walnut and geometrical veneer in other woods, particularly holly and box, whose highly accentuated and rich grain rather resembled seaweed.

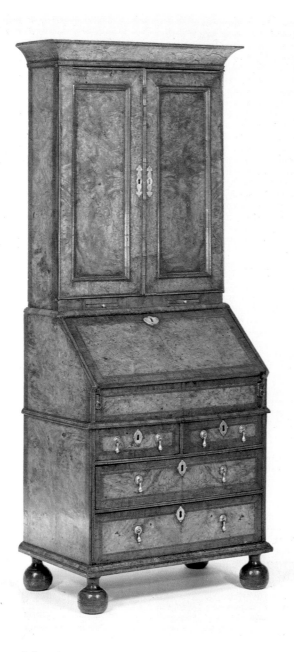

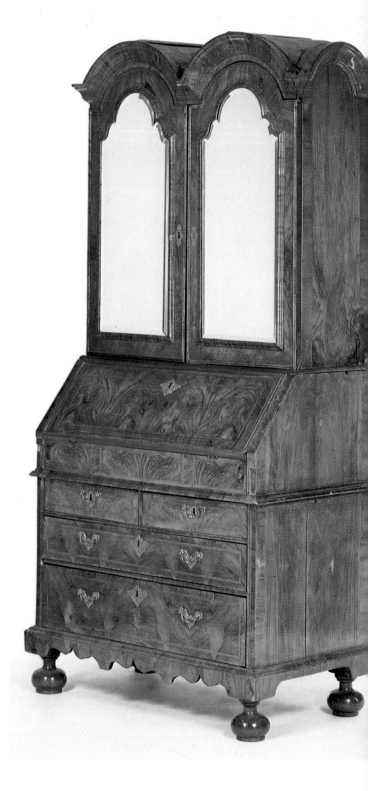

Gessoed furniture

The first examples of gessoed work appeared towards the end of the 17th century, comprising a distinct class of gilded furniture. Gesso was produced by grinding up the base mineral and heating it together with filling agents (linseed oil, size and parchment shavings); it was then applied to the roughly cut surfaces of the wood. When the various layers had dried, the gesso had to be carved again, polished or stamped, and finally gilded with gold leaf in a process called water gilding.

Gesso was a medium particularly suited to the realization of intricate decorative motifs, and was widely used on the carved supports of imported oriental cabinets, on elaborate console tables and on the frames of mirrors with ornate decoration in the French-inspired late Stuart style. It was also used for the surfaces of tables and during the Rococo period gesso, supported by a fine wire thread, replaced wood completely in order to achieve lighter and more delicate decorations.

Mention must be made of one particular craftsman working in the field of gilt-gessoed furni-

ture, viz. James Moore (d. 1726), a cabinet-maker active during the early 18th century, who produced pieces of high quality for the most important houses of his time. He made chairs, frames, consoles and pedestals, and his son sometimes worked to the designs of William Kent, which were richly carved and gilded to give the maximum gloss to the relief work, leaving the rest of the piece subdued in tone. Moore signed a few of his pieces, an unusual practice at this period, but it allows his work to be safely attributed.

English and imported lacquer

Lacquer had first appeared in England at the beginning of the 17th century on cabinets, caskets, coffers, screens and boxes imported from the Orient. Western craftsmen immediately attempted to imitate this art but without great success.

It is not known whether lacquer was fashionable during the period of the Protectorate of Oliver Cromwell, but it was certainly much in favour during the Restoration. In contrast to the rest of Europe, this fashion was not followed at court, at least until William III and Queen Mary succeeded to the throne (the years of their reign, 1688–1702, correspond to the style known as "William and Mary"), by which time lacquerwork had become highly popular.

The term "lacquering" denotes the application of a transparent or coloured varnish to objects made of wood or other materials, with or without decoration. In English the term "lac-

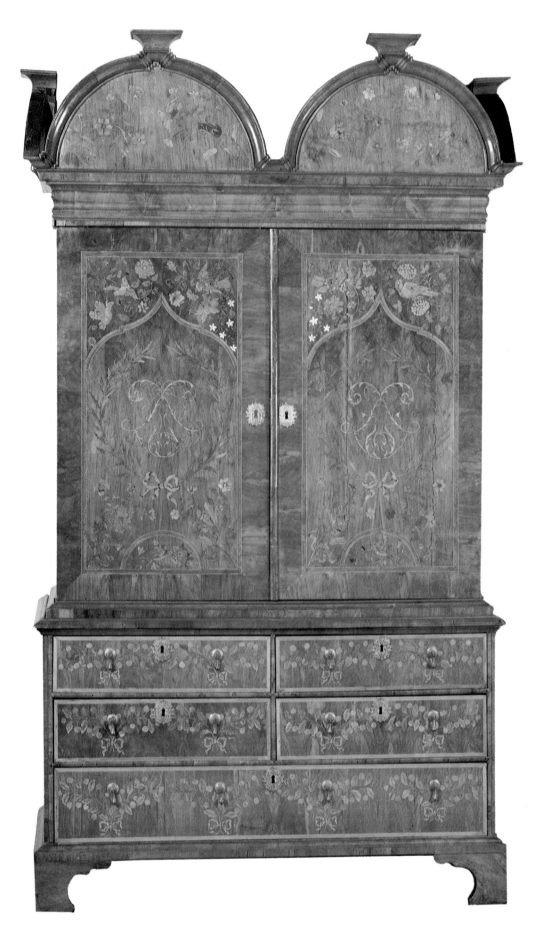

BELOW: bureau-cabinet (c. 1700), with gilt lacquered *chinoiserie* decoration of figures, flowers and animals. FACING PAGE, BELOW: bureau-cabinet (c. 1710), also with *chinoiserie* decoration. These two pieces differ in their arched surmount – the one double, the other a single broken arch – and in the shape of their feet, the one having pad feet and the other resting on spherical feet. ABOVE: typical early 18th-century English desk, lacquered in gold and black, with gate-legs supporting a fold-over top. Antiques trade.

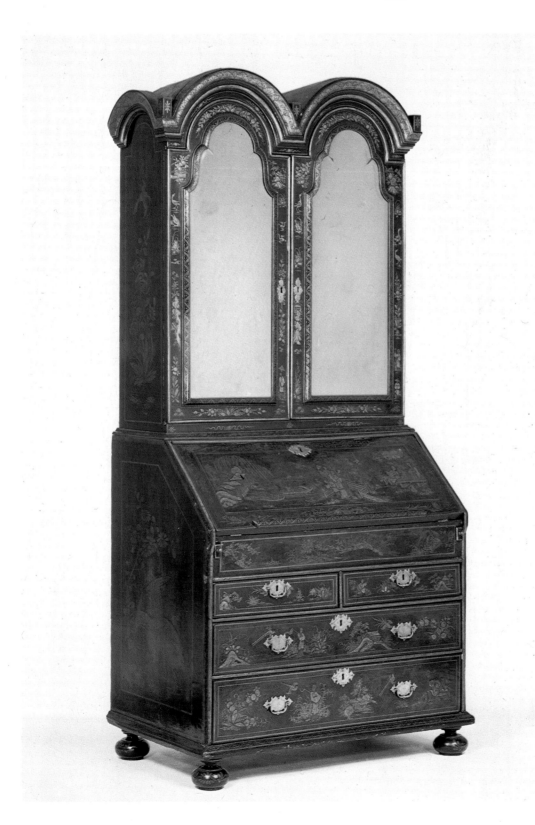

quering" or "lackering" is rather ambiguous, and can also be used to describe the protective varnish that prevents the oxidization of metals. The term "japanning" was adopted during the 17th century, and derives from the art's supposed country of origin. It must be emphasized that at this time geographical notions of the Orient were confused: the Orient was a vaguely defined part of the world loosely known as Cathay.

Hugh Honour, in *Chinoiserie, the Vision of Cathay* (1961), notes in this context an observation made by John Evelyn, who, in 1682, following a visit to a neighbour, comments that: " [his] whole house is a cabinet of all elegancies, especially Indian; in the hall are contrivances of Japan screens instead of wainscot […] The landskips of these skreens represent the manner of living, and country of the Chinese." In contemporary documents there is a similar confusion of terminology regarding the different types of lacquer, which is today known to have been imported largely from Japan and China.

The true oriental lacquers were obtained from the sap of a native tree, *Rhus vernicifera*, which was extracted from incisions made in the tree trunk. Once dry, this sticky sap hardened and could not be made to return to a liquid state, in contrast to Western lacquer, which could be liquefied with of ethyl alcohol.

One form of lacquer, developed in central and northern China excusively for export, was extremely popular during the second half of the 17th century. In the West this was called Coromandel work, a name derived from the Coromandel coast, a

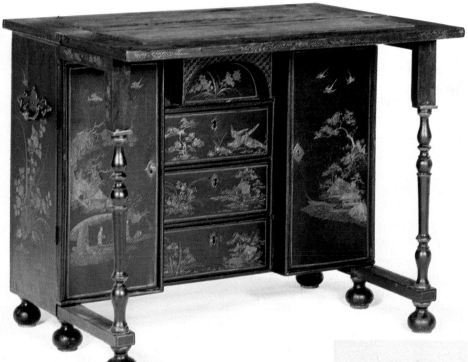

tives and the handling of light and shade peculiar to the Chinese artists were retained, however, to maintain – according to the authors – the antique and exotic character of the lacquerwork.

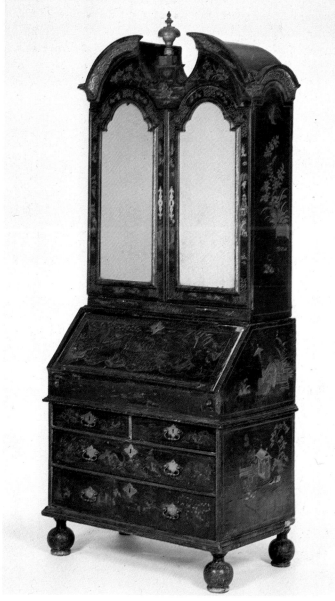

coastal plain of southern India lying on the gulf of Bengal, because the ports there were where the ships of the Dutch and English East India Companies were loaded with their cargo from the Chinese junks. The technique consisted of lacquering a layer of thick white chalk gesso; the decoration was then cut into the chalk so that the pattern appeared in relief and could be painted in bright colours. The fashion for Oriental lacquer meant that often wonderful screens were dismantled and the parts reused to make new cabinets of frames for mirrors and pictures, with complete disregard for the design of the decorations, which were broken up and reassembled in any combination, ignoring the original decorative concept.

Although in the West the raw materials were not available for the production of lacquer, other means were substituted, and by about 1680 Western craftsmen had made such progress in the art that a contemporary could boast that their prowess was superior to that of the Japanese, whom he accused of ruining good furniture by the careless application of lac-

quer decoration. It appears that in order to remedy these faults Western tools were imported into Japan so that local artists might improve their work.

Stalker and Parker's Manual

English lacquering techniques are described in a manual published in London in 1688 by John Stalker and George Parker entitled *Treatise of Japanning and Varnishing*. The treatise prepared by the two Englishmen was aimed not only at the specialist craftsman, but also at the dilettante – ladies of all ages would amuse themselves by applying lacquer decoration to every type of object.

It was for this reason that the book provided not only technical directions, but also drawings of designs to follow, revised from the original to be more appealing to Western taste – sketches of original motifs, landscapes, figures, delicate little trees, railings, cloud-capped mountains, mythical birds and pagodas with tiny bells. The strange perspec-

James Moore and gilt gesso

Gesso is a material particularly suited for the realization of complex decorative motifs. It is a mixture of the mineral calcium sulphate dihydrate, crushed and heated, with joiner's glue and zinc sulphate, which is first applied in layers to the surfaces of roughly carved wood, and then cut away to obtain the required decorative motifs: crests, monograms, arabesques, geometrical designs. Gilding is the finishing touch. This technique was introduced into England by the Huguenot exile John Pelletier, and enjoyed great popularity during the first two decades of the 18th century. It was a technique at which the cabinet-maker James Moore (d. 1726) excelled, and the gilt gessoed furniture he produced replaced almost completely the marquetry pieces by Gerrit Jensen. His name appears for the first time in 1708, and it is known that in 1714 he went into partnership with John Gumley (d. 1729), a cabinet-maker who specialized in the production of mirrors. Little is known about Moore's life, but his habit of signing his work – his incised surname appears cleverly disguised in the coats of arms and crests of his clients – makes the firm identification of his work possible, and also allows us to define his style and to attribute to his workshop examples displaying similar characteristics. Moore worked in an imposing Baroque style, often to designs by the architect William Kent or in his style, producing gilt gessoed furniture, especially tables, but also *guéridons* (pedestal tables) and candlesticks. He worked at Blenheim Palace and, together with Gumley, at Kensington Palace.

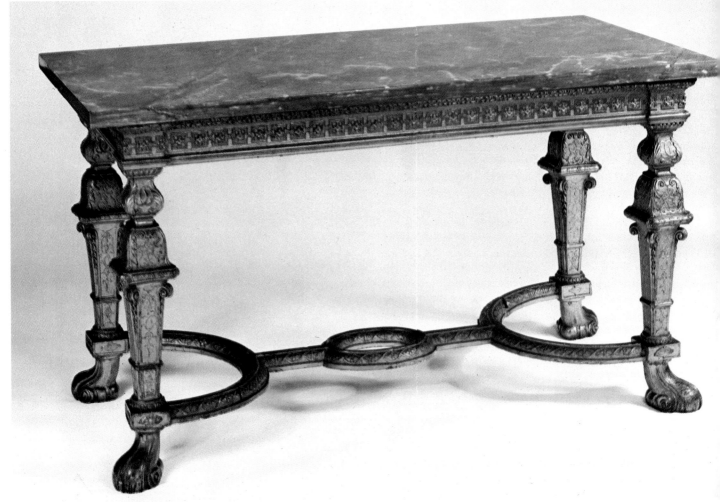

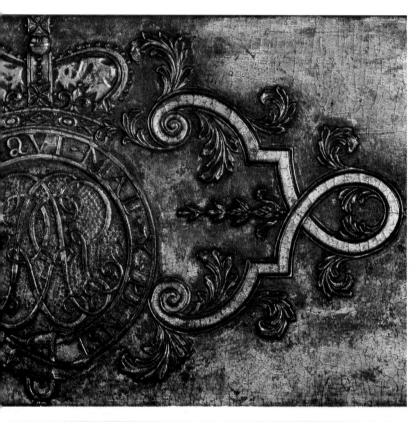

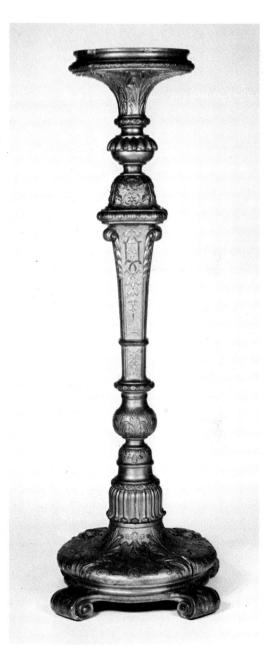

FACING PAGE, BELOW: marble-topped gilt gesso table (c. 1715), attributed to James Moore. Royal Collection, Windsor Castle. LEFT: detail of the surface of a gilt gesso table showing the initials of George I within the motto of the Order of the Garter, "Honi soit qui mal y pense". Royal Collection, Hampton Court Palace.

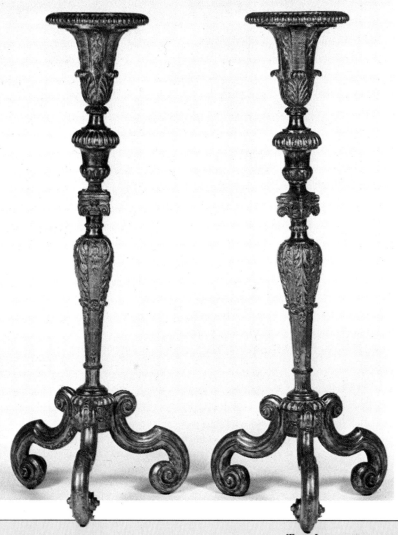

ABOVE: gesso candlestick (c. 1715), attributed to James Moore. Royal Collection, Windsor Castle. LEFT: a pair of carved and gilt gessoed wooden candlesticks (c. 1715), attributed to James Moore. Antiques trade. Identical candlesticks, definitely by James Moore, are at Hampton Court Palace.

The lacquer 'specialists'

The pieces produced between 1670 and 1720 are particularly interesting, and are works of great precision. Lacquer could be applied to almost any type of furniture, and in 1697 the guild of "specialists in lacquer in the Japanese manner" were able to offer a remarkable variety of furniture. Constructed mostly from softwoods such as pine and spruce, but also in oak or pearwood, following the design of contemporary English furniture in walnut, there were chests of drawers, corner cupboards, mirrors, screens and small tables.

Cabinets, frequently original rather than English copies, were mounted on supports that were heavily carved and gilded, sporting putti, garlands of flowers or fruit, scrolls and other Baroque motifs. Schemes of decoration became simplified until in the early years of the 18th century they developed into a pure English style, with cabriole supports and a homogeneous body, lacquered on all sides. The principal colours used for the base were black, a particular shade of red reminiscent of coral or sealing-wax, yellow, chamois, green, chestnut-brown, tortoiseshell and – the rarest colour – blue. To these bases decoration of all kinds could be applied – flat, gilded, relief, incised or carved, incrusted, polychrome or monochrome.

It is not difficult to distinguish between Western and oriental lacquers: in the first place European lacquers, as has already been mentioned, were of a different composition, generally comprising varnish, colour and shellac. Second, the ornamental motifs, though inspired by Chinese or Japanese decoration, are unmistakably Westernized and adapted to European taste.

Chairs with cabriole legs

Without a doubt the most interesting class of furniture, and the one that underwent the most significant development in the period between the Restoration and the reign of Queen Anne – a development that resulted in the introduction of the cabriole leg – was the chair. The typical chair of the second half of the 17th century was supported on spiral-twisted or baluster legs, joined by stretchers, the front stretcher being accentuated; the seat and high back would be caned, with a heavily carved top-rail to the back. Caned chairs enjoyed great popularity and remained in fashion until about 1740; they were mainly produced in the London region and were not too expensive.

According to Herbert Ceschinsky in *English Furniture from Gothic to Sheraton* (1929), the first change was the introduction of S- and C-curves, a style of Flemish origin, heavily employed in the early examples but used with more restraint in later pieces. Soon after, the front cross-stretcher began to be situated lower on the frame and was united with the side stretchers, which joined the front legs to the back legs, whereas previously it had been simply fixed to the front legs by tenons. In later examples the stretchers were flattened and placed so as to unite all four legs, forming a curved X-shape. Shortly before the Queen Anne period, this system was abandoned in favour of simple, turned stretchers, but these began to disappear from 1710 onwards, being rarely used in combination with cabriole legs. As we have already said, the cabriole leg, together with the claw and ball foot (a ball spanned by an animal's claw), were the most important innovations of the Queen Anne period.

The cabriole leg was first used in pieces of the late 17th century. The particular shape of this kind of support – that of the hind leg of an animal – necessitated the use of a special technique. A model would be prepared and the design then traced on to a thin piece of wood, which was afterwards cut out. The outline thus obtained – the template – then served to mark out where to cut on the piece of wood from which the leg was to be made. The first cut provided only one side of the outline; for the second and final cut, executed perpendicular to the first, the pieces that had been cut out were used as templates. At this stage the complete leg still had one square section, a feature that was retained in some examples. In other cases the square section would be retained only at the top of the leg, where the leg bends to form the "knee", and would then be rounded off towards the foot. In this case the junction of the various sections would be emphasized by means of a moulded "collar".

From this it will be apparent why rounded cabriole legs are rarely perfect: where a leg of square section was used it provided a template for all four supports, while to obtain a rounded section the craftsman could only rely on his skill, and his own judgement was his only guide. The curved line of the cabriole leg retained little of the original square-section outline and was the end-product of repeated workings by hand. This was particularly necessary when the knee of the cabriole leg had to support a seat of rounded shape, while for tables, where the leg formed the continuation of the corner, the square section was used.

"Club" or "pad" feet and "claw and ball" feet

The foot in the early examples of furniture from this period is usually a "club" or "pad foot". The "club foot" might sometimes resemble the French *pied-de-biche*, or a golf club; the "pad foot" is a club foot resting on a disc. Variations on the design of the club foot show acanthus leaves and scrolls on the terminal. This type of foot was followed chronologically by the "claw and ball" foot, which may have derived from the Chinese motif of the dragon's claw enclosing a pearl. In early pieces, the individual claws of the foot are widely spaced so that the ball in their grasp is clearly displayed. Later examples have webbed claws that conceal the ball almost completely, and the claw is no longer fashioned like that of a dragon but resembles that of a bird.

Similarly, the "knee" of the leg underwent a series of modifications. Excluding the smooth type of cabriole leg without any carving, the first decorative motif to be used was the scallop-shell and this gradually evolved through various stages into the acanthus leaf, a motif that is still to be found in pieces by Chippendale. The chair back is com-

Early 18th-century red-lacquered bureau decorated with *chinoiseries*, animals, flowers and fruit. The bureau was defined during the course of the 18th century, its structure deriving from that of the chest of drawers, with the addition of a table front, which opens to reveal compartments for writing materials. Antiques trade.

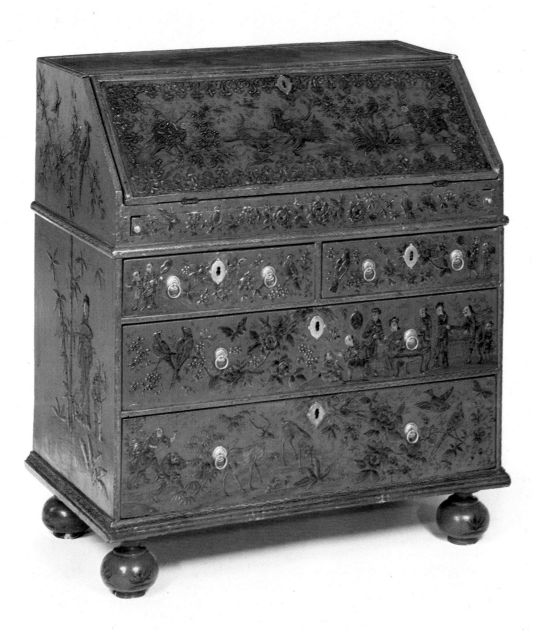

posed of two lateral uprights and a central strut, the splat, which in the earliest pieces assumes the shape of a violin; hence it is called a "fiddle splat". The proportions of this central splat lent themselves to the application of veneer or marquetry, techniques not very often used in chair-making. The fashion for carved and pierced splats came later, at the same time as carved and crested flat top-rails, which succeeded the early "hoop backs", chair-backs with bands of carving.

Sofas and tables

The proportions of the settee – a small two-seater sofa – which first appeared in the 17th century, assumed new and more elegant proportions during the Queen Anne period. The high backs, like the arms, were padded and the seat fitted with loose cushions. In some examples, projecting wings were added to the sides, which increased the comfort of the settee. Other types of seat in fashion at this time were sofas, day beds and small low-backed settees, known today as "love seats". Most of these types of seat still featured the stretcher, even when this had long since disappeared from chairs. The wood used in the manufacture of these items of furniture was principally walnut.

Tables of the period also used the cabriole leg, and the stretcher soon became redundant. The feet followed the same styles as those of chairs of the period. Side tables, known as console tables, were very much in vogue. These were either shelves or tables with supports set at right angles to the frame. Console tables were often placed together with large mirrors set in ornately decorated frames.

Mirrors and frames

From the time of their introduction to England in the 17th century, mirrors were very expensive. Their high cost was partly the result of the difficulty involved in their manufacture, but principally because of the exorbitant taxes imposed on them by the government in 1695, and again in 1698 and in 1745. It was not until 1845 that these taxes were abolished by Sir Robert Peel.

The manufacture of mirrors remained for a long time the monopoly of the glassblowers of Murano, who in about 1500 had developed the necessary technique. The glass was blown into cylindrical form and was then cut

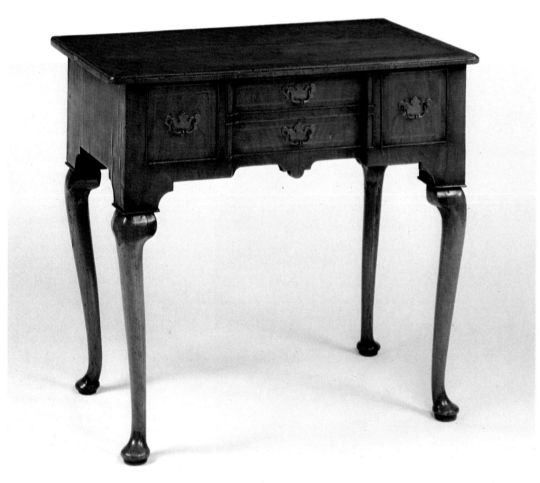

seldom survived because they easily became broken off from the body of the frame. The frame would be applied with veneer decoration with oyster-shell motif, or lacquered. Some frames were applied with marquetry or tortoiseshell. The shape of the frame was quite wide, with a marked convex cross-section.

A well-known specialist in the manufacture of mirrors was the successful furniture-maker was John Gumley, who worked between 1694 and 1729. He was probably also an astute businessman as well as a highly talented craftsman. We know that in 1703 he made magnificent mirrors for the furnishing of Chatsworth House, one of the greatest stately homes of the period. The mirrors were three metres high, and decorated with sapphire-blue glass and with coats of arms. These mirrors are still at Chatsworth today. By 1705 Gumley had opened a glassworks at Lambeth where he produced a variety of furnishings. As a result both of the "promotion" he undertook for his work from 1694 and of the fact that in 1715, together with James Moore (who has already been mentioned and with whom he had founded a company in the previous year), he succeeded Gerrit Jensen as royal furniture-maker. On his death in 1727, his mother, Elizabeth, carried on the trade.

Desks and bookcases

Yvonne Brunhammer, in *European Furniture from the 16th to the 19th Century* (1966), asserts that the small desk was one of the pieces of furniture that enjoyed the most widespread popularity

lengthwise and flattened by means of wooden tools at warm temperatures. The sheets thus produced were then covered on one side with a mixture of tin and mercury.

In the closing decades of the 17th century, French craftsmen developed a new technique that allowed the production of larger sheets with smoother and more homogeneous surfaces: the molten glass was poured into an iron framework in which there was a layer of sand; it was then rolled, ground and polished. The first patent for the manufacture of looking-glasses in England was taken out by Sir Robert Mansell in 1615. However, the process he used was not very successful, and it was not perfected until fifty years later, when a factory was

opened at Lambeth with the help of the Duke of Buckingham. This was the factory that produced the famous Vauxhall, or Foxhall, glass. Mirrors – symbols of wealth and magnificence – came to be regarded as an essential part of the furnishings of the houses of the English aristocracy in the 18th century. They were placed above toilet tables, but were also used to enhance entrance halls and reception rooms.

Typical of the 18th century is the pier glass: first conceived at the end of the preceding century, this was a tall and narrow mirror to be placed in the space between two windows. The frame of the pier glass was usually water gilded. The piece would usually be roughly carved and then handed over to a gilder (there was

a guild whose members were highly specialized and well paid), who would carry out the more delicate and detailed work and decoration. The design of the mirror-frame, together with the matching console table, was considered an integral part of the internal architecture of a house. This was one of the areas in which, from quite early on in the period, architects were involved, and as a result this profession was to play a significant role in the history of English furniture. Towards the middle of the 17th century, however, frames were still the province of cabinet-makers and carpenters. The shape of the frame was rectangular or square at this time, with a carved, and sometimes pierced, semicircular surmount; these surmounts have

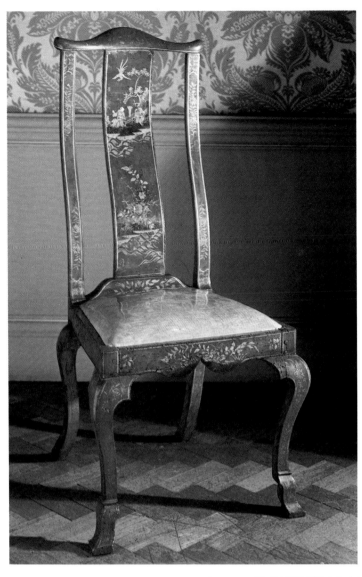

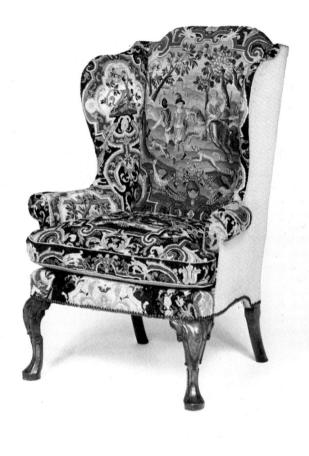

FACING PAGE: walnut-veneered side table (c. 1710), with rounded corners to its surface, and frieze drawers, the cabriole legs terminating in pad feet. Antiques trade. ABOVE, LEFT: a typical Queen Anne "Indian-backed" chair, the wood lacquered in red and gold with *chinoiserie* decoration, cabriole legs. Victoria and Albert Museum, London. RIGHT: armchair (c. 1710), with short cabriole legs and pad feet, in the style of the period, upholstered in the original fabric with *petit-point* embroidery depicting hunting scenes and floral motifs. BELOW: two further examples of chairs typical of the Queen Anne period, lacquered and decorated in gold with *chinoiseries*. The high backs are formed by an upright strut to either side of a broad and flat central baluster-shaped splat. The armchair on the left has a woven cane seat. Antiques trade.

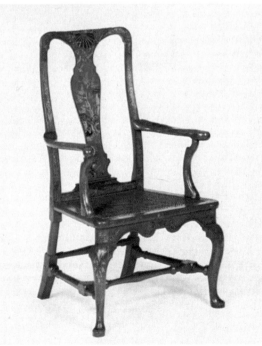

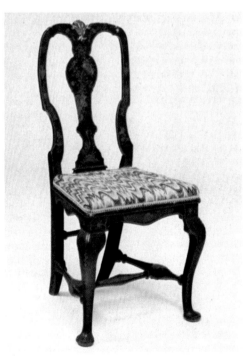

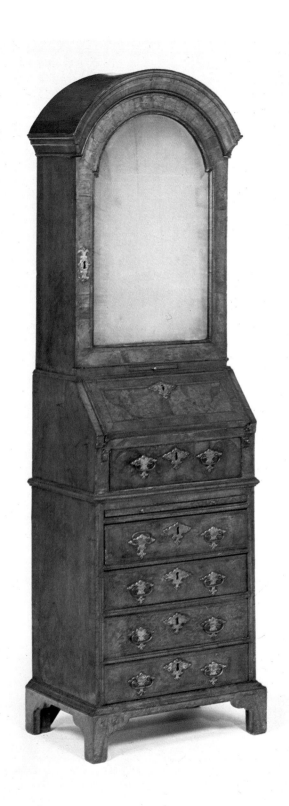

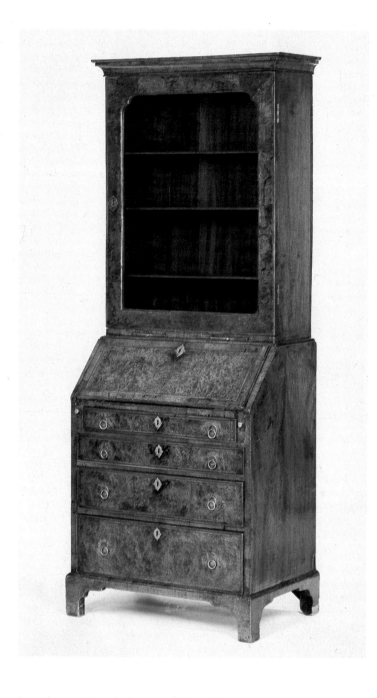

LEFT: bureau-cabinet, the lower part fitted with drawers, the upper section with a drawer, fall-front and mirrored door below a domed top. ABOVE: a similar piece in the Queen Anne style (c. 1714), in walnut, the glazed cabinet with moulded cornice set back above the lower section, which is fitted with drawers and a fall-front, on bracket feet. FACING PAGE: cabinet (c. 1710), the lower section fitted with drawers and supported on bun feet, below a recessed upper section fitted with two mirrored doors beneath a Gothic-style arch. Antiques trade.

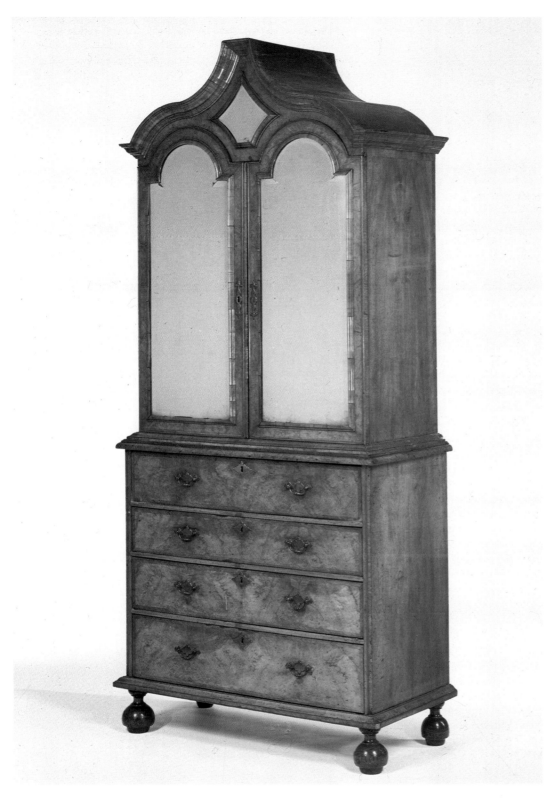

and it gradually assumed the shape of a more graceful body supported on slender legs.

The pieces of furniture let into the wall would also be provided with a niche, which could either be closed with a door, or left open and divided up into shelves for the display of porcelain. In the early 18th century this type of furniture was called a buffet, a word of French derivation which in its original language had quite another meaning, and more particularly denoted a quite different category of furniture.

The bureau and the bureau-bookcase, already in use in the 17th century, evolved during the 18th century to assume an important place in interior furnishing. The structure of the bureau had its origins in the chest of drawers, the traditional box-like form of which was embellished so that it assumed a more graceful and decorative shape. The lower part of the bureau consisted of drawers, sometimes provided in two columns so as to leave a kneehole between them. The upper section was fitted with a fall-front writing surface and a number of small drawers for paper and writing materials. The drawers below the desk were often used to store linen, a use explained by the fact that this piece of furniture would often be situated in a bedroom.

In the early decades of the 17th century the bureau-bookcase – a term explaining the dual use of this piece of furniture – was embellished with a gable surmount to the upper body of the piece. This surmount varied in design: sometimes it was in the form of an arc, or a broken pediment, sometimes with scrolling; at other times it would sport acroteria (pedestals), busts or

during the Queen Anne period. Supported on six legs, these small desks had a low super-structure, part of which housed a fall-front. In the decoration of these pieces of furniture, too, veneering and turned legs were prevalent.

Typical for middle class and provincial interiors was the practice of fitting sideboards and other pieces of furniture into the walls to be used for storing food, display cases for porcelain, and cupboards for storing both table- and other linen. This explains the

rarity of examples of freestanding sideboards and dressers, or at least the fact that these kinds of furniture were slow to conform to the new fashions in designs. During the course of the 18th century the lines of the sideboard became clearer and more elegant,

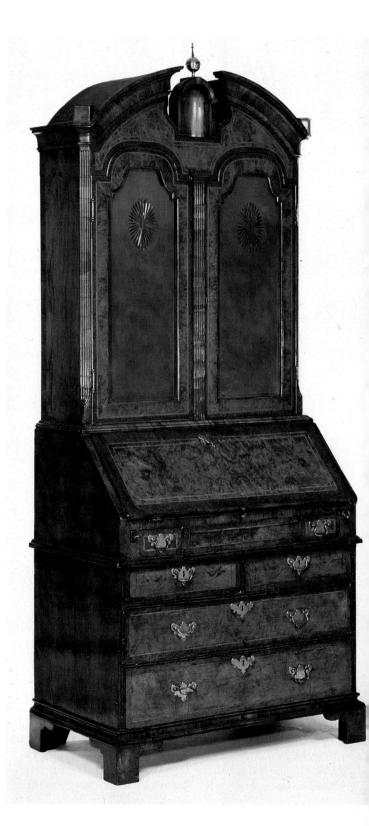

urns, or it might be decorated with both. The doors of the upper section were not veneered, but fitted with convex or concave panels, or with mirrors or glass. The lower section of the body was fitted with more generous shelves than the upper section, which usually did not have doors and was used to house larger books. The more generous dimensions gave the base section a gently projecting profile. However, despite its name, the bureau-bookcase was not used simply for housing books.

At the end of Queen Anne's reign, moreover, a new type of chest of drawers appeared, the chest-on-chest, which was literally one chest on top of another and sometimes known as a tall-boy. It was a sort of double chest of drawers, the upper section of which was slightly recessed, and it was often fitted with handles on both sides in order to make it easier to transport.

The most important furniture-makers

As already discussed, the Queen Anne style saw something of a revival in simplicity and severity of line – elements that confirm the independent style of English furniture. However, European influences, and particularly those of Holland and France, made their mark. The presence of the Fleming Gerrit (or Gerreit) Jensen (his name is often anglicized as Johnson) as cabinet-maker to the court is testimony of this, as is that of the French designer Daniel Marot (1663–1752).

Marot was forced to flee, first to Holland and then to England, to avoid the persecution of the

Huguenots that caused so much bloodshed in France after the revocation of the Edict of Nantes. He worked for a long time for the future William III while William was still Stadtholder in Holland, then followed William to England, where he worked from 1694 to 1697; he was in England again in 1698. Marot was employed by William III at Hampton Court Palace.

Daniel Marot's father, Jean Marot (c. 1619–1679), published two treatises on architecture known as *le Petit Marot* (c. 1660) and *le Grand Marot* (c. 1670). Daniel's uncle Pierre Golle (active between 1660 and 1690) had been an important cabinet-maker during the Louis XIV period, specializing in the production of magnificent and extremely expensive furniture carved and veneer in the manner of Boulle and Cucci.

It was probably to his father and his uncle that Daniel owed his training as an architect and as a cabinet-maker, and it was from them that he derived his particular style, which nonetheless shows clearly the influence of the French Baroque as seen in the work of such artists as Jean Bérain the Elder (1637–1711), Charles Le Brun (1619–90), Pierre Lepautre (1660–1744), and others who worked for Louis XIV. It also appears that Marot served his apprenticeship with Bérain before he was forced to flee to Holland. His style became well known in England thanks to the publication of Marot's *Œuvres* (1702), a collection of etchings and drawings.

Jensen, who was the most important of the Anglo-Dutch cabinet-makers, had a significant influence on the elaboration and

A small Queen Anne walnut bureau (c. 1710), resting on bracket feet, the sides supplied with handles for ease of transport, with fall-front, opening to reveal the interior fitted with a series of small drawers, above three long and two short drawers. Antiques trade.

definition of the William and Mary style. Having settled in London in 1680, in 1688, immediately after the Glorious Revolution, he secured important commissions from the court. He continued in royal employ for the best part of four reigns, from Charles II to Queen Anne. The furniture he made for William III and Mary has survived and is now at Hampton Court and Windsor Castle. His style is highly individual, even though it can be seen as a less flamboyant version of Boulle's Louis XIV style. He made for the court several important pieces of arabesque motifs executed in metal marquetry. He is also known to have produced mirrors and lacquered furniture, as well as many pieces in walnut and kingwood, called princesswood at the time.

Another family of French Huguenot artists, working at this period was that of John Pelletier and his two sons, René and Thomas, who records show were active between 1690 and 1710. Considered to be one of the most important makers of Baroque furniture, they brought the court style of Louis XIV to England, specializing in engraving and gilding. Their names appear in the royal account books and some of their pieces survive at Hampton Court and Boughton House. Along with Pelletier's work we should mention that of Thomas Roberts, who contributed to the furnishing of the royal residences with many carved pieces, especially chairs. He is recorded as working in the period 1685–1714, and his style is characterized by his application of applied foliate scrollwork to his chairs. Several examples preserved at Knole and Chatsworth are attributable to him as well as those at Hampton Court. He was succeeded in the post of court furniture-maker by Richard Roberts, a relative, who was active between 1714 and 1729 and to whom a series of walnut chairs at Hampton Court can be attributed, which he made in 1717 for the dining room of George I. In 1729 he was owed £ 1420 for work done at Houghton Hall.

Early Georgian Style

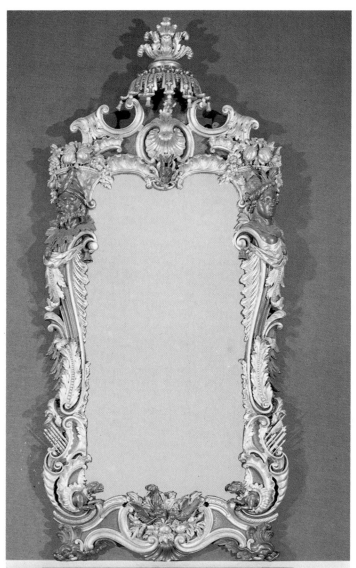

Introduction

The definition of the Georgian style is rather vague, and it is frequently used to indicate the reigns of four Georges: George I, (1714 to 1727), George II (1727 to 1760), George III (1760 to 1820), and George IV (1820 to 1830). The period thus embraces a considerable time-span, during which a succession of styles was established: Rococo, Palladian, Neo-Gothic, "Chinese", and finally, from the late 18th century into the 19th century, Neoclassical and Regency. The discussion in this chapter will be limited to the period between 1714 and 1760 which comprises the reigns of the first two Georges. During these years the style acquired the clearly defined characteristics that are implicit in the term "Georgian".

The introduction of mahogany

During the 1720s, walnut, which hitherto had been widely used for the manufacture of furniture, was replaced by mahogany, a change that brought with it substantial developments in both the design and the decoration of furniture. The introduction of mahogany was probably influenced by two significant events: in 1720 France, the supplier of all the walnut Britain required, prohibited its export; and in 1721, in order to remedy the lack of raw materials for naval construction, the government in England abolished the heavy taxes that had been imposed on all woods imported from the American colonies. This led to walnut being abandoned in favour of mahogany.

Mahogany was not a new wood, but its adoption as a raw material on a large scale meant that its characteristics were now better understood, and it became almost indispensable as a raw material for English cabinet-makers of the 18th century. At first, the variety of mahogany chiefly imported was that which grew in Santo Domingo, *Swietenia mahagoni*, whose characteristics were a warm brown colouring and little figure. It was possible to polish mahogany without the use of special substances or particular techniques; a wood rarely attacked by parasites, it had a very fine grain and so was resistant to scratching and bruising. Much wider planks could be cut from the section of the tree trunk than those obtainable from other species of wood, and they would rarely split or warp.

These characteristics resulted in a series of changes. First, the gloss and colour of the wood encouraged the abandonment of inlay, carving and veneering, which would only serve to obscure the wood's natural beauty. Second, the wood's toughness made it possible to produce delicate pieces of furniture with pierced decoration, requiring less substantial supports than the furniture of the previous period. Last, because of the size of the sections of wood cut from the trunk, surfaces such as table tops could be made out of a single piece of wood without the need to lay a number of pieces of wood side by side to achieve the same result, using a variety of techniques to hide the joins. But apart from these intrinsic characteristics of the wood itself, it must not be forgotten that mahogany blended well with bronze, gold and silver,

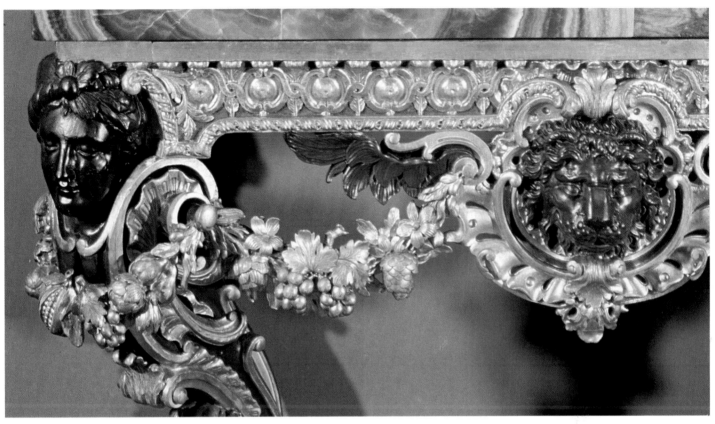

and there are many pieces of furniture that illustrate this.

It is to the use of this wood that the simplicity, elegance and clean lines that have given English furniture of the 18th century such a desirable and special reputation are largely owed. These were the characteristics that cabinet-makers and their aristocratic clients focused on.

Towards the middle of the century, the species of mahogany changed, and Cuban mahogany, *Swietenia macrophylla*, was used instead of the Santo Domingo variety. The Cuban wood was dark and richly figured, which made it suitable for veneering. Later, in about 1780, Honduras mahogany came in; this was equally richly figured but less expensive and softer in colour.

For a long time, however, the production in walnut continued alongside mahogany. Not many examples survive, but the predominance of mahogany pieces is perhaps explained by its more durable qualities. Towards the middle of the century Norwegian spruce was used, plus Swedish and English oak, Spanish walnut, Brazilian rosewood, and padouk, the commercial name of a group of woods that come from several species of plant belonging to the genus *Pterocarpus*. Softer woods such as beech, birch, pine, cedar and pear were used for gilded and lacquered furniture. Beech was used for chair frames, while oak was mainly used to line the interiors of drawers.

Architects and interior furnishings

As has already been mentioned, architects played an important role in the art of English furniture design in the 18th century. Jill Lever, in *Architects' Designs for Furniture* (1982), maintains that probably the first architect to create a global concept for the interior and exterior of a building, and then to turn his attention to the design of the internal decoration and furniture, was Inigo Jones (1573–1652), who was working during the 17th century. Jones and his assistant John Webb (1611–72) were known as exponents of the Palladian style, because they introduced into England the work of the great Venetian architect Palladio and

his pupil Scamozzi. They represent the beginning of a classicizing tendency, strict and austere, which would be taken up again fifty years later by Palladian-architects Colen Campbell (1676–1729) and Richard Boyle, third Earl of Burlington (1694–1753).

Although Jones left no designs for furniture, it seems certain that he was active in this field in the years between 1620 and 1630. One design by his pupil Webb has survived, datable to 1665, showing a recess with an imposing bed for the royal chamber of the Queen's House (designed by Jones) at Greenwich. French influences are evident in this furniture, especially the work of Jean Lepautre, who became known thanks to the

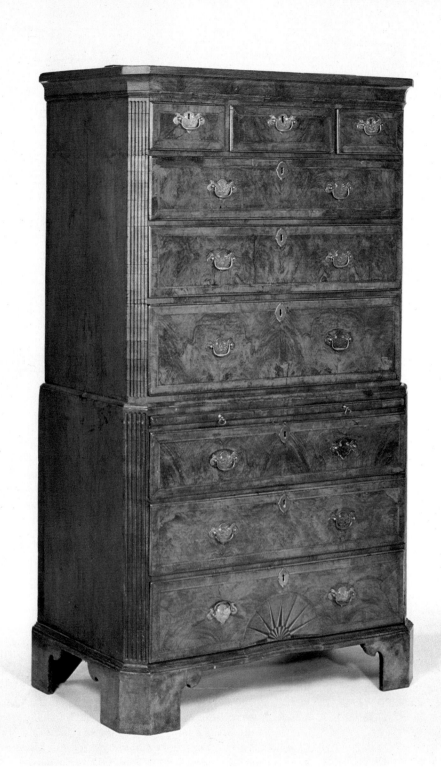

publication of his designs in about 1660.

The same tendency can be traced in the designs of William Talman (1650–1719) and his son John (1677–1726). A surviving drawing by the latter is the first English example of interior architecture in which the programme of decorations is conceived as a coherent whole by one artist, a concept brought to England by Daniel Marst. The ornamental elements are rich and opulent, and make many concessions to the Baroque, exhibiting the scrolls, acanthus leaves and scallop shells characteristic of that style. The architects were almost certainly responsible for the introduction of architectural elements into furniture design – elements such as columns, capitals, tympana, acroteria and mouldings which combined to give a greater harmony of proportion.

The architect James Gibbs (1682–1754) drew up a number of designs between 1720 and 1730 for interesting Baroque pieces, particularly mirrors, console tables and clocks. But the most important architect and designer of the first half of the century is William Kent (1685–1748), who was one of the members of the Neo-Palladian circle of Lord Burlington, with whom he collaborated on a number of occasions. While the exteriors of his buildings maintain the austere and simple lines of classical architecture derived from the buildings of Palladio and Scamozzi, the interiors are sumptuously decorated. His furniture on the other hand often reflects the influence of the Italian Baroque, which Kent had been able to study closely during his stay in Italy (1709–19).

All the pieces on these two pages in walnut and burr-walnut, with bracket feet, datable to c. 1720 show the develpment of the Queen Anne style in the reign of her successor George I. ABOVE: chest-on-chest, also known as a tallboy, the front and sides joined by moulded pilasters. ABOVE: kneehole desk. BELOW: small lady's desk with central recessed cupboard flanked by drawers. Antiques trade.

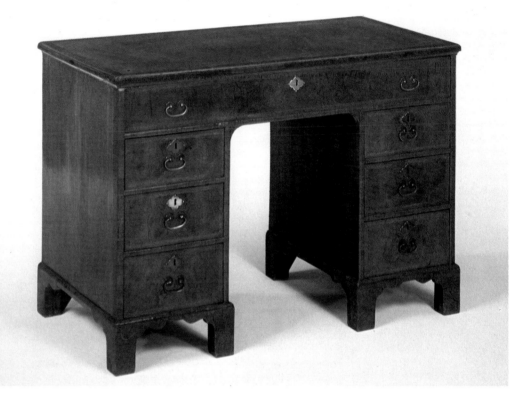

Since he was unable to draw his inspiration directly from Palladio and Scamozzi, or from Jones and Webb, who had left no designs for interior furnishings, Kent took his decorative motifs from their architecture, creating a style characterized by heavily carved and gilded relief decoration with scallop shells, acanthus leaves, putti, fantastic creatures, masks, festoons and mouldings. Kent also used partially gilded mahogany, and marble tops imported from Italy for side tables.

Kent worked in the most important Palladian houses of the period, for example Raynham Hall and Holkham Hall – the plans for which he drew up in collaboration with the Earl of Leicester –, where many of his pieces are preserved. He was also commissioned by Sir Robert Walpole to design the interior of Houghton Hall in Norfolk. The

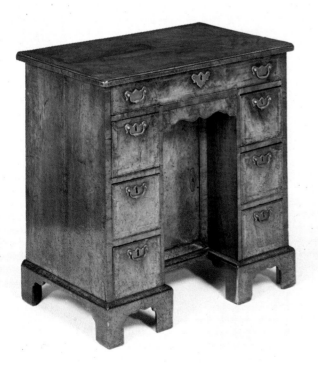

Green Velvet Bedchamber there contains perhaps one of the most perfect pieces of furniture of this English artist – a large curtained bed which displays at its head a marvellous and enormous scallop shell supported by a classical pediment. In 1744 John Vardy published *Some Designs of Inigo Jones and William Kent,* a work that contributed to the success of Kent's style.

Earlier a collection of drawings offering a more sober style than that of Kent and aimed at a less wealthy clientel was published by the brothers Batty (1696–1751) and Thomas Langley (b. 1702). This book, *The City and Country Builder's and Workman's Treasury of Designs,* was reprinted a number of times (1741, 1750, 1756), and besides illustrating pieces of furniture in

the Palladian style, included examples inspired by Continental fashions. In 1742 Thomas Langley published a more original treatise under the title *Gothic Architecture Improved by Rules and Proportions in Many Grand Designs of Columns, Doors, Windows.* A new edition appeared in 1747. This volume, which almost certainly served as an important source of inspiration for the furniture-makers of the period, sought to "regularize" and formalize decorative Gothic elements, and laid down orders such as existed in classical architecture. In this way it was hoped to avoid the mixing of motifs derived from the antique, from the classical and from the Orient, a phenomenon that became widespread from the middle of the 18th century.

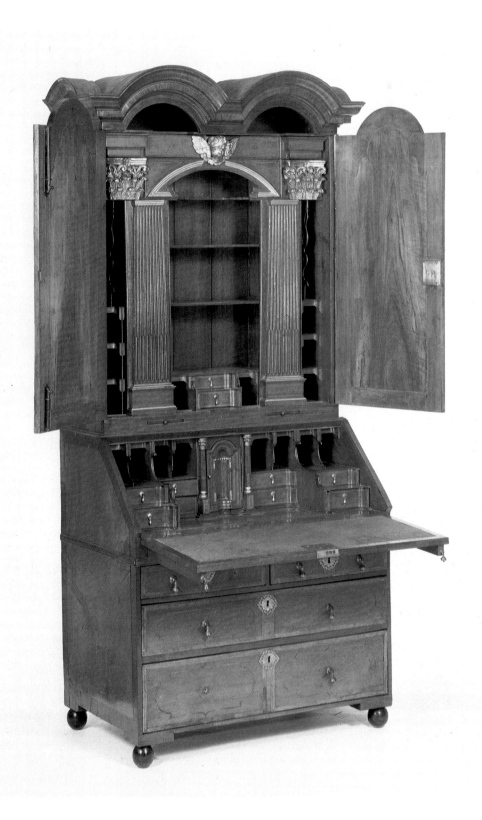

The cabinet-makers

Among the most fashionable furniture-makers of the period was the celebrated William Hallett (active 1732–1770), whose pieces are difficult to identify. The only known signed example is a cabinet preserved in a private collection. A number of documents testify to Hallett's work on the furnishings of famous houses such as St. Giles for the Earl of Shaftsbury and Canno Hall, York, for John Spencer. He seems to have retired c. 1750 and became a country gentlemen, transferring his business to his former apprentice, William Vile, for whom he probably acted as a sleeping partner.

William Vile (1700–67) and John Cobb (1710–78) together headed one of the most important furniture workshops of the mid-18th century. The quality of the pieces produced there was of the very best, perhaps even superior to Chippendale's, and justified their price, which was expensive even for the nobility.

Vile was a craftsman of immense good taste and great mastery of design, although he was not as original as some others, such as Chippendale. Much of his work shows the influence of Kent's Palladianism, although relieved by his use of carved Rococo motifs, such as the "raffle lear", a lighter form of the acanthus. His early work is difficult to identify as he was working for William Hallet, and only after c. 1750 does his name appear in the bills of the great country houses. From 1751 he was appointed royal cabinet-maker with John Cobb, and during the next few years executed a number of outstanding pieces for the king

FACING PAGE: walnut bureau-cabinet (c. 1720), the upper section with twin arches above a pair of doors opening to reveal two moulded pilasters with gilded, fixed Corinthian capitals, the pilasters sliding to reveal side compartments, the lower body being fitted with two long and two short drawers below a fall-front, resting on spherical supports. Antiques trade.

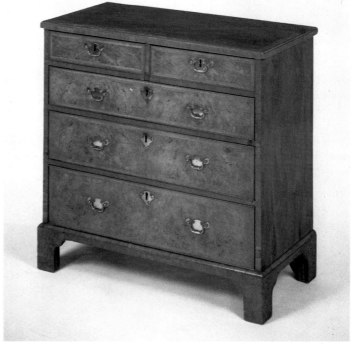

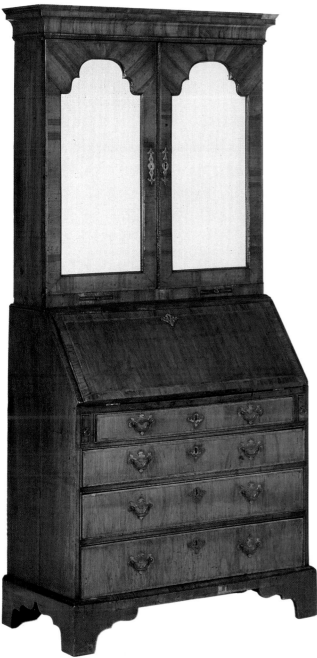

ABOVE: bureau-cabinet (c. 1725) on bracket feet, the upper section with moulded frieze above two mirrored doors. RIGHT: George I walnut chest-on-chest, with bracket feet (top), like the simple walnut chest of drawers (c. 1730), below. Antiques trade.

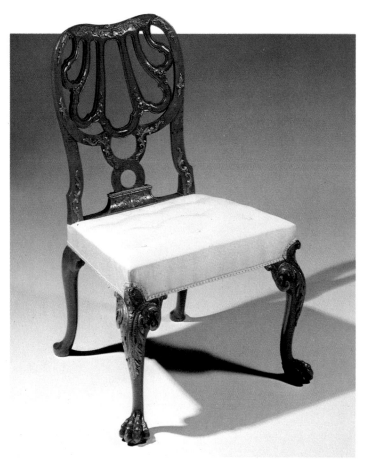

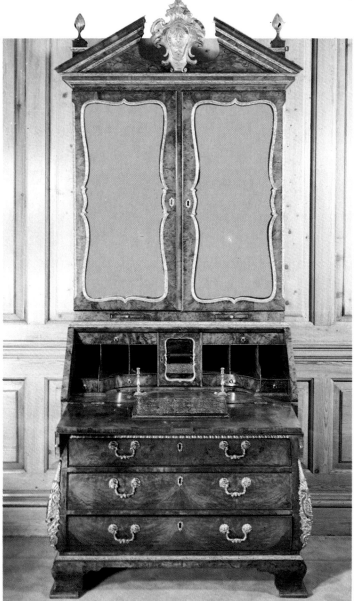

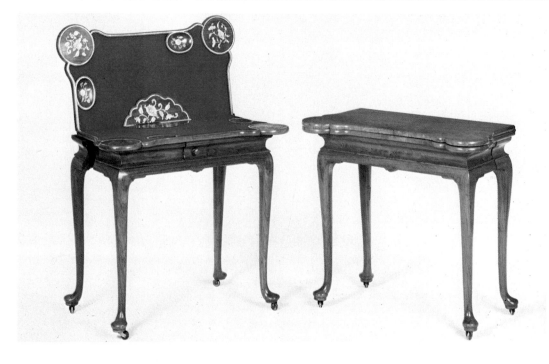

ABOVE, RIGHT: walnut and part-gilt bureau-bookcase (c. 1725), attributed to Giles Grendey, the upper section with a pair of mirrored doors within serpentine mounts below a broken pediment, the two portions of the pediment enclosing the coat of arms of the client who commissioned the piece; the corners of the lower section applied with gilt decoration. ABOVE: gilt walnut chair (1735) by Giles Grendey, with pierced back and cabriole legs terminating in claw and ball feet. A similar one is at the Victoria and Albert Museum. RIGHT: a pair of Anglo-Indian padouk gaming-tables (c. 1720), the fold-over top inlaid with mother-of-pearl flowers and leaves. Antiques trade.

BELOW: the Bateman Chest, a gilt-wood coffer made in 1720 for William Bateman, Lord Mayor of London, and carved on the lid with his monogram, the front of the chest terminating in ball and claw feet and decorated with classical masks, shells and acanthus leaves. Victoria and Albert Museum, London. BOTTOM: console table (c. 1730), gilt wood with green marble top above a dentil-carved frieze, the exaggerated curved legs terminating in claw and ball feet and enclosing above them a shell within a pierced and carved foliate frieze. Antiques trade.

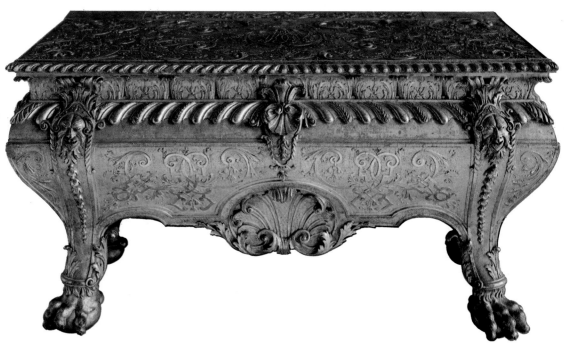

and queen. Several pieces of exceptional quality were made for Queen Charlotte – a mahogany secretaire, for example, at Buckingham Palace, which clearly displays German influence, and a jewellery cabinet in mahogany with Rococo decorations inlaid in ivory. Within the firm, Vile, who retired as court cabinet-maker in 1764, was mainly responsible for carving while Cobb specialized in upholstery. He too worked for the court (upholsterer to George III) and when Vile retired, he continued to direct the firm until 1777, producing many different types of furniture. Among the most interesting examples are the inlaid satinwood commodes and pedestals for Corsham Court in 1772, showing evidence of Adam's influence. Cobb is also credited with the invention of a special type of drawing table with a movable surface, for the use of artists and draughtsmen.

Benjamin Goodison, who was active between 1727 and 1767, was one of the most capable cabinet-makers of the Georgian period, specializing in mahogany furniture with gilt decoration. His style, close to that of Kent, is rather ponderous but nonetheless lively. He favoured the decorative device of acanthus leaves scrolling into a central shell, with garlands and trophies of plumes. He suceeded James Moore as royal cabinet-maker, and worked for the most famous members of the contemporary aristocracy, including the first Earl of Leicester, Sarah, Duchess of Marlborough, the Earl of Cardigan and Viscount Folkestone. His bills lists cabinets, candlestands, looking glasses and stools.

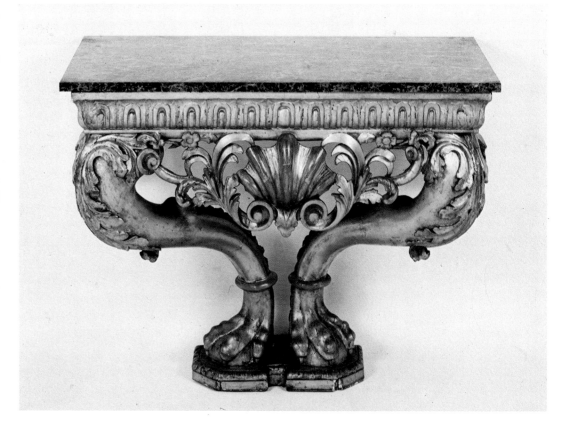

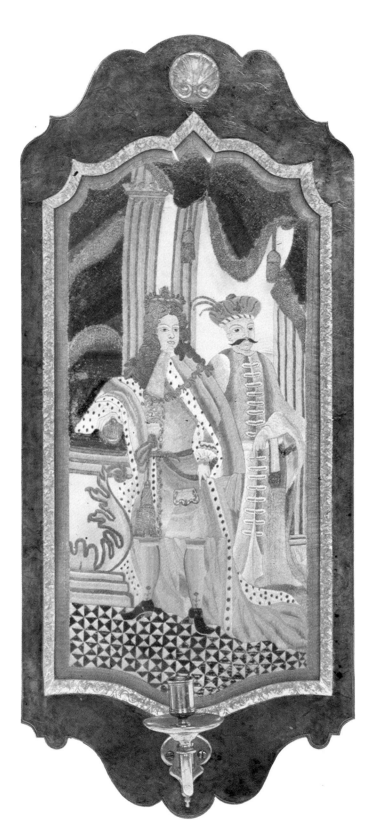

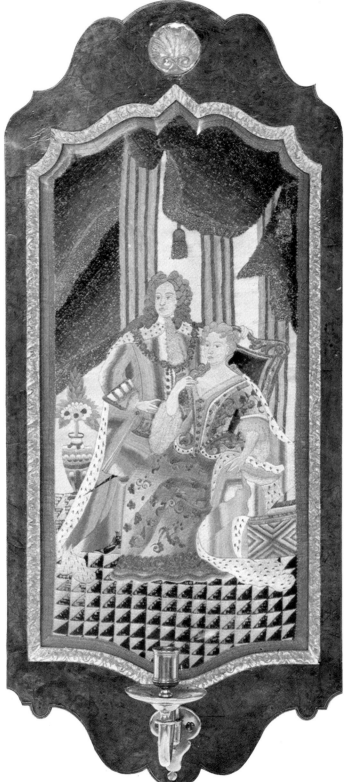

Finally, also worthy of note is the work of Giles Grendey (1693–1780), from Gloucestershire, who went to London in 1709, was appointed a member of the Joiner's Company in 1729 and made Master in 1766. In his thriving workshop he also produced furniture for export – a suite of lacquered furniture was preserved in Spain until the 1930s, when it was dispersed. A typical feature of Grendey's chairs is the incorporation of double serpentine panels in the backs, which are often veneered in walnut, although he also worked in mahogany.

The Rococo style

It was during the 1730s that the Rococo style began to acquire popularity in England. The severity of the Palladian style, even when embellished with Baroque decoration, led to an increasing gap between furniture designed by architects and that of cabinet-makers, who were the first to absorb into their work the French influences promoted in London by the publication in this period of numerous pattern books. Books available included designs by Pierre Lepautre (c. 1648–1716), architect and designer François de Cuvilliés (1695–1768), artists Boucher (1703–70) and Watteau (1684–1721), and sculptor and engraver Jean-Bernard-Honoré Toro (1672–31), to name but a few of the great names working in this style.

St Martin's Lane Academy in London played a very important role in the spread of Rococo in England. The academy was founded in 1735 in the part of London that had at that time

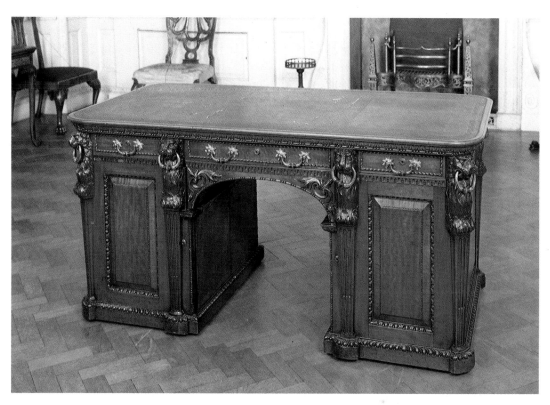

developed as the hub of the furniture industry, where the workshops of the most important cabinet-makers and upholsterers were to be found. The aim of the academy was first and foremost to instruct in the art of drawing from life. One of its teachers was the French artist and illustrator Hubert Gravelot (1699–1773). He had arrived in London in 1732 at the invitation of Claude du Bosc, who had asked Gravelot to work with him on the engravings for the English edition of the folio edition of *Cérémonies et costumes religieuses de tous les peuples du monde représentées par des figures dessinées par Bernard Picart*. The drawings of Gravelot's early period were more in the style of the French Régence than the Rococo picturesque. He adopted this style in about 1735, probably inspired by the *Livre d'ornements*

of Juste Aurèle Meissonnier (c. 1693–1750). Gravelot later developed a style of his own, which was to influence artists and students who attended his drawing classes at the Academy.

It is not easy to assess Gravelot's importance in the field of the decorative arts. Certainly he was primarily responsible for the spread of the taste for the picturesque, and he contributed to the introduction of the serpentine outline, which William Hogarth (1697–1764) was later to theorize in his famous treatise *Analysis of Beauty* (1753), describing it as the most effective way to express beauty of form. Hogarth called the straight line "unnatural" compared with the curved line, which he considered fundamental to design: the serpentine outline should be extended to all three dimensions (width, height,

and depth) to give a fluid shape to a piece of furniture.

Decorative motifs

Hogarth and the other Rococo artists all thought that Nature should be regarded as the principal source of inspiration for new decorative motifs. The classical acanthus leaf, no longer confined to capitals and garlands, was found as adornment everywhere. Irregular lines and asymmetry became synonymous with beauty: pediments and tympana were broken, bent, twisted and interrupted with fanciful curves superimposed and intertwined in a profusion of sculpted forms. Heterogeneous decorative elements such as shells, sprays and drops of water reminiscent of cascade motifs, flowers, branches, leaves,

William Kent and the 'classical Baroque' style

William Kent, the famous architect and interior designer, whose name is synonymous with the Palladian movement, served his apprenticeship varnishing carriages and went on to devote himself to painting. After his return from Rome, where he had spent ten years, he first worked as a painter and fresco artist, and undertook the task of restoring the painted ceiling by Rubens in the Banqueting Hall in Whitehall. Soon, however, he found his vocation under the cultural guidance of Lord Burlington, an important patron and talented amateur architect, and commenced his own career as an architect, interior decorator and furniture designer. An advocate of a return to the simplicity and classical dimensions of Palladio, he applied these ideals to both the external structure and interior decoration of his buildings – for example, the two splendid houses he built in Norfolk, Houghton Hall, for Sir Robert Walpole, and Holkham Hall, for the Earls of Leicester. In contrast, he found no satisfactory classical models for his furniture designs, and the Palladian architect unleashed his imagination and, influenced by his years in Italy, enthusiastically revived various designs from the Baroque to the Rococo. The decorations of his sumptuous and imposing furniture, architectural and statuesque in form, display a Baroque opulence in their sinuous lines and scrolled feet, their swags of sculpted fruit and shells large and small. Some of his contemporaries criticized this abundance, which could appear excessive, even though this type of furniture was in perfect accord with the interiors created for it, a fact that must be borne in mind when passing judgement on it. His furniture designs, however, display a particular type of late Baroque classicism and significantly influenced English furniture-making among his contemporaries and later generations, who showed their debt to him by creating sumptuous pieces in "the Kent style".

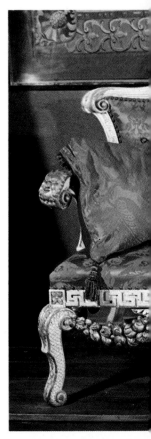

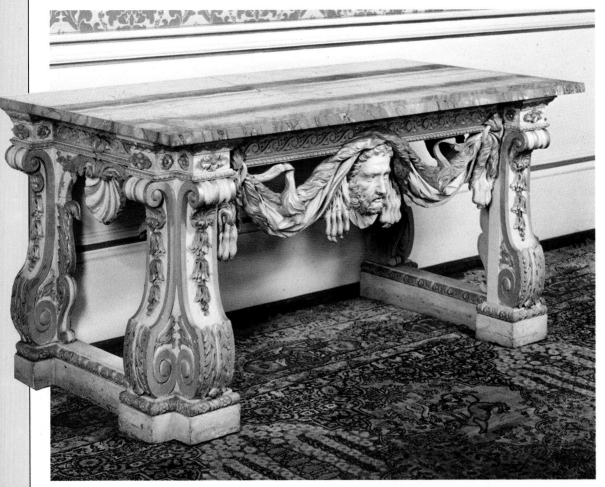

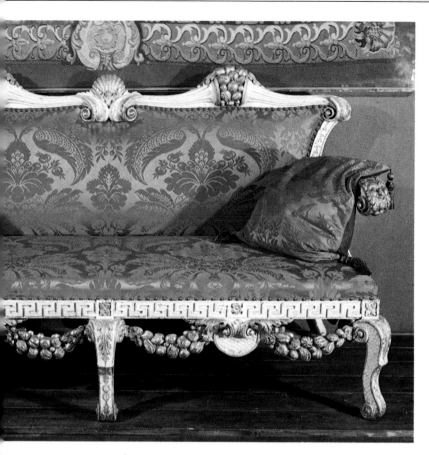

FACING PAGE: side table (c. 1740) by Matthias Lock in the sumptuous and imposing style of William Kent. Compare this with the side table (c. 1730), below centre, the design of which is attributed to Kent. Temple Newsam House Museum, Leeds.

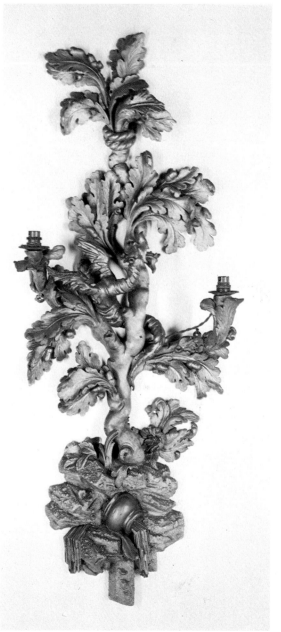

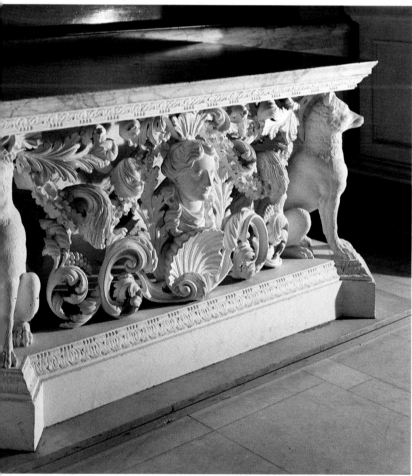

ABOVE, CENTRE: painted pine sofa, perhaps designed by Kent in 1735, with the decorations typical of his style: legs terminating in scrolled feet, swags of fruit, shells and Greek key pattern frieze. Victoria and Albert Museum, London. ABOVE: wall sconce (c. 1740), in ornately carved gilded and painted wood, a piece by an unknown maker which shows the wide influence of Kent's style. Antiques trade.

EARLY GEORGIAN STYLE · **183**

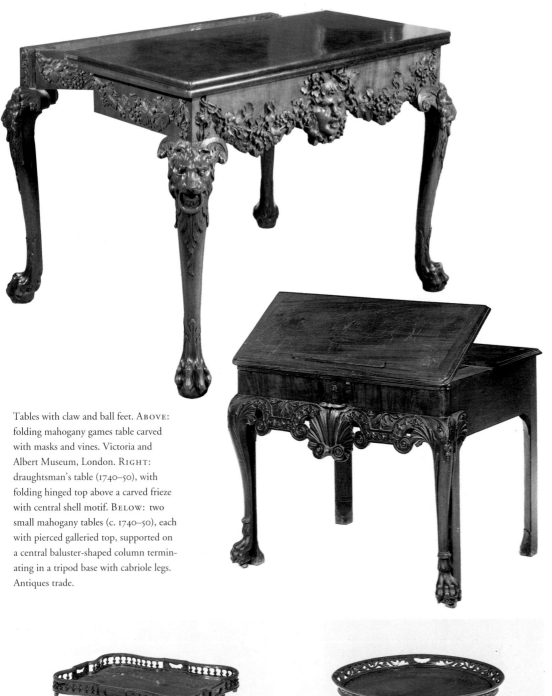

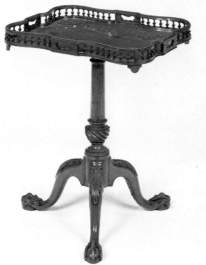

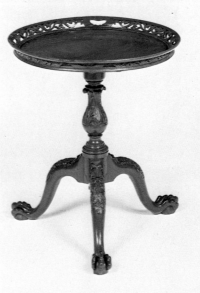

Tables with claw and ball feet. ABOVE: folding mahogany games table carved with masks and vines. Victoria and Albert Museum, London. RIGHT: draughtsman's table (1740–50), with folding hinged top above a carved frieze with central shell motif. BELOW: two small mahogany tables (c. 1740–50), each with pierced galleried top, supported on a central baluster-shaped column terminating in a tripod base with cabriole legs. Antiques trade.

pastoral figures or figures inspired by the antique, mingled gracefully, almost as if rivalling one another in improbable and bizarre combinations.

Dimensions and comparative sizes were ignored: the natural proportions of plants, animals, people and architectural features were exaggerated or improbably diminished, as in the oriental-patterned wallpapers. Furniture was graced with animals from Aesop's fables and characters from Ovid's *Metamorphoses*, with elegant shepherds and shepherdesses and the mythical inhabitants of forests, grottoes and gardens.

In England, unlike in France and Germany, there was no building completely in the Rococo style, from its architecture to its interior decoration and furniture. The Rococo was imited to one or two rooms for which a specific programme of decoration would be designed. Dining-rooms would boast vines and Bacchic figures, while drawing-rooms would be decorated with musical trophies, flowers and putti, and erotic themes and doves would adorn the bedroom; dressing-rooms would be dominated by *chinoiseries* and Gothic motifs – the former for the lady's dressing-room and the latter for the gentleman's.

John Hardy, in "Rococo, Furniture and Carving" (exhibition catalogue *Rococo, Art and Design in Hogarth's England*, 1984) notes that *Sixty Draughts of Different Sorts of Ornaments in the Italian Taste* (1736) by Gaetano Brunetti was one of the first and most important pattern books published in London on Rococo furniture. Here were the asymmetrical scrolls applied to items

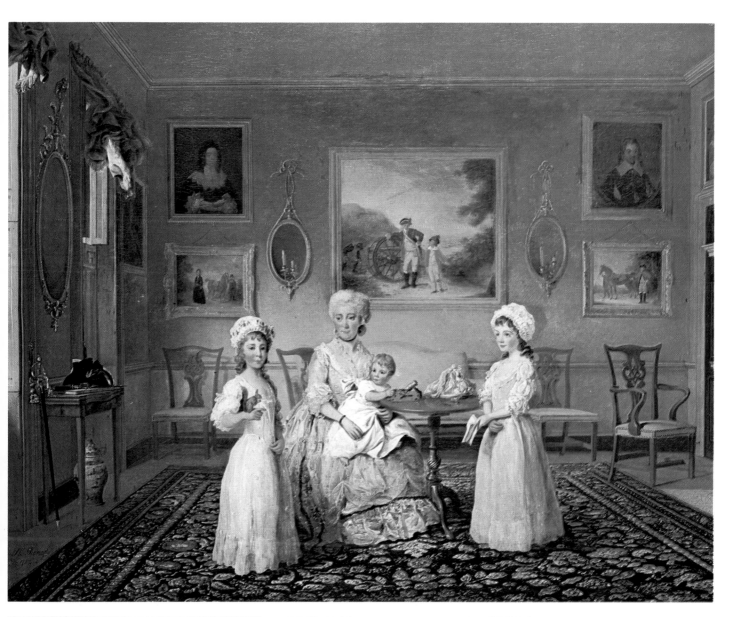

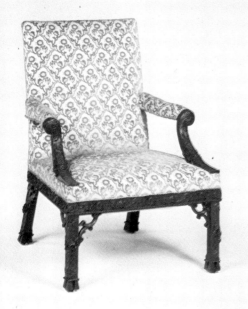

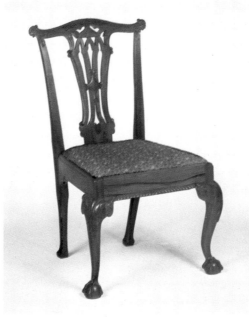

ABOVE: a typical English middle-class interior in a painting by Philip Reinagle, *Mrs Congreve with her daughters* (c. 1770). Note the highly popular tripod table and typical carved splat-back chairs. National Gallery of Ireland, Dublin. FAR LEFT: armchair (c. 1745), with upholstered back, seat and arms, the mahogany frame carved with flowers and double C-scrolls to unite the legs with the frieze of the seat. The feet are executed in the classical cylindrical "teardrop" shape of Doric capitals. This piece formed part of a twenty-nine-piece suite made for the residence of the Earls of Shaftesbury at St Giles, in Wimborne, Dorset by William Vile. LEFT: rose-wood chair (c. 1750), with pierced back and cabriole front legs terminating in claw and ball feet. Antiques trade.

Three examples of mirrors. The frame of the mirror, top left, in carved wood, painted and part gilt, with figures inspired by the 16th century, dates to 1740–50, as does the example illustrated below left, also in carved painted and gilt wood but with naturalistic Baroque-style decoration. The mirror below right (c. 1750) in a carved gilt gessoed frame, is heavily decorated with Rococo motifs – scrolls, foliage, flowers and fruit – and is surmounted by a central heraldic cartouche enclosed within asymmetrical scrolls.

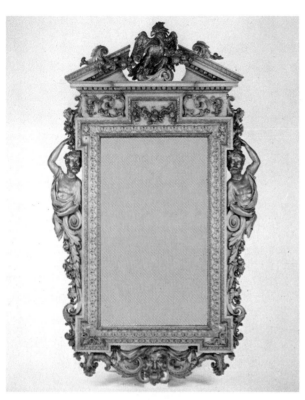

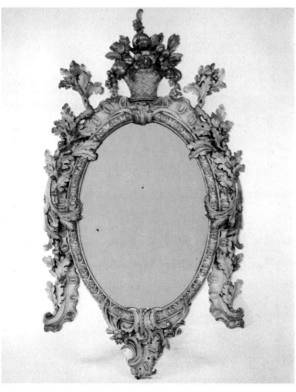

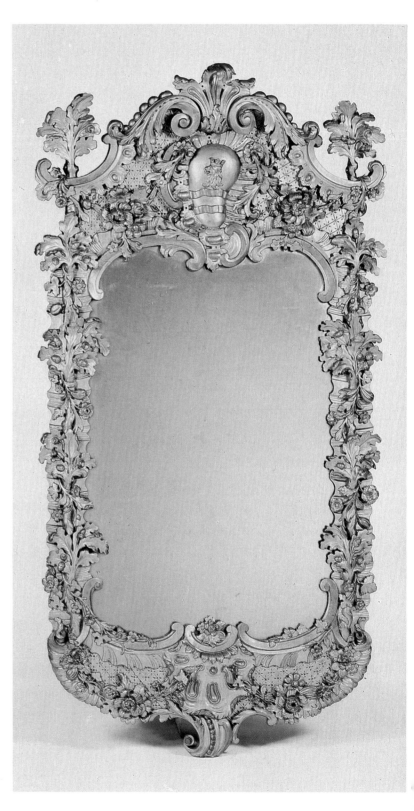

Armchairs and a two-seater settee *en suite*, in white-painted beechwood, made from a design by cabinet-makers William Ince and John Mayhew. Dating to c. 1760, the armchairs have circular backs with an arches pattern and geometric design, while the settee is upholstered. Antiques trade.

of furniture of every description which were subsequently found on furniture made after the book's appearance. Similar decorative elements are also found in the eight-volume work by William de la Cour (1741–48) and Henry Copeland's *New Book of Ornaments* (1746). A draughtsman and engraver, Copeland, collaborated several years later with the most important designer of English Rococo furniture, Matthias Lock (c. 1710–69), on another book of the same title. Lock had already published three treatises of interest: *A New Drawing Book of Ornaments* (1740), *Six Sconces* (1744) and *Six Tables* (1746). He set out a highly personal and very "English" view of the Rococo style gracefully combining asymmetrical cartouches, swags, grottoes inhabited by dragons, trophies and rustic motifs.

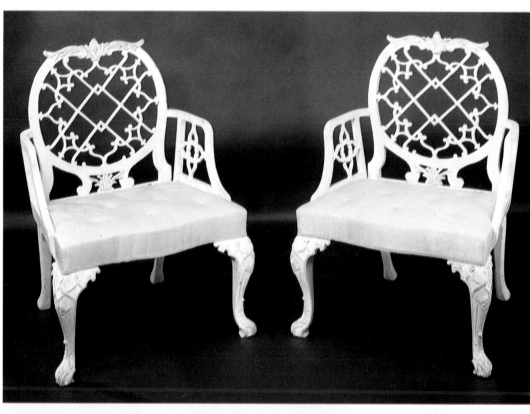

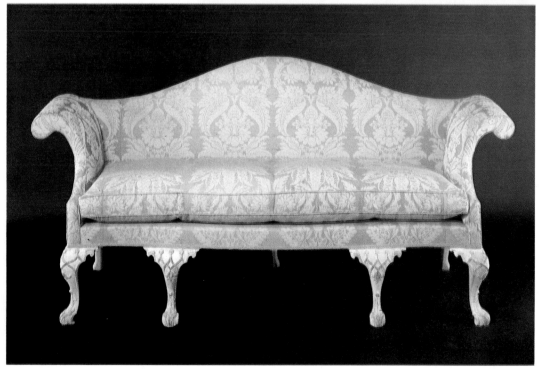

Cabinet-makers and wood-carvers of the Rococo period

An important figure of this period was the carver and designer Thomas Johnston (1714– c. 1778). He specialized in a type of work known as "carver's pieces", i.e. decorative items such as frames for pictures and mirrors, candlesticks, sconces, chandeliers and small tables. He did not make pieces of furniture in the usual sense of the word. The products he made were pieces of such elaborate and fanciful creation that it is hard to believe they are carved from wood. Johnston dedicated his pattern books to Lord Blakeney, the president of the Anti-Gallican Society, which had been founded in the 1740s with the aim of protecting British

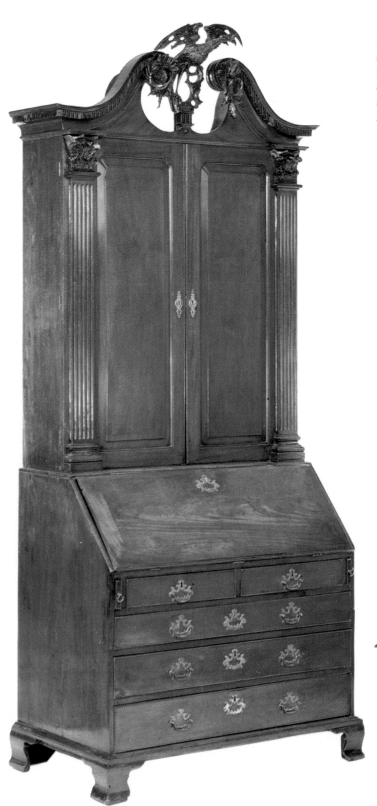

FACING PAGE: the Walpole Cabinet, a wall-mounted cabinet with rosewood veneer and decorated with carved ivory sculptures and medallions in high relief; made in 1743 for the writer and collector Horace Walpole (1717–97). The founder of a literary genre destined to achieve enormous popularity, the "Gothic novel", Walpole influenced the architectural style of the period as a supporter of the Gothic revival. Victoria and Albert Museum, London.

ABOVE: mahogany bureau-cabinet (c. 1750), the upper section surmounted by a carved ho-ho bird (showing Chinese influence) between scrolls above the double doors, flanked by moulded columns with Corinthian capitals. RIGHT: mahogany cabinet (c. 1750), the upper section surmounted by an ogee arch, a motif that is repeated in the frames for the glass panels of the doors. Antiques trade.

craftsmen from an excess of imported French products. He was a doughty champion of his own profession, and the frontispiece of one of his books shows the figure of an engraver burning French articles made of papier-mâché. In the delicate and fanciful pieces Johnston created he combined fruit, flowers and foliage with *rocaille* motifs, among which pastoral figures might roam, tiny buildings be glimpsed, and on which mythical birds and dragons might alight.

Matthias Lock was one of the first cabinet-makers to adopt the Rococo style in his furniture, as is testified by a suite made for Hinton St. George in 1745, the bills for which survive along with a sketch for the mirror and table. Lock may have gone to work for Chippendale later.

Craftsmen and engravers like Johnston and Lock could not compete with large firms manufacturing furniture and decorative objects who, in the middle of the century, would be commissioned to furnish complete interiors. These firms had at their disposal whole armies of specialist craftsmen, designers, engravers, gilders, turners, upholsterers and lacquerers. Among the best known workshops were James Whittle (d. 1759), Samuel Norman (active between 1746 and 1767), John Mayhew and William Ince (who were working between 1758 and 1802), Vile and Cobb (already mentioned above), Thomas Chippendale (1718–79) and William and John Linnell (father and son, active 1720–1763 and 1750–1796).

Trained as an engraver and gilder, Samuel Norman went into partnership with James Whittle, whose daughter he had married.

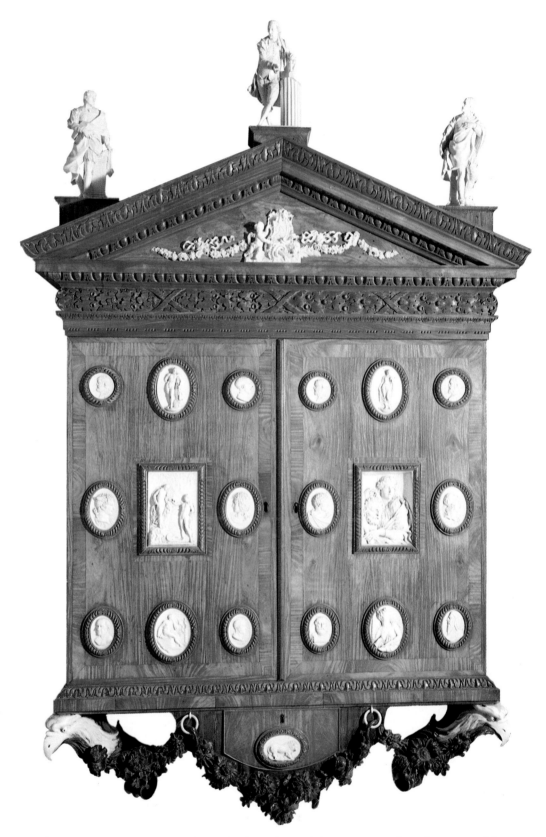

In the following years they produced upholstered furniture and examples of cabinet-making, and for a time John Mayhew joined them as a third partner. In 1760, after the death of his father-in-law and a fire in his workshop, Norman took over the firm of Paul Sanders, which specialized in upholstered furniture. Two years later he became "Master carver in wood to the Office of Works and surveyor of the curious carvings at Windsor Castle". Several pieces by him have been identified, including a Rococo bed for Hopetown House in Scotland and the frames for the

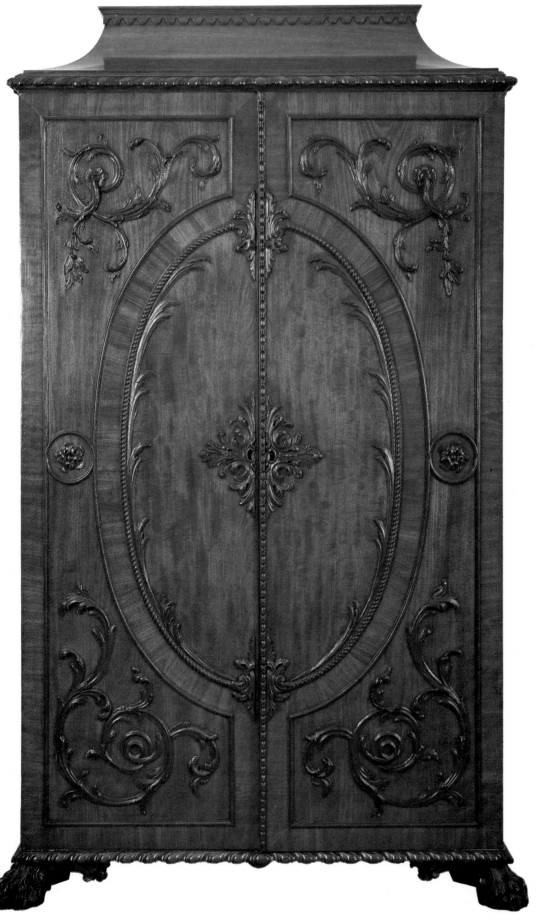

mirrors still to be seen today at Woburn Abbey in Bedfordshire.

The partnership of William Ince and John Mayhew enjoyed widespread success, although few documented pieces can be attributed to them. Their treatise *The Universal System of Household Furniture*, published in pamphlet form between 1759 and 1762, has designs of Gothic and Chinoiserie lattice work, but the decline of the Rococo style meant that it had limited success. In fact they achieved their best work in the Neoclassical style for architects such as Sir William Chambers and Robert Adam and for such important patrons as the Duke of Marlborough at Blenheim Palace, the Earl of Coventry at Croome

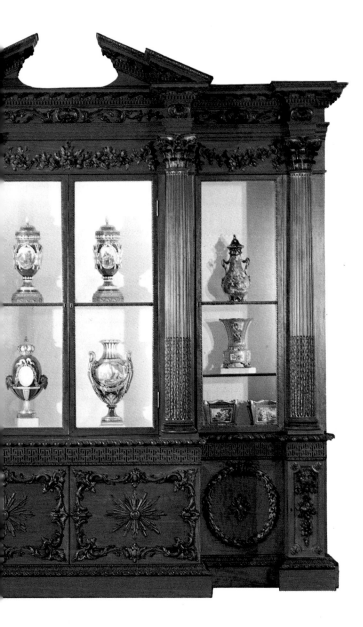

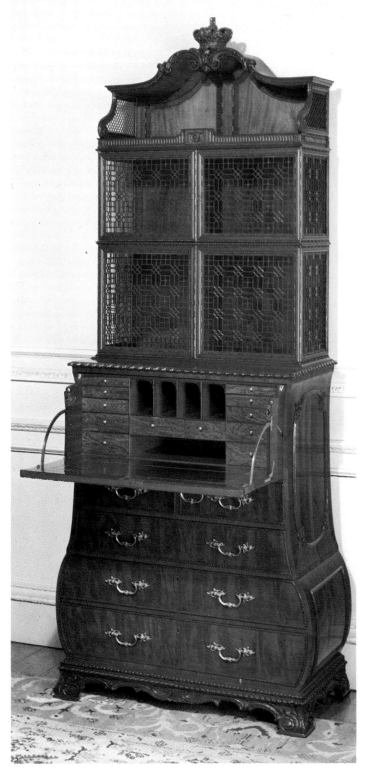

Three pieces by William Vile. FACING PAGE: mahogany cupboard (c. 1760), of simple classical form, adorned with mouldings and carved scrolling foliage. CENTRE: Cuban mahogany bookcase (1762) made for George III; of architectural design in the Palladian style, it is decorated in the Rococo style. BELOW: mahogany secretaire (c. 1762), made for Queen Charlotte. The lower body shows German influence, particularly in its *bombé* form, while the pierced grill enclosing the upper section is in the Chinese style. Royal Collection, Buckingham Palace, London.

Court and the Earl of Exeter at Burghley House.

The carver William Linnell established a large workshop in Berkeley Square, London, in 1754. His son John (1729–96), who trained at St Martin's Lane Academy, produced a series of designs for late Rococo furniture, but subsequently moved closer to Robert Adam. Among the examples of the Linnells' work in the Rococo style is the suite of furniture for the Chinese bedroom at Badminton House supplied to the Duke of Beaufort in 1752–55. The firm also supplied carved and gilded mirrors and chimney pieces at Woburn Abbey, Croome Court and Osterley Park in the 1750s.

Another important workshop under the direction of the cabinet-maker John Channon was active between 1733 and 1783, and a number of interesting examples of its furniture can be seen in the Victoria and Albert Museum and at Kenwood House in London and in the Fitzwilliam Museum in Cambridge. This furniture is inlaid with brass and applied with ormolu decoration. "Ormolu" is a French term used in the second half of the 18th century in England to describe bronze gilded by the mercury process.

Chippendale, Adam, Hepplewhite

Thomas Chippendale

Thomas Chippendale's *The Gentleman and Cabinet-Maker's Director* was published in London in 1754, and was the most famous and important pattern book of the period, a fact borne out by the numerous reprints and new editions (the second appeared in the following year and the third, revised and expanded, in 1762), which helped to spread Chippendale's influence, both in England and in the American colonies.

Few details are known of the life of Thomas Chippendale (1718–79). He seems to have been born in Yorkshire, the son of a carpenter. It is known that in 1754 he was living in London, where he had at his disposal a complex of buildings comprising a shop and a workshop as well as warehouses in St Martin's Lane. He married when he was about thirty, and five years after the death of his wife in 1772 he remarried. He had eleven sons of whom the eldest, Thomas, continued as director of the firm for fifty years after Chippendale's own death.

Chippendale's reputation as a creative artist has been much debated. The fact is often emphasized that he concentrated more on the management of his business affairs than on making and designing of furniture, and while it is certainly true that he probably never made any furniture himself after the success of *The Director*, Christopher Gilbert in *Thomas Chippendale, His Life and Work* (1978) has shown that he designed the pieces, chose the materials, supervised the workshop production and negotiated with clients. Moreover, by analysing his drawings and privately published material, Gilbert argues that Chippendale must have been responsible for most of the designs in *The Director*, which were then engraved by professionals such as Matthias Darly. The designs are not completely original; rather they reflect current fashion and represent a faithful and complete sample of the types and styles in fashion at the time. As the title suggests, the *Director* was directed at both patrons and craftsmen. Some designs were obviously fanciful and only suggestive of the type of furniture Chippendale could supply. Other designs have measurements and detailed drawings which could be of use to the cabinet maker. *The Director* contains pieces in the Georgian, Rococo, Chinese, Gothic and Neoclassical styles – which together form a complete and representative sample of the various trends of the period.

"Chinese Chippendale"

Of particular interest are the *chinoiseries* that characterize the style known as Chinese Chippendale, which in itself represents a conspicuous part of Chippendale's production. It has already been mentioned that, towards the middle of the 18th century in England, there was a renewed enthusiasm for decorative motifs that drew on the Orient for their inspiration. Rooms were lined with

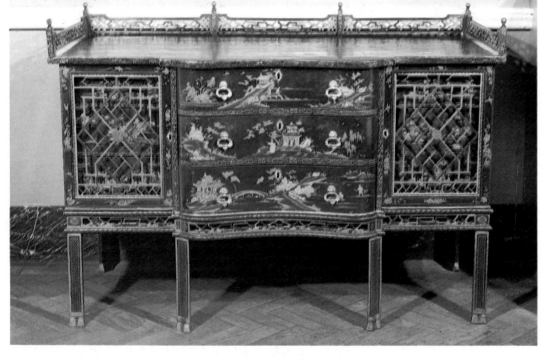

ABOVE AND FACING PAGE: commode and bed probably designed by Linnell in the "Chinese" style for Badminton House, Gloucestershire (c. 1754). The black lacquered and part-gilt-wood commode is decorated on the drawers, of curved outline, with imaginary "Chinese" landscapes; the drawers are flanked by doors decorated with a pierced latticework of geometric design. This motif is repeated in the latticework bedhead, in part-gilt and red and black lacquered wood, the bed itself being covered by a canopy resembling a pagoda roof, with fretted gallery and surmounted by mythical animals. Victoria and Albert Museum, London.

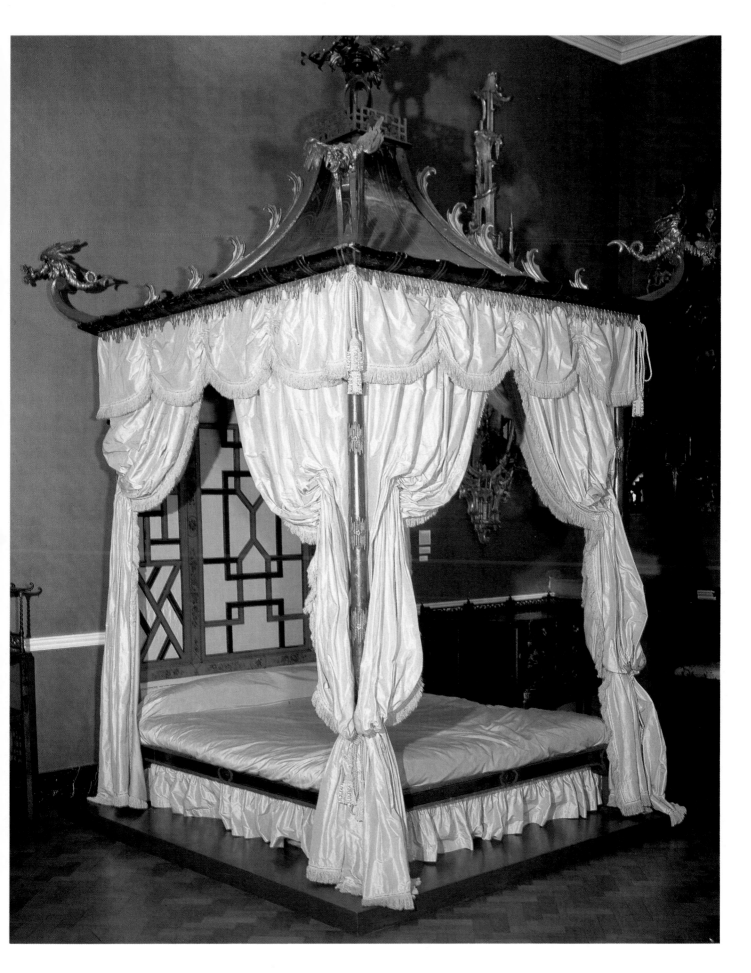

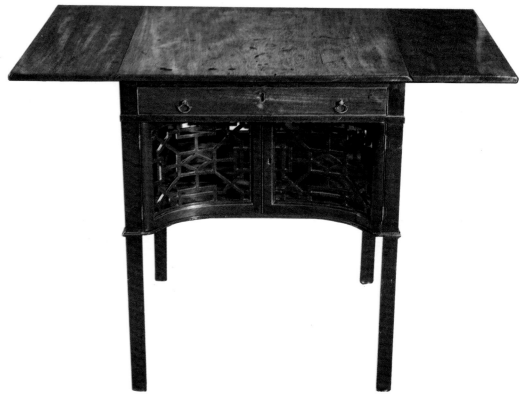

wallpaper painted with oriental buildings, little flowering trees, figures in Chinese costume and flocks of exotic birds flying about. Accessories and furniture in the Chinese style accompanied the decoration of the wallpaper.

Large Rococo mirrors were framed with entwined tendrils upon which ho-ho birds perched; dragons and scrolling foliage took the place of classical decorations on the architraves of doors and overmantel mirrors, which would often be surmounted with a model of a pagoda. Unfortunately the only surviving example of these rooms to have remained intact is that of Claydon House in Buckinghamshire, which was designed during the 1760s.

The taste for lacquered furniture continued through the reign of Queen Anne, particularly for lacquered games tables, desks, cabinets and boxes, and although such pieces were decorated with a profusion of orientally inspired motifs, they none the less maintained an essentially Western character in their lines and proportions. The technique of lacquering was practised until the second half of the century, as the treatises of the period show, although these were directed at an aristocratic readership rather than at the artisan. Examples of these works include *The Method of Learning to Draw in Perspective … Likewise a New and Curious Method of Japanning … so as to Imitate China and to Make Black or Gilt Japan-Ware* (1732), and *The Ladies' Amusement, or the Whole Art of Japanning Made Easy* (c. 1760).

Towards the 1750s lacquered pieces began to assume new forms: English models and also Rococo pieces in the French fash-

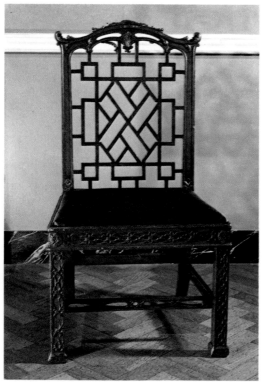

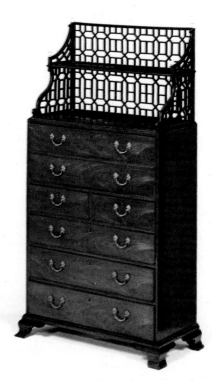

ion no longer seemed sufficiently exotic for lovers of *chinoiserie* decoration. This was the period of Chinese Chippendale, when furniture began to acquire pagoda surmounts, little bells, galleries of fretwork, interlaced little sticks and bamboo, like the

railings that appear on the wallpaper designs. These were, of course, works of fantasy inspired by the imagination, which in no way resembled authentic oriental furniture. The motif of interlaced batons appears again and again in the furniture illustrated in the

Director, on chair backs, on stretchers, on the doors of bookcases and of sideboards, on bedheads, and on chimneypieces.

However, when the *Director* was published, this style was already well known, and similar examples had already been illus-

Some examples of furniture in the "Chinese" style. FACING PAGE, ABOVE: breakfast table by Chippendale, with extending side-flaps and latticework doors to the cupboard. BELOW, LEFT: mahogany dining chair with geometrical latticework back, and "pagoda" style top-rail; the pierced lattice decoration is repeated on the legs and stretchers. Victoria and Albert Museum, London. BELOW, RIGHT: mahogany secretaire-cabinet (1765), with pierced grill superstructure. Antiques trade. THIS PAGE: mahogany cabinet of the type used for displaying porcelain, part gilt, with a fanciful pediment formed by three Chinese pavilions. Victoria and Albert Museum, London.

trated in the *New Book of Chinese Design* by Edwards and Darly, and in other collections of designs, alongside less angular examples closer in concept to the Rococo style. Examples of fanciful and complicated designs, with the inevitable dragons, figures of mandarins, flowering branches and deities, can still be seen – for instance, the pieces made for the bedroom at Badminton House, now in the Victoria and Albert Museum in London. Much in vogue, although rarely seen in the pattern books, were screens, frequently in Coromandel lacquer.

Return to the Gothic style

Typical of Chippendale's work are the ribbon-back chairs, in which the wood of the chair back is carved to resemble entwined ribbons; but in addition to these, he made chairs whose backs are decorated with pointed arches, finials, panels with quatrefoil motifs and other motifs inspired by the Gothic style, for this latter was also in fashion in the second half of the 18th century.

A great advocate of the Gothic revival was Horace Walpole (1717–97), who from 1750 onwards designed and built his own residence at Strawberry Hill (Twickenham), a house he himself described as a Gothic Vatican inspired by Greece and Rome. The building was an expression of the new fashion for whimsical eclecticism, a combination of history, sentiment, aesthetics and symbolism.

Among the advisers who helped Walpole to plan the Strawberry Hill project were two people in particular who represented typical attitudes. They

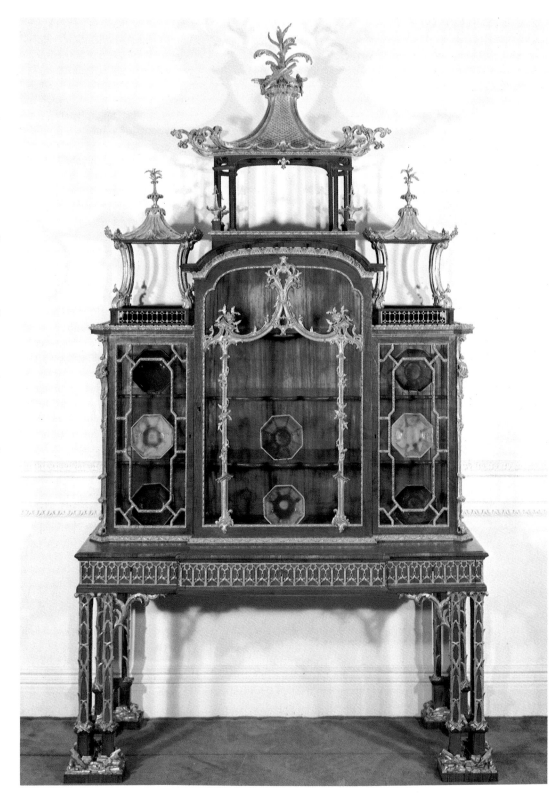

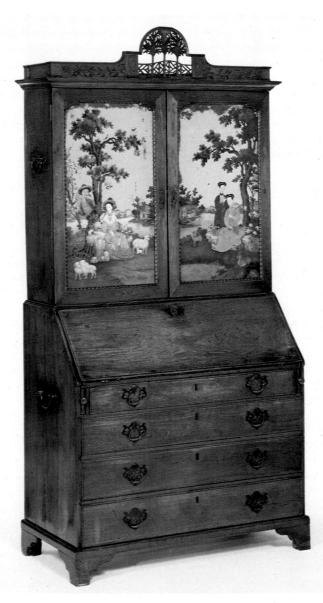

were Richard Bentley (d. 1782), who was fascinated by the combination of Gothic and Chinese motifs – as seen for example in the work of Thomas and Batty Langley – and John Chute, an advocate of a more strictly "archaeological" approach to the Gothic. Walpole adopted from each those elements that seemed to him the most picturesque and charming, thus creating the

foundations of a style which was to culminate in the late 18th century with the building of Fonthill Abbey in Wiltshire, the eclectic and bizarre residence of the writer William Beckford (1760–1844). Fonthill collapsed in 1825.

The interest in the Gothic dated back to an earlier period, and it must be remembered that the buildings and decorative ele-

ments of this style had survived in England and Scotland, outliving the innovations of the Renaissance and Palladianism. Thus there existed in literature and the other arts a strong tradition for the Gothic, which prepared the way for Gothic-inspired motifs to become fashionable once more. The *Director* contained not only chairs but also bookcases, desks and sideboards applied with finials and ogives, motifs often mixed with ornamental characteristics of other styles and imposed upon furniture that was typically Georgian in its structure.

Chippendale's success was owed not so much to his use of *chinoiseries* or the Gothic or Rococo styles but to the pieces he produced in a clearly defined Neoclassical style, which constitute the superior part of his output. These show his originality as a designer, for although they fit perfectly into the interiors designed by Robert Adam, it is clear from the records that Chippendale often supplied the furniture and interior fittings for these rooms independently of the architect, but with his and the patron's approval.

Neoclassicism: Robert Adam

The chief exponents of the Neoclassical style of furniture in Britain were Sir William Chambers (1723–96), James Stuart (1713–88) and Robert Adam (1728–92). Chambers was educated in Paris, where in 1749/50 he was a pupil of Jean-François Blondel. It was in France that he absorbed the theories of the brilliant architects Le Lorrain,

Legeay, De Wailly and Peyre, who had inspired the Neoclassical reaction to the Rococo style. Chambers then went to Rome, where he met Piranesi and Clérisseau. On his return to England he drew up some designs for Harewood House, although these were not used.

In 1759 he published his *Treatise on Civil Architecture*, a scholarly and well-documented exposition of the rules of classical architecture. It is interesting to note that only two years earlier Chambers had published another important work, *Designs of Chinese Buildings, Furniture, Dresses, Machines and Utensils*, the results of studies and observations on China that he had gathered during the course of his three voyages on board vessels of the Swedish East India Company between 1742 and 1749. This work is proof that he was one of the leading experts of the time on *chinoiseries*: he was in fact perhaps the only person actually to have visited the fabled lands spoken of and fantasized about by poets, architects and artists for decades. In his work, mingled with myths and fictitious descriptions, can be perceived the reality of the Orient.

However, Chambers was above all an architect and cabinet-maker in the Neoclassical style, and was perhaps the first to design (1759) and execute a piece of furniture that adhered strictly to the new style, viz. the armchair for the president of the Royal Society of Arts. For his part, James "Athenian" Stuart also produced designs for furniture for his interiors. There are some designs by Stuart for Kedleston Hall datable to 1757, but they were never used. His most important design is the

set of seat furniture for the Painted Room at Spencer House, London, executed for the young John Spencer (c. 1760).

Robert Adam, with his brother James (1730–94), visited France and Italy in about 1750. There, like Chambers, he met Piranesi and Clérisseau, and it was with the collaboration of the latter that in 1757 he executed the famous relief of the Palace of Diocletian at Split, the designs for which were published in a *de luxe* edition in 1764. There followed in 1773 and 1779 the collections of engravings showing the buildings designed by Adam and his brother under the title *The Works in Architecture of Robert and James Adam.*

Adam drew on many sources for his style and assimilated and renewed them in a light and graceful manner. In his interiors and the architecture of his buildings we find Greek, Roman, Renaisance, Palladian and picturesque elements: "simple façades

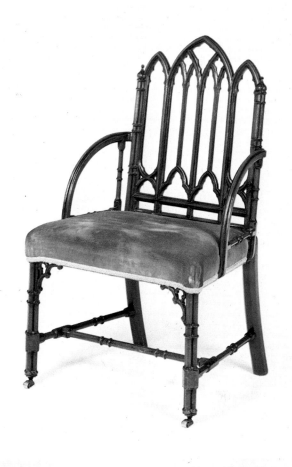

in reddish-brown brick, doors beneath an elegant fan-shaped pediment, between lacquered Ionic and Corinthian columns; the internal staircases and the ceilings of the rooms decorated with stuccowork: snow-white Rococo stucco or delicately coloured classical stucco – white, pale green, light Havana brown; chimneypieces fashioned from Italian marble, with the central figure of a goddess or a putto sculpted from alabaster. Venetian and Pompeiian stucco designs, the tombs of the Via Latina, the palace at Split: the Mediterranean world reaches out northwards, a pleasure garden hidden beneath white ceilings, just as the secret whiteness of the almond's kernel is hidden inside its simple shell" – this is how Italian author and art critic Mario Praz (*Gusto Neoclassico*, 1940) describes Adam's interiors. The light and delicate interior decorations of which Praz speaks here were achieved with artificial aids, such

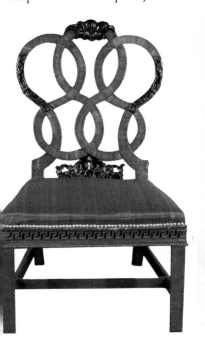

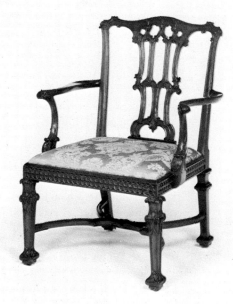

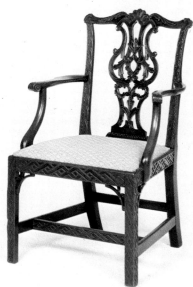

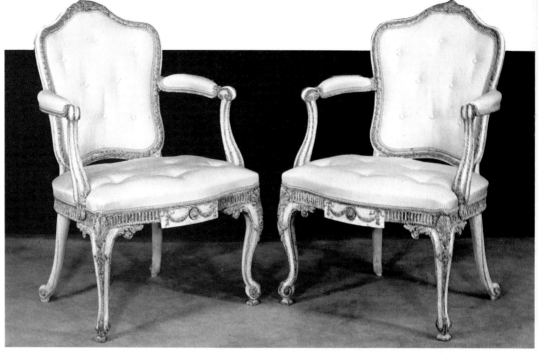

RIGHT: a pair of armchairs by Chippendale (c. 1770) of Rococo shape, but with Neoclassical decorations. Harewood House, Yorkshire. BELOW: chimneypiece with white-painted pine overmantel, originally at Winchester House, Putney, and an example of the late Rococo style. Victoria and Albert Museum, London. FACING PAGE: bedroom at Nostell Priory, with decorations by James Paine (1717–89) and the bed supplied by Thomas Chippendale.

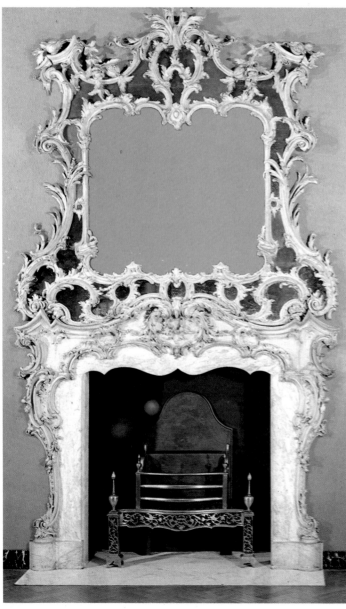

as nets of wire threads to support the stuccowork.

Italian artists such as Biaggio, Rebeccai or Zucchi painted the ceilings of Adam's buildings with elegant medallions depicting mythological scenes and motifs from antiquities recently discovered at the excavations at Herculaneum and Pompeii: the female centaur with a lyre, a female figure bearing a pitcher and a plate of figs, Europa and the bull, nymphs, birds and genies. Adam's Neoclassicism is characterized by a "domestic" spirit, described at the time as "Etruscan", but in fact it was a "Pompeiian" style, far removed from the severity and strict pomp of Kent's work.

Robert Adam: designs and types of furniture

Adam passed through various phases in furniture design for his interiors before he developed a rounded and mature style. He relied at first on the furniture-makers, from whom he learnt the basic principles of making furniture. His master in this field seems to have been John Linnell, who himself learnt the decorative principles of the Neoclassical style from Adam. The furniture of the houses designed by the

architect was sometimes also designed by him, especially mirrors, pier tables and other pieces that would have been placed against the wall. On other occasions, the furniture would be devised by the cabinet maker, who would use the motifs made fashionable by the architects, producing "lyre-back" chairs and semicircular console tables with slender pairs of legs, and painting of furniture in pastel shades so that it blended harmoniouly with the decoration of the wall and the designs of the carpets, the decorative motifs of which mirrored those of the ceiling.

Among cabinet-makers who adhered to Adam's Neoclassical style, mention should be made of Ince and Mayhew, Chippendale, Lock and Darly. Adam used designs and decorative elements inspired by the antique: tripods and plinths supporting urns and torches, Greek friezes, delicate swags and oval medallions. He introduced the oval-backed chair as well as the highly popular shield-backed chair.

His later style met with harsh criticism in the 1770s: Horace Walpole likened the decorative devices employed by the Neoclassical architect to the painting on fans and filigree-work, "gingerbread" and scraps of embroidery. This criticism hardened during

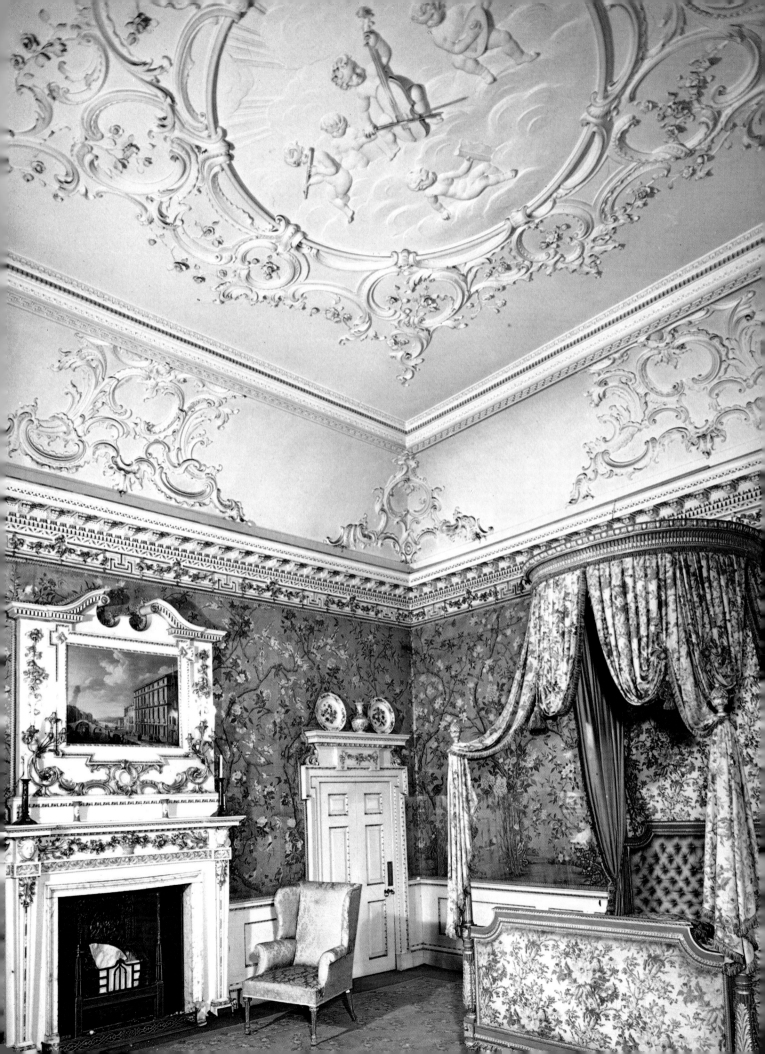

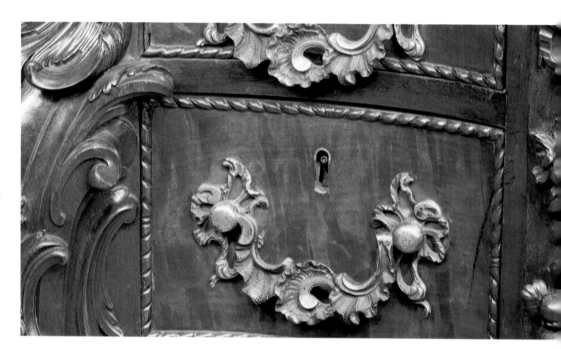

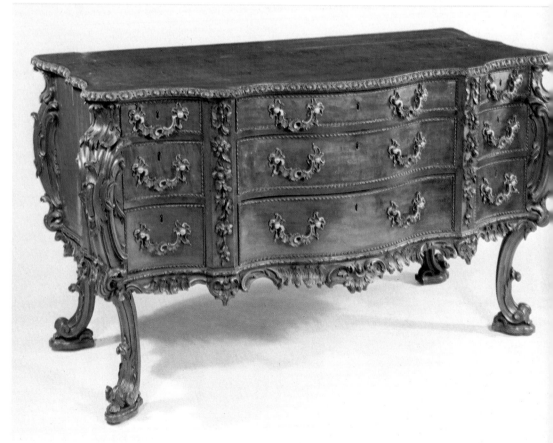

the Regency period, when a strict attitude towards archaeological knowledge made the licence taken by Adam in his combination of different elements unacceptable.

Adam's designs for interiors included those for Harewood House (1759–70), Kedleston Hall (from 1761), Syon House (1762–70), Osterley Park (1761–80), Luton Hoo (1766–70), Newby Hall (1767–85) and Kenwood House (1767/68). Towards the mid-1770s Adam's domination of the field of interior design began to decline. New architects came to the fore, among them in particular James Wyatt (1746–1813) and Henry Holland (1745–1806).

Among the types of furniture upon which Adam especially concentrated his attention were wall furniture, and notably console tables. As already mentioned, Adam preferred semi-oval and semicircular shapes, although important pieces do exist with rectangular tops. Some consoles, designed for precise internal spaces where the line of the wall followed a curve, have a concave shape on one side and convex on the other. Console tables were frequently matched with a mirror, the frame of which would repeat the decorative motifs of the frieze and legs of the table. Adam's commodes (chests or sideboards with doors or drawers), supported on four or six pilaster-shaped legs, are always semicircular or semi-oval in shape. Another item of furniture that Adam conceived as part of the wall decorations of a room was the bookcase. This developed into a structure let into the walls, with open shelves above and doors below. The same treatment

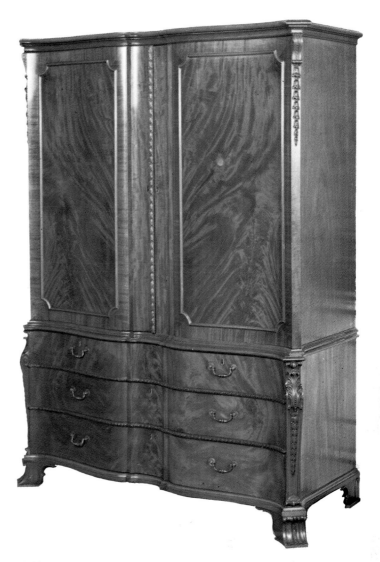

was extended to cabinets, sideboards and cupboards, all considered by Adam as decorative panels of the walls.

The popularization of a style: George Hepplewhite

George Hepplewhite (d. 1786) was the most important exponent of the Adam style and is its greatest populariser. Yet of the triumvirate of Georgian designers – Chippendale, Hepplewhite, Sheraton – he is the most mysterious, for there are very few records of his activity. He only achieved fame two years after his death, with the publication of *The Cabinet-Maker and Upholsterer's Guide* (1788), a collection of 300 engravings made from his drawings. We also know that he assisted with

the publication of *The Cabinet Makers' London Book of Prices* (1788) by Thomas Shearer, which was a manual used almost exclusively by cabinet-makers and craftsmen to help them calculate their expenses. The book contains precise lists of prices for every aspect of the cabinet-maker's work, whose sum would give the overall cost of the piece of furniture.

The preface to Hepplewhite's *Guide* declares that the purpose of the book is "To unite elegance and utility, and blend the useful with the agreeable". The author proposes moreover that his book should be useful to both the craftsman and the gentleman, a guide in which not only practical advice for the construction of furniture may be found but also examples to illustrate current styles.

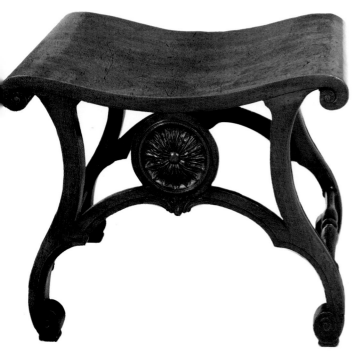

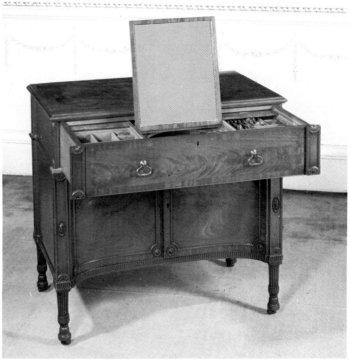

A shrewd businessman: Thomas Chippendale

Thomas Chippendale, "the complete interior decorator", who has given his name to a period – the mid-Georgian era – and a style, owes much of his renown to the 161 plates of the folio edition (200 in the third edition of 1762) of *The Gentleman and Cabinet-Maker's Director* (1754). This extensive catalogue, which covers every category of furniture illustrated in a variety of styles, from the Rococo to the "Chinese" and the Gothic, enabled Chippendale, adept as he was at self-publicity, to attract numerous clients, either through commissions or through other furniture-makers, to establish a vast business empire, and thus provide furniture for some of the most important clients of the day. The first edition of the *Director* appeared in 1754, almost simultaneously with the opening of his workshops in St Martin's Lane, which were organized so as to cover all aspects of production. St Martin's Lane was an early "Latin Quarter", where most of the artists resident in London lived – furniture-makers, painters, actors, sculptors, engravers –, their meeting place being Old Slaughter's Coffee House, situated opposite the building in which Chippendale lived and worked. Among those who frequented the coffee house were Matthias Lock and Matthew Darly, excellent designers themselves, who had been taught the principles of Rococo decoration by French designer and engraver Hubert Gravelot, another regular customer of the coffee house. Chippendale made use of Lock and Darly for his *Director*. But as soon as Chippendale perceived that a change of styles was in the air, promoted in England by James Stuart and Robert Adam, he adopted the new canons of Neoclassicism, and, interpreting freely Adam's decorative repertoire, he became one of the most brilliant exponents of the designs of the Scottish architect: Chippendale's work at Nostell Priory and Harewood House is among his finest.

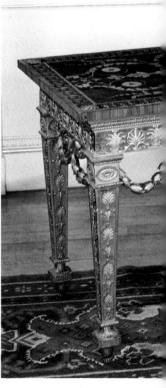

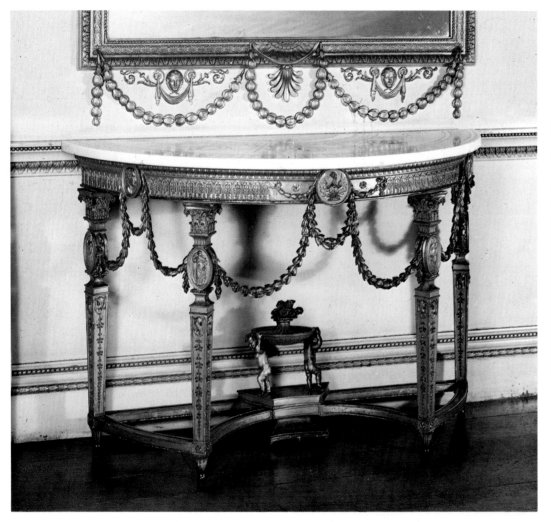

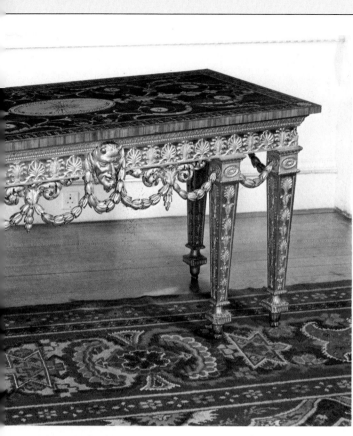

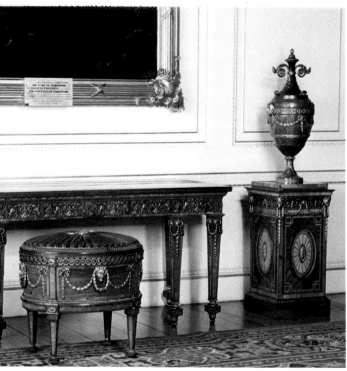

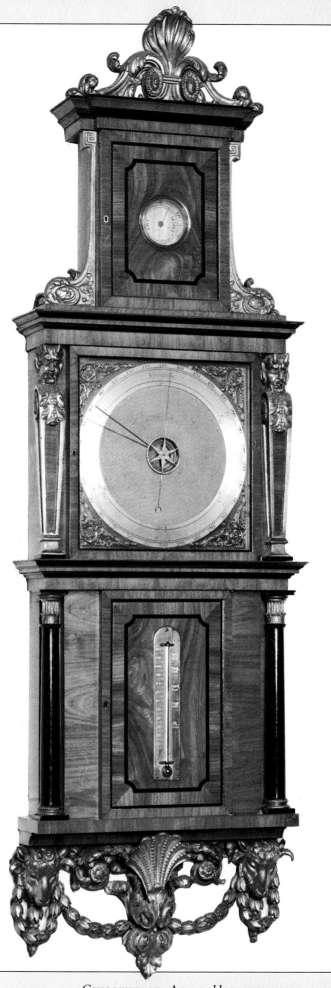

Garlands of berries adorn all the pieces of furniture by Chippendale on these pages.
FACING PAGE: console table, perhaps made from a design (1775) by Adam, the legs
joined by curved stretchers supporting two putti and an urn. Nostell Priory.
CENTRE, TOP: side table, following the Neoclassical principles of Adam and Stuart.
Harewood House. CENTRE, BOTTOM: suite of dining-room furniture (c. 1770), in
dark rosewood and tulipwood and gilt bronze decoration, comprising a table, wine
cooler and two pedestals, the interiors fitted with metal shelves to support a brazier for
hot coals and two urns. Harewood House. RIGHT: wall-mounted barometer (1769),
with rosewood and ebony veneer. Nostell Priory.

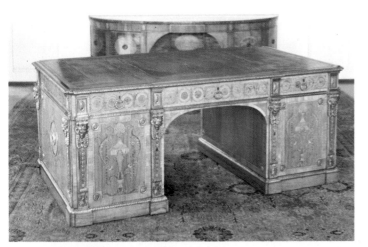

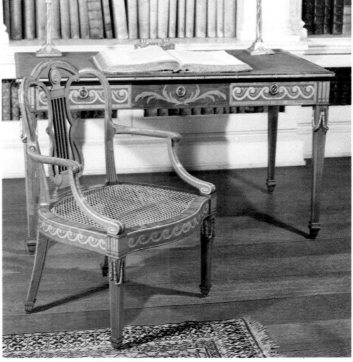

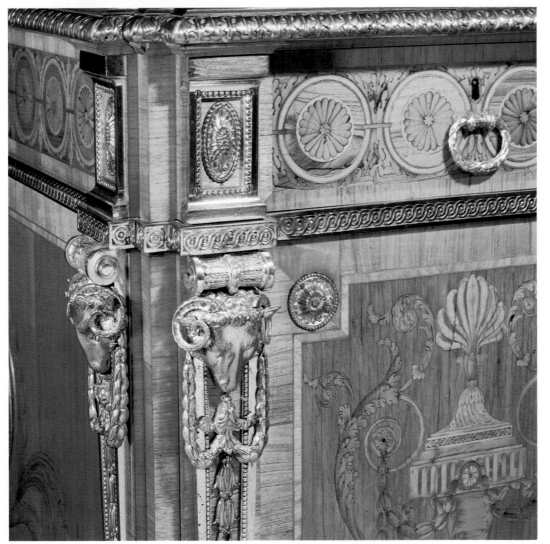

The book is thus aimed not at a restricted readership like Shearer's book but at a wider public, and in particular at those people living at a distance from London who lacked the tools and examples to improve their taste and their own furniture-making abilities.

No piece of furniture exists that can be attributed to Hepplewhite, either by documentation or signature. The single fact known about him is that he worked in the Cripplegate district of London. But despite this, it is the names of Hepplewhite and Sheraton that are associated with the popular style of the closing years of the 18th century. They created designs in a more restrained, simple and less pretentious style than that of earlier years, a style that one could almost describe as "bourgeois".

Hepplewhite's furniture and materials

According to the scheme devised by Ceschinsky, "Hepplewhite" furniture can be divided into four main categories: pieces that clearly show the influence of

FACING PAGE, LEFT AND BELOW (DETAIL): desk made by Chippendale (1770) for Harewood House; veneered in rosewood, with tulipwood crossbanding and marquetry of classical motifs in fruitwood of various colours, juxtaposed so as to give a shaded effect with the engraved frieze and embellished with gilt bronze mounts of goats' heads. Perhaps by Matthew Boulton of Birmingham. Harewood House. ABOVE, RIGHT: desk and chair designed (1773) by John Linnell for the library at Osterley Park, with bleached rosewood and satinwood marquetry of sycamore and with gilt bronze mounts. Osterley Park. THIS PAGE: View of the state bedroom at Osterley Park, whose interior furnishings and decoration were the work of Adam. The imposing bed, designed in 1776, has satinwood pillar supports, a gilded canopy and cupola, and satin and velvet drapes embroidered with Neoclassical garlands and heraldic devices.

Robert Adam; examples inspired by Louis XIV furniture and characterized by curved outlines and cabriole legs; Louis XVI pieces, with turned and often fluted legs; and pieces with tapered legs, perhaps the most original of the Hepplewhite styles. His chairs come in a number of forms: ladderback chairs, with serpentine top-rails; hoop-back chairs, in the Queen Anne style; shield-back chairs displaying various decorative motifs; and a few heart-back chairs, with tapering legs terminating in moulded feet.

Among the chairs that appear in Hepplewhite's pattern book are a variety of types of stool, small sofas with no backs and straight arms, made to be placed beneath windows, and called window-seats, sofas, *duchesse* seats and settees in the French Rococo style. "Hepplewhite" furniture reverted to an extensive use of mahogany, which during the height of the Adam period had been abandoned in favour of soft woods, gilded or painted, or pale woods suitable for marquetry decoration. "Adam" furniture was often in pine, which in some of his furniture was coloured to imitate Spanish mahogany, or yellow pine which was chosen for its natural colour. Two new woods with a yellowish colour were introduced: American satinwood, with its distinctive grain and rosewood from Brazil.

Furniture of this date exploited the particular qualities of mahogany and also satinwood to the full, emphasizing these in the shapes of the furniture. Cupboards, bookcases and desks display mostly straight lines and simple decorative motifs. Commodes, however, are of curved

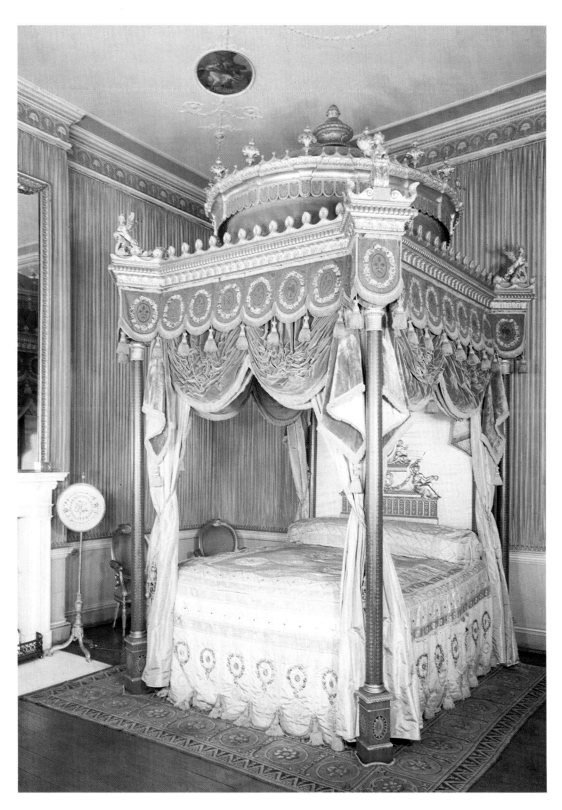

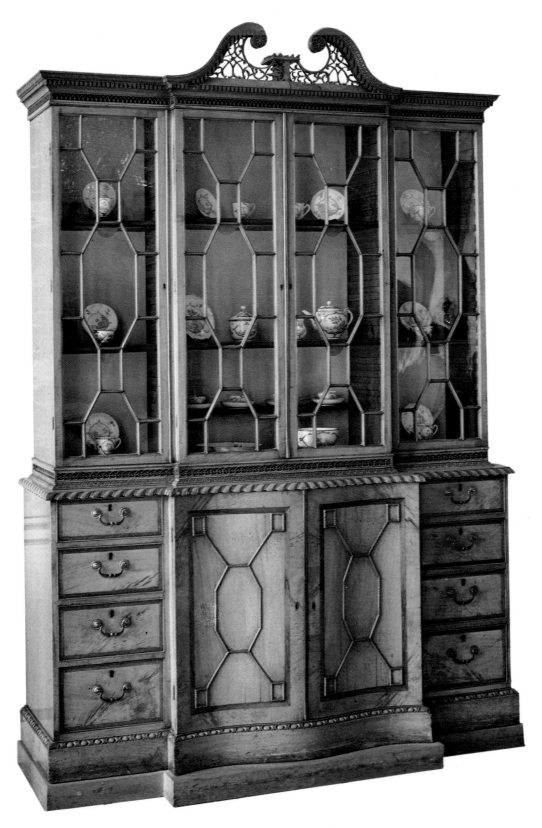

blending the structure of the canopy with the decoration of the walls, designing alcoves within which the bed could assume the simplest possible form.

The 18th century in England considered

Following the categories established by Mark Girouard in *Life in the English Country House* (1978), one could say that, over the course of the 18th century, English interior design gradually evolved from the "formal" country house of the early years of the century, adapting to new and more informal lifestyles. A symbol of this process is perhaps Humphry Repton's well-known picture in his *Fragments on the Theory of Landscape Gardening* (1816), which compares an old-style drawing-room with what he calls a modern "Living Room", in which groups of people freely mingle, devoting themselves to a variety of occupations – music, reading, or the study of engravings. The figure of the gentleman, the cultured aristocrat, the chief commissioner of furniture in the 18th century, has by the end of the century acquired various other connotations, and has become more middle class – a family man, the upholder of new moral and behavioural standards, a seeker of comfort, intimacy and emotion rather than beauty. 18th-century interiors, refined and elegant, the product of the culture of the Enlightenment and familiarity with the classical world, became the cosy, comfortable, upholstered "nests" of the 19th century.

outline, with slightly splayed legs terminating in bracket feet.

Among the sideboards illustrated in Hepplewhite's guide is a type divided into three sections by small pillars, which are the continuation of the front legs: a delicate piece provided with

drawers and doors and an interior designed to accommodate bottles, tableware, water containers and table linen.

In addition Hepplewhite's guide shows tables, varying in size and designed for a variety of purposes (games tables, writing

tables, tea tables, work tables), of delicate and elegant design and with fold-over tops. The beds maintained imposing dimensions, with canopies fitted with heavy draperies, signalling a return to the fashions of the Chippendale era, while Adam was

FACING PAGE: bookcase based on a design by Hepplewhite, in cherrywood with mahogany banding. The doors of the lower section are surmounted by a composite band of moulding, the glazed doors of the upper section are crowned by a broken scrolling pediment decorated with a geometric design. Temple Newsam House Museum, Leeds.

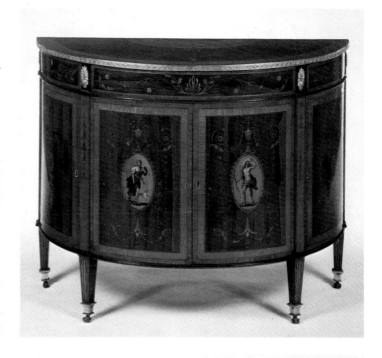

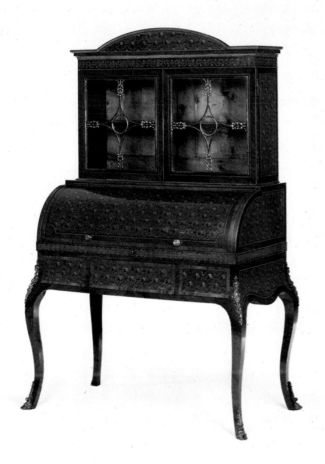

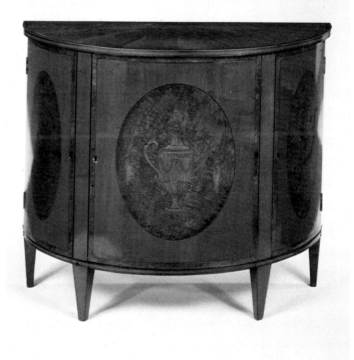

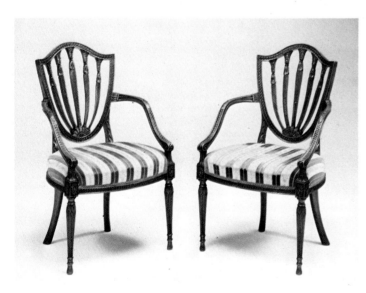

LEFT, ABOVE: George III cylindrical bureau-cabinet (c. 1775), with trelliswork marquetry and cabriole legs applied with gilt bronze decoration. BELOW: two small George III armchairs (c. 1770), in satinwood, with shield-shaped backs, turned front legs and sabre back legs. RIGHT: two semicircular commodes (c. 1775), the top example with painted medallions, the other, below, with burr-oak inlay and crossbanding. Antiques trade.

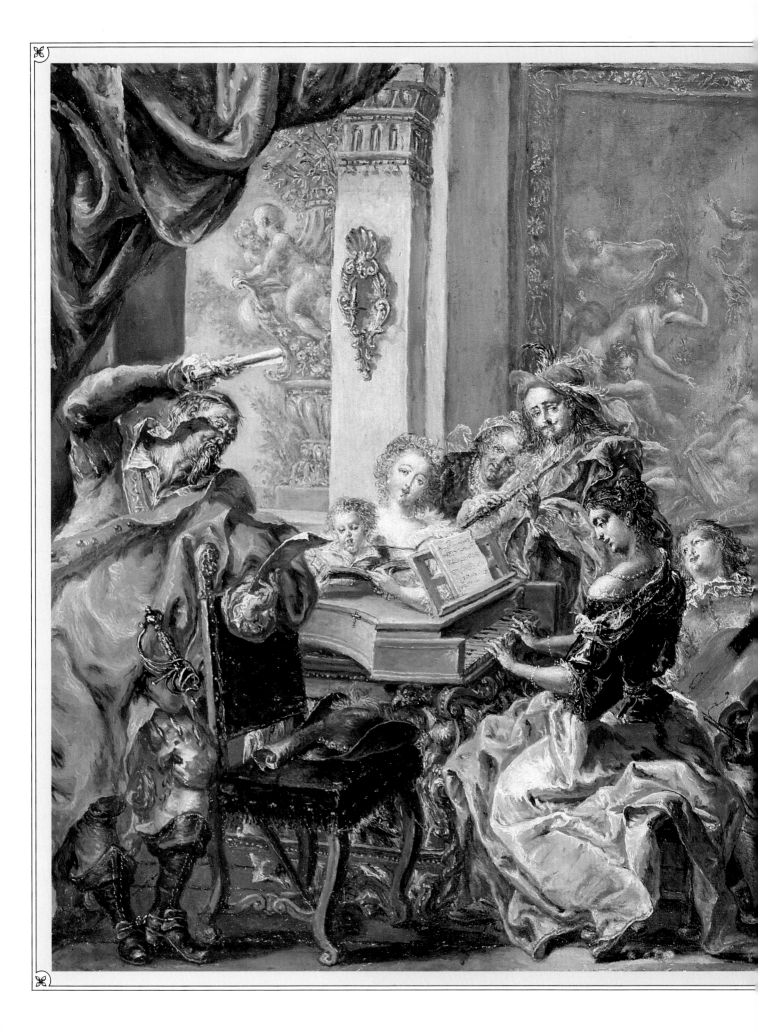

FURNITURE OF THE 18TH CENTURY

OTHER EUROPEAN COUNTRIES

by Massimo Griffo

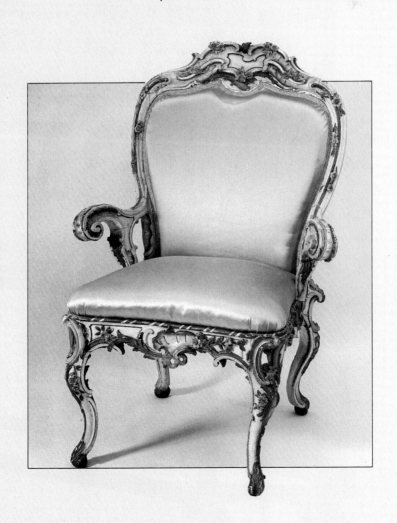

The situation in Europe

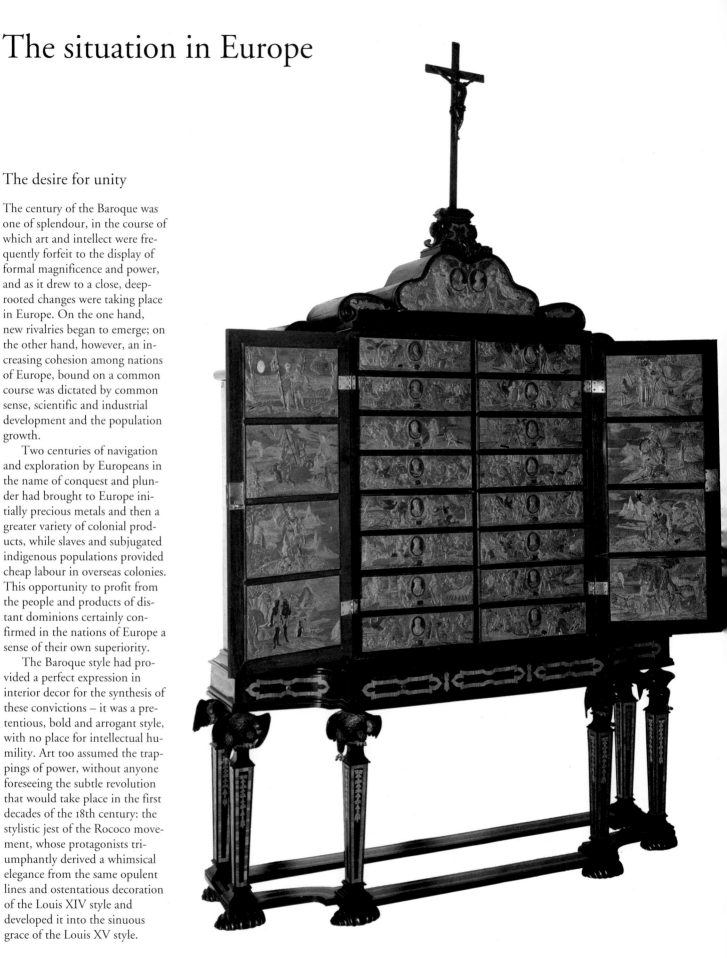

The desire for unity

The century of the Baroque was one of splendour, in the course of which art and intellect were frequently forfeit to the display of formal magnificence and power, and as it drew to a close, deep-rooted changes were taking place in Europe. On the one hand, new rivalries began to emerge; on the other hand, however, an increasing cohesion among nations of Europe, bound on a common course was dictated by common sense, scientific and industrial development and the population growth.

Two centuries of navigation and exploration by Europeans in the name of conquest and plunder had brought to Europe initially precious metals and then a greater variety of colonial products, while slaves and subjugated indigenous populations provided cheap labour in overseas colonies. This opportunity to profit from the people and products of distant dominions certainly confirmed in the nations of Europe a sense of their own superiority.

The Baroque style had provided a perfect expression in interior decor for the synthesis of these convictions – it was a pretentious, bold and arrogant style, with no place for intellectual humility. Art too assumed the trappings of power, without anyone foreseeing the subtle revolution that would take place in the first decades of the 18th century: the stylistic jest of the Rococo movement, whose protagonists triumphantly derived a whimsical elegance from the same opulent lines and ostentatious decoration of the Louis XIV style and developed it into the sinuous grace of the Louis XV style.

In order to understand better the reluctance of the Baroque period to draw to a close at the beginning of the 18th century, it seems fitting to turn to the political situation in the various countries which were either active participants in, or merely adherents of, the revolution in interior furnishings.

The weakness of France and the Iberian peninsula

The Iberian peninsula seemed at this point to be excluded from the struggle for power. Dazzled by Brazilian gold, Portugal was still idly pursuing dreams of wealth, which rested on trade policies that would soon be revealed as ruinous for her manufacturing industries and encouraging her total dependence on England. In Spain, ruled by the weak and sickly Carlos II, the crisis of economic and moral identity had intensified. Military evidence of this was seen in the loss of part of the Netherlands – the Protestant provinces – with the Treaty of Westphalia (1648) and the French invasion of Catalonia (1694). There was a partial recovery of some of these lost territories with the Treaty of Rijswijk (1697), but since Philip of Bourbon, Duke of Anjou and grandson of Louis XIV, became king of Spain at the beginning of the 18th century, there remained a measure of subjection to France. In this atmosphere of vanished former grandeur the Baroque style, so in tune with the Spanish soul, developed and assumed characteristics of a peculiarly national kind, described by the adjective "Churrigueresque" – of historical interest but little significance

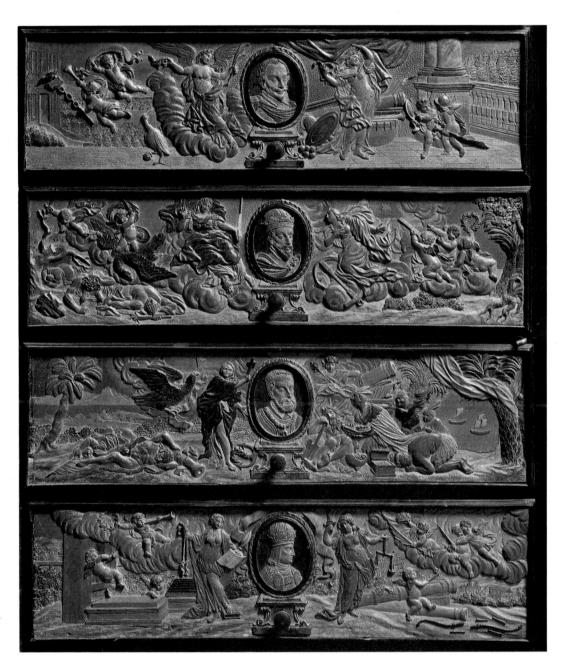

as far as the rest of Europe was concerned.

The cracks that were beginning to appear in the military and political structure of France had as yet no effect on the grandeur of this nation, which had imposed its language and canons of taste on the rest of Europe and which, through its diplomatic skills, had succeeded in controlling the continental situation. But the revocation of the Edict of Nantes (1685) and the subsequent emigration of the industrious Huguenots, the war against the League of Augsburg – which was accompanied by a terrible famine, the grand alliance of The Hague in which England, Holland, Austria and Prussia joined together against France (1701), the poorly supported colonial system and the excessive religious

BELOW AND FACING PAGE: details of reliefs showing historical and exotic scenes, carved on the interior of the cupboard doors of the cabinet made by Haberstumf for the Emperor Charles VI. The reliefs are the one concession to 18th-century taste in a piece otherwise completely Baroque in style. Österreichisches Museum für angewandte Kunst, Vienna.

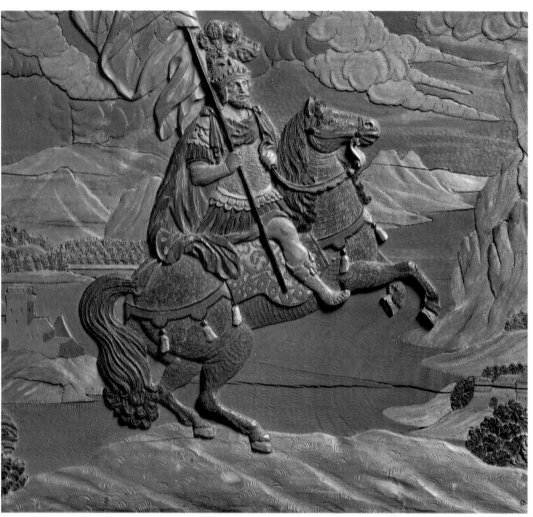

and canons of style soon began to emanate from England that were almost untouched by the fever of Baroque. Thus in the history of European interior decor the influence of England alternated with, and indeed replaced, that of France.

There is little to add about Italy in this context, since for religious, political and military reasons it was no longer in a position to play a leading role in the cultural sphere. For some time the artistic hegemony that had enabled it to impose Italian taste on the whole of Europe during the Renaissance had become a thing of the past. It is true that Italy's painters and architects, like her craftsmen, carvers and decorators, were still among the most gifted and ingenious, but their abilities were seen at their best and received the greatest recognition when they were working abroad.

This brief but necessary summary of the general situation in the countries of Eastern and Western Europe at the end of the 17th century clarifies why it was that during the 17th-century England and France alone were in a position to impose new canons of style on the rest of Europe in the fields of architecture and furnishing, which influenced the ideas of furniture-makers and decorators alike. Of lesser significance, but not to be overlooked, were the artistic developments in German-speaking countries and the Netherlands, which exercised an influence on the areas to the north and east, and at the beginning of the 18th century some elements of the Dutch style enjoyed a late flowering even in England.

intolerance of the Sun King in the last years of his life had destabilized the foundations of a colossus that continued to exert an intellectual dominance over a continent whose constituent countries remained politically independent. Educated circles in France took this process as an opportunity to reconsider certain attitudes. At the same time there developed in France preferences in taste, and splendour and magnificence that were no longer considered to be the criteria of style. However, this sea-change, already evident in France in the

opening years of the 18th century, had not yet spread beyond her boundaries, and in these years the splendour of the French Baroque continued to influence the Iberian peninsula on one border and central Europe on the other, as far as the distant Slav regions.

The pre-eminence of England

England, in contrast, was poised to assume a position of colonial, commercial and maritime predominance, symbolized perhaps

by the founding in 1694 of the Bank of England. It had undergone significant constitutional changes in the years between 1625 and 1688, under Charles I, Cromwell and Charles II, concluding with the reign of James II, his deposition and the ascent to the throne in 1688 of his eldest daughter, Mary, the consort of the Stadtholder of Holland, William II of Orange, who became King William III of England. London replaced Amsterdam as the centre of a variety of interests, including trade between Europe and overseas colonies,

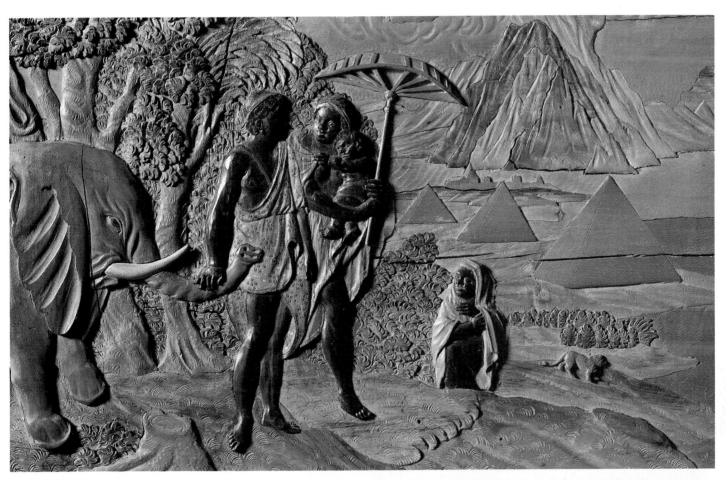

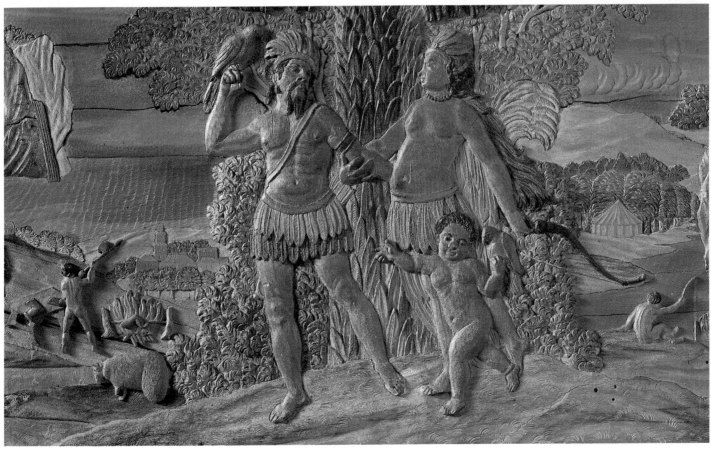

German furniture: late Baroque and early Rococo

Historical profile

The Treaty of Westphalia (1648), which marked the end of the Thirty Years War, also effectively signalled the dismemberment of what remained of the Holy Roman Empire on German soil, even though the imperial crown was still formally in the hands of the house of Habsburg. The subdivision of the German nation into approximately 350 small sovereign states resulted in different fashions developing at the various courts. However, these fashions did not spread beyond the immediate confines of each court, unlike in France, where a style that had started in Paris would

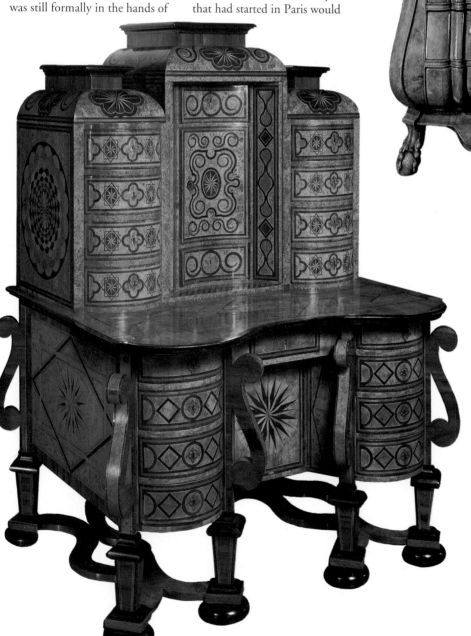

percolate throughout the whole of the country.

The turn of the century, however, saw the consolidation of Brandenburg-Prussian hegemony in the north, thanks to the Elector Frederick William of Hohenzollern and his son Frederick, who, with the consent of the emperor, crowned himself King of Prussia (18 January 1701). In the south the threat represented by Turkey was dispelled by the Treaty of Karlowitz (1699), by which Turkey had to cede Hungary and parts of Transylvania to Austria. Thus, the new century began with a considerable degree of Germanic power. Moreover, the Electoral Prince of Hanover had proposed himself as a candidate for the English throne, becoming King of England in 1714 as George I; and Frederick Augustus, Elector of Saxony, had become King of Poland in 1697. Thus it can be understood why, despite internal divisions, the German nation viewed its future with confidence, a confidence

FACING PAGE LEFT: *Schreibschrank* (bureau-cabinet, c. 1710) from southern Germany, of late Baroque design, supported on square-section legs tapering towards the base and joined by curved stretchers, entirely veneered with geometric design. Österreichisches Museum für angewandte Kunst, Vienna. RIGHT: commode from the Lower Rhine (c. 1710–20), with accentuated apron and ball and claw feet in the English style. Bayerisches Nationalmuseum, Munich. THIS PAGE: cupboard (c. 1720) with burr-walnut veneer, perhaps made in Frankfurt. Österreichisches Museum für angewandte Kunst, Vienna.

displayed in the magnificence of contemporary court furniture.

Brandenburg-Prussia

The scarcity of good-quality cupboards in the antiques market is an interesting indication of the importance assumed in the German courts by furniture as a symbol of wealth in the early 18th century. In fact, since the cupboard was used for domestic purposes, little finesse was applied to its production, and rather than restore a cupboard, the item would be destroyed and replaced.

Prestige pieces of furniture, to whose production the craftsman would devote all his skill and imagination, adorning them with lacquerwork or expensive inlay, included console tables, dining tables, desks, chairs, commodes, bureaux-cabinets, sideboards, sofas and long-case clocks, as well as occasional tables, games tables, screens and mirrors. Pieces such as these varied from one part of Germany to another.

At the court of Brandenburg-Prussia, English influences at first predominated. Indeed it was an English craftsman, Charles King (d. 1756), who was responsible for the exquisite carving on the furniture of Schloss Charlottenburg in Berlin. What is striking in the sinuosity of line and the decoration with flowers, foliage, fruits, animals, putti and forward-inclined female busts – signs of abundance rather than of grace – is the solidity and power of the furniture, which continued to display all the grandeur of the Baroque style while anticipating some of the decorative details of the Rococo. The carved decoration is mostly gilded, and adds a

richness to the precise detail of the structure. It may be compared to the Chinese lacquers introduced to Berlin by Gerard Dagly (b. c. 1650), which added a fine sheen to elements already well-defined aesthetically.

Saxony

In Dresden, Elector Frederick Augustus of Saxony, had ordered such a programme of building that the capital was described as a new Athens or Florence of the Elbe. It became the centre to

which artists, decorators and furniture-makers, as well as musicians and men of letters, flocked. To exalt his dual role as Electoral Prince and King of Poland, Frederick Augustus commissioned impressive buildings for his city, including the famous Zwinger

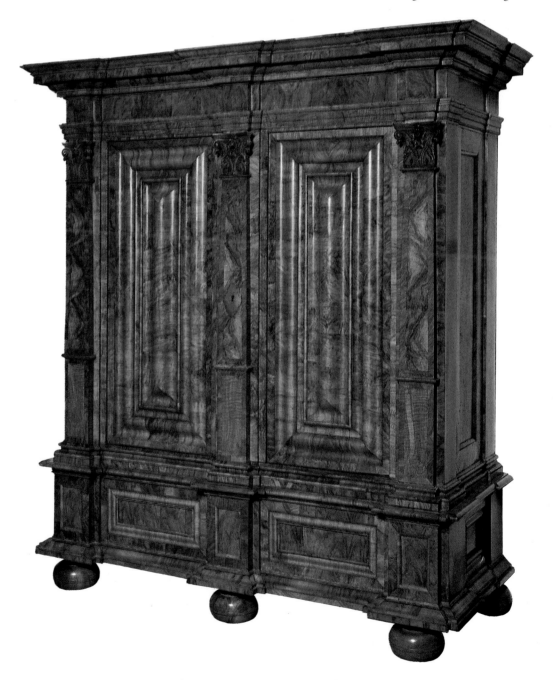

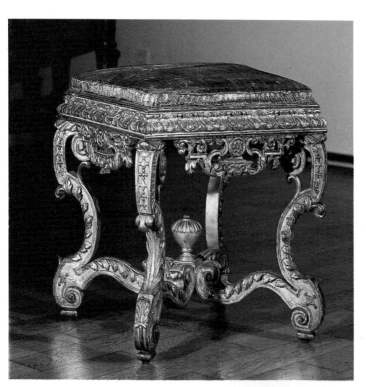

Orient, and were well suited to European tastes while still showing the Chinese influence. This was also evident in the development of the manufacture of porcelain in Saxony and in the pagoda-like structure of some of the furniture.

A piece of furniture typical of the transition from Baroque to Rococo is the bureau-cabinet, called in German a *Schreib-schrank*. English influences are readily recognizable in this class of furniture, which demonstrates the evolution of style from one of stately severity to the curvaceous lines typical of the Rococo.

The popularity of this kind of furniture also derived from the possibility it offered of inserting etched mirrors in the panels of the doors of the upper section, which achieved the effect of in-creasing the amount of light in a room. In Saxony, as in Prussia, a workshop for the production of mirrors was founded in order to avoid the use of imported mirrors, which were expensive. Much prized, too, was marquetry in woods of different colours, which were combined to depict little scenes, landscapes and geometric designs, or in ivory, metal, tortoiseshell and mother-of-pearl in the manner of Boulle.

Other regions

Furniture produced in Lower Saxony, where the principal centres were Hanover and Brunswick, displayed similar characteristics. Gradually Italian influences were replaced by English fashions, and in this area too,

constructed by Matthäus Pöppel-mann (1662–1736), which provided a splendid framework for the furniture made initially under the supervision of Michael Lindner (1679–1720).

The period during which his successor, Nicolaus Hingst (d. 1729), was active saw the transition from the late Baroque style to that of early Rococo; English influences became more evident, especially in the curvature of the legs, which assumed the cabriole form, sometimes terminating in a realistic or stylized cloven foot. Various examples of tables and chairs with these characteristics are to be found at Schloss Moritzburg, close to Dresden. Lacquerwork was very popular in Saxony too, and Martin Schnell (d. 1740), who had been a pupil of Dagly in Berlin, showed his skill in this field. The quality of his lacquers equalled those of the

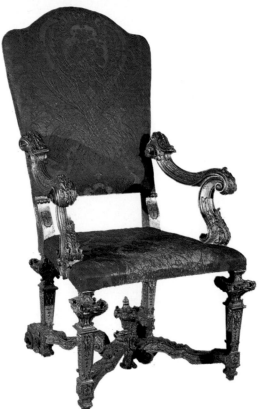

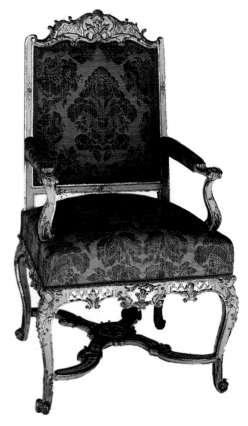

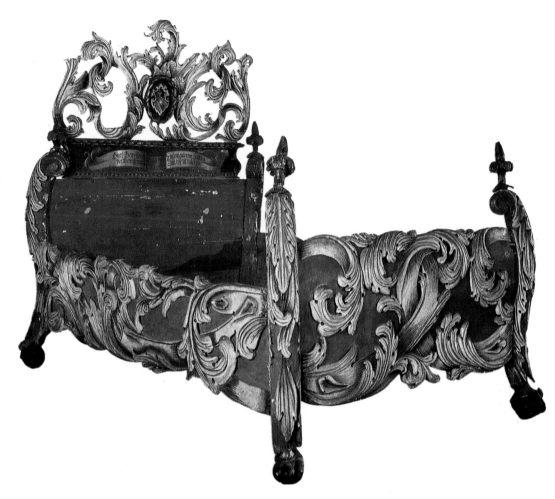

much use was made of lacquer and inlay, including *pietre dure*, as seen for example in a ponderous bureau-cabinet of 1720, inlaid with ivory, tortoiseshell, brass and *pietre dure*, now in the Herzog-Anton-Ulrich-Museum, Brunswick – one of the few pieces of furniture whose origin and date are known – and the wonderful collectors' cabinets made between 1725 and 1730 for the Schloss Salzdahlum. The exquisite craftsmanship of the marquetry on burr-walnut and the pierced gilt-bronze decoration of these pieces makes their magnificent excesses more acceptable.

The cabinet-makers of Hessen, in contrast, remained for many years attached to the Italian style of the 17th century, and, continuing a tradition which in Italy went back to the late Renaissance, made wide use of the hardstones in which the region abounded. The Florentine Francesco Mugliani was working in Kassel at the beginning of the 18th century. He produced marble tables inlaid to designs by Nicolaus Prizier (1683–1753). Sometimes a local semi-precious stone was used, whose surfaces, when cut in a particular way, resembled fantastic landscapes.

In Westphalia and the Rhineland, the chief influences in furniture production came from the Netherlands. Much use was made of carved oak, as in Flanders, and the heavy forms of the Baroque era prevailed here longer than elsewhere. More graceful pieces were produced in Cologne, thanks to the influence of nearby France, while in Düsseldorf work in the style of Boulle was very popular.

More conservative fashions prevailed in the independent and affluent cities of the Hanseatic League that lay along the coastal region of the far north. Here a wealth of cupboards could be found, rather ponderous in form and an embodiment of a solid bourgeois ideology. The persistence of a style that historically belonged to the 17th century was such that even in the 19th century cupboards were still being made in the style of the 17th, without any significant variation in the construction technique, and this has led to difficulties in dating these pieces.

Centres of production in southern Germany

The further south one goes in Germany, the less one encounters the influences of England and the Netherlands, and the more French styles prevail, as might be expected. This applies to Würzburg, Bamberg, Ansbach, Bayreuth and Franconia generally. In the Transition period between Baroque and Rococo, Ferdinand Plitzner (1678–1724) was still making heavy desks applied with exquisite Boulle-work marquetry, while the Rococo style was already evident in the slender elegance of Johann Matusch's side tables. Ansbach, where Matusch was working from 1701, developed as the centre of this new style.

The annual fair at Frankfurt played a significant role in the history of German furniture, for it was there that the cabinet-makers displayed their work, which would often be purchased by neighbouring courts. In this manner French taste spread, albeit a little belatedly, to the regions of central and southern Germany. Nearby Mainz also played an important role. Many young carpenters from the surrounding regions arrived there to seek their fortunes, even from as far away as Hungary. Mainz thus grew into an important centre for furniture-making, and furniture was purchased there for courts, monasteries and wealthy citizens alike.

The study of the statutes of the craftsmen's guilds in Mainz enables us to establish how tastes developed, for we can see that, for the examination to become a master cabinet-maker, the crafts-

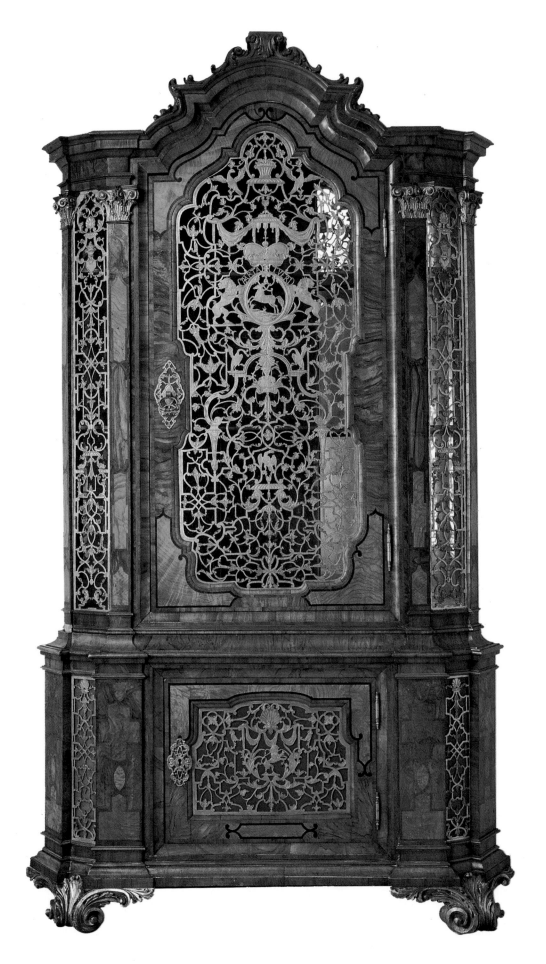

Cupboard, a collector's cabinet (1725–30), veneered in burr-walnut and inlaid, with delicate pierced gilt bronze decoration to the doors; made for the Schloss Salzdahlum, it bears the arms of the Duke of Brunswick. Museum für Kunst und Gewerbe, Hamburg.

man had to produce not a cupboard but a *Schreibschrank* (writing desk). The enormous success enjoyed by this type of furniture was born of the requirement of the wealthy bourgeoisie to combine in one piece both a desk and a number of drawers in which to keep paper and documents. The requirements of a bourgeois clientele also resulted in the further development of the commode – a type of furniture introduced into Germany relatively late – from a piece of furniture for storing clothes into a desk, by means of the introduction of a recessed space below the surface. The same duty was fulfilled by the desk with a folding top above the drawers, which was in widespread use about 1730.

Among the free cities of Germany, the only one to maintain a high quality in its cabinet-making during the course of the 18th century was Augsburg, a city that in the 17th century had already achieved fame for the manufacture of silver furniture, which was even exported to Russia and Sweden. Those who made this furniture, which was also sought after as an investment, were specialized craftsmen called *silberkistler*.

As tastes changed, they applied their skill to working with materials other than silver: ivory, amber, tortoiseshell and semi-precious stones were used to fashion magnificent inlay work. On some examples they applied coloured engravings and porcelain plaques, thus starting a fashion that was widespread throughout Europe by the end of the 18th century and which continued into the 19th. In Augsburg, too, pattern books for carving and cabinet-making were printed. These books used some French

Austrian cupboard (1730–40), lacquered in walnut, maple and rosewood, of late Baroque form, with curved front and shaped lateral pillars, and decorated with marquetry, the style of which prefigures the Rococo. Österreichisches Museum für angewandte Kunst, Vienna.

examples, and found their way from Augsburg to the rest of Germany.

Bavarian furniture

Bavaria was the region in which elegant furniture was most appreciated, thanks to the enterprise of the Elector, Maximilian II Emanuel (1662–1726), who in 1714 regained the lands that he had lost on account of his anti-Austrian stance. He brought back the sculptor Gullielmus de Grof (1680–1742) with him from the Netherlands, where he had been governor and many young craftsmen from exile in France, who were selected for their skill. He also began to send the most deserving of the young artists he retained to study in Paris. Joseph Effner (1687–1745) was one of these, the son of a court gardener. Others were the Bavarian Johann Adam Pichler, who remained in Paris for six years, and the Walloon François de Cuvilliés (1695–1768). Effner and Pichler were responsible for introducing to the court in Munich a late French Baroque style, which, while quickly assuming Bavarian characteristics, equalled the Parisian style in sumptuous elegance. Cuvilliés maintained this quality and perhaps even surpassed it, but he adapted the style to conform with the new precepts of *rocaille* decoration. It was in large measure due to Cuvilliés that Munich is considered to be the home of German Rococo. He was a dwarf who had begun his career as a court jester, and who from 1738 published a number of patterns of *rocaille* decoration which became widely known.

The transition from Baroque to Rococo was obviously a grad-

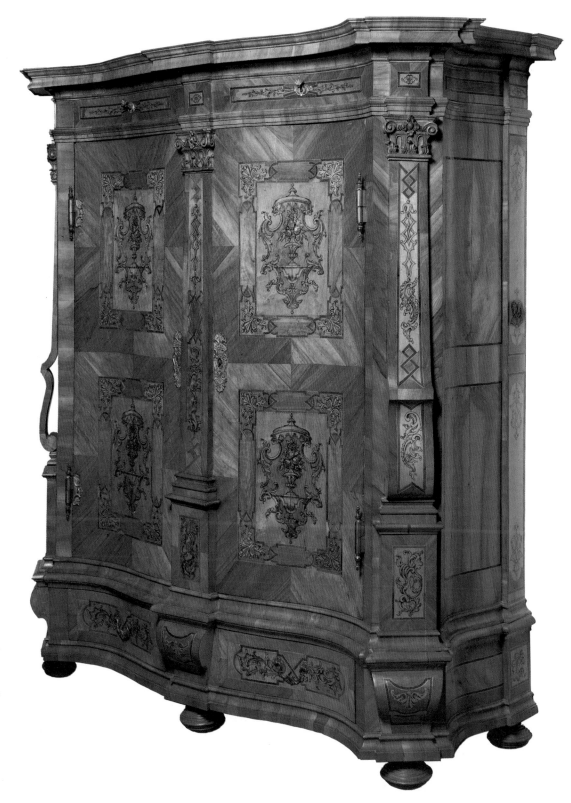

ual process. A group of eight consoles, designed by Effner and made by Pichler between 1720 and 1730, illustrate the evolution from the austere and pompous forms of the late Baroque to the more fluid, though still ponderous, lines of *rocaille*. In the early

examples, the legs are of tapering, square-section form and are embellished at their junction with the frieze, which supports the surface of the table, with Italianate acanthus leaves. Later on, herms took over this role of joining the legs to the surface; these

were initially flat, but in later examples had a raised profile. At the end of the period there is no anthropomorphic decoration to the legs at all, which retain an S-shaped line and in the latest examples are encrusted with scrolls, foliage and arabesques.

THIS PAGE: a massive library table (c. 1735), shown closed and partially open, veneered in walnut and maple, with four pull-out chairs fitted within the body of the piece. Österreichisches Museum für angewandte Kunst, Vienna. FACING PAGE: south German bureau-cabinet (c. 1740), in walnut. The door of the central, concave portion of the cabinet is flanked on either side by a column of four convex drawers, and inlaid in pewter with the figure of a huntsman, a motif that recurs on the fall front of the bureau, supported on four cabriole legs joined by a flat rectangular stretcher. Antiques trade.

A type of furniture that appeared in Bavaria around the third decade of the 18th century is the commode, usually veneered in burr-walnut and inlaid with geometric designs in ebony, mahogany, birch or fruitwood. The early examples have three drawers supported on bun feet. At court the commode was an item of furniture to be found in private apartments, not in reception rooms.

Austrian furniture

The victory over the Turks and the advantages gained at France's expense during the War of the Spanish Succession established Austria, at the beginning of the 18th century, in the role of the great power of the Danube region. The increased prestige of the emperor was reflected at the Viennese court, which was frequented by a refined and extremely wealthy aristocracy. Under Leopold I of Habsburg (1657–1705), and then under his successors Joseph I (1705–11), Charles VI (1711–40) and Maria

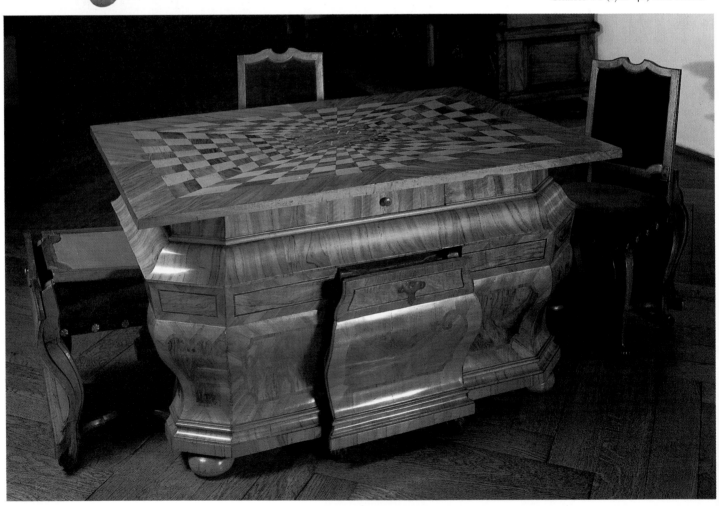

Theresa (1740–80), Vienna became the focus of art and elegance in central Europe. Neither wars nor diplomatic and dynastic disputes could halt this fever of activity, which gave the Austrian capital a wealth of magnificent buildings sumptuously furnished, so that the city could even have been considered a distant rival of Paris. The Viennese, however, avoided the ostentation of power and the excessive pomposity that were typical of the Parisian court throughout the century.

The Austrian Rococo style, which began to develop at the beginning of the 18th century, is a style that maintains a sense of control in its frivolity, so that its effect is of course less free, less casual and more contrived than that of its Parisian contemporary. In addition, most of Austria's artisans came from Italy, and were still influenced by the strict and formal principles of that country's Mannerist past. Simultaneously, more sensual and oriental influences arrived from Bohemia and Moravia. These different tendencies combined to create a style that united soberness of structure with an excess of applied decoration, and it is precisely this contradiction that lends a fascination to Austrian furniture of the 18th century.

Among the most highly prized furniture were side tables, where the carvers' imagination was permitted free rein, allowing them to adapt the typically Italian exuberance of foliate decoration to contemporary taste. Also popular were bureau-cabinets, inlaid cupboards and, soon, thanks to the blossoming of Bohemia's glass manufacturing industry, a profusion of mirrors, either framed or used to adorn entire walls.

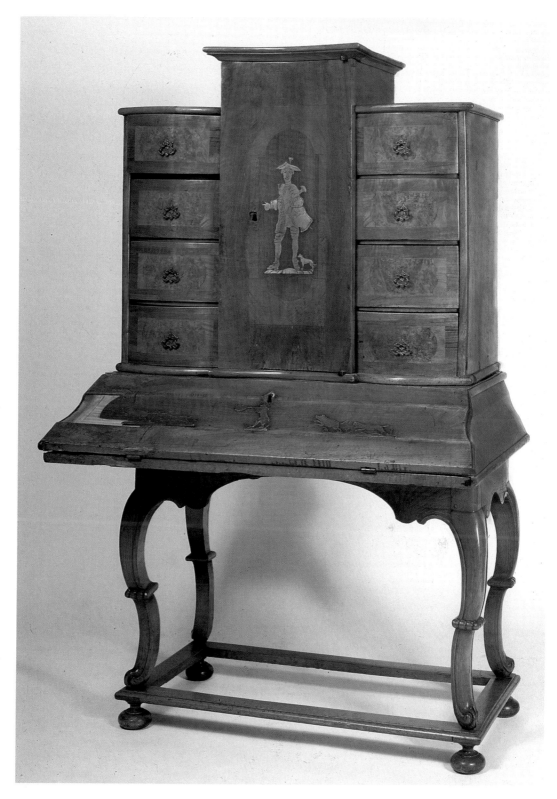

A type of furniture quite often encountered in the antiques trade is the *Maria Theresa bureau.* This is a type of bureau-cabinet without mirrors and divided into three parts: the lower section of the body, comprising an ordinary commode supported on bun feet, has a small cupboard with a lid fixed to it, itself surmounted by a cabinet fitted with small drawers whose central portion is slightly raised. The burr-walnut veneer is inlaid with bordered squares and, in the finest and most elegant examples, intricately veneered with a marquetry of lighter woods depicting figures, landscapes, geometric motifs and interlaced with classic borders.

The spread of Boulle-work in Germany

The complex marquetry technique that has taken its name from André-Charles Boulle (1642–1732) and was perfected and made fashionable by him produced wonderful contrasts of colours in the materials employed – tortoiseshell, ivory, pewter and brass bordered by ebony. The technique fascinated German cabinet-makers, too, and they used it with enthusiasm and skill, particularly in the production of court furniture. The Bavarian court enjoyed a privilege that others did not in that the Elector Maximilian II Emanuel had spent a period of exile in France, where he had had the opportunity of knowing the work of the French cabinet-maker and commissioning a number of cabinets and commodes directly from Parisian workshops. Maximilian returned from exile to Bavaria, where he saw to it that promising young artists received the best possible education, and to this end he sent many of them to Paris. However, one of the greatest German "experts" in the Boulle technique, Martin Schuhmacher, was working in the margravate of Ansbach. Little is known about his life, but he was a pupil of Johann Matusch, and one wonderful example can be attributed to him with certainty: this piece consisted of two sections and has a secret drawer in which was found a slip of paper inscribed: "*Ebéniste* Martin Schuhmacher. Fecit in Ansbach 1736". Although Schuhmacher also appears in court documents of the years 1720–80, his name is principally linked with this one example of his work.

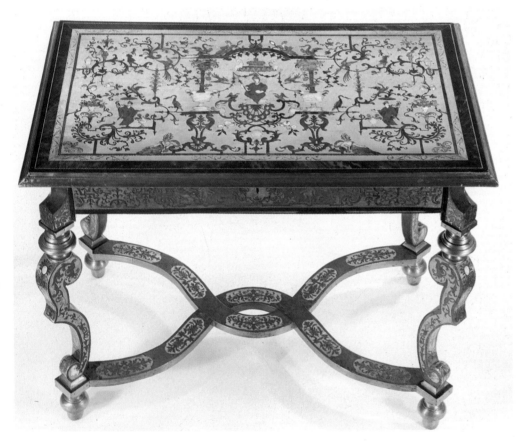

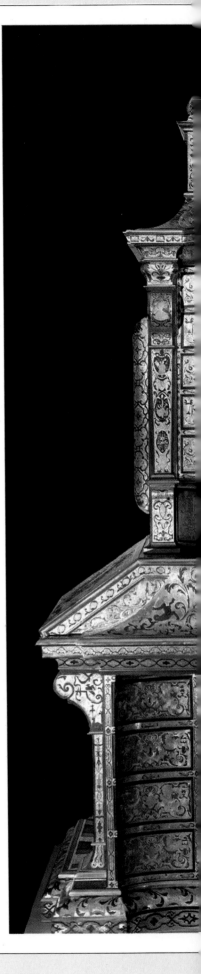

ABOVE: early 18th-century German writing table applied with marquetry in the manner of Boulle: it stands on S-shaped legs still linked by stretchers but of wavy outline, which marks the transition from Baroque to Rococo. Museum für Kunsthandwerk, Frankfurt. CENTRE: *Schreibschrank* or bureau-cabinet (c. 1700) made for the Elector Maximilian II Emanuel of Bavaria and attributed to Johann Puchweiser (d. 1744), who came to Munich from Vienna. It is veneered in Boulle-work marquetry in tortoiseshell, brass and pewter. Bayerisches Nationalmuseum, Munich. FACING PAGE, ABOVE: commode with cabinet superstructure, by Martin Schuhmacher; the commode below is a cupboard with four mirrored doors, surmounted in the centre by a clock and decorated with Boulle-work marquetry. Residenz, Ansbach. FACING PAGE, BELOW: detail of the inlay on a south German commode (c. 1730). Bayerisches Nationalmuseum, Munich.

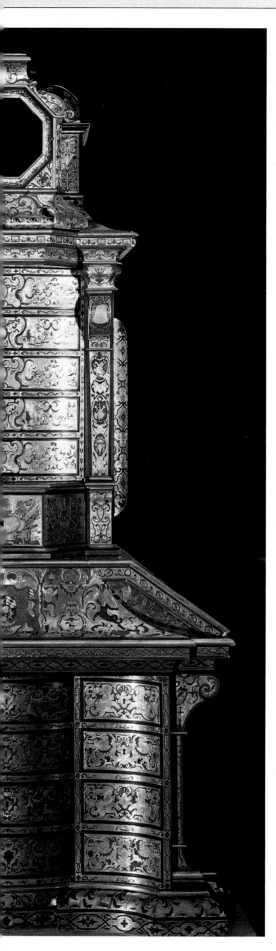

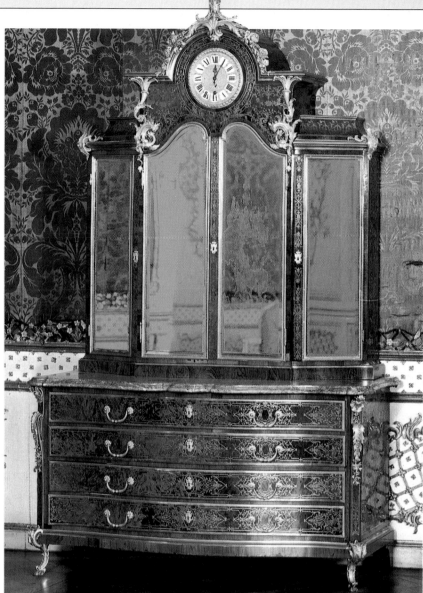

German furniture: from Rococo to Neoclassicism

Introduction

Rococo found its purest form almost exclusively in France and Germany, and the extent to which the style developed in the various parts of Germany depended on the strength of the relationship – be it one of friendship or emulation – with its French neighbour. Whereas Baroque furniture was displayed as a status symbol, Rococo furniture was something to enjoy and share with an intimate group of like-minded friends.

The first trend, which in a broad sense may be described as ideological, was the concept of integrating the furniture with the panelling of the rooms: the furniture needed to blend into the wooden panelling which was typically used to clad the walls of the rooms of the finest houses of the period. In order to achieve this effect, the furniture was made "flat", light and sinuous in line, and seemed to cling to the walls like a climbing plant.

This aspect of the fashion corresponds to the *rocaille* decoration which first appeared as a device in the countless artificial grottoes that sprang up in the gardens of the period, providing a retreat for meditation or for lovers' trysts. The word *rocaille* derives from *roc* ("rock") and *coquille* ("shell"), and refers to the mixture of mortar, pebbles and shells which was used to decorate these man-made caverns. The fashion for this type of "natural artifice" spread even to the decoration of the severe abstract architecture of internal apartments: there, surrounded by a cocoon of artificial branches, imitation foliage, flowers and birds suspended mid-flight and man-

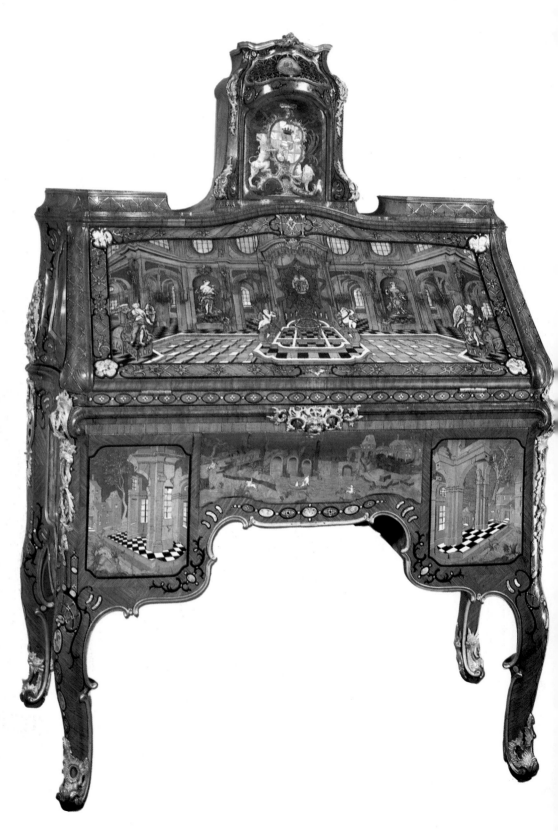

made skies evoked by mirrors, one could enjoy the sweet illusion of nature tamed in submission to man's whims.

Such a concept inevitably meant abandoning the straight lines, precise carving and clear divisions. The supports of console tables from this period cling to the walls in gentle curves, the façades of bureau-cabinets follow the curves of the wall-panelling, mirror frames blend into the plasterwork of the walls, the leg-joints of sofas and consoles melt into the decoration of the frame, while gilt bronze candelabra take on the appearance of bouquets of embalmed foliage.

The typically German differentiation between *bandelwerk*, a decorative device of intertwined ribbons and *laubwerk*, decoration in the form of acanthus leaves, became increasingly meaningless. There are certainly examples of the period that combine both types of decoration, and in some pieces they are even superimposed on one another. Decorative devices belonging to a tradition that dated back to the Renaissance were given new roles. Thus, for example, the traditional Renaissance shell motif developed a new form, in some cases acquiring the shape of a bat's wing. The original *rocaille* was enriched with a wealth of plant and animal forms and became enveloped in a mass of sinuous lines, bearing no resemblance at all to reality.

Only monarchs and the aristocracy could afford to adopt the new fashions and decorate their houses in the Rococo style. The middle classes had to be content with furniture in which the new style was barely perceived. This explains why one only sees pieces of the highest quality today; it is these examples alone that can

truly be described as Rococo furniture, and they appear but rarely on the art market. It was not until the second half of the 18th century that the middle classes became influential. In this period craftsmen started to work on their own account, without specific commissions, and they produced pieces of greater simplicity

for a less wealthy clientele. This was one reason for the swift rise to popularity of the more elegant but less expensive Neoclassical furniture.

Even at court or in the houses of the nobility a distinction was made between furniture for reception rooms and that for use in private quarters. The first cate-

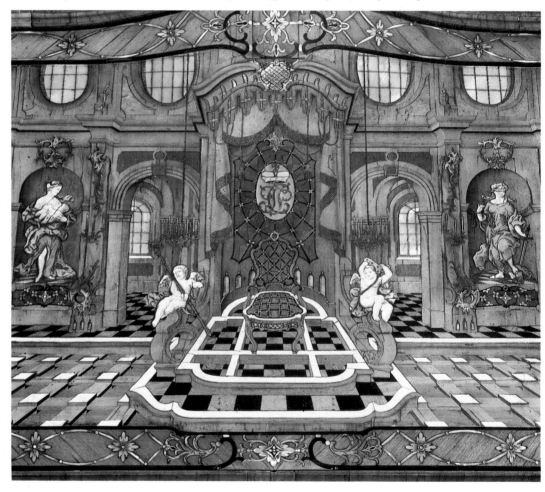

FACING PAGE: a drop-front writing desk (c 1765) made for the Prince Bishop Johann Philip von Waldersdorff, Elector of Trier, by Abraham Roentgen in his workshop at Neuwied; veneered with figures and geometric designs in ivory, silver, mother-of-pearl, ebony and other fine woods, the secretaire is fitted with compartments which open or slide out, thus maximizing the use of available space. ABOVE: detail of the marquetry, showing an architectural perspective which adorns the flap. Rijksmuseum, Amsterdam.

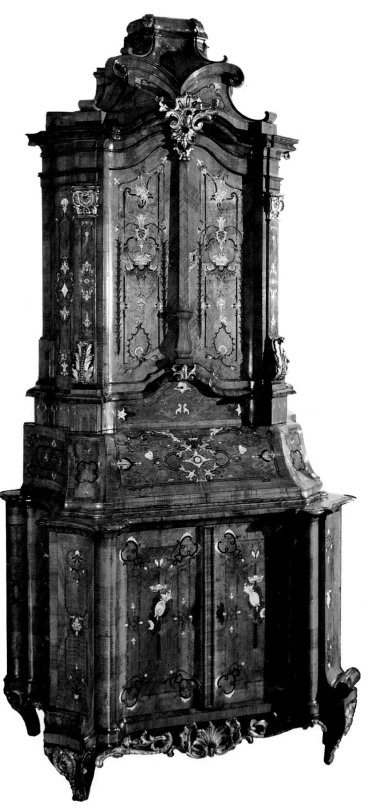

erned interior furnishings during the Baroque period was thus reversed: with one or two exceptions the finest and most expensive furniture was now reserved for the private apartments. A more "feminine" mood prevailed in interior furnishing.

Even at the zenith of the Rococo period there were considerable differences between north and south Germany. In the north, for example, cabinet-makers concentrated their skills on *bandelwerk* inlay, while in the south they preferred *laubwerk* carving. This was because in the north the influence of the Dutch cabinet-makers was largely prevalent, while in the south talented Venetian carvers ensured the diffusion of the Italian decorative style. In the west the influence of French taste prevailed, while in the Electorate of Hanover, home of the English kings George I and George II, the Rococo style assumed English traits. In the free cities of the Hanseatic League, where commissions came from the solid bourgeoisie, a style reminiscent of the 17th century still dominated, and the same was true of Nuremberg and Frankfurt, where serpentine cupboards were still popular and influenced the fashion in other types of furniture.

Prussian cabinet-makers

The Prussia of Frederick the Great (1712–86) was one of the regions of Germany most receptive to the Rococo style. It is worth noting the King's direct influence on the development of a style (Friderician Rococo) of great elegance and simplicity to which he gave his name. He

spared no expense in seeking advice, both stylistic an technical, for the craftsmen employed to furnish or restore his palaces in Berlin (Charlottenburg, Potsdam and Monbijou). Frederick's direct intervention and his impatience so upset one of his most skilled workers, Johann August Nahl (1710–85), that he fled to Strasbourg in 1746. He was replaced by the Hoppenhaupt brothers, Johann Michael (1709–69) and Johann Christian (1719–86), who quickly rose to international fame and exported furniture to Russia and Sweden.

The Rococo style of Nahl and of the elder Hoppenhaupt brother was characterized by an abundance of carved decoration, trelliswork, irregular friezes of gilt wood which hang like wet seaweed, and shells, which expand into coral-like shapes or fretted waterlilies. Sometimes the carving covers the whole surface of the piece of furniture, sometimes it is confined to one or two areas of the exceptionally elegant veneer. This veneer was achieved by the use of different grains cut from the same wood, which were then applied to form chequerboard or herringbone patterns. On some examples the carving surrounds the handles or other fittings in gilt bronze, which were produced in his Potsdam workshop by the sculptor Johann Melchior Kambli (1718–83). An expert in Boulle-work as well, Kambli was responsible for magnificent commodes inlaid with red tortoiseshell and gilt bronze or mother-of-pearl and silver, for the palace of Sanssouci at Potsdam. These pieces were made during the period following the Seven Years War (1756–63), which had strengthened Fred-

gory included console tables, sofas, large mirrors, desks and bureau-cabinets, the second small desks, work and games tables, commodes, *guéridons*, reading desks, fire-screens and, of course, beds. The last were smaller during the Rococo period and were

often placed *à la polonaise*, i.e. with one side against the wall, or in a niche enclosed during the day behind a curtain. In short, everything was designed to give an impression of intimacy, and the reception rooms were merely a prelude. The principle that gov-

erick's power and prestige. He now wished to surround himself with furniture that would reflect the status of an enlightened ruler and of a state whose star was rising.

Meanwhile, however, the bizarre lines of the Rococo gradually gave way to a more naturalistic style, which already anticipated the arrival of Neoclassicism. Apart from Johann Christian Hoppenhaupt, the Spindler brothers from Bayreuth – Johann Friedrich (1726– post 1799) and Heinrich Wilhelm (1738–post 1799) – were now also working for the Prussian crown. Working together with Kambli, they produced furniture of an impressive splendour for Sanssouci.

Central and northern Germany

Brunswick in Lower Saxony was an important centre for furniture-making, and here too the furniture was destined for an emergent and well-to-do bourgeois clientele. Once again, the styles of the 17th century persisted, and the Rococo was only evident in one or two of the decorative elements – in the curved legs of chairs, small tables and sofas, and in the round-bellied form of the lower body of bureau-cabinets. However, all the furniture made there was of a particularly high quality; even today Brunswick furniture is synonymous with refined taste. Typical Brunswick furniture included *Corallene Coffeetischblätter* – small coffee tables whose surface was inlaid with small glass beads of different colours, arranged to produce a bright and harmonious

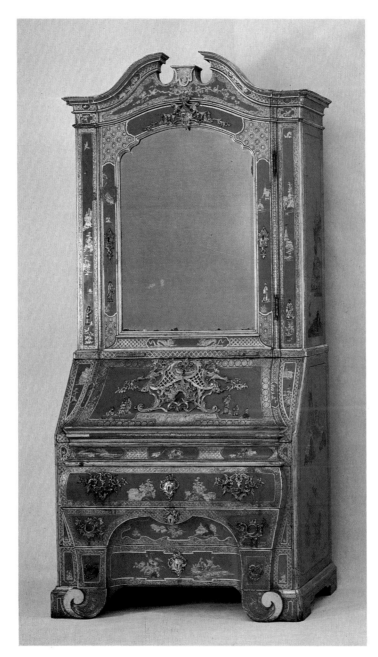

pattern – which were produced by Johann Michael von Selow between 1755 and 1767. Tables of this kind are difficult to find nowadays.

The Rococo furniture found in the countless palaces of neighbouring Westphalia is more

pompous and splendid. Oak was frequently used – evidence of the influence of the Netherlands, where this wood was popular.

In Saxony furniture had a courtly quality. Saxony's capital, Dresden, was, as we have already seen, a magnet for artists and

master craftsmen during the reigns of Augustus I (1694–1733) and Augustus II (1733–63), rulers in whom was vested from 1697 to 1763 the dual role of Elector and King of Poland. However, very few examples remain of the intensive production of furniture for the court in this period. During the Seven Years War Schloss Hubertusburg, whose furnishings had only recently been completed, was destroyed by Prussian troops. Other palaces were looted or burnt. A lot of furniture was then dispersed by public sale or later destroyed by bombing during World War II. The surviving pieces have almost all been assembled in the palaces at Pillnitz and Moritzburg, and are evidence of the very high quality of furniture produced in Saxony, from carved pieces to more delicate examples of cabinet-making.

Also to be noted is the perfection of the lacquerwork and the wonderful bronze ornamentation, which in many cases alone suffice to lend prestige to a piece of furniture. An example of this is the valuable green lacquered bureau-cabinet with *chinoiserie* decoration that was made in the mid-18th century and is preserved at the Museum für Kunsthandwerk in Dresden. The gilt bronze handles and mounts have the appearance of the finest lace, in perfect harmony with the other decorations in gilt gesso. There is a central recess in the two lower drawers of this piece – a typical feature of bureau-cabinets made in Saxony – for desk use. Rococo furniture produced in Dresden often has mirrors inserted into panels in the furniture and various veneers of rosewood and tulipwood. However such pieces do not even begin to compare

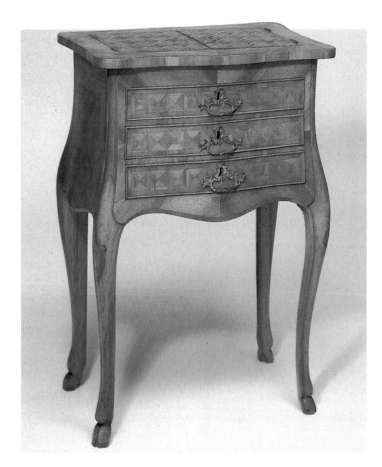

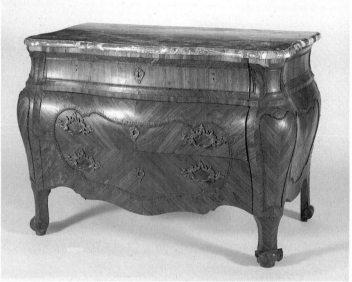

THIS PAGE: four mid-18th-century examples of south German furniture in a restrained Rococo style. LEFT, ABOVE: *chiffonière*, fitted with three small drawers and supported on cabriole legs terminating in cloven feet. LEFT, BELOW: small table with a slight apron front which continues the pleasing and graceful lines of the cabriole legs. Schloss Pommersfelden. RIGHT, ABOVE: *bombé* commode veneered in kingwood in a symmetrical pattern, with a marble top and bronze handles and lock mountings. RIGHT, BELOW: bureau with drop-flap and serpentine front, supported on short cabriole legs, veneered with marquetry in walnut and burr-birch. Both antiques trade.

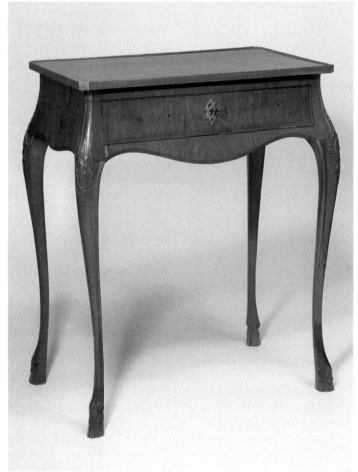

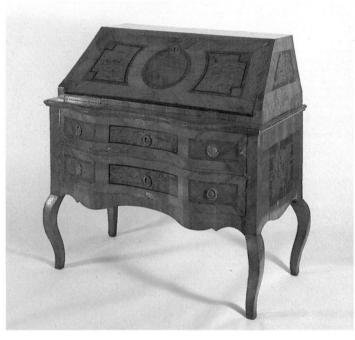

FACING PAGE: Johann Heinrich Tischbein the Elder (1722–89), *Portrait of the artist with his wife at the spinet.* The middle-class interior is decorated in the Rococo style. Staatliche Museen, Stiftung Preussischer Kulturbesitz, Berlin.

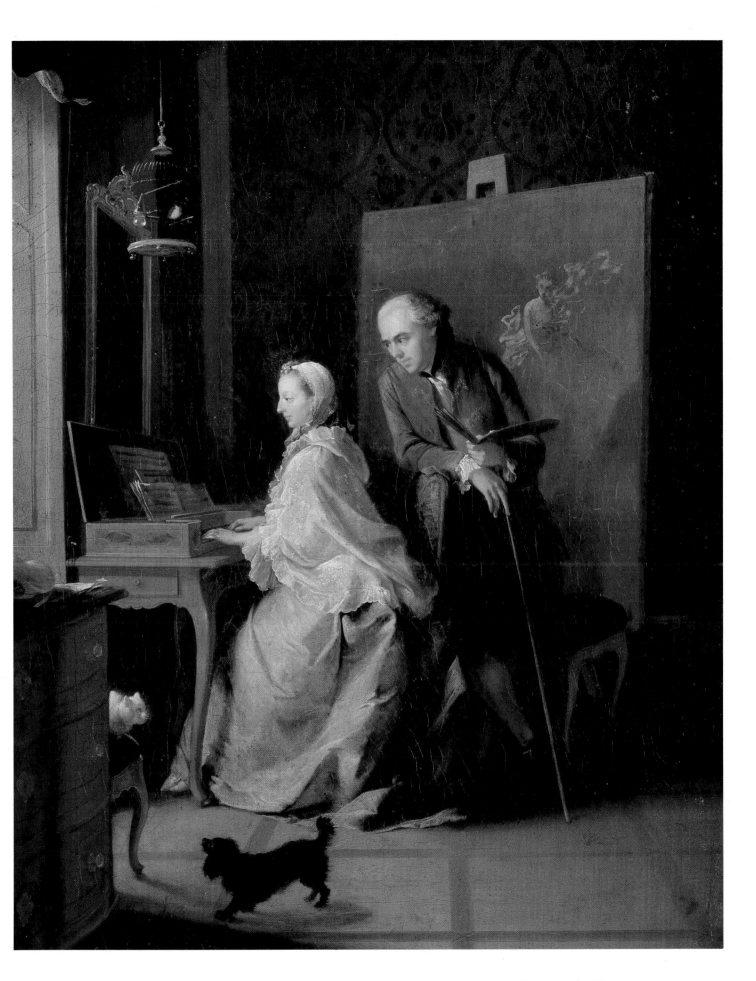

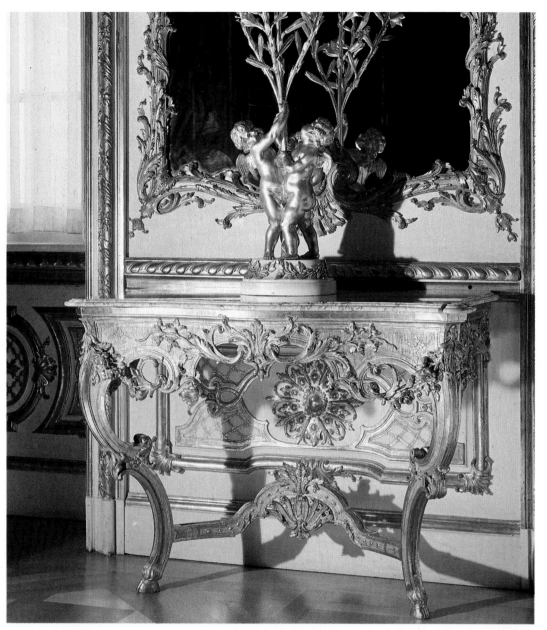

In Franconia, Bayreuth developed a highly individual version of the Rococo style, for which the Margravine Wilhelmina, sister of Frederick the Great of Prussia and an expert in oriental lacquers, was partly responsible. Typical of Bayreuth's production were chairs with caned backs. After the Margravine's death many of the cabinet-makers and carvers whom she had employed were summoned to Berlin by Frederick the Great to work at Sanssouci. Among these, as mentioned already in the discussion of Prussia, were the Spindler brothers, who were among the finest cabinet-makers of the German Rococo.

Some of the finest examples of German Rococo are found in the Residenz at Ansbach, the capital of central Franconia. Paul Amadeus Biarelle (well-known at Ansbach between 1737 and 1753) and Johann Georg Wörflein (active in Ansbach in 1736) were famous for their carving, while Martin Schuhmacher (1695–81) and Samuel Erdmann Beyer were noted cabinet-makers.

with the amazing and extravagantly exaggerated pieces produced by Johann Heinrich Balthasar Sang (b. 1726) and Thomas Körblein (c. 1713–53), who both made furniture for Karl I, Duke of Brunswick, around the middle of the century entirely composed of cut glass mounted on the furniture carcass.

Moving westwards, Thuringia produced furniture for the upper middle classes, with exquisite figured marquetry in woods of different colours. On pieces made in Erfurt inlaid inscriptions accompany the scenes as a sort of caption. The lacquerwork is generally applied to a base of bay oak.

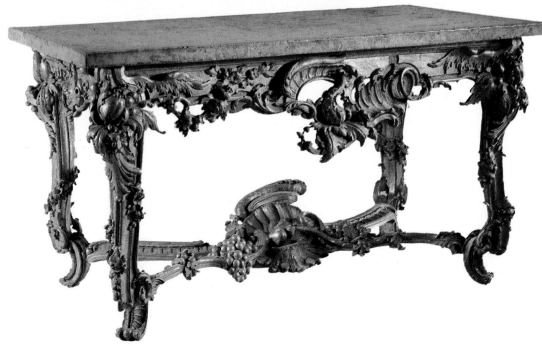

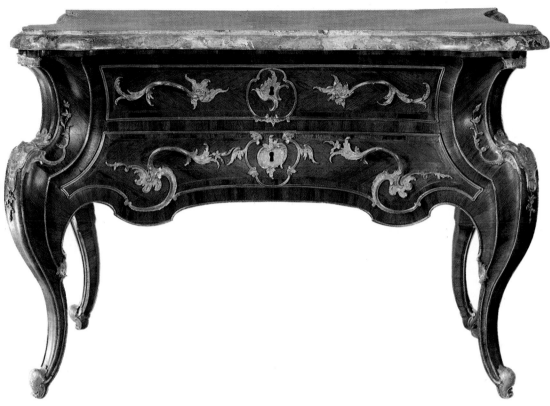

longcase clock – all exceptionally fine specimens of cabinet-making, adorned with inlays of brass, ivory, mother-of-pearl and applied with gilt bronze decoration.

In the Thurn und Taxis Residenz in Frankfurt there are magnificent examples of Rococo furniture in the Chinese style, and in Mannheim wonderful specimens of lacquered furniture from the 1770s. In general, the whole region of the Palatinate is noted for its good-quality furniture, some of which was sold for export, and which was mostly executed in fine woods.

Würzburg and Bamberg in Lower Franconia, united under the Prince-Bishop Friedrich Karl von Schönborn (1674–1746), produced expensive examples of a Rococo style that succeeded in combining the influences of Paris and Vienna. The furniture at the Residenz in Würzburg in particular shows the transition of style from Rococo to the Neoclassical. A number of workshops in Würzburg attracted considerable fame, but possibly the finest Rococo furniture was that produced by Carl Maximilian Mattern (d. 1770), although in his lifetime his talent went unrecognized and he died in poverty. Among examples of his work preserved in the Würzburg Residenz several merit particular mention: a desk with small drawers above, a writing cabinet on a console table, and a

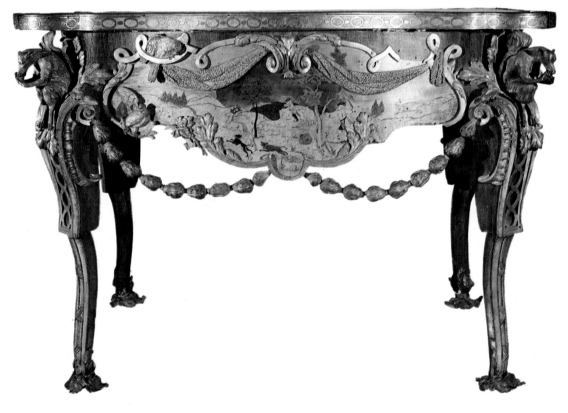

FACING PAGE, ABOVE: Bavarian console table (1730) showing the influence of the French Rococo style, brought to Bavaria by François de Cuvilliés, who returned to Munich from Paris in 1725. Residenzmuseum, Munich. BELOW: gilt-wood console table (c. 1745), made to a design by Johann August Nahl for the palace at Potsdam. Charlottenburg, Berlin. THIS PAGE, TOP: Commode (c. 1745), veneered in rosewood, also made for the castle at Potsdam to a design by Johann Michael II Hoppen-

haupt; the gilt bronze decorations are by C. Kelly. Charlottenburg, Berlin. ABOVE: desk (c. 1769), with marquetry by Heinrich Wilhelm Spindler and applied silver decoration by Johann Melchior Kambli, made for Frederick the Great of Prussia. Neues Palais, Potsdam-Sanssouci.

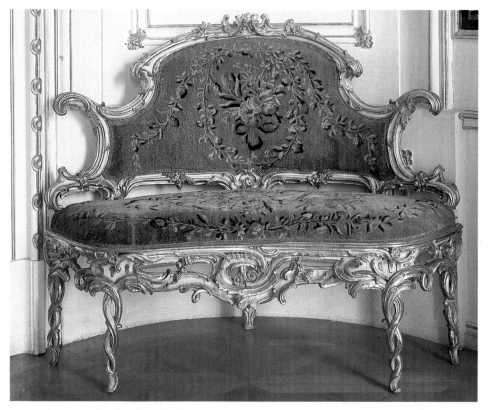

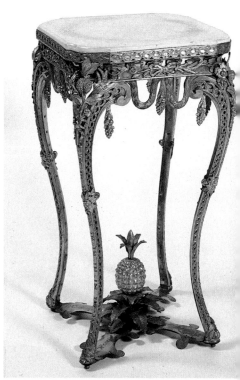

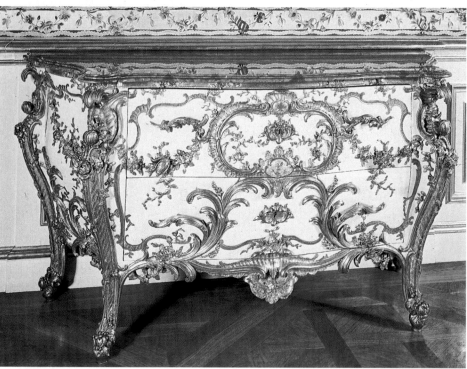

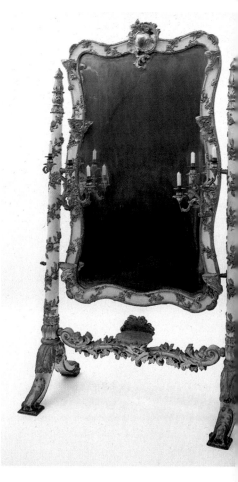

ABOVE, LEFT: corner sofa (1763), in full-blown Rococo style, with Savonnerie-style upholstery, by Johann Köhler. Residenz, Würzburg. BELOW, LEFT: commode (1761) in carved gilt wood on a white ground, by Johann Adam Pichler to a design by François Cuvilliés. Residenzmuseum, Munich. ABOVE, RIGHT: small table (1769), in gilt bronze, with a marble top, signed by Wilhelm Gottlieb Martitz. Österreichisches Museum für angewandte Kunst, Vienna. BELOW, RIGHT: Austrian dressing mirror (c. 1750), in white lacquered and gilt-wood. Bundessammlung alter Stilmöbel, Vienna. FACING PAGE: the so-called *Vieux-lacque-Saal* in Schloss Schönbrunn, Vienna. The French architect Isidor Carneval incorporated antique lacquer panels with a black ground from the Far East into the opulent Rococo decor of the room (1770).

Bavarian and Austrian Rococo

As has already been discussed, the German-speaking regions where the art of furniture-making reached its apogee were Bavaria and Austria. We shall now consider how the spirit of the Rococo developed in these countries in the mid-18th century. Had it not been for its obvious Parisian roots, this style could easily seem as if it had developed with the courts of Munich and Vienna specially in mind.

In Munich Cuvilliés's word reigned supreme, and countless carved wood decorations – the work of Joachim Dietrich (1736–53), Wenzeslaus Mirofsky (d. 1759) and Johann Adam Pichler (1717–61) – covered the internal walls and furniture of the Residenz. A technique invented by Cuvilliés was that of mounting carved gilt decoration on the white-painted surfaces of commodes, which resemble converted console tables with drawers.

Motifs ranged from pure *rocaille* decoration to interwoven flowers, tendrils, palmettes, carved, frothing lines enclosing great "eyes" like elongated teardrops, to a sculptural style that incorporated complete figures, heads, masks and animals. Cuvilliés's style influenced not only Munich: the whole of Germany was under his spell, and all the best furniture is indirectly due to him. In addition his example acted as a stimulus to other craftsmen, who were opening up their own workshops to satisfy the demands of the wealthy families of Munich and Bavaria. The furniture made in these workshops was less expensive, and in some cases papier-mâché mounts replaced carving in wood.

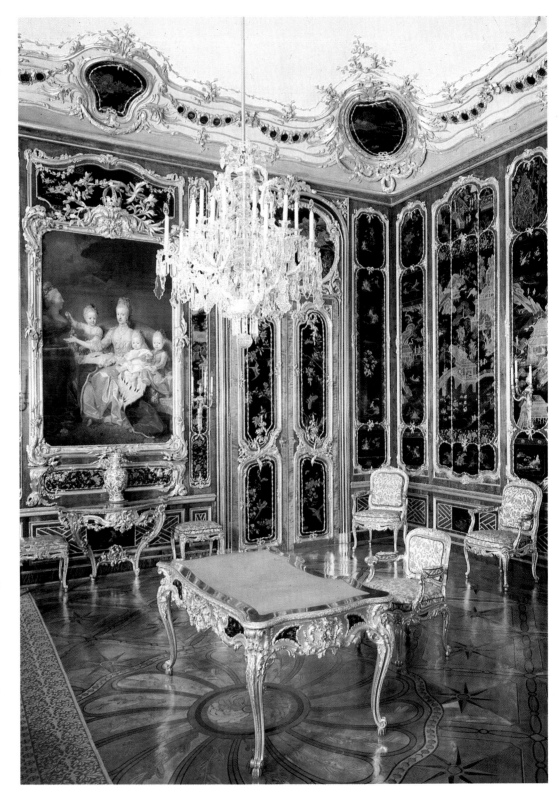

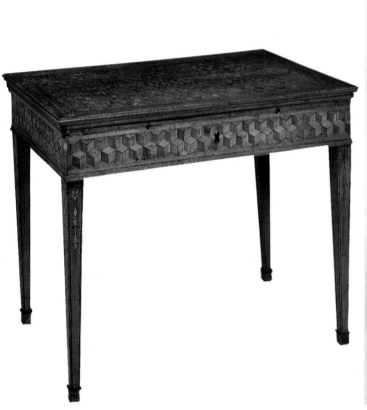

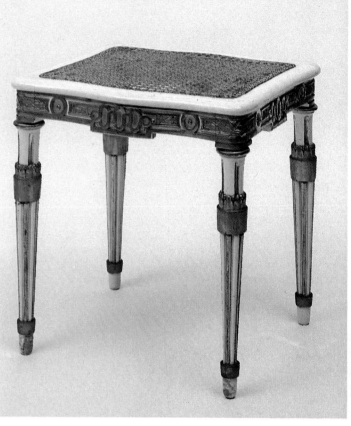

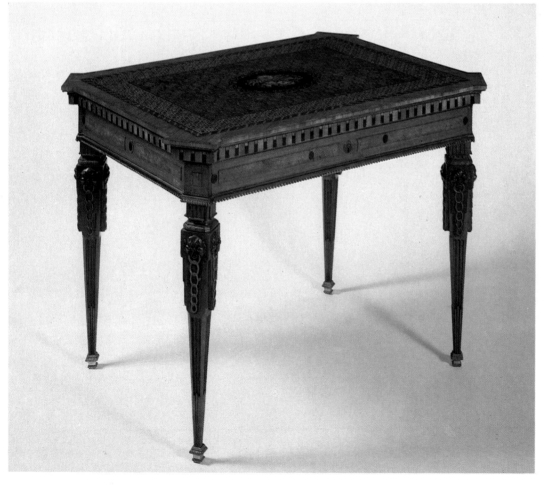

ABOVE LEFT: German writing table
(c. 1780) with geometric marquetry and
sliding surface concealing a space fitted
with four drawers. Antiques trade. LEFT:
a small Viennese table (c. 1800), whose
surface is similarly veneered with geo-
metric designs, here centred with an oval
enclosing a floral trophy. Österreichi-
sches Museum für angewandte Kunst,
Vienna. FACING PAGE, ABOVE: Vien-
nese stool (1774) in carved lacquered and
part-gilt wood, with classical-style decor-
ations. The two chairs (1774), above
centre and right, display the same fea-
tures. All Bundessammlung alter Stil-
möbel, Vienna. ABOVE LEFT: oak chair
(1760–70), with pierced oval back.
Couven-Museum, Aachen.
BELOW LEFT: chair (c. 1780), in walnut
and mahogany in the Hepplewhite style.
Schloss Charlottenburg, Berlin.
CENTRE: small painted and gilt arm-
chair made in Hamburg (1770–80), with
tapering front legs and sabre back legs
joined by stretchers. Jenischhaus, Ham-
burg. RIGHT: painted wood chair
(1770–80) with turned, fluted legs and
caned seat and back. Schloss Charlotten-
burg, Berlin.

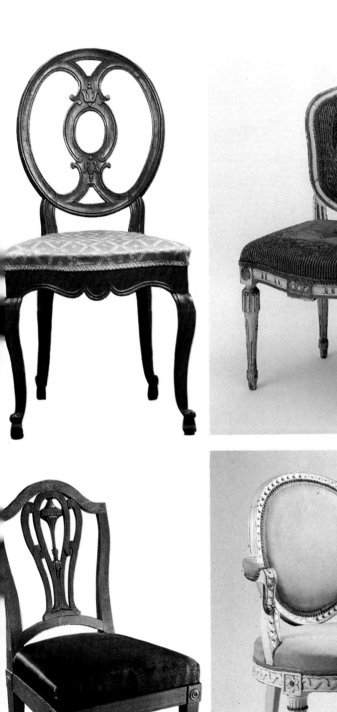

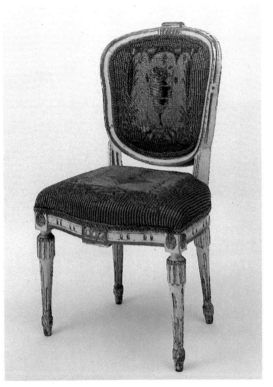

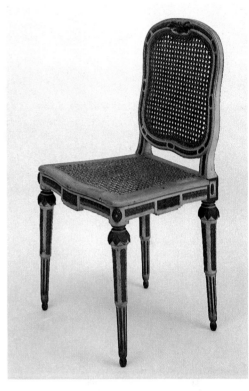

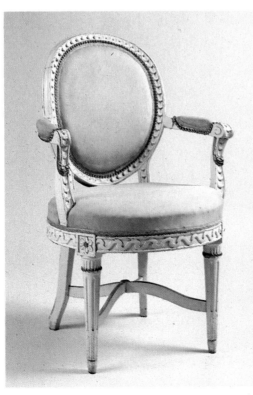

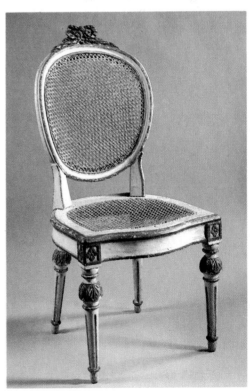

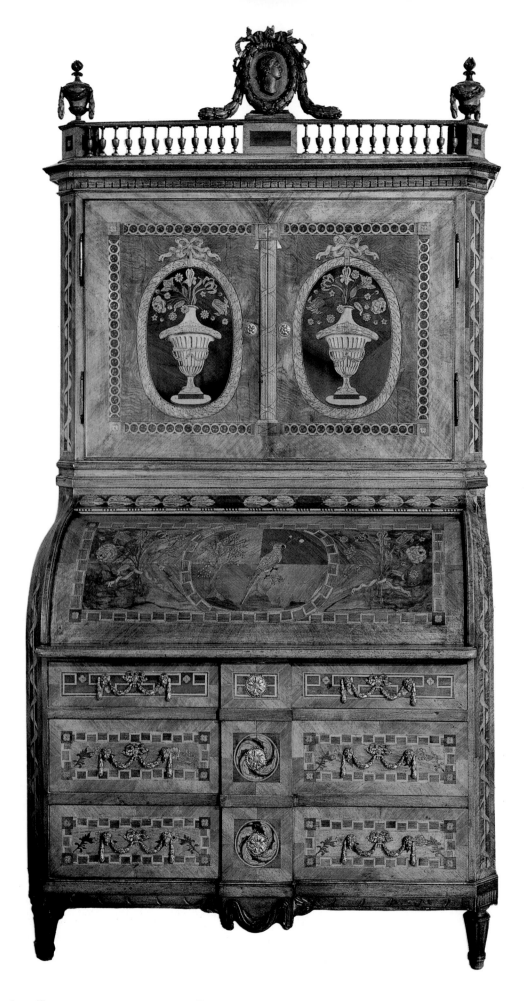

Switzerland, Bavaria's neighbour, a free country imbued with solid bourgeois traditions, produced very little in the way of quality furniture. However, in the second half of the 18th century local craftsmen were able to produce, somewhat belatedly, furniture similar to that produced in other European cities. One of the most important workshops for the production of furniture in Switzerland was that of the Funk brothers at Bern.

Austrian Rococo is of particular interest, not only for its historical, sociological and psychological implications but also for the forms of expression it found. Of fundamental significance in this context is the extraordinary fusion of court, nobility, upper-middle-class merchants and clergy in Vienna, a phenomenon perhaps unique to this city in Europe. Once the constant threat of Turkish invasion was finally lifted, Austrian society, conscious of its newly restored importance, was encouraged to devote itself to music, the arts, letters and, simply, the "good life", which in furnishings found expression in the word *Wohnkunst* – the art of living. This "art of living" was not confined as elsewhere to the court and to the nobility, but permeated other social strata and even the monasteries.

Viennese Rococo, while it shows many similarities to the style of Carl Maximilian Mattern in Würzburg, is quite distinctive from that of other regions: furniture of the finest quality is adorned with a profusion of bronze and carved gilt decoration, and the marquetry on a walnut-veneered ground is executed in harmonious designs of infinite precision.

FACING PAGE: Neoclassical bureau-cabinet (1780–90) made in Munich, veneered in cherrywood and inlaid with geometric motifs, flowers and birds on the cylinder, which opens to reveal the writing surface; it is further inlaid with vases of flowers on the cupboard doors of the upper section. Bayerisches Nationalmuseum, Munich. THIS PAGE, BELOW: Neoclassical *Schreibschrank,* veneered in walnut with maplewood decoration. Landesmuseum für Kunst und Kulturgeschichte, Oldenburg. RIGHT, ABOVE: walnut-veneered commode (c. 1780), inlaid with a variety different woods. BELOW: late 18th-century Austrian commode. Antiques trade.

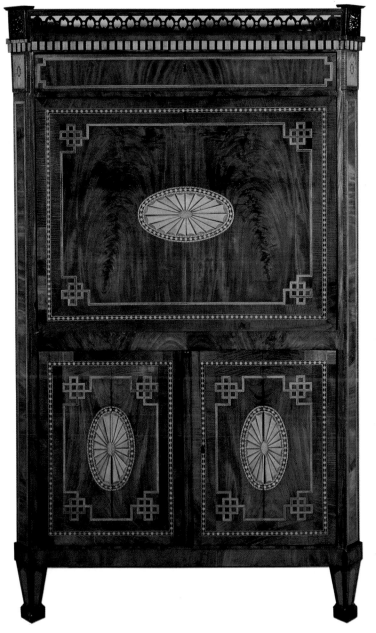

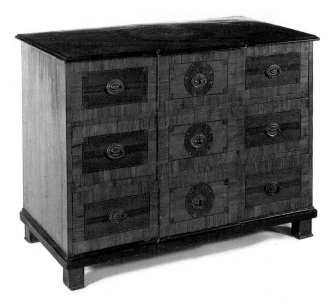

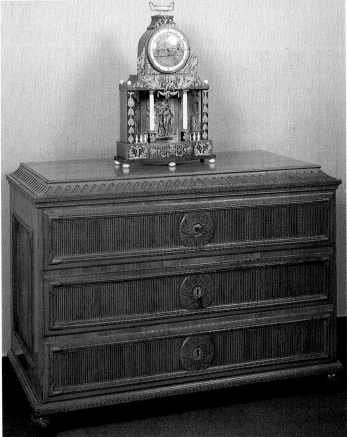

During the reign of Maria Theresa (1740–80) furniture of great magnificence was produced. Examples include the furnishings of Schloss Schönbrunn, with its glittering *Millionenzimmer* and elegant Chinese Salon – the *Chinesisches Kabinett* – and the *Vieux-lacque-Saal.* Typical of Rococo furniture produced in Maria Theresa's Austria are the long legs on the commodes, carved gilt decoration applied to a deep chestnut-brown ground, the slender form of white- and gold-decorated chairs and finally,

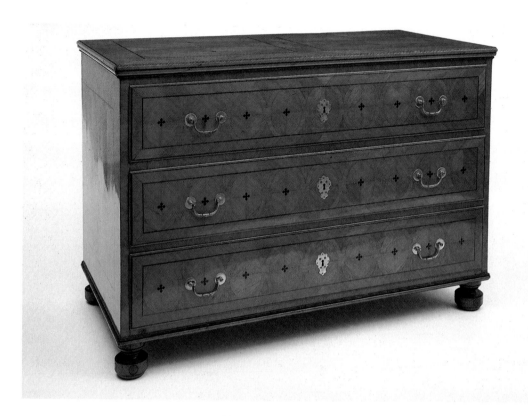

natural evolution towards a more simple style – a style that at that time was being developed in London by architects and furniture designers like Robert Adam, George Hepplewhite and, a little later, Thomas Sheraton. However, where German taste found expression in a style closer to that in vogue in Paris, the new fashion was accepted with reluctance, perhaps because the social and economic conditions that forced change on the France of Louis XVI had not yet matured. In Munich the new style arrived in 1799, although there had been a foretaste of it in 1775 when François de Cuvilliés the Younger furnished Palais Tattenbach.

In Berlin the first hesitant manifestations of Neoclassicism came in 1790 with the acession of Frederick William II as king, after the death of Frederick the

at the end of the century, an increasing emphasis on geometric, chequerboard, mosaic inlay.

Roentgen's workshop

In Germany the decline of Rococo did not coincide with the advent of Neoclassicism, a style that failed to achieve great popularity. In fact, if one excludes the exception that will be mentioned a little later, very little furniture was made in this style, whose strict canons contradicted the precepts of the Rococo decoration still used by furniture-makers. The regions in which the Neoclassical style was more marked were those which in the past had already been receptive to English influences and where one would speak not so much of a vogue for Neoclassicism as of the

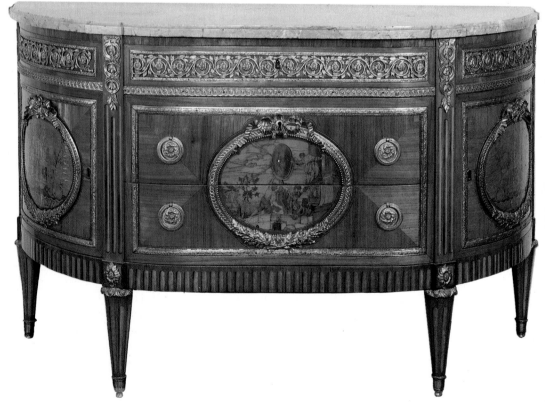

BELOW: Provincial German fruitwood cupboard (c. 1780), the solid structure relieved by the moulded cornice, which echoes the shape of the doors, and the carved motifs on the central panel and corner panels, which emphasize the blunt angle of the canted corners. Antiques trade.

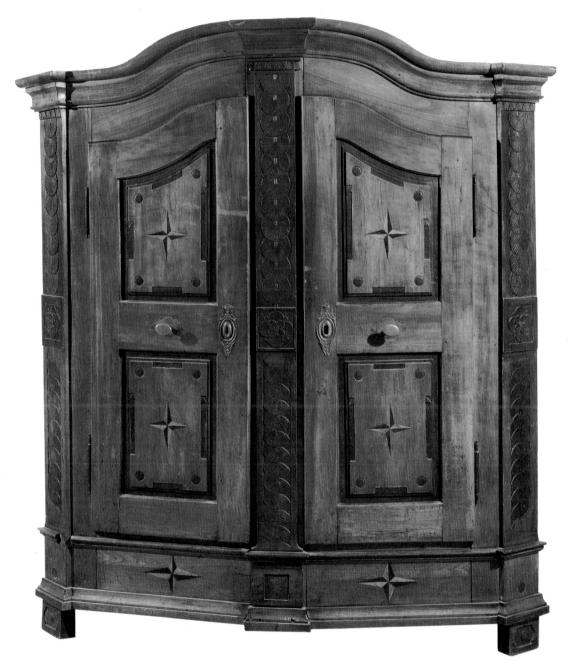

Great in 1786. As Crown Prince he had been presented with a great bureau cabinet in the style, made by David Roentgen. After his accession, Frederick William invited the architect Friedrich Wilhelm von Erdmannsdorff to Berlin from Dresden and appointed Carl Gottlob Langhans from Breslau as the new head of the royal workshops. Erdmannsdorff and Langhans created a number of interiors in the new style, the most important of which were in the kings apartments in the Stadtschloss, or Berlin city palace (1789–91), the Marmorpalais in Potsdam (1788–91) and Charlottenburg (1788 and 1796–97). This resulted in Berlin and Potsdam becoming centres of production of high-quality furniture, with work by important cabinetmakers such as Johann Gottlob Fiedler working in a style not dissimlar to that of David Roentgen. In Berlin the real sign of Neoclassicism was Schloss Charlottenburg. However it was not until the first decade of the 19th century that Karl Friedrich Schinkel introduced a truly Neoclassical style, which even then was not free of uncertainties and echoes of earlier styles. In Vienna, however, Neoclassicism quickly assumed the rounded contours of Biedermeier, in which one can find a few remaining traces of the Rococo.

Nevertheless it was two important German cabinet-makers, Abraham (1711–93) and David (1743–1807) Roentgen, who were to be among the first to assimilate the theory of Neoclassicism and then to transmit this to the rest of Europe, even as far away as St Petersburg.

At the age of twenty Abraham Roentgen abandoned his father's carpenter's workshop and went to seek his fortune through his own skill, first in the Netherlands and then in London. Here he met Count Zinzendorf, who admitted him to the strict Protestant religious sect he had founded, the Brothers of Herrnhut. He returned to Germany and married, but following a shipwreck he decided against going to America as a missionary for the sect, and instead to put to use the art he had learnt in Holland and afterwards in London, setting himself up as the *englischer Kabinettmacher*. His Georgian style is based on Queen Anne. He used dark walnut, employed cabriole legs for his tables and chairs, and introduced to Germany the ball and claw foot and later the club foot and the cloven foot.

In 1741, with the support of

Below: Cupboard with two long doors (1778), a piece in the popular tradition, painted in blue and decorated with flowers and gilt scrolls, the door panels painted with scenes depicting the four seasons, each within a framework of flowers in the Rococo style, by Martin Böheim. Bayerisches Nationalmuseum, Munich.

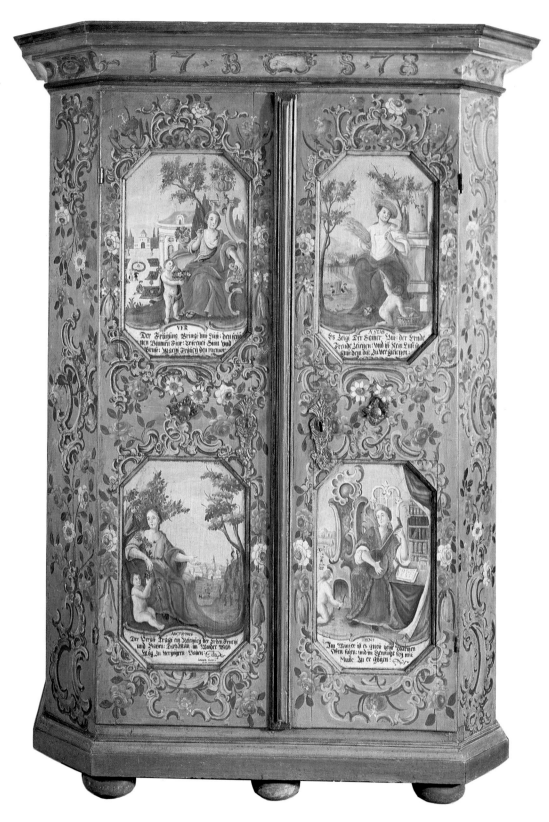

Count Ysenburg-Büdingen, a fellow member of the religious sect, he opened a workshop for the production of furniture characterized by simple and austere lines, a reflection of the strict principles of his sect.

In 1750 he moved to Neuwied, near Koblenz, where he commenced production of series of individual parts which could be assembled to produce furniture of varying price, according to the demands of his clients. The sober style of Roentgen soon evolved to include rich ornamentation, as can be seen for example in the wonderful desk with lid he made in 1765 for the Elector of Trier, Johann Philipp von Walderdorff. Inlaid with ivory, silver, mother-of-pearl, ebony, and other rare and fine woods, the desk is covered with figured decoration and meticulous geometric patterns.

The success of the Neuwied workshop surpassed all expectations. No other cabinet-maker in Germany produced so much furniture. By this time Abraham's young son David had joined the business, and c. 1768 (at the age of twenty-five) assumed control of its commercial and administrative aspects while his father continued to look after the technical side. However the enormous expansion of the business required finance, which the enterprising David resolved by organizing a lottery. This injection of capital gave a boost to the business and David, himself an expert cabinet-maker, toured Europe and was received by princes and rulers, to whom he sold furniture and from whom he received fresh commissions and offices, such as that of superintendent of works for the furnishing of their palaces. Other

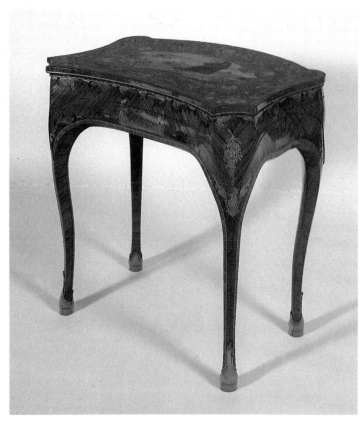

members of the Roentgen family were also honoured with official positions – Georg Roentgen for instance was appointed director of the Royal Furniture Repository by the Danish court in 1777.

David opened a branch of the business in Paris to retail his furniture, and perfected his own style there, which increasingly inclined to the simple and elegant proportions of Neoclassicism. Abraham died in 1793. These were the years when the privileged classes of Europe still believed that the French Revolution was a national phenomenon which could not possibly have any influence on the history and customs of other countries. But one of the first indications of its influence was in fashions in furniture, which everywhere – even in the regions most reluctant to absorb stylistic change – assumed the characteristics of simplicity and perfection to be found in the masterpieces being produced in the Roentgens' workshop at Neuwied.

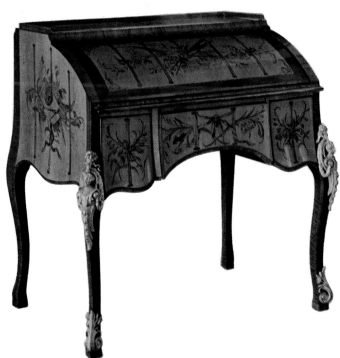

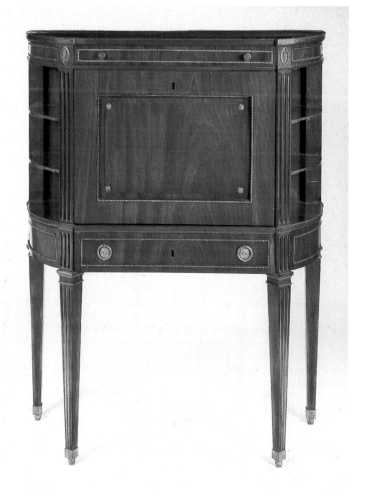

THIS PAGE: several examples of furniture from the Roentgen workshop in Neuwied.
TOP: lady's table (c. 1770), school of Abraham Roentgen. Antiques trade.
ABOVE, LEFT: desk veneered with tulipwood, walnut, cedar and box with gilt bronze mounts, made in 1773 by David Roentgen. Residenzmuseum, Munich.
RIGHT: mahogany secretaire (c. 1780), with brass mounts, in the style of David Roentgen. Antiques trade.

David Roentgen: cabinet-maker and manager

David Roentgen could be described as a pioneer of modern "marketing". He possessed the ability to see with his clients' eyes and to create furniture that corresponded exactly to their wishes and ideas. In brief, he was in tune with the spirit of the time. Thanks to his entrepreneurial abilities, *Meubles de Neuwied* found their way across the whole of Europe, and were much prized by courts and ruling families whom Roentgen would visit personally to advertise his "products", offering to make on commission whatever kind of furniture the client's taste demanded. The royal palaces of Paris, Vienna, Brussels and St Petersburg were all furnished with pieces from the workshop at Neuwied, which at the height of its fame employed about one hundred workmen, carvers, bronze founders and smiths. The items they produced, technically faultless and perfect in their mechanisms, which were made with the collaboration of Peter Kinzing (1745–1816) and are still in working order today, were fitted with secret little drawers and compartments, shelves that can be concealed and footrests and candelabra that spring out at the touch of a button. Of greater complexity are the stylistic and artistic aspects of this furniture, because Roentgen's workshop endeavoured to satisfy the whims and desires of all his customers. The marquetry work on the early pieces was in the form of floral motifs, animals, musical trophies and scenes with figures, mostly designed by Januarius Zick. But after Roentgen's visit to Paris in 1774, during which he met the cabinet-makers working there, Neuwied's decorative repertoire expanded to include views in perspective, pastoral idylls or scenes inspired by *commedia dell'arte* or the paintings of François Boucher. From the 1780s onwards David Roentgen adapted his work to the new style and also produced furniture with simpler decoration, mostly in mahogany veneer with simple gilt bronze mounts. He opened shops in Paris, Berlin and Vienna for the sale of the furniture made at Neuwied, and in 1783 he dispatched many items of furniture to the court of St Petersburg – Catherine II of Russia was a great admirer of his work and gave him many commissions.

LEFT: Neoclassical desk (1790–93), in mahogany, oak and pine, with gilt bronze mounts, made by David Roentgen at the Neuwied workshop. Schloss Wilhelmshöhe, Kassel. ABOVE: another elegant Neoclassical desk by the great German cabinet-maker, with a small architectural upper structure and restrained gilt bronze decoration. Bayerisches Nationalmuseum, Munich.

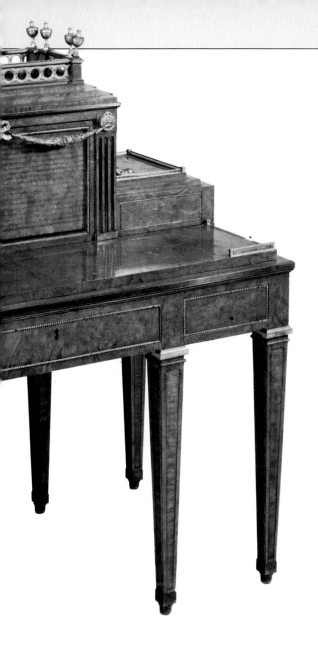

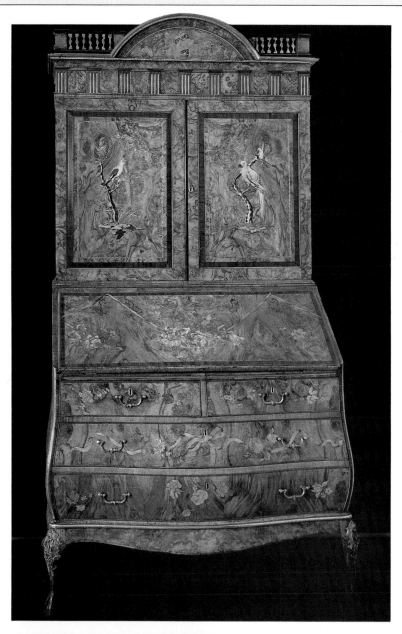

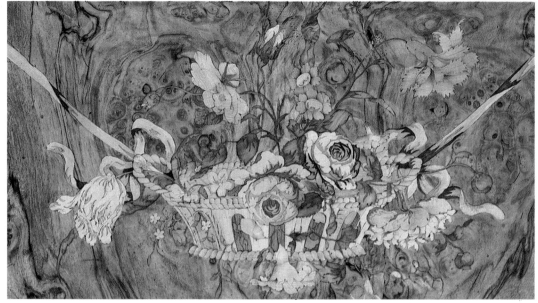

ABOVE: *Schreibschrank* made by
Abraham and David Roentgen at
Neuwied (c. 1768), veneered in
cherrywood with marquetry decor-
ation of polychrome flowers, birds
and ribbons, the lower section of
curved, *bombé* outline, below an
upper section of architectural design
with a classical frieze under an arched
surmount and gallery. LEFT: detail of
the marquetry of the fall front. Bay-
erisches Nationalmuseum, Munich.

GERMAN FURNITURE: FROM ROCOCO TO NEOCLASSICISM · **243**

The 18th century in other European countries

The northern Netherlands

In many countries of Europe the Rococo style was present as a tendency rather than as a dominant feature. Some features of design reflected the Rococo – the use of certain motifs, *bombé* outlines, more fluid lines – but the style was essentially still based on the Baroque and even the Renaissance. There are very few examples of furniture that are completely in accord with this style, otherwise so typical of the 18th century, although in this context it is worth noting that furniture in the Neoclassical style produced in countries that had ignored the influences of Rococo while it was at its zenith elsewhere betray a certain nostalgia for the latter.

The changing political and military fortunes of the Netherlands, which had coloured its history for centuries, also affected stylistic developments in individual areas, only geographically contiguous. Thus history of furniture in the 18th century cannot be considered as a single account either. The Netherlands must be divided into north and south, regions that today roughly correspond to Holland and Belgium.

In the northern region, the seven United Provinces had enjoyed a golden age during the 17th century, when maritime trade established their reputation as a flourishing economic power. The (Dutch) East India Company was founded in 1602 and the West India Company in 1621, and together they made Holland the hub of world trade. Cargoes of every kind arrived in the port of Amsterdam from the Baltic, England, France, Germany, the Orient and the Americas, and

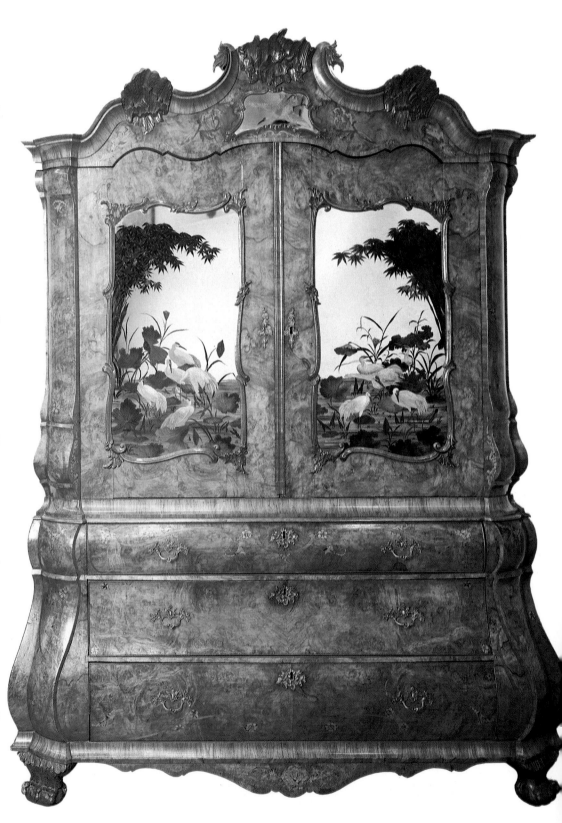

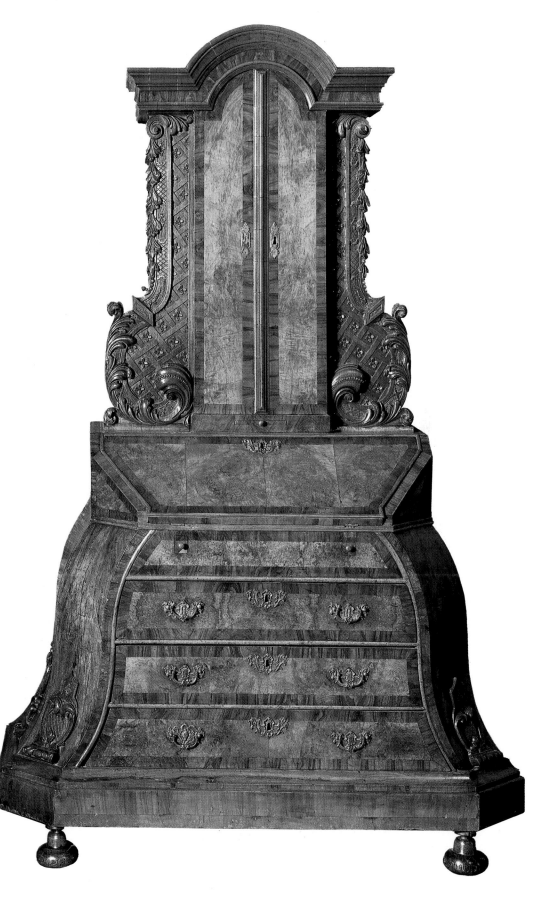

were shipped from there to their ultimate destination. The arts, science and industry all flourished in the cities of Holland, in a general atmosphere of affluence whose origins were mercantile rather than military, and thus bourgeois rather than limited solely to the aristocracy. This affluence was certainly affected by political fortunes but not destroyed by them, and it was reflected in people's desire for domestic comfort and a kind of furniture that combined opulence with practicality but was not ostentatious. A plain and yet generous style evolved.

The evolution of the *kast*

Among the types of furniture that best fulfilled the requirements of the last decades of the 17th century and the early years of the 18th was the cabinet, the style of which preserved in its basic shape the structure inherited from previous centuries. Individual details and decorative motifs changed, but basically the cabinet still consisted of a cupboard fitted with drawers enclosed by two doors and supported on a side table. The Dutch called this a *kast*, which means "cupboard", and its ancestor was the Spanish *bargueño*. This type of furniture actually had nothing to do with a cup-

Two examples of Dutch furniture showing the further evolution of the *kast*, the cupboard. Above: early 18th-century walnut bureau-cabinet; the lower section fitted with drawers of curved, trapezoid outline, below a straight upper section with two doors under an arched surmount. The geometric marquetry is combined with carved scrollwork to the flanks. Facing page: cabinet-commode (1764), veneered in walnut and inlaid with tulipwood and exotic woods; the lower section of *bombé* outline and fitted with drawers, the upper section with a pair of doors, each inset with a painted mirror showing waterfowl in the oriental style within an irregular scrolling framework, below a scrolled surmount interrupted by and centred with *rocaille* motifs, the silver mounts by Dirk Froger. Rijksmuseum, Amsterdam.

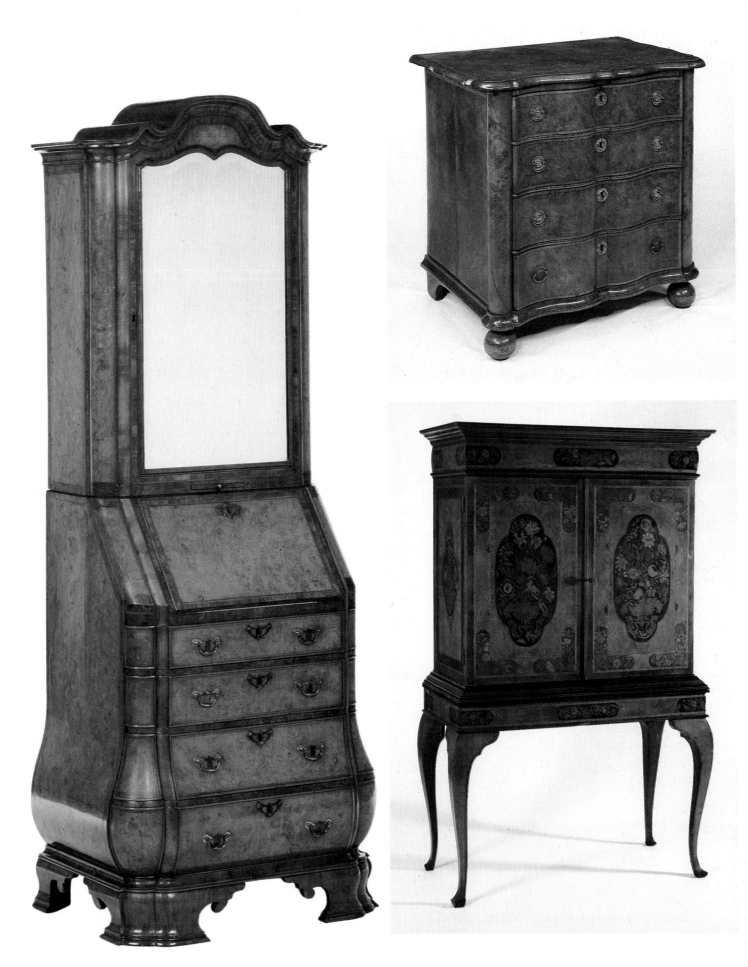

board as such, and in a middle-class home, where it was necessary to keep crockery and both table- and bed-linen out of the dusty and inconvenient depths of the marriage chest, it was completely useless. Thus in the first decades of the 18th century two changes occurred. One was the cupboard's development into a cabinet-desk, fitted with drawers below and a fold-out surface, which anticipated the structure of the secretaire (a combination of desk and cupboard), which was fashionable from the end of the 18th century. The other was the separation of the cupboard into two parts, where the lower section was fitted with drawers in what was previously a useless space between the legs of the table support. In other words, the lower section assumed the structure of a commode, and was used as such, while the upper part of the piece became a true cupboard fitted with small drawers, compartments and shelves, or, in much later examples, was completely empty, so that it could be used as a hanging space for clothes, enclosed by two doors. In a variation on this theme, dating to about the middle of the century, the interior of the upper section remained visible, enclosed by glazed doors, and sometimes the sides of the cupboard too were fitted with glass. This is the classical Dutch display cabinet, which, on account of its floral inlay and the *bombé* shape of its lower section, remains much sought after by collectors. Unfortunately it is a type of furniture that in Holland, and later on in England too, continued to be produced in countless examples both in the 19th and 20th centuries, ostensibly with the same characteristics, and for this reason it can be difficult to distinguish later imitations and possible fakes.

With the passage of time the glazed upper section of the piece expanded and grew longer towards the base. This meant the elimination of one level of drawers and the first step towards the display-cabinet, an essential piece of furniture in the drawing-rooms of the 19th century which protected small collections of objects while allowing them to be admired.

Bureau-cabinets and corner cupboards

A variation of the dual-bodied cupboard was the bureau-cabinet, which also evolved from the cabinet, and in which the upper section contained small drawers and compartments hidden by a pair of doors, while the lower section was fitted with large drawers below a sloping, drop-flap writing

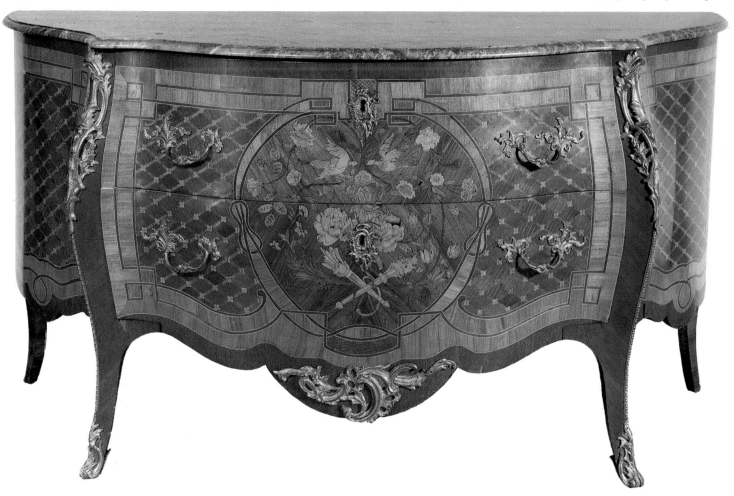

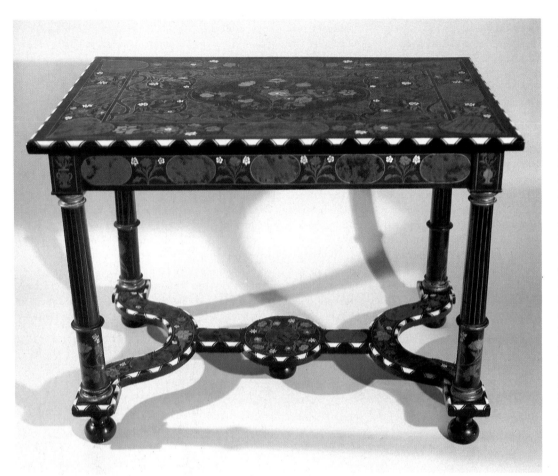

surface. It was in fact a halfway house between a cabinet-desk and a cabinet-cupboard. The bureau-cabinet in its many different national forms was to become the most popular type of furniture in the elegant drawing-rooms of Europe, and is still much sought after by present-day antique collectors. Typical of the Dutch bureau-cabinet was the absence of mirrors in the door panels of the upper section; and the profile of the pediment had five plinths for the display of the famous Chinese-inspired vases produced in Delft workshops. This is a detail that also occurs in cabinet-cupboards and two-section display cabinets.

A further variation of this type of furniture is the corner cupboard, which repeats in a triangular form the various structural possibilities already listed. Thus we find the cabinet-corner cupboard, whose lower part forms of a corner table, the corner display cupboard, the corner cupboard-on-cupboard, with doors to the upper and lower sections, and finally the corner bureau-cabinet, which instead of the drop-flap writing surface between the upper and lower part has a small opening which could be used for the display of a vase, a *majolica épergne,* or a small porcelain basket. The pediment of the corner cupboard was intended for the display of three vases, or two vases on either side of a central decorative motif.

Other types of furniture

In addition to this important class of furniture, commodes, *buffets*, desks, dining tables, tea- and work-tables and games tables, chairs and armchairs were also produced in the Dutch Republic. These types of furniture were also usually executed in a style of sobre elegance, in polished wood, with veneers of burr-walnut or thuja wood, but above all with a wealth of floral inlay in lighter-coloured woods, which

were sometimes also stained with colour. This tradition makes Dutch furniture instantly recognizable, with its meticulously repeated motifs of swags and garlands adorning the framework and the moulding of the tympana, the backs of chairs, the arms of chairs and the cases of long-case clocks, the last as popular in Holland as they were in England.

Another decorative feature widely used in other countries of Europe was employed over and over again in 18th-century English and Dutch furniture, almost to the point of being over-used, viz. the claw and ball foot. This was an aesthetically acceptable base for the slender supports of stout structures, and one typical of English furniture – the feature of an animal's claw enclosing a ball. Reciprocal influences between the Dutch Republic and England were strong at this time and many of the changes in Dutch style in the course of the 18th century were the result of English influence, and English styles, in their turn, were the fruit of variations in Dutch examples that had arrived in England after the marriage of William III and Mary.

The southern Netherlands

The art of furniture-making developed quite differently in the southern Netherlands, where the most active centre, Antwerp, had been destroyed economically by the Treaty of Westphalia in 1648 with the blockade of the Scheldt. The region came under Spanish, and then from 1714, under Austria something of a backwater culturally almost entiierly dependent on France.

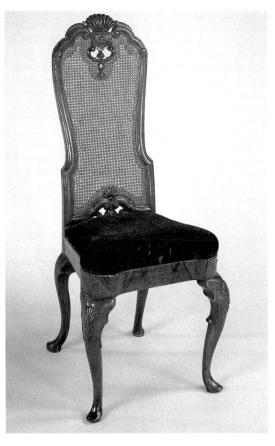

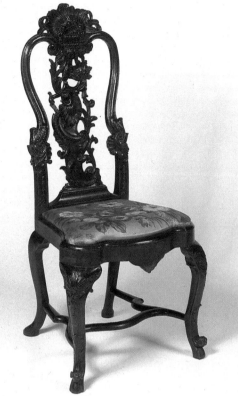

FACING PAGE: Flemish table (c. 1650) with marquetry in ivory, red tortoiseshell, ebony and exotic woods. Antiques trade. THIS PAGE, LEFT: Dutch chair in walnut (c. 1750), with carved and pierced splat back and cabriole legs joined by stretchers. Antiques trade. FAR LEFT: Dutch chair in walnut (1750), with caned back. BELOW RIGHT: armchair (c. 1750), its back applied with the arms of Holland, Zeeland and Friesland. Rijksmuseum, Amsterdam. BELOW, LEFT: walnut armchair (c. 1714) from the southern Netherlands, in the 17th-century style. Musées Royaux d'Art et d'Histoire, Brussels.

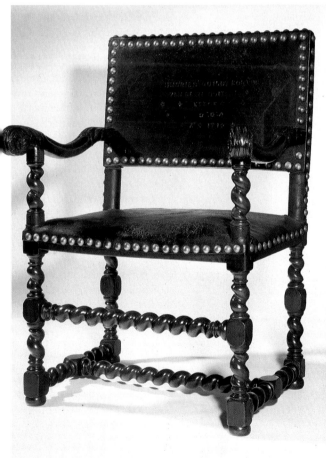

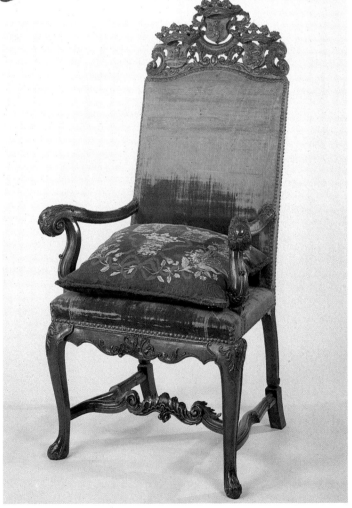

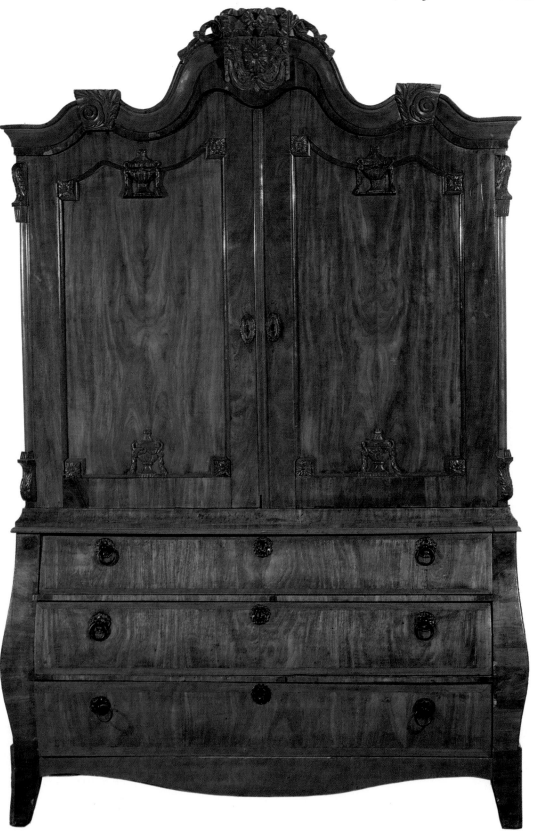

BELOW: Dutch cabinet on chest (c. 1770), in mahogany, the lower section fitted with drawers and of *bombé* outline, the upper section with shaped doors below a serpentine surmount. Antiques trade. FACING PAGE, ABOVE: Dutch burr-walnut chest of drawers (1760–70), with bronze fittings, the flanks and front of exaggerated curved outline, resting on claw and ball feet. Historische Museum De Waag, Amsterdam.

All of this was reflected in the region's furniture, which in fact clung to the examples of the preceding century and was generally unimposing, precise, austere and even gloomy owing to the wide use of bay oak, whose greyish-red grain absorbs the light, without increasing the luminosity of the wood itself.

Cupboards and commodes are the types of furniture most frequently found in what is now Belgium, but the cupboards are closed from top to bottom and the commodes repeat the most ponderous lines of the 17th century. The decorations, however, are more delicate and the fronts executed with a gentler convex line matching geometrically the slight concavity of the sides. This furniture is somewhat reminiscent of French furniture from Provence, or of Italian examples made in Piedmont, but with the difference that in southern France and in Piedmont the use of walnut gives the furniture a solid luminosity not achieved by the overly rustic and unsubtle grain of bay oak.

From this summary it is evident that generally speaking furniture made in Holland and Belgium in the 18th century achieved no "triumphs". However, this does not mean that it is without individual features. Nostalgia for the Renaissance and the memories of the Baroque that accompanied the Huguenots' arrival in the area combined in a hybrid style which is particularly evident in chairs of the period. In fact we find Rococo backs to chairs with Louis XIV legs, columns in the style of Bernini together with the curved lines of the Louis XV style, and low seats combined with high backs, shells and

second half of the 18th century, attributed to Matthijs Horrix of The Hague, in the French Neoclassical style, with concave sides, resting on inverted pyramid feet, and marquetry decoration in tulipwood, box and exotic woods, applied with gilt copper mounts. Rijksmuseum, Amsterdam.

stretchers. All of this betrays Flemish craftsmen's lack of ability to understand the new principles and technical requirements of the Rococo style. An exception to this mixture of styles is the "burgomaster's chair". This was a sort of stool supported on six legs with a fan-shaped back; usually made in mahogany, its structure and carving indicated its colonial origins, and in England it became the prototype of endless orientalising variations in the Victorian era.

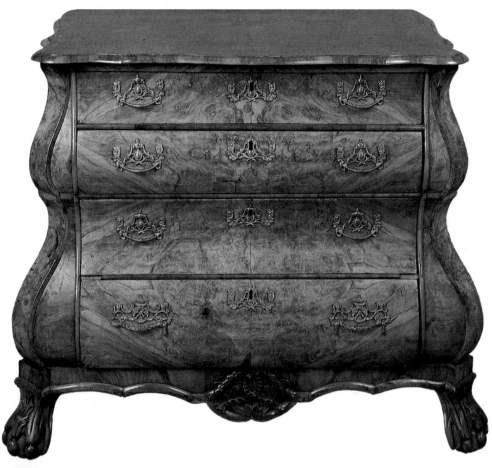

Heterogeneous styles

In dating a piece of 18th-century Flemish furniture it is not possible to refer to specific stylistic periods. One must investigate all the individual structural and decorative elements that have come together in any one piece and then date the whole by the most recent feature stylistically. This might be just one detail such as a shell, a scroll, a flourish or other decorative device, or it could be the curve of a leg, the luminosity of the veneer or the type of inlay. In general terms it may be said that in the Dutch Republic the Rococo style is revealed in the accentuated swollen, curved lines, particularly of the lower bodies, while in the south it manifests itself in relief carving on the faces of the drawers or along the mouldings of the doors. In the reticent and finely carved foliate decoration, which appears to mask itself in the grain of the wood and which is a mark of the craftsman's ability, one

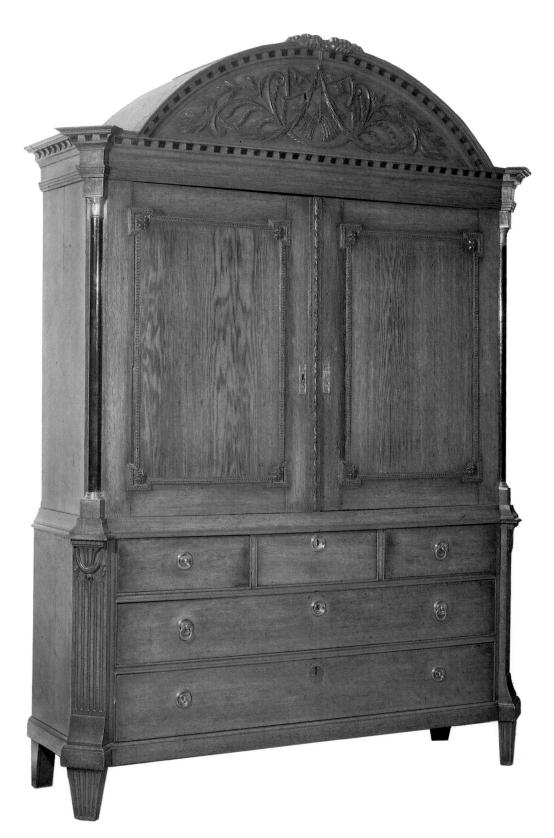

recognizes that these craftsmen sensed the mood of Rococo but were unable to find suitable ways in which to express it.

Thus, when the Neoclassical style arrived in the Netherlands, it found a country that had in effect been by-passed by the stylistic revolution that had affected most of the rest of Europe. And in fact Neoclassicism too was absorbed by the Netherlands without a true comprehension of its significance. In Holland particularly, pieces were produced with an excess of geometric inlay, which often suggests oriental influences – a notion confirmed by the frequent use of inset Chinese panels and Delft porcelain plaques.

Characteristic of Dutch furniture of this period was the frequent use of exotic woods like mahogany, kingwood, American satinwood and ebony, and feet in the shape of inverted, elongated pyramids.

A type of sideboard was produced in the Netherlands that is found in present-day Holland (in exotic woods) and in Belgium (in bay oak). It has a bowl set into the surface below a cover, which is provided inside with a folding table and a jug. The console provided by the lid when the latter is erected vertically against a wall could be used for the display of pewter. The provincial character of Dutch furniture at the end of the 18th century was also the result of the ban in 1771 on the import of goods from abroad. Undoubtedly this was an advantage for local craftsmen, who, in order to satisfy the demand for French furniture, resorted to vast numbers of imitations, but it also stifled competition and resulted in a sterility of new ideas, a phenom-

enon even more evident in the 19th century.

Denmark and Sweden

The history of Danish and Swedish furniture in the 18th century is essentially the story of the influences exerted by English, Dutch, French and German fashions on the craftsmen of Denmark and Sweden. It was not until the first intimations of the arrival of Neoclassicism at the end of the century that a national style developed. The production of the preceding decades was in effect a more or less faithful imitation of foreign examples, and when in 1746 Denmark imposed a ban on the importation of chairs from abroad in order to support local craftsmen (a ban that lasted for more than twenty years, not being abolished until 1768), chair-makers continued to reproduce, with only slight variations, the most recent examples that had been imported.

During the 18th century Norway was still closely tied to Denmark administratively and still used Danish as its official language. The union, which dated back to the Union of Calmar in 1397, when Queen Margaret united the Scandinavian King-

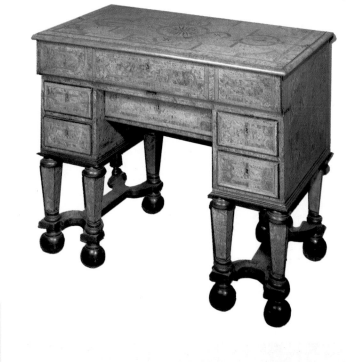

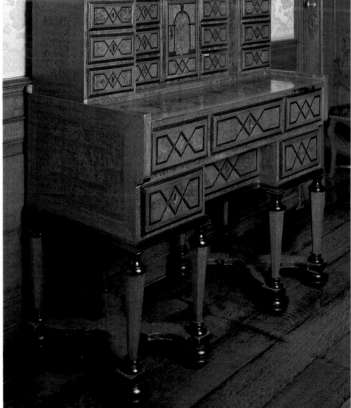

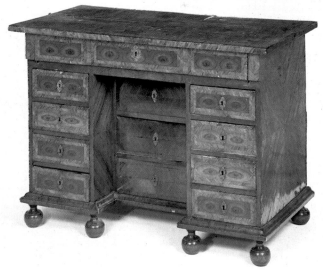

LEFT: bureau-cabinet from the Principality of Liège (first half of the 18th century), veneered in ashwood with geometric motifs in thuja and sycamore, supported on eight tapering supports, each set of four legs joined by X-stretchers; similar legs, but joined by double Y-stretchers, are illustrated in the top example here which is also from the Principality of Liège and dates from the first half of the 18th century. Musée d'Ansembourg, Liège. ABOVE: desk from the southern Netherlands, with fold-over top. Antiques trade.

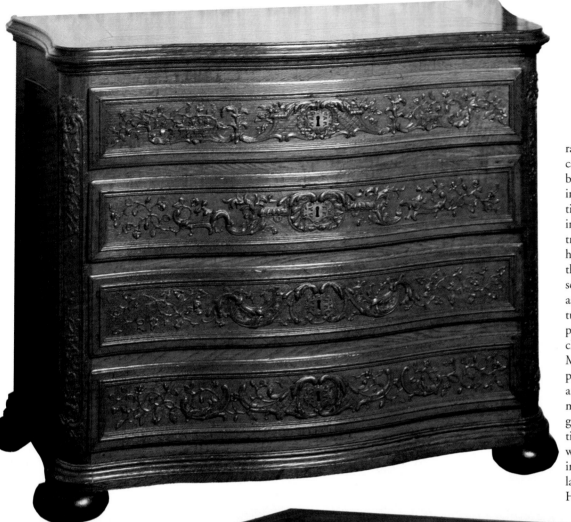

rapid absorption of the stylistic canons emanating from Paris, both in architecture and furnishing. As has already been mentioned, English examples arrived in the three Scandinavian countries as a result of trade. Experts, however, are of the opinion that these influences should be described as Anglo-Dutch, insofar as for several centuries the furniture that had enjoyed greatest popularity among the middle classes was in the William and Mary style, which does not easily permit the separation of English and Dutch elements. This was a mellow, warm style which made great use of floral decorative motifs and generally used light burr-walnut; it incorporated French influences brought first to Holland and then to England by the Huguenot Daniel Marot

doms, lasted until 1814. Sweden, in contrast, which had successfully fought Denmark from the time of Thirty Years War (1618–48) to the defeat at Poltava (1709), continued to pursue a policy of clear division from Denmark, even though their geographical proximity resulted in inevitable similarities in national customs. Both countries moreover engaged in active trade with England, and this inevitably resulted in similarities in the styles of furniture in both countries.

In Denmark, however, the influence of England was predominant and was received both directly from the sea and indirectly, via the northern regions of Germany. In Sweden, in contrast, links with French culture first established in the time of Queen Christina (1632–1654), led to the

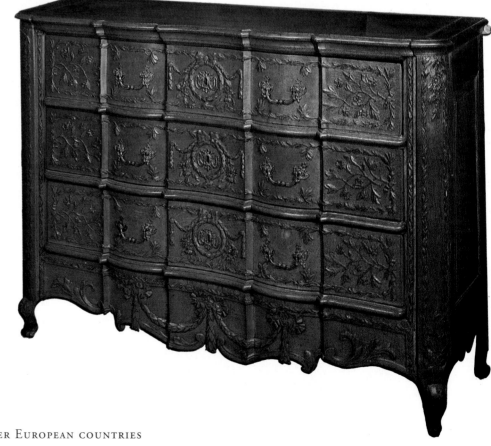

These pages show several examples of furniture from the Principality of Liège.
FACING PAGE, ABOVE: oak chest of drawers (c. 1750), the front of bowed outline,
each drawer decorated with a different combination of scrollwork and plant motifs.
BELOW: similar decoration, typical of the southern Netherlands, can be seen on this
late 18th-century commode, executed in a style marking the transition from Rococo to
Neoclassical. THIS PAGE, BELOW: carved oak cupboard (c. 1775). BOTTOM: late
18th-century Neoclassical commode. All Musée d'Ansembourg, Liège.

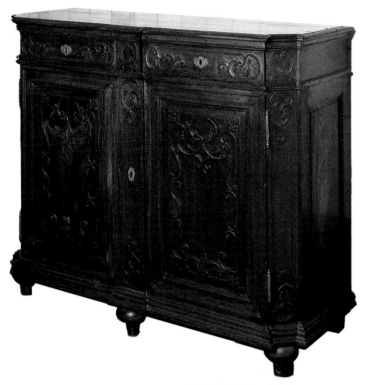

drawers, richly decorated with inlay employing naturalistic motifs, supported on four tall legs embellished with animal motifs. The broken double serpentine outline typical of many Dutch chests in the manner of the late German Baroque is found here too. In evaluating the effects of the various European styles on Scandinavian furniture, it must be mentioned that England, Holland and northern Germany influenced the sort of furniture made for the houses of the nobility, landowners and rich merchants, but it was France that influenced the fashions in furniture in the royal palaces. In Stockholm and Copenhagen new residences were built for the royal families at the beginning of the 18th century and these required complete refurbishment. The old castle of the

Swedish royal family had been destroyed by fire in 1697, and its reconstruction, under the supervision of Nicodemus Tessin the Younger (1654–1728), was very much in the style of Versailles, then popular in Europe. This provided good work for the furniture-makers of Stockholm, although the majority of the furniture was imported directly from France.

At Copenhagen, in contrast, the king ordered the demolition of the old castle and commissioned the construction of an imposing new edifice, the palace of Christianborg, which was later destroyed by fire in 1794.

(1663–1752). Thus we find in the Scandinavian countries chairs and armchairs where the techniques of carving and turning are combined. Local woods were used such as birch and ash, but also frequently walnut and beech, which was later partially replaced by mahogany. There are both commodes and bureau-bookcases in the austere Queen Anne style as well as examples that are typically Dutch in their over-ornate decoration, but with a touch of Rococo eccentricity, for instance in the boldly designed surmounts on some armchairs, where the central shell is replaced by an asymmetrical motif resembling a rising wave.

Direct Dutch influences also arrived in Denmark, unmarked by English style but showing one or two structural elements native to north Germany. Thus there are veneered commodes with four

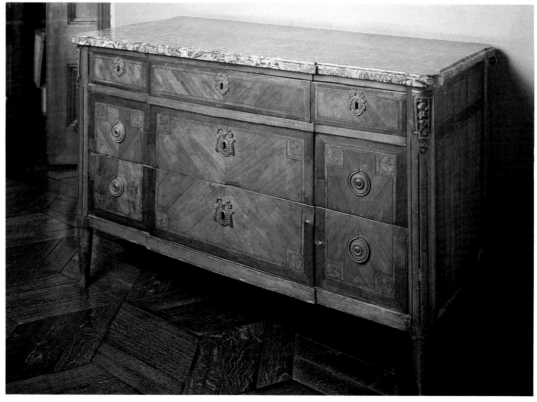

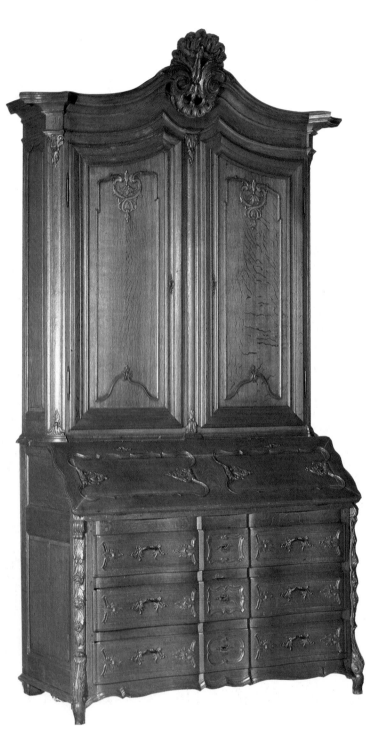

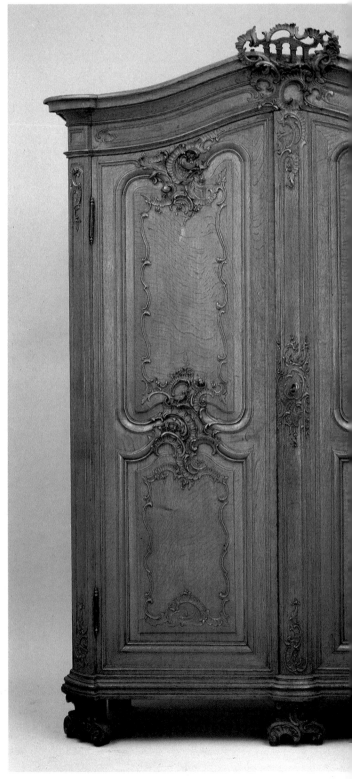

ABOVE: carved oak bureau-cabinet made at Namur in the first half of the 18th century: the lower section, with drawers and drop-flap, has canted corners decorated with *chutes* of alternating flowers and foliage; the drop-flap and the doors of the upper section are decorated with a curved and interrupted framework, and the cornice is centred with a *rocaille* motif. Musées Royaux d'Art et d'Histoire, Brussels.

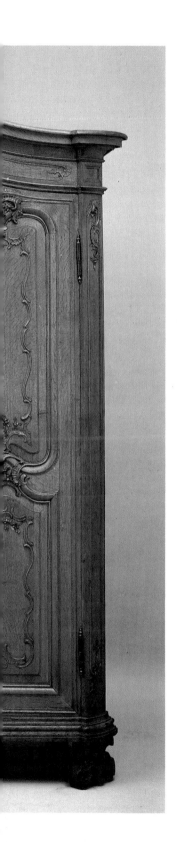

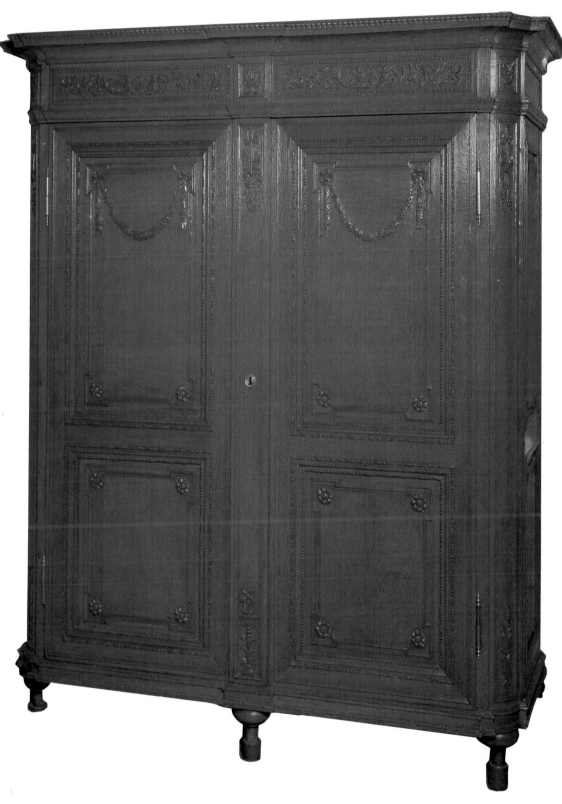

LEFT AND ABOVE: two examples of oak wardrobes from the Principality of Liège: the first (c. 1760) has a shaped cornice interrupted by a pierced *rocaille* motif and doors with moulded panels linked by Rococo carving; the second (late 18th century) has a frieze carved with tendrils and putti in the cornice above the doors, which are decorated with classical swags and rosettes. Musée d'Ansembourg, Liège.

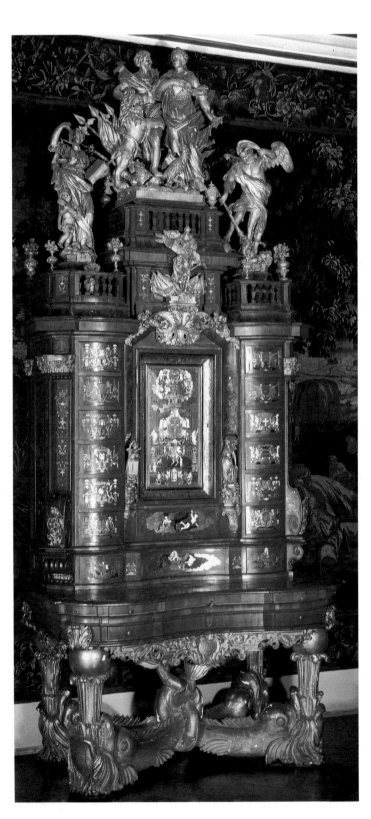

Provincial simplicity

The lack of national characteristics in Scandinavian furniture until the end of the 18th century renders superfluous any analysis on the basis of signature or stamp, whether and when a particular armchair or commode was made in Denmark, Norway or Sweden, or whether it was imported from abroad. One can say, however, that Scandinavian furniture of this period, in the rare cases when it is not a perfect copy of an imported work, and even when it seeks to imitate the exuberance of the Rococo style, is distinguished by a certain tranquillity of form. All this furniture is of a provincial simplicity which never threatens to lapse into bad taste. The craftsmen worked to a strict set of rules in order not to become entangled in the unpredictable eddies of the Rococo whirlpool.

It was thus natural that, in Scandinavia, it was only with the transition to the greater linearity of Neoclassicism, probably in itself more congenial to the Nordic character, that a typically national style evolved. In truth the flourishing of Neoclassicism in Denmark and Sweden can be attributed to two people who by example and instruction stimulated the imaginations of local craftsmen, who until then had only been required to demonstrate their technical ability and skills of production.

In Copenhagen the Frenchman Jacques-François Saly (1717–76), who was appointed director of the Danish Academy (c. 1753) at the time when the first intimations of the new style had become apparent, promoted the cultural status of craftsmen.

He established, for instance, that in order to obtain the title of master cabinet-maker, an applicant had to obtain the approval of the academy for the technical and aesthetic quality of the designs he submitted to the guild.

In 1769 the great cabinet-maker Georg Haupt (1741–84), who had spent a number of years perfecting his craft under the best masters in London and Paris, returned to Stockholm. Thanks to him, French Neoclassical influences came to bear and local craftsmanship was stimulated, so that Swedish cabinet-makers found a new self-confidence in their own abilities and developed an increasingly personal style. In the last thirty years of the century there thus developed a national style in furniture-making, which reached greater heights in the following century and was perfected in the 20th century. The situation was similar in Denmark, although here as in Sweden it was only at the beginning of the 19th century that Neoclassicism achieved widespread popularity with local characteristics, quickly developing into the Danish Empire style.

Poland

Specialized furniture production developed in Poland for the first time during the 18th century. In the country, the owners of the great estates usually selected the craftsmen best suited to the various requirements of the property from among their servants. Distinction would be made, for example, between farriers, grooms, bricklayers, smiths and carpenters. The last of these were responsible for making furniture

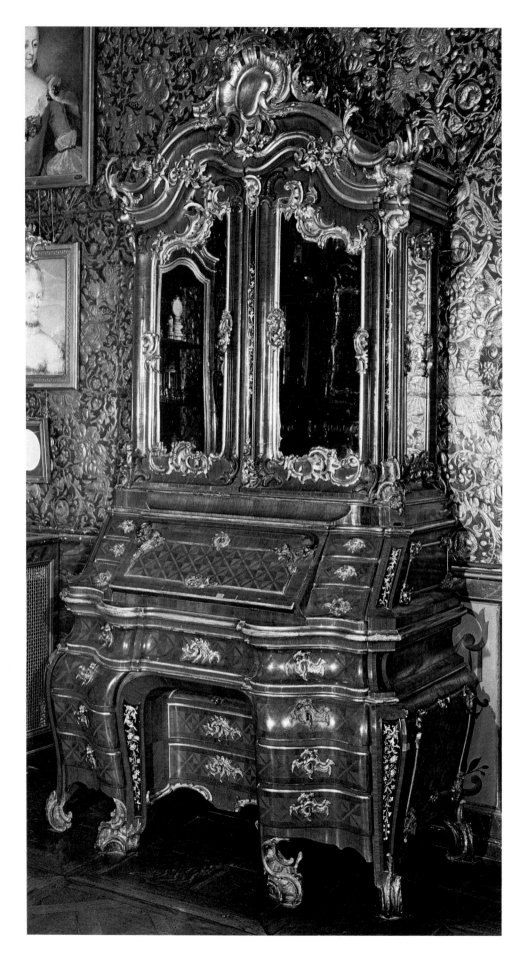

for their employers' houses. Despite whatever imagination and skill these carpenters employed, the results of their work were modest and lacked style, since the workmen themselves had received no education at the hands of capable instructors and had no examples to hand from which they could learn. Court furniture, on the other hand, and that purchased by the nobles living in city residences, was acquired abroad, from the great cities of central Europe and Italy.

A change in Polish furniture occurred with the ascent to the throne of Poland in 1697 of the Elector of Saxony, Frederick Augustus, as Augustus II, an event that had the support of the Habsburgs.

The German Elector took the Polish crown at a fortunate moment in Poland's history. Thanks to King John III Sobieski, who had liberated Vienna and Christendom with his victory over the Turks at Kahlenberg (1683), the country regained Podolia and most of the Ukraine under the Treaty of Karlowitz (1699), regions that had been ceded to the Ottoman empire in 1672. However, hopes of a lasting peace and organized economic development were soon dashed, first by the invasion of the Swedish king, then by internal discord, and finally after the death in 1733 of Augustus II, by the War of the Polish Succession. In the peace preliminaries in Vienna and the resulting treaty (1735–38) which ended the dispute, the son of the dead sovereign was recognized as the heir to the Polish throne as Augustus III (1733–63).

The first decades of the 18th century were thus not propitious for peaceful growth in the arts

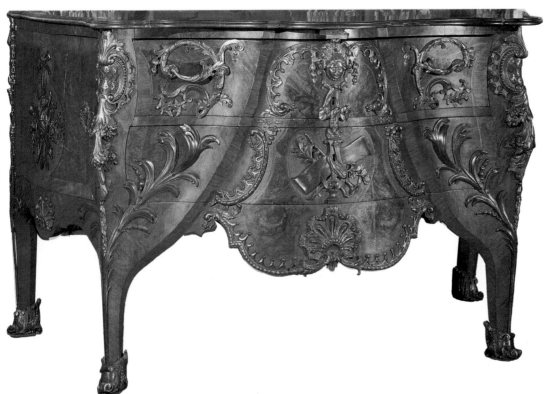

or with famous cabinet-makers. This was the path followed by Johann Michael Rummer, a pupil of Abraham Roentgen.

Russia

After centuries of isolation Russia now appeared willing to become an integral part of European culture. At the end of the 17th and beginning of the 18th centuries the young tsar, Peter I (1689–1725), had become aware during his visit to Europe how great the gap was in Russia's technical knowledge in a variety of areas – a gap it had to bridge in order to be able to compete with the countries of Western Europe. He therefore devoted all his energies to the modernization of his country. He raised its cultural sights, combating illiteracy and summoning architects, artists, men of letters and Western philosophers to his court. Furniture was imported first from Germany, then Holland and also France to furnish the palaces he had built in Moscow and St Petersburg in 1703. Armies of carpenters, carvers and cabinet-makers imitated the examples they saw from abroad, supplementing them with the Russian flair for decoration, but the popular love of colourful effects and owing to traditional decoration distorted the lines of the furniture which, when unadorned, copied the foreign models.

The gaps that Peter had to fill were nevertheless so great that for many years even the tsar's own residence remained unfinished, to the extent that during the reign of Elizabeth I (1742–62), when the empress moved from

and culture. However both rulers from Saxony brought a wind of change with them, and new projects were carried out by architects and craftsmen from Dresden, who began to transform the face of Warsaw under the influence of the Rococo style. The most significant projects came to fruition in the middle of the century, in a period of relative peace. This period also saw the blossoming of the art of furniture-making and, through the German influence now at work in Poland, the country came into contact with the new French style. In addition to imported furniture, locally produced work was now enthusiastically received, even by the nobility. Cabinet-makers and master carpenters opened specialized workshops in Warsaw and other important cities of Poland, and thus laid the foundations for

the development of furniture manufacture, which was to rise to greater prominence in the second half of the century after the death of Augustus III and during the reign (1764–95) of Stanislaus II Poniatowski (1732–98). Even after the division by Austria, Prussia and Russia in 1772 that led to the first partition of Poland, King Stanislaus succeeded in carrying out many reforms to improve living conditions in the towns. The arts and crafts enjoyed his special protection. Crown and nobility commissioned new public and private buildings, as well as transforming of existing edifices.

Tastes in furnishing changed, and the graceful lines of the Rococo were quickly replaced by Neoclassical austerity. Cabinets "in the German style" were still produced, with their lower sections supported on a base of

turned columns. The structure of this type of furniture maintained the lines of the 17th century, but was embellished with veneers and inlay in geometric or popular designs. The furniture-makers now took their lead from the publication of designs from France, which meant a swifter absorption of new styles. Although Polish furniture-makers endeavoured to achieve a more lighthearted appearance in their pieces, examples of the period are nevertheless still rather sombre owing to their ponderous structure.

During the closing decades of the 18th century increasing numbers of craftsmen came from the country into the cities, and the specialized workshops grew in importance – that of the Simmler family in Warsaw, for example, whose members often undertook a period of apprenticeship abroad

FACING PAGE: Danish commode (1740–43) by Preisler, which shows both French and German Rococo influence in its shape and bronze mounts. Rosenborg Castle, Copenhagen. THIS PAGE: two Swedish commodes, the one below with serpentine front datable to the mid-18th century. Antiques trade. The example above (c. 1779), inspired by the French Transition period, was made by Georg Haupt. Victoria and Albert Museum, London.

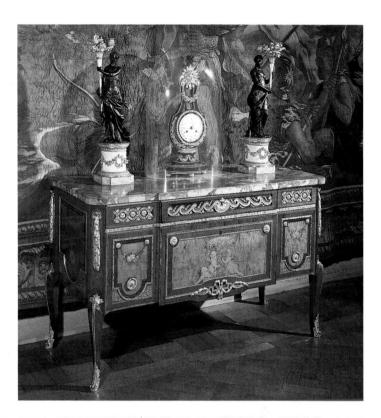

St Petersburg to Moscow, she had to take furniture and household items with her.

A tremendous new impetus was given to furnishings in Russia by Catherine II (1762–96), the German princess Sophia Augusta Frederica von Anhalt-Zerbst, who in 1745 had married the future tsar, Peter III. Peter was deposed after only six months by a coup d'état and met his death in mysterious circumstances. The privileges enjoyed by the nobility, but also the new literacy and the education programme now in force throughout Russia, together with court patronage, set the parameters within which a furniture-making industry could develop. The best furniture was still imported from abroad for the furnishing of the wonderful palaces at St Petersburg and Zarskoje Selo, which had been built by the Italian count Bartolomeo Francesco Rastrelli (1700–71) in a Rococo style that was already inclining towards Neoclassicism. Rastrelli also designed various pieces of furniture, which were made by highly skilled Russian craftsmen.

Russian craftsmen

The greatest difference between imported furniture and that produced in Russia at this period was in the proportions. Both the large sizes of rooms and the innate monumental nature of Russian taste influenced the large proportions of Russian furniture when compared with the English, French or German examples upon which it was modelled. A further feature typical of Russian furniture is the brightness of its decoration: it featured different

tones in gilding, coloured details and inlay in a variety of materials such as ivory, agate, jade, mother-of-pearl and amber.

Among the most important foreign cabinet-makers working for the Russian court was the German David Roentgen (1743–1807). His perfect assimilation of English and French taste in the transition to Neoclassicism made him the most influential of Catherine II's advisers in matters of furnishing. He was supported by the Scottish architect Charles Cameron (1740–1812), who was responsible for, among other things, the development of gilt bronze decoration for the furniture. A completely individual tradition was nurtured by the craftsmen of Tula, who at the end of the 17th century were already producing furniture and objects made entirely of steel. They pro-

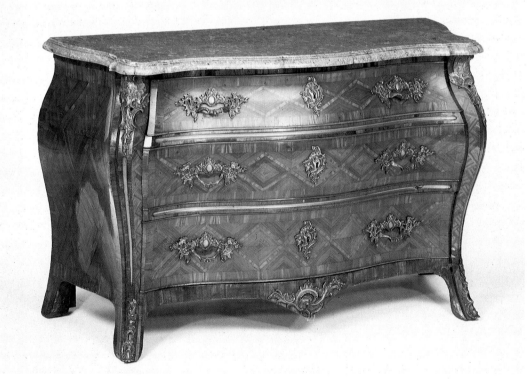

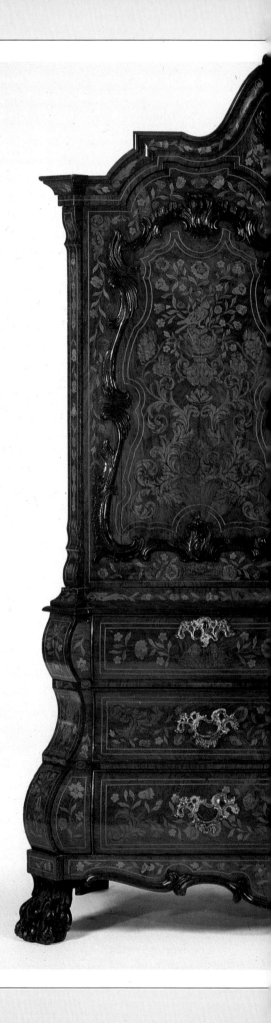

Dutch furniture: floral decoration and the *bombé* form

Dutch furniture was principally for "domestic" purposes, for use in cosy and intimate settings. For this reason Dutch cabinet-makers reinterpreted the new whimsical and elegant stylistic demands of the Rococo designed for the court and royal residences in a simplified version more appropriate to the needs of Dutch homes. Thus for example the *bombé* outline was filtered through this local fashion and resulted in excessively swollen shapes in the lower parts of furniture produced in Holland, and generated the more familiar and heavy style typical of 18th-century Dutch furniture. To refine and lighten these lines, Dutch cabinet-makers returned to traditional floral motifs for their inlay, and covered the entire piece – be it a table, a chair or one of the many variations of the *kast* – with garlands, swags, vases and bunches of flowers. They did not stop at the usual surfaces for this sort of decoration, but carried it over on to frames, mouldings, aprons, supports, and the arms and backs of chairs, so that the furniture became a triumph of floral decoration.

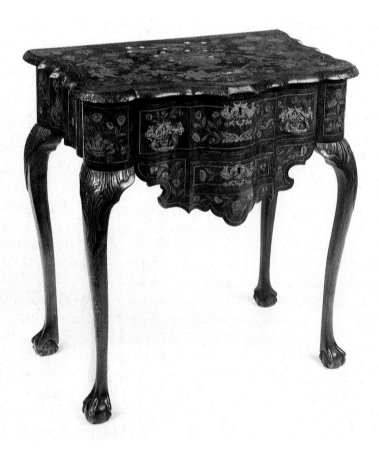

The examples of furniture on these pages are characteristic of Dutch floral marquetry. ABOVE: side table (c. 1750) with cabriole legs and claw and ball feet. CENTRE: cabinet chest of drawers (c. 1750), the upper section surmounted by a shaped and stepped cornice, the lower section with curved and waisted sides resting on claw and ball feet. FACING PAGE, ABOVE: *bureau en pente* (fall-front bureau; c. 1750), with S-curved front and buttressed flanks, the apron with tied ribbon decoration and central medallion; ball and claw feet to the front, bracket feet to the rear. BELOW: late 18th-century bureau-cabinet, veneered in walnut with *bombé* lower section, the upper section with doors inset with mirrors within scrolling framework, and surmounted by a curved and stepped cornice. Antiques trade.

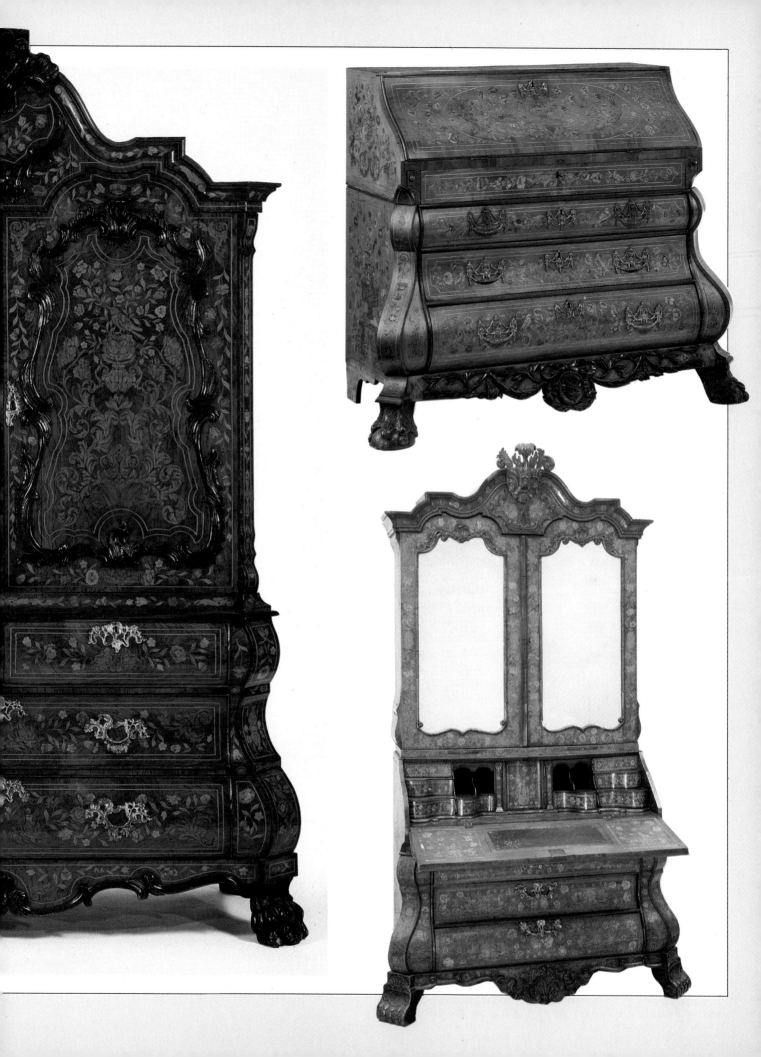

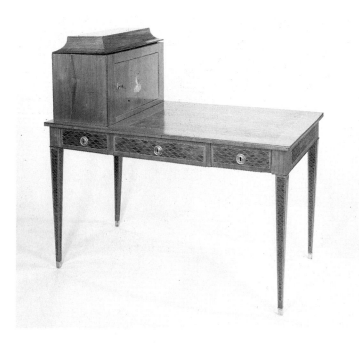

duced mainly tables, chairs and armchairs with pierced panels to make them lighter in weight. The earliest pieces are unmistakably Slav in character, both in design and structure, while later pieces tend more towards the Neoclassicism of Robert Adam and closely resemble the furniture made at the Boulton workshop in Birmingham. There seems to have been an exchange of craftsmen between the two workshops following the Empress's visit to England in the company of Count Orlov. The craftsmen at Tula used inlay and plated steel with precious metals.

Another material sometimes used in the interior decoration of the most magnificent buildings was coloured stones of paste glass. Various workshops began to produce glass paste in the second half of the 18th century and the walls of one room in Catherine II's apartments at Zarskoje Selo were completely lined with dark blue and milky white pastes.

For this same room and in the same colours, court architect Charles Cameron also had a small glass table made, mounted in gilt bronze.

Under Catherine II Russian craftsmen achieved increasing autonomy and also developed individual characteristics in the field of furniture-making. Meanwhile the great landowners continued to have furniture made on their own estates but with more updated techniques. The furniture workshops founded by Peter the Great near the shipbuilding yards at Okhata continued in production at least until the time of Alexander I (1801–25). It was here that the famous cylinder desk of the Empress Catherine was made, the design of which follows the dictates of French classicism but nevertheless proclaims its Russian origins by its rich inlay.

Spain: a dual influence

With his country torn between France and Austria, the weak and sickly Spanish King Charles II decided, before his death without a direct descendant in 1700, to nominate as his heir Philip of Bourbon, Duke of Anjou and grandson of Louis XIV. Philip was recognized as King of Spain by the other European powers only with the Treaty of Utrecht in 1713. Contact with the court of Versailles, where Philip V had been born, was thus inevitable, and these contacts brought French influence to bear on the furnishings of the court and the most influential Spanish families. Furniture in the style of Versailles was copied by court craftsmen at the sovereign's request. While Philip appreciated the French style, seen especially in the console tables surmounted by tall mirrors, he preferred to entrust the making of furniture to local craftsmen – an act of policy in which the Spanish nobility of pure Spanish stock did not consider it necessary to imitate their foreign sovereign. Thus their palaces were furnished in a manner whose elegance derived directly from the Parisian cabinet-makers.

Italian influence was also felt early on in Spain: in 1735 Filippo Juvarra was summoned to Madrid, where he worked in the palace at La Granja de San Ildefonso, which had become the royal residence after the fire at the Alcázar. Juvarra was responsible for the design of forty console tables made in Genoa by Bartolomeo Stechone.

When Ferdinand VI came to the throne in 1746, Italian influence became less pronounced, with the exception of Venetian

features seen mainly in the polychrome chairs of Catalonia. The lines of the furniture resembled more the French Rococo style, with a particular predilection for gilding and lacquerwork. This was combined with the English influence, for which Ferdinand's wife Barbara of Braganza was responsible, for there were close bonds linking England and her native Portugal.

With the death of Ferdinand VI in 1759 the Spanish throne passed to his half-brother Charles, Duke of Parma and Piacenza from 1732 and from 1734 King of Naples and Sicily. Along with a number of political advisers, he brought with him from Italy to Spain large numbers of architects and decorators, and among the latter Mattia Gasparini deserves particular mention. He was the director of the *Real Taller de Bordados* from 1765 to 1774, and in addition designed many items of furniture. He was also the expert in charge of all the minor crafts at the Palacio Real. The room there originally known as the *Salon de vestirse del Rey*, the furnishings for which were made by the Flemish cabinet-maker Joseph Canops between 1770 and 1780 to designs by Gasparini, is today named after the Italian. The bronze decorations on Canops's furniture are by Giovan Battista Ferroni, another Italian artist who arrived in Madrid in 1770.

French taste, only slightly influenced by Italian styles, continued to prevail in this period, at least in furniture design. Gasparini's chairs, above all his armchairs, are Italian in their "forceful expression" but Louis XV in their structure, lacquerwork and bronze decoration.

Finally, when the weak and

unfortunate Charles IV succeeded to the throne in 1788 (he had to cede the throne to Joseph Bonaparte in 1808), the royal cabinet-makers and carvers threw themselves into a frenzy of production. Thanks to the famous court architect Juan de Villanueva (1739–1811), who worked in collaboration with the most skilled craftsmen, Neoclassicism reigned supreme. Among the best furniture designers Manuel Muñoz de Ugena deserves mention, as does Ferroni, who designed among other things the famous *sillón de besamanos* (the "hand-kissing" armchair), which was made by José López in 1791 for Queen Maria Luisa. Ferroni was also responsible for wonderful bronze tables with surfaces inlaid with Florentine *pietre dure* mosaics.

Neoclassicism marks the end of the evolution of Spanish furniture in the 18th century, which was influenced by the furniture of Lombardy and Naples, Parisian elegance.

The various types of Spanish furniture

The type of furniture that underwent the greatest transformation during the course of the 18th century was the chair. It developed from the squat, still somewhat medieval *sillas* – which however were still being produced – to the *silla mallorquina*, with straw seats, turned legs and carved stretchers painted in vivid colours. Chairs then passed through a "cabriole" period, a largely unsuccessful attempt to obey Rococo influences, and finally arrived at a fragile and bizarre form of Neoclassicism

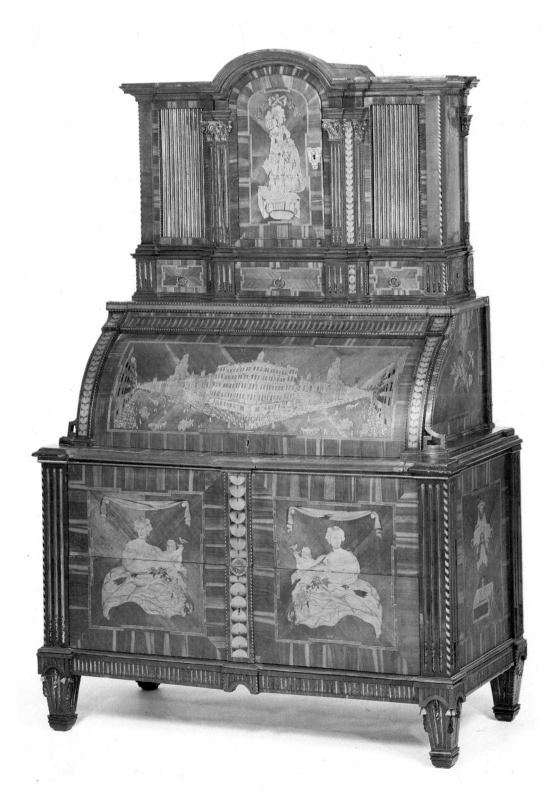

BELOW: the bed of Barbàra of Braganza (1711–58), Queen of Spain, who married the future king, Ferdinand VI, in 1729. Palazzo Reale, La Granja de San Ildefonso. FACING PAGE, LEFT: Spanish cabinet (c. 1730), still clearly in the Baroque style. Museo Arqueológico Nacional, Madrid. RIGHT, ABOVE: Spanish commode of the second half of the 18th century, veneered with marquetry of exotic woods and applied bronze decoration in the French style. BELOW: late 18th-century oval Spanish commode, decorated overall with marquetry scenes within rectangular borders, the scenes separated by classical columns. Palazzo Reale, Madrid.

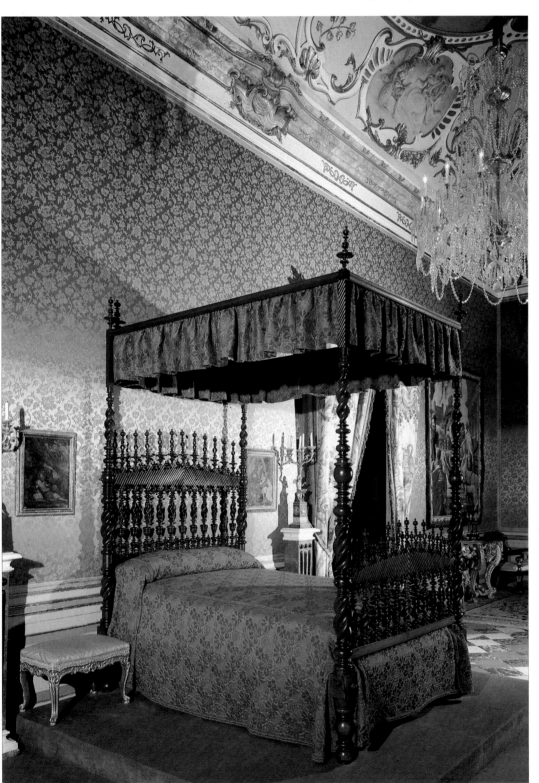

seen in incongruous chairs with
pierced and carved backs.

The cabinet also changed in character. The traditional *bargueño* disappeared quite quickly and was replaced initially by the architectural *arquimesa*, modelled on Italian and Anglo-Dutch examples, then by the classical *chinero*, whose two-section body comprised a desk fitted with drawers and a drop-flap writing surface beneath an upper section fitted with glass doors, of austere lines. This was eventually succeeded by another version of the same type of furniture with fluid lines and an exaggeratedly narrow top, which bore a distant resemblance to the Venetian bureau-cabinet. A curious characteristic of *chineros* is that some examples are capable of being changed into house altars, a function that can also be found in similar furniture in Sicily and the Portuguese *papleira*.

Perhaps the most typically 18th-century item of all Spanish furniture is the bed, with or without a canopy, whose pillars sometimes consist simply of short decorative supports. The whole beauty of the bed is often concentrated in the headboard, frequently ornately moulded and carved, its inner side either upholstered or painted with landscapes, genre scenes and religious figures.

Portugal: types of furniture

The most significant foreign stylistic influences in Portugal came from the Far East and England. French and Dutch influences also made an indirect impression via England. The period of exclu-

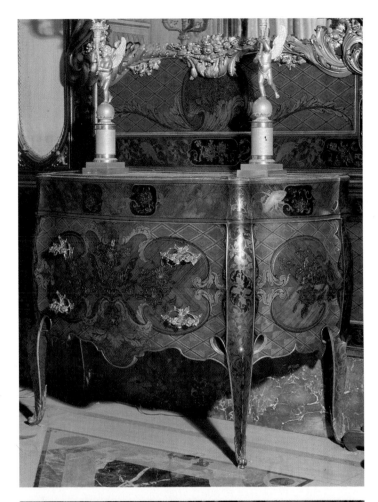

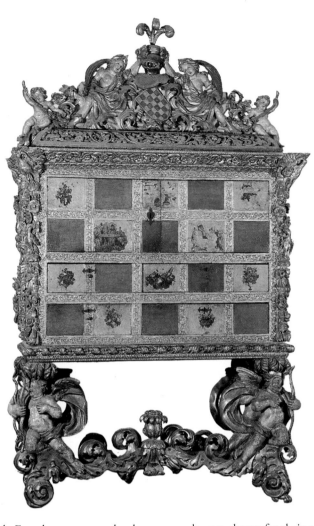

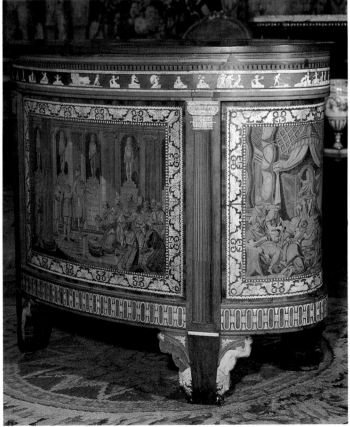

sively French taste spanned only a few years around the middle of the century, and was limited to imported furniture. It must be added, however, that some experts are of the opinion that Portugal itself influenced English taste. In fact a number of stylistic features that Portugal had adopted from China were passed on to England, whence they were re-imported into Portugal, as was the case with the Chinese Chippendale style.

Portuguese furniture of the 18th century is unmistakable on account of the woods used by the craftsmen – Brazilian mahogany, for example, rosewood or jacaranda, *paosanto*. All these woods were chosen for their compact quality, which made them particularly suitable for carving, as can be seen in the multitude of types of little turned columns in typical Iberian beds. The low table is a purely Portuguese type of furniture, which illustrates exceptionally well how Chinese influence was adapted to suit Western tastes. It was probably in Portugal that it found its real use, in the *estrado*, a room in which the lady received her guests, and where carpets and cushions replaced the normal chairs.

Towards the middle of the century the damaging consequences of the unevenly distributed wealth that had come into

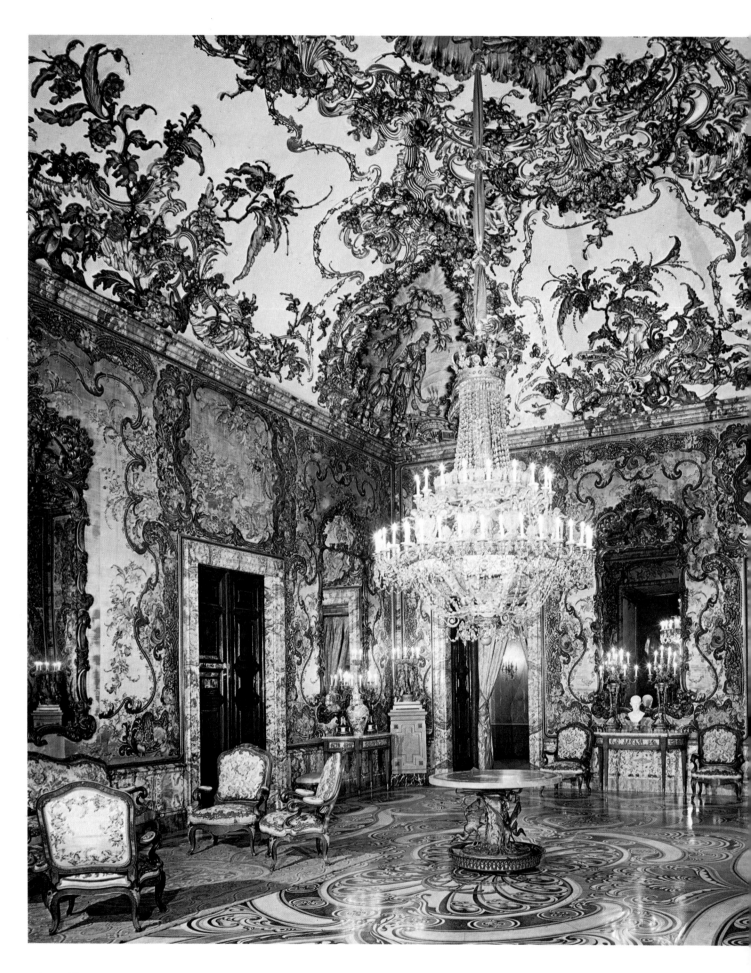

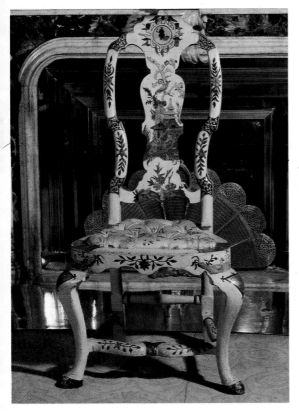

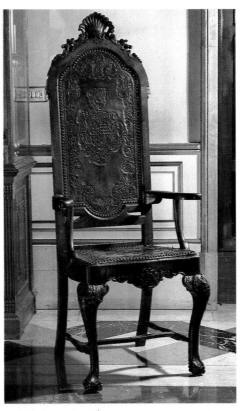

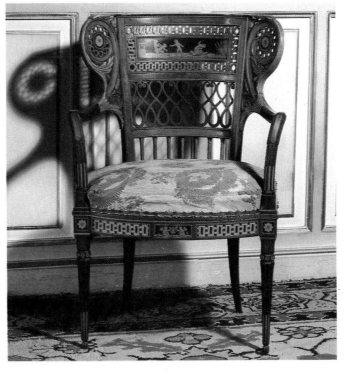

FACING PAGE: Salon of Charles III (the *Sala Gasparini*) in the Palacio Real in Madrid. It was refurbished by Charles of Bourbon when he came to the throne (1759). This room was designed by the Neapolitan Mattia Gasparini, as were the chairs in the room. The elaborate ceiling, decorated with Rococo stucco work in vivid polychrome colours and enriched with gilding, is complemented by the floor in inlaid marble and the wall coverings in embroidered silk. ABOVE, LEFT: early 18th-century Spanish chair in painted wood, in the contemporary English style. Palacio Real, Aranjuez. RIGHT: Spanish or Portuguese armchair (1725–50), with carved decoration, the front cabriole legs terminating in claw and ball feet; the seat and the back are covered in tooled leather, nailed to the frame. BOTTOM: late 18th-century inlaid Spanish armchair, designed by the French architect Jean Démothène Dugourc (1749–1825) the pierced back of "comb" design *(de peineta)* with a frieze decorated with classical motifs. Palacio Real, Madrid.

Portugal from abroad began to make themselves felt, and resulted in economic and moral paralysis in the country. The silvering and gilding of furniture was restricted by royal decree. The exuberance of the Rococo style was curtailed out of inner conviction and not just because furniture-makers were seeking to emulate the moderation of the English Chippendale style.

Meanwhile Joseph I succeeded to the Portuguese throne, and his reign (1750–77) was overshadowed by the terrible earthquake that almost completely destroyed Lisbon in 1755. The consequences of this as far as furniture-making was concerned was a period of uncoordinated development, which only ended in the late 1760s. The sole item of typical Portuguese furniture of this period is the *papeleira*, a commode with a fold-over top, often with a shaped or *bombé* front, where the carved decoration would be limited to the corners and feet, which were curved outwards like those of waterfowl.

The Portuguese commode is similar to the *papeleira* and was much taller than in other European countries. Other types of furniture were more directly influenced by English, French and even Dutch styles, but the decorative motifs used have a distinct Portuguese character. The most typical elements include the long deep apron, which is to be found below the frontal frieze of many chairs, consoles and small commodes on cabriole legs. This feature was so popular in Portugal that it can even be found on pieces of Neoclassical design.

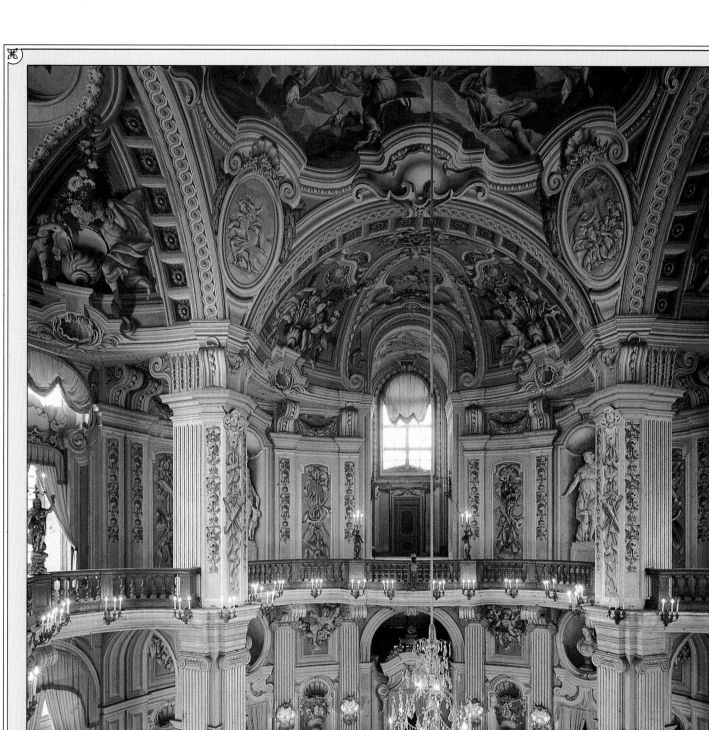
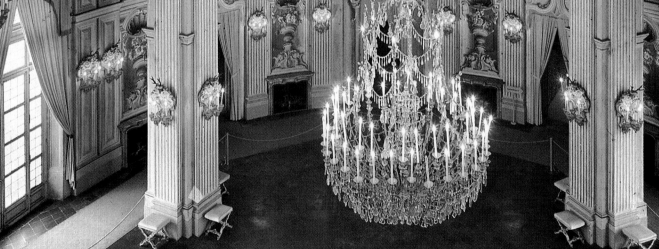

FURNITURE OF THE 18TH CENTURY

INTERIORS

by Andreina Griseri

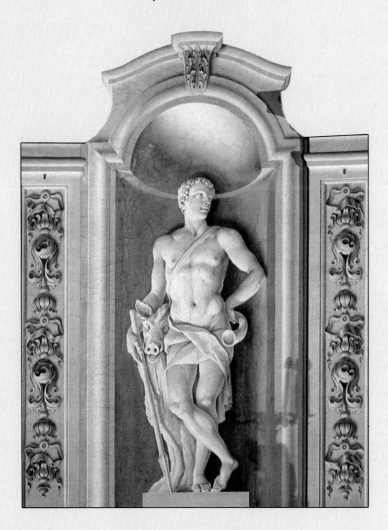

Nature and design in 18th-century interiors

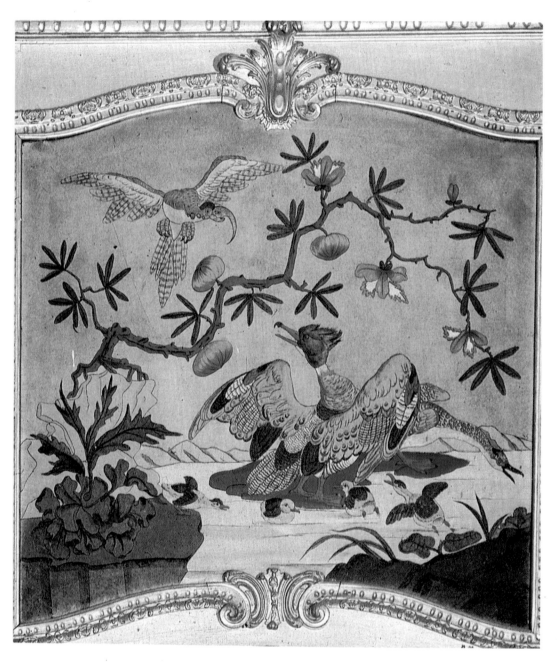

Living forms

The image of the 18th century appears as if reflected in a large, bright mirror that picks up and transforms even the smallest object so as to create a lively parallel to the natural world. It was a kind of garden within reach at all times, in which the simplest or the most sophisticated things might represent not only the illusion but also the delight of being "tamed" and adapted to "civilized life". Every idea is translated with good-natured impartiality into this "life of forms".

It is no coincidence that in the midst of this Parisian exoticism in the first half of the century, one of the wittiest and most liberated novels of the age was published – Claude Crébillon's masterpiece *The Sofa* (1735–42). This emblematic item of furniture is the narrator of the book; once a raffish Turkish vizier, he was reincarnated as a sofa as a punishment for his loose living. Thanks to a quite remarkable gift of recall, he is able to give a piquant account of the numerous passionate love-affairs and other events that have taken place on his comfortable upholstery. The objects, and especially the furniture, whose elegance delighted the eye and were a pleasure to touch were the embodiment of those years of the "vagaries of the heart and mind", to quote the title of another book by Crébil-

ABOVE AND FACING PAGE: details of the decoration in the gaming-room of the Stupinigi Hunting Lodge (1765) by Christian Wehrlin. The 18th-century preference for exotic subjects is evident in the imaginative and affectionate depictions of distant worlds remote from everyday life. People were drawn to what was unusual, elegant and

costly. PREVIOUS PAGES: the elliptical main drawing-room of Stupinigi, focus of the building by Filippo Juvarra, with a detail of the decor created by the brothers Giuseppe and Domenico Valeriani under the architect's direction – a dense network of pilasters, cornices, urns, shells, garlands and *trompe-l'œil* statues.

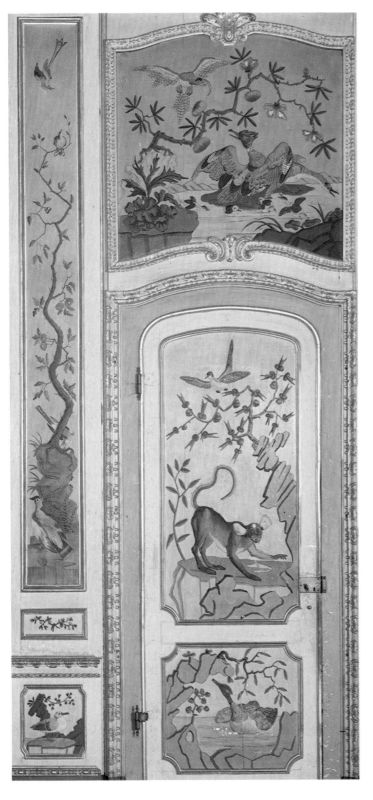

lon. A culture that was based on new discoveries and believed in technical progress, it clothed all useful things in a "mantle of beauty", a beauty refined by the unmistakable patina of daily use. The cumbersome designs of the 17th century no longer met the needs of this multi-layered society, open to the ideas of the Enlightenment. Furthermore, a great increase in foreign travel gave rise to a network of contacts; developments in other countries were followed with close interest. Frenchmen and Englishmen, Poles and Germans met on their way to Rome or Naples, in Venice or Parma and – less frequently – in Turin.

Because of the many ideas that were expressed in them, theatre and music played a decisive role in spreading the new taste – for example during Carnival celebrations or Easter Masses in the great cathedrals. The borders between the sacred and the profane were obliterated, leading to fundamental changes in art and craftsmanship. This was particularly true in the case of objects made from costly materials, such as carvings, fabrics, sculptures and porcelain, or articles of silver and bronze, which evolved in close association with architecture and – most significantly – garden design. This can be seen very clearly from the repertoire of motifs used for interiors, whether in valuable works of art or objects made by craftsmen.

As with the Gothic style, the overall concept of the Rococo is expressed in small details. Like the cathedral-builders of the 12th century, the designers of 18th-century palaces strove to give even the smallest object the "living form" and energy that would

reunite it with nature. The artists of the Rococo pursued this goal with even greater emphasis and directness.

In both periods the motif of the tree was basic. In Gothic art, which long retained its influence in both ecclesiastical and secular worlds, natural forms – plant and animal motifs – were used to decorate sculptures, tapestries, architectural features such as wooden choirs and objects of enamel and ivory. During the 18th century the range of these forms was extended and became more light-hearted and sensual, thanks to the new elective affinity of Man and Nature, the result of a more direct interchange.

Interiors as gardens

The architecture and furnishing of interiors were very reminiscent of gardens as both ideal and real places, in their interplay of art and nature. Elaborate confections involving fountains and rocks, typical of garden design of this period, were manipulated in such a way as to make them appear as if they had resulted from a whim of nature. The lively interiors of the 18th century were similarly furnished: with delicate furniture and mirrors, whose surreal effects of light alternate with the white of the stucco decorations, the blue of the tempera paints and the green of lacquer paintings, thus competing with the tones appearing in nature. The sky, especially when depicted in frescoes of mythological or Arcadian themes, played an important role during the Rococo period. A new perception of reality made it possible to combine realistic *vedute* by Canaletto and Bellotto with

The integration of countless nature-motifs in 18th-century interiors can be seen in the illustrations on these pages. BELOW: door of the *Sala del Caffè* (Coffee Room) in the royal palace. Palazzo Reale, Turin. CENTRE: carved stucco decoration, painted in white and gold, in the Ancestral Gallery of the Residenz in Munich (1730). FACING PAGE: door of the *Sala degli Arazzi* (Tapestry Room) in the Ca' Rezzonico, Venice.

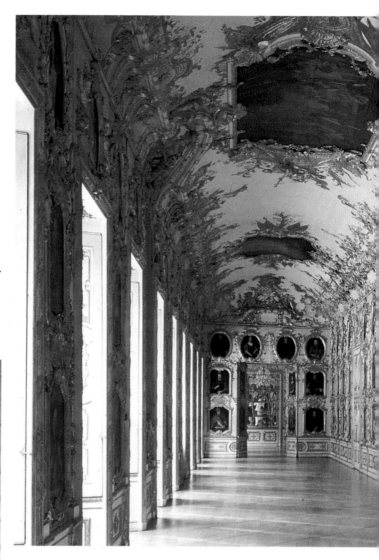

the monumental fantasies of Piranesi. Baroque artists had possessed the ability to integrate any motif in a colourful narrative structure inspired by nature, to anchor it firmly there and exploit it in pictures designed to astonish. The art of the 18th century followed this style of presentation; but the work of the period appears tenderer and less rhetorical. However, Baroque sculptor and architect Bernini remained

an important point of reference for artists and craftsmen as was the rediscovery of Correggio, who became a "tutelary deity" of the century, creating a fashion for extravagant folds of material, foreshortened perspectives and the depiction of grasses and putti. Decoration existed for its own sake, and with great delight artists set about pursuing the taste that the English termed "picturesque".

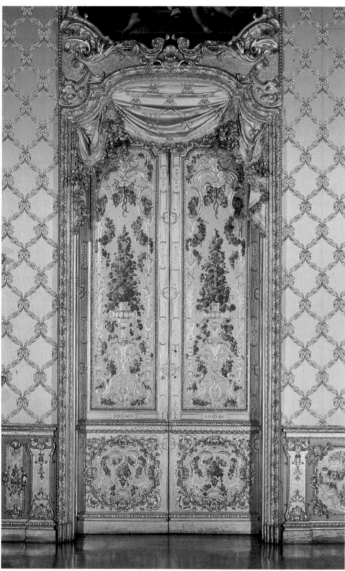

In these Arcadian scenes every object was closely linked with nature as the ideal refuge – trees and space played a crucial role. The comfort of interiors, as counterparts to garden grottoes, consequently gained a new degree of importance. Alongside extreme elegance, simple elements were found – very much in line with the intellectual fashion of extolling the simple, rustic life. It was in this social climate that the Rococo style developed. Readers are referred to detailed analytical studies by Kimball, Weise, Sedlmayr, Starobinski, Schönberger and Bauer.

In 1753 the English artist William Hogarth, in his *Analysis of Beauty*, defined the curved line as the "line of beauty". The turbulent *rocaille,* typical of the art of the age of Enlightenment bet-

ween 1750 and 1760, was gradually displaced by Neoclassical motifs from 1760 onward, as society began to develop an enthusiasm for antiquity.

The Rococo evolved not only in Paris, but also in the villas around Venice, the *palazzi* of Rome and Naples, the great estates around Vesuvius and the Bourbon residences in Parma and Piacenza. The example of the Stupinigi hunting lodge springs to mind, as do the castles of Moncalieri and Rivoli. In Turin, the Palazzo Reale and the residence of the Duke of Chiablese, who made numerous journeys to Schönbrunn, the Habsburg palace outside Vienna, were also furnished and decorated in this style. The penchant for luxury characteristic of the Rococo is typified by Chiablese's well-docu-

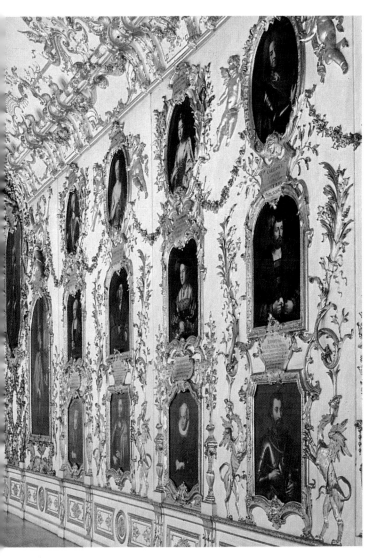

During the Rococo period, even the most mordant scenes were set in elegant, lively frames. The painting within this gilt setting could be full of sentiment and subtle melancholy, an intimate drama guided by intelligence as with Watteau, or a pungently ironic commentary on libertine behaviour, as with Hogarth. The *peinture morale* of Greuze proposed a better society based on Enlightenment principles; Canaletto and Bellotto painted accurate *vedute*, while Pannini's views, though equally true to life, were more light-hearted.

The lives of the people portrayed were lived out against a background of delightful alternation between house and garden, bathed in light from large windows and reflected in mirrors. The fondness for plants led them to fill their rooms with costly floral porcelain and artificial

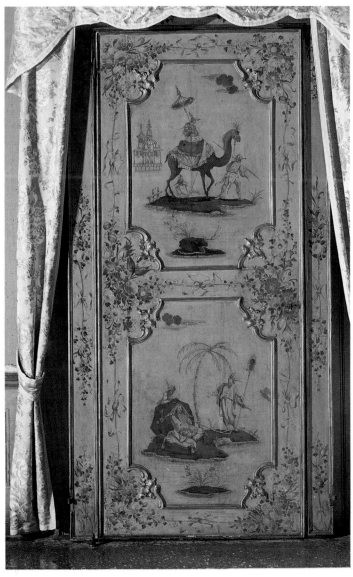

mented expenditure on chocolate, or the lemon hedges laid out in many country-house gardens. The rebuilt residences of Europe's monarchs, including palaces in Germany and Vienna such as Prince Eugene of Savoy's Belvedere, became Rococo's points of reference.

Engravings and chinoiseries

Chinese-inspired designs on wallpaper or the more expensive porcelain tiling of rooms and summer-houses from Dresden to Madrid and Turin to Naples, symbolize contemporary interest in things foreign and outside everyday experience. People took pleasure in looking at arrays of small objects in imaginative settings. *Singeries*, little monkeys in human situations, and the ever-present sea-shells were fixed components of the iconographic repertoire throughout Europe.

Engravings were of great importance in the spread of Rococo. For example, the lacquer paintings on Venetian furniture were intelligent interpretations of original engravings that harmonized perfectly with the heroic myths that were increasingly used in ceiling frescoes. In the princely palaces of Piedmont or the Royal Palace in Madrid biblical themes enjoyed greater popularity. Antiquity, predominantly Roman history, was also invoked, to the greater glory of the patron who commissioned the building. The "prayer-stools of the mighty" in their private chapels were decorated with themes from the Old and New Testaments.

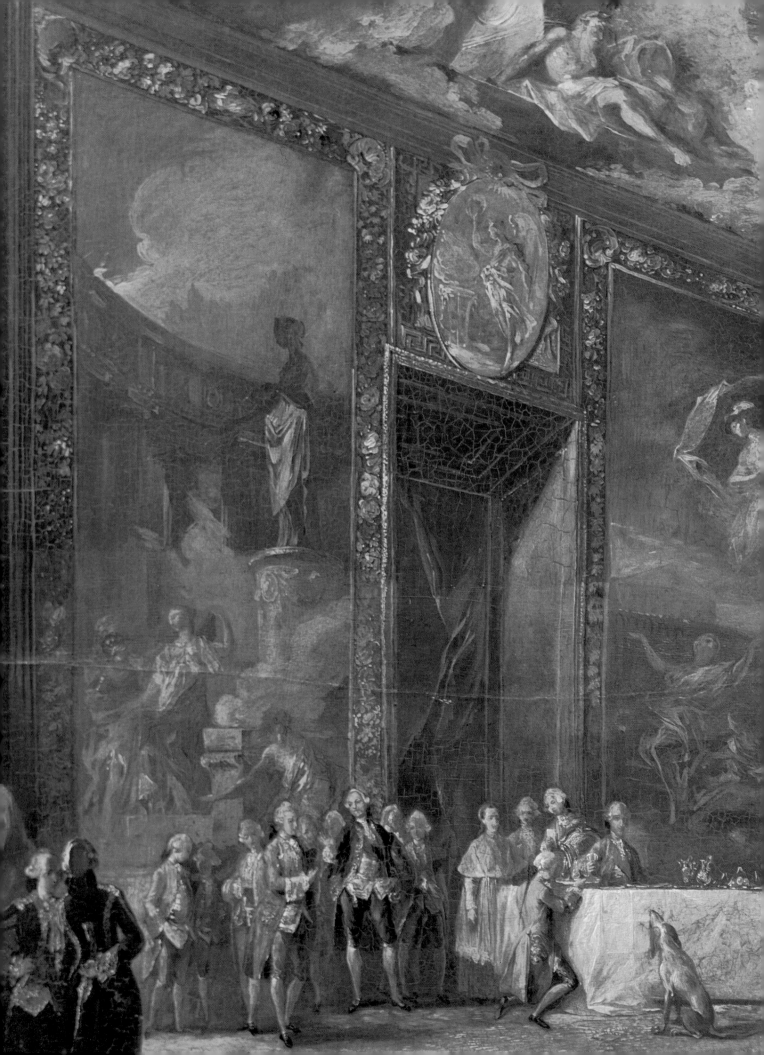

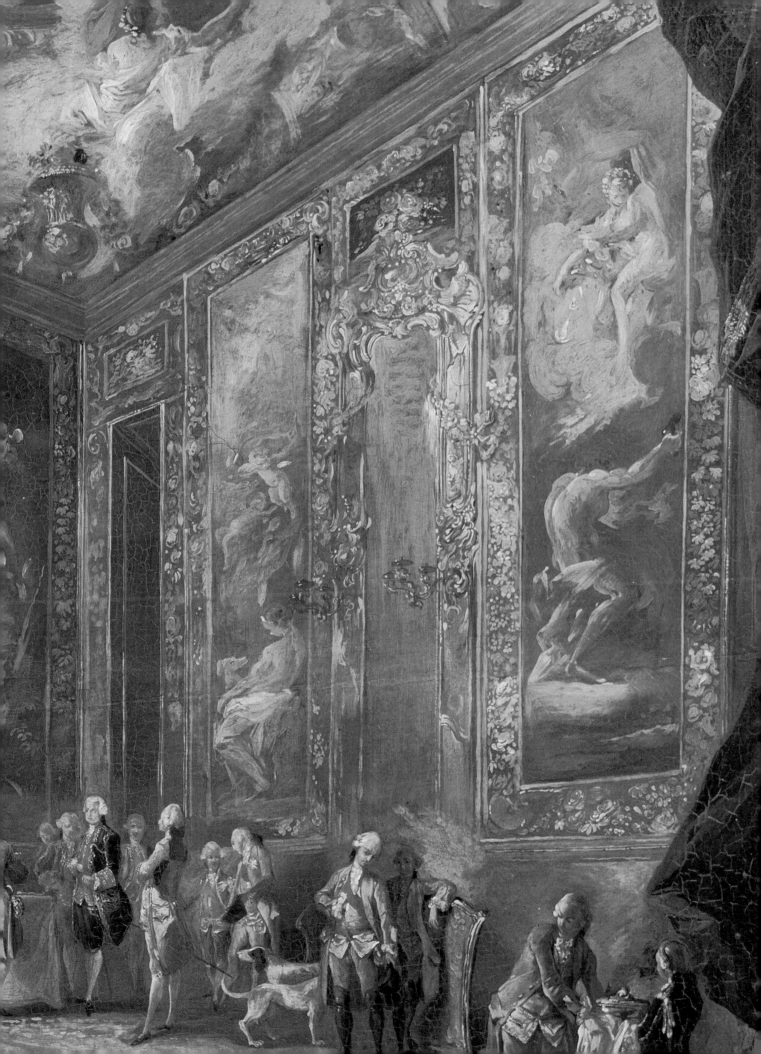

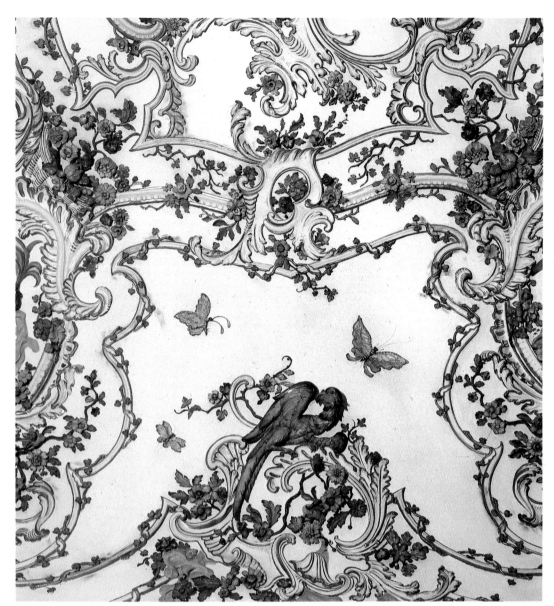

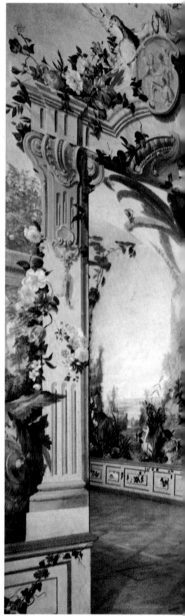

flowers that were scented to make them seem more authentic.

Faïence was also very popular, as were the designs of the decorator and goldsmith Meissonier, which were juxtaposed to tapestries based on cartoons by Boucher and produced by Michel Audran (1701–71) in the royal Gobelin factory. Decorative motifs *à la Bérain* were also widely used. The delicate, curling grotesques of Jean Bérain the Elder and his son were to have an influence on architectural decoration and also garden trelliswork even in the time of Benedetto Alfieri and Jacques-Ange Gabriel.

Playing with nature

During the 18th century houses became more comfortable; new types of room, sometimes very small, were intended to provide greater comfort. Each individual object was an integral part of a completely altered decorative scheme. The placing of items of furniture might seem random at first glance, but in fact followed loose, almost capricious rules which brought new objects and symbols within reach. An example of this is provided by the wide range of small tables and *tabourets*. The ideal home was connected directly to the garden. In the residences of the nobility the loggia fulfilled this function, though

simpler variants also existed. Decorative artists took account of this opening to the outside world and introduced special embellishments. Vaulted ceilings and porches were decorated with frescoes of blue sky, and even the wallpapers and fabrics in living-rooms were part of the new concept.

In this context of a close connection with nature the concept of the door underwent fundamental changes. It was intended to look like a garden gate, bright and full of light; this is why luxuriant cascades of flowers frequently decorate the mouldings over the doors and blend completely with the surrounding architecture. The iconographic repertoire of Rococo interior dec-

Exotic frescoes depicting rare plants and animals – probably based on specimens in the imperial greenhouses and palace zoo – decorate several of the rooms to the left of the entrance-hall of Schönbrunn Palace. These are known as the Bergl Rooms, since all the frescoes were painted between 1769 and 1777 by the Bohemian painter Johann Bergl. BELOW: a general view and (right) a detail from the decoration of the rooms. Situated on the garden side, they represent a perfect link with the surrounding landscape, completely in accordance with the love of the theatrical and the picturesque in that period.

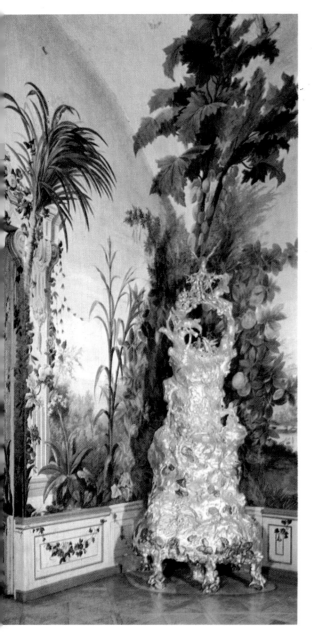

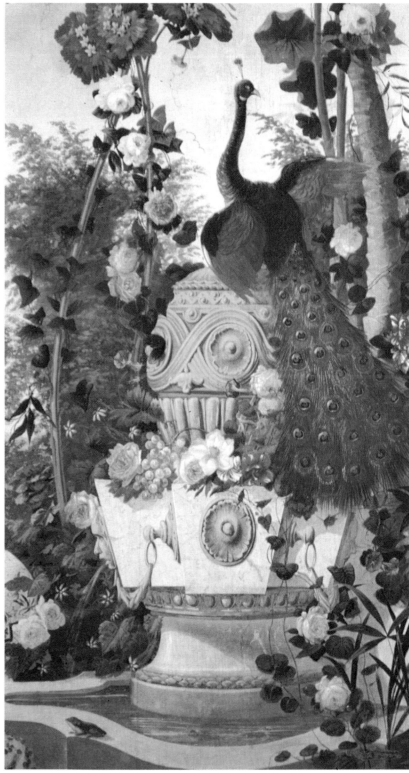

oration embraces allegorical and amorous subjects, historical motifs that appear almost light-hearted, and innumerable variations of cleverly combined grotesques and arabesques that always remain closely connected with the garden and nature. A good example of this is at Rivoli near Turin (1723), but there are others in Bayreuth and in the small drawing-rooms of the Ca' Rezzonico in Venice and the country houses around the foot of Vesuvius. A kind of natural lightness determined the rhythm of ornamentation and produced impressive results, e.g. the stucco decorations in the drawing-room and Hall of Mirrors of Nymphenburg Palace in Munich, or the small rooms for exercising the dogs, and faïence wall-tiles in the kitchens and bathrooms.

The functional shape of each object taken from nature dominated the Rococo interior. As in the Gothic age, flowers in bloom and tree-trunks once again served as load-bearing architectural features, for example in the carved and softly modelled covings. Typically, walls were covered with fabric or panelling, either in its natural state or gilded, and were embellished with white or coloured stucco. In each case the leitmotif was nature. The external outlines of the buildings appear even more turbulent and alive than those of the Baroque architects Bernini and Borromini. This sense of dynamism came from the enhancement of window and door-frames with white stucco, e.g. by Juvarra at Stupinigi, Turin and Cuvilliés in the Pagoda (1722) in the park of Nymphenburg Palace. Much the same is true of the façade of Santa Maddalena in Rome (1753)

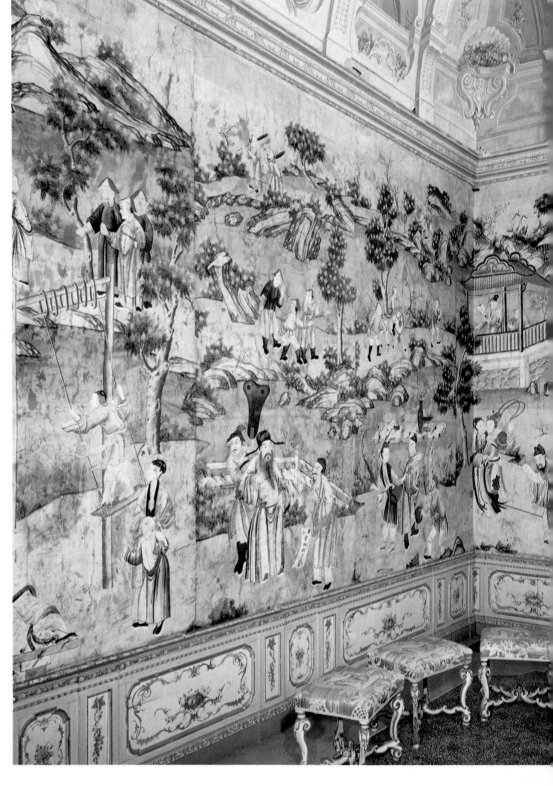

designed by Giuseppe Sardi and the Johann Nepomuk church in Munich (1733–45) by the Asam brothers.

The architects of the *Accademia dell' Arcadia* integrated natural elements in their construction. The undressed stone of the

Asams' church in Munich looks back to Bernini, and the framing of the main door is reminiscent of Borromini. Perhaps the most impressive stucco decorations are those of the Italian sculptor Giacomo Serpotta: for example the tendril-work on the spiral, gilded

columns of the altar in the oratory of San Lorenzo (1687–96) in Palermo. The putti, masks and pierced foliage on the capitals are reminiscent of Primaticcio and Mannerism taken to extremes; also to be noted are *décolleté* figures in the Genoese frescoes of

Gregorio de Ferrari (1647–1726), which are said to have inspired Fragonard. In fact, it all began with those Genoese artists who had worked on Bernini's building projects and who, in the late 17th century, had rediscovered the Mannerism of the Parma school

The *Sala delle Prospettive* (Prospects Room) in Stupinigi shows the close connection between interior decor, theatre and stage sets. The numerous *trompe-l'œil* paintings are by Giovanni Battista Alberoni, who worked in Stupinigi from 1751.

His specialisms were views of ruins, stage sets and backdrops set in wall in medallions, and exotic plants, vividly coloured parrots, scrolls and wreaths of flowers in full bloom.

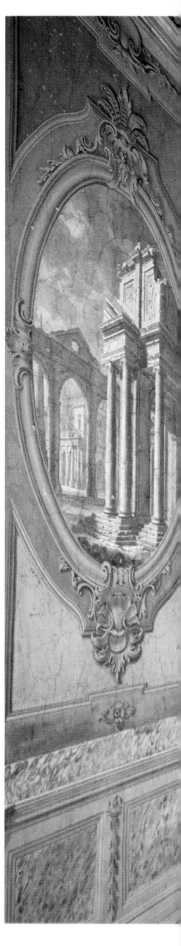

and the allure of Correggio. They freed their allegories and mythological representations from any kind of ballast and interpreted them in the spirit of the new trend in taste. Boucher and Fragonard partly based their work on these assumptions. Many paintings of this kind, in carved gilt frames, decorate the walls of drawing-rooms in Hogarth's series of engravings entitled *Marriage à la mode*. The palaces of the Genoese nobility were decorated with magnificent frescoes – light-hearted mythological themes and flowers – which harmonize with the realistic depictions of sky and light-suffused stucco clouds. The carefully worked out links between these very different motifs represented an innovation and are chiefly the work of two artists active in Genoa, Gregorio de Ferrari and Bartolomeo Guidobono (1654–1709).

De Ferrari's *Storie di Amor e Psiche* (Cupid and Psyche), and his *Storie die Nettuno e Amfitrite* (Neptune and Amphitrite), which he created for the Palazzo Granello around the turn of the century, are among his most convincing works. The pictorial language of the late Mannerist school of Parma and the sculptors of Bernini's atelier alternate with floral sprays of surprising modernity, anticipating many aspects of 18th-century French art. In the ceiling frescoes the nymphs with their rustic hairstyles, seem to belong to a new, elegiac world. They have a vitality not found in the *divertissements* of the Rococo; it is an elegance derived from 16th-century models, especially of Emilia, which enlivens the stucco and animates the foreshortened, finely modelled, fringed scrolls in the middle of a confusion of hu-

man figures, flowers and gilded foliage. They recall the stucco decorations and cycle of paintings by Natoire, Boucher and other Rococo artists in the oval drawing-room of the Hôtel Rohan-Soubise in Paris.

On the edges of the vaulted ceiling De Ferrari applied glowing stucco – tritons and layer upon layer of rocks covered in seaweed – which are plainly derived from Mantuan tradition and reinterpreted to suit Rococo taste. He transformed the elegant exemplars of the 16th century into a tender, high-spirited *fête galante à l'italienne*.

Interiors as architecture

Garden design and even theatrical sets had a close relationship with architectural principles. The basic idea of multi-layered space and the desire to open up "different" perspectives led to a freer pictorial language in 18th-century fresco-painting. Artists integrated the most daring elements of painting on canvas in their work, making use of more than one vanishing-point and allowing the space so represented to expand infinitely. In these frescoes dimensions appear to extend and things shown in the background can only be recognized in a fragmentary way. What resulted was an art form that is hard to define precisely – a mixture of painting, stucco decoration and applied art. An example of the last are the papier-mâché clouds which, when seen against the light, create a particularly illusory effect. This is also true of Tiepolo, the master of the triumphant and glorious use of colour, whose work was further enriched by his

son Giandomenico, who worked with his father and was very interested in themes from the New World. In Rome from 1750 onward there was a fruitful exchange of ideas concerning Neoclassical forms. As early as the end of the 17th century the encounter between picturesque taste and classical had taken place within the *Accademia dell'Arcadia* at festivals and seminars organized by the circle around Queen Christina of Sweden. Assimilation of this kind also proved valuable to the courts in Munich, Vienna, Dresden, Prague and Warsaw. The conceit of the *capriccio* or architectural caprices, described and promoted in the writings of Guarino Guarini and Andrea Pozzo, enjoyed great popularity throughout Europe in those years. In Vienna Fischer von Erlach, who lived in Rome between 1674 and 1686, produced successful interpretations of this style. Through Dietzenhofer and Pöppelmann, his ideas reached Salzburg and Schönbrunn.

The extraordinary elegance which was also to inspire the Classicism of the 18th century, is recognizable not only in the *capriccio* but equally in architecture between 1725 and 1740. In this context we may again cite Stupinigi hunting lodge, the Hôtel de Rohan-Soubise in Paris, the rooms of the Ca' Rezzonico in Venice and François de Cuvilliés's pagoda in the park of Nymphenburg Palace. In the design of ceremonial rooms artists gave even freer rein to their imagination, as in the ballrooms in the Ca' Rezzonico, the Schaezler Palace in Augsburg and above all the Summer Pavilion created by Mattäus Daniel Pöppelmann for the Zwinger Palace in Dresden.

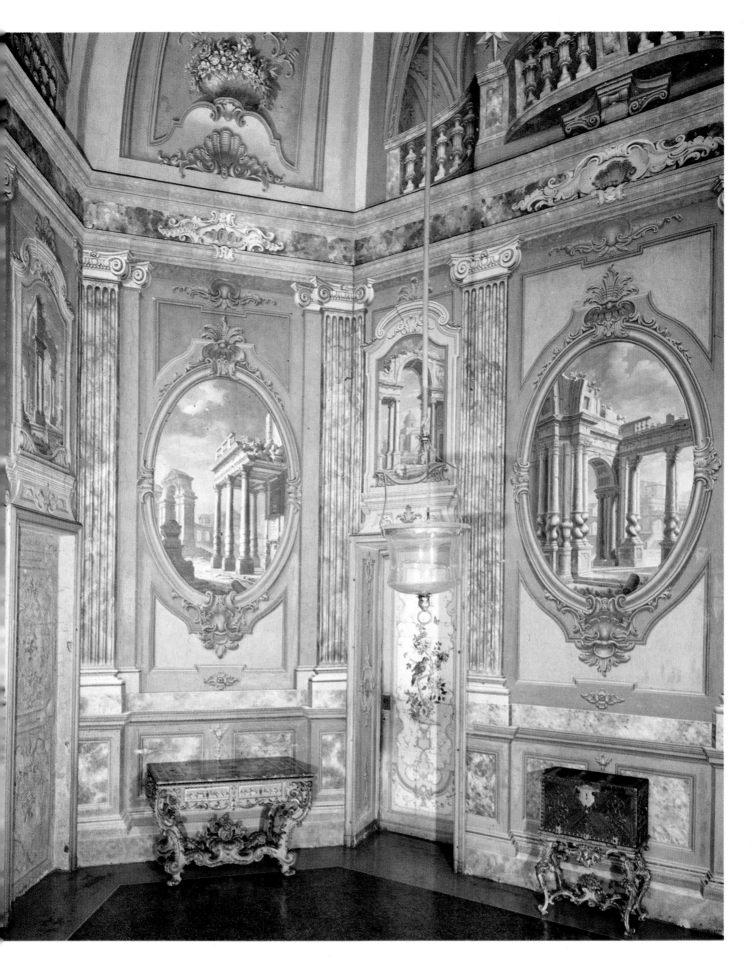

The sculptured decoration of this joyful building is the work of Balthasar Permoser. A similar delight in the representation of expanding space can be found in the pilgrimage church of Wies in Bavaria, designed by Dominikus Zimmermann.

In England inspiration came from the classical concepts of Palladio and the type of buildings he favoured. Leading architects in the Palladian style were Colen Campbell and William Kent, who built and decorated numerous elegant and comfortable upper class houses.

Elegance and comfort of accommodation

The siting and furnishing of the residences of European royalty, the homes of the upper middle class and the seats of the nobility in France, Genoa and Venice, Piedmont and England were designed for a way of life in which an agreeable elegance, utility and comfort played a crucial role.

Further variants evolved in Bologna via the theatre architecture and stage sets of the Bibbiena family, which reached all parts of Europe. This led to a theatrical style in interior decoration. In Rome use was made of costly materials to decorate the magnificent reception-rooms in the Palazzo Doria Pamphili, Palazzo Colonna and the Palazzo Braschi. Discussing Bologna, Eustachio Zanetti was to complain, in his *Trattato teorico pratico di prospettiva* (On the Theory and Practice of Perspective), that a large proportion of the palaces had been built purely to hold public celebrations and entertain large numbers of guests. The furniture

for the *palazzi* of the leading Bolognese families, the Malvezzi and Bentivoglii, were modelled on French styles.

The villas of the Turin nobility, on the other hand, were more domestic and kept a due distance from royal residences, while the court itself, thanks in the main to the intelligent architectural methods of Juvarra, made a distinction between the state reception-rooms of the Palazzo Reale and less formal rooms of Stupinigi hunting lodge, or between the Palazzo Chiablese and the Villa della Regina. German and French travellers were delighted by the carvings and interior decoration dating from the time of Benedetto Alfieri, both in the royal palace and the Palazzo Isnardi di Caraglio, which is today the home of the Accademia Filarmonica. The decoration there was designed by Giambattista Borra, who worked on the palace of Racconigi and also Norfolk House in England. French models, and in particular Bérain's pattern-sheets, were well known to him. He also travelled to see the ruins of Palmyra in Syria.

However, the numerous Baroque villas in Bagheria, Sicily, were based on rather different concepts. They include the Villa Palagonia, "famous for the countless statues which line the impressive drive leading up to it. These statues, of marble and local stone, are crammed together with no semblance of order and make a confused impression because they are all so different. They all come from churches or civic buildings which had no further use for them. Thus one could describe this drive as an example of madness and plunder. The pyramid-shaped piles – a puppet-theatre

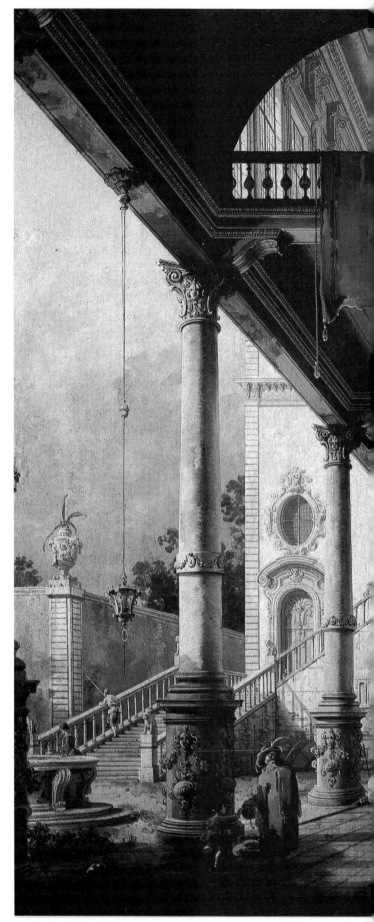

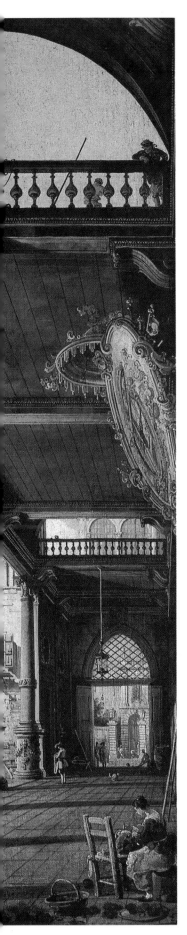

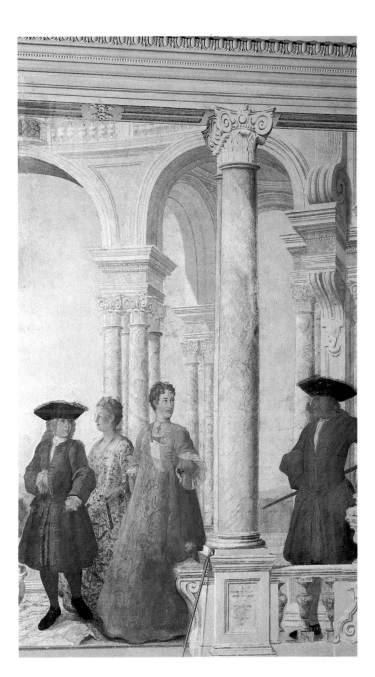

of statues on both sides of the drive – consist entirely of clownish figures, dwarfs, monsters and fantastical animals. All these things, the strange product of an eccentric imagination, were put up on the orders of Prince Ferdinando of Palagonia, grandson of the builder Ferdinando Gravina." This description is by the Marchese di Villafranca, whom the Italian author Leonardo Sciascia claims was the equal of Gogol. However, even here there are mirrored halls and Rococo ceilings with cartouches and coral ornamentation.

There are also some less bizarre buildings, which bring to mind *The Leopard* by Tomasi di Lampedusa, ranging from the Ducal Palace in Palma di Montechiaro in the province of Agrigento and the Villa di Boscogrande to the Palazzo Lanza Tomasi in Palermo. All these were built in the Louis XV style in the early 18th century. Consequently the predominant colours are white and gold. One of the courtyards is adorned with an impressive majolica fountain. Finally, mention should be made of the Palazzo Cutò in Santa Margherita al Belice, the Villa di Palma and the Villa ai Colli with its observatory.

A lively exchange of ideas developed – initially in the field of architecture – chiefly due to the 18th-century patrons being replaced to some extent by the more dynamic figure of the traveller, who interpreted the art of the ancient world in the light of modern taste. From this, major changes in interior decoration resulted. In the creation of furniture, tapestries, fabrics, silverware and pastel colours, new values were applied. In accordance with Enlightenment principles, the search for the maximum beauty ought not to neglect the "comforts of life". The aim was to create ideal surroundings recreating the delight in play and irony. These ideas were also taken up in Rome after 1705 by Cardinal Ottoboni and his circle, who commissioned theatrical scene-paintings from Juvarra and the Scarlatti and Corelli families. The comprehensive power of expression in the stage-sets created in this "laboratory" for the new music is later reflected in Juvarra's domestic interiors.

The same ideas reappeared in Caserta, Austrian palaces and Pommersfelden near Bamberg in Bavaria, Queluz Palace in Lisbon, Madrid's Palacio Real, Rosenborg Palace in Denmark and the great English country houses. A new kind of perception had taken hold. The ideas that had evolved during the 17th century – gilded stucco and frescoes which harmonized with it, fabrics and tapestries in strong colours – changed fundamentally: the very much paler gilding was reflected in mirrors and combined with lacquer paintings, furniture, *boiseries*, porcelain pieces and frames in white and subtle nuances of colour. The particular sensibility of the English, which Diderot commented on so favourably, proved to be extremely helpful in defining and popularizing these new decorative combinations.

New horizons

Ever since his youth in Savoy, Jean-Jacques Rousseau concerned himself with the natural world that he loved. This was especially true from 1728, when he stayed with Madame de Warens in her house Les Charmettes near Chambéry. His studies, which he summarized in his *Lettres sur la Botanique* (1772), and the researches carried out for his *Herbarium*, are proof of the wide interest in these phenomena in the 18th century: "The plants appear to have been scattered on earth like the stars in the heavens, [. . .] to awaken Man's curiosity to study nature."

Pleasure and curiosity, two fundamental ideas of the Enlightenment, were also to lead to a new concept of art. Rousseau called for the return to feeling and spontaneity, foundations of the happy life guided by instinct *(l'état naturel)*, which society had confined and stifled with too many laws and prescriptions *(l'état civil)*. This gave rise to a greater freedom in the field of

arts. The new concrete language of form and image which was presented to the observer included the figure of the "noble savage", or Man in his pure, primeval and happy state, not yet corrupted by civilization. Skilful craftsmen turned their attention

to the specific effects of their work and furnished the rooms in which everyday life took place. The designs created at that time in furniture and the other minor arts – impressive pieces made of hardwood with varied graining, and costly fabrics and silverware

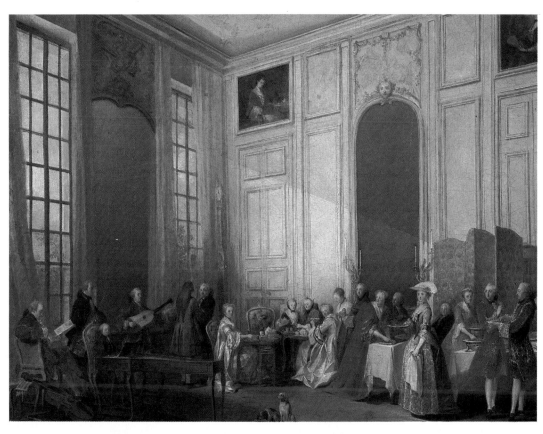

– served to point the way ahead. From the princely residences in Munich and Pommersfelden to the villas in the Veneto and Naples, architects copied the buildings of Juvarra in Turin, which were furnished by Piffetti, whose pieces had wonderful inlay work in ivory and mother-of-pearl.

Travel and exoticism

In the second century AD the Greek poet Lucian, in his *True Histories,* described imaginary journeys to the moon, which he made in order to observe the war between its inhabitants and those of the sun, and where he landed on the Island of the Blessed and of Dreams. But during the 18th century real voyages formed the basis of a new trend in taste: the interest in exotica, which was also promoted by the study of end-

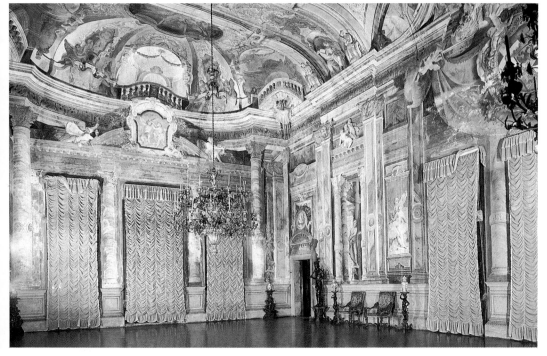

lessly fascinating and detailed maps. In these years Louis-Antoine de Bougainville (1729–1811) published an account of his world circumnavigation, *Voyage autour du Monde* (1772). In 1764 the indefatigable explorer, with a group of settlers from St-Malo, landed on the Falkland Islands, which he named the Malouines in honour of his fellow mariners. From there he completed his round-the-world voyage, in the course of which he discovered the Louisiade Archipelago and the northern group of the Solomon Islands. Everywhere he noted in great detail the customs and behaviour of the indigenous people. His *Voyage* appeared with "additional remarks" by Diderot.

The memoirs and accounts of Jesuit missionaries were re-read,

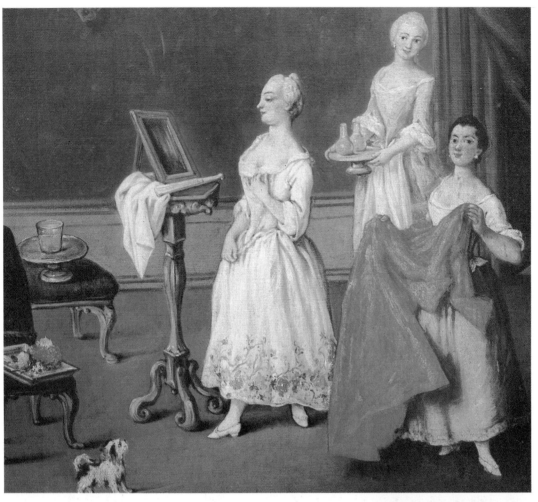

people living in those countries had preserved an ancient wisdom and possessed a refined and intelligent concept of beauty. With typical 18th-century charm, the *chinoiseries* are peopled with wise and smiling gods. There was a great affection for China, and in educated and enlightened circles it was believed that the West had much to learn from oriental laws and morality. These attitudes persisted right through the century and blended with the anti-clericalism and scepticism that accompanied harsh criticism of organized religion. The crisis that accompanied the end of the century was developing, and people were searching for the basis of a new ethical system. These were ideal preconditions for the advance of Neoclassicism, with

as were the oriental aspects of Baroque literature; and works like *Solimano* by Bonarelli, Racine's *Bajazet* (1672) and the "Turkish" joke in Molière's *Le Bourgeois Gentilhomme* enjoyed great popularity. The most pervasive influence, however, was exerted by Montesquieu in his *Lettres Persanes* (1721) and Voltaire's *Lettres Philosophiques* (1734), also known as the *Lettres Anglaises,* in which all the contemporary figures of interest and importance in England were discussed. The objects of this enthusiasm for all things foreign included, for example, the customs and traditions of India or the landscapes of America, which symbolized a mythical Golden Age. The Orient provided new subject matter, which was typically incorporated in works such as Diderot's *Bijoux Indiscrets* and Crébillon's *Sofa.* Against the background of these new discoveries by the explorers

and philosophers of the Enlightenment, with which they wished to demonstrate the intrinsic value of the customs and religions of foreign lands and to preserve the image of the "noble savage", i.e. Man in his aboriginal and natural condition, new iconographies and materials came into widespread use, displacing the decorative art of the Baroque. This is shown most of all by porcelain objects, even if most of the surviving examples are exceptional products of the Capodimonte and Meissen factories. At the same time, the technique of lacquer painting or japanning inspired by Chinese art had become established in London and Paris, from where it would spread throughout Europe. This interest in exotic countries brought 18th-century society into contact with alternative interpretations of the world. Europeans were particularly astonished to find that the

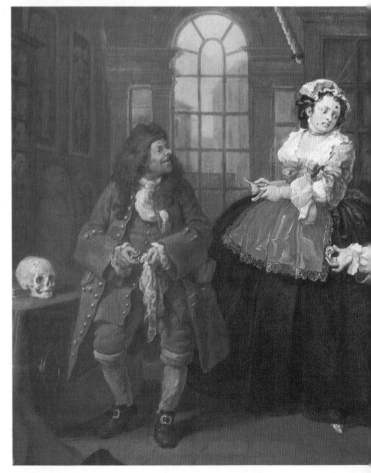

its call for rationalism inspired by the societies of ancient Greece and Rome.

The epitome of these journeys "to another place" is provided by Voltaire's *Zadig*, an oriental tale, the first edition of which appeared in London in 1747 under the title of *Memnon, histoire orientale*. In his *Micromégas* (1752) Voltaire went on to explore, in a highly imaginative way, the paradoxes of the world. He points out the ridiculous solipsism of Man's viewpoint in relation to the vastness of the universe; the absurdity of political and religious prejudices and the extreme insignificance of planet Earth.

Through encounters with gigantic creatures from other planets – Micromégas, himself 120,000 feet tall, visits Earth

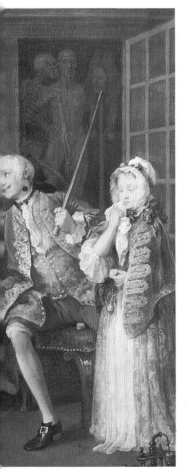

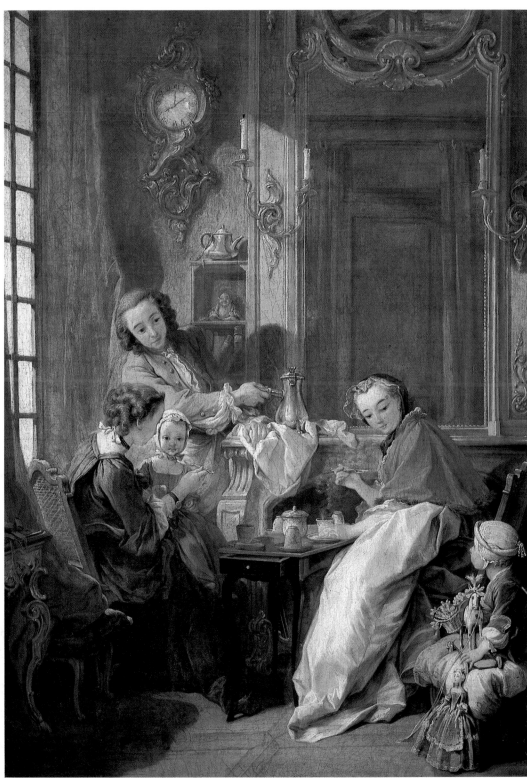

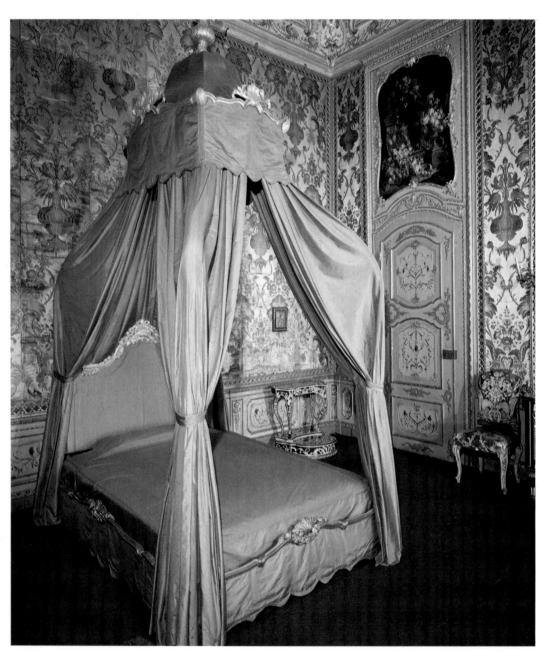

characters they portrayed and their relationship to nature had an influence on 18th-century society that extended to the frescoes and tapestries on the walls of country houses. An entirely new light-heartedness characterizes for instance mythological scenes and depictions of the ancient gods. Arcadian scenes were particularly popular. As early as 1686 Fontenelle (1657–1757) had published his *Entretiens sur la pluralité des mondes*, in which he explained the newly discovered astronomical cosmos. He followed this a year later with *Histoire des oracles*, a rational and psychological explanation of the origin of religions. In the age of the Enlightenment every divinity embodied the deep sense of the real world which Man strove so tirelessly to explore. In the 18th century the gods descended from Olympus: Man sought their origins and found them in the human perception of Nature. Man was to give form to these thoughts and feelings, and precisely from that came the vivacious style of the age, which was as characteristic of silverwork and carving as it was of the iconography of Watteau, Fragonard and Van Loo, and Boucher's mythological set-pieces.

Extravagant intimacy

A taste for the exotic was what determined style in architecture, landscape gardening and interiors. The imposing pavilions, battlements and small pagodas inspired by Chinese art were matched by "oriental" fabrics and wallpapers, carvings, porcelain and stucco embellishments in the interiors. Two factors were res-

from the star Sirius, in the company of a 6,000-foot inhabitant of Saturn – Man realizes how infinitely small he is. In addition to *Micromégas* and Swift's *Gulliver's Travels*, other writings from this period describe similar experiences.

More new and surprising insights were provided by the engravings of Piranesi, who was deeply convinced that only in the ancient world could solutions to modern problems be found. All this found its way into current literature, to be used by travellers

and in their ever-more sophisticated and comfortably appointed homes. In parallel with this orientation towards unknown lands and remote worlds, literary discussions developed concerning the imagery of Ariosto and Tasso, whose attitudes to the

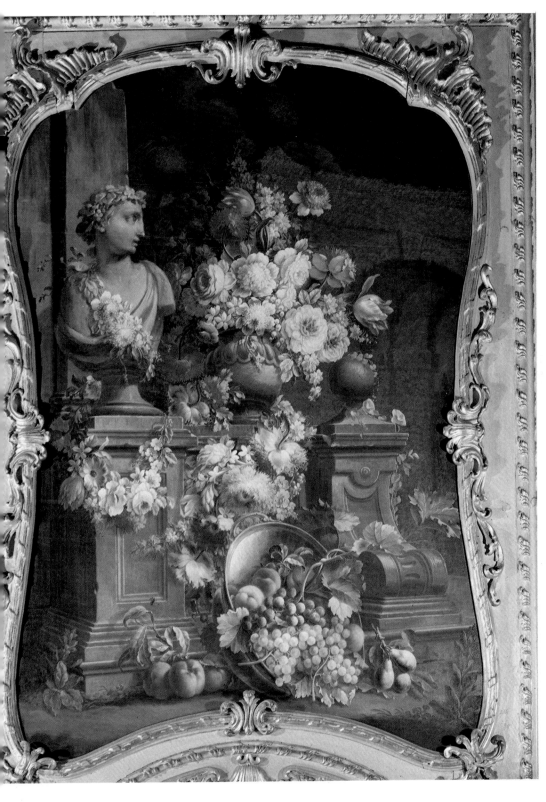

ental proliferation can be found in Bourbon residences in Naples and Madrid, though here other materials – mainly porcelain with oriental motifs – and techniques were used.

While the wallpapers for Stupinigi and the Palazzo Chiablese were imported from London, the figured porcelain for the walls of the royal summer residence in Portici was produced by the Capodimonte factory. But the palaces of the nobility should not distract our attention from the many simpler types of 18th-century house. In the early country houses among the vineyards around Turin, or those in Savoy and Provence, also Hungarian country houses, items of furniture were to be found that were less sophisticated but just as carefully made. And in mountain regions the interiors typically included rustic items, everyday pottery objects, bowls and plates, bobbins, equipment for lacework and embroidery, weaving-stools, cooking utensils, troughs, caskets, benches, not to mention engravings and woodcuts, including numerous depictions of local flora. Items from these houses can be found in regional museums, for example in the Musée Dauphinois in Grenoble. The names of the local silversmiths and their stamps are preserved on a panel there, which has proved of great help to researchers.

ponsible for this trend: first, the need for comfortable rooms of a manageable size – *boudoirs* and private drawing-rooms – furnished with valuable artefacts; and second, the new perspective of distant lands, which was directly reflected in the iconography. The

depictions of small Chinese motifs amid a typically spacious landscape stood in stark contrast to the theatricality of Baroque design. Exotic motifs were popular all over Europe, but especially in England and Germany, and in Italy, were obtained either from

London or directly from China. In this connection mention should be made of the lacquer paintings obtained by Juvarra for the *Gabinetto Cinese* in the royal palace at Turin, and his work in Stupinigi hunting lodge and the Villa della Regina. The same ori-

The return to antiquity

Interest in the ancient world was re-awakened in the middle of the 18th century. Thanks to the new fascination for Roman and Renaissance sculpture, and the Greek antiquities which delight-

The Pannini Hall (1735–40) in La Granja, the royal palace at San Ildefonso, near Segovia. The paintings by the Italian artist after whom the room is named alternate with oriental lacquer panels in gilt frames along the panelled walls, in the late Baroque manner. FACING PAGE: the Gasparini Drawing-room (1760–65) in the royal palace in Madrid. The lively Rococo botanical motifs in multicoloured stucco are echoed in the wall-coverings of embroidered silk and the floor made of inlaid marble of different colours.

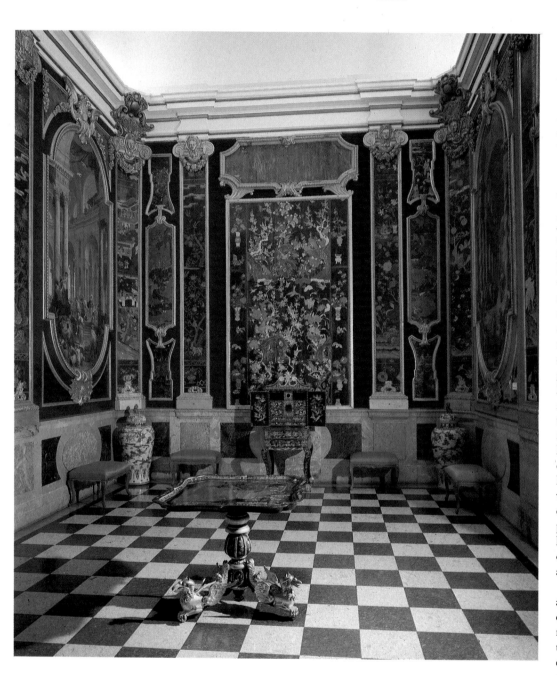

nigi the pools and fountains have disappeared, but they are still present in Caserta, Nymphenburg, Schönbrunn and in the Peterhof, near St Petersburg. The notion of wide vistas as a symbol of the sublime began to spread in these decades.

Stupinigi hunting lodge

Juvarra had initially specialized in stage design before turning to architecture. He planned the hunting lodge as a "surprise", which was intended to appear suddenly on the horizon at the end of an avenue of double rows of trees, as if it were being seen through the wrong end of a telescope. The garden seems like a gigantic *parterre,* or terrace to the house, and the distances appear magnified. Travellers who visited the park in the 18th century noted this in their journals. With his unerring feeling for the effects of light, Juvarra wanted to stretch his perspectives as far as possible; with Juvarra we see a culmination of the Baroque striving for a representation of infinity. It was to lead a little later to the discovery of the "sublime" and the liberation of the Enlightenment.

Inside the hunting lodge an astonishing counterpoint can be observed between frescoes and richly crafted detail. The Rococo taste which finds expression here eschews play for its own sake and embraces the pleasure in things of no practical use, as was considered necessary in the 18th century.

The centre of the drawing-room bears a close relationship to the central point of the garden, thus giving the impression of a "total work of art" projecting into infinity. This is what gives

ed travellers who visited the excavations, there came a relaxation of the strict iconography of the *Classicisme* of 17th-century France – the ornamentation of Le Brun and the architecture of Versailles – and Italian garden design. Thus the trees planted in

Stupinigi and Caserta seem less forbidding than the elaborate creations of the 17th century, and the gates built in the Rococo period – for example those of the Villa Manso in Lucca designed by Juvarra or those of the great courtyard of Stupinigi are more

delicate. The spatial conception of the garden design of this hunting lodge is founded on the principles of the Enlightenment. The "sculpted" garden, which was the universal design up to that date, was replaced by an open, rational and sensitive concept. In Stupi-

the scheme its extraordinary liveliness. The wings of the building, added later, are also designed for this effect. The work of Juvarra and his craftsmen allows the buildings and the gardens to "breathe". The courtly and ceremonial atmosphere of the Palazzo Reale in Turin is completely absent in Stupinigi. The paintings are by Nice-born Charles-André Van Loo and the Venetian Giovanni Battista Crosato. The lacquer of the Rococo seems to melt in Crosato's work; his frescoes have strong colour schemes, his *treillages* are less elaborate, such that the effete and rather bloodless concepts and techniques are filled with new vitality. The charm and naturalness of his *trompe-l'œils* are even more apparent when compared with the more reticent imagery of Van Loo, who devoted particular care to the cupids in his fresco-tapestry *Bagno di Diana* in the *Stanza della Regina* (Queen's Room).

Crosato's lively portrayals, by contrast, aim for a direct and scarcely attenuated awareness, and compete in this respect with the sculptures in the garden. Thus the Venetian painter chose for one of the central ceiling vaults the ancient and yet so modern mythical figure of Iphigenia, whose story, full of suspense and pathos, fascinated not only Goethe and Choderlos de Laclos but also Pier Jacopo Martelli, Gluck and the Marquis de Sade. Crosato emphasized the seductive element, and opted for a "rustic" style of portrayal, somewhat reminiscent of the *Wirtshausstücke* (inn plays) performed in Dresden. He created models of peasant girls which soon afterwards were taken up by the Vinovo porcelain factory. Coming from

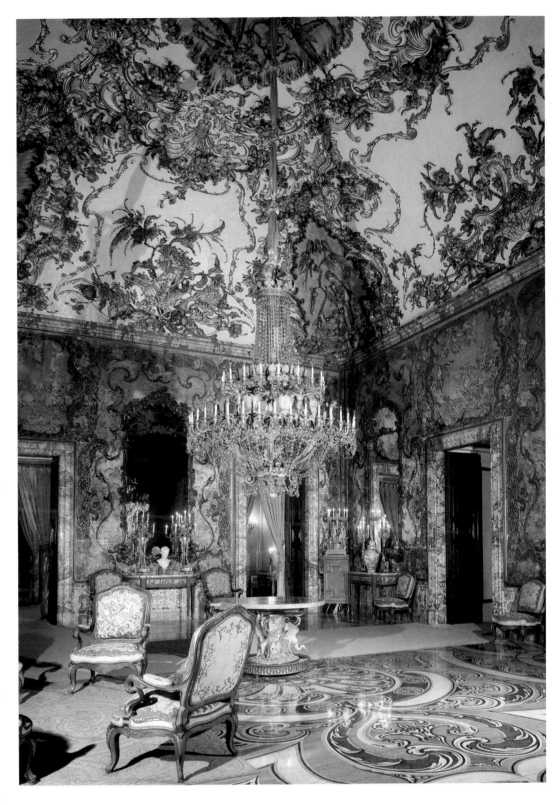

the Veneto, Crosato was familiar with rural life: his female figures wear striped calico dresses, shawls and blouses with puffed sleeves; their cheeks and knees are reddened. Thus they differ greatly from the figures of the pastoral idylls also originating in the

Veneto, and from those *fêtes galantes* of French artists who created the frontispieces and engravings for Ovid's *Metamorphoses* and Tasso's *Gerusalemme Liberata*. When looking at Crosato's *Stagioni* in the entrance hall of Stupinigi and its realistically

portrayed peasant couple, one thinks more of English musical comedies. Gerolamo Mengozzi Colonna, who was commissioned to paint the square panels for the ceiling, created still lifes and unusual *trompe-l'œil* galleries. When these were restored in the 19th

century, care was taken to recreate the original vivid colours reminiscent of Franz Anton Bustelli's porcelain figures of the *commedia dell'arte*.

The other rooms are decorated with luxuriant interwoven garlands with cupids and seashells – Arcadian depictions, perfectly modelled and with curving outlines. These were based on the pattern sheets of Bérain and Lepautre, which had become part of the craftsman's repertoire, just like the cartouches of Oppenordt, which were used for carved, gilded frames, and the picturesque ornamentation by Juste-Aurèle Meissonnier, "king" of the Paris goldsmiths, who was born in Turin in 1695 and became the royal silversmith in 1724.

Of equal importance is the fact that simplicity reached its zenith of elegance and charm in Stupinigi: stucco decorations were combined with plainly carved frames, and with small wreaths and garlands of flowers and foliage. In the gaming-room at Stupinigi Christian Wehrlin painted a fantastic landscape of rocks, with birds and wildcats, pheasants and ducks – an austere depiction which is the exact opposite of the extreme refinement of, for example, the *chinoiseries* imported from London or more probably from Amsterdam in Juvarra's unique *Gabinetto* in the royal palace in Turin. Even the works of the cabinet-maker Bonzanigo, inspired by incipient Neoclassicism, seem unadorned and reticent. The carvings by this craftsman, who had been acquainted with Ladatte and Benedetto Alfieri, are works of a master.

As in numerous other cases, the artists working at Stupinigi

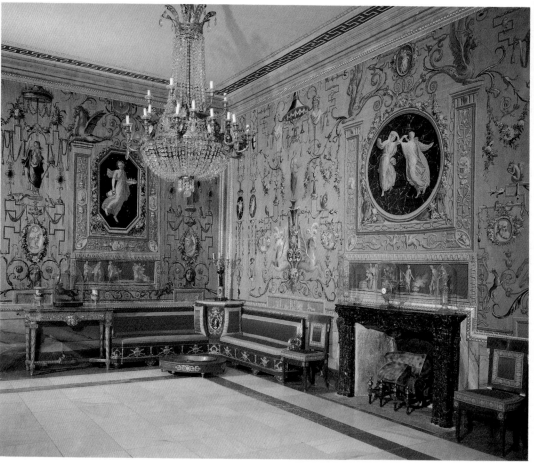

placed great importance on the careful crafting of every detail. This gave an overall impression of unity, reflecting on the one hand life and art as a game, and on the other a profound melancholy. The ruins and the subtle decorative schemes give rise to a sense of transitoriness: the changing seasons implied by the choice of flowers, the shell-work and the ever finer and more lacy plant motifs hint at a continual evolution beyond what is visible. The "living forms" culminate in a weft of the most varied and threadlike grasses, mosses and corals. These symbols of continuous change form the fragile and yet robust framework for the art of decoration in the last decades of the century.

The Palacio Real in Madrid: paradigm of a royal residence

Madrid's Palacio Real was to be built on the highest point of the city, now the Plaza del Oriente, on the site of the Alcázar, which burned down in 1734. Situated between the royal parkland and the forests on the outskirts of the city, the Alcázar was chosen as a hunting lodge for the Habsburg rulers of Spain; Charles V and Philip II spent much of their time there. After the Bourbons came to the Spanish throne in the early 18th century, Philip V commissioned the building of the palace of La Granja with its gardens in San Ildefonso, south-east of Segovia. The designs by Teodoro Ardeman dating from 1719–23 were attuned to French taste. However, for his capital city Philip dreamed of a palace which would reflect the new aims of the Spanish monarchy. The designs for it were drawn up in

1736 by Filippo Juvarra, who had worked in Piedmont for Victor Amadeus II. However, the architect died in Madrid in the same year and his project was completed by Giovanni Battista Sacchetti. The Palacio Real, begun in 1738, lived up to expectations: its high plinth recalled ancient fortresses; the Ionic columns and Doric pillars of white stone contrasted with the granite of the base. The great windows were crowned with classical pediments and the balustrades were embellished with sculptures which Juvarra personally supervised. The Palacio Real acted both as a residence for the ruling family and a venue for international meetings. This is also reflected in the interior decor and arrangement of the rooms – a mixture of splendour and domestication.

The small pillars of the grand staircase are clearly inspired by Juvarra, but the effect of pomp and elegance was the work of Sabbatini and Sacchetti. Here,

Neoclassical elements are already present, but they are relieved by the tender and glowing frescoes by the Neapolitan artist Corrado Giaquinto – *The Triumph of Religion and the Church*, and allegories of the *Four Elements*, Earth, Air, Fire and Water, which pay tribute to the *Victory of Spain over the Invaders*. The effects of light, on which both Giaquinto and the architects placed great importance, are enhanced by the interior furnishing of the drawing-room, with tapestries and Gobelins from the Madrid factory.

The individual rooms are notable for their mixture of different tastes and styles – Baroque paintings by the Neapolitan Luca Giordano, tapestries from Aubusson and Beauvais, frescoes by Tiepolo and Mengs and lastly the paintings and tapestries by Goya, which seem to imbue these halls of power with a strange magic. These are the elements of an ensemble that matched both the grandeur and the sensibility of the 18th century and made the Palacio Real a model for European palaces. An important part of the Rococo decorative scheme is Gasparini's superbly crafted botanical ornamentation in multi-coloured stucco: there is a harmony between the predominantly white decor, the different shades of green and pink in the flowers, fruit, birds and climbing plants, and the representations of figures inspired by Chinese art. The same motifs reappear on the silk wall-coverings with embroidery in silver and different colours. Through the many mirrors that reflect this symbiosis, the observer feels as if drawn into a visual whirlpool, so surreal is the atmosphere that is created.

The tapestries from the factories of Beauvais and Madrid provide evidence for the way taste evolved in this area, from the cartoons of Teniers, Luca Giordano and chiefly Jacopo Amigoni, who hailed from the Veneto, through French painters and finally to Goya. Beside Tiepolo's frescoes in the vast throne-room and magnificent dining-hall, with Brussels tapestries on the walls inspired by the Mannerism of the Fontainebleau school, and alongside the huge vases of bronze and Sèvres porcelain dating from 1830 which delighted Wagner, one finds intimate little rooms whose walls are lined with porcelain tiles. These were produced by the royal porcelain and majolica factory in the former summer palace in Madrid, Buen Retiro, which was directed by Giuseppe Gricci. His *chef d'œuvre* is a wall-cladding in white gold, violet and green decorated with Rococo botanical motifs. They form a framework for Dionysian scenes which look like modern cameos.

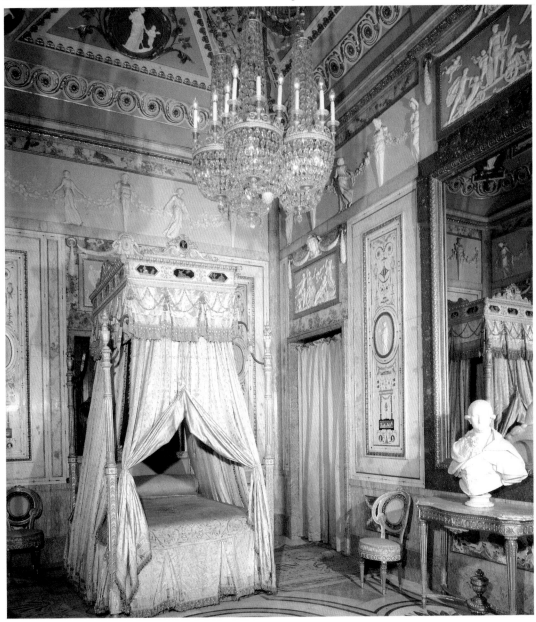

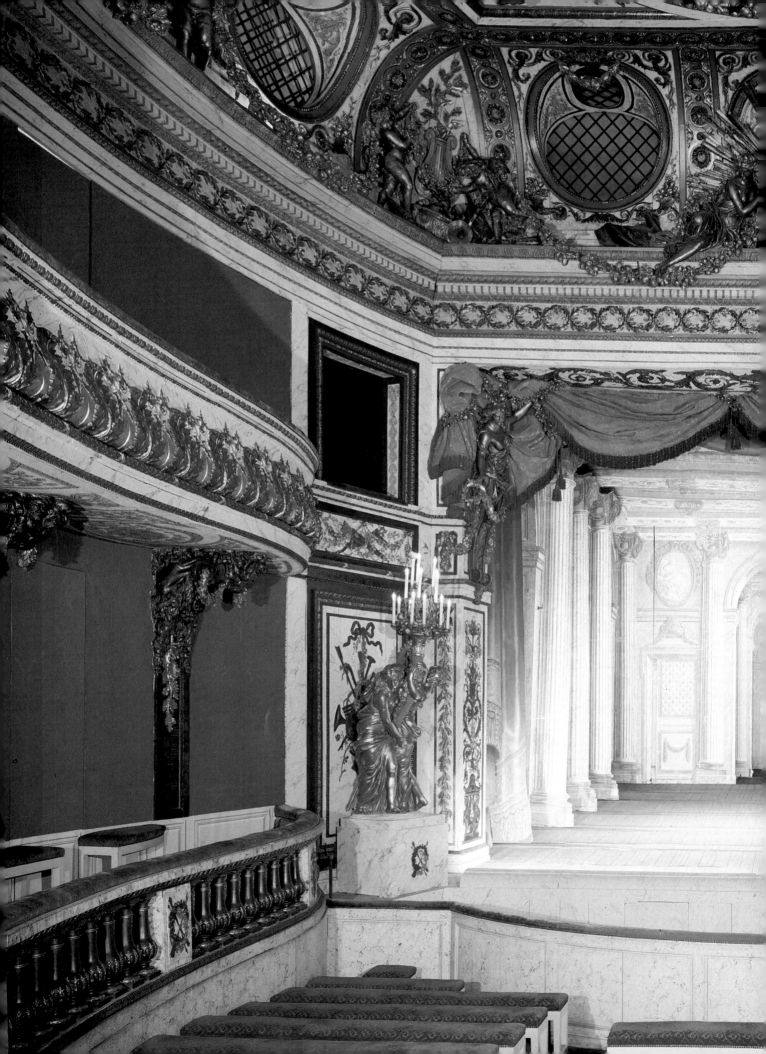

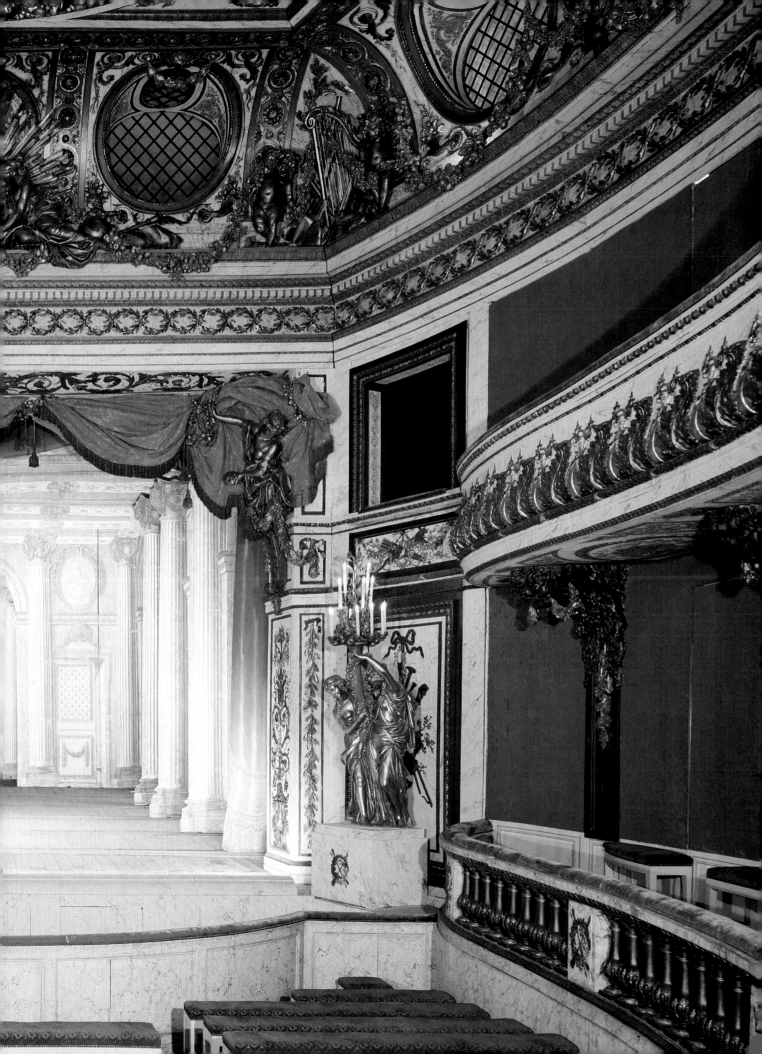

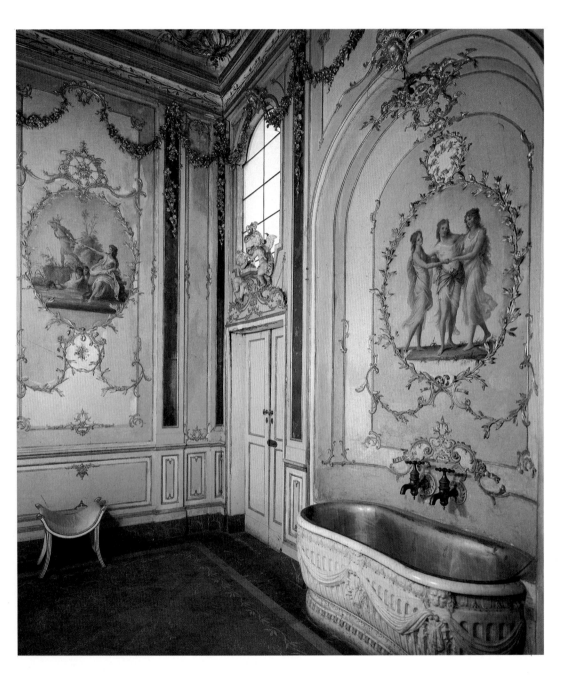

as well as the famous Tiepolo frescoes.

In Goya's day people recognized the modernity of such nature-motifs, which would be further developed in Gricci's porcelain pieces, Gasparini's *chinoiseries* and the figures in the few but intelligently hung paintings by Watteau. In a remarkable way the Palacio Real in Madrid reflects the sensibility of an entire century.

Caserta: the seat of the Bourbons

It is significant that in the late 17th and early 18th centuries the royal and princely palaces in European capitals were built outside the city centres, surrounded by parks and woodland. This is as true of Versailles as of the Venaria Reale in Piedmont, the summer home and hunting lodge designed by Amedeo di Castellamonte, the palace of Rivoli built a little later (in 1718), Filippo Juvarra's Stupinigi hunting lodge (1729) and finally the Reggia in Caserta, which was built for Charles IV of Naples-Sicily, who later reigned as Charles III of Spain. Designed in 1751 by Vanvitelli, Caserta was inspired by Bernini and Fontana, but more by the French and, in its interior decor, by the Bibbiena family. The palace is built on a cruciform groundplan with four inner courtyards, and its overall effect is of a prime example of prestige building in the Age of Absolutism. Behind the monumental façade the visitor is faced with three theatrically designed entrance-halls arranged around the central axis and linked by a three-sectioned gallery. On grand and

The blending of Arcadian depictions with subjects inspired by antiquity – and furnishings completed by porcelain vases, a mosaic floor and articles of gilded bronze – create a unique atmosphere is created in this room.

It is precisely these details, the countless ubiquitous plant motifs characteristic of the spirited and witty style of the 18th century, which reinforce the impression of a harmonious whole. The entire ensemble is rounded off by the delicate depiction of forest animals, urns and scrollwork with seaweed and zephyrs entwined in each other, which frame and provide a "breathing-space" for the tapestries of Arcadian scenes of knights, ladies and strolling musicians, based on drawings by Amigoni. The mirrors in the dining-hall reflect all these innovations

overcrowded ceremonial occasions, this layout provided space not only for guests but also for their processional coaches. The whole notion of omnipotence seems to be concentrated in the architecture of the staircase and its vestibule, with its stucco and marble, its statues of *Verità* (Truth), *Merito* (Merit) and *Maestà Regia* (Royal Power) and the two lions at its side entrances. Passing through the Hall of the Halbardiers, the Hall of the Bodyguard and the Hall of Alexander the Great, ceremonial rooms in the traditional sense, one reaches the throne-room and the council-chamber. However, of even greater interest are the smaller private rooms, for example the studies of the king and queen and the elegant dressing-rooms. The paintings of Fedele Fischietti and the sculptures of Gennaro Fiore show how Rococo motifs can be combined with borrowings from antiquity. The delicate colours – shades of pink, pale blue and white – cloak the architecture almost like a skin. These subdued delights are intended to underline the close connection with the "miracles" of the extensive garden and parkland.

The landscape gardeners exploited the wide spaces of the Peschiera, framed them with trees and created a magnificent vista. Mention should be made here of the *Fontana dei Delfini* (Dolphin Fountain) dating from 1779. As the water gushes down, it swirls round the mouths of three animals on Rococo-style rocks. On the other hand, the *Fontana di Eolo* (Aeolian Fountain) shaped in the exedra of classical grottoes, draws on garden design of the Italian Renaissance; in the *Fontana di Cerere* (Fountain of Ce-

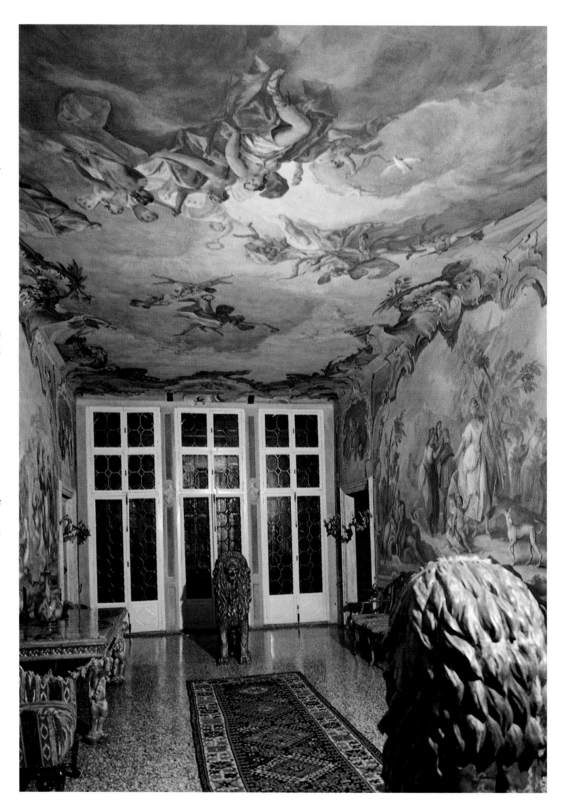

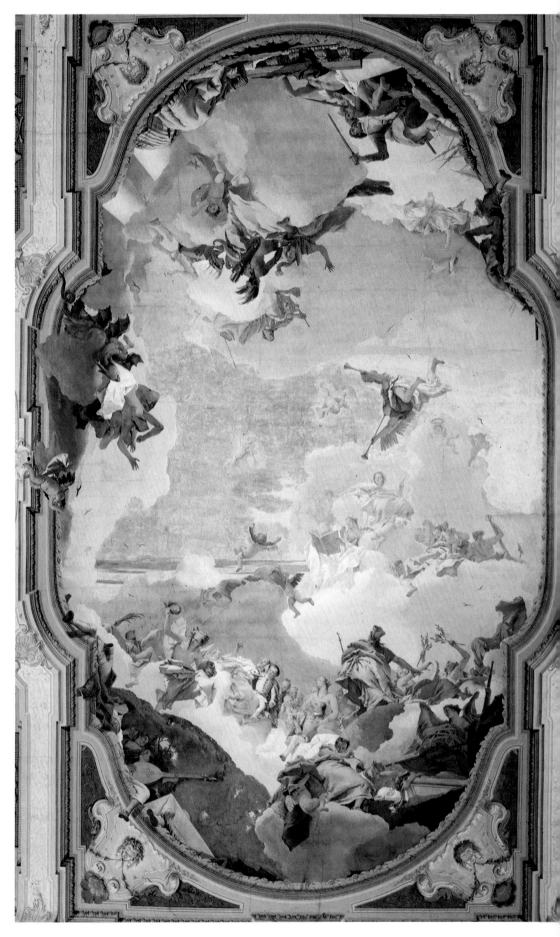

The Apotheosis of the Pisani Family,
a fresco by Giambattista Tiepolo
(1761–62) on the great vaulted ceiling
of the central hall in the Villa Nazionale
di Strà (formerly the Villa Pisani).

res), references to classical myth-
ology can be found, while the
true spirit of the 18th century
emerges in the Great Cascade
with its twelve levels, the *Fontana
di Venere* (Fountain of Venus)
and the Diana and Acteon group.
A little later (in 1782) Luigi Van-
vitelli's grandson laid out the
English Garden, the entrance to
which is situated to the right of
the Diana group.

The bathrooms designed at
about the same time for Maria
Carolina and her husband Ferdi-
nand IV in Caserta were not an
isolated case. Similar quiet rooms
with marble bathtubs were cre-
ated at Stupinigi and for Marie-
Louise, wife of Napoleon, in the
Palazzo Pitti in Florence. The
walls are papered or covered with
light material. The bath was
becoming a status symbol, and in
many palaces of Europe great
attention was paid to its installa-
tion. In the Palacio Real in Mad-
rid, for example, the bathroom
is situated between the king's
bedroom suite, the tapestry
rooms, the severely classical bed-
room of Queen Marie-Louise,
wife of Charles IV, and that of
Maria Cristina, fourth wife of
Ferdinand VII. It was also in-
creasingly common for music
rooms to be installed, as for
example in Turin, Naples and
England's Norfolk House. The
Hall of Mirrors in that house is
influenced by those of Juvarra and
Alfieri in Turin. Similar versions
are to be found in the Palazzo
Doria Pamphili in Rome, and the
mirror cabinets of German palaces
Pommersfelden or Würzburg, or
Madrid and in the quite remark-
able mirrored study in Rosenborg
Palace, in Denmark.

Detail of the ballroom of the Villa Maruzzi-Marcello in Levada di Piombino Dese, which was built in the 16th century. The frescoes were painted in 1763 by Giovanni Battista Crosato. On the ceiling is a representation of Olympus.

The ancient and the exotic

The new discoveries in the natural sciences in the Age of the Enlightenment had an important effect on the techniques of applied art. On a journey to Russia the Italian author Francesco Algarotti wrote about Dresden and the porcelain produced there: "It is the purest expression of this region," and added, "even more so than the embroidery that is made here." Algarotti would in fact have preferred Neoclassical models: "How fine it would be to be able to admire a good bas-relief, a series of medallions with the portraits of emperors and philosophers, or beautiful statues of Venus, the Faun, Antinous or Laocoön made from pure white porcelain." And thirty years later, between 1780 and 1790, precisely such pieces were created in the porcelain factories, which the master craftsmen based on illustrations from Diderot's *Encyclopédie*, the decorative language of the ancient world and the great folio journals brought back by explorers.

The ancient world was introduced into daily life in acceptable doses. In private houses mementoes of the past alternated with images from distant lands, above all China. New horizons opened up, revealing all manner of different peoples, and it was important to study and get to know their rituals and customs. To this end, the intellectually curious men of the 18th-century Enlightenment consulted accounts of travels and the memoirs of Jesuit priests and emissaries. The ceremonies and traditions of foreign peoples were studied. The ancient world of the distant past on the one hand and

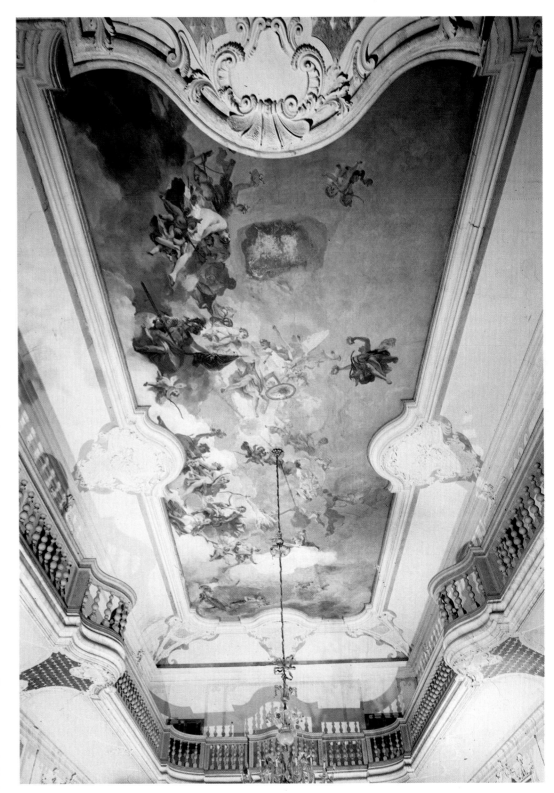

the new and exotic lands in geographically distant parts on the other existed side by side and sometimes even overlapped. There was a similar parallel between the development of theatrical ceiling-frescoes featuring daring and illusionistic perspectives and

the precisely detailed *vedute* of Canaletto and his camera obscura, and later Bellotto's attempts to achieve "true-to-life" representations of architecture, figures and even customs and behaviour.

People began to be aware that

the truth lay beyond what was visible, beyond the vagaries of the late Baroque; there, "another place" existed which had to be explored. The rational 18th century also defined the "sublime", which would then be expressed in the spatial concepts of Enlighten-

ment architecture, in numerous country houses and gardens from Stupinigi to Caserta, Schönbrunn to Nymphenburg, Augsburg to Vienna, Dresden to the squares of St Petersburg designed by architects from the Veneto.

While the interiors of small rooms radiated privacy, the exterior of the buildings were seen in wider dimensions, as the unified concept of architecture and landscape gardening, which in turn relates to the basic idea of Voltaire's *Micromégas* and his visit to Earth from the star Sirius. The *chinoiseries* of the interiors symbolize a kind of relativism: the readiness to get to know other peoples and, in the imagination, other planets and other

kinds of living creature; the Earth was able to expand its orbit, the infinitely small coexisted with the infinitely large. Extraordinary rooms – the Villa della Regina and Stupinigi hunting lodge, in Schönbrunn, Dresden and Würzburg and even country houses were decorated with *chinoiseries*. Fresco painters also developed new themes such as the "Four Ages of the World" and the "Four Corners of the Earth", which the painter Gregorio Guglielmi combined with "The Arts of Peace and War" in the palace of the Duke of Chiablese in Turin. The works of the Jesuit painter, sculptor and architect Andrea Pozzo were highly influential; examples include his

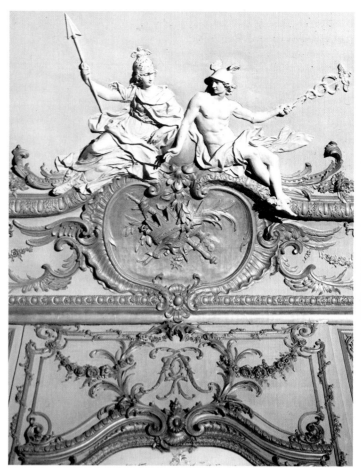

ceiling frescoes in S. Ignazio in Rome and the internal renovation and painting of the Jesuit church in Vienna. The iconography of the "Four Corners of the Earth" did, however, gain new inspiration from the Enlightenment and was linked to the more modern theme of the "Arts and Sciences in the Service of Mankind", which is depicted, for example, in the Archbishop's Palace in the Hungarian town of Eger. The wealthy middle class could by now afford to travel and to devote their attention to building and furnishing their houses.

The objects with which they filled their homes expressed their interest in novelty. Even the nobility began to favour smaller, more comfortable rooms. The porcelain factories of Meissen and Sèvres, Wedgwood in England and Vinovo in Turin, catered for this new clientèle.

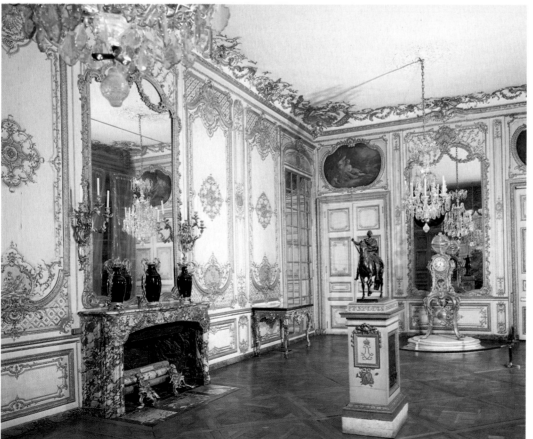

FACING PAGE, BELOW: the Salle de la Pendule in Versailles was named after the pendulum clock with an astronomical dial which was installed there in 1754. Its case of chased bronze is the work of Jacques Caffieri. The clock shows the day, month, phase of the moon and position of the planets in the solar system. THIS PAGE: The princess's bedroom in the Hôtel de Rohan-Soubise is entirely Rococo in style. As was customary in formal rooms, the bed was separated by a balustrade from the part of the room in which visitors attended the princess. The striking mythological scenes of romance are ornamented with gilded stucco (see Facing page, above). On both sides of the bed there are paintings by François Boucher.

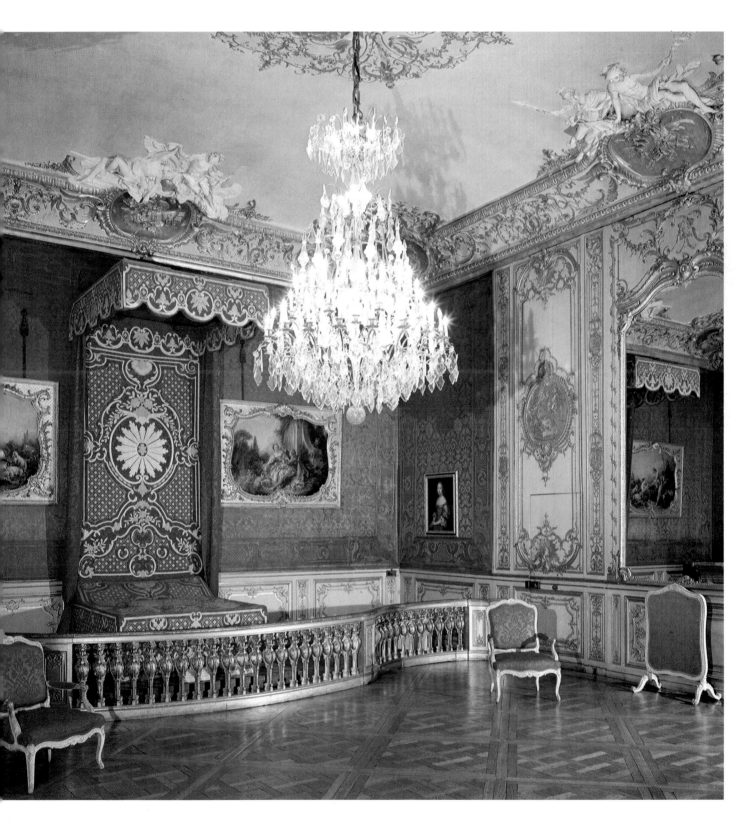

Bedroom in the Petits Appartements in Versailles, situated on the first floor of the palace. In these rooms, the *Cabinets intérieurs*, Louis XIV kept the masterpieces from his collection. His successor, Louis XV, had the cabinets completely renovated because he wanted to give them a more homely feeling. The individual rooms were functionally furnished and now served for his private use, far from court ceremonial. FACING PAGE: *La Toilette*, an 18th-century engraving in the Fabio Castelli Collection.

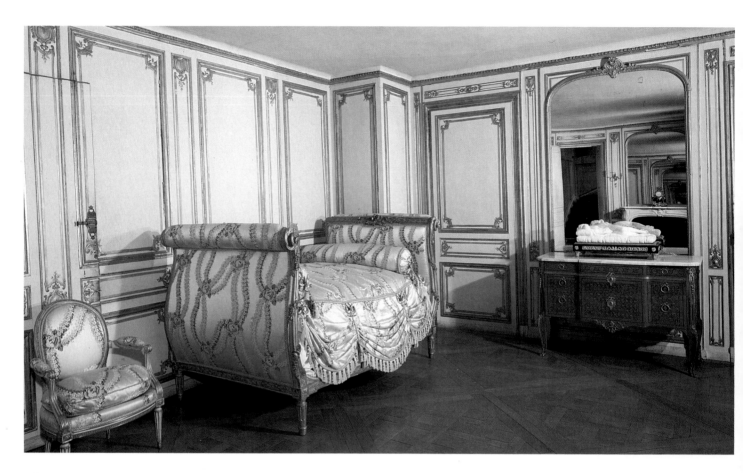

The mirror, a space for desires

Mirrors reflected costly materials, extolling gold, two-coloured lacquer paintings or the pale blue and white shades of silk fabrics. The mirror took in the entire interior decor and became a new and imaginative symbol of the ancient myth of Narcissus, who was equated with Pan and the young Dionysus in Hellenistic mythology, but who can also take the role of the spirit of sleep and death. In the wall-paintings of Pompeii Narcissus appears sunk in melancholy, his head garlanded with flowers, beside the figure of Eros. In other words, in the 18th century reflected light took

over this symbolic function. People were prepared for the unexpected; anything could suddenly appear in that enchanted and indefinable space. This in itself was an extraordinary concept, which differed from the elegant, Manneristically engraved mirrors – costly items of furniture which were especially popular in the Veneto. Even the massive painted Baroque mirrors of Maratta and Mario del Fiori, with luxuriant trailing flowers and little putti in the Casino Borghese and the Palazzo Colonna in Rome, or those designed by Luca Giordano and Anton Domenico Gabbiani in Florence's Palazzo Medici-Riccardi, were swept into the background by this new attitude.

In the early years of the 18th-century Enlightenment, the mirror was seen as an element of interior design, as a surreal wall that reflected the outlines of furniture and other items, the pastel colours and fabrics and wallpapers, and lifted every detail above the dimensions of the room. The connection with wall-coverings was closer, as with Verberckt's *boiseries* at Versailles. Above all, however, mirrors reflected the light entering from the garden: every material – silver, exotically decorated porcelain, bone china and tapestries – seemed to breathe more freely. In the mirror one could discover a new self, a venturer into the new world. Mirrors do not give a hard

outline of reflected objects; they seem replicated many times over, their contours float in an infinitely receding universe which the naked eye would not otherwise be able to capture. The perception of light and its reflection did not simply depend upon the time of day. Like Narcissus and artists painting self-portraits, the 18th century used the mirror, with its reflection of internal spaces, to fix the "crowning moment". Although Colbert had commissioned Baroque mirrors as early as 1665 from Venetian masters in the art of glass-polishing, in the 18th century the ornamentation which framed the gleaming crystal surfaces harmonized with the architecture. In the first half

of the century illusionistic representations of floral motifs were very popular. Alongside the brown tones of Chinese lacquer painting, the white and green of French and Venetian lacquerwork, the gilding and the paintings, the fiction of the framed mirror opened a new and lighthearted window: other reflections, other shadows, a kind of "picture within a picture" which came to represent another reality. In this way a distance was created from the actual room itself; directions and perspectives materialized beyond the objective world. The artists of the 18th century concerned themselves with the differing dimensions of space and time without being frightened off by the apparent transitoriness of such perceptions that were not recognizable to the casual observer. A new degree of detail and the departure from tradition enabled them to break new ground. It was a similar attitude that produced the interest in foreign countries and the preference for *chinoiseries*. Here too imaginative and unusual images multiplied on the road to a far distant "elsewhere".

Mirrors as the ideal elements of interior design adorn Nymphenburg Palace. They were installed by François de Cuvilliés to reflect the floral stucco decorations of Bavarian-born Zimmermann and the sculptures by Dietrich – an extraordinary interplay of French influences with German Rococo. Many German and Austrian Baroque sculptures with religious subjects form the basis of such combinations. At that time there was lively commerce between European courts, between Venice, Paris and London, or Turin, Naples and Madrid,

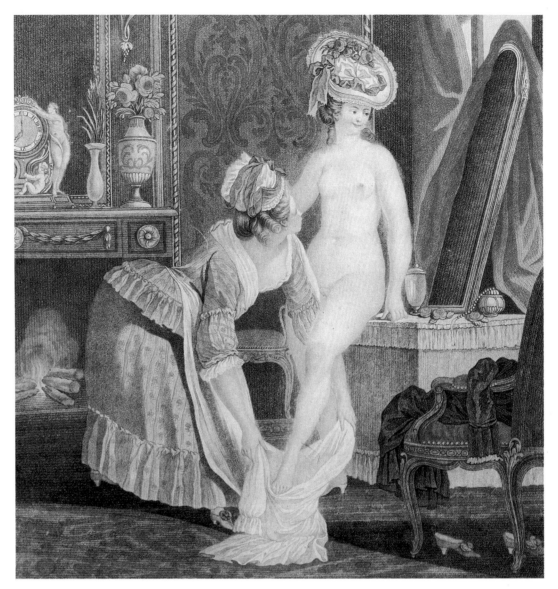

Würzburg, Vienna and St Petersburg. French art showed a particular capacity for interpreting the new sensibility. This is true not only of important painters like Watteau, Boucher and Fragonard, but also of Gillot and the etchers, through whom the ornamentation of Bérain, Audran and Meissonnier reached a wider public. Mirrors as "spaces for desire" are found in the palaces of Charlottenburg in Berlin, Waikersheim, Pommersfelden, Ludwigsburg, Meersburg on Lake Constance, Bayreuth and lastly Ansbach, where the influence of Alfieri's Palazzo Isnardi di Caraglio in Turin is evident.

Portraits and interiors

Portraiture played a special role in the 18th century. Pietro Longhi, who came from the Veneto region, the French painter Jean-Baptiste Chardin and Giacomo Ceruti from Lombardy posed their subjects in interior settings. Among the personalities to whom the artists devoted particular attention was Marie-Antoinette. Her many portraits possess an almost emblematic quality. The dress and coiffure of the queen, surrounded by furniture of the leading *ébénistes* of the day, gave rise to a fashion that placed nature and art in close affinity. Examples include the works of François-Hubert Drouais now in the Musée National du Château

de Versailles, the massive painting by Jean-Baptiste-André Gautier-Dagoty, in which Marie-Antoinette's pose resembles that of Louis XVI, and another work by that artist, in which the queen is shown with a harp and the painter himself is among her entourage in the music-room. With its mirror, white curtains and carved basket-work, the room looks almost like a *bonbonnière*.

The interiors harmonize perfectly with the temperament of the persons portrayed, who were constantly in search of new possibilities. In this context mention should be made of the portrait of Madame de Pompadour by Maurice-Quentin de la Tour, which can be seen today

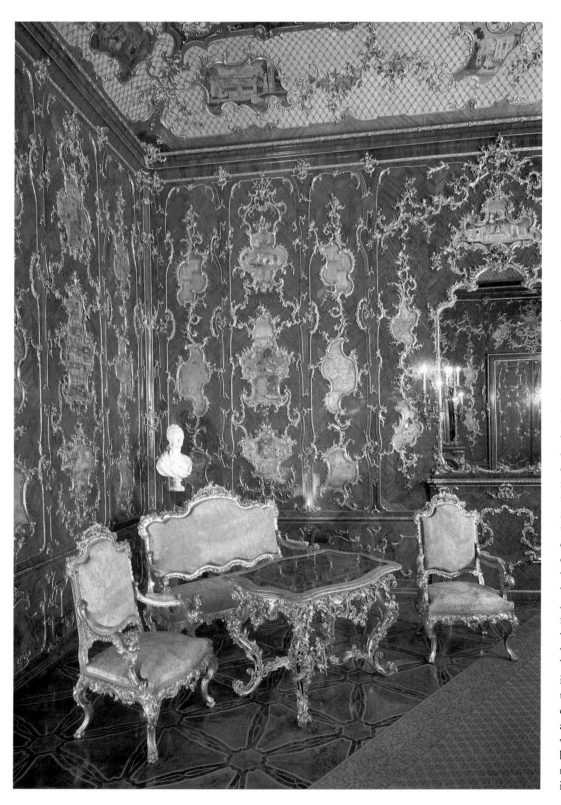

in the Louvre. The mistress of Louis XV is depicted in her "heroine's garb" of white and gold, surrounded by costly furniture and books. In the foreground we see a portfolio of drawings and, half in shadow, a musical instrument. The fastidious favourite of the French king promoted elegance and the arts and, as a knowledgeable collector, she was a patron of Falconet and Boucher.

In a chapter entitled "The Interrupted Supper" in his book *Mimesis, the Representation of Reality in Western Literature* (English edition 1953), the German-American scholar Erich Auerbach deals, with Prévost's *Manon Lescaut* and analyzes all the psychological elements that typify 18th-century literature, among which tears assume an importance for the first time as an independent motif: "Their effectiveness in the border region between the soul and the senses is exploited and found to be especially suited to produce the then fashionable thrill of mingled sentiment and eroticism." Painting in the 18th century was also intensely concerned with these psychological motivations. This is epitomized by the pathos in the work of Jean-Baptiste Greuze, which Diderot praised so highly. Artists captured the light which falls on tears and smiles, and which is often reflected in a variety of nuances by mirrors. These "representations of feelings" of ladies in extravagant attire always possess a "suave and coquettish elegance". Particular attention was paid to the frame, which in the 18th century was to be "held together" by familiar details. On the basis of designs by important decorative artists and

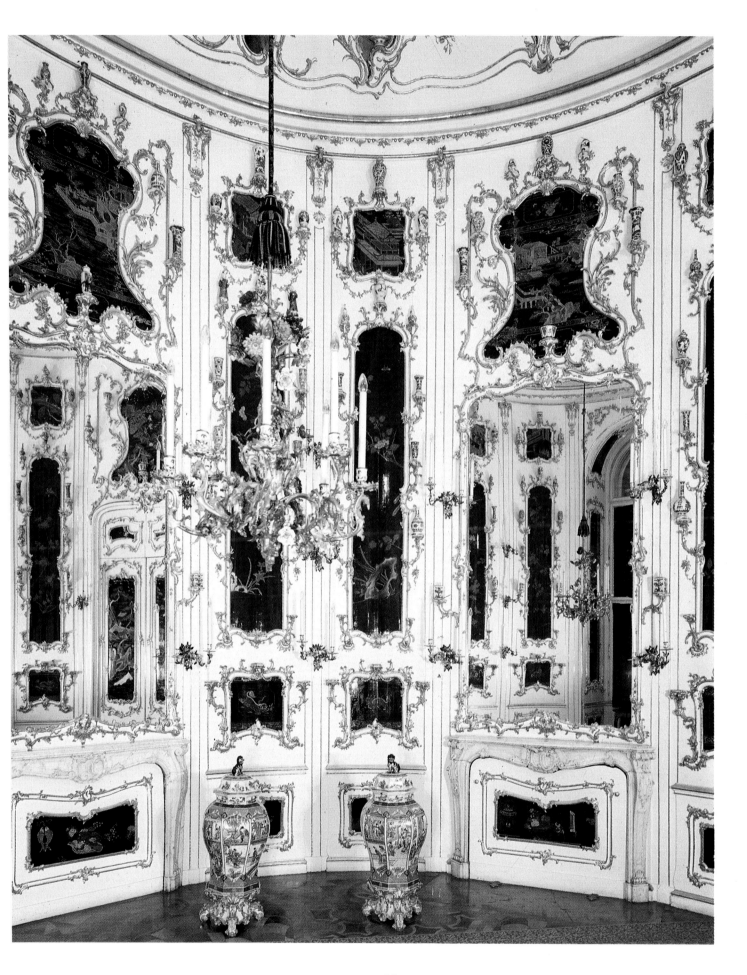

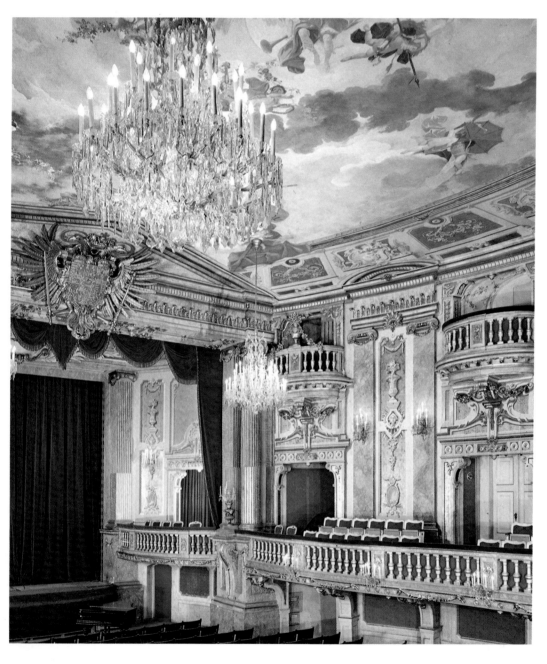

architects, artists developed elegant scrollwork, *agraffes*, shells, small heads and the familiar *espagnolettes*, which are linked together by botanical motifs – ranging from *trompe-l'œil* flowers and climbing plants in the Austro-German area to the floral cartouches of the decorator Meissonnier in Paris.

Even the interiors with which the painters of the 18th century – Frenchmen, masters from the Veneto led by Pietro Longhi and Hogarth in England – concerned themselves intensively, are defined by their frames. The new kind of perception influenced both the people portrayed and the interior spaces. On this basis, the lifestyle of the middle class was analysed into openly displayed emotions and stern morality. In painting as well, works were created in this period that possessed both irony and charm in "a kind of moderate style", the term which Auerbach applies to literature. He compares this to the much more realistic tone of Voltaire, who shed an ironic and critical light on the realm of Enlightenment thought, for example its tolerance, which required one to become familiar with all religions and customs and to direct one's gaze to the "four corners of the world". But even Voltaire expresses his ideas in a witty and delightfully conversational tone; however, his rapid narrative rhythm looks back again to classical forerunners, and his judgements, based purely on common sense, are presented in a form that brooks no contradiction. A similar articulacy can be found in the sculpture of busts, and even in still life, from Chardin to Goya. Auerbach rightly refers here to memoirs written in the 18th century which "in their character cannot separate realism from an earnest manner of observation". The supreme example which he quotes is Louis de Rouvroy, Duc de Saint-Simon (1675–1755) and his *Mémoires sur le siècle de Louis XIV et la Régence*. Such memoirs provided the soil from which many portraits grew: figures in magnificent attire or in their nightshirts, with a wide range of countenances – frank faces gazing straight ahead, or savage, hard and rough faces arousing fear and animosity – surrounded by elegant or comfortable furniture; people who radiate grim determination or coarseness, and others who seem to be inviting one into a tender and indissoluble friendship. All this can be found in the pastels of Jean-Baptiste Perroneau and

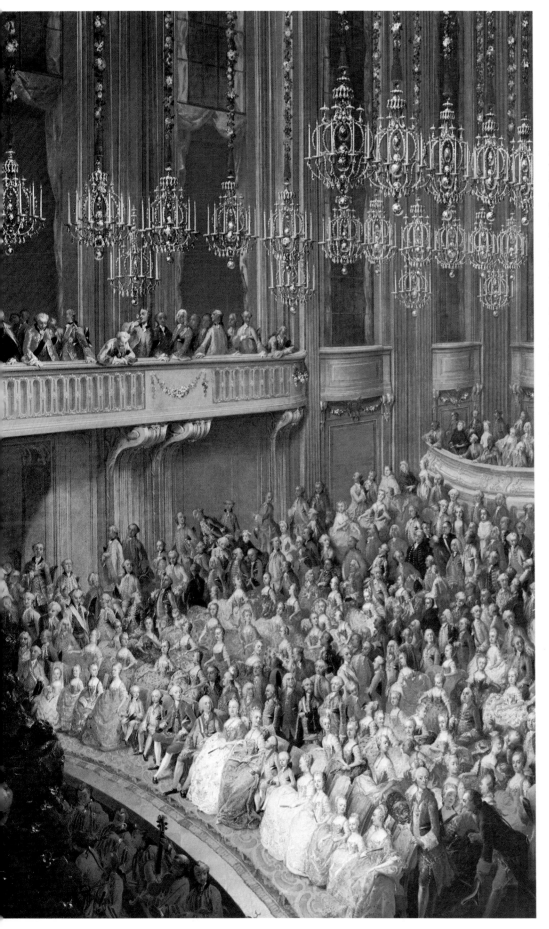

Jean-Etienne Liotard, or the paintings of Longhi and Ceruti.

Some idea of 18th-century taste in interior decor can also be gained from illustrations of plays and novels of the period. Good examples are found in the engravings by Charles-Antoine Coypel for Riccoboni's *Histoire du Théâtre Italien* dating from 1726 and his graphic work inspired by the plays of Molière (1728); ten years later Boucher also made a series of engravings from Molière. Mention should also be made of the descriptions of Parisian life in the Rococo period contained in the works of Gabriel de Saint-Aubin and the book illustrations of Hubert-François Gravelot. During a stay in England Gravelot produced engravings for the novels *Pamela* and *Tom Jones,* and on returning to Paris illustrated works by Voltaire, Rousseau and Boccaccio.

Among the vast number of books published – from the *Histoire du Chevalier des Grieux et de Manon Lescaut* to Goethe's *The Sufferings of Young Werther* – portraits of authors can be seen; not only Prévost and Goethe, but also Diderot, the Marquis de Sade and Casanova. Many engravers worked with live models. Not only can we admire Voltaire's profile, but we can also learn about his clothes and his favourite furniture. Even in the strictly scientific illustrations about arts and crafts in the *Encyclopédie* craftsmen can be seen at work. A new type of illustration "from nature" had come into being.

The functional and the functionless: both equally necessary

From Paris to Lyons and Venice to Turin, artists and craftsmen played a key role in the design of interiors, whether making carpets, fabrics, furniture or silverware. They worked with a wide range of materials – wood, papier-mâché, mother-of-pearl, chased bronze – and enhanced their surfaces with costly inlays. Their elegant and impressive work led to a change of direction in interior design, as exemplified by Verberckt's *boiseries* at Versailles, or the tureens produced by goldsmiths Thomas Germain and Juste-Aurèle Meissonnier, who was also *Dessinateur de la Chambre et du Cabinet du Roi* in 1726. Even scientific research was clothed in elegance. An example of this is the pendulum clock at Versailles, with an astronomical dial, which Danthiou built using the principles devised by Passement. The case and the *rocaille* embellishments are the work of Jacques Caffieri. Clocks and barometers, candelabras and table centrepieces made their appearance in the interior decor of the French houses, together with vases of celadon porcelain, Chinese lacquer paintings, porcelain from Sèvres and Vincennes, and marble and terracotta sculptures by Falconet, Pigalle and Clodion. The scene is completed with furniture by Louis Delanois, Cressent, Leleu, Delorme, Dubois, Petit, Tuart, Tilliard, Lacroix, Reizell, Oeben, Gaudreaux and Criaerd.

Interiors with this kind of animistic inspiration were to reappear with Richard Wagner and in Gabriele D'Annunzio's

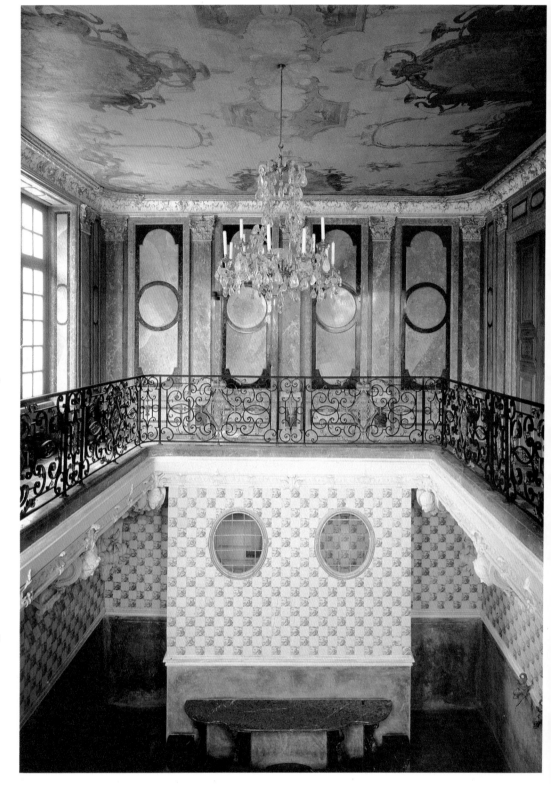

Piacere (Pleasure). These "living things, which are permanently on the brink of death or dissolution", as Giorgio Ficara wrote in the journal *Nuovi Argomenti* (1983), "possess a poetry of transition, which cannot be grasped objectively. As in the Baroque,

here too the reality of the poetic object lies not in its presence, but in its fragmentation and duplication, in rediscovery […]"

Juste-Aurèle Meissonnier devloped "picturesque" decorative motifs for gilt bronze mounts, candlesticks and candelabras

whose boisterous tracery breaks up the light that falls on them. This ornamentation, which Meissonnier modelled on nature – a similar path was taken by Nicolas Pineau – including scrollwork and little putti, formed a flexible backbone for the art of decor-

Two pavilions in the park of the palace of Nymphenburg, Munich, on which work was begun in 1664 by Agostino Barelli and which was remodelled in the 18th century. FACING PAGE: inside the Badenburg, built between 1718 and 1721 by Joseph Effner, one can look down from a gallery with wrought-iron balusters into the pool lined with Delft tiles. BELOW: the kitchen of the Amalienburg – a hunting lodge built in the park of Nymphenburg Palace by François de Cuvilliés between 1734 and 1739. It is also decorated with Delft tiles.

ation. In the botanical motifs with their strong, fluid elegance, the chief emphasis was now on representing the growth of grasses and flowers. Through the medium of engravings Meissonnier's ornamentation reached Germany and Austria and influenced the output of the Meissen porcelain factory. After leaving Turin, the city of his birth, where he had contacts with Juvarra – a decisive connection which has yet to be researched –, Meissonnier worked in Paris. While in Paris he created interior schemes for Polish and Portuguese nobility. His journeys through Europe were just as important as those of Venetian and Scottish architects of the Enlightenment to Russia and that of Jacques-Ange Gabriel from Paris to Madrid. Evidence of the close connection beween the decorative arts and painting is seen in the frames, perfectly matching the goldsmiths' work and wall-decoration of the rooms – for example in the great *singeries* (monkey paintings) in the Château de Chantilly, near Paris. Cabinet-makers drew their inspiration from painting and sculpture when they were making commodes, desks, folding-out secretaires and roll-top bureaux, different kind of chairs such as *marquises, bergères, fauteuils de commodité, chauffeuses* (in which one warmed oneself by the fireside), *voyeuses* intended for gambling and card-games, *duchesses* and *chaises-longues* and finally even coaches and sedan-chairs: beauty and elegance influenced craftsmanship as much as utility and the basic function of the articles they produced.

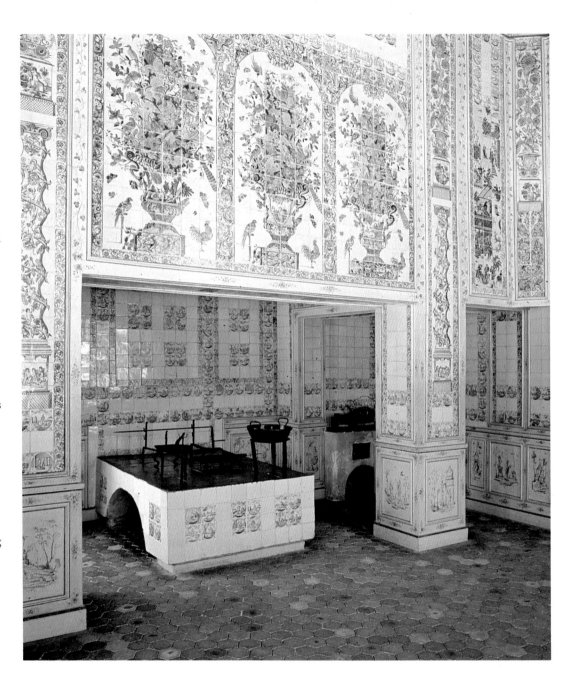

Artists and their subjects

The subjects of pictures in the 18th century varied according to the rooms they were intended for, whether private chapels, mirrored galleries, *boudoirs* or drawing-rooms. Above many doorways the mouldings depicted Alexander the Great or Julius Caesar, in honour of the "Virtues of the Ruler"; the staterooms of monarchs were decorated with subjects like the Labours of Hercules, Jupiter or Mercury. Thanks to the sensitive style of painting, heroic themes do not appear too severe. Since Nature in this age of reason was seen to be closely connected with the Sublime, the depiction of landscape also became increasingly important.

Arcadian idylls such as Diana

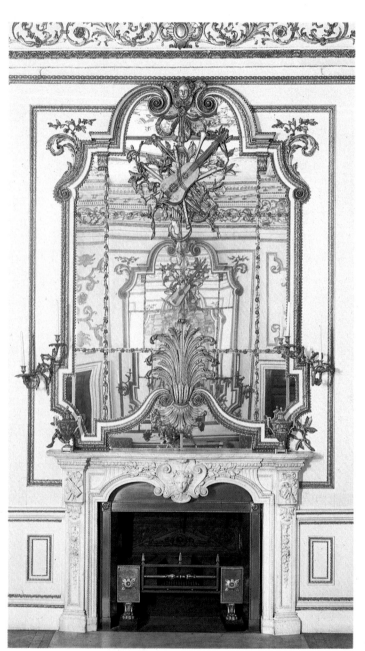

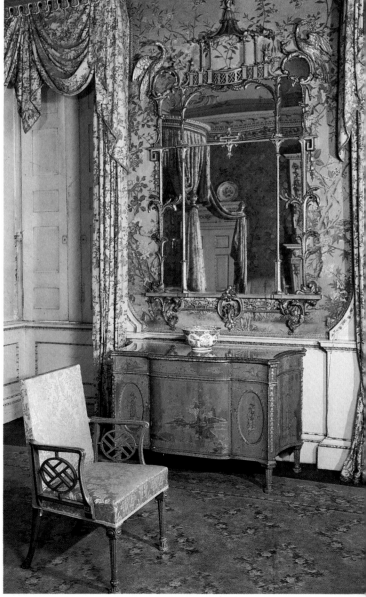

Chinese shadow-plays. These inexpensive portraits had a secure place among the expensive furniture and rarities.

Contemporary observers stress not only the elegant clothing but also the agreeable charm of even the smallest detail in paintings of the period. The "perfect beauties", which Madame de Sévigné already set such store by in the 17th century, now appeared in a purer, clearer light, as in the interior-paintings of Van Loo, Nattoire, Boucher, Beaumont, who created the decor in the queen's chambers of the Palazzo Reale in Turin, and his teacher Francesco Trevisani. The Roman painter Gregorio Guglielmi first

bathing or episodes from the life of Venus were popularized through engravings. A similar trend – popular variations on the art of the élite – took place in *vedute* (views) of Venice, which were bought by people on the Grand Tour, and portraits, as in the pastels of Peronneau, Chardin and Rosalba Carriera. In this context one should not forget the silhouettes in white paper on a black background or vice versa – for example the one of *Voltaire in his armchair,* a delightful and lifelike study which is reminiscent of

brought this new style to Vienna – where the artist interpreted pictorially the opera libretti of the court poet Pietro Metastasio – and then took it by way of Turin, Schönbrunn and Augsburg to St Petersburg.

The studios of provincial France, in which new ideas in the field of art and artistic craftsmanship were documented, played a crucial role in the Enlightenment. Thus there are paintings with titles like *The Embroideress* by Gresly, owned by the Comte de Caylus, and *The Seamstresses* by Antoine Raspal. The *Portrait of a Banker* by Pierre-Louis Dumesnil of Besançon, which now hangs in Bordeaux, is reminiscent of Hogarth. Portraits painted in these provincial studios even reached the royal courts of Europe. German and Polish masters, as well as Duprà in Turin, created sober and true-to-life representations of lace and fabrics, the production of which attracted much attention in the Enlightenment since it was closely related to social life. These materials were the creations of *homo faber*, Man as craftsman. The practical skills of craftsmen in the solution of scientific experiments aimed at "improving the conditions of life and production" were studied and respected. In the art of porcelain-making, hope was placed in popularizing new repertoires which included herbaria as well as Arcadian and classical motifs.

In the decades before the publication of the *Encyclopédie* numerous scientific writings had already been published, intended to appeal to a wide readership. They deal among other things with applied arts and the associated technologies, and were il-

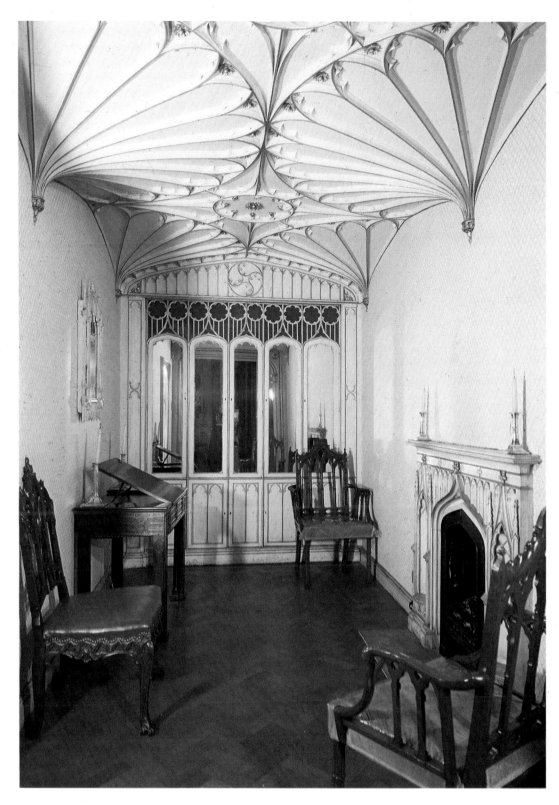

lustrated with engravings. They served as a model for D'Alembert and Diderot's ambitious undertaking, which took a long time to prepare, especially the illustrated section.

A publication which received great acclaim in 1731 was the *Geo-graphical Atlas containing information about the royal houses of Europe and the principal languages and religions and mankind.* This was followed by the *Enumeratio stirpium plerarumque quae sponte crescunt in agro Vindobonensi montibusque confinibus cum tabu-lis aeneis* (An illustrated natural history of the forests and hills around Vienna) by Nicolas Joseph Jacquin (Vienna, 1762), and finally by Rousseau's *Herbarium*.

A number of other books, which dealt with agriculture, were published all over Europe.

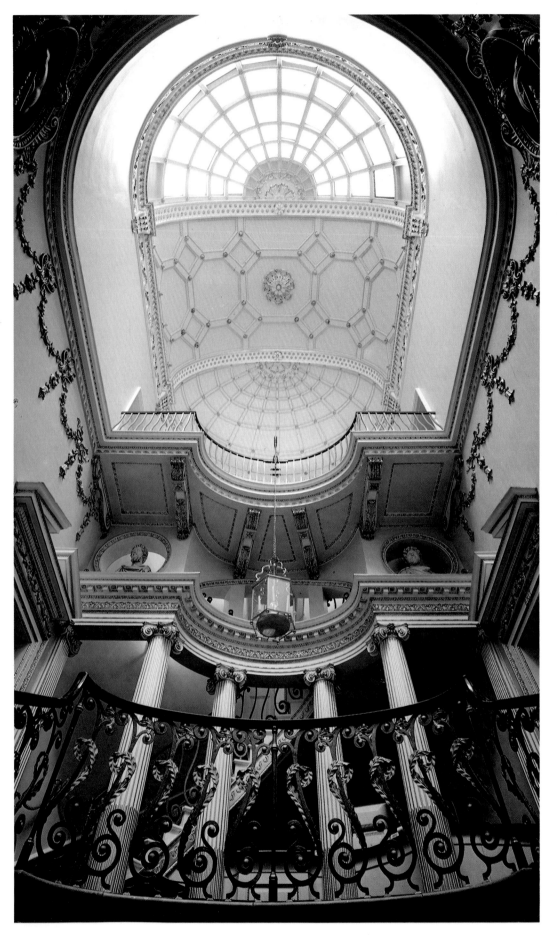

The engravings in *La nouvelle maison rustique ou économie générale de tous les biens de campagne* (The new country home or a general economy of all the produce of the countryside, Paris 1736), depict haymaking, harvesting and the grazing of livestock, with couplets from Virgil's *Georgics*. Here the artists abandoned the traditional genre of Arcadian idylls and came closer to Dutch 17th-century landscape painting and the intellectual world of the Enlightenment. There are other publications from this period which contain detailed illustrations and explanations of the abstract laws of physics and mathematics and their application, for example in musical instruments, fortifications and ship-building. Of similar importance were publications about clock-making, which was closely related to interior decoration.

A form of realistic "street art" grew up, as it had done in the 17th century. But this time the artists found themselves besieged by an eager crowd of buyers and connoisseurs. Similar themes from daily life were taken up by the Piedmontese painters of the group that centred on Pietro Domenico Olivero and Graneri in Turin, who looked more to the Dutch masters than to Bellotto. In the same way a greater realism also entered landscape painting.

In England Hogarth published his *Analysis of Beauty* in 1753, a modern work of art theory which also contained moral judgements on 18th-century society, blending irony and entertainment with an eye for realistic details.

FACING PAGE: detail of the interior staircase – it rises through a double apse-shaped space with a skylight – in a private house in London (44 Berkeley Square) which William Kent built for Isabella Finch, a relative of Lord Burlington, between 1742 and 1744. Behind a loggia of Ionic columns at the first floor level, a second staircase lies half concealed. It runs along the wide recess to the balcony on the third floor. BELOW: the corner of the dressing-room (1775–77) – known as the Etruscan Room – which adjoins the master-bedroom of Osterley Park in west London, built by Robert Adam. In the decoration the Scottish architect drew inspiration from ancient vase-paintings and the archaeological "fantasies" of Piranesi, which he combined with red and black grotesques on a cream-coloured background, silhouettes and small polychrome scenes in medallions. FOLLOWING TWO PAGES: *The Tavern*, from the series of pictures entitled *The Rake's Progress*, by William Hogarth. Sir John Soane's Museum, London.

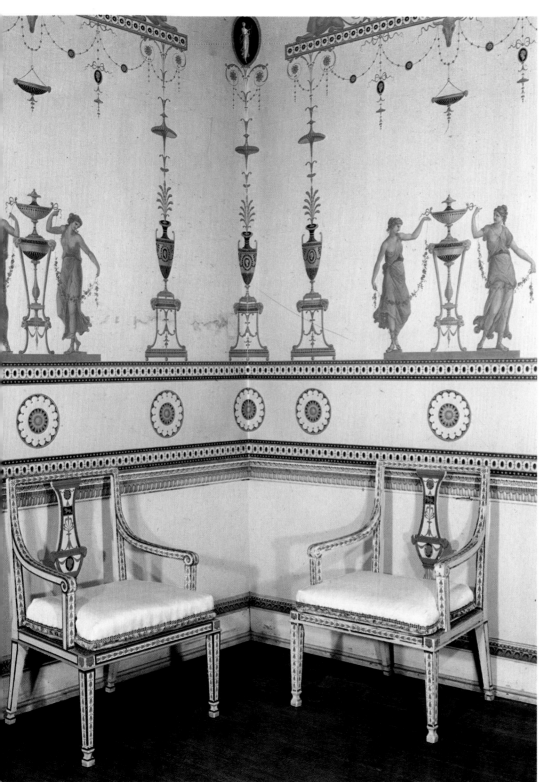

The new ideal of beauty

Returning from the Grand Tour, which took them to Rome, Naples and Venice, English, French and German travellers brought back with them a host of new ideas which influenced 18th-century taste. They imported *objets d'art* and paintings, furniture and sculpture, and above all engravings and drawings. All over Europe artists "helped themselves" from this literally inexhaustible treasure trove, in work commissioned by patrons and connoisseurs.

However, the 18th-century travellers remained chiefly focused on *objets d'art*. They collected terracotta figurines and silverware, watercolours, small ornaments, bronzes and cameos and had plaster-casts made of ancient sculptures. Probably the most interesting collection was that begun in 1792 by Sir John Soane, the English architect whose house in London is now a museum. From distant countries he brought back countless articles of widely differing styles. Ancient statues and perfect casts can be seen next to Egyptian sarcophagi, drawings by Flaxman and engravings by Piranesi, paintings by Hogarth and Adam furniture, Italian Renaissance bronzes from the Veneto, *vedute* by Canaletto and works by Turner, Italian majolica, alabaster objects, ancient coins and Wedgwood china.

This eclectic manner of collecting was none the less based on carefully considered principles. It was intended as a comprehensive tribute to the past and human development in distant, idealized lands.

Also of great importance are the collections in the spacious pal-

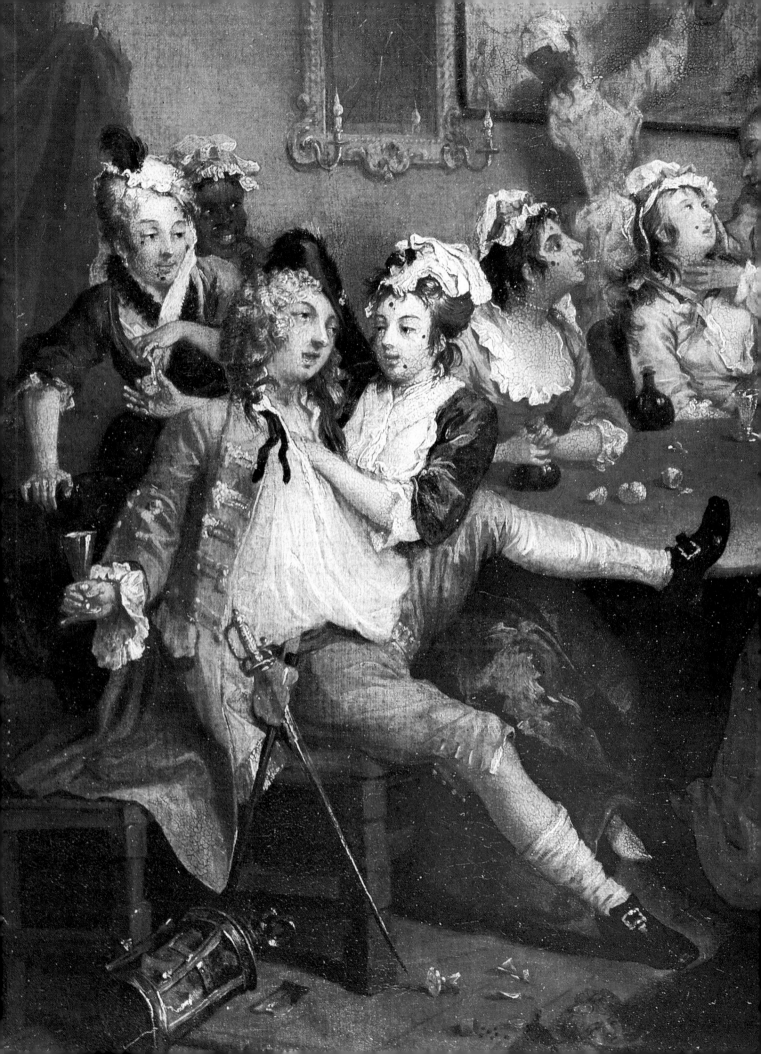

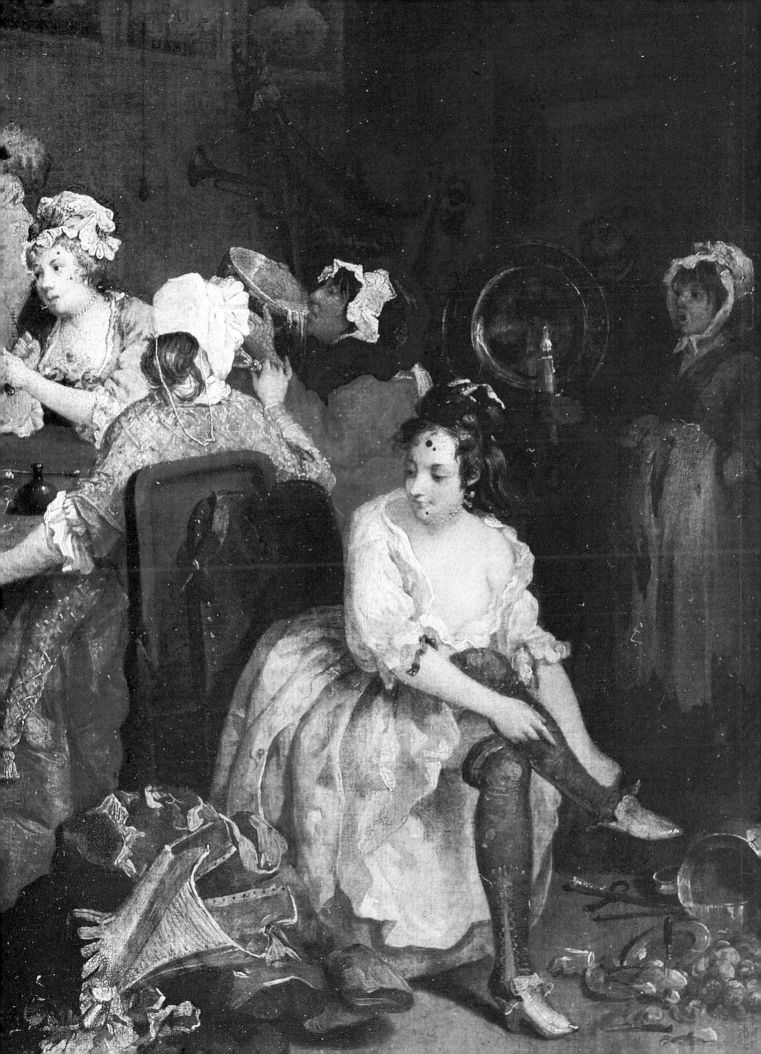

Two more rooms in houses built by Robert Adam on the outskirts of London. BELOW: the Red Drawing-room in Syon House (c. 1765) the seat of the dukes of Northumberland, with its remarkable ceiling. The cornice is decorated with carefully worked stucco rosettes and little tondi with "archaeological" silhouettes by Giovanni Battista Cipriani. The carpet was made in 1769 from a design by Thomas Moore based on Adam. FACING PAGE: the library in Kenwood House (1767–69), built for William Murray, Earl of Mansfield. Both "apses" are lined with bookshelves and separated from the body of the room by fluted columns with Corinthian capitals.

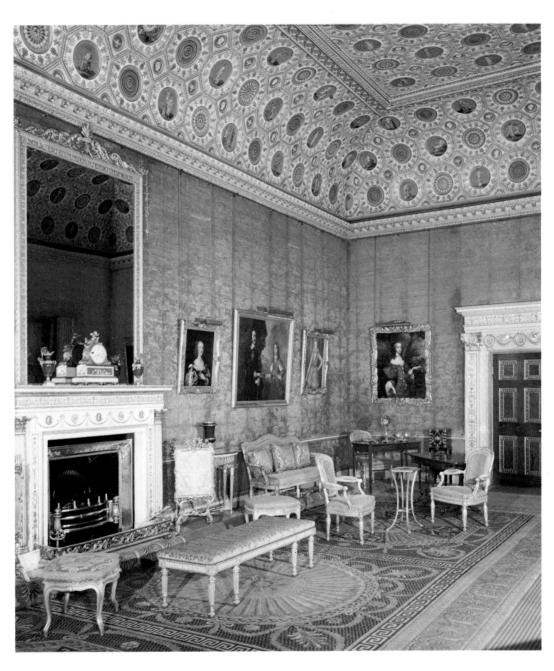

the perspective of the newly defined Sublime. In a kind of wide-angle viewfinder Soane brought together the classical and the modern in a single, panoramic shot.

Everything appears inseparably linked under the influence, drawing the observer in. A new ideal of beauty had taken root. As well as ancient statues and nudes, Soane collected numerous urns: the new ideal even embraced death, powerful but at the same time fragile. Characteristic of this reevaluation were the return to medieval styles in art and the emergence of "Gothic" horror novels in literature.

This new perception of past and present had considerable influence on furniture design, small ornaments, china and porcelain, and also bronzes, to which as much importance was now given as to silverware. Thus artists in bronze combined ancient working methods with modern engraving techniques. The obsession with detail and the striving for perfection far exceeded the demands placed on craftsmen by the *Encyclopédie*.

The notion of the Sublime was only one of many new concepts which found their way into daily life. Thanks to the discovery of the beauty of antiquity, the human soul could now be led to Beauty *and* Truth. There was now a desire to examine more closely the human emotions that emerged from the sinister depths of the psyche, while the "dynamic sublime" made Man appear superior to nature. This development had an impact on the painting of Hubert Robert (1733–1808), for example, and is seen in Jean-Honoré Fragonard's (1732–1806) subtle spatial awareness and atmospheric use of light,

aces of Europe, which were assembled during this period of Enlightenment. With less generous space at his disposal, Soane even made use of corridors and fitted the rooms of his house with mirrors. The visitor finds himself in a narrow labyrinth;

and from raised balconies new and surprising lines of sight open up. The niches in the walls recall the large exedras with masks and urns typical of the 16th-century villas that Soane knew well. The past and the modern are placed side by side. In a carefully analy-

zed framework, every detail was thought about and Soane, for example, put original sculptures together with plaster-casts to make new arrangements.

Antiquity as it were seen through a magnifying glass, in the light of a new perception, in

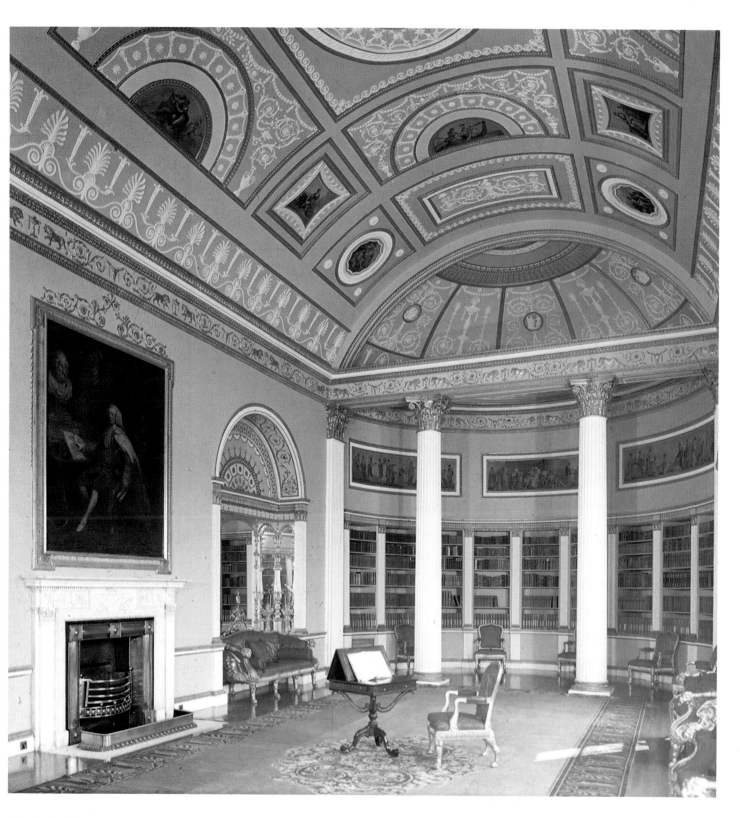

which in his later paintings creates a new sense of atmosphere and emotional mood in even the simplest of subjects, such as *The Swing* (Wallace collection, London)

Disregarding certain English classical pieces or the designs for fireplaces in Piranesi's *Diverse maniere d'adornare i camini ed ogni altre parte degli edifici* (Various ways to decorate fireplaces and all other parts of a house, 1769), one sees that the furniture of this period is designed with good taste, charm and intelligence; i.e. it matches the highly sophisticated society of the 18th century.

FURNITURE OF THE 19TH CENTURY

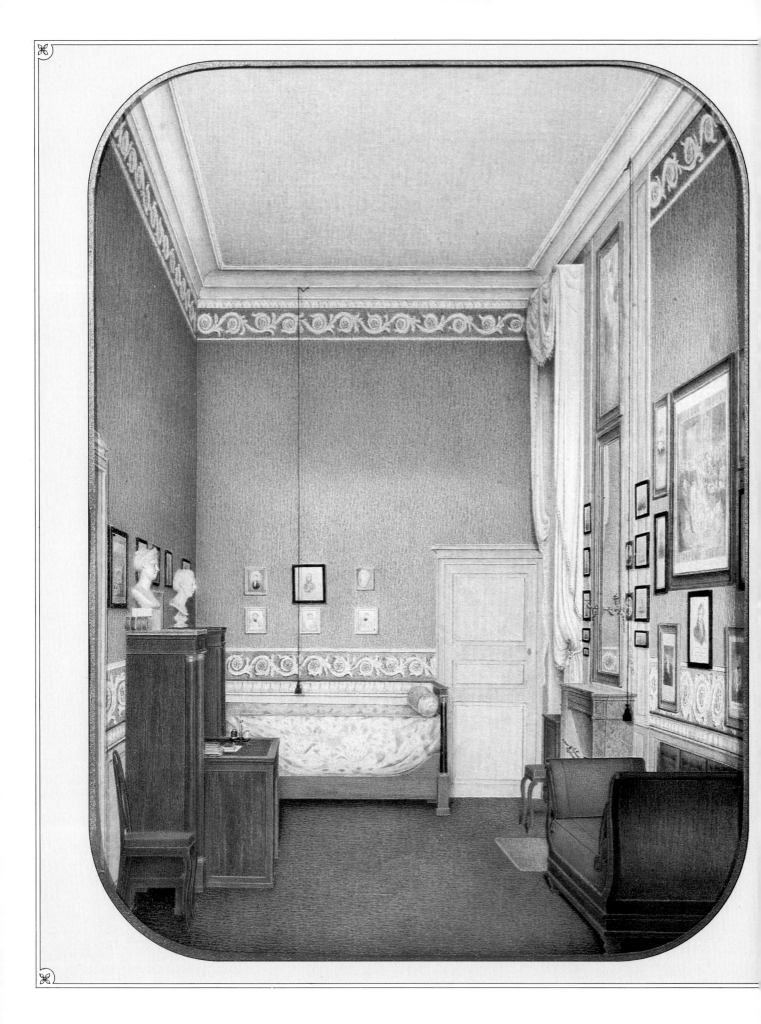

FURNITURE OF THE 19TH CENTURY

ITALY

by Elisabetta Cozzi
and Alessandra Ponte

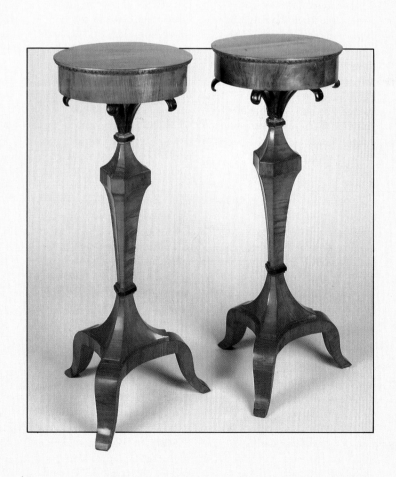

The styles of the century

In the 19th century, Italian furniture design, like that in the rest of Europe, was based on a whole series of combined and overlapping styles. Furniture-makers freely interpreted a complex variety of design trends emanating from England and France. They were also influenced by the Central European styles finding their way westwards via the then all-powerful Austro-Hungary. While the Neoclassical period had imposed a more or less common language on the applied arts, from the 1830s craftsmen were swept up in a wave of revivalism, taking their inspiration from widely differing sources.

Neoclassicism

The Louis XVI style, which more or less coincided with the reign of the French king of the same name (1774–92), had given the new century a taste for symmetry, balance, and the more sparing use of ornamentation and curves. What little decoration there was recalled the ancient world, with particular emphasis on Graeco-Roman motifs.

In Italy, too, the delicacy and elegance of the late Baroque was quickly abandoned. Chair and table legs became cylindrical, either turned, pyramid-shaped or tapered, but always rigorously straight, often fluted, on a decorative square base. The arm-rests of chairs might still curve, but their backs were as straight as the legs. Sofas were designed on simpler lines, supported by fluted legs. Furniture produced for a more aristocratic clientele was frequently lacquered or painted in very pale colours, with white especially popular. Among the most recurrent of the restrained decorative motifs were the "Louis XVI knot" and the Baroque-style metal or gilt bronze trellis mounts frequently used on inlaid furniture. At the same time there was a re-emergence of themes drawn from Classical architecture: trophies, Greek keys, frets, beading, rosettes and candelabra.

During the French Revolution and subsequent Directoire period (1792–1804), French stylistic influence remained powerful. Louis XVI themes continued to flourish and were developed further, with lines becoming even more austere. A decisive moment came when the Emperor Napoleon took control of Italy. Under the patronage of the French rulers, the new Empire style spread throughout the peninsula. Some pieces were made using unmistakably French techniques and materials, while others betrayed a more obviously Italian provincial flavour.

Empire and Restauration

The Empire style marked the triumphant return to a formal classical vocabulary in furniture, inspired by the world of antiquity. Typical of the period was the use of polished mahogany, inlaid with gilt-wood or ormulu mounts.

Following the French example, Italian furniture became "Roman" or "Imperial", with eagles abundantly used, and a swathe of sphinxes, mythical figures, lions and phoenixes. Trophies composed of weapons of war or musical instruments were widely-used motifs, but fasces, laurel wreaths, citharas, palm leaves, torches and lamps were also much in evidence. Elements of Classical architecture such as architraves, egg and dart mouldings, columns, demi-columns and colonnettes, timpani and frontons were used for both structural and decorative purposes. Furniture designed for state rooms was lacquered or painted in white or in one of the other fashionable shades, like very pale blue, cream or eau-de-nil, with gilded mounts. Excavations at Herculaneum and Pompeii brought to light other inspiring decorative motifs such as cupids, putti, winged female dancers, mythological beasts and garlands. One new feature of contemporary furniture, which was in fact borrowed from the world of antiquity, was the tripod, which appeared in the form of small three-legged tables, wash stands, flower holders, perfume-burners or candelabra. Chair-backs meanwhile featured lyre-shaped splats, and sofas resembled triclinia, the couches on which the ancient Romans reclined.

In Percier and Fontaine's *Recueil*, which established Neoclassical tastes in decoration during the Empire period, we find constant references to trends derived from Herculaneum: a winged charioteer flanked by two sea monsters adorning a branch of a bronze candlestick, a Nereid enhancing a bronze appliqué; a nymph on the door of a commode; and Medusa heads and masks appearing repeatedly on Empire pieces.

After the fall of Napoleon, the Empire style coexisted with the French-inspired Restauration style until around 1830. In Italy, however, the latter was merely a transitional trend with no clearly defined characteristics. According to Valentino Brosio in *Mobili italiani dell'Ottocento* (19th-century Italian Furniture), this period marked the rise of the middle-classes and a slow but progressive increase in mechanization. Furniture-makers mechanised their manufactories and the craftsman's workshop was replaced by a well-organized workplace, with new machinery to carry out manufacturing processes previously done by hand. The market for furniture was no longer confined to the court and aristocracy. The middle and entrepreneurial classes filled their houses with furniture, perhaps not so aesthetically pleasing, but nevertheless well-made and practical.

As far as materials were concerned, the use of mahogany declined and walnut and light-coloured woods increased in popularity. Bronze decorations became more sober. Fine ebony, amaranth, rosewood, ivory, brass and silver inlays returned. The first signs appeared of the Gothic revival that was to be predominant in later years. As form and structure became more organic and curvilinear, the profiles of furnishing softened.

The birth of Eclecticism

The style of furniture design during the reigns of Louis-Philippe in France (1830–1848) and Carlo Alberto in Savoy (1831–48) became known as Louis Philippe. The very fact that European dealers used the name of the French king underlines once again the powerful influence of French taste. The style, a fusion of Baroque, Gothic and Neoclassical elements, was epitomised by the furniture commissioned by Carlo Alberto for his palaces.

The vogue for furniture with

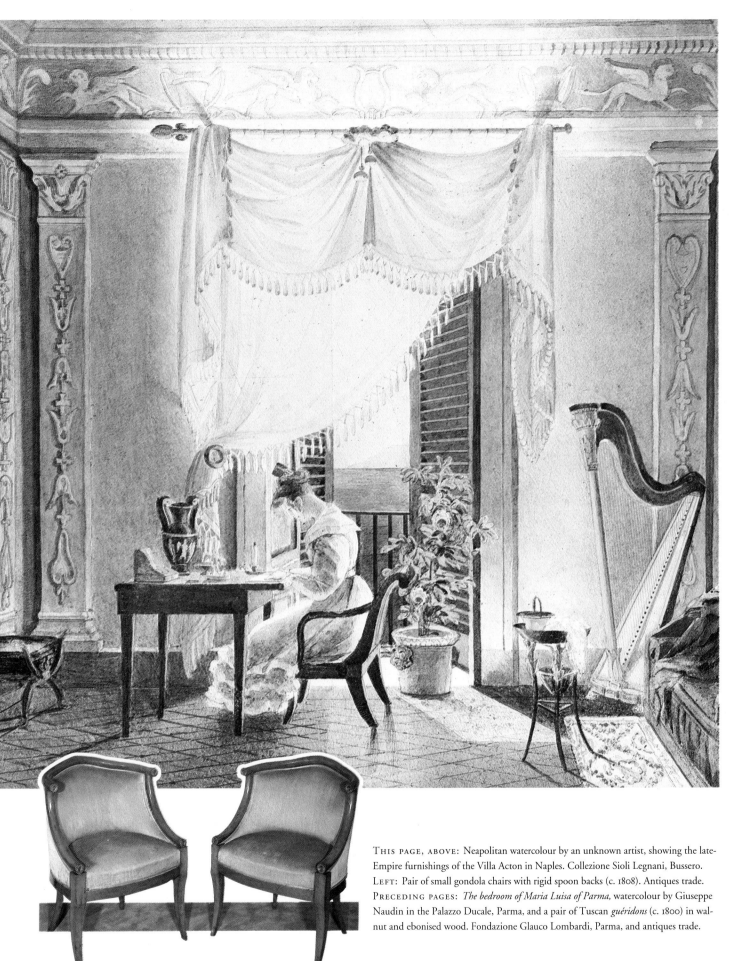

THIS PAGE, ABOVE: Neapolitan watercolour by an unknown artist, showing the late-Empire furnishings of the Villa Acton in Naples. Collezione Sioli Legnani, Bussero.
LEFT: Pair of small gondola chairs with rigid spoon backs (c. 1808). Antiques trade.
PRECEDING PAGES: *The bedroom of Maria Luisa of Parma,* watercolour by Giuseppe Naudin in the Palazzo Ducale, Parma, and a pair of Tuscan *guéridons* (c. 1800) in walnut and ebonised wood. Fondazione Glauco Lombardi, Parma, and antiques trade.

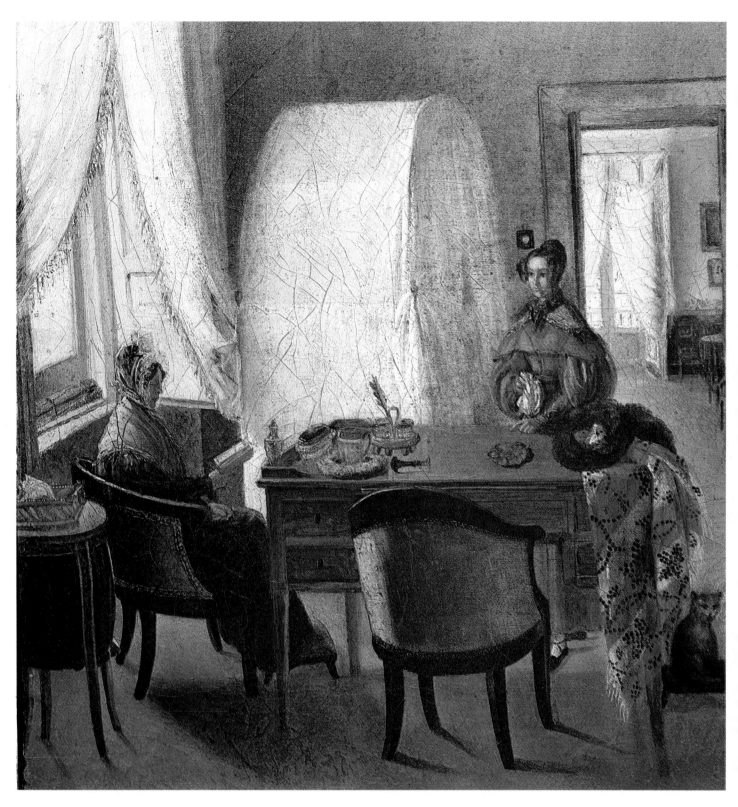

softer profiles and accentuated curves, and the increased importance accorded to carved or relief friezes reminiscent of the 17th and 18th centuries, clearly harked back to the Baroque era. Because the most striking Neo-Baroque designs were made in

Rome and Naples, Italians dubbed the style "Garibaldi" or "Pius IX" Baroque. Florentine furniture-makers combined Neo-Baroque taste with late 16th century motifs.

The fanciful Gothic style, which began in England in the

mid-18th century, found an immediate response among Italian furniture-makers, but the true Gothic revival only gained wider popularity in the 19th century. Ornamentation borrowed from medieval architecture such as rosettes, ogee arches, spires and

pinnacles, added a distinctly Gothic flavour to furniture usually furniture constructed on severe Neoclassical lines.

The Louis-Philippe style also coincided with the Restauration taste for light woods, although ebony or ebonized wood – wood

painted black to look like ebony – was also used. Black lacquered furniture painted with vividly-coloured floral motifs or, more rarely, romantic pastoral scenes also became popular.

While in France the Second Empire style, which flourished under Napoleon III (1852–70), was a further development of Louis-Philippe Eclecticism, Italian furniture combined the Neo-Baroque and Neo-Gothic with motifs inspired by Greek, Etruscan, Chinese, Moorish, Assyrian and Babylonian decorative art. Louis XVI reproductions appeared, although not on such a grand scale as to amount to a full-blown revival. Furniture-makers employed a full range of materials and techniques, and also resorted to all manner of trickery to imitate exotic or expensive materials, among which the favourite was imitative bamboo or *faux bamboos*. Sofas and armchairs were extravagantly over-stuffed so that the entire frame was hidden beneath fringes and bulging cushions. Upholsterers had a field day, enhancing rooms with lavish draperies to harmonise with the rest of the upholstery. The fashion grew for lightweight chairs known as *chiavarine* (after the town of Chiavari) and for Thonet's Austrian-made bentwood chairs.

The originality and quality of Italian-made furniture declined. The eclecticism of the second half on the 19th century culminated in what was known as the Umbertino style – after King Umberto (c. 1878 – 1900) – which characterized (or rather confused) the furniture styles of the final three decades of the century. The result was a hotchpotch of styles, the most predominant

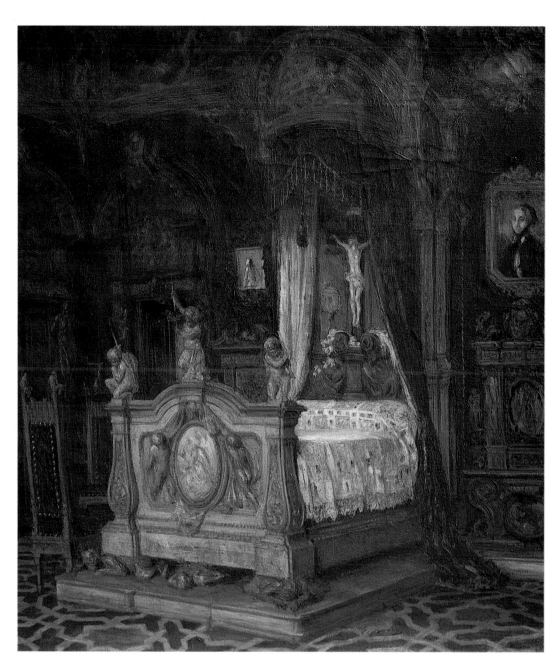

of which was Renaissance. While in England and Germany makers turned to the styles of the Middle Ages, evoking the glory days of their respective nations in the Romanesque and Gothic designs, so the Italians revisited the era of their country's cultural apotheosis, producing furniture and objects in the Neo-Renaissance style. In their free interpretation of 15th/16th-century pieces, craftsmen still stuck to the sombre, heavy style characteristic of their own era.

Viable design possibilities were remarkably enhanced by the late 19th-century revolution in technology. Mechanization provided alternative, simpler ways of tackling difficult, time-consuming tasks such as repetitive wood carving and complex wood joints.

Centres of Production: 1780–1860

Lombardy

Milan was one of the major centres of Italian Neoclassicism, although nearby Palma, where contemporary French culture was enthusiastically promoted, also played an important role. Many of the leading artists who were to contribute so much to the craft of furniture-making in Lombardy trained at the city's Accademia. Among them was Giocondo Albertolli (1742–1839). As Anna Finocchi points out in her essay on the artists and craftsmen who participated in "the transformation of a city" (in *L'idea della*

magnificenza civile [The Idea of Civic Splendour], 1978) Albertolli has been unfairly dismissed as a minor figure, an assistant to court architect Giuseppi Piermarini (1734–1808), who was a leader of Milanese Neoclassicism. Born in Ticino, Switzerland and raised in the local tradition of stucco specialists and builders, Albertolli spent ten years in Parma before visiting Florence, Rome, Naples and Caserta. Invited to Milan by Piermarini, his greatest achievements were the decoration and furnishing of the Palazzo Reale, the Villa Reale at Monza and the Palazzo Belgioioso.

As a professor of decorative arts at the Accademia di Brera in Milan from its foundation in 1776 until 1812, Albertolli was enormously influential. The most talented students from Milan's schools of arts and crafts were enrolled on his courses in order to perfect their skills. As a result, all kinds of local artefacts were enhanced by the new Neoclassical decorative vocabulary. Influenced by the teachings of the French-born architect Ennemond-Alexandre Petitot (1727–1801), Albertolli became the exponent of a brand of Classicism unconcerned with archaeological con-

siderations. He aimed to rationalize and simplify decorative motifs, and was more interested in the "majestic relics of the grandeur of Rome" and the principles of Vignola and Palladio than in the paintings and all the recent discoveries at Pompeii and Herculaneum, which he regarded as "childish whims". As well as carrying out interior decoration projects, Albertolli designed furniture, fireplaces and candelabra, details of which appeared in a series of publications including *Ornamenti diversi* (Various Decorations), 1782; *Alcune decorazioni di nobili sale ed altri ornamenti*

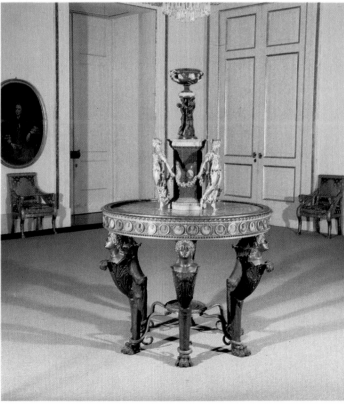

(Some Decorations for Stately Rooms and Other Ornaments), 1787; *Miscellanea per i giovani studiosi del disegno* (A Miscellany for Young Students of Design), 1796; and *Corso elementare d'ornamenti architettonici* (An Elementary Course in Architectural Ornamentation), 1805.

As well as Albertolli, other notable architects of the period were Leopoldo Pollack (1751–1806) and Giacomo Quareghi (1744–1817). Although a student of Piermarini, Pollack was strongly influenced by French and Austrian culture. He is best known for his design for the Villa Belgioioso in Milan.

A man of many interests was Agostino Gerli, an historian, archaeologist and decorator, who championed the introduction of motifs inspired by the Ancient World in the decoration of palaces in Milan. In 1769 he designed the interiors of Villa Longhi at Vialba. He too was influenced by Petitot's innovative styles and concepts, recognising the latter as one of the leading figures then active in the artistic field. A number of inlaid commodes after the style of Maggiolini and bearing the initials A.G. are thought to be Gerli's work. Also famous are his *Opusculi*

RIGHT: A marble-topped centre table with six supports in the form of ormolu female busts emerging from vegetal motifs (detail above), with "lion's paw" feet carved in lava.
CENTRE LEFT: The frieze, reminiscent of ancient Roman friezes, is decorated with medallions containing the busts of the kings of Naples. Museo di Capodimonte, Naples.

Giuseppe Maggiolini and the art of marquetry

Lombardy's greatest interpreter of the Neoclassical style in furniture production, Giuseppe Maggiolini applied the techniques of intarsia with results remarkable both for their technical expertise and the quality of design. The finest artists working in Milan at the time, from Andrea Appiani and Giuseppe Levati to Giocondo Albertolli, supplied him with designs and cartoons for decorative elements, architectural fantasies and mythological scenes, often enclosed in medallions, which the virtuoso craftsman Maggiolini reproduced in wood. In order to highlight the delicate nuances of the design, he used up to 86 different types of wood without ever resorting to artificial colouring. His furniture, often signed by the maker and popularly known as "maggiolini", is constructed in an unpretentious and linear classical style that echoes but simplifies Louis XVI designs. It ranks among the finest work ever produced by Italian cabinet-makers, and still remains unique. After his death, production continued in his workshop under the supervision of his son Carlo Francesco in collaboration with Cherubino Mezzanzanica. Although working from Maggiolini's patterns and designs, his successors could never achieve the same extraordinary quality.

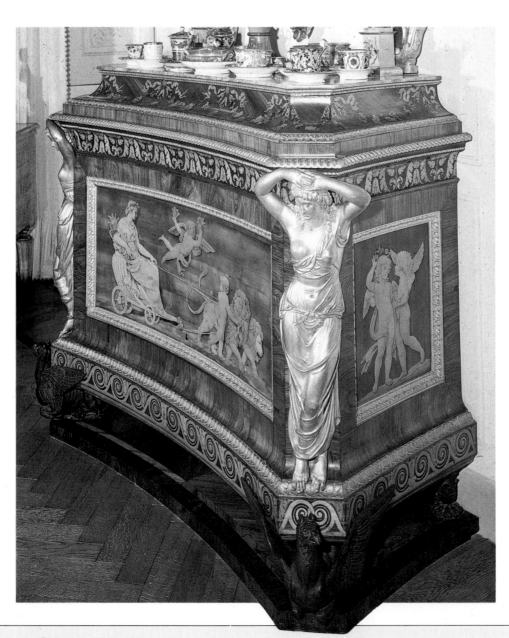

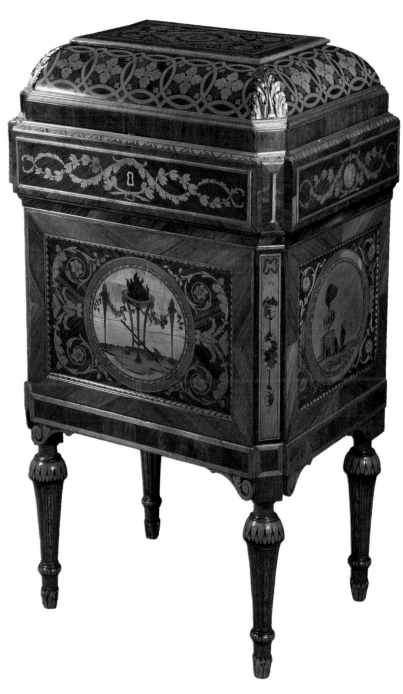

These pages show some splendid examples and details of furniture signed by Giuseppe Maggiolini. FACING PAGE: A commode from Casa Sola-Busca, Tremezzo, with panels designed by Andrea Appiani, decorated with gilt-wood caryatids. Private collection. CENTRE: Two details of the writing table commissioned in 1773 by the Archduke Ferdinand of Austria, then governor of Lombardy, for his mother, the Empress Maria Theresa.

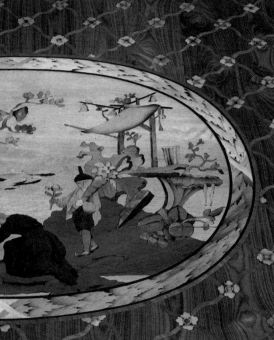

The palisander veneer is inlaid with various lighter woods arranged to form a delicate trellis of rosettes. The medallions contain Chinese motifs. BOTTOM, CENTRE: musical instruments and a view of the Castello Sforzesco and Milan Cathedral (top centre) based on designs by Giuseppe Levati. Bundessammlung alter Stilmöbel, Vienna. THIS PAGE: Jewel box on gilt legs from the last quarter of the 18th century, commissioned from Maggiolini by the Borromeo family, with inlays in various types of wood. Private collection.

(Minor Works) published in Parma by Bodoni in 1785.

Another fascinating personality was Giuseppe Levati (1748–1828), who created decorations and furniture in which neoclassical Louis XVI forms appeared side by side with motifs of Chinese inspiration. Small Chinese figures supported chairs and sofas, which were richly adorned with acanthus leaves. The furniture designed by Levati for Count Silva is now in a private collection.

After Napoleon established the kingdom of Italy, there was a stronger tendency to follow the dictates of Paris. Nevertheless, we find touches of quiet originality in the work of artists like the architect Luigi Canonica (1762–1844), who reflected the tastes of the new bourgeoisie, or Pietro Ruga, most famous for a collection of design sketches (1811) of Neoclassical inspiration in which 18th-century allusions appear alongside motifs suggested by the works of French architects and designers Percier and Fontaine.

At this time, the severity of Neoclassical forms was accentuated by the widespread use of walnut and mahogany. Carving became less prominent, and it was almost exclusively used to emphasise the shape of structural elements. Thus, a chair leg might take on the form of a lion or the uprights of a commode be shaped like a herm. The arms of chairs were adorned with lion's heads, winged sphinxes, swan's necks, colonnettes and demi-columns with ormolu capitals. Chased and gilded bronze became one of the main ornamental elements.

The Manfredini brothers made a major contribution to the production of bronze pieces. Towards the end of the 18th century they opened a foundry in Paris, which they then transferred to Milan at the invitation of Eugène de Beauharnais. There, the foundry operated for more than fifty years, although ownership passed from the Manfredinis to the Viscardis.

They also produced iron, brass and pewter ornaments, but their real forte was chased and ormolu bronze. The foundry often provided the actual structural elements for cabinet-makers. Exam-

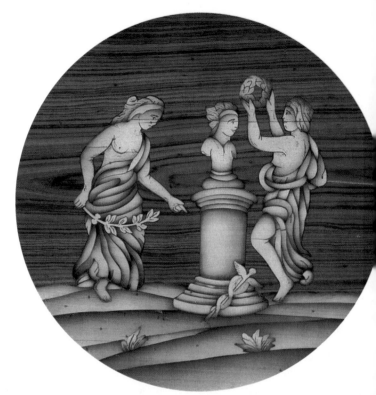

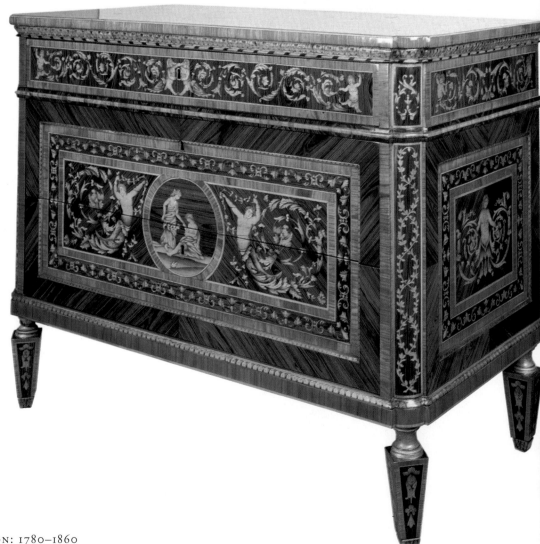

A late 18th-century commode in walnut with inlays of various exotic woods, made in Giuseppe Maggiolini's workshop. The austere lines, characteristic of the maker's simplified Louis XVI style, are embellished with scrolled floral motifs and classical figures. The tondo on the facing page is a detail, showing a ritual in honour of the god Mercury. Antiques trade.

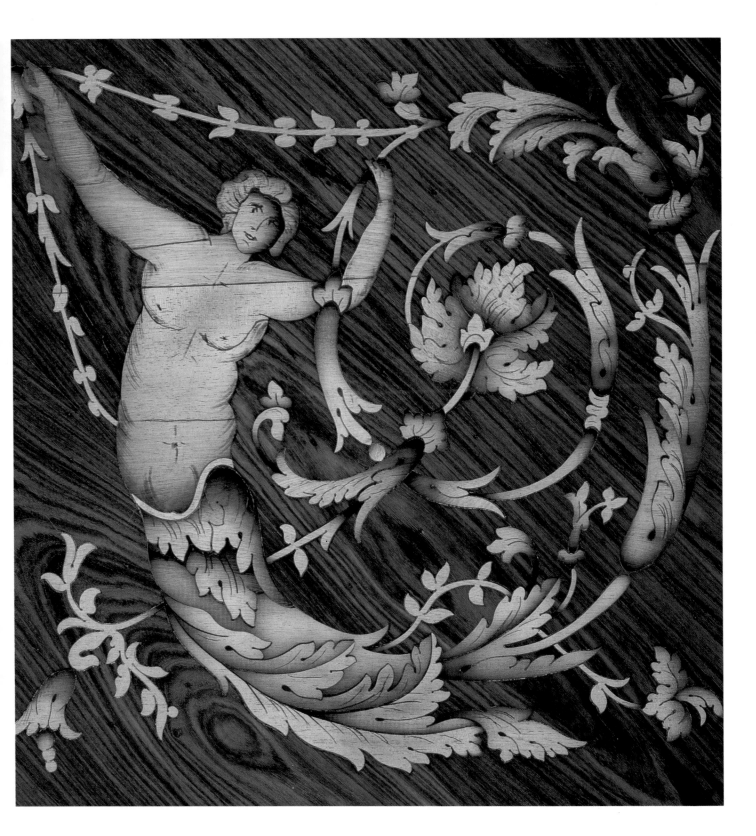

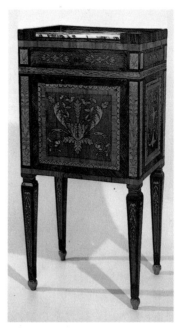

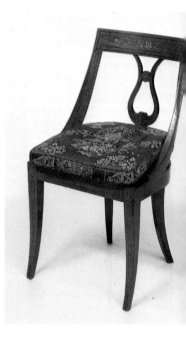

ples included the bronze supports for the Maggiolini commodes at Casa Sola-Busca at Tremezzo, which had two claw feet in dark-varnished bronze at the front, while the two back supports took the form of vases with lion's paw feet. Luigi Manfredini, famed as the greatest medal-maker of his time, was also responsible for the bronzes on the Arco della Pace in Milan.

The powerful Empire influence on furniture production in Lombardy could be seen in the outward curves of bed heads and sofa- and chair-backs. Legs became square rather than circular. New items of furniture emerged, such as the *psyché*, a cheval-glass, with its mirror mounted on pivots, and the monopodium table.

Gerolamo Benzoni, Giuseppe Cavagna and Domenico Moglia were among the finest carvers and builders of Empire furniture. The best-known was Moglia, who succeeded Albertolli as professor at the Brera, and continued in the academic, Neoclassical tradition until 1840. In 1837 he published his *Collezione di oggetti ornamentali* (Collection of Ornamental Objects), containing prototypes for the Baroque-influenced Empire style typical of the Restauration, some of which appear to be less-sophisticated versions of the models of the Venetian craftsman Borsato. Moglia

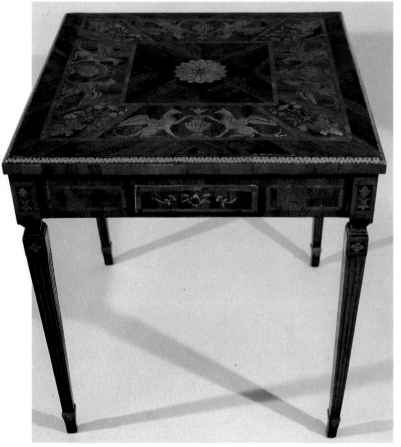

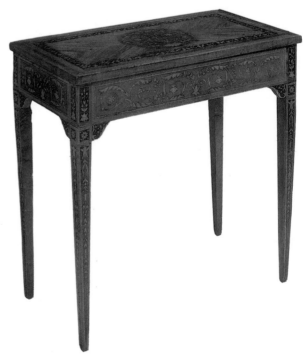

FACING PAGE, ABOVE: commode inlaid with various woods to form an antique-style vase on the front. BELOW: solid walnut Neoclassical commode dating from the last quarter of the 18th century. The entire surface is covered with a host of tiny inlaid motifs, rosettes, festoons of flowers and acanthus in boxwood and other rare woods, typical of furniture from Maggiolini's workshop. All antiques trade.

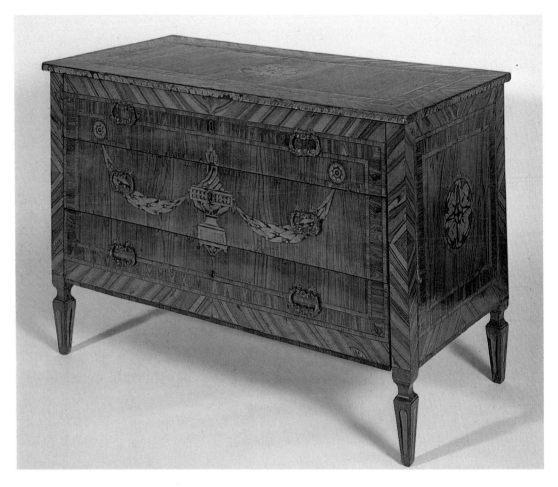

was surrounded by sculptural carvers and highly skilled cabinet-makers such as Arrigoni, Brambilla and Giovanni and Carlo Ripamonti, who all executed his designs.

Within the general Neoclassical movement in Lombardy, there was one artist who succeeded in creating his own highly personal style. Giuseppe Maggiolini (1738–1814), was born into a modest family in Parabiago. He began his working life as joiner's apprentice, later setting up his own workshop. One version of the Maggiolini legend tells how he would have remained a humble artisan making rustic furniture, had he not been "discov-

ered" by the painter Giuseppe Levati, who was decorating and furnishing the Villa Litta at Lainate. Strolling through the square in neighbouring Parabiago, the artist was struck by the excellent quality of the furniture displayed in front of Maggiolini's workshop. Levati immediately ordered him to make a commode, for which he supplied the design. This encounter in 1766 launched Maggiolini's brilliant career. He soon became one of the most famous craftsmen of the age and cabinet-maker to the aristocracy and the court of Italy. Active at the same time as Rosario Palermo in Rome and the accomplished Piedmontese inlay artists, the brothers Ignazio and Luigi Revelli, Maggiolini enjoyed the patronage of a society whose fondness for luxury was the subject of Parini's satirical poem, *Il Giorno*. He undertook commissions for the Beauharnais family and Milanese supporters of the new régime, without devi-

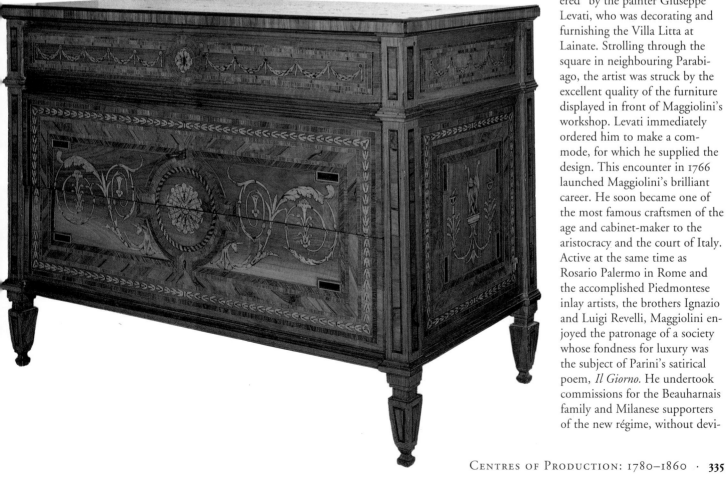

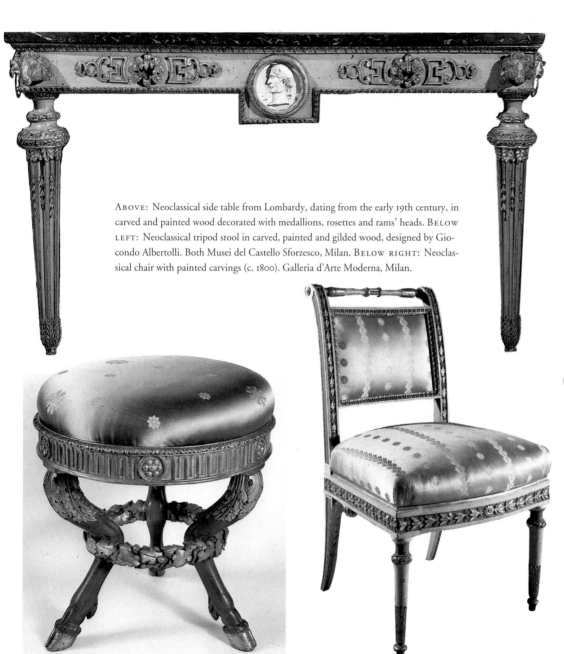

ABOVE: Neoclassical side table from Lombardy, dating from the early 19th century, in carved and painted wood decorated with medallions, rosettes and rams' heads. BELOW LEFT: Neoclassical tripod stool in carved, painted and gilded wood, designed by Giocondo Albertolli. Both Musei del Castello Sforzesco, Milan. BELOW RIGHT: Neoclassical chair with painted carvings (c. 1800). Galleria d'Arte Moderna, Milan.

from imitations. Only rarely were they adorned with sculpted reliefs, like those built for the Casa Sola-Busca, considered the most interesting and idiosyncratic of all his output. Their powerful expressiveness was achieved by the clever combination of the two techniques of inlay and carving, and the bold mixture of materials such as bronze, marble, various types of wood and gold.

The beauty of his inlaid work also owed much to the designs supplied by artists such as Appiani, Levati, Comerio and Albertolli. Maggiolini himself also invented some of the smaller motifs such as rosettes, festoons of flowers and candelabra, which often became major features of in-

ating very much from his original style.

Around 1770, during the transition from the late Baroque to Neoclassicism, he was producing curvilinear, slightly *bombé* commodes, but few pieces dating from this early period bore his

signature. The Neoclassical-style pieces made during the period immediately following were signed and can therefore be attributed with certainty to Maggiolini. These items were devoid of carving, their lines were simple and the surfaces clear, the fronts

and sides were flat and rectangular, enlivened by a highly personal touch of inlay and beautifully turned legs. Indeed the legs, elegant, rounded, tapering and well proportioned, were one of the elements which distinguished genuine Maggiolini commodes

BOTTOM: North Italian Neoclassical commode (c. 1800). The decorations on the front are executed with tempera under glass to imitate Wedgwood china, and framed with gilt-wood carvings. Musei del Castello Sforzesco, Milan. RIGHT: Early 19th-century console table surmounted by a mirror, painted in white with exquisite gilt carving. Galleria d'Arte Moderna, Milan.

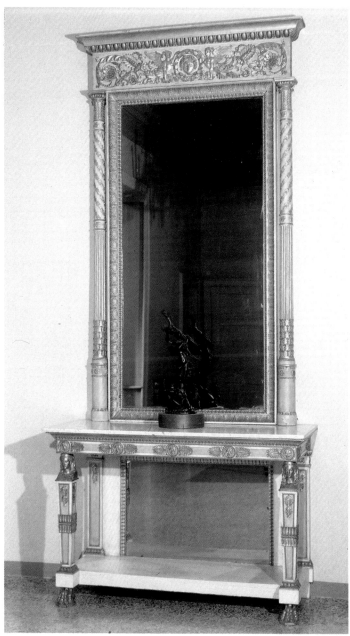

dividual items of furniture. The superb quality of his work was, above all, due to the many different kinds of wood he used – up to 86 different types, of varying strength, grain and colour. Maggiolini only used the techniques of dyeing to achieve the colours blue or pink, obtaining a multitude of nuances by immersing in red-hot sand the tiny pieces of wood to be used for the inlay. The overall effect of the inlaid surface was a warm, almost golden tonality, becoming darker in places.

He always used a walnut carcass, and his inlays, at least two millimetres thick, were as precise as pen-drawings. Very rarely did he resort to superficial inlays of the type often seen on the soft wood frames of "Maggiolini-style" furniture.

His surviving furniture has remained in an excellent state of preservation, because he protected the pale boxwood, which was a fundamental component of his inlaid work, with a special varnish which prevented oxidation and retained the magical golden colour.

More than any other type of furniture, Maggiolini produced commodes with legs either tapered or circular in section, sometimes with bronze ornamentations. He made few pier-glasses, writing tables or corner cupboards, but numerous night tables and wall cabinets. Few and

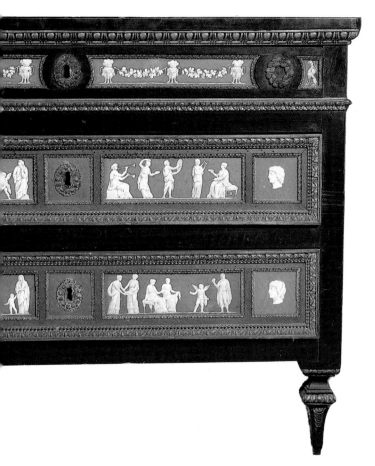

far between were the oval centre tables whose inlays displayed Maggiolini's craftsmanship to the best advantage. He did not make many chairs, since they had fewer surfaces suitable for decoration. The few he did produce had gondola-shaped backs, whose broad top rails provided some space for inlaid work. His early works were more elegant and slender; with the advent of the Empire style, lines became heavier, usually with plumper and stumpier legs and generally more sober ornamentation.

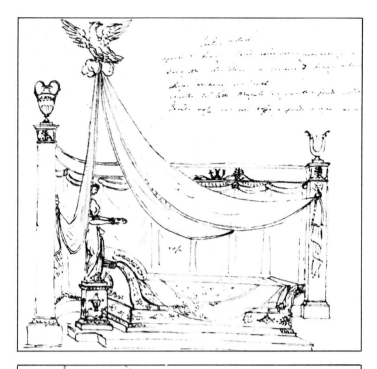

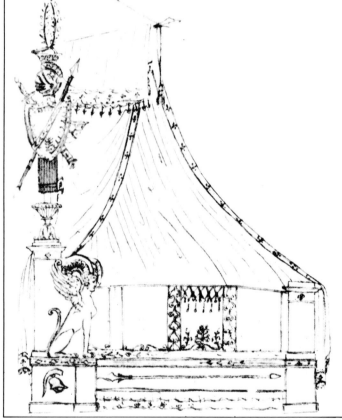

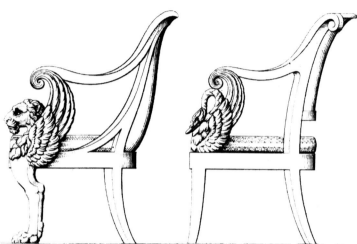

His finest works were executed between 1780 and 1796, the years marking the end of Austrian domination and arrival of the French with their highly-polished, bronze-mounted mahogany furniture. Maggiolini tried, unsuccessfully, to keep up with the times, but was nevertheless not short of commissions, one of them being the writing desk ordered by Beauharnais in 1805 to mark Napoleon's coronation.

On his death in 1814, his workshop with thirty craftsman was handed on to his son Carlo Francesco, who was in charge until 1834, when the business was taken over by Cherubino Mezzanzanica, who continued until 1866. Both men, with other artisans such as Epifanio Moreschi, Giuseppe Vignati, Gaspare Bassano and Giuseppe Cassina, continued the tradition of inlaid work "in the style of Maggiolini".

One of his most talented followers was Cremonese cabinetmaker Giovanni Maffezzoli (1776–1818), famous for his inlays depicting views of 17th-century monuments. Another was also a native of Cremona, Paolo Moschini, born in 1789, a specialist in the art of mosaic, the most typical and most sought-after characteristic of Lombard furniture. From Giuseppe Grasselli's *Abecedario Biografico* (Biographical Directory) of 1827, we learn that, after a short apprenticeship with a craftsman in Soncino, his home town, he went to Milan to work with Epifanio Moreschi, mentioned in the documents of Milan's Società Patriottica as an inlay specialist of great expertise and rival to Maggiolini himself.

During his stay in Milan,

Moschini specialised in carving elm and bird's-eye maple to create tortoiseshell effects. An article in the Milanese newspaper *l'Eco* on 14 December 1835 reported how "he cuts the young elm at the point where the lateral branches grow upwards, and then continues to cut, little by little, the other shoots, so as to form a kind of surface which, when cut and polished, shows a number of concentric circles which would not be found in burrs". In *Della scultura e tarsia in legno dagli antichi tempi ad oggi – Notizie storiche monografiche* (Sculpture and Inlay from Antiquity to the Present Day – an Historic Monograph, 1873), Carlo Finocchietti confirmed that Moschini spent some time in Florence as Spighi's pupil.

While it is hard to find examples of his inlaid work, furniture made for his middle-class customers is more readily available. For such pieces, rather than exotic woods he preferred solid walnut covered with large burr walnut veneers from the trees of the Ferrara area, reassembled on smooth surfaces so that the extraordinary grain created sinuous,

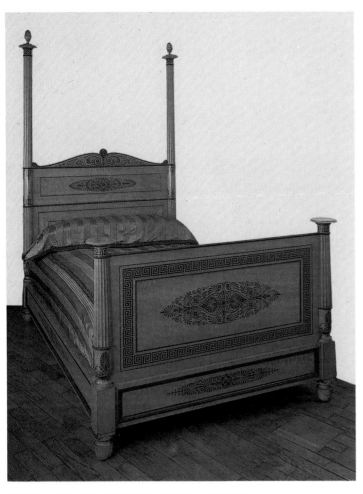

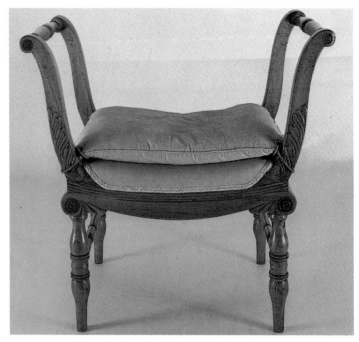

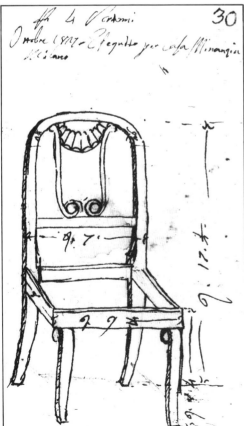

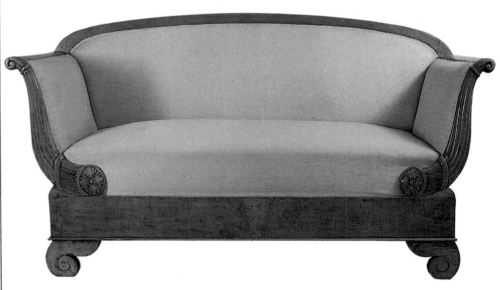

THIS PAGE, TOP LEFT: bed in bird's eye maple from 1830, with palisander intarsia, constituting part of a bedroom suite made by Paolo Moschini for the Palazzo Barbò di Soresina, Cremona. TOP RIGHT: a walnut stool from Lombardy (1820–30) with carved acanthus leaves and turned legs. ABOVE: solid walnut divan, also from Lombardy (1820–30) with carved cornucopia-shaped arms and scroll feet. Both private collections.

BELOW: walnut *secrétaire à abbatant* made in Lombardy in the late Empire style, of a kind which became particularly common during the third decade of the 19th century. Designed on simple architectural lines, the secrétaire, when open reveals a complex system of small drawers and open compartments for letters and documents; the mounts on the brackets framing the front are ormolu. Antiques trade.

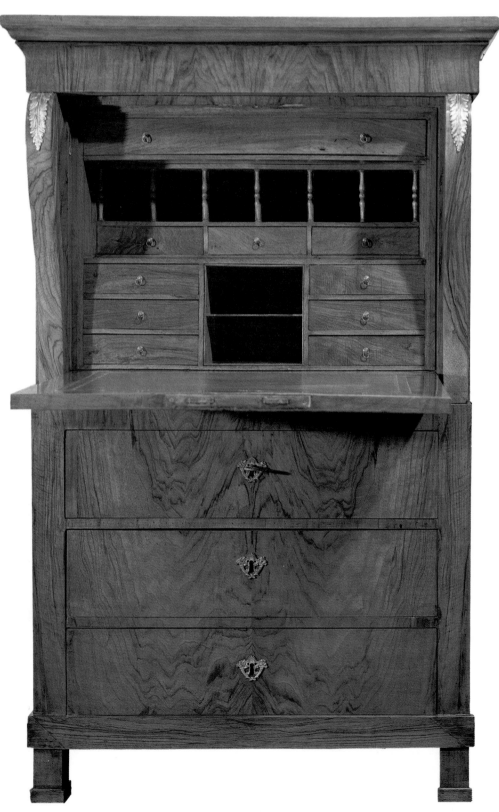

amber-coloured arabesques. His talent lay in his imaginative burr walnut veneers, which he offset against the solid carcass to create a contrast between paler and darker colours, in the skill with which he sealed the joints, and his brilliant, warm sense of colour, which he preserved by using a shellac varnish.

Moschini's Neoclassical training was most apparent in the architectural composition of his furniture, which preserved its elegant proportions without falling into the trap of extravagant virtuoso displays. There were in Moschini's Neoclassical designs indications of the growing Neo-Baroque trends, which started around 1850, and the increasing taste for the Neo-Renaissance style, but they did not overwhelm the elegant simplicity of form and the sober architecture, which was itself a means of capitalising on the decorative virtues of the rich burr walnut grain.

The care and precision of the finishing of the internal parts could only be compared to those exercised by English cabinet-makers and French *ébénistes* like Youf, whose work Moschini had happened upon in Florence. Even in the least visible parts, the finishing was impeccable. The joints of the surfaces were absolutely exact, and there were ingenious mechanical devices like the locks which came to be known as *cremonesi*. A single turn of the key would lock the top, bottom and sides of a cabinet. Further evidence of Moschini's interest in mechanical gadgets was clear from the complex system of small, "secret" compartments concealed beneath perfectly smooth table tops or inside secrétaires or cupboards.

These designs document the spread of Neo-Gothic decoration throughout Italy in the first quarter of the 19th century: the chair is from the sketchbook of Giuseppe Maggiolini, while the two interior designs are by Basoli (1826). BELOW LEFT: Small north Italian writing table (c. 1830) in cherry wood and ebonized wood. Private collection.

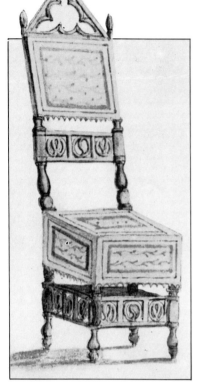

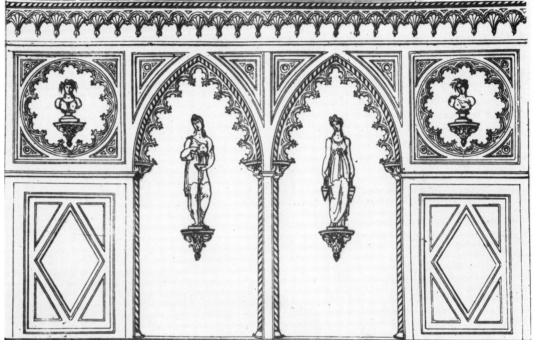

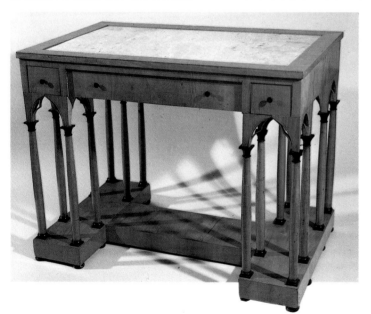

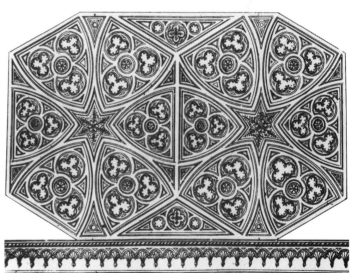

The Austrian restoration brought to Milan an influx of Viennese Biedermeier furniture. The style was a playful corruption of the Neoclassical style, a domesticated yet luxurious mishmash of French Empire, recalling English Regency and Sheraton. If we add to this the vaguely Neo-Gothic and Neo-Baroque flavours inspired by the simpler style of Romantic movement in literature, we can easily understand the degree of eclecticism to which the craftsmen of Lombardy were exposed.

Exotic woods like mahogany, so popular during the Empire, were superseded by warm-coloured local varieties (the so-called *bois clairs*). Maple, cherry, cedar and light burr walnut were combined with dark woods such as amaranth and rosewood to produce elaborate inlays. In fact, Moschini himself was the finest interpreter of the new fashion for light woods.

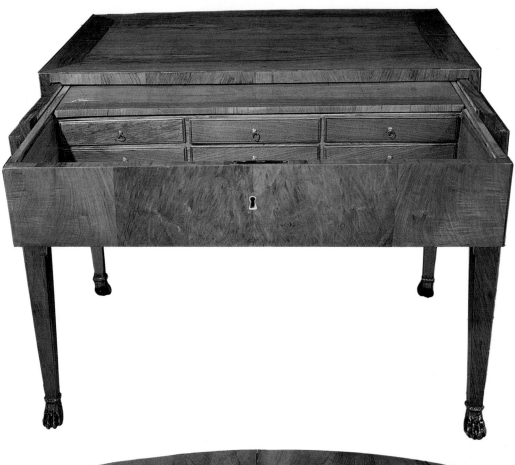

Veneto

The last manifestations of a local style of furniture in the Veneto appeared in the final decades of the 18th century, a time which saw the inexorable advance of the French influences which would finally overwhelm the Italian style. The typically Venetian technique of lacquering, popular during the Rococo period, was in slow decline. The taste for colour persisted in the earliest Neoclassical pieces, and in some examples of furniture of English or Dutch inspiration.

The most austere items of furniture, with turned or fluted, predominantly straight legs, were adorned with traditional painted motifs such as flowers and branches, as well as medallions, garlands and ribbons inspired by Neoclassicism. Similar decorations appeared on the pierced-splat backs of chairs and armchairs in a style very similar to Chippendale.

Towards the end of the 18th century, polychrome wood was gradually abandoned in favour of natural wood. Walnut, sometimes dark stained, was particularly popular. Cabinet-makers in Venice and throughout the Veneto created smaller, cosier furniture more in tune with bourgeois tastes. Some charming pieces were produced for the *porteghi* – the long galleries running from front to back of Venetian middle-class houses. They included simple benches and cane chairs, and tables with wooden tops painted to look like marble. There were also examples of *lacca povera*, or poor man's lacquer, ready-printed decorations which were simply stuck on to the furniture and sealed with clear varnish.

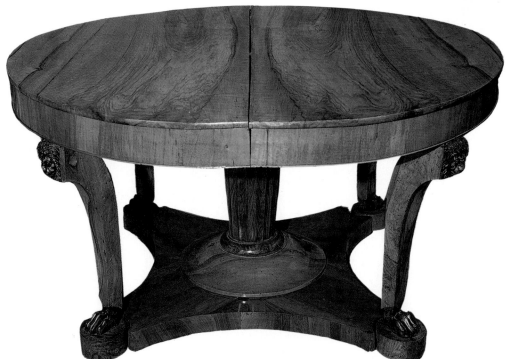

Obviously, this was a cheaper process and far less time-consuming than painting by hand.

The fall of the Venetian Republic in 1797, the victorious French entry into Venice and the Treaty of Campoformido, under which Napoleon ceded the Veneto to Austria, and the subsequent return of the French occupiers in 1805, caused great upheavals in administration and manufacturing and in the field of craftsmanship, not least in furniture production. While there was some continuing resistance to the predominant Neoclassical style, there were in Venice strong supporters of rationalism and the ideas which had led to the evolution of this particular style. These are outlined by Francesco Milizia in his 1781 articles *Principi di architetture civile* (Principles of

These pages show items of furniture made in the Veneto in the late 18th/early 19th centuries. FACING PAGE, ABOVE: a burr walnut writing desk with double writing surface and internal drawers. BELOW: extending dining table in burr walnut, with fluted central support and four sabre legs with claw feet. Both antiques trade. THIS PAGE, BELOW: cherry wood and *bois clair* worktable. TOP RIGHT: cherry wood side table with hoof feet in lacquered and gilt-wood and rams' head mounts on either side of the drawer. BELOW RIGHT: palisander table designed by Borsato, with pedestal support in the form of a caryatid. All private collections.

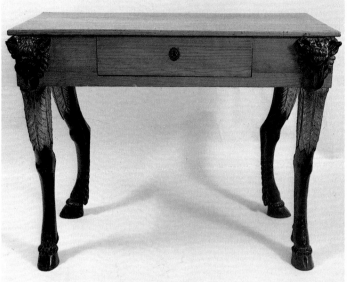

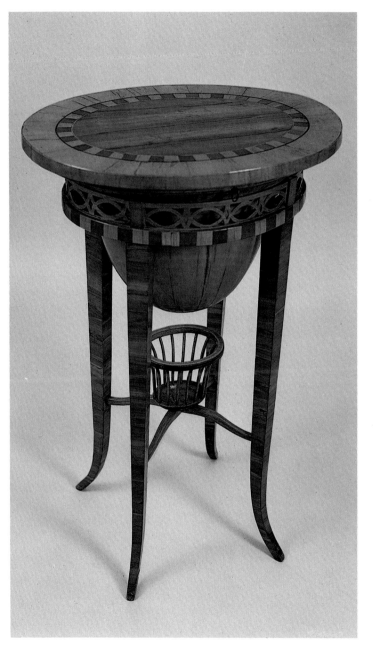

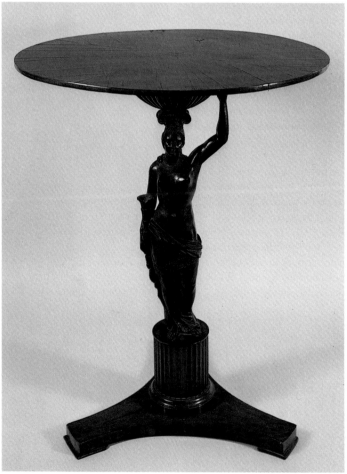

Civic Architecture) and *Dell'arte di vedere le Belle Arti* (Ways of Seeing the Fine Arts), and in his *Dizionario delle Belle Arti del Disegno* (Dictionary of the Art of Design), 1787, and those of Andrea Memmo in *Elementi de Architettura Lodoliana* (Elements of Lombard Architecture), 1786, and Piranesi's series *Diverse maniere d'adornare i camini* (Various Ways to Decorate Fireplaces), 1769 and *Vasi, candelabri, cippi, sarcofagi, tripodi, lucerne ed ornamenti antichi* (Urns, Candelabra, Memorial tablets, Sarcophagi, Tripods, Lamps and Antique Ornaments), 1778. As Giovanni Mariacher points out in his essay about Venetian furniture in *Venezia nell'età del Canova* (Venice in the Age of Canova), 1978, Venetian taste was still recognisable, even during the Neoclassical period, thanks to "a certain softness and delicacy of construction and sparsity of decoration". Lacquer was abandoned altogether and replaced by white-painted wood with gilt decorations. The unmistakeable, Empire-style bronze adornments were combined with

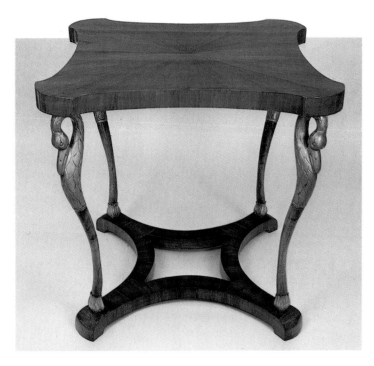

the wide use of natural woods such as walnut and cherry, preferably in delicate, pale colours. Inlays were a rare occurrence, since Venetian craftsmen lacked the patience and the refined techniques required for this type of work. The interiors and concealed parts of Venetian furniture tended to be crude, and it may be that this lack of expertise was the reason why Venetian pieces never carried the maker's mark.

The finest Venetian exponent of the Empire style was Giuseppe Borsato (1771–1849), painter, architect, decorator and teacher at the city's academy of fine arts. In 1831, he published his famous *Opera ornamentale* (Ornamental Works), a collection of 60 plates documenting his work. He also edited the Italian edition of Percier and Fontaine's *Recueil*, to which he added 48 plates illustrating his own works, with annotations describing the materials used. During the Napoleonic period, Borsato was responsible for decorating and furnishing Venice's Palazzo Reale. Some evidence of this project is preserved in the Museo Correr, part of which was also decorated by Borsato. The *cathedra* and chair for the president of the academy of fine arts were also attributed to him. He also worked on the Teatro La Fenice, the Palazzo Pappadopoli and the Palazzo Patriarcale. Among work for private patrons the most outstanding achievement was the furniture for the Casa Treves de' Bonfili at San Moisè.

In the Veneto, some memorable commissions were carried out in Padua by the architect Giuseppe Jappelli for Count Alessandro Papafava.

The count was fascinated by the works of Canova and strongly influenced by Francesco Milizia's theories. He became famous for having furnished his ancestral residence, the Palazzo Papafava, and his country house at Frassenella in the Euganean Hills in pure Empire style. The furniture was designed by Gaetano Manzoni and made by the Paduan craftsman, Carnera.

Jappelli (1783–1852) was an architect, engineer, expert landscape gardener, decorator and furniture designer. One of the Veneto's leading representatives of the Neoclassical movement, he also designed and executed projects in the Neo-Gothic style, which became increasingly popular towards the middle of the century. A notable example of Jappelli's work is the Caffè Pedrocchi in Padua, which is designed in sober, functional Empire style, perhaps inspired by the designs of the Englishman Thomas Hope. Jappelli is also credited with the furniture for the *Salotto Pompeiano*, now housed at the Fondazione Querini-Stampalia.

The development of mid-19th-century taste can be followed in a number of publications which appeared at the time. Among the most interesting is Giuseppe Zanetti's collection of architectural and ornamental studies published in 1843, which included "furniture, decorations and household requisites to meet the needs of the century". 200 engravings reproduced items of furniture far less sophisticated than Borsato's, in a jumble of styles ranging from the Neoclassical,

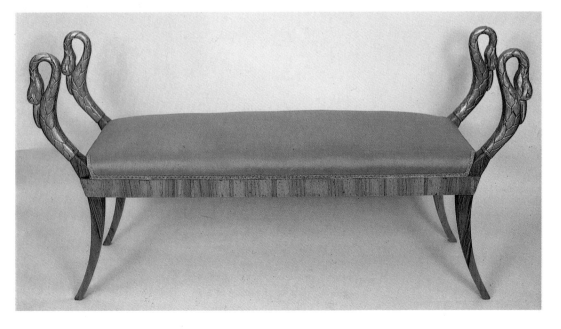

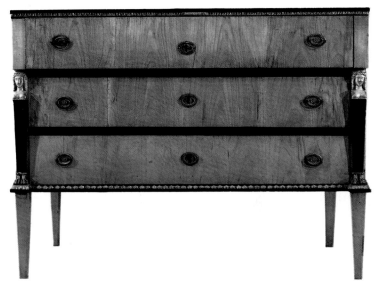

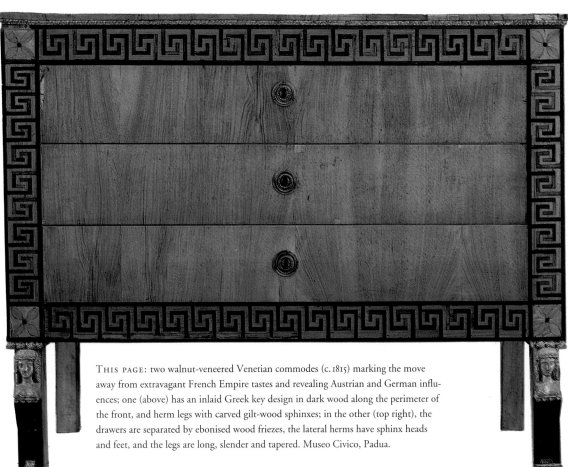

THIS PAGE: two walnut-veneered Venetian commodes (c. 1815) marking the move away from extravagant French Empire tastes and revealing Austrian and German influences; one (above) has an inlaid Greek key design in dark wood along the perimeter of the front, and herm legs with carved gilt-wood sphinxes; in the other (top right), the drawers are separated by ebonised wood friezes, the lateral herms have sphinx heads and feet, and the legs are long, slender and tapered. Museo Civico, Padua.

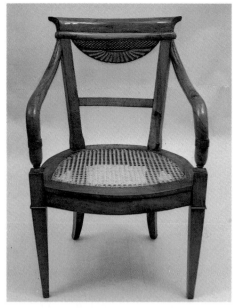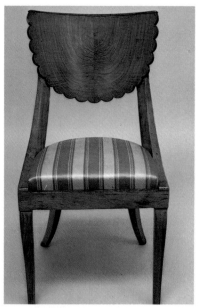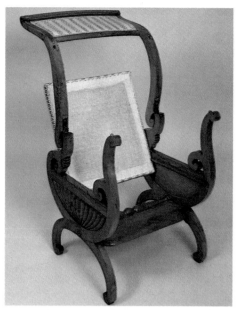

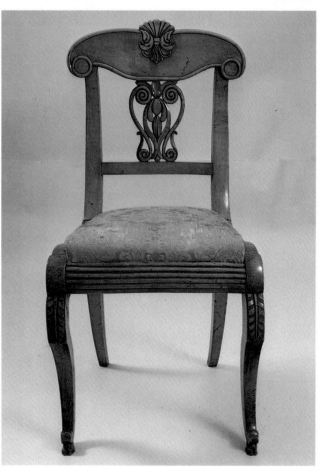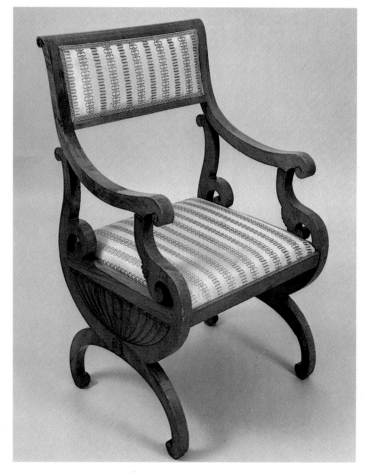

through Empire to Biedermeier, even including Neo-Gothic.

In 1850, Giovanni Maretti, a sculptor, architect and teacher of drawing, published *Opera mobiliare architettonico-ornamentale* (Architectural and Ornamental Furniture).

Maretti and Zanetti clearly showed how Neoclassicism was disintegrating into an assortment of trends and styles which varied with shifts in taste and aesthetic theories.

Emilia

The Academy of Fine Arts in Parma was one of the centres mainly responsible for the propagation of French culture in Italy. Founded in 1752, the academy received its first charter in 1757

from Guillaume Du Tillot (1711–74), to whom the Bourbon Duke Filippo gave virtually free rein in the running of the Duchy of Parma and Piacenza. Du Tillot promoted a policy of intelligent reform and renewal in the arts. He was the wise man who sum-

FACING PAGE: chairs made in the Lombardy-Veneto region in the late 18th/ first half of the 19th centuries. TOP LEFT: Walnut chair with a cane seat and carved shell back. TOP CENTRE: walnut chair with scalloped back. BELOW LEFT: cherry wood chair from the Upper Veneto, with carved foliate back and hoof feet. BELOW RIGHT: walnut armchair, convertible into a *prie-dieu* (above right). THIS PAGE: chair from Emilia, in cherry wood with cane seat and back with openwork giltwood foliate design (1790–1800). All private collections.

moned to Parma as court architect and teacher at the academy the Frenchman Ennemond-Alexandre Petitot (1727–1801), a student of Jacques-Germain Soufflot (1713–80) and ardent champion of the Classical revival. Among Petitot's colleagues at the academy were Gian Battista Boudard (1700–68), who taught sculpture, Giuseppe Baldrighi (1732–1803), painting, and Simon François Revenet (1748–1814), engraving. Adjacent to the academy was the royal printing works.

Under the direction of Giovan Battista Bodoni (1740–1813), popularly known as "the prince of typographers", the press published a series of "universal" catalogues, so helping to increase the fame and prestige of the court of Parma. Bodoni supervised the engraving and printing of Petitot's works, expounding motifs, decorations, embellishments and many other features.

Local craftsmen were given fresh impetus when Duke Ferdinando arrived to find the interior of the ducal palace in Parma completely bare and dilapidated, and ordered their redecoration and refurnishing. Possibly inspired by lessons learned from their French counterparts, cabinet-makers like Marco Vibert, Nicolas You and Michel Poncet created some elegant and individual pieces. Also involved in the project was Sprocchino, one of Poncet's outstanding students, who was among the most sensitive interpreters of Petitot's style. Sprocchino's furniture was rationally structured, decorated in the Neoclassical style and featuring carvings that were both technically perfect and naturalistic, in character with the traditional Emilian style of woodcarving.

Domestic furniture produced in Parma was both innovative and exceptionally well crafted. The preferred material was solid walnut, and typically ornamented with chiselled and gouge-worked panels reminiscent of Provençal and Piedmontese motifs. The lock handles and plates were invariably in finely-chased bronze, while most luxury furniture was lacquered in white with gilt ornamentation. Not only was Petitot one of the very first to introduce the Neoclassical "Grecian" style which was soon to influence furniture design in general – notably the furniture for several rooms at the residence of the court in Colorno –, he also led the revival of the exotic *chinoiserie* which had started to appear in the early decades of the 18th century.

Among the artists who helped to popularise the new trends in the region were the architects Giovanni Furlani, Nicola Bettoli and Paolo Gazola, and the decorator Evangelista Ferrari. The influence of French culture continued in the early 19th century with the installation of Duchess Maria Luisa in 1814. In 1833, she commissioned Bettoli and Gazola to modernise the ducal palace, a project supervised by, among others, Paolo Toschi (1788–1854). The furniture was made by craftsmen from Parma and Piacenza, but mostly by Milanese artisans, who constructed massive pieces based on Borsato's ideas. Rather than the sumptuous severity of the Empire style, Maria Luisa preferred comfort, and her furniture reflected the bourgeois taste typical of the Restauration.

When the duchess died and was succeeded by the new Duke Carlo Lodovico (1847–48), he and the last members of the

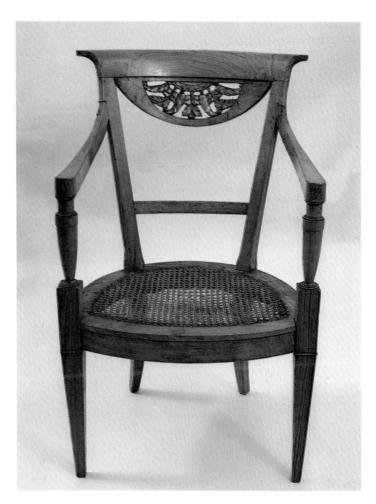

House of Bourbon set about building up the ducal palace's collection of furniture. They ordered Neo-Rococo items and redesigned the various rooms according to the eclectic taste of the period. The family was also very fond of antique and reproduction furniture, and in 1852–53 Paolo Gazola (1787–1857), appointed official State Architect in 1854, created a number of reconstructions in various Venetian and Tuscan styles.

After the creation of the Kingdom of Italy in 1861, furniture from the ducal palaces in Parma and Colorno became part of the heritage of the House of

Savoy and was distributed between the Palazzo Reale in Genoa and the royal family's other official residences in Alessandria, Milan, Piacenza, Modena and Bologna.

A distaste for the Baroque was already apparent in Bologna in the mid-18th century, when Pope Benedict XIV ordered the demolition of the Baroque statues in the University Church because "they are monstrosities of crumbling plaster".

A leading figure in the city in the 1790s, Felice Giani (c. 1760–1823) returned to Bologna after a period in Rome full of enthusiasm for the work of Piranesi

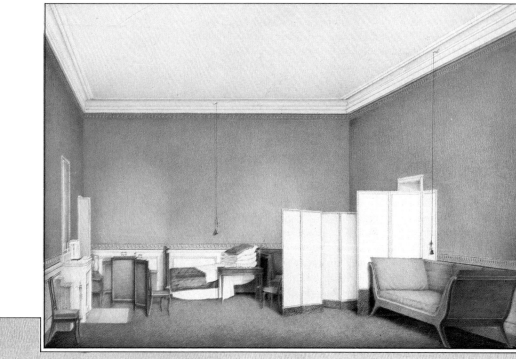

Two watercolours by Giuseppe Naudin, showing rooms in the Palazzo Ducale in Parma. RIGHT: the bedchamber of Count Adamo di Neipper, second husband of Maria Luisa, Duchess of Parma. BELOW: her children's schoolroom. Fondazione Glauco Lombardi, Parma.

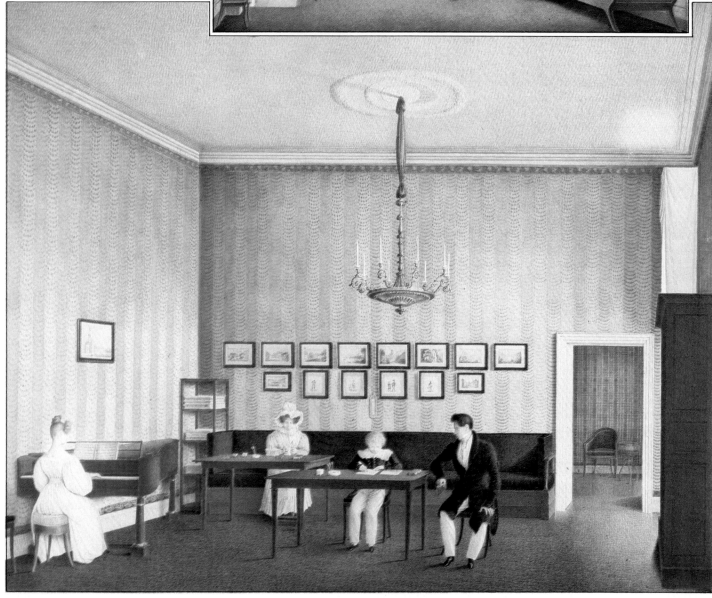

Neoclassical *demi-lune* commode, in purplewood veneer with inlaid Greek key designs and views of architectural monuments in the centre of each door. Built 1785–1790 by Ignazio and Luigi Revelli of Vercello. Museo Civico, Turin.

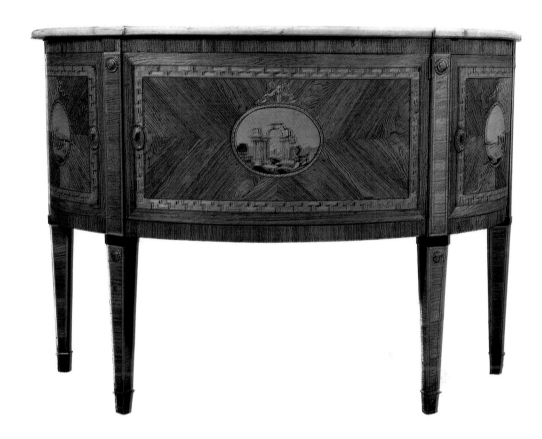

and the intense archaeological activities then taking place. He championed the revival of Classical motifs, also influencing the Bolognese artists Antonio Basoli and Pelagio Palagi, who in the first half of the 19th century were associated with the archaeological style but later turned their attention to combining Classical motifs with the Neo-Gothic forms typical of the Restauration.

Giani's obvious influence on Palagi can be seen in the collection of drawings presented by the artist to the city of Bologna and preserved in the Biblioteca dell' Archiginnasio. It was in the same city that Palagi began his career as an ornamental artist and interior designer. Basoli's sketches, now in Bologna's Accademia Clementina, were also used by Duchess Maria Luisa for the modernisation of her residence in Parma in 1833. Although he still adhered to Piranesian motifs and themes and produced work showing Giani's influence, Basoli managed to reconcile the austerity of the Empire style with the duchess's demand for comfort. His chairs had curved backs of the type that first appeared during the Directoire period, designed to fit the shape of the body. His divans were adorned with delicate spiral scrolls, and his writing desks were fragile and elegant.

Bolognese furniture, in ebony or lacquered walnut, was decorated with Neoclassical Graeco-Roman or Renaissance motifs. The Venetian influence could often be detected in the refined colour harmony. Gold, treated in such a way as to produce a pleasing, lustrous effect, was complemented by Pompeiian red and blue.

In Faenza, where there was lively interest in the Neoclassical movement and the ideas of the Enlightenment, Felice Giani's introduction of Empire motifs had a dramatic effect on local furniture production. Artisans turned away from 18th-century ideas, and there was far less demand for carving and inlaid work, which was usually executed locally in pewter or ivory on a carcass of dark wood such as walnut, or directly on to black ebonized wood.

In *La Casa Faentina dell'800 – The 19th-century House in Faenza* (vol. II, Faenza, 1970), Ennio Golfieri compiled a fascinating list of artists and their achievements in Faenza in 1800, including craftsmen such as Giuseppe Sangiorgi, Giuseppe Casalini, Raffaele Bucci and Giovanni Mingozzi and their contribution to the design and furnishing of Casa Milzetti, Casa Emiliana and Casa Archi e Cavina. Mingozzi was an outstanding exponent of the carver's art, who from 1840 onwards produced works of great technical virtuosity and remarkable elegance, linking him to the contemporary movement originating in Tuscany, where artisans were rediscovering the Renaissance art of woodcarving and the value of "primitive" artists. Another craftsman from Emilia who led the field in Central Italian wood intarsia and cabinet-making was Giovan Battista Gatti, a native of Faenza active in Rome from 1844. His exquisite taste, precise composition and refined execution are displayed in his table tops, cabinets, and chests of varying size.

It is thanks largely to men like Gatti and the Florentine Falcini brothers, and the introduction of mother of pearl, ivory and tortoiseshell, that inlaid work was given a new lease of life in the mid-19th century.

The proximity of Lombardy, particularly Cremona, plus the presence in Emilia of Maffezzoli and Moschini, generated interest in inlaid furniture, but no other craftsman ever achieved the refinement and elegance of Maggiolini. Piacenza and Rolo were the centres of production for inlaid pieces of this type.

Piedmont

Because of its geographical position, Piedmont produced furni-

Giuseppe Maria Bonzanigo: virtuoso carver

A talented carver, Giuseppe Maria Bonzanigo did not confine himself to building sumptuously elegant Neoclassical furniture but was also responsible for a whole range of carved objects, from vases and picture frames to *appliqués*, small ivory bas-reliefs and ornamental trophies, all made in his substantial workshop in Turin. He also decorated entire rooms, playing a leading role in the renovation of the palaces of the House of Savoy, as several interiors at the Palazzo Reale in Turin and the hunting lodge at Stupinigi bear out.

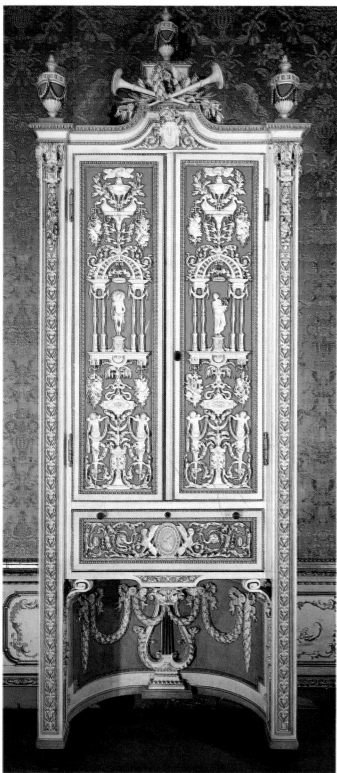

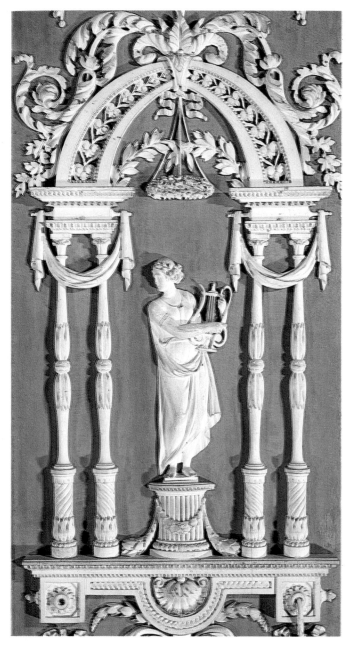

THIS PAGE AND OPPOSITE: examples of furniture by Giuseppe Maria Bonzanigo. THIS PAGE, ABOVE, AND DETAIL LEFT: The *Monumento Militare*, a cabinet-writing desk, built in the Louis XVI style for the court of Savoy (c. 1780), featuring portraits of the European monarchs. FACING PAGE, BELOW: carved giltwood commode decorated with arabesques of acanthus leaves, and garland and scroll reliefs on a pale yellow lacquered background. The locks and handles are ormolu and the top is of green alpine marble. Both Museo d'Arte e d'Ammobiliamento, Stupinigi hunting lodge. TOP: details of a carved, painted screen. Palazzo Reale, Turin.

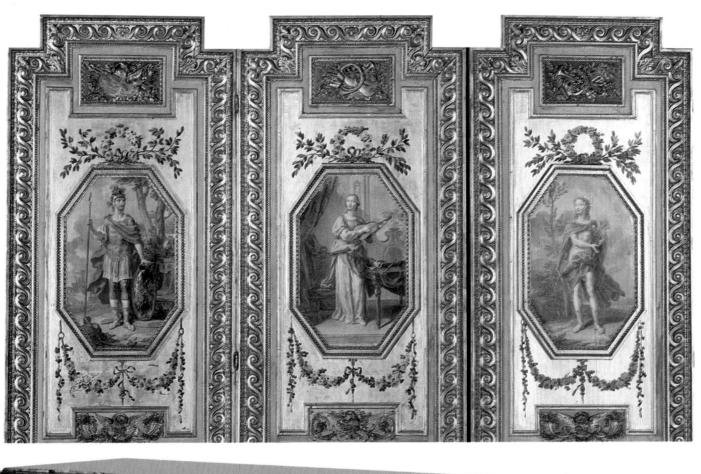

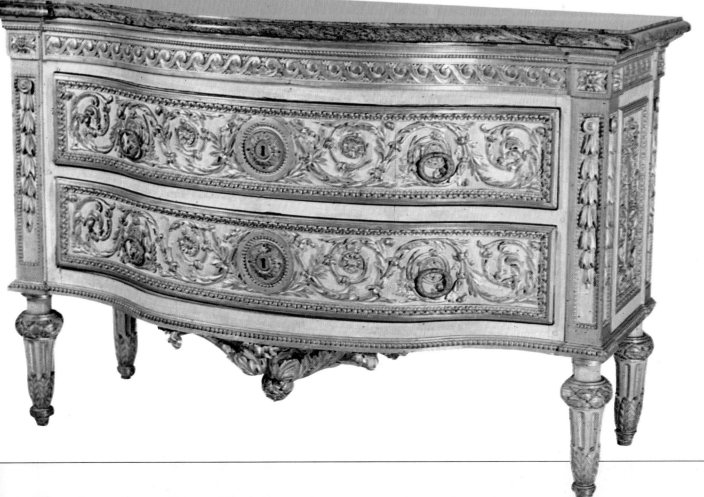

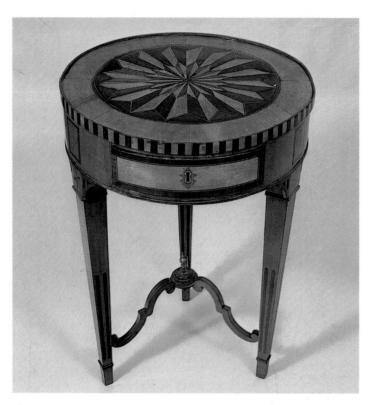

ture which, before and during in the Neoclassical period, had a distinctly French feel, so much so that it is often easy to confuse the provenance of some pieces. This was particularly true of furniture in the late Baroque style. However, despite their overwhelming loyalty to their local traditions, Piedmontese cabinet-makers adhered – albeit hesitantly – to Percier and Fontaine's academic Empire style, while preferring and retaining softer, lighter and more graceful Louis XVI lines.

Even so, thanks to a typically local technique unknown in France, they were able to add something new and idiosyncratic, decorations modelled in gypsum and size, in a style known as *a pastigilia*, although some of the best examples were, in fact, modelled in wood to simulate gesso. A major contributor to this particularly light and agile type of carving was Giuseppe Maria Bonzanigo (1745–1820), who mounted grotesque figures in pale shades on a coloured background. Born in Asti, he took on many apprentices in his workshop. His father and uncle, natives of Bellinzona, specialised in elaborately carved organ cases. With his technical virtuosity, Giuseppe Maria was able to develop and even improve on their art. Between 1773 and 1793, he built furniture for the palaces of the House of Savoy and, in 1775, Vittorio Amadeo III appointed him court sculptor. He would continue to work until his death in 1820, both under French rule and then again under the monarchs of Savoy.

His raw materials were less refined than those used by his French counterparts, but the quality of the carving was flawless and at times as striking as the os-

tentatious virtuoso displays of the late 18th century. Not only was Bonzanigo a distinguished cabinet-maker, he was also the highly-skilled creator of picture-frames and portraits in wood, for which he combined the techniques of *alto* and *basso relievo*.

In terms of decoration, Bonzanigo's style was typified by the traditional Piedmontese *a pastiglia* technique. This consisted of carving in pear wood, lighter or darker in shade according to Bonzanigo's specific requirements for the figures and ornamentations he commonly used. Once finished, the decorative motifs were mounted on to the structure so that they stood out against the lacquered surface, or in the case of small objects such as boxes, picture-frames or snuff-boxes, against the background of ebony or other darker woods.

Thanks to this technique, the artist never detracted from the basic sturdiness of the wood used in his furniture and objects. Instead, he enhanced and enlivened the surfaces with exquisite and elegant applied decorations. This expertise in carving tiny roundels motifs also enabled him to achieve excellent results in ivory.

The items of furniture built by Bonzanigo for the royal Savoy palaces – from commodes and screens to cupboards and painted doors – featured sharply outlined carvings of festoons of flowers and trophies of musical instruments. His most demanding work was the *Monumento Militare*, executed for the court of Savoy in the Louis XVI style. Now housed at the Stupinigi hunting lodge, this cabinet-writing desk, finely carved, stuccoed and lacquered in white on a blue

background, features the portraits of all the European monarchs.

Bonzanigo had many assistants and a large workshop in Via S. Filippo in Turin, next to the friary church. In order to raise sufficient finance to be able to extend his wood- and ivory-carving business, he suggested to some of his fellow citizens that they form a limited company. Part of the plan was to improve his workshops with a view to moving into mechanised production of beautifully-designed ranges of carvings, cameos, fine engravings and high-class sketches, as well as installing a library and other facilities to promote the smooth running of this important enterprise. However, the idea was turned down by these same fellow citizens, who did not think very highly of the artist and could not see his potential.

French visitors also failed to appreciate Bonzanigo's art, accustomed as they were to the refined, austere simplicity of Georges Jacob's Parisian interpretation of the Empire style. They were irritated by the excitable, compositional exuberance of Piedmontese furniture, which they considered out of fashion and decidedly archaic.

In Turin, the traditions of wood-carving and the *a pastiglia* technique were continued by followers of Bonzanigo such as Schouller, Migliari and Marchini.

Alongside Bonzanigo, two other outstanding furniture-makers were the Vercello-based Ignazio and Luigi Revelli, who supplied inlays for the audacious "technical pieces" created by the royal cabinet-maker Pietro Piffetti (c. 1700–71). The simple lines of their furniture are

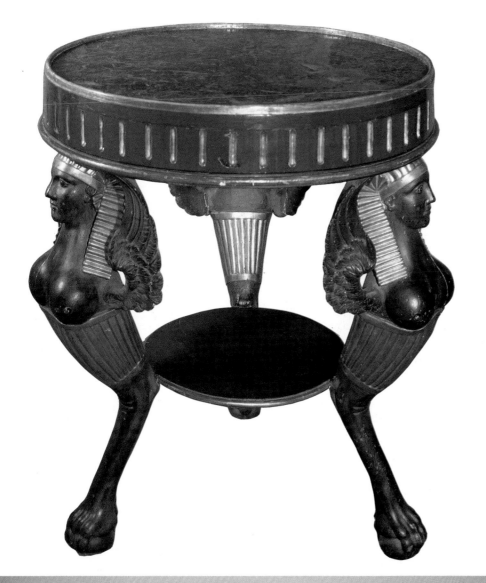

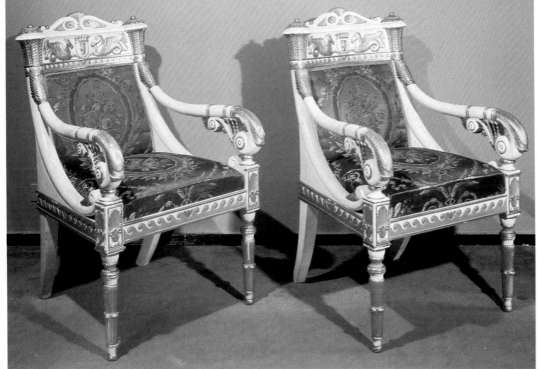

enhanced by sober inlaid decorations showing rural scenes, panoramic views and flowers which adorn the smooth, Neo-classical-style surfaces.

In 1833 Carlo Alberto of Savoy summoned the painter, sculptor and architect Pelagio Palagi to renovate the interiors at Castello di Racconigi. Trained in Bologna, Palagi was well equipped to satisfy the King's demands with a decorative scheme rich in historical reference. In "La promozione delle arti negli stati italiani dall'età delle riforme all'Unità" – Patronage of the Arts in the Italian States from the Age of Reform to Unification – (in *Storia dell'arte italiana* [The History of Italian Art], 1982), Sandra Pinto tells how Palagi drew on the decorative repertoire of Etruscan motifs based on archaeological discoveries to decorate the king's study at Castello di Racconigi. The relationship between king and artist continued with a commission to decorate the state apartments at the Palazzo Reale, where Palagi chose a decidedly Neo-Empire style. The results of his detailed study of books and prints during his time at the various Italian courts (Naples, Milan and Turin) are brought together in his very personal interpretation.

As well as Classical allusions, his furniture also displayed a clever incorporation of Neo-Gothic elements. Indeed, Palagi was one of the leading champions of the Gothic revival in Piedmont. Among the most interesting examples of this style we may mention the Torre Traversi at Desio, the Castello di Pollenzo and the Margheria lodge in the grounds of the Castello di Racconigi.

These pages show examples of Piedmontese furniture from around 1835. THIS PAGE: chair inlaid with ivory, ebony and other woods, built by Gabriele Capello and based on a design by Pelagio Palagi. FACING PAGE, BELOW LEFT: Palagi's sketch, conceived for the Etruscan Room at Castello di Racconigi, which was later shown at the Great Exhibition in London in 1851. Castello di Racconigi.

He was succeeded by Nicola Ferri, proprietor of a "prizewinning establishment", who was entrusted with the reorganization of the Palazzo Reale in Turin for the arrival of dowager Tsarina Alexandra, widow of Tsar Nicolas I of Russia.

To carry out his projects, Palagi used artisans including Godone, Ferrero, Bertinotti, the Manfredini brothers, Novaro (known as "il Brassié"), a pupil of Bonzanigo, and the inlay specialist Gabriele Capello (known as "il Moncalvo"). Capello was credited with the revival and refinement of the intarsia technique, which had fallen into disuse after the death of the Revelli brothers. Finocchietti quotes from a passage written by Capello himself: "[...] after many unsuccessful attempts to take hold of two pieces of wood veneer, one coloured, the other not, I sketched a simple S-shape and with the small saw I cut around the upper part, forming the lower space in the very centre, and, having completed the process I realised I had made a discovery: it required no more than straightforward manipulation of the saw." It was one of Capello's greatest virtues that he continued to strive to perfect his own technique, examining and correcting every error in order to achieve an ever more pure, discerning and controlled style. This process of experimentation and improvement ran parallel to his activities as a teacher, indeed many excellent craftsmen were to emerge from his workshop.

Moncalvo was responsible for many works in the Palazzo Reale in Turin. They included exceptionally fine inlays, clearly influenced by Piffetti, which Moncalvo created for Carlo Alberto's

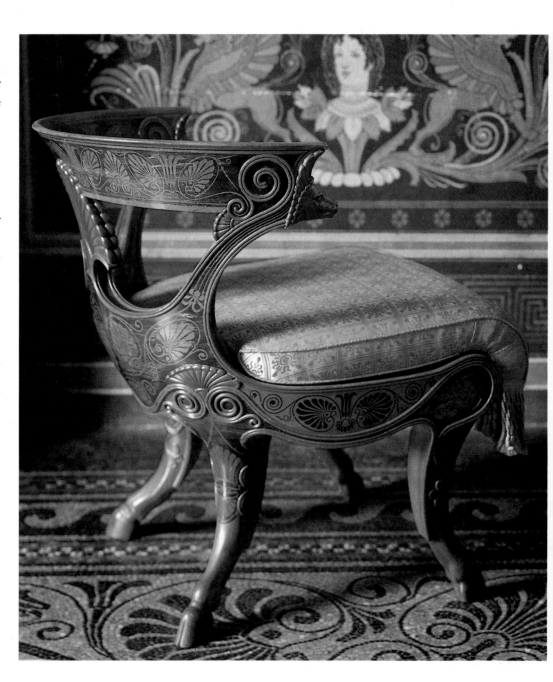

FACING PAGE: further examples of the Palagi style with its many archaeological allusions. ABOVE LEFT: carved and inlaid mahogany *guéridon* with marble top supported by four mythical beasts. ABOVE RIGHT: chair with inlaid rails, the arms supported by winged sphinxes. BELOW RIGHT: palisander veneer writing table, with light maple inlays. All antiques trade.

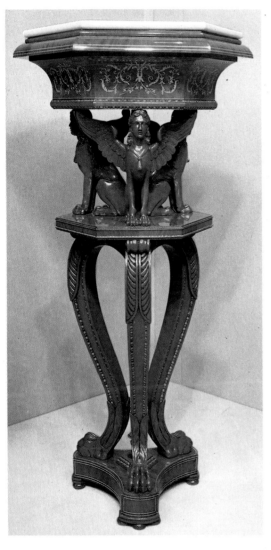

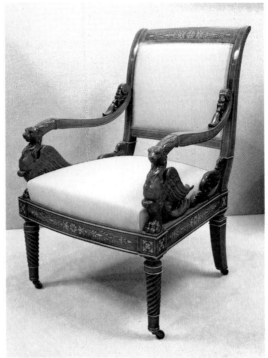

private chapel. He also made an excellent job of the floors in various rooms, especially the one laid in the throne room in 1843, in which he strikingly used woods such as walnut, hornbeam, rosewood, mahogany, sandalwood, olive wood and blackthorn with dark ebony stringing. He was also responsible for the magnificent inlays on the doors and furniture in the Etruscan Room at Castello di Racconigi, the wooden ceiling and the sumptuous floor of the ballroom at the Palazzo Reale in Turin, completed with the collaboration of the cabinet-maker Giovanni Battista Ferrero.

Liguria

In 1800, in the wake of the Battle of Marengo, Liguria, which had been under French influence since becoming a republic in 1797, came under the more direct control of Napoleon, who despatched Jean François Déjean to reorganize the administration. Commercial and cultural interchange between North Italy and the rest of Europe was made much easier by the construction of the Sempione highway, and the abolition of customs restrictions between France and Italy.

The prime examples of the Neoclassical style in Genoa were the work of Charles de Wailly, who was summoned from Paris in about 1770 to redesign the Palazzo Spinola. Some of the most beautiful Ligurian Neoclassical furniture, with exquisite carving and gilding, are preserved in the building constructed by Wailly with the help of Andrea Tagliafichi. Nevertheless, the English influence was no less important than the French. Among

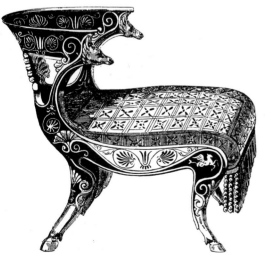

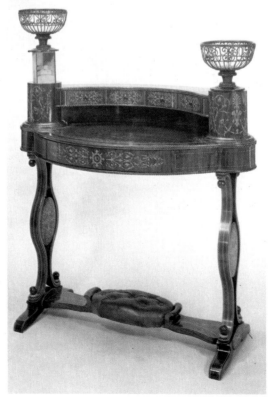

the region's leading artisans was an Englishman, Henry Peters, active around 1830, who interpreted the Empire taste with the simplicity of line and sober but functional elegance typical of contemporary English craftsmanship.

His furniture was distinguished for its precise workmanship, the technical perfection of the surface joints, the impeccable finishing in the less visible parts, cunning mechanical devices designed to conceal perfectly fitting doors, and tightly fitting locks. Such qualities were unlikely to be found in furniture manufactured in other regions of Italy. Peters opened his first workshop in Genoa in about 1835, and his furniture was carved with his trade mark "Peters Maker Genoa".

As cabinet-maker to the court of Savoy, Peters was commissioned by Carlo Alberto to build furniture for the Palazzo Reale in Genoa. As well as the ostentatious, gilded and richly carved pieces ordered by the king, he continued to design more aus-

tere, practical and usually smaller items, which were far more suited to meet the ever growing demand from the new middle-class clientèle.

There were innumerable inlay specialists and carvers operating along the Genoese coast, about whom at present we know very little, since, as Finocchietti points out, "they were more interested in doing their job than in art". Among them were Rubino, Schenone, Pisani, Martinelli and Bartolotti (famous for his large inlaid pieces, one of which is housed in the Reggia in Turin). Another was Ignazio Scotti, criticised by Finocchietti for his lack of attention to the proportions and designs of his inlays.

Some exceptional work was produced by the Descalzi brothers, makers of the typically Ligurian *chiavarina*, an extremely light and elegant but solid chair designed by Gaetano Descalzi, production of which began in Chiavari in 1807. This type of chair was extremely popular

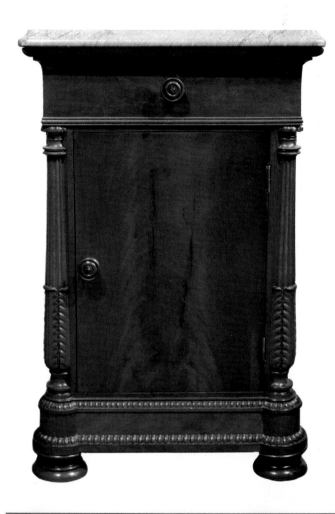

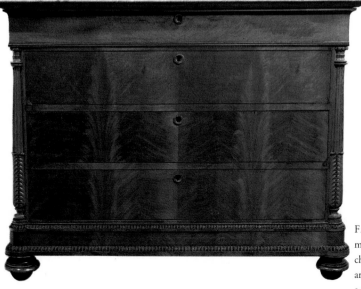

FACING PAGE: three examples of Genoese furniture. ABOVE: a secretaire in mahogany and maple, made c. 1850 by Henry Peters. BOTTOM LEFT: a walnut chair with carved shell motifs on the back and sculpted plant motifs supporting the arms (c. 1840). FAR RIGHT: a solid mahogany divan with carved decorations on a mahogany veneer base (c. 1830). All antiques trade.

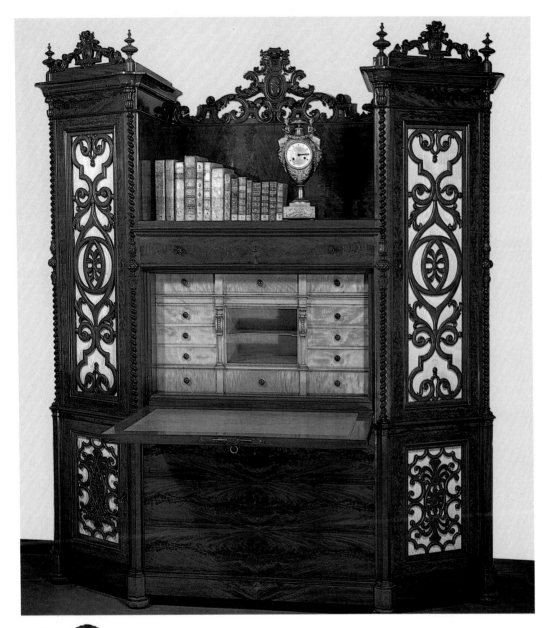

throughout the 19th century. The ornamentation and shape of the pierced-splat back could be adapted in line with various stylistic revivals, but the basic structure of the turned cherry wood elements remained unchanged.

At the same time, so-called "Dutch" chairs and those designed by the Vienna-based Michael Thonet, manufactured under licence in Italy from 1870 onwards, became increasingly fashionable.

Tuscany

The turning point for furniture production in Tuscany came in the early years of the 19th century. After the Neoclassical period, which produced some pleasing but hardly original items, the installation of Napoleon's sister Elisa Baciocchi in the principalities of Lucca and Piombino in 1805 and her subsequent move to Florence after she was appointed Grand Duchess of Tuscany in

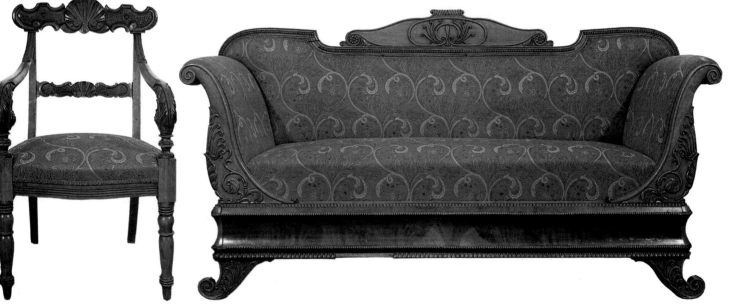

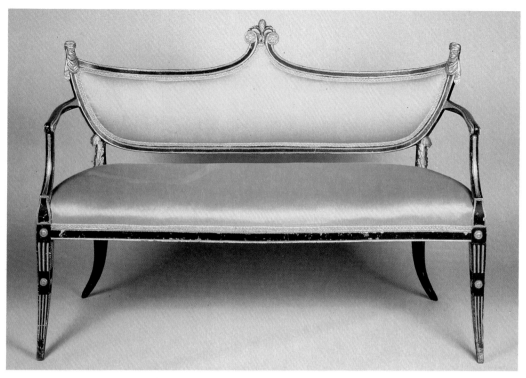

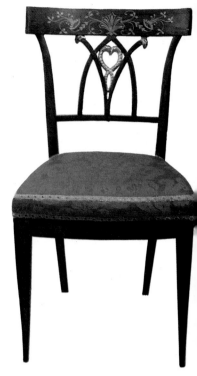

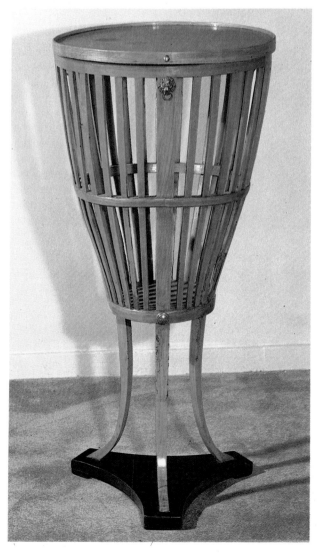

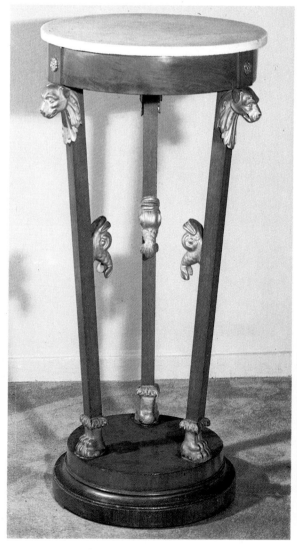

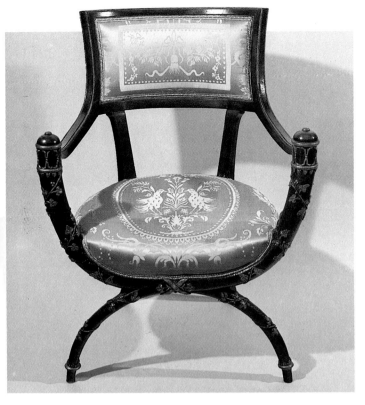

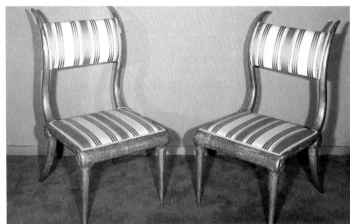

All these examples of typical Tuscan furniture are in classicising styles. Produced between c. 1790 and 1820, they present a stylistic overview from Directoire to late Empire. FACING PAGE, TOP LEFT: Directoire sofa from Lucca with a contoured, shield-shaped back in ebonised wood outlined with gold. TOP RIGHT: Neoclassical red and gilt lacquered Lucchese chair (c. 1790). BELOW LEFT: a Lucchese work table (c. 1790) in cherry wood, originally lined with silk. BELOW RIGHT: Florentine cherry wood Empire-period guéridon with white marble top and gilt animal-head mounts and claw feet. THIS PAGE, TOP LEFT: a lacquered and inlaid X-frame chair made in Lucca (c. 1810). TOP RIGHT: pair of Lucchese giltwood chairs, with horn-shaped back uprights (c. 1800). CENTRE LEFT: X-frame chair with wing-shaped arms in imitation bronze. CENTRE RIGHT: lacquered and gilded *bergère* from central Italy (c. 1825). BOTTOM: walnut divan with ebony stringing and gilt lion's head mounts, made in central Italy (c. 1820). All antiques trade.

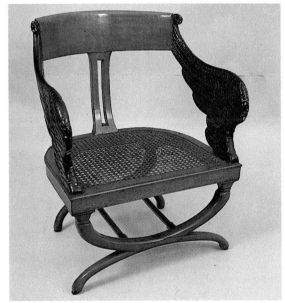

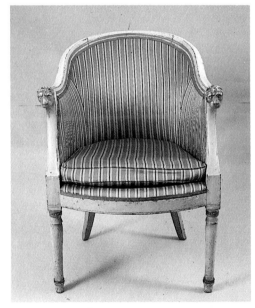

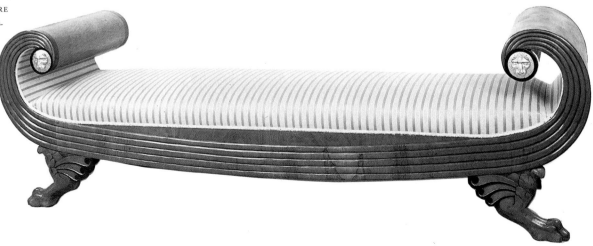

1809, provided fresh impetus for
the furniture industry.

Napoleon's appointees in
Italy compelled local artisans to
work according to the style of
cabinet-makers such as Jacob and
other famous Parisian *menuisiers*.
The architect Bienaimé, who su-
pervised the interior design of the
Pitti Palace for Elisa Baciocchi,
sent to Paris for several pieces of
furniture designed by Percier and
Fontaine, thus ensuring that local
craftsmen had the correct proto-
type to follow.

In 1805, the Grand Duchess
of Tuscany ordered the renova-
tion of Lucca's Palazzo della Sig-
noria, now the Palazzo della
Provincia, established a *Manufac-
ture Royale* and appointed the
ébéniste Jean-Baptiste-Gilles Youf
(1762–1838), who came from
Paris, to the post of director. The
great factory produced furniture
for the ducal palaces in Lucca and
Massa, and the Villa della Marlia
and Pitti Palace.

Youf's creations signalled the
advent of the Empire style in
Tuscany, also influencing local
craftsmen like Pietro Massagli
and Luigi Manetti. Tuscan arti-
sans typically used cherry wood,
with very understated decora-
tions in bronze or carved gilt-
wood.

Youf's workshops were proba-
bly the training ground for Gio-
vanni Socchi, cabinet-maker to
the grand ducal court from
around 1807 until 1839, who
made an enormous contribution
to the Empire style in Tuscany.

He was commissioned to
build much of the furniture for
the Pitti Palace. He also made a
number of tables and commodes
very similar to Parisian models,
and a series of drum-shaped cre-
denzas, supported by pine-cone

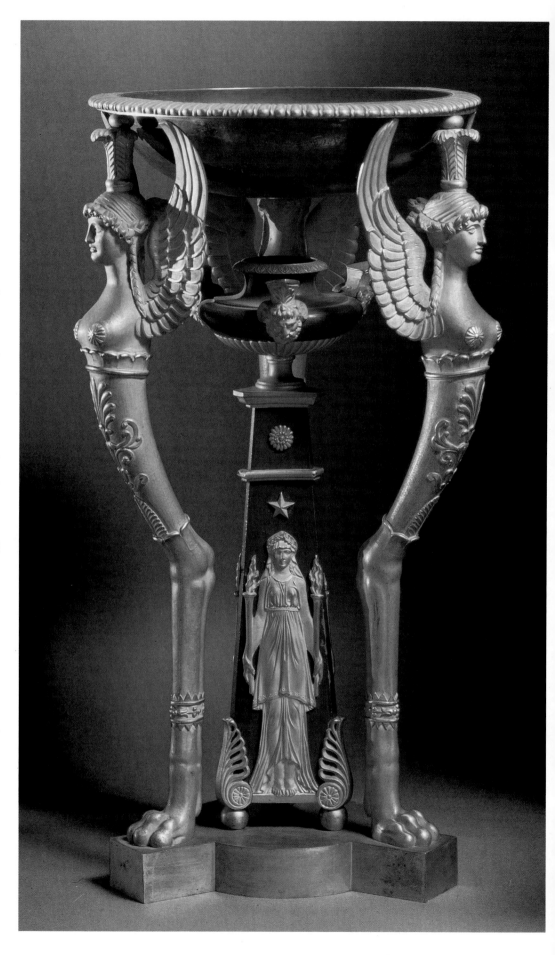

FACING PAGE: bronze perfume burner, a perfect example of the Empire style. The bowl is supported by two winged caryatids with lion's claw feet. Palazzo Pitti, Florence. THIS PAGE, BELOW: two *guéridons*. The one on the left is Florentine (c. 1805), with carved swans, gilded and varnished to imitate antique bronze. The one on the right, in mahogany supported by caryatids lacquered in imitation bronze and gold, is of Tuscan origin. Private collection. BOTTOM: console table, possibly made by Giovanni Socchi for Elisa Baciocchi, in solid mahogany with mounts, caryatids and gallery in chased bronze (c. 1810). Palazzo Pitti, Florence.

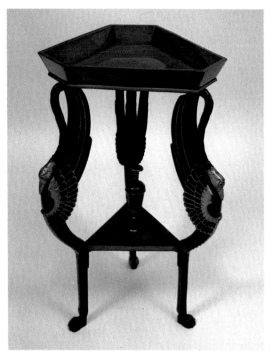

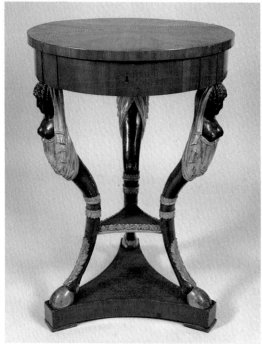

legs for the appropriately named *Sala dei Tamburi* (Drum Room).

However, Socchi is most famous of all for a series of ingenious and sophisticated writing desks. Two of these, signed by the maker, are in the Pitti Palace, another is at Malmaison and a fourth is recorded as being sold at auction in London. At first sight, the desks resemble oval commodes. One side of the desk conceals a small pull-out armchair. Under the edge of the top are two handles which, when pulled, shift the two halves sideways, exposing and raising a central panel which serves as a writing surface and a small elevated rack equipped with drawers.

Although they are rather cumbersome, it appears that Socchi intended these desks to be portable. He produced several examples, revealing a degree of ingenuity to match that of the cabinet-makers of the Ancien Régime such as Oeben and Roentgen, who devised furniture which could be converted for various uses with the aid of complex mechanical devices. Two of the desks, that in the Pitti Palace dated 1807 and the one housed at Malmaison, are known to have been made for Maria Luisa, "Queen of Etruria".

In accordance with contemporary taste, Socchi gave his furniture an architectural image with severe, simple outlines. Equally unpretentious is the ormolu ornamentation made by the *bronzeurs* Marchesini and Martini. A characteristic of Socchi's design was his tendency to simplify the Empire style. He also had a predilection for hard woods such as cherry or ebony. Other contemporary Tuscan cabinet-makers like Messagli, Manetti, Ricci,

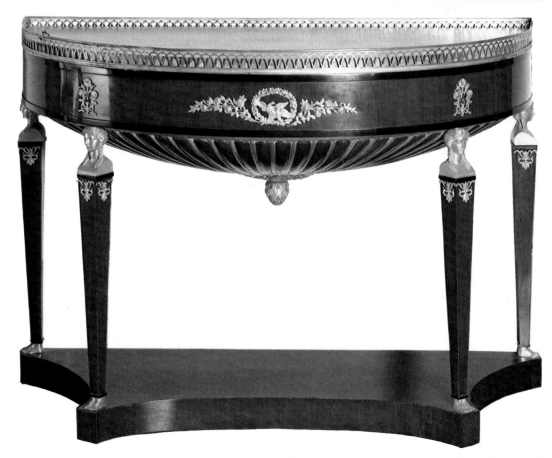

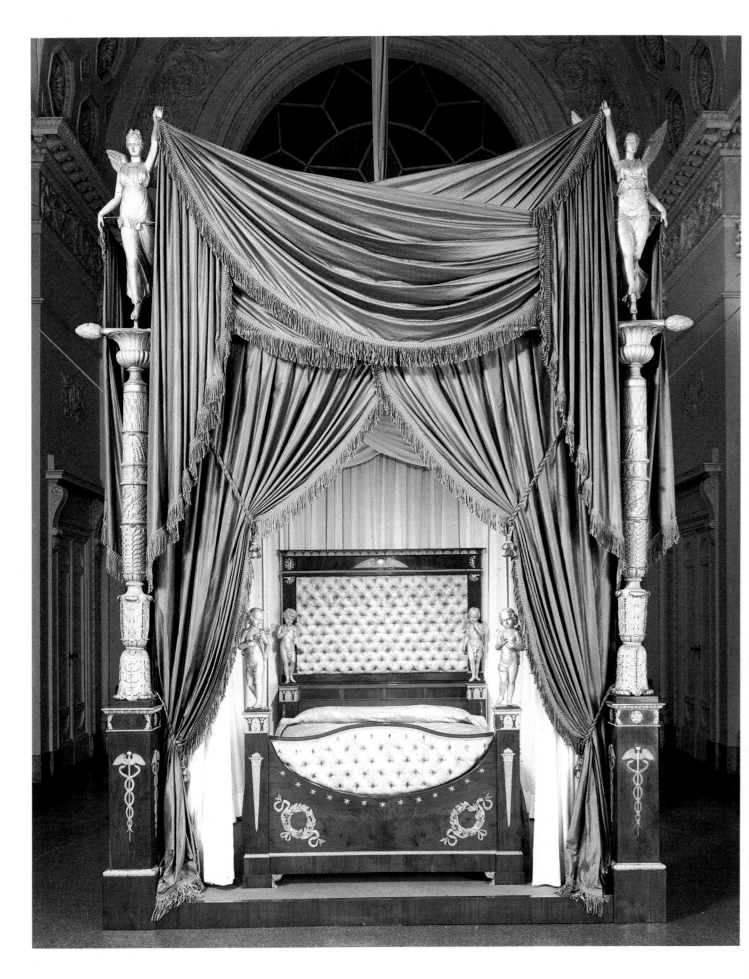

FACING PAGE: Florentine state *lit en bâteau* in solid mahogany, with mounts and statuettes in chased bronze (c. 1820). THIS PAGE, RIGHT: commode built around 1829 for Maria Louisa of Bourbon, the "Queen of Etruria", veneered in various woods and decorated with ormolu mounts, signed "Jacopo Ciacchi fabbricatore di mobili lungo l'Arno presso Ponte Vecchio" (Jacopo Ciacchi, furniture-maker of Arno embankment, near the Ponte Vecchio). Both Palazzo Pitti, Florence.

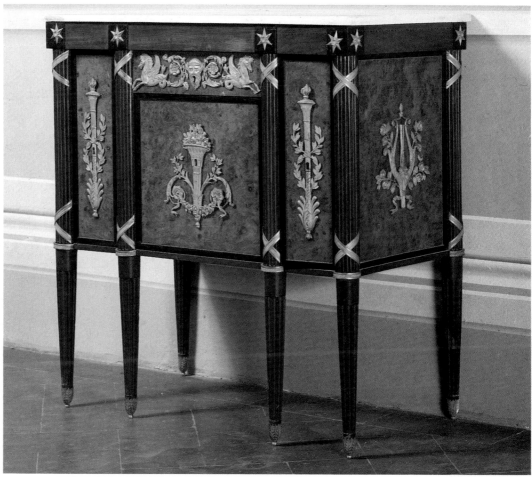

BELOW: early 19th-century Lucchese *lit en bâteau* with carved, imitation bronze giltwood mounts which, following the example of French furniture, are typical of grander pieces. Antiques trade.

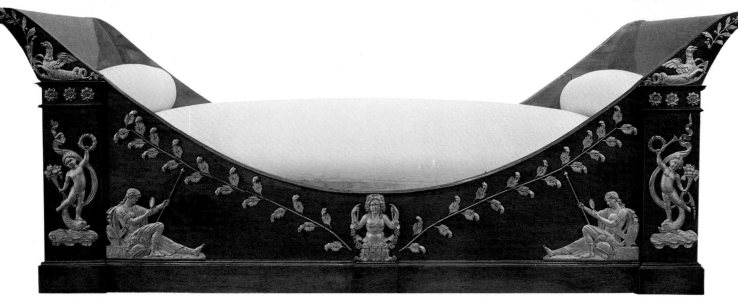

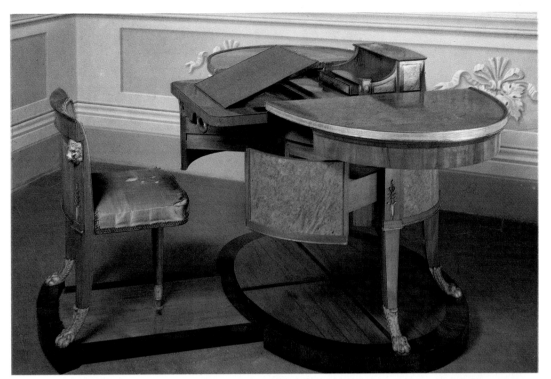

Umbria

The Neoclassical taste spread throughout the Papal States thanks to the work of the architect Giuseppe Valadier (1762–1839). With the advent of Neoclassicism in the 1830s, the traditional, tempera-painted, rustic and somewhat provincial furniture of Umbria took on simpler lines, albeit with painstakingly executed ornamentation. The main item of furniture in Umbrian households at

Ciacchi, Conti, Liverani and Sebastiani followed the same trend.

The art of inlay, which in the past had experienced periods of considerable splendour, was revived by Spighi, an artisan active in Florence around 1780. He perfected the technique of linear "stringing", which he passed on to his pupils, who included the Florentine Pietro Minuti and the Cremonese Paolo Moschini. A major part of Spighi's fruitful output included small table tops made up of geometric designs in boxwood. His inlays were usually monochrome, but there are examples in coloured wood, mainly shades of green, although the poor dyeing process has resulted in virtually all the colour fading.

Sometimes, Spighi tried to get away from the rigid geometrical repertoire by making inlays of animal figures or vases of flowers, but the results were never satisfactory. Faced with the advances made by his fellow artisans using new techniques, he almost completely abandoned his craft. The few works from the final period show how he remained true to his own technique, even though he himself realized it was then outdated.

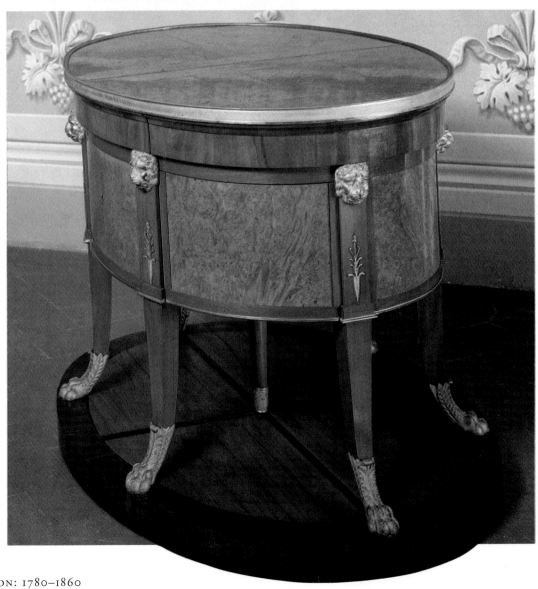

FACING PAGE, TOP AND BOTTOM: portable writing table made for Napoleon I by Giovanni Socchi in mahogany with ormolu mounts, shown in both open and closed position. The oval carcass, supported by sabre legs with claw feet, is intricately structured in order to provide pull-out surfaces and drawers. Palazzo Pitti, Florence. THIS PAGE: Tuscan centre table-cum-desk dating from the first quarter of the 19th century, inspired by the historic example opposite. Veneered in burr walnut with a removable top, it has one drawer at the front and two on either side. Antiques trade.

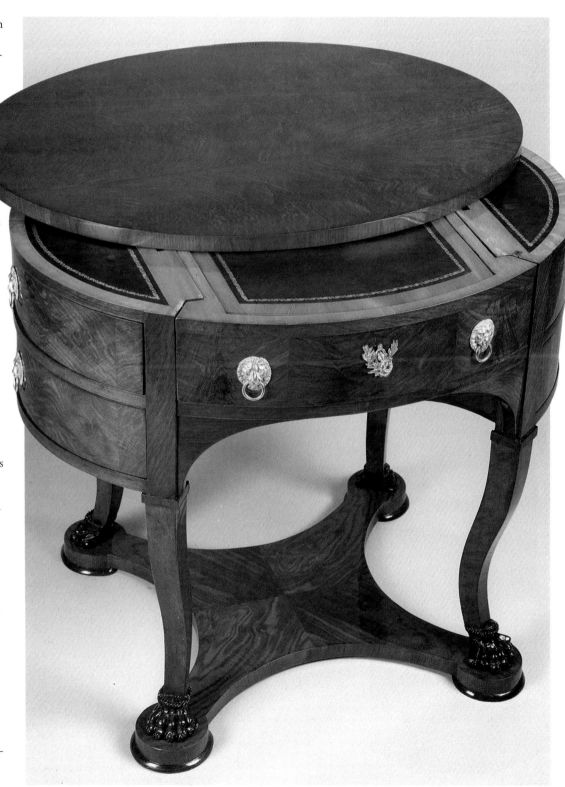

the time was the commode, which retained its functional character both structurally and formally, especially during the Empire. An atypical aspect of the Umbrian version compared with other areas was its use of gaudy colours.

During the Neoclassical period, Umbria produced some veritable masterpieces of the traditional local art of wood-carving. One example was a reliquary made in 1775, the best-known work of Fortunato Gettarelli of Perugia. In his eccentric but orderly way, Gettarelli blended styles such as "German", "Roman" "Greek" and "Gothic". The architectural proportions of his works and the multiplicity of the minute, boldly-applied and exquisitely carved mounts, cleverly creating a totally harmonious effect, make his work easily recognizable.

Around the beginning of the 19th century, Valadier, Appiani and Wicar were among the artists active in Umbria. The most memorable works of the period include pieces with inlays of walnut and olive wood veneer depicting rural landscapes or views of small Umbrian towns, and showing the influences of the Lombard Maggiolini and the Piedmontese Revellis.

Few examples of Empire furniture can be traced to this region. Furniture in a simple, essentially Umbrian style was mainly built by unidentified craftsmen, especially pieces for everyday use. More significant were items intended for public use, such as ecclesiastical furniture designed for sacristies. Overall, the careful choice of wood and elegant execution with

meticulous attention to detail largely compensated for the simple, solid forms. The supreme post-Restauration example of the Umbrian artistry in wood is the wooden choir in Spoleto Cathedral (1834), executed by Sante Arcioni, Giovanni Carpisassi and Emidio Speca.

The Marches

The walnut and cherry wood furniture of the Marches was yet an-

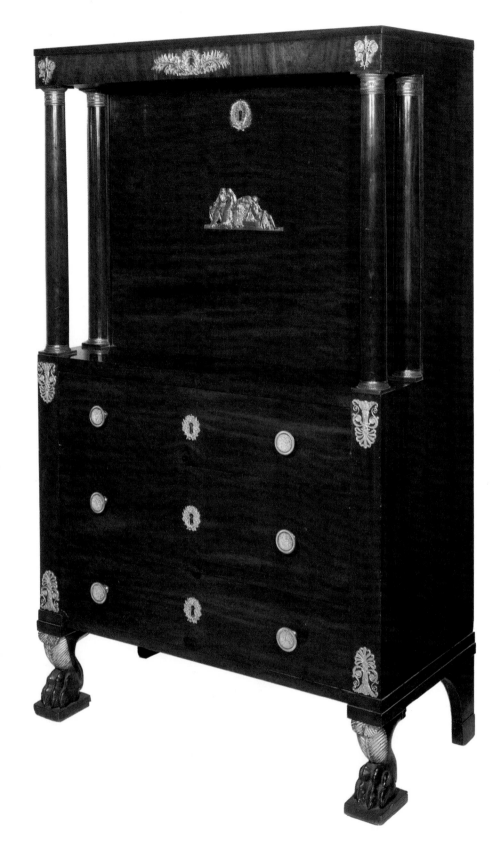

LEFT: Column-shaped Tuscan pot table from the first quarter of the 19th century, in mahogany with cherry wood stringing, amaranth mounts and white Carrara marble top. ABOVE: Tuscan mahogany secretaire from the early Empire period. The recessed upper section is flanked by twin columns, and the mounts are ormolu. Both antiques trade.

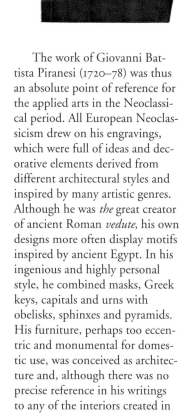

other provincial version of the late Empire style, and shared many features with items manufactured in Lucca. The Empire style made its mark on the region with the interior design of the Villa Bonaparte at Porto San Giorgio, carried out in 1826 by the Sanseverino architect Ireneo Aleandri for Jérôme Bonaparte. The appealing Marches interpretation of Empire style, of which there were numerous examples in 19th-century middle-class houses, incorporated traditional local characteristics. The finials and feet of the uprights were often in gilded terracotta, a typical regional element, also used to decorate the fronts of commodes and secretaires.

Rome

In an introduction to his study of Roman furniture, Alvaro González-Palacios asserts: "[…] For anyone wishing to explore Roman furniture, the most interesting period covers 150 years, from 1620, when Gian Lorenzo Bernini began work, until 1769, when Giovanni Battista Piranesi published his famous *Diverse maniere di adornare i cammini ed ogni altra parte degli edifizi desunta dall'architettura egizia, etrusca e greca* (Various Ways to Decorate Fireplaces and All Other Parts of Buildings based on Egyptian, Etruscan and Greek Architecture). Before and after these dates, other work of this nature produced in Rome was always of excellent quality and not without a certain elegance, but unexceptional in terms of creative originality" (*Il Mobile nei secoli* [Furniture through the Ages], Milan, 1969).

The work of Giovanni Battista Piranesi (1720–78) was thus an absolute point of reference for the applied arts in the Neoclassical period. All European Neoclassicism drew on his engravings, which were full of ideas and decorative elements derived from different architectural styles and inspired by many artistic genres. Although he was *the* great creator of ancient Roman *vedute*, his own designs more often display motifs inspired by ancient Egypt. In his ingenious and highly personal style, he combined masks, Greek keys, capitals and urns with obelisks, sphinxes and pyramids. His furniture, perhaps too eccentric and monumental for domestic use, was conceived as architecture and, although there was no precise reference in his writings to any of the interiors created in

Rome in that period, much Roman furniture was inspired by his designs.

We know of only one piece built to Piranesi's design, a console table from the private apartments of Cardinal Rezzonici. Five curved legs in the form of winged lions' legs support the top, whose frieze is adorned with palmettes and bucranes (horned ox skulls).

Also dating from the late 18th-century were the marble and bronze tables with Atlas supports, designed by Valadier for the Vatican Library, and Antonio Asprucci's imitation marble furniture.

After the short-lived Roman Republic (1798–99), Rome became a little more than a provincial city, despite the fact that Napoleon regarded it as the sec-

ond capital of his expansive empire. There were no great champions of the Empire style in Rome, and what Empire designs were produced were on a modest scale. The decorations of the Quirinale undertaken at that period, on which Ingres also worked, were never finished.

The situation did not improve with the Restauration. Rome became increasingly provincial and excluded from the national cultural debate. Stylistically, there is little to suggest that Lorenzo Righetti's furniture, now at the Museo di Roma, dates from 1815 (as accurately dated) rather than 1770. It was, in fact, inspired by Piranesi and the monumental tables designed by Valadier for the Vatican Museum and executed in bronze and marble by the sculptor Vincenzo

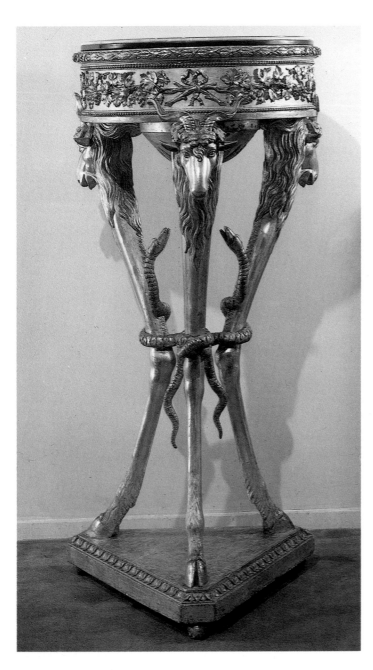

Neoclassico (Neoclassical Taste), published in 1939, Mario Praz clearly illustrated how jealously the sovereigns guarded the excavations of Herculaneum and Pompeii. Permission to visit the antiquities and the royal museums was strictly limited. At first, *Antiquità Ercolanese*, a series of books published over a forty-year period (1752–92), with illustrations of the objects excavated and the delightful motifs of the wall paintings, could only be consulted by the favoured few.

Collections such as this represented one of the main sources of inspiration for the decorative arts of the period, and were later reproduced and copied throughout Europe. The paintings at Herculaneum also contained details of Graeco-Roman furniture, which inspired early 19th-century furniture-makers and designers, the most famous of whom were Percier and Fontaine. Contemporary Neapolitan artisans did not confine themselves to copying the antique repertoire. They preferred a free interpretation, but added their own very personal style to their beautifully executed works.

The leading exponents of Neapolitan Neoclassicism were court architects Luigi (1700–73) and Carlo Vanvitelli (1739–1821), the latter also producing some notable furniture designs.

Although the Vanvitellis oversaw the decoration of the old apartments at the royal palace at Caserta, their Neoclassical ideas were overwhelmed by the Rococo taste of the young wife of Ferdinando I, the Austrian princess Maria Caroline. She was eager to follow the European vogue for the pretty and frivolous, especially in her private apartments.

The architects were forced to comply with Maria Caroline's own taste in furniture and hangings. The young queen chose the damask for the panels that alternated with wall-mounted mirrors, and the fabric for the chairs and stools in her study. The furniture also included a console table supported by five ivory legs and decorated with gilded scrolls and female heads, a small work table and two commodes in the French taste, with bronze ornamentation and geometric inlays. The Venetian mirrors were surrounded by garlands of brass flowers. The walls of the *boudoir* were completely covered with pilaster strips, where ribbons were interlaced with bunches of flowers and doves nestling among the blooms. The furniture, made by local craftsmen, combined Rococo characteristics with the new fashion for gilt and ivory lacquering, featured on the corner shelves and console. The interiors are a superb example of the moment of transition from the Rococo to the Louis XVI, or as the Neapolitans called it, the "Ferdinandeo" style.

Meanwhile, the Neoclassical style predominated in Ferdinando's study, where the furniture was designed by German artists. In *Il mobile napoletano del Settecento* (18th-century Neapolitan Furniture), 1977, Antonella Putaturo Muraro suggests the possible involvement of the celebrated cabinet-maker Adam Weisweiler. Certain stylistic touches were typical of Weisweiler. They included tapered legs connected by curvilinear stretchers, and above all black and gold lacquered panelling with Japanese landscapes, which adorn the commode, writing desk and

Pacetti. The same lack of originality is reflected in contemporary pattern books. Uggeri's *I Trapezofori antichi di greca scoltura* (Ancient Greek Trapeziform Sculpture) of 1831 just is a revamped version of Piranesi, reintroducing heavy Classical

prototypes interpreted in the traditional Roman Baroque taste.

Naples

In Naples, Neoclassicism came to the fore around 1770. In *Gusto*

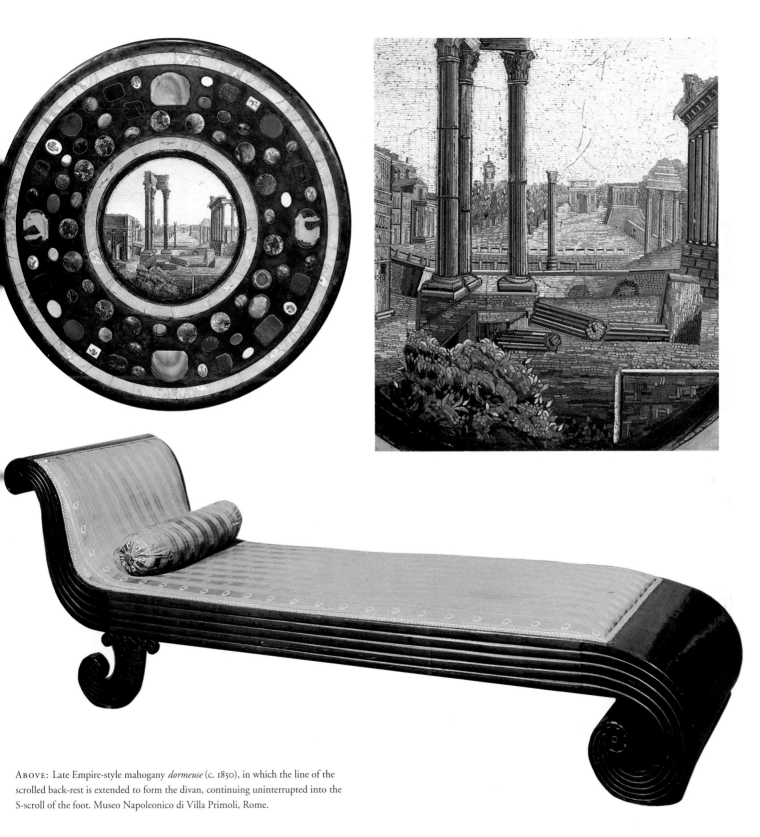

FACING PAGE: carved and gilded Roman *guéridon* (c. 1800), whose inventive design suggests that the maker may have been inspired by Piranesi. THIS PAGE, BELOW AND RIGHT: marble top of a *guéridon* made in Rome. The central mosaic depicts a classic veduta of the Forum Romanum, while the outer border in black marble with antique yellow inlays contains fragments of semi-precious stones, some of which are carved. Both antiques trade.

ABOVE: Late Empire-style mahogany *dormeuse* (c. 1850), in which the line of the scrolled back-rest is extended to form the divan, continuing uninterrupted into the S-scroll of the foot. Museo Napoleonico di Villa Primoli, Rome.

Neapolitan Neoclassical furniture

The project to design and furnish the royal apartments at the Villa Favorita at Resina, near Naples, marked an important chapter in the history of 18th and 19th-century Neapolitan furniture. The suites of furniture in the Neoclassical style provide incomparable examples of products turned out by Neapolitan workshops of the period. To harmonize with the pastel stucco of the walls and the classically-inspired decorative motifs, craftsmen built finely-carved and stuccoed console and centre tables, sofas and chairs painted in ivory white, with gilt-framed painted panels showing priestesses of Bac-

chus and other classical subjects taken from the excavations at Pompeii. Among those who designed and made furniture between 1796 and 1799, particularly the items intended for the Gallery and the Bacchus Room, were the carvers Nicola and Pietro Fiore, the decorator and gilder Antonio Pittarelli and probably the painter Carlo Brunelli, who is mentioned in contemporary documents in connection with the work carried out at the villa. In 1806, the furniture made for the villa at Resina went with the Bourbons when they were exiled to Palermo.

THIS PAGE, RIGHT: lacquered and carved sofa and chair from a famous suite made for the Gallery at Villa Favorita, the royal residence at Resina. The backs feature oval paintings of priestesses of Bacchus on a blue ground, attributed to the painter Carlo Brunelli. FACING PAGE, ABOVE: detail of chair-back. Museo e Galleria Nazionale di Capodimonte, Naples. THIS PAGE, BELOW: detail of the back of a carved, lacquered chair, with a group of monochrome putti on a gold background, part of a set created for the Triumph of Bacchus Room in the Royal Palace at Caserta. FACING PAGE, BELOW: detail of a late 18th-century chair, created as a set designed as a "finishing touch" to the Palace at Caserta. Caserta, Palazzo Reale.

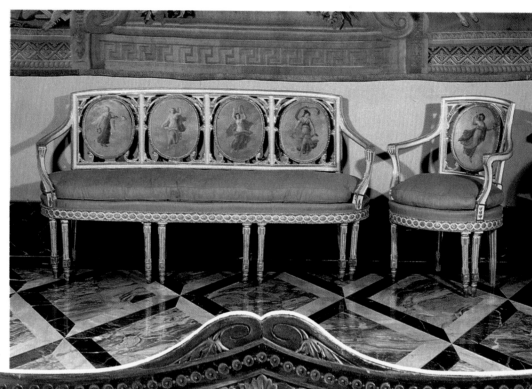

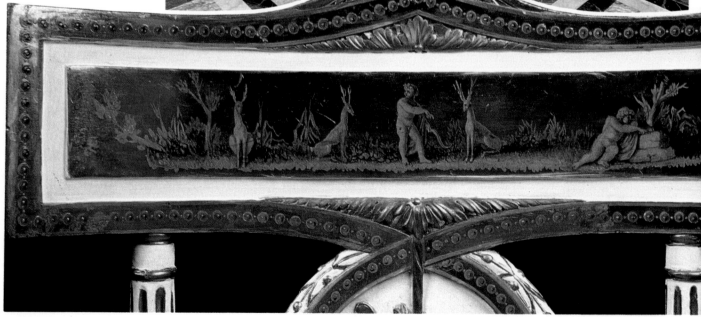

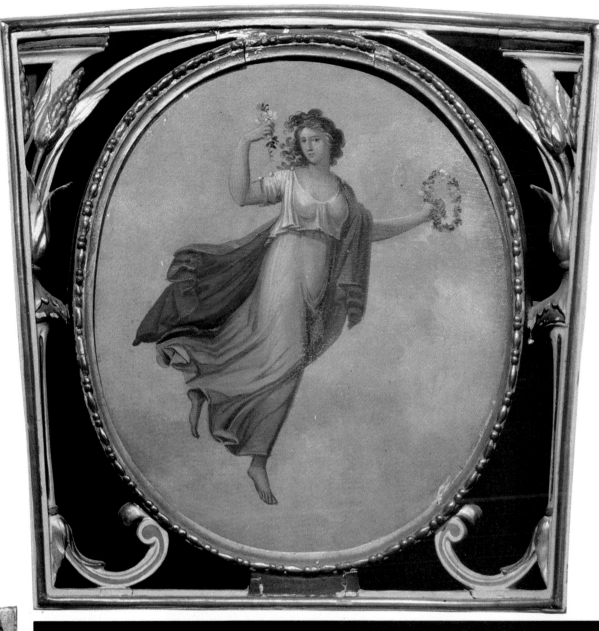

two secretaires. In the rooms of the Caserta Library completed in 1784, Carlo Vanvitelli seems to have been allowed greater freedom to express his own taste, creating a unified design and a more austere Neoclassical form of decoration. On the simple shelves covering the walls, decoration was limited to subtle stringing and shell motifs on the pilaster strips, and Classical scrolls on the inlaid cornice above the shelves in the first room of the library. A pyramid-shaped, revolving bookcase in mahogany and palisander completed the furnishings. A team of cabinet-makers (Fretter, Lener, Meyer, Chebel, Altel and Poel), led by an artist of German origin, Anton Ross, worked to Carlo

Vanvitelli's specifications to create the furniture now housed in the "Four Seasons" Room at Caserta. Here, straight lines predominate, whereas the spindle legs of the chairs and armchairs are embellished with stylised naturalistic motifs. The long friezes of the side tables comprise "seed pods, fluting, braiding, bunches of grapes, palmettes, rosettes, studs and pendants, which create a frame around the principal decorative motif, frequently in actual bas-relief". This decorative scheme, described by G. Morazzoni in *Il mobile neoclassico italiano* (Neoclassical Italian Furniture) in 1955, was still limited to the craftsmen working for the court. By contrast, Neapolitan

furniture-makers of the period preferred to stick to the naturalistic forms of the preceding Rococo style. Late 18th-century Neapolitan furniture made widespread use of white lacquer, while retaining the polychrome decoration so closely associated with the climate and character of the city, whose gaudy colours under the radiant Mediterranean light so enchanted Goethe. The magnificence of the furniture was also accentuated by the type of gilding, for which craftsmen resorted to the more economical process of *doratura a mecca* which, instead of gold, used silver leaf, which showed through very thin layers of green, blue, red or pink varnish.

Geometric designs were still

preferred for inlays. "Unlike other Italian inlay specialists," says Morazzoni, "the Neapolitans preferred geometric compositions of small lozenges, scales and herringbone, covering vast surfaces suitably framed by fillets or stringing." Local artisans made extensive use of exotic woods such as rosewood, purple wood or Indian walnut, skilfully combining the various styles of natural grain.

One of the most felicitous examples of the furniture-maker's art of the period is at the Villa Reale Favorita at Resina, for which Nicola and Pietro Fiore created some sophisticated "finishing touches for the drawing room". Among them is a group of armchairs and a sofa, now housed in the Museo di Capodimonte, the backs consisting of painted ovals interspersed with "winged" Bacchantes dancing, inspired by the excavations of Herculaneum. Chairs belonging to

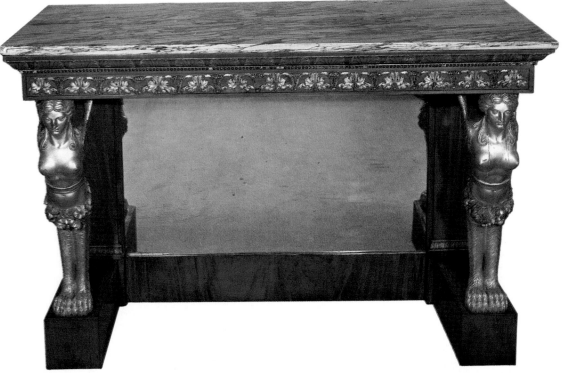

ABOVE: lavish Neapolitan console table in cherry wood, with marble top supported by gilt-wood caryatids. The frieze (c. 1810) is elegantly decorated with gilt plant motifs. Antiques trade.

BELOW AND RIGHT: *En suite commode à vantaux* and secretaire in "plum pudding" mahogany with ormolu mounts. The influence of classical taste is particularly noticeable in the detail of the secretaire (below). The Bonaparte and Murat courts imported the Parisian style to Naples, and furniture produced between 1808 and 1815 displayed obvious French Empire characteristics. Palazzo Reale, Naples.

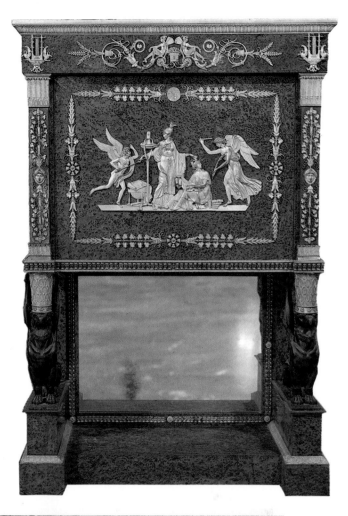

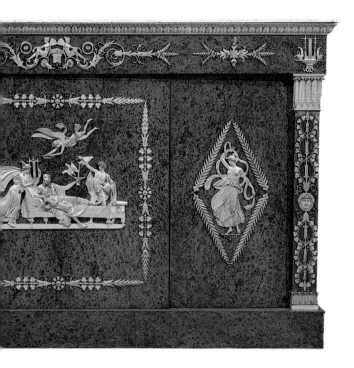

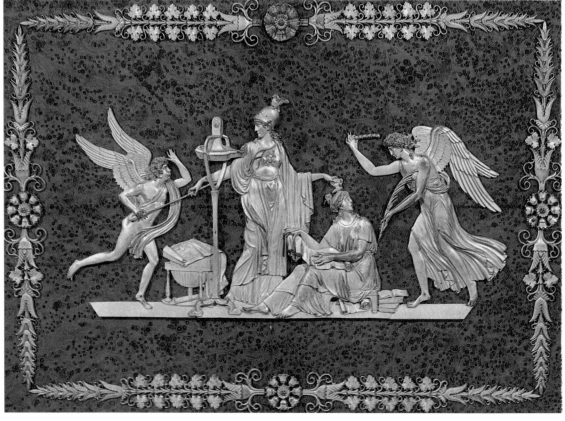

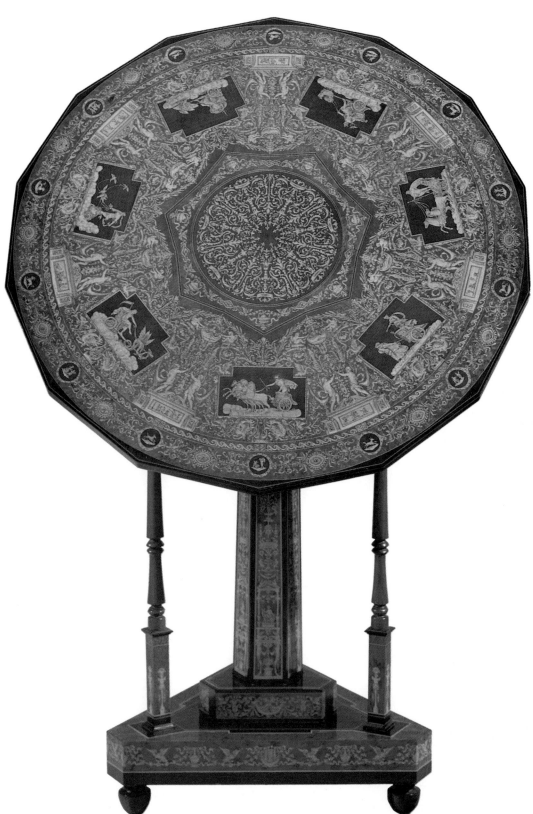

yet another group have elaborately carved backs and are painted with garlands, putti and cameos. From the same villa are a tripod with sphinxes, garlands and goats' heads and an oval table with a top in glazed wood, designed by Giovanni Mugnai.

Il mobile Italiano (Italian Furniture) by M. Gregori, R. Ruotolo and L. Bandera Gregori, 1981, confirms that, during the final decades of the 18th century, there were many examples of Neapolitan furniture with inserts of painted glass or imitation precious stones, alongside gilded carving.

Under the Napoleonic régime (the French having occupied Naples in 1806), the interiors of the Palazzo Reale in Naples, the Reggia at Caserta, and the Villa di Portici were renovated. The purely Empire style furniture in the various rooms was rich in allusions to military symbolism. Since much of the work was done by court artisans who followed Napoleon from France, the influ-

THIS PAGE, BELOW RIGHT: drop-front cabinet (c. 1810) decorated with inlays and lacquered and gilded carvings. The blend of Neoclassical elements typical of the Empire period and Baroque-style details exemplifies the 19th-century Sicilian taste for extravagant ornamentation. BOTTOM LEFT: Two of a set of four Sicilian *guéridons* (c. 1820) representing the four seasons, in mahogany with sculpted figures and decorative details in gilt-wood. All antiques trade.

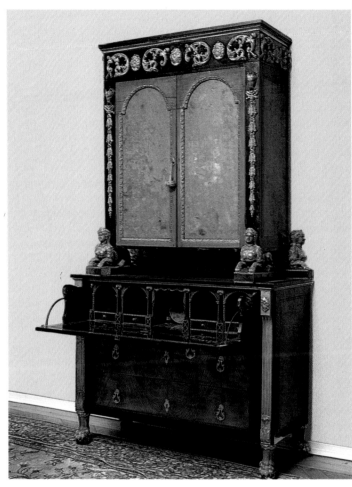

ence of the Parisian cabinet-maker Jacob was obvious. A typical example of his inspiration is a set of stools with crossed sabre legs based on a 1807 Jacob model, although the white and gold paint recalled the local furniture of the late 18th century. The console tables were decorated with the sphinxes, winged lions, monopodia in the shape of lions, palmettes and amphorae typical of the Empire period. There were also frequent allusions to the antiquities of Herculaneum in the bronze mounts found on the mahogany pieces.

Naples attracted Europe's most discriminating connois-

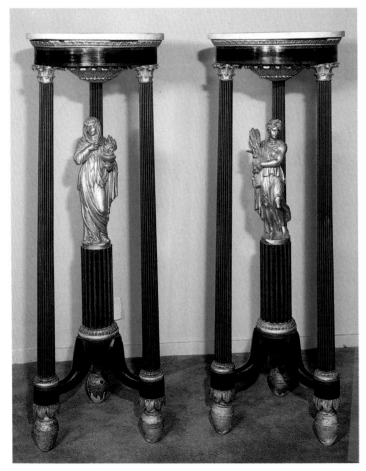

seurs, who came to admire the archaeological finds and enjoy the rich cultural life of the city. As a result, many houses were furnished with a view to creating an ambience of comfort and intimacy, modelled in the main on 18th-century English houses. The flourishing local furniture industry manufactured items with little in common with the exuberant style of other Italian furniture, instead producing furniture of modest proportions inspired by work from beyond the Alps.

Among influences was the English designer George Smith, whose presence lent Neapolitan furniture a touch of elegant simplicity and practicality which was to become a popular and enduring fashion in the city.

Empire furniture continued to be manufactured until 1830 and beyond until it was corrupted by the Biedermeier style imported from Austria by Isabella, wife of Francesco I. Under Francesco I and Ferdinando II, the Royal Palace at Capodimonte was furnished with pieces made by local craftsmen. Most of the furniture was in bird's-eye maple, with dark amaranth inlays in the French Restauration style.

Late 19th-century Eclecticism

A "European problem"

Writing in 1870, the German critic Jakob von Falke analysed and compared the advances in the decorative and industrial arts in countries across Europe. Furniture styles and construction methods, he observed, were more or less the same everywhere, and products aimed at the less well-off were mostly manufactured industrially, with little in the way of innovation. On the other hand, furniture designed for a more prosperous clientèle followed French fashions, with certain modifications which related to the individual tastes of the architect, decorator or client. According to Falke, French cabinet-makers typically favoured heavy ornamentation, treating wood as though it were metal. They categorised specific styles of furniture for use in specific rooms. In reception rooms, pride of place went to "a slightly modified" Louis XVI style, "interwoven with the primary motifs of primordial French antiquities"; the Renaissance, which Falke appeared to prefer, flourished in libraries, smoking rooms, dining rooms and other "masculine" environments (perhaps combined with Henri IV and Louis XIII). Gothic was the choice for small houses and villas occupied by enthusiastic collectors of antiques, and for English country houses and churches. England was somewhat different in that furniture-makers submitted to international exhibitions items "which do not lay claim to any specific style, but which strive to achieve proportionally constructed, generally good and noble forms, with appropriate and relatively less rich ornamentation both in terms of relief and inlay". The major exception within the panorama described by Falke was Italy.

The situation in Italy

This was the only country, he wrote, "to adopt a distinctive and individual attitude to artistic endeavour, [and] to adhere strictly to its own traditions in two main ways." The first of these was represented by the reproduction of pieces from the Renaissance and the age of Raphael, a style which was skilfully repeated in Turin, Florence, Siena and Rome. The second, predominantly in Venice and the surrounding area, went back to the Baroque tradition of Andrea Brustolon. Venetian carvers produced a large number of copies of such works, which Falke described as "bold, fresh and highly convincing", passing them off as genuine antiques to any buyer who cared to purchase them. Falke also applauded the dexterity of Italian inlay artists, although he considered that lacquered furniture did not retain the purity and beauty of bygone days. The modern works were, he said, "in the main, too gaily and gaudily coloured". Finally, the author turned his attention to the Florentine *pietre dure* (decorations using precious stones) and Roman *pâte de verre* (fired ground glass), especially the larger examples, which he defined as "superior works, executed with artistry".

Falke painted a picture of an Italy still deeply attached to its craft and regional traditions. His commentary also provided confirmation of the major national revival emerging at the time. Artists, industrialists, politicians and intellectuals aspired, albeit in an uncertain, somewhat contradictory and uncoordinated way, to give new impetus to furniture production. With Italy finally unified, the aim was to promote moves from manual to industrial methods of construction, and at the same time to create a markedly national style capable of competing within European markets. Even so, it was to Europe that Italy looked for inspiration. Books and magazines reported on visits to exhibitions, schools, museums and various other institutions linked to the skills of arts and craft.

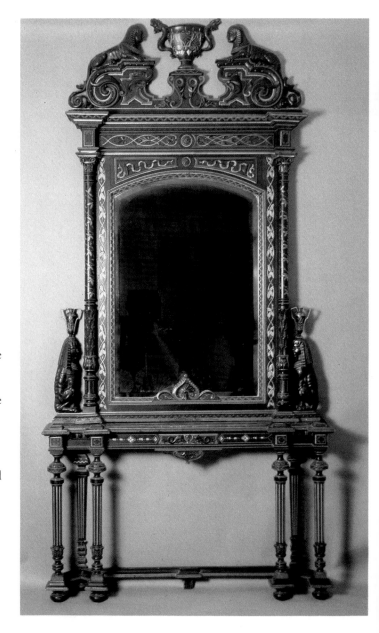

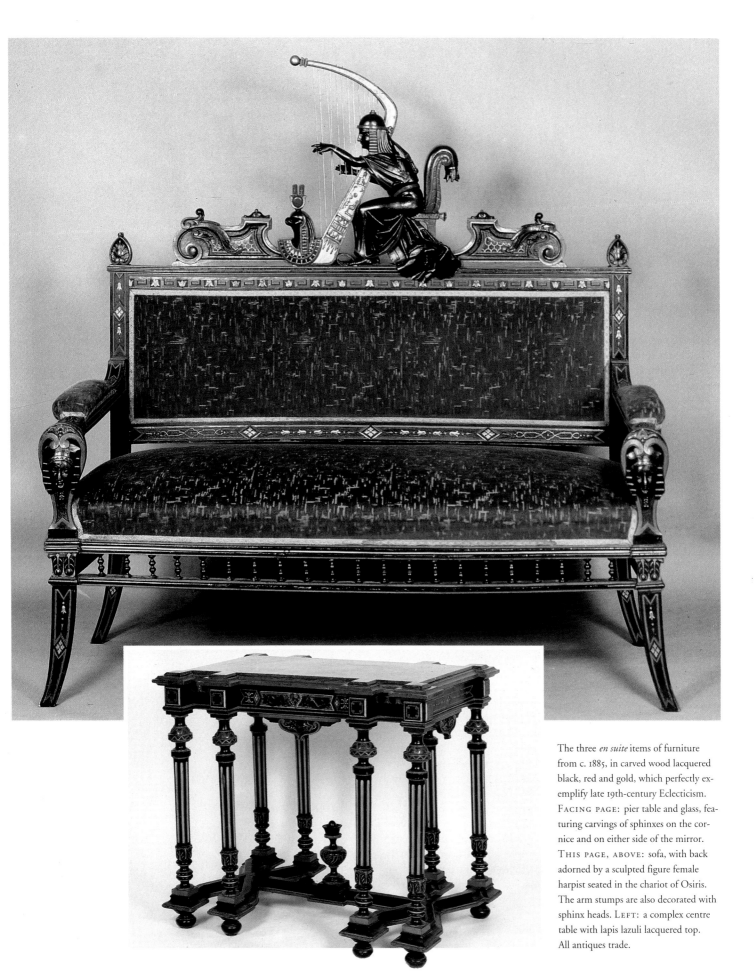

The three *en suite* items of furniture from c. 1885, in carved wood lacquered black, red and gold, which perfectly exemplify late 19th-century Eclecticism. FACING PAGE: pier table and glass, featuring carvings of sphinxes on the cornice and on either side of the mirror. THIS PAGE, ABOVE: sofa, with back adorned by a sculpted figure female harpist seated in the chariot of Osiris. The arm stumps are also decorated with sphinx heads. LEFT: a complex centre table with lapis lazuli lacquered top. All antiques trade.

An artisan's guide

In fact it was in one such publication entitled the *Guida per le Arti e Mestieri, destinata a facilitare il loro progresso in ogni ramo speciale* (Arts and Crafts Guide, Designed to Promote their Advancement in Every Specialized Field), that Falke's article came out, along with contributions from foreign authors and examples of decoration and studies of various styles. The magazine set out to educate artists, skilled artisans and workmen by providing them with a precise and comprehensive vocabulary for each historical and artistic period. It included lists of Gothic, Renaissance, Pompeiian and Baroque decorations, studies of motifs inspired by the world of nature, examinations of the various uses of acanthus leaves, lion's heads, table-legs and shelves, and even essays on the influence of Chinese and Japanese art on modern industry. On this last subject, one contributor asserted that "from the decorative point of view, even in the most modern and most common Asiatic products, the colours never clash, nor are they ever too strong or too harsh, as has unfortunately been the case in recent times and even nowadays with those produced by the modern craft industry". The publication also presented the best examples of contemporary furniture produced in France, England, Germany, Austria and Sweden.

The overall result was similar to that created by the catalogues of the International Exhibitions held throughout the second half of the 19th century. In these exhibitions, there were endless displays of extraordinary furniture of the most disparate styles, and objects overloaded with decorations appealing to very eclectic and specialised tastes. In the name of "comfort", the English term universally used to define the fundamental quality of the 19th-century home, countless arguable offences were committed against good taste and common sense. A suitable piece of functional furniture was devised for each and every daily activity: book-rests, folding stools, reclining chairs, head-rests, foot-rests, gaming tables, work tables, writing tables, *jardinières,* lamp-stands, sofas, cushions and revolving bookcases. There were pieces of furniture with no other purpose than to store pipes and tobacco, and monumental hall-stands designed to accommodate walking-sticks, hats and overcoats. This obsession with supposed but socially accepted comfort survived until the end of the century. Commenting in an 1898 article describing the furniture sections of the Turin Exhibition, a female writer enthused over: "charming movable bookcases with racks and compartments, turning on a pivot like a wool-winder. Bookcases which can be adjusted to your mood, or put beside the work table, on the balcony or the veranda, or in the evening beside the little tea table, without too much encumbrance, enabling one to have conveniently to hand one's favourite books, magazines and newspapers." Italian furniture-makers responded to the demands of the market and current fashion, developing new methods of construction and mechanising some of the manufacturing processes. In turn, standardised inlaid and carved decorations were added to the furniture produced by these new processes.

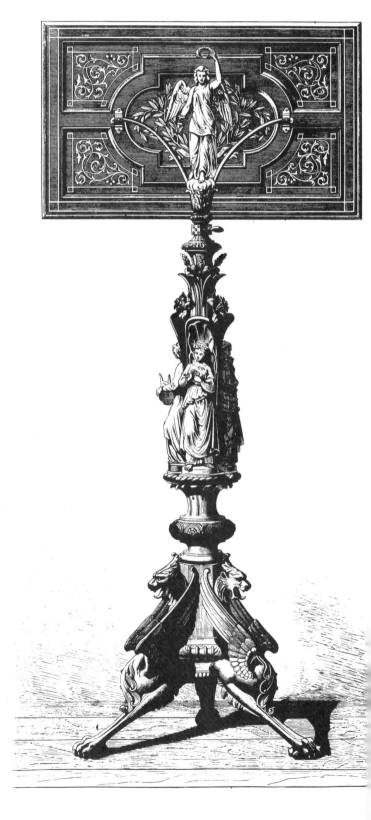

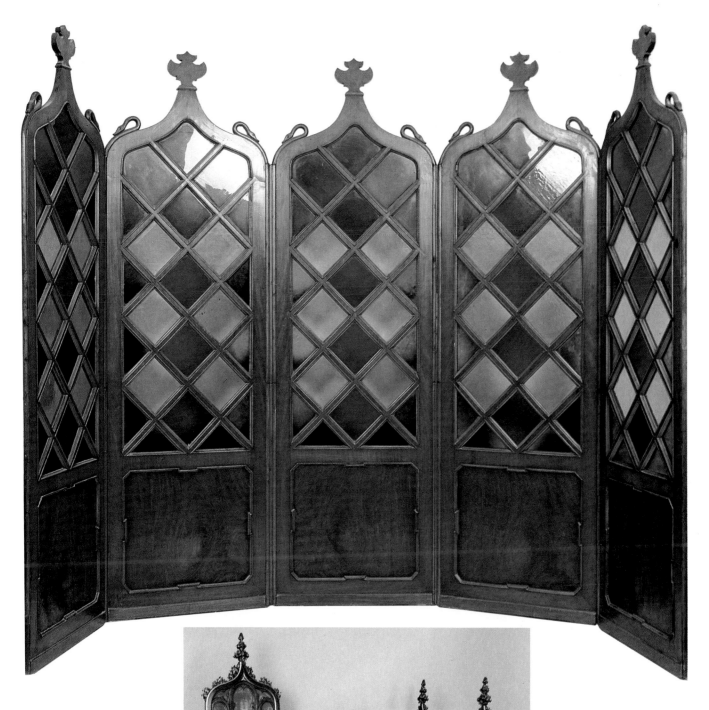

From manual to mechanized production

A report presented by Guggenheim, owner of a large Venetian company and an unusually innovative entrepreneur, to the province's Chamber of Commerce and Crafts provides an excellent illustration of the actual process of transforming furniture production from a manual to a mechanical operation in the second half of the century. "I began in 1858," Guggenheim wrote, "with four or five carvers to re-

place any small item sold in the square. Thereafter, little by little, I followed the route mapped out for me, always striving for the most progressive expansion, through exporting directly to manufacturers and merchants in the leading centres of Europe." By 1885, when the report was compiled, Guggenheim had four large workshops, each employing some thirty "artists and workmen".

More staff were taken on for special commissions. Two workshops were engaged exclusively to construct the "architectural" parts

THIS PAGE, LEFT: two chairs designed for the apartment of Gian Giacomo Poldi Pezzoli. TOP LEFT: mahogany chair with mother-of-pearl and ebony inlays, made for the Dante Room (c. 1860) to a design by Luigi Scrosati. BOTTOM LEFT: mahogany chair inlaid with ivory, ebony and bronze, designed by Giuseppe Bertini and built by Spelluzi for the dining-room. Museo Poldi Pezzoli, Milan. BELOW: Fall-front cabinet (c. 1860) by Ferdinando Pogliani. Private collection. FACING PAGE: design for a Neo-Renaissance desk, from *Guida per le Arti e Mestieri*, 1871. Biblioteca Ambrosiana, Milan.

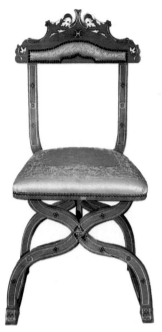

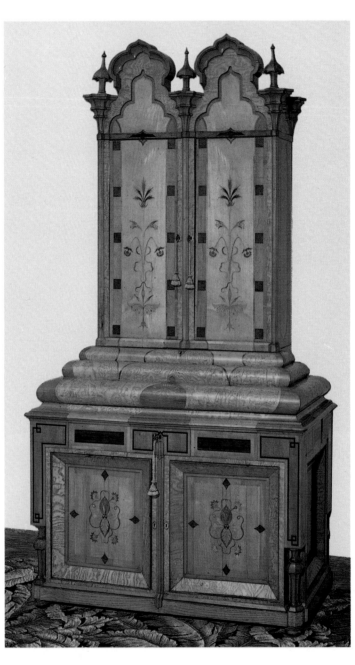

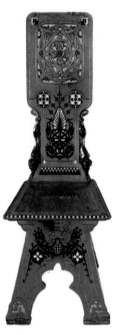

port also provides details of expenditure, showing materials accounted for 15% and labour costs 85%. The picture presented by Guggenheim is far removed from the situation described by Falke only fifteen years earlier. Here was a genuine industrial enterprise, where production was divided into separate tasks, a complete contrast to the craftsman's workshop, where the master instructed and guided his workers.

Guggenheim made a distinction between workmen and artists and, for the latter, he called for a new kind of vocational, technical education. Referring to the carved and painted figures supporting the hall-stands then in vogue, the industrialist observed that a well-executed ornamental statue of a blackamoor or page boy, or a charming picture frame adorned with putti, was no guarantee that the artist responsible, however competent, would be capable of designing the architecture, or in other words, the underlying structure, of a piece of furniture.

Expanding on the argument, he wrote: "it is not irrelevant to remember that, in the long term, our industry needs to supply furniture which, although a luxury, will become a necessity, while figures, frames and putti are pure whims and therefore subject to the strange vagaries of fashion, and to greater or lesser foreign influences […] These days […] people with money to spend have the most diverse tastes […] resulting in a florid confusion that ends up producing a hotchpotch which conveys either nothing at all, or too much."

Guggenheim's attitude was pragmatic. Aware of the lack of a predominant style, he demanded

of the furniture and to execute "fine carving". Between 90 and 120 piece-workers could be hired to handle components and "ordinary carving", to work from drawings and patterns supplied by the owner.

Referring to the technical side, Guggenheim said: "as the work involved carving and inlay, the tools used by these workers are few and invariable". Only a short time before, he had replaced the old saws with new German ones (supplied by Emmerich Nach of Leipzig) while

smaller tools had been supplanted by the most up-to-date versions from Vienna. Guggenheim exported to America, Austria, France, Germany and Great Britain, with only a small percentage of production destined for the domestic market. The re-

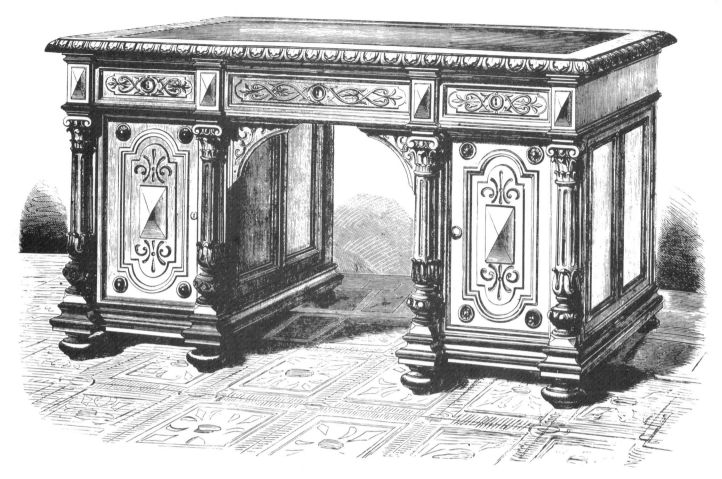

the training of "artists" capable of correctly exploiting the decorative vocabulary of past styles. He also suggested that they be taught to design architecturally rationalized furniture. This could be achieved neither in schools of architecture nor in academies of fine arts. In the first case because, he claimed, architecture itself, the very art which should inspire all other art forms, was trapped in the blind alley of Eclecticism. In the second instance, such instruction was not possible because the current realist tendencies in contemporary painting and sculpture did not meet the demands of applied arts.

The teaching of ornamentation was undervalued by the academies, while "in industrial and decorative art, ornamentation is the *sine qua non.*" To meet these new demands, the manufacturer called for the establishment of schools of applied art. He himself had helped set one up in Venice, but subsequently resigned because he disagreed with the methods adopted. Guggenheim's initiative was part of a widespread movement in which even the Italian government played an active role.

Schools of applied art

National delegations were sent to report back on the various International Exhibitions and examples of European applied arts, and to investigate the situation in manufacturing in Italy's factories and craft workshops. Although the results were not always satisfactory and delegates were not always competent, these delegations were seen as a sign of encouragement and support for various kinds of initiatives. One example is that of the assistance provided to the Neapolitan archaeologist and founder of Naples's arts and crafts museum and workshops, Gaetano Filangieri (1824–92), Prince of Satriano and Duke of Taormina. In a report to the Minister of Educa-

tion, dated 1881 (there also exists an earlier report dated 1879), Filangieri set out the agenda and aims of his museum and workshops. "Art and industry", he wrote, "encompass all human activity; each has its own way of working. Industry is utilitarian, while art strives for beauty. Hence where industry is informed by art, the useful can be beautiful. This is the problem which we are attempting to solve in these modern times, by means of our art and industry museums and their attendant educational workshops." The establishment of a museum of this kind was first suggested in 1871 at the 7th Italian Education Congress. The issue was raised again and put to the vote by Camillo Boito (1836–1914), a leading figure on the cultural scene during the second half of the 19th century, at the 3rd Artistic Congress held in Naples in 1877. As far as Boito was concerned, the plan was only part of a major programme which would involve all academies of

fine art. Delegates voted on the proposal that the academies should become colleges of art at which the teaching of painting and sculpture should be confined to "precise and intelligent imitation of reality". At the same time, with the aid of a first-class industrial museum, a study programme would be developed covering the application of art to decoration and industry. A further aim was to teach scientific disciplines to reinforce the professional training of future workers in industry.

The programme was put into practice in Naples, where the academy was split into two departments, the first devoted to fine arts, the second to crafts, which included wood-carving. A ministerial decree of 1880 established the Museum of Arts and Crafts "with the purpose of serving Section 2 of the Institute of Fine Arts, and the instruction of young and adult workers", as well as the adjacent training workshops for the manufacture

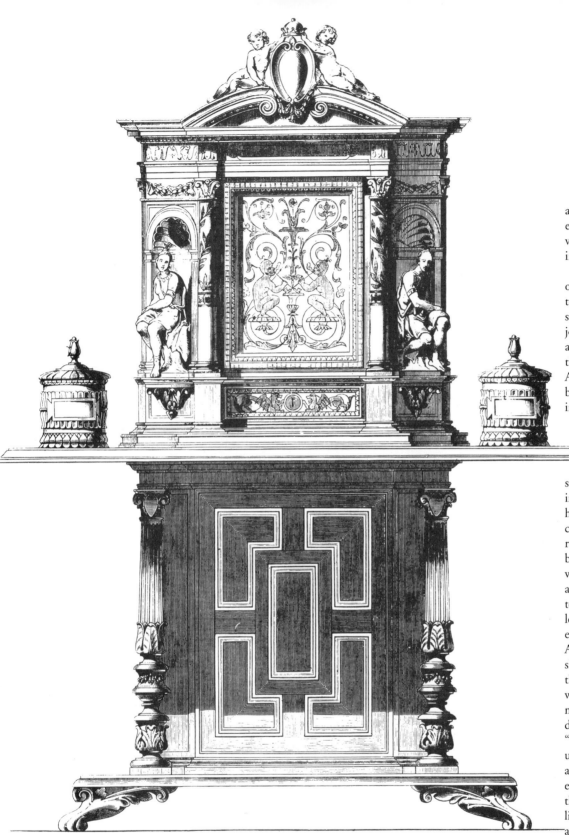

and carpenters, and quoted the examples of Franceschi, Ottaviano and Pagano, then working in Naples.

In outlining the organization of the workshops that would teach general woodworking skills such has how to cut wood to make joints and the arts of inlay, mosaic and carving, Filangieri confronted the formidable problem of style. After surveying the methods used by French schools and museums in Reims, Saint Quentin, Lyons, Lille, Limoges and Epinal, London's South Kensington (now the Victoria and Albert) Museum and the museum at Ghent in Belgium, he turned to Vienna, home of the newest and most comprehensive of the contemporary schools of applied arts. His basic conclusion after his research was that to instruct future workers and artists, it would be necessary to put together an exhaustive collection of examples of styles from every period and every nation. Any museum of industrial design should be a grand illustrated tour through history in which nothing was left out, from the most remote prehistoric era to the present day. "Thus," Filangieri declared, "with, at one extreme, the products of prehistoric antiquity, and at the other, the products of modern Europe, one may learn from the skills practised during the civilizations of Assyria, Egypt, Greece and Rome, and from examples of Christian art, from the fall of the Empire, through the Middle Ages until the Risorgimento. At the same time, one may observe those of Eastern civilizations such as India, Indo-China and Japan, and the crude but nonetheless singular artefacts of Africa and Oceania."

of ceramics, coral and tortoiseshell, plus the crafts of intarsia, carving and marquetry. In order to better organize the museum and training workshops, Filangieri studied manufacturing processes in conjunction with contemporary taste. He came to the conclusion that, following the demise of the Empire style, "with houses reduced in size and with tendency towards a bourgeois way of life, furniture is losing all predetermined shape, twisting and bending in a thousand directions, dictated by need and demand and by a certain imitation of the English, and the complete lack of style which nowadays increasingly pervades this branch of the art." He did, however, acknowledge the existence of skilled industrial designers, carvers, cabinet-makers

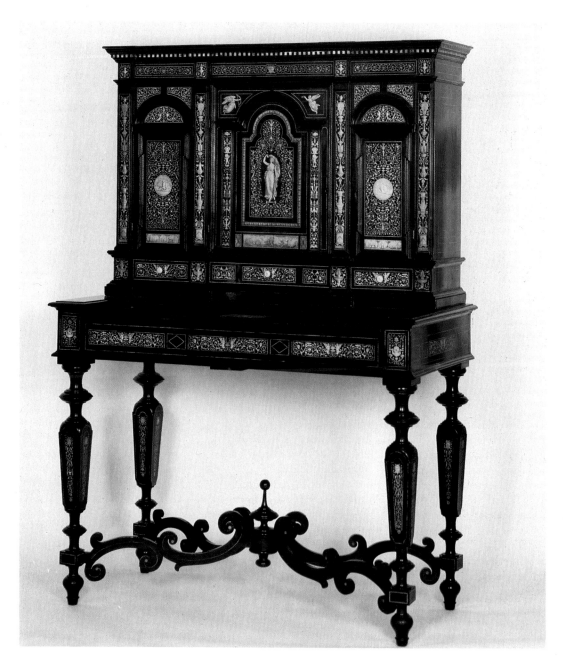

All these stylistic examples would be a source of inspiration for industry and the population at large, an alternative to the dreary collections on show at the Universal Exhibitions and the bewildering choice of styles. Filangieri did not favour any particular style, all he wanted was for each style be correctly interpreted. He also wished to see craftsmen equipped with design skills and a comprehensive and properly organized repertoire of design possibilities. He wanted to guarantee quality in the reproduction of the various styles, and he encouraged technical competence and precision in creating imitations and refused to accept any crude hotchpotch of decorative motifs.

Style wars

With the unification of Italy and the Romantic movement in the arts, the Renaissance came to epitomize Italian culture and the new ideas of nationhood. The Renaissance revival satisfied both middle-class aspirations and academic tradition. Although the Neo-Renaissance trend so strongly symbolised the glory of Italy, until the end of the 19th century it still had compete with other design tendencies, above all the Gothic and Romanesque revivals, which also had political and ideological undertones. To trace the various stages of the style debate that raged throughout the second half of the 19th century, we must briefly examine the writings of Pietro Selvatico (1803–80), architect and theoretician, Carlo Cattaneo, patriot, historian and man of letters, and Camillo Boito, architect, writer and teacher at the Milan and Venice academies. Influenced by the German Romantic movement, Selvatico, a student of Jappello and professor of aesthetics at the Venice Academy, took the Gothic style beloved of the Romantics and injected it with an original Italian flavour.

It was, Selvatico argued, the Venetians who first adopted ogival architecture, "a language of oriental origin" and passed it on to the countries of northern Europe. According to Selvatico, the duty of the modern architect was to study and imitate the pointed arches of Italian church architecture and the "styles of Lombardy and Bramante" in both private and public buildings. He also argued for the autonomy of medieval Italian architecture, which he referred to as "Lombard, since it was born in Lombardy and from there spread far and wide".

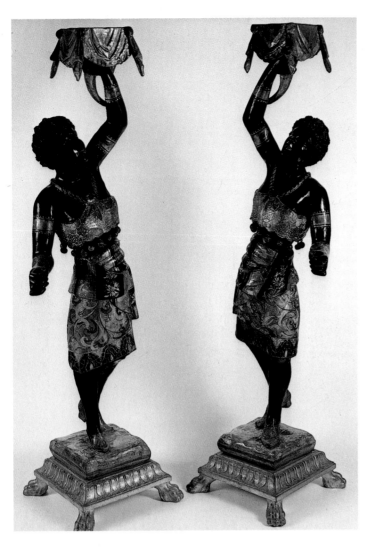

This attitude did not affect his judgment of other styles. He was interested in Eclecticism, above all because it provided him with a vast range of topics for critical analysis and a repertoire on which to draw in order to satisfy the demands "of modern tastes and way of life". Selvatico's theories did not prevent him supporting the very latest revivalist ideas. He defined architecture as "the art of constructing buildings according the civic and spiritual requirements of the people, and decorating them in such a way that the ornamentation indicates their significance and the purposes for which they are intended". Unimaginative interpretations of these principles led to the sort of classification which dictated that Romanesque and Gothic styles be used for churches, Byzantine, Roman-esque and Neo-Gothic for cemeteries, Moorish for cafés and Neo-Renaissance for private residential buildings.

In the field of furniture we find the same kind of stereotyping and a system of interior design which instantly revealed the purpose of a room and the gender of its occupant; women's rooms were frivolous, masculine spaces severe.

In an introduction to Domenico Moglia's book published in 1837, *Collezione d'oggetti ornamentali ed architettonici* (Collection of Ornamental and Architectural Objects), in the magazine "Politecnico", of which he was both founder and editor, Cattaneo tackled the concept of "beauty in decorative art", putting forward ideas very similar to Filangieri's. Cattaneo applauded Moglia, who took over from Albertolli at the Brera Academy, for having trained a whole team of artists in ornamental sculpture. However, he reproached Moglia for accusing contemporary artists of "meek compliance with the capriciousness of the clientele".

In the essay, reprinted several times, Cattaneo denounced Moglia's Neoclassicism and demanded that artists should be free to choose between a number of styles, while suggesting that the choice be limited to those of their native land. "We firmly believe," Cattaneo wrote, "that our craftsmen should give preference to that style of decoration which is native to our peninsula and contemporary with our noble nation. Likewise, we believe that the ability to discover beauty cannot be the exclusive province of a few nations and a few periods of history. Hence, we fear that excessive uniformity may cause the masses to weary of the products thrust upon them with such excessive zeal. Above all, we do not believe that it is the duty of the artist to make war on the society in which he lives […]" Cattaneo considered that it was right to welcome the gifts of every civilization and every age, and to make of them "not bundles of all kinds of weeds, but garlands of all kinds of flowers", in other words, to make a judicious selection of the "genuinely beautiful" from each style. 19th-century style," he continued, "should emulate that of the aristocracy in the early years of the century who, having acknowledged the charm of Greece, learned to appreciate the beauty of the High Renaissance and Gothic and even the Turkish, Indian and Chinese, and should imitate the rich man of elegant spirit and noble imagination, who loved to adorn his house and garden with the discoveries of the genius of the various centuries and various nations."

Beauty and practicality

Cattaneo believed that the problem of the age lay in the lack of education of the ordinary population, who had no other guide than fashion in order to distinguish between the vast array of products with which manufacturers flooded the market.

Modern objects were produced by designers only concerned with practicality and comfort, with little regard for beauty. Meanwhile, decorative objects were completely useless and tawdry. Virtually echoing Filangieri's words, he called for a combination of beauty and practicality. This could only be achieved if people knew how to choose from among the decorative repertoire genuinely beautiful objects which were also useful and suited to present-day needs. Cattaneo saw a gap between "false, dead art and true, living art, […] the former obliges objects to assume bizarre and repugnant shapes, the latter discovers and develops the possibility of beauty in the inherent nature of each object." He concluded his essay by extolling the virtues of the Italian character, and encouraging liberated artists to use their talents to practise the arts to which Italy had given birth.

Camillo Boito: a critique of Eclecticism

Camillo Boito, probably the only contemporary Italian intellectual of European stature, took a more uncompromising stance, at least as regards architecture. As an opponent of Classicism and a champion of the Romanesque and the style of the great Renaissance architect Donato Bramante, he adopted a new and different approach to the study of the decorative methods of the various periods. The aim, he believed, was not to become a connoisseur of historic styles, but rather to discover the reasons behind their creation and the ways in which they were applied. He saw the Romanesque and Bramantesque as flexible and logical enough to be adapted to modern manufacturing. Boito somewhat modified

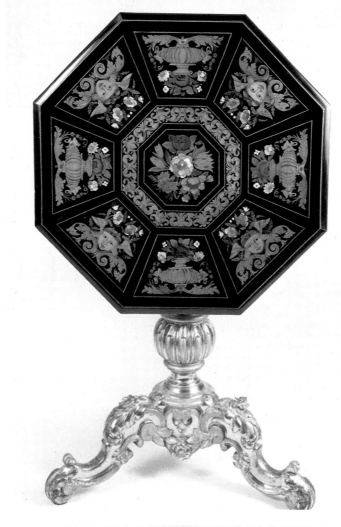

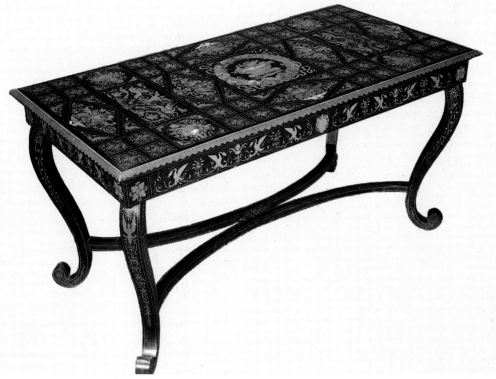

his point of view when confronted with the problem of industrial decorative art. Famously, in *I principi del disegno e gli stili dell'ornamento* (Principles of Design and Ornamental Styles), published in 1881, he lamented the fact that the 19th century had no original language of its own and went on to describe the predicament of the cabinet-maker engaged to furnish a house, who ponders over which style to adopt – Italian Renaissance, Lombard or Bramantesque, or even the 14th-century. At the same time, the craftsman realizes that he should not forget the Moorish or Byzantine, nor overlook the Greek or Roman. He could even combine different styles of decoration. "A little bit of this, a little bit of that, do as bees do, as Zeus did for his daughter Helen with the maidens of Croton. We are the heirs to all the glories of the past, and Eclecticism, which is, after all, a mixture of so many good things, will only produce good things." But, Boito argued, Eclecticism could only produce "a muddle, or a dilution" – a muddle when each room was in a different style, and a dilution when all the styles were mixed together: a shape from one period, a frieze from another, and foliage from a third. Nevertheless, Boito acknowledged that some semblance of order had emerged in recent years. In Rome, artists and public alike did not like Neoclassicism, while in Tuscany, where tastes seemed more refined and thoughtful, the Renaissance was in favour. The greatest confusion of decorative languages occurred in the north, in the Veneto, Lombardy and Piedmont, the regions "where the restless, innovative spirit of present-day society

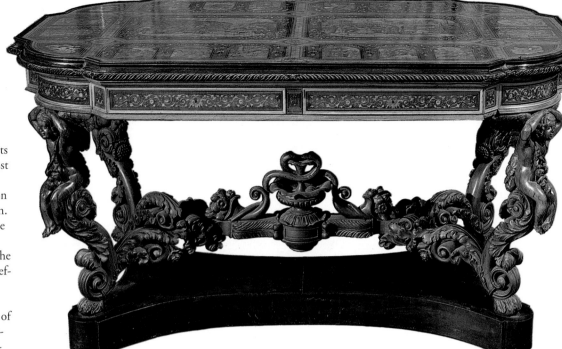

with its great benefits and also its disadvantages, has found its most fertile ground".

Boito reacted to the situation but could not provide a solution. A new style, he wrote, cannot be invented by one, nor even one hundred artists, it can only be the mature result of the prolonged efforts of an entire society. The only answer was "to study the most notable ornamental styles of the past and try to discover conclusively their nature and explanation; and then apply them unobtrusively to present-day artefacts, so that they pleasingly and effectively express the practical use or purpose for which the object intended." In choosing a style, the artist should bear three things in mind: the function and purpose of the object; the most commonly used and attractive style typical of the region in which he plied his craft; and the style most suited to his own talents. In other words, Boito did not reject Eclecticism, he merely sought to establish more intelligent criteria for its application. Decoration should not hide the function of the object but glorify it. In objecting to the custom of decorating industrial machinery and tools, he was to some degree distancing himself from current attitudes.

In an article entitled *Industrie artistiche alla Esposizione di Milano* (Artistic Industries at the Milan Exhibition) written in the same year, he condemned "machines standing on architectural bases with fine pedestals and mouldings, perhaps adorned with Doric or Corinthian columns with heroic beams and posts, or even buttresses or ogival pinnacles." Boito called for honesty in the choice of decoration, which

expressed and glorified the function of the object or the material of which it was made. He scorned gesso and cement imitations of nobler materials such as bronze, marble and granite. "All materials correspond to an appropriate form and appearance; change the material, and suddenly form and appearance become unacceptable and false."

Boito's appeals for honesty and truth were ignored. In the second half of the 19th century, fake materials were big business. Magazines were published with information about the latest devices for imitating the patina of bronze, the veining of marble or the sheen of oriental lacquer. Endless mass-produced knick-knacks invaded 19th-century homes. People lived in dark, dimly-lit rooms, cluttered with furniture of all sizes, shielded by curtains and hangings, surrounded by artificial flowers, embroidered cushions, seashell ornaments, gesso statuettes, papier-mâché snuff-boxes and trays, and framed photographs of the King and Queen and deceased loved ones. As Siegfried Giedion wrote in 1948 in *L'era della meccanizzazione* (The Age of Mechaniza-

tion), "any innate feeling for materials or form was lost. This despite the fact that the whole state of affairs had been acknowledged and criticized *ad nauseam* by the middle of the century".

The symbolic value of interior design

It is hard to define in sociological or philosophical terms the effects of this chaotic scenario, or the reactions to the tastes and morality of the period. Perhaps the Surrealists were the first successfully to grasp the banality and fascination of those domestic interiors. Max Ernst's *Femme 100 têtes* (1929), which according to the punning French title could mean "The woman with 100 heads" or "The headless woman", was a work symbolizing the mutability of the 19th century and its capacity for transformation. The collages of wood-engravings of objects cut out of old, anonymous and long-forgotten catalogues, arranged in an apparently illogical manner, revealed the symbolic importance of that style of interior design. Having shattered the glass of the 1850s bookcase, the 100-headed

woman, transformed into a gesso bust, appeared about to fall onto the head of the cultured viewer, while the lion's head on the arm of a chair was transmuted into a huge ape, dangerously alive and gnashing its teeth.

In the name of interior design, terrible crimes were committed in 19th-century homes. It was as though strange phantoms stalked Victorian houses, frightening children and their governesses. In one of his essays, Thomas Carlyle (1795–1881), historian, critic and social prophet, perfectly captured the atmosphere illustrated by Max Ernst. Carlyle observed that the fine arts had long since been divorced from anything resembling truth, only to be publicly united in matrimony with falsity and sham. The arts had frankly descended into a state of lunacy but, because no one suspected how dangerous they had become, they were wandering free and unguarded and abandoning themselves to a preposterous dance.

Not only were materials faked, styles imitated and masterpieces reproduced in miniature. Items of furniture were camouflaged, concealed, transformed. A

bed was hidden in a piano, which in turn was concealed in a cupboard; an armchair could be converted into a *prie-dieu*; a table was transformed into a bench or a small step ladder, a revolving bookcase into an occasional table. Then there was the tip-up writing table whose top was carved to imitate a book, and the matching stool, its wooden seat shaped like a swathe of cloth held by a *putto*. Furniture-makers could use their materials to imitate cloth, leather, paper or bamboo. Shapes were fluid and deceptive. But maybe this is the very reason why 19th-century furniture and interiors still fascinate us today.

The Renaissance revival

Perhaps the publication that did most to disseminate Boito's views and those of the medievalist tendency in general was the magazine *Arte italiana, decorativa e industriale*. A different point of view was represented by the *Guida per le Arti e Mestieri* referred to above. In 1875 the guide published the translation of an article by W. Lübke, a follower and admirer of the German architect and theorist Gottfried Semper (1803–79). The article, entitled *Degli stili nell'arte industriale* (Styles in Industrial Design), declared Lübke's support for the Renaissance style. Under the pretext of nationalism, he wrote, the Gothic style was upheld against all logic. As we have already seen, the Italians subscribed to the same principle in proudly claiming paternity of the ogival and Romanesque styles. According to Lübke, his contemporaries should have looked back, not to the Middle Ages,

but to the Renaissance. "Our age is not essentially religious as the Middle Ages were," he argued, "but as materialistic as the Renaissance and the Roman era. The requirements of secular life, both public and private, are what matter most […]" Demands for comfort required the fulfilment of many more conditions, which could be provided merely by resorting to Renaissance art. Lübke recommended that "rabid fanatics of the Gothic" should be con-

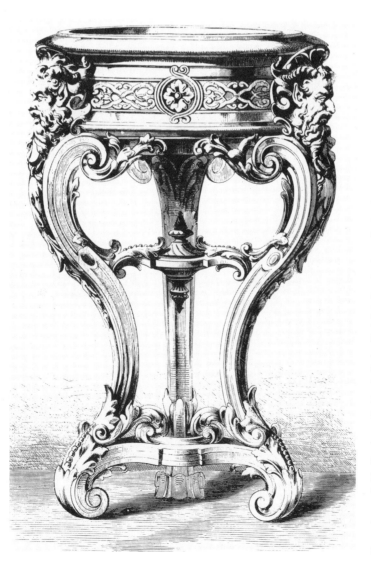

demned to spend their whole lives sitting on uncomfortable, angular chairs, drinking from crude cups, in other words to live the hard life of the Middle Ages. The decorative arts of the Renaissance, meanwhile, offered immense riches and great possibilities. "It was precisely the late Renaissance which, in introducing curved lines, could best respond to the requirement for comfort and luxury in the realm of furniture." Moreover, Lübke

contended that the source which inspired Gothic decoration was arid, eternally producing monotonous geometric combinations. How much richer was the art of the Renaissance, which imitated Antiquity, drawing inspiration from the world of plants and animals, creating masks, emblems and mythological motifs. It might be said that the variety of shapes and decorations were excessive, but one only needed to step back a little further in time, to Greek and Roman art. The ancient world invented an enduring code of forms and ornamentation "because the elements used originate necessarily and legitimately from the very nature of the decorated object. The desire to achieve innovations in such things is tantamount to wishing to create a new code (as Semper has rightly remarked); whereas the aim should be to use the ancient code to develop new concepts." Lübke believed that it was right for modern industrial design to draw inspiration from the Renaissance, not by slavish imitation, but by remaining faithful to the truth and always bearing in mind the universal laws expressed by Classical art, whose legacy should be brought to perfection. There would be brief periods in which gaudy outward appearances would triumph, "but the day will come when the eternal laws of truth and beauty will emerge victorious".

We have already seen how, in the cause of nationalism, Italian artists and intellectuals championed the revival of the Renaissance as the Italian style *par excellence*. In his 1883 article entitled *Dello stile architettonico proprio italiano* (Italy's Own Architectural Style), F. De Cesare as-

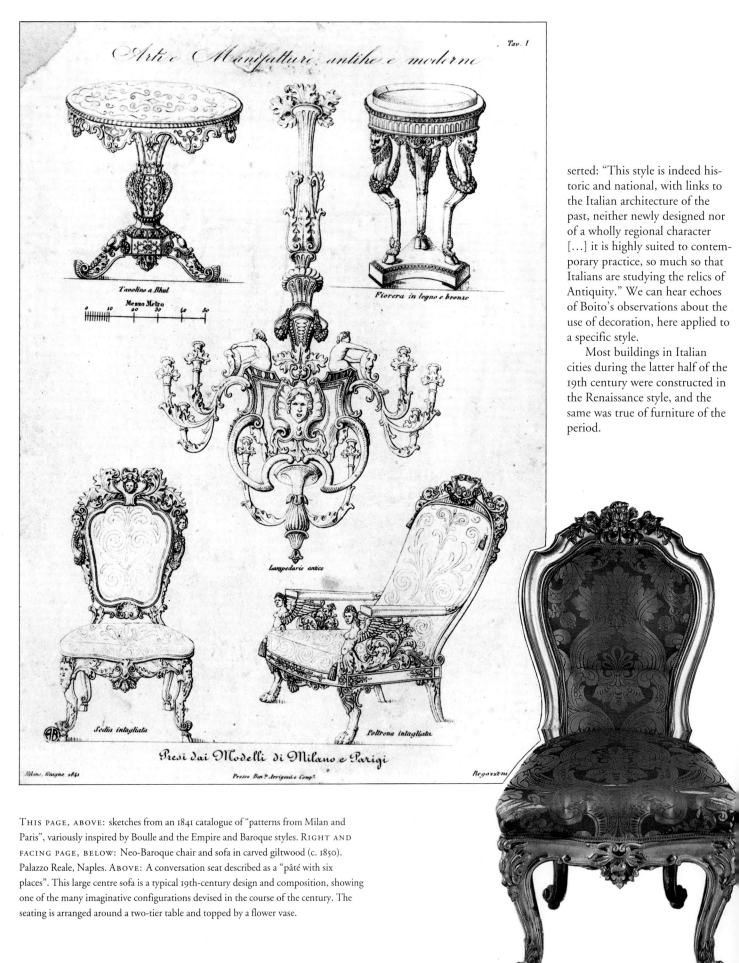

Arti e Manifatture antiche e moderne

Tav. 1

Tavolino a Bhul

Mezzo Metro

Fiorera in legno e bronze

Lampedarie antico

Sedia intagliata

Poltrona intagliata

Presi dai Modelli di Milano e Parigi

Milano, Giugne 1841

Presso Dan? Arrigoni e Comp?

Regazzini

serted: "This style is indeed historic and national, with links to the Italian architecture of the past, neither newly designed nor of a wholly regional character […] it is highly suited to contemporary practice, so much so that Italians are studying the relics of Antiquity." We can hear echoes of Boito's observations about the use of decoration, here applied to a specific style.

Most buildings in Italian cities during the latter half of the 19th century were constructed in the Renaissance style, and the same was true of furniture of the period.

THIS PAGE, ABOVE: sketches from an 1841 catalogue of "patterns from Milan and Paris", variously inspired by Boulle and the Empire and Baroque styles. RIGHT AND FACING PAGE, BELOW: Neo-Baroque chair and sofa in carved giltwood (c. 1850). Palazzo Reale, Naples. ABOVE: A conversation seat described as a "pâté with six places". This large centre sofa is a typical 19th-century design and composition, showing one of the many imaginative configurations devised in the course of the century. The seating is arranged around a two-tier table and topped by a flower vase.

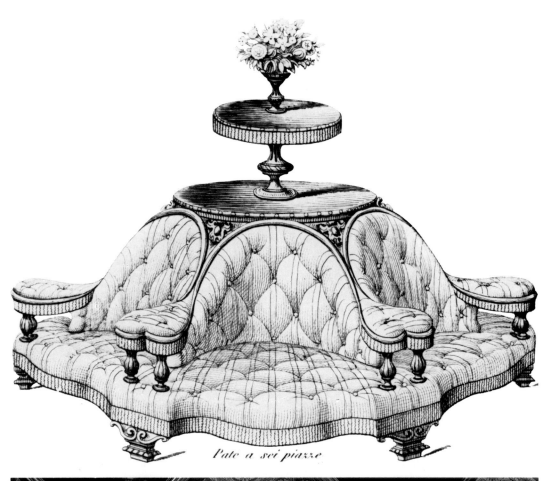

l'ate a sei piazze

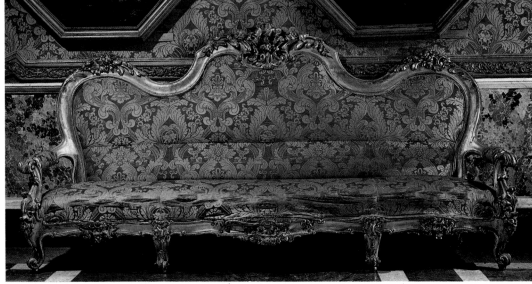

Artists and cabinet-makers

Among those who joined the Renaissance revival was the painter, theatrical set designer, architect and sculptor Ludovico Pogliaghi (1875–1950). His exquisitely made furniture with its sumptuous ivory inlays was inspired by 16th-century architectural forms, and his ornamentation by the Classical period. A similar style was adopted by the Pogliani family, father Ferdinando (1832–99) and his three sons Giuseppe, Paolo and Carlo. They designed a bedroom for Napoleon III (1865), for which Ferdinando is thought to have received the commission from the emperor himself. Giuseppe was responsible for the structural design, Carlo and Paolo for the carvings, while the elegant bronzes were attributed to Mario Favini. The bed, in glossy black wood, was adorned with sgraffito mythological figures on an ivory base, and bronze sphinxes, dragons, goblets and horses, with a Juno Pronuba – patroness of matrimony – mounted on a tympanum, to symbolise potency. Similar motifs recurred on the pair of cabinets, each in two sections with doors and drawers, and two small bedside cabinets supported by bronze dogs.

Meanwhile, the black-painted wood of the large glass-fronted cabinet, topped by bronze griffons and supported by dragons, was complemented by white maple colonnettes. Ivory inlays depicting grotesques and mythological scenes appeared on the elegant, architectural cabinet fronts and consoles. The Pogliani family's creations enjoyed considerable success both in Italy and at the Universal Exhibition in Vienna (1873), the Centennial Exhibition in Philadelphia (1876) and the first exhibition of the Third Republic in Paris (1878). Other talented Italian cabinet-makers famed at home and abroad for their Renaissance-style furniture were the Florentines Mariano Coppedé and Emilio Truci, Lancetti of Perugia, the Venetian Vincenzo Candorin and the Neapolitan Ottaviano De Luca.

Fabio and Alberto Fabbi were inspired by a quite different culture when, in around 1890, they designed a bedroom for the Gonzaga family at Guastalla. The bed, built in a selection of woods with ivory and *pietre dure* inlays, was shaped like a pyramid and flanked by Egyptian-style walls and pylons, while the commodes were decorated with inlays of views of Nineveh and Thebes and

An eclectic room

Around 1890, the Gonzagas decided to redecorate one of the bedrooms of the Palazzo di Gua-stalla, the family home near Mantua, in accordance with contemporary needs and tastes. The result was a highly original, charming and eclectic room which perfectly encapsulated late-19th-century revivalism and the kind of aesthetic experimentation that characterized the culture of the age. The wonderfully rich and complex decor was the work of the Fabbi brothers, Fabio (1861–1946) and Alberto (1858–1906), Bolognese painters who both worked as interior deco-rators specialising in oriental themes. The brothers had completed their artistic education by travelling abroad, particularly to Egypt. For this room, they devised a complex iconographic programme comprising a sequence of scenes in a continuous frieze on the upper part of the walls, with separate episodes on the wainscoting and the supports, which were of natural wood panelling inlaid with human figures and decorative motifs. The subjects chosen evoke stories in exotic settings and mythological scenes, extending from Egypt, Palestine, Persia, Babylon and Assyria to Greece and Rome, and from Germanic mythology to Arabia and China.

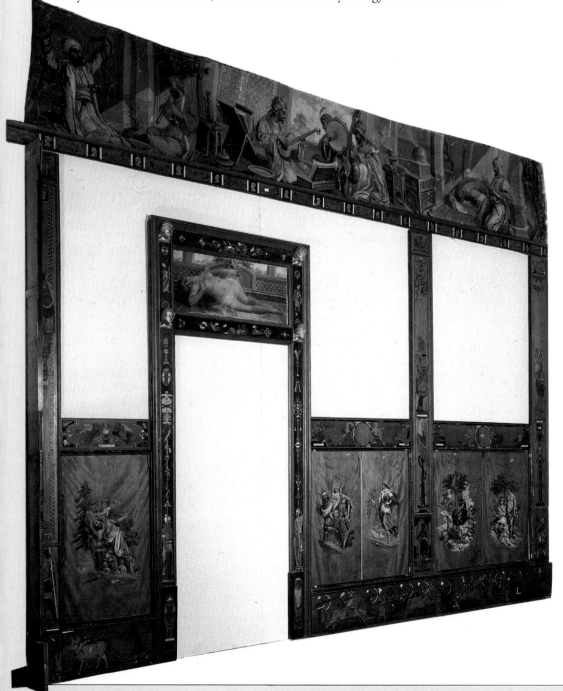

This page shows reproductions of paintings and inlays from the walls of a bedroom in the Gonzagas' Palazzo di Guastalla. The details of the wall panels decorated by Fabio and Albert Fabbi, representing classical myths and legends, perfectly capture the spirit of contemporary culture.

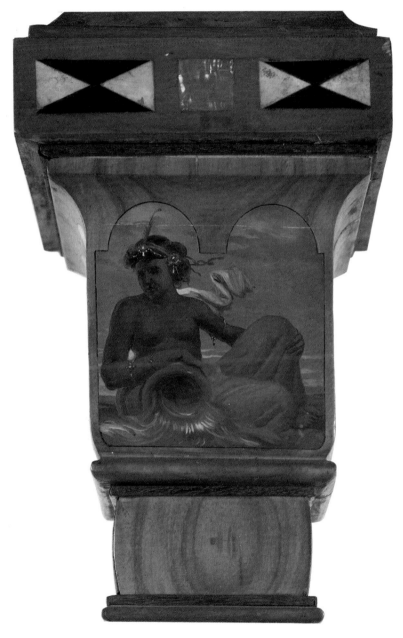

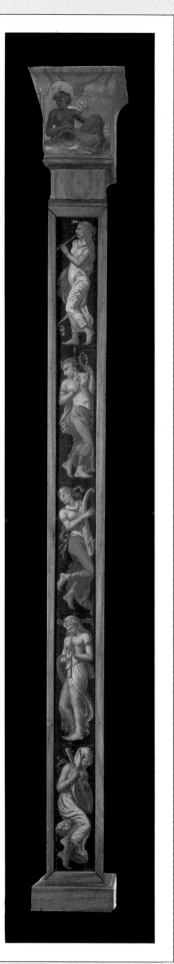

The paintings evoke rural life, hunting parties, sumptuously exotic and domestic interiors. The female figures, suffused with an aura of languorous sensuality, foreshadow the aesthetic hedonism of the Decadent Movement. The polychrome decorations are highlighted by inlays in ebony, ivory and mother-of-pearl.

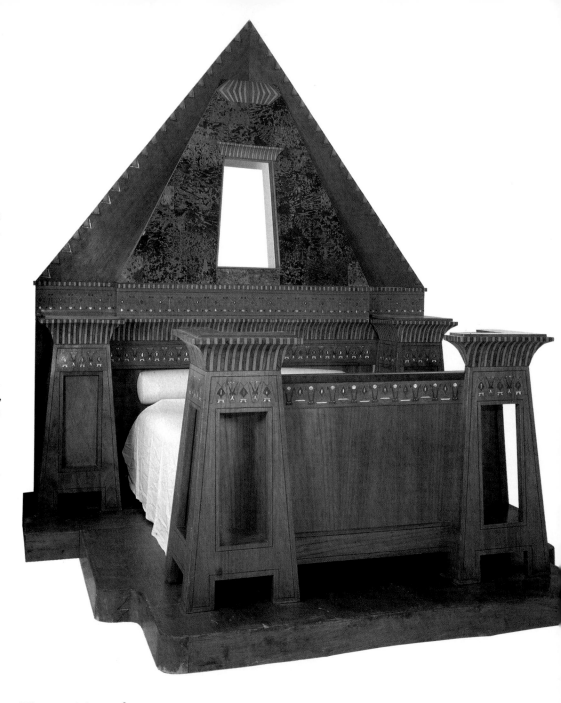

guarded by winged sphinxes. The warm, golden colour of the wood recalled the sands of the desert, while the massive proportions were a reminder of the monumental architecture of Ancient Egypt. Two carved sphinxes appeared on the arm fronts of the sofa, while the back-rest was surmounted by the figure of a female harpist seated in Osiris's chariot. More sphinxes decorated the sides and top of the pier-glass, while the bases of the colonnettes supporting the top of the lapis lazuli-coloured top of the centre table were embellished with papyrus leaves. Mouldings, legs and every unoccupied surface of the pair of chairs and wall cabinet which completed the furnishing of the room were adorned in the Egyptian fashion with rows of geometric motifs and stylized leaves and flowers. The craze for all things Egyptian, so much in evidence in the 18th century (examples included Piranesi's fireplaces and the rooms with Egyptian friezes designed by the same artist for Rome's English café) and given a new lease of life by Napoleon's Egyptian campaign of 1798, had still not run out of steam. Throughout the 19th century, new studies and publications about the Ancient Egyptians' customs, way of life and monuments helped to maintain interest in this exotic culture. The fascination was reflected not only in Italian furniture but also in the Egyptian inspiration in the decorative arts throughout Europe, especially in England.

Another favourite style of late 19th-century Italian furniture-makers was the Baroque, albeit a rather freely interpreted version.

The exoticism of Carlo Bugatti

Highly original interpretations of exotic themes were the hallmark of the work of Carlo Bugatti (1855–1940). Born in Milan the son of a decorator, Bugatti studied architecture at the Brera. Although he set up a workshop to produce "artistic furniture" in 1888, he had already created numerous pieces before that date, presenting at the Italian Exhibition in London a "Turkish style" suite for a smoking room and a screen featuring his own version of the Japanese style. He went on

to create highly original furniture with ebony and metal inlays, tassels and vellum, and painted and poker-work decorations. His style freely combined Japanese and Middle Eastern elements, and his use of circular and semicircular shapes even suggest a Romanesque influence. His furniture was exhibited at the 1898 Turin Exhibition and the Paris Exhibition of 1900, the year in which he also worked on the interior design for the Khedive's palace in Istanbul. His suite of chairs and drawing room furniture with upholstered backs covered with white fabric framed by copper studs also date

from this period. Cylindrical legs decorated in ivory and hammered copper supported seats with aprons enhanced by Moorish crescents inscribed with stylised Arabic characters. A matching wall cabinet consisted of a tower resting on a brightly-coloured semi-ellipse with copper, ivory and copper mounts. In the same year, Bugatti created a brass and metal mirror supported by two colonnettes, whose surfaces were decorated with finely delineated geometric motifs. More multi-coloured geometric shapes featured in the group of table and four chairs with intersecting cir-

FACING PAGE: bed designed and built c. 1890 by Fabio and Albert Fabbi for the bedroom at the Gonzagas' Palazzo di Guastalla. Constructed of various woods with ivory and pietre dure inlays, the bed is conceived in the form of a pyramid, with Egyptian-style city walls and pylons at the head and foot. THIS PAGE: two imaginatively designed and skilfully carved Eclectic pieces: a tilt-top desk in the shape of a book, and stool, whose wooden seat takes the form of a swathe of cloth held up by a *putto,* the legs are in wood, fashioned to imitate bamboo. Antiques trade.

cular, rectangular and triangular surfaces, the interplay of shapes and primitive decoration recalling Ancient Egyptian, Moorish and Romanesque styles. The Moorish inspiration was perhaps more obvious in the structure of the occasional table and bench upholstered in vellum (c. 1890), although the naturalistic design appeared to owe more to Japanese ink-paintings. Similar stylistic elements appeared in a table produced in Lombardy in the 1880s. The "ace of hearts" structure in shiny black wood was exquisitely decorated with geometric and highly stylised naturalistic motifs in mother-of-pearl. Bugatti's greatest triumph came in 1902 when he was awarded first prize at the Turin Exhibition. Among his various exhibits was an extraordinary series of curvilinear pieces: chairs with G-shaped supports, a table resting on a huge scroll, and a display cabinet resembling an enormous snail.

After taking part in the Paris Salon des peintres divisionistes of 1907, Bugatti left Milan, and his studio was taken over by the De Vecchi company, which continued to produce rather less complex furniture. Settling at Pierrefonds in France, Bugatti designed silver tableware for Hébrard, but his main activity was painting. Although as an artist he is usually seen as belonging to the Art Nouveau movement, his output can also correctly be categorized, as it was by his contemporaries, as part of the trend for Eclectic experimentation which marked the final decades of the 19th century. In a review of the Turin Exhibition of 1898 published in *Arte italiana* edited by Boito, Bugatti's furniture was mentioned alongside Pogliani and

Cadorin's Neo-Renaissance pieces. As well as the table and four chairs described above, he exhibited an extravagant turreted pedestal with two colonnette supports and two sabre legs, resting on a base with the customary crescent moons and topped by a female figure; a large polychrome cabinet adorned with a huge central circle and a series of glass panes of Romanesque-Moorish inspiration in the upper section; and a Moorish style work table with matching chair. "Curious" was the word used by the writer of the exhibition review, Marta Antelling, to describe Bugatti's creations.

She wrote: "His furniture in the Oriental style, with its fantastic forms and refined and witty eccentricity, was much admired [...] The Moorish character of these pieces, the long silk fringes ending in little diamond-shaped tassels of tinkling, glittering brass, the sheets of hammered metal framing the opaque, brown-painted vellum, all contribute to the originality of this furniture

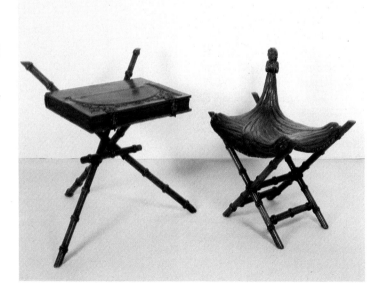

[...] But Bugatti is an artist. And *I* would like to see us all decorating our own homes according to the personality of lady in residence and adapt the style to suit her particular kind of beauty."

Furniture and the "intended user"

Antelling was again raising the issue of choosing a style to suit the character of the intended use – and user – of the furniture. She advocated that Bugatti's drawing rooms should be occupied by black-eyed, raven-haired, oriental beauties, in order that they might be encircled by those glistening metal discs and half-moon mirrors with their cascades of fringed white silk, so flattering to the brunette complexion! Ethereal blondes, she suggested, might imitate the gentle chatelaines of old and select the medieval styles offered by Fratelli Mora of Milan. Their austere leather furniture, glittering with gold and decorated with fanciful flowers or

chivalric motifs, would provide them with a superb setting. Leather or the imitation leather developed by the Milanese company made it possible to produce "furniture of sumptuous appearance and regal magnificence. In those medieval armchairs, behind those screens with ladies and knights engaged in courtly exploits, we seem to catch sight of a melancholy Yolanda."

Ideal for poor old grandparents were chairs made by a Florentine manufacturer. The stuffed backrest, curved to form two large wings, would protect them from the draught as they enjoyed a "delicious" snooze and relived memories of lives almost at an end [...] For drawing rooms where ladies received visitors, Antelling recommended "adorable Louis XV" furniture from a manufacturer in Turin. Fashioned in giltwood, its lines sober, light and seemingly as fragile as a leaf, it avoided the clumsiness characteristic of inferior imitations.

The fabric was in the same rose-pink beloved of Madame de Pompadour, although Antelling admitted some might prefer pale blue. Blonde beauties should surround themselves with these shades, preferably dotted with the little sprigs of flowers like those which delighted "that most intellectual of all the king's favourites". The same style was most suited to bedrooms. Small divans, where one could curl up as if in a shell, graceful curved lines and elegant, refined and discreet voluptuousness – these made the Louis XV style most likely to encourage relaxation and seduction.

Furniture produced by certain Venetian manufacturers, featuring opulent Baroque and Renaissance lines and charming,

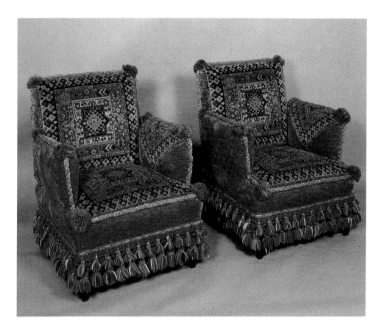

chubby *putti* decorations, provided a rich and exuberant selection which was best limited to dining rooms "because it seems to me that such refined, almost baronial, overabundance is more appropriate to the convivial reunions and succulent feasts of the gentry, typified by leather chairs with gilt studs, fine antique majolica dinner services, silverware engraved with coats of arms, goblets of Venetian and Bohemian glass, and servants in wigs and silk stockings and shoes with silver buckles, scurrying silently across polished floors."

Antelling also mentioned *stile Liberty* – as Art Nouveau was known in Italy – and imitations of the "English style" exhibited by Turin furniture-makers, but, curiously, detected a 15th-century inspiration, albeit in a modern interpretation. She then passed straight on to the revival of the Empire style which "graces some drawing rooms". She admired its austere lines, cornices, rigid Minerva caryatids, militaristic trophies, the nostalgic fascination with imperial myths and the purity of the Graeco-Roman style.

Italy was on the threshold of the 20th century, but the images promoted by magazines and exhibition catalogues were still rooted in the 19th. Elsewhere, real transformation was taking place. The example set by the aristocracy and the upper middle-classes, who filled their gloomy, decorous rooms with carefully-collected, eclectic bits and pieces, was followed by other social classes.

Middle and lower middle-class homes and even those of better-off white- and blue-collar workers were caught up in the same spirit as those inhabited by wealthier and more cultivated cit-

izens. The lower orders, too, were driven to fill their houses with reproduction furniture to be admired with nostalgia, exotic objects to set them dreaming, and reproductions of paintings and statues, and mass-produced porcelain and bronze, in an attempt to recapture the mood and values of bygone ages which still exerted their power.

Italian production: the northern regions

Mid-19th-century nostalgia for every period of history led Lombardy's architects and craftsmen skilled in the art of decoration to publish pattern books such as *Raccolta di ornati a fantasia applicabili a diversi generi d'arte* (Collection of Imaginative Decorations Applicable to Various Forms of Art), by Antonio Bossi (1842), *L'addobbatore moderno* (The Modern Decorator) by Giuseppe Cima (1840), and *L'artista italiano* (The Italian Artist) containing lithographs designed by Carlo Invernizzi and Alessandro Sidoli (1854). One of the most interesting figures in Lombard Eclecticism, Ferdinando Pogliani, was one of several cabinet-makers active at the same period.

Among the best exponents of the Gothic revival was the painter Luigi Scrosati, who worked between 1840 and 1860, often collaborating with architects such as Chierichetti, Palagi and Sidoli. Scrosati's most interesting works include the Neo-Gothic furniture made for the Villa Amalia at Erba and a number of items for the bachelor apartment of the great Milanese aesthete and intellectual, Gian Giacomo Poldi Pez-

zoli. In 1855, he ordered the redecoration of his home in Milan, in order to house his art collection. He turned for help to painters Bertini (director of the picture gallery at the Brera) and Molteni, the architect Blazaretti, the sculptors Pogliaghi and Brazaghi, the cabinet-makers Spelluzzi, Ripamonte and the stucco artist Tantadini. Between them these artists and craftsmen splendidly satisfied the desire for luxury and the love of precious materials which were to become the hallmarks of contemporary Lombard interior design.

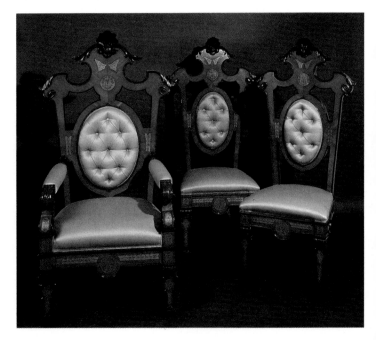

Thanks to a new middle-class clientele and new manufacturing processes, furniture production underwent some dramatic developments. In his *Storia e statistica dell'industria manifatturiera in Lombardia* (History and Statistics of Manufacturing Industry in Lombardy), published in 1856, Giovanni Fratini estimated that some 3,000 workers were employed in the furniture industry, and named Cesano Maderno, Cinzago, Seveso, Lazzate, Lissone, Barlassina and Meda as the region's main centres of production, most notably of seat furni-

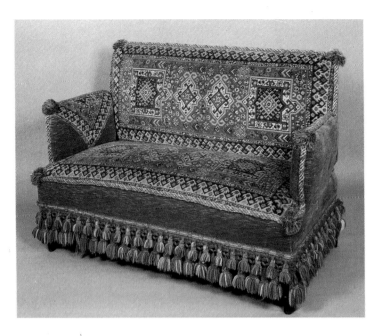

ture. Milan was still the commercial heart of the region, and every Saturday morning there was a market in Piazza S. Marta (now Piazza Mentana) trading in furniture from all over the area.

The 1898 All-Italy Exhibition in Turin attracted numerous workshops and "award-winning companies", among them Fratelli Mora of Milan, a firm founded in 1775 and specializing in reproduction Baroque furniture, Carlo Corbetta, Carlo Perlasca, the Meroni Fossati company of Lissone, manufacturers of Empire furniture, and the prizewinning Carlo Zen concern, specialists in Renaissance and Gothic furniture.

As well as Palagi, another leading champion of the Gothic style was Alfredo D'Andrade (1839–1915), a native of Lisbon who studied in Genoa and began his career as a landscape painter. After a period spent in Geneva, he returned to Genoa, where he was appointed professor of decorative art at the city's academy. In his teaching, he no longer promoted Albertolli's Neoclassical decorative ideas but used new textbooks inspired by the Gothic and Renaissance styles. His research in the field earned him commissions to restore ancient monuments in Liguria and Piedmont. One of his most famous achievements was the Borgo Me-

dievale, a pseudo-medieval town in Turin.

In addition to his teaching activities, D'Andrade's collection of documents, sketches and decorative details was to have an enormous influence on the decorative arts in Piedmont and Liguria, in terms of both technique and design.

In the Veneto, rampant Eclecticism was stimulated by the demands of a wealthy middle-class clientèle. At the same time, there was a desire to preserve local craft traditions and characteristic Venetian styles. As Guggenheim pointed out in his report to the local Chamber of Commerce and Crafts, typical lacquered and carved furniture was offered for sale to tourists and other visitors.

Between 1870 and 1915, Guggenheim himself ordered copies of antique furniture from some of the most talented artisans, including the Besarel brothers.

Valentino (1839–1915) Panciera popularly known as Besarel, and his brother Francesco, natives of Zoldo in the province of Belluno, homeland of the famous Andrea Brustolon, followed in the great man's footsteps as woodcarvers. After studying at the Accademia, Valentino opened a workshop in Venice in 1870.

Having distinguished himself

at the National Art Exhibition in Florence in 1861, he also enhanced his reputation with picture frames and candelabra exhibited in Vienna in 1873, and a magnificent altarpiece displayed in Paris in 1878, described in glowing terms by Finocchietti, who particularly admired the superb composition of the bas-reliefs. Then in Milan in 1881 and in Turin in 1884, he presented a series of benches, credenzas, chests and busts in pine and cherry wood in the style of Brustolon, and a combined table-jewellery box, made for Margherita of Savoy.

His predecessor and fellow-countryman Brustolon was a powerful influence on his work. Although Besarel's furniture maintained the Neo-Renaissance features and proportions then in vogue, its spectacular Baroque appearance owed much to Brustolon.

Besarel's artistic flair was shown to best effect in his bold treatment of *amorini* and delicately-carved carvings of flowers and foliage.

He was assisted by a number of co-workers and apprentices, to whom he delegated the honour of actually building the furniture, while he concentrated on design and on performing the trickiest stages of the process. He and his staff were equally skilled at working in wood and marble.

At that time Renaissance revival furniture was all the rage, as can be seen from the sales catalogues of the Veneto's "award-winning companies", such as Vicenza-based Opificio Artistico di Antonio Zanetti, Emilio Bianchi, also of Vicenza, and Bachi and Treves of Venice, or the quarterly directory published by the Venetian arts and crafts specialists Sar-

fatta & Co. One typical 18th-century artefact to re-emerge during this period was the "blackamoor".

The central regions

In Tuscany, cradle of the Renaissance, interest in traditional Renaissance woodcarving began earlier than in some other parts of Italy, due in part to the activities of the "purist" movement, which rediscovered the "primitive" painters of the 14th century such as Gozzoli, Botticelli, Mantegna and Carpaccio. At the Italian Exhibition in Florence in 1861 and the International Exhibition in 1862 in London, the Neo-Renaissance trend was strongly represented and its success was confirmed at subsequent exhibitions in both Europe and America.

The Sienese Antonio Manetti and Angiolo Barbetti were the first to recreate Renaissance-style furniture. As early as 1830, Barbetti opened a school of carving in Florence, a training-ground for countless talented craftsmen. They included Antonio Rossi, Vincenzo Corsi, Marchetti, Giusti, Leoncini, Ferri and Bartolozzi, all active between 1850 and 1870. Frullini, Fanfani, Torelli, Ricci, Bacetti, Scaletti of Arezzo, Picchi and Gaiani, all former students of the school, distinguished themselves at the 1861 Florence exhibition.

Egisto Gaiani (1832–90) was celebrated for his grandiose and assured style, his flair for carving human and animal figures and the elegance of his designs. Finocchietti specifically mentions a walnut and gold *jardinière* created in honour of the future Queen of Italy. Gaiani's pupil, Ferdinando Romanelli (1839–c. 72), who was

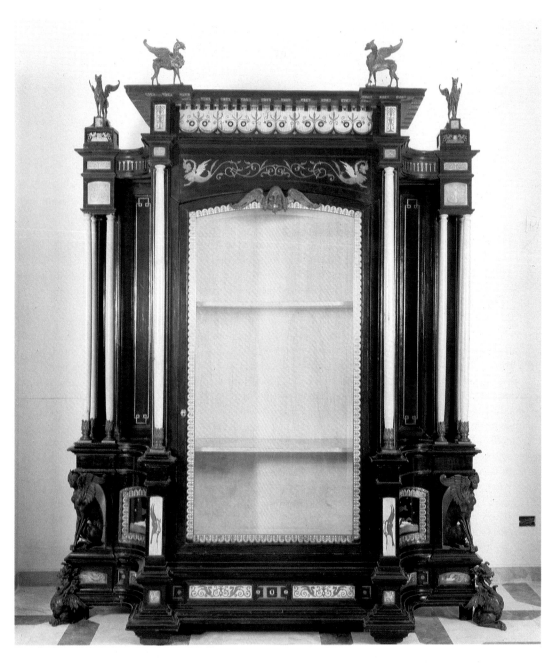

tions of tiny, fluttering *putti*, he was less successful as a designer. His travels enabled him to study the works of foreign artists, and also put him in touch with an American clientèle fascinated by his abilities. At the Centennial Exhibition in Philadelphia in 1876, he exhibited typically Tuscan and Neo-Renaissance sideboards, chests of drawers and tables in the Neo-Renaissance style.

Some less gifted carvers resorted to gilding, an art which was developed to a very high level, particulary in Florence, in order to disguise imperfections.

Inlay, another technique typical of the region, was the speciality of the Falcini brothers' workshop. Established in 1840, when Restauration Eclecticism was enjoying widespread popularity, the brothers progressed from imitation Renaissance to stately Neo-Baroque furniture. They improved on Spighi's style of monochrome inlay by using mother-of-pearl, tortoiseshell and metal, but most of all through the painstaking selection of woods according to their difference nuances of

commissioned to decorate furniture for palaces in St. Petersburg, Moscow, Paris and London, added 15th-century-style carved friezes to solid bourgeois furniture.

Another Sienese, Pasquale Leoncini, remembered as an exquisite designer and skilled carver, became famous for his refined bas-reliefs and his work as a cabinet-maker. Commissioned by a wealthy citizen of Siena, Pietro Pieraccini, he designed and built a walnut bureau "of graceful forms with fine figures and candelabra", complemented by a

slender, elegant sofa and wooden chairs, and a round table.

Pietro Giusti (1822–c. 65), who in 1862 was appointed lecturer in woodcarving at the technical college of Turin's industrial museum, was also a gifted designer, noted for his exquisite carving.

Frullini, whose style was characterized by finely-carved ornamentation, made a name for himself at the 1861 exhibition with two bas-reliefs in jujube wood. Often compared with Giusti for his skills as a carver, especially for his tasteful composi-

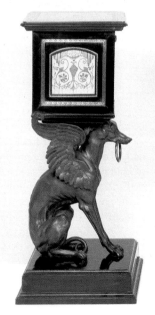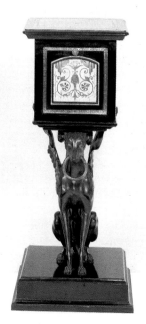

These pages show furniture built c. 1865 for a state bedroom, probably created for Napoleon III by the Lombard cabinet-maker Ferdinando Pogliani, possibly in collaboration with the bronzesmith Mario Favini. FACING PAGE, ABOVE: ebonized wood and white maple vitrine with ivory and copper inlays and small sculpted figures of sphinxes, dragons and gryphons. BELOW: pair of pot cupboards in the form of small cabinets, supported by bronze winged greyhounds and inlaid with copper and silver grotesques. THIS PAGE: a two-tier cabinet decorated with grotesques in ivory, copper and ebonized wood. All antiques trade.

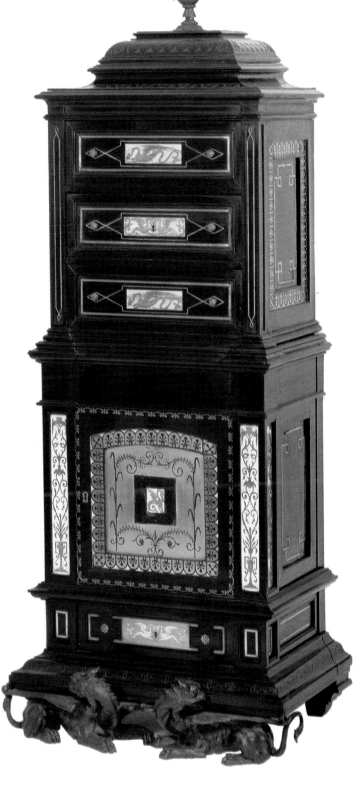

colour. Furthermore, in order to overcome the problem of finding sufficient colour gradations, they resorted to chemical dyes. To achieve yellow shades on lime, poplar and maple, they used turmeric solution, while to obtain deep or bright orange, they added chloride to the turmeric. In order to accentuate the grain of the wood, they applied gamboge (yellow gum resin) to lime wood and saffron to pear wood.

In *Del risorgimento e dai rapidi progressi della lignotarsia in Firenze. Atti della Accademia Toscani di Arti e Manifattura* (The Revival and Rapid Progress in Wood Inlay in Florence. Proceedings of the Tuscan Academy of Arts and Crafts) in 1863, Giuseppe dal Noce wrote: "In order to achieve different shades of green, they discovered the method of boiling Pyrenean *Berberis vulgaris* with holly, adding various measures of indigo, until the green became darker, while to achieve shades of blue, they gradually added indigo solution to small sprigs of holly, or to the fibrous parts of this plant which most resembles the grain of chamois leather. Finally, for purple, they successfully added indigo to a solution of cochineal and alum, which was then added to the same holly." To enhance the chiaroscuro effect of their inlaid work, the Falcini brothers heated very fine sand to different temperatures and used it to blacken and shade the different varieties of wood. The harmony of the deep ebony black and the lustrous colours of the paler woods, alternating with mother-of-pearl, evoked lush, late 17th-century Florentine plant motifs, and was a reminder of the furniture made for the Medicis using the "Dutch"

technique introduced by Lennart van der Vinne.

Among the Falcinis' most admired works were the rectangular table and *guéridon* made for Prince Demidov, and a Cosimo I table with decorations in the style of Benvenuto Cellini. Falcini furniture, especially those items made by Luigi, was most valued for its elegant, vaguely Raphael-esque designs, harmonious proportions, colour gradations, precise, clean profiles, the perfect coordination of the frame, veneers and inlays and the evenness of the surfaces.

Other fine Tuscan inlay artists of the period included Luigi Landi of Siena, Domenico Ghelli of Pisa, Anacleto Gonfiantini of Pistoia, the Florentines Giuseppe Benvenuti and Antonio Parenti.

Umbrian furniture of the final decades of the 19th century had much in common with that produced in Tuscany. The mid-century revival of historic styles and the passion for decorative arts brought into focus the problem of restoring the fine examples of woodcarving in which Umbria was so rich. This in turn led to a revival in the technique of inlay, which had fallen into disuse, and to renewed enthusiasm for carving. Craftsmen became so practised in imitating Renaissance motifs that they even succeeded in fooling connoisseurs. The best-known artisans working in Perugia included Federico Lancetti, Alessandro Monteneri and Venceslao Moretti.

Lancetti distinguished himself at the 1861 All-Italy-Exhibition in Florence, the London exhibition of 1862 and later at the 1867 Paris exhibition, where he presented tables inlaid in ivory, coloured woods and mother-of-pearl, sim-

ilar to items produced by his contemporaries, the Falcini brothers, of Florence, Angiolo Barbetti of Siena, and Ragnini of Chiusi. Finocchietti wrote of Lancetti: "[...] his works are outstanding for their beautiful harmony of colour and the precision and as-

surance of their execution." Monteneri, who exhibited in Florence and London, also produced inlays that were particularly interesting for his attempt to improve the effects of colour through experimenting with chemicals. His greatest claims to fame were a

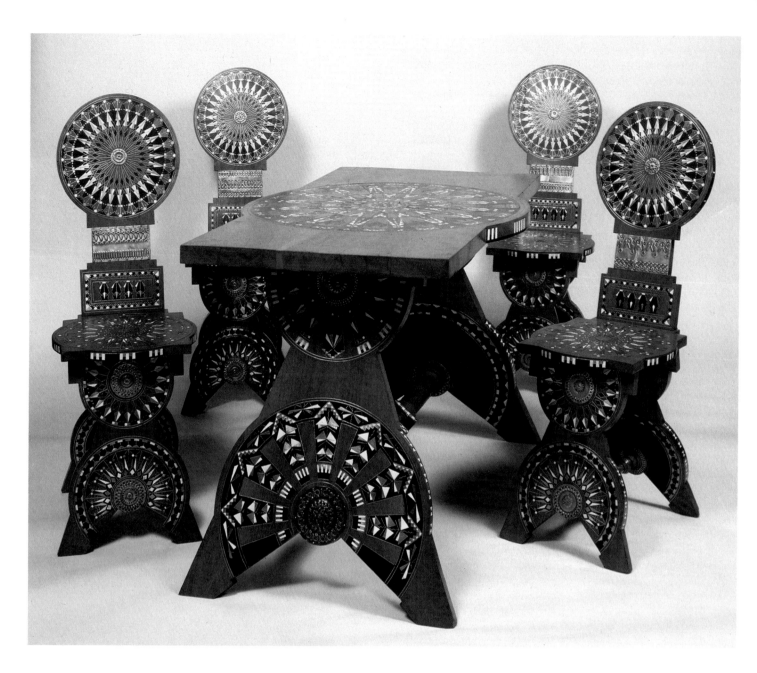

cabinet designed to house the crown of Italy and the restoration of the choir of Todi Cathedral in 1880.

Roman furniture dating from the second half of the 19th century showed a predilection for the Neo-Baroque style, known in the capital as *Barocco di Pio IX*. In Rome, the heartland of Baroque art, this hybrid style was characterized by grandiose and sumptuous shapes, accentuated by an abundance of inlays and gilding. Some particularly lavish items, including entire suites of lacquered and gilded furniture in the Neo-Baroque and Neo-Ro-

coco styles, were made after 1870 for the state rooms of the Palazzo del Quirinale, home of the Italian royal family in Rome.

The southern regions

Neapolitan furniture-makers were ahead of the northerners Borsato and Basoli in starting a trend towards medieval styles. In some of the secretaires and display cabinets at the Palazzo Reale, dating back to as early as 1820, Neoclassical motifs appear alongside Neo-Gothic elements. Another example is the large

Neo-Gothic bookcase in olive wood and other woods of varying grains built for the Marquis Taccone di Stizzano.

There were also later manifestations of the Baroque taste typical of the Late Romantic period, of which the leading exponents were the architects Antonio and Fausto Niccolini, followers of Gaetano Genovese. Their flamboyant, bulbous furniture, was overloaded with ostentatious carving and gilding.

In Sicily in the second half of the 19th century, furniture in the local tradition came to the fore. The glittering opulence of the

decorative carvings and inlays which characterized contemporary Sicilian pieces harked back to the splendour of the ancient Swabian, Norman, Bourbon and Murat courts. Sicilian furniture-making, like that of Liguria and Naples, was strongly influenced by the presence of foreign, especially English, craftsmen, who lent sobriety and elegance to local pieces made for a middle-class clientèle. In mid-19th-century Palermo, meanwhile, virtuoso cabinet-makers such as Salvatore Valenti and Salvatore Coco developed carving and inlay to a fine art.

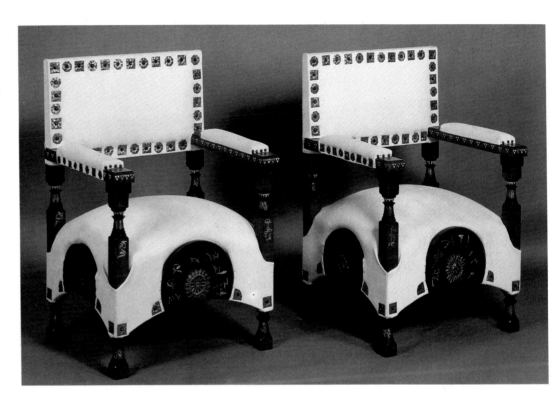

While Valenti's work was unknown outside Sicily, Coco gained an award of merit at the 1861 All-Italy-Exhibition in Florence, also distinguishing himself in 1867 in Paris, where he exhibited an exquisite walnut cabinet decorated with a plethora of subtle and delicate bas-reliefs. Coco undertook numerous commissions for Palermo's aristocracy, creating Medieval- and Norman-style seat furniture with arms in the shape of lions and back-rests in the form of spread-winged eagles. For Queen Margherita of Savoy, he made a walnut and ebony writing desk, decorated with Sicilian agates, with the collaboration of Marco Ciappa, a student at the technical school in Palermo, who executed the desk's chased silver ornamentation.

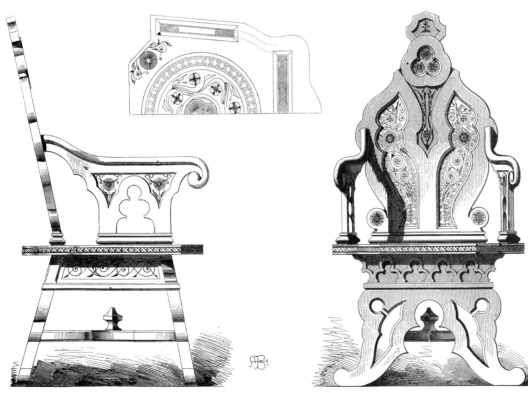

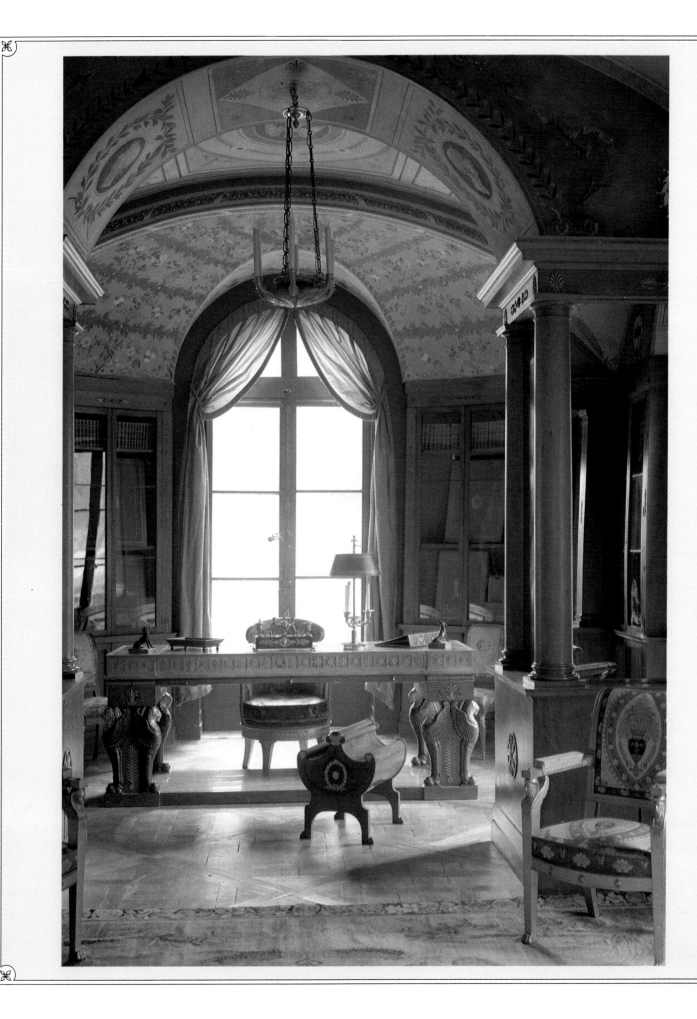

Furniture of the 19th Century

France

by Adriana Boidi Sassone

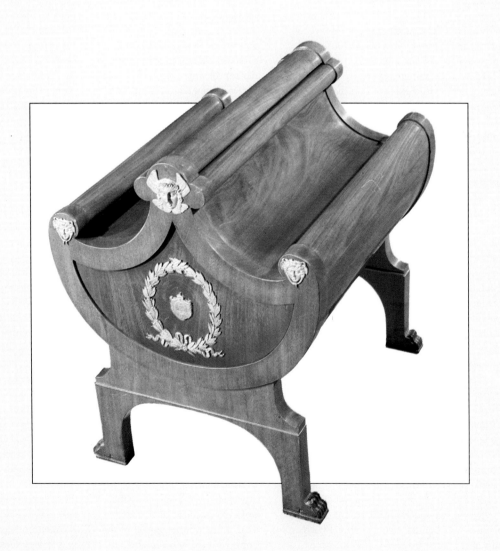

The origins of the Empire Style

In recent years, critics have called for a reassessment of furniture not just for its museographic interest but also its value as historic evidence showing the evolution of taste in French society through the works of first-rank artists, viz. the *ébénistes* (cabinet-makers) and *menuisiers* (joiners) active from the end of the 18th century to about 1870.

Throughout the 19th century there was clearly an enthusiastic exchange of ideas between artists, artisans and clients. Teamwork of the highest order and a continuous dialogue between the fine and applied arts is revealed by the harmonious relationship between structure and decoration. So persuasive were the results that France was to influence European aesthetic taste for decades.

Politically, the Directoire only lasted four years, from 1795 to 1799, but the regime's aesthetic ideals, which originated in the Reign of Terror (1793–94), survived until the introduction of the Empire style, which was firmly established by about 1810.

The parable of the Revolution was over, but France was not to find in the political regime of the Directoire the force needed to restore the country to normality. The political upheavals caused prices to escalate, so that sustained and profitable artistic output was impossible. Only a handful of *parvenus* could afford to furnish their homes with furniture put up for sale or auctioned off from the former royal palaces and châteaux abandoned by the aristocracy. The desire for unrestrained luxury was completely at odds with the conditions endured by most French citizens.

Stylistically, Directoire furniture was a much simplified version of Louis XVI, anticipating the forms of the Empire style. Genre paintings by such minor French masters as Louis-Léopold Boilly (1761–1845) and Marguerite Gérard (1762–1830) show late 18th-century interiors all furnished in a very similar manner. The society of *nouveaux riches* set the trends, with feminine tastes, particularly those of Joséphine Bonaparte, predominating.

Continuity and renewal

The suppression of the French *Corporation des Menuisiers-Ebénistes*, or Guild of Joiners and Cabinet-makers, by the decree of 13th February 1791 did little to hinder the activities of its former members, who were now free to set up their own high-class workshops. Among them was Georges Jacob (1739–1814), who had made furniture for Marie-Antoinette, the Comte d'Artois and the King's cousin, the Duc de Chartres. Liberated from the strict rules and regulations imposed by the craft guild, Jacob was finally able to produce works which, although much simpler, were just as fine of those made in earlier years.

As one of the last 18th-century *menuisiers* and one of the first to produce Empire furniture, Jacob was among the best chair-makers in Paris, and from 1780 onwards he had many foreign clients, especially English. For his mahogany pieces, he appeared to prefer the so-called Etruscan style, decorated with palmettes and other "antique" motifs. In 1788, he made a set of chairs and a couch for the studio of the painter Jacques-Louis David at the Louvre, using the same Graeco-Roman decorations as appear in David's own works, *The amours of Paris and Helen* (1788) and *The Lictors bring Brutus the Bodies of his Sons* (1789), now in the Louvre.

In 1796, Jacob handed over the business to his sons Georges II (1768–1803) and François-Honoré-Georges (1770–1841), known as Jacob-Desmalter. Jacob Senior continued to act as consultant, lending his prestigious name to the many pieces of furniture built in the family workshop for the consular apartments at the Tuileries. The maker's mark "Jacob Frères" was used until the premature death in 1803 of the elder son Georges. After this, Jacob *père* was obliged to resume artistic control, aided by François-Honoré-Georges. The younger son was a cultivated and refined young man who proved to be a gifted designer, creating harmoniously proportioned case and seat furniture in mahogany, with exquisite ebony inlays and steel mounts, as well as some items in lemon-wood.

In 1797, the first of a series of French manufacturing trade exhibitions was held in the courtyard of the Louvre. Among the exhibitors were cabinet-makers who had already been active at the court of Marie-Antoinette. One such was the German-born craftsman Jean-Guillaume Beneman (or Benneman), active between 1784 and 1811, attaining master *ébéniste* status in 1785. Despite his earlier clients, he continued to work throughout the Revolution, the Directoire and the Consulate, achieving a rather unexpected fame. Inspired by the work of Joseph Stöckel, Beneman, a fine cabinet-maker of the Louis XVI era, made mahogany or elm furniture which featured claw feet, caryatids with Egyptian-style heads and elegant copper mounts. Some examples can be studied at the Louvre and in the Wallace Collection in London. Often mentioned is a commode-secretaire bearing his stamp designed by Charles Percier, now preserved at the château of Fontainebleau. Another piece worth singling out is the purple-wood desk and vitrine in the Palazzo Madama in Turin, signed "G. Beneman" and executed under the supervision of the sculptor Jean Hauré, datable to 1785–90. It is decorated with gilt bronze mounts, possibly chased by Thomire or Forestier, with corner caryatids, extremely finely-worked bases and capitals and a crest pavilion with sphinxes.

Ebénistes of the Ancien Régime

Other major figures to emerge during this period beside George Jacob and Beneman were Adam Weisweiler (c. 1750–1810) and Bernard Molitor (d. 1833).

German-born Weisweiler, who had settled in Paris, became a master *ébéniste* in 1778, and worked mainly for the dealer Dominique Daguerre, supplier of furniture to Marie-Antoinette and the royal palace at Saint-Cloud. Weisweiler also made items of furniture for the residence of the Prince Regent, Carlton House, now preserved at Buckingham Palace. He specialised in secretaires (examples in the Metropolitan Museum in New York and the Rijksmuseum in Amsterdam), *bonheur-du-jour* desks, consoles, *guéridons* and commodes with spindle legs. Despite having had

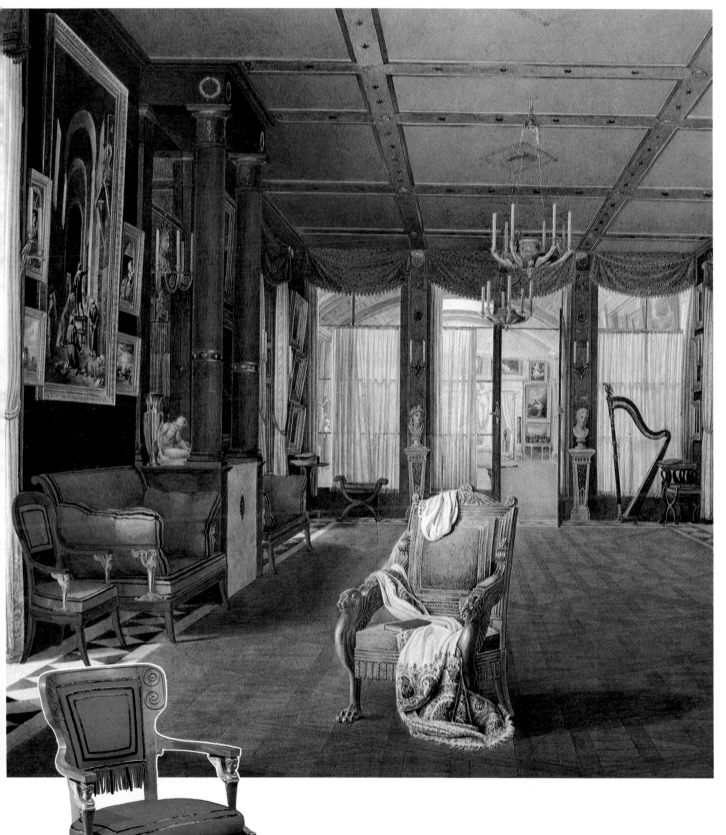

ABOVE: watercolour by Auguste Garneray (1785–1824) showing the Music Room at the Château de la Malmaison as it was in 1812. The room is elegantly furnished in the Empire style. The furniture includes the chair shown on the left, bearing the maker's mark of Jacob Frères. PREVIOUS PAGES: paper rack with the coat-of-arms of Joséphine Beauharnais bearing the stamp of Martin-Guillaume Biennais, and the Library at the Château de la Malmaison.

BELOW: *secrétaire à abattant*. FACING PAGE, ABOVE: *en suite* cabinet-commode, made for the Music Room at the Château de Malmaison in "flame" mahogany. Both pieces are decorated with a frieze of gilt-bronze *putti* and festoons, Classically-inspired mounts representing trophies of war. Both Château de Malmaison. FACING PAGE, BELOW: triumphal arch writing table (c. 1800) by Jacob Frères based on a design by Percier and Fontaine, with three-dimensional Winged Victory figures at each corner. Musée National du Château de Versailles et du Grand Trianon.

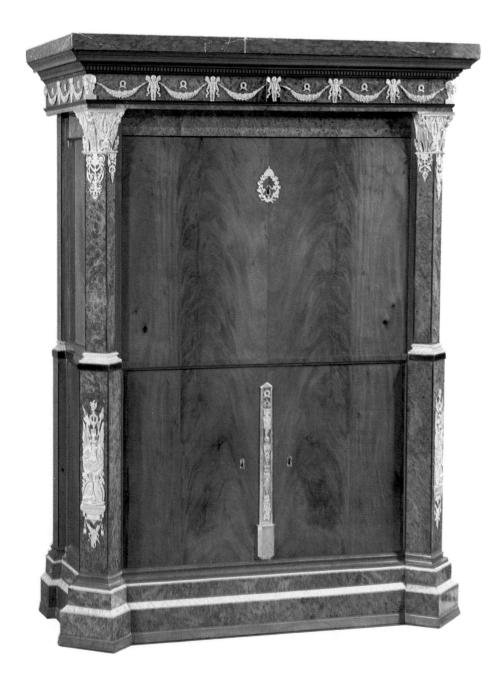

A furniture-maker in the style of Georges Jacob to gain fame was Claude Séné (1747–1803), even though in reality most of his chairs were designed by Gondouin and Dugourc. Séné was responsible for furnishing Marie-Antoinette's bedroom at Fontainebleau in 1787, as one of the last projects to be commissioned by the Ancien Régime. He continued to work after the Revolution and during the Directoire, leaving behind a series of bureaux for government functionaries but above all large mahogany chairs modelled on those produced by Georges Jacob, with fluted legs and arms supported by caryatids and griffins.

The triumph of the "antique"

Engravings in the *Journal des dames et des modes* and the *Collection de meubles et objects de goût*, published by La Mésangère between 1802 and 1835, still showed furniture in the Louis XVI style, although shorn of its former splendour. The so-called "Etruscan" style was now all the rage. The Antique or Classical style that the Consulate foreshadowed was already in evidence in 1778 in Jacob's furniture designs for David's studio. The style was directly inspired by relics of classical antiquity that figured in sketches by travellers returning from Italy and were widely disseminated by Napoleon's architects Charles Percier and Pierre Fontaine in a series of plates published in 1801/02.

Just as the prettiness of the 18th century was giving way to the grandiosity of the official style, so political circumstances

so many royal patrons, even during the Revolution Weisweiler was left to ply his craft in peace, and la-ter became one of the most renowned cabinet-makers of the early Empire period, working closely with the bronzesmith Pierre-Philippe Thomire. To-gether they produced a number of items for the Château de la Malmaison.

Another German to move to Paris was Bernard Molitor, who arrived with his brother Michel (1734–1801) in 1773, obtaining his *maîtrise* in 1787. After the Revo-lution he was recognised as one of the most brilliant exponents of the Directoire and Empire styles, best known for his mahogany chairs with ebony inlays and gryphon heads and other "an-tique" motifs (Musée Marmot-tan, Paris).

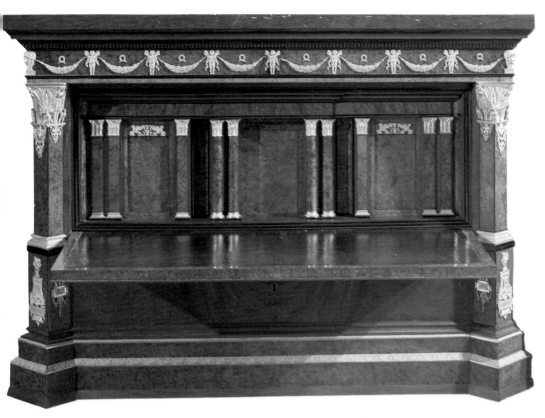

work of Adam and Sheraton continued to influence French furniture production during the Directoire and the Consulate. Similarly, the English Regency style owed much to French influence. Despite the resumption of Anglo-French hostilities between 1803 and 1815 and the Continental blockade of 1806, ideas still flowed between the two countries.

also favoured the trend in the arts towards a classicizing decor that was to spread throughout Europe. In 1798 Napoleon returned triumphant from his Egyptian campaign. The victory launched a programme of intense scientific research, prompted by the large numbers of archaeological discoveries collected in Egypt by the throng of scholars accompanying the expedition. The worlds of fashion and the applied arts also took up the Egyptian theme, with motifs such as sphinxes, winged lions, lotus blossoms, caryatids and scarabs appearing everywhere. All over Europe, Egyptian motifs, as well as those drawn from Ancient Greece and Rome, were to become prominent features of the sumptuous Empire style of decoration. Of some importance in the ferment that was generating an international taste were commercial contacts with England enshrined in treaty since 1786, which encouraged exchanges between collectors, dealers and travellers. Interrupted by the war, they were resumed in 1802 following the Peace of Amiens, so that the

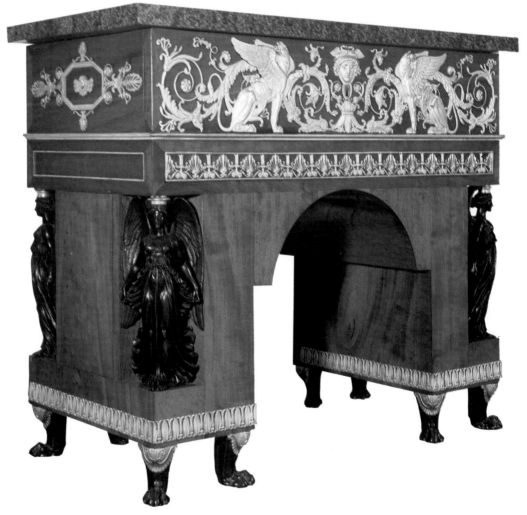

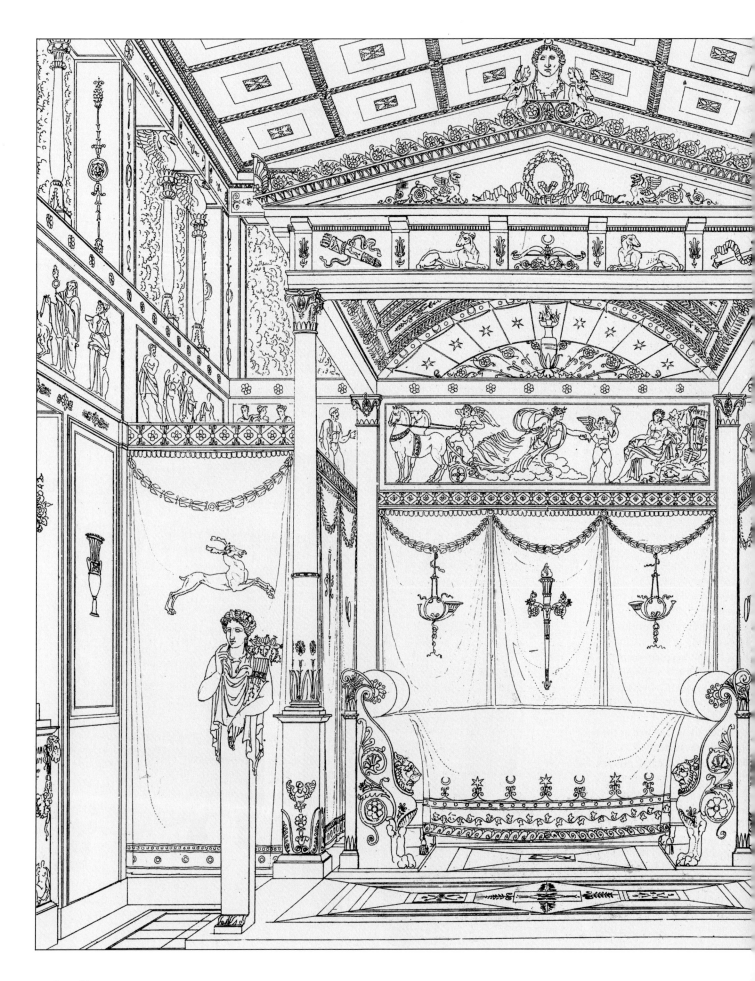

Classical styles

Directoire

Under the Directoire, decorative motifs not only included symbols of the Revolution such as the Phrygian cap, the lictor's fasces, pikes, oak leaves, clasped hands, cockades and cockerels, but also urns and amphorae, arrows, sirens and gryphons drawn from the world of antiquity. The classical allegorical female figures representative of Fame and Dawn were also used to symbolize the coming of a new era.

Most Directoire furniture was made in workaday woods like elm, walnut, fruitwoods and beech. The exceptions were the luxury items in solid mahogany or mahogany veneer, embellished with brass rather than bronze mounts. Ornamentation was restrained, and did not detract from the sober, geometric lines and very gentle curves. Angle pilasters, caryatids and chimeras, placed at the corners of larger items such as secretaires, commodes and console tables to add a touch of lightness to the severe profile, were the most frequent choice of adornment. Handles were oblong.

Stylistically, commodes, built *en suite* (i.e. in matching style) with secretaires, tended to be somewhat lacking in imagination. Rectangular with flat fronts and sides, they had marble tops with bronze palmette and rosette mounts, and the front uprights took the form of plain columns.

There were, however, some exceptional, more refined pieces signed by Georges Jacob. Among them was a veneered mahogany commode dated 1795 (Lefuel Collection, Paris), with several drawers separated by horizontals and ornamented with inlaid

swans, set on a contrasting citrus wood ground. The frontal uprights are in the form of caryatid monopodia, patinated in dark green to resemble antique bronze.

Besides bow-fronted console tables such as the typical mahogany piece by the Jacob Brothers with ebony and pewter inlays (Musée National du Grand Trianon, Versailles), there were rectangular versions supported by slender columns with chimeras in lemon wood and fine copper

castings (Musée des Arts Decoratifs, Paris).

The *Journal des dames et des modes* provides examples of the types of bed in vogue during the Directoire. They include the *lit à l'antique,* usually built of mahogany, whose single headboard would have a broad decorated cornice curving outwards; and the *lit à la turque,* which had head- and foot-boards of equal height and short tapered legs, and a connecting dado decorated in

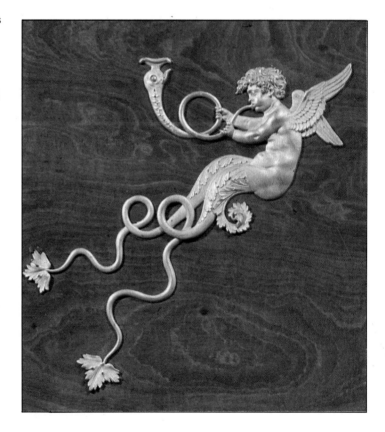

FACING PAGE: design for a bedroom from the 1801 edition of Napoleonic architects Charles Percier and Pierre Fontaine's *Recueil des décorations intérieures.* ABOVE: gilt bronze *putto*, detail of a mount on a commode-secretaire made for Napoleon by the cabinet-maker Beneman to a Percier and Fontaine design. Musée National du Château de Fontainebleau.

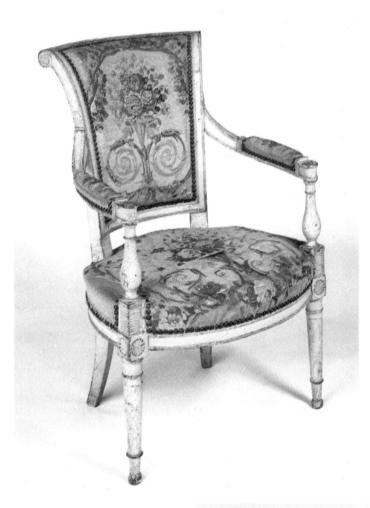

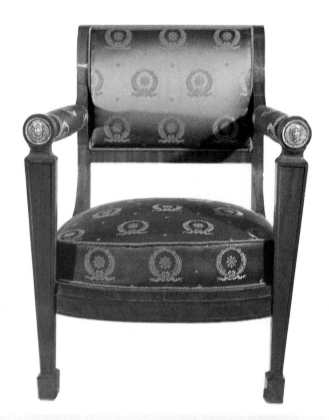

the centre with a carved rose set in a lozenge. Day-beds or *méridiennes* were long and narrow, with out-scrolling headboards and sabre or spindle feet. One mahogany day-bed built by Bernard Molitor had a single *à crosse* – or scrolled – headboard and lion's paw feet.

Although it did not disappear completely, marquetry was no longer in fashion, although some discreet inlays in pale citrus wood, maple and sycamore were occasionally used. Cabinet-makers contented themselves with brass mouldings or a copper ring handle. Wood, carved and gilded or painted in "antique green" or imitation bronze, was often used instead of the real bronze reserved for luxury Graeco-Roman-style furniture. One accomplished *bronzier* was Pierre Gouthière (1732– c. 1812.), who produced mouldings, rings, laurel wreaths and profiles enclosed in medallions for use as mounts.

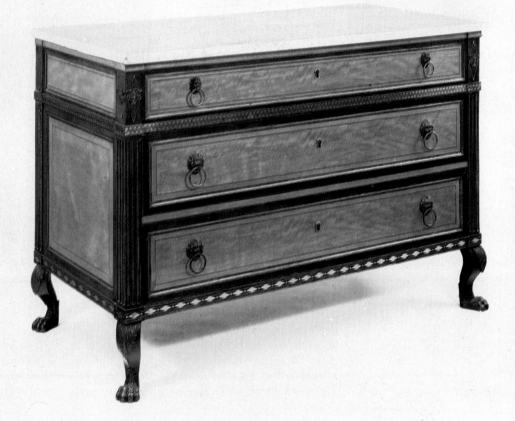

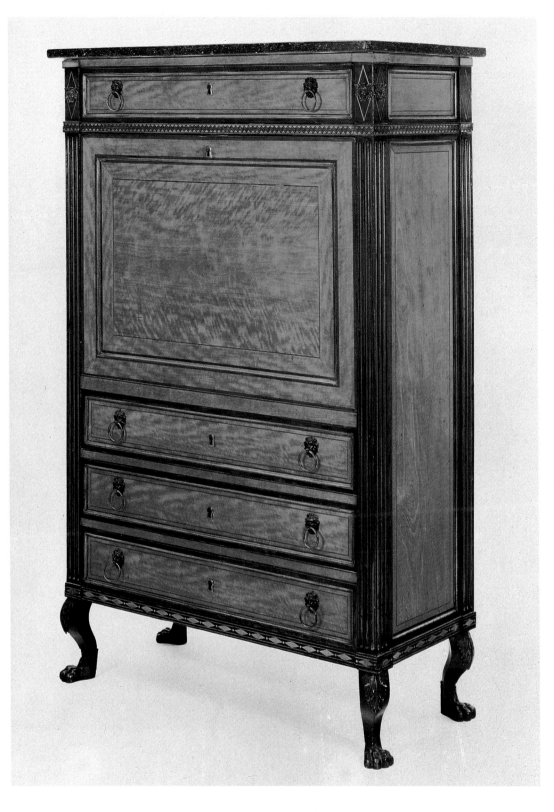

ABOVE AND FACING PAGE, BELOW: two matching pieces of Directoire furniture: a *secrétaire à abattant*, and a commode in mahogany and citrus wood with copper stringing and lozenge inlays. The Mercury masks, mounted on the angular fluted uprights, are in bronze. These simple and elegant pieces stand on elongated paw feet, with S-curves which retain a hint of 18th-century refinement. Both antiques trade.

The *guéridon*, or small, round table with a single pedestal support, had changed little since Louis XVI's day, but now chimeras, gryphons and sphinxes adorned the base of the pedestal, heralding the Empire style then developing. There were also round mahogany tables, some with marble tops, supported by a pedestal on a triangular base. One example is a mahogany table (Lefuel Collection, Paris) made by Jacob between 1790 and 1792. The circular top is veneered and inlaid with a star in ebony and citrus wood, and decorated with palmettes and a denticulated frieze round the edge. It is supported by a column decorated with lattice-work containing gilt flowers on a dark green ground. The triangular base has claw feet.

Other items typical of the period were worktables and *jardinières*, or flower-pot stands. The *secrétaire à abattant, bureau à cylindre* and *bonheur-du-jour*, built out of solid wood with flat sides, tended to supplant other types of desk. Instead of inlaid work, they were decorated with terms on tapered pilasters or simple columns.

Curved chairs *à gondole* were a Directoire innovation, although straight Louis XVI-style chair-backs were still much in evidence. With their curved, rounded backs, gondola chairs imitated chairs appearing in Greek vase decorations. Curved, scrolled chair-backs were often pierced to create delicate *treillages* or trellises or, more rarely, a lyre-shaped splat, such as those built by Jean-Baptiste Sené. Crest rails were rounded off, as on the chair signed "Jacob Frères" (1796–1803) in the Lefuel Collection. Occa-

Empire bronzes

From the 18th century onwards, gilt bronze was very widely used in the production of household furnishings, ornamental objects, clocks and in the inexhaustible array of decorative mounts for furniture. French craftsmen achieved elegant, perfectly executed designs which have never been equalled. Among the most famous artisans was Pierre-Philippe Thomire (1751–1843), a *bronzier* who was one of the most sensitive interpreters of the Empire taste. He began his career in the reign of Louis XVI at the workshop of Pierre Gouthière (1732–1813/18). From 1790 he worked closely with the *ébéniste* Beneman, becoming the main supplier of bronzes for the royal residences, and under Napoleon, France's most celebrated bronzesmith. In 1809, his *atelier* employed more than 700 workers. After its founder retired in 1823, the firm of Thomire et Cie. continued to operate until the Second Empire, producing mostly bronze replicas and reductions of famous sculptures.

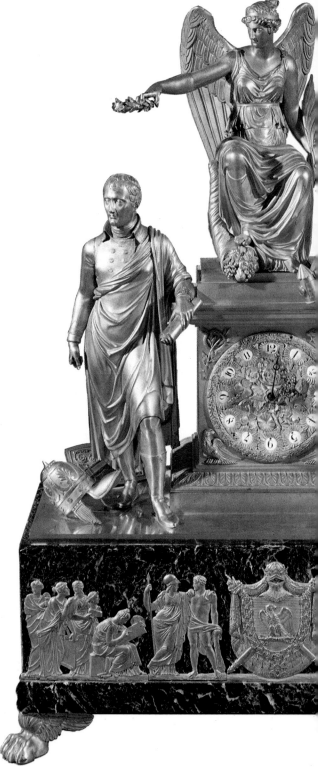

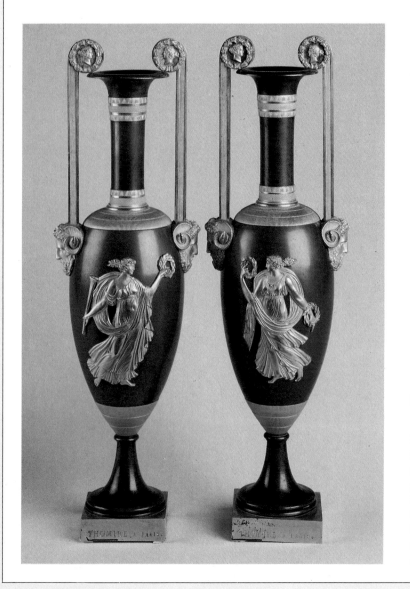

LEFT: pair of amphorae, with "Thomire à Paris" inscribed on the base, in finely chased gilt bronze and patinated bronze, decorated with Classical female figures. ABOVE: the clock known as *Pendule de Diogène*, depicting the coronation of Napoleon, First Consul, by the figure of Victory, while the philosopher Diogenes extinguishes the lamp. FACING PAGE, ABOVE: two gilt-bronze firedogs, one in the form of a Roman helmet bound with a laurel wreath, the other a crouching panther mounted on a base decorated with a Classical scene. All Musée National du Château de Malmaison.

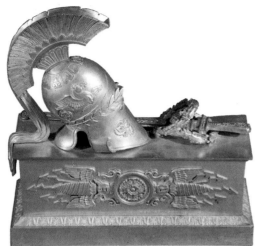

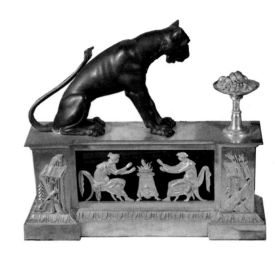

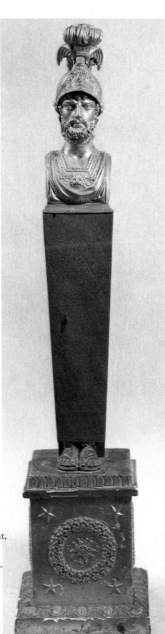

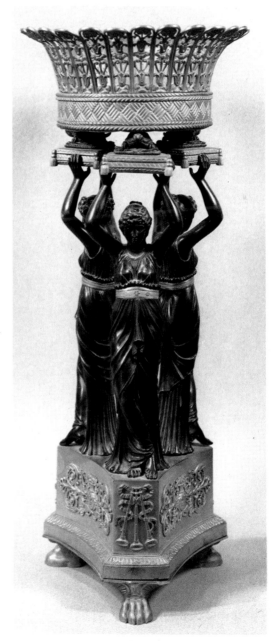

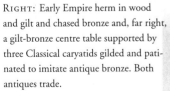

RIGHT: Early Empire herm in wood and gilt and chased bronze and, far right, a gilt-bronze centre table supported by three Classical caryatids gilded and patinated to imitate antique bronze. Both antiques trade.

sionally, the stiles were pointed at the corners in chairs *à cornes*. The archaeological influence was revealed by the shape of the legs, with those at the front being straight, tapered or balustered, while the back legs were sabres in the classical manner. Curule chairs, modelled on X-frame stools used by the Ancient Roman magistrates, were relatively rare, while elegant, comfortable *bergères*, with upholstered backs and arms and furnished with a down cushion, lingered on from the days of Louis XVI.

Around 1800, mahogany was in widespread use, for both interior decoration and furniture, being elaborately carved on more refined pieces. It had been employed as a material since the days of Louis XVI. However, in 1806 it disappeared from the French market when Napoleon's naval blockade of England prevented its importation.

The Consulate

In 1802, Napoleon's appointment as First Consul for life marked both a return to the pomp, ceremony and court protocol associated with the Ancien Régime and the beginning of the splendours of the Empire. The First Consul commissioned the architects Percier and Fontaine to decorate and furnish the Council Chamber at Malmaison in the "Roman" style. The prudent policies of the Consulate in the early years of the century reassured the middle-classes, engendering an atmosphere of calm serenity. The decorative arts, especially cabinet-making, were revitalised and the master craftsmen who had established reputations during

Louis XVI's reign were flooded with orders.

In this respect, the period of the Directoire and the Consulate, though brief, constituted a crucial phase in the art of furniture-making. It produced a transitional style which still appears attractive in its calculated elegance, the result of the search for novelty by artists who had worked under the Ancien Régime and remained nostalgic for 18th century grace and charm.

The spectacularly successful exhibitions of French manufactured goods of 1801 and 1802 in the courtyard of the Louvre, which the First Consul championed as an opportunity to "revitalise commerce and industry", drew many visitors from abroad. The quality and originality of the works produced by the Jacob brothers and Jacob-Desmalter's father-in-law, Martin-Eloy Lignereux, attracted special attention, and they were awarded a gold medal in Year IX (cf. *Rapport du ministre Chaptal*, Anno IX and Anno X, 1802).

The Consulate style was palpably a transition. It presented a degree of instability in leaving a choice between forms of the Directoire and those that would constitute the basis of the Empire style. The historical dates that mark the duration of the Consulate create further problems in defining the features of the style.

As Praz wrote in *La filosofia dell'arredamento* (The Philosophy of Furniture): "Furniture was more lavish and more varied; sphinx monopod *jardinières*, although inspired by the famous tripods of Pompeii, no longer had an archaeological air [...] fabrics created a new softness [...] The 'antique' style of the Consulate

had an Alexandrian delicacy." There was a Neoclassical revival, kindled by the widespread interest in archaeology, but the perception of antiquity was filtered through the forms of the sculptor Antonio Canova, whom Napoleon invited to Paris in 1802 to portray members of the court in marble, and the work of Napoleon's official architects, Charles Percier (1764–1838) and Pierre-François-Léonard Fontaine (1762–1853).

The excavations at Herculaneum (1738) and Pompeii (1748) had caused great excitement in cultivated circles throughout Europe. Between 1801 and 1802, Percier and Fontaine wrote in their *Recueil de decorations in-*

térieures: "The excavations on the sites of Herculaneum and Pompeii, recovering a multitude of objects which once formed part of domestic furnishing and interior design, increased this taste for imitating the antique even more."

As a result of this fashion for the antique, architects, including Percier and Fontaine themselves, were obliged to take up interior decorating to meet the requirements of their aristocratic clientele. In the introduction to the *Recueil*, a collection of 42 plates first published in 1801/02 and reissued several times between 1802 and 1812, the authors invited readers to examine carefully the

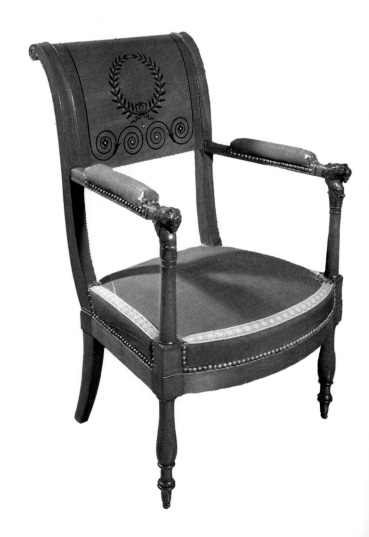

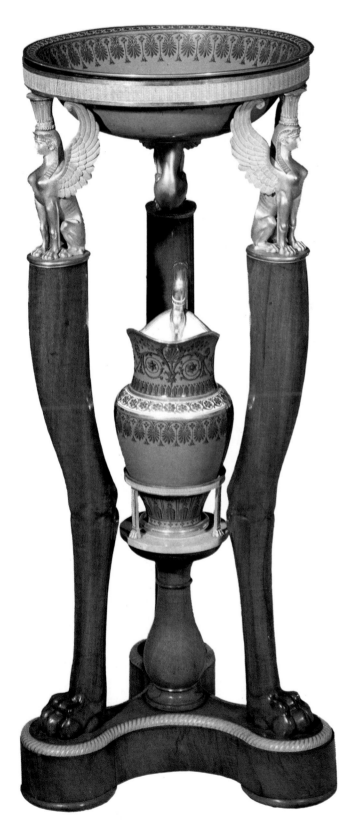

characteristics of the styles of different periods, but to choose among them and adapt them to suit contemporary taste. "The power of fashion, that great dictator of works of art, owes its influence to three things: the first is of a moral nature and arises from the human spirit's love of change: the second is social and depends upon the conventions of our society, in which the desire to give pleasure is strongly influenced by the relationship between the two sexes and likewise the custom of meeting socially purely for diversion; the third is commercial, and concerns the interest of all craftsmen that luxury should become out of date, so that such objects must be renewed more often and trade in them be increased."

The Château de la Malmaison, acquired by Joséphine Beauharnais in 1799, epitomises the style of the period. The charm of its interiors, designed under the supervision of Percier and Fontaine, is skilfully captured by Auguste Garneray in a series of contemporary paintings now in the Musée de Malmaison, Paris. Faithfully interpreting the drawings provided by the two famous architects, the Jacob brothers created furniture of the highest quality, particularly for the Music Room and the Library. These rooms, among the few to have survived to the present day completely intact, were to influence the market for years to come.

As is evident from the plates in the *Collection de meubles et objets de goût* published by La Mésangère in Paris between 1802 and 1835, the Jacob Brothers produced a lot of furniture in this period, while maintaining their high level of craftsmanship.

Beds assumed new shapes, typically the *lit en bâteau* (so called because it curved at either end like the hull of a ship), which sometimes stood on a raised platform. Beds of this type were mostly found in patrician houses, while simple bedsteads like the Louis XVI-style *lits droits* usually ended up in middle-class and rural houses. Two types of bed dating from the Directoire period remained popular: the classically-inspired *lit à l'antique* and the *lit à la turque*. Upholsterers were to play a leading role in the construction of beds. Decorative curtains and hangings in sumptuous fabrics were increasingly used, often supported by posts or suspended from canopies above.

The use of solid mahogany for smooth surfaces highlighted the effect of ormolu mounts on beds and *psychés*, the cheval glasses for bedrooms and dressing rooms which first appeared during the Consulate. These tall, tilting mirrors were framed in wood and supported by two columnar uprights or balusters. The favourite decorative mounts were also classical: terms and sphinxes, swans, rosettes and palmettes.

Another item of bedroom furniture was the *saut-de-lit* or wash-stand, shaped like a classical tripod and equipped with pitcher and basin. A splendid example dating from around 1802 can be seen in Joséphine's bedroom at Malmaison. The blue Sèvres porcelain basin fits into a ring of chased bronze, which is supported by three gilt bronze sphinxes on mahogany legs with lion's paw feet. The blue porcelain pitcher stands on a central baluster.

Other typical Consulate pieces are the Jacob brothers'

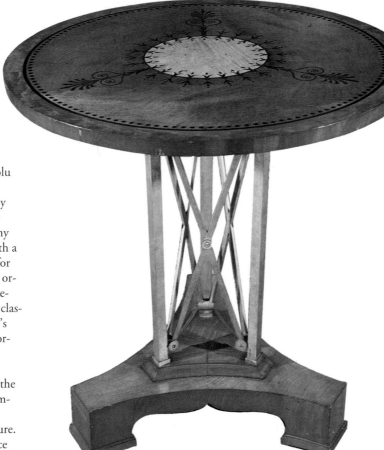

mahogany cabinet with ormolu mounts (Fontainebleau), in which the doors are framed by the top drawer and lateral pilasters, and the 1804 mahogany veneer fall-front secretaire with a top of Carrara marble, built for Saint-Cloud when Napoleon ordered all the furniture to be replaced. It is decorated with a classical representation of Apollo's chariot (Musée des Arts Décoratifs, Paris).

The Directoire vogue for *guéridons* continued through the Consulate, and during the Empire they became an essential item of drawing-room furniture. Typical of the period is a piece made in Paris in 1800 (Musée des Arts Decoratifs) to a design that evokes the elegance of Louis XVI pieces. It is veneered in mahogany, with three bronze supports, partly patinated green to imitate antique bronze and partly ormolu, and a plaque of white and blue Sèvres porcelain on top. The *guéridon* still carries the Saint-Cloud inventory number.

Also commissioned for the First Consul's apartments at Saint-Cloud was a veneered tea table with a central support adorned with palmettes and three colonettes supported by winged lions (Victoria and Albert Museum, London).

Consulate chairs still had rectangular backs with curved crest rails. The front legs were turned in spindle, column or baluster forms, as in the Louis XVI period, while back legs were sabres, in the Greek manner. Sometimes, the back curves towards the top in the form of a volute, with colonettes inlaid with ebony and metal, like the Jacob chairs now in the dining room at Malmaison.

The Empire

The first decade of the 19th century coincided with the incontestable affirmation of French predominance in Europe. Not only did Napoleon provide the fulcrum of court painting – offi-cial commissions were now shared between Gros, David, François Gérard and Ingres – he also dictated artistic tastes as well as political strategy. "In the decoration and furnishing of the numerous palaces, Napoleon was resolute in his desire for grandeur and magnificence, to reaffirm the sense of his Olympian power throughout the continent," comments Alvar González-Palacios *(Dal Direttorio all'Impero* – From the Directoire to the Empire, Milan 1966).

Although we usually regard the Empire style as belonging only to the period when Napoleon was Emperor, in reality

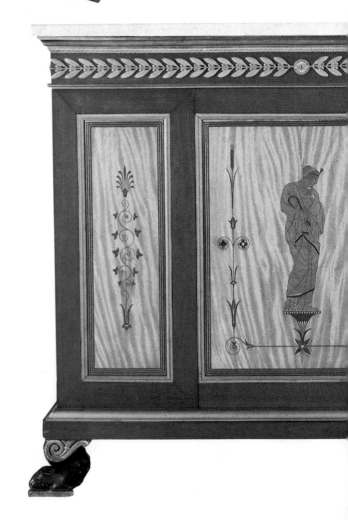

RIGHT: this mahogany and citrus wood *commode à vantaux* (c. 1800–02), with its clean, geometric lines emphasised by polychrome wood, metal and ivory inlays, reflects the general elegance and harmony of Jacob Frères furniture. ABOVE: *guéridon en athénienne* (c. 1804) with mahogany top decorated with inlays, and supported by crossed bronze bars. All Musée National du Château de Fontainebleau.

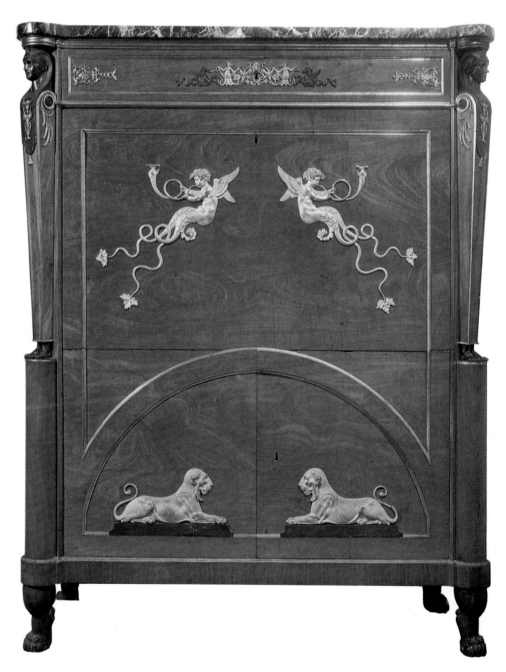

it was not a break with earlier styles, but had its roots in the Louis XVI period and developed, albeit hesitantly, during the Directoire and Consulate periods, reaching full maturity between 1804 and 1815. Its decline set in with the restoration of the Bourbons. Its career described a parabola similar to the evolution of Neoclassicism in Europe. This does not detract from the originality, coherence and refinement of Napoleonic art, the ultimate expression of the glory of a period which chose *la grandeur antique* as the model for its own *grandeur* (Chadenet, *Les Styles Empire et Restauration*).

The Napoleonic style was the standard-bearer of a cosmopolitan and heterogenous society with a taste for splendour and spectacle, centred around the Imperial court in Paris. The furniture in the châteaux at Fontainebleau and Compiègne, the Trianon, the Elysée Palace and the residence of Prince Eugène de Beauharnais in Paris still testify to the extraordinary splendour of a decade in which the cabinet-maker's craft reached its zenith. The history of furniture and social history were never so closely identified as they were during the Empire. The style which began to emerge under the Consulate perfectly reflected both the contemporary evolution in taste and the social mores of the time.

In the transitional period

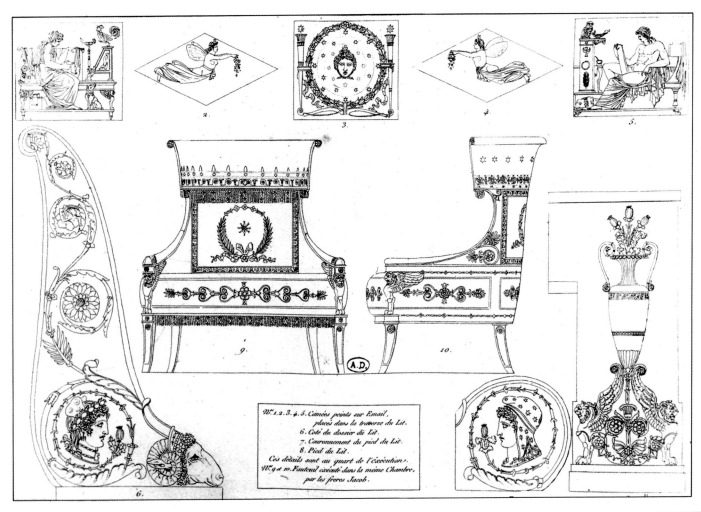

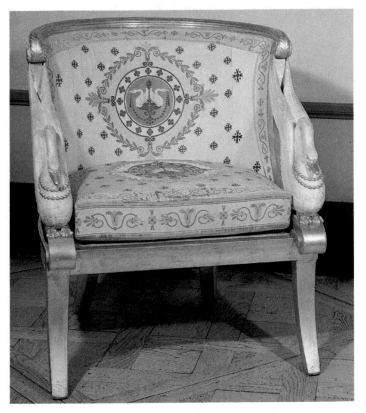

ABOVE: designs from Percier and Fontaine's *Recueil des décorations intérieures* for a gondola chair and various classically-inspired mounts, including enamelled and bronze plaques for the sides, feet and head- and foot-boards of a state bed.

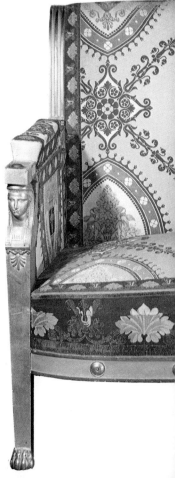

Three pieces by Jacob-Desmalter. LEFT: gondola chair in painted and gilded wood based on designs by Percier, with arms in the form of three-dimensional carved swans, made for Joséphine's apartments at Saint-Cloud. Musée National du Château de Malmaison. RIGHT: *en suite canapé-causeuse* and Lyons silk-upholstered chair in carved gilt-wood, dating from between 1803 and 1805. Musée National du Château de Fontainebleau.

This carved gilt-wood armchair and matching foot stool, upholstered in Lyons velvet, were part of a suite commissioned from Brion by Napoleon (c. 1810) for a drawing room in the Petits Apartements at Fontainebleau. Musée National du Château de Fontainebleau.

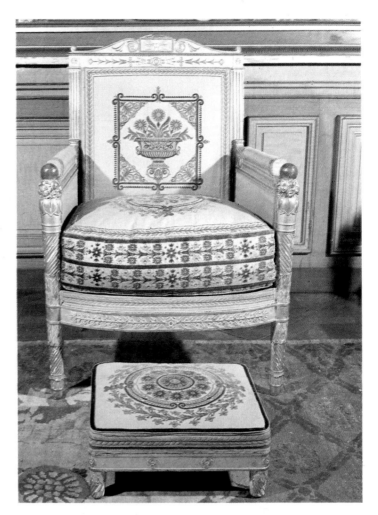

between Louis XVI and the Consulate, the differences in ornamentation were so vague that it is difficult to define the variations in style. As the affectations of the 18th century waned, a new taste emerged for massive and imposing furniture on simple lines, with decorative elements making constant allusions to military campaigns. The new style underlined the authority of the emperor, who regarded the Neoclassical mode as the most suitable medium through which to proclaim his victories around Europe. In his *Coronation of Napoleon* (Louvre) and *Distribution of the Eagles* (Versailles), David, Imperial Court painter from 1805 to 1810, captures the exceptional magnificence of the

style. The Imperial Seal itself bears symbols of power: the imperial crown surmounted by an eagle, the sceptre and the "hand of justice", which were reiterated as decorative motifs on furniture.

The Paris *ateliers*, the main centres of furniture production since the Consulate, now set to work to solicit the patronage of Napoleon and Joséphine. The imperial pair took a lively interest in the exhibitions of *produits de l'Industrie*, where they selected items for refurnishing their various residences. In the years between 1800 and 1813, more than ten thousand workers earned a living in the furniture industry in Paris. In 1807, there were 88 employers, among whom was the famous Jacob-Desmalter, with a

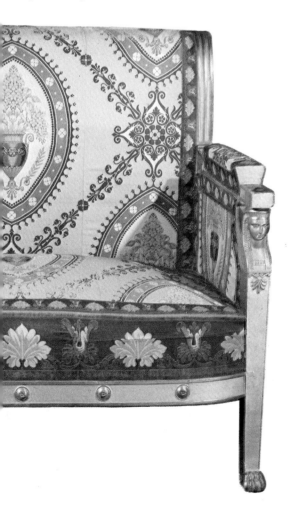

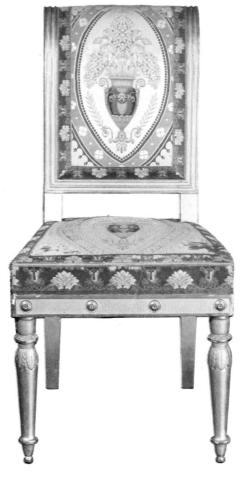

workshop in Rue Meslées. Within the confines of the vast output of these *ateliers*, partly operating under the control of the Garde Meuble Impérial, a taste emerged which fluctuated between severe archaeologically-inspired forms and a certain expressive freedom encouraged by the Romantic movement in the arts.

A court style

In 1810, Napoleon was at the height of his powers and, taking their cue from Paris, practically all the courts of Europe officially adopted the Empire style. The European scene was dominated by the figures of Percier and Fontaine, who set the canons of fashion with the famous plates of their *Recueil* (1801), leaving a lasting mark particularly on production in Germany and Italy, espe-

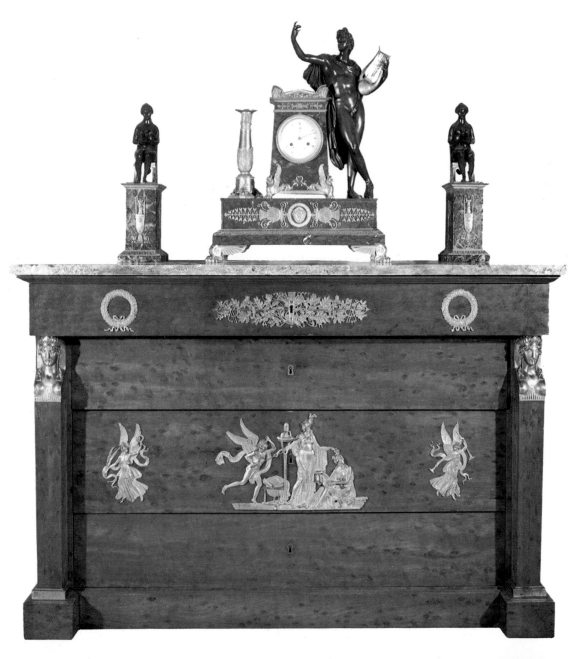

cially in the decoration and furnishing of state apartments. How profound their influence was is indicated by, among other things, the sustained critical acclaim accorded the work, which was republished in Venice in 1843, and an article in the *Gazette des Beaux-Arts* in 1881 by Ernest Chesneau which, while reproaching the authors for "the absence of variety, the lack of agility and imagination […] the constant repetition of the same motifs […] winged figures of repellent rigidity, ill-conceived monsters […]," acknowledged that they had created "a style in the absolute sense". Born between two opposing régimes, the Revolution of 1789 and the restoration of 1814/15, the Empire style can indeed be considered as a French style in the "absolute sense".

Apart from the innovations in form and decoration introduced by Percier and Fontaine, considered the original inventors of forms and decorations for furnishings, a whole host of designers provided model designs for

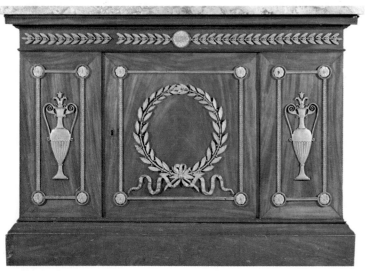

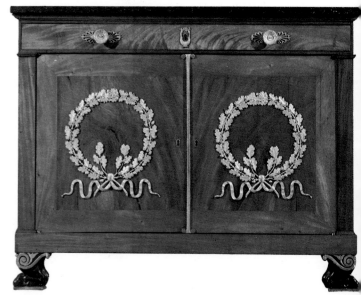

RIGHT AND FACING PAGE, ABOVE: two "plum-pudding" mahogany pieces dating from between 1805 and 1810, bearing the stamp of Charles-Joseph Lemarchand: a *bonheur-du-jour*, or small lady's writing table, with fire-gilt bronze mounts, and a commode. Musée des Arts Décoratifs, Paris. FACING PAGE, BELOW LEFT: *commode à vantaux* by the Jacob Brothers. RIGHT: first Empire mahogany *bas d'armoire* by Pierre-Benoît Marcion. Both Musée National du Château de Malmaison.

furniture *à l'antique*, the same "antique" style which influenced not just the arts but also aristocratic fashions. The designs by Vivant Denon, archaeologist and engraver as well as director of the Musée Napoléon at the Louvre, and Pierre de La Mésangère, author of the *Collection de meubles et objets de goût* (1802–35), which contained some 400 plates of simplified versions of Percier and Fontaine's furniture, had a lasting effect on popular taste and the goods produced for it.

From 1795 onwards, gowns, cameos and jewellery copying those worn by Roman matrons, and hairstyles like those of Horace's sisters in David's *Oath of the Horatii* became the height of fashion. Bedroom furniture like that shown in Isabey's watercolour of 1811, in which Napoleon is seen placing his newly-baptised son in Marie-Louise's arms, was also inspired by antiquity.

Empire *ébénistes*

How busy sculptors and *ébénistes* were can be gauged from the Mobilier de la Couronne's vast expenditure on furniture for the imperial palaces between 1810 and 1811. More than half a million francs were paid to Jacob-Desmalter alone for the furniture for the Palais des Tuileries.

Though the 1806 industrial exhibition held at Les Invalides was a triumph for Jacob-Desmalter, there were other notable craftsmen among his contemporaries, such as the Bellangé brothers, Pierre-Antoine (1758–1837), who became a *Maître-ébéniste* in 1778, and Louis François (1759–1827). Their separate workshops were later both inherited by Pierre-Antoine's son, Alexandre-Louis (1799–1863). The brothers were careful to maintain distinct characteristics in their products: one was renowned for his use of dark woods, especially mahogany, while the other was noted for pieces decorated with porcelain and, later, for Boulle-style furniture.

Another cabinet-maker considered a favourite of Napoleon's was Pierre-Benoît Marcion (1769–1840), whose "Aux Egyptiens" workshop in Paris operated between 1798 and 1817. In 1809, he and Jacob-Desmalter collaborated on the furniture for the Grand Trianon at Versailles, examples of which are now at Malmaison, Compiègne and Fontainebleau. Marcion is also remembered for the furniture of the Palazzo di Monte Cavallo in Rome.

His contemporary Adam Weisweiler, who worked in Paris as *Maître-ébéniste* from 1778 and was the favourite cabinet-maker of Queen Hortense, Napoleon's stepdaughter and sister-in-law, for whom he made jewel caskets in 1806, is credited with pieces commissioned by Napoleon's younger sister, Caroline Murat in Naples. They include a "plum-pudding" mahogany commode, a *bonheur-du-jour* and a large *bureau plat* (a flat writing-desk).

Martin-Guillaume Biennais (1764–1843), with an *atelier* "Au singe violet" in the Rue Saint-Honoré, was another of Napoleon's favourites, for whom he produced some fine goldwork, such as the liturgical plate for the Emperor's marriage to the Archduchess Marie-Louise. Though also an outstanding cabinet-maker, his real forte was as a

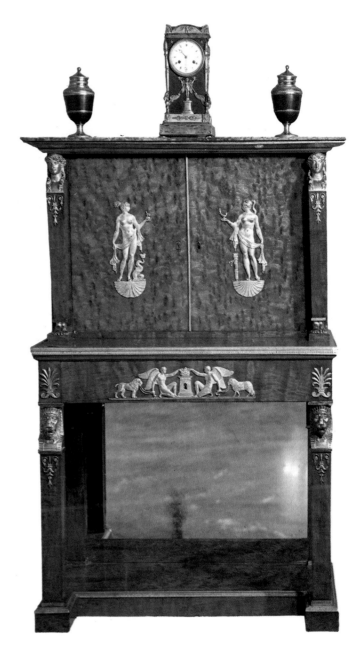

tabletier, a maker of very small objects. He made some charming *nécessaires* (travelling cases) and card tables and a paper rack bearing Joséphine's coat-of-arms, now at Malmaison. Biennais's *nécessaire* for Napoleon of 1806 (Musée des Arts Décoratifs) measures 14 x 54 x 35 cm and has 86 containers and compartments. Other carvers besides Pierre-Philippe Thomire (1751–1843), already mentioned as a major *bronzier*, include Pierre-Gaston Brion, active until around 1838, and Rode (active from about 1765), who, working for the

Garde Meuble Impérial, constructed the Emperor's bed at Fontainebleau, as well as a number of chairs and *tabourets* (stools). Furniture dealers played a major role in setting fashions and guiding consumer taste. Antoine Thibaut Baudouin led the market from 1802, transferring his business in 1811 from Rue de la Grange-Batelière to the Hôtel de Choiseul. Among the finest pieces left to posterity by Baudouin are an elm desk and a toilet table (Musée des Arts Décoratifs, Paris.)

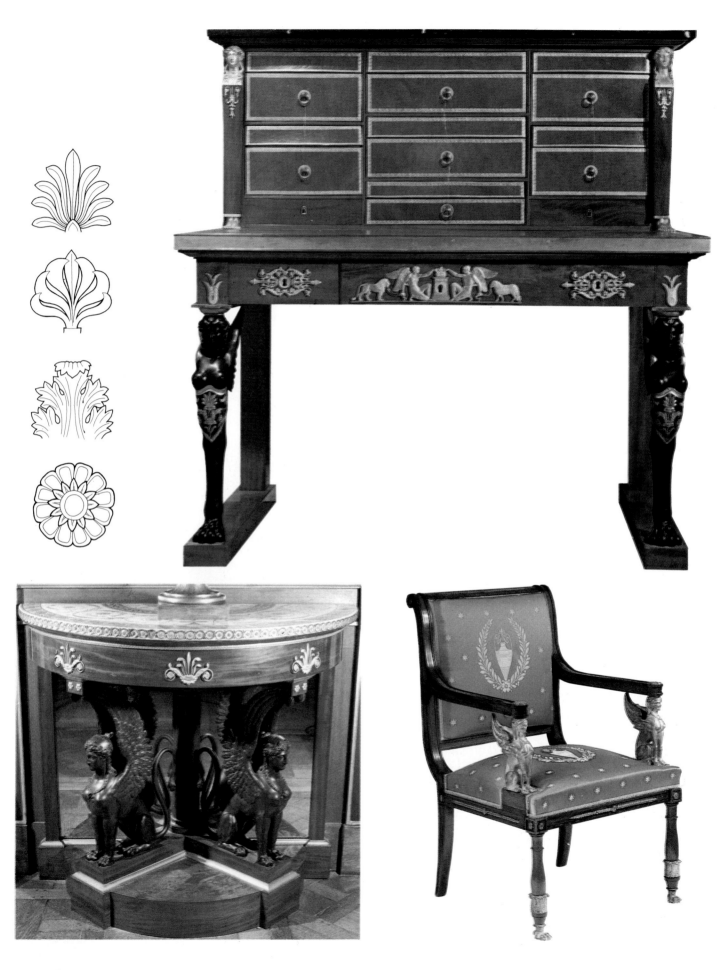

FACING PAGE, FAR LEFT: Classically-inspired decorative motifs from the Empire period. LEFT: the stylistic features shared by this mahogany writing desk and the *bonheur-du-jour* and commode on the previous page suggest it can be attributed to Charles-Joseph Lemarchand. BELOW LEFT: a large mahogany console by Jacob-Desmalter, Musée National du Château de Malmaison. BELOW RIGHT: right, mahogany chair (c. 1810). THIS PAGE: "flame" mahogany commode, dating from 1809/10. Musée National du Château de Versailles.

Styles and types of furniture

Under Napoleon, interior design was rigorously uniform. Forms of furniture were based on architecture. This is particularly evident in the commodes, console tables and secretaires, which in the severity of their rectangular and geometric lines emphasize the stateliness of the Empire style.

The rigidity of line was relieved by sculptural ornamentation in wood or bronze or, in the case of console tables and fireplaces, gesso or marble, which emphasised the bases of *guéridons*, the capitals of columns and pilasters on the fronts of commodes and secretaires and the prominences on wood wainscoting.

While preserving their rectangular structure, console tables resorted to an interesting variety of supports: the two front legs are carved with zoömorphic motifs, while the back legs are simple pilaster supports. To produce an even grander effect, consoles were often matched by imposing looking-glasses.

For interiors of the *élite*, coloured marble tops with porcelain plaques and fitted ormolu mounts were used as decoration. A typical example is the console table signed by Lemarchand (1759–1826), now at Malmaison but originally from the apartments at Saint-Cloud. As in Louis XVI, commodes might be *à tiroirs* (with drawers) or *à vantaux* (with doors concealing the drawers). Commodes might be rectangular or bow-fronted, usually framed by two pilasters in the form of caryatids or sphinx-head

terms, with ormolu mounts featuring heroic or mythological motifs. One quite exceptional piece was the cabinet-commode made by Simon Mansion for the Music Room at Malmaison. It features a frieze adorned with ormolu festoons and multiple colonnettes. Commodes usually came with a matching fall-front *secrétaire à abbatant*.

Tables were regarded as prestige items, judging by some distinguished examples such as the octagonal *guéridon* in the *Salle Dorée* at Malmaison, signed by

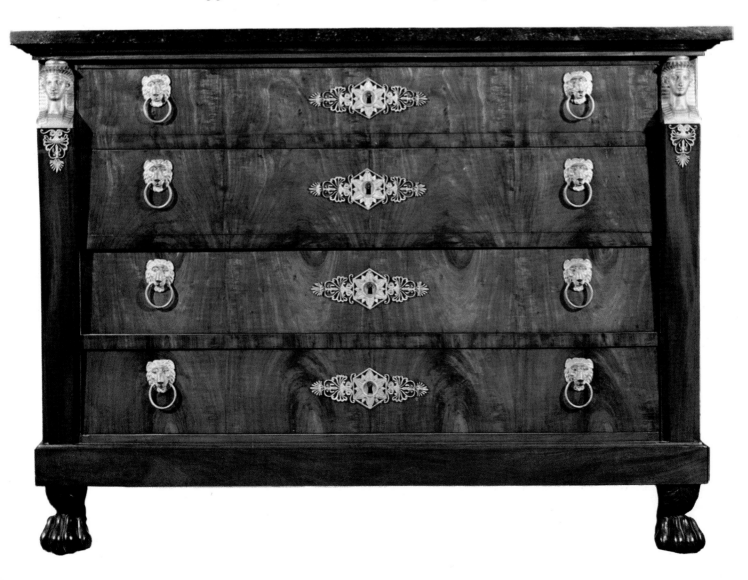

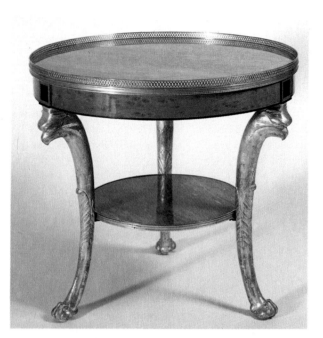

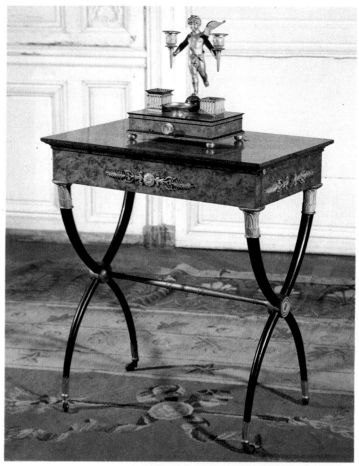

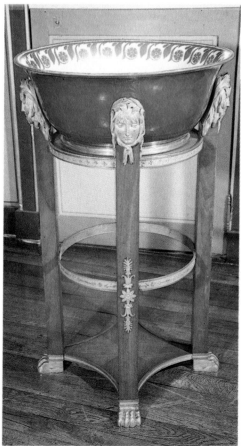

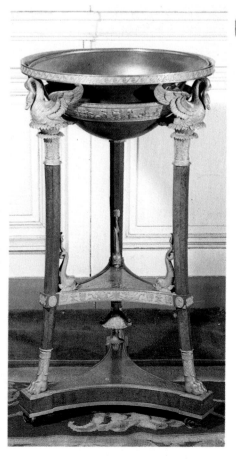

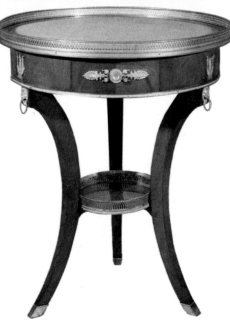

ABOVE LEFT: mahogany *guéridon* with giltwood front legs. Antiques trade. RIGHT: elm-root table (c. 1805) attributed to Pierre-Philippe Thomire. Musée National du Château de Fontainebleau.

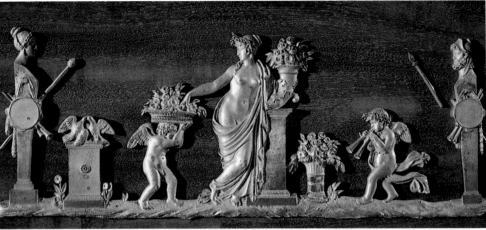

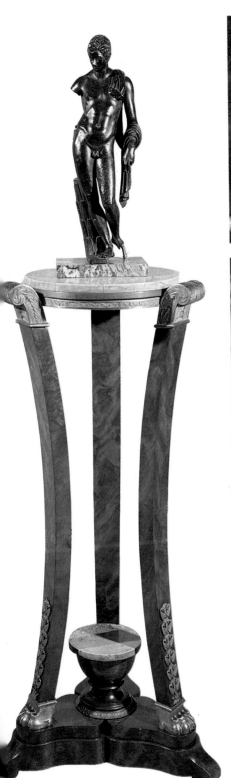

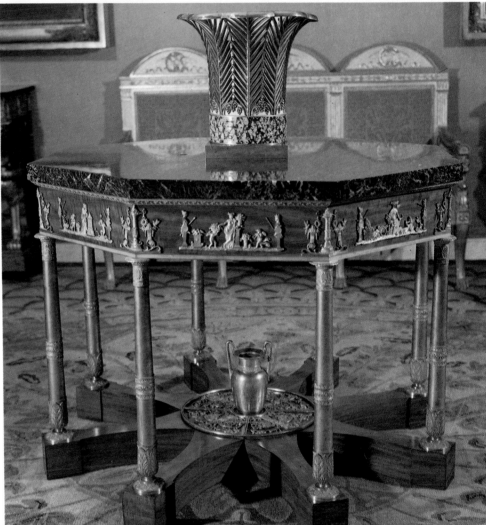

FACING PAGE, BELOW LEFT: *saut-de-lit* created by Marcion in 1805/06 for Joséphine Beauharnais's bathroom at Malmaison. Musée National du Château de Malmaison. CENTRE: *saut-de-lit* from the Emperor's bedroom at Fontainebleau. Musée National du Château de Fontainebleau. RIGHT: sabre-legged mahogany *guéridon*. Musée National du Château de Malmaison.

THIS PAGE, LEFT: mahogany *athénienne* with gilt-bronze mounts. Musée des Arts Décoratifs, Paris. ABOVE: large, octagonal, mahogany *guéridon* by Jacob-Desmalter with gilt-bronze mounts by Thomire. The frieze around the drum top depicts the four seasons; the detail above shows the Allegory of Spring. Musée National du Château de Malmaison.

BELOW: mahogany *lit en bateau* with gilt-bronze mounts; BELOW RIGHT: *lit en bateau* decorated with blue enamel medallions and gilt-bronze frieze, with the same motifs repeated on the matching pot table. Musée des Arts Décoratifs, Paris. FACING PAGE: pen and watercolour design by Arnoux for an imposing Empire bed. Ecole Nationale Supérieure des Beaux-Arts, Paris.

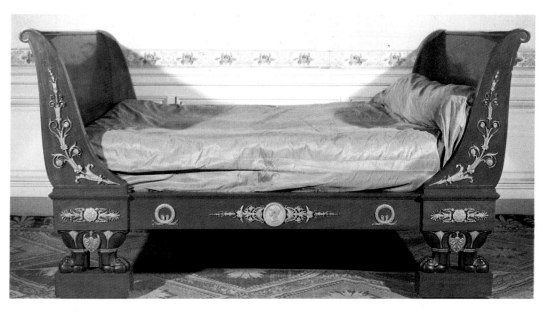

pivots which had already made an appearance during the Directoire and the Consulate, and the *coiffeuse,* a dressing table likewise equipped with a mirror. The pot table was a night table which might be cylindrical, a truncated pyramid or oblong but always matched the bed, i.e. it was adorned with the same kind of bronze or wood decorations. Bed structure had changed little since the Directoire and the Consulate, though there was now a preference for beds *en bateau, en pupitre* (with straight head- and foot-boards) and *à l'impériale* on a dais (*estrade*) with columns and a canopy of brilliantly-coloured hanging draperies.

Joséphine's bed at Malmaison, built by Jacob-Desmalter in 1810, was decorated with the Empress's much-loved swan motif. Bronze swans also provided the supports for the *athénienne* (a tripod wash-stand in elm root) designed by Percier for Napoleon's

Jacob-Desmalter and with ormolu mounts by Thomire. Also at Malmaison are the "Maréchal" or "Austerlitz" table (1808–10), to a design by Percier and Fontaine, and the flame mahogany pedestal table with an elegant dancing girl figure, in the *Salle Princesse*

Georges de Grèce. Guéridons with various types of support, to hold *bouillotte* lamps (for games of *bouillotte,* or rummy), bookcases with doors or open shelves, screens and fire-screens were displayed in rooms hung with tapestries. There were occasional digressions *à la gothique,* as in the Gallery at Malmaison (1808), or *à la turque,* as in the *boudoir* of the Hôtel Beauharnais (1806).

As well as traditional furniture, there were other *meubles mouvants,* like the *psyché,* the large cheval glass mounted on

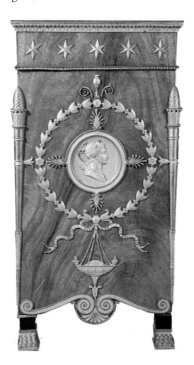

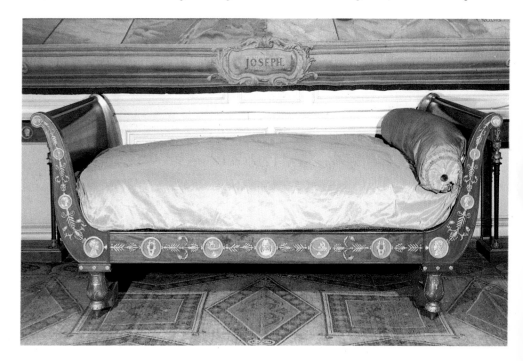

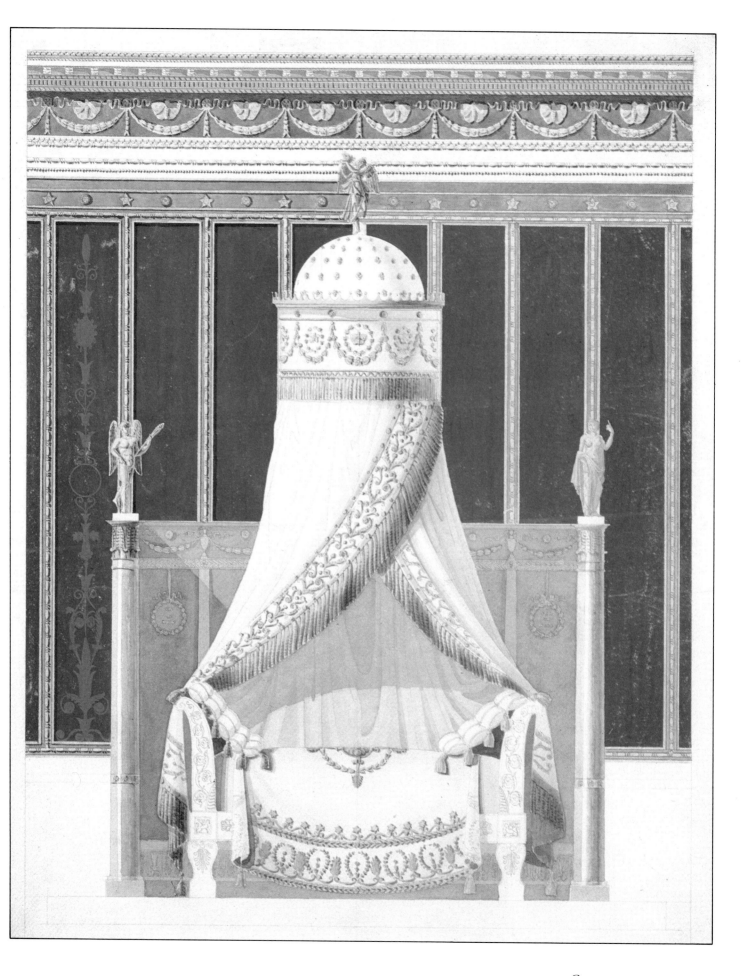

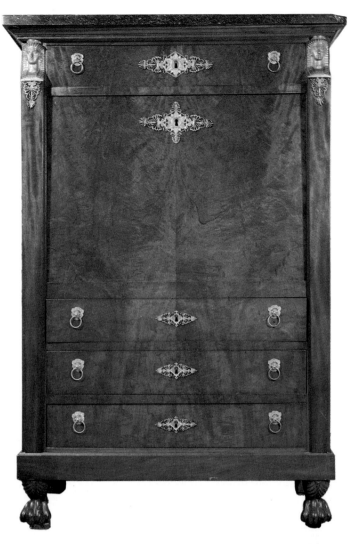

The uprights of all the furniture shown on these pages, dating from between 1810 and 1820, all feature caryatid terminal figures, a characteristic of the First Empire. LEFT: mahogany *secrétaire à abattant*. Musée National du Château de Fontainebleau. BELOW: "plum pudding" mahogany commode. FACING PAGE, ABOVE LEFT: *secrétaire à abattant* attributed to Jacob. Brucoli Collection. RIGHT AND BELOW: *en suite secrétaire à abattant* and commode in flame mahogany, the front columns surmounted by carved lacquered and gilt swans.

Paris) and has front legs decorated with female heads and a scrolled back. Apart from Napoleon's imposing throne at Fontainebleau, made by Jacob in 1805 to David's design, the Imperial court was also equipped with some interesting X-frame stools reserved for courtiers and featuring crossed sabre legs. A popular innovation was a small day-bed (*méridienne*) for common use, known as a *paumier*.

Mahogany, frequently used by Georges Jacob for chairs during the reign of Louis XVI, became even more popular during the Empire, but declined when Napoleon's Decree of Berlin of 1806 brought about the Continental System, banning the importation of goods from English and American colonies. *Menuisiers* and *ébénistes* resorted to indigenous woods such as wal-

nut, beech, pear, maple, lime, elm root, yew and ash, which were greatly appreciated for the variety of their grains. Very occasionally Jacob-Desmalter chose ebony, which he used for the Tuileries furniture. The same wood was also used for inlays in high-quality seating. *Bois de rose* (rosewood) was no longer as popular as in the previous century. Instead, cabinet-makers used beech, which was admirably suited to white lacquering, with gilt lining. Marble was used for the tops of various items of furniture and the walls of some rooms, ormolu was often combined with Sèvres porcelain to create medallions, and finally mention should be made of the use of painted or gilt glass plaques, a speciality of Antoine Rascalon.

Literature played a decisive role in creating a demand for this

bedroom in the Petits Appartements at Fontainebleau and presumably executed by Martin-Guillaume Biennais in 1805. It also has swan supports, in bronze.

Chairs became heavier and more rectangular, with arms carved in the shape of caryatids or sphinxes, and were often upholstered with fabrics to match the decor. For her dressing room at Fontainebleau, Joséphine chose gondola chairs, as did Marie-Louise for her *boudoir* at Compiègne. The *causeuse* – an ample double chair for two to *causer* (chat) – also made its appearance. The soberly designed settees found in many bourgeois homes during the Napoleonic era were often in solid mahogany. A typical example dates from about 1805 (Musée des Arts Décoratifs,

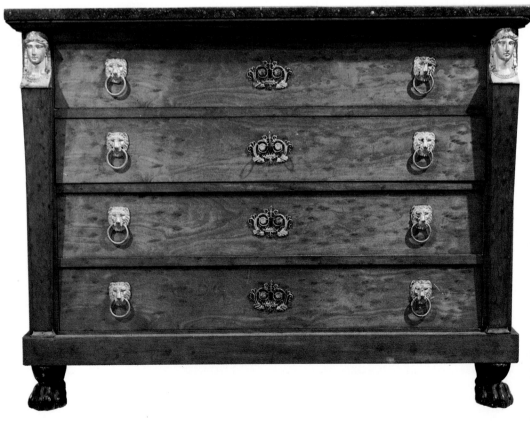

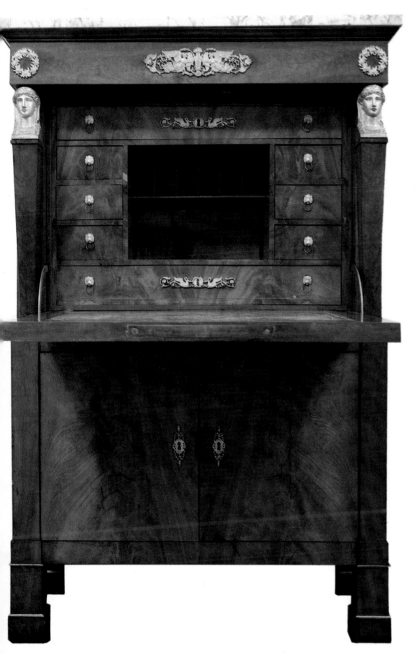

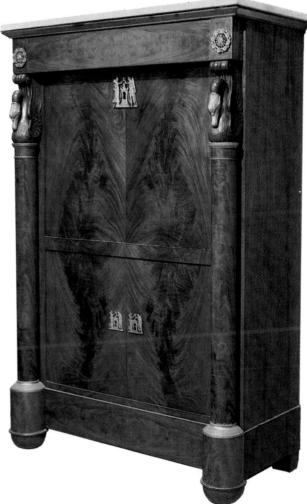

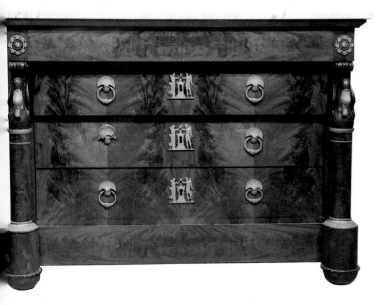

style of furniture, hinting at the coming vogue for Romanticism, in particular Madame de Staël's *De la littérature considerée dans ses rapports avec les institutions sociales* (1800), and Chateaubriand's *Génie du Christianisme* (1802), which conjures up the medieval atmosphere of the *style troubadour*. It is also literature that most effectively evokes the mood of the Empire period. Much later Rostand's *L'Aiglon* (1900) describes the final years of Napoleon's son at the Viennese court, while the great Stendhal, who lived in Paris under the Empire and served as a quartermaster during the Russian campaign, presents an incomparable portrait of Napoleonic society in *The Charterhouse of Parma* (1839).

The Restauration

The restoration of the Bourbons to the French throne brought with it not only political retreat but also a period of great uncertainty that is reflected in the decorative arts. Louis XVIII

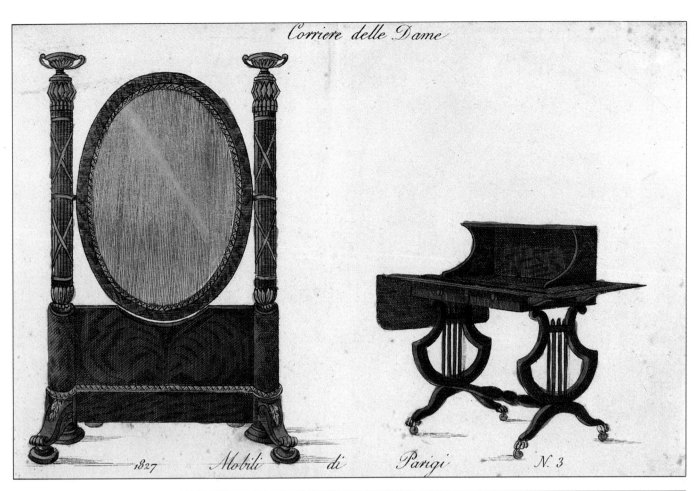

Corriere delle Dame

1827 *Mobili* *di* *Parigi* N. 3

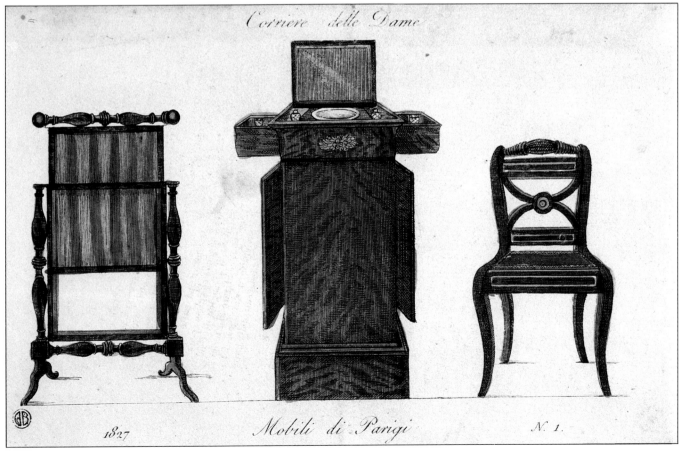

Corriere delle Dame

1827 *Mobili di Parigi* N. 1

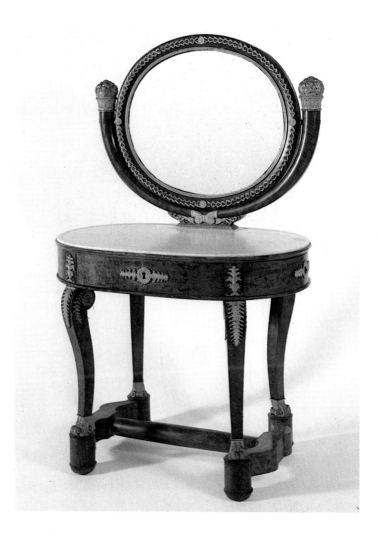

(reg. 1814–24) and his brother Charles X (reg. 1824–30) were both eager to rid the Tuileries and Saint-Cloud of the seals and monograms and all the other Napoleonic emblems, but were quite happy to keep the interior decorations. Craftsmen came nowhere near achieving the record output of the preceding years, perhaps because there was no one to give them precise guidance, or perhaps because they had lost most of their best customers. Artistically, the whole of the 19th century was a period of adjustment and the elaboration of new values bound up with the ferment of Romanticism, which would have a profound effect on contemporary life and tastes.

During the Restauration period, further industrial exhibitions were held in 1819, 1823 and 1827 which put within the reach of the general public a type of furniture better suited to their need for comfort and simple elegance. Curvilinear forms, virtually abandoned during the Empire, began to reappear in every kind of furniture, and the introduction of the "Gothic" style added variety to decorations. La Mésangère's engravings, illustrated publications such as *Modèles de meubles et de décorations intérieures pour l'ameublement … dessinés par M. Santi et gravés par Mme Soyer* (Paris, 1828) and Michel Jamsen's *Ouvrage sur l'ébénisterie, dédié aux fabriquants … avec échelle de proportions* (Paris 1835) encouraged decorators and furniture-makers to be creative. Gothic-style dark wood furniture built by Alexandre-Louis Bellangé (son of Pierre-Antoine), Youf and Bigot was on show at the 1827 exhibition. Baudry, Durand, Gamichon and

Kolping remained faithful to the styles of previous years but used mostly light woods.

During the first twenty years of the century, the Empire style undoubtedly reigned supreme, but after 1815 the increase in industrial production and the use of machines in the manufacturing process led to a lowering of artistic standards. Softer, more rounded forms and columns on a circular base were preferred, although militaristic motifs persisted, as in the commode created by Jean-Jacques Werner (1791–1849) for the governor's apartment at Les Invalides (Musée des Arts Décoratifs, Paris). The severity of Werner's renowned ash secretaire now in the Musée des Arts Décoratifs is relieved by inset mirrors and mounts. The cabinet-maker also exploited the colour nuances and grain of the wood. A pull-out drawer under the drop leaf transforms the secretaire into a *toilette* (Musée des Arts Décoratifs, Paris). One of the finest Restauration furniture-makers, Werner made his name with pieces in indigenous woods presented at the 1819 and 1823 exhibitions, marking the end of mahogany.

Characteristics of the Restauration style

Restauration furniture created a style all its own through a combination of grace and heaviness, while preserving Louis XVI and Empire motifs. Surfaces were outlined by inlaid stringing and marquetry, which achieved a level of refinement worthy of a goldsmith. Profiles, vine tendrils, stylized flowers, classical rosettes and lyres contrasted with the pale

wood carcass and the dark wood of the inlays to create light, original ornamentation. Inlays were in ebony or ebonized wood, brass or pewter. Some rarer, more refined examples, like the bed and chest of drawers built by Benard c. 1825 for the actress Mademoiselle Mars, were inlaid with porcelain plaques.

Chased bronze mounts reminiscent of the designs of Percier and Fontaine continued to be used for luxury pieces. One such example was the roll-top bureau in indigenous French wood shown by Louis-François-Laurent

Puteaux (1780–1864) at the 1819 industrial exhibition and now in the Musée Carnavalet, Paris. In 1833, the bureau was acquired by Louis-Philippe for his personal use at the Tuileries.

The Charles X style

The Charles X style was a singular mixture. Based on the Neoclassical taste, it also made very skilful use of motifs borrowed from the Gothic revival. The highly elegant effects of the inlays, the design of which results

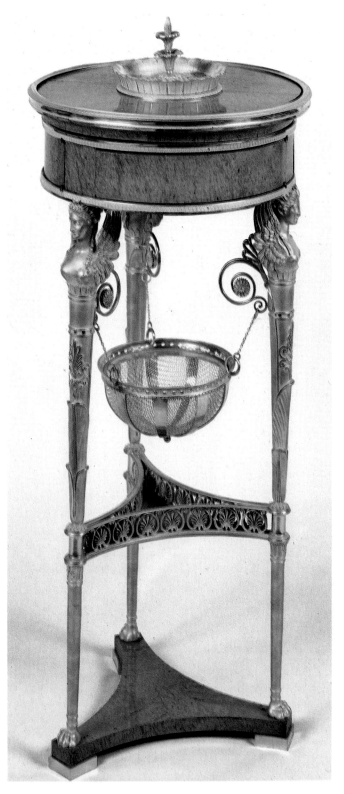

Bois clairs

Bois clairs, light woods in warm blond tones, were the height of fashion during the Restauration period. They were often used as veneers cut in such a way as the show to advantage the grains and markings of the wood. Maple, ash, plane, elm, poplar, thuya, sycamore, orange- and lemonwood, acacia and speckled root woods were the favourites. The fashion for *bois clair* began during the Empire period when, as a result of Napoleon's Continental System in 1806, craftsmen were obliged to look for suitable alternatives to mahogany "from the Indies", till then the most most commonly used material. In 1811, Jacob-Desmalter used indigenous woods for the cradle of the infant King of Rome. After 1815, peace treaties and the political situation in Europe made it even more difficult to import wood. Besides which, public taste was moving towards cosier, less formal rooms. Since paler woods were better suited to this new concept of interior design, they became extremely popular during the third decade of the 19th century. One of the greatest champions of *bois clairs* was the *ébéniste* Jean-Jacques Werner (1791–1849), who made furniture of extraordinarily high quality in light wood veneers, enriched by refined ormolu mounts inspired by classical ornamentation.

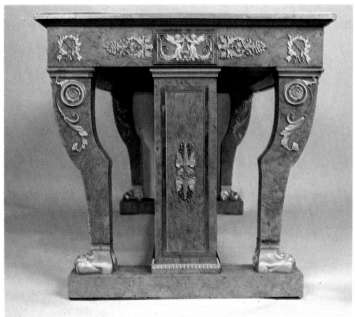

ABOVE: exquisite *athénienne* perfume burner in elm root and chased gilt-bronze, made in around 1815 by the cabinet-maker Adam Weisweiler, displaying all the characteristics of the Louis XVIII period and marking the transition from Empire style to the Eclecticism typical of the Restauration. RIGHT: side view of an ash veneer *bureau plat* with gilt-bronze mounts, built by Jean-Jacques Werner between 1815 and 1820. FACING PAGE, ABOVE: another large *bureau plat* in ash veneer with finely chased ormolu bronze dating from the same period, with "lion's paw" supports. An elaborate trophy of arms, a typical Empire motif, serves as a handle for the central frieze drawer. All Renoncourt Collection, Paris.

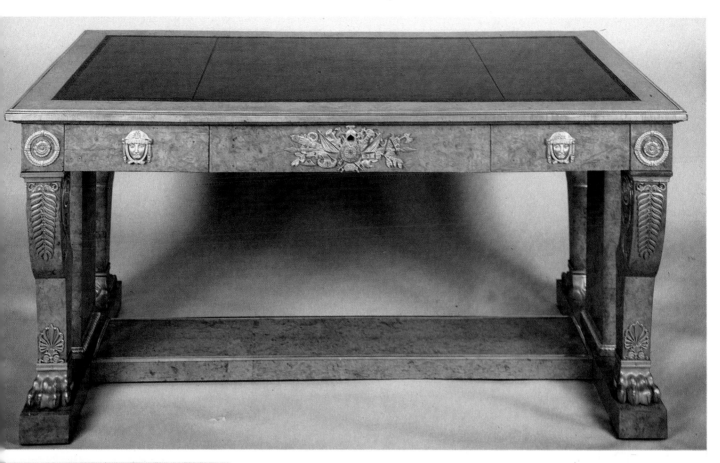

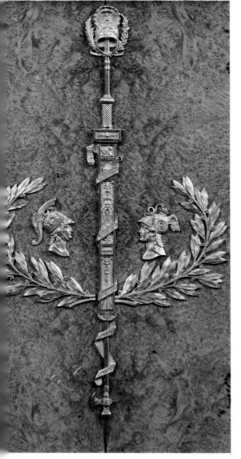

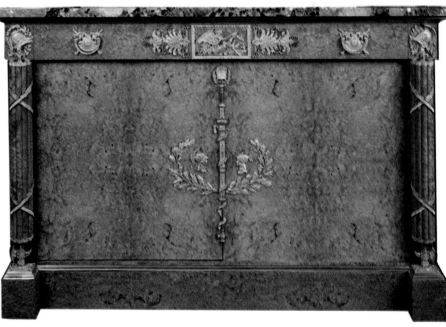

ABOVE: *commode à vantaux* (c. 1815–20) by Werner in the Louis XVIII style. The severe, geometric front of this piece, also in ash veneer, is flanked on either side by two uprights in the form of fasces of arms. DETAIL LEFT: the chased, gilt-bronze mounts exemplify the militaristic motifs popular during the Napoleonic era: swords, pikes, helmets and the Classical laurel wreath. Renoncourt Collection, Paris.

These pages show examples of the sober, geometric furniture, refined by exquisite inlays and bronze mounts, typical of the Charles X period. BELOW LEFT: veneered secretaire with ebony, ivory and mother-of-pearl inlays, bearing the mark of the Jeanselme company (c. 1820). Antiques trade. BELOW: maple *commode à vantaux* with gilt-bronze and ebonised wood stringing. Musée des Arts Décoratifs, Paris. FACING PAGE: secretaire made later than 1830, in bird's-eye maple with palisander inlays. Antiques trade.

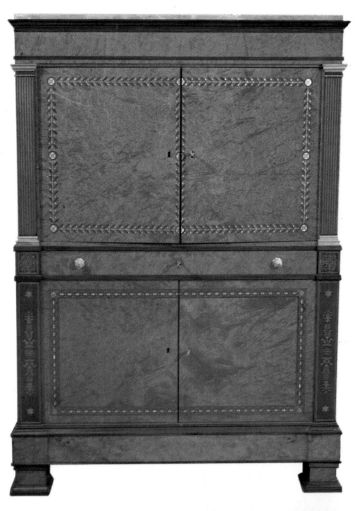

Restauration interiors

It was still customary to plan the design and colour scheme of an entire room. White, yellow, green and blue were the favourite shades, and there was greater emphasis on drapery, as can be seen from the plates in Santi's *Modèles de meubles et de décorations intérieure,* and the designs displayed at various exhibitions. François Baudry (1791–1859), later appointed Louis-Philippe's *Ebéniste du Roi,* scored a major success in 1827 with a bedroom designed in ash and decorated with geometric inlays, and a bed *en nacelle* (Musée des Arts Décoratifs, Paris), i.e. shaped like a seashell on a stepped platform.

Restauration interior design was an amalgam of styles, with furniture of all shapes and sizes deliberately scattered about willy-nilly, to give an impression of movement, an idea propounded by the Romantics in opposition to the rigid and static nature of Neoclassicism, of which the Restauration style was the final stage. This persistent dichotomy of taste is confirmed by the contents of the Prince de Condé's residence at Chantilly (1822) and the Duchesse de Berry's apartments at Saint-Cloud (1828). The latter are depicted in a watercolour by Garneray, now in the Musée des Arts Décoratifs in Paris. The Duchesse de Berry, wife of Charles X's second son and grand-niece of Marie-Antoinette, was among those who set the trend in contemporary decorative arts. A client of Louis-François-Laurent Puteaux, Felix Rémond and Baudry, she is credited with starting the fashion for *bois clairs.*

The Parisian *ateliers* attracted many British, German and Russian buyers. In 1827, President Monroe of the United States took delivery of furniture made for the White House by Alexandre-Louis Bellangé. This international exchange of ideas of furniture manufacture resulted in enormous diversity and creativity in terms of decorative detail, especially in the years between 1830 and 1840, although forms and types of furniture remained in line with those of the Empire period. This was particularly true of chairs, which were still dominated by the gondola style of Jacob-Desmalter's early 19th-century designs, even if backs differed widely between cross-backed and semicircular.

Chairs in *bois clair,* typical of the Charles X style until 1830, later appeared alongside models in dark wood, some with cabriole legs and ogee pierced-splat backs that indicate a predilection for the troubadour style which was soon to become popular.

The influence of Romanticism and early Victorian England

from cultural brushes with archaeological tastes, leads us in bizarre fashion back to the English-inspired Gothic revival. Pale colours and light woods predominate. White, used for interiors at the Château de Saint-Cloud, is evidence of the desire for freshness and luminosity. Dark woods like palisander, mahogany and ebony fell into disuse, making way for sycamore, maple, ash, amboyna and citrus wood.

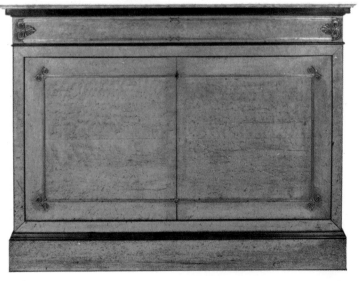

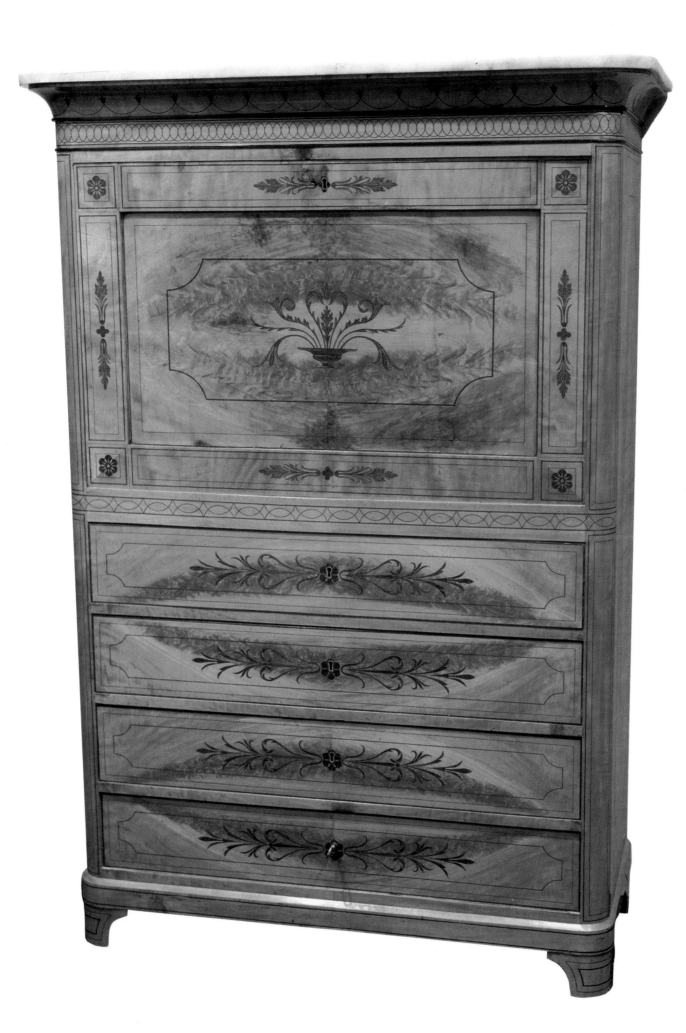

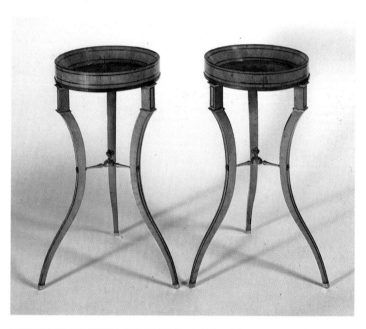

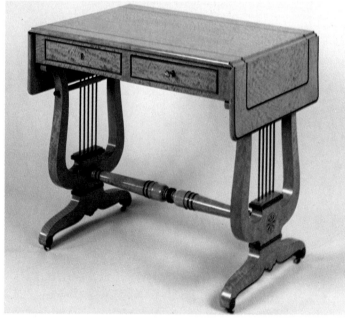

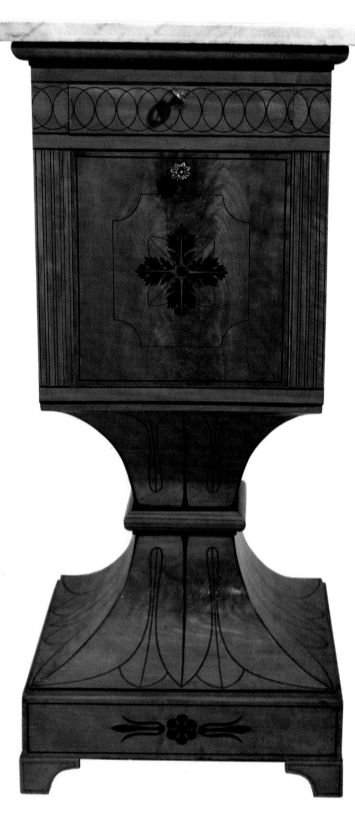

Examples of Charles X *bois clair* pieces. ABOVE: pair of *guéridons*, and small drop-leaf table in citrus wood with amaranth stringing. The lyre supports can be better appreciated from the detail on the facing page. Renoncourt Collection, Paris. RIGHT: bird's-eye maple night table on a vase-shaped pedestal, with palisander inlays. Antiques trade.

ABOVE LEFT: large centre table with stringing; RIGHT: elaborately inlaid table with book-rest. BELOW, LEFT: citrus wood pot table on a Classical plinth. All these items are inlaid with amaranth. Antiques trade. BELOW, RIGHT: *guéridon* top in citrus wood with inlays of garlands, vases of flowers and stylised plant motifs in various types of dark wood. Collection L'Epoque Romantique, Paris.

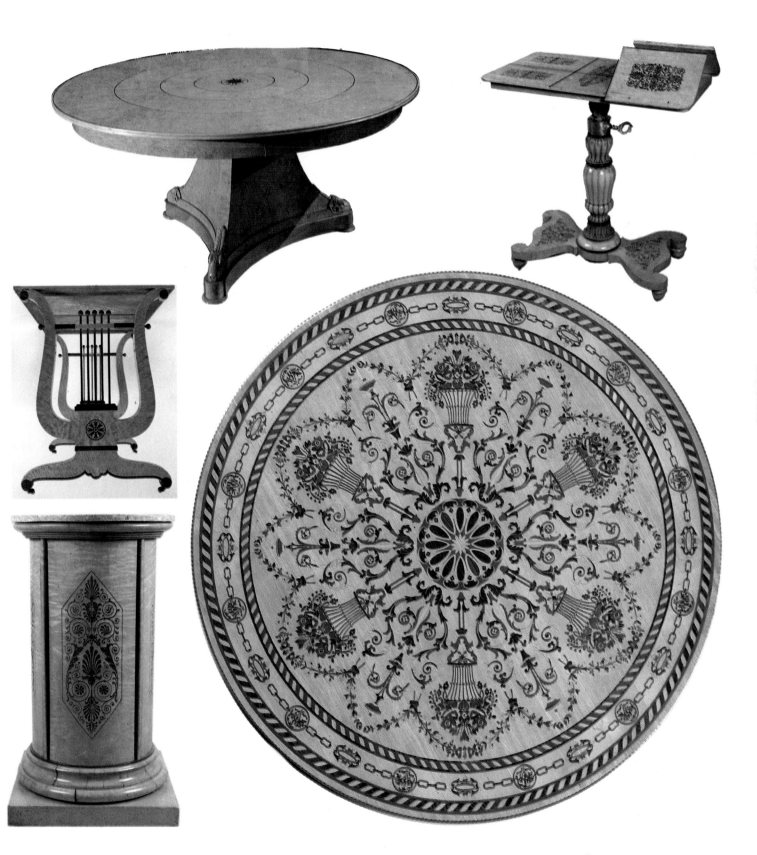

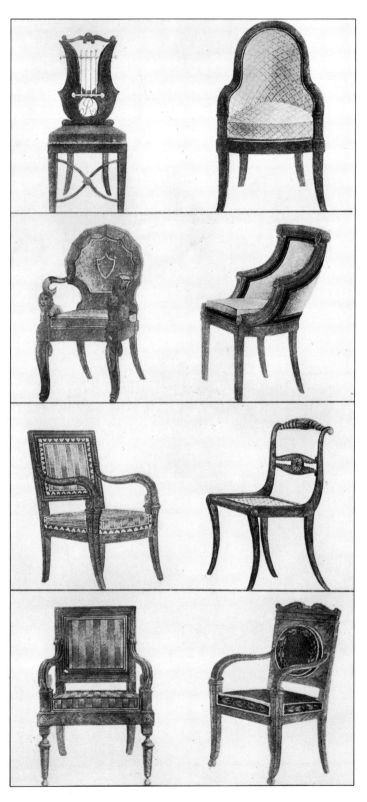

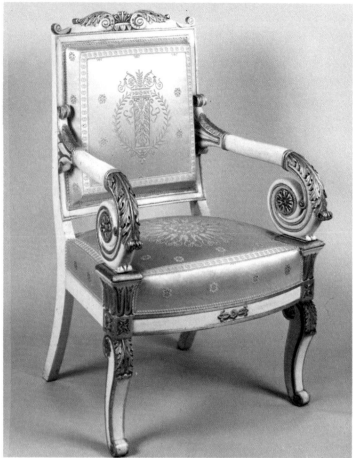

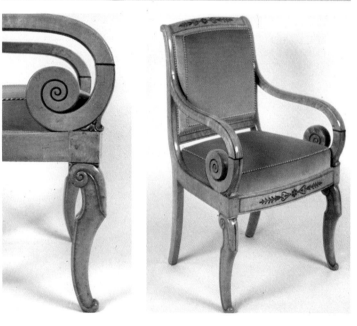

LEFT: examples of typical Restauration style chairs from the *Collection de meubles et objets de goût* published by La Mésangère between 1802 and 1835. ABOVE: white-painted Louis XVIII chair with gilt carving, with back legs *à console* and scrolled arms. BELOW: scroll-armed maple chair with amaranth inlays (c. 1824); the scroll motif can be more clearly seen from the detail, left. Both Renoncourt Collection, Paris.

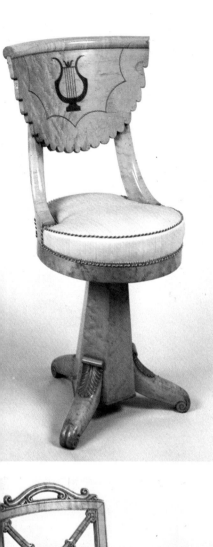

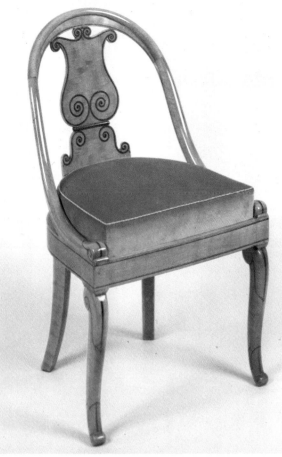

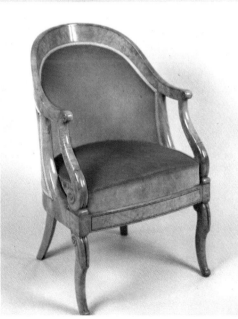

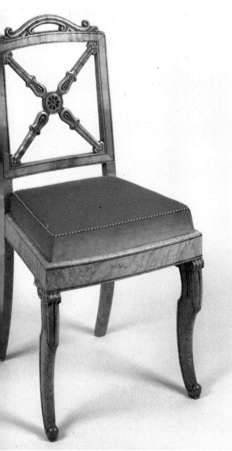

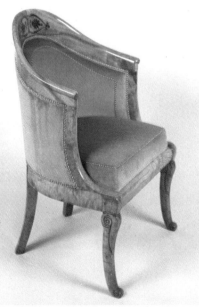

TOP, LEFT: harpist's chair belonging to the Duchesse de Berry (c. 1820). CENTRE and RIGHT: gondola chair by Bertaud (c. 1824) in citrus wood with amaranth stringing and inlays, with detail. LEFT: chair with crossed splat in *moucheté* or dappled maple, by Lemarchand (c. 1820). ABOVE, CENTRE and RIGHT: two ash gondola chairs in different styles. CENTRE: *à consoles opposées* (c. 1824). LEFT: *à chapeau de gendarme.* All Renoncourt Collection, Paris.

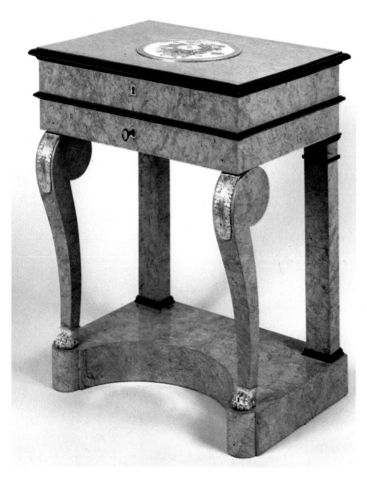

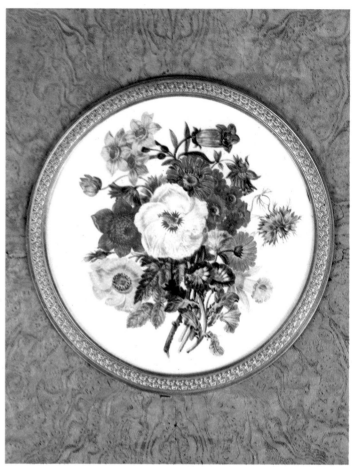

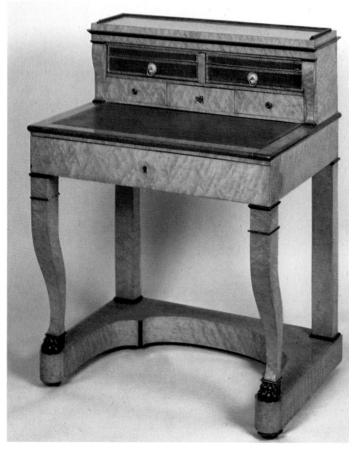

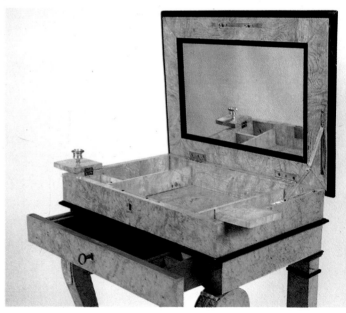

ABOVE LEFT and BELOW RIGHT: combined ash veneer work and toilet table, seen in open and closed positions, the top decorated with a central porcelain plaque (detail, above right). BOTTOM LEFT: dappled maple *bonheur-du-jour*, dating from the Charles X period, with ebony stringing and leather-covered top and drawer-fronts, and stamped with the maker's mark of "Lesage, Rue Grange Batelière". Both Collection L'Epoque Romantique, Paris.

Examples of Charles X pieces in *bois foncé*, i.e. dark wood, which became as popular as *bois clair* in the third decade of the 19th century. ABOVE, LEFT: palisander *bonheur-du-jour* (c. 1827). RIGHT: detail of the back of a Neo-Gothic chair *en cathédrale*. Both Collection L'Epoque Romantique, Paris. BELOW RIGHT: rosewood *coiffeuse* or dressing-table inlaid in boxwood (c. 1827). LEFT: a side view of the same piece. Antiques trade.

favoured the development of numerous eclectic fashions that would penetrate the Neoclassical environment.

The Neoclassical age, apparently so conformist, was nurturing neo-Gothic and orientalising currents even in France. The first derived from a renewed interest in the medieval, while the second would appear chiefly after the conquest of Algeria in 1830.

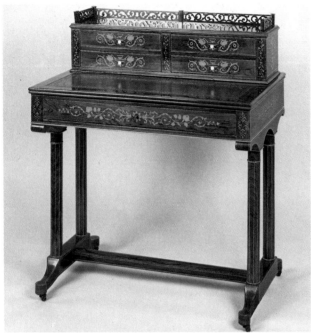

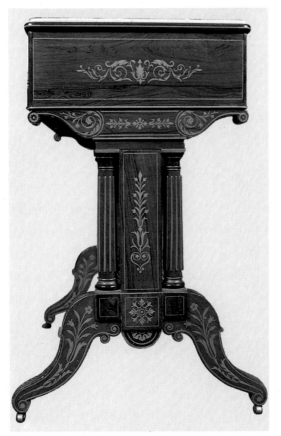

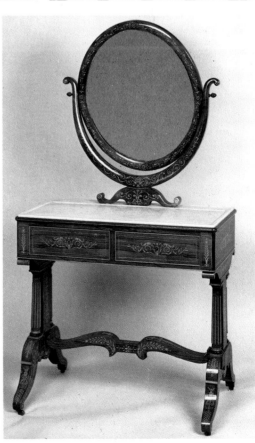

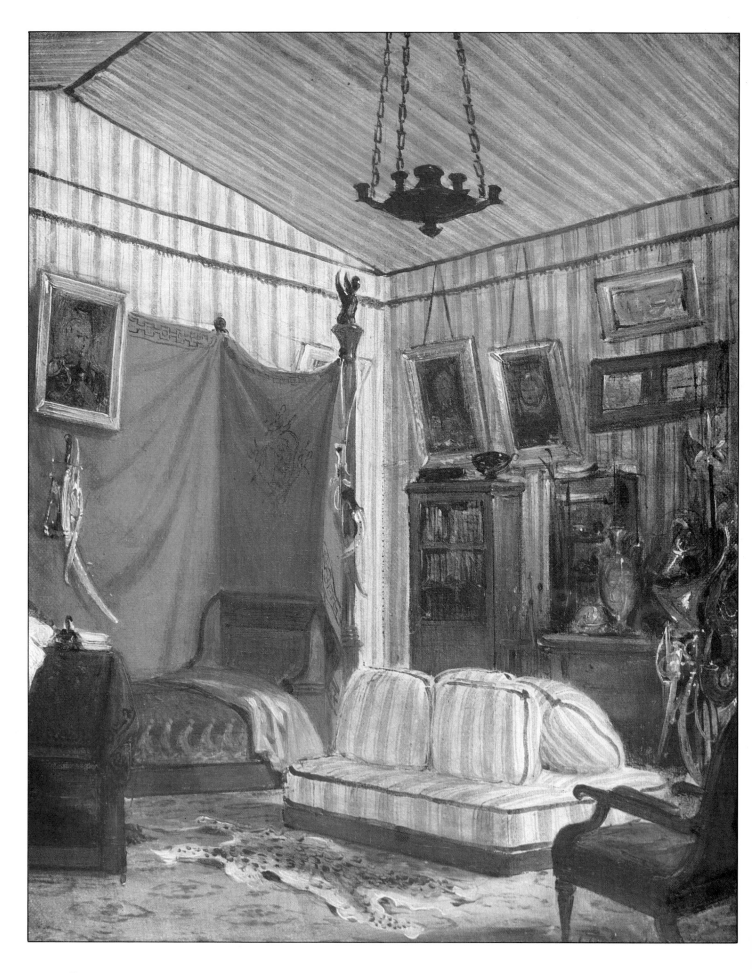

Eclecticism

Louis-Philippe

Like Napoleon, Louis XVIII and Charles X before him, Louis-Philippe d'Orléans, King of France from 1830 until 1848, and his court occupied the Tuileries, Fontainebleau and the Trianon. Louis-Philippe did not instigate many changes, apart from some modernisation carried out at the behest of Queen Marie-Amélie, but her taste had little influence on artists practising at the time.

In 1837 Versailles was turned into a museum, while Jacob-Desmalter's son Georges-Alphonse Jacob undertook the reconstruction of Louis XIV's apartments. Jacob built furniture for the Palais Royal and the Château d'Eau, still under the guidance of the architect Fontaine, who during Louis XVIII's reign had overseen the restoration of the Château de Neuilly, home of Louis-Philippe, Duc d'Orléans.

In 1847, Jacob-Desmalter sold his business to Joseph-Pierre-François Jeanselme (d. 1860), who set up a workshop specialising in imitations of historic styles.

In both architecture and interior design, there was a noticeable confusion of styles. The eclectic taste was inspired by the *Album de l'ornementiste*, by Aimé Chenavard (1798–1838), a pattern book published in 1835 embracing the possibilities offered by mechanization as well as responding to the demands of fashion. It also

re-examined the antiques collected by dealers like Lesage, who formed a company with Granvoinnet and Vervelle in 1838, and Louis-Philippe's own suppliers, the Giroux brothers.

Cabinet-makers attuned to the tastes inspired by Romantic literature and the widespread interest in archaeology continued to produce some Empire-style furniture on the lines suggested by Fontaine, whom Louis-Philippe appointed as his chief architect. An example of this continuing tradition was the carved and gilt throne made for the Palais Royal by Georges-Alphonse Jacob (1799–1870).

There was also interest in historic French styles, from the Renaissance – inspired by patterns published by Michel Liénard (1810–70) – to Louis XVI. Louis-Philippe's daughter, Marie d'Orléans, was famous for her receptions in the Renaissance Salon.

The role of the upholsterer became increasingly important. Lyons silk with floral motifs on a white background became a popular choice, as can be seen in Delacroix's painting of the Comte de Mornay's bedroom, now in the Louvre, or Leger's 1844 *Projet pour une chambre bleu* and Eugène Lami's *Projet pour le petit salon du duc de Nemour aux Tuileries* (both at the Musée des Arts Décoratifs, Paris).

Imagination was given free rein in the style and decoration of

furniture and objects, from porcelain to curtains, or *chinoiserie* to dried flowers in bell jars. Shapes and ornamentation became more massive, and the taste for fussy, over-ornate objects heralded the arrival of the Second Empire.

Ebénistes

The best-known furniture-manufacturers of the Restauration period made successful appearances at the French industrial exhib-

itions of 1834–38, 1844 and 1849. Among them was the Jacob-Desmalter company, which, before the business was sold to Jeanselme, caused a sensation with a cabinet with three mirrors, two of them mounted on hinges and folding outwards.

Pierre-Antoine's Bellangé's son Alexandre-Louis (1799–1863), *Ebéniste du Roi* to Louis-Philippe, kept the two workshops of his father and uncle separate, with each producing their distinctive type of furniture. Bellangé made

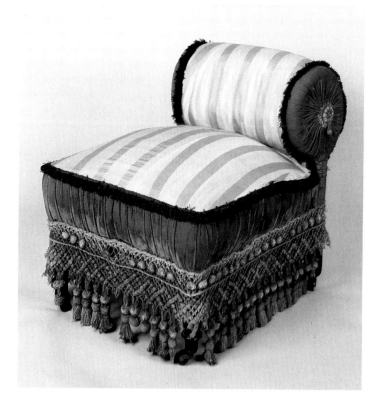

FACING PAGE: painting by Eugène Delacroix (1798–1863) of the Comte de Mornay's bedroom. Crowded with furniture, objects and pictures, the room is a good example of the typical Louis-Philippe style. Louvre, Paris. ABOVE: deep, low, upholstered chair from the Napoleon III period, with long woven fringes hiding the feet. Castaing Collection, Paris.

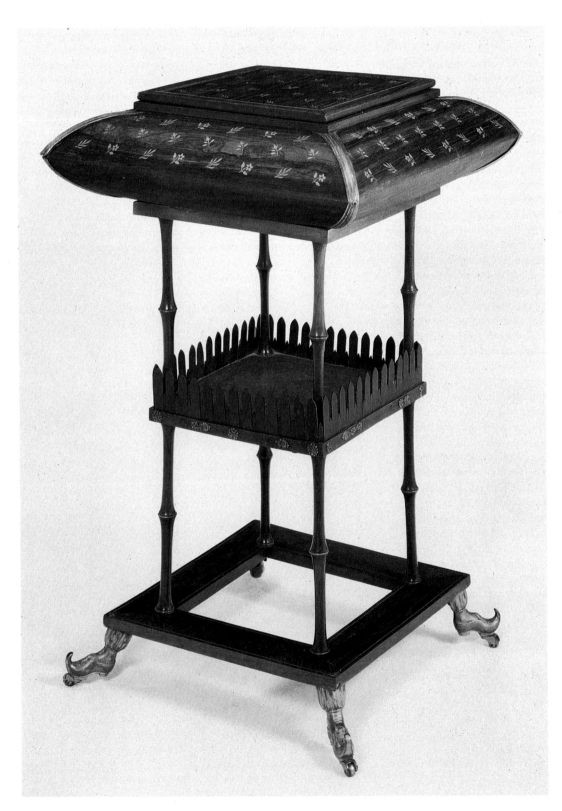

his mark with large numbers of Louis XV-style pieces. Louis-Edouard Lemarchand (1795–1872), who began his career as an architect, also made Empire-style furniture for Charles X and Louis-Philippe. In 1846 he went into business with Lemoyne, who later managed the *atelier*.

The German-born Grohé brothers, Guillaume (1808–95) and Jean-Michel, were particularly successful at the 1834 exhibition. Jean-Michel, who settled in Paris in 1827, exhibited Neo-Gothic and Neo-Egyptian items. Guillaume, for whom Liénard provided inlays and Fannières supplied bronze mounts, numbered Louis-Philippe, Napoleon III and the Empress Eugénie and Queen Victoria among his clientele. Another exhibitor at the 1844 Exhibition was Louis Durand, whose speciality was mahogany toilet tables with gilt-bronze mounts and white marble tops.

Materials and forms

Inlays in dark wood on a light ground or vice versa became increasingly stereotyped. As fashions changed, light wood was superseded by darker types, sometimes adorned with bunches of painted or mother-of-pearl flowers. As well as reddish mahogany, rosewood, ebony, yew and beech were used.

Legs and ornamentation were usually turned, especially those for items embellished with Boulle-style inlays or plaques of Sèvres porcelain or *verre églomisé* – glass with gold or silver leaf on the back, with the decoration protected by varnish or another piece of glass.

Types of furniture

Wardrobes with mirrors were less common and in some cases were replaced by a *psyché* or cheval glass. Cheaper commodes had flat fronts and sides, and very short tapered or scroll legs. Some examples featured drawers concealed *à l'anglaise* behind doors. Popular types of case furniture included the low cabinet *à hauteur d'appui*, with two doors and a single drawer, the *commode-toilette* with small drawers and a

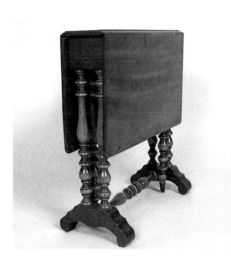

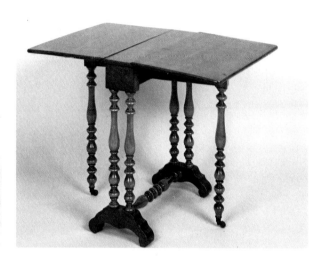

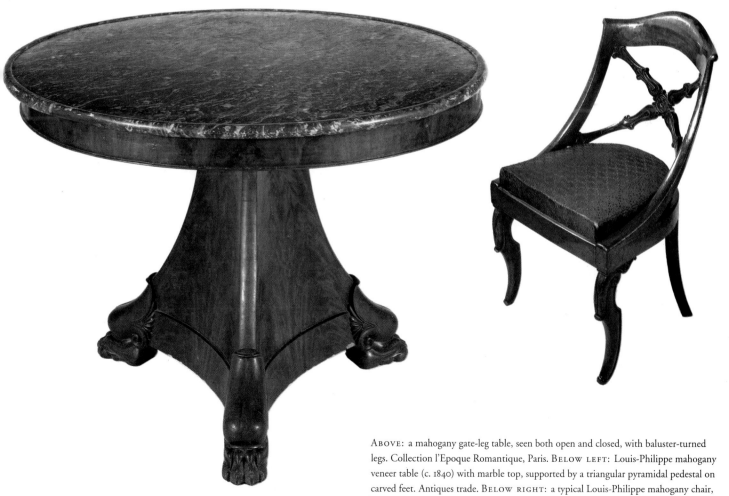

ABOVE: a mahogany gate-leg table, seen both open and closed, with baluster-turned legs. Collection l'Epoque Romantique, Paris. BELOW LEFT: Louis-Philippe mahogany veneer table (c. 1840) with marble top, supported by a triangular pyramidal pedestal on carved feet. Antiques trade. BELOW RIGHT: a typical Louis-Philippe mahogany chair, in a style already popular during the Restauration, with softly curved back with crossed splat and sabre back legs. Musée des Arts Décoratifs, Paris.

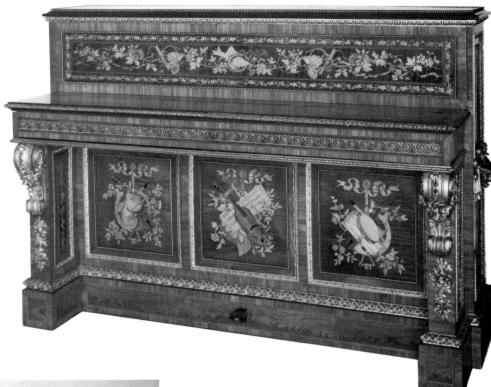

Three examples of the 19th-century revival of inlaid work in the 18th-century style. RIGHT: upright pianoforte by Roller et Blanchet Fils (1850), in the Louis XVI style, with trophies of musical instruments suspended by ribbons. BELOW LEFT: buffet composed of two superimposed parts by Grohé (1845), typical of the Rococo revival. Both Musée Condé, Chantilly. RIGHT: *meuble d'appui* with marquetry and gilt-bronze mounts by Grohé (c. 1845). Lécoules Collection, Paris.

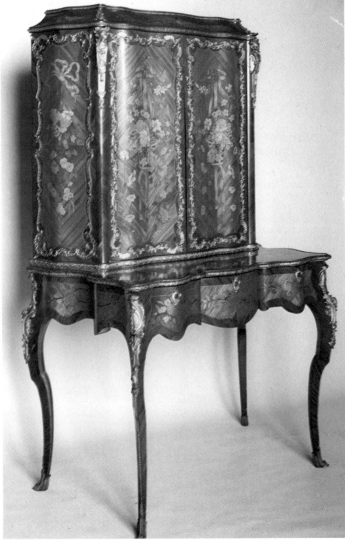

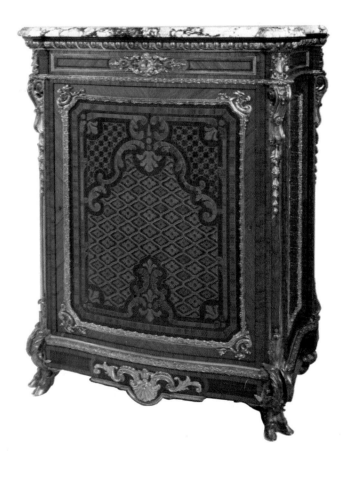

BELOW: exquisite commode in light amboyna veneer with exceptionally fine chased gilt-bronze mounts. The structure and ornamentation is in the spirit of the ceremonial furniture of the Louis XVI era, but in fact dates from the mid-19th century, bearing the stamp of the French cabinet-maker Winckel. Antiques trade.

mirror, the *chiffonnier* (a small cabinet with drawers) and *semainier,* a kind of tall, narrow secretaire with seven or eight drawers for storage.

There was also a fashion for long, shallow *étageres* surmounted by open shelves with spiral front uprights, a famous example of which was made in 1839 by Georges-Alphonse Jacob, in ash with pierced panels on the sides (Musée National du Grand Trianon, Versailles).

Consoles were simpler than before, with rectangular marble tops on two sturdy scrolled legs resting on a robust pedestal with tapered legs. *Bonheurs-du-jour* were plain and simple, with the upper drawers set slightly back from the lower surface.

Some *guéridons* were designed with adjustable tops; games tables had rectangular tops with a double frame. The *table servante* or serving table was an idea borrowed from England.

Coiffeuses (dressing-tables) were surmounted by oval mirrors, while others like the one built by Louis Durand had rectangular looking-glasses. A masculine equivalent of the *table de toilette*, known as a *barbière*, was also introduced.

Beds were built on similar lines to those of the Restauration period but were somewhat heavier. Some had upright headboards and canopies, while *lits en bateaux* came with or without canopies.

Chairs were comfortable and solid, the backs with horizontal, vertical or diagonal intersecting rails. Armchairs were solid, mostly stuffed with horsehair or sprung and covered. The backs were straight, the front legs scrolled or baluster-turned and the back legs square, and the feet were usually fitted with castors. A prime example was the high-backed, short-legged *Voltaire* introduced under Charles X. More and more attention was paid to

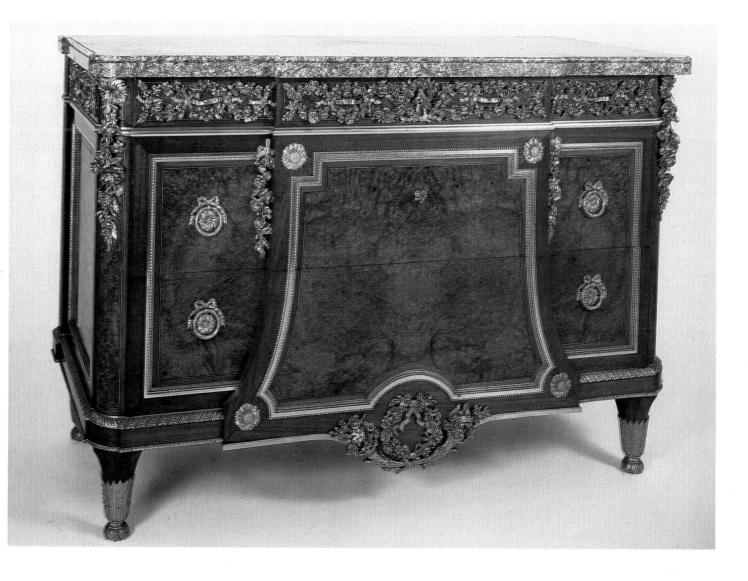

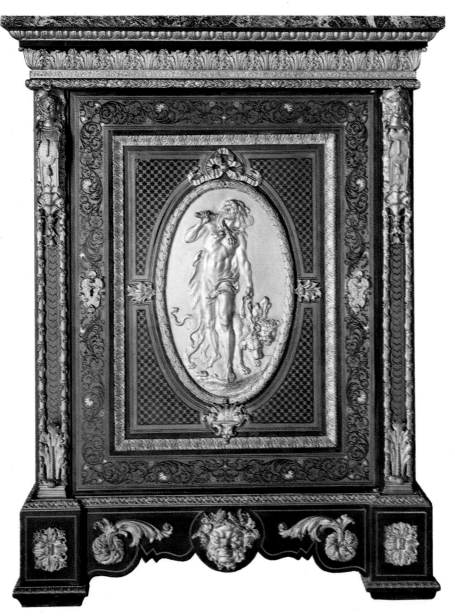

phere of the Second Empire, with its *nouveaux riches* and *parvenus*, speculators and adventurers, artists and *cocottes*, is brilliantly portrayed in the novels of Balzac, and similar characters appear in Zola's *Nana* (1880), another reflection of contemporary life in France.

The vast urban development schemes of the period saw the construction of palatial houses on the Champs-Elysées, in Avenue Foch, Avenue de l'Opéra and Boulevard Voltaire. Part of the Louvre was also rebuilt by the architects Lefuel and Visconti, under the guidance of Viollet-le-Duc (1814–79), the architect who believed Gothic to be the most authentic of all French styles and who, in 1845, won the competition to restore Notre-Dame. He also decorated the Imperial railway carriage, presented to the Emperor by the Compagnie des Chemins de Fer d'Orléans.

upholstery fabric, the most popular choices being velvet or silk, in plain colours or with stripes or floral motifs. Also much in evidence were overstuffed armchairs with long fringes to hide the legs, like the *bergère* with upholstered back and sides and a feather cushion on the seat.

Napoleon III

After the brief interval of the Second Republic (1848–51), the reign of Napoleon III (1852–70) brought with it a period of national prosperity encouraged by industrial expansion. The International Exhibitions of 1855 and 1867 led to a rapid spread of the Napoleon III and Empress Eugénie styles.

As well as the sumptuous, flamboyant furniture favoured by a wealthy, cosmopolitan clientele with ostentatious tastes, there was also a demand for suitably fashionable pieces to add luxury to middle-class homes. The atmos-

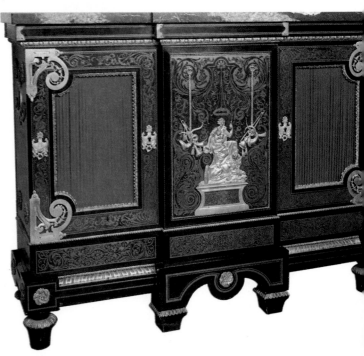

FACING PAGE, BELOW: bookcase by Louis-Edouard Lemarchand (1830–40) with bronze inlays and mounts in the manner of Boulle. Musée National du Château de Versailles. BELOW: three troubadour or Neo-Gothic-style pieces. LEFT: Louis-Philippe chair (c. 1840). Musée des Arts Décoratifs, Paris. CENTRE: *prie-dieu* with painted porcelain plaque (c. 1840). RIGHT: chair (c. 1875) by Guillaume Grohé. Both Musée Condé, Chantilly.

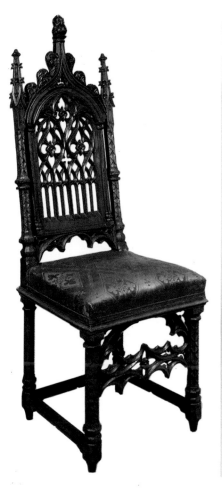 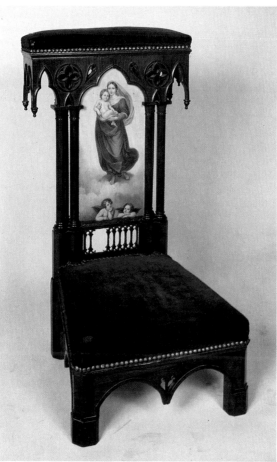 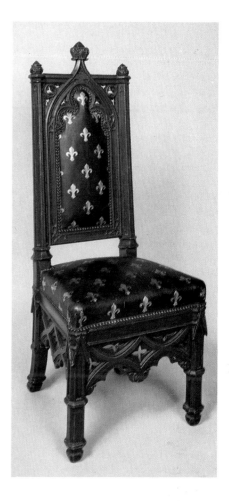

Interior decorators and cabinet-makers

Following in the footsteps of the predecessors of the Louis-Philippe era, Second Empire furniture-makers continued to draw on classic French styles up to and including Louis XVI. Eclectic interior design schemes were provided by famous architects like Pierre Mauguin (1815–69), who furnished Madame de la Païva's house on the Champs-Elysées built between 1856 and 1866, and Charles Rossigneux, who was responsible for the Villa Pompéienne built for the Emperor on Avenue Montaigne in 1860.

These Napoleon III interiors reveal that styles had changed little since the days of Louis-Philippe, although people were more inclined to clutter their rooms with endless assorted objects, occasional tables, stools and *cachepots*, to the complete despair of contemporary critics. Nevertheless, more recently, the 1979 exhibition of French art under the Second Empire, cast a more favourable light on artistic innovation under Napoleon III.

At the International Exhibitions of 1855, 1861 and 1867, craftsmen presented a rich repertoire based on a variety of tastes, notably reproducing the styles of Boulle and Riesener, favourites of the Empress Eugénie.

Inlaid ebony pieces after the manner of Boulle were produced by Bigot, Roux and Bellangé. *Cabinets d'entre deux*, cabinets in ebony inlaid with gilt-brass arabesques on an imitation tortoiseshell ground, flanked by sets of shelves at each end, became highly fashionable. Some superb examples were supplied by Alexandre Roux's brother Frédéric for the Imperial Apartments at the Tuileries and subsequently copied for upper middle-class homes.

Alexandre-George Fourdinois (1799–1871) and Joseph-Pierre-

François Jeanselme and his son Charles-Joseph Marie (b. 1827), who designed the interiors at the Château de Compiègne in 1859, participated in the 1867 Exhibition. They worked as a team with upholsterers like Henry Penon, who had enormous talent for designing the heavy curtains and hangings loaded with braids and trimmings which graced ladies' boudoirs and bedrooms, with the aim of creating a warm, cosy atmosphere.

In 1855, the Jeanselmes' workshop had more than 300 employees. Between 1856 and 1857 they made seat furniture for Saint-Cloud and Fontainebleau, and

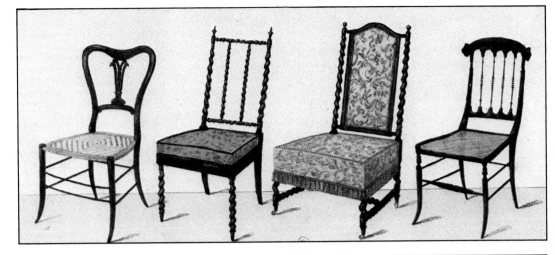

furnished most of the Palais Royal for Napoleon. Like Quignon, Meynard and Grohé, the Jeanselmes also proved their skills in creating pieces in the Henri II style. This heavy Renaissance furniture in oak, walnut or pear wood was particulary suited to dining-rooms. Among the most successful cabinet-makers and joiners participating in the various exhibitions of the period were Tahan, with a Louis XVI-style bookcase, Bardenienne, Fossey, Fourdinois and Guillaume Grohé, who supplied numerous pieces, including a carved walnut table and armchair, for the François I gallery at Fontainebleau.

Julien-Nicolas Rivart, who died in Paris in 1867, Gros and the Charon brothers took their inspiration from the 18th century, using rosewood and palisander with porcelain inlays and gilt-bronze mounts. The Charon brothers created a jewel casket with two doors, decorated with bunches of porcelain flowers made by Guérou.

Alexandre-Georges Fourdinois, active from 1835 onwards, was considered one of the leading makers of Renaissance-style furniture. Jules Fossey, who joined Fourdinois in 1849, made a carved giltwood *table de toilette* with porcelain plaques for the Empress in 1855.

The largest company making 18th-century reproduction furniture was under the control of Louis-Auguste-Alfred Beurdeley (1808–82). Lemoyne, Lemarchand's successor, was also a major supplier to the Garde Meuble. Monbro (d. 1884), a contemporary of Lemoyne, advertised himself in the 1838 *Almanach du Commerce* as "eldest son, maker

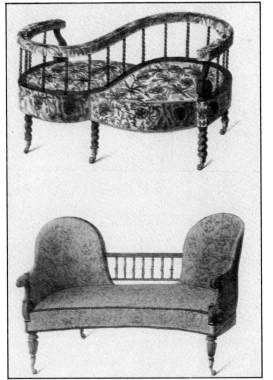

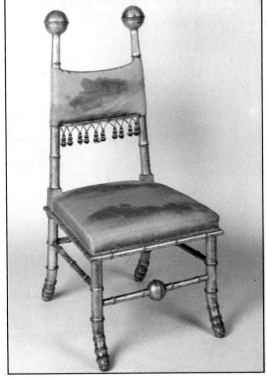

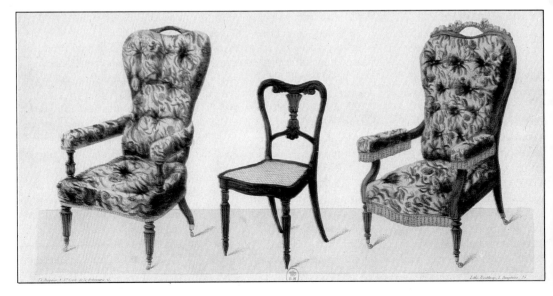

A selection of typical Second Empire chairs. FACING PAGE, ABOVE: chairs with rush or upholstered seats, pierced splats and spiral or baluster-turned uprights; CENTRE, LEFT: two settees: a *confidante*, with seats facing in opposite directions, and a small *canapé*. BE-LOW: chair and two upholstered armchairs; all these models are taken from Pasquier's *Cahier de dessins d'ameublement*. Bibliothèque Nationale, Paris. CENTRE RIGHT: gilt-wood chair with legs and uprights in imitation bamboo. Castaing Collection, Paris.

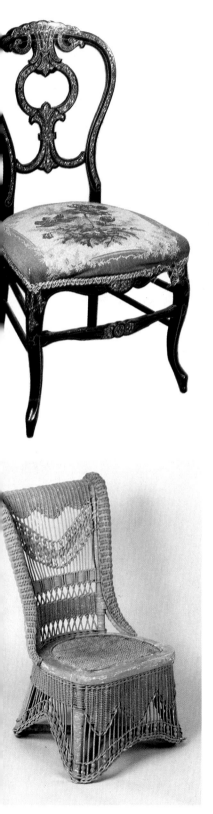

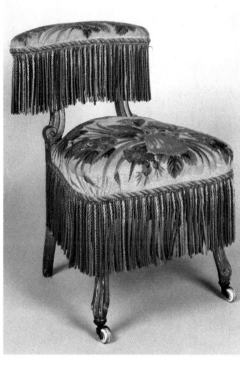

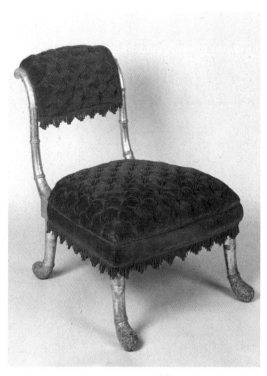

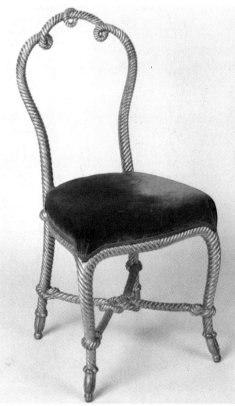

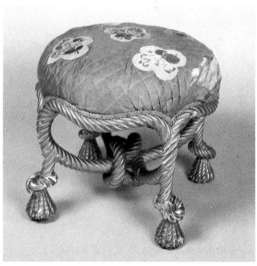

THIS PAGE, ABOVE, LEFT: lacquered wood chair with mother-of-pearl inlays. CENTRE: a *voyeuse*, a chair used for watching card-playing. Both Musée National du Château de Compiègne. RIGHT: low chair with deep-buttoned upholstery and imitation-bamboo gilt-wood legs. FAR LEFT: wicker arm-chair. Castaing Collection, Paris. LEFT AND ABOVE: chair and *pouffe* with carved giltwood legs simulating knotted rope. Musée National du Château de Compiègne and Castaing Collection, Paris.

19th-century copies: fakes to order, by master craftsmen

With the advent of the Second Empire in 1848, France saw the culmination of a phenomenon, the first signs of which had begun to emerge over the previous twenty years. Not only in France but to a greater or lesser extent in the whole of Europe, the applied arts, including furniture and interior design, were influenced by the revival of a series of "historic" styles, from Gothic and Renaissance to Louis XIV, Louis XV and Louis XVI. This new historical awareness led each country to hark back to the styles dating from the most glorious moments in its artistic history. The finest French craftsmen revived the art of their 18th-century predecessors, producing a rich array of exquisite copies and reconstructions, many of them commissioned by the Imperial family and members of the nobility. With extraordinary technical expertise, they produced reproductions using the finest veneers and the most sophisticated and complex inlays, chased ormolu mounts and polychrome lacquers to create furniture as beautiful as the originals.

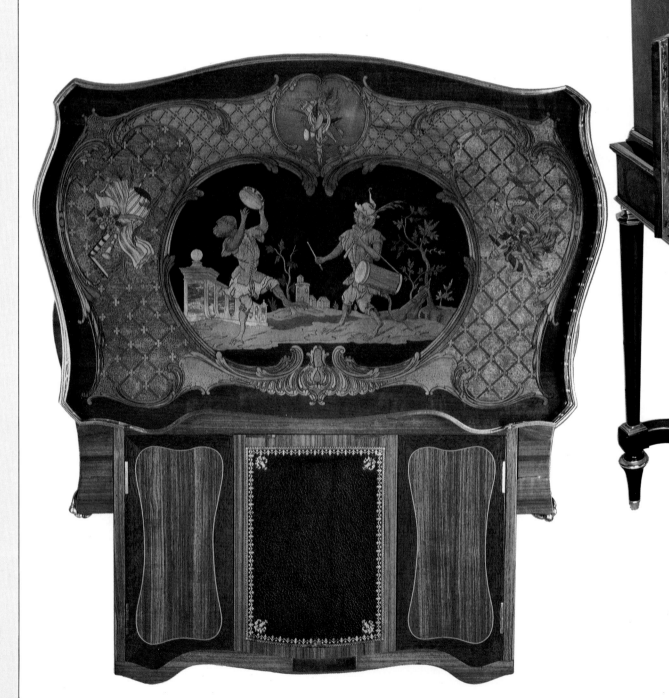

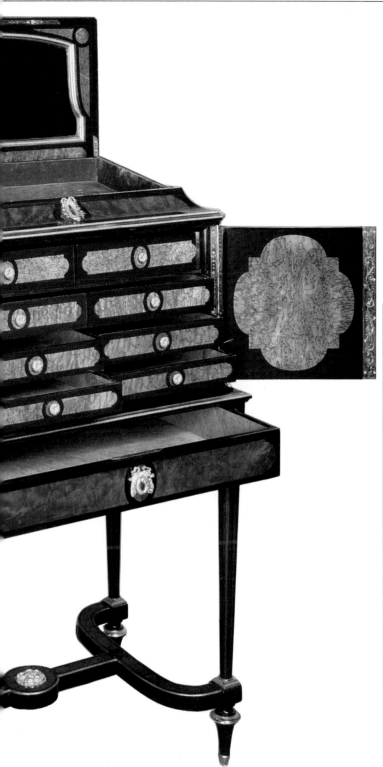

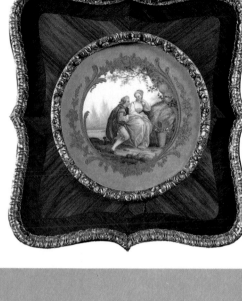

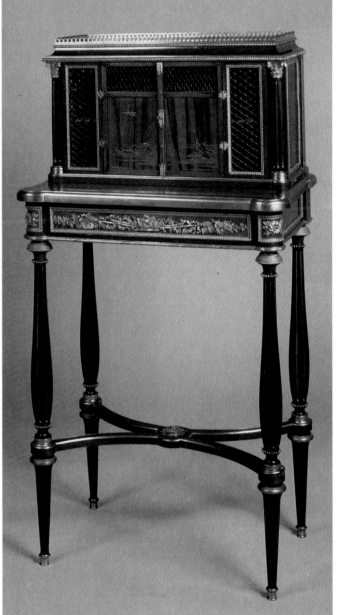

Facing page: the pull-out top of a rare writing table in the Louis XV style, made by the cabinet-maker Beurdeley in 1850, showing the flawless and intricate inlays, seen from above. Lécoules Collection, Paris. This page, above: a small cabinet with drawers, signed Sormani. Casa Bella Collection, Paris. Above right: detail of a 19th-century French rosewood veneer cabinet with Sèvres porcelain plaque and bronze mounts. Musei del Castello Sforzesco, Milan. Right: *bonheur-du-jour* in the manner of the 18th-century cabinet maker Adam Weisweiler, made post-1867 and bearing the stamp of Henry Dasson, who specialised in this type of reproduction. Lécoules Collection, Paris.

Below left: an example of the "historic" style: Fossey's monumental dressing table in carved giltwood with porcelain panels painted by Roussel, made for the Empress Eugénie and presented at the 1855 Universal Exhibition in Paris. The piece, which combines a wealth of Baroque and Rococo detail to create an extraordinarily sumptuous style of decoration, illustrates the eclectic taste of the time. Musée National du Château de Compiègne.

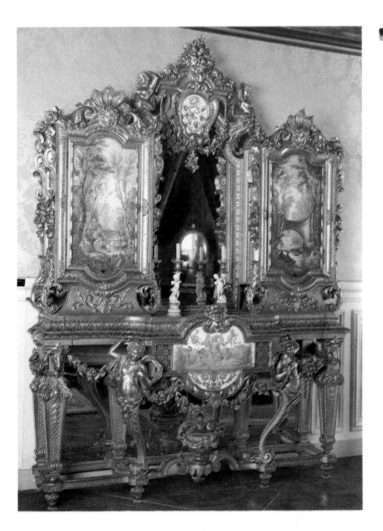

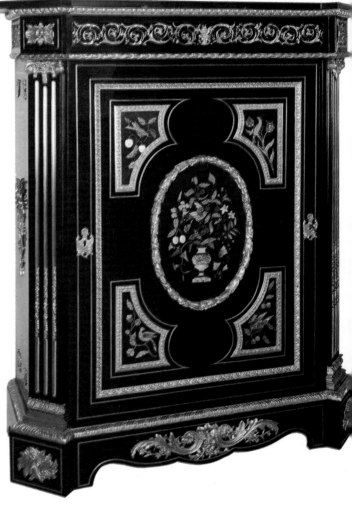

of antique cabinets, sale and repairs of antique furniture; curios, objets d'art". Michel-Victor Cruchet, who arrived in Paris in about 1836, was an ornamental carver commissioned by the Emperor to supply consoles and seat furniture for the Council Chamber at Fontainebleau.

Meanwhile, cheap, inferior Napoleon III-style furniture was produced industrially to satisfy a public eager to follow the fashions of the imperial court, leading to an inevitable decline in standards.

New furniture for the Imperial residences

However, furniture of the highest artistic quality, albeit overloaded with scrolls, *rocailles,* cornices, arabesques, flowers and all manner of trophies and allusions to Napoleon I, continued to be made for Chantilly, Compiègne, the Tuileries and Fontainebleau. Two watercolours of Empress Eugénie's *boudoir* at Saint-Cloud, one by Masson painted in 1855 and another by Fournier dating from 1863, show authentic pieces such as Oeben and Riesener's

famous Louis XV *écritoire* and a Louis XVI *commode-étagère* combined with contemporary sofas and armchairs to create an elaborate, over-abundant jumble.

Favourite colour schemes included various blends of red and green velvet or damask, shades of violet with pale cream borders, and black and gold to match furniture in ebony and painted wood. Mahogany and walnut were widely used for pieces with Renaissance motifs. Furniture created by Drugeon, Mainfroy, Perier and Rose & Cie were characterized by contrasts of bronze

and gold on tortoiseshell, ivory and mother-of-pearl. Striving to create ever more sumptuous furniture, makers combined enamel and silver, giltwood, inlaid panels and lacquered wood.

The door of an ebony *meuble d'appui* or cabinet with gilt-bronze mounts, made for Compiègne by an unknown cabinet-maker some time around 1860, is decorated with a *pietra dura* representation of a tree in blossom clearly of Louis XVI inspiration. The *buffet* composed of two superimposed parts made by Grohé in 1845 is inlaid in the Louis XV

style with baskets of flowers suspended by ribbons on a pale wood ground (Musée Condé, Chantilly).

At the Universal Exhibition of 1855, Fossey presented a carved giltwood *table de toilette*, decorated with three porcelain panels painted by Roussel depicting Arcadian scenes, surmounted by a medallion bearing the insignia of the Empress Eugénie. The piece, a reworking of Louis XV and now in the Musée National du Château de Compiègne, is a definitive example of the excessive ornamentation of the period. A further example of Fossey's technical virtuosity is the "Chinese" cabinet, which the artist himself appropriately christened *La musique chinoise.* The piece epitomizes academic Eclecticism, unashamedly imitative but at the same time seeking the kind of free artistic expression that would characterize Art Nouveau.

Among the most famous examples of Second Empire furniture were the upright piano (c. 1850) built for the Château de Chantilly by Roller et Blanchet Fils, adorned with exceptionally – but perhaps excessively – detailed inlays; the tall ebony cabinet with gilt-bronze mounts made for Madame de Païva's house on the Champs-Elysées (Musée des Arts Décoratifs, Paris); Guillaume Grohé's gilt-wood console with a white marble top in the Louis XV manner (Musée National du Château de Compiègne) and another console (c. 1860), likewise giltwood and white marble but this time in the Louis XVI-style, preserved at the Château de Chantilly. The Wassmus brothers' centre table made in 1859 of grey maple with amaranth lozenge inlays, fluted legs and

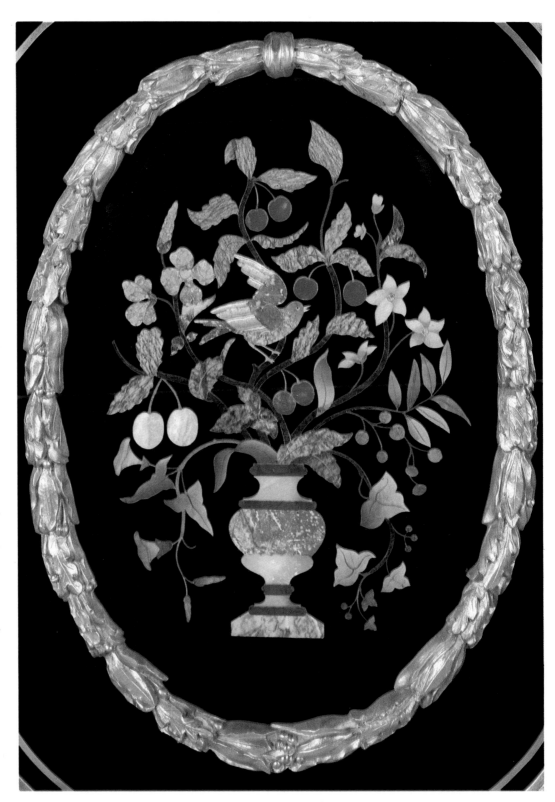

RIGHT: Ink and gouache drawing of Princess Mathilde's winter garden by Sébastien Charles Giroud, showing an interior crammed with furniture imitating all the styles of the 18th-century, as well as statues, carpets, ornaments and huge flower vases. BELOW: *travailleuse* made by Durand in the late 19th century. A replica of a famous piece made by the famous 18th-century artist Martin Carlin; the work table is in rosewood and palisander, with gilt-bronze decorations. A Sèvres porcelain plaque forms the surface of the upper section. Lécoules Collection, Paris.

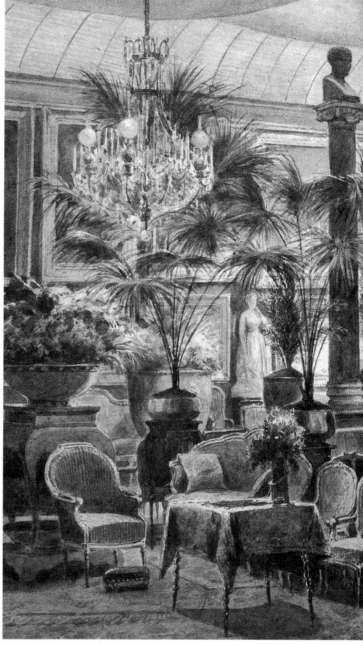

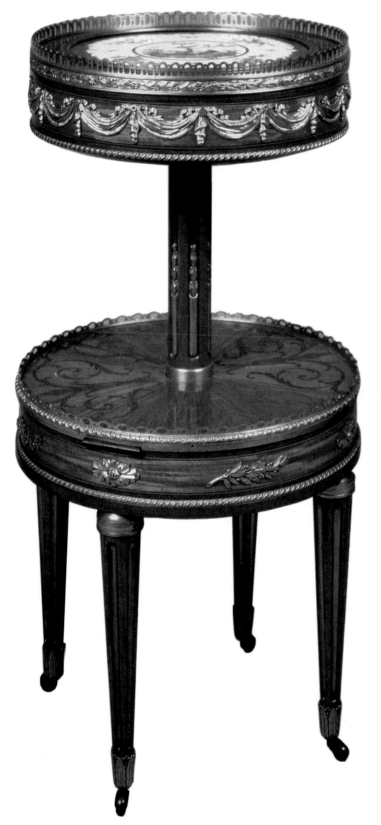

gilt-bronze mounts also echoes the Louis XVI taste (Musée du Château de Compiègne). Yet more pieces could be added to a long list drawn from contemporary inventories, such as the console tables by Poindrelle and Cruchet made for Fontainebleau and Compiègne respectively, and a similar piece by Aimé-Jules Dalou (1838–1902) for the Hôtel de la Païva (Musée des Arts Décoratifs, Paris). Another worthy addition is Paul Christofle's bronze, marble and lapis lazuli dressing table (Musée des Arts

Décoratifs, Paris), the *desserte* or sideboard for the *Salle de la Chasse* dining room at Chantilly and the table by Fourdinois, also in the Musée des Arts Décoratifs. All these items responded to the desire for luxury and solidity rather than to any notion of good taste.

Beds, too, were sumptuous, surmounted by canopies on barley-sugar posts, like the so-called Queen Victoria bed at Fontainebleau.

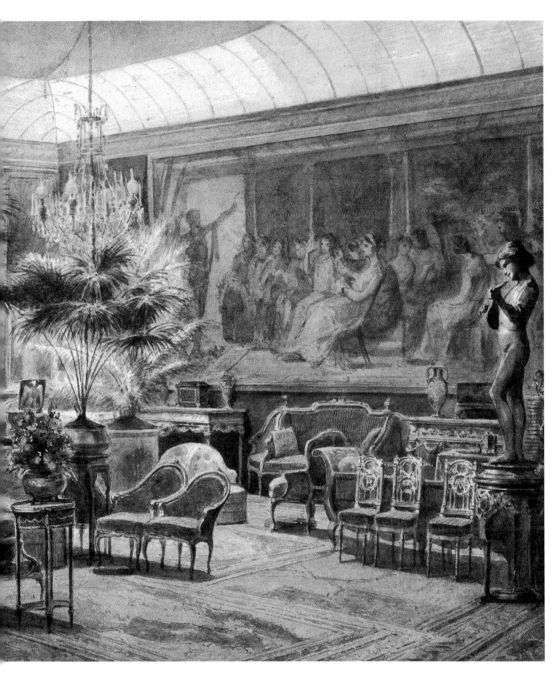

carved gilt-wood and nearly always upholstered in red damask were also Louis XV imitations. The ebonized wood chairs with mother-of-pearl inlays made in Paris in around 1850 recaptured the Napoleon III taste for rich, iridescent materials.

While the period could not boast any outstanding craftsmen, there were some imaginative designers such as Jean Feuchère, his pupil Jules Klagman and Liénard, whose *Spécimens de la décoration et de l'ornamentation au XIX siècle* published in Liège in 1866 displayed daring originality.

The extravagant Second Empire salons, with their chairs and sofas covered with Chinese silk, Genoese velvet, Beauvais and Aubusson tapestry or linen with velvet or embroidered appliqués provided a perfect and harmonious setting for the crinolines and lace, frills and furbelows favoured by fashionable ladies of the period.

New types of furniture: Second Empire seating

Pasquier's *Cahier de dessins d'ameublement,* published in 1840 (Bibliothèque Nationale, Paris) is still a rich source of information about the period. It contains a vast repertoire of patterns, including those by Jeanselme for upholstered armchairs and a whole variety of imaginative seat furniture. As Praz observed in *La filosofia dell'arredamento* (The Philosophy of Furniture), "never at any time in history was there

such an abundance of seat furniture as in the mid-19th century. Not only were new kinds of seating such as the *confortable,* the *causeuse,* the *indiscret,* the *fumeuse,* the *crapaud* and the *pouffe* added to those introduced in the 18th century; following the introduction of springs, the old types became more massive and clumsy, their balloon backs taking up most of the room space."

Cane seats were a new fashion, while upholstered or deep-buttoned seat furniture appeared in all shapes and sizes, from

pouffes – like the one at Compiègne, made by Fournier in about 1860, with carved gilt-wood legs simulating knotted rope – and small *tabourets* (stools) to large centre sofas, like the *borne* or *milieu salon* (a settee arranged in a circle so that a plant or candlestick could be placed in the middle). Other forms of seating included low armchairs known as *crapauds* and *chauffeuses* (low chairs for sitting in front of the fire) in the Louis XV style. *Confidantes, indiscrets à trois places* or *canapés de l'amitié* in

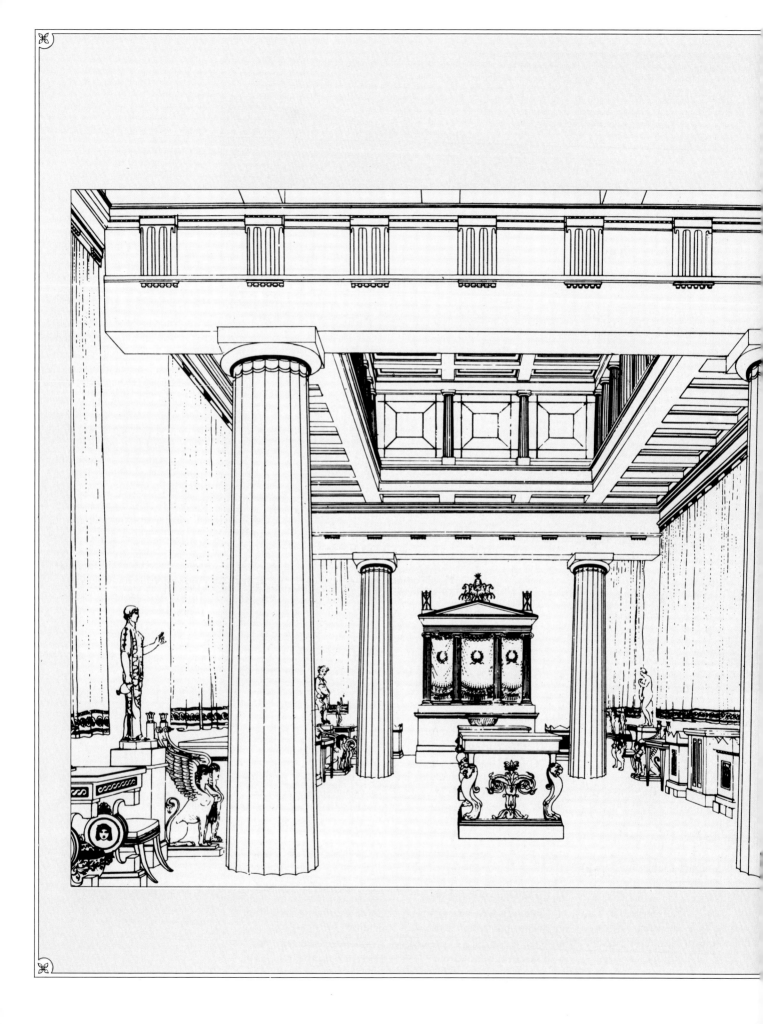

Furniture of the 19th Century

England

by Alessandra Ponte

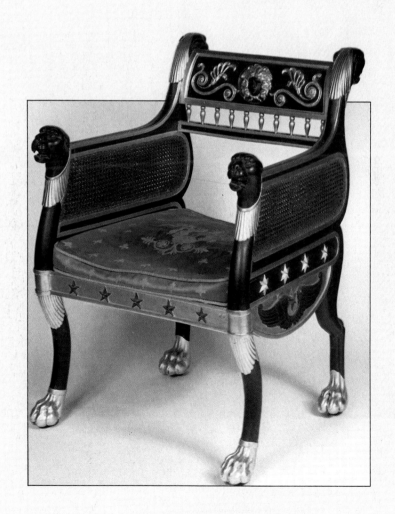

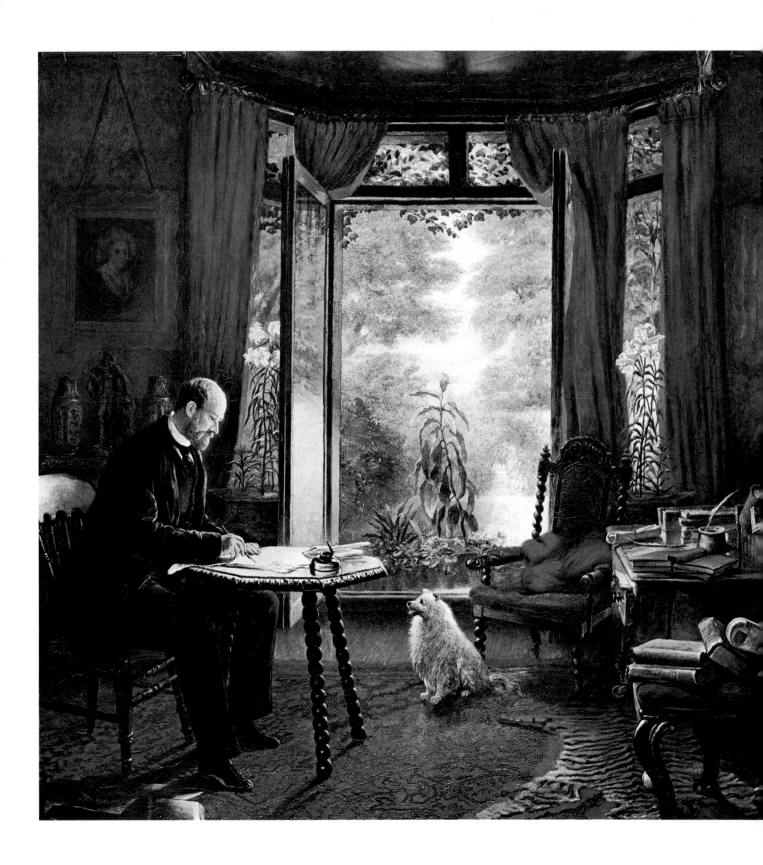

ABOVE: Charles Mercier's painting of Charles Reade in his study (1838) depicts a typical Victorian domestic interior; a comfortable, restful atmosphere produced by the warm tones of the curtains, upholstery and carpets and the furniture, with its typically turned wooden legs. National Portrait Gallery, London. FACING PAGE: Victorian games table in Indian walnut with maple and rosewood inlays. PREVIOUS PAGES: Drawing by Thomas Hope of the plan for the picture gallery in his own house, from *Household Furniture and Interior Decoration* (1807), and an armchair in the Egyptian manner designed by George Smith in 1806. Victoria and Albert Museum, London.

In pursuit of comfort

The great Austrian architect Adolf Loos, writing in 1898 in his essay *Das Sitzmöbel*, contended that the English and Americans were "[…] absolute and genuine masters of the art of relaxation. During the past century, they have invented more types of seat furniture than have been devised at any time in the entire rest of the world. Based on the principle that each type of fatigue requires a different kind of seating, one never finds identical types of chair in an English room. In one single room, there is seating of the most disparate types. Each person may choose the seat he considers most comfortable. The exception may be in rooms which are only occupied for short periods for a specific purpose, such as ballrooms or dining rooms. In the 'drawing-room', which is our *Salon*, given the use for which it is intended, there will be chairs which may easily be moved about. They are not designed for repose, but must be suitable for sitting through a pleasant and lively conversation […]" Here, Loos is stating the fundamental causes that transformed furniture and interior design in the course of the 19th century, namely the body was being used in new ways, and attitudes towards relaxation were changing. "Comfort" was what mattered. Of Latin derivation, the English word was widely used in 18th-century Western culture to denote the feeling of well-being engendered by the manner in which homes were designed.

As Siegfried Giedion notes in *Mechanization Takes Command* (1948), the process began with the shape of Rococo seating. The stools, benches, thrones and chairs of previous centuries took no account of the comfort of people sitting on them. Rococo chairs, however, were carefully moulded to fit the shape of the human body. They were constructed on flowing lines, backs were adapted to provide support for the spine, and seats were modelled to match the line of the thigh and the bend of the knee. Arms were set back, and some parts of the chair were upholstered and stuffed.

Spoon-back chairs easily accommodated the human form in

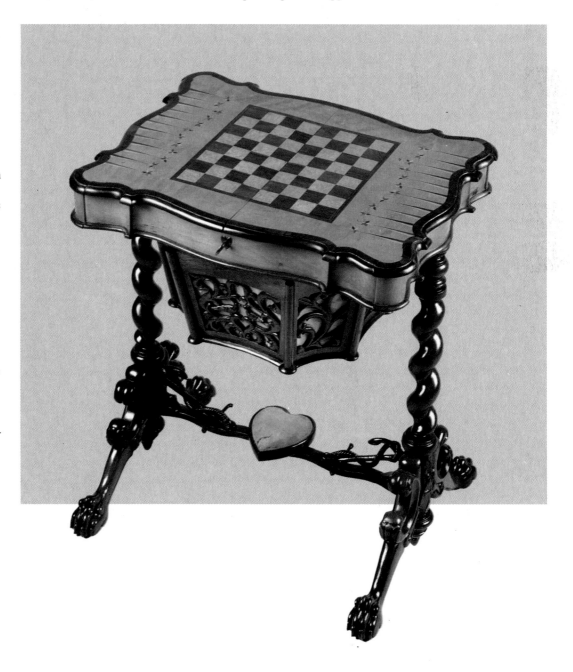

relaxed positions. English furniture-makers based their designs for sofas and easy chairs on the 18th-century *bergère, marquise* and *chaise longue*. The *bergère* (especially the gondola version), a sturdy armed chair with a fairly low, curved back, was the prototype for the development of upholstered easy chairs with coiled springs, a very popular form of 19th-century seat furniture whose contours were softened and wooden frames completely hidden under layers of upholstery and mounds of cushions. The *marquise*, a kind of two-seat *bergère* derived from the settee, was to survive well into the 19th century, in fully upholstered versions with the feet concealed by long fringes. The *chaise longue* (otherwise known as day-bed, couch or settee) first achieved popularity in France and England as a seat on which one could recline, with mechanical devices to regulate the angle of the backrest. It was superseded during the Rococo period by a couch with a rigid backrest, in which the top rail and other wooden elements were carved in the elaborate, curved lines then in vogue. In the early 19th century, under the influence of the prevailing Pompeian taste, the design became more severe, only to return to softer lines to accommodate a greater flexibility and, by the middle of the century, it too was fully upholstered. Couches in every style – Egyptian, Gothic, Greek, and Louis XIV – were found in boudoirs and bedrooms, and it was on such couches that well-bred ladies would arrange themselves in languid poses to have their portraits painted.

In pursuit of ever greater comfort, certain types of seat furniture were fitted with gadgets to adjust their various parts. As easy chairs and divans were hidden under ever more upholstery, a multitude of accessories such as adjustable book-rests, writing tables, head-rests, fire-screens, candle-holders and reading lamps were introduced as aids to relaxation. Upholstered and patent furniture were the hallmarks of the 19th century. In England, the cabinet-maker's art had reached its pinnacle with the works of Chippendale, Hepplewhite and Sheraton. Furniture-making now became the province of upholsterers and engineers.

The importance of the upholsterer

From the Empire period onwards, the role of the upholsterer became increasingly important. The taste for elaborate hangings, ornate upholstery, innumerable curtains, both around and between rooms and around beds and sofas, all transformed these erstwhile simple skilled workmen into interior decorators. They were less interested in quality than in achieving dramatic effects. The furniture created by this new army of professionals – and we are referring here to a huge variety of upholstered seating – had no rigid structure, indeed it seemed to have no frame at all. The wooden elements, which were later often replaced by iron, disappeared under increasingly voluminous padding, while long fringes covered the tiny feet. Giedion attributes this new trend to Oriental influences, especially the Turkish style which persisted throughout the 19th century. Research has revealed

that, although such influences had been present in England since the 16th century, it was only in the later 18th century that furniture directly inspired by the orientalising style came into fashion (cf. *The Islamic Perspective, An Aspect of British Architecture and Design in the 19th Century* by Michael Darby, 1983). In Louis XV's time, a small seat known as a *turquoise* had been introduced. It was composed of cushions arranged side by side to provide seating, with other loose cushions which could be lined up against the wall as backrests. Among Thomas Sheraton's designs, discussed below at greater length, was a sketch for a "Turkish" sofa, to be inserted in a U-shaped recess. Mid-19th-century watercolours of interiors often show these so-called "Turkish corners". English and French upholsterers alike created an amazing range of armchairs and sofas of the type which took up so much space in 19th-century homes. They included S-shaped seats for two or more people and chairs for two to use only for serious conversation. Other well known examples of the period were the *vis-à-vis* (face to face) and the *dos-à-dos* (or back-to-back), which later formed the basis for the *petite boudeuse* (from the French *bouder*, to sulk), which first appeared in about 1870. It consisted of two stools with a shared upholstered backrest, in which the occupants sat facing in opposite directions. *Pouffes*, upholstered stools with long fringes, looking more and more like enormous decorated cakes, appeared in mid-century, along with circular, octagonal, pentagonal and trefoil sofas placed in the centre of the room.

The English versions of these pieces tended to be of more modest dimensions than the French and were without fringes. It was a French upholsterer, Dervillier, who in 1838 introduced the sprung, cushioned easy chair on an iron frame. Iron was easier to work with than wood, but it did have an unfortunate tendency to bend easily, for which reason furniture-makers reverted to wooden frames.

Patent furniture

The first patent to be granted for a sprung armchair went to Samuel Pratt, an English furniture-maker in 1826. Pratt designed a chair to alleviate the rocking and rolling that caused sea-sickness. Sheraton had already used springs in his famous "Chamber Horse", a chair designed for those who wished to take exercise in the privacy of their bedrooms. The style adopted in most homes was known in England as "Naturalistic" or "Louis XIV", despite the fact that it was really a reinterpretation of the Louis XV style, i.e. a variant of Rococo.

There was also a move towards patent (or mechanical) furniture devised by engineers and amateur inventors. Already in the 18th century Chippendale, Hepplewhite and Sheraton had relied considerably on mechanical devices, systems of hinges, pivots, runners, rollers (used for roll-top desks, for example) and sliding tops which enabled a single item of furniture to be put to a surprising variety of uses. As well as being masters of form, English 18th-century cabinet-makers seemed to be trying to find out

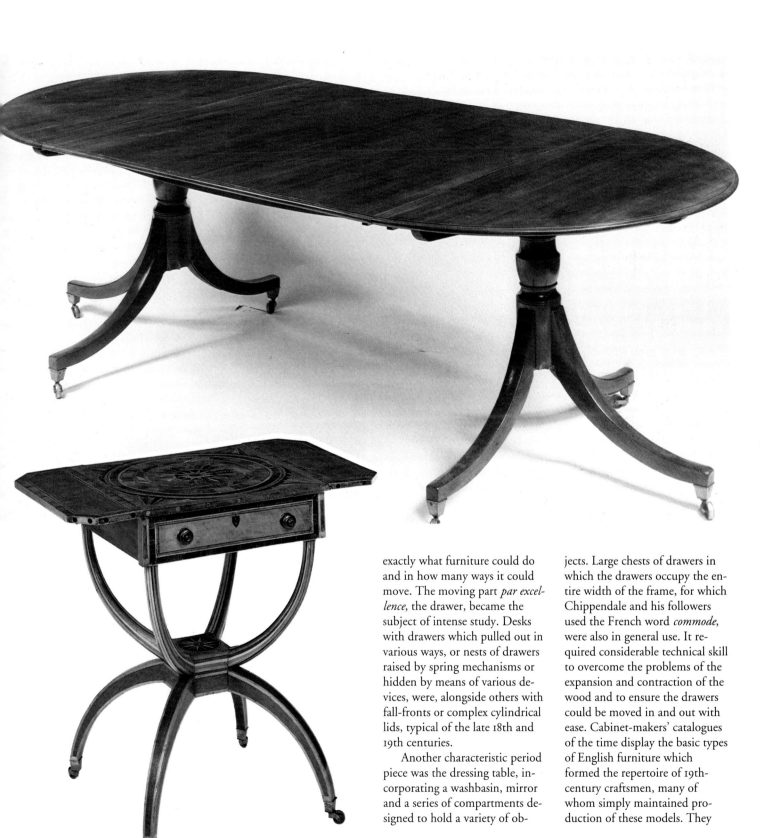

BELOW: typical George III extendable dining table with two supports and splayed feet, fitted with castors; and an inlaid drop-leaf, bow-legged Pembroke table. Antiques trade.

exactly what furniture could do and in how many ways it could move. The moving part *par excellence*, the drawer, became the subject of intense study. Desks with drawers which pulled out in various ways, or nests of drawers raised by spring mechanisms or hidden by means of various devices, were, alongside others with fall-fronts or complex cylindrical lids, typical of the late 18th and 19th centuries.

Another characteristic period piece was the dressing table, incorporating a washbasin, mirror and a series of compartments designed to hold a variety of ob-

jects. Large chests of drawers in which the drawers occupy the entire width of the frame, for which Chippendale and his followers used the French word *commode*, were also in general use. It required considerable technical skill to overcome the problems of the expansion and contraction of the wood and to ensure the drawers could be moved in and out with ease. Cabinet-makers' catalogues of the time display the basic types of English furniture which formed the repertoire of 19th-century craftsmen, many of whom simply maintained production of these models. They

These pages show images of the Royal Pavilion in Brighton, rebuilt by the architect John Nash between 1815 and 1821 for the Prince Regent, taken from *Nash's Views of the Royal Pavilion*, published in 1826. Left: the domed Banqueting Room (1822) with a dome designed to represent the open sky adorned with huge banana leaves, from the centre of which is suspended a chandelier with silver dragons. Below: the Long Gallery (1815), decorated in an exotic Chinese style. FACING PAGE: the Great Kitchen (1820), with the banana-leaf motif repeated on the slender iron pillars.

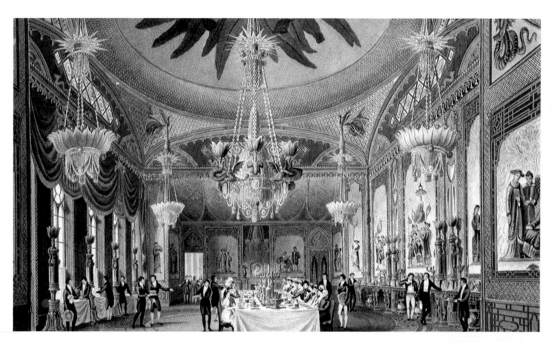

Alternative materials

The 19th century was also an age of replicas, simulation and overt kitsch. As one style copied or hybridised another, so materials were inappropiately were used to imitate others.

According to Giedion, between 1837 and 1846 at least 35 patents were issued for inventions for covering metal and other objects with coatings other than lacquer, or for the use of gesso and other cheaper materials substituted for more expensive ones. Artificial precious stones were produced, metal was painted with graining and papier-mâché was

included glass-fronted bookcases (often combined with desks, with the writing surface usually a surface that revolved on hinges or slid on runners), sideboards and side tables, light leather-backed chairs (manufactured until the end of the 19th century), small chairs and tables which converted into library steps and large dining-tables (known to the French as *tables à l'anglaise*) which could take various forms, thanks to systems of hinges or removable inserts that allowed them to be folded or extended.

The devices used by great cabinet-makers were complex mechanisms adapted by engineers who, unaware of problems of form, focused all their attention on structure and technology. Surfaces were separated into sections and furniture was made in pieces, which were then joined and adjusted by mechanical devices so that they could be adapted to serve different functions. The

main problem was to design furniture which could be adapted to suit the shape of the human body. A variety of articulated chairs were invented to meet the requirements of invalids, barbers, dentists, theatres, railway carriages, offices, schools and workshops. One example was the sprung, swivel office chair, which provided both comfort and mobility. There were also a variety of folding chairs. More and more convertible furniture appeared – armchairs which could be converted to beds, beds which became wardrobes, pianos or desks – plus furniture for use in the garden and countryside or for travelling. America led the field in this kind of novelty, although in England growing numbers of patents were issued either for ingenious items of furniture or for imitation materials and simplified procedures that allowed furniture to be manufactured more cheaply.

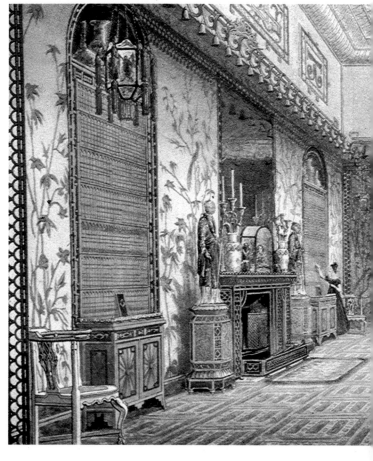

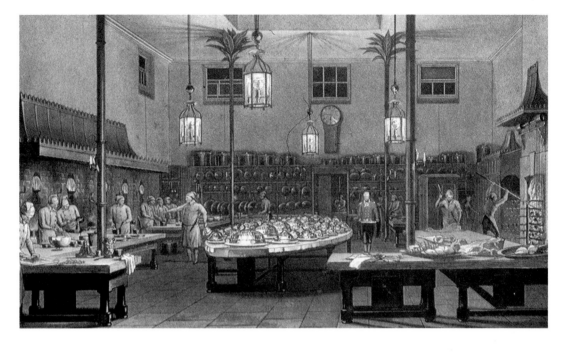

used instead of wood. Machine tools to press, engrave and prepare moulds and ingenious systems to reproduce concave, convex and moulded surfaces were also patented. The middle of the century saw the introduction of steam-powered machines, initially used to cut thin sheets of wood for veneering (a common technique at the time, allowing the manufacture of less expensive furniture using a carcass of cheap wood covered by a thin layer of costlier wood). Such machines were also employed to cut and carve simple components. These forms of economical imitation were not confined to industry. Even reputable artisans published

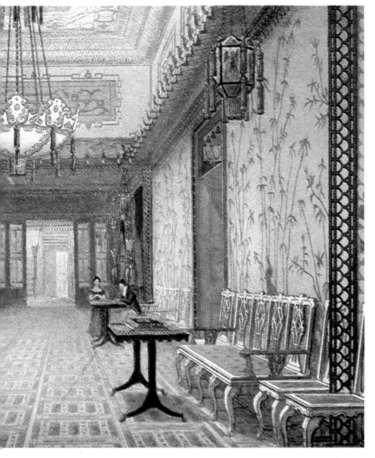

advice on how to create imitations of expensive materials, such as these instructions for making rosewood printed in 1825: "Take half a pound of log-wood, boil it in three pints of water until it is very dark red, to which add about half an ounce of salt of tartar, and once boiling hot, stain your wood with two or three coats, taking care that it is nearly dry between each; then with a stiff flat brush such as you use for graining, make streaks with a very deep black stain, which, if carefully executed, will be very near the appearance of dark rosewood."

Around 1850, new materials were used more widely. Particularly popular was furniture made of metal and papier-mâché. Papier-mâché as a material for furniture or parts of furniture was introduced to England from France in the late 18th century. According to Geoffrey Wills's *English Furniture 1760–1900*, published in 1969, the first and most important maker of papier-mâché at that time was Henry Clay of Birmingham, who patented his process in 1772. The best-quality papier-mâché was made by gluing together sheets of unsized porous paper and shaping the resulting card-like material in a mould before drying. The inferior version, using paper pulp, was also subjected to pressure moulding. This material had many advantages: it was cheap, easy to paint, varnish or lacquer, and so could be used as a ground on which to create decorative mother-of-pearl or

shell patterns. A thin layer of sliced mother-of-pearl was applied to the entire surface and the pattern painted on with transparent varnish, then the area unprotected by this mask of varnish was removed with acid. One famous firm in the 19th century was Jennens and Bettridge, also of Birmingham, which produced these and smaller items such as boxes of various kinds japanned in black, green or red, decorated with gold and inlaid with mother of pearl. A few other manufacturers produced papier-mâché furniture, mostly chairs and small items such as polefire-screens, tables and frames for mirrors and pictures. A more ambitious project was a complete luxury bedroom suite in papier-mâché for Temple Newsam House near Leeds, although the supports were made of wood and iron.

The most frequent use of iron and other metals was for beds. Iron bedsteads became popular around 1820, mainly for reasons of hygiene. Wooden beds attracted bed bugs, making it necessary to dismantle the bed at least once a year, and the change to iron bedsteads went some of the way towards eliminating the problem. Bed manufacture became a major part of English furniture production around 1850.

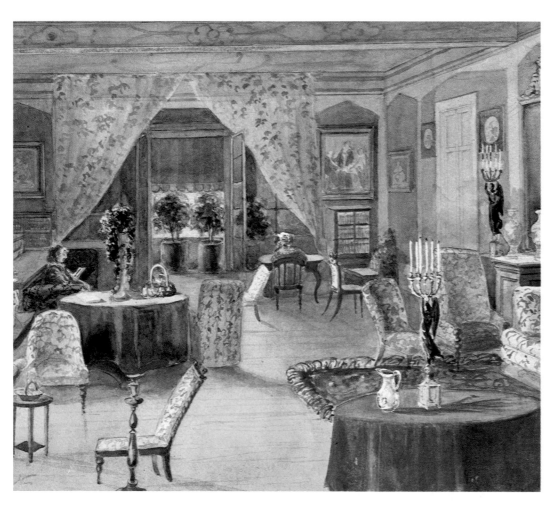

BELOW: a watercolour by an unknown artist showing the drawing room at Acton House, Bridgnorth, furnished in typical Victorian style; the upholstered chairs, armchairs and tables are arranged so that groups of people may engage separately in private conversation. FACING PAGE: watercolour by G. M. Gandy showing a room at Sir John Soane's Museum, London.

By 1875, the industry was turning out almost 6,000 beds a week, most of them for export. J. C. Loudon's *Encylopaedia of Cottage, Farm and Villa Architecture and Furniture* (1833) contains numerous examples of tubular iron chairs, tables of various sizes, beds and armchairs, as well as plates showing patterns for iron supports, which continued in production for many years. Metal chairs, tables and armchairs were popular as garden furniture, but people continued to prefer wood for indoors. Bedsteads in iron and other metals (especially brass) in one or other of the fash-

ionable styles, were on display at the Great Exhibition of 1851 held in London under the sponsorship of Albert, the Prince Consort.

The same exhibition also featured some items in gutta-percha (a material extracted from the sap of a Malayan tree, presented for the first time in Paris in 1842 and London in 1843), and bentwood furniture of the type which the German-born cabinet-maker Michael Thonet was to make internationally famous.

A plethora of styles

With the 19th-century fondness for revivals, different furniture styles coexisted quite freely. In the early years of the century, alongside examples of the Georgian taste continuing the fashions set by Chippendale and Hepplewhite and the enduring Neoclassical influence of Robert Adam, we find the refined archaeological style of Thomas Hope, the eccentric *chinoiserie* beloved of the Prince Regent, the personal Eclecticism of Sir John Soane's later work and Pugin's first Neo-Gothic creations. In *La filosofia*

dell'arredamento, Mario Praz quotes Alfred de Musset, who in the early 1830s deplored rooms "in which one finds furniture from every age and every land jumbled together. Our age is without form. We have stamped the imprint of our own times neither on our homes, nor on our gardens, nor on anything else. The homes of the wealthy are showcases for curiosities: Antiquity, the Gothic, Renaissance and Louis XIII styles are all there in utter confusion. In a word, we have something from every century but our own, something which has never been seen before at any other time. We take pleasure in Eclecticism; we pick up everything we find, one piece because it is beautiful, another because it is old, and yet another because it is ugly; and so we live on scraps, as though the end of the world were at hand." This devastating attack echoed the views of many progressive designers in the second half of the century.

Many voices were raised against the "horror" of Eclecticism, most notably those of Ruskin and Pugin, who called for the creation of a new, universal style rooted in the Gothic age. In reality, late-Victorian drawing rooms were no more than a confused muddle of sofas, tables, flowers, knick-knacks, *pouffes,* cross-stitch embroidered Berlin woolwork, trimmings, tapestries, fire-screens, stools and countless other bits and pieces in every style imaginable.

Added to all this, the Eighties and Nineties brought the Japanese and Queen Anne styles favoured by a certain sophisticated section of the bourgeoisie sympathetic to the doctrines of

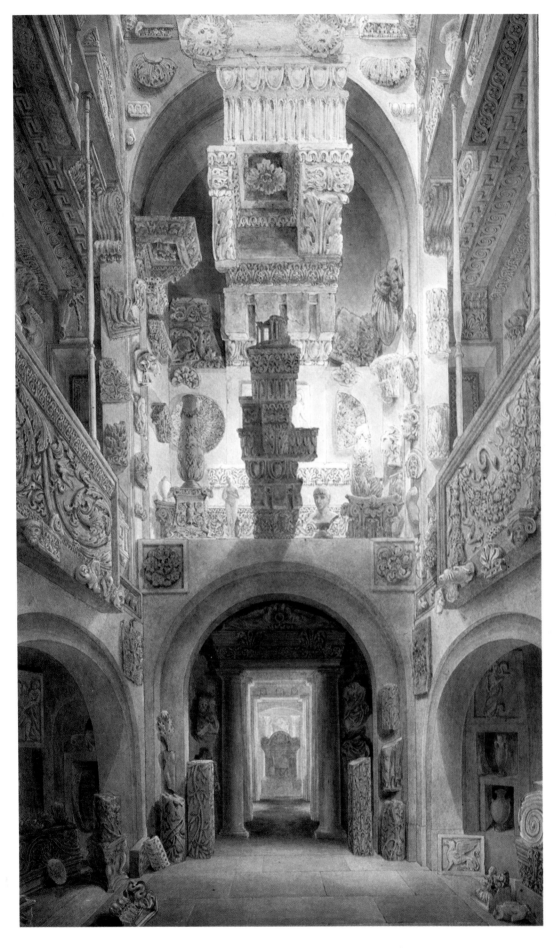

the Aesthetic Movement, exemplified by such luminaries as Oscar Wilde, Walter Pater and James McNeill Whistler.

Alongside mass-produced furniture catering for middle and lower-middle-class tastes were the sophisticated creations of Charles Lock Eastlake, Edward William Godwin and the architects and craftsmen belonging to the guilds of the Arts and Crafts movement, which sought to promote craftsmanship and the reform of industrial design. Reacting against the Victorians' *horror vacui* and under the banner of "good taste" – a subtle instrument of distinction far more powerful than *nouveau riche* money – they paved the way for a fresh, modern style. The spread of white paint on walls, wardrobes, cabinets and bathrooms and strict simplified volumetrics in furniture were signs of an imminent triumph – the union of hygiene and morality in the British home.

From Sheraton to the Regency

The school of Sheraton

Thomas Sheraton (1751–1806) was the last of the line of great cabinet-makers who gave their names to the styles of the Georgian era. In *English Furniture* (1929), Herbert Ceschinsky tells how Sheraton arrived in London from his home town of Stockton-on-Tees, in the North of England, in 1790, only to die there in poverty, a little-known draughtsman. His obscurity may well have been due to the uncertain political situation, which can hardly have tempted the aristocracy to remodel their homes. The French Revolution was causing near-panic throughout Europe, and England had recently suffered the loss of her American colonies.

Sheraton was in fact an expert cabinet-maker, skilled in his craft, with a sound knowledge of mechanical contrivances. He also had an unusual mastery of design and geometry, and it is no coinci-

dence that his pattern-books are introduced by writings on perspective and design. We know nothing definite about his work in London, but it is almost certain that he never did any woodwork and probably supported himself by giving drawing lessons. He devoted most of his efforts to writing ambitious manuals: *The Cabinet Maker and Upholsterer's Drawing Book*, financed by a long list of subscribers, which ran through three editions between 1791 and 1802; the *Cabinet Dictionary* (1803), written after he had come under the influence of the Neoclassicism of Thomas Hope; and the unfinished *Cabinet Maker, Upholsterer and General Artist's Encyclopaedia* (1804–06). As there are no surviving items that can be ascribed to him with any certainty, these pattern-books are the only sources on which to base a study of his style. It was their widespread use by contemporary furniture makers that brought him the fame he

never achieved during his lifetime.

Style and types of furniture

Sheraton's style is often confused with that of his immediate predecessor, Hepplewhite, but his primary source of inspiration is more likely to have been the work of Thomas Shearer, author of *Design of Household Furniture* (1788). However, even if Hepplewhite did influence the style of his tables, cabinets, sideboards and bookcases, Sheraton was definitely original in the design of his chairs. Of special interest are his square-back chairs, which are akin to French examples from the latter part of Louis XVI's reign. Characteristic features of his style, best exemplified in the *Drawing Book*, are slender, often cabriole, legs; the predominance of inlays and painted motifs; the rarity of carving, which was re-

garded as too expensive a technique; and the use of reflective, light-coloured woods (introduced by Hepplewhite and his school) such as satinwood – a satiny, yellowish-brown wood used for veneers. His favourite wood was mahogany, particularly varieties imported from Central and South America, which he considered essential for dining-room furniture.

Of the highest quality, as we have already mentioned, were his mechanical pieces: the lady's writing firescreen; the French work table; various types of Pembroke table, with square, rectangular and round tops; and finally the harlequin Pembroke table. Though an extremely sober piece of furniture, with straight, square-section legs, the latter is mechanically complex: it has a wide frieze supporting four drawers on the shorter sides; there is a special mechanism for extending the top; and the body of the table houses a series of compartments

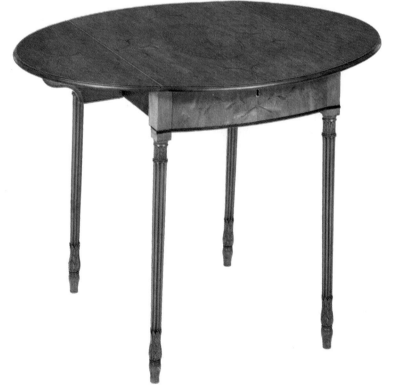

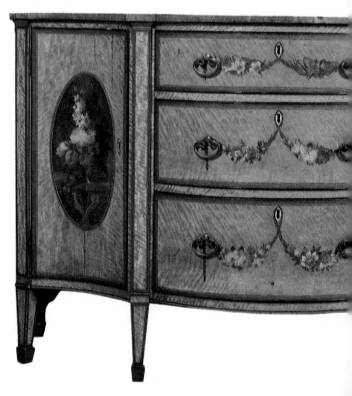

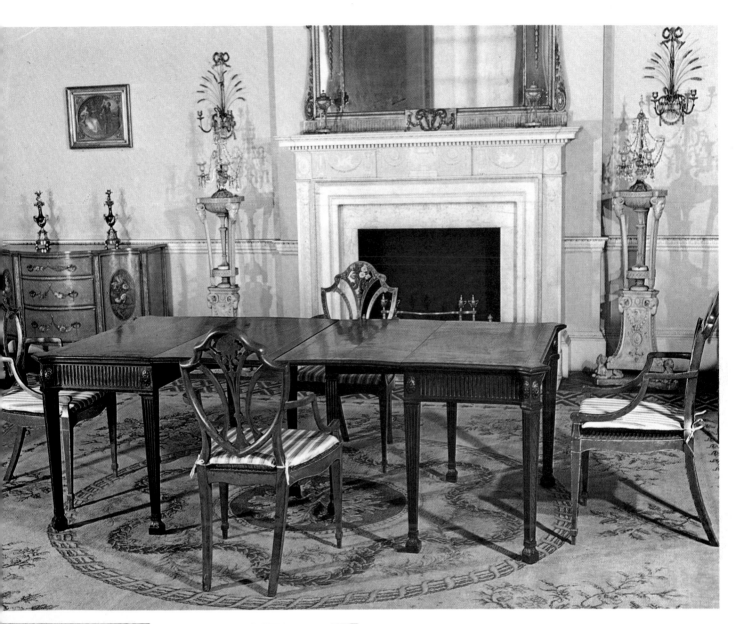

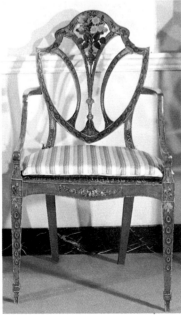

and drawers that can be raised above the work surface. His larger pieces of furniture also have a sobriety of line and decoration which makes them outstandingly elegant. In his *Drawing Book*, Sheraton refers to an interesting text of the period: the *Cabinet Maker's Book of Prices*. Catalogues of this type, with many variations, remained in use until the end of the 19th century – essential tools of what was still an artisan industry. Cabinetmakers charged for a completed piece of furniture rather than the number of hours labour involved. Such books not only catalogued and priced every kind of joint, groove, intaglio and stain, and all the processes and operations pertaining to the craft; they also

FACING PAGE, LEFT: Pembroke table with hinged flaps from the time of George III. Antiques trade. CENTRE: chest of drawers from the final decade of the 18th century with painted floral decoration on satinwood. THIS PAGE, LEFT: shield-back satinwood chair with painted decoration, a popular 18th-century model revived by Sheraton. Both private collection. The chair and chest of drawers are featured in the room above, which also contains an extending rectangular table, with hooks to hold the leaves in place.

The items illustrated on these pages are from the reign of George III, all dating from the period 1790–1800. THIS PAGE, BELOW: small satinwood writing desk. BOTTOM: games table that folds up to stand against a wall. RIGHT: mahogany music cabinet decorated with stringing and marquetry ovals featuring floral motifs. This piece has much in common with Sheraton's patterns. All antiques trade.

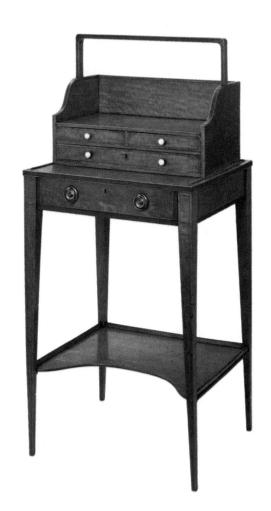

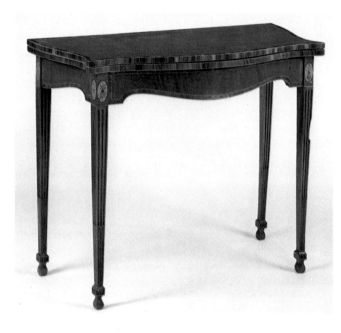

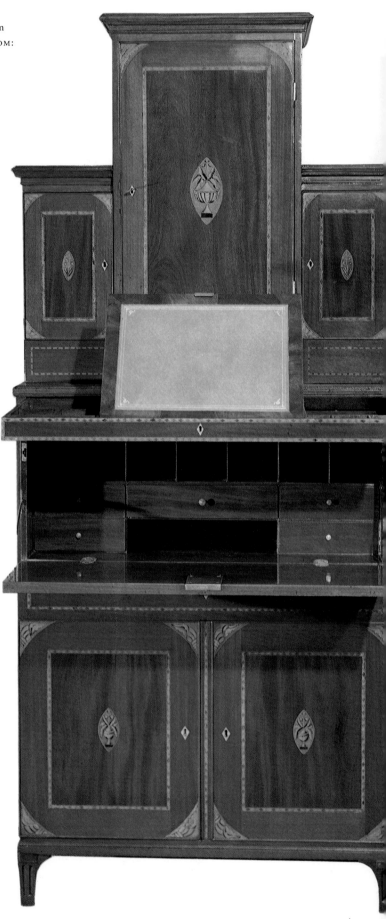

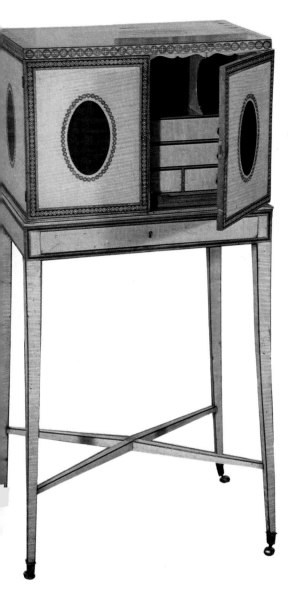

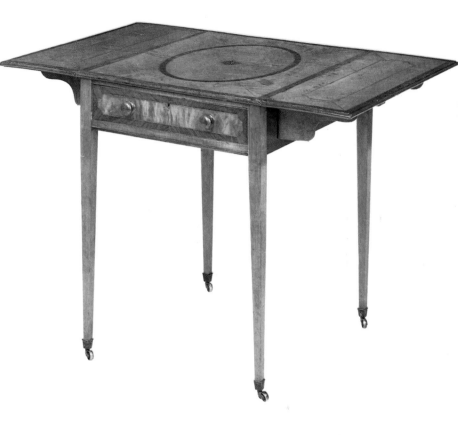

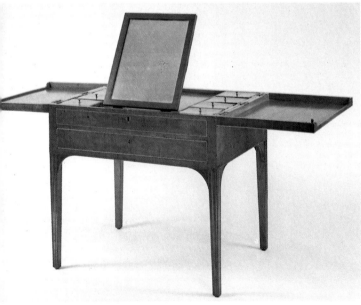

Left: satinwood writing cabinet with stringing and inlaid yew-wood medallions. The simple, geometrical style is typical of Sheraton. Above: Pembroke table with hinged flaps and inlaid friezes and stringing. Below left: mahogany dressing table in the open position. Right: mahogany writing table with reading stand and curved legs typical of the period. All antiques trade.

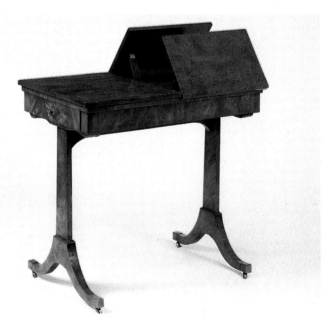

The linearity of Thomas Sheraton

Where English furniture design is concerned, the final decade of the 18th century is closely linked with the name of Thomas Sheraton. The 133 engraved furniture patterns in his *Drawing Book*, designed entirely by himself and accompanied by technical notes on construction methods, created a style characterized by distinctive linear decoration and graceful, elongated shapes, and laid a basis for new forms that came to full expression in the Regency period. These new forms were more clearly spelt out in Sheraton's two later works: the *Dictionary*, which prefigures the development of curving, sabre legs, and the unfinished *Encyclopaedia*, which featured the first English examples of Egyptian-style furniture – later to become a popular fashion.

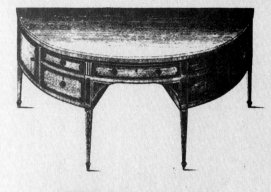

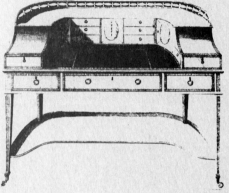

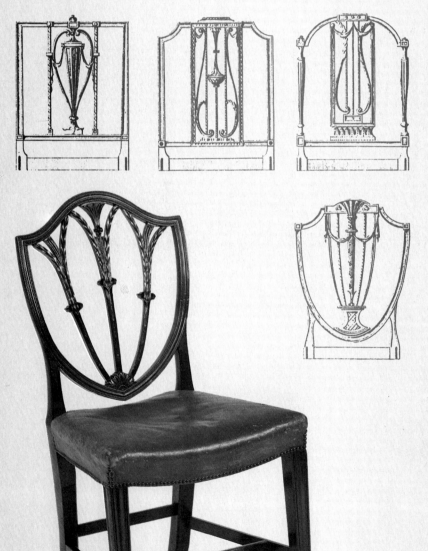

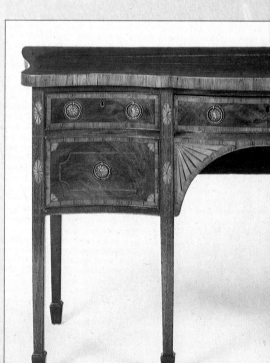

Designs for chair backs, two sideboards and a two-section cabinet from Sheraton's *Drawing Book*, a collection of patterns for cabinet-makers, published in three editions between 1791 and 1802. It proved very influential, and the Sheraton style was "revived" in various forms throughout the 19th century. The three items of furniture illustrated here, all from the reign of George III, have obvious affinities with

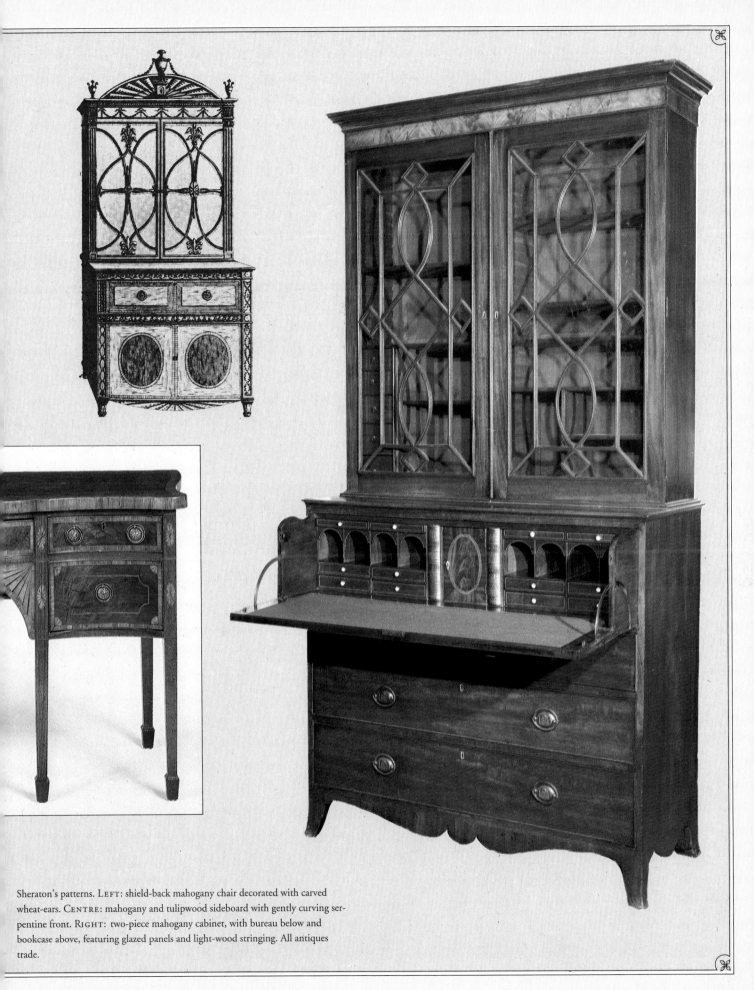

Sheraton's patterns. LEFT: shield-back mahogany chair decorated with carved wheat-ears. CENTRE: mahogany and tulipwood sideboard with gently curving serpentine front. RIGHT: two-piece mahogany cabinet, with bureau below and bookcase above, featuring glazed panels and light-wood stringing. All antiques trade.

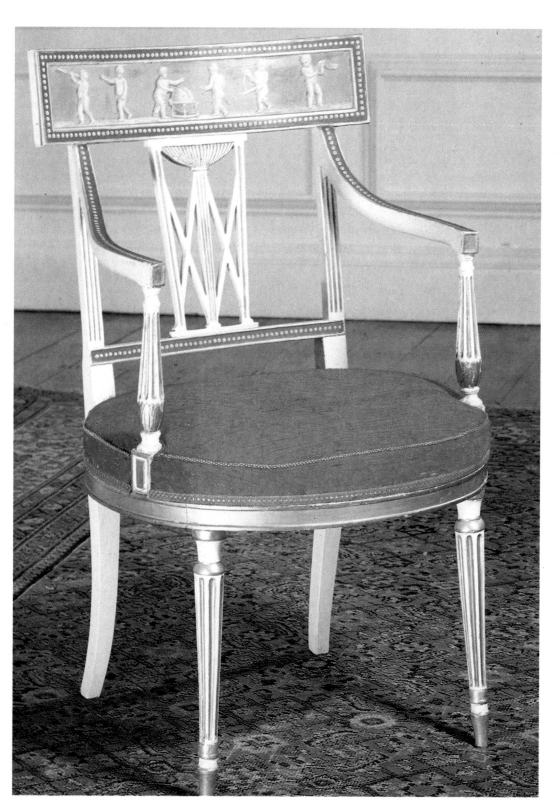

codified and anticipated every possible combination and variation. To work out the price of a piece of furniture, all the cabinet-maker had to do was total up the cost of the different operations involved, then add the cost of the raw materials. These texts were illustrated with many plates. In the case of the catalogue mentioned by Sheraton, the author of some of the illustrations was George Hepplewhite.

Thomas Hope and Neoclassicism

English Neoclassicism, as Edward Lucie-Smith explains in *Furniture, a Concise History* (1979), falls into two distinct phases. The first was represented by the work of Robert Adam and later of Henry Holland(1745–1806), favourite architect of the Prince Regent (the future George IV) and of the Whig aristocracy; the second by the work of Thomas Hope.

Holland's work had already shown a closer and more detailed study of Greek and Roman sources. Following in the footsteps of two French architects and interior designers, Charles Percier and Pierre Fontaine, Holland had sent his pupil Charles Heathcote Tatham (1772–1842) to Italy to collect drawings of ancient monuments and especially reliefs of classical decorative motifs. Tatham's work, published as *Etchings of Ancient Ornamental Architecture*, first in 1799 and again in in 1810, provided accurate archaeological documentation for decorative artists. However, Holland's precise use of Greek and Roman decorative terminology was not followed by Hope.

On these pages are illustrated several types of chair deriving from Sheraton's patterns. FACING PAGE: painted and parcel-gilt drawing-room armchair, dating from around 1895. Private collection. THIS PAGE: three square-back armchairs: the first, below, made of mahogany and satinwood; the second, bottom left, lacquered in black with decorative gilding; the third, bottom right, in beech worked to look like bamboo (c. 1800). BELOW, CENTRE AND RIGHT: two different types of balloon-back dining-room chair.

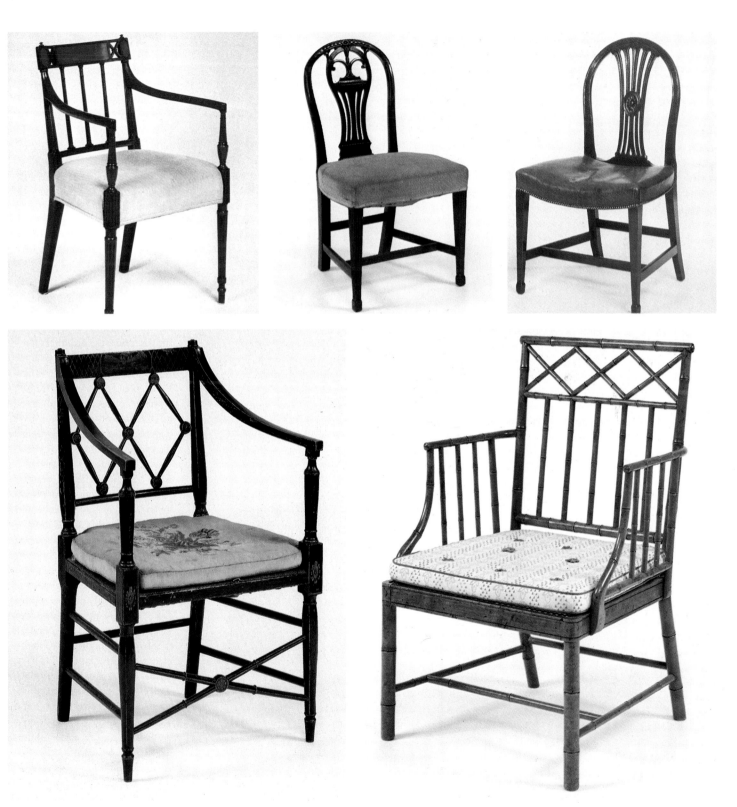

Thomas Chippendale junior, who had worked with his father at Nostell Priory and Harewood House and continued in the trade, made this palisander writing desk in 1804 for the library of Sir Richard Colt Hoare, at Stourhead in Wiltshire. The pilasters are in the form of herms with the heads of philosophers and sphinxes, a motif of Egyptian inspiration that was to become popular in the Regency period.

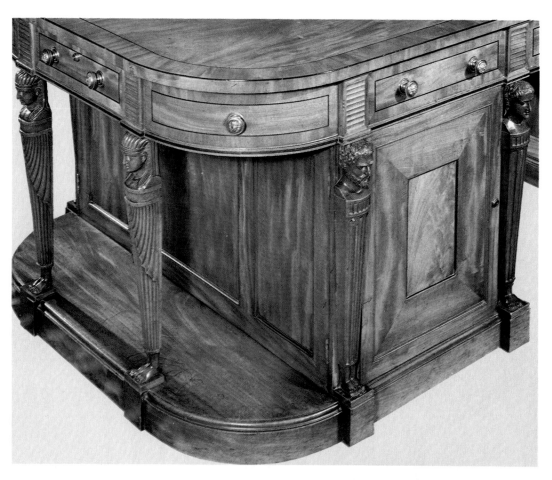

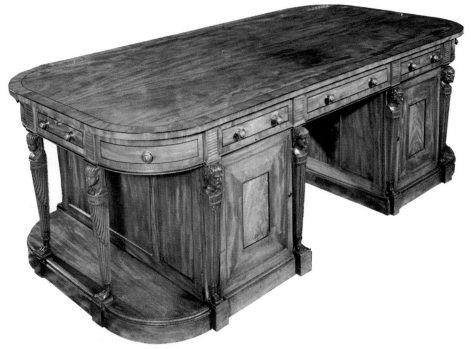

Thomas Hope, born in Amsterdam in 1769 of a family of Scottish bankers, settled in London in 1794. He was first and foremost a connoisseur and collector, a dilettante in the 18th-century sense of the term. In the best traditions of the aristocracy, in his youth he had made the *Grand Tour*, a journey through various European and Near Eastern countries that was regarded as rounding off a young man's education. In the years 1787 to 1795 he had visited France, Italy, Greece, Turkey, Egypt and Syria, and passed through a number of other countries, studying the local monuments and decorative arts and making notes on buildings, landscapes and other subjects of artistic interest.

On his return, he settled in London and, obsessed with the ambition of becoming a master of visual history, attempted a synthesis of all styles and religions in his enormous house in Duchess Street. Hope had purchased it from Lady Warwick, sister of Sir William Hamilton, from whom he had bought most of the sculptures and Greek vases in his collection. Engravings of the various rooms, accurately reproduced by Edmund Aikin and George Dawe, were subsequently published in a folio volume entitled *Household Furniture and Interior Decoration* (1807). Hope paid for the work, hoping to advertise his ideas to a wider public. The house in Duchess Street was demolished in 1851, but some of the furnishings survived and are now conserved in the Victoria and Albert Museum, London, and the Royal Pavilion, Brighton.

Ensuring the correct application of a style, be it Roman, Egyptian or Greek, was almost a

THIS PAGE: items in the "archaeological" style inspired by classical antiquity. BELOW: sofa manufactured by Gillows of London for Kimmel Park in 1805. BOTTOM, RIGHT: carved chair dating from around 1820. Victoria and Albert Museum, London. LEFT: lacquered and gilded *torchère*, made around 1808 to a design by George Smith. Normanby Hall, Shenthorpe.

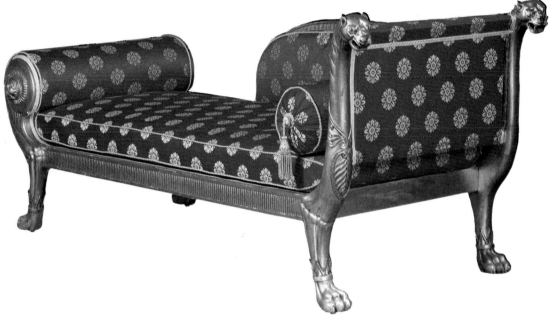

missionary endeavour for Thomas Hope. He insisted that his furniture must have three qualities: beauty, character and appropriate meaning, which was to be conveyed mainly through symbols.

"Archaeological" furniture

The items designed by Thomas Hope, all somewhat rigid and not particularly comfortable despite their archaeological authenticity, exemplify various styles: Turkish and Egyptian as well as Greek and Roman. We touched briefly on the origins of the Turkish

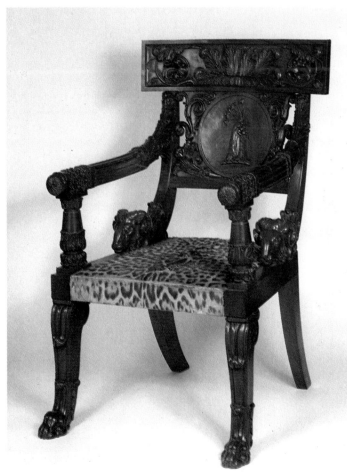

style in the introduction to this work. Where the Egyptian style is concerned, we would recommend Nikolaus Pevsner's essay *The Egyptian Revival* (1956). He points out that, in England, the popularity of this style was associated with the cult of Admiral Horatio Nelson and his naval victories. An entire room in Thomas Hope's sumptuous house was decorated in the Egyptian manner, with items in granite, basalt and porphyry. The furniture included a couch and chairs that might have come from an Egyptian tomb: they are strikingly similar to those found a century later in the tomb of Tutankhamen.

George Smith

The work of Thomas Hope was popularised and commercialized by George Smith. In 1808, a year after the appearance of Hope's book, Smith published *A Collection of Designs for Household Furniture and Interior Decoration*, including over a hundred and fifty

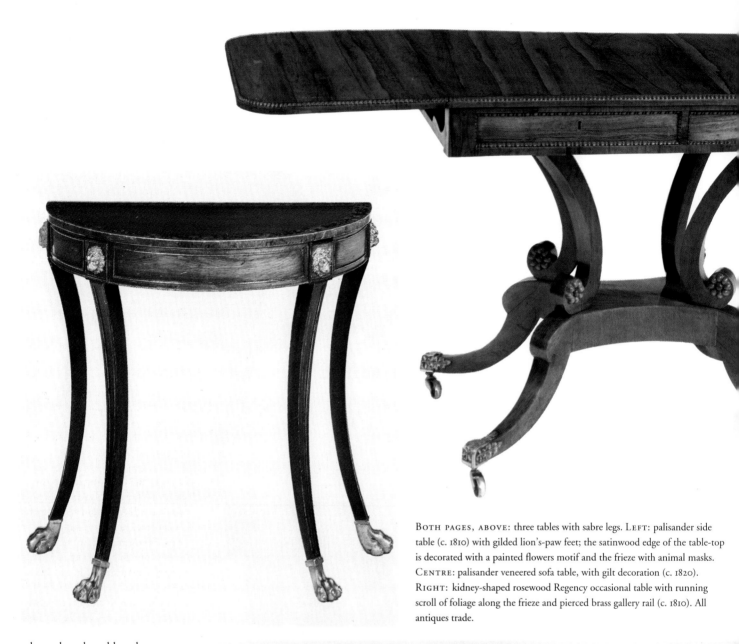

BOTH PAGES, ABOVE: three tables with sabre legs. LEFT: palisander side table (c. 1810) with gilded lion's-paw feet; the satinwood edge of the table-top is decorated with a painted flowers motif and the frieze with animal masks. CENTRE: palisander veneered sofa table, with gilt decoration (c. 1820). RIGHT: kidney-shaped rosewood Regency occasional table with running scroll of foliage along the frieze and pierced brass gallery rail (c. 1810). All antiques trade.

colour plates based largely on Hope's designs. Hope's influence is also very evident in *A Collection of Ornamental Designs after the Antique*, published in 1812. However, because of his training as an upholsterer, Smith also gave prominence to upholstered and fabric-covered furniture. He made copious use of zoomorphic decoration on tables, chairs, sideboards and sofas; added winged feet to cabinets and occasional tables; and applied Greek and Roman ornamental motifs to items of all kinds. Among his classical or pseudo-classical features, Smith favoured straight lines, particularly for chairs, abandoning the 18th-century emphasis

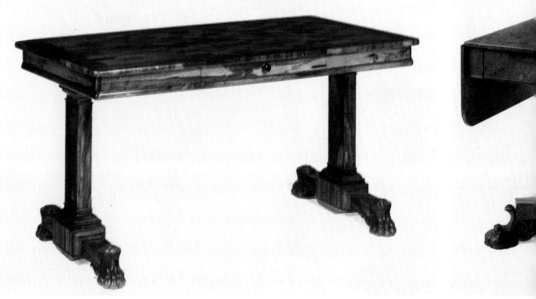

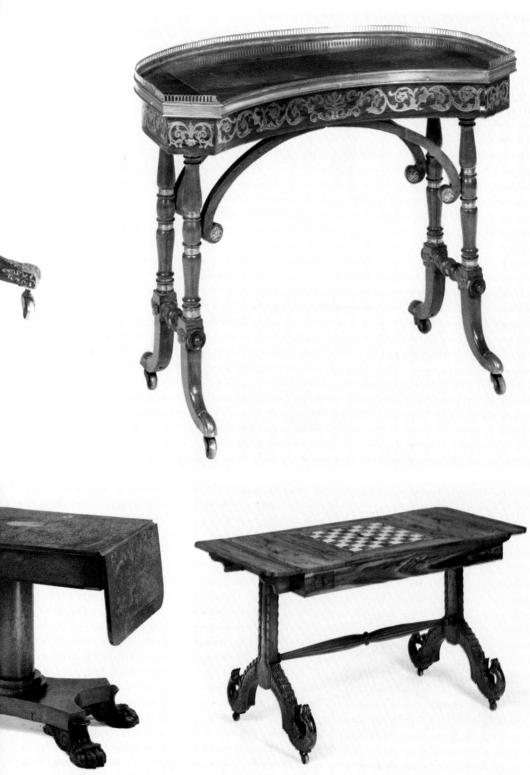

on comfort. Unlike Hope, he was also interested in the Gothic and, in his book, presented a series of patterns in this style. He claimed that the Gothic period had produced a far greater abundance of forms and ornaments than any other. This explains the character of his own "Gothic" furnishings: there is really little genuinely Gothic about them apart from the ornaments, which he applied liberally to contemporary forms.

In 1826, George Smith published his final collection, *The Cabinet-Maker and Upholsterer's Guide.* It included one hundred and fifty-three plates illustrating Egyptian, Greek, Etruscan, Roman, Gothic and Louis XIV interiors. The text is interesting in that it shows how taste had changed over the last few decades: eclecticism was in the ascendant.

The Regency period

The Regency style corresponded more with the tastes of George Prince of Wales, subsequently Prince Regent, then king as George IV, rather than exactly with the years of his Regency (1811–20), when the prince performed the duties of his father, George III, during the latter's madness. It is thus now generally accepted that the term Regency also refers to the previous decade and the decade that followed, embracing the work of Henry Holland, Thomas Hope, George Smith and other artists active in the 1820s.

In 1790, the then Prince of Wales, enthused by the fashion for *chinoiserie*, asked Holland to design him a Chinese drawing-room for his London residence, Carlton House.

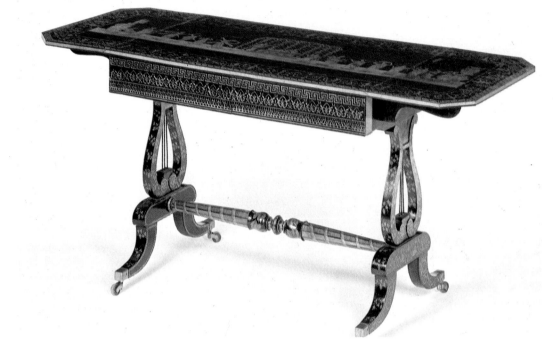

Originally a garden designer of the school of Capability Brown, Holland took what was in fact a severely classical structure and clothed it in exotic forms. Twelve years later he also created a gallery for displaying Chinese wallpaper and gave an exotic veneer to other rooms by adding bamboo furniture and Chinese decorative accessories. In 1803, Holland was replaced by the architect William Porden, who drew up the initial plans for a pavilion in Brighton, of Chinese and Indian inspiration.

The Royal Pavilion: the triumph of exoticism

The Pavilion project was revised by Humphrey Repton, another garden designer and a collaborator of John Nash, but it was Nash who finally rebuilt the Royal Pavilion, the ultimate expression of Regency taste.

Mario Praz, in *La filosofia dell'arredamento* (The Philosophy of Interior Design), quotes Repton's opinion as a telling example of Regency eclecticism. Repton believed that neither the Greek nor the Gothic style could harmonise with a building that already had so oriental a character. Nor did it seem appropriate to consider the Turkish style, which was a corruption of the Greek; nor the Moorish, which was a poor imitation of Gothic; the Egyptian was too bulky for a villa, and the Chinese too light and capricious for the exterior, however suitable it might be for the interior. So, of all the known styles, the only one that might furnish suitable forms was the Hindustani. Nash, following Repton's recommendations, constructed a building that

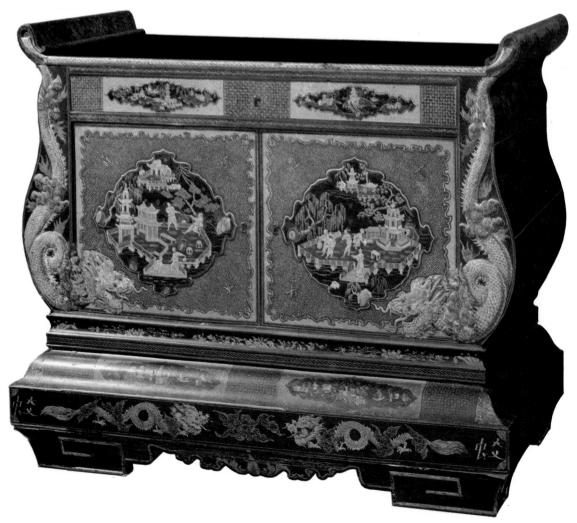

FACING PAGE, TOP: sofa table (c. 1810) with lyre-shaped supports, sabre legs and penwork top (India ink drawing on a japanned background). Antiques trade. BOTTOM: cabinet (c. 1815), attributed to Frederick Crace. The door panels are examples of Chinese Ch'ien-lung lacquer work; the rest was lacquered in England. Victoria and Albert Museum, London. THIS PAGE, BELOW: Regency rosewood bookcase; the carved and ebonized decoration, picked out in gold, is in the "archaeological" manner. Antiques trade.

was Hindu without, Chinese within. His water-colours of the interior of the Pavilion, completed in 1812, faithfully depict the light-opera extravagance of this splendid "folly". Serpents twist decoratively around columns, chair legs, tables and lamp-stands; dragons, banana leaves, bamboo and its cast-iron imitations run riot, together with lotuses, little bells, water-lilies, mandarin oranges and exotic flowers; the favoured materials were lacquer, porcelain, gilt bronze and silk. The Prince Regent's predilections gave rise to the taste for bamboo furniture, or furniture worked so as to resemble bamboo, which remained in vogue for the rest of the century.

Another designer of the Regency period was Richard Brown, who in 1820 published *Rudiments of Drawing Cabinet and Upholstery Furniture*. A second edition appeared two years later. Brown called himself an "architect and teacher of perspective". He wrote a treatise on this subject and, between 1804 and 1828, exhibited architectural drawings at the Royal Academy. His writings were strongly influenced by Hope, particularly in advocating the use of symbolic ornaments, which Brown pushed to a ridiculous extreme. He warmly recommended the use of a wide variety of flowers, foliage and plants for decorative purposes, with special emphasis on national types.

He suggested, for example, that dressing tables be embellished with sweet-smelling plants, or fig leaves as a reminder of the clothes worn by Adam and Eve. Sofas, on the other hand, should be adorned with symbols of comfort, and mirrors with the figure of Narcissus, to show the folly of

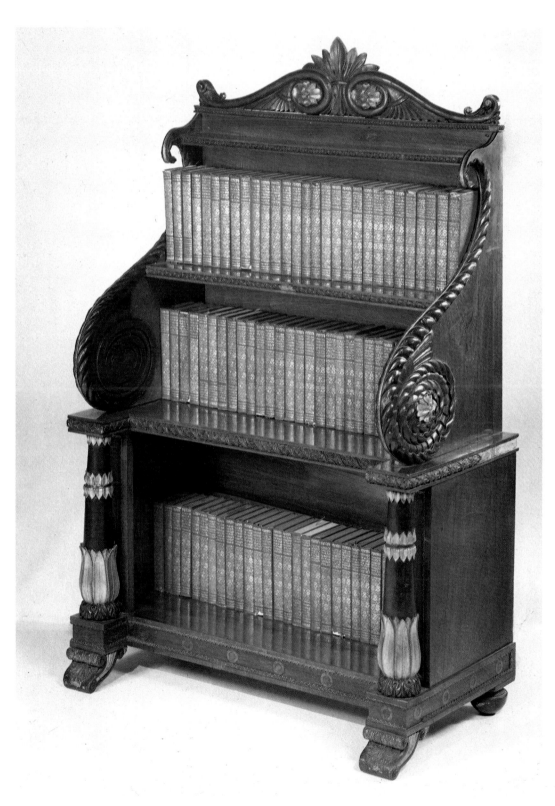

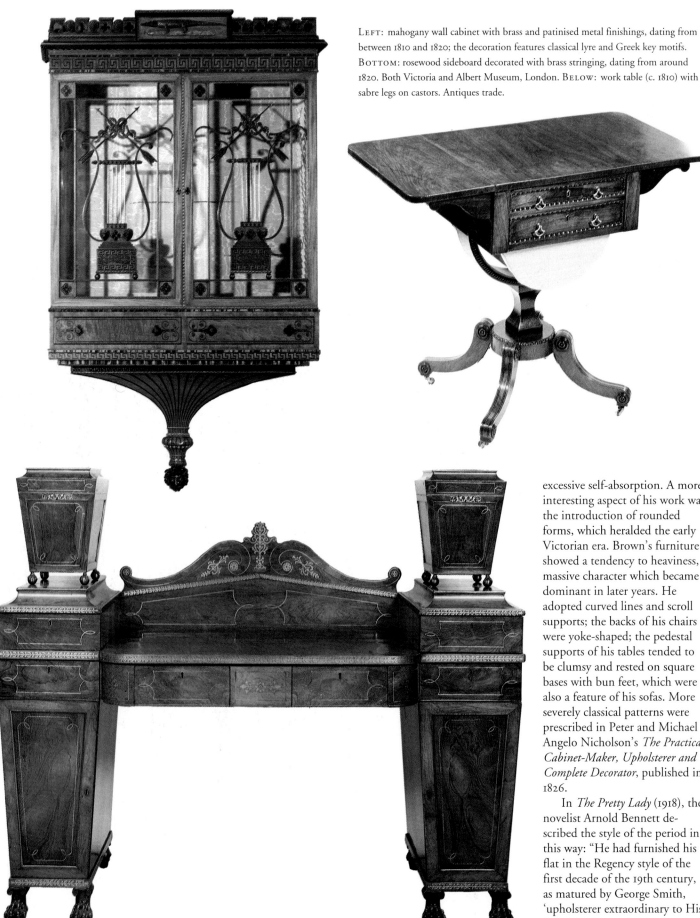

LEFT: mahogany wall cabinet with brass and patinised metal finishings, dating from between 1810 and 1820; the decoration features classical lyre and Greek key motifs. BOTTOM: rosewood sideboard decorated with brass stringing, dating from around 1820. Both Victoria and Albert Museum, London. BELOW: work table (c. 1810) with sabre legs on castors. Antiques trade.

excessive self-absorption. A more interesting aspect of his work was the introduction of rounded forms, which heralded the early Victorian era. Brown's furniture showed a tendency to heaviness, a massive character which became dominant in later years. He adopted curved lines and scroll supports; the backs of his chairs were yoke-shaped; the pedestal supports of his tables tended to be clumsy and rested on square bases with bun feet, which were also a feature of his sofas. More severely classical patterns were prescribed in Peter and Michael Angelo Nicholson's *The Practical Cabinet-Maker, Upholsterer and Complete Decorator*, published in 1826.

In *The Pretty Lady* (1918), the novelist Arnold Bennett described the style of the period in this way: "He had furnished his flat in the Regency style of the first decade of the 19th century, as matured by George Smith, 'upholsterer extraordinary to His Royal Highness the Prince of

The illustrations on this page show two pieces of Regency furniture with typical lions'-paw feet: a feature taken from the classical repertoire along with Greek keys, fluting, rosettes, caryatids and lyres. BELOW: gaming table dating from around 1820. RIGHT: mahogany book cabinet with open stepped shelves and spiral-twist lateral columns. Both antiques trade.

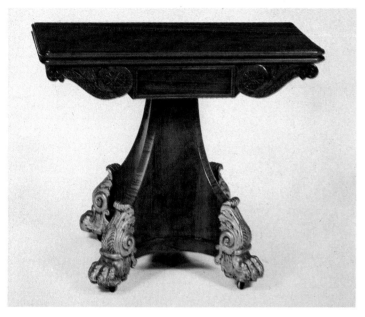

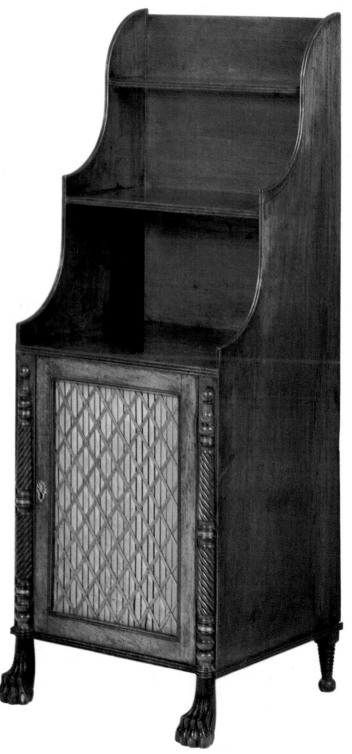

Wales'. The Pavilion at Brighton had given the original idea to G. J., who saw in it the solution to the problem of combining the somewhat massive dignity suitable to a bachelor of middling age with the bright, unconquerable colours which the eternal twilight of London demands [...] In the drawing-room [...] the clash of rich primary colours, the perpendiculars which began with bronze girls' heads and ended with bronze girls' feet or animals' claws, the vast flat surfaces of furniture, the stiff curves of wood and drapery, the morbid rage for solidity which would employ a candelabrum weighing five hundredweight to hold a single wax candle, produced a real and imposing effect of style; it was a style debased, a style which was shedding the last graces of French Empire in order soon to appeal to a Victoria determined to be utterly English and good; but it was a style".

The Regency: conclusions

In the overall context of 19th-century English furniture-making, which was characterised by an enormous variety and freedom of form, the Regency – taking the term in its widest sense – presents a dual aspect. Stylistically, it is possible to distinguish earlier (1800–20) and later (1820–30) periods, both deriving from the recovery of a classical formal language. This was first interpreted in a rigorous, "archaeological" manner – in Hope's "reconstructions", for example. It then fragmented into a highly varied Eclecticism, with the emphasis almost exclusively on decorative features (Greek keys, fluting, rosettes, lions'-paw feet, caryatids and lyres), while the composite, varied forms prefigured Victorian developments. Early Regency signalled a revival of interest in continental tastes, particularly that of the French Empire, but continental forms were always interpreted with considerable free-

dom. British interpretations of classical furniture in fact often anticipated future continental styles, for instance the Restauration style, Charles X, or Biedermeier.

What particularly distinguished the Regency was a "pictorial" sensitivity to surface, in contrast with the compact uniformity of French mahogany furniture. There was a predominance of light-coloured exotic woods – strongly figured, satiny or with natural bird's eye markings – such as amboyna or American maple, or artificially stained European maple. Surfaces were enhanced by a mirror-like shellac finish, to produce which flakes of lacquer were dissolved in alcohol. Though an inexpensive tech-

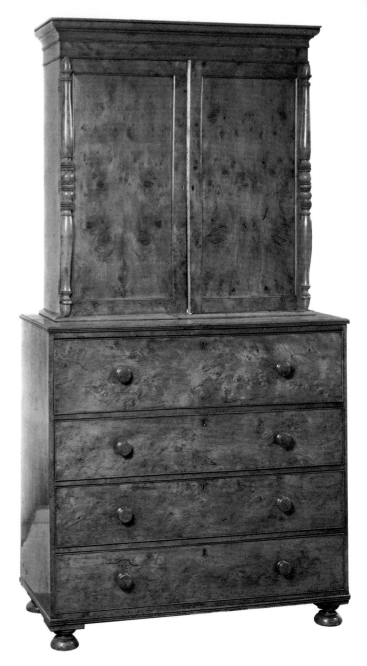

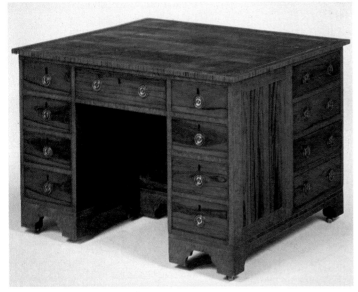

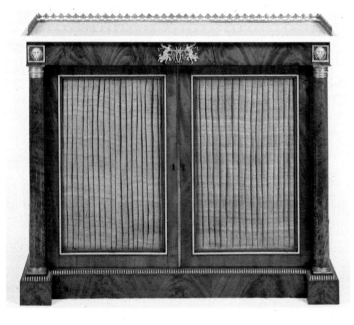

nique, it lends furniture a distinguished appearance. Wide use was also made of all kinds of mahogany, which responds to carving with a hard, almost bronze-like brightness. This technique, which had almost fallen from favour, though still much used by Hope, was restricted to decorative details. Sparing use was also made of marquetry, stringing with ebony or ebonized woods such as blackened pear and willow, and gilding.

Wherever possible, Regency cabinet-makers tried to avoid the use of costly materials and techniques, though, as we have seen, they chose attractive finishes and eye-catching woods to give their furniture a luxurious appearance. Veneering was the preferred way of achieving an expensive effect for a limited outlay. The French Empire style, with which British taste was coming to terms, however bizarrely, in the first decade of the 19th century, and the late 18th-century tradition of structural sobriety (exemplified by Sheraton) were both well suited to the technique, providing broad, flat surfaces for the veneers to adhere to. It was much more difficult if veneers had to be applied to irregular surfaces.

During the Regency period, the use of veneers was also ex-

tended to chairs and armchairs, traditionally worked in solid wood. The current models had curving sabre-shaped legs and scrolled or sinuous arm supports based on 18th-century examples, but they were more and more commonly square in section, to give flat surfaces for the application of veneers.

A characteristic of the Regency period was the great variety of tables with precise functions, for drawing-room, study and library: sofa tables, Pembroke tables, occasional tables, kidney tables, library tables, work tables and so on. A fashionable development was the nest of tables – a set of three, four or five tables, gradually reducing in size so as to fit one under the other. The gaming table, so popular in the 18th century, was less common. There was also a wide range of large, extendable dining-room tables, supported by pedestals on polygonal bases and lions'-paw feet, with additional folding legs for the extensions. Another popular item of dining-room furniture during this period was the sideboard. With a flat surface for serving, it was designed to hold cutlery and tableware. In its typical Regency configuration it consisted of two pedestal units connected by a top incorporating drawers. The empty central space was designed to receive a wine cooler – a closed container of round, oval or rectangular shape, mounted on legs.

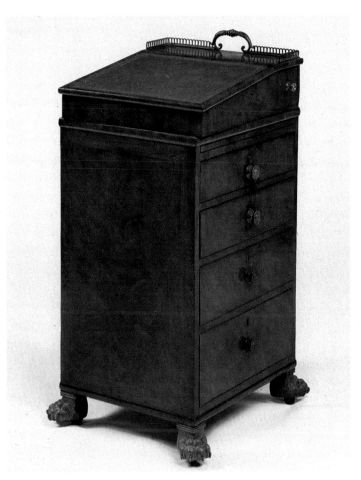

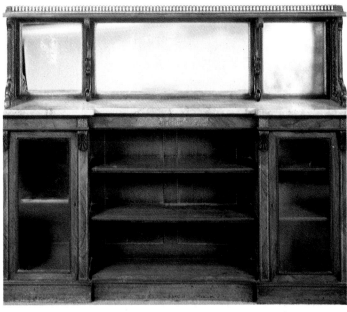

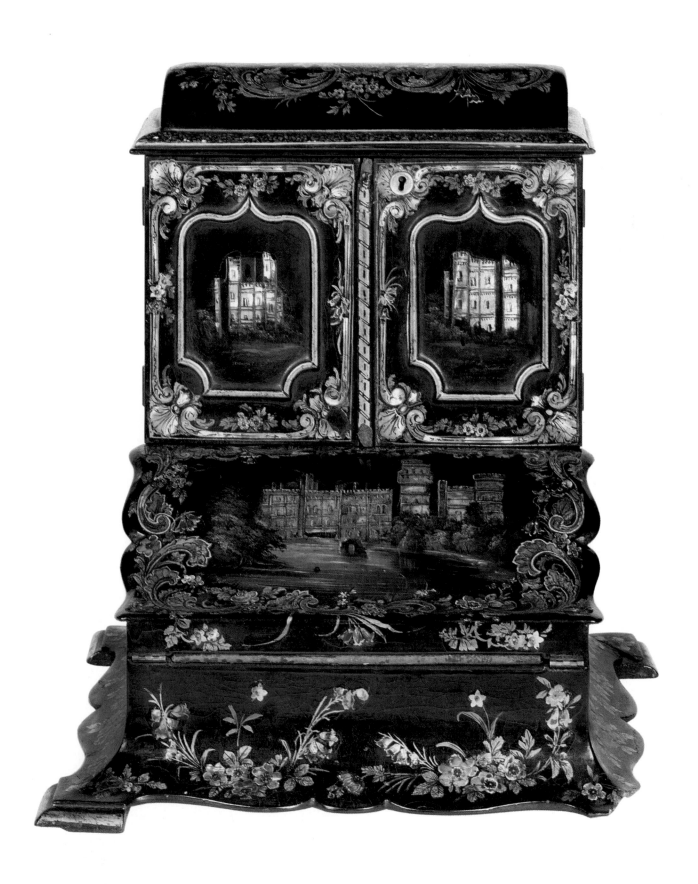

Victorian Eclecticism

From "Louis XIV" to the Naturalistic

In a well-known passage from his *Encyclopaedia of Cottage, Farm and Villa Architecture and Furniture* (1833), John Claudius Loudon describes the four styles then in vogue as Grecian, Gothic, Tudor and Louis XIV. The latter – a style in which decorative elements played a vital part in determining form – was a misnomer, being in fact a free mixture of Rococo and Baroque features. Together with the Naturalistic, it was in fact the dominant style of the Victorian era. The Naturalistic style itself was derived partly from Louis XIV, partly from Gothic. From the former it borrowed swelling curves and full, rounded shapes; from the latter the love of ornamental motifs of a floral kind, inspired above all by Pugin's *Floriated Ornament* (1849).

The Naturalistic and Gothic styles were more popular with upholsterers and interior decorators than with architects, who regarded them as frivolous and tasteless. It is no coincidence that one of the first representatives of the new trend was an upholsterer, Thomas King, who, like many members of his profession, has remained relatively obscure. The best known of his many pattern-books is *The Modern Style of Cabinet Work Exemplified* (three editions: 1829, 1835 and 1862). King particularly commended the French Rococo revival style on the grounds of economy: pieces could be produced rapidly, and the ornamentation was not complicated. His furniture does not, however, match the elegance of its French exemplars, tending to be rather heavy.

Manuals and models for the craftsman

A more interesting figure is Henry Whitaker. His *Practical Cabinet-Maker and Upholsterer's Treasury of Design* is regarded as the most important work on furniture published during the period immediately prior to the Great Exhibition of 1851. Whitaker became famous for the commissions he executed for the Queen, the Marquis of Exeter and the Duke of Devonshire. In fact, his pattern-books include few examples of the Rococo style, his preference being for the Elizabethan and the Renaissance. The Renaissance style was the last of the revivals that preceded the Great Exhibition, and figured prominently there.

The best account of the state of furniture design at the time of the Exhibition itself is given by Wornum in his essay in the *Art Journal* catalogue *The Exhibition as a Lesson in Taste*. Wornum identified nine styles: three classical, three medieval and three modern. The ancient styles include Egyptian, Grecian and Roman; the medieval styles were Byzantine, Saracen and Gothic; and finally the moderns were Renaissance, Cinquecento and Luigi XIV *(sic)*. The Renaissance, as he understood it, began with the conquest of Constantinople in 1204. Therefore, for Wornum, the Italian *trecento* was synonymous with early Renaissance, a style which he identified, somewhat confusedly, as a mixture of Venetian and Norman-Sicilian.

The *cinquecento* period is referred to as High Renaissance. It is pointless to go through the long list of distinctions and definitions proposed by Wornum: suffice to say that furniture-makers like Whitaker mixed up these styles and muddled their ornamental features. In some cases, it is difficult to make a valid distinction between "Renaissance" furniture and "Elizabethan".

Returning to the Naturalistic and Louis XIV styles, of note is the work of Henry Lawford who, in the *Chair and Sofa Manufacturer's Book* (c. 1845), depicted a

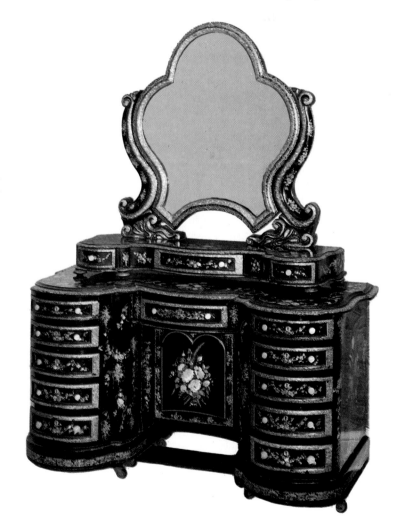

Two typical examples of mid-century Victorian furniture. They are made of papier-mâché, often decorated with mother-of-pearl and painted floral motifs on a black background. Antiques trade. FACING PAGE: writing box. Antiques trade. THIS PAGE: dressing table. Temple Newsam House, Leeds.

BELOW: palisander worktable (c. 1850) with hinged flaps and cabriole legs on castors. BOTTOM LEFT: round walnut table (c. 1850) with carved central support. BOTTOM RIGHT: an elaborately carved Canterbury (1863), typical of the taste of the period. Antiques trade.

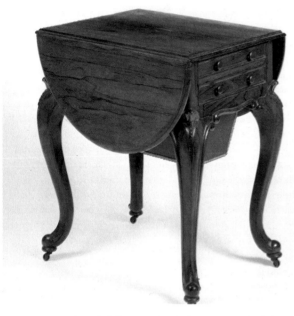

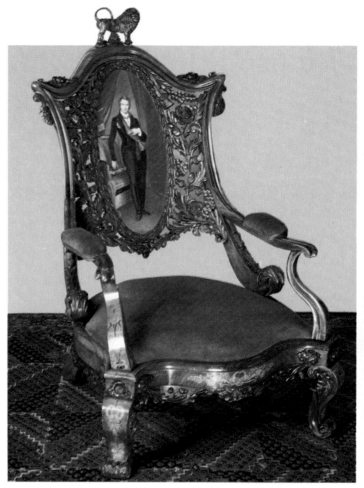

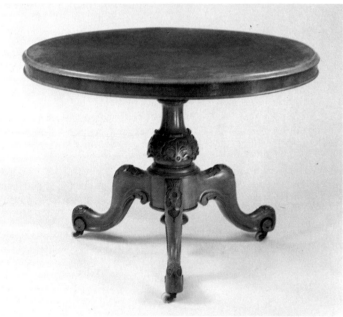

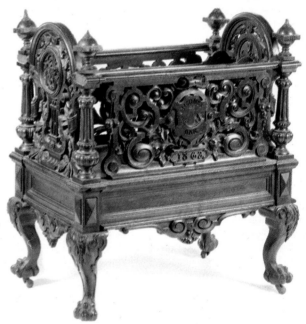

series of chairs and sofas in these styles with generously padded and buttoned upholstery. Typical features were generally rounded shapes, curved and balloon backs to chairs, naturalistic decorative carving and curved legs.

Furniture production in the period immediately after the Great Exhibition was described in Blackie's *Cabinet-Maker's Assistant* (1853), which included all the styles mentioned to date, with the addition of Moorish. The most important manufacturer of the period was William Smee and Sons, whose products were advertised in *Designs for Furniture* (1850–55), a catalogue aimed at middle-class customers. The firm's designs were not particularly original, and its reputation was founded chiefly on the high quality of its furniture.

Other furniture-makers working in the post-Exhibition period were John Braud, author of *Illustrations of Furniture* (1858), Henry Lawford and Lorenzo Booth, whose *Exhibition Book of Original Designs for Furniture* (1864) marks a transition from

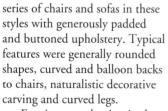

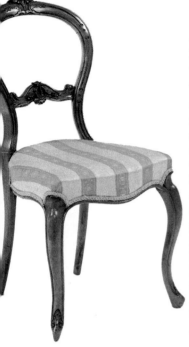

Elizabethan, Jacobean and Restoration styles

The so-called Elizabethan revival (Elizabeth I reigned from 1558 to 1603) began around 1830. The most popular of the parallel styles of the late-Regency perioed, it was adopted mainly for private houses, in contrast with Pugin's austere, heavy Gothic, which was regarded as more suitable for public buildings and churches. In its best achievements, the Elizabethan style attained to the coherence of the most severe Gothic. The architect Anthony Salvin, for example, created some beautiful interiors for Mamhead, a country house in Devon, and

1603–25) and Restoration, combining elements of 17th-century furniture with features from the 18th and 19th centuries. This hybrid style is increasingly referred to as "Jacobethan". In conjunction with turned columns, rigid and flat strapwork chair backs and carved Italian Renaissance motifs as interpreted by 17th-century English craftsmen, we also find 18th-century cabriole legs and upholstery in pure early Victorian taste.

Furniture in the Restoration style (Charles II, 1660–1685), in particular cane-seated chairs, came into vogue in the 1890s with the fashion for collecting and reproducing 17th and early

bethan style featured prominently in *Furniture with Candelabra and Interior Decoration* (1833), published by Richard Bridgens in collaboration with Henry Shaw (author of *Specimens of Ancient Furniture*, 1836) and including many hand-tinted colour plates. Bridgens sought to justify current styles by, often misinterpretedly, reference to classical models, revealing the less than clear thinking of a period whose tastes were essentially eclectic and shaped by historicism.

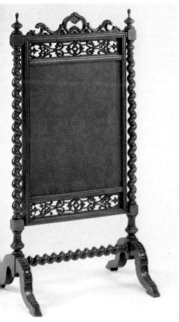

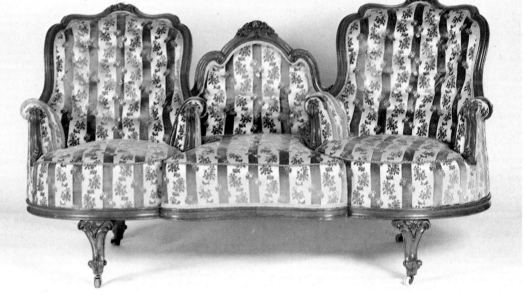

the Victorian style – or rather styles – to the new fashions initiated by such figures as William Morris and Philip Webb.

for Scotney Castle in Kent (between 1820 and 1840).

In the absence of models, it was difficult to lay down precise rules for the style. As a result, what the Victorians called Elizabethan was in fact a mixture of Tudor, Jacobean (after James I,

18th-century furnishings. Restoration chairs of this type were produced in large numbers and adapted to match dining rooms in the Jacobean or "Early English" manner, as the style of the early Carolean pieces in oak was loosely known. The Eliza-

Gothic revivals and reformers: Pugin

Interest in the Gothic first surfaced in the 18th century, when its greatest exponent was Horace Walpole. Interpretations of the style had already appeared in the

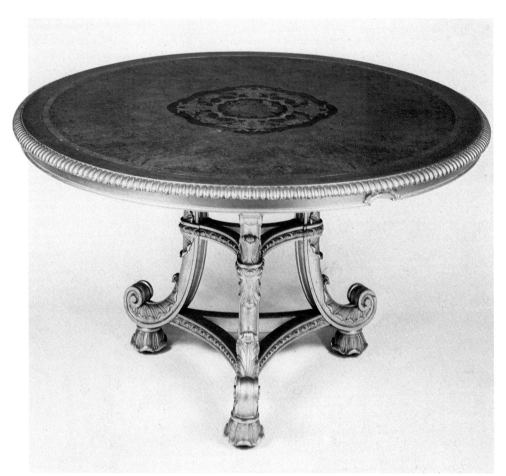

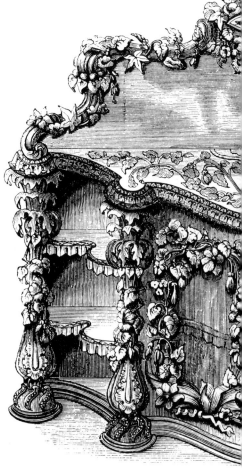

catalogues of Chippendale, Hepplewhite, Sheraton and Smith. These, however, involved the undisciplined application of medieval decorative motifs such as pinnacles, pointed arches and trefoils.

The real champion of Gothic was Augustus Welby Northmore Pugin (1812–52), who at an early age was already designing Gothic furniture for Windsor Castle. His later conversion to Catholicism (1835) intensified his inherent religious fervour and generated a new interpretation of Gothic as the only "true" style. For Pugin, just as there was one true faith, so there should be one true style, and that was the style developed by the Christian Church; all other styles were not only pagan but also aesthetically unacceptable. However, it was not a question of applying Gothic decoration indiscriminately to contemporary forms, but of developing a whole new grammar of structures and ornaments.

In the year of his conversion, he published *Gothic Furniture of the Fifteenth Century*, a collection of drawings which proved enormously influential. Soon after, he was at work with Charles Barry on the interior of the Palace of Westminster, which remains the best example of early "Victorian Gothic". In 1841, his *Principles of Pointed or Christian Architecture* appeared, in which he laid down two rules: a building should not incorporate unnecessary elements; and all ornaments should be regarded as enrichments of the essential structure. Decoration was not to be used purely as structure.

The same rules were applied to furniture. Pugin's fundamental contribution to Victorian design was in fact his determination to bring out – with "honesty" – the constructional features of a piece of furniture, a principle deriving from medieval craftsmanship and quite contrary to the practice of the day. In his panelled furniture, for example, the pegs used to se- cure mortise and tenon joints are clearly visible.

In 1849, Pugin published *Floriated Ornament*, a book from which many contemporary designers and furniture-makers drew inspiration. Based on a late 16th-century botanical manual, it identified the plants from which Gothic decorative elements were derived. In 1851, for the Great Exhibition, he organised the Medieval Court, which aroused heated controversy.

John Ruskin

The creed of the new movement was the chapter "On the Nature

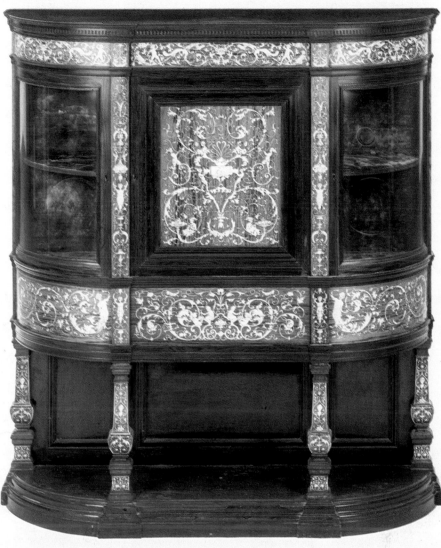

of the Gothic" in *The Stones of Venice* by John Ruskin. Already in *The Seven Lamps of Architecture* (1849) Ruskin, like Pugin, had preached the universal adoption of a single style as the only possible remedy to the chaos of contemporary eclecticism, adding that this style must be an existing one. "The forms of architecture already known are good enough for us", he wrote.

Ruskin rejected the Grecian style as insane, Tudor as degraded, and earlier styles as infantile and barbarous. Finally, as Pevsner shows in *Studies in Art, Architecture and Design*, he evolved a sort of compromise between Pisan Romanesque, the

early Gothic of the Italian city-states, the purest form of Venetian Gothic and Early English Gothic.

Ruskin was a theorist, reformer and writer, and accepted a teaching post as such at the Working Men's College, founded by the Christian socialist William Morris. He saw this as a way of spreading his ideas rejecting the division and mechanisation of labour in favour of a return to artisan methods. He believed that a craftsman's love of his work would ensure the high artistic quality of the finished product.

His teaching activities put Ruskin in touch with the circle of young Pre-Raphaelite artists whom he had already supported

in various newspaper and magazine articles. Members of the Pre-Raphaelite brotherhood were Dante Gabriel Rossetti, William Holman Hunt, John Everett Millais, Edward Burne-Jones, Ford Madox Brown, Arthur Hughes and William Morris.

Morris & Co

In 1860, William Morris took up residence at the Red House, a building symbolising "modern" architecture designed and furnished for him by Philip Webb (1831–1915). The following year, Morris, Webb and others founded a company, Morris, Marshall,

Faulkner & Co., to carry over the ideas then gaining credence in the major arts into the field of interior design. Among the first of Morris's associates to apply these ideas to furniture was Ford Madox Brown. His designs derive from those of Pugin: simple, with flat surfaces and linear profiles, they belong more to the tradition of medieval carpentry than refined 18th-century cabinet-making.

Morris, Marshall, Faulkner & Co. expanded rapidly, specializing in wallpapers, but also producing furniture for everyday use and more elaborate items, distinguished by Morris as "necessary workday furniture" and "state furniture". Not all of the designs

Historicism and revivals

Revivals of historical styles, so characteristic of the Victorian era, had their roots in the social changes that occurred in Britain during the long reign of Queen Victoria (1837–1901). Most commissions now came from middle-class patrons who, having no inherited traditions or knowledge of style, made the imitation of "historical" styles the basis of their taste.

The Great Exhibition in London in 1851, where the most absurd stylistic pastiches were on show, reflected the jumble of styles that marked the period. The "new" patterns were derived from the 17th-century "Elizabethan" style, the French Rococo and above all the medieval period. The Neo-Gothic propounded by Pugin was adopted as the national style. Battlements, rose windows, pointed arches, spires and other architectural features found their way into furniture-making, and were used to decorate a wide range of articles, ranging from stoves to lamp-stands, and furniture to household fittings.

In polemical parallel to these historical expedients a movement developed aimed at reassessing ideas of beauty and style. Propagated by John Ruskin and William Morris, these ideas took form and gave rise to the Arts and Crafts Movement. Though attached to the Middle Ages by nostalgia, these latter-day aesthetes and proponents of 'art for art's sake' endeavoured to offer a high-quality alternative to mass-produced commercial furniture. The Exhibitions of 1862 and 1871 would confirm their success.

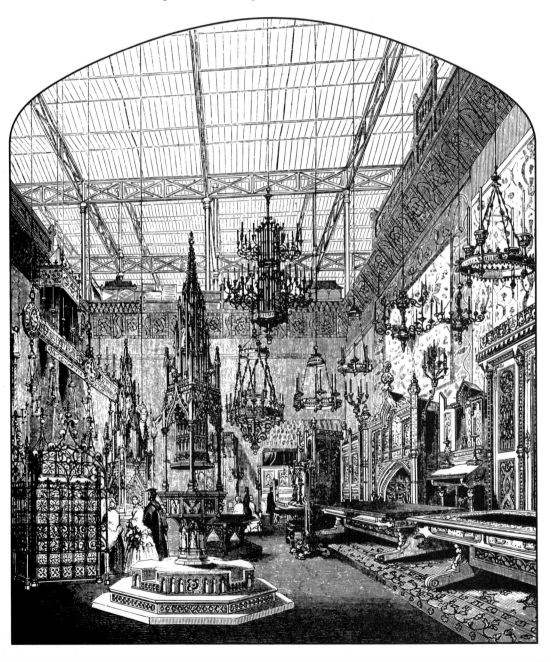

LEFT: view of the Medieval Court, the section of the 1851 London Exhibition devoted to Gothic revival furniture, including items by Pugin. BELOW: for the same exhibition, Cookers & Sons of Warwick made a buffet. The complex carvings were inspired by Walter Scott's novel *Kenilworth* (1821), which is set in Elizabethan England.

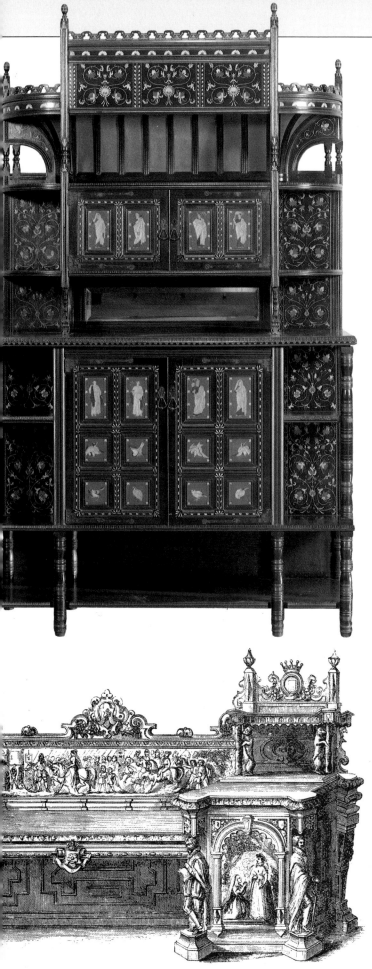

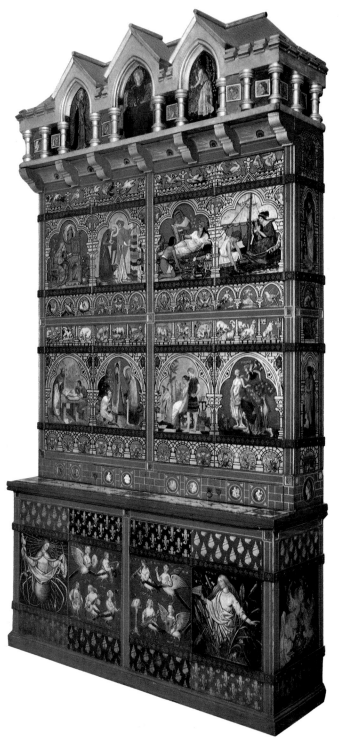

ABOVE: a High Gothic bookcase designed by William Burges, presented at the London International Exhibition of 1862. The panels were painted by various artists. TOP LEFT: carved, painted cabinet regarded as a symbol of the Aesthetic Movement. It was designed by the architect T. E. Collcutt and made in 1871 by the firm of Collinson & Lock for the London Exhibition of 1871. Victoria and Albert Museum, London.

LEFT: iron bedstead in the neo-Renaissance style, presented at the London Exhibition of 1851. BELOW: Mahogany desk by Gillows with flat decorative carving and writing surface that converts into a reading stand. Private collection. FACING PAGE: mahogany music cabinet with compartments for storing printed music. The influence of the Aesthetic Movement is evident in the ebonized and gilded finish, the naturalistic decoration of the painted panel and the shape of the balusters (c. 1880). Antiques trade.

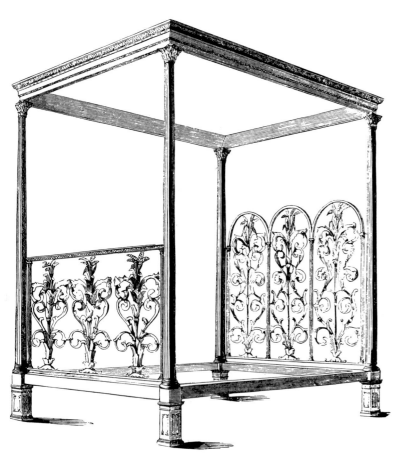

Richard Norman Shaw (1831–1912) and William Burges (1827–81) also presented Gothic designs.

Norman Shaw had begun his career as a Neo-Gothic architect, before turning to furniture-making in the Old English, Queen Anne and finally Classical-Baroque styles. Of special interest are his rush-seated Queen Anne corner chairs, settles (medievally inspired high backed benches with two arms), sideboards and beds in the manner of Burges and Webb, chairs with turned baluster legs and furniture displaying increasing interest in Japan.

The furniture of William Burges is characterised by its massive construction and the frequent use of painted decoration and inlays of various kinds, whereas carving is uncommon. His "trademark", as John Andrews points out in *Victorian,*

Edwardian and 1920s Furniture (1980), was pitched "roofs" complete with imitation tiles. A typical example is the cabinet with paintings depicting *The Contest between the Wines and Beers,* which he presented at the 1862 Exhibition and is now at the Victoria and Albert Museum, together with a gilded bed he designed c. 1879 for his own house in Marlborough Road, Kensington.

Burges was also among the first to take an interest in Japanese art. Under his influence, English furniture came close to parody and displayed a degree of theatricality that was somewhat ridiculous and veered towards kitsch. Renaissance motifs persist in his work, and the influence of medieval English and French furniture is evident in his drawings. A designer to the aristocracy, Burges built and furnished the romantic Castell Coch (Glamor-

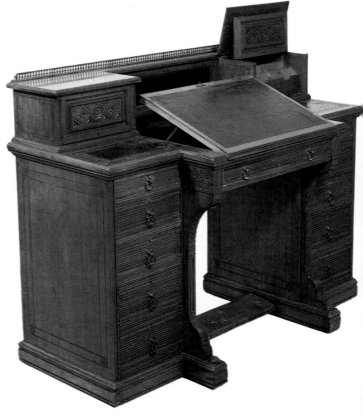

were by Morris himself. Most work was done initially by his early collaborators, Ford Madox Brown, Rossetti and above all, John Pollard Seddon (1827–1906), one of whose cupboards, an example of 'state furniture' now in the Victoria and Albert Museum, has panels depicting the story of *King René's Honeymoon,* painted by Brown, Rossetti and Burne-Jones.

Of the simpler furniture, it is worth mentioning some pieces designed by Philip Webb for Major Gillum. These included an unstained round table with short, circular legs, constructed of panels and with no attempt to conceal the hinges. There was also an oblong table with tapering, turned legs, a narrow top and a long drawer with metal ring han-

dles. The company became Morris & Co. in 1875. Its most typical products were Sussex rush-seated chairs, derived from a traditional local design. They were originally made of birch, stained black or dark green. The green was an innovation of Ford Madox Brown, who also used it for other items of furniture. Furniture by Morris & Co. remained in production well into the 20th century, with very few changes in style, until its closure in 1940.

Victorian Gothic designers

Morris, Marshal, Faulkner & Co. launched its furniture on the market in time for the 1862 Exhibition in London, at which

gan) as well as re-decorating Cardiff Castle for his most famous patron, the Marchioness of Bute.

One of the best-known Victorian designers to adopt and reform the Gothic style was Bruce Talbert (1838–81). More interested in the work of Burges and Webb than in Pugin, he advocated the use of English 12th- and 13th-century styles as well as smaller, more domestically suited furniture. He also simplified decorative motifs, enabling their application to general furnishings.

Originally a wood-carver, then an architect, Talbert worked for many of the major Victorian furniture manufacturers, including Doveston, Bird and Hull of Manchester, and Holland and Sons of London, for whom in 1867 he designed a dresser which won a prize at that year's Paris Exhibition. The small cabinet that accompanied it, now at the Victoria and Albert Museum, is one of the best known pieces of the period, as is his "Pet" sideboard, made by Gillows with carved boxwood panels of fauna, which set a fashion.

Pauline Agius sums up the typical features of Talbert's style: straight lines, long flat metal hinges, ring handles (again in metal), mouldings embellished with dentils and other architectural motifs, panels made of tongue-and-groove boards (often arranged diagonally), fretwork and rows of small turned spindles, enamelled stones and painted panels, inlays, bas-reliefs and intricate carving, plain and clear joinery featuring dovetail joints and tenons, metal inserts, woods neither stained nor painted, with an emphasis on oak of an occasional rather livid or-

ange colour. His first designs appeared in 1867 in *Gothic Forms Applied to Furniture*. His later manual *Examples of Ancient and Modern Furniture, Metal Work, Tapestries, Decoration* (1876) is less interesting and original, featuring Tudor, Stuart and Jacobean styles, which Talbert's imitators translated into eclectic, more popular versions.

The last designer to be considered in this section is Charles Lock Eastlake (1836–1906), who in 1868 published *Hints and Household Taste*, which was to become the bible of the mistress of the house with artistic aspirations. Eastlake's book, which also proved popular in the United States, where his ideas were propagated, featured simple domestic furniture akin to that of Webb, Burges and Talbert. Eastlake also recommended the use of natural, unpainted woods, and iron or brass for beds, which he sensibly considered more practical and hygienic.

The Aesthetic Movement and "art furniture"

Around 1860–70, art lovers, art collectors, professionals and craftsmen, artists and men of letters all played their part in defining a new concept of beauty and style, variously justifying it in the name of ethics, religion or aesthetics in a strict sense. Over the decade, the new thinking, led by personalities such as James McNeill Whistler, Algernon Charles Swinburne, Walter Pater and Oscar Wilde, gave rise to the movement known as Aestheticism, which adopted attitudes and ideas borrowed from the French avant-garde.

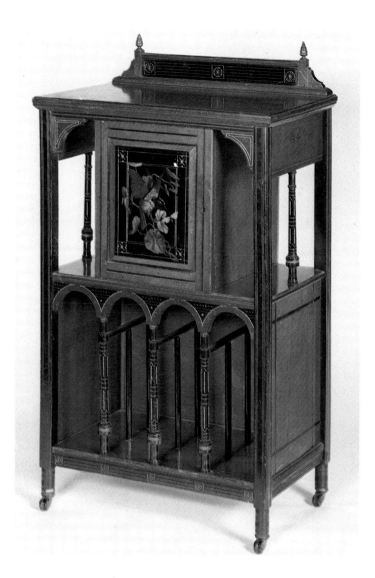

In contrast with the concepts of honesty of form, a return to craftsmanship and the raising of moral standards through art propounded by Ruskin, the new aesthetes supported the idea of "art for art's sake". They turned their attention to a heightened sensory perception, bizarre and sophisticated fantasies, and the worship and definition of beauty as something remote from daily life and above all from the banal respectability of bourgeois society. Out of this attitude came the idea of "art furniture", for those who were aesthetically aware as opposed to commercially manufactured products suitable for the "philistines".

The term "art furniture" probably appeared for the first time in *Building News* in 1868, where it was applied to some ex-

hibition pieces in the Gothic style designed by Walford and Donkin. Charles Lock Eastlake used the term twice in his *Hints and Household Taste*. Soon there was even an Art Furniture Company.

The symbol of the new movement was the cabinet designed by Collcutt, made by Collison & Lock and presented at the International Exhibition in London in 1871. It encapsulated most of the future characteristics of art furniture: the choice of ebonised wood; curved, painted panels; mirrors with bevelled edges; rows of turned balusters; a predominance of straight lines; fretwork galleries crowning sideboards and bookcases; slim, turned ring moulded supports, often picked out with gilding; there were other decorative elements based on the human figure

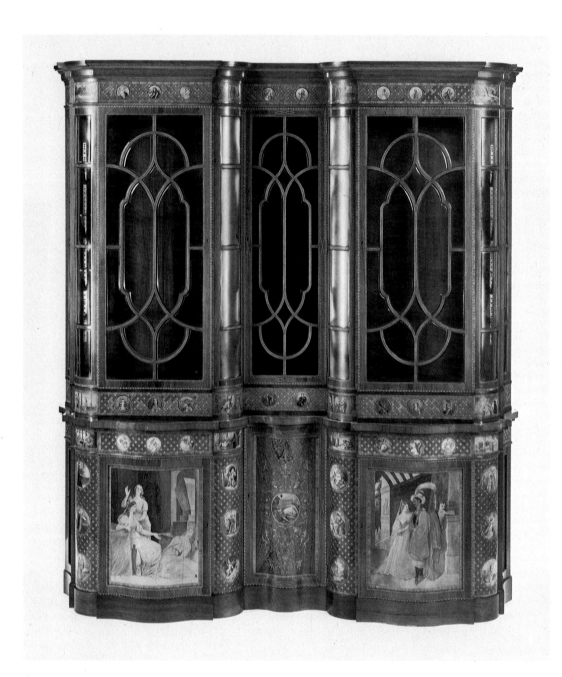

Writing about interior design at the close of the 19th century in *La Filosofia dell'arredamento*, Mario Praz comments: "Middle Ages, Renaissance, China, Japan — the most disparate ingredients were mixed up together in a *ragout* that passed for 'taste' at the time. With little expense, fairy fingers could conjure up surprises, miracles; only one thing was to be avoided: symmetry; the art to be prized above all others was the oriental. *Les Japonais sont tous artistes*. Only understand Japanese art, and you will be automatically trained in good taste: ideas will follow, originality will follow on their train, and you will know how to furnish a house."

Edward William Godwin

We do not know with precision when Edward William Godwin (1833–86), the foremost exponent of this trend, began to take an interest in the delicate, exotic forms of Japanese art. He may have visited the 1862 Exhibition, or been infected by the enthusiasm of Whistler, for whom he later built the celebrated White House in Chelsea (1877), designing the interiors according to the owner's instructions. Whatever the circumstances, the sophisticated fragility of Japanese furniture came to constitute the basis of his work, and he himself called the style Anglo-Japanese. His pieces were advertised in a catalogue produced by the firm of William Watt, published in 1877 under the title *Art Furniture*.

Around 1867, Godwin made a famous sideboard (now in the Victoria and Albert Museum), which in subsequent years was

and flowers, plus numerous small shelves for displaying knick-knacks. The woods most frequently used initially were bay-wood (Honduras mahogany), basswood (American lime) or black walnut. Sometimes the wood was stained green.

One manufacturer of such furniture was J. Shoolbred and Co., who produced items ranging from Gothic to Japanese, and Jacobean to Egyptian. The sources of art furniture were diverse, and the label covers the work of figures as diverse as Eastlake, Talbert and Morris plus the distinct "Japanese" style of Godwin.

To this mixture of fashions and styles was added a persistent affection for Georgian furniture – a term which effectively meant the whole of the 18th century, including Queen Anne (1703–14).

followed by other versions of it. The predominance of vertical and horizontal lines, the slenderness of the supports, simplification of shapes, and the arrangement of voids and solids, prefigured the achievements of later avant-garde designers. Godwin's style is well exemplified by two types of chair: the rounded Jacobean chair; and the better known Greek chair, which was linear and often stained black.

The idea of ebonizing furniture, in whole or in part, soon caught on with other designers, along with various other innovations such as painted and carved panels, mirrors with bevelled edges and finally, rows of slender turned spindles, which became a recurrent feature of art furniture.

Victorian furniture and society

The configuration of household furniture, according to Jean Baudrillard, gives a faithful picture of the family and social structures of a period. The typical Victorian household was patriarchal. This is evident if we examine the furniture of the dining-room and the bedroom: though different in function, it was highly integrated in both. In the former, it revolved around the *buffet*, sideboard or medieval-style dresser; in the second, around the marriage bed. Every piece, every room, seemed to interiorise its own function, to the point of symbolising the interpersonal relations of the semi-closed, traditional family group.

As early as 1876, in *The Art of Furnishing on Rational and Aesthetic Principles*, Cooper wrote that it was not good taste to dis-

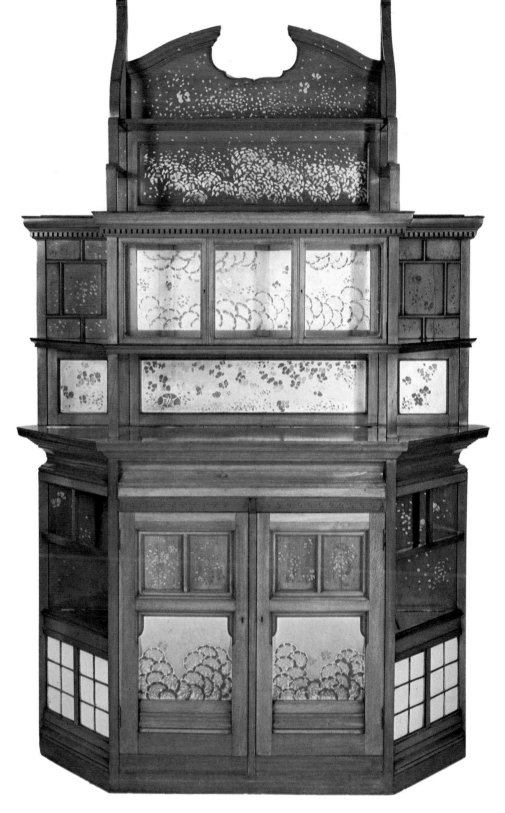

play the poverty of spirit and concentration of personal interest that was satisfied by the pure contemplation of forms embodying abstract beauty per se. It was quality of life, Cooper suggested, that counted in the choice of furnishings. These should not be influenced by a withdrawal into the private sphere characteristic of early Victorian family life, nor by an undue interest in fashion and 'good taste' as a status symbol, as preached by *fin-de-siècle* aesthetic revolutions. Interestingly the 20th century has inherited both these negative attitudes where the domestic environment is concerned: for better or worse, we are more "Victorian" than we think.

America between England and France

The main centres of furniture production at the end of the American War of Independence were New York, Salem and Baltimore. With the cessation of hostilities between Britain and the United States, the furniture and catalogues of the great Georgian manufacturers were imported in increasing quantity, and contemporary American products clearly reflected English tastes.

One of the most prestigious early American 19th-century cabinet-makers was Duncan Phyfe (1786–1854). Of Scottish origin, he came to the United States with his family at the age of fifteen or sixteen. His father settled at Albany, in New York State, where he earned his living as a furniture-maker. By 1792, the young Duncan Phyfe had moved to New York, where two years later he was registered with the Chamber of Commerce as a cabinet-maker.

Phyfe built up a vast clientèle in various states of the Union, including the South, and was eventually employing over a hundred people in his workshops, warehouse and showroom. His enterprise was run on industrial lines, and he became known as "America's greatest furniture-maker". West Indian hardwood exporters are said to have named their best grade of timber after him.

Phyfe's preferred woods were Santo Domingo mahogany and, later, palisander (purpleheart rosewood). His designs were not particularly original. Like other American furniture makers, he was influenced by English models, especially the Neoclassical patterns of Thomas Sheraton, and he drew on the plates of *The Cabinet Maker and Upholsterer's Drawing Book*. Later, he pro-

duced Directoire and Empire furniture characterised by high-quality veneering, carving and brass finishings. He made some interesting chairs with rather heavy top bars and posts that formed a single piece with the seat rails. Recurrent features are sabre legs and X-shaped bars, or lyre or harp shapes, for the chair backs. Common decorative motifs include sheaves of corn, arrows, drapery and festoons.

In the final phase of his life, his work shows the influence of the so-called "fat classical" style, featuring heavy curves and a great deal of sculpted decoration. This massive, opulent type of furniture – not greatly loved by Phyfe himself, who called it "butcher's furniture" – is also less highly regarded by furniture historians.

One of Phyfe's noteworthy contemporaries was the French cabinet-maker Charles-Honoré

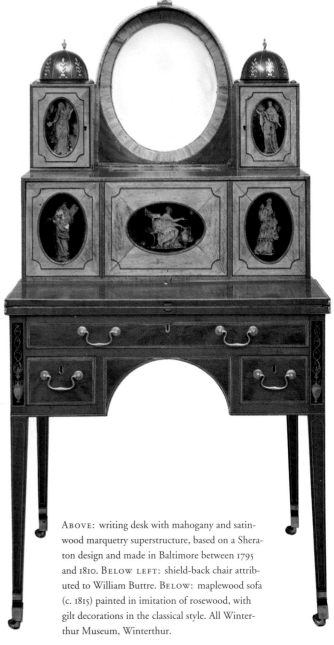

ABOVE: writing desk with mahogany and satinwood marquetry superstructure, based on a Sheraton design and made in Baltimore between 1795 and 1810. BELOW LEFT: shield-back chair attributed to William Buttre. BELOW: maplewood sofa (c. 1815) painted in imitation of rosewood, with gilt decorations in the classical style. All Winterthur Museum, Winterthur.

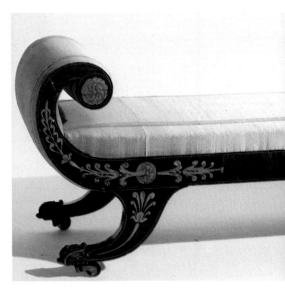

BELOW: palisander cabinet of Renaissance inspiration with eclectic decoration, made by Alexander Roux (1866). Metropolitan Museum of Art, New York. BOTTOM: Love seat in the Rococo revival style, manufactured by the German born furniture-maker John Henry Belter in New York (1855). American Museum, Bath.

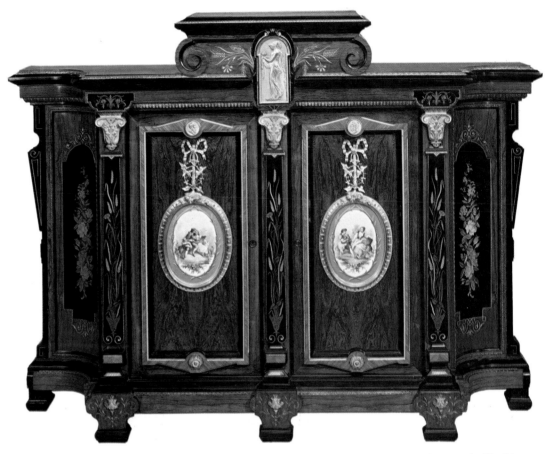

Lannuier (1779–1819), who emigrated to America in 1803. He had completed his apprenticeship in France, probably under the guidance of his brother Nicolas, who became a *Maître ébéniste* in 1783. Charles-Honoré settled in New York, where he made high-quality furniture, most of which is signed or labelled. His early work is pure Louis XVI, but by around 1812 he had arrived at a personal version of the Empire style. Not easily distinguished from French pieces, his furniture is made of costly materials with ormolu decorations probably imported from France.

Phyfe's later style was developed by German-born John Henry Belter (1804–63), who settled in New York in 1844 and eventually inherited Phyfe's title of "America's best furniture maker".

Originally Johann Heinrich Belter from Stuttgart, in Württemberg, he completed his apprenticeship as a woodcarver in his native region, which was then at the forefront of technical developments in woodworking.

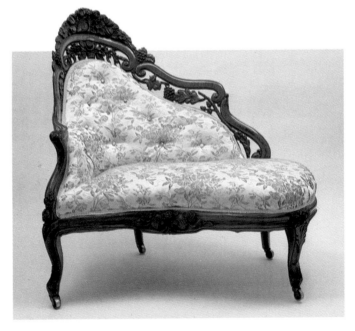

Belter's style is marked by his training in an environment dominated by the Biedermeier and (post 1830) German Rococo revivals. He was also versed in some unusual assembly and woodworking techniques, in particular the system of gluing together layers of wood previously pressed and shaped using steam, which enabled him to obtain exaggeratedly curved shapes. He preferred to work in palisander and oak, and his pieces are skilfully decorated with intricate carvings of fruit, flower, leaf and scroll motifs, and virtuoso fretwork.

Some of the craftsmen who perpetuated the Belter tradition were George Henkels the Elder of Philadelphia, I. and I. W. Meeks, Leon Marcotte and Gustave Christian Herter of New York, as well as Prudent Mallard of New Orleans.

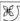

Furniture of the 19th Century

Other European Countries

by Massimo Griffo

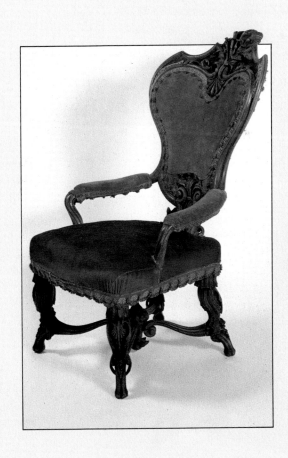

The spread of the Empire style

Introduction

The widely held opinion that wars and revolutions have so strong an impact on the social fabric as to change fashions and furnishings as well as customs, though appropriate in many cases, is clearly not true of the late 18th century. The French Revolution and the wars that sprang from it, while involving the whole of Europe, did not substantially alter the styles adopted by furniture-makers, who continued to follow the aesthetic and structural canons that has inspired their predecessors. Many scholars see in the Empire

style a more exalted and ostentatious version of Louis XVI, and in Louis-Philippe a Rococo nostalgia whose awkwardness reflects an inability to escape the influence of a stiff classicism.

But we can go even further. Apart from the burst of stylistic symbolism that was Art Nouveau, the canons that dominated furniture-making in the second half of the 18th century continued to hold sway as the 19th century moved into the 20th – and they are still valid today. They re-emerge, with obvious Neoclassical allusions, in much Italian and French Art Deco furniture, in geometrical 20th-century desks,

and more recent "Swedish" furnishings. The same late 18th-century rigour is apparent in the inventions of modern "designers", and humbly greets us in the more popular products of workaday joiners.

There is a simple reason for this continuity. The revival of classical art was no mere fashion, but an expression of general disgust with anything that smacked of excessive artifice. At the same time, it expressed a need to simplify constructional rules at a time when the Third Estate was beginning to impose its own requirements and reduce the prestige and power of the clergy and nobility. In practice, the history of modern furnishing begins in the second half of the 18th century. At that time, geometrical simplicity of form – which, incidentally, seems to have coincided with a spontaneous process of adaptation to the forthcoming use of machinery and industrial methods – spread from the court, where it was expressed in a sophisticated use of materials and decoration by the more original craftsmen, to middle-class homes, which were furnished in fundamentally the same style. This would have been unthinkable in the Baroque or Rococo periods, whose pieces of furniture were of necessity unique, opulent and extremely expensive.

It could be argued, at least where furnishings are concerned, that Neoclassicism had anticipated the outcome of the French Revolution, and that in this field there was very little for the Revolution to revolutionize.

In the rest of Europe, the ascent of the Third Estate had not occurred in so traumatic a form, and the Neoclassical style was welcomed spontaneously, as a logical consequence of the triumph of reason over caprice. The prevalence of dignity, public spiritedness and good intentions in achieving social justice, for which the Revolution had violently indicated the need and which matured more gradually in the rest of Europe, explains why the 19th century was a somewhat confused period in the field of furnishing.

Europe under French influence

It was thus amid a general trend towards simplicity of form that had been gathering strength in the second half of the 18th century, that Europe prepared to cross the threshold into the 19th century.

This trend differed slightly in the forms it took, depending on local tradition, social structures and external influences. In cen-

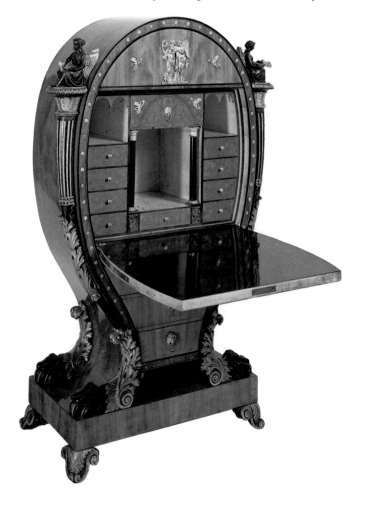

THIS PAGE: mahogany secretaire with gilt-bronze decoration by Franz Dettler, made in Vienna around 1810 (detail on the facing page). Ebonised and gilt-wood carved cornucopiae, surmounted by winged female figures, frame the lyre-shaped body of the piece. Österreichisches Museum für angewandte Kunst, Vienna. PRECEDING PAGES: the drawing-room of the Archduchess Sofia at the Hofburg in Vienna (c. 1854) as depicted in a contemporary lithograph; ashwood armchair stained to a walnut colour by the Austrian cabinet-maker Carl Leister, exhibited in London in 1851. Bundessammlung alter Stilmöbel and Österreichisches Museum für angewandte Kunst, Vienna.

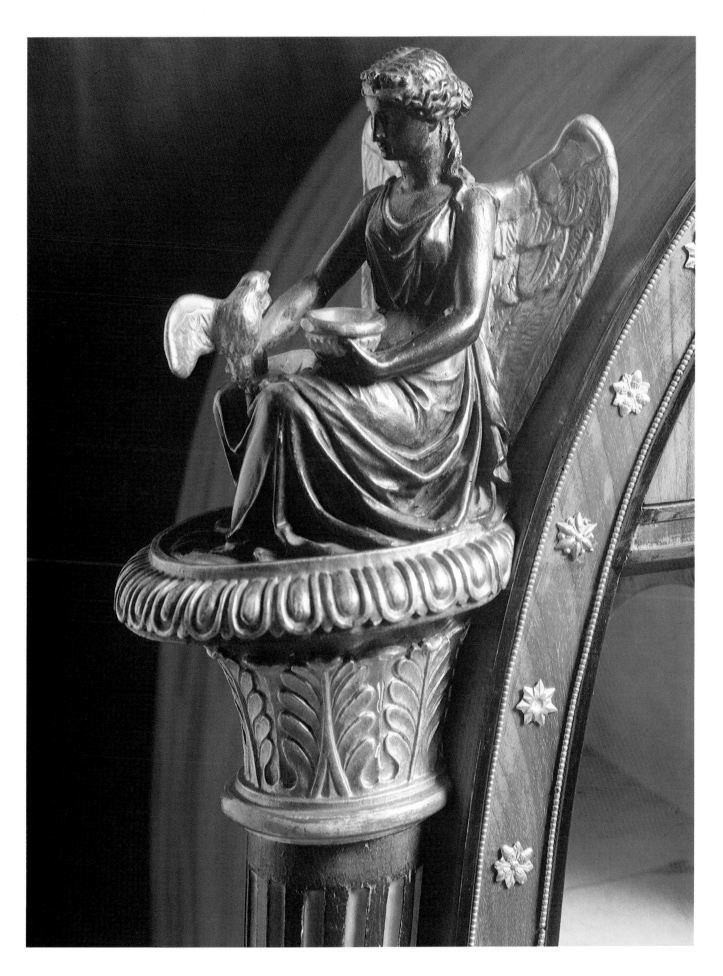

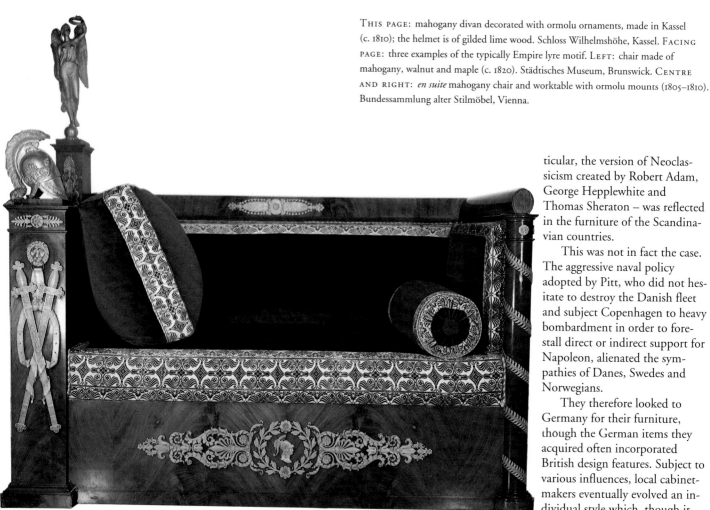

tral and eastern Europe and in Scandinavia, the main influences, though not clearly distinguishable, came from France and England, and were dictated largely by the political situation.

With the Treaty of Campo Formio (October 1797), Napoleon had already begun to transform the territorial boundaries of Europe. The area of the later state of Belgium was annexed to France, and the Cisalpine Republic included territory that had been under Austrian rule.

The Austro-Russian counter-offensive, undertaken while the ambitious general was occupied in Egypt, led to a more decisive riposte by the French army, and the new century opened with Bonaparte firmly in control in Paris, after the *coup d'état* of 1800.

The consequences were not long in coming. In just a few months, he had brought Austria to heel and secured the benevolent neutrality of Russia, Prussia, Sweden and Denmark. From Holland to Italy, French influence was extending ever further eastwards, and this led to renewed war with England, which regarded the European political balance as dangerously compromised. By skilful diplomacy, William Pitt managed to bring Russia, Austria, Sweden and the Kingdom of Naples into the Third Coalition, but Napoleon, who in the meantime had been crowned emperor, defeated the Austrians at Ulm and Austerlitz (1805), occupied Vienna, established the Confederation of the Rhine, put his brother Louis on the throne of Holland after the Battle of Jena (1806), entered Berlin and reached Warsaw.

In just a few years, the whole of central Europe had come within the French orbit, and strong links with Paris, combined with the example of courts governed by client rulers or members of the Emperor's own family, ensured that French fashions and tastes held sway.

Northern Europe: English and French influences

The situation was slightly different in Northern Europe. British naval supremacy, confirmed by the victories of Abukir (1798) and Trafalgar (1805), facilitated trade with countries with a North Sea coastline, and this factor, combined with the prevalence of smuggling, might have been expected to ensure that the English "cabinet-making gospel" – in particular, the version of Neoclassicism created by Robert Adam, George Hepplewhite and Thomas Sheraton – was reflected in the furniture of the Scandinavian countries.

This was not in fact the case. The aggressive naval policy adopted by Pitt, who did not hesitate to destroy the Danish fleet and subject Copenhagen to heavy bombardment in order to forestall direct or indirect support for Napoleon, alienated the sympathies of Danes, Swedes and Norwegians.

They therefore looked to Germany for their furniture, though the German items they acquired often incorporated British design features. Subject to various influences, local cabinet-makers eventually evolved an individual style which, though it also extended to Norway and Sweden, used to be known as Danish Empire but is now, at least in Norway and Sweden simply called "Empire".

Its chief characteristics are simplicity and sobriety of form, which reflects partly a natural disposition among Nordic peoples and partly the events of the war, which led them to be self-sufficient and sparing in their choice of raw materials. For instance, expensive, exotic mahogany, whose dark grain goes perfectly with ormolu mounts, was replaced by light-coloured woods of local origin, particularly maple and birch, which are better suited to decoration with delicate inlays of dark wood.

When the naval blockade was over and mahogany was back in vogue, they preferred to use it as a veneer for less prestigious woods, such as pine or oak. By now, however, the eschewal of

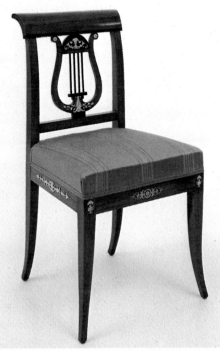
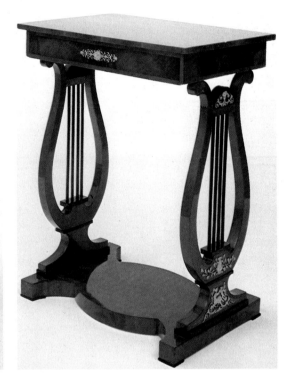

bronze mounts, born of necessity, had become a fashion, and inlay continued to be the preferred technique for decoration, using light-coloured woods on a dark background. Another decorative feature that tended to give lightness to furniture was the insertion in the veneer of various inlays, generally lunettes, made of burr thuja, alder or some other light-coloured, strongly figured wood.

In Sweden, French influence was even more pronounced. Since the previous century, the cultured classes had nourished strong sympathies for France and its artistic, literary, philosophical and – with some reservations – revolutionary achievements. In 1810, Charles XIII even nominated the French general Jean-Baptiste-Jules Bernadotte heir to his throne. These sympathies also found expression in the adoption of French models for furniture. However, the Swedish love of light is evident in a more pronounced linearity and, in the case of painted furniture, in a preference for reflective, pale colours, which give a distinctive mother-of-pearl quality to the furnishings of certain Swedish palaces. In short, Swedish furniture has a provincial character similar to that in 18th century Venetian furniture which justifies the distinction made between *Venezia acqua* and *Venezia terra*. Incidentally, this also explains how unscrupulous dealers in the antiques trade have been able to pass off items of Swedish furniture as Venetian.

The fact that Poland and Russia, though not totally rejecting English influence, continued to appreciate French styles, either directly or through the mediation of Germany, leads to the conclusion that Parisian fashions tended to predominate throughout Europe. Where furniture was concerned, the continent was increasingly detached from the British Isles, with a few notable exceptions in countries with access to the North Sea.

Germany: a mediating role

In continental Europe, if we exclude geographic Belgium, which in this respect had become virtually a province of France, it was Germany and Austria that maintained the closest links with French furniture-makers. Cabinet-makers from Germany such as Beneman, Molitor, Papst, Riesener and Weisweiler had been settling in Paris since the 18th century, to be followed by many more in the 19th, and this was bound to have repercussions on furniture back home.

A clear instance of this is the visit David Roengten (1743–1807) made to Paris in 1774, which produced a change in the style of furniture manufactured in the workshop which his father, Abraham, had established at Neuwied in 1750. As a result, imitations of English Chippendale were superseded by a Neoclassical style of French inspiration. David Roentgen, a genius of a cabinet-maker, made his own creative contribution to the new style, winning fame, honours and commissions throughout Europe, from Paris to St Petersburg.

Curiously, the linear version of Neoclassicism introduced into Germany by Roentgen after his

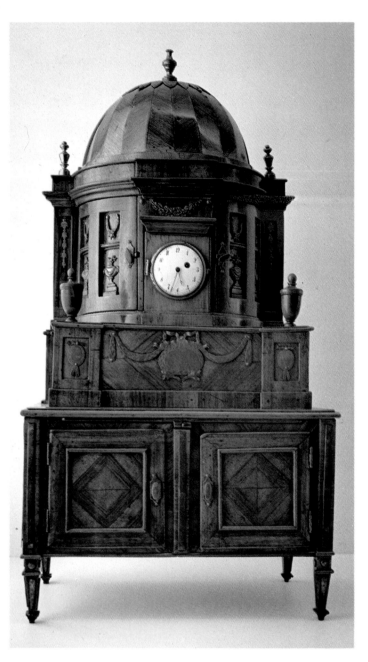

stay in France led to a rapprochement with English styles in the northern parts of the country. In fact, items of furniture of that period manufactured in northern Germany could easily be taken for English imports. In some cases, their Englishness is emphasized by Wedgwood ceramic decoration.

Instead of ormolu, local taste also preferred ornamentation in more unusual and expensive materials such as alabaster and ivory, and the use of rare woods. All this was to satisfy what we might call the softer aspect of Neoclassicism. Although on the one hand this style represented a reversion to sobriety, on the other it was also just another fashion and, as such, was capricious. Love of luxury and frivolity found expression in the sophistication of the decorative accessories, but these did not always harmonise perfectly with the hard edge lines of Neoclassical furniture.

At the same time, imitating foreign models did not prevent

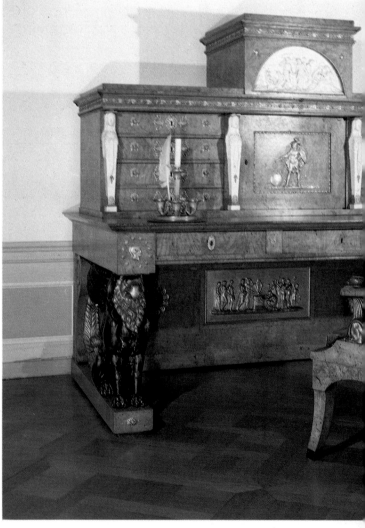

FACING PAGE: clock cabinet from southern Germany (c. 1810); the "architectural" upper section incorporates a clock framed by classical ornaments. Bayerisches Nationalmuseum, Munich. BELOW CENTRE: desk made by Friedrich Wichmann (1810/11); the application of fashionable Empire features has resulted in a heavily monumental piece of furniture. Schloss Wilhelmshöhe, Kassel. BELOW RIGHT: Late 18th-century German secretaire remodelled in the Empire style (1815–20). Österreichisches Museum für angewandte Kunst, Vienna.

native German tendencies finding expression, nourished by a nostalgia for the national past which was just surfacing in a return to the Gothic style. The origins of this movement were philosophical and literary in character, which roots in the Romanticism most clearly exemplified by the literary works of the Schlegel brothers, the poet Novalis and Wackenroder, and later, the fairy tales of the Grimm brothers.

It is interesting to observe

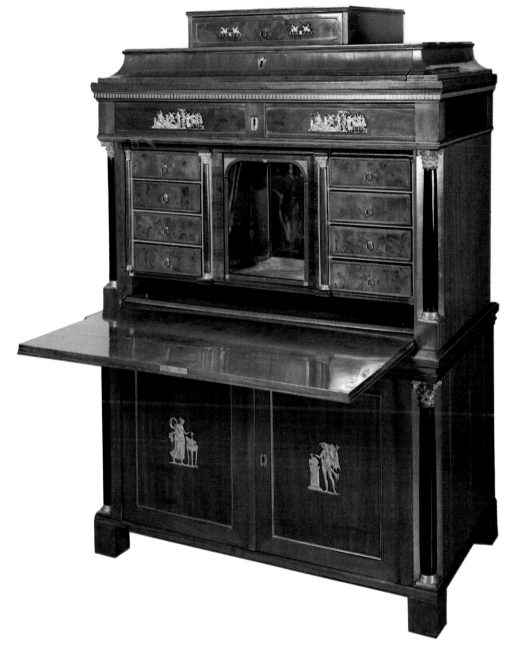

how quickly the Romantic tendency spread to furniture. The pointed arches and quatrefoil tracery we find in German furniture of this period heralded a revival that did not spread to other parts of Northern Europe until the following generation.

In Russia, meanwhile, the spread of Neoclassicism was based mainly on approximate imitations of furniture that the Empress Catherine II had imported directly from Paris or from Neuwied. The typically Russian features of this period were the

use of Karelian birch, light-wood inlays on mahogany veneers, metal mounts, chair backs carved in bird shapes, and the use of semi-precious stones from the Urals.

Although there was a long tradition of skilled craftsmanship,

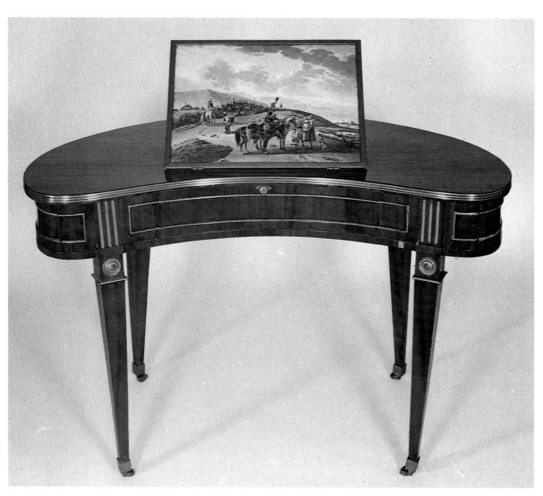

new star rising upon the European scene was greeted with enthusiasm.

As early as 1801, three years before the First Consul had himself proclaimed Emperor, a young joiner from Bremen, Gottfried Lehrknecht, presented as his test piece for the status of master craftsman a secretaire surmounted by a crowned eagle and with the bust of Bonaparte inlaid on light wood in an array of marbled columns.

The times were ripe for change. As had previously occurred with Rococo, the Neoclassical style had now slipped into repetitiveness. Regarded as old hat, it was pejoratively described as *zopfig,* derived from *Zopf,* the now unfashionable male pigtail – in other words antiquated and pedantic.

German furniture production

The conditions were therefore highly favourable for the new fashion from Paris to gain rapid acceptance in Germany and, from there, spread to Russia. German craftsmen had been settling in Russia since the end of the 18th century, and there we find evidence of the work of pupils and followers of David Roentgen such as Heinrich Gambs of Strasbourg, Johannes Klinkerfuss (1770–1831) of Stuttgart, and Christopher Meyer.

Also significant in diffusing the Empire style were the first publications on fashion and furnishing, which were beginning to bring the influence of the great arbiters of taste into middle-class homes and craftsmen's workshops. In France, Percier and

the impulse towards elegance in furnishing, which in any case was of fairly recent origin, did not really gather strength until the reign of Alexander I, after the Napoleonic threat had passed.

Though somewhat approximate and arbitrary, the distinction between the hard edge and soft line aspects of furniture design helps us to achieve a better understanding of the upheaval brought about by the Empire style in early 19th-century Europe. If there is a style which, better than any other, reflects the pomp and circumstance of a period, it is that which the architects Percier and Fontaine im-

posed, first in France then throughout Europe, at the orders and under the inspiration of Napoleon. With glorious intuition, they developed the hard edge characteristics element of the Neoclassical style.

The Empire style expresses both the warrior's triumph and his hard-won repose. Its regal, mythical panoply of lions, sphinxes, chimera and griffins maintain their original arrogance, but at the same time allow themselves to be yoked to the victor's triumphal chariot. Its laurel wreaths are the victor's crown; its palmate ornaments and metal mounts the equivalent of the braiding and

epaulettes of military uniforms; its bronze figurines in sensual attire suggest pleasure. Feminine fashions and the furnishings of the non formal rooms, with their *lits en bateaux* and softer surfaces, suggested domestic felicity.

A style of this kind could not have spread gradually, winning its way with slow, patient changes: it followed the dragoons in their lightening progress and triumphed in the wake of victory. A Stendhalian spirit was abroad in Europe, a grandeur ready to catch fire, even among those fighting against Napoleon's armies. Even outside France, everything connected with the

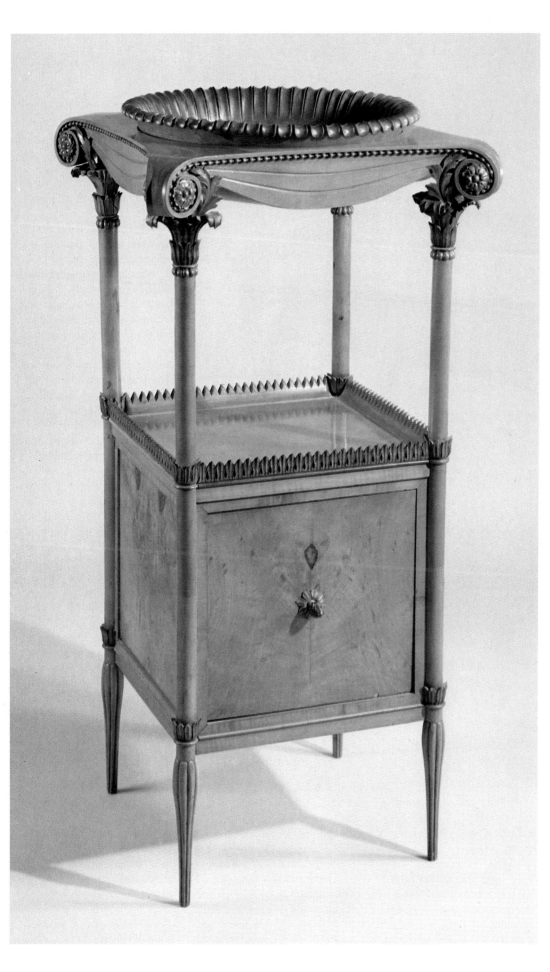

Fontaine published their *Recueil de decorations intérieurs comprenant tout ce qui a rapport à l'ameublement* (1801), defined by Serge Grandjean as the "bible" of the Empire style. The following year, Pierre de la Mésangère began writing an insert for the *Journal des Dames* entitled *Collection des meubles et objets de goût.*

Well received in Germany, these publications gave rise to imitations. The first German review of this kind was the *Journal des Luxus und der Moden,* and it was soon followed by others. In Leipzig, Friedrich August Leo advocated Empire furnishing styles in many publications aimed at manufacturers and their customers and, in 1805, summarized his ideas on the subject in a publication significantly entitled *Ideen zu geschmackvollen Möbeln mit reicher und einfacher Verzierung* (Ideas for tasteful furniture with rich and simple decoration). Berlin, meanwhile, had its own publication, the rival *Journal für Kunst und Kunstsachen, Künsteleien und Mode* (Journal of art, *objets d'art,* crafts and fashion).

It should however be noted that, although these new vehicles for fashion and taste – distant ancestors of the present-day mass media – aroused widespread interest in the more strictly French style, they failed to propose models which fully translated the Napoleonic spirit into the local idiom.

Among the German furniture manufactured after 1806 in Berlin, Vienna, Leipzig, Jena and other parts of Germany and Austria in accordance with the dictates of the new style, we find many examples of this unsatisfactory marriage. Even the furniture which the great Karl Friedrich

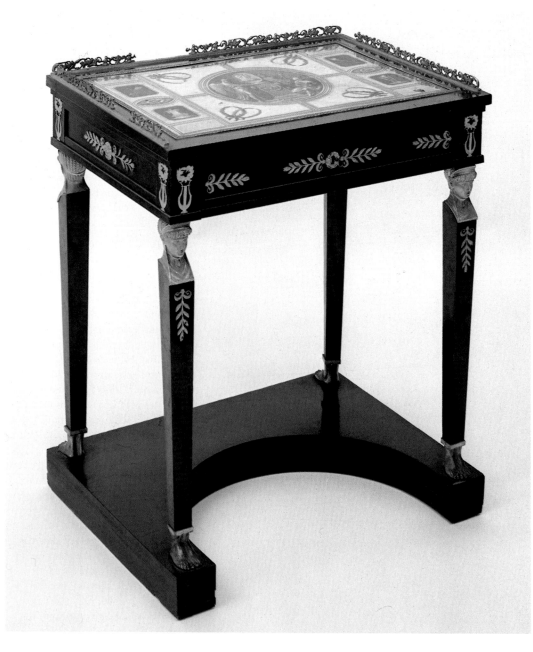

transforms even the most modest piece of furniture into a monument.

Nonetheless, despite the rapid spread of Napoleonic triumphalism across central Europe, the extent to which the spirit of the age asserted itself depended on the different personalities of architects and sovereigns. The Empire style, unlike those that soon followed, was still a court style, and its adoption depended largely on the will of those whom politics and Napoleon's military advances placed at the head of government. This clarification is also important because of the way it affects the antiques market, which distinguishes between early and late Empire styles. Early Empire pieces – dating from Napoleonic times – are rare and valuable, mostly kept in museums and public art galleries. The few examples that come on to the market fetch very high prices. The opposite is true, however, of late-Empire furniture, which was still popular with the middle-classes when the Emperor himself was no more than a memory. Items of this kind replicate the features of the Napoleonic era, sometimes with real elegance, but because of their intended clientele, and the fact that they merely repeat and simplify an outmoded style, they are greatly inferior in quality.

No survey of the different guises assumed by the Empire style in Germany would be complete without a mention of the pieces made by the sculptor and furniture-maker Friedrich Wichmann for the castle of Wilhelmshöhe in 1810/11 when Napoleon's brother, Jérôme Bonaparte, moved to Kassel as King of Westphalia. The exagger-

Schinkel (1781–1841) designed in 1809 for the bedchamber of Queen Louise at Charlottenburg, with its fluttering ribbons, scalloped ornamentation and slender fluted legs, is more 18th-century than Empire in style.

A perfect reconciliation of the new style with Germanic taste was not achieved until Nicolaus Friedrich von Thouret (1766–1845) designed the furniture for Duke Friedrich von Württemberg's palace at Ludwigsburg, and even then, the part of the work entrusted to Klinkerfuss, whose kidney-shaped writing table can still be seen there, shows the continuing influence of Roentgen. Elsewhere, we tend to find heavy columns, angular profiles, rigid lines, exaggeratedly thick structural components and a rigid Teutonic symmetry which

FACING PAGE: Empire-style worktable made by Viennese craftsmen (c. 1810): the herm legs culminate in antique heads; it has ormolu mounts and a Viennese porcelain top with polychrome decoration in imitation of Roman mosaic. Bundessammlung alter Stilmöbel, Vienna. THIS PAGE: mahogany bed in late-Empire style decorated with ormolu classical palmettes and rosettes, made for the Viennese court around 1825. Österreichisches Museum für angewandte Kunst, Vienna.

atedly monumental desk with heavy marble reliefs he made in 1810 shows what excesses were possible when ill-digested artistic criteria were applied with rigidity. There are plenty of other smaller-scale examples in the same castle. Of a quite different character is the furniture designed in Würzburg between 1807 and 1809 by the architect Nikolaus Alexander Salins de Montfort for Ferdinand III of Habsburg-Lorraine, Grand Duke of Tuscany. His taste, like that of the two cabinet-makers who executed his designs, had been formed in France, as is evident from the harmonious way in which he managed to blend lightness and opulence. A typical example is the cedarwood table conserved at the Residenz in Würzburg, largely executed by Johann Valentin Raab in 1809. The circular top seems barely to touch the swans' wings that support it, while the arched necks of the birds are daringly echoed by the scrolls rising from the base of the table.

The Austrian version

The German version of the Empire style reached the apogee of its splendour in Vienna. In 1809, the architect Georg Pein (1775–1834) expounded his thoughts on furnishing in a book that may be regarded as the Viennese equivalent of Percier and Fontaine. His patterns were never actually put into production, but they had a great influence on contemporary taste, and their emphasis on strong curves can be said to have anticipated the rounded softness of the Biedermeier style.

A famous piece is the mahogany secretaire with bronze mounts by Franz Dettler, now in the Museum für angewandte Kunst in Vienna. What strikes one about it is the perfect blend of solidity and grace, caprice and gravity: air and empty spaces play a vital role in lightening its powerful presence. The base does not rest directly on the ground, but on acanthus-leaf feet. Immediately above, lions' paws support the drawer compartment. This swells out to meet the lyre-shaped writing cabinet, veneered with maple on the inside, which is gracefully framed by two cornucopias surmounted by victories with gilded wings.

Another typically Viennese secretaire likewise in the Museum für angewandte Kunst in Vienna was made by Johann Härtle in

1813. The "Germanic" heaviness of this piece is virtually cancelled out by its cylindrical form and the architectural layout of the interior, which, in its combination of grace and geometry, is reminiscent of decorative schemes from the Italian Renaissance.

The atmosphere of the Viennese court, anticipating the myth of *Austria felix*, spread to patrician residences and the inspiration of craftsmen, whose work during the Empire period combined caprice and regality with a taste that, though lacking autonomous features, was more akin to the exuberance of Parisian manufacturers. However, the vitality of Viennese Empire had very different origins, which may be sought in the sensual, highly spiced influence of the Orient. It owes something to a part-Byzan-

tine, part-Moorish taste that is even more pronounced in other eastern European countries.

Belgium and Holland

Viewed as a mere geographically stylistic appendage of France and economically exhausted, Belgium offers no conspicuous examples of a local version of the style introduced by Percier and Fontaine. Those with the necessary means ordered their furniture directly from Paris, and the few cabinet-makers who worked in the official style seemed more taken with its solidity than its magnificence. Rather than majestic, their interpretation of it is provincial, rigid and massive.

In Holland, there were initially other reasons – in particu-

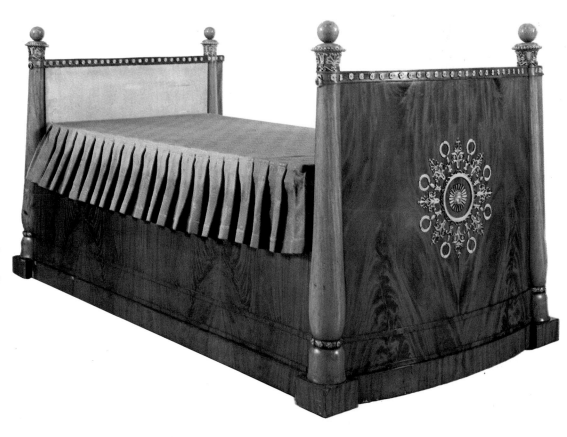

The Empire style of Vienna

In Vienna, the Empire style that had overrun Europe in the wake of Napoleon' armies, was interpreted in a particularly graceful, "pictorial" manner. The austere structure of French furniture took on softer lines, and lighter, more vivacious forms. It became more refined, achieving a perfect blend of solidity and grace, fantasy and geometry. For the veneering, local craftsmen favoured mahogany, cherry, ash, maple and yew, whose delicate graining was well suited to light, sophisticated decoration of classical inspiration: marquetry and delicate patinised and gilded carving, bronze and brass mounts and copper inlays.

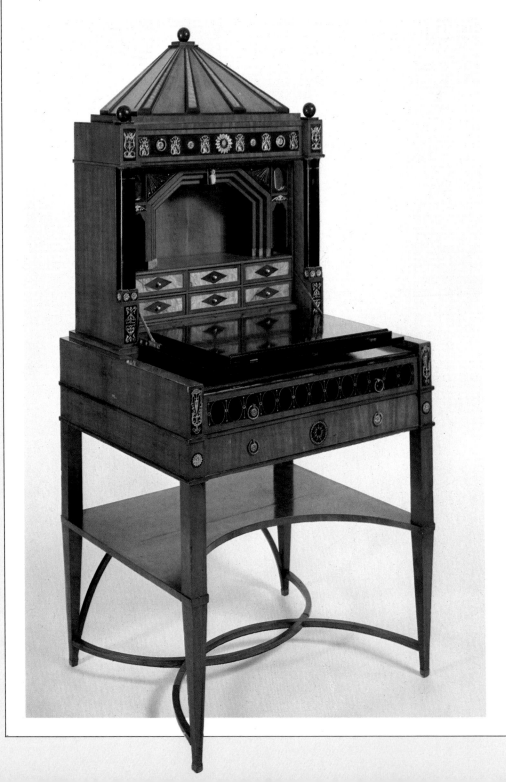

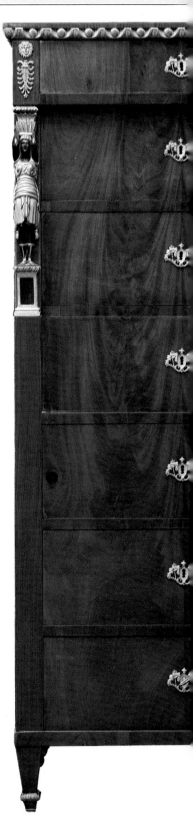

LEFT: mahogany writing desk: the su
perstructure is embellished with ash a
ebonized pear inserts, ormolu mounts
and copper inlays (c. 1805). Österrei
chisches Museum für angewandte Ku
Vienna.

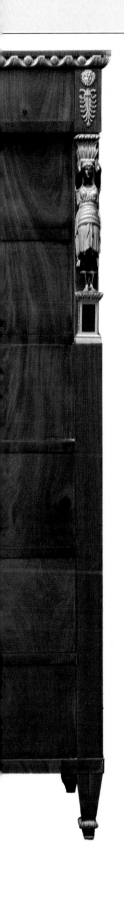

LEFT AND BOTTOM OF THIS PAGE: Empire-style *semainier* and *lit en bateau*, part of a full suite of mahogany bedroom furniture, showing obvious French influence. Typical features are the carved caryatids on the lateral pillars of the *semainier*, gilded and patinised to simulate bronze, and the use of ormolu for the escutcheon plates of the *semainier* and mounts of the bed. Bundessammlung alter Stilmöbel, Vienna.

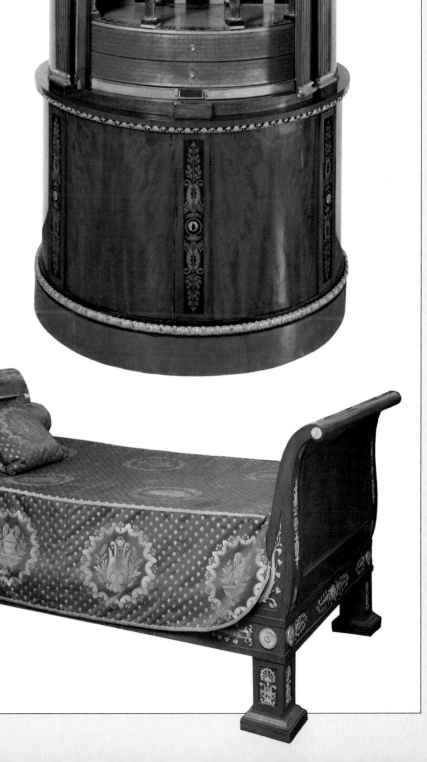

RIGHT: cylindrical mahogany secretaire with maple and ebonised wood inlays, painted decoration and gilded pewter mounts, made by Johann Härtle in 1813. Österreichisches Museum für angewandte Kunst, Vienna.

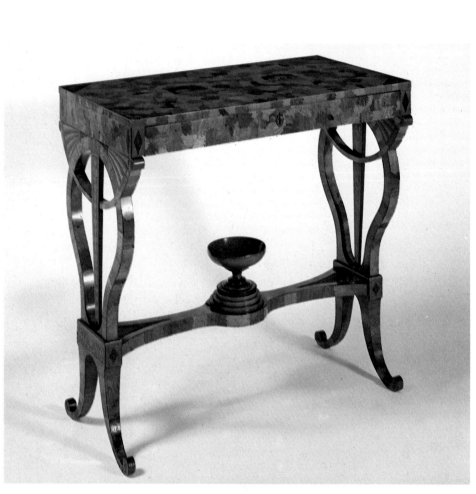

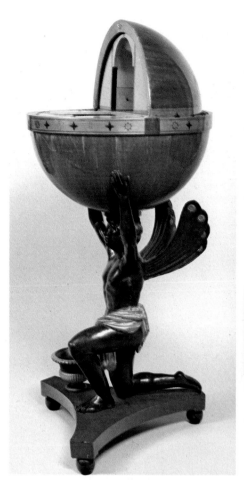

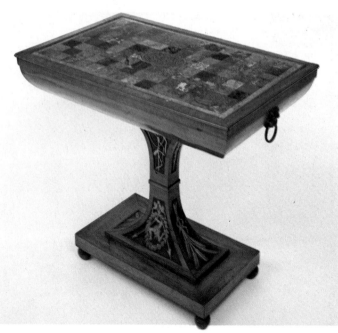

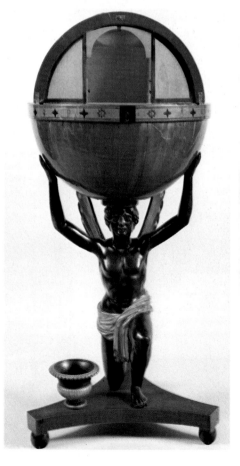

THIS PAGE, BELOW LEFT: worktable (c. 1805) also designed for use as a desk, shown here in open and closed positions; the cylindrical upper part opens to reveal a number of compartments and drawers. FACING PAGE, TOP LEFT: worktable of similar design (c. 1810) veneered with irregular fragments of different woods and contrasting colours. Both Österreichisches Museum für angewandte Kunst, Vienna. FACING PAGE, BOTTOM LEFT: "Chalice" table (c. 1830) with inlaid and gilded wheat-ear motifs on the base and the green-patinised leg; the top is a polychrome marble mosaic. Bundes- sammlung alter Stilmöbel, Vienna. FACING PAGE, RIGHT: spherical worktable (1800–10), seen from the front and side: the main body, fitted with compartments and drawers, is supported by a winged genie, carved in wood, painted to imitate patinised bronze and picked out in gold. Antiques trade. THIS PAGE, RIGHT: cherrywood worktable with ebony inlays and carved, gilded rams' heads, by the Viennese cabinet-maker Karl Schmidt (1825). Private collection.

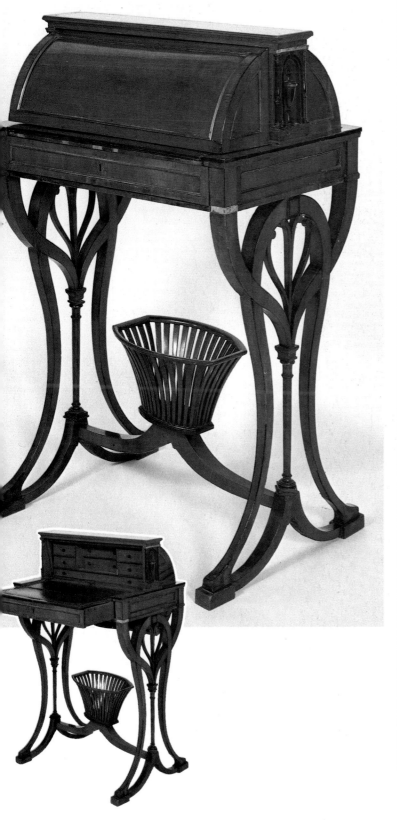

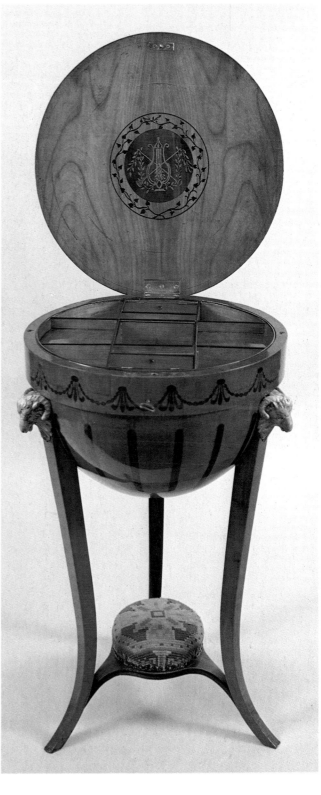

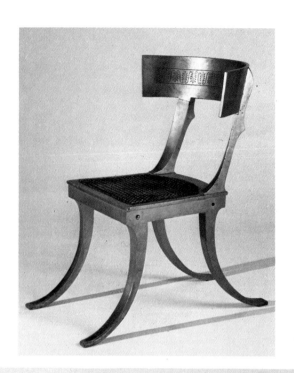

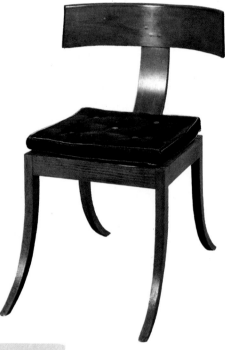

lar, a kind of political hostility – to hinder the spread of the Empire style, though in compensation it was to survive longer there even than in France. In practice, the style was *de rigueur* in the official residences of Napoleon's brother, Louis Bonaparte, after he was appointed King of Holland. The first items of furniture were ordered from Paris, to help the French economy, but as the king became increasingly fond of his new country, local artisans were able to establish themselves as suppliers, and adapt the newly imported style.

The most important of these cabinet-makers was Carel Breytspraak, who designed the king's bedchamber. One notable item

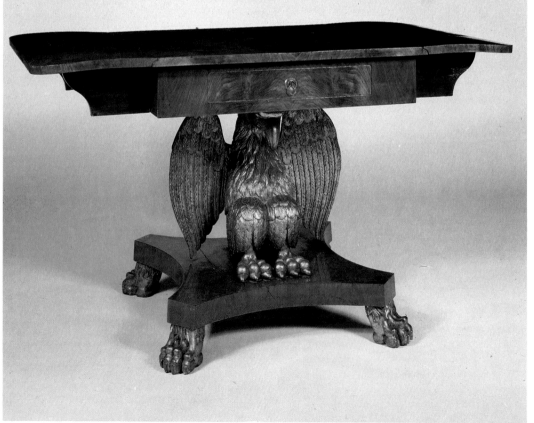

of furniture in this room was a chest of drawers now in the royal collections. What distinguished it from French models was the use of mouldings between the drawers to impart a rhythm to the front of the piece, and the repetition of the veining of the mahogany within horizontal bands. Other characteristics of the work of Dutch cabinet-makers were the retention of square, sharply tapering feet (French Empire pieces tended to rest directly on the ground); and the canting of the front pillars, to slim down the façade of the piece and reduce its apparent bulk. These features really denote an imperfect assimilation of the Empire style and a reluctance to adopt the trappings of imperial grandeur. Though this is sometimes expressed in a greater blandness than we find in other countries, at others it is apparent in a failure to abandon the legacy of outmoded styles or, even worse, in a mixing of forms

BELOW, LEFT: *secrétaire-cabinet* in flamboyant mahogany (c. 1800), made to a design by Nicolai Abilgaard for the future King Christian VIII of Norway and Denmark: note the laurel wreath on the classical pediment. Frederiksborg National Historical Museum, Hillerod. RIGHT: secretaire by the Swedish cabinet-maker Johan Petter Berg (1811): simple in its basic design, it is embellished with bronze mounts and white marble columns. Nordiska Museet, Stockholm.

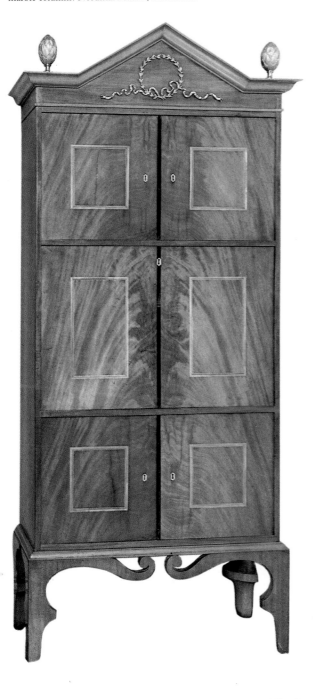

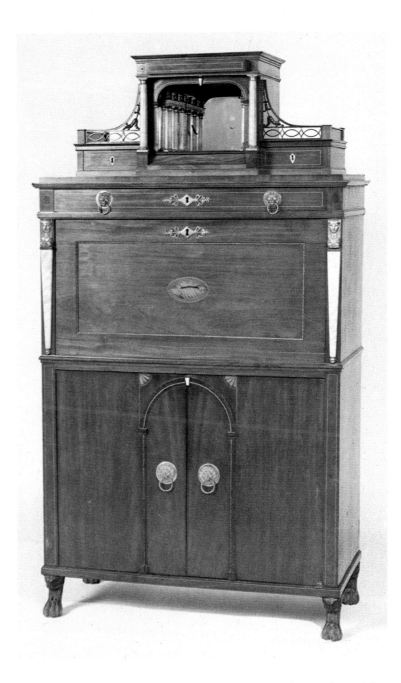

which, though belonging to the same style, clash with one another.

We have already noted that in Holland the Empire style proved more durable than elsewhere. With the end of political hostilities, it even became popular with the middle-classes, assuming characteristics very similar to those of northern Germany. We might perhaps say that the "overt" triumphalism inherent in this proud, bemedalled style infected princes, country gentlemen and wealthy merchants once the only person capable of humiliating them had disappeared from the European scene. Of course, the pieces concerned were derivatives devoid of any real magnificence, but the principal features persisted until the early 1840s.

The wood normally used for veneering was mahogany, while pear, stained black, replaced ebony for the lateral columns. Fantastic zoomorphic elements were common, as were small stylized leaf decorations. The use of ormolu was reduced to a bare

THIS PAGE, BOTTOM: Russian chest c. 1800, with inlays of exotic woods and chased and gilt-bronze mounts: the front of the chest is framed by a pair of sphinx-headed marble herms. TOP LEFT: Russian occasional table in gilt and chased bronze with round marble top (c. 1810): the slender fluted legs, culminating in antique busts, support a frieze embellished with rosettes and palmette motifs.

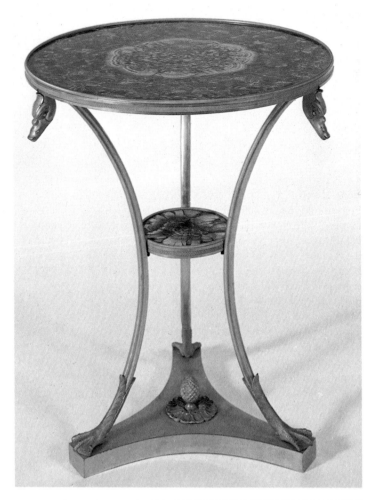

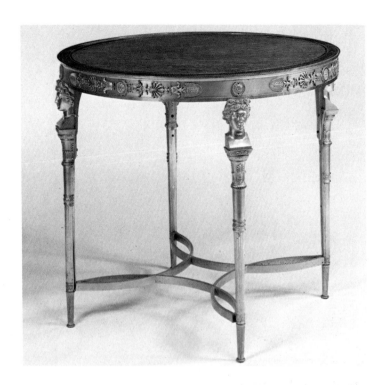

minimum. Most items come into the category of traditional, functional furniture, in particular *lits en bateaux* set against the wall or fitted into niches hung with curtains.

In Holland, as elsewhere, the Empire style lost some of its rigidity as the years went by. Except in the vaguest sense, however, it never assumed the reassuringly florid forms of Biedermeier.

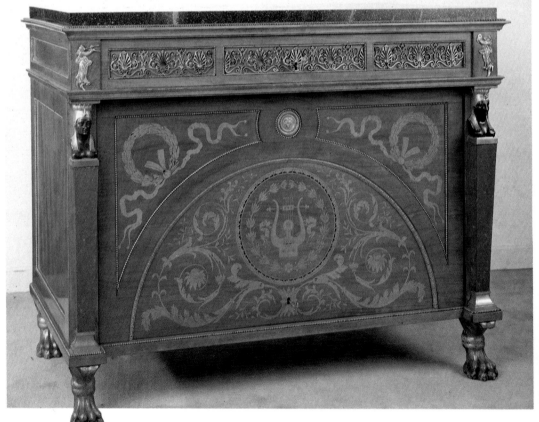

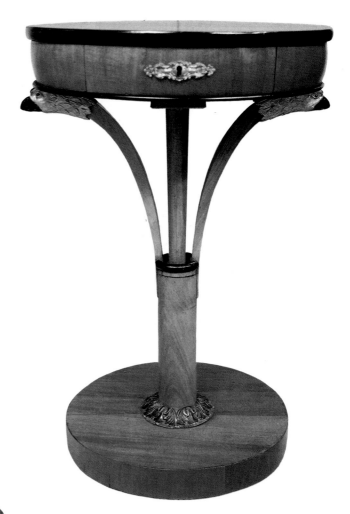

Scandinavia

The three Scandinavian countries were subject to both English and French influence, as well as being in direct contact with the old Hanseatic regions of Germany that bordered on the Baltic and North Sea. As we have seen, they eventually developed a style formerly known as Danish Empire. Moreover, the Scandinavian interpretation of Empire classicism had already evolved distinctive characteristics of its own. An example is the chair designed by the architect Nicolai Abilgaard (1703–1809) in 1800, now in Copenhagen's Museum of Decorative Arts, which draws on ancient Greek types.

In its pronounced calligraphic style, it has nothing in common with chairs of the same period manufactured in other countries; if anything, it bears a resemblance to the chair designed in 1835 by the sculptor Hermann Freund (1786–1840) for his house in Copenhagen, now at Frederiksborg Castle.

This tendency to reinterpret the styles of others in unusual ways was for many years characteristic of almost all the furniture manufactured in Scandinavia, as

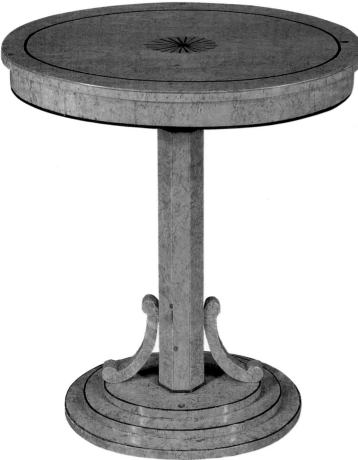

is borne out by the secretaire produced in Stockholm in 1811 by the cabinet-maker Johan Petter Berg, now kept in the city's Nordiska Museet. It combines a Teutonic heaviness with decorative features in the French style and a marquetry shell motif in the centre of the drop leaf characteristic of Sheraton.

A typically Danish item of furniture from the early years of the century, which also became popular in Russia at a later date, was the divan framed by hollow armrests with closing doors to create small cabinets. At the rear, on either side of the seat back, the cabinets rose above the divan like two miniature towers. For reasons of cost, citrus wood inlays were generally preferred to ormolu mounts on mahogany veneer, and this was also true in other parts of Scandinavia: labour was cheap at this time, while metals were ex-

pensive. Pieces of this kind were much used as long as the Danes kept to the custom of eating their meals sitting on divans in the drawing-room and resting their plates on the arm supports. Glasses, cutlery and other items of equipment were kept in the side cabinets. The various revivals also arrived there later than in other European countries, and were suffered rather than enthusiastically adopted.

Russia

Russia holds a special place in the history of interior design in the first decades of the 19th century. Since Catherine II's day, major items of furniture had been purchased directly from France or Germany or had been made to the designs of foreign architects and cabinet-makers working in Rus-

sia. The main influences were
therefore from Germany and
Paris, but much also came from
England. Also influential were
Italian architects such as Giacomo
Antonio Domenico Quarenghi
and Carlo Rossi (1775–1849).
Continuing the work of Bar-
tolomeo Francesco Rastrelli and
Antonio Rinaldi, in conjunction
with the Scot Charles Cameron
(1740–1812) and the Muscovite
Stasov, they gave a distinctly Neo-
classical impetus to the urban re-
newal of St Petersburg and to
many buildings at Tsarskoye Selo,
the summer residence of the tsars.

Furniture followed the same
trend. In the absence of any offi-
cial Bonapartist imposition, the
Empire style was adopted only
sporadically, or is apparent in the
grafting of alien decorative fea-
tures on to wholly autonomous
structures. This confirms that the
new French style had spread
throughout Europe more by au-
thority than conviction. It was
immediately adopted in the offi-
cial milieux of states governed by
members of Napoleon's family or
trusted entourage, influenced the
taste of countries where Bona-
parte was liked or admired, and
penetrated only to a limited ex-
tent in places where the Emperor
could not exercise direct influ-
ence, such as England and Rus-
sia. However, true though this
may be in principle, it is not pos-
sible to make rigid distinctions.
In the states governed directly or
indirectly by Napoleon, the Em-
pire style, initially restricted to
court circles, later spread by a
process of osmosis to a much
wider public. Similarly, even
where Napoleon's word was not
law, the most characteristic fea-
tures of this grand Imperial style
eventually made themselves felt.

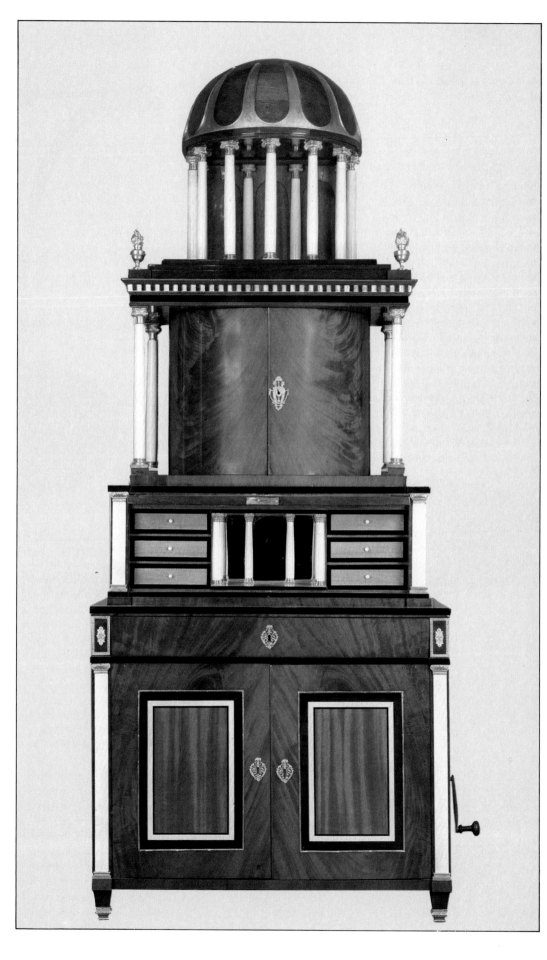

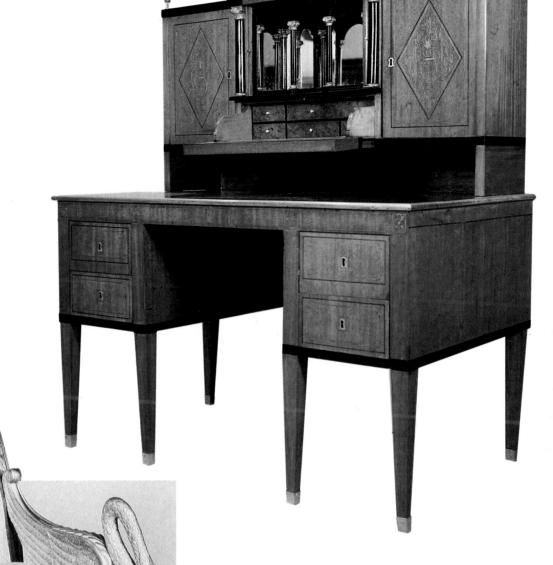

We therefore need to assess piece by piece the extent to which Russian furniture-makers absorbed the French influence, and with what degree of conviction. If we examine items manufactured more or less during the same time span, we find that they seem to belong to different periods. Yet in all of them we detect a spirit which, though having some affinity with the West, is decidedly Russian. This is apparent in the mode of execution and the materials employed, and sometimes in the exuberantly oriental ornamentation. The chair which Andrei Voronikhin (1760–1814) designed in 1804 for the tsar's summer residence at Pavlovsk, in which he used the bold expedient of concealing the break between legs and armrests with the wings of two sphinxes, anticipates solutions typical of Biedermeier. It also harks back to the amusing but exaggeratedly zoomorphic *retour d'Egypte* armchair designed by Georges Jacob, and the *en gondole* chairs made by the same craftsman for the Château de Malmaison to Percier's design. Similarly, we find both pre-Empire and post-Empire elements in the many side tables of the period, which exhibit a French elegance but nevertheless are unmistakably Russian in structure and in the use of marble or malachite for the tops.

Despite the Napoleonic threat, finally averted only after the disastrous invasion of 1812, the reign of Alexander I (1801–25) was a period of prosperity for Russia. Territorial expansion (in Finland, Bessarabia, Georgia and Azerbaijan) was accompanied by a flowering of the arts which is also reflected in furniture produc-

A characteristic of rustic furniture, particularly in Austria, is brightly coloured decoration applied to forms which may be a century out of date: THIS PAGE: bed dated 1830 and signed "Schmidt", though still 18th-century in structure. Private collection. FACING PAGE, LEFT: painted two-door wardrobe with carrying handles (1832). RIGHT: Tyrolean wardrobe signed and dated 1806. Österreichisches Museum für Volkskunde, Vienna.

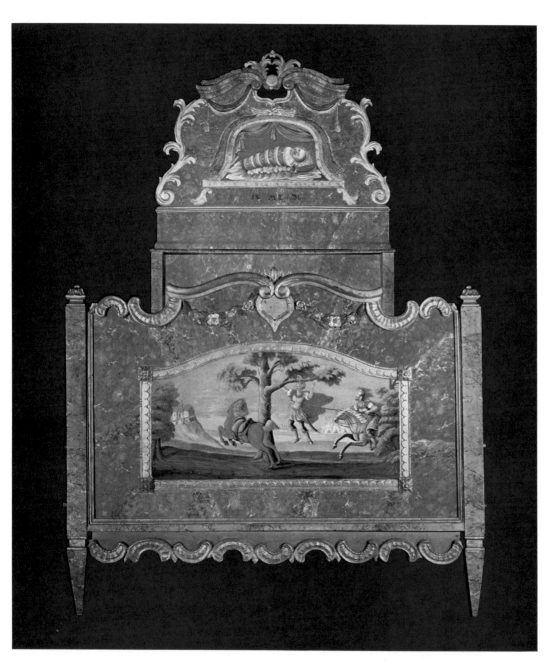

olive and sandalwood, and the practise of patinising or gilding the wood to make it resemble burnished or gilded bronze. Widespread use was made of Siberian marble and malachite. The latter was sometimes cut so thin that it could be used as a cladding veneer even for slightly curved or *bombé* surfaces.

Poland

In Poland, too, the patterns most widely adopted were the French and English Neoclassical styles, and later Viennese Biedermeier. The woods most commonly used for veneering were ash and birch on pinewood carcasses. Lime, elm, poplar and fruit-tree woods were also popular, but there was a decline in the use of mahogany and rosewood. In any list of cabinet-makers, we must include the Simmler family (descendants of Andreas Simmler, who was active in Warsaw in the 18th century) and the brothers Friedrich and Johann Daniel Heurich, who showed great skill in adapting the lines of Biedermeier to suit Polish tastes.

The folk tradition

In Russia, Scandinavia, the Tyrol and Bavaria there developed a popular tradition of decorating rustic furniture, painting it in bright colours with geometrical patterns, flowers, landscapes, figures or religious scenes. This had nothing to do with the cultured 18th-century fashion for lacquered furniture. It was the naïve art form of mountain and rural peoples, practised during the long winter evenings when the house-

tion. However, there was no typical or well-defined style, but rather a mixture of Grecian, Pompeian, Neoclassical, English Regency, Biedermeier and even Moorish elements. Despite this blending of diverse influences, Russian furniture of this period

communicates a feeling and harmony which tempers even the most garish decorative features. This is due to a relatively recent but nonetheless sophisticated tradition of craftsmanship, whose strengths were already apparent in the arsenal at Tula, the ship-

yards of Okhotsk and the factories of Bauman and A. Tour. A common feature was the use of light-coloured, mainly birch, veneers inlaid with darker woods or metal stringing or, conversely, citruswood on darker surfaces. Other features were the use of

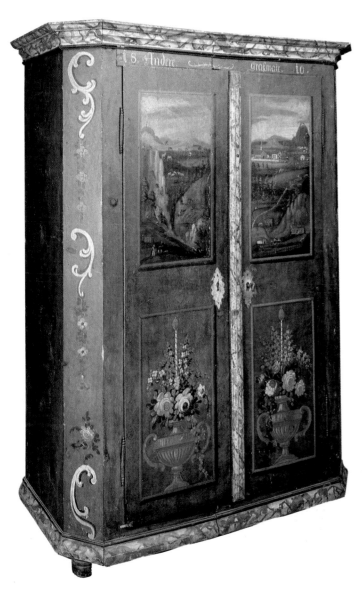

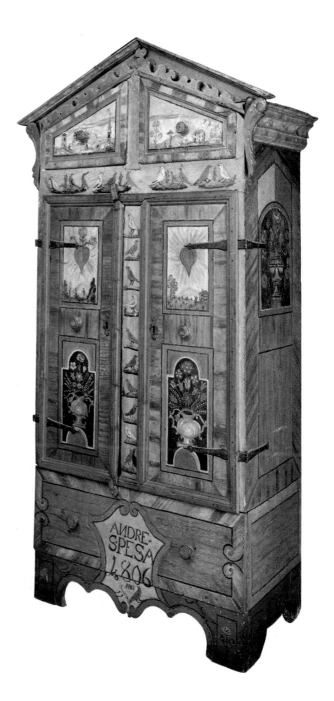

hold was kept indoors by the snow. The structure of this type of furniture dates from earlier centuries. Such designs had been very slow to reach the villages, but were regarded as convenient because, four-square and uncomplicated, they made the fullest use of the space available. The pieces were mostly chests, wardrobes and beds, in other words the basic furnishings of less well-off people. Sometimes the craftsmen expressed their flights of fancy in cornices, mouldings and carvings, which were easy to execute because softwoods were invariably used. Often the author painted or carved his initials and the date on the finished piece. It is the latter inscription, usually much later than one would imagine, that

serves as a warning to the unwary collector who, judging from the lines and constructional technique, might think he had stumbled on a genuine 17th- or 18th-century piece of furniture.

In the Skansen in Stockholm, there are many reconstructions of 19th-century peasant interiors featuring painted furniture of this type, all dating from the second half of the last century. Other pieces can be seen in the farm museums of Denmark and in the many museums of folk art in Austria and southern Germany. In the antiques trade, it is also quite common to come across furniture of this kind, which is sometimes very original and functional in its design and construction.

Biedermeier

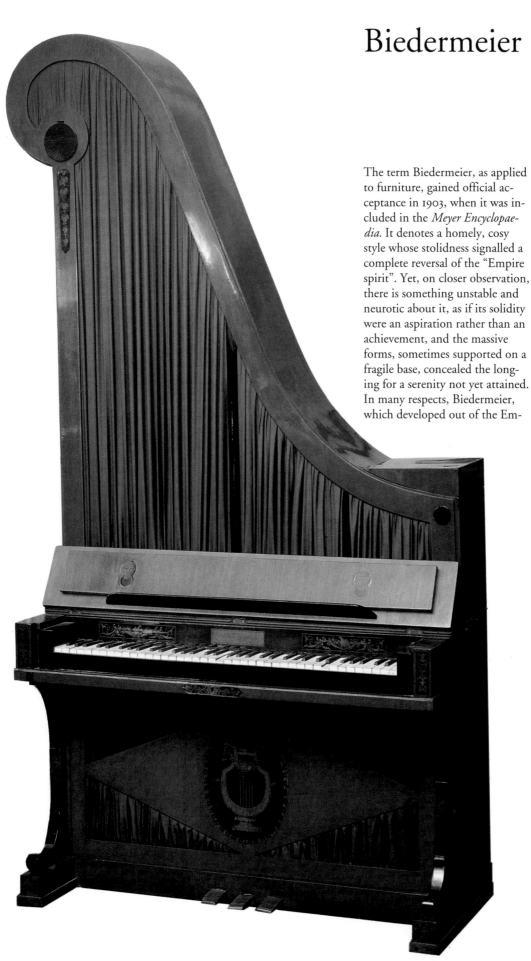

The term Biedermeier, as applied to furniture, gained official acceptance in 1903, when it was included in the *Meyer Encyclopaedia*. It denotes a homely, cosy style whose stolidness signalled a complete reversal of the "Empire spirit". Yet, on closer observation, there is something unstable and neurotic about it, as if its solidity were an aspiration rather than an achievement, and the massive forms, sometimes supported on a fragile base, concealed the longing for a serenity not yet attained. In many respects, Biedermeier, which developed out of the Empire style, perfectly represents the period of social frustration and disappointment that resulted from the failure of the French Revolution.

The new order established by the Congress of Vienna (1815) and the spirit of the Holy Alliance had created an authoritarian, police-state atmosphere that stifled any expression of social and cultural ferment, while Metternich's repressive policies reached out from Vienna to the whole of central Europe. The reaction of the well-off middle-classes was to renounce political aspirations and thoughts of glory and retreat into a quiet, comfortable way of life, pursuing purely domestic satisfactions and applying themselves to commerce and industry. Biedermeier reflects this tendency, both in style and in the types of furniture most in demand: chairs (with or without arms), sofas, drawing-room tables around which friends would gather to make music, engage in conversation and sing, desks, secretaires for keeping correspondence, worktables and side tables. But the structural solidity and decorative sobriety of this furniture is sometimes belied by elements of caprice and lack of balance – tell-tale signals of an underlying neurosis.

An imposing upright piano from the first half of the 19th century. It still has decorative motifs typical of the Empire style, such as the lyre. Bundessammlung alter Stilmöbel, Vienna.

Viennese furniture-makers

The main centre of Biedermeier was Vienna, where the Empire style – regarded as too monumental in its original French form – had been interpreted with considerable freedom. By decreeing that cabinet-makers could not practise their trade unless they had attended a course in design at the Academy of Figurative Art, the Emperor Joseph II had done much to improve the quality of furniture. In 1816, in Vienna alone, there were 578 duly licensed joinery workshops and 297 master cabinet-makers. Some workshops operated on an industrial scale, for instance the factory of Joseph Ulrich Danhauser, founded in 1804, which in 1808 was employing 130 workmen.

Danhauser was the greatest exponent of Biedermeier, and some 2,500 of his drawings have survived. Of equal reputation was Johann Nepomuk Geyer (1807–74), who worked in Innsbruck but was also known and appreciated in court circles. Both were strongly inclined to embellish their furniture with curved or elaborately shaped components, anticipating the technical revolution brought about by Michael Thonet. Another noted Viennese cabinet-maker was Benedikt Holl, who drew inspiration from

Fall-front Biedermeier secretaire veneered in cherry wood and with inlaid mahogany interior, made by F. Schmidt between 1841 and 1843. Antiques trade.

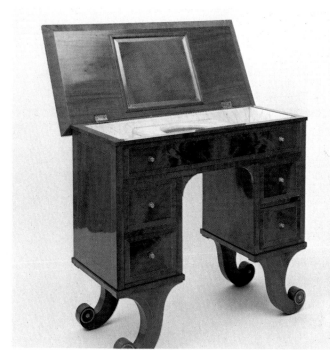

English Sheraton furniture in developing his own version of the Biedermeier style.

After a brief period of eclipse – as a reaction against Empire furniture – the wood most widely used was mahogany, generally applied in thin veneers to carcasses made of less valuable woods. The aim was to achieve soberly elegant effects by using the grain of the wood to best advantage. However, walnut and lighter woods were also used, in particular cherry, birch, maple and ash. Bronze mounts were very rare, replaced by gilt-wood or gilded plaster-and-sawdust ornaments, or by inlays.

Even high-quality Biedermeier furniture has a homely character, evident in its size and the use to which it was put. Wardrobes are relatively low, and features that in other styles are purely decorative here have a functional purpose. For instance, the lateral columns

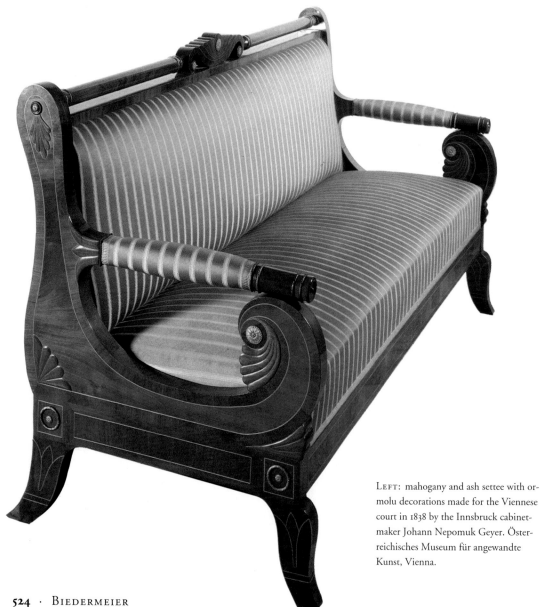

LEFT: mahogany and ash settee with ormolu decorations made for the Viennese court in 1838 by the Innsbruck cabinet-maker Johann Nepomuk Geyer. Österreichisches Museum für angewandte Kunst, Vienna.

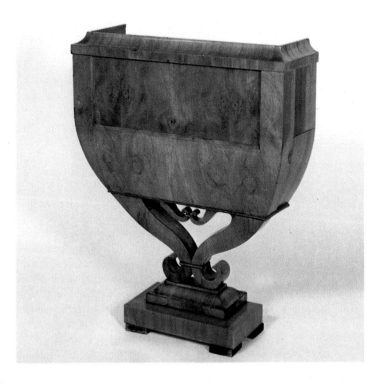

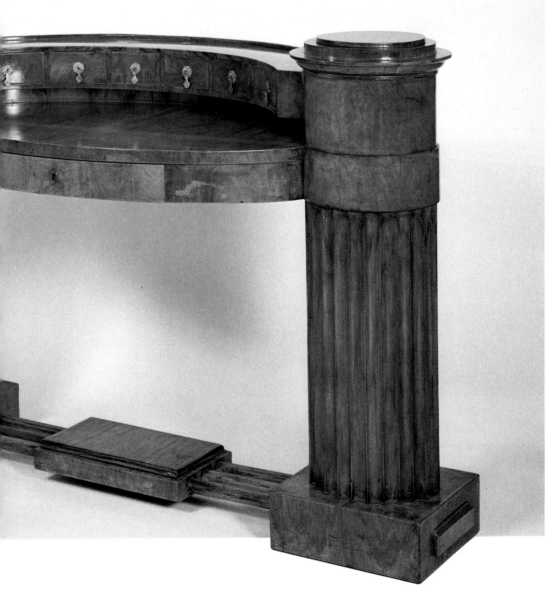

FACING PAGE: wash-stand (1838) with marble basin by Johann Nepomuk Geyer, one of the most representative of Biedermeier cabinet-makers. Bundessammlung alter Stilmöbel, Vienna. THIS PAGE, LEFT: plant-holder veneered with strongly figured walnut (1820–30), attributed to the Viennese cabinet-maker Josef Danhauser. Österreichisches Museum für angewandte Kunst, Vienna. BELOW: desk (1820–25), by Josef Danhauser: the oval writing surface is supported by fluted columns, which can also be used as plant stands. Schloss Geymüller, Vienna.

of Danhauser's oval desks (one in the Bundessammlung alter Stilmöbel, the other in Schloss Geymüller, in Vienna), as well as supporting the writing surface, were designed to afford the user a degree of privacy.

Types of furniture

Given this tendency, it is easy to understand why the place of hon-our among Biedermeier furniture went to the sociable sofa. Inviting guests to make themselves at home in the drawing-room, it was generously upholstered and provided with comfortable cushions. In less wealthy households, it might also serve as a bed. The arm-rests, initially of bare wood, then upholstered, tended to be flared and sinuous in shape, sometimes with a suggestion of oriental influence.

Chairs, also a popular item, tend to fall into two main categories. In the first, the front legs terminate at the seat rail; in the second, they bend, knee-like, at this point and run into the side rails, rising slightly towards the back, where they join the stiles. The legs took various forms, initially square in section, then becoming more and more elaborately turned. Many chairs were imported from England, with the result that Adam and Sheraton models also had an influence on Biedermeier. Chair-backs, though highly varied, were generally of open design, perhaps allowing the eye to roam freely around the room without encountering too many obstacles.

Initially less common except in court circles, armchairs eventually won the favour of the middle classes, but were distinct from side chairs only in having arm-rests and a more generously padded seat. The front legs of heavier fauteuil models began to be fitted with casters, so they could be moved around more easily. In the case of sofas, chairs and fauteuils, upholstery was of prime importance. Horse hair was the basic material employed until, in 1822, the Viennese Georg Junigl patented the use of springs. The covers were mostly

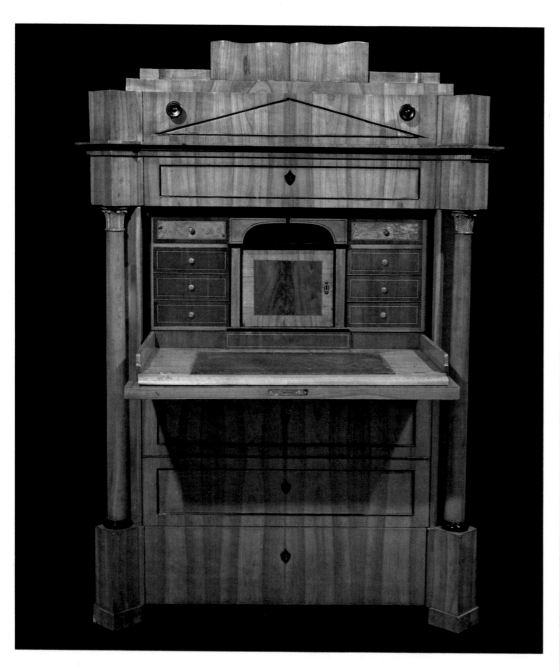

the most important item of Biedermeier furniture was the fall-front secretaire with drawers below and a highly decorated interior compartment for safe-keeping letters, documents and money. The fundamental structure of such pieces had remained constant since the 18th century, and was to remain so for another hundred years. However, there

of striped or floral fabrics, sometimes designed to match the wallpaper.

The most common type of Biedermeier table had a round or oval top and a central support. This left plenty of space between the top and the base, generally smaller in diameter and embellished with carvings, so that the table could be moved close to a sofa, or a circle of chairs could be drawn up to it. From this it is apparent that Biedermeier furniture was designed for comfort and for a family style of informal hospitality. Craftsmen also lavished a lot of attention on small worktables, card tables and side tables. Some of these are minor masterpieces in the quality of their workmanship, elegance and the abundance of compartments and secret drawers they contain. But

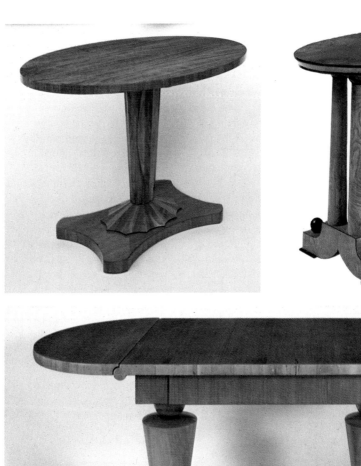

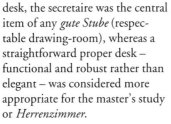

were changes in the way the furniture was made and the proportions of the different parts. The design of secretaires tended to become heavier with the passage of time and distance from Vienna. This is evident if we compare early Viennese models with later ones manufactured on the periphery of the Austro-Hungarian Empire. Although it served as a desk, the secretaire was the central item of any *gute Stube* (respectable drawing-room), whereas a straightforward proper desk – functional and robust rather than elegant – was considered more appropriate for the master's study or *Herrenzimmer*.

Another item of middle-class drawing-room furniture was the display cabinet, often with a mirror at the back and shelves covered in velvet. A variant was the corner cupboard, which took up little space and made the room appear less angular.

Imaginative design was less in evidence in the bedroom, though there were some highly original and elegant night tables, not all produced in Vienna. Small items of furniture have always appealed to craftsmen's fancy. Some fine examples were made by Johann

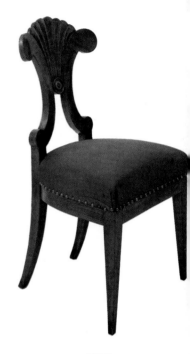

Nepomuk Geyer, especially in the 1830s, when Biedermeier was about to be superseded by the revival of historical styles.

The spread of the style

Though Vienna was the cradle of Biedermeier, the style also spread to other German-speaking areas, assuming slightly different forms according to the economic situation and prevailing taste. In Berlin, where in 1820 most of the city's two hundred thousand inhabitants lived in damp, insalubrious apartments, the new style, like Empire before it, was in practice restricted to court circles and therefore reflected the preferences of architects such as Schinkel rather than craftsmen. The best known supplier of furniture to the court was Karl Georg Wanschaff, who was active from 1806 to 1848. German Biedermeier tends to be severe, stately and architectural, having little in common with the more homely Viennese style.

In northern Germany, Biedermeier was not popular everywhere, and it is true to say there was something of a confusion of styles. The influence of Berlin was fairly strong in Mecklenburg, but in the Hanseatic towns – Bremen, Hamburg, Lübeck – English fashions were paramount.

In Westphalia, on the other hand, even after the fall of Jérôme Bonaparte's kingdom, the Empire style continued in vogue, and spread from the palaces of aristocrats to the homes of the emergent industrial bourgeoisie.

In the Rhineland, too, Biedermeier remained rooted in the Empire style: square forms framed by columns, smooth surfaces, and no decoration except for symmetrical arrangements of the wood grain. Burred finishes were much appreciated, as was mahogany, though for reasons of cost the latter was little used. The most important centre of furniture production was Mainz, where 130 master craftsmen were

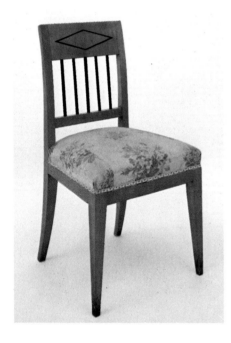

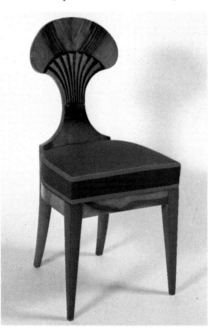

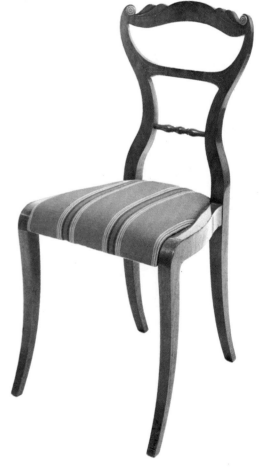

This page, right and facing page, top left: The chairs (c. 1830–35) have sabre legs at the front continuing uninterrupted into the side rails of the seat. Bundessammlung alter Stilmöbel, Vienna. Facing page, bottom left: Austrian chair (c. 1820) with an inlaid and pyrographed hunting scene in the centre of the shaped back. Antiques trade. Top right: Viennese chair (c. 1812). Bottom right: an unusual piece (c. 1835), incorporating various combinations of the double-scroll motif. Österreichisches Museum für angewandte Kunst, Vienna.

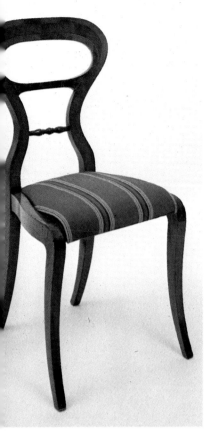

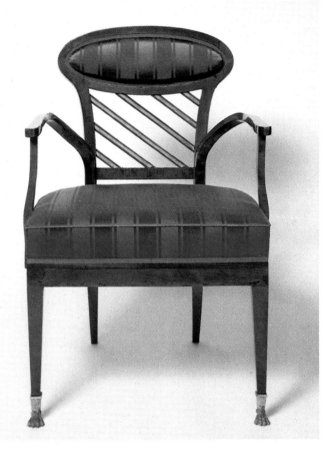

active in 1815, some of international renown. Three of the best known were Johann Wolfgang Knussmann (1766–1840), Wilhelm Kimbel (1786–1875), whose descendants continued in the trade until 1945, and Philipp Anton Bembé (1799–1861): his factory, opened in 1835, continues in production to this day.

In Munich, the distinguishing feature of Biedermeier furniture was a form of decoration reproducing figures – mainly of classical inspiration – from engravings and drawings. The technique was similar to the transferprint process used in ceramics. It was first adopted in 1818 by

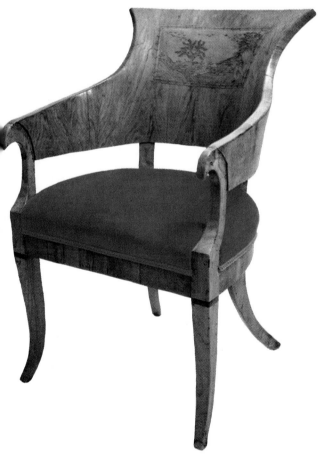

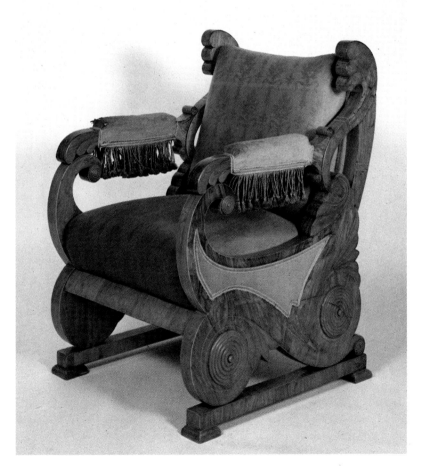

Occasional furniture

The defining aspect of Biedermeier furniture, even of high quality, is its homely character. It seemed to mark a rejection of outward show and decorum in favour of domestic peace and privacy. Its rounded, comfortable forms corresponded to the atmosphere prevailing in Europe after the Congress of Vienna, when political repression prompted the bourgeoisie to withdraw from public life and devote themselves to private pursuits. This situation encouraged the creation of small items of functional furniture: desks and work-tables of complex and varied design, card tables, dumb waiters, music-stands, canter-buries, flower holders, the tea cosy for keeping the teapot warm, and laundry baskets. These proliferated in homes throughout the Austro-Hungarian Empire, creating a sense of warmth and intimacy. In making these occasional pieces, which did not fit into the traditional categories but were nonetheless elegant, contemporary craftsmen showed great inventiveness. Some are minor masterpieces.

They used the same woods as for major pieces, exercising great care in making the movable, adjustable or rotating components and arranging the veneers, to create sober, elegant designs that emphasized the basic shapes. Imported mahogany, which had returned to favour after a period of eclipse for cost reasons, was used for veneering carcasses of less prestigious woods, alongside walnut, cherry, pear, birch, maple and ash. For surface decoration, craftsmen were also skilled in stringing and marquetry, using light woods on mahogany, dark or ebonized woods on the warm, honeyed backgrounds of fruit woods.

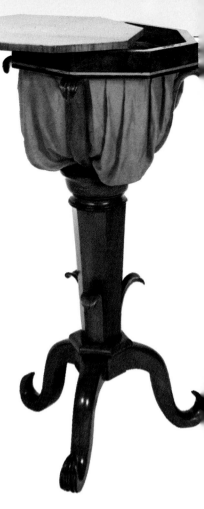

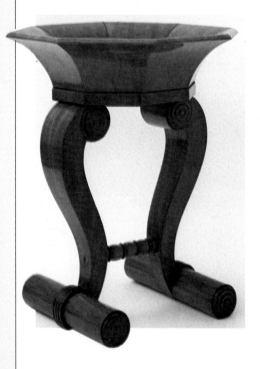

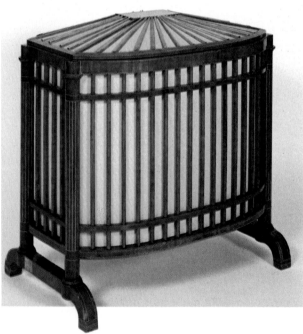

This page: items of occasional furniture, all dating from between 1815 and 1840. Above, left: mahogany-veneered spittoon by Johan Nepomuk Geyer. Bundessammlung alter Stilmöbel, Vienna. Right: open-work mahogany linen basket with ash stringing and silk lining. Top right: north German work table with tripod pedestal and sliding top, which gives access to a fabric bag. Facing page, bottom left: semicircular plant holder, made of ash with rosewood stringing and inlays. All Österreichisches Museum für angewandte Kunst, Vienna.

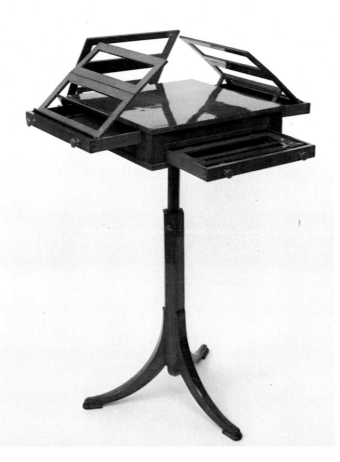

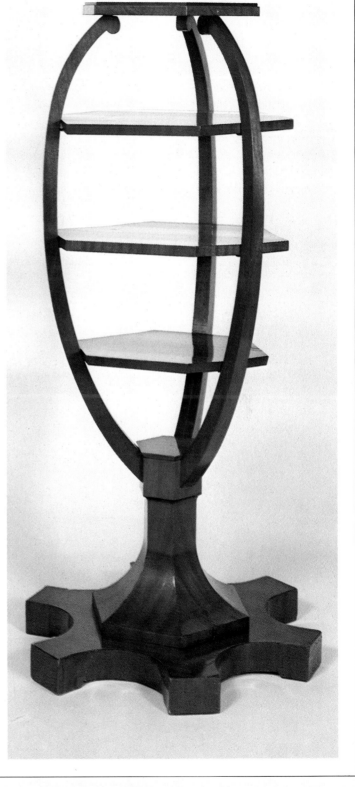

This page, left: table with four drawers, each containing a lectern so that it can be converted into a music-stand for four players. Bundessammlung alter Stilmöbel, Vienna. Below: Chalice-shaped mahogany dumb waiter with bow supports, polygonal shelves and cusped base. Österreichisches Museum für angewandte Kunst, Vienna.

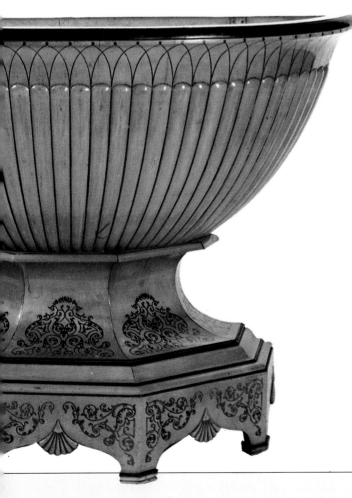

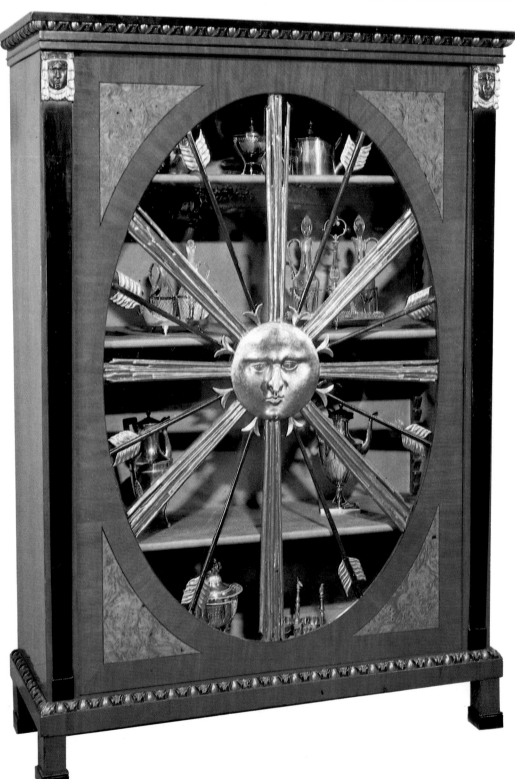

This page: Austrian cherrywood display cabinet/bookcase (1820–30) with maple, palisander and amaranth inlays and gilded decoration. Antiques trade. Facing page, top left: Viennese mahogany wash-stand of 1828, with *bois clair* marquetry panels in the classical manner. Bottom left: lectern-style mahogany writing desk which once belonged to the Austrian Emperor Francis II; he and his family are represented in the print that features on the writing slope. Bundessammlung alter Stilmöbel, Vienna. Right: work table (c. 1820) of Hungarian ash and with steel inlays, attributed to Benedikt Holl. Österreichisches Museum für angewandte Kunst, Vienna.

Johann Georg Hiltl. However, the popularity of Biedermeier in Bavaria was short-lived, despite the proximity of Vienna, and it would be virtually true to say that there was a direct transition from Neoclassicism to Revivalism, skipping both Empire and Biedermeier styles.

Looking beyond Austria and Germany, the Biedermeier impact on other parts of central, northern and eastern Europe was limited, though there were some local variants of the style.

Two leading figures

In the history of German furniture, there are two outstanding names we must note if we are to understand developments during the first half of the century, viz. Karl Friedrich Schinkel of Berlin and Leo von Klenze of Munich. Both were architects steeped in the classical world and, though their main activity was the planning of buildings, they also applied their stylistic credos to furniture. Their romantic, picturesque interpretation of classical forms and decorations gradually spread to the work of local craftsmen.

After travelling in France and Italy, Karl Friedrich Schinkel (1781–1841) began his career in the employ of the Prussian state, in 1817 drawing up a development plan for the city of Berlin. He was concerned with the conservation of historic buildings and the restructuring of Berlin's museums. For sixteen years, he was stage designer for the National Theatre. The development of his style and ideas, from Neoclassical rigour to the eclectic forms of Revivalism, can be fol-

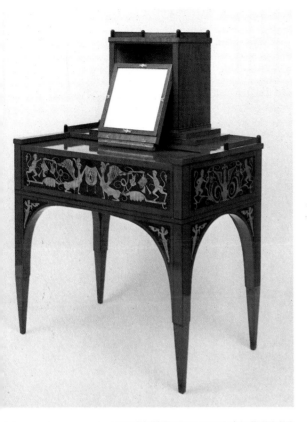

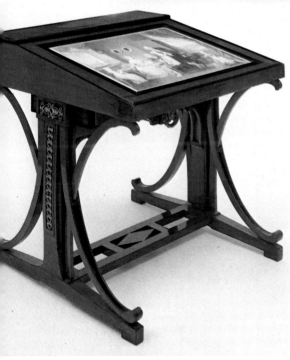

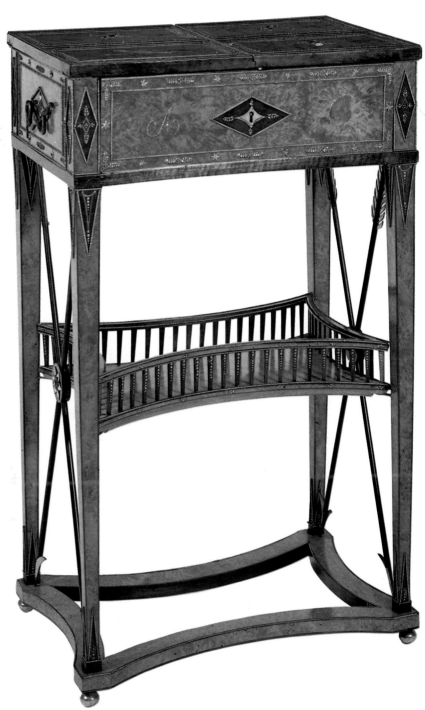

lowed in the buildings he designed over the years: the Schauspielhaus (theatre, 1818–21), the Altes Museum (1824–30), the palaces of Princes Charles and Albert on Wilhelmstrasse, and the palaces of Charlottenhof and Babelsberg.

The same concepts are evident in his prolific output of furniture designs, including some in cast iron. Not many of these designs were translated into reality, but they had a profound influence on trends in Prussian furniture-making, even after his death. It should be noted that there was no contradiction between the Neoclassical style Schinkel favoured in the early part of the century and the Renaissance manner of his latter years. His own view was that classical antiquity should not be slavishly imitated, but was there to be drawn on for inspiration, as the artists of the Renaissance had done. This is a vital distinction which explains the thinking behind the revivalist approach.

Slightly younger than Schinkel but longer-lived, Leo von Klenze (1784–1864) was the

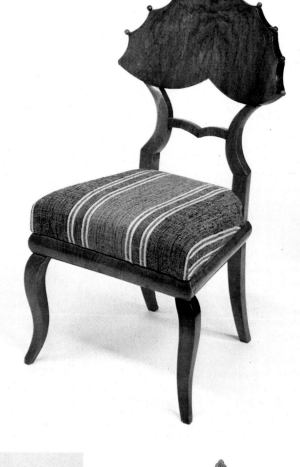

THIS PAGE: chairs of various kinds demonstrating the popularity of Biedermeier in different parts of Europe. TOP RIGHT: an example (c. 1840) from northern Germany, with fan-shaped back. BELOW LEFT: Austrian chair (c. 1830) made of *bois clair* with amaranth inlays. CENTRE: chair of Swedish or Danish manufacture (c. 1825). BOTTOM RIGHT: Russian chair (c. 1850) made of *bois clair* with amaranth inlays; the complicated outline of the shield back is based on motifs from folk art. All antiques trade.

main proponent of Neoclassicism in Munich. He had studied in Paris with Durand and Percier, then spent time in England and Italy. He later visited Greece, whose temples were the inspiration for all his subsequent architectural achievements: the Hermitage in St Petersburg (1839–49), the Valhalla in Regensburg (1830–42), the Munich Glyptothek museum (1816–30), the Temple of Fame (Ruhmeshalle, 1843–63) and the propylaea of the Königsplatz (1843–63).

ever, his adoption of the Renaissance style at an early stage was the reason for the rapid spread of revivalist styles in Bavaria.

In Scandinavia, too, there was an almost direct transition from the Empire style to Revivalism. In Poland and Russia, meanwhile, Biedermeier was very popular, though in practice it is difficult to distinguish locally produced items from imported ones. Another important influence, especially in Russia, was English Victorian furniture.

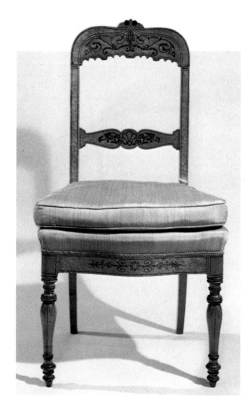

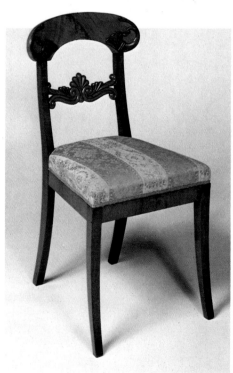

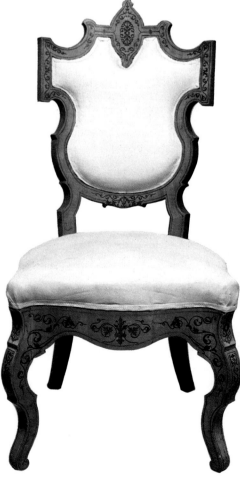

Unlike Schinkel, Leo von Klenze designed furniture only for his own buildings, not for the Munich furniture-makers. They nevertheless drew inspiration from his pieces. As he was no lover of Biedermeier, the style never really caught on in Munich. How-

Thonet furniture

Bentwood furniture belongs historically and stylistically to the second half of the 19th century, but its origins lie in Biedermeier. The technique of using heat and humidity to bend wood had long

RIGHT: Hungarian marquetry walnut and burr walnut secretaire from Brassó, Transylvania, with ash interior compartment; the lyre shape of this piece is typical of Biedermeier. Österreichisches Museum für angewandte Kunst, Vienna.

been employed by carpenters and wheelwrights for shaping ships' hulls and making carriage wheels.

Around 1750, an English engineer working in Brunswick, Major Trew, built four steam presses for bending wood. But it was German-born Michael Thonet (1796–1871) who perfected the process, applying it systematically to the design of furniture and fully developing its potential for mass production.

Thonet conducted his first experiments in 1821 at Boppard on the Rhine, making decorative components for Biedermeier furniture. In the following decade, he made the first sofas of a type that was to become traditional, and beech armchairs and chairs. Using steam to bend the wood, he accentuated the sinuosity to which the Viennese Biedermeier style was already tending. His great opportunity came in 1841 when his furniture, exhibited at Koblenz, was admired by Metternich, who invited him to Vienna. There he perfected his craft and worked with established cabinet-makers.

By 1849, the ingenious carpenter from Boppard, who meanwhile had patented a chemico-mechanical process for bending wood, had a factory of his own. Two years later, he presented his furniture at the Great Exhibition in London, in the legendary Crystal Palace, whose metal structures influenced him in the design of a number of chairs and armchairs.

Although major critics of the period failed to grasp the revolutionary importance of Thonet furniture in stylistic terms, his success, and the award of a gold medal, made him a household

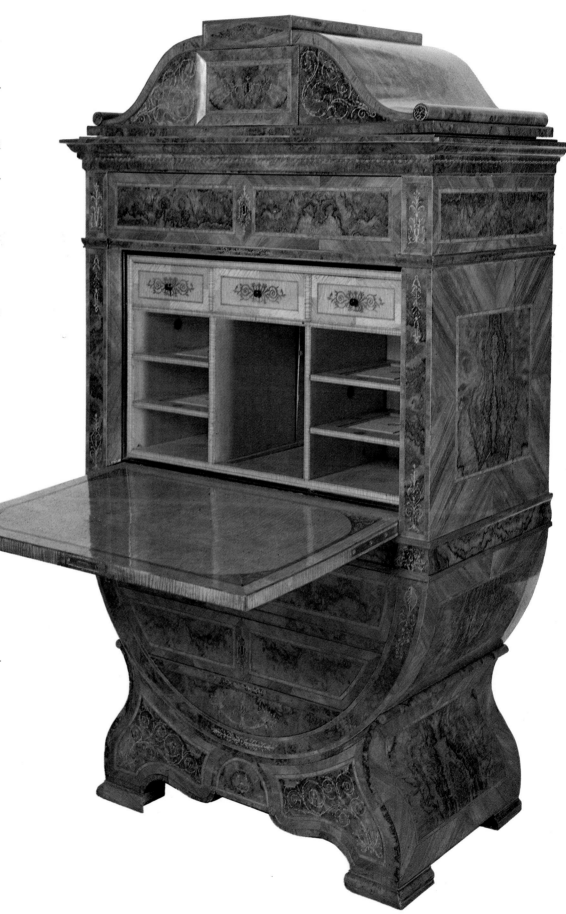

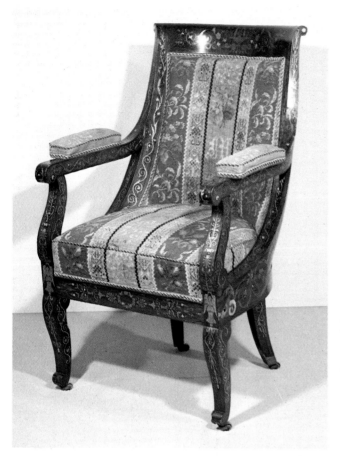

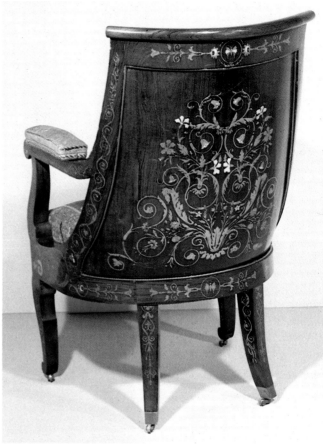

name. It also enabled him to set up new factories and invent new models, and so develop the mass-production methods that were the real purpose of his experiments. A good example of such furniture was the chair he manufactured for the Café Daum in Vienna.

Although chairs accounted for most of his output – and these were very much the firm's trademark – he also applied the same techniques to the manufacture of rocking chairs, occasional tables, sofas, small beds, umbrella stands, music-stands, wash-stands, hat-stands, small items of dressing-room furniture and even *prie-dieux*.

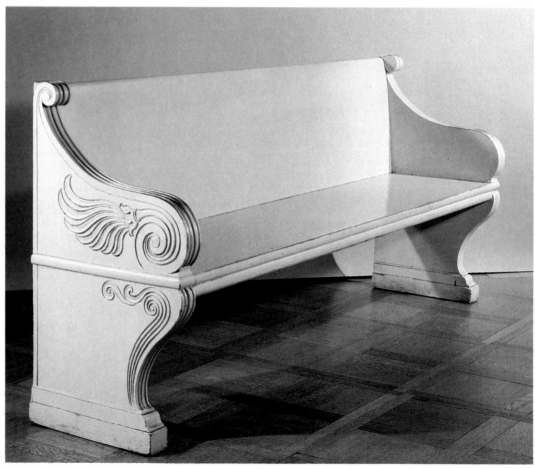

FACING PAGE, TOP LEFT AND
RIGHT: armchair made in 1840 by Franz
Xaver Fortner of Munich; made of pal-
isander with stylized plant-motif inlays
of copper, bronze, mother-of-pearl and
ivory, particularly on the broad, shaped
back, it echoes the chairs *en gondole* of
the Empire period. Neues Schloss,
Baden-Baden. BOTTOM: carved,
painted bench seat (c. 1820) attributed to
the architect Karl Friedrich Schinkel.
THIS PAGE, RIGHT: workingchair de-
signed by Schinkel (c. 1824) for Friedrich
Wilhelm III of Prussia, made of pal-
isander and upholstered in black leather;
comfort is ensured by the "anatomical"
line of the back, as well as the padding,
and the chair incorporates a functional
reading stand. Both Schloss Charlotten-
burg, Berlin. THIS PAGE, BOTTOM
LEFT: a simple, linear coat-stand de-
signed by J. & J. Kohn. Österreichisches
Museum für angewandte Kunst, Vienna.
BOTTOM RIGHT: experimental armchair
by Michael Thonet, a prototype of classic
models he produced in his workshops at
Boppard (1836–1840), which were very
popular in the second half of the 19th
century. Technisches Museum, Vienna.

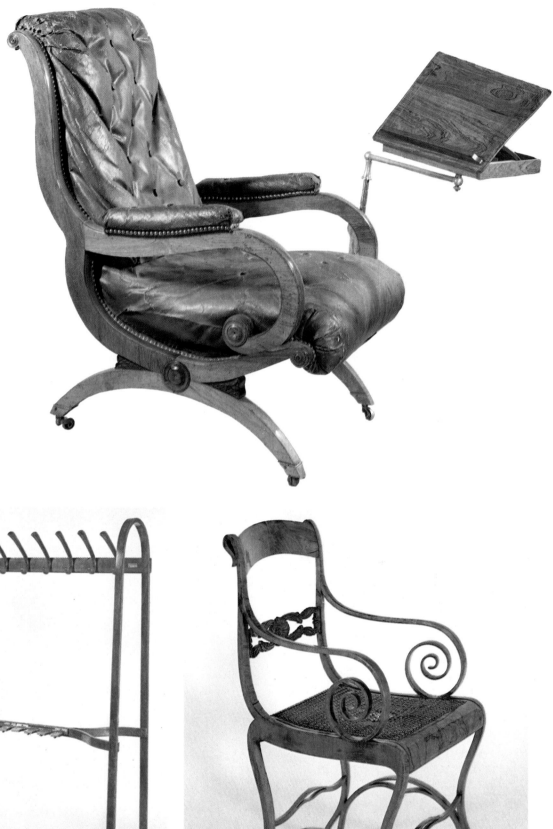

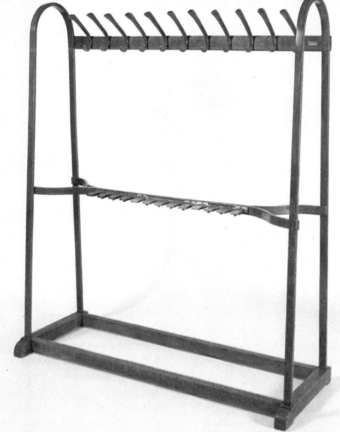

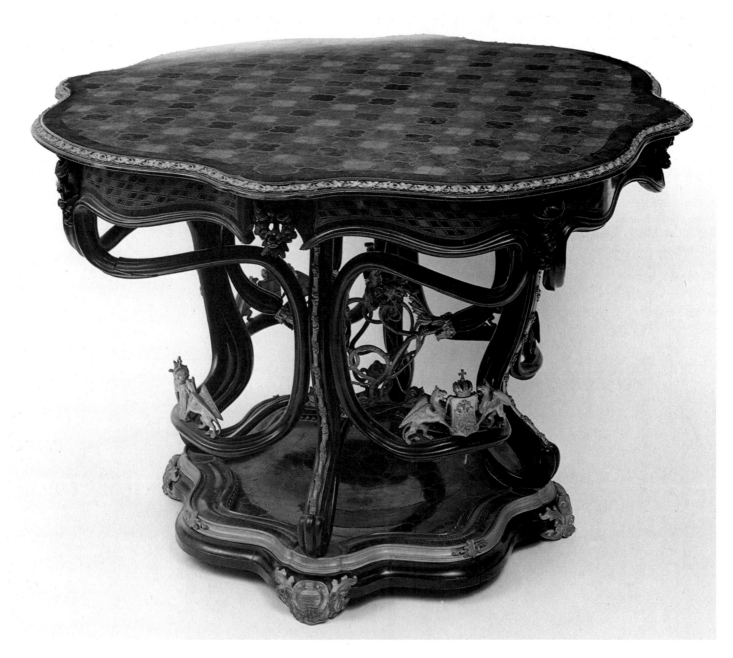

Survival of the Empire style

The style most widespread in Europe in the 1830s was a version of late Empire which, by combining richness of form and comfort, satisfied the aspirations of the rising middle classes and the needs of daily living.

It was not really a style in the true sense of the word, but the practical adaptation of a style that had already run its course. As such, it persisted for several decades and, with the advent of Napoleon III, enjoyed a new lease of life.

Its popularity was assured, especially in Germany, by the spread of magazines on the subject of interior design, craftsmen's associations, reductions in customs duties and the expansion of the railway network. Models and ideas circulated more freely, eventually unifying taste and eliminating differences in production methods between north and south. This levelling process was also furthered by technical factors and the development of

wood-working tools. Improved machinery was introduced for cutting wood into ultra-thin sheets for veneers; the circular saw, the router and the planer were invented; kilning techniques were perfected, and even a method for artificially ageing oak. The best machinery was manufactured in England. Artificial woods, made by pressing woodchip and sawdust, were at the experimental stage and, in Berlin, Mencke's Holzbronzefabrik specialized in artificial compounds for simulating bronze sculpture.

Two of the most important furniture-makers of this period were the younger Josef Danhauser (1805–45) of Vienna and Franz Xaver Fortner (1798–1877) of Munich, who specialized in inlays of precious materials, his trademark being coloured horn. Some of his furniture, inlaid with brass, copper, mother-of-pearl and ivory, was more reminiscent of Boulle than of the Empire style. But Fortner is also important because he exemplified a reversal of the traditional relationship between furniture-makers and architects. In the past, it was the latter who designed furniture and the former who made it to their orders. With Fortner, the furniture-maker became an industrialist who placed orders with architects for furniture designs to meet the requirements of consumers. Neither he nor Danhauser junior, however, were content merely to rehash the Empire style, but forged ahead as pioneers of the revivalist movement.

Indeed, while the late Empire style continued to limp along in the salons of the mercantile bourgeoisie, a tide of revivalism was breaking over Europe.

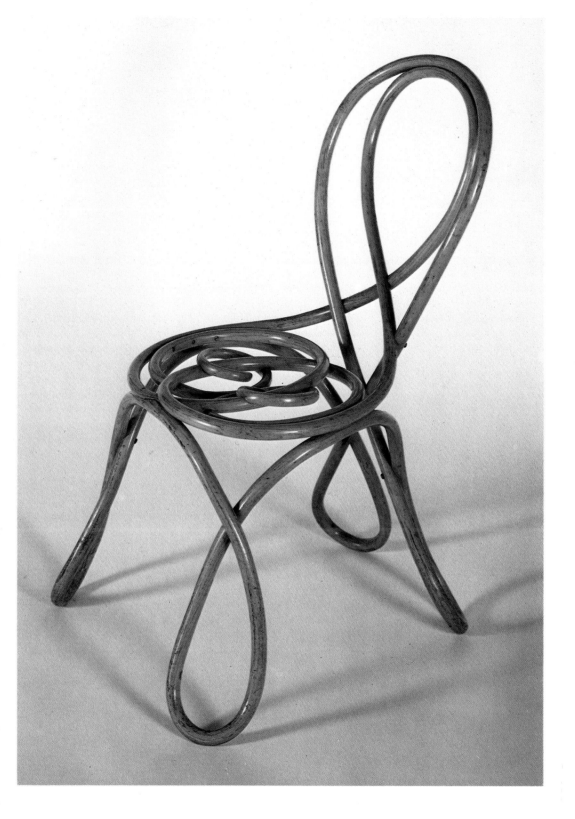

Revivalism

As with Biedermeier, the German term for Revivalism – Historismus (Historicism) – was first used many years later, in 1925, long after the movement to which it applied had run its course. Primarily a philosophical concept, it was only later applied to literature and the arts. It should be distinguished from Romanticism, which it grew from, even though the two movements overlap in many ways.

In furniture-making, Revivalism, which was closely related to architecture, manifested itself in the production of furniture inspired by the styles of previous centuries. Since there was borrowing from every period and every country, it is also referred to as Eclecticism. Which style found favour at any given time depended on the prevailing taste, setting, sentiment and political situation. There were countries in which a Neo-Rococo style proved the most popular, though never exclusively so; others where the Neo-Gothic prevailed; and others again where a Neo-Renaissance style triumphed. At the same time, we find individual items and entire rooms furnished in the Moorish, Egyptian, Indian or Chinese manner.

But it went even further than this. Towards the end of the century – and this was common everywhere – the various rooms in a house or apartment might each be furnished in the style regarded as most suited to its particular function. So we might find a Renaissance dining-room, a Rococo bedroom, a Gothic, Renaissance or Baroque study, a Neoclassical or Biedermeier-Empire drawing-room, and a Moorish smoking-room.

Austrian Neo-Rococo

In Vienna, the first Neo-Rococo influences came from the France of Louis-Philippe, and many saw the trend as a happy return to the golden age of Maria Theresa. As Louis-Philippe was very much a bourgeois king, the style named after him was a moderate, watered-down, domesticated Rococo, and what people found attractive about it, more than its bizarre forms, were its nostalgic, feminine aspects. For the same reasons it was also appreciated in Austria, where furniture-makers could again concentrate their efforts on decoration rather than form. The first pieces in this style, by Josef Danhauser, were exhibited at the Central Exhibition of Craft Products in 1834.

The fashion soon spread to circles close to the court and ordinary middle-class homes, retaining the style's essential features but with somewhat less emphasis on elaborate detail.

Revivalism: Germany, Belgium, Scandinavia, Russia

In other German-speaking countries, however, the Neo-Rococo was tolerated rather than loved, being regarded as too frivolous to reflect the self-consciously virile soul of Germany. Although Frederick William IV of Prussia allowed the Belvedere at Potsdam and the Castle of Monbijou to be furnished in this style, it was more out of homage to fashion than from personal preference, which favoured the Neo-Gothic. Neo-Rococo furniture can also be seen at Charlottenburg in Berlin. But the style did not really come into its own until the final decades of the century.

The fact is that from the decline of Biedermeier around 1835 until the advent of Art Nouveau in the closing years of the century, revived styles followed one another and intermingled in so

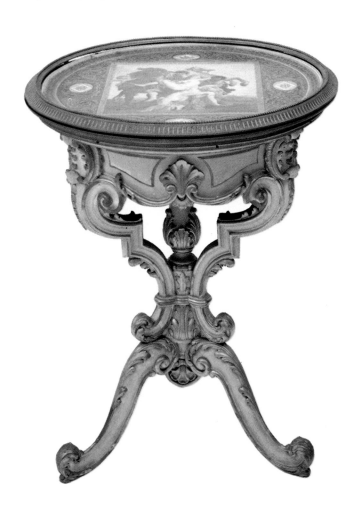

ABOVE: carved, lacquered and gilded occasional table (1854) in the Neo-Baroque style, with a Viennese porcelain top. FACING PAGE, TOP: lithograph of Princess Sophia's Salon in the Hofburg, Vienna (c. 1862): the furnishings are in a mixture of styles typical of the second half of the 19th century, but the Neo-Rococo predominates. BELOW: carved and gilded Austrian side chair: an eclectic piece, formerly part of the furniture of the Castello di Miramare in Trieste, it was made around 1880 and incorporates stylistic elements as diverse as Baroque and Louis XVI. Bundessammlung alter Stilmöbel, Vienna.

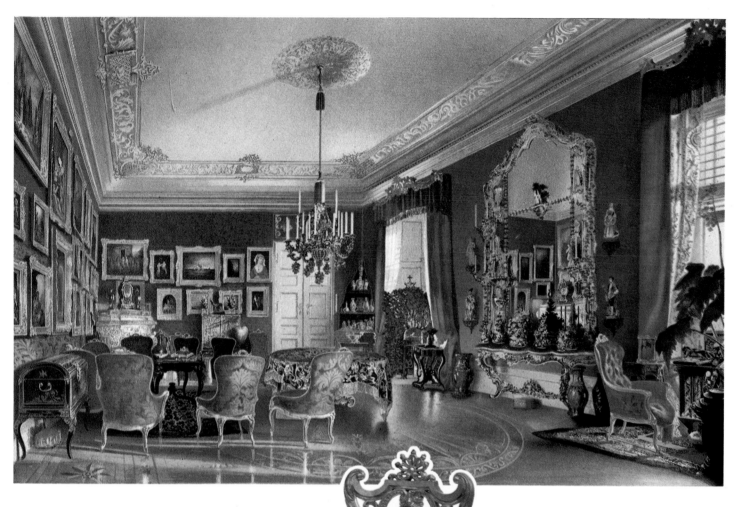

bizarre and discontinuous a fashion that it is impossible to trace an exact chronological development.

The height of Rococo revival stylistic and decorative licence was reached in 1884 in the shape of the rosewood-veneered oak desk with blue leather writing surface and porcelain and gilt-bronze plaques made by Anton Pössenbacher for Ludwig II of Bavaria's castle at Herrenchiemsee. It was designed by Julius Hofmann (1840–96), the architect who had furnished the Castello di Miramare at Trieste for Archduke Maximilian of Habsburg. This piece was overtaken in exuberance only by the *étagère* that Hofmann had previously made for Linderhof, near Oberammergau, another residence of the King of Bavaria, furnished in a style described as "Neo-Versailles".

Similar developments occurred in countries bordering on Germany. In Belgium, as in the Scandinavian countries, the most obvious manifestations of the Rococo revival and other revivalist styles belong to the second half of the century, as the economic and social situation gradually improved. However, these manifestations were not sufficiently autonomous to warrant separate treatment.

In Russia, on the other hand, there were unique developments. A new historical awareness – evident at the beginning of the century in the narrative writings of Karamzin and his monumental *History of the Russian State*, and then in the Romantic movement in literature pioneered by Pushkin, Gogol and Lermontov – found expression in a nostalgic style which blended the European heritage with Tartar-Byzantine influences.

But extant examples are few and far between. Enlightened initiatives of the kind taken by

Large carved walnut sideboard with upper section (c. 1850), of Austrian origin. The 19th-century structure is decorated with features taken from architecture and Renaissance and Gothic decorative vocabularies. The resulting style is highly eclectic. Österreichisches Museum für angewandte Kunst, Vienna.

Prince Savva Mamontov, who would gather musicians and artists together in his country house at Abramcevo and sponsored a return to popular traditions, touched only an *élite*. They give some idea of contemporary trends but cannot be compared, in their results, with what was happening in all the other courts of Europe.

The Netherlands

The situation was different in Holland, a commercial crossroads between England, Germany and France – countries whence furniture was imported and styles borrowed. One of the chief difficulties in studying Dutch furniture, from the 19th century on, is that items manufactured locally are barely distinguishable in materials and techniques from imported ones. The only thing one can point to is a uniquely Dutch preference for a certain type of furniture, be it imported or locally made. A well-known characteristic of the Dutch was a fondness for comfort. A clear indication of this was the great popularity, after the Amsterdam Exhibition of 1859, of the low French armchairs with a shaped back known as *crapauds* (toads).

In Holland, too, new manufacturing techniques and the introduction of machinery brought about profound changes in production methods. Alongside the old craft workshops, industrial enterprises of various kinds sprang up. The most important of these was the factory belonging to Matthieu and Willem Horrix, founded in The Hague in 1853, which eventually employed 250 workers. The brothers' main con-

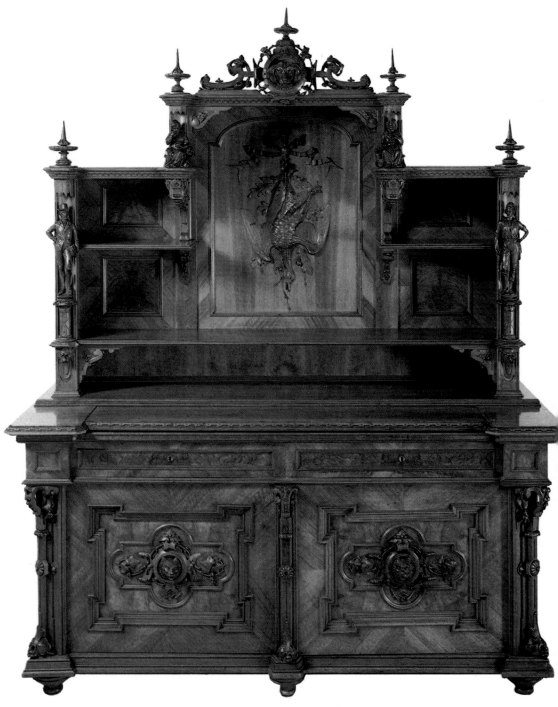

FACING PAGE: Renaissance-style cabinet designed by Oskar Beyer and made by Franz Nichel of Vienna in 1877. The metal inlays on ebonized pear wood are reminiscent of decorative work by Boulle; in the centre of the upper section is a circular medallion painted in oils by Georg Sturm. Österreichisches Museum für angewandte Kunst, Vienna.

tribution to the history of furniture-making is their copious photographic archive of all the pieces they produced, and an account book giving a breakdown of costs for the manufacture of each item of furniture.

This archive gives an interesting insight into the tastes of Dutch people in the second half of the century, an insight confirmed by the pieces that have found their way into public collections. The Neo-Rococo was very popular in all its successive developments, but a great deal of space was also devoted to "revivals" of the Renaissance and Baroque, even though this often boiled down to taking a few features of these styles and applying them to totally anachronistic structures. The Neo-Gothic, on the other hand, was not greatly favoured, though the archive includes a few examples. It is apparent that in Holland, as elsewhere, the various styles co-existed in an eclectic hotchpotch, and one can even detect influences from as far away as Japan.

One type of furniture in the Horrix catalogue is an extravagant rustic genre imitating interwoven knotted branches. The inventor of this fashion was an English furniture-maker, Robert Manwaring, who in 1765 described it as "country" furniture. Almost a century later, at the London Exhibition of 1851, the celebrated French firm of Tahan presented a rustic wardrobe made of walnut. The idea must have appealed to the Horrix brothers, because their archive is full of items of this kind, which remained in fashion until the turn of the century.

Another fashion that caught

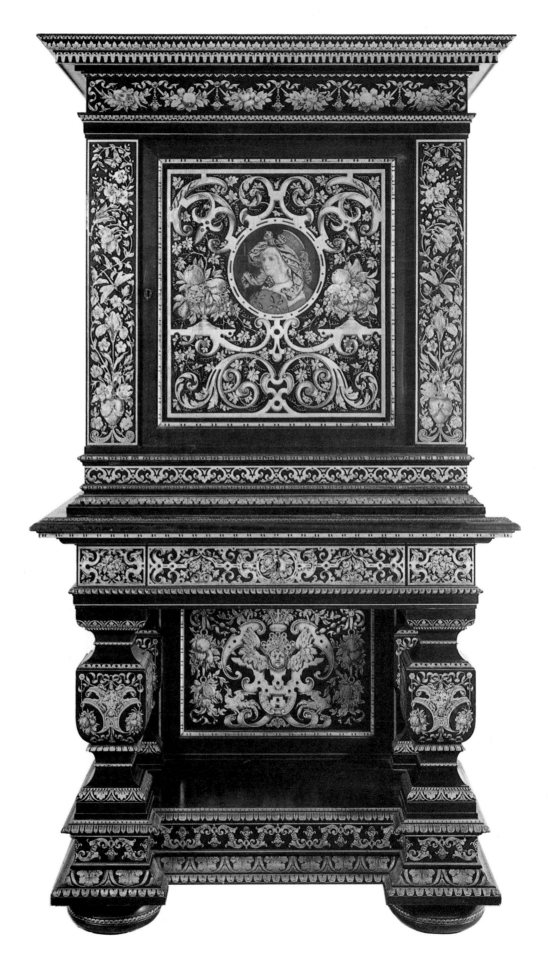

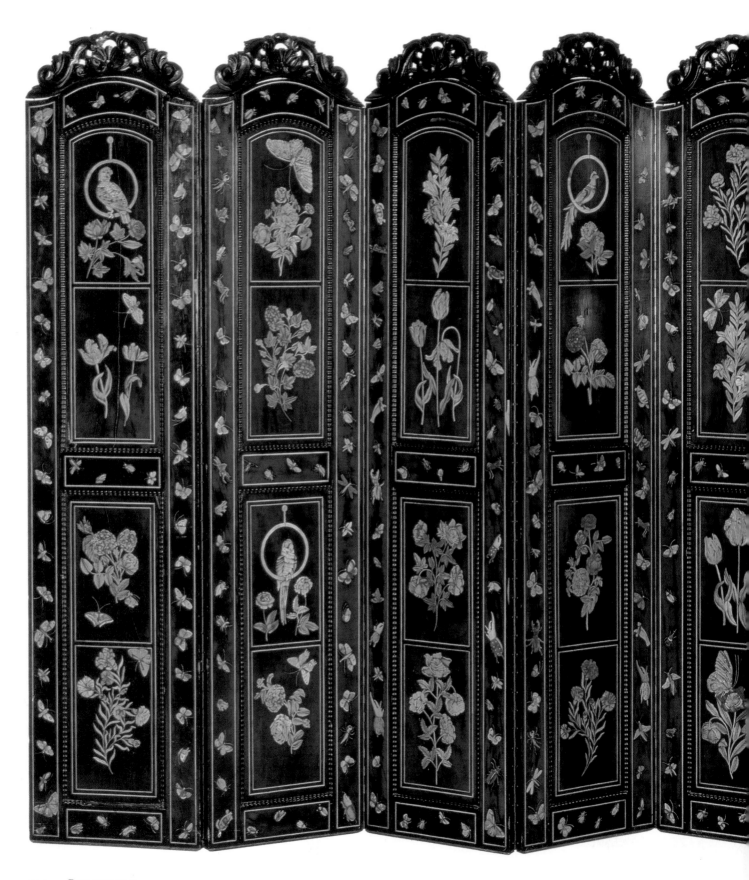

Dutch screen (c. 1840): the marquetry panels are typical of Dutch 17th- and 18th-century work. Antiques trade. BELOW RIGHT: central panel from a circular table top (1878), with marquetry portraits of Prince Hendrik, brother of the Dutch King William III, and his wife. Royal collections. By kind permission of HRH Queen Juliana.

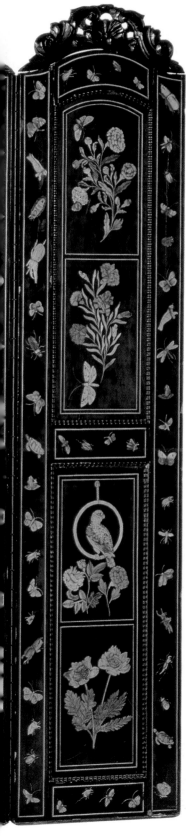

on in Holland around the mid-century was for furniture with metal inlays in the manner of Boulle. This gained in popularity when King William II had some items imported from Paris by the firm of Enthoven, but the fashion did not last. By 1876, the J. van Munster works at Roermond, which had specialised in this style, had gone out of business.

Alongside the more bizarre revivalist styles, there were of course faithful reproductions of old furniture. To reduce costs, this was produced using the new machinery then becoming available to cabinet-makers. Among the items most in demand were the typically Dutch glass-fronted cabinets inlaid with flower and foliage motifs. Some of these still come on to the antiques market, to become confused with original 18th-century pieces.

Towards the end of the century, the hybridisation of the competing styles was complete, and it is often very difficult to separate out the various stylistic components. The results were sometimes pleasing and functional, at others heavy and awkward. Meanwhile, new developments were under way and, alongside the pompous, clumsy manifestations of 19th-century taste, we begin to find the spare linear simplicity of 20th-century furniture, especially in smaller "occasional" items.

Revivals: from the Gothic to the Renaissance

It is not surprising that in Germany fascination with the past resulted in a predilection for the Neo-Gothic and Neo-Renaissance styles, as expressions of periods dear to the German psyche. The Gothic style first surfaced in architecture, and the late 18th century had already seen a proliferation of pseudo-medieval buildings and romantic follies hidden away in leafy parks and gardens.

A typical example is the building erected in the vicinity of Schloss Wörlitz, belonging to Prince Leopold Friedrich Franz von Anhalt-Dessau, which had a Venetian-Gothic front elevation and Tudor-Gothic rear, an armoury in the classical style and pseudo-Gothic furnishings.

The first furniture designs in this style appeared in a cabinet-makers' pattern-book published in Nuremberg between 1832 and 1837 by Carl Alexander Heideloff, a pupil of Thouret. The style soon spread, and many great houses were furnished in the medieval fashion.

Attention later switched to the Renaissance style, from which the architect Gottfried Semper (1803–1879), active around the mid-century, drew his inspiration. The height of refinement was to build a Gothic castle and furnish it with antique and pseudo-antique items, creating a mix of different styles to give a sense of the passage of time.

Of the many castles built and furnished on these lines, the most celebrated are those of Ludwig II of Bavaria, the patron of Wagner, who committed suicide after he was deposed in 1886 for his scandalous extravagance. We have already mentioned his castles at Linderhof and Herrenchiemsee. To these should be added the castle of Neuschwanstein, the Gothic furniture of which reflects the period of the Hohenstaufens, the imperial dynasty which died out in 1286 with Conradin of Swabia.

Ludwig II's extravagances can be regarded as the swan-song of revivalism, still fashionable at the end of the century, but now totally devoid of ideological content. Revivalism was also triumphant in painting, with minutely faithful reconstructions of historical settings. Even if we disregard these cloying phenomena, tables, cabinets and sideboards mixing Neoclassical with Gothic, Renaissance with Rococo, often reflected no more than a total lack of imagination.

In Norway and to some extent Sweden, patriotism required that styles of furniture and decoration be of Viking inspiration, while in Poland Stanislaw Witkievicz's Za-

kopane style was rooted in Polish folk tradition. But in the Scandinavian countries new tendencies towards order, clarity and practicality were already anticipating 20th-century developments. And, in Germany, Austria and Holland, as in England, traditional craftsmanship was breaking free of superfluous bombastic decoration, thanks in part to the advent of new wood-working tools. During the last quarter of the 19th century, it became almost impossible to identify most commercial furniture according to its region or country of origin.

The great increase in international and state exhibitions led to such a widespread dissemination of techniques and models that even the few original items were immersed in a great sea of imitations. This was the effect of the Universal Exhibition held in Vienna in 1873, the Munich Exhibition of 1876, and the even larger one held in Munich's Glaspalast in 1898. It is perhaps worth recording that, amid this great confusion of ideas, even the Empire and Biedermeier styles staged a comeback.

Even so, as the third quarter of the century

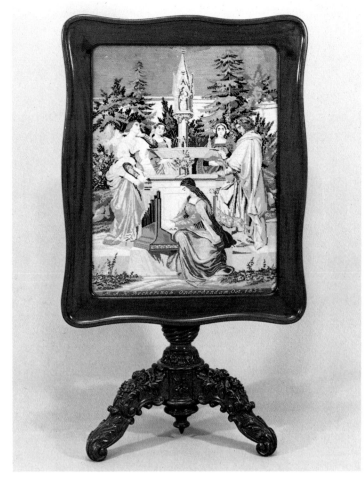

ABOVE: Dutch mahogany table (1852) with embroidered top, which, when folded into the upright position, could also be used as a fire-screen: the tripod base is richly carved with Rococo decorative motifs. Museum de Waag, Deventer.

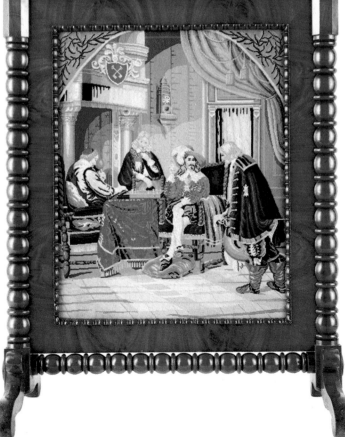

LEFT: Dutch mahogany fire-screen (c. 1850) with bobbin-turned uprights and stretcher, a technique borrowed from 17th-century English furniture; the embroidered scene in the panel is typically Flemish. Stedelijk Museum de Lakenal, Leiden.

gave way to the last, there was no lack of arbiters of taste, personalities able to put forward original ideas and suggest a national direction in furniture styles, even if they generally remained too attached to the past. Such was the case with some of Schinkel's pupils, for instance Fritz Hansen in Vienna and August Stüler in Berlin.

As it was, an illusion of omnipotence was created by the proliferation of exhibitions and schools of craftsmanship, the development of a museum culture and the gathering of historic artefacts into public galleries, the breaking down of the centuries-old divide between the major and minor arts, and above all the widespread development of machine tools, which speeded up and standardised the whole business. One result of all this was the manufacture of display pieces intended to be exhibited in museums or presented to heads of state. A good example is the celebrated desk designed by Josef Storck in 1881, now in the Kunsthistorisches Museum, Vienna. This piece was given by Viennese industrialists and businessmen to the Emperor Francis Joseph to celebrate the marriage of his son Rudolf (the archduke who died at Mayerling) to Stephanie, daugh-

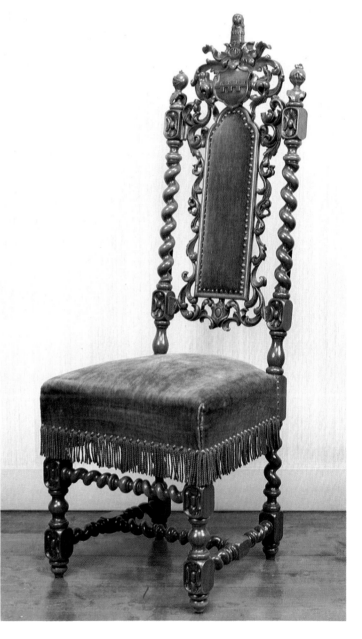

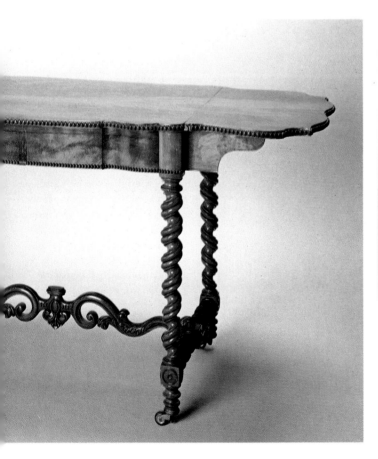

LEFT: mahogany table with hinged flaps. ABOVE: turned and elaborately carved walnut chair. Both pieces, dating from around 1850, draw on 17th-century Dutch models and decorative features such as the spiral-turned uprights. The back of the chair is crowned with the arms of the Van Diemen family. Both National Rijtuigsmuseum, Leek.

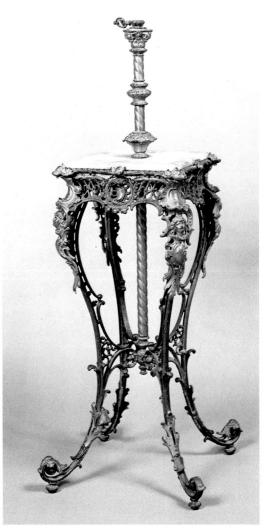

LEFT: gilt-bronze lamp-stand/table in the Neo-Rococo style. BELOW: Dutch basket for holding periodicals dating from the last quarter of the 19th century. Both Rijksmuseum Paleis Het Loo, Ajeldorn. By kind permission of HRH Queen Juliana. BELOW: walnut armchair and two side chairs from a picturesque "rustic" series made around 1865–70 by the Dutch firm of Horrix: they are intended to create the effect of interwoven knotted branches. Gemeentemuseum, The Hague. FACING PAGE: bamboo fire-screen of Japanese inspiration dating from the final decade of the 19th century. Royal collections. By kind permission of HRH Queen Juliana.

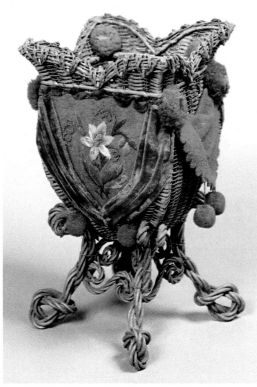

ter of the King of Belgium. It is a monumental work in ebony and silver. Renaissance and Baroque influences are apparent in its imposing structure and rich decoration, allegorical motifs competing for attention with its opulent Louis XVI features. Mainstream products were naturally influenced by sumptuous models of this kind, albeit interpreted in a minor key.

The end of the 19th century coincided with the passing of a civilization – in art, literature, industry, politics, international relations and furniture-making. But however revolutionary, youthful and futuristic Art Nouveau might appear, it was really a final flare-up in the twilight, or rather one of the tongues of a dual flame, the counterpart of which was a return to Classicism.

The future lay elsewhere: in a discipline devoid of decoration. But it would take the upheaval of a world war to clear the ground and allow it to come to the fore, however much the need might be felt.

As always happens in the arts, some far-sighted people felt the new wind that was blowing, appreciated that change must come for social, functional and industrial reasons, and saw that furniture was no exception. For instance, the beautifully simple table and chairs designed by Adolf Loos in Vienna in 1898 look forward to the pioneering work of the Bauhaus.

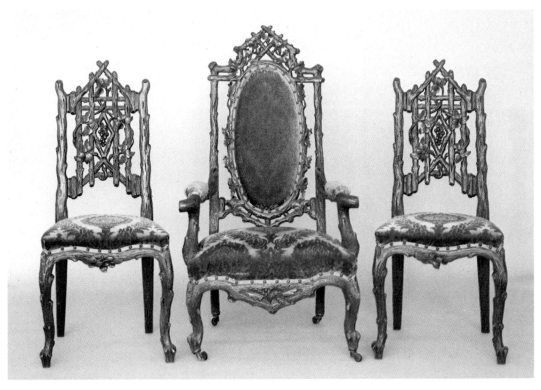

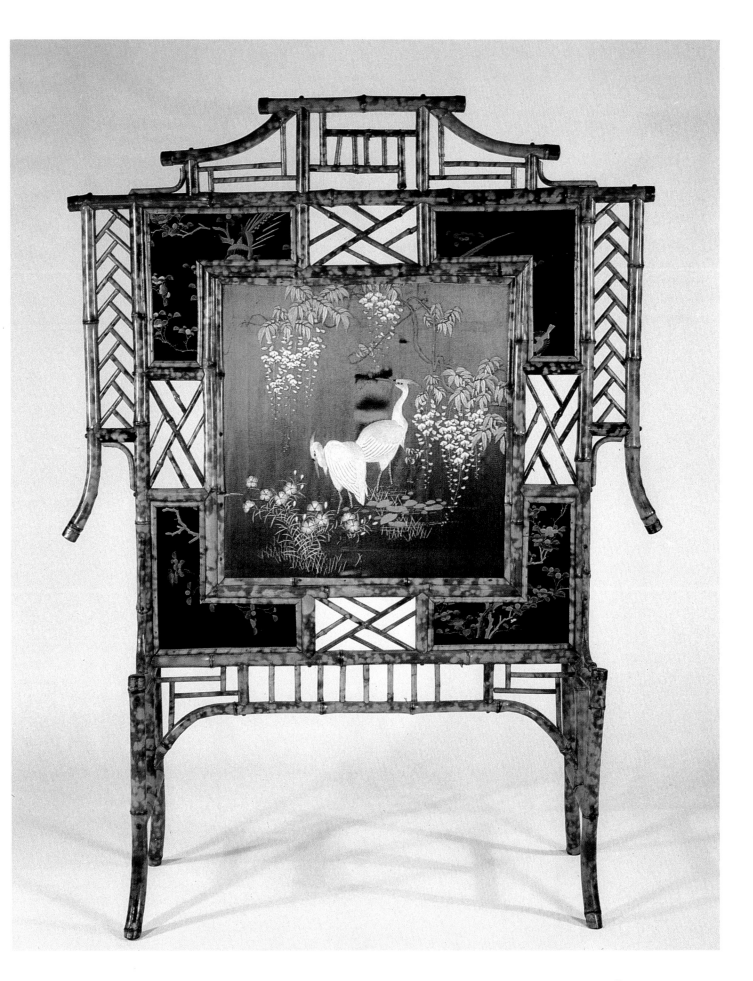

A return to the past: Neo-Rococo

The Neo-Rococo style was popular in central and northern Europe in the mid-19th century, when Revivalism was fashionable generally. The first furniture of this kind was exhibited in Vienna in 1834, the idea having come, as always, from France. But the Neo-Rococo reached its peak in the 1870s, in the "Neo-Versailles" exuberance of the residences of Ludwig II of Bavaria.

The Neo-Rococo was often a more moderate, domesticated variant of the style that inspired it. People found it attractive because there was more emphasis on decorative features than on basic forms. The fashion soon spread to circles close to the court and ordinary middle-class homes, retaining the style's essential features but somewhat less elaborate in detail. It was characterized by fluid forms typical of 18th-century Rococo furniture; an abundance of decoration and gilding, which could be incongruous and exaggerated; and a tendency towards heaviness, due in part to a fondness for comfort. It was in some ways a response to the desire of the new middle classes to show off their increasing wealth by indulging in luxury.

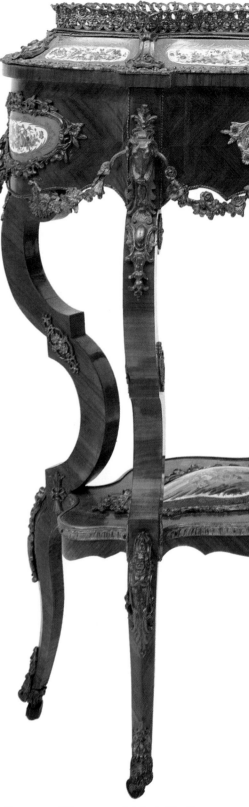

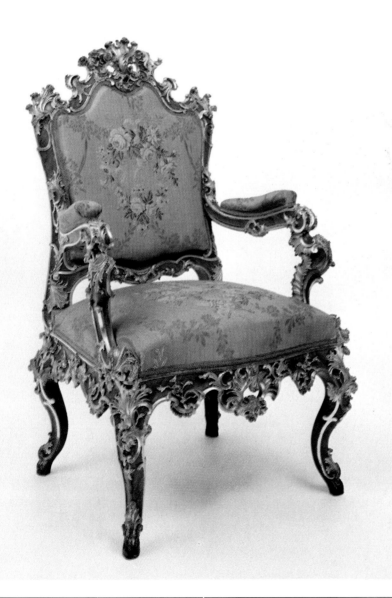

LEFT: carved Viennese armchair in the Neo-Rococo style with painted and gilded decoration. ABOVE: rosewood plant stand with bronze mounts and porcelain plaques. Both late 19th century. Bundessammlung alter Stilmöbel, Vienna. FACING PAGE: Dutch Neo-Rococo furniture. TOP LEFT: carved mahogany chair (c. 1870). Dutch royal collections.

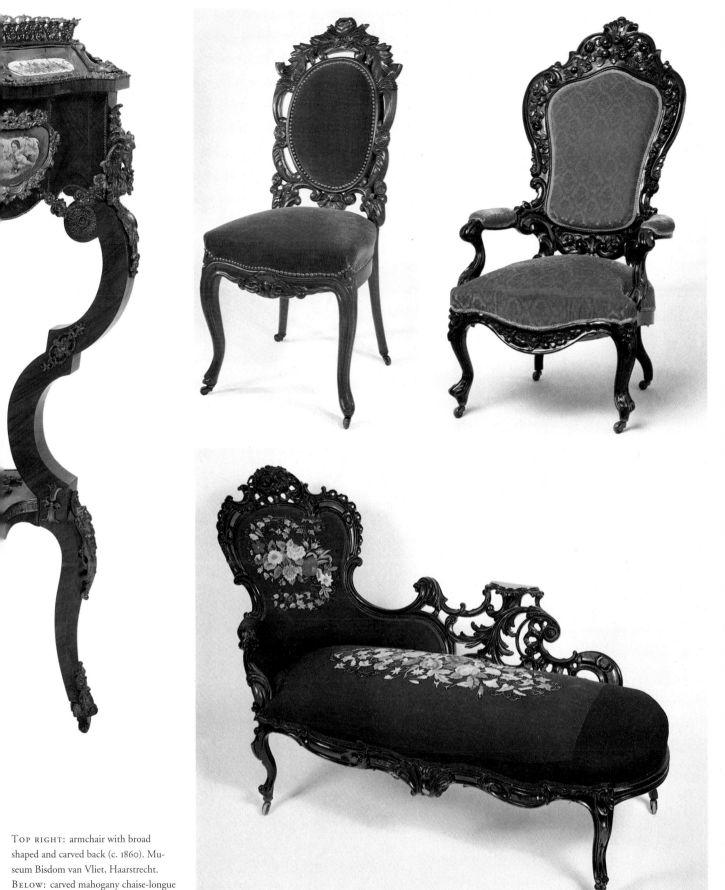

TOP RIGHT: armchair with broad
shaped and carved back (c. 1860). Mu-
seum Bisdom van Vliet, Haarstrecht.
BELOW: carved mahogany chaise-longue
with asymmetric back (1860). Historical
Museum, Rotterdam.

Spanish and Portuguese furniture

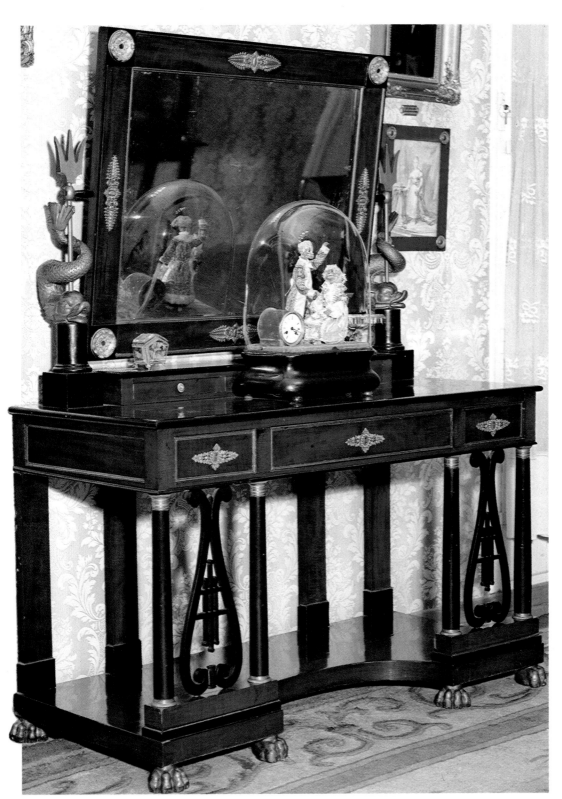

In the Iberian Peninsula, stylistic developments in furnishing during the 19th century generally mirrored those in other parts of Europe. However, tastes and techniques of furniture-making were undoubtedly influenced by the different historical and cultural backgrounds and traditions of the countries concerned, their peripheral position, overseas connections, and difficult political circumstances. We therefore find considerable differences, not only with furnishing styles from north of the Pyrenees, but between Spain and Portugal, and between the various regions of each country.

Spain

In Spain, particularly in the south, echoes of Moorish civilisation, evident in the sophisticated *mudéjar* decoration which gave rise to the opulence and exuberance of the plateresque style, are apparent not so much in the ornamentation as in the heavy lines of the furniture produced during this period. It was as if craftsmen, no longer able to find an outlet in decorative splendour for its own sake, gave vent to their frustration by carefully avoiding all rules governing sobriety of proportion.

For a practised eye, the difference between an English or French piece of furniture and its Spanish counterpart (apart from the Spanish preference for walnut, pine, cedar and olive wood, and the sometimes pretentiously spare decoration) is immediately evident in a kind of awkwardness: the Spanish piece is likely to be exaggeratedly tall in proportion to its depth, or excessively sinu-

FACING PAGE: an imposing mahogany wash-stand with bronze mounts (c. 1820), in clumsy interpretation of the French Empire style. Museo Romantico, Madrid. THIS PAGE, BELOW LEFT: patinized bronze stool with parcel gilt decoration. Casita del Labrador, Aranjuez. RIGHT: unusual carved mahogany armchair with yoke-shaped supports and heavy upholstery, and carved wooden gilded swans'-head ornaments. Palacio Real, La Granja.

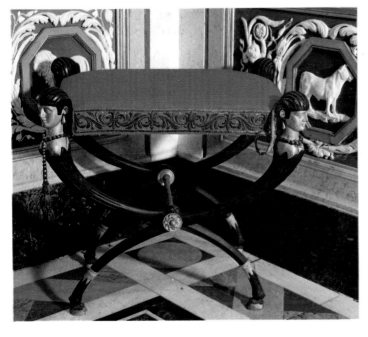

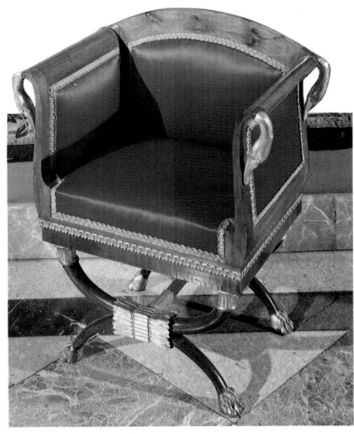

ous in structure, or there will be a disproportion between, for instance, a table top and its supporting structures, or between the back of a divan and its base.

Towards the end of the 18th century, French influence had given rise to a "classical" style of some grace, while the presence of British cabinet-makers on the island of Minorca had encouraged the spread of English stylistic principles. There had also been a strong Neapolitan influence at the court in Madrid during the reign of Carlos III (1759–1788), who had brought architects, designers and cabinet-makers with him from Naples.

In the political volte-face of 1796, Spain allied itself with France against England, and in 1808 Napoleon's brother, Joseph Bonaparte, usurped the Spanish throne and imposed the Empire style. As in other European countries, this not only survived but flourished after the fall of Napoleon himself, giving rise to

the *Ferdinandino* style, named after Ferdinand VII, who reigned until 1833.

In this heavy, exuberant version of the French Empire style, mahogany and gilt-bronze mounts are often replaced by cherry and direct gilding of the carved wood. It was soon transformed into a grotesque imitation of Biedermeier, particularly where divans were concerned.

During the reign of Isabella II (1833–1868), it was the Spanish version of the Romantic styles – known as *Isabellino* – that came to the fore, with an abundance of Gothic features. This was soon joined by a version of the Neo-Baroque, characterised by extensive use of valuable woods, bronze mounts, inlay work and porcelain plaques from the royal factory of Buen Retiro.

Mechanization developed rapidly during this period, and furniture production was stimulated by the various International Products Exhibitions. These were

held right up to the turn of the century, culminating in the great exhibition in Barcelona of 1898, where the Real Fábrica de Marquetería was located.

More obviously than in other European countries, the quality of furniture differed according to the social class for which it was produced. The court engaged the services of highly skilled local or foreign artisans, while the higher nobility acquired their furniture directly from France.

The lower nobility and middle classes had recourse to run-of-the-mill furniture-makers, who imitated and simplified the French styles. At a lower level still, there were simple carpenters who expressed their artistic aspirations by combining traditional patterns with ill-digested fashions adopted long after they had become fashionable.

Given this complex stratification of taste, and the complications associated with eclecticism, it is difficult to identify any over-

riding trend in 19th-century Spanish furniture-making. Towards the end of the century, a reaction against bad taste was led in Catalonia by artists such as Josep Puig i Cadafalch (1867–1956) and Antoni Gaudí i Cornet (1852–1926), creators of a Catalan Modernist style which combined Gothic and Baroque elements with Art Nouveau.

Portugal

In Portugal, the influence of Islamic art was less long-lasting. However, the country's strong links with India and China gave rise to a Portuguese colonial style, with centres in Goa and on the Malabar coast, in which European and Far Eastern traditions, sometimes enriched with *mudéjar* elements, were inextricably mixed. When dealing with individual items, it can be difficult to distinguish between metropolitan Portuguese and local manufacture.

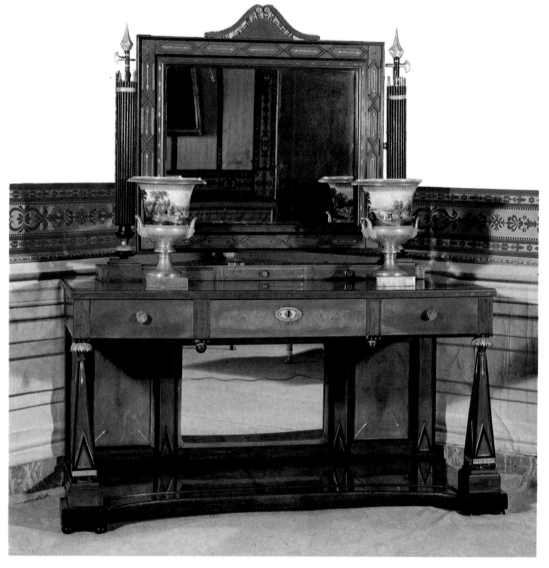

From the end of the 18th century, English stylistic canons were also added to this cultural blend, and there was widespread use of exotic woods imported from the forests of Brazil.

The type of furniture that resulted was distinctive in the way it assimilated European fashions and influences, and in the prevalence of carving, for which the fine-grained imported woods were ideal.

Before the brutal Napoleonic occupation (1807), the most popular style was English Neoclassicism. This was followed, for a very brief period, by a version of the Empire style noticeably heavier than its French exemplar. After the defeat of the French, full powers were assumed by General Beresford, and the English Regency style had a free run in Lisbon.

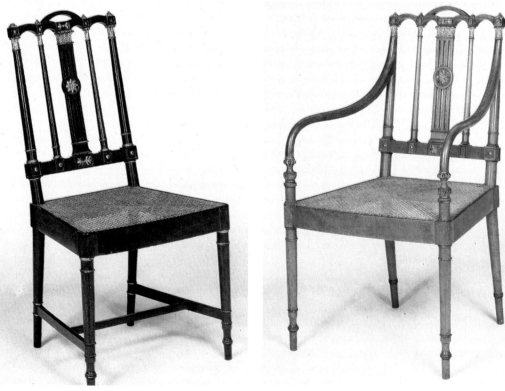

ABOVE: imposing mahogany washstand of Spanish manufacture in the late Empire style, with gilt and ebonized decoration, dating from the second quarter of the 19th century: the top is supported by obelisks and the mirror by lictors' fasces. Palacio Real, Aranjuez. LEFT: matching side chair and armchair (c. 1800), one patinized, the other in partially gilded mahogany, of Spanish or Portuguese manufacture. Antiques trade. FACING PAGE, TOP: the bedroom of Isabella II in the Palacio Real at Aranjuez: the furniture, with its heavy Neo-Baroque lines, expensive hardwood veneers and marquetry, and opulent gilt-bronze mounts, was made around the middle of the 19th century. Palacio Real, Aranjuez. BOTTOM: veneered *bombé* chest (c. 1850) in the *Isabellino* style, with stringing and inlays of various woods; with its heavy, rounded forms, this represents the Spanish counterpart of the Louis Philippe style. Museo Romantico, Madrid.

This was followed by decades of political turbulence, with alternating periods of prosperity and poverty, marked by the return of John VI from Brazil and civil strife during the reign of Maria II da Gloria (1826–53). This long period of disorder was accompanied by an economic decline that was bound to have repercussions on furniture-making. The only significant development was the introduction of the Biedermeier style by Ferdinand of Sachsen-Coburg-Saalfeld, consort of Maria II, who commissioned a German engineer, General Wilhelm Ludwig Baron von Eschkege to design the Peña Palace. This residence, built in the 1830s, was furnished with a mixture of items representing every period and style, reflecting the unbridled eclecticism that was then affecting the whole country.

The mid-century brought a period of greater political stability, accompanied by economic recovery and a flowering of the arts and literature. But in furniture-making it unfortunately led to nationalistic excesses, with much furniture harking back to the

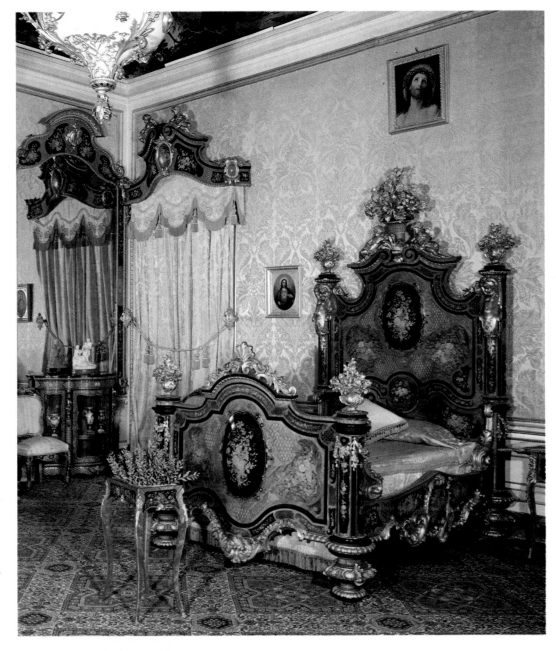

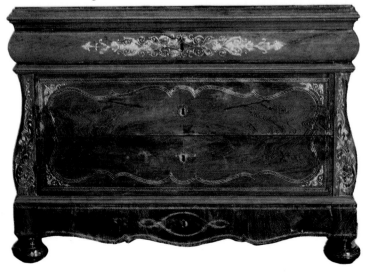

17th century and the Neo-Baroque style of the reign of John V (1706–50). As in other European countries, the style regarded as the most opulent and glorious in Portugal's history was inevitably the one chosen for "revival".

Internationally, conflict with England over policy in Africa led to humiliation and the gradual isolation of Portugal from the rest of Europe. Although some artists and people of taste strove for a return to appropriately modernised versions of antique furniture, the vast majority of buyers opted for a revived 16th-

century style known as *Manuelino* (from Emanuel I, king of Portugal from 1495 to 1521), devoid of all artistic and cultural legitimacy.

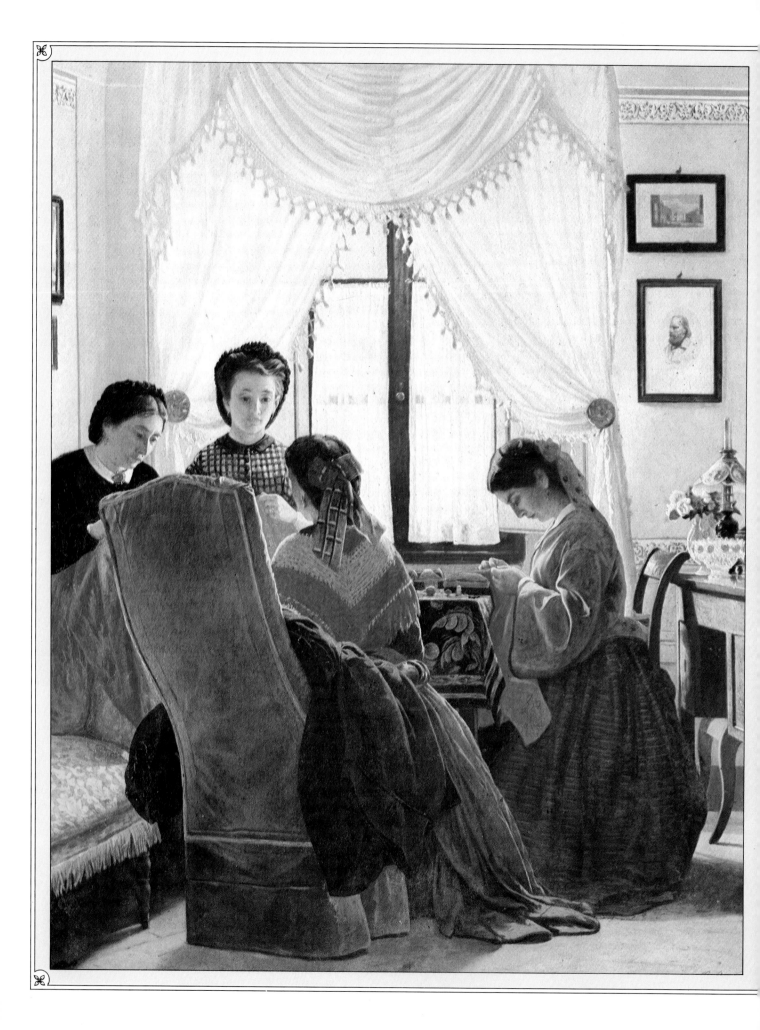

Furniture of the 19th Century

Interiors

by Gianni Carlo Sciolla

Empire and Restauration design

Introduction

Taste in furniture in 19th-century Europe is best thought of in terms of a complex and highly varied piece of marquetry. It developed in a diversified cultural context, marked by continual and far-reaching change: in the relationship between artist and patron, and the artist's own social function; in developments in art criticism and the dissemination of ideas; and in fashions and the symbolic meanings accorded to artefacts.

From the beginning of the century, patrons included members of the bourgeoisie – the new class that had emerged as a result of social reform – as well as the court and aristocracy. Together with the court, the middle-classes determined and popularized new stylistic developments in the art of decorating, embellishing and furnishing the domestic environment.

In addition to the *maître de chambre*, traditional organiser of schemes of decoration, there gradually emerged the idea of a team of specialist designers who, from the mid-19th century, were no longer exclusively controlled by the client or architect but by the contractor. Industrial production methods generally superseded the old patterns of craftsmanship, even though in some parts of Europe there was heated opposition on the part of those who did not want to see manual creativity succumb to soulless mass production.

In the formulation of standards and symbolic models for interior design, a vital role was played by art critics, who adopted new methods to propagate their ideas and opinions, in particular illustrated periodicals and catalogues.

Taking political developments into account, it is usual to divide the years from 1800 to 1890, somewhat artificially, into three major categories: Empire, Restauration and Eclecticism. In fact, many cultural factors affected furniture-making and interior design in the course of the century. These included the persistent influence of classical antiquity; the equality of treatment accorded to the 'major' and 'minor' arts; the phenomenon of revivalism; stylistic controversy; and a tendency to try and escape from contemporary reality into exotic orientalism.

Empire: a style fit for Napoleon

Funereal and austere, gloomy and mysterious, enigmatic and sinister, monumental and classical, rigid and devoid of intimacy: these are the labels most commonly attached to the style of the 1800s or, to be more precise, the Empire style. For some critics, it is simply an introverted extension of the Neoclassical movement, now devoid of inspiration. Others, however, perhaps more rightly, see it as a season of Classicism projecting into the 19th century, enriched by a rationale of its own, which achieved valid outcomes in terms of both poetry and idiom.

The Empire style, which was already emerging under the Directoire and the Consulate, is certainly connected with the general and complex phenomenon of Neoclassicism, from which it derived its aspirations, typology and stylistic features.

However, in expressing the power, pomp and magnificence of Napoleonic imperial grandeur, and particularly in identifying with it, it shows a preference for certain aspects and features of the Neoclassical movement. Two main factors, both originating in France, concurred in the creation of this artistic phenomenon: the impulse given by Napoleon himself to the collection of classical artefacts, and the design of the official residences commissioned by the imperial court.

Central to the plans for an imperial collection was Vivant Denon, a diplomat with a passion for art history, who first met Napoleon in 1798 and took part in the Egyptian expedition. De-

RIGHT: the bedroom of Josephine Beauharnais at the Château de Malmaison, redesigned in 1810, is a clear statement of the Empire style at its most stately and intimate. PREVIOUS PAGES: two typical 19th-century interiors are depicted in *Women Sewing Red Shirts* by Odoardo Borrani (1834–1905), and *Self-portrait in his Studio* by Tommaso Minardi (1787–1871). Private collection and Uffizi Gallery, Florence.

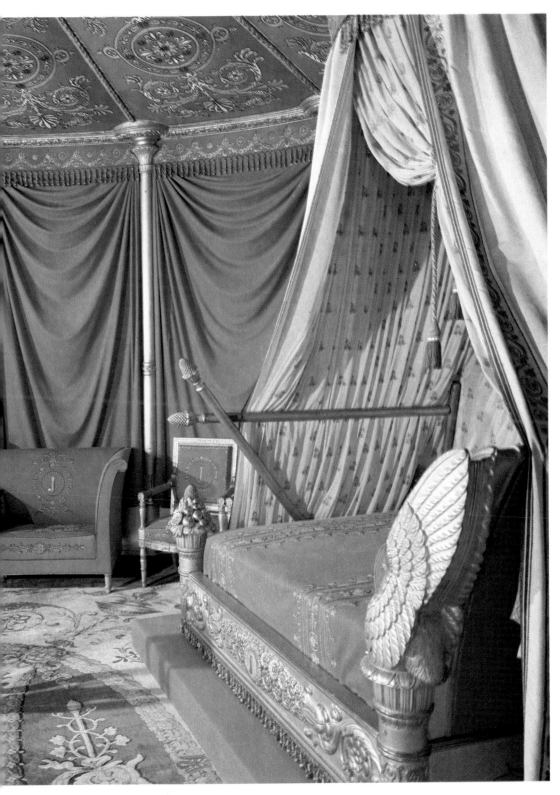

non was the man responsible for the Musée Napoléon, ceremoniously inaugurated in 1802. This grandiose institution, which was actively supported by other scholars (including Lenoir, Dufourny, Visconti, Lavallée and Wicar), was intended to house masterpieces, paintings, sculptures, medals, engravings and drawings from countries that had come under the political dominion of France.

Between 1797 and 1813, Vivant Denon made constant visits to the countries occupied by the Grande Armée, personally selecting hundreds of works of art and sending them back to Paris. The classical and modern artefacts brought together in the Musée Napoléon played a decisive role as models of the "classical" style, to which artists could refer in creating new figurative forms.

When Napoleon was appointed First Consul (1799), he decided to make his official residence at the Tuileries. The palace was then remodelled by a team of artists including Jacob, Delors, Boulard, Lavacher and Cartier. They partially redecorated the apartments, which, however, were used only for official functions. According to contemporary documents relating to the work: "The Consul regards the display of luxury and splendour as a necessity; the furniture in his apartment is also rich and magnificent. His bedroom is the chamber originally occupied by Louis XIV, but he does not normally use it."

Napoleon's official residences

On his return from Egypt, Napoleon normally lived at Malmaison, a country house near Paris, the redesign of which was undertaken by Joséphine Beauharnais. In 1804, having taken the title of emperor, Napoleon also gave orders for the redecoration of other residences: Fontainebleau, which he described as "the true home of kings, custodian of the centuries", the Elysée Palace, Rambouillet, Versailles, Saint-Germain, Meudon and Saint-Cloud. Finally, between 1804 and 1807, he also had alterations made to the château of Compiègne in the Oise, where operations were personally directed and supervised by the Empress Maria Louisa of Austria.

Apart from Denon, the artists who superintended the redesign of the imperial residences were the painter David and the architects Percier and Fontaine. During the revolutionary period, Jacques-Louis David had been giving the task of organising national festivities. For these popular celebrations, he had drawn on all the resources of painting, sculpture, music and stage design.

National festivals were supposed not only to build a sense of citizenship and propagate revolutionary ideas, they were also essential vehicles for disseminating new styles in the arts, especially a love of classical antiquity. In 1804, David was appointed *Premier Peintre de l'Empereur* and became one of the major protagonists of the Empire style.

Pierre-François-Léonard Fontaine and Charles Percier,

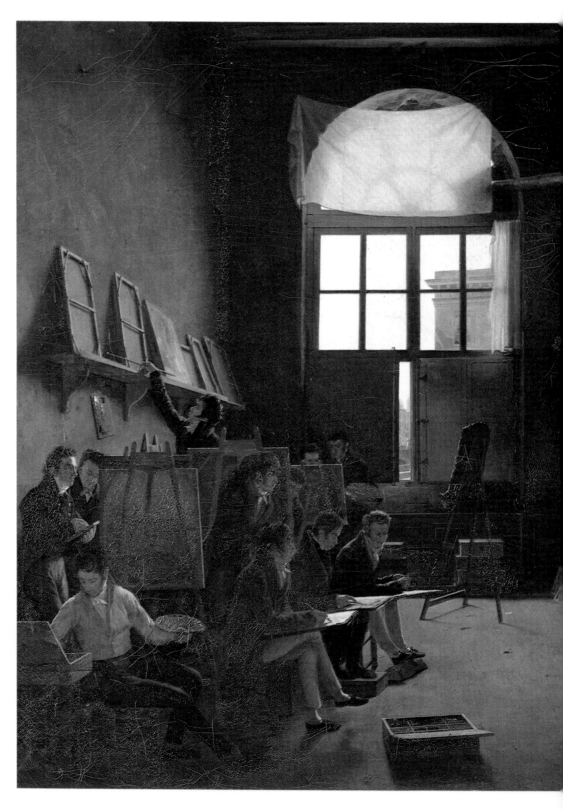

FACING PAGE: *David's Studio* by Léon-Mathieu Cochereau (1793–1817), a pupil of the great Neoclassical artist. Louvre, Paris. BELOW: *Napoleon in his Study* by Jacques-Louis David (1748–1825). The furnishings are typical of the Empire style, in particular the writing desk with lion monopodia supports, the gilt-wood armchair and the *bouillotte* table-lamp. National Gallery, Washington.

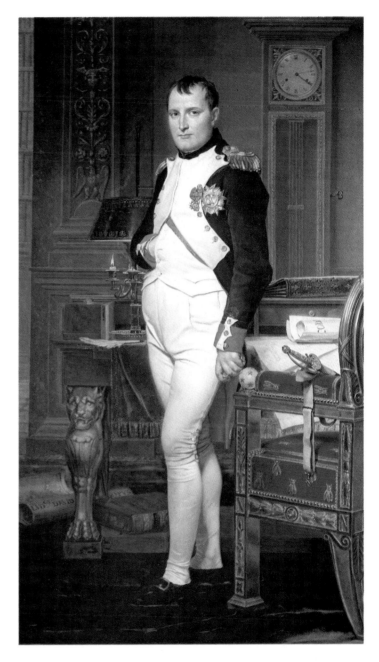

who worked together without a break from 1794 to 1814, were the real creators of the Empire style in furniture. As imperial architects, they collaborated on the restructuring of Napoleon's principal residences, designing not only the architectural features but also the furnishings. They selected individual pieces of furniture and gave orders to the craftsmen involved in the various projects, for instance the metal-workers Jacob-Desmalter and Odiot; the silk-designers Pernot and Grand; the furniture-makers Prudhon and Moench; and the decorators Dubois and Blondel.

Malmaison and Compiègne

Of all the imperial residences, Malmaison and Compiègne were especially significant in the formulation of the new style.

At Malmaison, the country house for which Joséphine was personally responsible, the room which best gives an idea of the Empire style is the Library. It is a semicircular room, whose panelled, gilded doors are reflected in silver-plated mirrors located symmetrically opposite on the chimney breasts. The wooden panelling was done by the Jacob brothers; the ceiling painting, depicting classical themes, by Moench. Prominence is given to the names of Demosthenes, Euripides, Plautus, Molière, Montesquieu and Montaigne, framed by a decor of birds, lyres, oak leaves and garlands. Bright painted decoration is also a feature of the walls and ceilings of the various reception rooms: the ceiling of the Music Room is embellished with mythological fig-

ures; the walls of the dining-room with sinuous dancing women in the style of Pompeii; Joséphine's bedroom has a painted frieze of amphorae and medallions featuring her own profile; the ceiling of the Salon Doré is decorated with foliage

and palmette motifs alternating with lyres and medallions; finally, the Council Chamber was designed in the form of a classical tent. "It seemed appropriate – wrote Percier and Fontaine in their *Recueil de décorations intérieures*, published in 1812 and

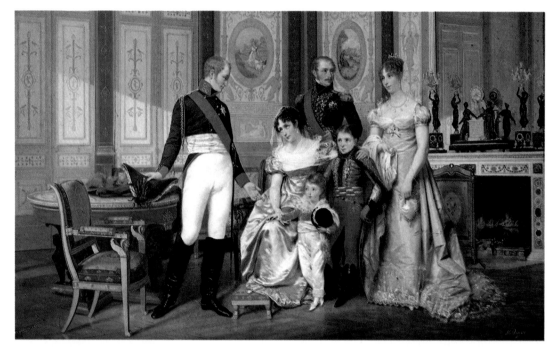

BELOW: two rooms at the Château de Malmaison, the favourite residence of Napoleon's first wife, Josephine Beauharnais, who herself took charge of the redesign and refurnishing: the Music Room and (bottom) the bathroom.
RIGHT: *Alexander I of Russia Visiting Josephine at Malmaison in 1814,* as depicted by Hector Viger (1815–79). Musée National du Château de Malmaison.

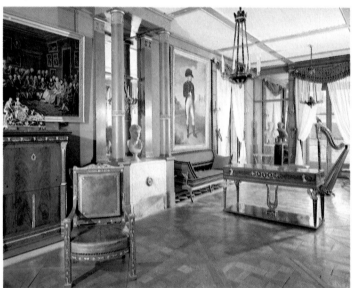

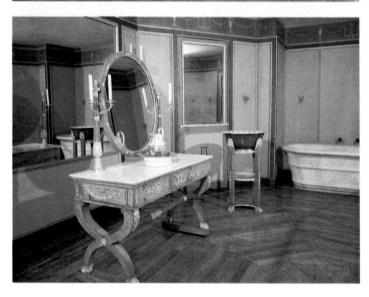

including detailed descriptions of their work on the Napoleonic residences – to adopt for this room the form of a tent supported by pikes, fasces and flags, and hang it with weapons emblematic of the world's most famous warrior peoples."

Compiègne reflects the final period of Napoleon's government. The overall plans were drawn up by Percier and Fontaine, and the work was faithfully carried out by Berthaut and Daru, general stewards of the imperial household. Napoleon's new wife, Maria Louisa of Austria, took up residence there in 1810. Compiègne was to be the principal home of the Empress, future mother of the *Enfants de France.* Knowing her love of plants, the Emperor had one whole room (the *Salon des Fleurs*) decorated with floral motifs and part of the surrounding park laid out in imitation of the gardens at Schönbrunn.

The decoration of Compiègne was entrusted to the painters Girodet, Redouté, Regnault and Dubois; the sculptor Tannay; and the furniture-makers Jacob-Desmalter, father and son. The ceiling of the ballroom was painted by Regnault and members of his workshop, under the supervision of Blondel. The decoration in the Empress's dining-room was in the Pompeian style, with panels of yellow stucco, while the furniture was upholstered in antique-style red leather. The Empress's study, the *Salon des Fleurs,* is a real masterpiece: the wall panels, featuring floral designs on a simulated velvet background, were painted by the Dubois brothers following plans drawn up by Redouté; the upholstery of the chairs also features floral motifs, while the curtains are made of white silk edged with violet. Adjacent to the Grand Salon, decorated in delicate harmonies of gold and green, was the *Salon Bleu,* intended for the future royal children. The name derives from the lustrous blue fabric wall hangings, which contrasted with the red marble fittings and the gold of the pilasters supporting the chimney breasts. The ceiling was painted in fresco by Girodet with portraits of the Roman kings. Girodet also decorated the Empress's bedroom with allegorical motifs symbolizing day and night. Adjacent to the bedroom was a *boudoir* hung with white taffeta and crimson velvet. The Emperor's bedroom, in contrast, is monumental and austere, with furniture made by Jacob-Desmalter and paintings by Girodet.

Bedroom designed for Napoleon at the Château de Serrant in 1808; "classical" features of the Empire-style furniture include the lion-monopodia table legs, the swan-shaped front legs of the small armchair, and the *lit en bateau,* which is typical of the period; on the mantelpiece is a bust of Napoleon's second wife, Maria Louisa of Habsburg-Lorraine, by Canova.

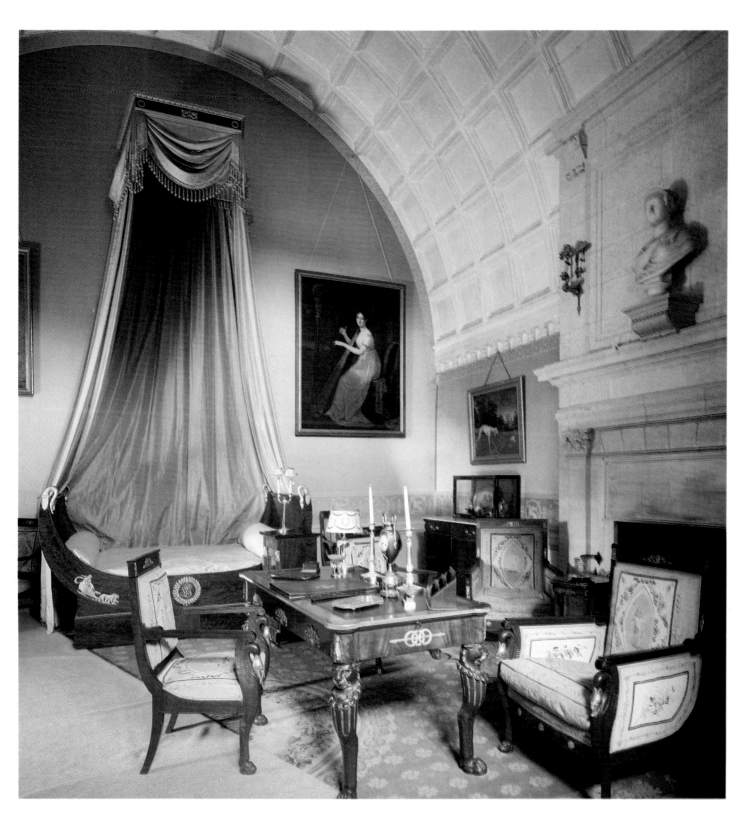

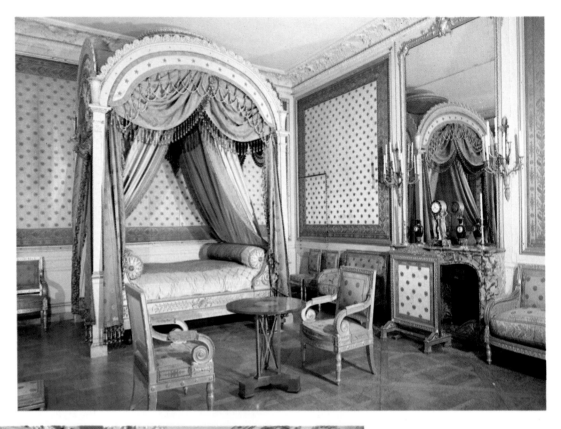

Sources of inspiration

The well-springs of the Empire style, as we can see from these few examples, were the recovery of the decorative models of classical antiquity and their organization into a harmonious system of strictly symmetrical structures and compositional modules. These elements were already part of the Neoclassical linguistic code, but in the Empire style they took on a unique aura of magnificence, opulence and monumentality, obtained by the selection and use of precious ma-

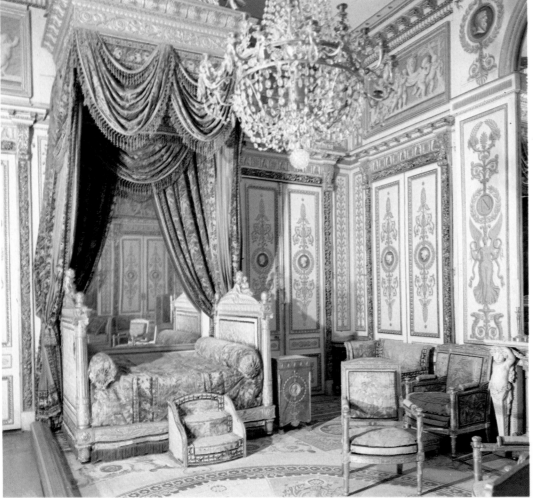

terials and the creation of original colour harmonies.

"We made every effort to imitate the antique – wrote Percier and Fontaine – in its spirit, in its principles and in its precepts, which are timeless […] We would be deceiving ourselves – they added – if we thought it possible to find forms preferable to those handed down to us by the ancients. It is therefore vital to adhere to classical models, not blindly, but with the discernment that modern customs, practices and materials demand."

In the Empire style, however, classical models were made to serve the interests of luxury, monumentality and imperial grandeur. During the Directoire, the classical models generally adopted were derived from Greek culture – a Greek culture moderated by a knowledge of Italian art and filtered through the Hellenistic examples of Herculaneum and Pompeii.

During the Consulate, and then under the Empire, however, the prevailing influences derived from imperial Roman and Egyptian culture, which were more in

keeping with current political and historical developments. Sometimes the borrowings consisted of entire monumental complexes; sometimes of selected motifs recombined into composite new creations. The Arc du Carrousel, for example, was derived directly from the Arch of Septimius Severus, and the Colonne de la Grande Armée, in the Place Vendôme, was inspired by Trajan's Column.

Swords, laurel wreaths, eagles, triumphal chariots, stars, thunderbolts and other emblems on the other hand were simply a mine of decorative motifs, borrowed from the same classical period and freely drawn on in interior decoration.

Egyptian stylistic features were, as we know, already a component of 18th-century Neoclassical culture. Ledoux and Boullée, following in the footsteps of Piranesi, popularised the cult of ancient Egypt, the grandiose and monumental aspect of which was well suited to the revolutionary climate and aspirations of the times. Boullée, in particular, in his *Treatise on Architecture* (1803) celebrated the "colossal" aspect of Egyptian architecture.

Interest in Egyptian civilisation came to the fore again at the end of the century as a result of Napoleon's Egyptian campaign and the excavations organized by the indefatigable Denon. In the wake of Denon's discoveries and publications, the French acquired a deeper theoretical knowledge of Egyptian civilization, and frequently adopted its ornamental motifs for the purposes of decoration.

A good example of the first of these developments is the analysis published in 1803 by one of the

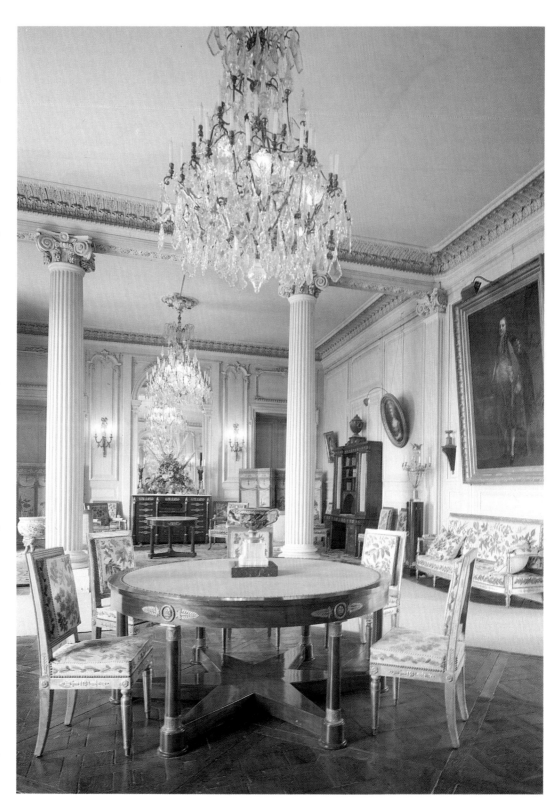

greatest theoreticians of imperial Neoclassicism, Quatremère de Quincy, in his *Mémoires de l'Académie des Inscriptions et Belles Lettres*, of Egyptian art as compared to Greek.

The fashion for Egyptian-style decoration was to determine one of the predominant ornamental components of the Empire style. Again, complete monumental artefacts – pyramids, obelisks, sphinxes – were adopted wholesale, and there were sporadic borrowings of decorative motifs – lotus leaves, human and animal heads with the divine characteristics of the pharaohs, winged disks and hieroglyphs – for use in new and original contexts.

Harmony of composition and colour

In Empire decoration, the nostalgic pursuit of classical forms was accompanied by the harmonious organisation of the individual parts within a whole. The concept of harmony, which was itself based on the idea of symmetry as a balanced presentation of varied components, derived from 18th-century art theory. But now it assumed a value virtually symbolic of the outward order imposed by the new political régime.

In his *Dizionario*, published in 1797, Francesco Milizia wrote that: "Symmetry lies in the well-proportioned relationship that the parts must have among themselves, and with the whole. Variety derives from contrasts, which in all tasteful works are highly pleasing. In architecture, contrasts consist principally in the opposition of the different heights, projections and shapes

which constitute a building, and in the opposition between unadorned and embellished parts, and between different situations and different colours. Contrast therefore need not imply contrariness, and certainly not contradiction."

Those involved in theoretical

debate during the Empire period in France also insisted on the importance of a harmonious unity between the various components of a work of art (and therefore between the elements of the decor of a room), and the acceptance of this by the patron.

One who put forward this

view was the French art theoretician Quatremère de Quincy, in his celebrated *Essai sur la nature, le but et les moyens de l'imitation dans les beaux-arts* (Paris, 1823). "It is this kind of unity (the unity of visual impression) – and forming a whole of this kind – that is aimed at such as the combining

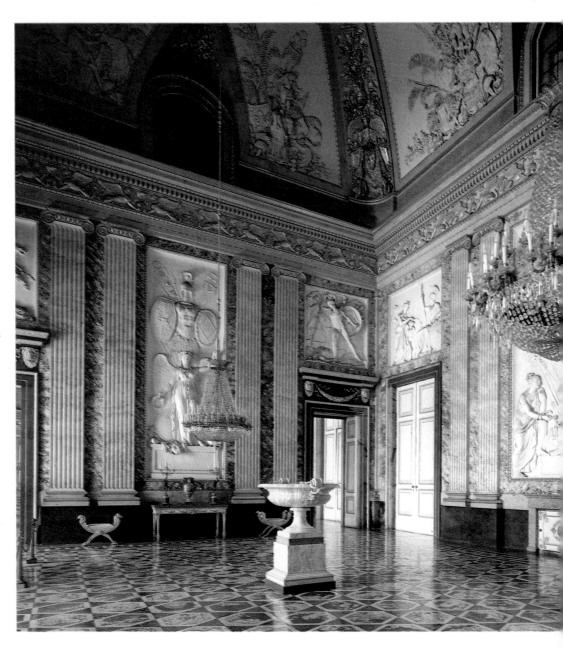

19th century. BELOW RIGHT: the Malachite Room at the Hermitage in St Petersburg, designed by Brullov (1798–1877) after the fire of 1837: built as a "private" museum by Catherine II, the Hermitage was enlarged and opened to the public (1852) in the time of Tsar Nicolas I.

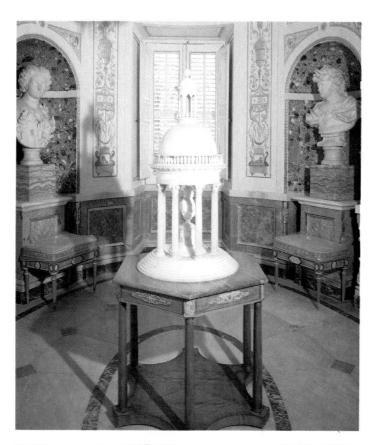

of arts I wish to discuss," he wrote in Paragraph VIII of his work – a paragraph devoted specifically to the "nature and spirit of the combining of several arts to create a joint work that may be defined as an *assemblage*". "In this lies their character and their merit. The pleasure they give results from this condition, without which they are incapable of involving the mind of the spectator, or they invole him only very slightly. There is a most significant difference between what may be termed a combining of arts to produce a single work formed from several works and a mingling of the elements of several arts. In the first case, each art retains its uniqueness and its portion of the work remains distinct.

Where, on the other hand, the different arts mingle, each is neutralised, and its specificity is lost. Where arts combine, the observer can enjoy the part played by each, one after the other, by a more or less rapid effect of transition, and can get a sense of the whole. Where they mix, each individual part, and the whole, escape him. If painting, sculpture and architecture combine in the decoration of a room as a whole, this whole is their joint work, and the sense of unity that results will be the cause of a general pleasure, which the eye will experience, even though it may not be able to rest on a particular bas-relief or painting."

In Empire settings, symmetry was achieved principally by the harmonious distribution and succession of rooms, then by the strict distribution of individual architectural features: wall panels, pilasters, white-and-gold painted stucco columns, doors, windows, fireplaces and cornices, all matched by the harmonious distribution of decorative elements.

On the other hand, the harmony that resulted from this symmetry was obtained by the careful and appropriate combinations of colours and of individual decorative features. The dominant colour relationships were black

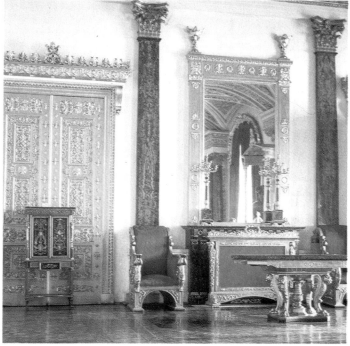

and gold; white and antique yellow; emerald green and orange. Pieces of furniture, bronzes, lamp-stands and *appliqués* alternated with fabrics, wall-hangings, ceramics and clocks, fire-dogs and glassware, all brought together with a *parvenu* taste for opulent display. The effect was enhanced by the choice of precious materials and the use of the most elaborate techniques, to emphasize the economic and political might of the patrons. Among the materials commonly used in Empire furnishing, we find fruit tree

woods such as pear, olive and cherry (after 1806, the importation of mahogany was banned); chased and gilded bronze; coloured marbles; and materials that could be used to simulate others, such as stucco, plaster, and varnished wallpapers.

Spread of the Empire style

In the wake of Napoleon's conquests, the Empire style spread throughout Europe, reaching even those countries not under French domination. It thoroughly penetrated Italy, Spain, Prussia and Austria. On the periphery, Russia and Britain – the latter despite its isolation – were profoundly affected.

In Italy, features of what became the Empire style, appeared even before Napoleon himself. Its chief protagonists had, after all, been trained in Rome, including Percier, David and Ingres. The style achieved a deeper penetration with the constitution of the various Napoleonic kingdoms: in Milan, the real imperial capital in Italy; in Lucca and Florence, with Elisa Baciocchi and Eugène Beauharnais; in Naples, with Caroline and Joachim Murat; and in Rome, with Paolina Bonaparte's husband, Prince Camillo Borghese.

The royal palaces of the new kingdoms – Palazzo Reale in Milan, Palazzo Ducale in Lucca, Palazzo Pitti in Florence, Palazzo Reale in Caserta, and the Quirinale and Villa Borghese in Rome – were entirely redesigned in the Empire style, with furniture and hangings often imported directly from workshops in France.

In Italy, the Empire style persisted longer than in other parts

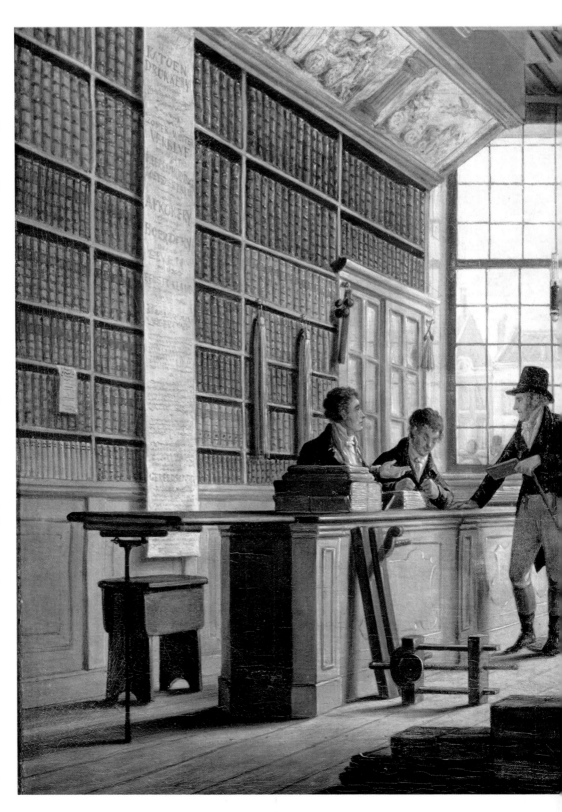

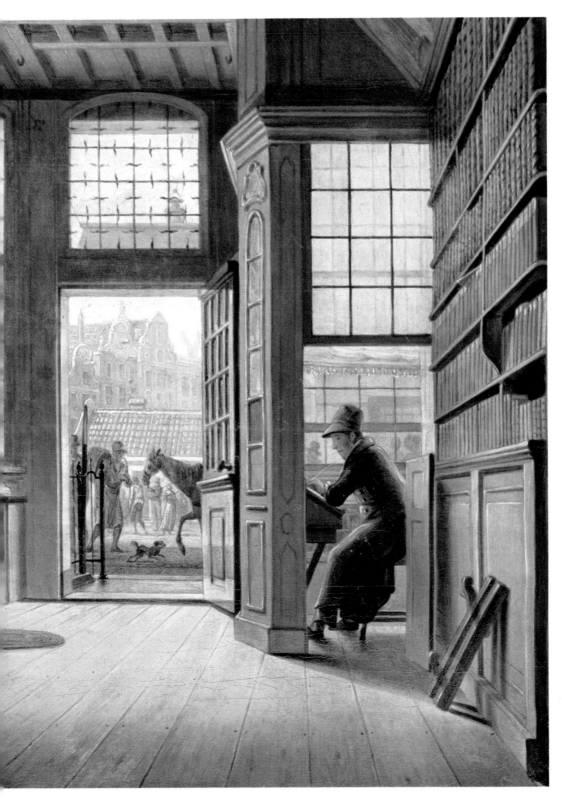

of Europe, to the extent that some art historians talk of a distinct "Italian" Empire style. It remained the preferred style in Italy even during the Restauration, from 1815 to 1840. Good examples of this tendency are the royal palaces of Turin and Genoa, both remodelled at the close of the Napoleonic era by the House of Savoy.

In Spain, the Empire style made inroads during the troubled period of French occupation. The most significant example is perhaps the Casita del Labrador at Aranjuez, near Madrid.

On the fringes of Napoleon's empire, it was in Russia that the Empire style proved most popular. According to Mario Praz, who in his essay *Gusto neoclassico* defines the moment of transition from 18th-century Neoclassicism to Empire: "The Neoclassical fashion in Russia began with Catherine the Great and reached its peak during the reign of Alexander I. Always full of grandiose and magnificent ideas, the Empress of Russia wanted a palace in all respects similar to that of the Caesars [...] And the architect Clérisseau, dazzled by Diocletian's palace at Split, designed her a villa that might have been built for Augustus at Tusculum, with atrium, vestibule, triclinium and all the classical appurtenances, including a *cryptoporticus* and *xystus*: a Pompeian house enclosed in the Baths of Caracalla [...] Clérisseau's plans were not put into effect, but they were a seminal influence on later architects. Cameron used them for Tsarskoe Selo, on whose walls the slender columns and delicate capitals of the Pompeian frescos, festoons of flowers and candelabra from Raphael's Loggie

blended with Wedgwood medallions, and were repeated in long vistas of mirrors; grotesques in gilt stucco and bronze medallions stood out against panels of milky white marble [...] Catherine adored showy colours; she wanted multicoloured lustres – green, red and dark blue – at the centre of chandeliers enriched with precious stones. Shot through by the light of hundreds of candles, the gems were reflected in the mirrors or on the walls clad in agate or polished jasper, and the tables, too, were decorated with precious stones. Those fortunate enough to have seen these things tell us that a submarine atmosphere filled these sumptuous, fragile apartments: the opaline white, violet, dark blue and green wrought a magic similar to that of the enchanted waters seen by Coleridge's Ancient Mariner."

Whether Russian or Italian, the artists who worked on the Empire-style decorations of the Tsar's palaces in St Petersburg and the country houses in the vicinity were united in a common classical culture. They included Andrei Voronikhin, Andreyan Zacharov, Carlo Rossi, Vassily Stasov, Ivan Prokofiev, Ivan G. Martos, Giovanni Battista Scotti and Antonio Vighi.

The theatrical aspect of these Empire-style residences is combined with a sense of serenity, luxury and calculated sophistication very redolent of French prototypes. There is something French about the furniture, incorporating such varied materials as glass, amber, lapis-lazuli, gilt-bronze, ivory and steel; something French about the classical, exotic, Egyptian-style decor of the rooms; something French in the fondness

for antique colours – blue-green columns, Pompeian yellow pilasters; something French in the way antique sculptures, pictures of ruins, portraits of beautiful women and mythological landscapes are incorporated into the architectural settings.

The classical, funereal and monumental aspects of the Empire style also had an influence in England, despite that country's relative isolation. There it coincided, in part at least, with the English Regency style, named after the period (1811–20) during

which George, Prince of Wales, the future George IV, governed on behalf of his father.

The preferences and predilections of the Prince Regent shaped a style that derived many of its components from French Empire. Court tastes were dissemi-

nated and codified by contemporary publications on furnishing – luxury albums with detailed illustrations of furniture, *objets d'art* and ornamental motifs for interior decoration. Some of the best known were Thomas Hope's *Household Furniture and Interior Decoration* (1807), *A Collection of Designs for Household Furniture and Interior Decorations* (1808), *Sheraton Designs for Household Furniture* (1812), and finally *The Cabinet Maker and Upholsterer's Guide* (1826).

The characteristics of the Regency style, as is evident from the models published in these catalogues, constitute an austere version of standard Empire features: severity of decor, based on the harmony of individual parts and individual pieces; the robustness of single items of furniture, which tended to be dark in colour and massive in form; strongly contrasting colours for the walls and upholstery – purple and imperial reds combined with vivid blues and greens; and finally, the use of classical decorative models in conjunction with traditional 18th-century English ones, or motifs of non-European, Egyptian or oriental origin.

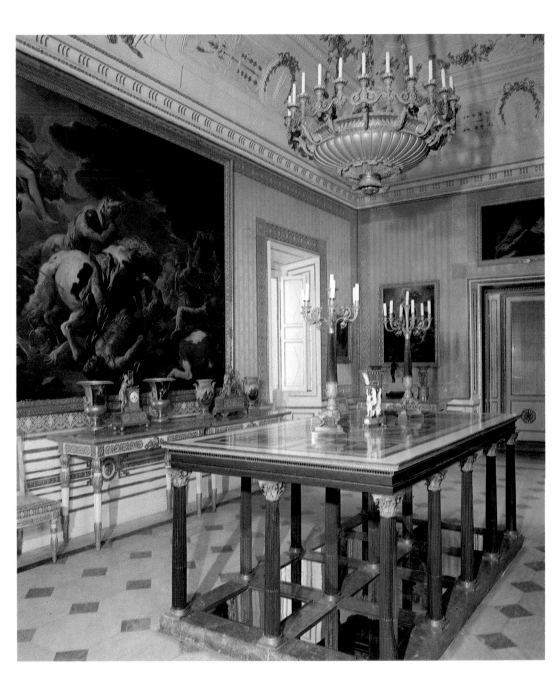

The Restauration: the Gothic revival

During the period usually referred to as the Restauration – when the major ruling houses of Europe were reinstated after being pushed aside by Napoleon at the beginning of the 19th century – the main trend in the arts was towards reviving the historical styles of the past. Of these, it was the Gothic style that enjoyed by far the greatest favour.

The choice of this style, at the beginning of the century, coincided on the one hand with the general outlook of the ruling houses, intent on reaffirming their grandiose dynastic aspirations; on the other, it was identified with the underlying assumptions of the Romantic movement and its nationalistic ideals. The

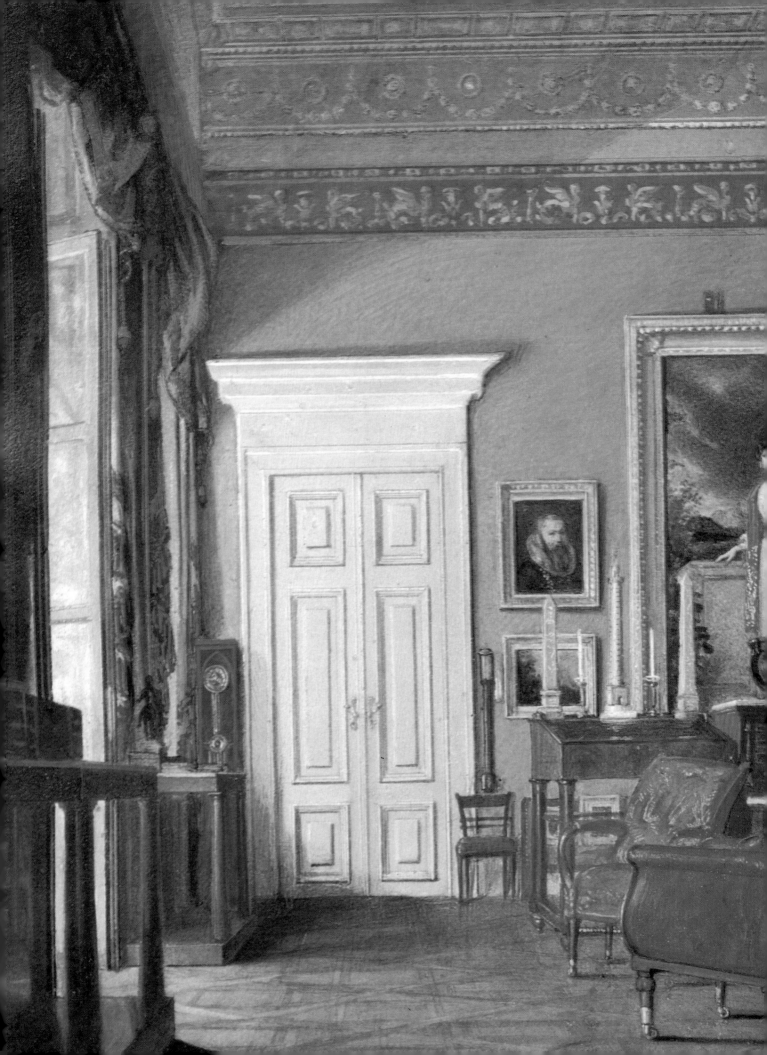

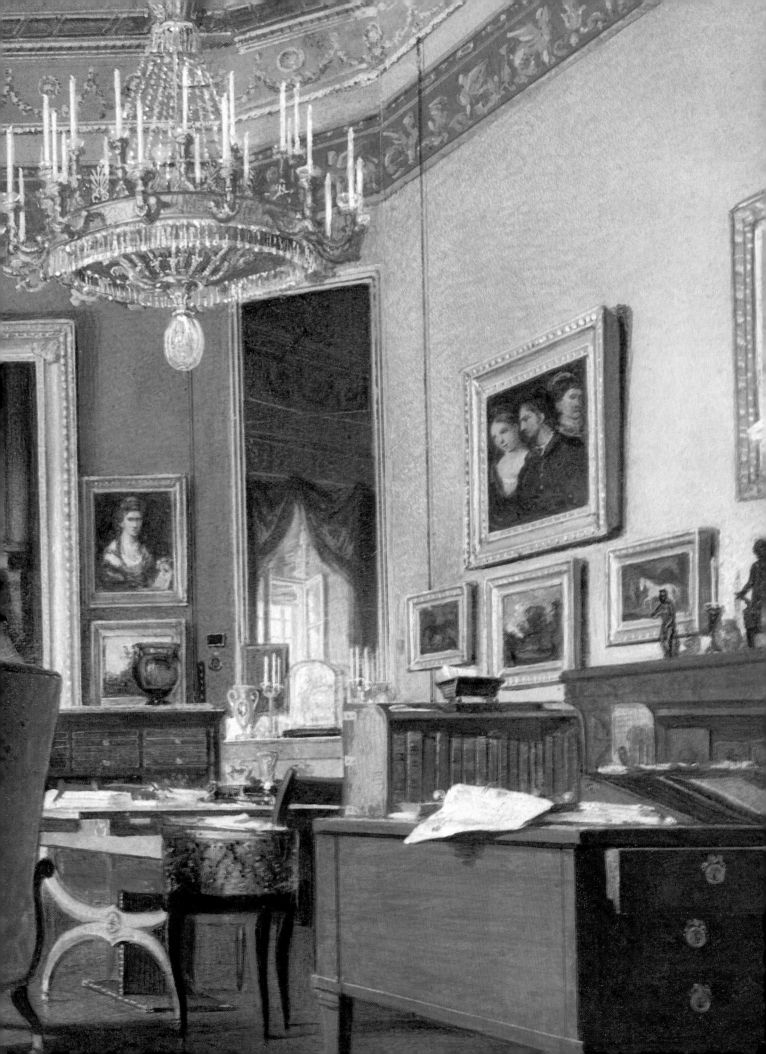

Imposing and grandiose, the Empire style was adopted by all the royal courts of Europe and long outlasted Napoleon himself, as is apparent from these interiors at Palazzo Reale in Caserta: the bathroom (c. 1825, below) and Ferdinand II's bedroom (1814–22, right) show a predilection for heavy Empire furnishings and bronze decoration, although this was the time of the Bourbon Restauration.

desire of the great monarchies to return to their roots after the period of Napoleonic imperialism was borne on a new wave of Christian ideology, which found strong historical and symbolic confirmation in the art and civilization of the Middle Ages. Hand in hand with this, Romanticism provided a stimulus to evaluate the individual character of national styles and decide which artistic forms would lead to a recovery of the primitive sense, spiritual childhood and radical truths of nationhood.

The origins of this fondness for revivals and in particular the Gothic style which developed in the early years of the century in England, Germany, France and Italy, must again be sought in 18th-century culture. Scholarly interest in Gothic art first surfaced in early 18th-century England, sustained by sentimental, literary and decadent tendencies. There, the Gothic was perceived through the filter of the picturesque, the fantastic and the imaginary, taking the form of a passionate and nostalgic love of ruins and gardens.

At the beginning of the 19th century, however, this more or less archaeological approach towards medieval styles, and medieval monuments gave way to a more complex and history-orientated vision. In England, the Gothic was chosen for its structural rigour, primitive purity and moral intent. John Ruskin and Augustus Welby Pugin, in particular, pointed out its structural soundness and the imaginative aspect of its decorative and ornamental elements.

But they also stressed its social dimension, the sense in which the style was fully suited to reflect the real aspirations of the community. In *The Seven Lamps of Architecture*, Ruskin propounded the view that the only style suited to modern society was the Gothic: the northern Gothic of the 13th century that had found its highest expression in the English cathedrals of Lincoln and Wells and, in France, in the cathedrals of Paris, Amiens and Chartres. He advocated the adoption of this style for churches, palaces and cottages, and indeed for all public and private buildings.

These aspirations were reflected in a multiplicity of Gothic-style designs, not only in the theoretical writings of the movement, but in the illustrations of architects' and designers' catalogues, which were printed in large numbers, particularly around the 1830s. Some fascinating ideas are offered in such publications as *Designs for Ornamental Villas* (1827), *Village Architecture* (1830) and *Designs for Farm Buildings* (1830).

In Germany, too, the return to the Gothic was associated with a quest for national identity, and the national wars of unification. Goethe had already shown great insight when, in his *Neue deutsche religiös-patriotische Kunst* (1817), he had pointed out the close connection between political and cultural developments.

The Gothic revival, in Germany as in England, was part of a far wider reassessment of medieval civilization and its religious, social and philosophical values. As pointed out by the Nazarenes – a group of painters working in Vienna and Rome under the leadership of Friedrich Overbeck and Franz Pforr, who advocated a return to the medieval workshop system – artistic forms should present the most immediately accessible image of this ancestral vitality, which was being rediscovered together with the nation's historical roots.

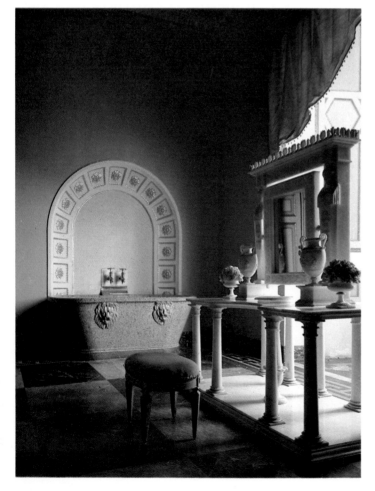

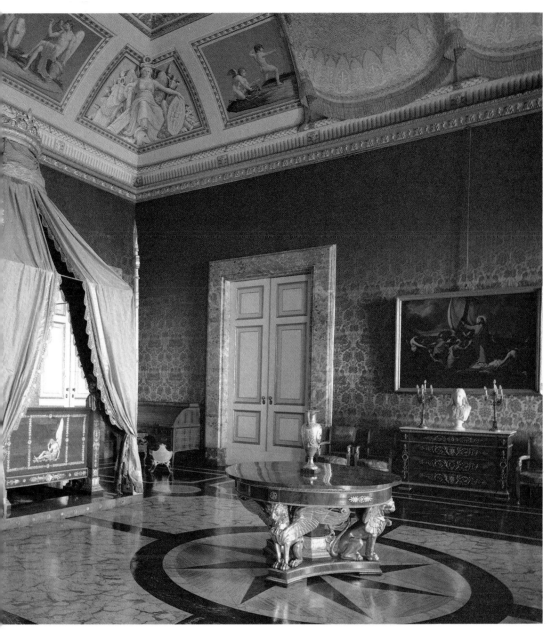

These ideas also spread to centres such as Munich and Dresden.

In France, too, the Gothic revival began in the 18th century, and was preceded by the archaeological study of ancient monuments, reports on the state of conservation of works of art and proposals for restoring them, scholarly historical publications and travel journals. These activities, continued in the early 19th century, provided a point of reference for subsequent developments in interior design and architecture.

Books on related topics were published by Alexandre Lenoir (*Musée des monuments français*,

1791–92), Jean Baptiste Seroux d'Agincourt (*Histoire de l'art par les monuments depuis sa décadence au IVe siècle jusqu'à son renouvellement au XVIe*, 1811–23), Charles Nordier, Taylor, Cailleux (*Voyages pittoresques*, 1820–78), and Alexandre de Sommerand (*Les arts au Moyen Age*, 1834). The French taste in medieval interior design is also referred to as the "troubadour", or "cathedral", style. It was popular during the reign of Charles X (1824–30), when the fashion was to recreate medieval, preferably Gothic, settings – dimly lit, pregnant with evocative, exotic suggestions and nostalgic symbolism. The me-

dieval aspects of these interiors were echoed in paintings depicting ancient feudal dwellings, monasteries and cloisters.

Also medieval in style were the often technically complex *objets d'art* chosen to decorate these interiors. They could be acquired in some of the highly fashionable Paris bazaars, such as the Petit Dunkerque. A varied assortment of stained-glass windows, chairs, armchairs, wardrobes, choir-stalls, benches, chests, pendulum clocks, boxes, barometers, ink-wells and *veilleuses* was displayed in charming disorder – a theatrical setting offering an unusual means of escape into the medieval past.

The fashion percolated down from the court and the upper middle classes, and was disseminated by many specialised publications. In the royal palace at Versailles, the most signal example of this type of decoration was the *Salon des Croisades*. Among the *haute bourgeoisie*, it is worth noting the apartment of the Duchess de Berry; the pavillion at Saint-Ouen with painted wooden furniture made by Pierre-Antoine Bellangé in 1821 for the Countess de Cayle; the oratory of Princess Maria; the medieval gallery of the apartment of the Baroness Betty de Rothschild; and finally the collection of Alexandre de Sommerand, who had a passion for Gothic furniture and artefacts: chests, four-poster beds, thrones and trumpets.

There were many richly illustrated publications offering models that could be easily imitated, in particular: *Le journal des dames et des modes, Le magazine pittoresque, Le recueil des décorations intérieures*, published by Bance in 1828, and *Le recueil de mobilier*, brought out in 1831 by Jacob Petit.

Italy: a plurality of styles

In Italy, major examples of the Neo-Gothic fashion are to be found mainly in Piedmont, where the style found favour with the ruling House of Savoy. Interest in the new style began during the reign of Carlo Felice, who in 1824 asked the architect Melano to restore and remodel the abbey complex of Altacomba in Savoy, founded by Amadeus III. Altacomba was the eagle's nest of the dynasty and, on the king's orders, it was transformed into a dynastic

pantheon dedicated to illustrious family members. The quest for the historical roots of the dynasty, initiated by Carlo Felice and visualized in terms of the Gothic style, was carried forward by Carlo Alberto with the help of the Bolognese architect Pelagio Palagi.

For Carlo Alberto, Palagi built the Margheria di Racconigi, restored the Castello di Pollenzo, and decorated some of the rooms of the Palazzo Reale in Turin (the Chapel of Carlo Alberto and the Public Audience Chamber) in the Neo-Gothic style. Carlo Alberto's revival of the Gothic Middle Ages was of great symbolic significance in relation to the restoration of the monarchy, intended to emphasise the nobility, Italian origins, religious obedience and antiquity of the ruling house in Turin.

Carlo Alberto's programme was energetically supported by court historians and scholars such as Vernazza and Cibrario, who were motivated by patriotic pride to reconstruct the cultural identity of the king's dominions, and consequently to restore the works of art and ancient monuments that lent credence to that culture.

However, in the redesign of royal residences put in hand by Carlo Alberto the Neo-Gothic was not the only style adopted. In carrying through his restoration programme, the king was moved to revive a number of different styles, each corresponding to a different need where the image of the monarchy was concerned. This pluralistic approach to historical revivals was already apparent in the work done under Carlo Felice, who had also favoured the Neo-Egyptian, Graeco-Roman and Italo-Etruscan styles.

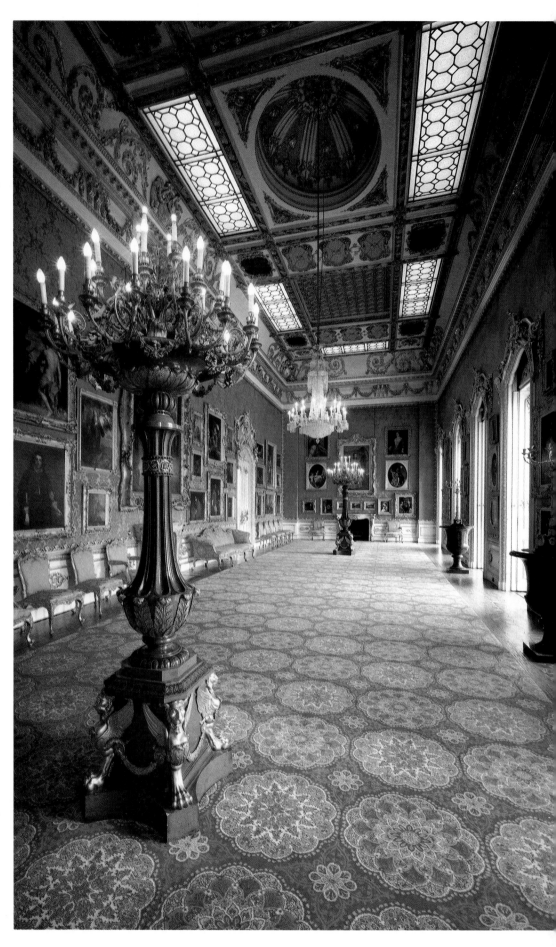

FACING PAGE: the Waterloo Gallery (1828), Apsley House, London. While England was falling into line with the historical revivals – Greek, Egyptian, Etruscan and others – sweeping the rest of Europe, the United States still seemed to be under the influence of the English Regency style. The American preference is evident in this painting of a *Dinner Party* (this page) by Henry Sargent (1770–1845). Museum of Fine Arts, Boston.

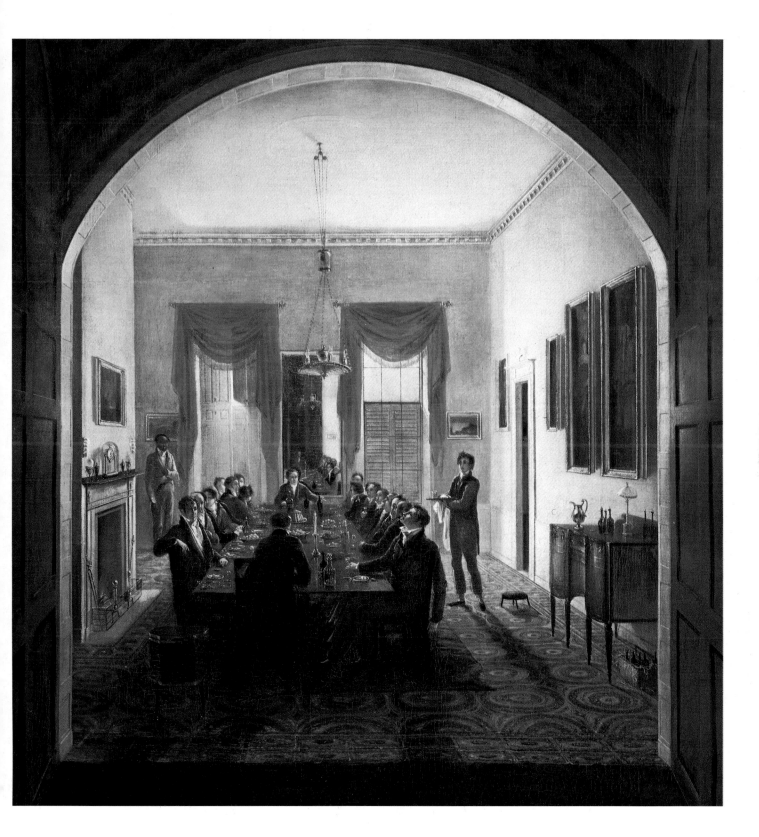

In decorating the Castello di Racconigi for the royal House of Savoy, the revivalist architect Pelagio Palagi (1775–1860) drew heavily on classical motifs for wall paintings and furniture. The ancient world and Greek vase painting are brought to life in the friezes and wall and ceiling decoration of the *Sala di Apollo* (below) and the *Gabinetto Etrusco* (facing page).

Under Carlo Alberto, the Neo-Egyptian style received a great impetus from the founding of the Museo Egizio in Turin. Its starting point was the acquisition of the archaeological collection of Bernardino Drovetti, commissioner of the Piedmontese government, *aide-de-camp* to Joachim Murat and French consul in Egypt. Also of Piedmontese origin was Giovanni Battista Belzoni, who on returning from a long stay in Egypt published, in English, a *Narrative of the Operations and Recent Discoveries within the Pyramids, Temples, Tombs and Excavations in Egypt and Nubia* (1820) – a work that proved very influential in popularising Egyptian decorative motifs in interior design.

The kind of Neo-Egyptian decor developed in this hot-house of study is well illustrated by a patrician residence in the Canavese region of Piedmont, the Castello di Masino, which has a splendid ante-chamber imitating the interior of one of the Nile temples. It is decorated with green, black, white and pink malachite to give an effect of subtle, fanciful sophistication. Masino is not far from another of Carlo Felice's residences, the Castello di Agliè. Here, the king and his consort Marie-Christine of Bourbon assembled an important collection of ancient artefacts unearthed at Tusculum and Veii, which were to have considerable impact on artistic taste, not only in the time of Carlo Felice, but under his successor, Carlo Alberto.

In the time of Carlo Alberto, the promoter of these classical revivals was the architect Pelagio Palagi mentioned earlier, who was made responsible for "the

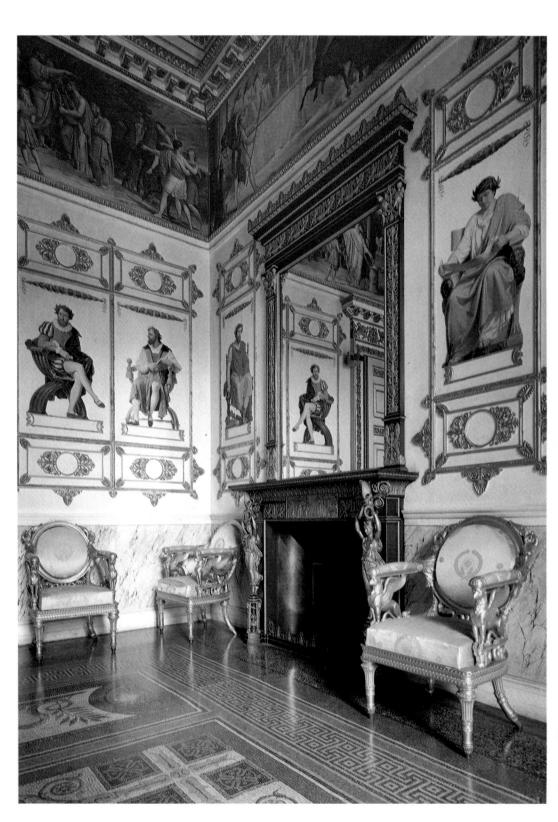

decoration of the royal palaces"
in 1832. Palagi's thought was
deeply rooted in Historicism. His
Compartimenti di camere (1827)
reveals a direct interest in the
Empire style, but also a concern
to revive the styles and furnish-
ings of the past. He was also a
knowledgeable collector of Et-
ruscan and Egyptian antiquities
and owned a well-stocked library
of books on the classical world.

It was in Palazzo Reale, in
Turin, that he made widest use of
classical styles, notwithstanding
some concessions to the Neo-
Gothic. For instance, in some of
the rooms on the second floor of
the palace, in particular the Ap-
partamento dei Principi di
Piemonte, he opted for the Neo-
Pompeian manner. Palagi also
adopted classical styles for some
of the interiors of the Castello di
Racconigi, for instance the *Sala
dei Dignitari* (or *del Caffè*), the
Gabinetto Reale, the *Gabinetto
Etrusco* and the king's bathroom.

In the *Sala dei Dignitari,* the
walls are decorated with panels in
the Pompeian manner, while the
ceiling is similarly adorned with
animal and floral motifs taken
from the *Aeneid.* Also in the
Pompeian style is the decoration
of the *Gabinetto Reale.* In the
Gabinetto Etrusco on the other
hand, the themes and genres de-
rive from Etruscan culture and
Greek vase painting: the ceiling
and frieze are of Etruscan inspira-
tion while the painted motifs and
figures on the walls are obviously
modelled on Greek originals. Fi-
nally, the subtle architectural
structures and painted decoration
of Carlo Alberto bathroom draw
their inspiration from Hellenistic
archaeological sources.

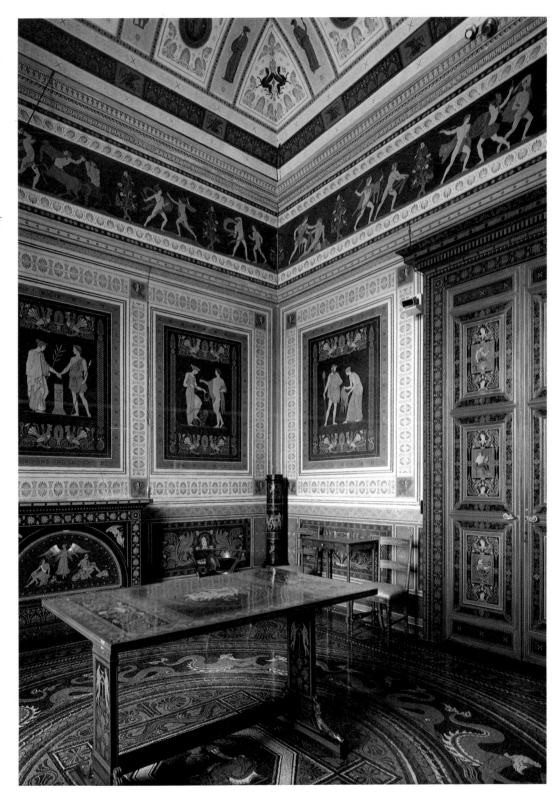

The illustrations on these pages show a girl's bedroom (below), a married couple's bedroom (right) and a dining room (bottom) in the Biedermeier style, dating from between 1820 and 1830, all reconstructed in the Bundessammlung alter Stilmöbel in Vienna. Characteristic features are the simple furniture made mainly of light-coloured woods, and the way they are arranged to create a comfortable, functional environment. Facing page, below: water-colour of a boy's bedroom in similar style. Kunsthistorisches Museum, Vienna.

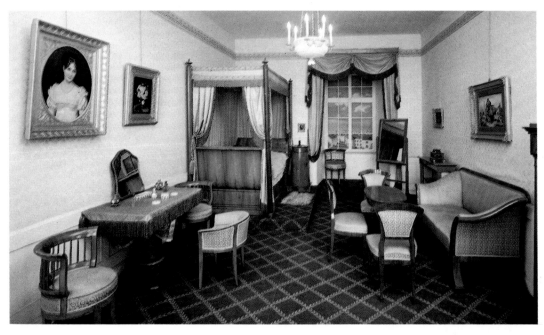

Biedermeier: an intimate style

Between 1855 and 1857, two friends from southern Germany, the physician Adolf Kussmaul and the poet Ludwig Eichrodt, published in *Fliegende Blätter* a collection of verses purportedly written by Gottlieb Biedermaier. They were in fact freely edited versions of poems by a schoolmaster, Samuel Friedrich Sauter (1766–1846). Biedermaier *(sic)*, the "decent common man", was the prototype of the average German citizen of the period. He was emblematic of the former Romantic enthusiast of Jena or Heidelberg, disillusioned after the national wars of independence, who had settled down and adopted middle-class habits. His characteristics were "good-natured decency" and a timorous and reverential respect for authority.

Biedermeier was essentially the middle-class man of the Restauration period, impoverished by wars and new taxes, disappointed by the revolution, obliged by the difficult economic situation to forego travel and international contacts and live in the restricted sphere of his own native parish.

By extension, the term Biedermeier *(sic)* was later used to describe the taste and style of furnishing popular in German-speaking countries between 1815 and 1848, almost exactly corresponding to the Restauration era. This period saw a major crisis in agriculture and commerce, which were subject to ruinous British competition, the beginnings of industrialisation, difficulties in communication, and therefore a kind of spiritual stagnation, resignation and withdrawal into individual values. The German word for it is *Gemütsruhe*, a quietism signifying an abandonment of the passionate feelings and ideals of Romanticism.

In Germany, it was the pe-

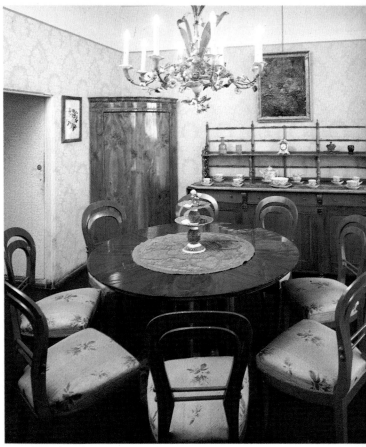

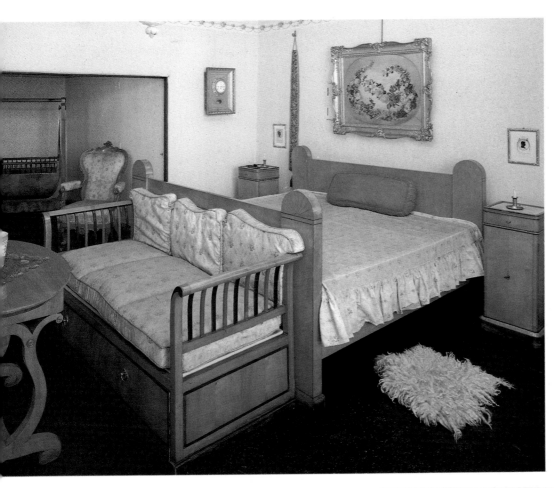

ual rooms might be used for more than one purpose. The typical Biedermeier house consisted of an entrance hall, sitting room, study, bedrooms, kitchen and bathroom. The focal point of the home was the sitting-room, where the family would meet together, converse and receive friends. The importance of the sitting-room in homes of this period is well documented in contemporary paintings. In depicting the sitting-room, with the family gathered together, Biedermeier man wanted to give visual emphasis to his sense of belonging to a family group and sharing its values.

The interior design of a Biedermeier sitting-room and other

riod during which no less than thirty-eight independent states formed the Deutscher Bund; the time of an absolutist political system tempered by neglect; of the beginnings of industrialization marked by a customs union (Deutscher Zollverein) and the first railways (1835). But it was also a time of mass emigration. In Austria, it was the period that saw the re-establishment of absolute monarchy and a strengthening of the Habsburg dynasty. It is sometimes referred to as the *Vormärz*: the period preceding the uprisings of spring 1848, which resulted in the abdication of Ferdinand I in favour of Francis Joseph.

A novella entitled *Der Nachsommer* (Indian Summer) by the Austrian writer Adalbert Stifter (1805–1868) clearly illustrates the *Lebensgefühl*, or sense of the purpose of life, typical of the Biedermeier period, which also informed the taste and style of the domestic environment. The long-

ing of the hero of Stifter's novella is for a serenity and middle-class security expressed principally in domesticity, reverential respect for tradition, and the celebration of ancestral virtues.

The home became the refuge of Biedermeier man, the place into which he could hedonistically withdraw and enjoy the objects with which he surrounded himself: old books, good music, tasty food. It was also the privileged place for meeting friends and family, his private sanctuary. In its structure and furnishings, it therefore had to reflect these ideals and aspirations.

Comfort and cosiness

In city households, every room had its own, well-ordered function, in conformity with a quiet, simple way of life tending to promote family and community values. However, in country villas built as holiday homes, individ-

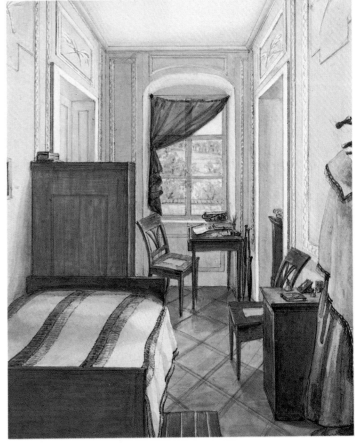

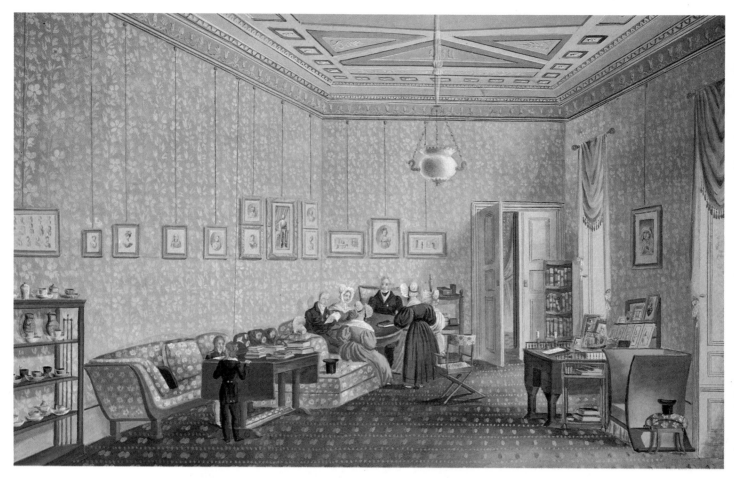

reception rooms contrasted with the principles of Empire taste in renouncing the rigid rules of symmetry. The purity of Empire decor and the uniformity of its component parts gave way in Biedermeier to a concern for comfort and convenience, which reflected the personality and interests of the occupants.

Biedermeier interiors were light in colour and well lit. The ceilings were slightly in shadow, of a different colour from the walls, which tended to be pale in tone and always papered with simple designs. The floors, too, tended to be carpeted in pale colours, which matched the curtains and the fabrics used to cover chairs and tables.

Furniture was a key aspect of Biedermeier interior design. Until around 1825, the preference was often for older styles, which served as a reminder of the past. Subsequently, antique furniture, specially in the Empire style with gilt-bronze mounts, fell com-

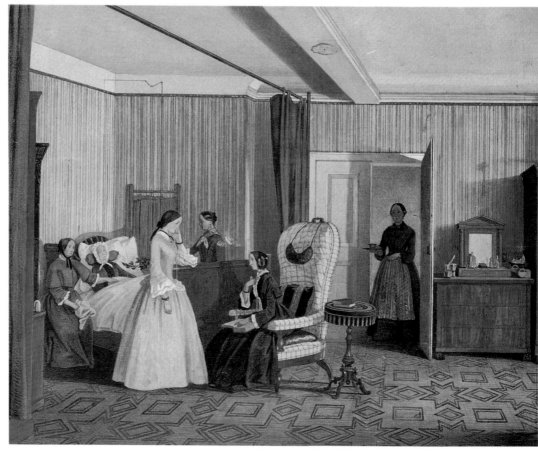

These water-colours depict Biedermeier interiors from the years 1830 to 1840. FACING PAGE, TOP: a sitting room. FACING PAGE, BOTTOM: a bedroom. THIS PAGE: a study. Their common feature is a concern for simplicity and comfort in the arrangement of the furniture, though vestiges of the Empire style are still evident. Kunsthistorisches Museum, Vienna.

pletely into disuse. The most common items of modern furniture were sober in form and made of light-coloured woods: centre tables; upholstered chairs; a *servante* or small display cabinet for silverware, porcelain and vases; small writing desks or secretaires, where the man of the house would keep his papers; musical instruments; small armchairs, often positioned near a window; plant holders, often of the kind mass-produced by the Danhauser Möbelfabrik in Vienna. Biedermeier settings were often enlivened with flowers and vegetation: greenery, which was rarely lacking in homes of this period, emphasised the vital link between man and nature.

Paintings also played a fundamental part in Biedermeier decoration, with a preference for oils and water-colours. The latter, much appreciated for their transparent, spontaneous effect, were imported into German-speaking countries from France and England. The preferred genres were those exalting the ideals of the time: domestic interiors; the group portraits known as *Familienbilder*, inspired by 18th-century English conversation pieces of similar intent; landscapes, both urban and rural, but especially Alpine scenes recalling time-honoured traditions, adopting the style and iconography of 18th-century Dutch art; scenes from daily life, in particular children's games, and street scenes with a good-natured, paternalistic slant; and, last but not least, national historical events.

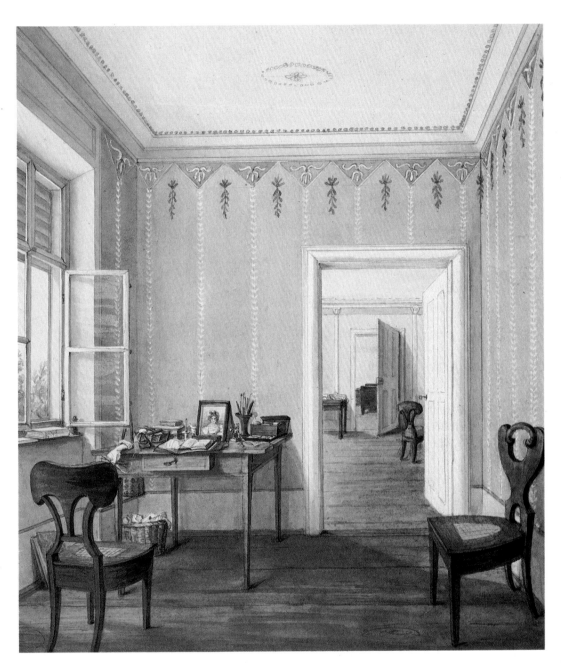

The many faces of Eclecticism

Louis-Philippe: an excessive style

Louis-Philippe is the term normally used for the style that became popular in France in the years 1830–48, coinciding with the constitutional monarchy of the "bourgeois" King Louis-Philippe, of the House of Orléans. It reflects the tastes of a society that was basically conservative and attached to material values, but with Romantic leanings.

Initially, the royal family lived in the residences occupied formerly by Napoleon, then by Louis XVIII and Charles X, making only minor changes to the interior decoration. Subsequently, a more radical remodelling was undertaken, especially at Versailles and Fontainebleau, including the introduction of furniture and artefacts in historical styles. Tastes at court were followed by the aristocracy in the design and decoration of their new town houses (*hôtels*).

It became fashionable to revive historical styles by introducing genuine antique furniture, or almost perfect reproductions, into a given setting. One of the most popular styles was Louis XV, which, though it satisfied the need for comfort, tended to create a sense of heaviness and excess, and conveyed a feeling of unease and pretentiousness. But, to make matters worse, Louis XV was bizarrely combined with styles of classical derivation; with Boulle furniture, which was undergoing a revival; and with decoration of Neo-Gothic or exotic inspiration.

Excess was the predominant feature of the Louis-Philippe style, paving the way for the fashion that was to prevail in the sec-

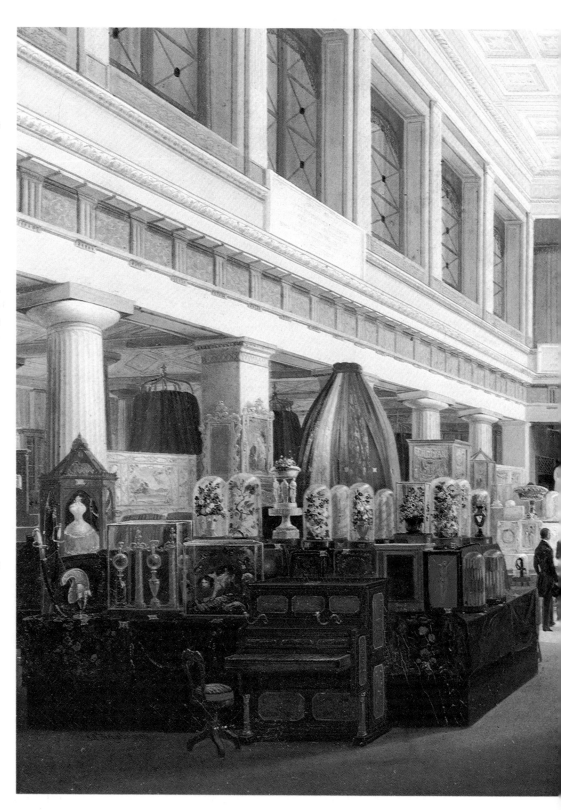

The exhibition of arts and crafts held in Naples in 1854 is recorded in this painting by Salvatore Fergola (1799–1877), *Prima Mostra Internazionale Napoletana alla Sala Tarsia nel 1854:* displayed in a vast hall decorated in a style clearly inspired by Pompeii, the exhibits included flower arrangements in glass cloches, paraffin lamps, musical instruments, sculpture, and "archaeological" porcelain and ceramics, which reflected the eclectic tastes of the period. Museo Nazionale di San Martino, Naples.

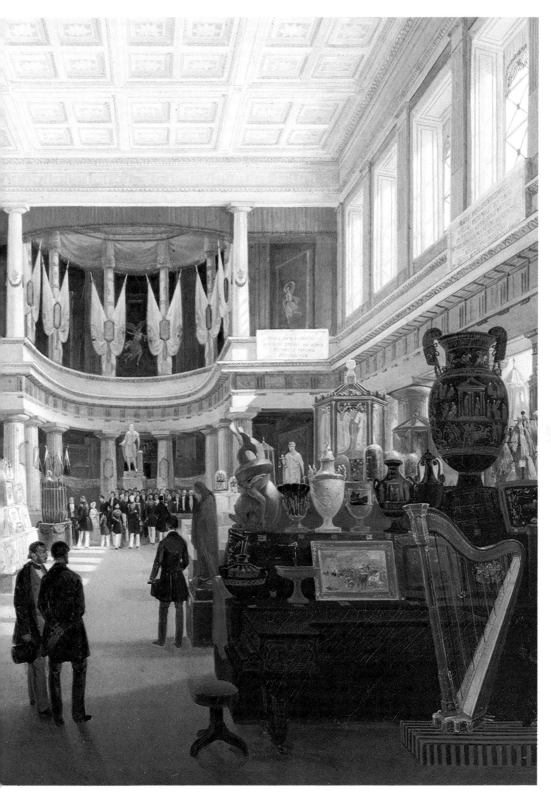

ond half of the 19th century – the Eclecticism of the Second Empire period. It was reflected in the design of the rooms, the furniture, and the individual objects used as decoration. Furniture had to satisfy the requirements of comfort and ostentation. Upholstered, button-back divans and armchairs came into favour, as did marquetry, painted and sculptured decoration (including papier-mâché), leather upholstery and lacquer.

Excess was also a characteristic of *objets d'art* and collectors' pieces: sculptures, bronzes, clocks, curtains, wall-hangings, masks, porcelain, cornucopias and book bindings. The general superabundance of decoration and ornament gave a sense of melancholy and artifice. Floral motifs were everywhere: on walls and upholstery, decorative vases and furniture, carpets and floor tiling, and in the form of flower arrangements housed under glass cloches.

The rationale of Eclecticism

Around the middle of the 19th century, there was a strong trend, in architecture and interior design towards a kind of cultural syncretism, with stylistic elements borrowed from a diversity of past civilisations: Romanesque and Gothic; Renaissance in all its Italian regional variants and European guises; Mannerism and Baroque; and also Turkish, Indian, Chinese, Byzantine and Moorish.

As we have seen, the revival of historical styles, which was the driving force of Eclecticism and which dominated Europe be-

tween the mid-century and the 1890s, was not without precedent. But during this period, it became a widespread and virtually unified phenomenon, although it found a wide diversity of expressions and meanings in the different cultural settings where it took hold.

The mid-century revivals took place against a background characterized by advances in technology, rapid industrialisation and new demands from the emergent bourgeoisie involved in capitalist expansion, but also overt protest on the part of artists against the way in which power was exercised by the middle-classes.

The eclectic love of historical styles, which led to sometimes questionable and tasteless results, was still in some respects a manifestation of the Romantic tendency to justify art in terms of history, and to see the past as the only acceptable model for lifestyles and customs and the only valid reference point in matters of morality. In some ways, it may be regarded as the last gasp of Romanticism. However, properly understood, Eclecticism was also a fruit of a new understanding of history, which began to emerge in the middle of the 19th century.

"The pre-eminent characteristic of our century is its sense of history", wrote Gustave Flaubert in a letter dated 1854. The past was closely associated with the present: in fact, past and present were the two faces of one and the same experience of on-going life. During the eclectic era, reflection on the past was not therefore intended to lead merely to various acts of restoration, but to an improvement of present reality based on comparisons with, and appropriate choices of, earlier forms.

History became a scientific discipline. All events and styles making up the flux and development of history were, without exception, scrupulously examined and objectively classified with a strict and detached sense of dis-cernment, free of metaphysical or aesthetic moralising.

Some of the defining aspects of historical eclecticism were a tendency to escapism, the cult of objects, a fondness for theatrical settings and illusion, the quest for a unity of the different arts and, finally, the veneration of technology and progress in producing works of art.

Historical styles and exotic influences

Eclectic escapism consisted partly in mythologising the fruits of earlier experience, which were regarded as historically valid and reusable in new settings. It was born of an intolerance of the present, and of a need to safeguard timeless human values threatened by modern civilisation. It therefore found expression in the revival of historical styles, and the introduction of exotic influences from beyond the borders of Europe.

Like revivalism, exoticism also had roots which went far deeper than the mid-19th century. The passion for exotic cultural forms in fact dates back to the Baroque era, to the time when western civilization was first brought into sustained contact with the way of life and customs of peoples living overseas. In the mid-19th century, this passion was reawakened by the systematic process of colonization undertaken by the western powers. Deeper knowledge and the renewed importation of exotic objects, materials, customs and styles stimulated the imagination of contemporaries.

As had happened in the past, the way in which exotic and non-

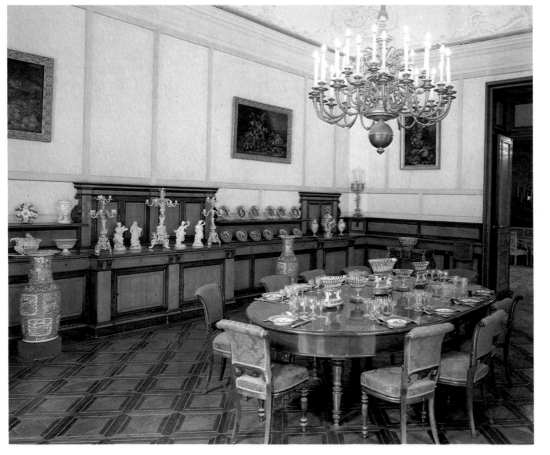

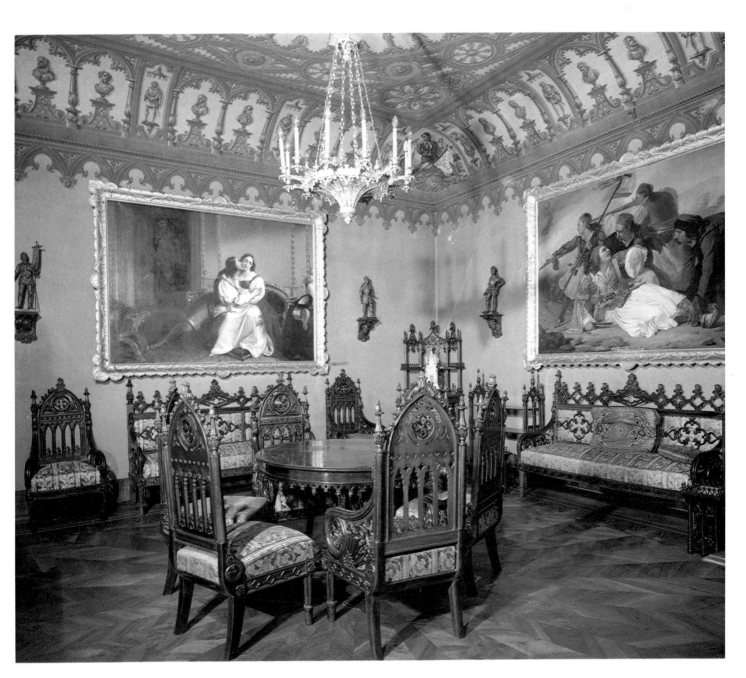

European styles and artefacts were introduced led to a loss of their historical relationship with the cultures concerned. In other words, oriental styles and artefacts were regarded purely as fragments, self-contained phenomena, detached from and independent of the cultural context in which they originated.

The oriental items we find in European interiors dating from the second half of the 19th century in fact exist outside time, their main purpose being to trigger day-dreams, nostalgic memories, hidden desires and repressed longings.

Along with the revival of models and styles from the past and non-European sources, a fundamental aspect of Eclecticism was the cult of the object, which was admired, sought after and displayed for the sake of its metaphorical value and power of suggestion.

Paintings, daguerreotypes, cushions, rugs, mirrors, console tables, armchairs, bamboo side-chairs, screens, lamp-stands, card tables, velvet curtains, bibelots,

Some of the rooms in the summer residence of the Savoy family at La Mandria, near Turin, showing how, by the mid-century, very different styles could co-exist in the same building. BELOW: the *Sala del Consiglio,* with solid, natural-wood furniture and trophy-style decoration and hunting scenes, creating a bourgeois version of the Rococo. FACING PAGE, TOP: the Antechamber, furnished in the Neoclassical style, with typical lacquer-work and gilding. BOTTOM: the Rococo-style *Sala Verde* (left) and the bedroom of Vittorio Emanuele II (right), in the style known as Louis-Philippe.

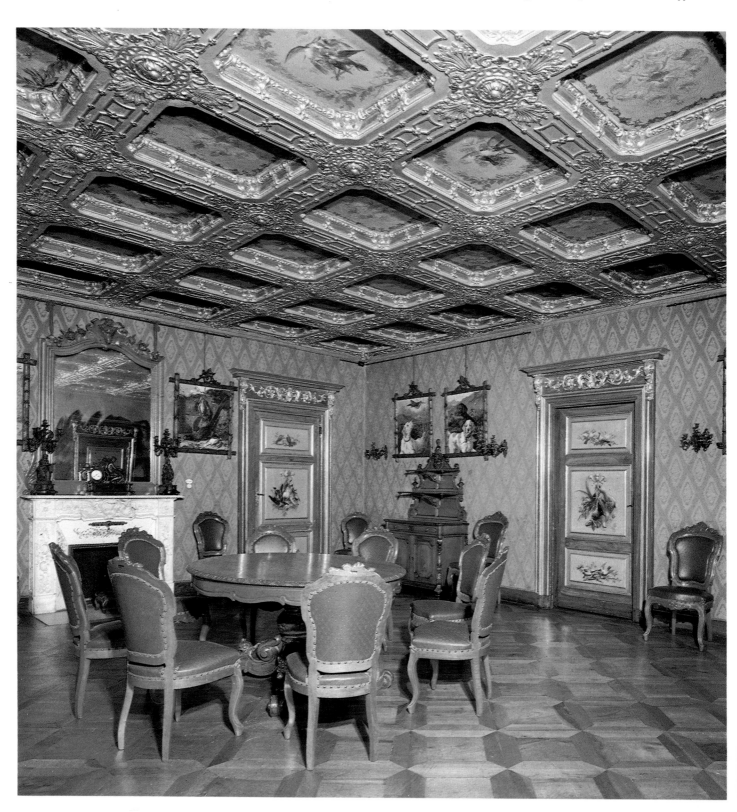

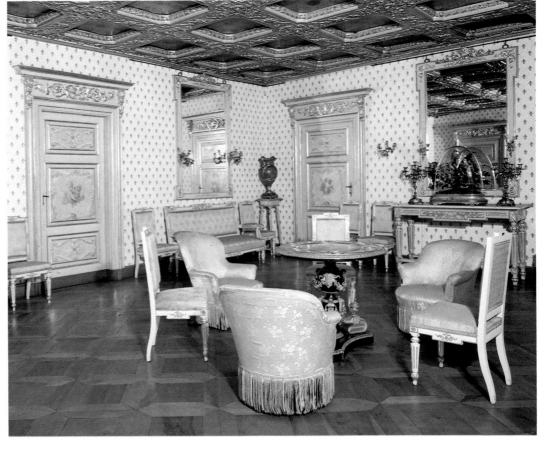

amphorae, filigree silverware, *cloisonné* enamel-work and damascene inlaid daggers were the props of a highly charged stage set, whose allegorical allusions and references were intended to suggest a dimension of ambiguous and disturbing beauty, and also of well-being and timelessness.

Objects considered individually for their inherent value conveyed the idea that history is made up of fragments perceived through the filter of human experience. They were used to enhance their surroundings and help create a dramatic, theatrical atmosphere.

Interiors conceived as stage sets

Theatricality and illusionism were in fact another essential component of Eclecticism. This aspect of the style was grounded in the contemporary experience of melodrama, which at the time was one of the most popular forms of entertainment.

Melodrama was a stage-based, musical type of fiction, containing constant references to historical and everyday events, intended to arouse strong feelings and psychological tensions in the spectator, and create a continuous interchange between art and live, past and present.

As in melodrama, the theoretical tendency underpinning Eclec-

ticism was that of the *Gesamtkunstwerk*: the quest for a synthesis of the arts, which from an expressive point of view were all regarded as equally valid. In late-Romantic theory, the validity of such a synthesis was justified in terms of a common goal, i.e. the intense and undifferentiated emotional impact the various arts were intended to have on the spectator.

Music produced effects similar to those of painting and literature; the figurative arts, in their turn, were capable of producing a musical effect. The theatre was a synthesis of the various arts, the place where the barriers between their different modes of expression could be finally abolished. Richard Wagner and Philipp Otto Runge in Germany, Arrigo

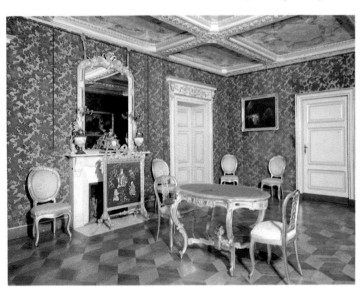

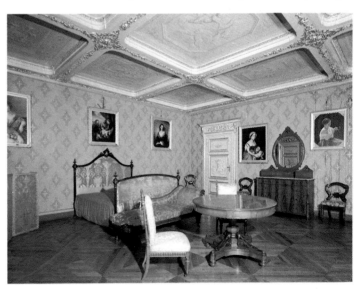

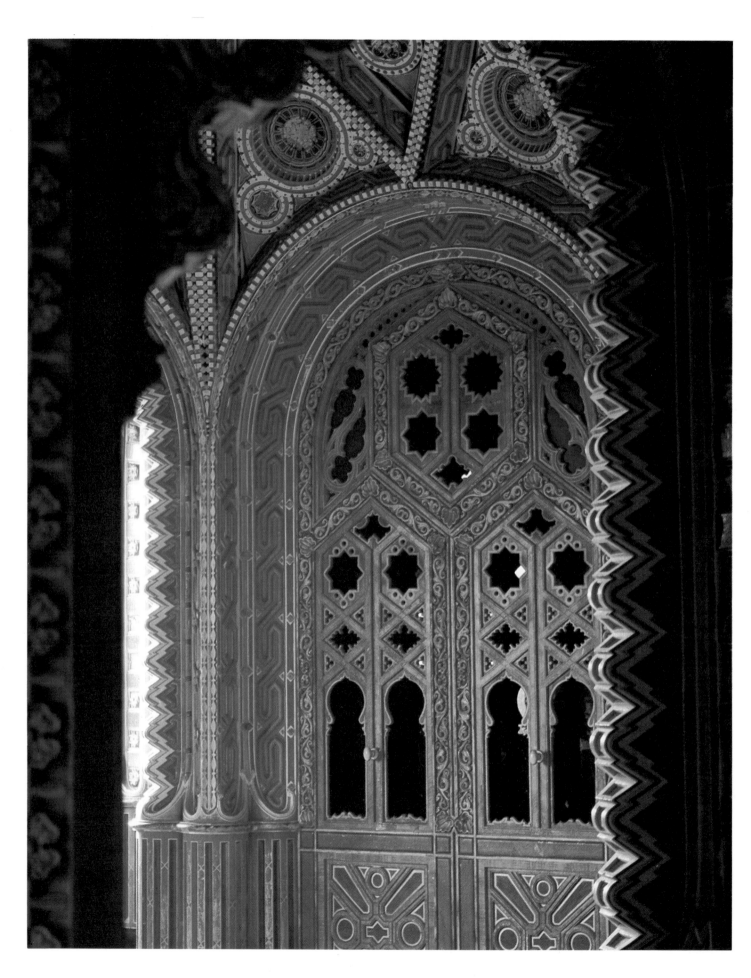

Two interiors from the Castello di Sammezzano, near Florence, a Tuscan villa converted into a Moorish palace by Marquis Ferdinando Panciatichi Ximenes d'Aragona: FACING PAGE: one of the false windows in the "Spanish-Plate" Octagon. BELOW: the bathroom, equipped with a Renaissance-style marble bath tub. FOLLOWING

PAGES: the State Bedroom of Ludwig of Bavaria at the castle of Herrenchiemsee, built between 1878 and 1883 in the Neo-Baroque style by Georg Dollman: one of the most theatrical castles built by the king, who sank a fortune into these lavish enterprises.

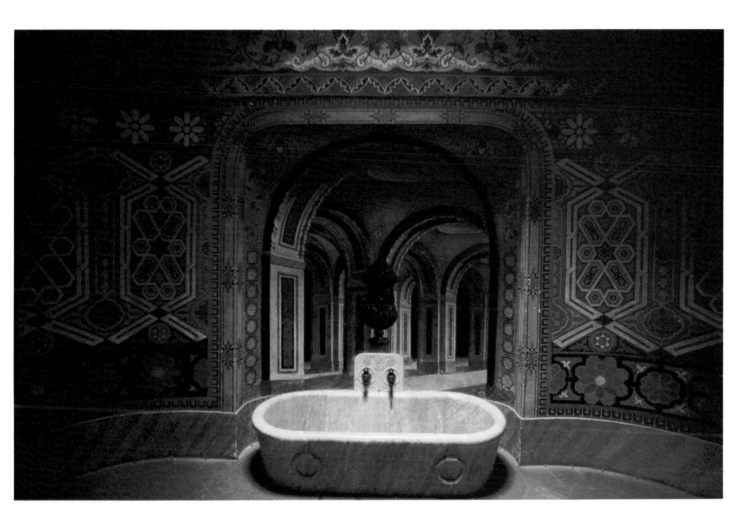

Boito in Italy and Eugène Delacroix in France were the main proponents and supporters of this theoretical position, which midway through the century seemed to be gaining acceptance and finding expression. Whereas in Delacroix and Boito the idea of a synthesis of the arts was still presented in terms of the late-Humanistic theory of *ut pictura* (or *musica*) *poësis*, in German culture it was elaborated in considerable depth. Schlegel, in his *Aphorisms* (1798), and later Runge, in *Hinterlassene Schriften* (Posthumous Writings, 1841), put forward the theory that the different

forms of linguistic expression were all equally capable of acting on and engaging the spectator so as to convey life, imagination and divine revelation through a work of art. Wagner, in *Die Kunst und Revolution* (Art and Revolution, 1849), gave the problem a sharper sociological focus, pointing to sculpture and musical drama as the forms best suited to translate this theoretical hypothesis into reality.

New types of decoration

The breaking down of the barriers between the different arts was immediately reflected in new forms of interior decoration. In rooms crammed with *objets d'art* designed to convey a sense of fullness and comfort, and rarefied, ambiguous beauty, decorative artefacts assumed architectural forms and connotations; furniture was designed as sculpture; and the materials of the individual components of the decor were deliberately used to achieve interchangeable expressive effects: wood in imitation of marble, pa-

per which simulated wood, patinized wood as if it were gold, painted wallpapers, photographs represented sculptures or were touched up to resemble paintings.

Progress in the arts and technology, their capacity to develop and stand free of the past, was one of the great myths of the mid-19th century. This idea found its truest expression in the Universal Exhibitions organised at intervals in different parts of Europe, beginning with the Great Exhibition of 1851 in London. In the various sectors products were displayed representing

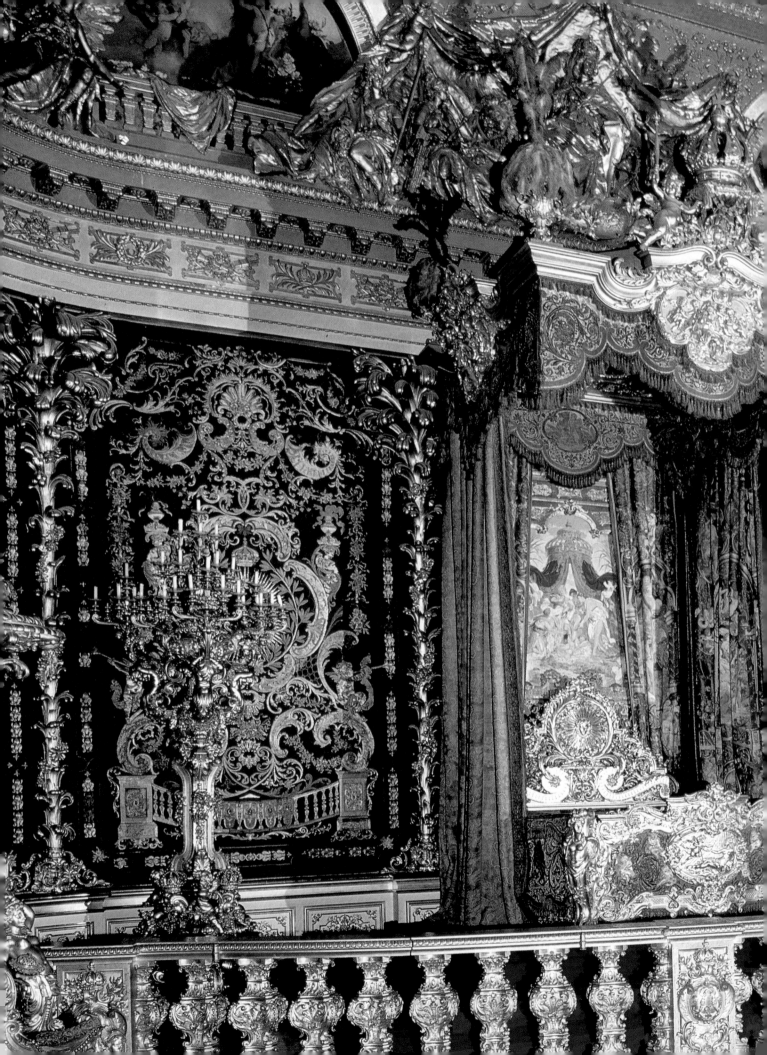

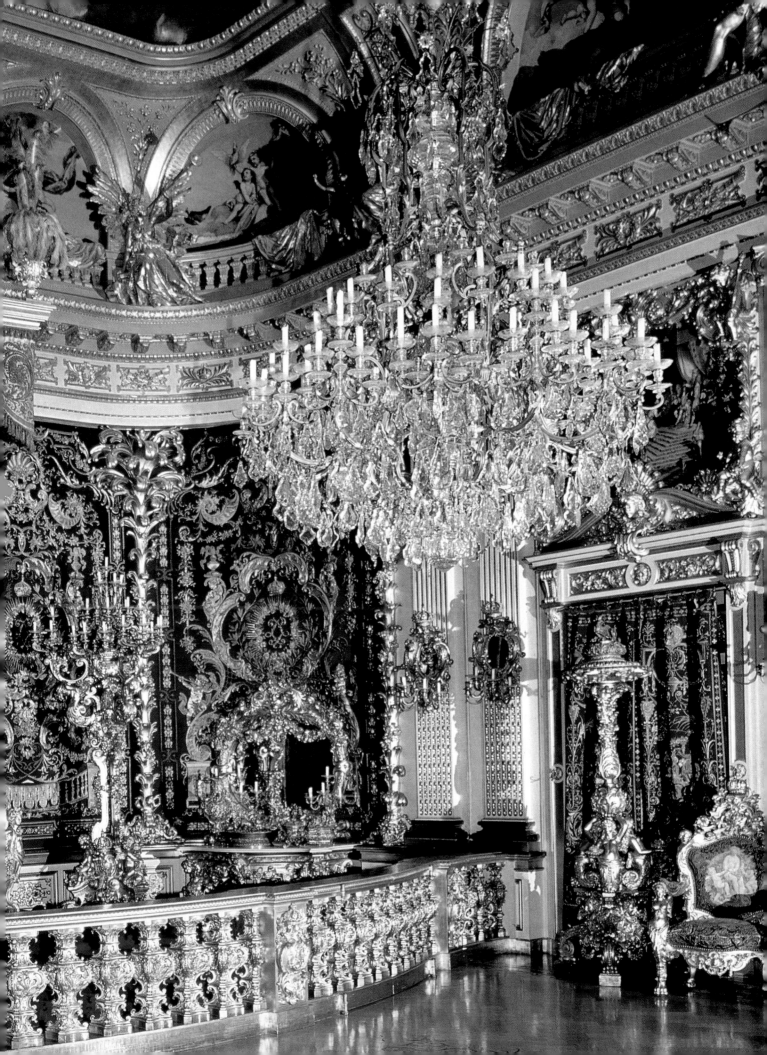

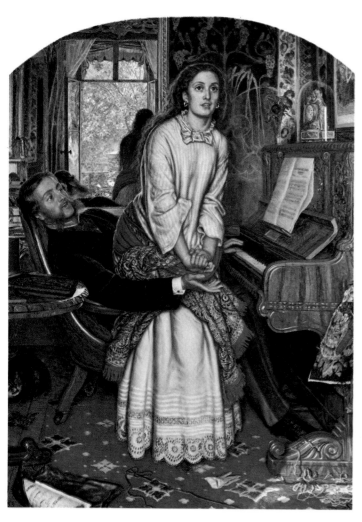

rooms and libraries. They contained reproductions of all the exhibits and served as a permanent reminder of these passing events, which inevitable ended with the closure and dismantling of the Exhibition buildings.

The new eclectic style was also disseminated by reviews and periodicals which set out to comment on and explain the on-going debate in the arts, and to present new products. Periodicals of this type flourished throughout Europe. They were printed and sold in large numbers, and reached a vast readership.

The Victorian age

In a speech given at a banquet held in his honour to mark the inauguration of the Great Exhibition of 1851, Prince Albert noted that anyone observing the signs of the times could not doubt for a moment that they were living through a wonderful period of transition, which tended to achieve the great purpose on which all moments of history converged: unity of action. The distances separating different nations and the most remote parts of the globe were being rapidly reduced by modern inventions and could be overcome with incredible ease. Thought was communicated with the speed and power of light. The powerful principle of the division of labour, which could be defined as the driving force of civilization, had been extended to all branches of science, industry and art. The products of all parts of the earth were at their disposal, and all they needed to do was to choose the best for their purposes. Man was, therefore, much nearer to

the accomplishment of the great and sacred mission that was his to fulfil in the world. Prince Albert's sentiments reflected the generally held ideas and convictions of Victorian culture, which themselves influenced the choice of artistic styles, particularly in interior design.

The guiding principles of this outlook were faithfully reflected in the London International Exhibition of 1851, held in the glass-and-iron Crystal Palace, which was specially built from designs by Joseph Paxton (1803–65). They can be identified by study-

the highest achievements in the arts and crafts and the latest technological developments. The objects on show were intended to acquaint the public with new materials and processes. Some of these became fashionable and were immediately applied to interior design, in particular zincography, chromolithography and photographs of sculpture. The popularity of these techniques was due to the fact that the resulting products were cheaper than those made by traditional artists, introducing art to a much wider public.

According to François Ducuing, writing in 1867 about the

silverware made by the Parisian firm of Christofle: "I have already said that in our time art is obliged to become industrial. The fact is that taste and luxury have become the heritage of the less wealthy. Art loses nothing by being popularised in this way; on the contrary, it can gain in resources, as it has already done by making science its servant."

These new discoveries in the arts and technology were also spread by publications that appeared throughout Europe in the wake of the Exhibitions themselves, in particular illustrated albums, beautifully bound editions of which were kept in drawing

FACING PAGE: a typical Victorian interior, comfortable and welcoming, crammed with warm-hued wooden furniture and objects of different origins and styles, as depicted by William Holman Hunt (1827–1910) in *The Awakening of Conscience*. Tate Gallery, London. BELOW: the Reception Room of the Plein Palace in The Hague (1849) in a water-colour by H. F. C. ten Kate: a Neoclassical setting furnished with mainly Neo-Rococo furniture, in particular the large ottoman in the centre and the corner divan which completely blocks one of the doors. Oranje-Nassau Museum, Delft.

ing two aspects of Victorian culture, which together constitute a chapter of the more general phenomenon of Eclecticism. For convenience sake, we shall examine them separately.

First let us look at the activities of the designers favoured by the British royal family. They worked mainly in the field of the decorative arts, concentrating particularly on the domestic environment. Secondly, there is the vast body of written material published in parallel with their activities. Albums, essays and periodicals provide a very full picture of the underlying mechanisms determining the tastes of this cultural environment, in both theoretical and practical terms.

Two of the most celebrated Victorian designers were John Thomas and Alfred George Stevens, who produced plans for chimney pieces, trophies, table displays, clocks, wall-lamps, furniture, porcelain, ceramics, glassware, fabrics, lamps, plant holders, upholstery, stoves, decorative vases, carpets and wallpapers. John Thomas (1813–62) was one of the favourite court architects and sculptors. Trained in Birmingham, he worked to revive styles and techniques belonging to the Classical and Renaissance tradition. Alfred George Stevens (1817–75), who lived in Sheffield from 1850 to 1852, showed a thorough grasp of social problems in his work as craftsman and designer.

Naturalism and Historicism were the two dominant aspects of the products of the early Victorian period. According to the German architect and thinker Gottfried Semper (1803–79): "Inspiration from nature is the most praiseworthy aspect of the best contemporary design" – a point of view echoed by the English critic John Ruskin (1819–1900), who believed that everything beautiful and honest in architecture was imitated from natural forms.

In other words, naturalism, as conceived by the Victorians – and indeed by the French and German realists – was the true end of art, in that it represented fidelity to reality as perceived and experienced.

By remaining close to nature, conceived as visible reality, artists saw themselves as correctly performing a scientific task. In England, the scientific outlook embraced artistic research and experimentation and directed them towards the scrupulous rendering of visible forms and natural phenomena.

The interest in historical styles, combined with naturalism, was all part of the belief in a close relationship between history and man's experience of reality. However, it was also a way of achieving a sense of illusion and surprising *trompe-l'œil* effects; and better rendering the billowing, spontaneous vision that lies at the heart of artistic experience.

Theoretical articles and essays

The plans and compositions of Victorian designers were, as we have seen, widely disseminated by magazines and periodicals. Some of the publications with high circulation figures were *The Art Journal, Building News, The Illustrated London Building News* and, especially, *The Journal of Design and Manufactures*, the

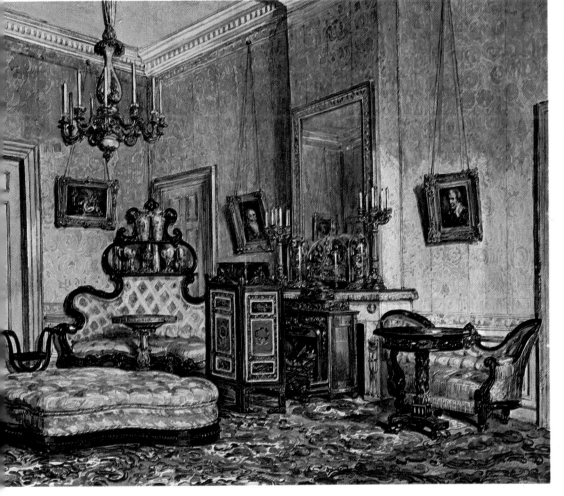

Interiors of the Château de Ferrières (1859), near Paris, designed for the Rothschild family by Joseph Paxton: whereas the Grand Hall (right) includes elements of Renaissance, Baroque and Mannerist architecture and decoration, the Main Staircase (below) is faithful to French 18th-century models. FACING PAGE: design for a bedroom, gouache (1874) by G. Félix Lenoir. A rethinking of Renaissance and 17th-century styles is evident in the wall decoration, pod motifs of the base of the canopied bed, and the tabernacle-style bedside furniture. Musée des Arts Décoratifs, Paris.

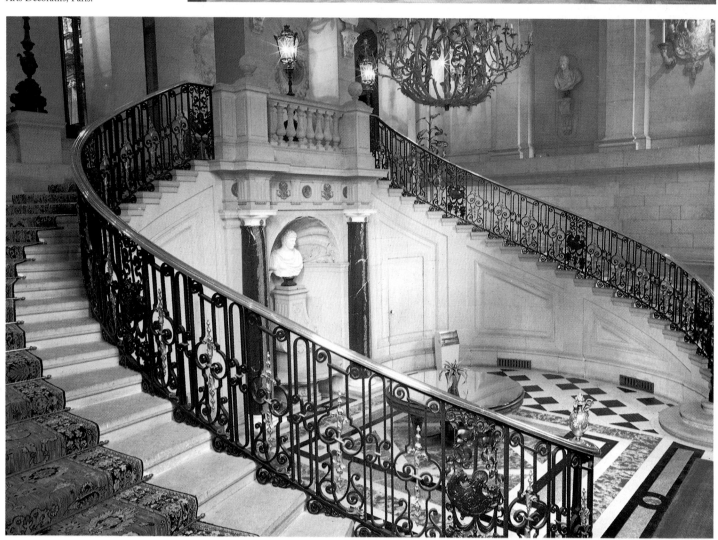

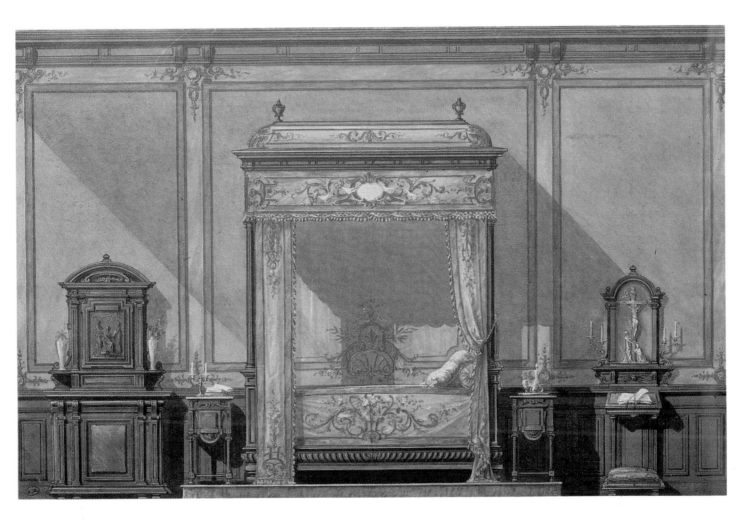

mouthpiece of Henry Cole, was edited by Richard Redgrave, which was published from 1849 to 1852. In parallel with the illustrations and articles that appeared in periodicals, new developments were discussed in theoretical essays concerned with the aesthetic bases for different styles. Nikolaus Pevsner (1968) has given some interesting examples of these debates.

In 1841, Richard Brown attempted a rational classification of styles in a widely read work entitled *Domestic Architecture*. It was illustrated with patterns for the styles of interior design most fash-ionable in the early Victorian period, and which continued to be popular until the 1880s and 1890s. Those taken into account by the author were Norman, Tudor, Stuart, Anglo-Grecian, Grecian, Pompeian, Florentine, Venetian, Anglo-Italian, French, Persian, Moorish, Chinese and Spanish.

The problem of reviving historical styles, their varied nature, and their inclusion in schemes for interior decoration and furnishing was central to other studies of the early Victorian period, such as those published by Ralph Nicolas Wornum, Richard Redgrave and George Gilbert Scott.

For Wornum (*The Exhibition as a Lesson in Taste*, 1851) as for Richard Brown, the starting point of his studies was a classification of the styles that could be used in designing an interior. His theoretical system included no less than nine styles, subdivided into three classical, three medieval and three modern. In his opinion, however, the final three (Renaissance, Cinquecento and Louis XIV) provided the best sources of inspiration for decorative and ornamental features.

Wornum's classification was also accepted by Richard Redgrave in his *Supplementary Report on Design* (1852), the theoretical part of which was concerned with expounding the principles on which modern design was based and the ways it differed from design in the past.

Other contemporary authors, rather than concern themselves with stylistic matters and ornamentation, preferred to focus on technical questions and the new materials becoming available. In a dissertation on the products displayed at the Great Exhibition, Matthew Digby Wyatt, first Slade Professor at Cambridge, sang the praises of iron and brick and, in a lecture given at about

The Neo-Rococo, an excessive interpretation of the original 18th-century style, was very popular with almost all the royal families of Europe, who adopted it for court and official settings. Bottom left: the Grand Salon of the Ministry of Finance (1870–80), Paris. Below right: the *Comedor de Gala* (1879) in the Palacio Real, Madrid.

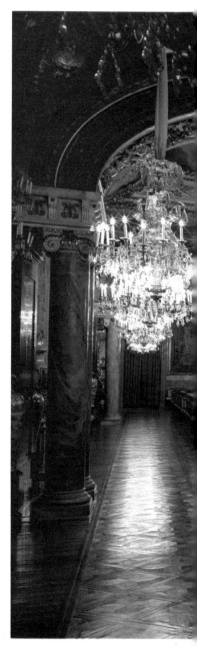

the same time (*An Attempt to define the Principles which should determine Form in the Decorative Arts*) looked at the problem of ornamentation in relation to the materials and techniques adopted.

The use of metals was also central to George Gilbert Scott's treatise, published in 1858, *Remarks on Secular and Domestic Architecture*. One thing that is beyond doubt, however, is that all these essays were influenced by the thinking of Semper, whom we mentioned earlier.

The great German architect and critic was in fact in London in the years of the Great Exhibition, following an enforced stay in Paris after his involvement in the Dresden riots of 1849. He was directly involved in the Great Exhibition of 1851, for which he arranged some of the buildings. In 1851, he published his first important theoretical work: *Die vier Elemente der Baukunst* (The Four Elements of Architecture) and in 1852, *Wissenschaft, Industrie und Kunst* (Science, Industry and Art).

The latter was an essay taking stock of the London Exhibition, and should be studied in conjunction with other commentaries on the event published by Semper in contemporary English periodicals. In these notes, and again in his last famous work, *Der Stil* (Style, 1860), despite reservations due to his abiding love of classicism, the German architect gave great prominence to materials and techniques, which he saw as having a determining influence on style. He also emphasised the manual aspects of creative art, and "minor" art forms.

The influence of William Morris

The importance of technology, materials and, above all, manual labour as components of the productive process comes through strongly in the works of William Morris, a key figure in the culture of the mature Victorian era. Painter, designer, poet and writer, Morris began producing furniture and decorative artefacts in 1859.

In 1861, he set up a firm, Morris, Marshall, Faulkner & Co., to manufacture furniture, wallpapers, tiles, textiles and stained-glass windows to designs by Ford Madox Brown, Dante Gabriel Rossetti, Philip Webb and John Pollard Seddon. Convinced of the virtues of old-fashioned craftsmanship, Morris began from the assumption that art should free modern man from the degrading conditions in which he was forced to work. "Art is a positive necessity of life", he wrote in the essay *The Beauty of Life*, and as such should be born of a revival of manual labour and a re-valuing of craftsmanship.

Like Pugin and Ruskin, Mor-

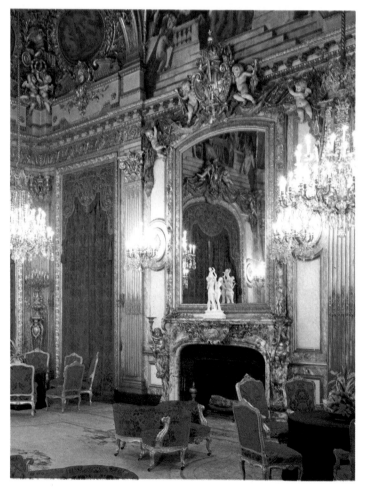

ris turned to the Middle Ages for inspiration. Unlike them, however, he did not identify the medieval period with the realisation of religious ideals and a liberation of the imagination, but saw it as a time of social solidarity when artistic endeavour was based on

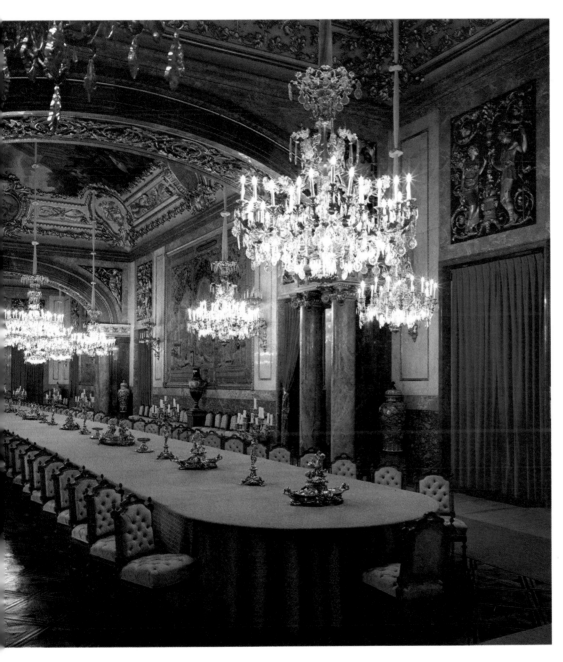

the anonymous craftsman's workshop and cathedral building site, with their collective subdivision of labour and technical skills.

Morris's influence persisted throughout the Victorian era, evident in practical achievements and published material. J. Loftie (*A Plea for Art in the House*), O. Smith (*The Drawing Room*), Baker (*The Bedroom and Boudoir*), R. A. Garrard (*Suggestions for a House*), H. R. Harveis (*The Art of Beauty*), R. W. Edis (*Decoration and Furniture of the Town House*) and Bruce Talbert (*Gothic Forms Applied to Furniture*) were the authors who best codified many of Morris's ideas.

The basic themes of these publications, which found practical realisation in interiors designed by E. W. Godwin, Bruce Talbert and William Burges, continued to be simplicity, purity and rigour of form and ornament. The house should speak an everyday language with spontaneity, honesty and clarity. Simplicity was achieved by the use of wooden panelling, and a revival of furniture in the English Gothic style, the Elizabethan and Tudor tradition, or deriving from Adam, Chippendale or Sheraton.

There was also a great deal of interest in oriental styles, in particular the Japanese. Like France and Germany, England was struck by a wave of enthusiasm for things Japanese in the 1860s. Japanese art influenced western tastes in graphic design, painting and ceramics, particularly in the areas of landscape, costume, buildings and ornamental motifs. Interest in Japan offered an escape from everyday reality and a stimulus to return to nature. "The influence of Japan", wrote Emile Zola, "helped free us from mere tradition and showed us the luminous beauty of nature". According to Bing, writing in the *Japon artistique* in 1888, "it is like a drop of blood mixed with our blood, that no force in this world can destroy".

The "pompier" style

Pompier was the name given to the style popular during the Second Empire, the reign of Napoleon III (1852–70), which was the final period of absolutist rule in France. The Emperor himself had no special interest in the arts. In the early years of his reign, he lived in the residences that had been occupied by his predecessors without making any substantial changes. Not until around 1860 did he decide to

modernize the royal palaces, by then regarded as old-fashioned. However, Napoleon III was by no means a typical patron of the arts. He regarded the work on the royal residences purely as a practical means of stimulating certain sectors of the economy, which during the Restauration had fallen on hard times, in particular the silk, ceramics and cabinet-making industries. As the Emperor saw it, his venture into the world of the arts served primarily a social purpose, giving a new lease of life to craft activities.

Other members of the French court were, however, patrons of the arts in the sense that they exercised a real influence in matters of taste: first of all the Empress Eugénie, then the Princess Matilde and her brother, Prince Napoleon. Eugénie had artistic aspirations. She was a competent water-colourist and drew a plan for the Paris Opera, retouched by no less a figure than Garnier. Her interest in interior design was proverbial, to the point where, in *Corde sensible* (1862), Morny and Mérimée have one of their characters – an out-of-work artist – say: "If I tell her she is beautiful, witty and charitable, she will probably not reply. But if I swear that she knows better than any upholsterer how to chose the furniture and fabrics for a sitting-room, might she not employ me to do the decoration?"

In sponsoring the redecoration of the royal residences, Eugénie went in for a hybrid mixture of Rococo and contemporary furnishings. For example, she had the Louis XIV-style furniture of Saint-Cloud transferred to Compiègne, and combined it with newly made modern furniture because it was more comfortable.

Once a week, she would invite to Compiègne the artists she liked to have around her: Viollet-le-Duc, Hittorf, Garnier, Carpeaux, Dubois, Meissonier and Doré.

The Princess Matilde's interest in the figurative arts is also well known. A lover of painting (she exhibited several times at the Salon between 1859 and 1867), she regularly entertained a circle of famous artists at her home in the Rue de Courcelles, which was attended by Carpeaux, Gavarni, Doré, Meissonier, Hébert and others. From the court registers, it also emerges that she personally commissioned and selected several hundred items for the decoration and embellishment of the royal residences.

Her brother Napoleon also took a serious interest in art. He was fond of revivals, particularly of the classical styles, as is clear from his model of the temple of Empedocles, or the Pompeian-Style decoration of his own home in the Avenue Montaigne, where the Prince would often stage drama performances in the classical manner.

A bourgeois *clientèle*

The influence of the court in promoting new artistic fashions was, however, limited. Of far greater weight was the emergent bourgeoisie. After the Revolution of 1848, the middle classes were very much in the ascendant in France, as elsewhere. They embraced the arts because they served to create a comfortable, reassuring framework for daily living. This new clientèle, which began to dictate the prevailing fashion, rejected Naturalism as vulgar and unsuited to the pur-

poses of entertainment and display.

They looked for a style that would better project their self-image, power and aspirations. They therefore adopted a sugary, slightly idealised form of Realism, rejecting Impressionism, which they judged devoid of ideals. They gave prominence to comfort, luxury and opulence, believing that excess was a sign of acquired prestige, ostentation of the state of well-being and importance to which they had attained.

Second Empire interiors tended to have expensive damask wall-hangings, which created a reassuring sense of privacy and isolation, cutting off contact with the outside world and muting the clamour of modern civilisation, represented by the busy traffic in the streets below. Massed around the new gas lamps, which created a sense of solemn opulence, decorative and functional items such as pendulum clocks and zinc or black-wood candelabra formed a complex pattern with the furniture, the velvets and brocades of the curtains and upholstery, and the carpets.

Furniture was mostly machine made. The dark-oak, heavily carved pieces were often enhanced with zinc plating, or lacquered, following the fashion of the immediately preceding period. The item that truly represents the Second Empire period was the padded (*capitonné*) armchair, first introduced around 1840.

The luxurious and, at the same time, depressing excesses of the Second Empire were also connected with a standardisation of decor, resulting from mass production methods. Machines

could achieve precision in the rendering of detail, but were also responsible for repetitiveness in decorative schemes and ornamental motifs.

The Second Empire saw the final disappearance of the *Ouvrier de chambre*, the foreman who had played a central role in organising interior design projects in the late 18th and early 19th centuries. He was replaced by a team of artisans supervised by the manager of the firm responsible for making the various furnishings. Individual craftsmanship was superseded by central planning, and this pattern soon spread from France to other European countries.

Ludwig of Bavaria's castles

Ludwig reigned from 1864 to 1886, the year of his suicide. From the 1860s until the time of his death, he pursued an intensive building programme, the eclectic style of which reflected his fantastic, utopian ideals. The main stages of this programme were the planning of a monumental Festival Theatre, the Winter Garden and the remodelling of the Royal Palace in Munich, the castles of Neuschwanstein and Schachen, the Royal Villa at Linderhof, and finally the palaces of Herrenchiemsee and Falkenstein.

The Festival Theatre was planned for staging the works of Wagner by the greatest German architect of the period, Gottfried Semper, but it remained just a project. The Winter Garden was built by Karl Effern between 1867 and 1871, to crown Ludwig's apartment in the Residenz in Munich. An iron-and-glass con-

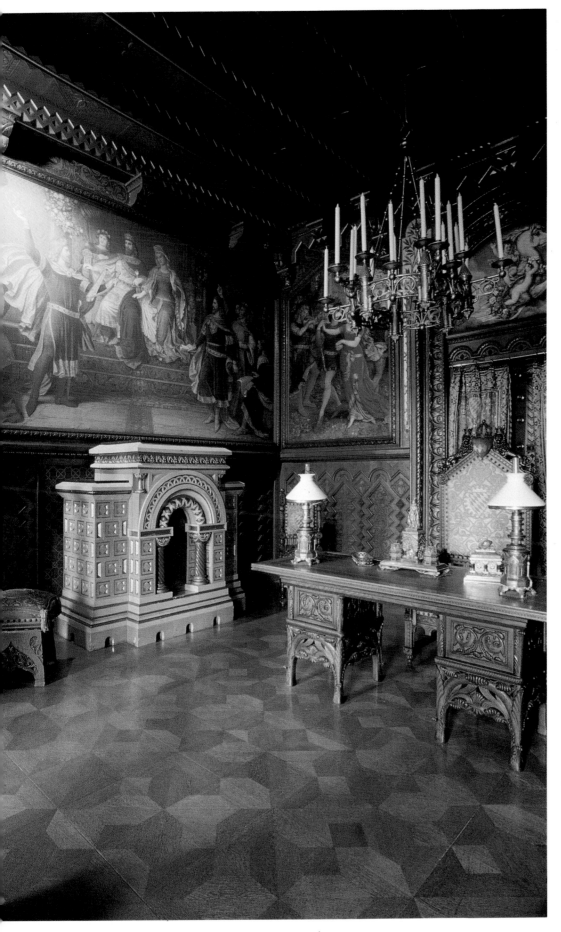

struction in the tradition of Paxton, it was a naturalistic fantasy, surrounded by a charming tropical garden with an oriental-style kiosk and Himalayan scenery painted by Christian Jank.

The remodelling and refurbishment of the Residenz in Munich was undertaken by Franz Seitz, a stage designer, who decorated the royal apartments in the Louis XIV style.

The same extravagant Neo-Baroque inspiration is evident in the castle of Neuschwanstein, built in the years 1867 to 1884 to plans by the architects Eduard Riedel, Georg Dollman and Julius Hofmann. The castle, which was never completed, was a Neo-Gothic fantasy reflecting the medieval climate of Wagner's operas such as *Tannhäuser* (Dresden, 1845; Paris, 1861) and *Lohengrin* (Weimar, 1850). The interior decoration was in the flamboyant Gothic, Byzantine and Moorish styles. The castle of Schachen, built in 1870 to plans by Georg Schneider, was on the other hand a spectacular example of exotic, oriental tendencies.

Modelled on the Neo-Rococo style of Versailles, Linderhof was begun in 1869 and finished in 1873. The palace itself was the work of Dollman, Seitz and Jank, under the direct supervision of the king; the theatre, in imitation of its counterpart at the Residenz by Cuvilliés, was designed by Julius Lange; the garden was planned by August Dirigl.

Herrenchiemsee was constructed between 1878 and 1883 by Dollman in the Neo-Baroque style. The king occupied it for just ten days in all.

Finally, Falkenstein was restored in the Neo-Gothic style between 1883 and 1884 by Max

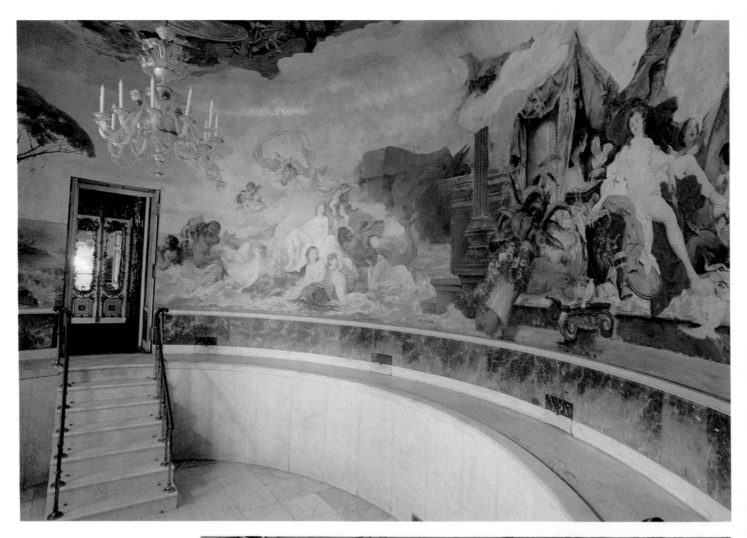

Schultze, but Ludwig never lived there.

The King's eclectic fantasies, built in a frenetic burst of energy in the late 1870s and early 1880s, cost the royal exchequer enormous sums of money. As well as the architects already mentioned, the greatest German craftsmen and decorators of the period were employed on these projects. They included the furniture-maker Anton Pössenbacher, the sculptor Philipp Perron, the bronze-caster Ferdinand Harrach, the clock-maker Carl Schweizer and the lace-makers Dora and Mathilde Jörres.

Utopian settings

King Ludwig's residences were an expression of late-Romantic feeling, making him a unique figure in his time. His architectural and

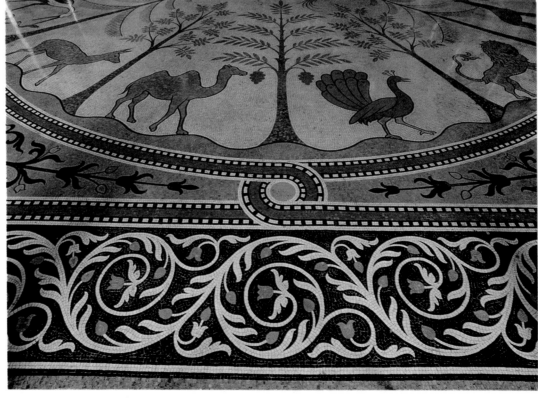

Other examples of the eclectic and bizarre decoration common to all the castles of Ludwig II of Wittelsbach, King of Bavaria, who personally supervised his lavish, utopian building programme. FACING PAGE, TOP: the bathroom at Herrenchiemsee (1878–83); this castle, created by Georg Dollman, was occupied by Ludwig for just ten days. BOTTOM: part of the decoration. THIS PAGE: a view of the Neo-Romanesque dining room at the castle of Neuschwanstein (1876–84).

decorative projects reflect on the one hand an egocentric, theatrical outlook on life; on the other, the utopian dream of a return to absolute monarchy. "These arc my favourite companions" – wrote Ludwig in a letter concerned with his castles, for which he personally selected the furnishings and materials, as well as supervising the general design – "they appear and disappear according to my will".

The castles were the fantastic settings for the king's anguished solitude, his political setbacks, his personal tragedy which began with an unhappy childhood spent in his father's medieval castles, continued in madness and ended in suicide.

Ludwig delighted in these fantasies, which he nourished by absorbing himself in the music and melodramatic productions of his favourite artist, Richard Wagner. They stimulated his individualism and frustrated sensibilities, convincing him of the sacredness of his mission and his role as the new Parsifal. This is clear from the paintings in the *Sängersaal* at Neuschwanstein, where the throne is sanctified by the presence of Christ and his apostles, and his canonized royal predecessors.

For the practical implementation of his ideals, Ludwig resorted to the cultural models provided by contemporary European eclecticism. It has been pointed out, to some extent rightly, that one historical source of inspiration on which Ludwig may have drawn were the exotic Neo-Rococo and Neo-medieval projects of George IV of England such as the Brighton Pavilion. There is no doubt, however, that Ludwig also drew on more recent and easily assimilated sources.

French models

In his elaborations of the Neo-Baroque which so dominated his imagination, Ludwig was able to draw on the revival of this style as practized in France at the time of the Second Empire. Ludwig visited France in 1867, and was also greatly impressed by the Château de Versailles.

The Neo-Baroque, or Louis XV, revival dated from the 1830s. This return to the Pompadour style is well illustrated in contemporary catalogues such as *L'Art Industriel* published by Léon Feuchère, which provided a wealth of models for furniture, *objets d'art* and decorative features. The Neo-Rococo continued to be in vogue during the reign of Louis Philippe, when its influence extended far beyond the frontiers of France: to Tunis, where the Pasha Ahmed Bey (1837–55) built his palace at Mohammedia in imitation of Versailles; to Stuttgart in Germany, where between 1835 and 1845 Queen Olga of Württemberg commissioned Villa Berg (an interesting prototype of Linderhof); and to Vienna, where the Neo-Rococo style was adopted for the restauration of the palaces of the Prince of Liechtenstein and Albert von Rothschild (designed by the Parisian architect Walter Destailleur).

During his visit to France in 1867, Ludwig had greatly admired the Château de Pierrefonds, restored by Viollet-le-Duc, whose ideas on the conservation of medieval monuments were widely accepted at the time. In the years 1854 to 1868, the latter had published his *Dictionnaire raisonné de l'architecture française*, and in 1863 a first volume of *Entretiens*.

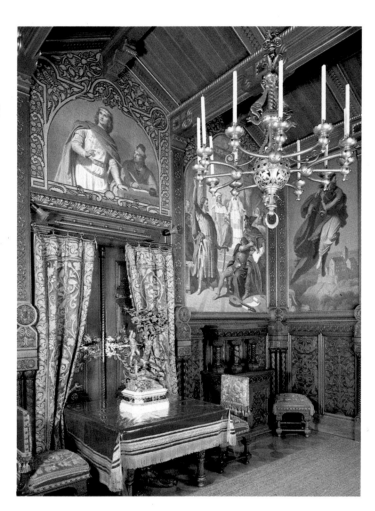

In this work, the architect and restorer of countless medieval French buildings set out his defence of the Gothic as the expression of a community deeply penetrated by secular thinking, a style founded on rational principles of construction and decoration, comparable with the greatest advances of the modern era.

In Germany, too, there was no lack of contemporary Gothic models, the most significant being the castles of Stolzenfeld, Schinkel and Löwenburg. The king could easily make the connection between these examples and those of his childhood, espe-

cially the castle of Hohenschwangau, near Füssen, restored in the Neo-Gothic style by his father and decorated with the Lohengrin stories by Moritz von Schwind.

Exoticism and literature

The exotic, oriental component so evident in Ludwig of Bavaria's castles is an essential feature of European eclecticism. However, the exotic was not something new, being already present as models in the elaborate Rococo residences of Dresden, Potsdam and Nymphenberg.

Ludwig's interest in exotic and oriental culture was filtered through literature. We have documentary and unequivocal evidence of his reading works relating especially to the Arab and Middle-Eastern countries (Arabia and Turkey). A literary culture of this kind in any case spread to all the countries of Europe between 1840 and 1880, encouraged by colonialism and trade with overseas territories, particularly on the part of France and England. This gave rise to a large number of myths: the way of life, customs and physical features of these peoples, and particularly their exotic artefacts and ancient and modern architectural settings, were widely written about, commented on and recreated. Illustrated books such as Pascal Coste's *Arab Architecture* (1818–34), Charles Texier's *Description de l'Arménie, la Perse et la Mésopotamie* (1842–52) or Owen Jones's *Alhambra* (1836–46) are typical of the illustrated albums that circulated everywhere, including Germany.

Moreover, just a few years before the implementation of Ludwig's utopian projects, a number of buildings had been erected in Germany tending to popularise oriental styles. One of these was the Moorish villa built for King William I of Württemberg in Stuttgart between 1842 and 1846, by Ludwig von Zanth, the decorative features of which were published in a folio edition in 1865. Another was the music pavilion, again in the Moorish style, erected in 1858 at Baden Baden by Charles Séchan.

Ludwig of Bavaria's suicide in Lake Starnberg brought to an end one of the most amazing chapters in the history of 19th-century Eu-

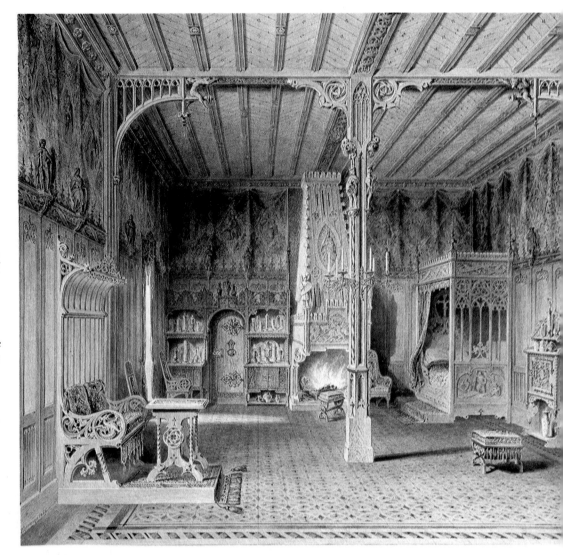

ropean taste. Paul Verlaine's poem might serve as a fitting epitaph, summing up its aspirations, longings and contradictions: *"Roi, le seul vrai roi de ce siècle, salut, Sire, / qui voulûtes mourir vengeant votre raison / des choses de la politique, et du délire / de cette Science intruse dans la maison, / de cette Science, assassin de l'Oraison / et du Chant et de l'Art et de toute la Lyre, / et simplement, et plein d'orgueil en floraison / Tuâtes en mourant, salut, Roi! Bravo Sire! / Vous fûtes un poète, un soldat, le seul Roi de ce siècle où les rois se font de peu de choses, / et le Martyr de la Raison selon la Foi; / Salut à votre très unique apothéose, / et que votre âme ait son fier cortège, or et fer, / Sur un air magnifique et joyeux de Wagner."**

LEFT: Neo-Gothic design (1869) by Peter Herwegen for Ludwig of Bavaria's bedroom in the castle of Neuschwanstein. BELOW: the Moorish Room in the castle of Schachen, as furnished by Heinrich Breling (1880); it exemplifies the Arab and Oriental tendency characteristic of the eclectic style in the second half of the 19th century. BOTTOM: Exotic influences are also evident in the painting of the period, for instance the celebrated *Odalisque with Slave* by Jean Auguste Dominique Ingres (1780–1867). Fogg Art Museum, Cambridge (Mass.).

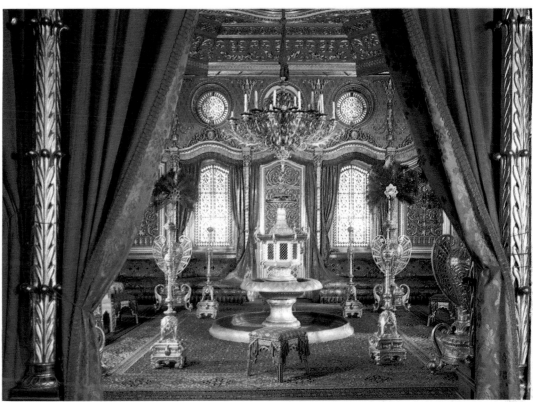

*King, the only true king of this century, hail, Sire, / Who desired to die avenging your Reason / Of the things of politics, and the madness / Of Science that has intruded into the home, / Of Science that has murdered Prayer / and Song and Art and all Music. / Simply, and full of swelling pride, / In dying you killed it. Hail, King! Bravo, Sire! / You were a poet, a soldier, the only King of this century in which kings are of so little account, / And a Martyr of Reason according to Faith; / Greetings to your unique Apotheosis, / May your soul be borne in a proud cortege, of gold and iron, / to the strains of a magnificent, joyful tune by Wagner.

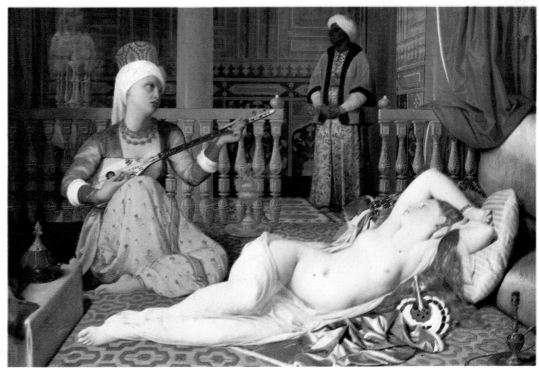

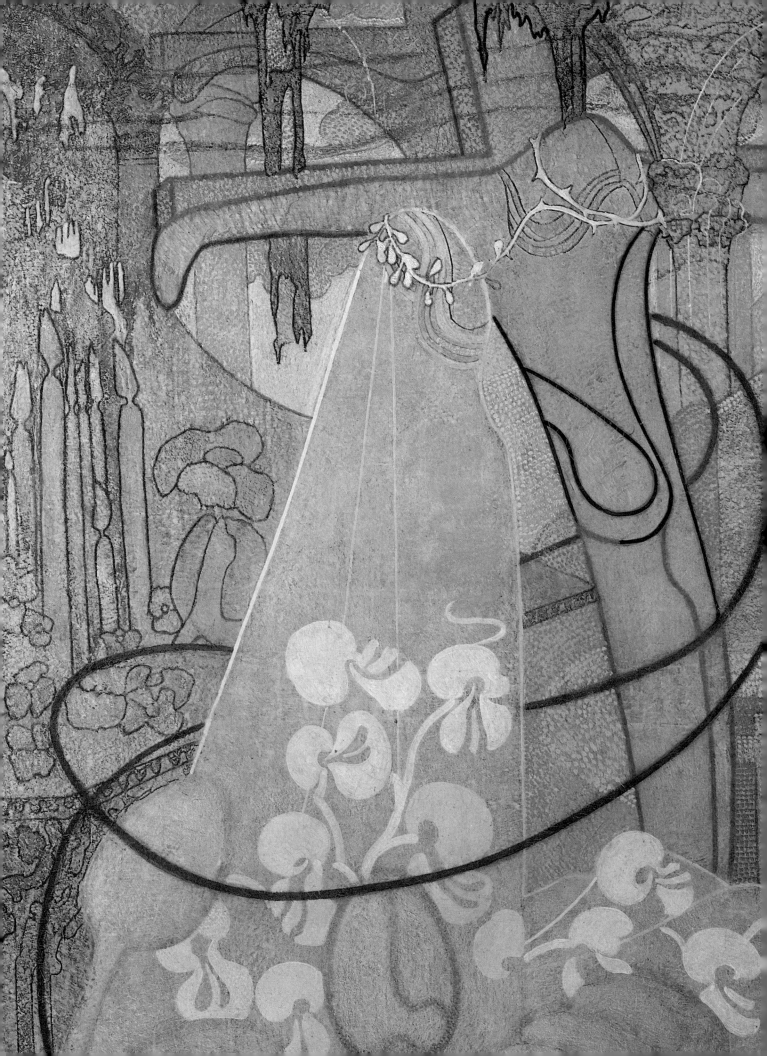

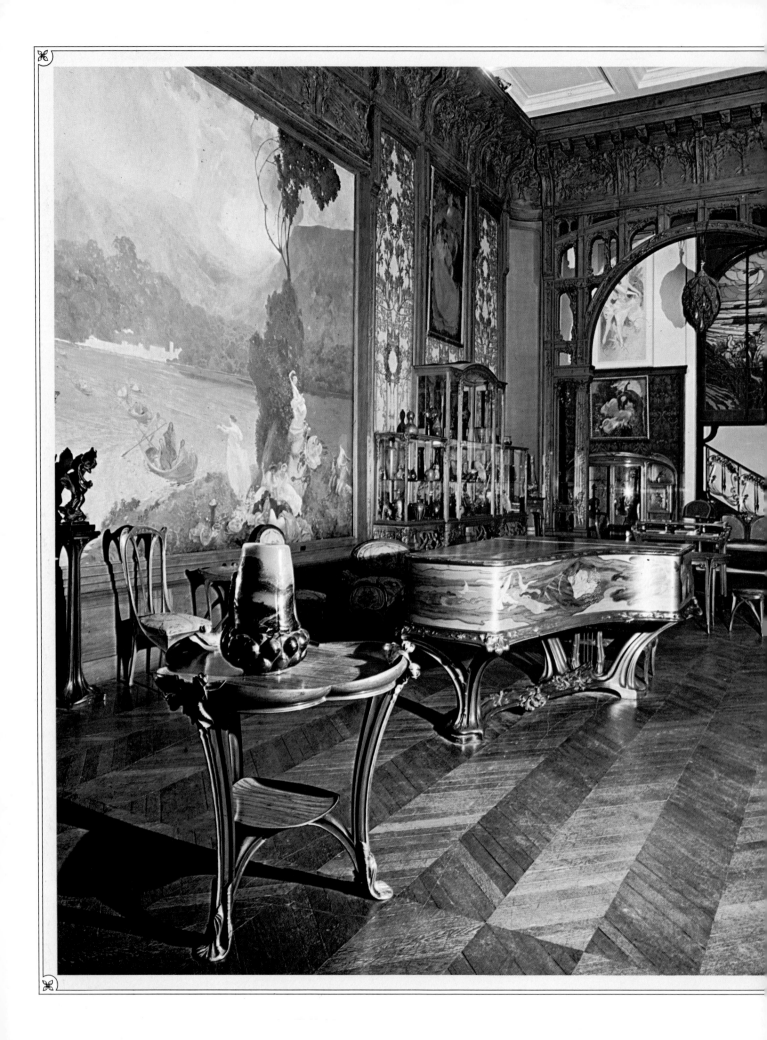

FURNITURE OF THE 20TH CENTURY

ART NOUVEAU

by Ornella Selvafolta

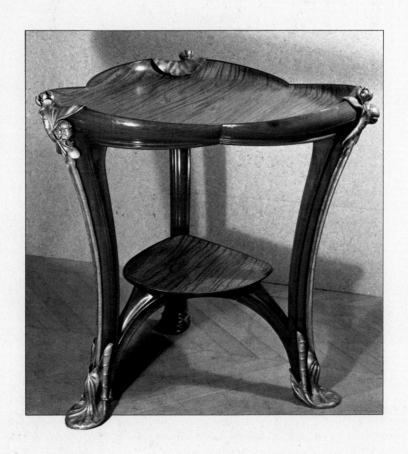

Introduction to Art Nouveau

A desire for the new

To sum up the desire for innovation that manifested itself across Europe in the last twenty-five years of the 19th century there is, perhaps, no better phrase than one used by Robert Musil in his novel, *The Man without Qualities.* In it he refers to "the exhilarating fever" because of which "people were rising to fight the past". This clearly captures the spirit of a collective aspiration to re-examine artistic expression and production, and to formulate an up-to-date language that could interpret and communicate the nature of contemporary society.

This phrase may be taken as a reflection of a crisis (albeit one that also had beneficial and constructive consequences). However, it can equally be used to describe a period of major – and often turbulent – social and economic transformations taking place in the wake of scientific progress, technological advances and industrial development, as well as a population explosion

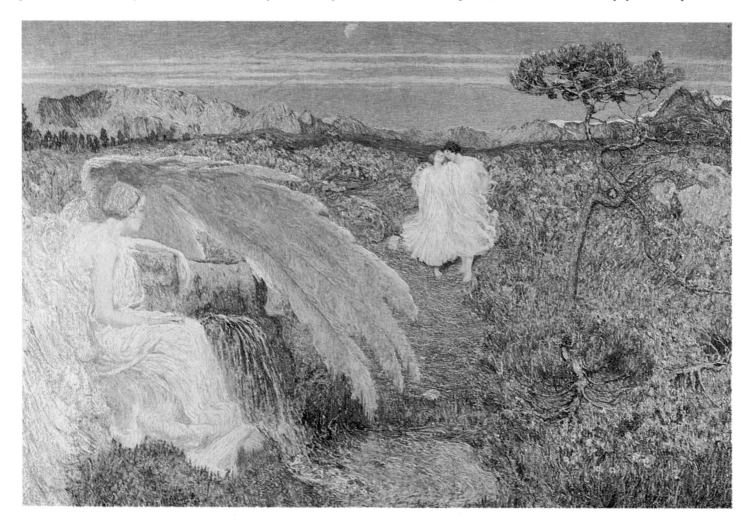

ABOVE: *L'amore alle fonti della vita* (1896). FACING PAGE: *L'angelo della vita* (1894), two paintings by Giovanni Segantini (1858–99) that mark a moment of passage from naturalistic to symbolic, mystical themes in which the figures are simplified and take on sinuous curving lines very similar to those that were to characterize Art Nouveau. Galleria d'Arte Moderna, Milan.

PREVIOUS PAGES: reconstruction of the pavilion of the Union Central des Arts Décoratifs designed by Georges Hoentschel for the 1900 international exhibition in Paris. The furniture, including the tamarind wood *guéridon* with lily mounts in gilded bronze, was made by Louis Majorelle. Musée des Arts Décoratifs, Paris.

that brought with it ever-larger cities, bigger markets and more extensive communications networks. "Carriages, galleys and sailing ships are finished," Sylvius Paoletti wrote in the magazine *L'arte decorativa moderna in 1902*, "and railways, trams and steamships are taking over. There are no more oil lamps or candles; gas and electric light have arrived." Moving on from transport and applied technology to the spatial and social organization of the home, he added: "No longer do we construct grand, lavishly decorated family homes, symbols of an authoritarian, privileged splendour, but instead houses for citizens [...] not the huge fireplaces that used to leave

the surrounding room cold but radiators instead [...] Ineluctable autocracy, rigid, stately splendour and arrogant, opulent pomp have been succeeded by delicate, intimate refinement, invigorating freedom of thought and the subtle fever of ever-new sensations."

The contrast between past and present – once again defined as a "subtle fever" – played on the static nature of the aristocratic system on the one hand and the dynamism of the new democratic ideal on the other, crediting the latter with the ability to engender a completely new line of thought and action.

The crisis of language

The crisis and the ensuing novelty of its solution also derived from close observation of contemporary artistic production. In the late 19th century, this was based largely on the revival of historic styles of the past, often through simple picturesque curiosities, romantic evocations or commercial novelties. Industry itself, because of its new technological potential, could be held partially responsible for what was emerging as a crisis of language and a general decline in standards of taste. With no cultural model of its own, and anxious to assert itself in a rapidly expanding market, industry opted for a stylistic

FACING PAGE: a painting by Galileo Chini (1873–1956) from his series on the seasons. Centre: La nuotatrice, mosaic by Leopold Forstner. Private collection. From *Le arti a Vienna*, Mazzotta Editore. RIGHT: *Salomé* by Gustav Klimt (1862–1918), the leading exponent of the Viennese Sezessionstyle. Museo d'Arte Moderna – Ca' Pesaro, Venice.

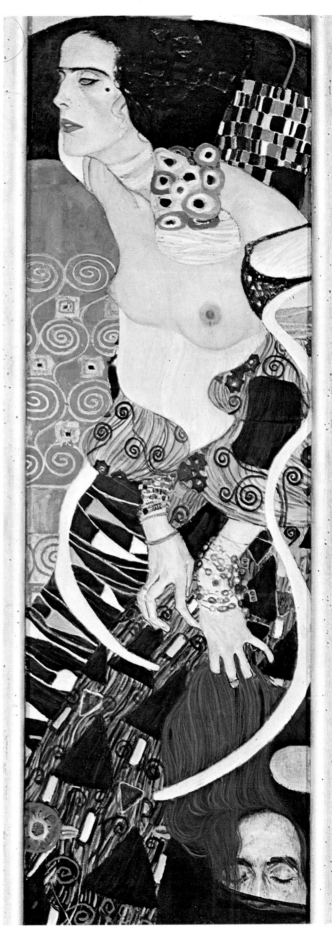

BELOW: the façade of a building designed by the architect Antonio Sant'Elia (1888–1916). Villa Olmo, Como. FACING PAGE: detail of the façade of the majolica house on the Wienzeile in Vienna, completed between 1898 and 1900 by Otto Wagner (1841–1918). The artist's preference for static shapes with a rectilinear outline and a "pure" structure is only slightly relieved by the polychromatic decoration of naturalistic motifs.

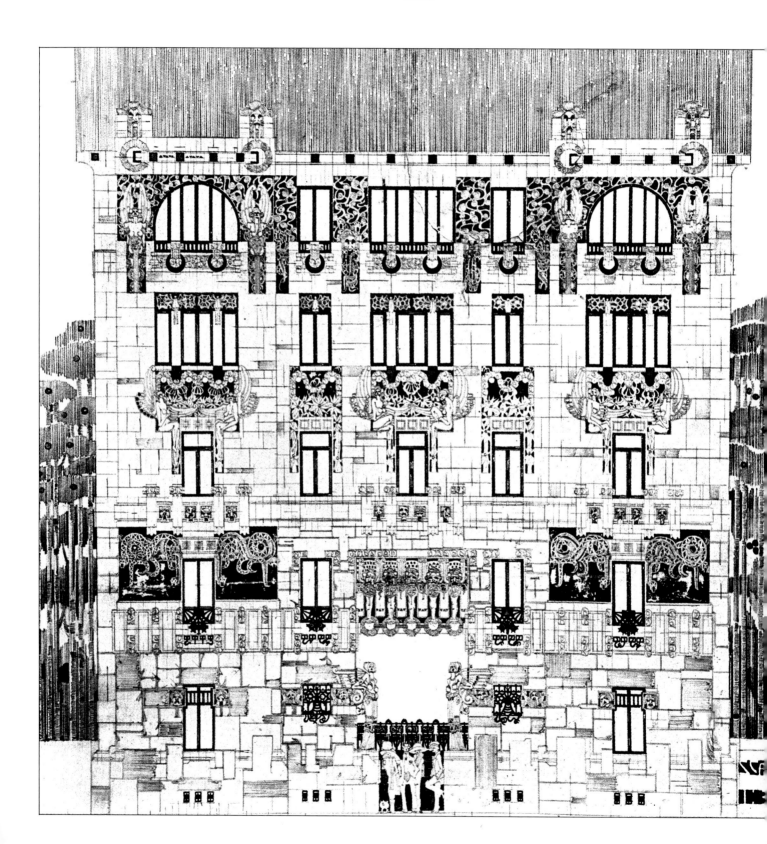

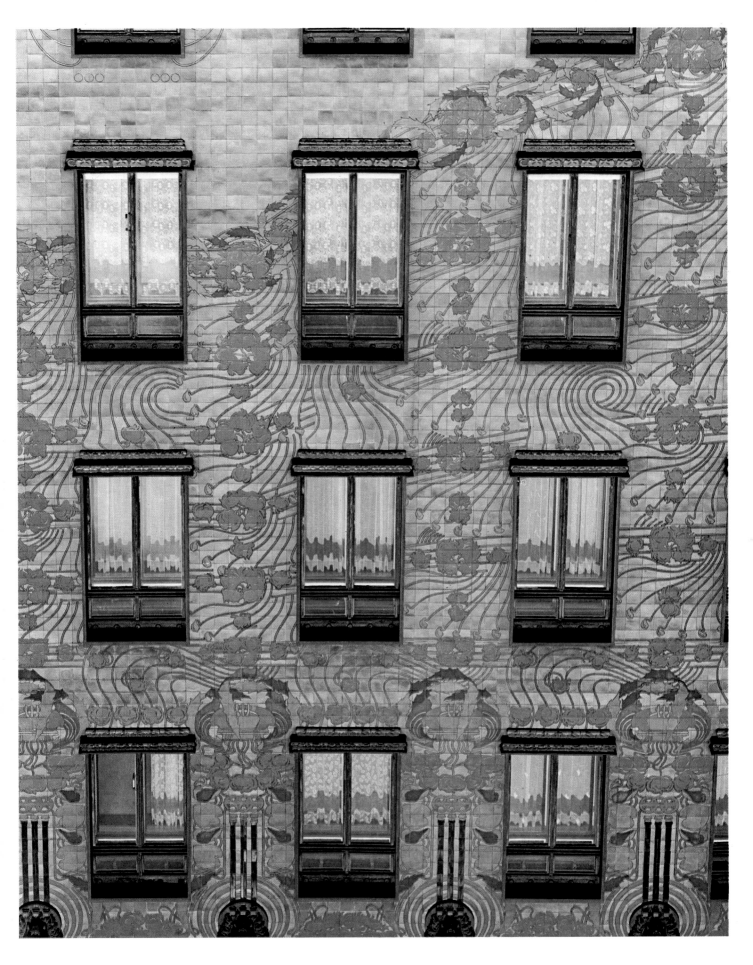

Gaudí and nature – a mystic union

It was not only artists and designers who were fascinated by the "natural" disposition of the animal and vegetable world to "construct itself" harmoniously by solving complex structural problems in an aesthetically perfect manner. The great Catalan architect, Antoni Gaudí i Cornet (1852–1926) was also enthralled. Essentially a loner with a religious conception of architecture (his sole passion), Gaudí took inspiration for shapes and colours from nature, choosing the mysterious and alluring "organic" world with its wealth of surprises and new discoveries as the basis for his work. That is how, for example, Gaudí conceived the arborescent columns of the Sagrada Familia (1883–1926), which he designed in the belief that nothing was better suited to supporting his cathedral than the superb lines of a tree, a sturdy form which has stood the test of centuries. Indeed all Gaudí's buildings were designed to fit perfectly into the natural environment from which their very inspiration and form are drawn. A fine example is the Parco Güell, where it is difficult to isolate the work of nature from that of the architect.

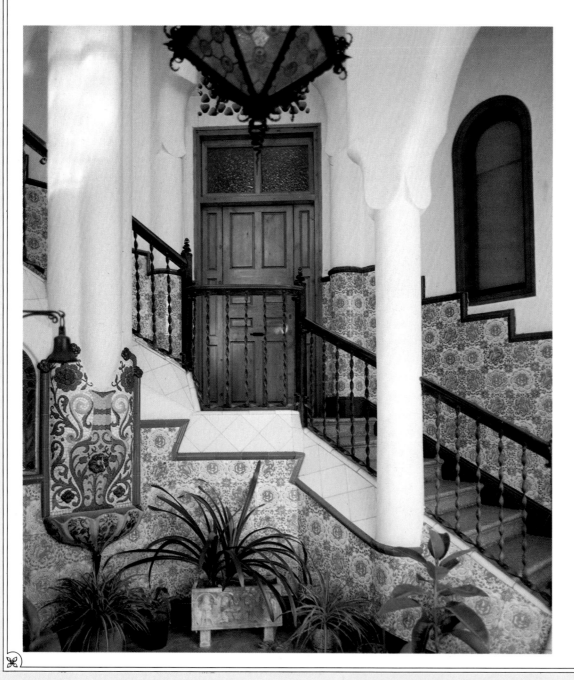

FACING PAGE: detail of the staircase at Bellesguard (1900–16) on the outskirts of Barcelona. The villa was built to a design by Gaudí, who also supervised work until 1909. CENTRE: the two fountains on the staircase at Parco Güell in Barcelona. The one above is decorated with the crest of Catalonia and the one below with an iguana.

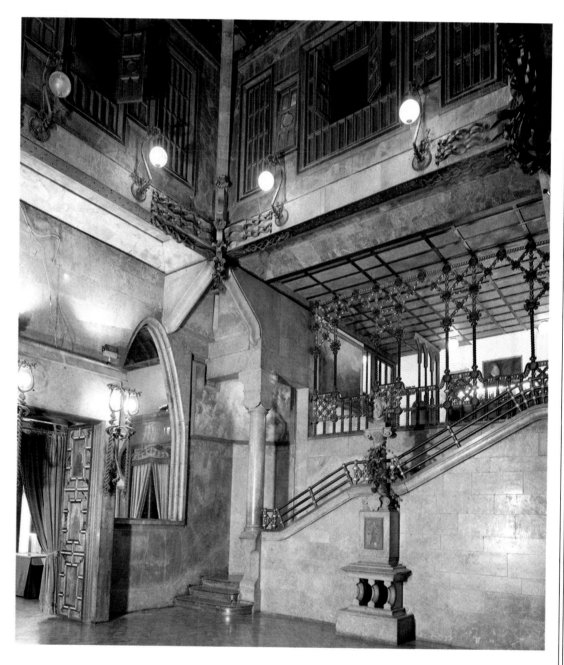

BELOW: The original idea of building a garden city, for which Eusebio Güell had allocated some land he owned on the outskirts of Barcelona, was elaborated by Gaudí, who produced one of his most imaginative works. Nevertheless, the task was never completed and in 1922 the area was converted into a public park. ABOVE: the main hall of Palacio Güell, which was Gaudí's first independent project. He worked on it from 1889.

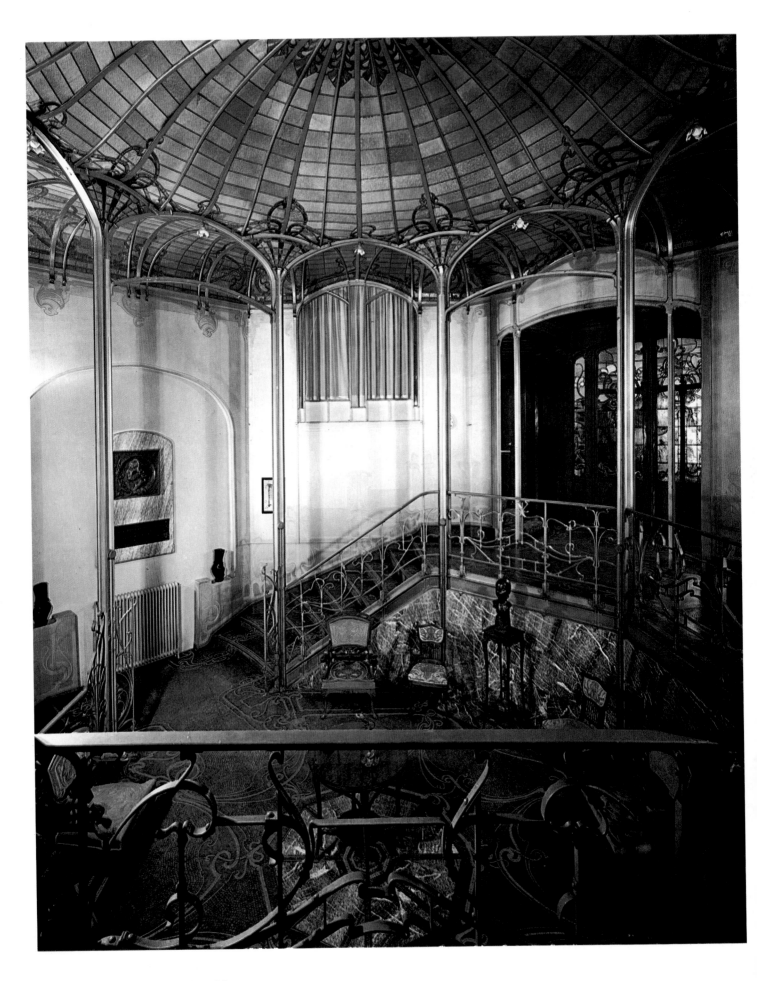

FACING PAGE: the entrance hall of the Hôtel Van Eetvelde in Brussels, designed by Victor Horta (1861–1947) in 1895. BELOW: the main staircase of Palazzo Castiglioni in Milan, built (1901-03) by the architect Giuseppe Sommaruga (1867–1917), the leading exponent of Milanese Art Nouveau.

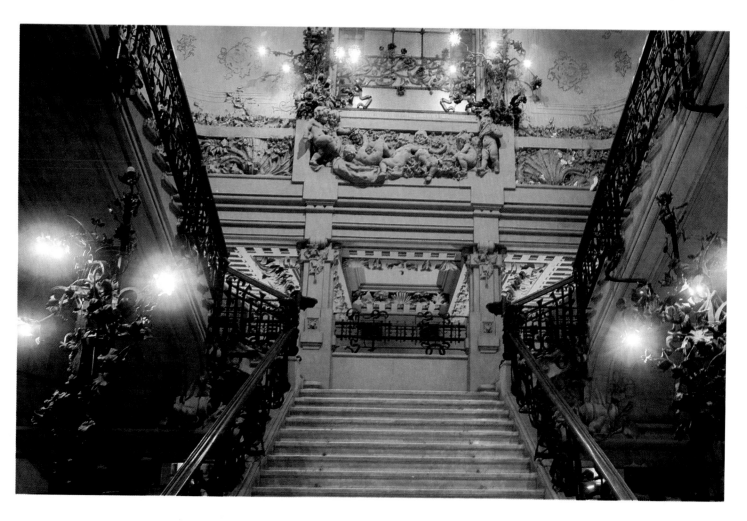

conformity compounded by repetitive production methods. And so objects created for a select few by the intuition of a single craft worker hundreds of years previously were recycled, and the most disparate artistic periods imaginable were merged indiscriminately so that Romanesque, Gothic, Rococo and the Italian Cinquecento were contaminated with exoticisms or elements from Eastern cultures.

This profusion of decorative schemes could only have a deleterious effect on the public, confusing expectations, undermining its critical ability and disorienting consumers with an unceasing divergence between the real advances of technology and cultural benchmarks that were firmly rooted in the past.

At the turn of the century, these sentiments were voiced by Alfredo Melani, one of the most passionate supporters of the new art in Italy: "The same public that boos in disapproval at the theatre if it thinks it sees an old situation or plot in a new play or the latest opera, and that consults fashion magazines before having a new suit made, and that would laugh out loud at the idea of dressing up today in the Renaissance style, seems to undergo a transformation when it comes to furnishing or decorating private homes. Everyone is an archaeologist as soon as they step through their own front doors. They are watered-down archaeologists, if you like, who upholster medieval furniture and hide electric light bulbs inside 15th-century lanterns when they are not fitting them onto china candles. They appreciate good radiators, provided they are discreetly hidden behind a fake fireplace with wrought-iron fire-dogs for a non-existent blaze, and such like."

This piece is taken from an article with the significant title *Due tendenze* (Two Trends), published in 1902 in the magazine *L'arte decorativa moderna* for the Esposizione Internazionale d'Arte Decorativa in Turin. It was at this exhibition that, somewhat later than in other countries, the ideals of aesthetic renewal were given physical form in a display of objects, furnishings and ornaments inspired by the new decorative language. Turin was also, at least for Italy, indicative of a collective effort that was already under way but not yet firmly established,

and focused on the meeting point of two opposing intellectual trends. These were the "Due tendenze" of the title -one in decline, the other just emerging. On the one hand there were the rules and restrictions of academe and its associated movements (Classicism, Pragmatism, figurative art and historical eclecticism) and on the other there were the forces pushing for spontaneous, anti-dogmatic creativity, aspiring to understand and interpret every aspect of reality through new, more appropriate forms of expression.

To that end, there was no better forum for the new ideas than interiors as a whole. And there could be no better instrument to penetrate the social structure than everyday life itself, as embodied in domestic ornaments and furniture, the design of a window, the composition of a façade or the image of a street or city. In fact the seamless integration of art and life was one of the foundations on which desire for the new rested.

A precedent – the Arts and Crafts movement

Such concerns were not entirely new. In spirit, they were a re- elaboration of the theories put forward in mid–19th century Britain with significant effects. They were proposed predominantly by William Morris (1834–96) and John Ruskin (1819–1900), and by the group of artists and craftsmen who came together in 1880 to form the Arts and Crafts movement. Everyone, wrote Morris in *Art and Socialism,* had a duty to safeguard the proper order of the countryside with his own spirit and his own hands. He launched an intensely felt message that called attention to the entire natural and constructed environment, undermining the time-honoured distinc- tion between pure and applied, or major and minor, arts.

Morris's activities went beyond mere statements of principle. In line with the proposition that art should be integrated with life, and ideas with action, he produced concrete examples, such as his own house in Bexleyheath, Kent (the Red House, built in 1859 and designed by the architect Philip Webb), where every detail was carefully studied from both a morphological and a functional point of view. Such work constituted, as it were, a material transposition of his ideological model. In London in 1860, Morris opened his factory

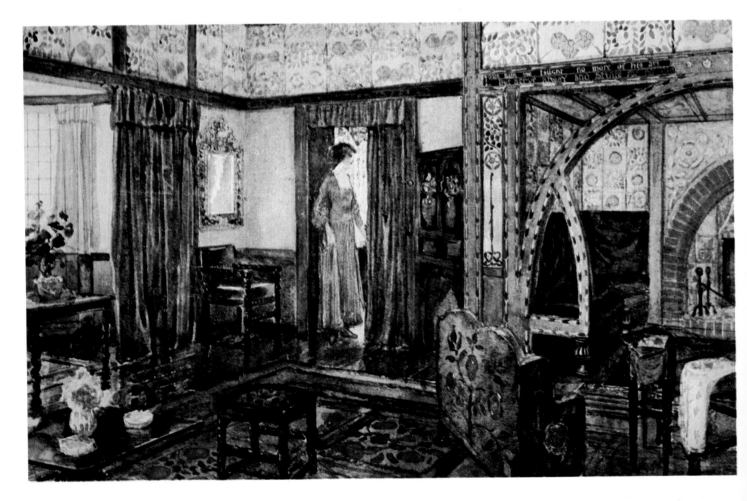

FACING PAGE: interior design for a living room, from the *Decorative Art Journal,* dated 1910. BELOW: design for a "music room" by Mackay Hugh Baillie Scott, from a series of plates presented in the *Haus eines Kunstfreundes* ("An Art-lover's House") competition organized by Alexander Koch's *Zeitschrift für Innendekoration,* Darmstadt, 1902.

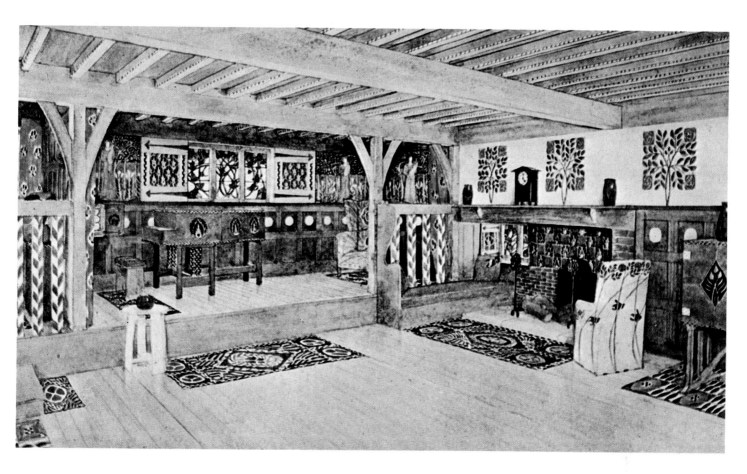

Morris, Marshall, Faulkner & Co. for the manufacture and sale of utensils, furniture and decorations for interiors, designed and produced by artists who contentiously called themselves "art workers". In 1888, Morris also became the main organizer of a series of exhibitions of applied art, with contributions from the architects, decorators, painters and engravers who formed the Arts and Crafts movement. Behind these initiatives lay a moral objective to contribute to a more just society in which beauty would not remain the privilege of the few and be denied to the masses. It was no coincidence that many adherents of the Arts and Crafts movement were socialists, often of an idealistic and utopian temper. Morris himself rejected manufacturing industry in the name of an anachronistic society with no machinery and no classes. He was inspired by a mediaeval vision and effectively withdrew from the dynamic of contemporary life. On a practical level, however, this led to the production of objects of unquestionable value that were so expensive they were beyond the reach of the very masses their manufacturers hoped to enlighten.

Despite the difficulty of combining good intentions with the reality of production, and high quality with low prices, Morris and his circle of artists did effect a radical change in the way environmental design was conceived. They had a profound and lasting influence all over Europe.

It is therefore possible to identify a single unifying theme that starts from the experience of late 19th-century England and pervades the most innovative art at the turn of the century, branching out into a myriad different streams that can all be traced back to the common driving force : the search for a new art.

Groups, magazines and labels

Following in Morris's footsteps, the longing for change and the sense of belonging to a time of strong creative tension between tradition and innovation prompted the formation of other groups of closely collaborating artists with common goals. In England, the Arts and Crafts movement encouraged the establishment of associations like the Century Guild (1882), the Art Workers Guild (1883) and the Guild of Handicrafts (1888). (Significantly, all called themselves "guilds", reflecting their inspiration from mediaeval craft associations.) In Scotland, there were the Glasgow Four; in France, the Ecole de Nancy; in Austria, the Secession; and in Germany, the Darmstadt Colony. Ideas and experiences were circulated via new media – the specialist magazines

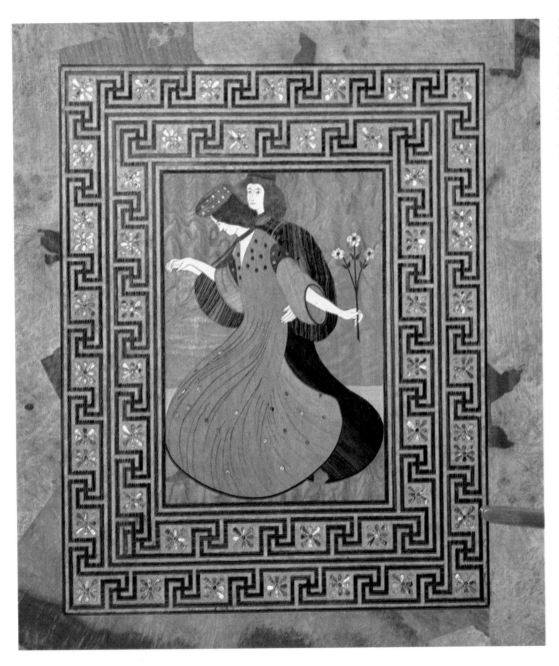

Lasenby Liberty in London in 1857, specializing originally in imports from the East. In Germany, it was Jugendstil and in France, Art Nouveau, from the name of the gallery opened by Samuel Bing in Paris in 1895 with the aim of "displaying the products of the artistic potential of our times". The new art was also known as Secessionstil in Austria and Modernismo in Catalonia. There were other names such as "whiplash" or "coup de fouet", or more polemically the "tapeworm" or "spaghetti" style, which instead of focusing on the idea of modernity, alluded to formal characteristics, identifying the linearity and dynamism of the artwork as its fundamental traits.

A simplified decorative language

The ideas, programmes and intentions inspiring the groups of artists that sprang up at the turn of the century took as their common starting point the rejection of the forms of the past, above all the ornamental motifs so dear to academic art and the stylistic repertoire of historical Eclecticism.

The first move was therefore a progressive simplification of decorative language in the search for forms that were significant in their own right and had meaning not by virtue of any supplementary content but because of their inherent expressive power. This tendency was particularly evident in the figurative arts where, around the middle of the 19th century, there had been a reaction against positivist-style realism and naturalism. The subsequent search, in part influenced

that had emblematic names such as *Ver Sacrum* (the organ of the Vienna Secession), *L'art moderne* (which had links with the Belgian movement), *Jugend* (in Munich), *Art et décoration* (in Paris), *The Studio* (in London), *Emporium* and *L'arte decorativa moderna* (in Italy) and *Joventut* (in Barcelona). Proposed and completed projects were illustrated on their pages; programmes and plans were formulated; and the magazines themselves exemplified the new trends in their careful graphic design.

In such publications, it was possible to identify the characteristics of the so-called "new style", or Art Nouveau, that changed its name from country to country and from artist to artist. In Italy it was called Stile Liberty, after the store opened by Arthur

by the increasing popularity of oriental art and, especially, Japanese prints, strove to achieve a more extreme abstraction of the figure and a more rigorous composition of the whole, balancing surfaces through graphic articulation and clear-cut contrasts of background colour.

A certain success had been enjoyed by the book *The Grammar of Ornament,* published in 1856 by British architect, oriental art expert, illustrator and decorator, Owen Jones (1809–74). In it, Jones examined a vast range of decorations from many different periods and countries, explaining their main features in short pieces of text and illustrating them in splendid full colour plates. His intention was not to propose further models for imitation but instead to deduce from the rich heritage of history general rules that could be applied to the present.

In the final chapter of the volume, "Leaves and Flowers from Nature", Jones declared that the greatest artistic civilizations had studied nature to perceive its principles and understand its processes rather than merely to scrutinize isolated natural phenomena. General laws were to be analysed, not contingent details. "We believe," he wrote, "that if a student in the arts, earnest in his search after knowledge ... will examine for himself the works of the past, compare them with the works of nature, with the wonderful variety of form, [...] if he will dismiss from his mind the desire to imitate it, but will only seek to follow its principles ... we doubt not that new forms of beauty will more readily arise under his hands [...]"

Jones was active in the

schools of design which had sprung up since the middle of the century. Such was his desire to educate that he included at the end of his work ten plates that would exemplify to young students the path they should follow. Chestnut, oak and ivy leaves, lilies, convolvulus and other plants were illustrated with graphic precision, yet unencumbered by any naturalistic intent, to show how "no art can rival the perfect grace of its form, the perfect proportional distribution of the areas, the radiation from the parent stem, the tangential curvatures of the lines, or the even distribution of the surface decoration".

This was a true "grammar of ornament", which was explained for all to appreciate in its living forms. The book was a compendium of natural beauty that could be summarized in a phrase that was to prove prophetic, remaining the key-note of the Art Nouveau movement: "Beauty of form is produced by lines growing out one from the other in gradual undulations." (O. Jones, *The Grammar of Ornament,* London, 1856; reprinted New York, 1982)

In 1873, Christopher Dresser, who was also involved in the reform of taste under way at the schools of design, revived Jones's theories, going even further to define a hierarchy of linear motifs, which he considered were more interesting the more elaborate they became.

From his point of view, the arch was the least elaborate motif, while the ellipse and all its possible elaborations reigned supreme. With reference to nature, Dresser wrote in *Principles of Decorative Design* (London, 1873) that he

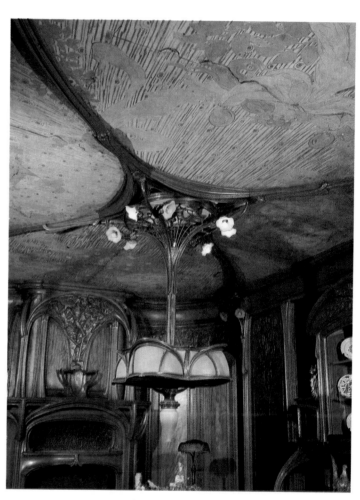

used the same lines that can be seen in buds emerging in the springtime, when the energy of growth is most vigorous. In effect, he was attempting to represent the moments that witness changes and to reproduce through the instruments of design what we might call a "phenomenology of creation".

Nature and the exponents of Art Nouveau

The same focus on the natural world and its translation into stylized forms motivated the decorative renewal of the late 19th

century. The examples we have mentioned had a crucial influence on the new art, pushing it ever further away from its historical heritage. Nature for Art Nouveau artists was caught in the dynamic processes of development and growth. These were subsequently transposed into flowing, more or less convoluted figurative representations that evoked a sense of an endless coming into being. In the same way, line was not conceived as a static element but as a trajectory characterized by serpentine or enfolding movements. It could be fast or slow and it might be aligned almost parallel to the ver-

tical, or serpentine, parabolic, twisting or helical.

A glut of plant, flower and animal manuals resulted, illustrating the various stages from naturalistic representation to analogical, allusive figurations, often dipping audaciously and arbitrarily into the wealth of material available. The study of a frog's movements, for example, could give rise to various different vases or the design for a chair leg. Winged insects such as dragonflies, butterflies or even beetles enthralled artists with their ethereal quality, colours and shading as well as the easily discernible organic interplay of their intricate structures.

Significantly, Victor Horta (1861–1947), the best-known architect in Brussels and one of the most important European exponents of the new style, advised the young Hector Guimard (1867–1942), a Parisian architect and decorator who was visiting his studio, not to look at the flower but to examine the stem and to try to understand the logic of its construction. In Munich, August Endell (1871–1925) proclaimed the importance of learning to look at the details and concentrate on the shape of plant roots – the way in which a leaf is attached to its branch and the texture of bark, following each twist, each thickening, each contraction and expansion.

Reference to nature and her irregular forms brings us to another characteristic of Art Nouveau: the moving line that recoils from the conventions of Euclidean geometry and right angles to flow freely, tracing outlines, delimiting surfaces and hinting at volumes.

Instead of individual trajecto-

ries, artists preferred more complicated interweaving patterns. Bunched lines begin from a point and spread out in various directions in a carefully balanced design where each curve is offset by its mirror image and every upward movement has a corresponding downward surge, while divergences are underpinned by supporting links.

A forerunner – Thonet

Resolute linearity of design combined with, among other things, modern furniture production methods had already appeared thirty years before Art Nouveau emerged to disseminate its principles and its call for renewal. The man responsible was Michael Thonet (1796–1871), an extraordinary craftsman, inventor and industrial entrepreneur who was to produce outstandingly enduring furniture.

Today, thanks to aesthetic and functional criteria that transcend their historical context, Thonet's work continues to exert a profound appeal. Born in the town of Boppard, on the Rhine, Thonet was only twenty years old when he opened a small furniture workshop. Then in 1830, he began to experiment with techniques for bending wood in order to dispense with expensive carved modelling systems and joints.

Thonet's procedure involved treating bundles of thin layers of suitable wood, bound together and immersed in vats of boiling glue. When they came out, the bundles were placed on moulds and rapidly bent, using presses. The result, after the drying process was complete, was a kind of "artificial solid wood" that could be cut into the shapes and sizes needed for furniture components, and subsequently screwed together. The system was already used by carpenters, especially to make carriage wheels, but there was a drawback: the hygroscopicity of the glue. The degree of its humidity tended to vary, and with it the tightness of the seal obtainable from different pieces in their original shape. Thonet's brilliant insight was to focus not on identifying the most suitable glue but to study the nature of the wood itself and to observe the transformation of a living branch or trunk into a piece of seasoned timber ready for use in the craft workshop.

The main difference between these two stages of the wood was

BELOW: a poster designed in 1895 by the Dutch artist Jan Toorop (1858–1928). Paris, Bibliothèque des Arts Décoratifs. RIGHT: poster (1898) by P. Berthon for the Folies-Bergère. Musée de l'Affiche, Paris. FACING PAGE: the magazine *Ver Sacrum* (1900), the official organ of the Viennese Secession. The first issue was published by Gustav Klimt (1862–1918) in 1898.

the degree of its humidity. In the first case, high humidity ensured elasticity and flexibility and in the second, low humidity produced robustness and rigidity. Thonet aimed to recreate the natural life cycle. The cut, sapless wood would be "regenerated" by absorbing water and then dried to combine the advantages of both stages.

Carefully cut strips of wood underwent "revitalization" in very humid environments, at first by immersion in vats of boiling water and later under pressure in autoclaves. Water vapour thus penetrated the fibres of the wood, restoring the natural properties that enabled them to bend into the desired shape in metal moulds. The wood would then be dehydrated by placing the moulds in a special drier.

The discovery of this technique ensured Thonet unprecedented success as a furniture-maker, but it was also the source of a new manufacturing aesthetic. It was not only simpler than that of traditional furniture-making, it was also freer and allowed the

production of designs that would have been unimaginable by any other means.

Industrial-scale manufacture

Thonet's success coincided with the height of the Biedermeier period, and he sensitively reproduced its graceful, elegant lines while shedding its ornamental excesses, the better to exploit his technique.

Thonet's manufacturing policy paid off in 1841 at an industrial exhibition in Koblenz, when he came to the attention of Prince Metternich, the Austrian Chancellor. At Metternich's invitation, Thonet moved to Austria with his five children, obtaining from Emperor Francis Joseph a patent to "curve all kinds of wood by means of chemical or mechanical processes".

In 1849, having collaborated with both Franz List, a manufacturer of inexpensive furniture, and the sophisticated, exclusive craftsman Karl Leistler on the furnishings of the Liechtenstein Palace in Vienna, Thonet founded the Gebrüder Thonet company. He set up mass production factories first at Koritschan in Moravia (near extensive beech forests which provided his raw material), and then at Bistritz (Bystřice) and Hallenkau (current-name) (both in Moravia), Wsetin (Poland), Nagyugróc (Velké Uherce) (Hungary), Frankenberg (Hesse) and Brno (Moravia).

This was the foundation of Thonet's huge industrial and commercial success in which modern manufacturing techniques were combined with effi-

ciency, low costs and aesthetic value. Thonet's triumph was only partially jeopardized when his patent expired in 1869 and he was challenged by other competitors, of whom the most interesting were Jacob & Josef Kohn of Vienna. In the final analysis, however, competition served only to validate Thonet's own model and to stimulate new versions of the product.

Thonet and his family's contribution also extended to their investment in the burgeoning market of the lower middle and middle classes on the one hand and of bars and commercial premises on the other (not least the famous Daum café in Vienna), thus further encouraging mass production.

One of the better known items in the Thonet catalogue is the no. 14 chair produced in 1859. It is estimated that in the space of

forty years, around 45 million were sold. A production range that included 25 items of furniture in 1859 had expanded by 1915 to embrace 1,400 different products (G. Santoro, *Il caso Thonet*, Rome, 1966).

The key feature in each item was the round-section beechwood that could easily be manipulated into curves or scrolls, elaborate volutes or broad, transparent sweeps to make backs for

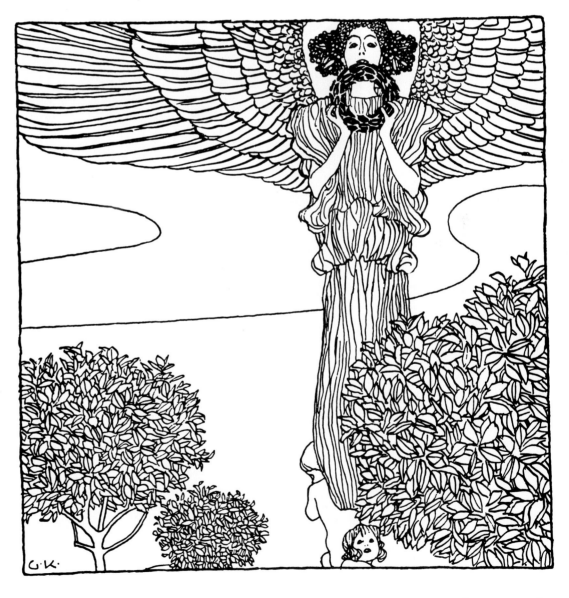

chairs, armchairs and sofas, arms for superb rocking chairs, table supports, headboards for beds, cot sides, commodes, magazine or music racks, flowerpot holders or coat stands. It was a domestic universe of elegant yet dependable dignity, where the early echoes of Biedermeier were swept away in a process of continuous structural refinement.

These were, moreover, objects whose design sprang from the technological exploitation of an organic principle and from the transformation and re-elaboration of a natural condition. Quite apart from this, the design produced concrete results easily and on a large scale thanks to a manufacturing procedure that utilized semi-skilled labour.

These principles anticipated modern design with results remarkably similar to Art Nouveau. The distinguishing feature of Thonet furniture was a modulated, articulated, curved line that connected with other lines tangentially to become an independent feature, itself susceptible to elaboration. There were, however, other important consequences such as the transparency and impression of spatial permeability that ensued (appropriately called *en plein air*), the lightness of the structure, the decoration that is fully integrated into the manufacturing process and the lack of historical references. All these are symptomatic of an effective manufacturing approach and a never-before-seen freedom of expression which already contained the seeds of much of the New Art's success.

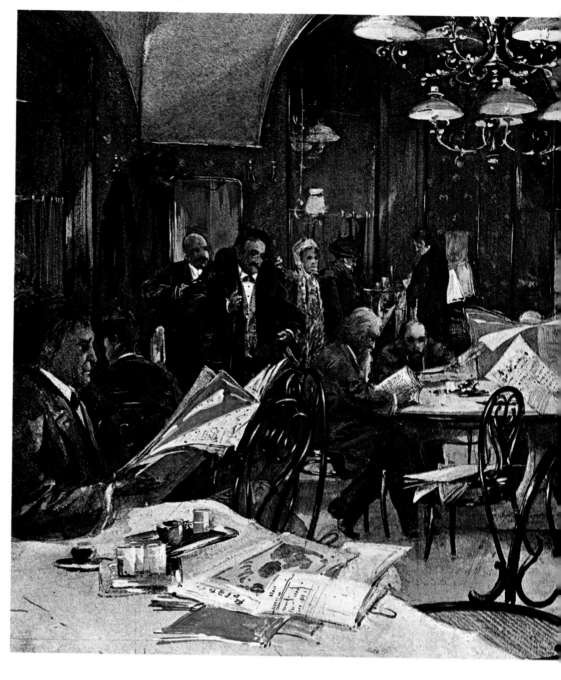

Designer furniture

L'art dans tout (named after a Paris craft association founded in 1897) became the slogan of the new style, not only in the sense of an environmental awareness but also of the end of the artist's isolation. There would therefore be a review of the artist's role in society and value as a professional. One of the most important characteristics of Art Nouveau items is that they are often "designer" works. The traditional anonymity that had hitherto characterized

everyday objects of run-of-the-mill craft production was spurned in the name of personal creativity.

The concurrent enhancement of design and manufacture and the extension of design to the entire range of manufactured objects encouraged new recruits who would be active as artists, architects and decorators. There was even a partial inversion of the traditional hierarchy of the arts.

The Belgian Henry van de Velde (1863–1957) abandoned his original calling as a painter and in

1898 founded the "Arts d'industrie de construction et d'ornamentation" workshop to devote himself to the applied arts and architecture. Paul Gauguin himself designed and made ceramic objects and inlaid decorative wooden panels, setting an example for other artists in the School of Pont-Aven. Hermann Obrist (1867–1927), who was originally a sculptor, founded an embroidery workshop in 1894 at Munich, expanding production to include furniture, pottery and fabrics.

Since Art Nouveau was most

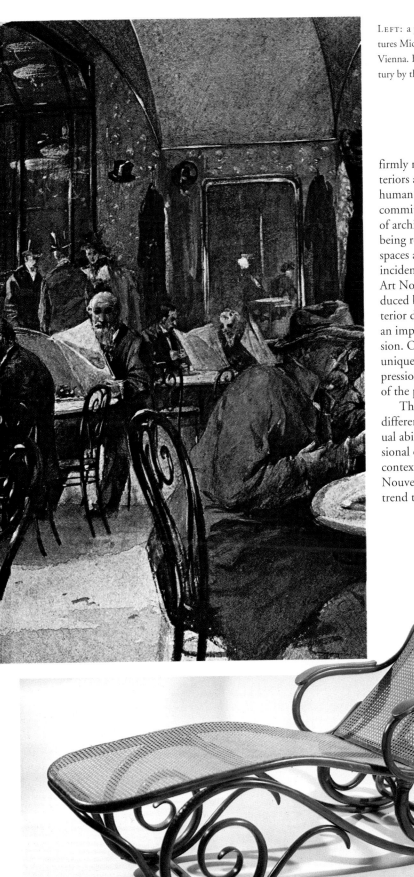

firmly rooted in the design of interiors as the setting for everyday human existence, it found many committed followers in the field of architecture, which was already being reconfigured in terms of spaces and volumes. It was no coincidence that many articles of Art Nouveau furniture were produced by architects, nor that interior design should become such an important part of the profession. Often, interior design was a unique forum for the artistic expression of the greatest architects of the period.

Thus whatever the qualitative differences deriving from individual ability and varying professional opportunities or cultural contexts, it is still true that Art Nouveau represents the birth of a trend that would subsequently acquire a much wider importance: it marked the end of the anonymity of objects of applied art and a new involvement of the designer in the production process, in line with modern conceptions of design theory.

The Europe of Art Nouveau

England

As we have already noted, England is acknowledged as home to the direct predecessors of Art Nouveau. Morris, along with his Arts and Crafts movement, formulated the thinking that underpins one of the most significant schools of the new style. From the late 19th century on, however, English Art Nouveau took a stance of its own that was distinct from the rest of Europe and the renewal "fever". The specific characteristics of the English style that may be seen in the use of shapes from nature and above all in the free flow of lines through space are only marginally useful in defining the country's output. Neither should it be forgotten that Morris's influence and his ideal of a social, moralizing art was direct and unfiltered in England. There was none of the inevitable interpretations, adaptations and transformations that take place when ideas move from their culture of origin to other places and other contexts. Similarly, it is important to remember that England had anticipated renovation of the domestic environment and since the middle of the century had produced items of

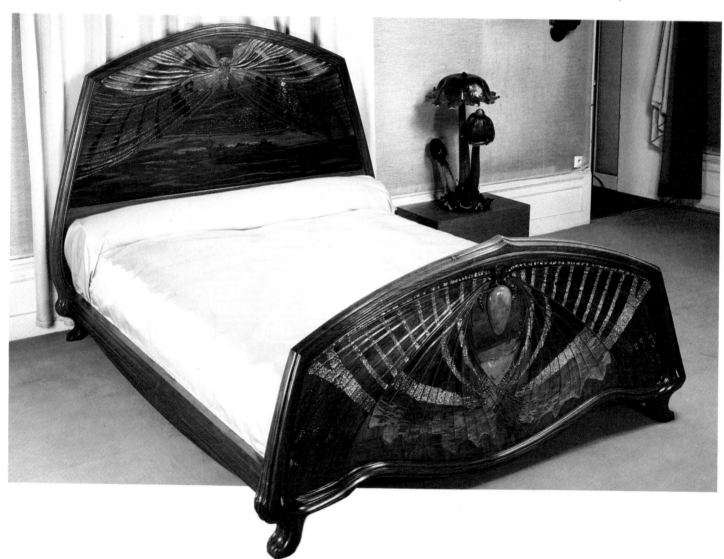

ABOVE AND FACING PAGE: full view and detail of the famous "butterfly bed" known as *Aube et Crépuscule*, designed by Emile Gallé in 1904. It was the swan song of one of the greatest French Art Nouveau *ébénistes*, or cabinet-makers, for Gallé died shortly after completing it. The bed is inlaid with a variety of woods, metals, gemstones and mother-of-pearl. The headboard and footboard echo one of the new style's favourite themes: two butterflies spreading their wings against a background that hints at the surreal. Musée de l'Ecole de Nancy.

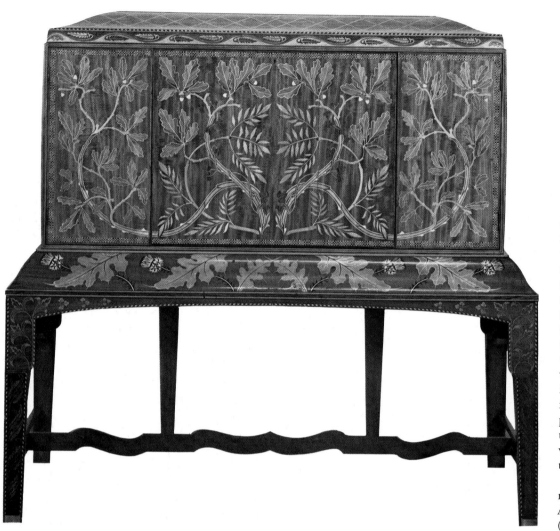

In the 1870s, pieces made by Morris and the Arts and Crafts movement began to appear. Painstakingly crafted, they were often challenging not so much for their formal virtuosity as for the way in which they were made. Mechanical tools were shunned, so outstanding craft skills were demanded. The plain forms, the use of wood facings, the refusal to employ veneer of any description and the predilection for straight lines called for work of the highest order. Finishes and joints had to be perfect, and surfaces carefully planed to bring out the grain of the material but also to render it velvet-smooth and pleasing to touch.

Furniture in the spirit of the new style was also designed by Arthur Heygate Mackmurdo (1851–1942), an architect and de-

furniture with uncomplicated lines and a functional design. Stylistic imitation had been abandoned in favour of a modernized re-working of the traditions of the past.

The Neo-Gothic movement, for example, was part of this tendency in the sense that it was a re-appraisal of a hitherto neglected period in the history of art and a re-interpretation of themes and design principles that could still be relevant to the society of the day. Equally significant in this increasing simplification of furniture models were the Functionalist theories which were championed by John Ruskin, for whom the essential structure of an object could never be hidden under secondary ornamental forms, and echoed by the architect and art historian, Charles Lock Eastlake.

The influence of the Orient

In the years when Functionalist theories held sway in England, the influence of oriental, especially Japanese, art was making itself felt. Japanese products on show at the 1862 universal exhibition in London had attracted much interest from the more discerning members of the public and provided a starting point for the hoped-for modernization of the language of decoration. The Japanese-style furniture of the architect Edward Godwin (1833–86) dates from these years, long before Art Nouveau was to make its appearance on the European scene. Godwin's pieces are characterized by a light, simple design in which the minimal structure comprises strips of wood meeting at right angles.

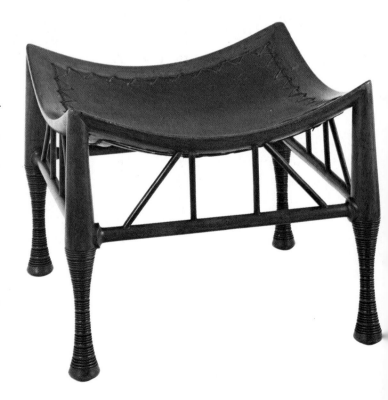

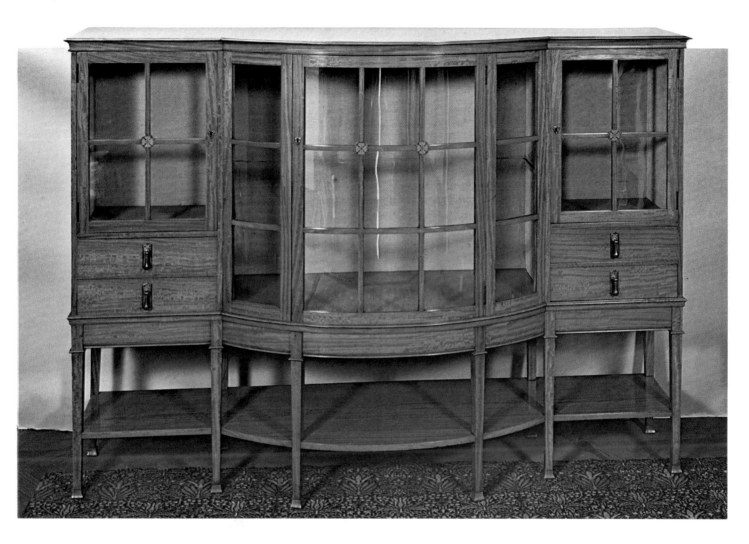

signer who belonged to the Arts and Crafts movement and who founded the Century Guild for artists and artisans.

The items Mackmurdo produced in the 1880s followed both the Arts and Crafts tendencies and the taste for all things Japanese, while at the same time drawing an extraordinary force of expression from their extreme simplicity and rationality of design. The fabric-covered panelled wood screen with an abstract upward-curving floral pattern, as well as other characteristic products of Mackmurdo's genius, such as his chairs, tables and

small writing desks, eliminated decorative superfluity in favour of a leanness of form and structure that could almost be called proto-Rationalist.

Typical features of Mackmurdo's work are long, straight vertical supports that taper slightly towards the bottom, where the foot spreads out to make a small geometrical base subtly underlining the idea of purchase on the floor. The grain of the wood is exposed, in line with Morris's concept of sincerity. There is almost no inlay or carving. The lines are clean and precise, and points of contact be-

tween the planes are accentuated. The projecting horizontal surfaces provide a distinctive feature, crowning vertical elements like a capital that has been flattened and reduced to a pure geometrical "entity".

Examples like this and the others mentioned were therefore clear benchmarks, underpinned by a strong theoretical basis whose validity was practically unassailable. There was no need to transform it. All it required was elaboration.

The designers – Voysey and Ashbee

Some of the most important furniture designers at the turn of the century were therefore the spiritual heirs of the most innovative 19th-century trends. Here again, we see the convergence of interest between architecture and design that is implicit in the incorporation of art into everyday life.

For example, both Charles Francis Annesley Voysey (1857–1941) and Charles Robert Ashbee (1863–1942) were architects whose training adhered to Morris's precepts and who fol-

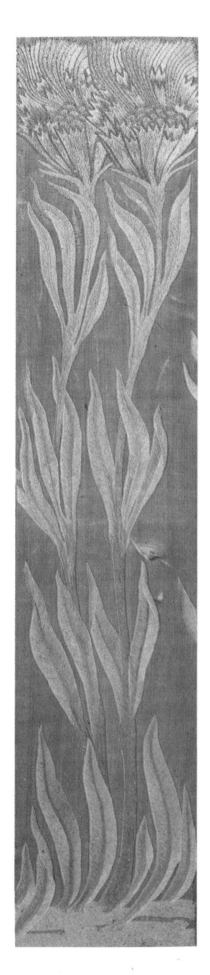

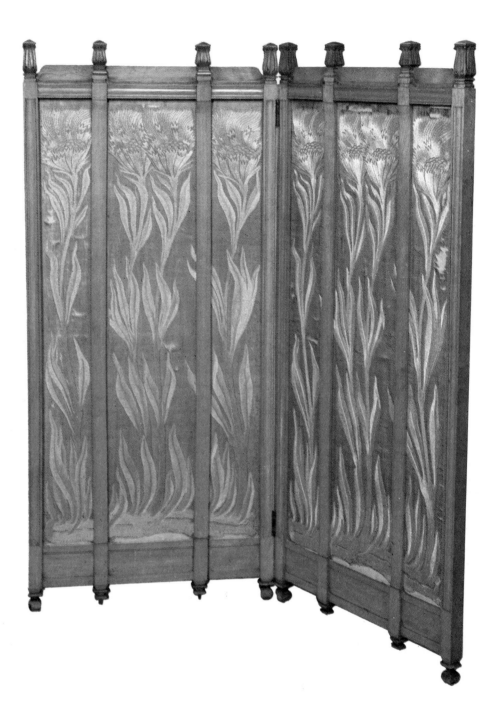

ABOVE AND FACING PAGE: three pieces by Arthur Heygate Mackmurdo that illustrate the main features of his work: simplicity and rationality of line, an upwardly directed momentum and the use of natural wood. ABOVE: screen with fabric-covered panels and detail of panel fabric. FACING PAGE, ABOVE: writing desk (c. 1886) with long tapering legs. BELOW: mahogany chair (1882-83) with floral-motif fretwork back made by Collinson & Lock. William Morris Gallery, London.

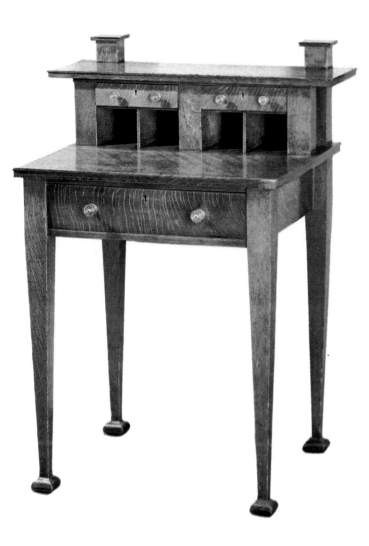

this period. His work in the two decades after 1890 is remarkable, even given the high standards of much contemporary English furniture-making. The sobriety, good taste and refinement of Voysey's work were qualities that were employed in line with Functionalist canons derived from a non-imitative, personal reading of the Tudor tradition. Voysey's interiors and furniture were generally distinctive for the linear geometry of their construction. Although rigorously rational, it was never dry or forbidding. Voysey's work was reassuring, readily comprehensible and fitted smoothly into its destined environment. His chairs, tables and cabinets featured lightweight structures with a clear preference for vertical lines and right-angles albeit with some concessions to decoration. The hinges of a cabinet door, for example, might provide an opportunity for the addition of austere, understated ornamental motifs. Exposed hinges were extended into abstract designs and, in the form of ornate metal plates, they echoed the tradition of mediaeval furniture in a modern key.

In contrast to Morris and his more inflexible disciples, Voysey believed in mechanization and the advantages industrial production would bring to society by making good-quality products accessible to an ever-wider public. His pieces were therefore often designed for large-scale manufacture and incorporated the most straightforward, least costly systems of joints and fixings. He selected relatively inexpensive woods – oak was a favourite – and sought to enhance their natural texture.

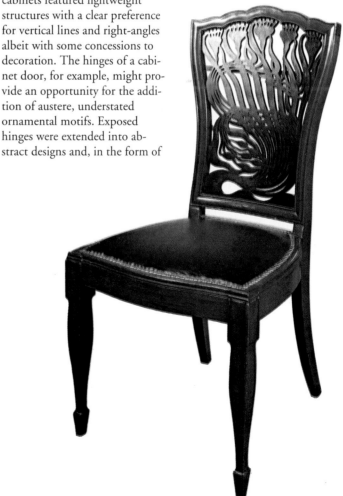

lowed the example of Mackmurdo. Their work embraced all aspects of the domestic environment.

In 1888, Ashbee founded the Guild for Handicrafts, which, although organized on non-capitalistic lines, encouraged the use of mechanized technology. He designed austerely unadorned furniture of great simplicity, whose sinuous lines, reminiscent of continental Art Nouveau, dwindled away until they were scarcely perceptible or emerged in the form of painted ornamentation or light metallic surfaces with stylized floral designs.

Ashbee's workshop also made furniture designed by other artists and architects who did not belong to the guild but who shared its ideals and interests.

One such was the architect Mackay Hugh Baillie Scott (1865–1945), creator of the pieces made in the Manx style. This featured distinctive upward lines and sophisticated decorative nuances, which in some respects were similar to those of the Glasgow School.

Nevertheless, it was probably Voysey who made the most significant contribution to architecture and interior design during

Emile Gallé and the Ecole de Nancy

Nature, the primary source of all Art Nouveau, found in Emile Gallé (1846–1904) one of its supreme interpreters. Compositions of flowers, leaves, ears of corn, dragonflies and butterflies adorn his glasswork, a field in which he was an undisputed master. They decorate his furniture, either as inlays of precious wood or carved decorations on uprights and cornices. Initially austere, Gallé's furniture quickly acquired more complex, "organic" forms in which Neo-Rococo motifs mingled with oriental overtones to create inventive designs featuring asymmetrical movements and deeply curving profiles. Gallé was the moving spirit behind the Nancy Group and it is to him we owe the foundation, on the example of the English Arts and Crafts movement, of the Ecole de Nancy, Alliance Provinciale des Industries et des Arts. This was a school-cum-workshop whose goal was to modernize technical education in the decorative and applied arts. Among those who adhered to the initiative, and ran the school with Gallé, were some of the finest *ébénistes* and designers of the day: Louis Majorelle, Eugène Vallin, Victor Prouvé and the Daum brothers.

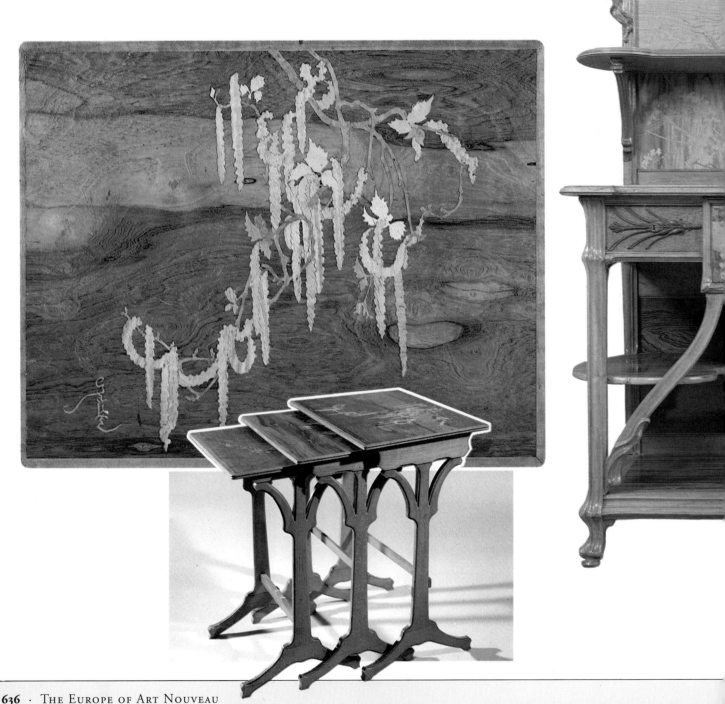

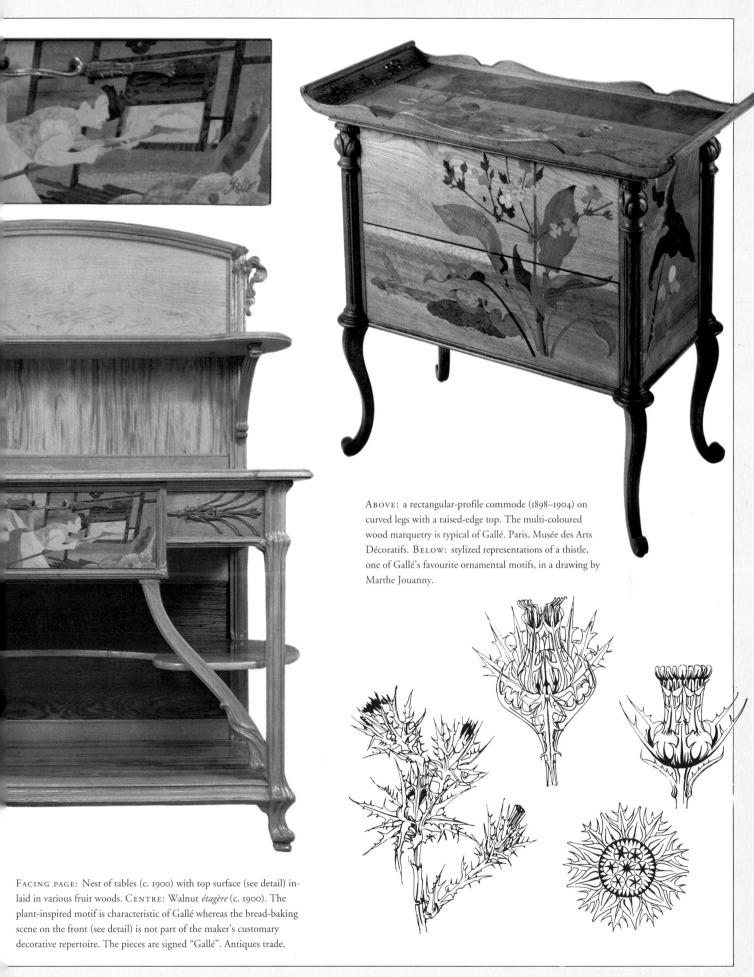

ABOVE: a rectangular-profile commode (1898–1904) on curved legs with a raised-edge top. The multi-coloured wood marquetry is typical of Gallé. Paris, Musée des Arts Décoratifs. BELOW: stylized representations of a thistle, one of Gallé's favourite ornamental motifs, in a drawing by Marthe Jouanny.

FACING PAGE: Nest of tables (c. 1900) with top surface (see detail) inlaid in various fruit woods. CENTRE: Walnut *étagère* (c. 1900). The plant-inspired motif is characteristic of Gallé whereas the bread-baking scene on the front (see detail) is not part of the maker's customary decorative repertoire. The pieces are signed "Gallé". Antiques trade.

The Barnsley brothers

The move towards naturalness, which in the case of Voysey and Ashbee was combined with a sophisticated, personal concern with ornament, could on other occasions lead to over-simplification and a kind of wilful, self-conscious primitivism that made little effort to win over the expectations of the public.

The brothers Ernest (1863–1926) and Sidney (1865–1926) Barnsley, members of the London branch of the Arts and Crafts movement who took part in all the group's exhibitions, made rigorously geometric, almost experimental pieces in which the wood's natural finish exposed the joints to view and all decoration was eschewed, with the exception of the design of the handles and a few minute linear inlays to enhance the outline.

These were without doubt difficult pieces that impress us today with their modern essentiality. At the time, they were greeted as unapproachable items that appealed only to the select few of the avant-garde and would have little lasting effect on the wider tastes of society.

A somewhat harsh opinion was expressed by Hermann Muthesius, founder of the German Werkbund and a discriminating observer of English household furniture from his privileged viewpoint as an attaché at the German embassy in London from 1896 to 1903. On returning to Berlin, he published in 1904 and 1905 *Das englische Haus,* a three-volume work in which he scrupulously and perceptively analysed every aspect of English dwellings. In the section that deals with interior design and furnishings, there are many insightful reflections on furniture-making. In some cases, such as the Barnsley brothers, he is rather critical but overall his assessment of the household items he describes is favourable.

High standards of manufacturing

Muthesius also had a good opinion of the general standard of quality that could be found in all market segments of production and distribution thanks to a code of professionalism to which all those involved implicitly subscribed. Part of that professionalism was the selection of wood types. Mahogany was the most in demand, followed by oak and walnut, there being no substantial difference in price. Natural finish oak was the material of choice for members of the Arts and Crafts movement, even though its reddish-yellow colour was vulnerable. Dirt often ruined the carefully contrived visual effect in a short space of time. This led to the perfection of finishing and colouring techniques that nevertheless shunned polishing and heavy lacquering. Instead the wood was allowed to show off its grain through a light varnish, which was sometimes darkened by exposing the finished article to ammonia fumes. Generally, however, surfaces were given a velvety opaqueness that revealed a regard for the wood's tactile qualities in use and focused on substance rather than appearance, as a rule without recourse to complicated inlays or intricate veneers.

The code of professionalism is also clear from the custom of making furniture from the same

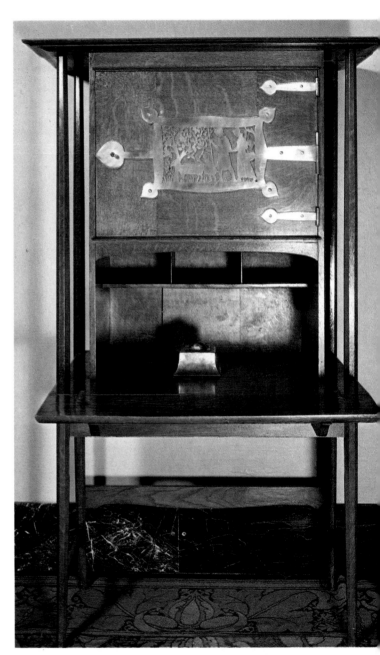

species of wood throughout, whereas drawers were traditionally made from poorer-quality materials. This was another sign of Morris's moralizing influence, and one which was made possible by England's particular climate. The moderate variations in temperature and constant humidity rendered special measures against shrinkage or cracking unnecessary.

English furniture also tended to be smaller than the average on the continent. Items were therefore lighter and easier to move into modest-sized rooms with small doors. They were plain and simple, to the point of looking coarse. All this implied an attitude that Muthesius defined as typical of the English temperament, in which "natural intelligence, free of affectation" combined with "a generous measure of good sense". In short, these were eternal qualities that went beyond time and history but which were none the less rendered more effective for having been recovered at the turn of the century in the context of a movement of cultural renewal for the socialization of art and its applications.

Belgium

In Belgium, the success of the new style was the culmination of a process that had begun in 1830, when the country, having obtained independence from Holland, was searching for an identity and an autonomous culture of its own. By the 1880s, that process had reached an advanced stage and took the form of a widespread reform movement that focused on the new, and was especially attracted by manifestations of the avant-garde in all areas of art.

The atmosphere was therefore particularly favourable towards the theories of the new style, which soon took root in a fertile terrain. In 1881 in the first issue of *L'art moderne*, the theoretician Octave Maus wrote, paraphrasing Morris and in the certainty of finding consensus, that: "The artist is not content to construct on an ideal level. He is concerned with everything that interests and touches us. Our monuments, our houses, our furniture, our clothes and the smallest objects that we use day after day are ceaselessly examined and transformed by Art, which merges with all things and remodels our entire life to render it more elegant, more dignified, brighter and more social."

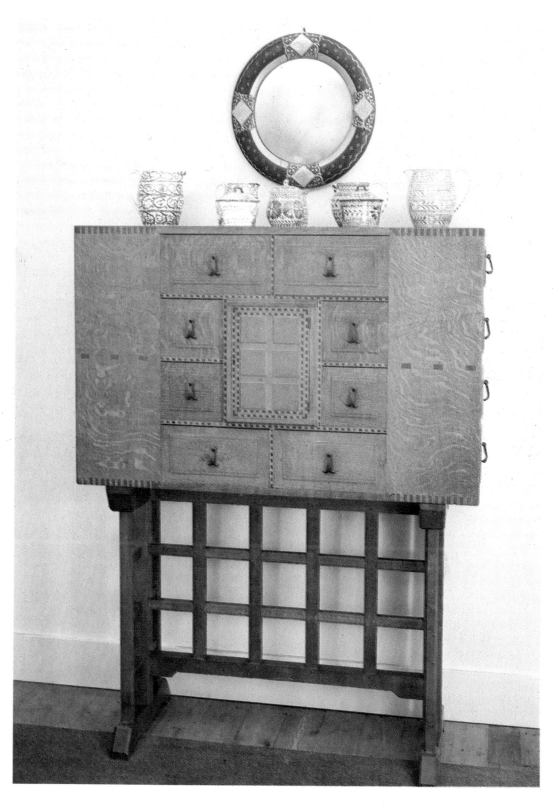

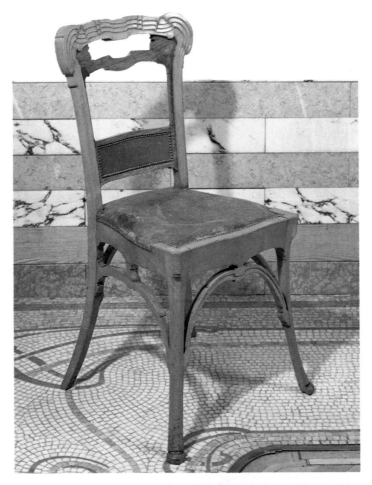

content, it projected the new style into the city and into direct contact with the young, dynamic, emerging urban culture of an industrial society.

Victor Horta

Victor Horta (1861–1947) was particularly intrigued by plant structure and declared that he had adopted it as the driving principle behind his designs. Reference to the organic world was not expressed in naturalistic so much as in evocative, elemental terms.

Horta's furniture is characterized by sinuously curving lines that allude to stems and branches without actually depicting them. None of the shapes are usually recognizable. For example, the living room furniture in red ash, designed in 1899 for Villa Car-pentier at Renaix, features flowing lines for the table legs, and the open-fan motif of the chair and sofa backs recalls the branches and leaves of a palm tree but does not portray them.

Nevertheless, Horta's furniture is difficult to evaluate if removed from the architecture of the spaces for which it was designed. His opinions were clear on this point, for he maintained that interior design and architecture interacted to define a house "as a personal, living being [...] not merely in the image of the life of the individual who lives there but as his portrait". Created for an upper middle class clientele (he was the most expensive interior designer in the Belgian capital), Horta's furniture reflected the wealth and aspirations of the Brussels merchant class in the expensive materials he employed and the highly skilled

The message took concrete shape in exemplary works inspired by criteria of oneness and environmental coherence, which were produced by architect-artists such as Victor Horta, Henry van de Velde, Gustave Serrurier-Bovy (1856–1910) or Paul Hankar (1859–1901).

Horta in particular is usually attributed with initiating continental Art Nouveau in its most complete and convincing form. His Hôtel Tassel (1893) and Hôtel Van Eetvelde (1895) in Brussels are often held up as examples of the new artistic ideas in all their splendour. Indeed, the Hôtel Tassel displays an avant-garde architecture that overturns previously accepted rules of composition to achieve a totally new organization of space. Innovative in language and structure, form and

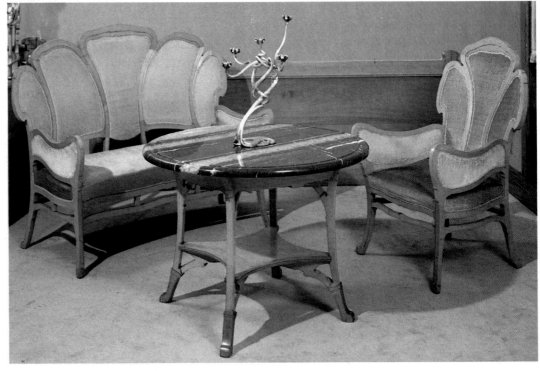

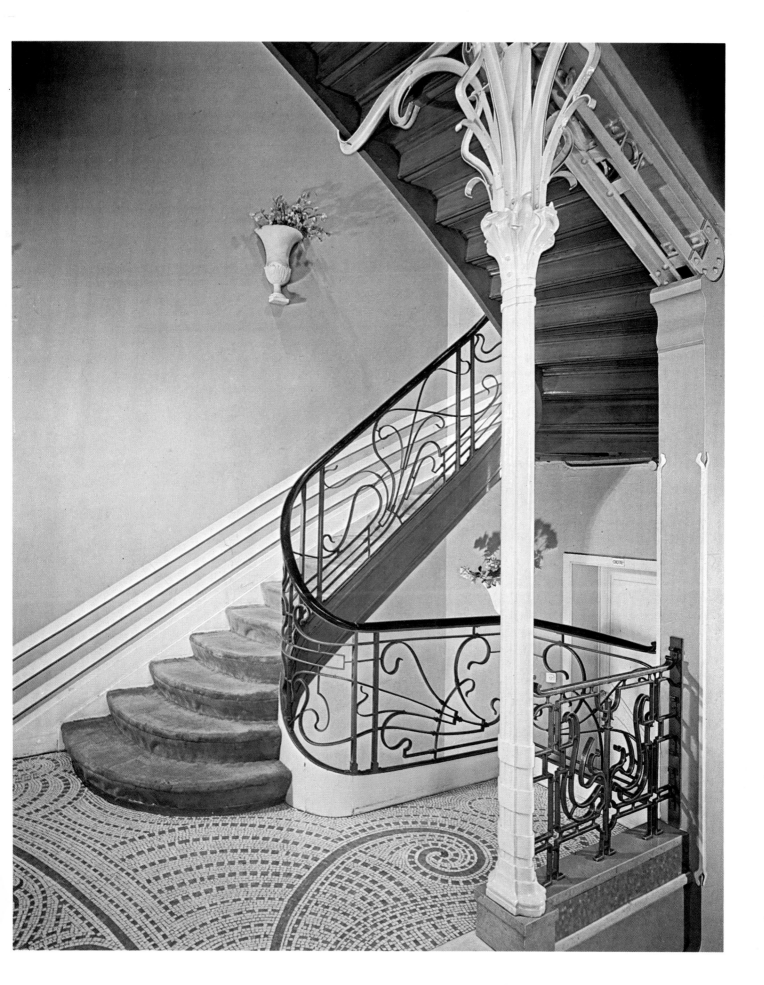

THE EUROPE OF ART NOUVEAU · 641

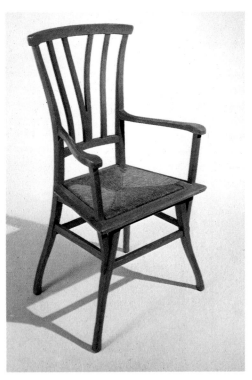

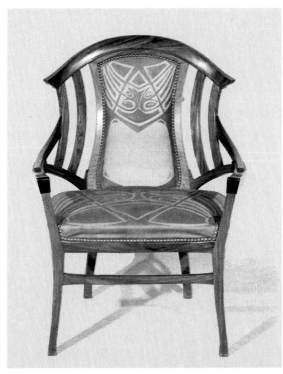

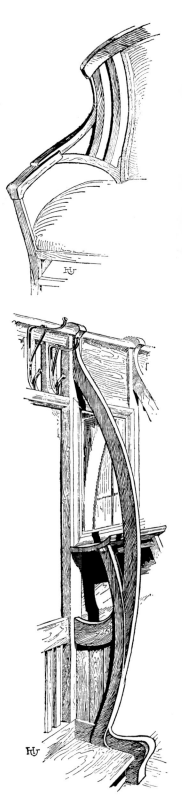

workmanship of artisans who often worked to clay models made by the great man himself.

The rhythmic interplay of curved lines, accentuated at the rounded corners, and the free flow of decoration carved in the wood gave his work the quality of sculpture. Formal distinction was further enhanced by the use of costly woods. Exotic timber imported from the Belgian colonies in Central Africa was harmoniously flanked with European woods, expensive leather or silk upholstery and bright colours ranging from red to moss green, and from yellow to pink. All were brought together to create stunningly effective, coherent interior design that took organic line as its guiding principle, extrapolating it into an ideal, abstract form.

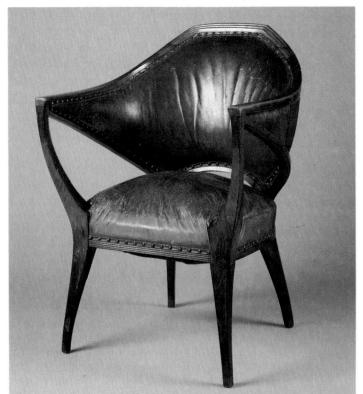

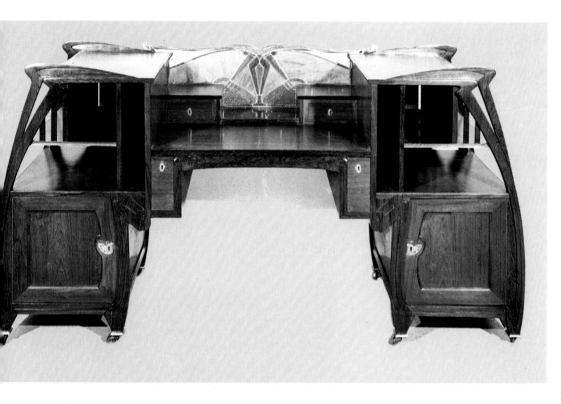

Henry van de Velde

In addition to Horta, Belgium could boast another leading designer of indisputable stature. Henry van de Velde (1863–1957) was perhaps the most intriguing personality of the period for the breadth and commitment of his work, the influence of which reached beyond the borders of his homeland to become a cultural benchmark for much of Europe. Van de Velde combined architecture and interior design through intense theoretical efforts aimed at clarifying the ideals of the new style and substantial activity as a popularizer of artistic ideas. Ethical and expressive values fused in van de Velde's work, giving it a significance that would endure beyond the fascinating albeit brief season of Art Nouveau and provide a starting-point for the subsequent developments of the modern movement.

Starting with the Bloemenwerf House which van de Velde designed for himself in 1895 at Uccle, he showed his skill as an interior designer, seeking a vision that would unify the various components in a seamless, flowing whole with an all-embracing, linear dynamic.

Line was not merely an expressive sign or a morphological statement; it was above all a rigorous design principle that could reveal the real structural and functional nature of objects. Van de Velde's stance can therefore be defined as Functionalist, and was characterized by the ceaseless search for maximum correspondence between structure and ornament, and form and purpose, by identifying and complying with the internal logic of each in-dividual item. "So we begin by laying bare the joints and skeletons," he wrote in *The Renaissance of Modern Applied Arts,* "to subject them to examination and the most scrupulous of checks. It is absolutely indispensable to investigate as thoroughly as possible the logic of these forms [...] to be able later, when we want to add ornamental motifs, to graft them on in the same way as nature."

The above statement effectively sums up van de Velde's expressive technique. For him, the austerity of Functionalism did not entail an absence of decoration but rather its organic integration into the form of the object.

One example of this is the *butterfly* writing desk from the end of the 19th century, in which the schematic zoomorphic motif's two symmetrical "wings" – themselves subdivided into various-sized compartments to accommodate a range of objects – are adapted to the end-use of the desk. Another is provided by van de Velde's superb and much less elaborate armchair. Here the design of the chair back, marked off by curved vertical elements, is clean, definite and free of any decorative affectation, the pale shades of the upholstery under-lining the economy of design.

These two objects could be thought of as stages in the progress of a design concept striving for ever-greater formal simplicity and coherence of construction. In his article "A Chapter on the Design and Construction of Modern Furniture", published in 1897 in the magazine *Pan,* van de Velde stated that he had adopted reason as the watchword for his work in the conviction that the new style should not produce anything that "lacked a practical and rational foundation ... if necessary having recourse to the aid of that now omnipotent tool, manufacturing industry". Having accepted "machine-ism" as a means and method of production, van de Velde went on to analyse furniture in all its components, including screws, hinges, locks and handles, which were no longer held to be unimportant accessories but integral parts of a single object.

The same design criterion informed van de Velde's use of materials. In the same article he affirmed that he made furniture in which the wood actually looked like wood and the features of each articulation were clearly evident. He then theorized the virtues of a design approach that reduced bulk to a minimum and

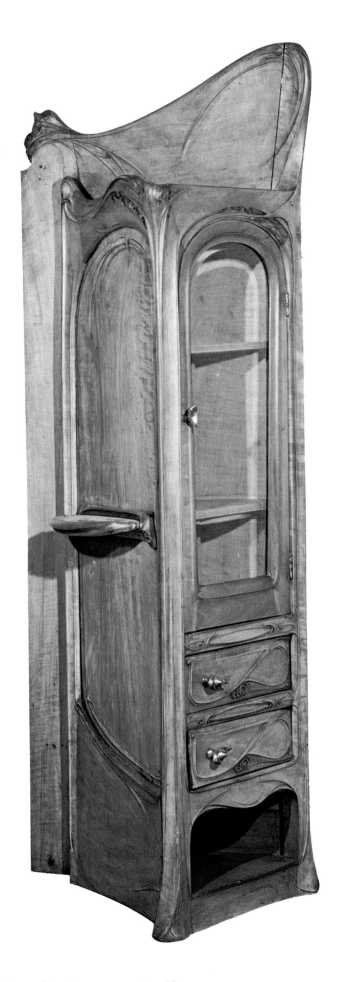

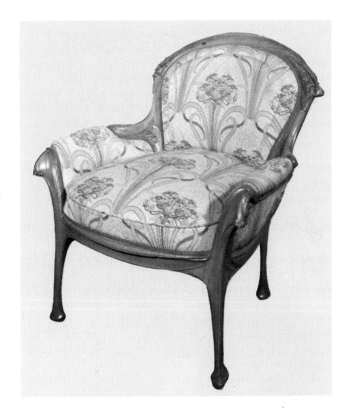

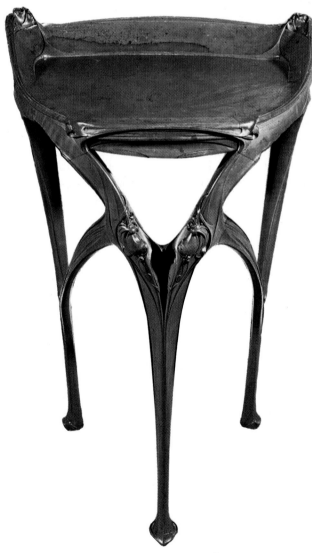

had an open-work structure (such as the armchair described above), sacrificing volume to line.

In functional and expressive terms, the reduction of bulk meant less waste of materials but also enabled the designer to establish a precise relationship between article and ambience, intervening in individual articles or the complementary forms generated by their interaction in their specific setting.

Each item was defined by its own contours, which delimited the material it contained but also involved the profiles of the equal and opposite surfaces it traced on the wall. A total design was therefore required to take account of the complex interplay of the individual elements in the ambience.

One of the distinguishing features of Art Nouveau was in fact the tendency to make objects open and transparent so that the background showed through the figure. The result was a sense of internal resonance, contraction and expansion in a mutual exchange of points of view. A striving for dynamic extension was, as we have seen, one of the overriding concerns of the new style. It was, as van de Velde noted, a collective achievement of the best artists.

France

The progress of Art Nouveau in France is marked by outstanding individuals, artistic groups and circles in which the new forms were experimented with, and by intelligent, well-informed commercial initiatives that aimed to promote the new style. One of the most remarkable protagonists was Siegfried Bing (1838–1905), a

dealer and patron of the arts. Bing was an enthusiastic collector with a particular love of oriental art, and he was responsible for the publication of the magazine *Le Japon Artistique,* which was to play a crucial role in popularizing Far Eastern art.

In 1895, Bing transformed his antiques shop in Rue de Provence in Paris into the Galerie Art Nouveau, dedicated to the collection and sale of objects that embodied renewal, within a context that nonetheless acknowledged the contribution of tradition.

The work of those who had gone before was, for Bing, an example. It was not to be taken as the model for shabby, slavish imitations but rather as the source of an inspiration coming from the spirit in which it was conceived. It was necessary to immerse oneself in the ancient traditions, striving to recover their elegance, purity and clear logic, and enrich the French heritage with a vital modern spirit (cf. L. Buffet-Chaillé, *Art Nouveau Style,* London, 1982). Despite the nationalistic overtones of this statement of intent, Bing's activity was unblinkered by prejudice, and he gathered a group of authentically innovative artists around his gallery. His search took him abroad – Bing's role in promoting the works of van de Velde and Tiffany was crucial – and he created an atmosphere that encouraged the constant exchange of information about the arts.

Another gallery that had much in common with Bing's was the Maison Moderne, set up in Paris in 1896–97 by the German art critic Julius Meier-Graefe with the aim of making and selling "only that which has been en-

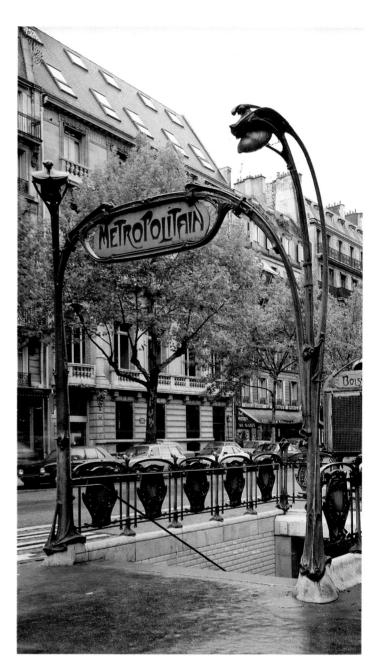

nobled by art with the prestige of beauty". More realistically, the Maison Moderne concentrated on semi-standardized items suitable for industrial production. On a different level of artistic quality, the department stores of Paris put their distributive muscle

at the service of Art Nouveau, using its fashion element to entice consumers with the appeal of novelty.

It was no coincidence that commercial architecture frequently used Art Nouveau for publicity purposes. The Lafayette

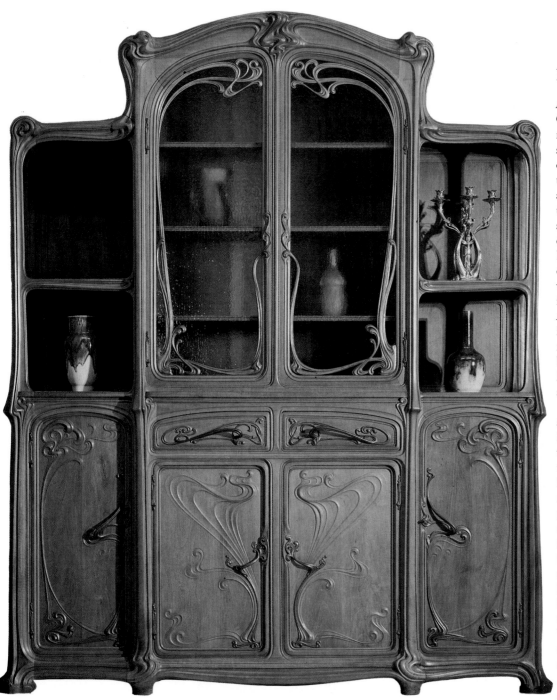

Hector Guimard

A disciple of Horta, Hector Guimard (1867–1942) applied his master's principles but demonstrated an original temperament of his own, capable of intense three-dimensional interpretation and bold figurative representations that ignored traditional symmetrical composition. His architecture, exemplified by Castel Béranger in Paris (1897–99) or his own home in Avenue Mozart, reveals a taste for unexpected effects with a hint of the irrational. A window could be transformed into an open mouth, a grille might become a tentacle or a banister could be designed to follow the rhythmic movements of someone going up the stairs.

The same intensity of expression was implicit in the design of his furniture, where Guimard went his own way, inspired, as the critic Gustave Soulier wrote in 1899, "by the underlying movements, by the creative process in nature [...] and he assimilates these principles in the formation of his ornamental contours [...] The floret is not an exact representation of any particular flower. Here is an art that both abbreviates and amplifies the immediate facts of nature [...] We are present at the birth of the quintessence of a flower" (see the entry "Guimard", in J. Mackay, *Dictionary of Turn of the Century Antiques*, London, 1974). This interpretative comment in fact serves to qualify most of Guimard's work.

The early pieces in solid, inflexible mahogany were nevertheless enlivened by the busyness of the structure, and in his second phase, from 1900 to 1910, he used soft pearwood, which could more

and La Samaritaine stores, for example, featured the interwoven patterns, arabesques and linearity of the new style in the glass and iron façades that the architects Georges Cheanne and Frantz Jourdain designed in 1900 and 1904 respectively.

As well as galleries and department stores, exhibitions also played their part, especially the international exhibition held in Paris in 1900. Public taste was also heavily influenced by Art Nouveau. It was applied to much street furniture, extending its

curving lines over shop and restaurant signs, the awnings outside theatres and music halls, and most notably the extraordinary *métro* stations designed by the architect Hector Guimard between 1899 and 1904.

FACING PAGE: a display cupboard by Eugène Gaillard presented at the international exhibition held in Paris in 1900. Inspired by the Neo-Rococo style, it is decorated with the typical Art Nouveau motif of the *coup de fouet,* which can be clearly seen in the door detail below. The finely chiselled bronze hinges and handles follow the flowing lines of the carved decoration. Danske Kunstindustrimuseum, Copenhagen.

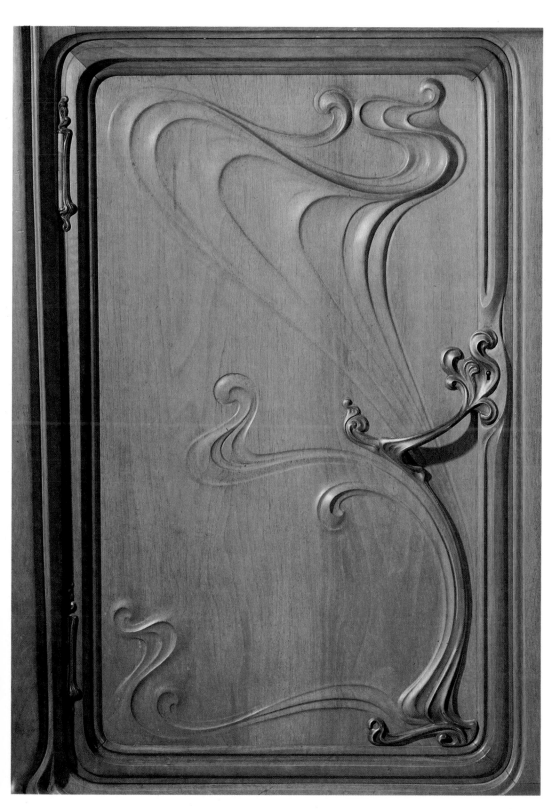

easily be curved and modelled to suit the designer's imagination.

Guimard liked to call himself an *architect d'art* and thought of his creations as environmental sculptures with a strong three-dimensional connotation. A good example is the three-legged pear-wood table that evokes a living shape, albeit one that is unidentifiable. The ornamental carvings allude to a burgeoning shoot, a bud growing out of the wood whose slender appendages attach themselves to the mouldings of the supports, while at the same time defining the shape of the entire piece. Similarly the feet, lanceolate in the table and embellished with subtle mouldings in his padded Louis XVI-style armchair, serve to underline the organic, sculptural quality of pieces that are, ideally, brought to life by a hidden natural force.

Eugène Gaillard

The vital impulse that drove Guimard's work was diluted in a more refined decorative approach in the production of other artists of the period, such as Eugène Gaillard (1862–1933), a designer who belonged to the informal group at Bing's gallery. One of the most important of his surviving pieces is the display cupboard made for the international exhibition held in Paris in 1900, a piece whose design revived the Rococo tradition – "a sort of direct evolution of the light, agile furniture and decorations created for Louis XIV, XV and XVI". Made in walnut in a traditional, symmetrical configuration, the piece is embellished with sinuously curving carved decorations and metal handles

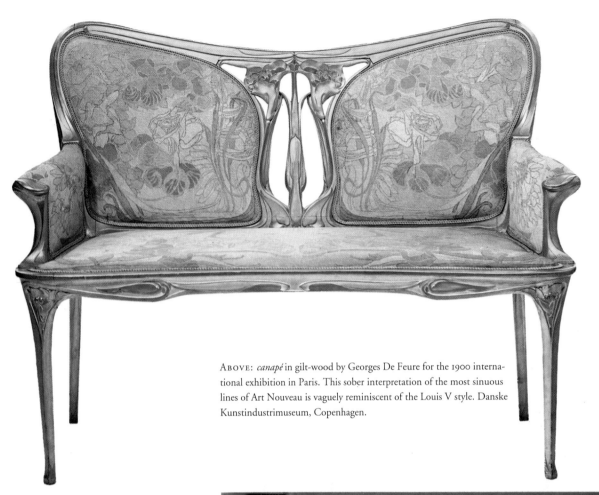

ABOVE: *canapé* in gilt-wood by Georges De Feure for the 1900 international exhibition in Paris. This sober interpretation of the most sinuous lines of Art Nouveau is vaguely reminiscent of the Louis V style. Danske Kunstindustrimuseum, Copenhagen.

and hinges in a characteristic Art Nouveau *coup de fouet* pattern that masterfully merges the two materials.

The development, expansion and synthesis of the mouldings marry the wood and gilded bronze without hiding the characteristics of either, yet achieve a superb continuity of design. The metal handles curve out to meet the ridges and grooves of the wood, highlighting the gently rippling surface like a brushstroke shading off into the background of a painting.

Gaillard was as attentive to the structure and comfort of his furniture as he was to the aesthetic effect, as is clear both from his work and from his autobiography, *A Propos du Mobilier*. In his book, Gaillard explains how reference to nature, and to aquatic plants in particular, underlay the formal realization of his furniture and their functional and structural logic. The venation, elasticity and tenacious

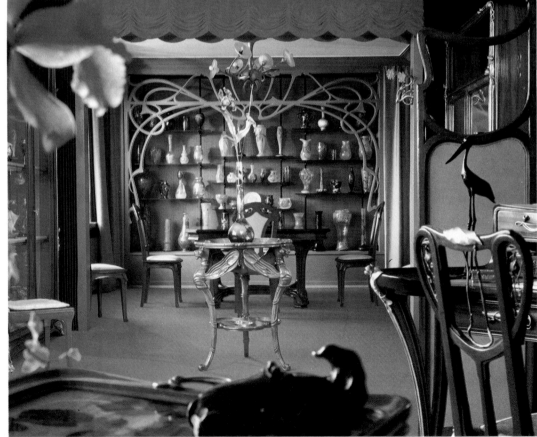

De Feure and Charpentier

Among the artists in the group at Bing's gallery was the Dutchman and naturalized French citizen, Georges De Feure (1868–1928), one of the most versatile painters, poets and artists of the time. His passion for the decorative arts frequently spilled over to become an excuse for his aesthetic lifestyle. He kept greyhounds, whose slim, streamlined profile he admired, and was a lover of symbolist literature, especially of the "Satanic beauty" school reminisent of Edgar Allan Poe, Charles Baudelaire or the soft curls and opium-perfumed images of Aubrey Beardsley. De Feure's versatility of expression was applied to areas ranging from furnishing to graphic art, to ceramics and stage design. He was continually stimulated by innovations and by the use of new materials, including wood, ivory, porcelain, glass, bronze, silver, paper, wool and silk.

De Feure's search was at times an arduous one, but in his furnishings it resolved itself in pieces of great refinement that hinted at past tradition, in line with the theory already proposed by Bing.

flexibility of plants suggested more comfortable designs for seats and backs as well as more robust structures.

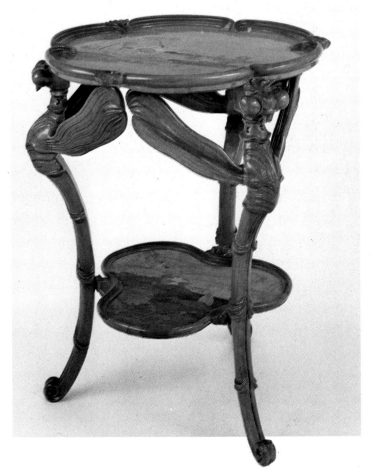

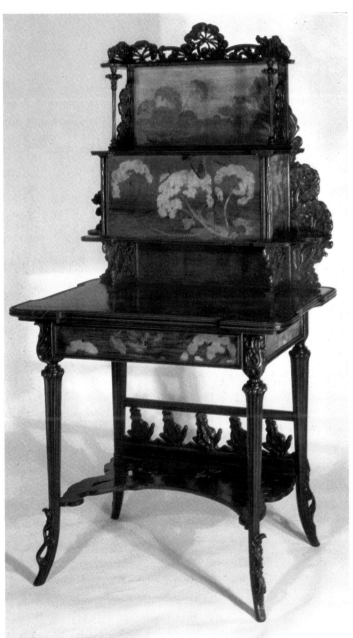

LEFT: the *guéridon aux libellules* (c. 1900), a piece by Emile Gallé at the height of his artistic maturity. Antiques trade. FACING PAGE, BELOW: the Lilac Room in the Hôtel Gillion-Crowet in Brussels, with furniture by Louis Majorelle, Gallé's celebrated *guéridon* and a collection of vases by Gallé. ABOVE: a Gallé writing desk in robinia presented at the Paris international exhibition in 1900. The decorative motifs of the inlay are mirrored in the carved elements and fretworked sections. Félix Marcilhac Collection.

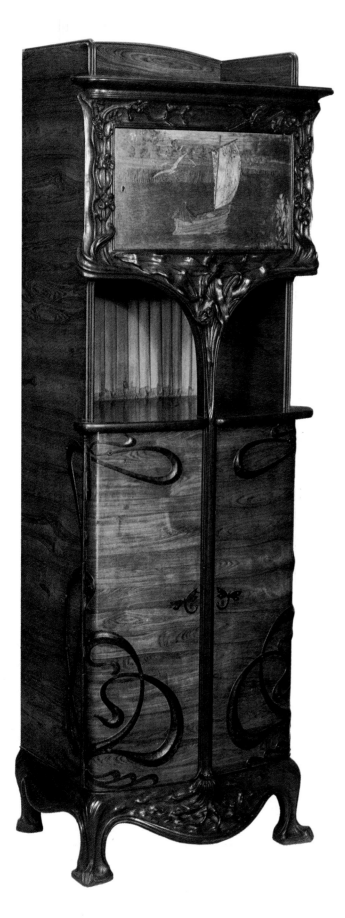

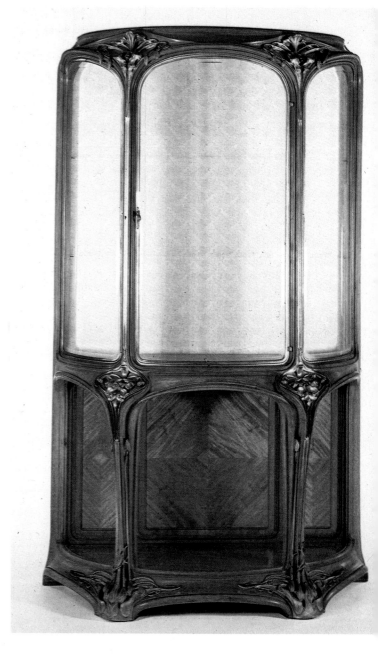

BELOW AND FACING PAGE: furniture by Louis Majorelle. LEFT: a cabinet inlaid with different kinds of wood, one of the artist's most original pieces. An aquatic plant, whose roots are carved on the apron, rises up to spread its leaves over the cabinet door and frame a lake scene. Bethnal Green Museum, London.

ABOVE AND FACING PAGE: two matching pieces from a suite of living room furniture known as *aux orchidées,* from the flowers that inspired the gilded bronze mounts on the anterior supports. The doors of the mahogany buffet use the intricate, undulating pattern of the grain in a fanlike symmetrical arrangement to create a refined ornamental effect. Antiques trade.

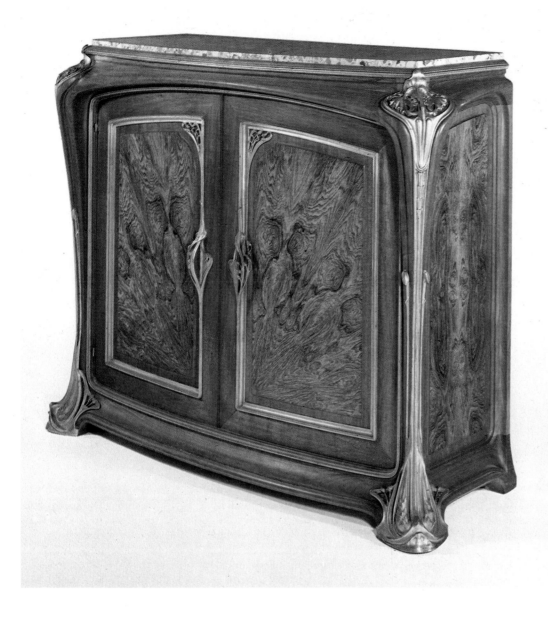

De Feure was a sophisticated manipulator of colour who preferred gilded finishes and restrained shades of green, mauve and blue for his screens, settees and chairs. His slender, graceful furniture was in gilded wood, delicately carved with plant motifs combined with silk fabrics in sophisticated patterns that underlined the link with the great 18th-century French tradition of *ébénistes,* sculptors, lacquerers, upholsterers, plasterers and decorators.

In contrast, Alexandre Charpentier was a sculptor before he became a decorator. He presented a music room at the Esposizione Internazionale d'Arte Decorative in Turin from which there survives an instrument cupboard in walnut. This article reveals a certain three-dimensional, architectural gift on the part of its designer in the basket arch that holds the design together.

It is also apparent in the deliberate allusion in the metal plaques decorated with bas-relief dance motifs, the carved female figures playing musical instruments and in the design of the lateral elements, with their mouldings that recall harp strings, all of which contribute to a pleasing interplay of reflection and reference between object and function.

The Ecole de Nancy – Emile Gallé

A more marked form of symbolism characterized some of the greatest works of French Art Nouveau – the furniture and other objects produced at the Ecole de Nancy (founded in 1901) by the group of artists and artesans who gathered round the theorist and brilliant experimenter of form and technique, especially in glass, Emile Gallé (1846–1904).

Inspiration from nature was for the members of the group the driving principle behind their efforts and the force that generated all their work. In their hands, it became a near absolute passion for all living forms and a blind faith in the mystery of creation. On the door of the glass and ceramics workshop he inherited from his father in Garenne, and which he would move to Nancy at the turn of the century, Gallé hung a plaque engraved with the words "Our roots lie in the forest floor and in the moss round the edge of a pond".

This bore witness to his inclination for a romantic evocation of the natural world. In Gallé's furniture, that evocation could result in the anthropomorphization of the object, which was treated as a living, feeling, speaking being.

The most extraordinary example of this is his *Autumn Pathways* cabinet, constructed in 1892 and delivered to his client with a long message in prose, inspired by the poetry of Stéphane Mallarmé. In it Gallé revealed an almost obsessive love of plants and animals, a delight in a job well done and his regret at having to take his leave of a painstakingly created item. Neither did he forget to include instructions on how to maintain, clean and polish the piece while respecting its nature and personality.

It is well worth quoting here part of that text, which in a sense constitutes the artist's spiritual testament and a statement of the aesthetic that inspired his production: "My intention was to build a credence in the accents of autumn [...] All of us who love good work feel that it springs straight from the ground and fancy that we hear the harmonies which presided over its birth. May this present piece be to you as a forest growth rising from the floor to the beam of the ceiling

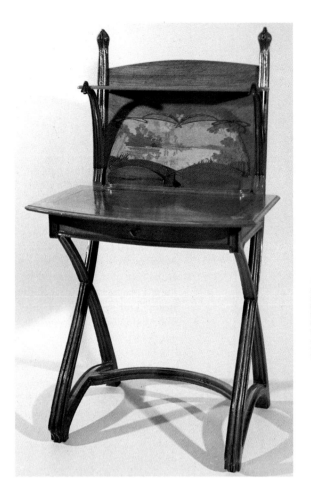

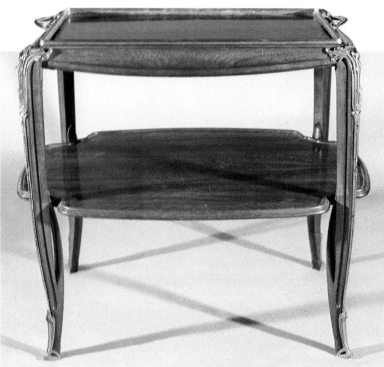

[...] Look below. Here the ornament makes contact with our ancient land and the life of the fields. Above, in contrast, the depths are full of shadows; the decoration abandons naturalism to become misty and symbolic [...] I have emphasized the antithesis between realistic representation and symbolic adornment by applying a waxy patina only in certain places [...] Elsewhere, on the other hand, I have taken a daring course which is without precedent in the cabinetmaker's art: the surface of the wood has been left in its natural virgin state, without varnishing or patina ... The wood is sufficent unto itself" (M. Rheims, *The Flowering of Art Nouveau*, New York, n.d.).

Gallé's furniture comprised unique, signed items, often engraved with verses by Hugo, Verlaine or Baudelaire. These were fully fledged symbolic manifestos, pieces of speaking furniture in which nature was present in the grain, the softness or the roughness of the material, or again was portrayed in the inlays of different kinds of wood. These were generally from fruit trees, such as apple or pear, which were plentiful in the Nancy area, and depicted flowers, stems, leaves, insects and other animals in a sort of "biological enclave" that metaphorically extended the life of the tree.

Love of symbolism and an intense emotional involvement in the vitality of nature are also evident in another memorable piece by Gallé, the *Aube et Crépuscule* bed he made in 1904, shortly be-

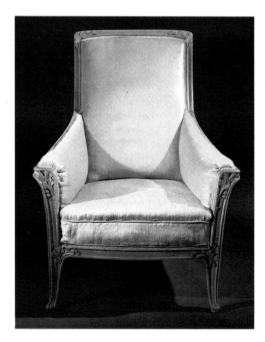

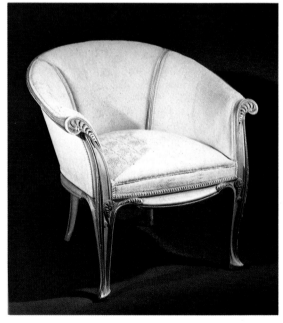

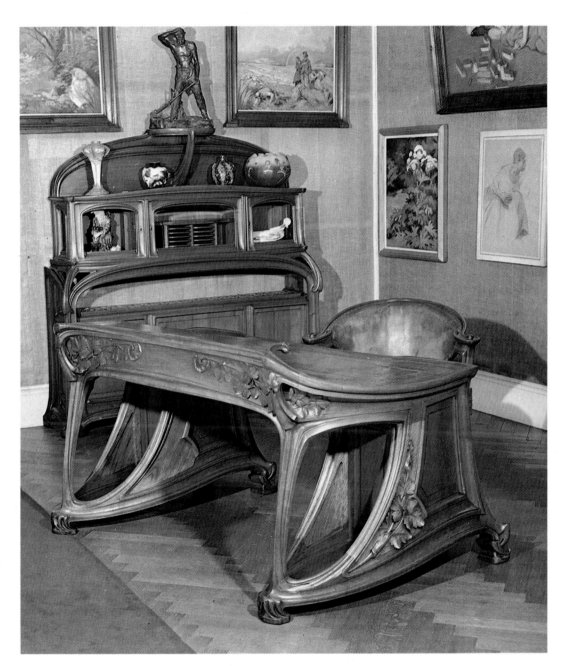

fore he died, for the magistrate Henry Hirsch. The headboards opened out into broad butterfly wings inlaid with wood, metal, gemstones and mother-of-pearl, alluding, not without an element of melancholy, to the ephemeral nature of daylight and the mysteries of the night. The design is a journey whose beginning and end are recreated every morning. Like the opalescent glass body of the butterfly, it marks the pulsating rhythm of life itself.

Louis Majorelle

Inlay, which was the distinguishing feature of Gallé's work, was used in the same period with equal mastery by Louis Majorelle (1859–1929). Majorelle had trained as an artist but inherited an *ébénisterie* workshop in Nancy, where he learned the secrets of the trade from the craftsmen employed there. One of the pieces by Majorelle that show most clearly the influence of Gallé is the cabinet from the early years of the century that seems to grow from an aquatic plant, rising from the roots up the stem to the inlay at the top with its lake scene. Majorelle also makes brilliant contrastive use of carved and inlaid motifs, as well as metal mounts, on perfectly smooth surfaces that are densely patterned by the rippling, wavelike grain. Two butterflies, or perhaps dragonflies, flutter over the motifs where the locks are inserted.

Majorelle's furniture nevertheless had a less naturalistic flavour than Gallé's, and the inlay often features abstract designs, matching walnut with exotic woods like mahogany or tamarind in linear strips of panels with sinuously flowing profiles.

Majorelle wrote that nature was a marvellous collaborator and an inexhaustible source of decorative motifs. However, it was wrong to let nature dictate the shape of a piece of furniture. For Majorelle, a sumptuous effect should not be sought by means of an unbridled profusion of ornaments, but through elegance of line and a sense of proportion (cf. L. Buffet-Challié, *Art Nouveau Style,* London, 1982).

It is clear from the above that plastic and construction considerations prevail in Majorelle's work, as the designer himself openly asserted: "The first aim in the construction of a piece of furniture is to seek a healthy structure capable of inspiring a sense

Broad, arching lines are the keynote of the display cabinet by Eugène Vallin, made (c. 1905) as part of the furniture for a dining room. The suppleness and vitality of the structure is evident in the details below of a corner and two drawer handles, which bulge out from the furniture almost as if they were made of some yielding, malleable material. Musée de l'Ecole de Nancy.

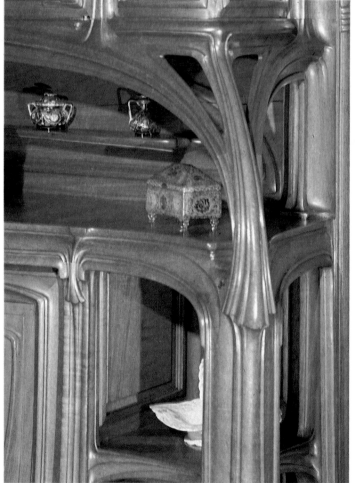

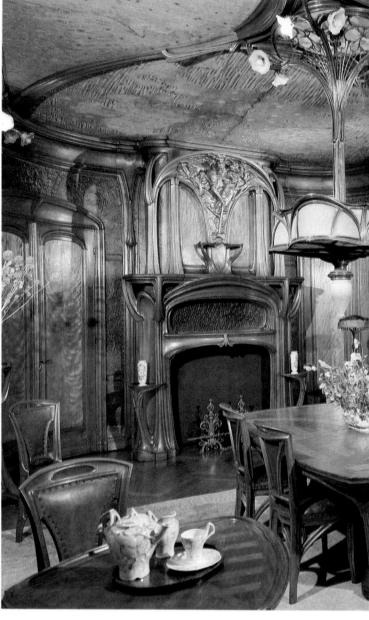

of harmony and such that the essential lines should have an architectural sense of elegant proportions. Whatever the function of a piece of furniture, the craftsman must ensure that the lines can exist without decoration." (See the entry "Majorelle", in J. Mackay, *Dictionary of Turn of the Century Antiques,* London, 1974.)

The desire to control the spatial extension of his pieces induced Majorelle, like many other designers of the period, to make clay models to give to his carpenter. In this way, he was able to obtain the cavities and protuberances of the soft shapes that

attested the handmade quality of the furniture. The viewer's eye was invited to follow the lines traced by the hands of the craftsman who had created the model. As was the case with De Feure and Gaillard's work, there is in Majorelle a clear continuity with the past, which is nowhere more obvious than in the chairs and armchairs made in the style of Louis XV. This earned him the appellation of "le Cressent de l'Art Nouveau" (which was in no way derogatory) from the critic M. Rheims in his study *L'art 1900.*

The reference to Charles Cressent, one of the greatest

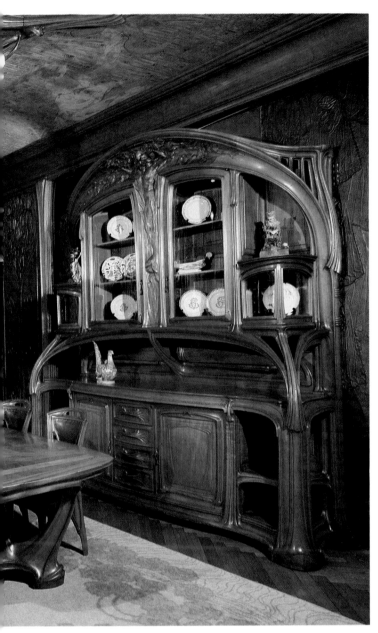

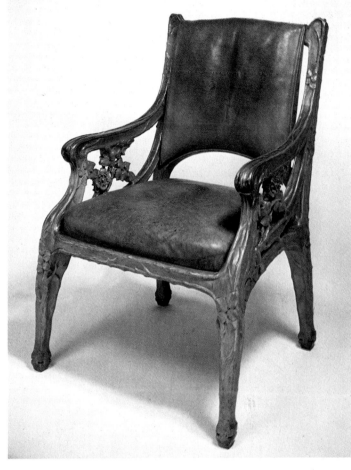

The Algerian planewood armchair, from about 1900, was conceived by its designer, Georges Hoentschel, as an unbroken continuum of plant life, the distinctive feature of furniture made by the architect and interior designer who also produced the design for the pavilion of the decorative arts at the 1900 Paris international exhibition. Musée des Arts Décoratifs, Paris.

ébénistes of the 18th century, is justified by the overall design of the Louis V-style pieces and by the tendency of both designers to used gilded bronze ornamentation. Bronze orchids and lilies can often be observed in Majorelle's works (for example the tamarind *guéridon* or the 1900 serving table). They add the sinuosity of their leaves and stems to the elasticity of the wood's own grain, underlining Majorelle's recourse to the "marvellous collaboration" of nature and at the same time serving as physical reinforcement for the supporting structures.

Vallin and Hoentschel

The furniture of Eugène Vallin (1856–1922) reveals sculptural qualities and striking effects obtained with materials. Vallin was an architect and decorator active in Nancy who had previously designed church ornaments as well as restoring ancient monuments in the footsteps of Eugène Viollet-le-Duc. His surviving work includes a complete dining room, now on exhibition at the museum in Nancy, which conserves the most important pieces by the artists of the Ecole de Nancy. The dining room is made in sup-

ple cedarwood, and the individual pieces seem to push the possibilities of the material to the limit. The structure ripples and stretches in a way that is not un-reminiscent of the "muscular" architecture of Viollet-le-Duc, puckering into carvings or opening out into sweeping curves and eye-catching arches that splay to provide supports. The drawer handles project like folds of fabric resting on the surface of the wood. In the centre of the upper section of the cabinet, there is a relief carving of a female figure by Victor Prouvé (1858–1943), a painter, woodcarver and sculptor

who collaborated with a number of furniture-makers including Gallé and Majorelle.

Apart from differences attributable to the styles of the individual designers, all the items illustrated so far share a common purpose, and all take nature as a guide in their efforts to interpret and synthesize reality. The only exception to this tendency is Georges Hoentschel (1855–1915), an architect and ceramic artist whose decorative ideas would not admit stylization and whose furniture took the form of a seamless continuum of plants in a descriptively naturalistic key.

Josef Hoffmann and the Wiener Werkstätte

The desire to make plain, functional, appropriately designed objects that were also unique and valuable, in a way that would enhance the role of the artisan-artist, prompted Josef Hoffmann (1870–1956), Koloman Moser (1868–1918) and Otto Czeschka to set up the Wiener Werkstätte in Vienna in 1903. Created on the example of similar organizations in Germany and England and active until 1933, the Wiener Werkstätte influenced taste in the decorative and applied arts for thirty years. The contrasting personalities of the artists who took charge of the enterprise ensured that the Viennese workshop was continually renewing its stylistic orientation. Hoffmann in particular guided its early production in the direction of an intrinsic coherence and modernity. Care was taken to ensure functionality and a rigorous line that in some ways anticipated Art Deco, while strikingly effective notes of colour and a dichromatic tendency that polarized into a contrast of black and white were typical of Wiener Werkstätte objects from the Hoffmann period.

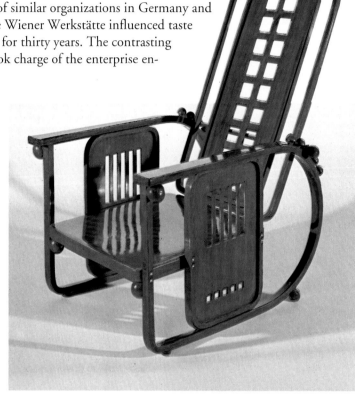

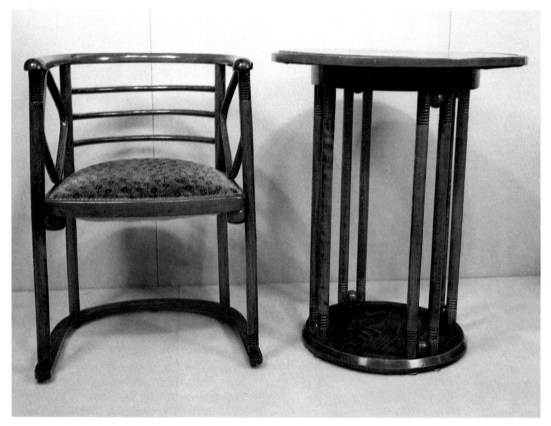

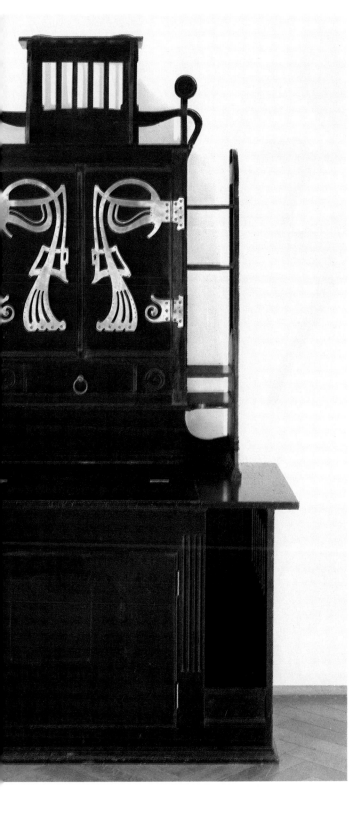

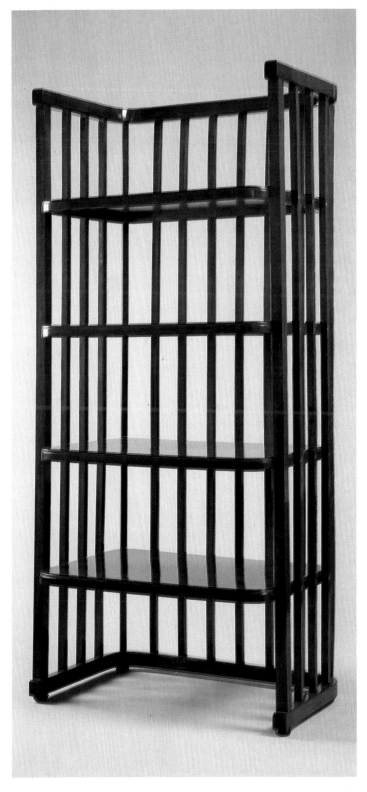

FACING PAGE: three pieces by Josef Hoffmann in curved beechwood. They all feature the use of spheres to connect flat surfaces and supports. ABOVE: The reclining armchair dates from 1903. BELOW: The side table and chair were made in 1906. Antiques trade.

LEFT: an alderwood cabinet, part lacquered and part stained black, designed by Hoffmann in 1898. The tendency towards simplification, typical of the Viennese school is tempered here by the sinuous lines of the decoration. Österreichisches Museum für angewandte Kunst, Vienna. BELOW: a curved mahogany *étagère* made by J. & J. Kohn in 1905 to a design by Hoffmann. Antiques trade.

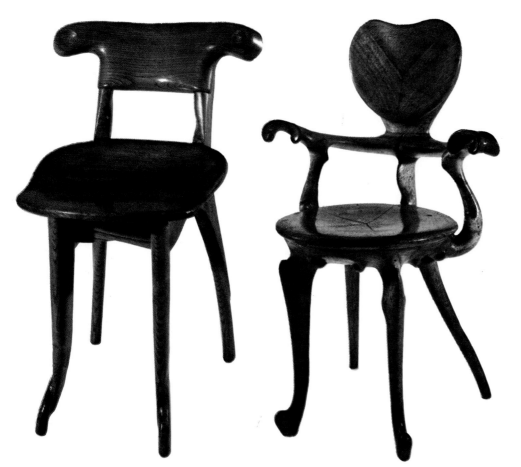

Chairs designed by Antoni Gaudí for Casa Calvet and Casa Batlló in Barcelona. LEFT: armchair and chair with writing table. BELOW: bench seat. Museu Gaudí, Barcelona.

tion ran riot in his decorative details, which include fragments of tiles set in the walls or asymmetric wrought-iron ornaments whose lines expand, rise up and twist back over themselves in elegant arabesques.

His furniture, too, elicits the same awe, or in some cases even alienation. The seats Gaudí designed for Casa Batlló and Casa Calvet in the early years of the 20th century are particularly memorable. They can justifiably be described as sculptures born of a continuous conception of space and volumes. The objects emerge from space in the same way as Gaudí's furniture "frees" itself from the wood. The seats bear witness to an intense process of

Gaudí's Spain

Catalan Modernism, in the sense of a movement that brought together influences from elsewhere in Europe and autonomous elements based on local traditions, will remain forever linked to the name of an astounding architect who was truly "one of a kind" – Antoni Gaudí (1852–1926).

What modern historians have called absolute creative freedom was the driving force behind Gaudí's extraordinary work, from the Casa Batlló (1905–08) with its bow windows protruding through "organic" excrescences and "bone" frames, to the Casa Milà (1905–10), whose façade undulates like the waves of the sea from which lumps of seaweed emerge and cling to the balconies.

Palacio Güell and Parco Güell, again in Barcelona (1889–1914), also sport sweepingly curved terraces resting on superb Doric columns. Gaudí's imagina-

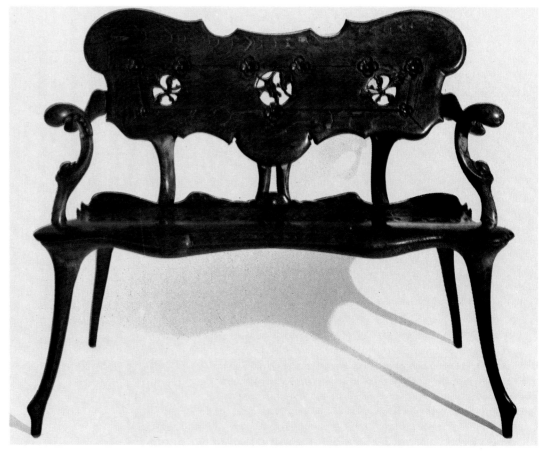

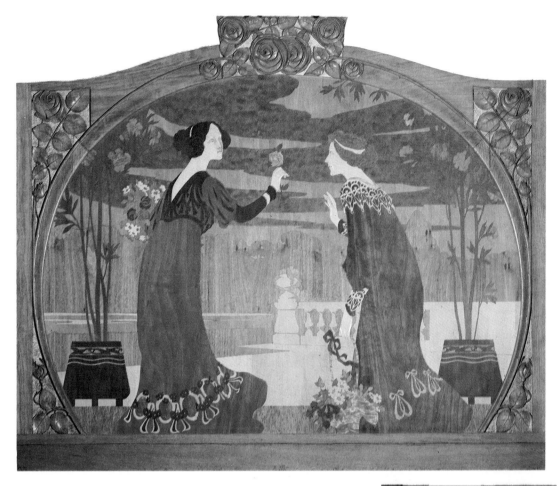

Four, or Four Macs, comprising the architects Charles Rennie Mackintosh (1868–1928) and Herbert McNair (1870–1945), and the Macdonald sisters, Margaret (1865–1921) and Frances (1874–1921), graphic artists and interior designers.

Originality and sincerity were certainly the distinguishing characteristics of their work, which drew partially on the Arts and Crafts movement but developed independently both in the field of architecture and in the applied arts.

The Glasgow Four excited considerable interest in Europe, having greater success, ironically, on the Continent than in Great Britain. They won immediate ac-

modelling that is both symbolic and structural at the same time. The swelling of the oak into hard, massive cores stiffens the object at the points where it is most flexible while being transformed into almost anthropomorphic shapes that contrive to bring the piece concerned to life.

The bends and distensions in the wood are also genuinely functional, like the seats resting tray-like on their support structure and modelled to fit the user's body. The hollowed "ears" on the sides of the chair back are perfectly designed for the thumbs of anyone who wants to lift or move it and the back of the armchair is curved like a concave shield protecting the user's back.

Although Gaudí was certainly the most original, Spain and especially Catalonia produced other major exponents of Art Nouveau. Two significant designers were Gaspar Homar (1870–1935) and Juan Busquet (1874–1949), who were outstanding both for their

skill as cabinet-makers and their precocious adoption of the new style. As early as 1890, Homar in particular was creating furniture and interiors that featured the typical whiplash motif in combination with sophisticated decorative inlays which preserved the characteristics of traditional Catalan figurative decoration while re-elaborating the ideas of the Ecole de Nancy.

Scotland – the Glasgow Four

"Originality is the seed; the fruit is sincerity. It is difficult to find another school more original or sincere than the Scottish one." These words by Alfredo Melani in his 1902 article "Inghilterra e Scozia" for the magazine *Arte italiana decorativa e industriale* refer to the objects presented at Turin by one of the most important groups of artists from the Art Nouveau period: the Glasgow

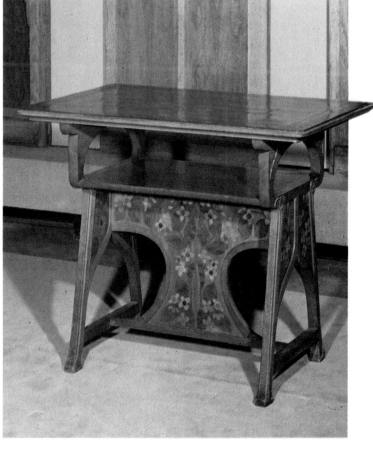

In 1901, Charles Rennie Mackintosh took part in a competition, eventually won by Baillie Scott, to design the dining room of the *Haus eines Kunstfreundes* ("House of an Art-lover"), Fritz Wärndorfer. Mackintosh presented this colour drawing, which exhibits all the features of the Glasgow architects: linearity, purity and austerity of form and highly stylized plant-inspired decorative motifs, such as the recurrent flattened rose. University of Glasgow.

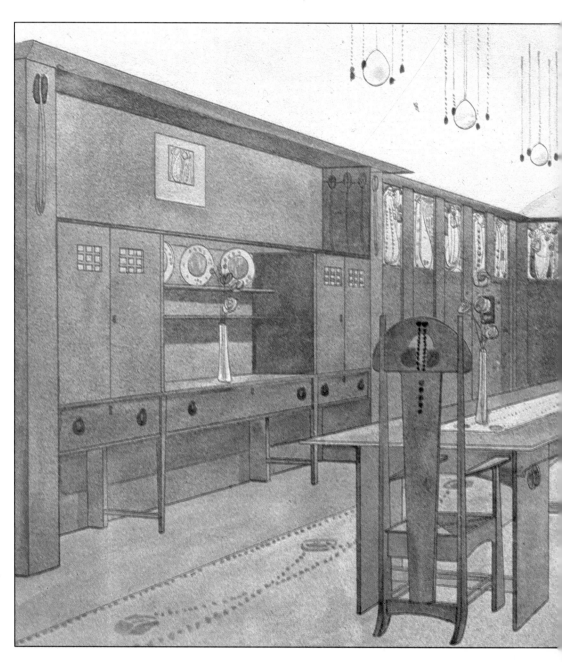

claim at exhibitions, in particular at the eighth exhibition of the Viennese Secession, and had a profound influence on much of the work that was produced in the German-speaking countries. What attracted the critics' attention and the public's curiosity was not the flamboyance of the new style so much as its simplicity, its use of patterns and geometrical compositions and its highly original approach to decoration and colour selection.

Mackintosh himself favoured white, combining it with soft shades of mauve, pink, green and ivory, or with black for maximum contrast. This choice did not just mean the substitution of one colour for others, even though white had not been used for furniture since the days of Louis XVI and was therefore a genuine innovation. It also involved a radical re-thinking of interiors and the reclaiming of volumes to increase space and light. The rooms furnished by the group for the Turin exhibition impressed visitors with their candour and their exquisitely refined, rarefied atmosphere. Here, too, the dominant element of the design was the line, which eschewed serpentine curves and whimsical convolution to rise in a slow, measured fashion that kept under control the slightest deviation from the vertical. The design was enriched with equally original, symmetrically positioned decorations: elongated human figures, stylized flowers and intricate linear motifs in glass, metal or enamel.

Mackintosh, too, looked for inspiration to the hidden, less obvious aspects of nature, frequently alluding to winter landscapes of bare stems and branches

and clumps of dry bushes in the snow.

But he also examined nature's structure with a scientific approach, as in his famous rose seen in two dimensions, which was to become the group's emblem, featuring widely in its architecture

and furniture. In designing it, Mackintosh claimed to have been inspired by the sight of a cabbage cut in half.

Furnishings and types of furniture

Fortunately, among the group's most important works there are several complete interiors that survive today, allowing us to observe the characteristic fea-

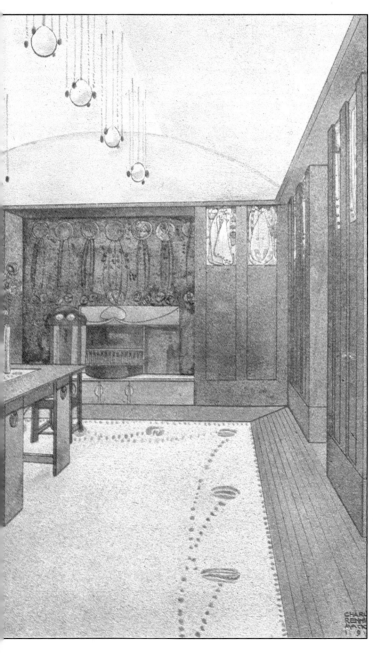

tures of their aesthetic philosophy.

One such example is Hill House, built between 1902 and 1905 at Helensburgh near Glasgow for the publisher Walter Blackie. It fuses interior design and furniture in an exemplary fashion, its innovation blending with a careful re-elaboration of local tradition. The most interesting rooms at Hill House are the living room and the bedroom, both elegant variations of the theme of white and ivory with black counterpoint. In each case, the design encompasses the tiniest details of the room. Certain motifs dominate the group's furniture: Japanese art, which can be seen particularly in the side tables and ceiling light fittings; the preference for two-dimensional figurative representation rather than the suggestion of volume; the rising vertical line; the almost complete absence of mouldings; a predilection for right-angled junctions of wooden strips, the so-called "crate" style; wood, either lacquered in white or black, or stained to leave the grain visible; plain decorative inserts of abstract figures and geometrical motifs; and a transparency and lightness of structure.

The chair was one of the items of furniture that most fired Mackintosh's genius. He made it the object of careful study and designed many different versions, all equally original. Their main feature is the back, sometimes narrow and elongated with horizontal slats like the rungs of a ladder, sometimes low and "material" to display the texture of the wood, and on other occasions curving into an arch to make a body-enfolding sculpture. Some chairs have an intricate frame, upholstered in fabrics designed by Margaret Macdonald and an ornate upper section; others are slender and taper up to a wooden element resting gently on the uprights. The composition of these chairs is generally plain, based on the orthogonal junction of rhythmically modulated, carefully dimensioned plane surfaces, enclosed in ideal, elementary geometrical spaces.

Other kinds of furniture designed by Mackintosh evince the same design logic, including the beds and other pieces of various sizes he produced for Hill House in 1904.

These range from the delightful white cabinet with its silver-covered doors and glass and mosaic decoration to the more utilitarian dressing table, a perfect parallelepiped that opens to reveal drawers, a folding mirror, cabinets and a towel rack. Taken as whole, Mackintosh's work is wonderfully successful, combining moderation, decorative restraint, and even austerity in some cases, with superb freedom and originality of design. His best pieces were to become genuine "classics" of modern furniture-making and continue to feature in the catalogues of today's manufacturers.

The Austrian Secession

The foundation in Vienna in 1897 of the free association of artists known as the "Secession" marked the beginning of one of Austria's most fertile Art Nouveau initiatives as well as the formalization of a general protest against academic stagnation. One year later, work began on the building that would house the Secession's exhibitions. Designed by the architect Joseph Maria Olbrich (1867–1908), it definitively and officially signalled the existence of a cultural tendency that was firmly oriented towards the new art.

Musil's "exhilarating fever" found a particularly receptive climate in late 19th-century Vienna, which was in the grip of avant-garde perplexities and an intellectual tension that heralded profound upheavals. The imminent demise of the Austro-Hungarian Empire, which was to fall at the end of the First World War, had

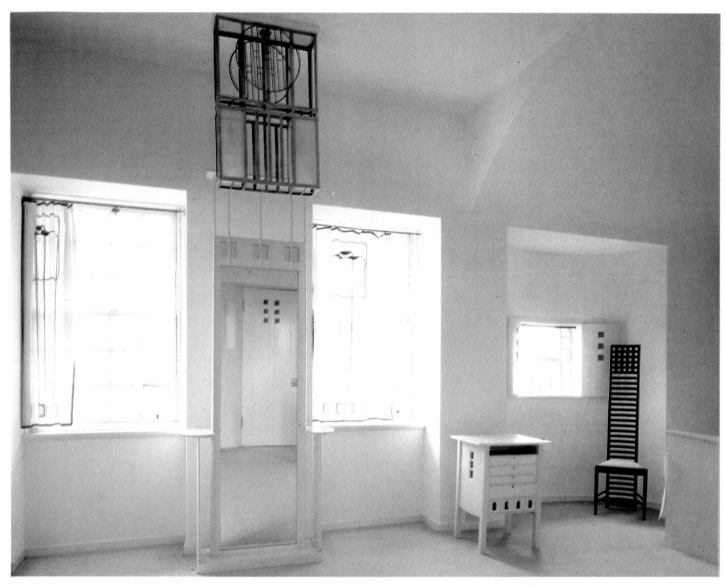

already manifested itself by the end of the century as a widely shared awareness of the need for urgent change.

Sculptors and artists were active in the Secession – Gustav Klimt (1862–1918) for one – as were architects and interior designers of outstanding merit, of whom the most representative undoubtedly was, on a par with Olbrich, Josef Hoffmann (1870–1956). Hoffmann, who was active during three distinct artistic periods (Art Nouveau, Art Deco and Proto-Rationalism), began in the applied arts as a graphic designer for the magazine *Ver Sacrum*, which was published not just as a vehicle for art and architectural theory and information but also as a "training

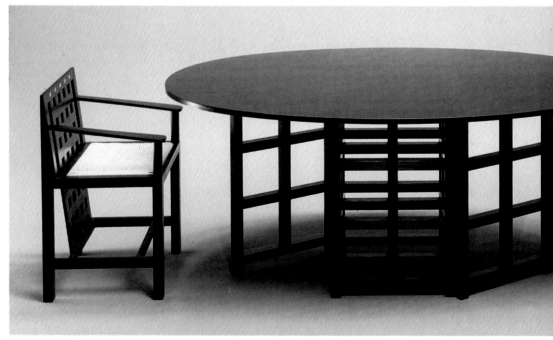

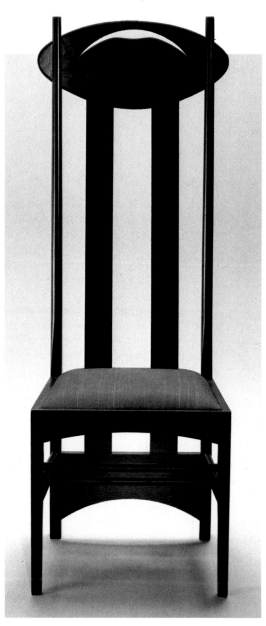

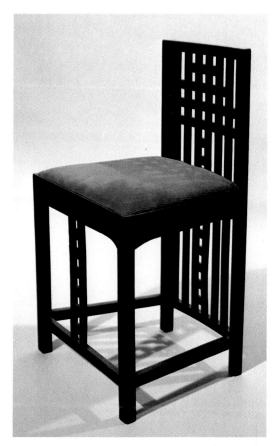

school" for graphic composition, commissioning work from artists like Klimt, Olbrich and Koloman Moser (1868–1918). In Hoffmann's case, his work for *Ver Sacrum* is crucial to any understanding of his subsequent furniture, since it explains the special two-dimensional, geometrical quality that was typical of the first decade of the 20th century.

Thus while Hoffmann's early furniture, dating from the end of the 19th century, reveals sinuously curving Art Nouveau with a distinctly Belgian flavour, his later work is progressively plainer and more syncretic. In addition to his graphic training, Hoffmann was also inspired by his contact with the designers of the day in Great Britain, including Voysey and Ashbee but above all Mackintosh. In 1900, Hoffmann had the opportunity to compare his own production with that of British designers at an exhibition of applied art organized by the Secession.

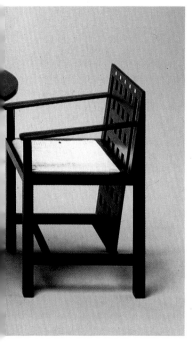

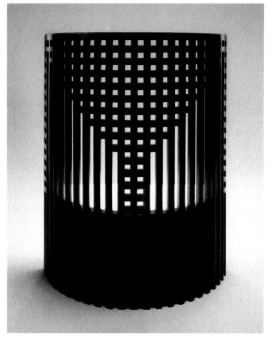

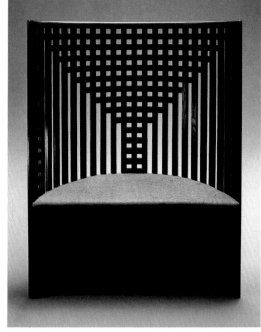

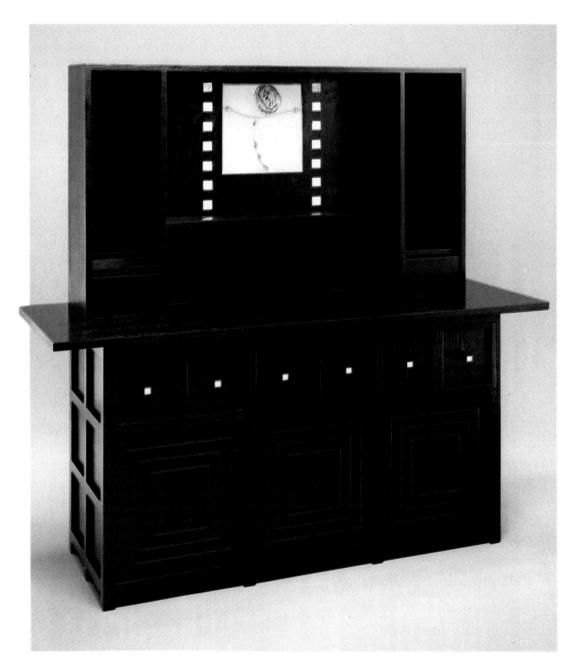

The experience prompted him to strive for greater equilibrium and control, abandoning the excessive "opulence" of some of the French and Belgian artists. From that moment on, the work of Hoffmann and those Secessionists active in the applied arts began to acquire a personality of its own, thanks in part to their efficient organization of manufacturing and distribution.

The Wiener Werkstätte

The Wiener Werkstätte, or "Viennese Workshop", was founded in 1903 by Hoffmann and Koloman Moser, who was to leave in 1906 to devote his energies exclusively to painting. It was intended to be an atelier of the applied arts that would integrate the skills of the designer with those of the artisan, in line with the theories of the Arts and Crafts movement. It was sponsored at first by the enlightened financier Fritz Wärndorfer, and enjoyed an encouraging commercial success, continuing in production until 1932.

The Wiener Werkstätte was active in all fields of the decorative arts, from fashion to furniture, from theatre to graphic art, and from everyday objects to jewellery. It called on the services of a large number of artesans, and in 1905 had one hundred workers of whom thirty-seven were *Meister* (skilled craftsmen) and artesans with their own marques.

Items from the Wiener Werkstätte bore the stamps of the designer and the craftsman who made them, and were renowned not only for the painstaking care with which they were made but also for their distinctive figurative features.

The hallmarks of the workshop's output (and of Hoffmann's in particular) were simple, linear design, smooth surfaces, well-defined outlines, a rectangular scheme and geometrically defined volumes. These same qualities could also be found in the finest contemporary architecture, such as Hoffmann's own Palais Stoclet in Brussels (1905–14), where line is restricted to the intersection of right-angled planes, and so is reduced to no more than the outline of the building's surfaces.

The objects themselves disclose other, more consistent characteristics such as a preference for decoration based on elementary geometrical shapes, often flaunted and repeated until it be-

comes the dominant theme of the piece.

The square, for example, was widely used not only for furniture but also for ceramics, cutlery and graphic ornamentation, so that it came to be something of a trademark and was facetiously referred to as the "Hoffmann square".

Line tended to be rectilinear and surfaces were perfectly orthogonal. They were smoothed and stained by rubbing the dye into the wood, so that grain and texture were left on view. Some of the most important examples of this technique are the chairs designed by Hoffmann at the Wiener Werkstätte for the convalescent home at Purkersdorf in

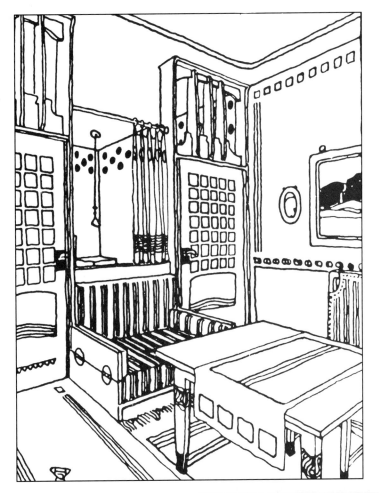

1905. These dining chairs and long-seated armchairs enjoyed a popularity that went well beyond their original purpose, for in 1906 they became part of the catalogue of the large Viennese furniture manufacturer Kohn.

The dining chairs were executed in curved beechwood with a leather seat, and were the forerunners of an armchair version and a settee accompanied by a side table. They feature a circle motif, in open-work on the back and in the form of a reinforcing spherical element to join the surfaces to their support structures. The curved beechwood recalls Austria's legacy from Thonet, of which Hoffmann was certainly

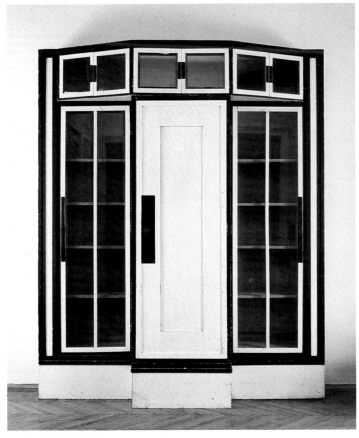

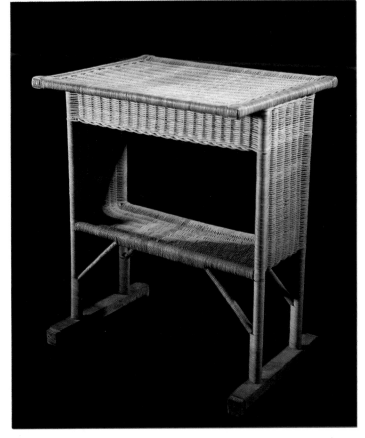

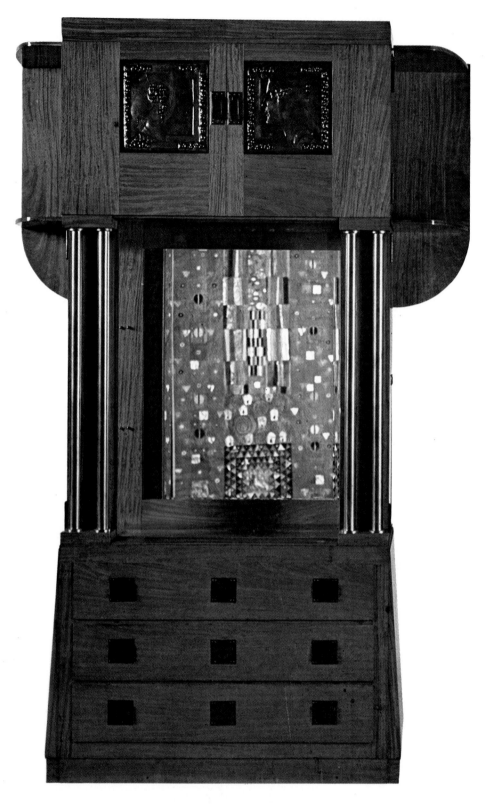

Left: a lemonwood veneer cabinet made in 1907 to a design by Koloman Moser, by Niedermoser of Vienna. Museum für angewandte Kunst, Vienna. Facing page: *The Kiss* by Gustav Klimt. Österreichische Galerie, Vienna.

Germany – Obrist and Endell

Known, significantly, as Jugendstil ("Youth Style", a name connected with the popular review *Die Jugend),* Art Nouveau in Germany became popular in the final decades of the 19th century thanks to the theories and practice of van de Velde, who completed many projects there, and to the intense activity of a group of exceptionally gifted artists.

One of the earliest exponents of the new style was Hermann Obrist, founder in 1894 of an embroidery workshop in Munich. To him we owe many exciting and elegant pieces in which symbols and structure are inspired by the plant world.

The symbolist leanings that led Obrist to associate natural forms with human emotions can also be observed in August Endell. A native of Berlin, student of philosophy and self-taught designer, Endell was active in the Secession group in Munich, formed in the spirit of the contemporary Austrian Secessionists as a reaction to hidebound academic rules.

The Elvira photographic studio, whose façade and interior Endell redesigned in 1897–1898, was the most radical signal of avant-garde tendencies. The main prospect was a single, huge abstract decoration, where ebullient or huddled groups of zoomorphic shapes exalted the burgeoning energy of spontaneous growth. The critic Ahlers-Hestermann called it "a whole warehouse of exploding fireworks [...] with horns, teeth, barbs, jets and flames" (in L. V. Masini, *Art Nouveau,* Florence, 1976). Endell's decoration had a precise psychological foundation,

very much aware and whose technical and formal approach he reworked to his own aesthetic ends. Thus, in the Vienna beechwood and straw rocking chair, Thonet's curves are stretched into straight lines. The curves and open curls close into an ellipse that is the

hub of the carefully studied rocking motion.

The reclining armchair, again in beechwood, is in contrast almost a *sitzmaschine,* a machine for sitting. Based on the long-seated armchair designed for Purkersdorf, the motif of openwork

squares on the sides and back constitute the only concession to decoration. Technique and function prevail over aesthetics, yet the chair itself is extremely sophisticated and offers original formal ideas that anticipate the mechanistic aesthetic of the Rationalists.

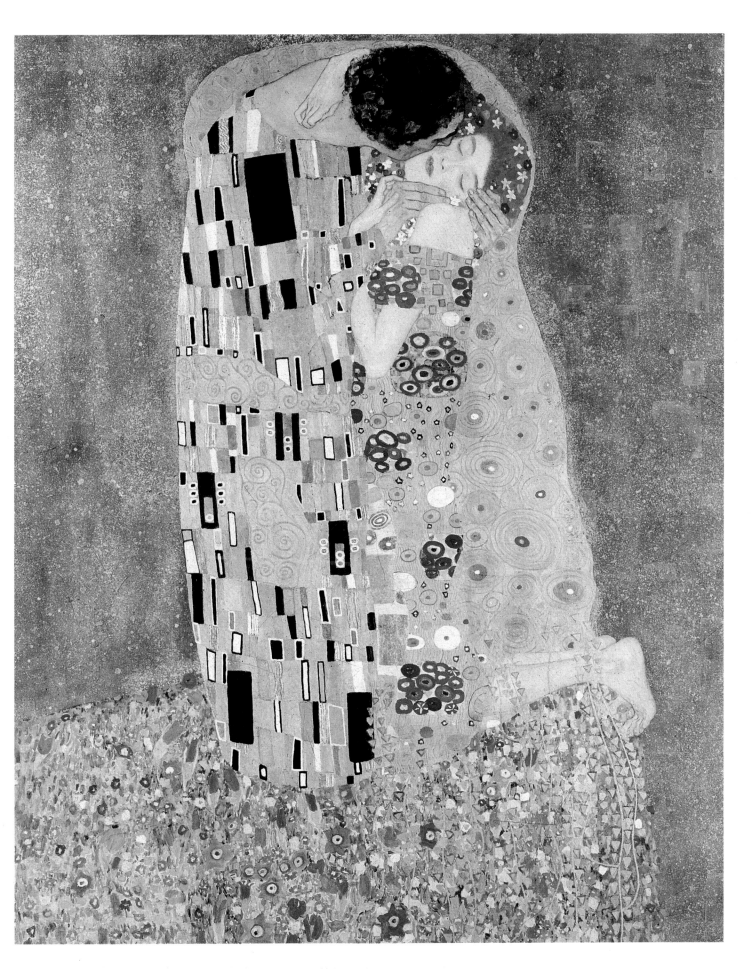

Serpentine elegance and sinewy linearity are the distinguishing features of Hermann Obrist's work. BELOW LEFT: leather-topped table in maplewood and brass (1902). Antiques trade. BELOW: side table (1898). Stadtmuseum, Munich. FACING PAGE: two pieces designed by Peter Behrens for a study (1908). The colour contrast between the pale birchwood surfaces and the decoration and trim in an ebony finish echo Biedermeier on the one hand and anticipate Art Deco on the other. Museum für Kunst und Gewerbe, Hamburg.

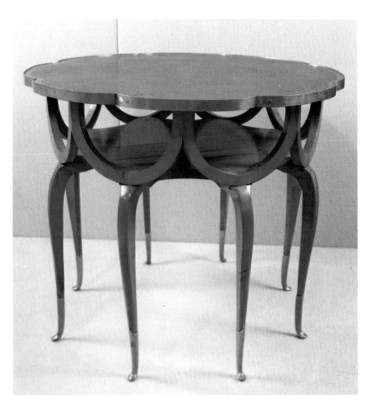

obliged to live and work there for an annual salary paid by the Grand Duke, thus extending the ideals of the Arts and Crafts movement to everyday life, which was conceived as a work of total art. The colony was largely the work of the Austrian, Joseph Maria Olbrich, and included residences built expressly for a number of artists. Among these, the house that Peter Behrens de-signed for himself is one of the most convincing products of German Art Nouveau.

Behrens's house (1900–04), like those of Morris and van de Velde before it, was a total design that embraced the configuration of internal volumes, walls, ceilings, furniture, handles, curtains, bedspreads, crockery and cutlery.

All featured decorative motifs from the same pattern, which was

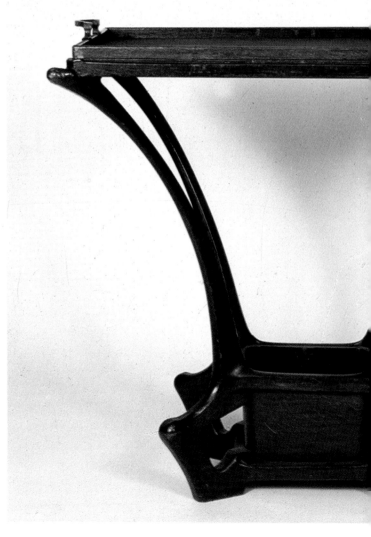

as he himself explained at the end of the 19th century: "We are on the threshold of developing a completely new kind of art [...] made up of forms which have no direct significance and represent nothing [...] but which speak to the depths of our souls [...] A thousand emotions are aroused within us. New emotions, shadows of emotions and continual, unexpected transformations."

Abstraction served to identify intensely communicative analogical forms, discovering in the natural world what Musil called "another secret life that is ignored by all [...] the other, mysterious, unseen life of things" (both passages are quoted in: G. Massobrio, P. Portoghesi, *Album del Liberty*, Bari, 1975).

Endell's intensely emotional vision, transposed with breathtaking imagination into architec-

ture and interiors, was less auda-cious when it came to furniture. His pieces evince a vigorous de-sign and great attention to detail, enriched by frames and wave mo-tifs that sweep together into a point, while at the same time avoiding ripple effects and heav-ily carved trim. The undulations are kept under control, and there are no weird shapes or heavy dec-orative additions.

The Darmstadt Colony

As in the other countries of Eur-ope, so too in Germany guilds and organizations of artists were beginning to be formed. The most noteworthy and original of these was at Darmstadt, founded in 1899 by Ernst Ludwig, Grand Duke of Hesse. It took the form of a colony of artists who were

deconstructed and re-elaborated in different ways. The designs of the façade and section, in which the furniture and wood panelling were already incorporated, show some of the features of Behrens's aesthetic: the system of ribbing that articulates the solid body, the vertical and horizontal lines whose movement comes from rising diagonal lines and curves, subtly varied rhomboid and oval

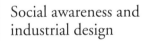

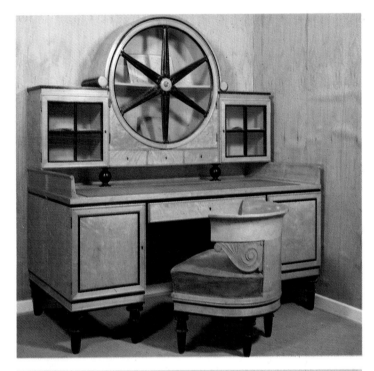

geometric patterns, in many cases reminiscent of the structure of a crystal, considered to be the symbol of the order of the universe.

In fact there was a distinct element of esotericism at Darmstadt, encouraged by the atmosphere of isolation and the idea of belonging to a cultural elite that could sublimate life through art. That is why Behrens went so far as to identify his pieces with the people who would use them: chairs for women had curved arms and softer lines, while those for men had a straight back and a thrusting upward line. Ornaments in black and gold were employed in a way that was polemically described at the Esposizione Internazionale di Arte Decorativa Moderna in Turin in 1902 as "cabalistic, so that the house was transformed into an almost church-like place of meditation".

Social awareness and industrial design

These tendencies lived cheek by jowl with other more functional and utilitarian leanings. Behrens himself was to gain more fame from his work as a consultant for the AEG company in Berlin, for which he designed everything from factories to street lamps, than he would from his Art Nouveau pieces in the same period.

Indeed Germany stood out at the Turin exhibition not just for the exclusivity and luxury of some of the interiors it presented but also for being the only nation that offered furniture for lower-income consumers, thereby displaying a remarkable social awareness.

Architect Richard Riemerschmid (1868–1957), for example,

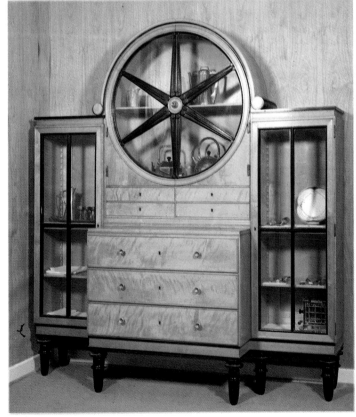

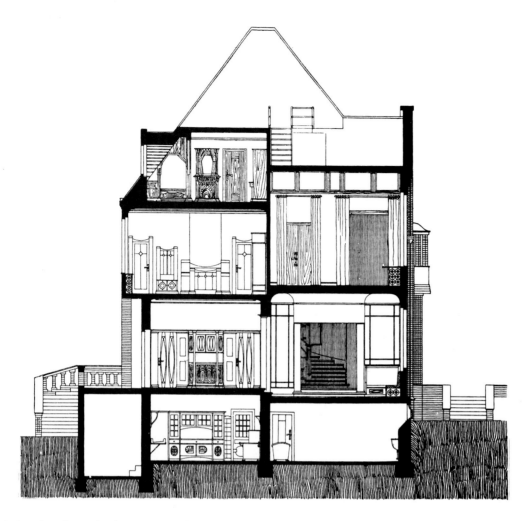

designed working-class houses as well as villas and theatres. In his furniture, he strove for an extreme simplicity of form that would favour the rationalization of manufacturing systems and techniques.

Active since 1897 at the Vereinigte Werkstätten für Kunst im Handwerk (United Workshops for Applied Art) in Munich, Reimerschmid drew on the German decorative tradition of Celtic origin, re-elaborating its themes in a contemporary mode. His furniture was therefore characterized by its "organicism", which meant that wood was left in its natural state and colour, and the grain provided the main decorative element. His chairs, designed in a range of versions, were particularly original. Sobriety was not allowed to stand in the way of beauty, and diagonal elements were inserted from the back to the front legs for solidity. At Turin, Germany was also remarkable for the sheer breadth of her production, "providing food

for thought for other nations as an awesome industrial competitor" (V. Pica, *L'Arte Decorativa all'Esposizione di Torino. La Sezione Germanica,* Bergamo, 1902).

Thus right at the beginning of the 20th century, there was already a tendency to tackle the problems of applied art on an industrial scale. In 1907, that tendency would result in the foundation of the German Werkbund, an organization of artists and architects involved in capital-intensive manufacture whose aim was to improve industrial products.

The initiative signalled the end of Art Nouveau in the sense of unfettered artistic creation, the recovery of craft skills and the taste for refined, wholesome decoration. The architect Hermann Muthesius, founder of the Werkbund, openly attacked the new style, which he considered to be a superficial tendency that "substituted a rectangular frame with a curl-based pattern". Faced with

such opposition, the fortunes of Art Nouveau could only decline. The style became subject to the whims of fashion and thus effectively interchangeable with other languages. Nevertheless, the effort to define the new style had produced undeniably valuable results with great significance and a wealth of functional solutions, as Muthesius himself admitted was the case with Art Nouveau furniture.

Holland – Dijsselhof and Thorn Prikker

The main features of Dutch Art Nouveau were clearly summed up by the critic Vittorio Pica in yet another article on the 1902 Turin exhibition: "More than any other people, the Dutch [seem to remain] faithful to the customs, tendencies and tastes of their forefathers, while that perspicacious serenity [...] which underpins their character, now and again perturbed by a breath of

exoticism from the distant colonies, keeps them free of any reactionary hostility to novelty [...] but also safeguards them almost always from exaggeration and excess" (V. Pica, *L'Arte Decorativa all'Esposizione di Torino. La Sezione Olandese,* Bergamo, 1902).

Acceptance of the new, continuance of tradition, moderation and balance barely coloured by exotic references were the features of a Dutch Art Nouveau whose models were to be found in British culture rather than in that of neighbouring Belgium. The same tendency was also evident in Dutch architecture, whose greatest exponent, Hendrich Petrus Berlage (1856–1934), strove for simplicity of structure and ornament. Here, as in the fairly limited quantity of furniture he designed, Berlage took Art Nouveau linearity as his starting point to simplify volumes and transform physical elements into colour.

The numerous groups of artists that emerged from the

FACING PAGE: vertical section of Peter Behrens's house in a drawing by the architect. THIS PAGE: an elegantly uncomplicated chair (below right) designed in 1898 by Johan Thorn Prikker. Gemeentemuseum, Den Haag. The other two pieces below, a chair and a walnut cabinet, date from about 1900 and are by Richard Reimerschmid. An exponent of the Vereinigte Werkstätten für Kunst im Handwerk in Munich, Riemerschmid preferred natural wood and straightforward shapes in which the structural connections were obvious, and thus suitable for mass manufacture. Stadtmuseum, Munich.

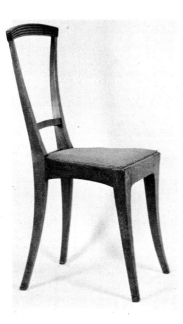
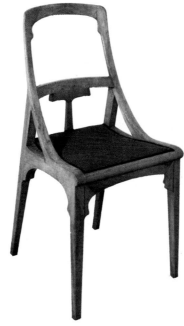

derivation indicate that the new decorative trends had not gone unobserved.

The work of another artist, Johan Thorn Prikker (1868–1932), is also remarkable. Although his paintings are characterized by a somewhat recherché esoteric symbolism, as a designer he was much more attentive to the functional content of his pieces. One excellent result was the chair he designed in 1898. It is lightweight, extremely practical, refined and elegant, with barely hinted-at curves contributing to its outstanding economy of design.

Amsterdam school of applied and decorative arts or associations, such as Artes et Industriae or Labor et Ars, were substantially similar. It was Labor et Ars that could boast amongst its members one of the most representative artists of the new style in Holland, Willem Dijsselhof, whose creations married the cultural heritage of northern European interiors with the stimulus of Art Nouveau. The so-called Dijsselhof Room, dating from 1890-92 and now in the Gemeentemuseum in Amsterdam, is exemplary in this respect. The Flemish traditions of serene comfort and domestic intimacy are echoed in the use of warm, natural wood for both furniture and wainscoting, in cosy, private corner spaces and in the vernacular flavour of the whole. But the room also displays Neo-Gothic influences, nuances borrowed from English interiors, multi-coloured wood inlays framing the panelling, and upholstery motifs like the peacock or the flamingo whose evidently exotic

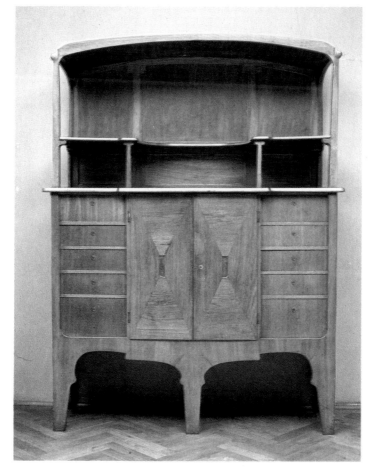

Art Nouveau in Italy

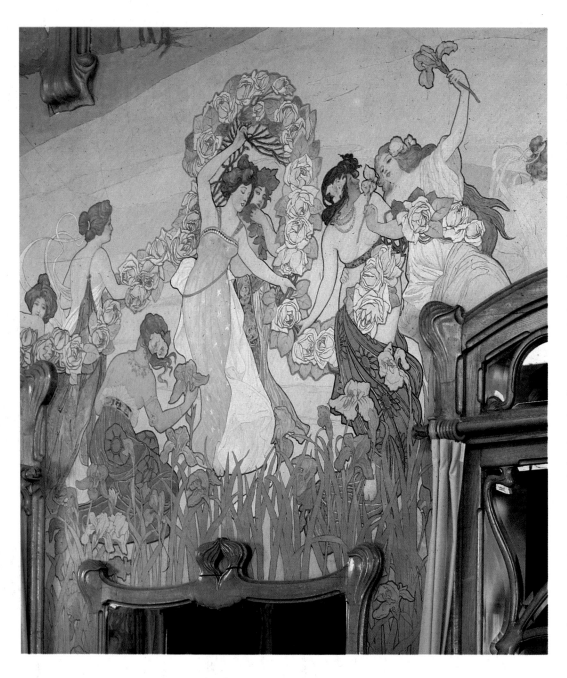

Historical and cultural background

Although by the end of the 19th century the theories and figurative canons of the new style could be said to have established themselves throughout Europe, in Italy they continued to manifest themselves as aspirations for a vaguely defined idea of renewal. The political situation in Italy, a country which was fragmented into areas of profoundly diverse cultural and economic conditions, rendered the progress of the new ideas extremely difficult. However, the northern regions and industrial conurbations were more advanced. Through specialist magazines and personal visits to exhibitions and shows, theorists such as Camillo Boito or Alfredo Melani, Enrico Thovez and Vittorio Pica in particular, kept abreast of what was going on in France. It is to their missionary zeal and the activity of a few isolated craftsmen that we owe early attempts to renew the applied arts in Italy. The task was an arduous one. Despite all the efforts that had been directed towards the cultural unification of the peninsula, and despite all the museums and schools that had been created for this purpose, the history of Italian decoration remained essentially regional. It was anchored to the splendour of the local past, with a distinct

FACING PAGE: the *Salone delle Feste* in the Grand Hôtel Villa Igea (1898–1900) at Palermo and, above, detail of the frescoes that decorate its walls. Designed by the local architect, Ernesto Basile, it is one of the most successful products of Art Nouveau in Italy. Basile was assisted by Ettore De Maria Bergler for the frescoes and by the Ducrot-Golia company, which made the furniture. In the early 1890s, Vittorio Ducrot went into partnership with Carlo Golia, the Palermo representative of a Turin wallpaper manufacturer. Basile began to collaborate with them in 1898, setting up an industrial-scale manufacturing enterprise that was unusual for the time and unique in Italy.

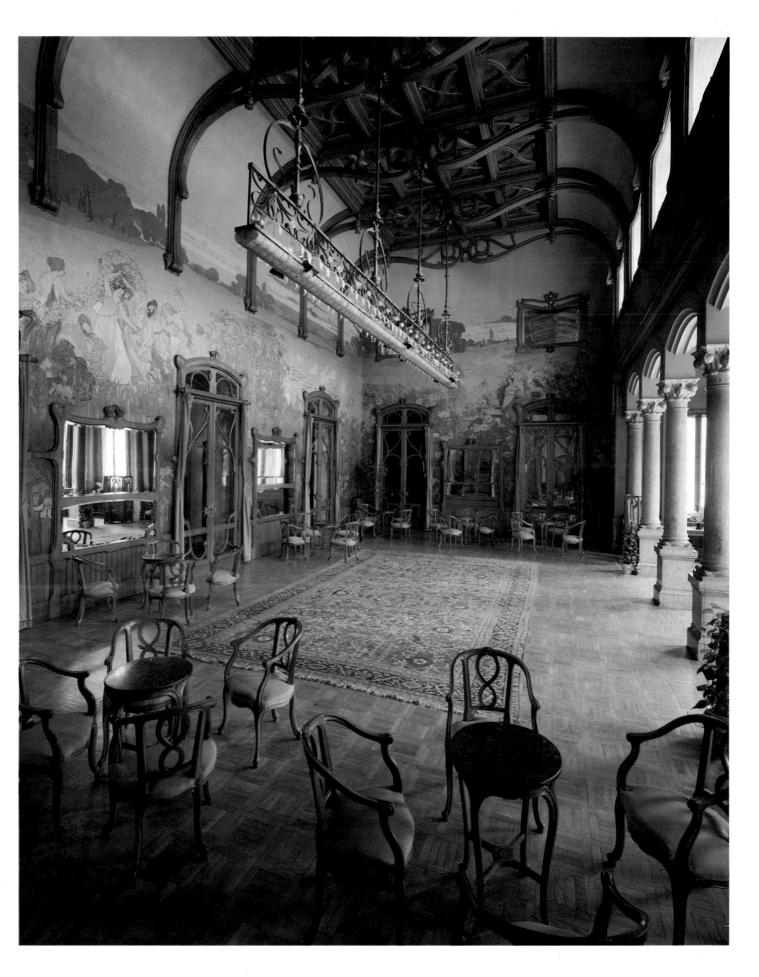

of decorative language on this basis when he wrote: "The young creative artist should live among plants and flowers, falling in love with them and absorbing their essence until he is able to extract their decorative core which, sublimated together with the aesthetic spirit, condenses into an original, profound work." The passage is taken from an article entitled *L'Arte italiana e l'ornamento floreale* ("Italian Art and Floral Ornament") written for the magazine *Arte italiana decorativa e industriale* and published in 1898, the year of the Esposizione Generale Italiana held in Turin.

The exhibition had given ample space to the furniture sector, arousing optimistic comments about the Italian furniture industry.

What appeared to Italian eyes as concrete signs of renewal were actually only timid hints overwhelmed by a mass of articles in a rather out of date eclectic taste. At the 1900 international exhibition in Paris, Italy came across as a "country of copiers", immobilized by the myth of its illustrious heritage and for that reason – with a few isolated exceptions – unwilling to renew its decorative repertoire. After Paris, appeals

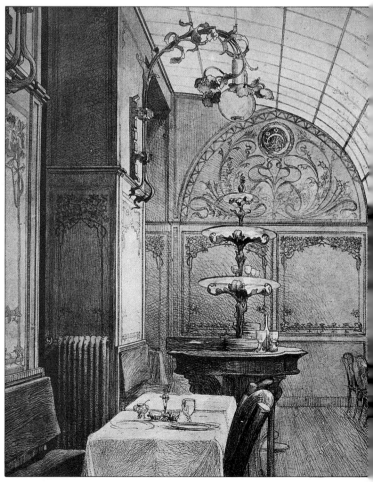

preference for anything reminisencent of that golden age, the Renaissance.

In spite of these difficulties, however, the new style did acquire adherents quite rapidly although their work was neither homogeneous nor radical precisely because it was mediated by non-Italian results that had different implications depending on their areas of influence. Neither had there been an unhurried, autonomous process of consolidation.

The Italian term for Art Nouveau, "Liberty", first appeared in 1895 when an article in *Emporium* presented the products of the Regent Street store with their plant-inspired decorative motifs. Ornamentation based on nature had of course a long history, which was claimed as exclusively Italian. The "roots" of the tradition were traced to mosaics from Roman times and its "flowering" to the Renaissance and Baroque periods.

And so Camillo Boito gave official ratification to the renewal

were made and programmes drawn up to raise the question in the specialist press. The few designers who, like Carlo Bugatti, Carlo Cometti and Eugenio Quarti, had had a modest personal success enjoyed a substantial increase in popularity.

The International Exhibition at Turin

It was in this climate that the Esposizione Internazionale di Arte Decorativa Moderna was organized in Turin. The event was an exceptional one as it was the first

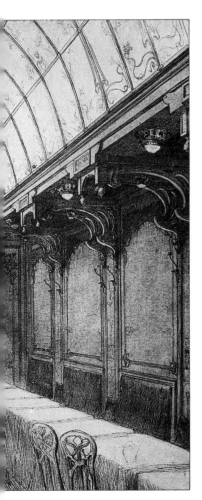

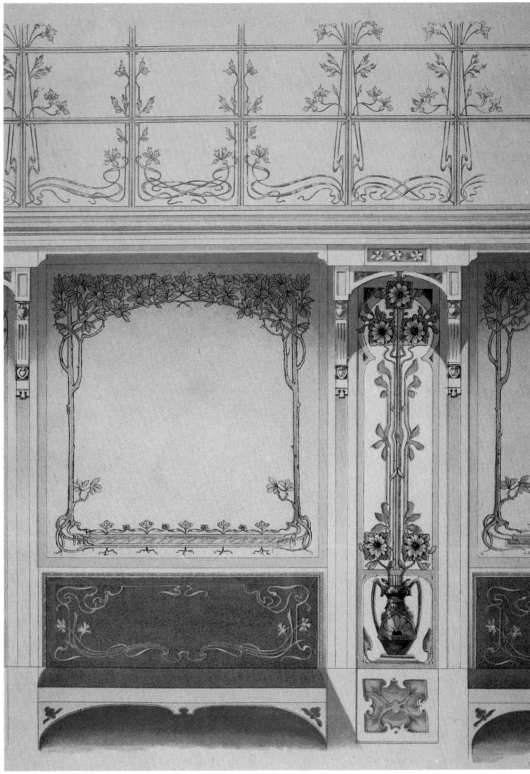

FACING PAGE: cover (August 1899) by Umberto Bottazzi for the magazine *Emporium*. Published from 1895 by the Istituto d'Arti Grafiche of Bergamo, *Emporium* was the first magazine in Italy to concern itself with the new style and to support its proposals. LEFT: drawing by Angiolo d'Andrea (1880–1942) of the interior of the Gambrinus restaurant in Milan, one of the earliest examples of the floral style. ABOVE: decorative detail by Gottardo Valentini. Raccolta Sormani, Milan.

The world of Carlo Bugatti

Carlo Bugatti was a highly original furniture-maker and a proponent of the most extreme form of eclecticism. His work embodies a world of fantasy inspired by a desire to escape from everyday life. It is minutely decorated with circles, columns, pinnacles, arches, floral motifs, stylized birds and insects and includes specific references to mediaeval, Japanese, Byzantine, Babylonian-Assyrian, African, Egyptian and Islamic art. These are brought together with self-assured panache, as if Bugatti was giving a physical shape to his dreams and imaginings in his furniture. This apparently "irrational" element was combined with a craftsman's skill to fashion the wide range of delicate materials his decorative tastes demanded.

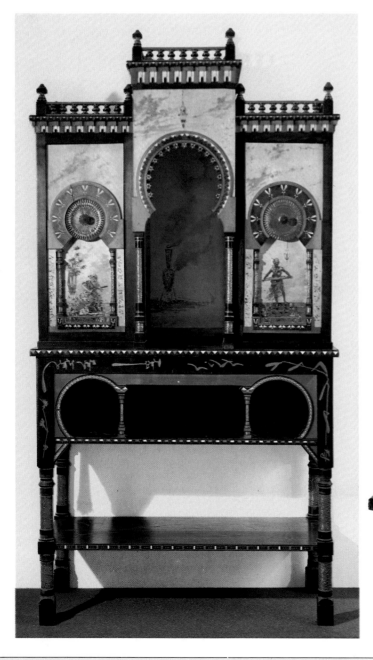

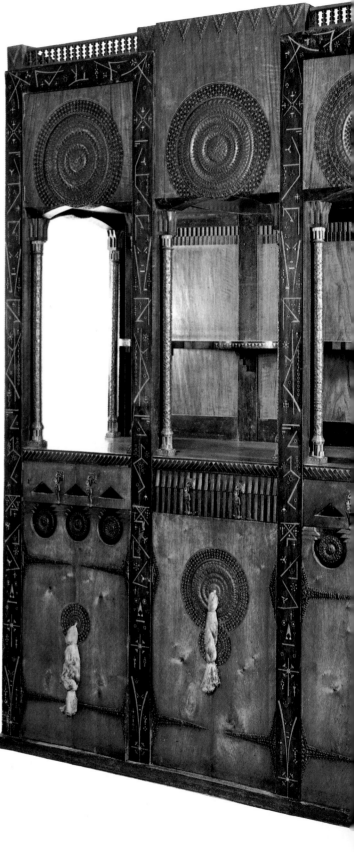

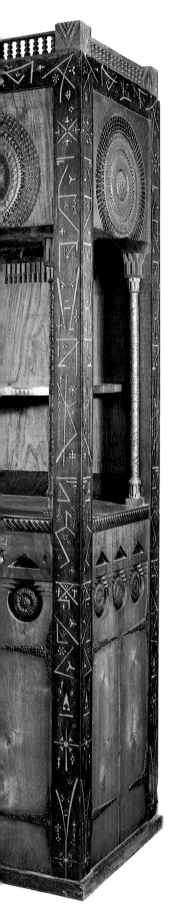

The furniture on this page and the facing page bears witness to Carlo Bugatti's "eclectic" Art Nouveau style. FACING PAGE: signed table and cabinet, dated 1898, in natural and ebony-finish wood with bone inlays, *repoussé* bronze mounts and, on the side doors, parchments painted by Riccardo Pellegrini. CENTRE: large cabinet (c. 1900) with back and *repoussé* bronze and ivory mounts. The drawer handles are small bronze mummies. Antiques trade.

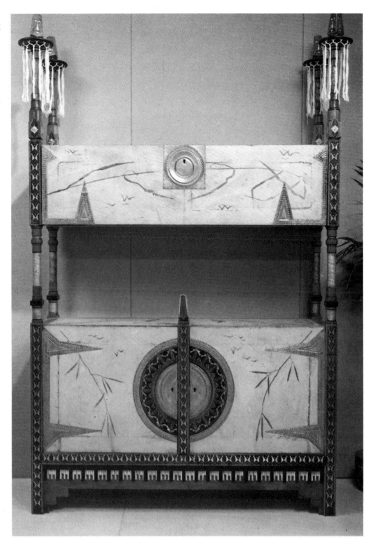

RIGHT: twin cabinet in painted parchment with mounts in brass, silver and ivory. BELOW: two armchairs (c. 1902) upholstered in painted parchment with bronze decorations and ebony and metal encrustations. The chairs are part of a suite of bedroom furniture. Antiques trade.

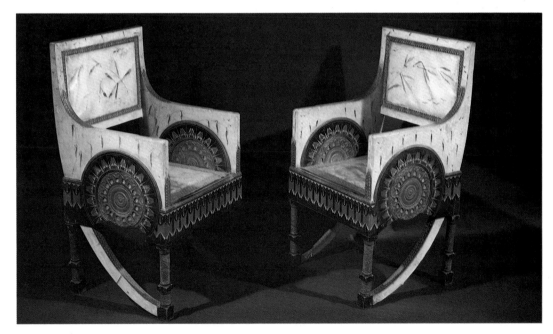

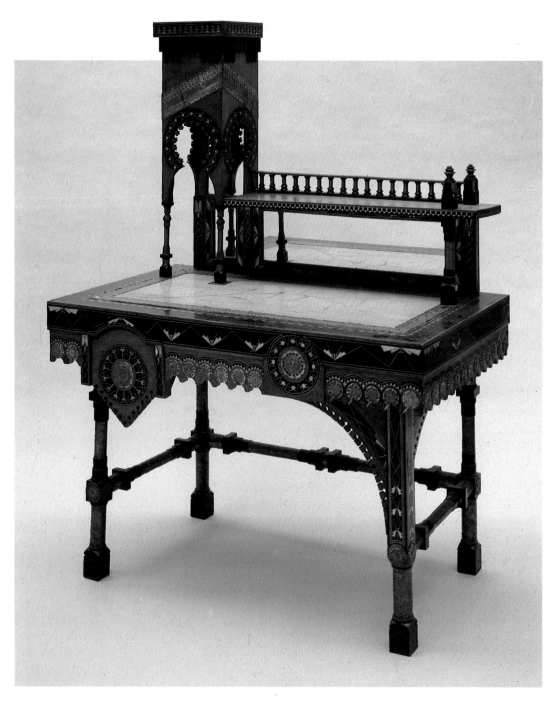

internationally significant exhibition dedicated exclusively to the applied arts with the aim of promoting modernity in all its forms. We read in article 2 of the exhibition's General Regulations (Turin, 1901): "The Exhibition shall include artistic creations and industrial products that are concerned with the aesthetics of the street, the home and the room. Only such original artefacts as shall demonstrate a precise intention to renew form shall be accepted. Simple imitations of past styles shall not be accepted nor shall those industrial products which are not inspired by artistic sensitivity."

This was undoubtedly a courageous decision that threw down the gauntlet in no uncertain fashion. Immediately – and predictably – it sparked off a heated debate between traditionalists and innovators that was widely reported in the publications of the period. Alfredo Melani (1860–1918) was an architect, a critic with an international reputation and also a furniture designer whose work incorporated the new style in its soberly geometrical, functional decoration. Melani engaged in a lively discussion with the opponents of Art Nouveau, who appealed to nationalist sentiments and maintained there was an obligation to hold on to the past and to Italy's own heritage. There emerged a "visceral need for certainties", characteristic of the post-unification period (M. Nicoletti, *Architettura Liberty in Italia*, Bari, 1978), which was based on a fanatical parochialism. In reply, Melani argued that there was also a need for an international culture and modernization unfettered by provincial prejudices.

ABOVE AND FACING PAGE: more furniture by Carlo Bugatti. ABOVE: writing desk with asymmetrical back in walnut with ebony-finish elements, oriental-motif metal inlays and *repoussé* bronze mounts. The writing surface is in parchment, painted with a plant motif. FACING PAGE, LEFT: screen (c. 1910) with parchment panels and mounts in bronze and brass.

ABOVE RIGHT: chair (1902–04) with stamped leather seat, back and front cross rail in painted parchment, and brass and pewter inlays and mounts. BELOW RIGHT: hall chair with back-mounted tray (1902) in parchment painted with dragonfly motifs, and brass and *repoussé* bronze mounts. Antiques trade.

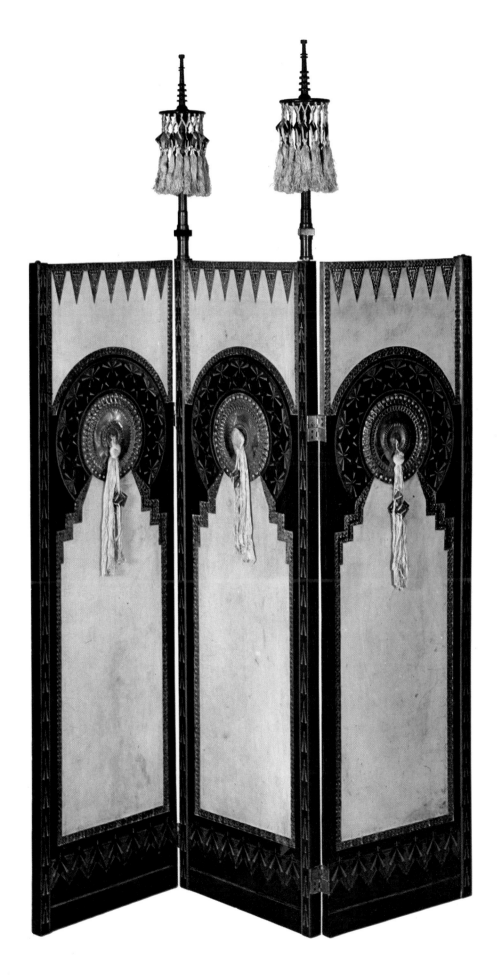

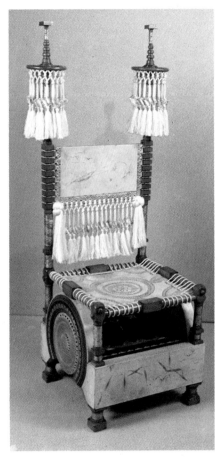

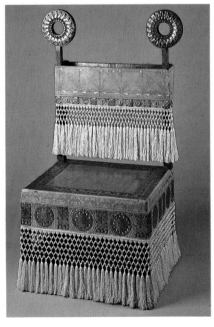

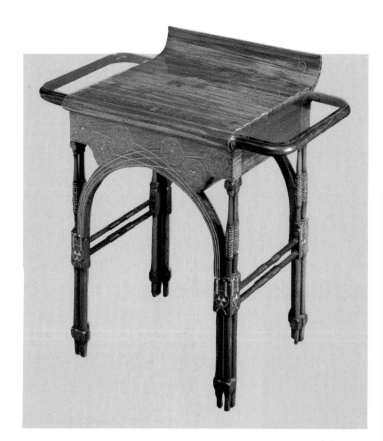

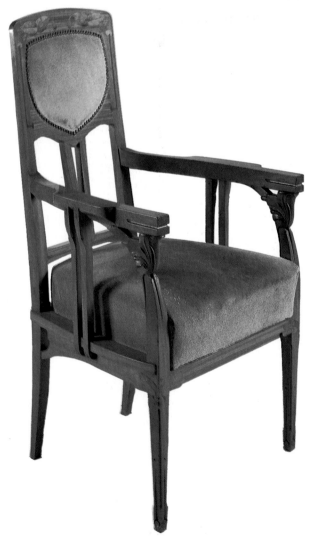

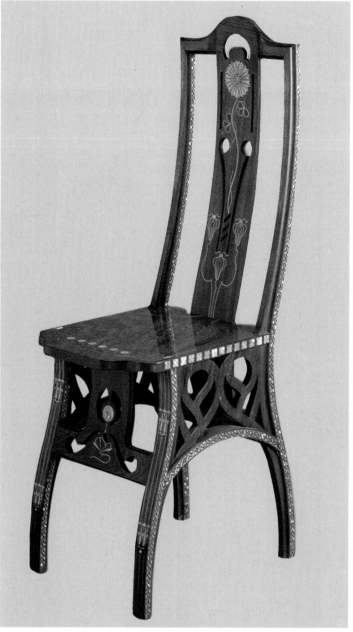

BELOW AND FACING PAGE: furniture by Eugenio Quarti. LEFT: coconutwood writing desk (1898). BELOW: matching chair with silver, brass and mother-of-pearl inlays. Private collection. BELOW LEFT: mahogany chair (c. 1900) with floral motif inlays in various kinds of wood. FACING PAGE: living room mirror unit in ebony and green-stained maplewood, presented at the 1900 Paris international exhibition and

the Turin exhibition in 1902. It comprises open shelves and cupboards closed by doors, and combines lacquer finishes with stains that allow the natural grain of the wood to show through. The metal and mother-of-pearl encrustations are engraved with stylized floral motifs. Antiques trade.

The Turin exhibition was therefore a unique opportunity to examine the best work from abroad with an open mind, to take stock of Italian products, and to identify the appropriate stimuli to prompt a critical re-examination of conventional decorative themes.

The first feature that signalled the modernity and unconventional nature of the event was, of course, the setting in which the exhibition was held. The splendid pavilions designed by the architect Raimondo D'Aronco (1857–1932) were themselves a systematic questioning of the language of design. D'Aronco's riot of dynamic forms, colours and decorations melded cutting-edge technology with a root-and-branch renovation of taste.

The new style – voices of approval and dissent

Opinions of the exhibition were many and varied. Some were enthusiastically in favour of the *dolce stile nuovo*. Others attacked unreservedly what they considered to be a passing fad, a brief interlude or merely the irritatingly predictable "*plat du jour* on everyone's menu".

Ugo Fleres wrote in 1902: "The universal application of the new style inflicts on us a trial of patience that not everyone deserves [...] As soon as you step out the door – if indeed Art Nouveau has not already wormed its way inside and taken up residence in your own home – there will be a playbill, or a shop poster or an announcement for a competition on the street corner parading its flat, be-ribboned figures, flowers and landscapes, the lines

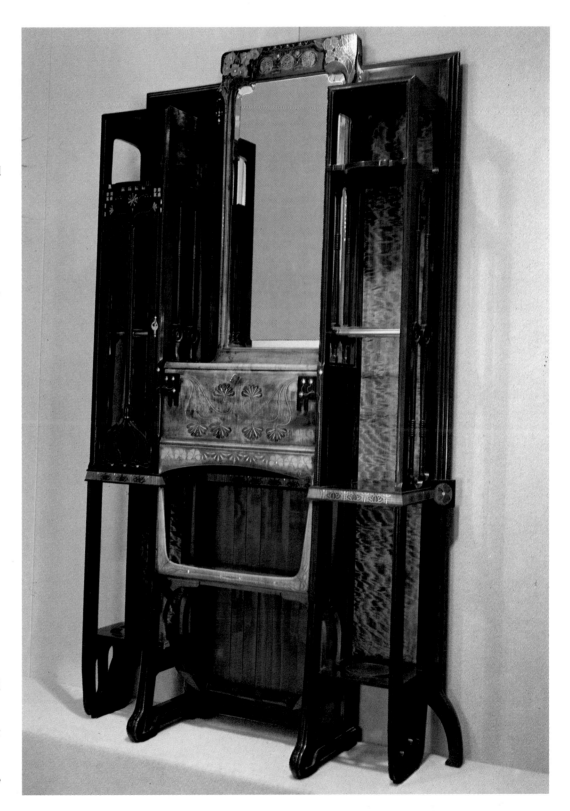

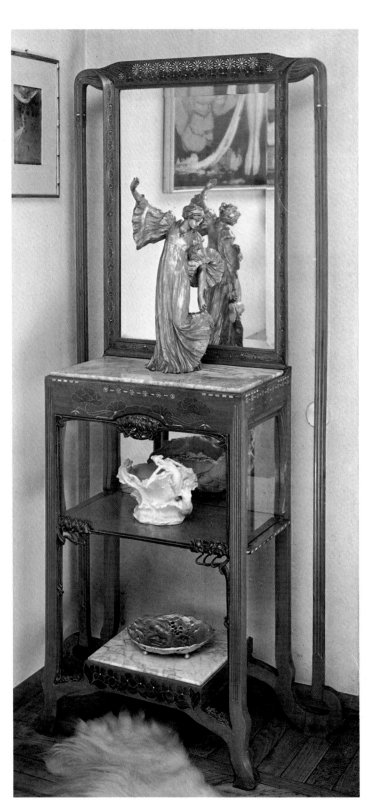

flowing up and down to form letters, or serifs, or nothing at all. 'How pretty! How original!' you say. But a little further on there will be another poster with precisely the same original pattern of ribbons and lines. And just across the street, those same curves have penetrated the wall, framing windows, festooning the shop fronts and adorning paper, fabrics, wood and stone." (U. Fleres, "Lo stile nuovo", in *Rivista d'Italia*, 1902)

Elsewhere the architect Luca Beltrami spoke in terms of "exuberance of meaning" in relation to the furniture exhibited at Turin. Beltrami was referring to a redundancy of form and excessive desire for novelty, putting his finger, not without justification, on the weak point of an event that had inevitably restricted a programme of cultural renewal to the confines of a trade fair: "Let's allow these products of the 'new style', pieces that today have been thrown together in artificial compositions, to spread out and stand alone.

"Their pretentious artifice of form will then be evident. We will realize that their originality is as transient as fashion, based as it is on the *leitmotiv* of a sweeping curve that strives to avoid traditional shapes by imitating smoke curling up from a cigarette or the blind nervous energy of a cracking whiplash. Sometimes, the line meanders lazily like a railway track, sometimes it quivers restlessly like the hem of a dancer's dress. If we make a dispassionate analysis of these floral-motif interiors ... we find not organic lines but shapes drawn with the infinitely variable whimsicality of the calligraphic sign." (L. Beltrami, "La mostra della Ditta Cerutti

(Architetto Gaetano Moretti) all'Esposizione d'Arte Decorativa Moderna di Torino", in *L'Edilizia Moderna,* 1902).

Beltrami's reservations were not entirely unfounded. The floral motif as the decorative theme on the one hand and the endlessly shifting linearity of form on the other were often handled uncritically, and both applications were used indiscriminately in most of the objects presented by Italians at the exhibition, including furniture, ceramics, silverware and textiles. Italy could, however, boast a number of artists with a more sophisticated approach who had already attracted attention in Paris in 1900. For these designers, Art Nouveau was more than just a decorative formula and became instead the starting point for new, original designs.

Carlo Bugatti

Originality was certainly a feature of the pieces made by Carlo Bugatti (1856–1940), an artist and craftsman with a daringly creative imagination and a language all of his own. The son of a sculptor, Bugatti trained at the Brera Academy and was already working as a cabinet-maker in the latter years of the 19th century, opening a workshop in Milan in 1888. His early output shared the contemporary delight in exoticism, and Bugatti blended Japanese themes with Moorish to create brightly coloured pieces with an oriental flavour.

They were built in the manner of Islamic architecture, with arches in relief, pinnacles, minutely decorated balustrades and smooth, rounded columns. In the late eclectic period,

Bugatti's work stood out for its unconventional approach, which extended to his choice of materials. "These are brash yet elegant pieces", it was said of him, "knick-knacks for the living room in a wide range of shapes and colours that together take on a distinctive appearance in a cheerful blend of colours" ("Mobili artistici del Bugatti", in *L'Edilizia Moderna*, 1901).

Bugatti achieved that "cheerful blend of colours", ranging from black to vermilion, purple, gold and blue, by covering his chairs, writing tables, cabinets and sofas – whose visible sections were generally in walnut and the hidden parts in deal – with an initial layer of white paper, which was then covered with a parchment "skin". This was subsequently decorated with delicate, highly stylized motifs of Japanese derivation or naturalistic scenes in the Moorish idiom. But Bugatti's individualism was not limited to the use of parchment.

His furniture also features engraved copper or brass plates in the shape of large discs, white silk or natural cotton bows and cords, inlays in pewter, brass, copper, ivory, bone and mother-of-pearl as well as yet more materials that have been appropriately described as "various other bits and pieces".

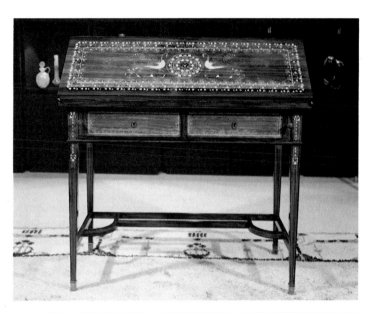

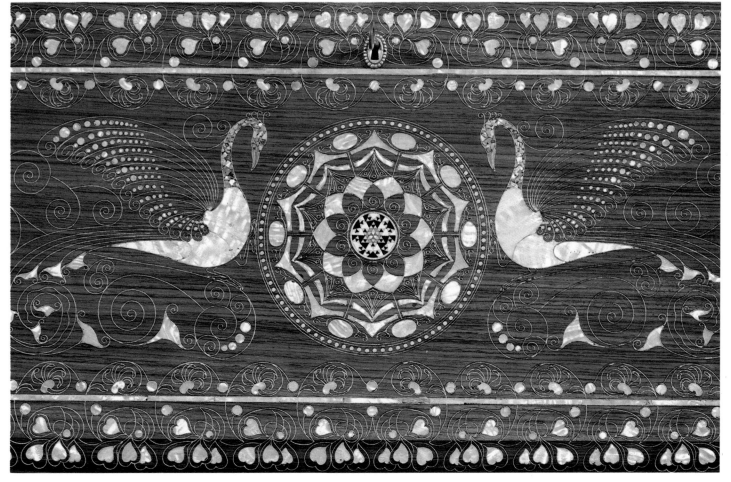

Bugatti's early work had a characteristically, stiff, rectilinear style, but at the beginning of the 20th century he adopted a more "organic" approach that on occasion duplicates the whorls of a large snail shell. Articles were conceived as sculptures whose sweeping profiles defy the rules of composition. They were upholstered all over in parchment and decorated with abstract representations of insects and flowers. Many were created from scale models in clay and full-size details that Bugatti gave to "the various artisans, starting with carpenters and going on to painters and decorators" ("Mobili artistici del Bugatti", in *L'Edilizia Moderna*, 1901).

Bugatti's artistic background had much to do with this approach, as did his intense desire to express, in objects of everyday use, an aesthetic of his own. This process reached its peak at the Turin exhibition, where Bugatti presented a "conversation room", a bedroom and various other pieces. Undoubtedly challenging, they received a lukewarm response from the public and found no buyers, but they did attract praise from critics who had espoused the new style.

Their comments acknowledged Bugatti's creativity and the courage of "a temperament that follows the lead of his own spirit ... and conceives furniture-making as a genuine art form. He makes a sofa the same way an artist paints a canvas or a sculptor carves a statue, not with the idea of satisfying the public but with the aim of creating an artistically complex work [...] He transforms an interior into a place where fairies, an oriental emperor or the Sun itself are at

home." (E. Aitelli, "L'Italia e gli Italiani", in *Natura ed Arte*, 1902)

This evaluation, which stressed individual commitment and the uniqueness of the artist's intervention, failed to make Bugatti's work any more saleable. Disappointed at the poor commercial outcome of the Turin exhibition, he moved to France and devoted his energies to artistic metalwork, making small objects, bronze furniture mounts, jewellery and silverware.

But Bugatti's heritage was not lost with the closure of his workshop. The business was purchased by Amedeo De Vecchi, who sold off the pieces that remained in stock and began his own production, continuing to use parchment. The advertisement for the De Vecchi company, which appeared for the first time in the magazine *L'arte decorativa moderna* in August 1902, declared that the "Italian artistic furniture factory" made "study furniture; decorations in *chartreuse* and painted parchment; entire suites of furniture". While maintaining a significant part of Bugatti's heritage, De Vecchi had however completely redesigned the form and structure of the furniture.

Perhaps in reaction to the seamless, organic shapes that had had so little commercial success, De Vecchi preferred sharp, angular designs with broken lines criss-crossing at oblique angles, interwoven diagonal elements and square wooden slats in dark wood that contrasted with the lighter-coloured parchment. His furniture was in a very personal style that heralded the Cubist and Art Deco production of the following decades.

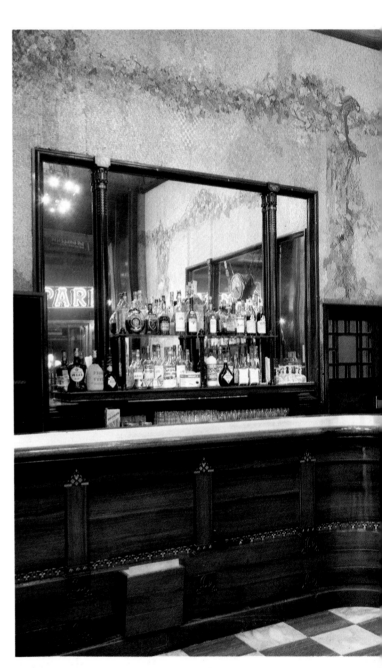

Eugenio Quarti

These were the years in which the best of Italy's Art Nouveau furniture, capable of exciting interest and attention abroad, was being made by or in the style of Eugenio Quarti (1867–1929), a sophisticated cabinet-maker who had trained in the glorious tradition of French *ébénisterie*. Quarti had moved to Paris at the age of fourteen to work as an apprentice. On his return to Milan in 1888, he opened his own workshop after working for a few months

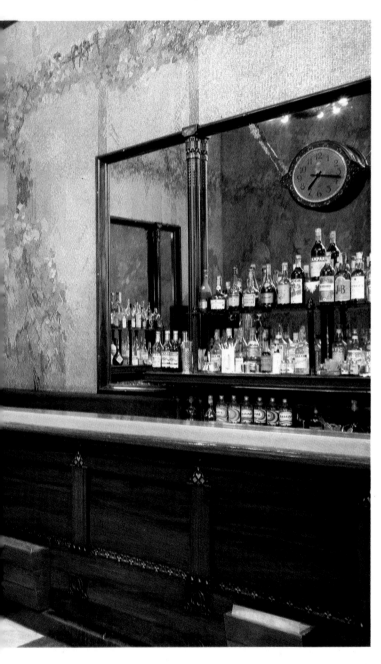

with Carlo Bugatti, from whom he absorbed a taste for exoticism and all things eastern. Quarti presented "Arabian-style" pieces, characterized by details from Moorish architecture reproduced in miniature, at the international exhibition in Antwerp in 1894,

but by 1898 in Turin he had developed his own style, striving, as Alfredo Melani wrote, "to find himself in sumptuous furniture, to a rhythm of metal and mother-of-pearl inlays" (A. Melani, *L'arte nell'industria*, vol. II, Milan, n.d.).

At the 1900 exhibition in Paris, Quarti was awarded a certificate of merit, which firmly established his status as a critical and commercial success. His style was called "attractively sober", and his work has a slender, almost immaterial aspect deriving from the upward, rectilinear dynamic of its structure and the extreme elegance and simplicity of its design, coupled with beautifully crafted materials.

His pieces in precious woods such as teak, mahogany, rosewood, jacaranda, coconut and natural or stained maple are embellished with delicate inlays (Quarti himself referred to the process as *incastonature,* or "mounting jewellery"), whose filaments of silver, ivory or mother-of-pearl either delineate or enhance outlines framing animal- or plant-motif decorations. There are many examples of this style, not least Quarti's famous display cabinet with mirror, made between 1900 and 1903, in which the rear section is transparent, its symmetrical twin supports framing the background. The linear, vertical composition is accentuated by very fine threads of silver and the horizontal surfaces feature inlays in various kinds of wood, tiny geometrical patterns in mother-of-pearl and floral-motif metal mounts.

Quarti was called "the goldsmith of upholsterers who makes caskets of jewels" and was already famous by the time he arrived in Turin for the exhibition, where he presented the living room suite that had won the certificate of merit at Paris as well as a much-praised bedroom. Ugo Ojetti, a notorious opponent of Art Nouveau, wrote: "The living room ... whose sea-green silk-cov-

ered furniture is adorned with silver and mother-of-pearl heart's-ease, the bedroom in violet-coloured walnut and cedar, and even the doors in yellowish mahogany with their contrasting grain and turquoise-drop handles are all masterpieces of form and execution in which the hint of affectation is so well-judged that it charms the eye." (U. Ojetti, "L'arte nuova a Torino. I tappezzieri italiani", in *Corriere della Sera,* 27–28 July 1902)

Quarti was an extremely painstaking worker, indeed Melani once wrote that his furniture was as permanent "as a monument", but he was also a successful entrepreneur who ran a cabinet-making workshop with more than fifty skilled craft workers capable of carrying out every stage in the manufacturing process in-house.

Quarti's products were made for an upper middle class clientèle, and were unique both in the quality of their workmanship and their homogeneity of style. Almost every piece was signed and instantly recognizable, even when it was part of a substantial order from, for example, a large hotel.

Post-1906, Quarti's furniture reveals his growing predilection for simple, geometrical ornamentation. His chequered or semi-circular inlays in alternate dark and light wood or glass allude to the Viennese model. Moreover, his Milan workshop also set a remarkable example of manufacturing continuity.

Whereas most of its Turin-based competitors had moved on to other products or disappeared from the scene altogether, Quarti soldiered on until his death. One major project worth mentioning was the interior of the café Il

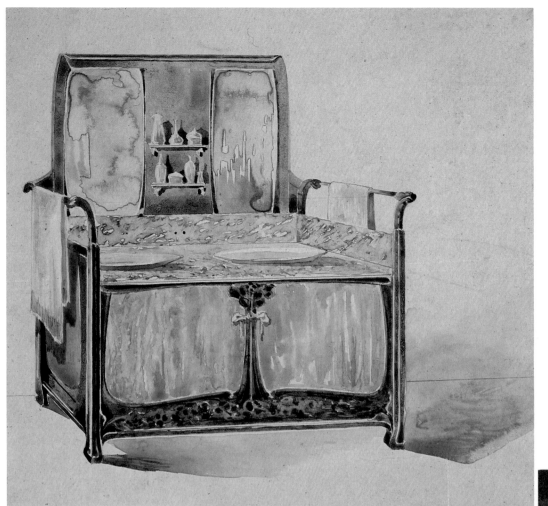

LEFT AND BELOW: two water-colours by Eugenio Quarti. LEFT: a washbasin unit with the date "Milano 27–10-1902". BELOW: a wardrobe. Civica Raccolta di Stampe Bertarelli, Milan. Both items bear the unmistakable imprint of the Bergamo-born cabinet-maker. Simple in structure and plain of line, they leave ample space for decorative inserts in metal, ivory and mother-of-pearl, Quarti's *incastonature,* or "jewellery mountings". The stylized plant motifs typical of Art Nouveau merge with the Moorish and Arabian influences that the designer absorbed during his short period at Carlo Bugatti's workshop. FACING PAGE, ABOVE: chair designs by Ernesto Basile. BELOW: table and chairs for the Grand Hôtel Villa Igea in Palermo, designed by Basile and made by Ducrot.

Camparino, for which he collaborated with Alessandro Mazzucotelli and Angiolo D'Andrea. Quarti's son, Mario, took over the business on his father's death and ran it throughout the Thirties.

Ernesto Basile

Important work was also done in Palermo by the architect Ernesto Basile (1857–1932) and furniture-maker Vittorio Ducrot (1867–1942), whose joint industrial-scale manufacturing enterprise was unusual for the Italy of the day. Theirs was a practical example of the collaboration between creator and manufacturer that would later come to be known as "industrial design". The interiors they presented at Turin revealed a designer who was capable of responding to a

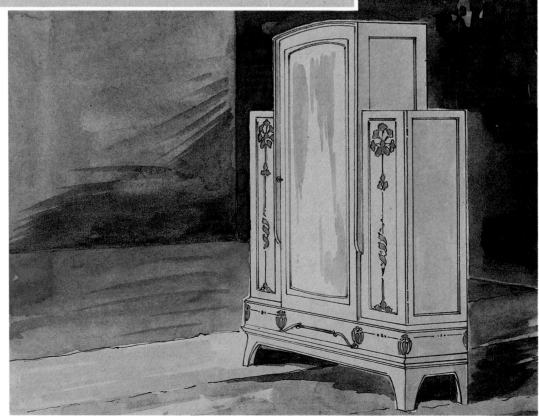

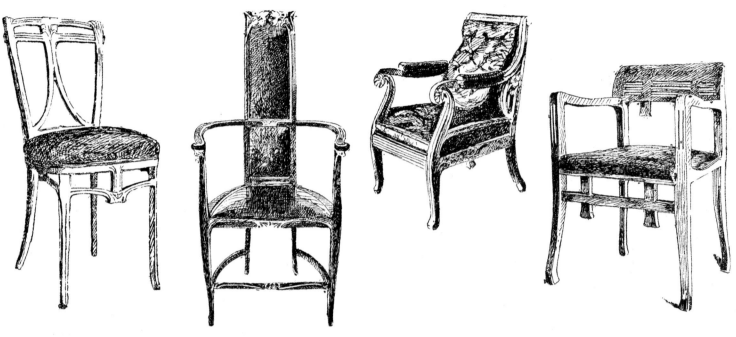

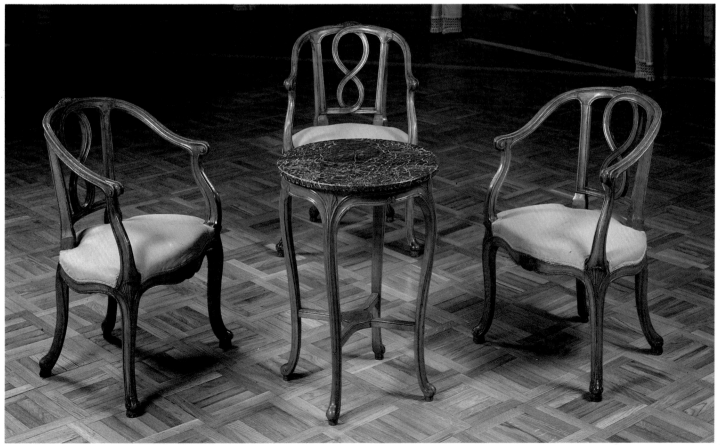

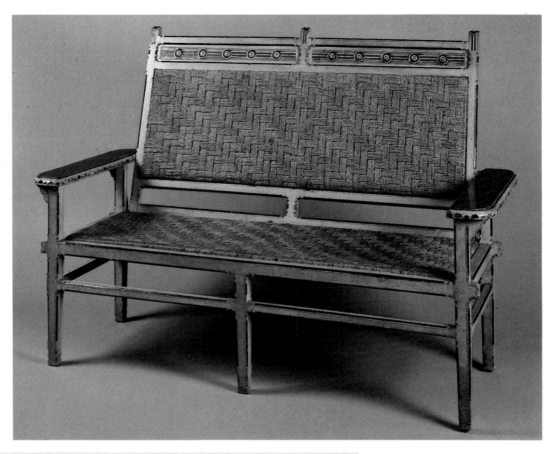

vast range of market demands, from sumptuously carved suites for special commissions through to more modest yet innovative designs whose understated elegance rendered them suitable for mass production. One such was their workroom in oak, where the design was conceived not in terms of decoration but of composition and elegance of form, embodied in support structures of skilfully interlocking solid wood rods. Ducrot later turned out hundreds of examples of these pieces, with slight variations, calling them "Turin-style" furniture.

In contrast, the mahogany cabinet has a more massive,

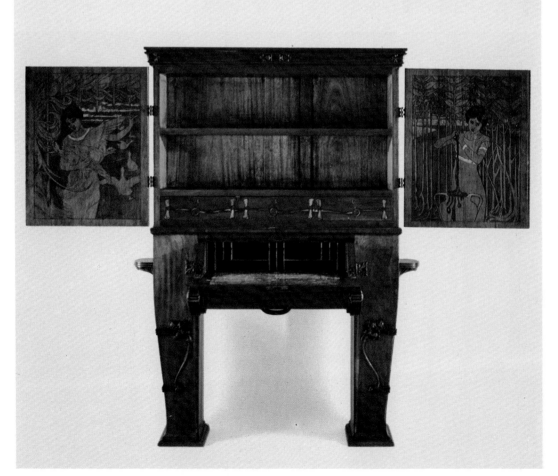

monumental set and the "tectonic" design betrays Basile's training as an architect. It adapts the themes of Art Nouveau to traditional motifs, such as the Renaissance-type cornice or the feet of the supports, and its execution called on a number of craft skills, including Antonio Ugo's bronze bas-reliefs and Ettore De Maria Bergler's paintings on the insides of the doors.

Aemilia Ars

The most innovative exponents of Art Nouveau in Italy were Bugatti, Quarti, and Basile, to whom we might add Giacomo Cometti (1863–1938), the sculptor and cabinet-maker from Turin, Giambattista Gianotti (1873–1928) and a few other artists with a markedly personal style. However for a deeper understanding of how the new style developed and spread throughout Italy, it is also necessary to examine high quality furniture-making with a solid base in traditional

FACING PAGE: two pieces designed by Ernesto Basile. ABOVE: a double settle (1900) from the *carretto siciliano* ("Sicilian cart") series. Antiques trade. BELOW: cabinet (1903) by Vittorio Ducrot inspired by the structure of the Renaissance *stipo*. The bronze mounts are by the sculptor Antonio Ugo, and the paintings on the inside of the doors are by Ettore De Maria Bergler. Private collection. THIS PAGE, BELOW: preliminary sketch of a display cabinet by Alfredo Tartarini, one of the designers who belonged to the Aemilia Ars co-operative. Museo Civico, Bologna.

skills and the manufacturers who were by now catering for a wider market and who used Art Nouveau to attract consumer interest and increase sales.

One maker of high quality pieces was the Bologna-based Aemilia Ars co-operative company. Founded in 1898 by a group of artists and sponsors, its aim was to promote the decorative arts by collaborating with the region's principal craft workshops. Aemilia Ars was directed by the architect Alfonso Rubbiani (1848–1913), a keen mediaevalist and noted restorer of 15th-century buildings in Bologna, and the co-operative could call on a group of prominent arts professionals, including Achille (1861–1948) and Giulio Casanova (1875–1961), Alfredo Tartarini (1875–1905), Giovanni Romagnoli (1872–1966) and Augusto Sezanne (1856–1935).

Following the example of other groups modelled on the Arts and Crafts movement, Aemilia Ars attempted to establish a new relationship between art and manufacturing that would embrace life and everyday objects in a new aesthetic ideal of material and moral beauty.

The co-operative also undertook promotional activities to achieve its goal, organizing annual competitions open to artists in the region and attracting support from the Chamber of Commerce, the provincial authorities and local banks.

A year after its foundation, Aemilia Ars announced twenty-four competitions, many of which were for interiors or individual pieces of furniture such as iron beds, the notice for which, significantly, specified: "a very inexpensive type that shall avail it-

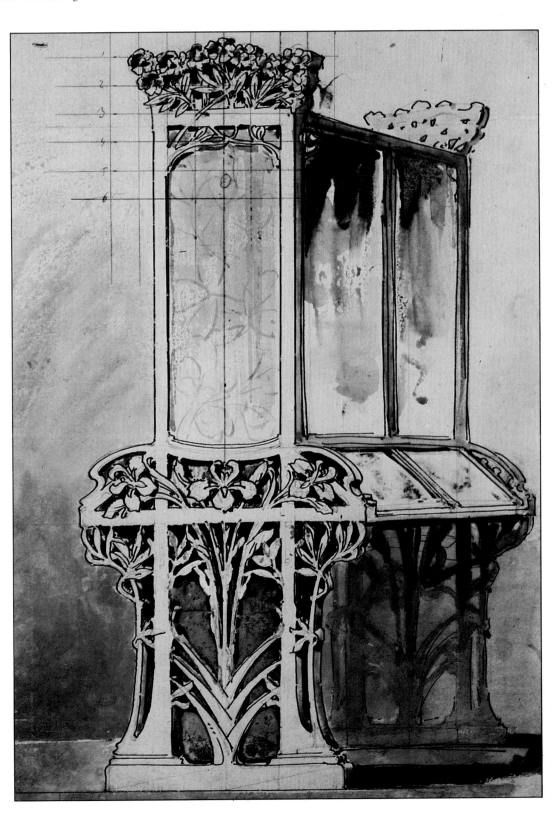

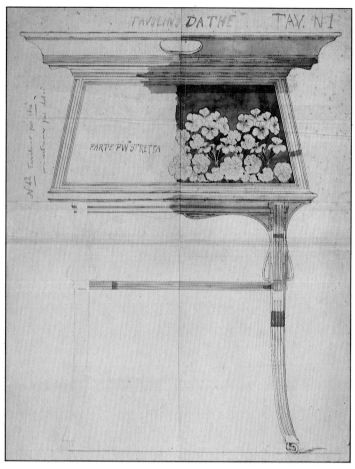

This panorama of nearly all the applied arts was well received, and the furniture by the cabinet-makers Casalini of Faenza or the Fiori company from Bologna, including banquettes and chairs, various types of table, cabinets, cupboards and bookcases, drew the public's attention thanks to its minutely detailed floral decoration, executed in the manner described by Alfonso Rubbiani: "It is a noble thought to suppose that the plant is still thriving and to recall its life. With carvings, gold and colour, make the wood sprout branches, blossom and fruit [...] Instead of misusing dreary Greek key patterns, adorn your cupboard doors with an es-palier of iris or a hedge of fierce thistles" (*Il Liberty a Bologna e nell'Emilia Romagna,* Bologna, 1977).

Thick tangles of iris, lilies, orchids, sunflowers or "fierce thistles" were carved into the furniture and also appeared on the upholstery and embroidery, or else they were cut into leather or painted on to parchment. In this way, Aemilia Ars products maintained an unmistakable uniformity of style that was further enhanced by their often symmetrical design and a traditional structure deriving from 15th-century models.

The Aemilia Ars approach was, as we have already said, a

self of the technical facilities of local factories […], but shall adapt to the bare iron a new harmony of plant forms, rejuvenating the endless repetition of curves and vertical railings in the headboard and footboard" (E. Ferioli, "L'Aemilia Ars: alcune precisazioni", in *Alfonso Rubbiani: i veri e i falsi storici,* Bologna, 1981). Despite the banality of the subject, this statement is indicative of the co-operative's intentions. It aimed for a cautious renewal that would respect the heritage of craft techniques and skills.

The year 1902 and the international exhibition at Turin provided the opportunity for Aemilia Ars to introduce itself to a public that went far beyond the boundaries of Emilia Romagna. The entire range of products was on show, including jewellery, lacework and embroidery, fabrics, sculptures, ceramics, wrought iron, glassware, leather goods and book-binding as well as furniture.

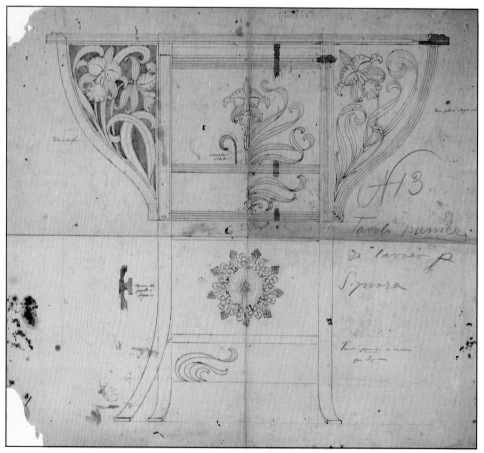

These pages show some furniture designs drawn in the characteristic style of the Bologna-based Aemilia Ars company. Sobriety of form is married to "substantial" floral decoration. FACING PAGE, ABOVE: tea table by Edgardo Calori, who drew heavily on French models. BELOW: a table panier, or lady's work table. THIS PAGE: front and side view of a wardrobe by Achille Casanova. Museo Civico, Bologna.

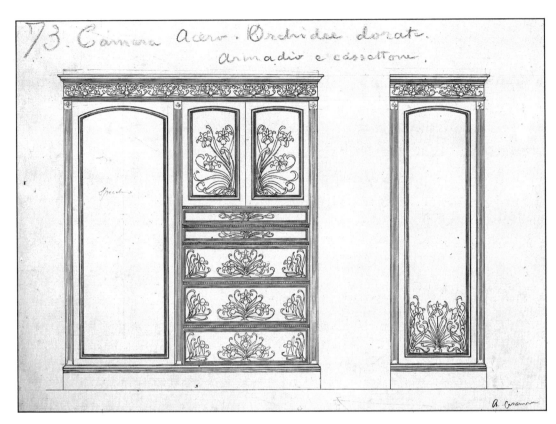

prudent treatment of the new style. Notwithstanding the co-operative's brief existence – in 1903, only the lacework and embroidery section would still be operating – it provides a characteristic example of how Art Nouveau was applied in Italy.

It was an experience that, after an initial "nervous burst of flame", came to have "a better founded and more extensive substance" (A. Melani, "L'Esposizione d'arte decorativa odierna di Torino", in *Arte Italiana Decorativa e Industriale*, 1902) and was to attract numerous disciples in the first decade of the new century.

Cutler e Girard

Cutler e Girard, founded in Florence by the American Marshall

Cutler (1853–1938) and Carlo Matteo Girard (1876–1948), who was also the workshop's design director, were another firm of furniture-makers that produced high quality artistic pieces in the finest craft tradition. Prize-winners both at the Paris international exhibition in 1900 and in Turin in 1902, Cutler e Girard interpreted Art Nouveau in the light of Renaissance Tuscany, forging the same link with the past that Aemilia Ars achieved. It was no coincidence that critics discerned that in the production of both workshops "an ancient rigour" would grow "patiently, alone and in silence".

In other words, a gradual, carefully reasoned path was plotted that Sem Benelli, in his article "L'Italia centrale all'Esposizione di Torino" (in *La Rassegna inter-*

nazionale, 1902), considered was only possible in less industrialized regions where commercial forces were not paramount, and renewal need not be hurried and superficial.

He also said of Cutler e Girard's furniture: "The lines are plain, the designs are extremely elegant and the carving is certainly the finest on show at the exhibition. The chisel has bitten vigorously yet gracefully into the wood, here leaving the finished work only roughly hinted at and there bringing it delicately out into full view [...] I am of the opinion that these works alone bear the imprint of the Italian genius [...]".

This Italian and Renaissance-based style informed the design and decoration of Cutler e Girard's various cabinets, coffers,

chests and screens, which were characterized by relief carvings often echoed by *repoussé* motifs on metal plaques and decorated with paintings and inlays that featured landscapes, jousting mediaeval knights, profiles reminiscent of Dante and caravelles. They were thus able to show that artistic furniture-making, despite competition from "boring, precise and cruel machinery", continued as a craft and was able to draw on Art Nouveau to further enhance its professional repertoire.

Carlo Zen

Italian industrial furniture manufacture was almost entirely concentrated in the north of the country where, according to Sem Benelli, "one marvels at the volume of business, the vast movement of goods and the immense output but there is nothing to satisfy the eye". The name of Carlo Zen, however, did stand out. Zen was the owner of the Zara & Zen company which had been active in the final years of the 19th century producing furniture in an eclectic style for a middle and lower-middle class clientele.

But when Zen presented his designs at the Turin exhibition, he took into account the changes that were taking place in fashion and tastes. He exhibited a number of interiors from the so-called "modern" department of his factory in Via Nino Bixio in Milan, where at the time he employed over two hundred workers. The new style is evident in the curving lines of a bedroom, described as "round-bellied and gilded" with a clear reference to Louis V.

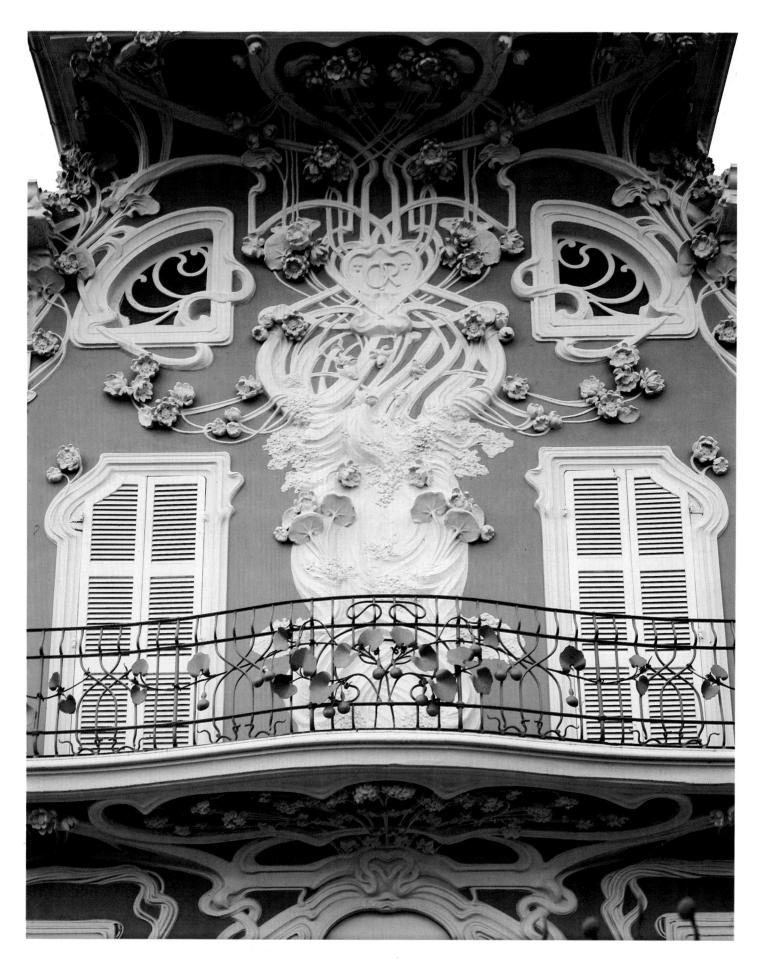

Details of the interior and exterior floral decoration of Villino Ruggeri at Pesaro, designed by Giuseppe Brega. Facing page: The eastern façade flaunts the initials of the client, Oreste Ruggeri, framed in a lively design of naturalistic stucco lilies and intricate linear ornamentation in the Art Nouveau *coup de fouet* style. Below: The ceiling of the *Stanza dei glicini* ("Wisteria Room") is resplendent with gilded and painted stuccoes.

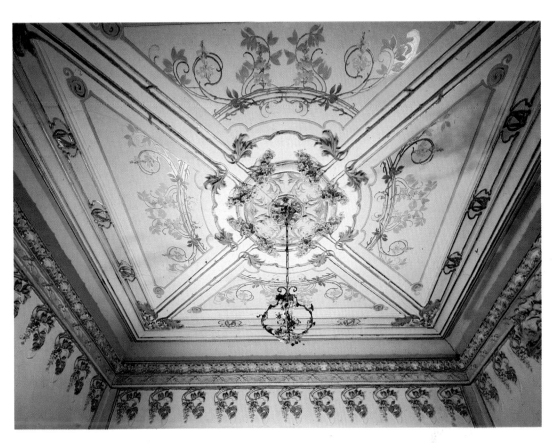

It featured elaborate plant-inspired carvings and "winked" from gilded wood bas-relief inserts where nymphs, cupids and venuses alluded amusingly to the bridal chamber while at the same time creating a vigorous, flowing decorative pattern.

The lack of conviction and unscrupulousness of "the industrial manufacturer when up against the new aesthetic" (A. Melani, "Mobili italiani", in *Arte italiana decorativa e industriale*, 1902) is increasingly clear if we take an overview of Zen's output. Other interiors, including a living room with settees, chairs and tables of various kinds, looked to Quarti's example. Their lighter physical presence, thanks to the ingenious framework of their structures and white metal, brass and mother-of-pearl inlays, did much, along with their relatively low cost, to bring otherwise exclusive furniture within the reach of a wider public.

In 1905, the company changed its name to Fabbrica Italiana di Mobili and appointed Giulio and Giovanni Sicchirollo to run the "modern" department. The brothers proved to be intelligent and sure-footed interpreters of what was now a well-established style.

After the Turin exhibition, Zen's company had at once adapted to meet market expectations, frequently seeking the contribution of well-known artists and architects such as Luigi Maria Brunelli (1878–1966), who was perhaps more aware of Viennese trends than anyone else in Italy, Giuseppe Sommaruga (1867–1917), the architect who designed one of the most representative Art Nouveau buildings of the time, Palazzo Castiglioni

in Milan, Galileo Chini (1873–1956), a ceramic designer, painter and very sophisticated decorator, and Alessandro Mazzucotelli (1865–1938), a highly skilled craftsman and creator of superb wrought-iron work.

The Issel company

Although smaller than Carlo Zen's, the company established in Genoa in 1880 by Alberto Issel (1846–1926) was nonetheless a substantial enterprise for the time. Issel had begun his artistic career as a painter, but switched to the applied arts when his sight was affected by illness. His factory, equipped with modern machinery and employing about seventy workers, at first produced

furniture in the late eclectic idiom but quickly went over to the Art Nouveau style. Issel's furniture tended to become increasingly simple in its overall form while adopting an ever-richer and more complicated ornamentation of plant-inspired decorative motifs.

Issel's initial training as a painter whose favourite subjects had been landscapes, nature and military scenes emerged in his intricate carvings of leaves, stems and flowers, or in the addition of painted decoration, or even in the way he treated the colour of his furniture, which was often finished with a dark green lacquer.

Despite the relatively large size of his factory, Issel always treated his elaborately decorated

items of furniture as unique, and made individual pieces that were by and large too expensive for the pockets of middle-class consumers. However, it is interesting to note his attempts to satisfy that clientele by adding more economical pieces with a less intricate design to the range. Indeed Issel developed and refined openwork decorative techniques especially for these models.

At the Turin exhibition, the Issel company presented furniture for "an entire apartment", comprising "anteroom, dining room, breakfast room, lady's boudoir, living room and other rooms".

This, flanked by individual items, enjoyed moderate acclaim from critics, who acknowledged that its designers had shown "a

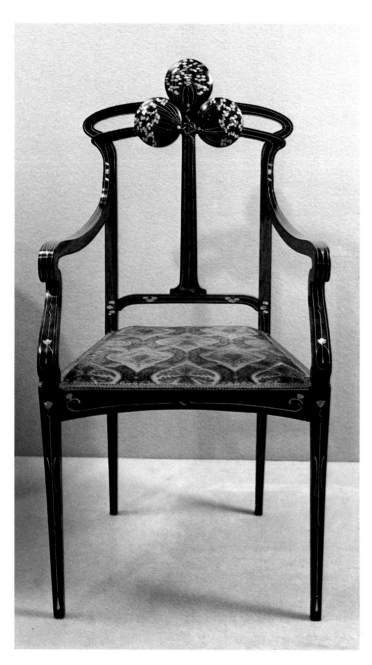

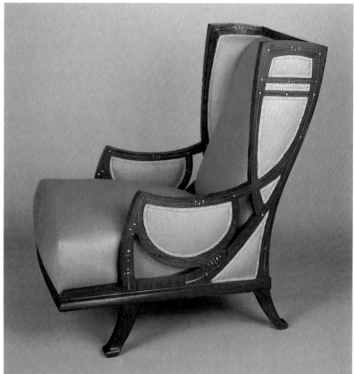

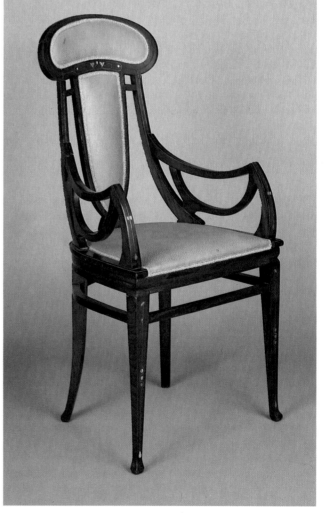

Some typically elegant, sinuously curving articles from the Milan factory of Carlo Zen. ABOVE: armchair. RIGHT: matching chair and long-seated armchair (c. 1902) in coconutwood decorated with brass and mother-of-pearl encrustations. Antiques trade and private collection. FACING PAGE: display cabinet in coconutwood. The particularly painstaking and intricate decoration includes mother-of-pearl encrustations and inlays in gold, silver and brass. Private collection.

desire to achieve elegance and grace of expression rather than undertake an authentic search for the new," while their "somewhat ill-defined style" was offset by the "great elegance of the execution" (E. Aitelli, "Esposizione internazionale d'arte decorativa moderna in Torino. L'Italia e gli Italiani" in *Natura e Arte*, 1902).

The Turin companies – Lauro and Valabrega

These were also the years in which the factory of Agostino Lauro was active in Turin, where it followed a similar path of initial uncertainty regarding decoration, shifting from Neo-Gothic to the English style and the floral idiom before settling firmly on Art Nouveau. At the 1902 exhibition, that policy was on display in the company's own pavilion, a self-contained building that was intended to demonstrate the potential applications of the new style, its versatility and its significance in terms of improving the domestic environment.

Designed by the Turin architect, G. Velati-Bellini, the Palazzina Lauro housed a collective exhibition of the artisans and manufacturers who had contributed to its construction and, as well as Lauro furniture, they had upholstery, ceramics, lighting fitments, glassware, mirrors, flooring, stucco decorations and iron utensils on show. It was, in effect, a house which gave concrete form to the full potential of Art Nouveau, embodying the longed-for integration of all the arts in a total environmental design, one of the main ideological principles of the new international idiom.

That evidently didactic intention resulted, however, in an over-elaborate decoration that was described as being "varied and animated [...] with greenish walls where gilded roundels and strips stood out with gold-ringed blue-coloured studs [...] bunches of dog roses [...] ceramic mounts on the windows, in the pediments, in the cornices [...] with marrows, grapes, wisteria, busy lizzies, poppies, roses, chrysanthemums, lilies, thistles and horse chestnuts [...] " (A. Frizzi, "Prima Esposizione Internazionale d'Arte Decorativa Moderna tenutasi in Torino nel 1902, La Palazzina Lauro", in *L'Ingegneria Civile e le Arti Industriali,* 1902).

Into this world of artificial nature, Lauro introduced furniture in a range of colours from coffee-and-cream to reddish brown, often with "scattered roses" upholstery, in a sort of minor, specialized range within the main production. This caused some perplexity because of the "anarchy" that appeared to reign "with curlicued, rectangular and geometrical cabinets, tables, writing desks, cupboards and beds where there is more affectation of expression than blending of tones" (E. Aitelli, "Esposizione internazionale d'arte decorativa moderna in Torino. L'Italia e gli Italiani", in *Natura ed Arte,* 1902).

Again in Turin, Vittorio Valabrega (1861–1952) was also turning out very good work. Having inherited a furniture factory, Valabrega was active from the latter part of the 19th century, employing about fifty workers, including upholsterers, carpenters, woodcarvers and lacquerers. At the 1900 international exhibition in Paris, Valabrega had enjoyed

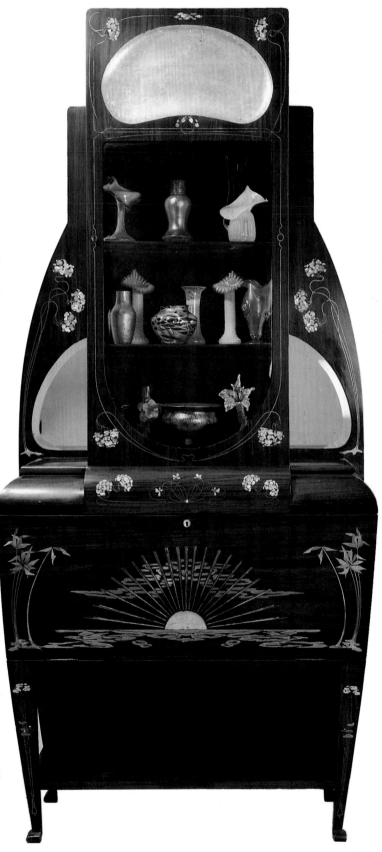

Harmony, elegance and asymmetry in the furniture of Carlo Zen

The Milan-based furniture-maker Carlo Zen (1851–1918) had already taken part in the 1881 Milan manufacturing and trade fair under the name Zara & Zen, and towards the end of the century, the company consolidated its position thanks to the ability and business instincts of its owner. Zen was well informed on what was going on in Europe, collaborating with the Haas textiles and furnishings company of Vienna, which opend for business in 1898. He made a well-timed exit from the eclectic market and began to produce furniture that at first was entirely floral in inspiration but quickly opted for a more sober, functional idiom that proved particularly popular with the middle classes. Zen's style was called by the experts a "floralized Sheraton". As early as the 1898 Esposizione Generale Italiana in Turin, it had embraced Art Nouveau, yet it also conserved a measured elegance in its arrangements of straight lines and curves, its understated decoration, and the carefully judged asymmetries of surfaces, mirrors, drawers and cornices. Having received a very positive reception at the 1902 Turin Esposizione Internazionale di Arte Decorativa Moderna, the company changed its name and transformed its former production site in Via Montenapoleone into an antiquarian centre. The re-organized and expanded furniture-making activities were transferred, under the name of Fabbrica Italiana dei Mobili, to Via Nino Bixio. Responsibility for design was entrusted to the Sicchirollo brothers, who added a less expensive range of simple, functional pieces to the output of furniture for the top end of the market. At the same time, Carlo's son Pietro Zen (1879–1950) was starting a new company in Milan in Via Stelvio, making high-quality furniture that could compete with Quarti's products.

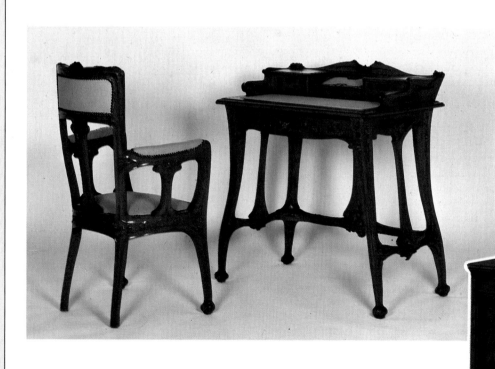

ABOVE: chair and writing desk in carved stone pinewood (c. 1900). RIGHT: oak settee (c. 1900) flanked by two cabinets, a configuration typical of the early 20th century. Above the back is a mirror framed by an openwork floral decoration featuring the iris motif that was so popular with Art Nouveau designers. Both Antiques trade.

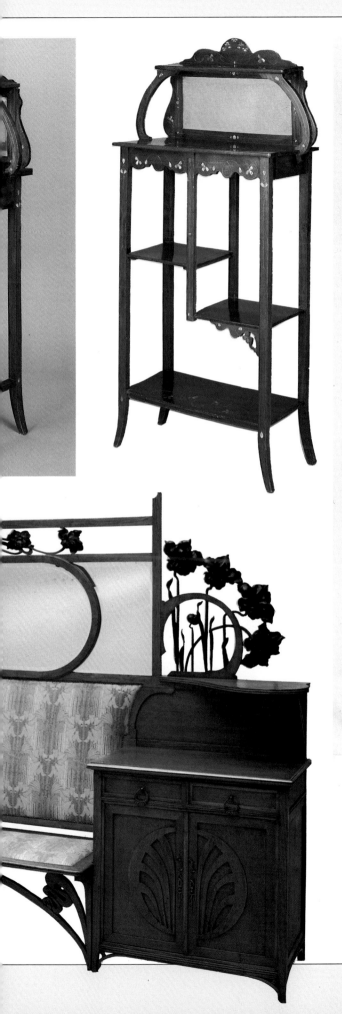

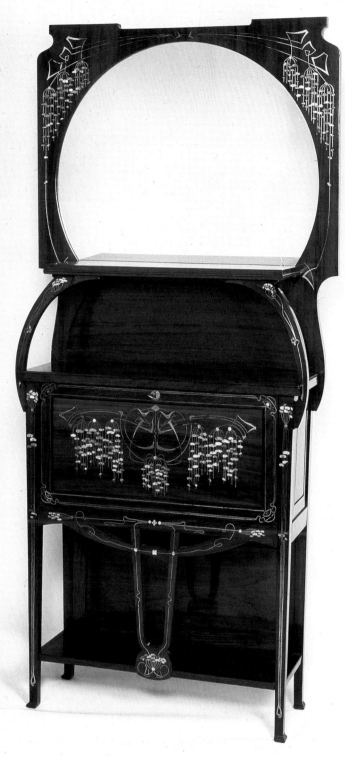

ABOVE LEFT: writing desk and shelf unit (c. 1900) with metal and mother-of-pearl encrustations. Private collection. RIGHT: mahogany living room unit decorated with stylized wisteria-motif metal and mother-of-pearl inlays from a range of furniture that Carlo Zen presented at Turin in 1902. The structure's combination of curved and straight lines is noteworthy. Antiques trade.

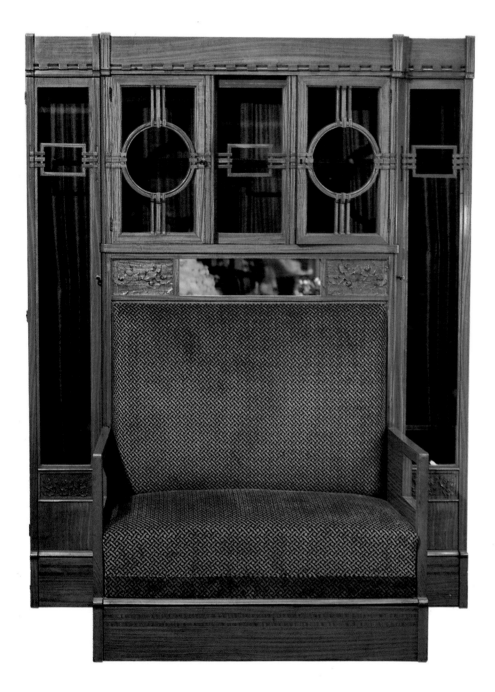

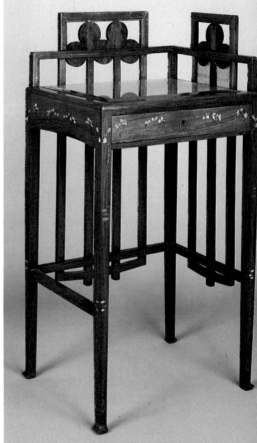

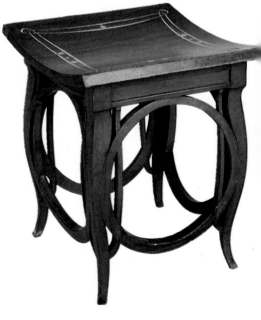

THIS PAGE: some more examples of furniture by Carlo Zen. These pieces are from
the company's later production in which the form is more rigid and geometrical, a
precise reference to contemporary Austrian furniture. ABOVE: a *vagoncino* unit com-
prising a sofa flanked by two tall, narrow display cabinets. Antiques trade. ABOVE
RIGHT: side table. RIGHT: stool (c. 1900), both in walnut with silver and brass string-
ing and mother-of-pearl inlays. All private collections.

Left: small walnut writing table (c. 1910) made by the Issel company. The elliptical top features a "tabernacle"-style raised tray and cabinet with inlays in mother-of-pearl and various kinds of wood on the doors. Inside the drawer, there is a label with the inscription "Alberto Issel Genova". Antiques trade.

Right: bedside table (c. 1900) made by Vittorio Valabrega's Turin-based furniture factory. Built to a plain, traditional design, it is decorated with floral inlays in various kinds of wood on the door and the small raised back. A carved openwork leaf-motif raised edge surrounds the lower shelf. Private collection.

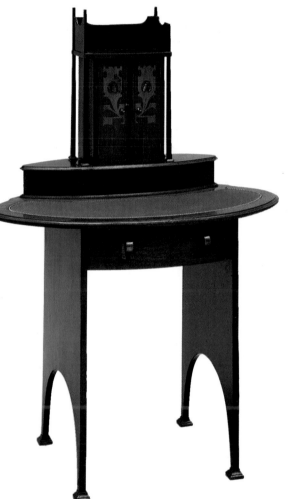

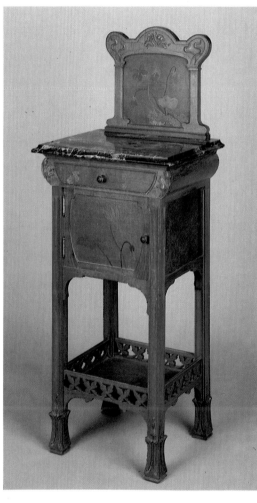

great success and was awarded a gold medal for a series of relatively restrained pieces that may for that reason have been considered more rigorous and less subject to the fashions of the day than other offerings.

Valabrega's series of sideboards and second sideboards, often in walnut with an uncomplicated structure, or in three sections with interchangeable decorative friezes, usually with a grape leaf or hydrangea theme and unconventional glass inserts, perhaps best exemplify the company's work. In the years that followed the Turin exhibition, Valabrega designs tended to become simpler. The architect Giannetto Fiorentino was the moving spirit behind this and his geometrical, broken-line motifs significantly anticipated the direction Art Deco was to take.

A variety of relationships

The overall picture was therefore moderately heterogeneous, with contributions that ranged from "designer" furniture, or at least items that were better known either for their craft heritage or the techniques used, to the creations of anonymous artisans and small factories. The critics, however, tended to be harsh in their judgement of the latter, emphasizing the still unresolved question of the marriage of artistic imagination and mass production. Sem Benelli, whose misgivings about the semi-industrial manufacture of furniture in the north of Italy have already been noted, wrote of "cruel, precise machines that have ordered and smoothed over everything, filling all the holes left by an art that is entirely absent.

The desire to sell and shift stock has taken the place of any serious artistic principle [...] At the end of the day, most of the exhibitors prove with their furniture that they have taken part only in order not to be left behind by the threatening new fashion of the floral, modern style etc." (S. Benelli, "L'Italia centrale all'Esposizione di Torino", in *La Rassegna internazionale,* 1902). In fact, in addition to stimulating decorative imagination in a sort of "liberalization" of ornament that could adapt itself to market demands, the characteristic motifs of Art Nouveau also found a fertile terrain in the great Italian craft tradition that manipulated flowers, cupids, female figures, animals, scrolls, garlands, carvings, inlays, brass, glass and mother-of-pearl with consummate skill.

Techniques and increasing popularity

It would not have been possible for ever more complicated ornamentation, with the growing range of materials used, and the increasing sophistication of design to gain widespread popularity unless simpler techniques had allowed manufacturers to achieve these effects at a reasonable cost. Two procedures in particular aided this process. Although they were not new, steam-bending wood and veneering had never before been applied so intensively. Steam-bending of course immediately brings to mind the system developed by Michael Thonet.

The decorative vocabulary of Art Nouveau was employed widely in Italy by craftsmen both celebrated and unknown, as the pieces below and on the facing page clearly show. BELOW AND LEFT: a chair and armchair in carved walnut. Private collection. RIGHT: a *guéridon* candlestand in stone pinewood (c. 1910), whose elongated and elegant structure alludes to the leaves and stems of a water lily. Collezione ALP. FACING PAGE: This corner screen has a linear *coup de fouet* decorative motif and boldly carved female figures. The flowing, wavy line develops freely to provide a keynote for profiles and volumes. Antiques trade.

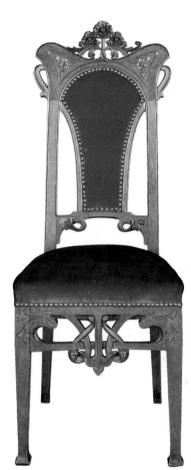

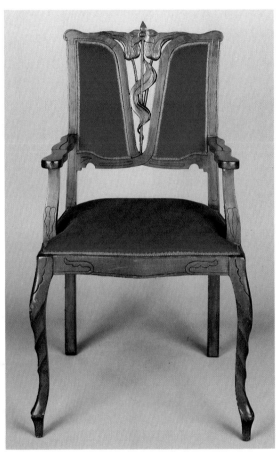

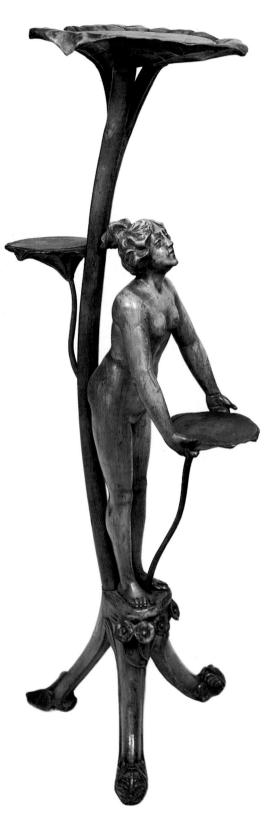

This was gradually perfected but remained largely unchanged, while veneering was the ideal medium for Art Nouveau's decorations. Furthermore, furniture veneered with exotic woods, mosaic finishes, wood, ivory, glass or enamel was not prohibitively expensive. The carcasses, consisting of cheaper woods such as deal or poplar, had only to be well seasoned and carefully planed to take the thin slice of wood finish. Structure and veneer were coated in hot glue, attached and pressed. Defects were stuccoed over, frames fitted, and the piece was then carved, turned and polished. The finished article was structurally sound, consisting of a combination of different materials that ensured its solidity. It was also less susceptible to decay and attack by woodworm than more costly articles in solid wood.

The Art Nouveau "look" could also be achieved by other means. The colour and appearance of wood could be varied, for example, by applying oil of turpentine to beechwood or maple and so obtaining an effect very similar to ivory. Horn could be coated in a solution of gold in nitric acid to achieve a speckled red tortoiseshell effect. Furniture could be embellished with metal encrustations by pouring into the groove of the pattern an alloy of tin and lead, which could then be

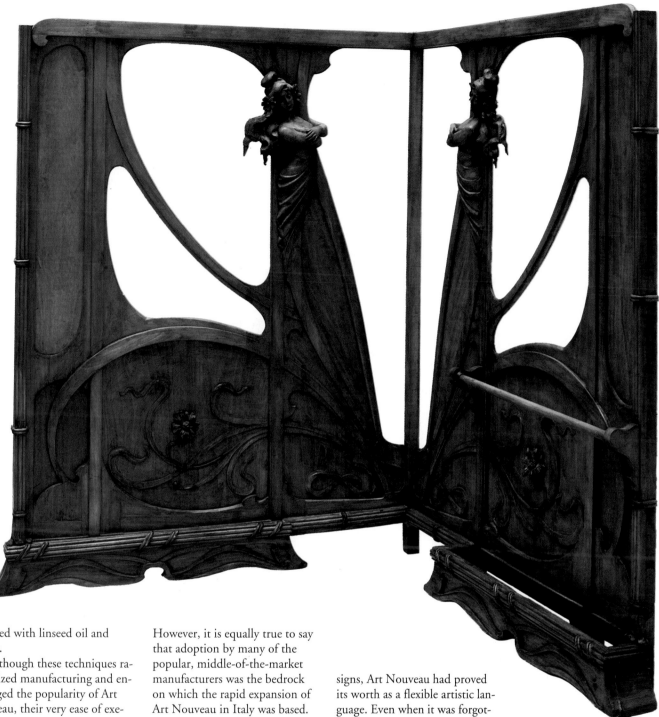

polished with linseed oil and emery.

Although these techniques rationalized manufacturing and encouraged the popularity of Art Nouveau, their very ease of execution encouraged the over-ornamentation that was branded at the Turin exhibition as a superficial "cosmetic" treatment.

It must be said that most furniture-makers looked to foreign models without much discrimination. It was the most ostentatious details that tended to be copied, so that curving profiles, serpentine carvings and animal or vegetable motifs were tacked on to articles that were often traditional in structure and composition.

However, it is equally true to say that adoption by many of the popular, middle-of-the-market manufacturers was the bedrock on which the rapid expansion of Art Nouveau in Italy was based. It satisfied a "taste option" whose importance cannot be ignored, even though it was short-lived. At the end of the first decade of the new century, Art Nouveau had already exhausted its innovative impact in terms of both style and of market while nonetheless having demonstrated a surprising power of penetration into Italian society. From interior design to street furniture, from places of recreation to the family tomb, and from printed books to shop

signs, Art Nouveau had proved its worth as a flexible artistic language. Even when it was forgotten as a possible mode of figurative representation, it would remain valid as a design-mediated message capable of transforming all aspects of the environmental arts.

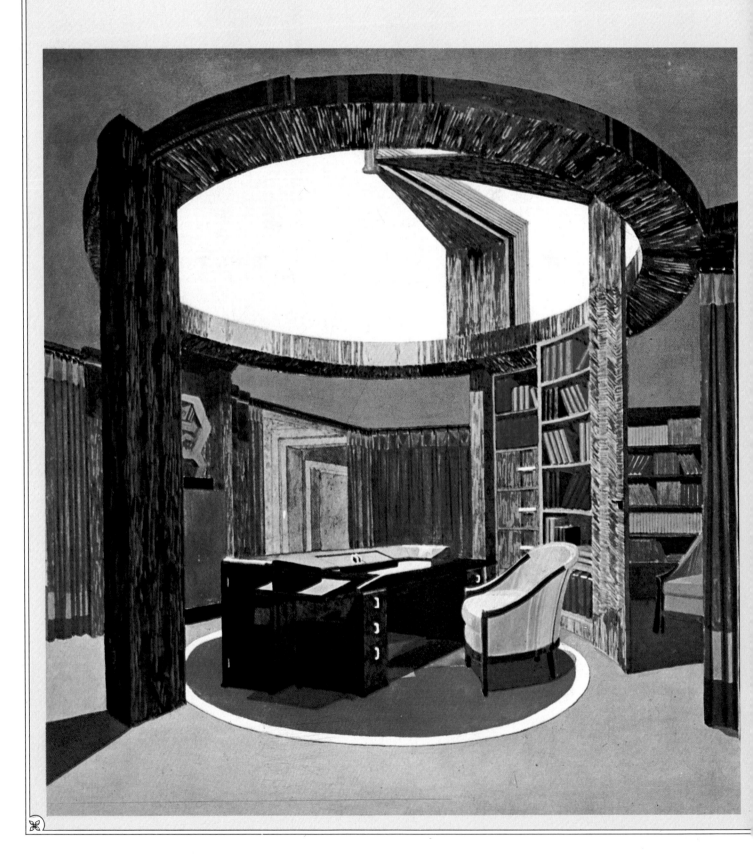

FURNITURE OF THE 20TH CENTURY

ART DECO

by Ornella Selvafolta

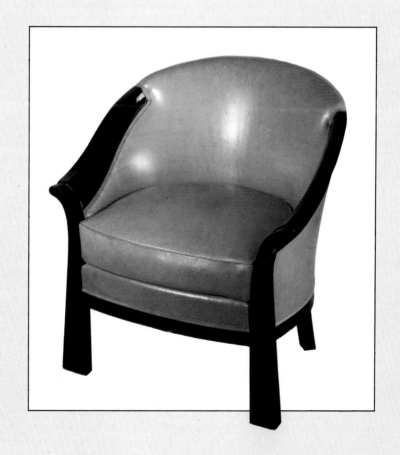

Introduction to Art Deco

The dual soul of modernity

The history of furniture in the early decades of the 20th century is inextricably tied to the concept of the "modern", in terms of the desire to be faithful to the reality of the age, to interpret and respond to its needs through utterly contemporary products. It was an idea that dated back to the industrial revolution in the 19th century, when objects were divorced from their traditional origins and subjected to the logic of production, distribution and consumption.

The introduction of economic processes in which the production of large quantities no longer represented an obstacle set off a chain reaction that either rejected mechanization as the source of all undesirable forms or embraced it as an opportunity to develop a new aesthetic. There was a call for renewal of both traditional decorative canons and the intrinsic characteristics of a specific object's construction. Form and language of structure and functionality were all called into question. The dual nature of this "modernity", identifiable beyond the very varied results it led to even in the context of Art Nouveau, is at the root of the often heterogeneous and certainly complex furniture production of the early 20th century. On the one hand, there was an "anti-machine" reaction that strove to recover the craft skills of exclusive furniture made for an elite in a set of revised formal rules. This was opposed by those who saw manufacturing industry as the

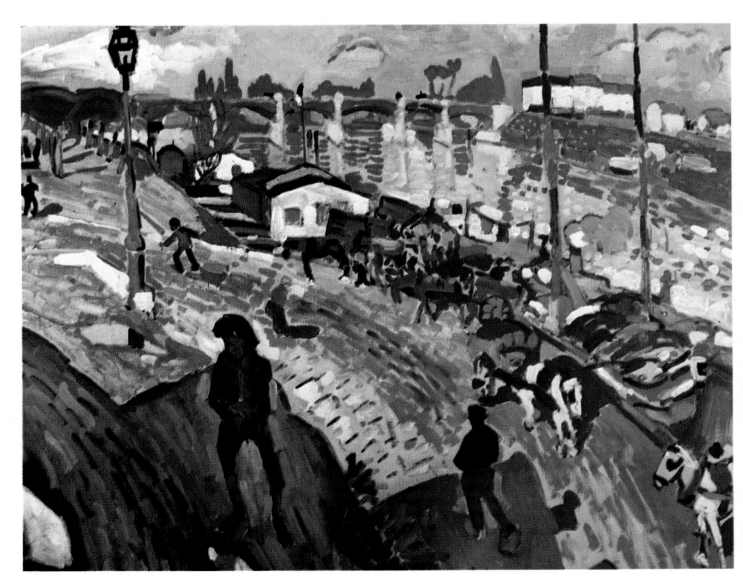

medium for a new design culture. These two very distinct lines of thought, which reached the height of their influence in the Twenties, co-existed throughout this period.

The champions of a complete break with even the very recent past were characterized by their brusquely geometrical, functionalist lines, in which it is possible to discern the beginnings of Thirties rationalism. Those who opted for continuity after Art Nouveau, while frequently failing to declare themselves or sometimes even denying their orientation, developed the new style's decorative language and focus on the aesthetic and symbolic significance of the object. It was the latter trend that had greater success in the early decades of the 20th century, a triumph that reached its peak at the International Exhibition of Decorative Arts held in Paris in 1925. Indeed, much of this chapter will deal with that event since, as well as being a major milestone in the formation of collective taste, it was also the final stage in the century-long saga of furniture as an expression of fundamentally decorative values.

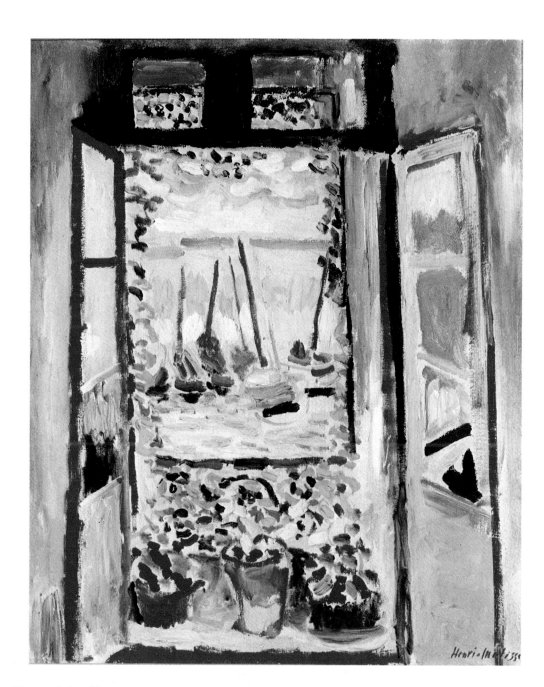

Beyond Art Nouveau

The 1900 international exhibition in Paris had ushered in the 20th century with a flourish of decoration. Its iron and glass pavilions had housed a comprehensive collection of the very best that Art Nouveau, and its decoration based on a free interpretation of nature, had to offer. The same event, however, also revealed symptoms of a worrying unevenness of quality and a fragmentation that ranged from the compact, seamlessly co-ordinated contributions of the École de Nancy or the Glasgow Four to one-off pieces whose innovation was no more than skin-deep. Such fashion-conscious articles were out-dated almost as soon as they were presented.

The great merit of Art Nouveau was nevertheless that it had focused attention on total environmental design, including in that concept the traditionally neglected area of the applied arts. The late 19th-century artists' associations and guilds for the design and manufacture of objects and utensils continued to be active into the new century. In France, they gave birth to the Société des Artistes Decorateurs (1901), the Musée des Arts Decoratifs foundation at the Pavillon Marsan in the Louvre, stage exhibitions in the sector, and the periodic organization of exhibitions at the Salon d'Automne. These aimed to embrace all innovative, independent expressions of art that were unable to find a home on the academic circuit. The Salon d'Automne was open to decorative arts, without which, according to Frantz Jourdain (1847-1935), the architect, designer, writer and art critic whose formative years were dominated by Art Nouveau, "there can be no true, complete image of the aesthetics and taste of an age". The decorative arts should be neither "the Cinderella of the art world" nor the "poor relation only allowed to sit in the kitchen with the servants".

But it was also at this time that the first objections to Art Nouveau were being expressed by furniture-makers, who saw it as dangerous competition for conventional "revival"-style ranges, as well as by some sectors of the general public for whom the domination of artistic values over functional qualities and the emphasis on one-off craft pieces were at odds with everyday furnishing needs. By the second decade of the century, the major

figures of Art Nouveau were either dead or no longer active, and their most brilliant insights had been rendered banal by poor quality copies. Once again, there was a widely felt need for renewal.

The liberation of colour

Further motives and stimuli directly related to the world of art intervened at the same time to modify the decorative tastes of the day, insinuating themselves into a predisposition towards change that was fuelled above all by economic progress and the powerful currents in turn-of-the-century society. One of those stimuli was the liberation of colour that shook the art world at the 1905 Salon d'Automne with the arrival of the group of young artists who would become known as the Fauves.

Their name derived from a remark by critic Louis Vauxcelles, who, pointing to a quattorcento-like sculpture standing beside the group's paintings, exclaimed: "Donatello parmi les fauves!"

("Donatello among the wild beasts"). The work of Henri Matisse (1869-1954), Raoul Dufy (1877-1953), André Derain (1880-1954) and Maurice de Vlaminck (1876-1958) exalted the constructive potential of colour and the violent chromatic contrasts of precariously balanced surfaces, offering solutions that were the complete opposite of the graphic, evocatively shaded approach of Art Nouveau. The group opened up new and unexplored areas of research in the applied arts.

The Fauves' exhibition may have been the work of a cultural elite but other art forms were passing into popular usage with immediate repercussions on taste and the development of decorative language. From 1909 to 1914, the last champions of the short-lived Art Nouveau movement suffered a severe blow at the hands of the art critic, choreographer and theatrical impresario Sergei Diaghilev (1872-1929), whose Ballets Russes were staged for the first time in Paris at the Châtelet theatre, and then at the Opéra, with costumes and stage design by Léon Bakst (1886-1924).

The rhythmic and dynamic value of the spatial trajectories of the dance were set against the loud energy of strongly accented, intensely coloured music such as Rimsky-Korsakov's *Sheherazade* and Igor Stravinsky's *The Firebird*. The daringly simplified patterns of the stage decoration freely exploited the most effective achievements of late-period Symbolism and Russian folk art. The orange of the sets, the bright blues of the floors, the sky blue of the curtains and the reds, greens, golds and sequins of the costumes constituted a theatrical revolution that was echoed by the many other artistic revolutions of the time. Cubism, for example, with its non-perspective-based representation, rejection of spatial terms of reference and breakdown of objects into a multiplicity of individual facets was exploring new pictorial territory. This gives an idea of the intensely rich range of cultural influences active in this period.

Fashion is of course a crucial aspect of the history of taste. Its ability to popularize trends, and the fact that it is symptomatic of

changes not just of form but also of behaviour mean that it plays a decisive role in shaping decorative styles. For those were the years in which the great Parisian couturiers were making France a byword for sophisticated elegance, thanks to the superb creations whose influence went far beyond the world of clothes. It was no coincidence that many of the period's major fashion designers, such as Jacques Doucet, Paul Poiret and Jeanine Lanvin, were also the patrons of artists and decorators. Stylists sponsored and encouraged new ideas, commissioned some of Art Deco's most significant works and organized editorial initiatives, exhibitions and even a number of commercial ventures.

The fashion designer Paul Poiret

The leading figure among the couturiers was Paul Poiret (1879-1944), the spokesman of the new taste in clothes, decoration, design and above all in colour. As he himself said: "Love of 18th-century refinement took women to the point of deliquescence, extinguishing every vital sign. 'Nymph's thigh' tonalities, lilacs, the 'swooning' shades, mauve, light blue, hydrangea, Nile green, straw yellow and every insipidly pale, pastel colour were the order of the day. So I threw a few wolves into the sheepfold. Reds, greens, purples and bright blues made all the rest come alive." The overwhelming impact of Fauvism and the stage designs of Diaghilev's Ballets Russes was echoed in Poiret's superb fashion plates, designed by Erté and the great decorator Paul Iribe, as well

RIGHT: watercolour by Georges Lepape
for Diaghilev's Ballets Russes (1912). It is
one of the sketches for *Petrushka,* the
famous ballet in four tableaux by Igor
Stravinsky.

as in the spectacular fabrics and
wallpaper created by the artist
Raoul Dufy, one of whose earliest
backers was in fact Poiret –
Proof, if proof were needed, of
the general tendency towards a
new independence of form and
colour.

In 1911, Poiret also founded
the Atelier Martine. It was a
school-cum-workshop open to
girls of twelve years of age where
the rudiments of painting and
design were taught. Lessons were
supplemented by direct observa-
tion of plants and animals. The
Atelier's young pupils were free
to express their own feelings. It
was the founder's intention that
they would contribute to the cre-
ation of new ambiences that
would be an appropriate setting
for the new fashion-driven
lifestyle of free, dynamic, dar-
ingly elegant individuals.

The emphasis on spontaneity
enabled the Atelier Martine, with
which Raoul Dufy was to collab-
orate, to produce remarkably
fresh-looking work characterized
by the intense vitality of its
colours and designs.

Abstract ornamentation

During this period, the specific
area of furniture-making also
evinced indications of possible
changes of orientation. The exhi-
bition of the Deutscher Werk-
bund held at the Salon d'Automne
in 1910 had been hugely successful,
indeed mounted police had been
needed to keep waiting crowds un-
der control. The pieces on show
were well-made in an "absolute"
sense, incorporating new materi-
als, intense, audaciously "crude"
colours, simple forms and a co-or-
dinated, uniform style. Frantz

Jourdain wrote: "The Bavarian ex-
hibition has taught our chaotic,
higgledy-piggledy furniture indus-
try a lesson in discipline that it
sorely needed ... In effect, after this
event the number of interior de-
signers, up until now very small,
has grown significantly with the
acceptance of an overall unity of
style that had previously excited
little interest."

That overall unity of style ex-
pressed itself in France through a
return to the late 18th and early
19th century heritage, which was
concisely stylized to adapt it to
contemporary taste. It was a re-
turn, however, that implied nei-
ther imitation nor a mere revival
of the style. Instead, it responded
to a desire both for a simplifica-
tion of form and a firm link with

the past, in line with the aspira-
tions of an increasingly assertive
upper middle class that had taken
over the running of the country
from an aristocracy that had
ceased to be relevant.

Half-hidden filigree began to
reestablish a dialogue with the
Louis XVI, Directoire and early
Empire styles as well as with
Louis Philippe, replacing the exu-

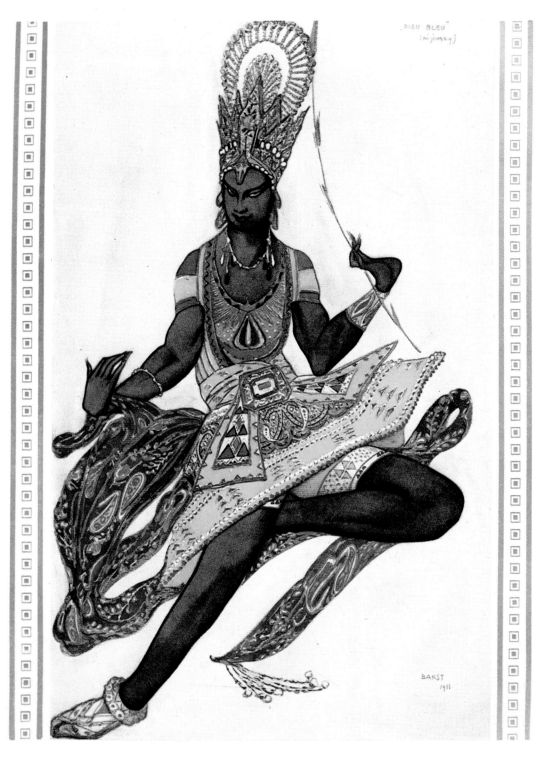

BAKST
1911

was nothing if it had none of the style or the values inherent in "the soul of things". "Every piece of furniture and every object has a soul and a style which is, for a period, what a personality is for an individual," he went on, demonstrating his faith in expression, creative research and psychological values as derived from Goethe's concept of "sympathy for things".

In classic Art Deco, "sympathy" manifested itself as a clearly stated desire to create comfort ("how agreeable it is to find a fireplace and a rug, how reassuring to sink into a comfortable, tomb-deep armchair", Dufrêne wrote elsewhere) that should not however be distinct from elegance and refinement. There also had to be an artistic element, due in most cases to the fact that the fashionable Art Deco designers were painters, sculptors or architects.

Most of the movement's production therefore went beyond the bounds of functionality. It sought to achieve artistic effects for sumptuous interiors, destined for an exclusive, well-informed clientele who viewed the home as a frame for the social life and rituals of urban entertaining. The cityscape with its lights, consumerism, shows and shop windows was the perfect setting for furniture and interiors in which luxury was achieved by sophisticated design, and enhanced by expensive materials, highly skilled workmanship and unusual colour combinations in both inlays and lacquering.

This was how the Italian critic Roberto Papini put it: "The furniture is clad in exotic wood veneers from the colonies. Some woods are as lustrous as satin, others shimmer like watered silk.

berant profiles of early 20th-century furniture with more sober outlines based on straight lines. Volumes were kept within clearly defined geometrical patterns, and a fairly limited range of stylized decoration was used, including the characteristic garlands, festoons and bouquets of the Neo-Classical repertoire. The effect was to confer an evidently architectural line. With great perception, the eminent designer Maurice Dufrêne (1876-1955), director of the La Maîtrise furnishing department at the Galeries Lafayette department store in Paris, declared: "A furniture designer is an architect and not merely a decorator. In designing a piece of furniture, it is vital to conscientiously study the balance of volumes, the silhouette and the proportions in accordance with the materials and techniques to be used."

Valuable materials

To this "constructivist" approach, Dufrêne added the conviction that a well-made object

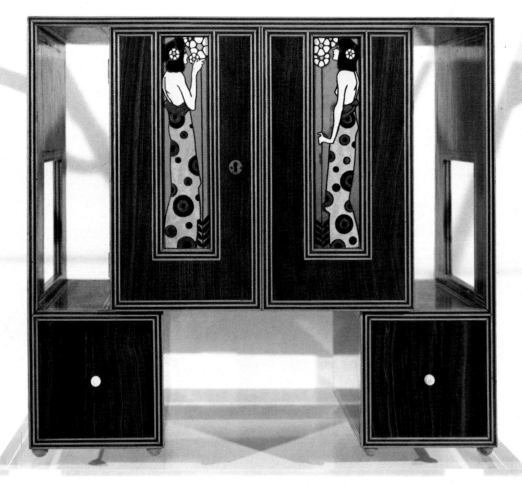

ment about its tastes and lifestyle, the pieces recovered in expensive elegance what was taken away from the complexity of their design.

The continuity of the Wiener Werkstätte

"The Viennese Secession is at the origin of a certain reduction of design to a linear element," wrote Giulia Veronesi in her book, *Stile 1925* (Florence, 1966). Veronesi meant that one of the sources of Art Deco has to be sought in the decorative arts of turn-of-the-century Austria. In the complicated evolution of experiences that incorporated extremely diverse and very distant inputs ranging from Neo-Classicism to Cubism, before crystallizing in

There are roots as hard as agate; maplewoods as soft as velvet. And on these surfaces, precious in themselves, a bronze ring or a slender fillet of ivory is sufficient decoration. The fabrics sing their bright song in the midst of great simplicity of form and precious materials. The refinement of modern taste is free to express itself to the full."

The dark stripes of macassar ebony, the delicate patterns of amboina wood, imported from the Moluccas, as well as those of highly polished walnut, tortoiseshell, horseskin, snakeskin and shagreen (sharkskin, known as *galuchat* in French and used for the first time in the 18th century for small ornaments) were all distinguishing features of Art Deco furniture. Manufactured for an élite that wanted to make a state-

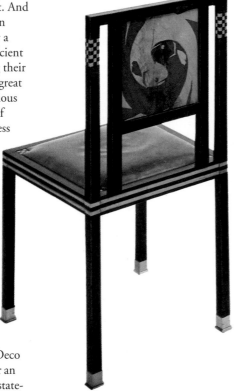

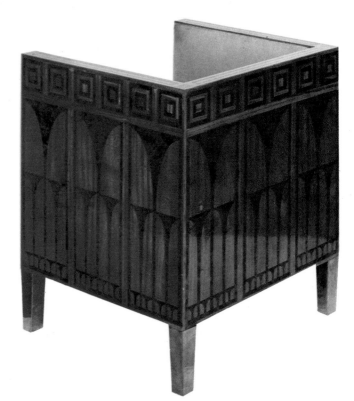

Art Deco in the period just before the First World War, a thread of continuity is provided by the architect Josef Hoffmann (1870-1956) and his work in the applied arts workshops of the Wiener Werkstätte.

In the first ten years of the new century, the Wiener Werkstätte had taken on an international dimension, opening branches in Berlin, Marienbad Zurich, Lucerne, Trieste and New York and offering itself as a model for a lively, productive artistic guild.

The interest aroused by Austrian production, and in particular by the Wienerstil represented by Hoffmann, may be summarized in the words of Paul Poiret. He himself was not averse to the idea of setting up in France a broad-based movement on the Viennese example: "In 1910 I visited in Vienna and Berlin all the exhibitions of decorative art and met some of the most influential artists, such as Hoffmann, the founder and director of the Wiener Werkstätte [...] I met [...] a large number of innovative architects [...] I spent entire days visiting modern interiors, built and furnished with a wealth of new ideas such as I have never seen at home [...] and I dreamed of creating in France a movement of ideas that could renew interior design [...] I went specially to Brussels to see the Palais Stoclet." The reference to the Palais Stoclet, built by Hoffmann between 1905 and 1914 for an extremely wealthy patron, shows how the Wiener Werkstätte's style matched perfectly the most intelligent aspirations and the finest traditions of middle class culture.

Its success was founded on measured proportion, sophistication and ambitious, carefully

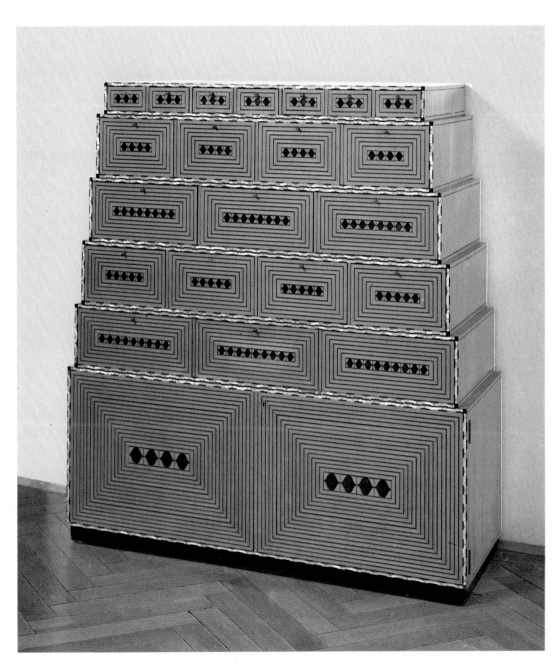

thought-out standards of design and execution. The Wiener Werkstätte also made a point of rejecting manufacturing industry in favour of craft skills. Right from the early days of Hoffmann's activity, in his most rigorously geometrical period influenced by the contemporary experience of the Glasgow Four, we may observe a number of benchmark features that anticipate some of Art Deco's eccentricities.

These include the two-dimensional interplay of surfaces that nevertheless preserve their own distinct identities, the exacerbated linearity of the corners (for example, the Palais Stoclet), purity of colour, simplification of design, the positioning of ornamentation in well-defined areas, the use of expensive materials and precision techniques.

Below left: display cabinet designed in 1934 by Josef Hoffmann and made by Franz Konectny. Below: tulipwood linen cabinet by Josef Franck, made before 1925. Österreichisches Museum für angewandte Kunst, Vienna. Facing page: a grand piano (c. 1931) in chrome-plated metal, plexiglass and leather, built by Andreas Christensen to a design by Paul Hennigsen. Antiques trade.

In the years following the turn of the century, other traits began to appear, such as the use of moulding to lend vibrancy and light to surfaces, the controlled sweep of line, interrupted profiles with alternating curves and straight lines and a vertical or horizontal step motif that defined the configuration of surfaces or volumes. The step motif was, as has been pointed out by Massorio and Portoghesi *in Album degli* *anni Venti* (Bari, 1976), to become a constant feature of Art Deco. The "syncopated" rhythm of objects and buildings continued into the Twenties, providing an opportunity for virtuoso bravura from Hoffmann's famous chest of drawers (1910-14), with its six-step configuration and ornamental mother-of-pearl inlays, to the pyramidal tops of New York's skyscrapers.

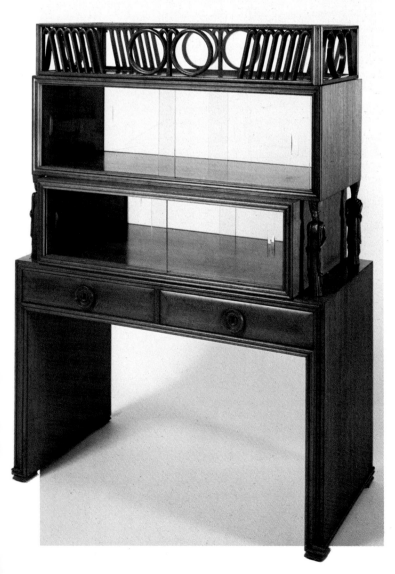

The Werkstätte's new direction

From the second decade of the new century onwards, Hoffmann's style began to follow a new direction, gradually abandoning the avant-garde to re-embrace the values of the classical tradition. As we have seen, this, too, was one of the features of Art Deco. In the specific case of the Wiener Werkstätte, the tendency found expression in the emphasis of formal details as minor additional elements with a symbolic, rather than a structural or functional, role.

The new iconography of the *Wienerstil* is particularly well exemplified in the work of Dagobert Pêche (1887-1923), who joined the workshop in 1915 and was very active and influential in all its areas of production. Pêche was a firm believer in the manual nature of art, and had developed his own idiosyncratic approach to design which, independently of the demands of everyday use, saw the object as the result of a "joyful" process of creation, free of outside influence.

The second generation of Werkstätte furniture therefore had a "fantastic" flavour, adopting forms that paid little heed to the object's structure and rejected Hoffmann's elementary geometry of cubes or squares for the allusive charms of the cylinder, the sphere, the cone, the bell, the pyramid and the ovoid. Geometrical though they obviously were,

these shapes were less functional than rectangular parallelepipeds, and were assembled in such a way as to create objects with a "personality".

Decorative motifs from the Biedermeier repertoire, such as small bouquets, swags and garlands, were added, as might be patterns of leaves interwoven to resemble spears, arrows or pointed hoes. These were drawn with a miniaturist, almost calligraphic, taste that complemented a profile often highlighted by richly carved corners.

The object itself was thus transformed into a medium or vehicle for symbols and surface values. Form was taken to its most pretentious limits in a triumph of decoration. That principle, in an even more ostentatious interpretation, received an official blessing at the 1925 exhibition in Paris, where there was a vast, spectacular selection of Art Deco objects flaunting an expressive style which fluctuated, like that of the Wiener Werkstätte, between abstract ornamentation and more accessible figurative elements that drew on the language of tradition.

Prague – Cubist furniture design

At the turn of the century, the city of Prague was not only the spiritual heart of Bohemia but also a thriving centre of cultural activity that was particularly open to the artistic avant-garde of the day. The vigorous nationalist movement that was struggling for independence from the Austro-Hungarian Empire, the intense exchanges of ideas that Prague's traditional role as an in-

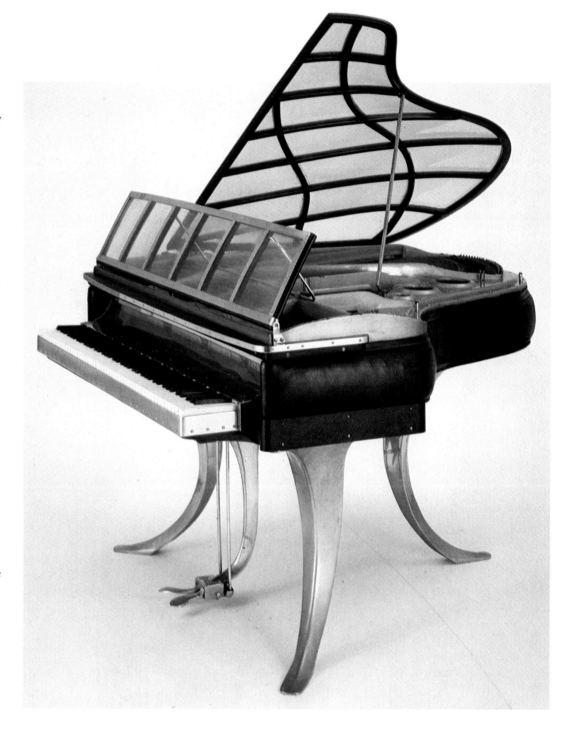

tellectual crossroads generated, and the desire to break free from academic restrictions and give free expression to artistic inspiration all conspired to make the city an ideal terrain for new ideas. Thus, the Cubist theories

were welcomed without hesitation since they represented a clean break with the figurative tradition. Cubism's new conception of space and time, backed up by the latest scientific discoveries (Max Planck's quantum

theory was published in 1900 and Einstein's special theory of relativity in 1905) became the starting point for young Czech artists seeking to protest and at the same time to find artistic legitimacy for their rejuvenation of

Below, clockwise from top left: chair design (1911–12) by Pavel Janák; sketch of armchair (1911–14) and design for a writing desk (1917–19) by Antonín Procházka. Facing page: *Velocity of an automobile + light* (1913), a Futurist painting by Giacomo Balla in which the artist studies forms in movement, and movement itself as an abstract plastic expression. Museum of Modern Art, Stockholm.

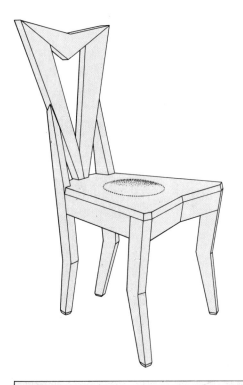

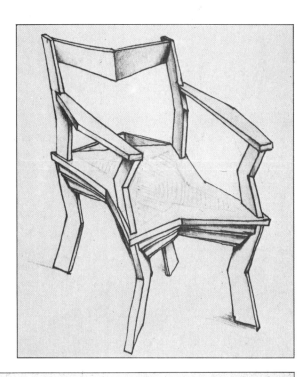

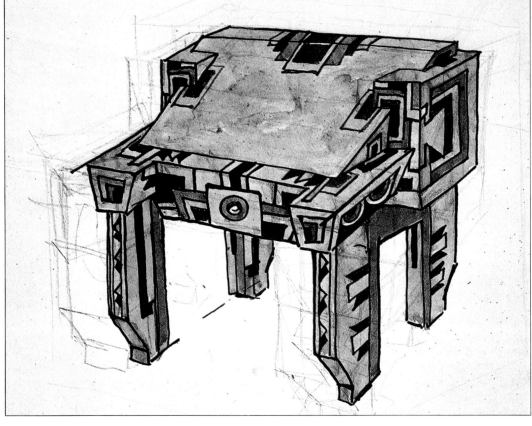

modern culture through the destruction of form and spatial relationships.

This was the climate in which Cubist design, a unique phenomenon in the history of furniture, was to emerge. Spanning only five years, from 1910 to 1915, Cubist furniture design was nevertheless a significant step in the evolution of figuration that would lead to Art Deco in the Twenties. The leading figures were a group of Prague-based avant-garde architects including Pavel Janák (1882–1956), Josef Gocár (1880–1945) and Vlastislav Hofman (1884–1964) plus the artist Antonín Procházka (1882–1945). They all shared an anti-positivist stance that affirmed the absolute supremacy of the spirit, in the sense of creativity, over matter and perceived form as the primary creative principle.

Thanks to Pavel Janák's efforts, in 1912 the group managed to set up the Prague Artistic Workshops (PUD) on the model of the Wiener Werkstätte, to make artistic furniture for unwaveringly modern interiors. Chairs, sofas, cupboards, tables and writing desks designed at the PUD were remarkable for the manner in which they rejected the traditional rules of composition. Surfaces had sharply angular profiles, and legs and backs were bent or twisted.

The object was broken up into its constituent parts in compliance with analytical Cubist precepts, to be put together again in a new, unexpected configuration. In this way, Procházka's design for a writing desk, while remaining relatively faithful to conventional expectations, was totally revolutionary

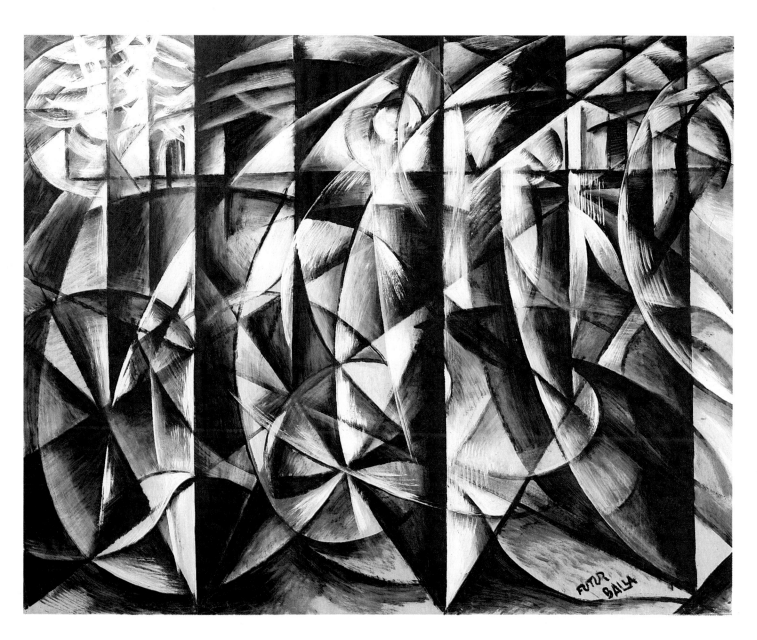

in its use of interlinking surfaces and volumes based on oblique lines and sharp corners. The fragmentary nature of the design is underlined by the geometrical-motif decoration.

Even more radical were the chairs designed by Janák, with their crooked legs, triangle-based surfaces, wedge-shaped carvings and slanting corners. As well as breaking up the outline of the chair, these features demanded elaborate manufacturing techniques, especially at the joints, which could not always be constructed using traditional methods. The more rakishly angled surfaces required screw fixings, which then had to be covered by veneer, or complicated systems of reinforcement which rested on top of each other in a series of inclined planes.

The contrast between concave and convex corners, projections and indentations and the abandonment of what would appear to be the most elementary rules of functionality all served to produce "dramatic" shapes that aimed to achieve a three-dimensional effect rather than to comply with the rules of construction. The object was forced into designs whose equilibrium defied physical science and whose materials, such as oak, were selected to be "easily workable, easily available and unostentatious", thus producing a more effective result.

The geometries of Fortunato Depero

The dynamic tension of images that was peculiar to early Futurism became less intense in the paintings of Depero. It was transformed into a purely decorative interplay that found new expression and original effects in the artist's activities as a designer of stage sets, tapestries and interiors, commercial artist and furniture designer. Depero's ever-wider range of interests and experience in many fields was partly a result of his contact with Giacomo Balla, who supported his inclusion in the 1915 Futurist exhibition in Rome, where Depero had moved the previous year. Balla shared Depero's desire to expand the scope of the Futurist aesthetic into a complete "reconstruction" of the environment that would conform to the language of contemporary fashion. It was with this in mind that Depero founded his Casa d'arte at Rovereto in 1919. Simplicity of structure deriving from rigidly geometrical combinations, jagged, wavy profiles that still featured the geometrical element so characteristic of all his work, stylization, energy and imaginative decoration were the keynotes of Depero's interiors and furniture, yet they were always in strict conformity with the precepts of the Futurist painters.

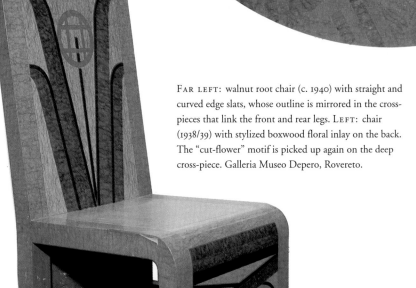

FAR LEFT: walnut root chair (c. 1940) with straight and curved edge slats, whose outline is mirrored in the crosspieces that link the front and rear legs. LEFT: chair (1938/39) with stylized boxwood floral inlay on the back. The "cut-flower" motif is picked up again on the deep cross-piece. Galleria Museo Depero, Rovereto.

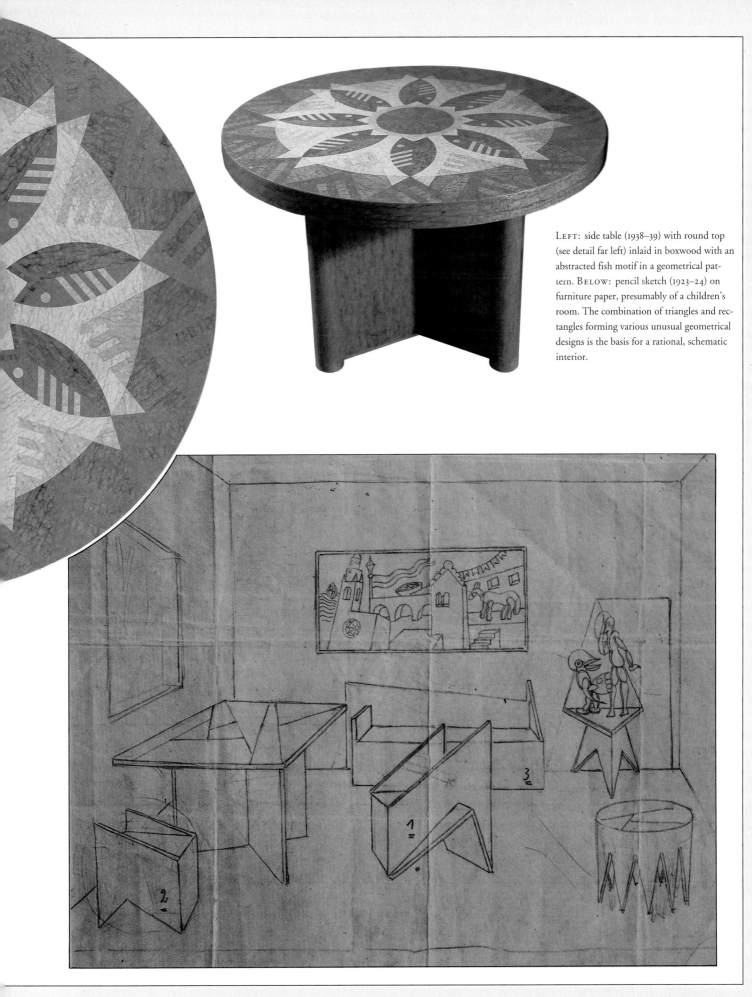

LEFT: side table (1938–39) with round top (see detail far left) inlaid in boxwood with an abstracted fish motif in a geometrical pattern. BELOW: pencil sketch (1923–24) on furniture paper, presumably of a children's room. The combination of triangles and rectangles forming various unusual geometrical designs is the basis for a rational, schematic interior.

Furniture designs and drawings in pencil on paper by Fortunato Depero. BELOW: sketches of tables and chairs (1922–24) in which linear and curved elements are put together in bizarre combinations to make attractive, "country-style" objects. ABOVE RIGHT: chair design (1921–22) for a "Devil's cabaret". BELOW RIGHT: an inlaid wooden armchair. Galleria Museo Depero, Rovereto.

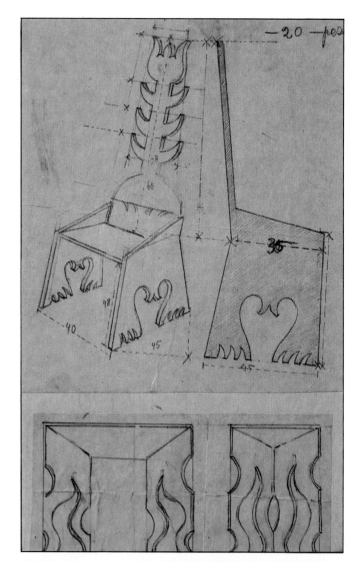

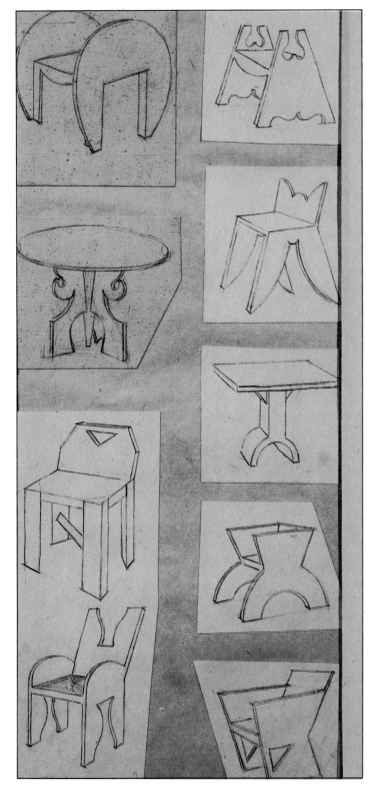

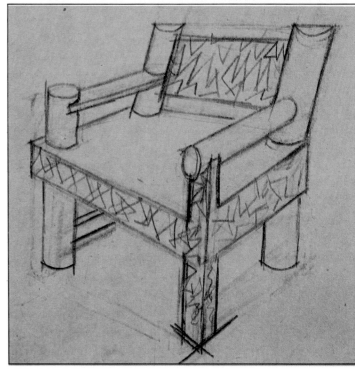

The geometricality of Depero's furniture can also be observed in his pencil-on-paper design (1920) for a bed and two bedside tables (below) and his Indian ink design (1929) for a "serious" armchair in which the circles and triangles of the decoration complement the stylized figure of a griffin on the back. Galleria Museo Depero, Rovereto.

the atmosphere of a project in which the "Futurist reconstruction of the universe" manifested itself in everyday living and household objects: "Balla was the first person in Italy to attempt to endow the house with a sense of well-being, novelty and cleanness, yet without making people regret the passing of all the mediocre styles ancient and modern that require space but do not use it.

He did it with his painted panels, upholstery and lampshades, his first rotating multicoloured tissue-paper theatres

The "Reconstruction of the Universe"

In 1914, the Futurist painters Giacomo Balla (1871–1958) and Fortunato Depero (1892–1960) signed the manifesto entitled *La Ricostruzione dell'Universo*. It was published the following year by Marinetti (Giampiero Giani, in the catalogue for the *94a Mostra Depero* exhibition, Trento, 1953) with the aim of expanding the Futurist aesthetic beyond the traditional areas of the figurative arts to include all aspects of the environmental arts.

"We, the Futurists Balla and Depero, wish to achieve this total fusion to reconstruct the universe by gladdening it, that is by recreating it entirely [...] We shall find abstract equivalents for all the forms and elements of the universe, then we shall combine them according to the whim of our inspiration [...] ." That was how the two artists expressed a creative tension – a characteristic feature of the Futurist movement – that strove to extend its expression into a dimension that was

universal, and therefore virtually inexhaustible. The precepts of Art Nouveau, which sought to highlight and enhance the reciprocal integration of object and ambience, were thus re-presented as axioms that were to produce a number of major works, in the second decade of the century.

Their main exponent was Giacomo Balla, who designed the furniture for the no longer extant Löwenstein residence in Düsseldorf between 1912 and 1914. His drawings reveal an explicit attempt to fuse furniture and architectural context using diagonal marks and "iridescent penetrations", or decorations that extended from pieces of furniture on to the walls.

However, Balla created his most remarkable furniture and interior designs for his own house in Rome between 1914 and 1920, for which he designed decorations and ornaments such as carpets, tapestries and sculptures as well as a bedroom and a dining room.

A passage written in 1933 might be useful here to recreate

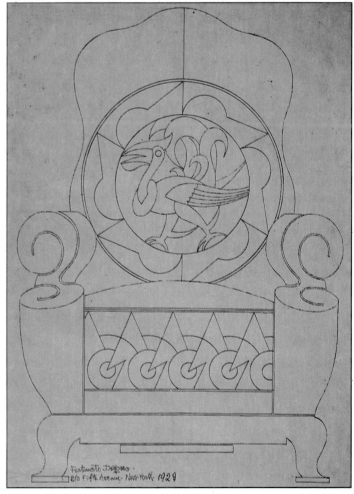

and landscapes, his Futurist flowers and vases, his square coloured sticks, his embroidery, his painted furniture that could be dismantled and put together again to adapt to all transformations of its assigned interior." (G. Jannelli, "Futurballa", in *Futurismo*, 1933)

Balla's house was a truly remarkable "place" where the spirit of play combined with a powerful imagination but where there were also elements of unadorned practicality. His furniture, some of which was later reproduced in a limited series, is striking both for its steadfastly unconventional figuration, its extreme clarity of conception, and what one might call the normality of its structural solutions.

The stools, chairs, side tables, dresser and studio couch are intensely artistic sculptures in the deliberately asymmetric design of their profiles and even more so in the sharply contrasting interplay of a colour scheme that sets flat expanses of yellow against orange and green. At the same time, however, Balla's furniture reveals its essentiality in the simple technique employed to join its surfaces at right angles. It is a method that greatly streamlined the "generating forms" of the furniture and which made explicit reference to the traditional models of the central Italian craft heritage (the dresser, in particular). Balla had been interested in craft furniture since the turn of the century, discovering the elegant simplicity of its wedge joints for surfaces attached at right angles to each other.

Simplicity was also the keynote of the furniture that Fortunato Depero made from 1919 in the *Casa d'arte futurista Depero*

and at his home town of Rovereto. The workshop, which had a solid tradition of craft production behind it, at first made only "tapestries and cushions," with the aim of "first of all replacing in an ultra-modern idiom all the various Gobelin tapestries Persian, Turkish, Arab and Indian carpets which today have invaded interiors without distinction.

"Secondly, and as a consequence of the first step, it is necessary to begin at once to create an interior space, the domestic living room, in the theatre, in hotels or in the residences of the aristocracy. This will be an interior in conformity with contemporary fashion and appropriate for housing all the avant-garde art that today is at the height of its development." (E. Crispolti, *Ricostruzione futurista dell'universo*, Turin, 1980)

An ambience "in conformity with contemporary fashion" was exactly what Fortunato Depero presented with his personal room at the International Exhibition of Decorative Arts held at Monza in 1923. Next to the paintings, cushions, tapestries and superb wooden toys, Depero arranged furniture whose structure was uncomplicated and whose profiles were dynamic, vigorous and brightly coloured.

It was the joyous expression of an art that was able to infuse a room with hints of fairy-tale fantasy. The exhibition evidently fired the imagination of a designer who generally turned out furniture of a more rigorously geometrical configuration and a rectilinear dynamic that rejected compact, closed shapes in favour of a broader spatial interpenetration of surfaces and volumes.

The energy that lay at the root of Futurist painting therefore also found its way into the objects its artists designed, many of which appeared during the Twenties with the opening of the many Futurist art galleries that sprang up all over Italy.

The most important of these was the run by the painter Enrico Prampolini and the art critic Mario Recchi in Rome from 1918 to 1921. The distinguishing feature of their production was the abandonment of Balla and Depero's imagism for a more purist style whose unremittingly rectilinear profiles were very close to the work of the Rationalists.

The Omega Workshop

The artistic avant-garde also inspired the items turned out by the Omega Workshop, a British craft enterprise founded in 1913 by the art critic Roger Fry (1866–1934) and the painters Vanessa Bell (1880–1961) and Duncan Grant (1885–1978). Fry was an impassioned admirer of the French Post-Impressionists, Henri Matisse and Pablo Picasso, and he had organized major exhibitions of avant-garde art. His views ran counter to those of the British art establishment, but his theories and insights were nevertheless admired by the better informed, more progressive members of the interested public.

The Omega Workshop, as Fry himself admitted, followed the example of Poiret's Atelier Martine and was therefore intended to catalyse the creative energies of the younger generation by offering them a way to express themselves without constraint.

The refusal to accept mechanized production, the search for joy and pleasure through work and the desire to imbue everyday objects with artistic significance identify Fry and his group as direct descendants of the Arts & Crafts movement. They, too, displayed a somewhat anachronistic romanticism which was at least in part responsible for their lack of financial success and which led to the closing of the business in 1919.

Notwithstanding its commercial failure, the Omega Workshop is still one of the most important, and indeed successful, attempts to combine painting with the applied arts, to merge art and everyday utensils and to marry the beautiful to the useful.

The furniture featured surfaces painted directly onto the wood with designs freely inspired by the Fauves and Cubists. There were abstract or naturalistic motifs, upholstery embroidered with designs of balanced blocks of colour and geometrical carvings along the edges or in fantastic patterns that became the group's trademark, all in a style that sought gratification in ornament.

Omega Workshop furniture was therefore usually uncomplicated in design, with flat surfaces that were suitable for painting. It was made outside the workshop itself by specialized furniture-makers. The Omega Workshop's furniture was made unique by a combination of its deliberate lack of finishing detail, at odds with the spirit of creative spontaneity, the range of decorative themes, the texture of the brushstrokes, and the lack of concern for the techniques and materials employed to enhance the effects of colour.

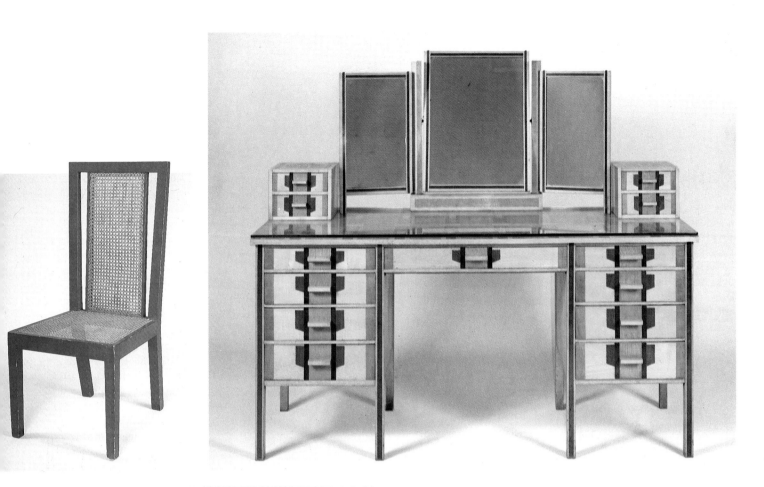

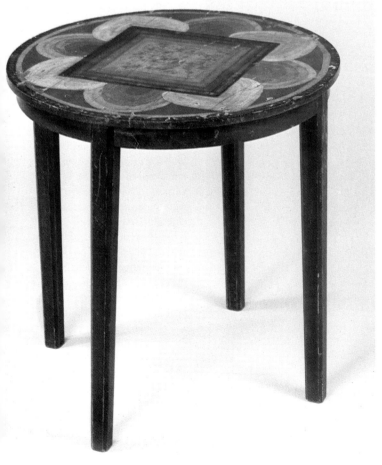

Each item was designed to communicate to the interior where it was located the richness and variety of inspiration of an artistic culture that would otherwise have been relegated to museums and the more exclusive galleries.

Art Deco furniture

The 1925 Paris exhibition

The year 1925 and the International Exhibition of the Decorative Arts in Paris marked simultaneously the triumph and the decline of Art Deco, as Georges Besson has suggested: "It was, at least in the field of interior design, a feast of decoration and of ornament at all costs, whether cheap or lavish, ingenious or ridiculous, and whether its vul-

garity was attenuated or transformed. But a feast of ornament, nevertheless. It marked the consecration of the stylized floral motifs from the Ecole de Nancy, of 1913's stylization of Cubism-derived themes, this last ornamental system being used quite shamelessly by even the most violent critics of that school of painting."

This passage, which focuses on the provocative artistic para-

dox of the avant-garde's assimilation into traditional formal and compositional schemes, nevertheless fails to do justice to a period in the decorative arts that undoubtedly produced works of great distinction.

The 1925 exhibition itself, judged harshly not just by Besson but by most of the experts, was a crucial moment in which the two contrasting souls of "modern" art confronted each other in a

highly charged debate. However it was also the belated realization of an idea that had been mooted in 1912 and then dropped at the outbreak of the Great War. Further delays arose because of the costs of post-war reconstruction. In a certain sense, then, the 1925 exhibition was already out of date. It became a synoptic retrospective of everything that had emerged over a period of ten years of exciting research, production, theory and practice, and which had been forcibly held in check by the war.

The ornamental exuberance that Besson lamented was moreover justified by the euphoria and relative prosperity that followed the end of the war as well as by the context of the exhibition, for it was a unique occasion that inspired artists to produce exceptional pieces of outstanding technical virtuosity. Many of the pieces on show had been created prior to 1925 and could in no way be considered representative of contemporary trends. So critics' opinions aside, the 1925 Paris exhibition for us today is an important point of reference. It bears witness to tastes which must be seen in perspective as tracing the emerging stylistic trends in the production of the major designers.

The refined opulence of the pieces by Emile-Jacques Ruhlmann, Süe and Mare, the production of DIM (Decorations

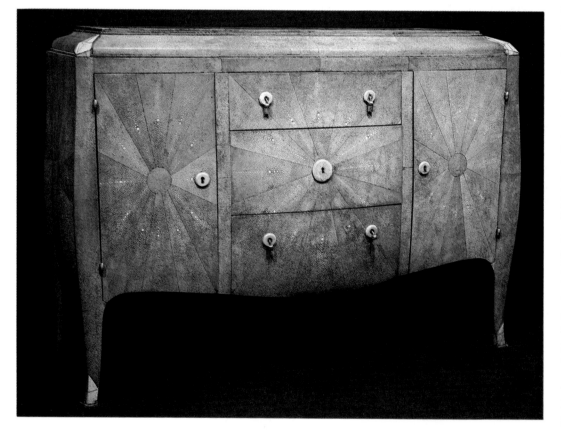

ABOVE: a three-drawer, two-door commode presented by André Groult at the 1925 Paris exhibition. It formed part of the furniture for a *chambre de Madame* in a fictitious French Embassy and is finished in green *galuchat*, or shagreen, a natural material that was popular at the time. Shagreen is made from the skin of a small dark-coloured shark native to the Mediterranean and North Atlantic and, after treatment, was glued onto furniture. Often dyed green, or occasionally blue, it was highly prized for its fine-grained texture, which is illustrated in the detail on the facing page. Galerie J.-J. Dutko, Paris.

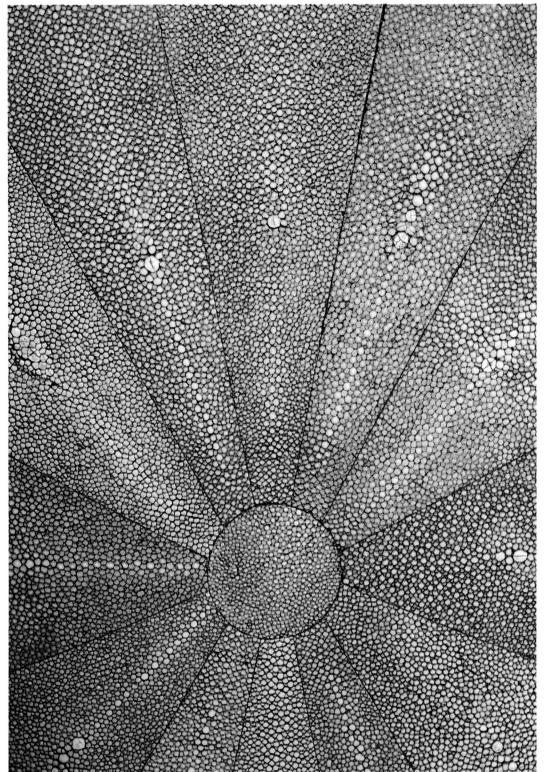

Intérieurs Modernes), the more markedly geometrical lines of articles by Pierre Legrain or Marcel Coard and the furniture sections of the Paris department stores, all represented at the Paris international exhibition, were to become the benchmarks of a movement that had for a decade pursued a new vision of interior design.

Materials

Art Deco furniture was destined mainly for a sophisticated, elegant public and at times became a sort of treasure trove of rare, precious materials on which the furniture-maker's skills could express themselves at the highest technical levels. In that sense, Art Deco was a continuation of 18th-century *ébénisterie*, and it was no coincidence that ebony was the wood of choice during the Twenties. It was employed for its lustre and its subtle, almost imperceptible, grain, which made it ideal for creating dark, smooth surfaces that could be lovingly polished to a gloss, enhancing the piece's configuration of surfaces and volumes.

Nevertheless, ebony was a relatively rare wood, reserves of which were beginning to run out in the Twenties. This led to the wider use of veneer, while the solid wood was kept for single components such as feet or other support elements.

Veneering techniques had by this time reached a level of sophistication and precision that permitted a much wider range of decorative effects than was possible with solid wood. A vast range of unusual woods was available, whose rarity and "exoticism" were exactly what the taste for ex-

BELOW LEFT: a glass-fronted console table (c. 1910) in forged iron with glass surfaces by Émile Robert. An ear-of-corn motif adorns the fascia around the console top and as the support under the glass. Antiques trade. CENTRE: a console table (1930) made from parallelepiped-shaped pieces of glass with marble surfaces by Marius Ernest Sabino. Galerie J.-J. Dutko, Paris. FACING PAGE: a chrome-plated metal *guéridon* with mirror surfaces. Antiques trade.

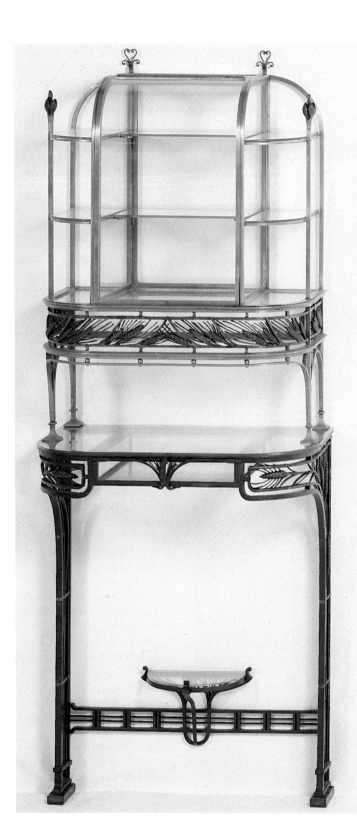

clusive materials and ambiences required.

A few such woods were macassar ebony, from the Indonesian island of Celebes, Brazilian rosewood from Rio, plus the more familiar mahogany or acajou, amaranth and sycamore. These woods were often used as veneers next to solid components in maplewood or ash, whose less uniform grain contrasted strikingly with the fine surface of the precious woods. The only limits to the effects thus obtainable were those imposed by the imagination of the furniture-maker.

Veneering technique

Lacquering took on great importance as a finishing technique during the Art Deco period and its finest practitioners, such as Eileen Gray and Jacques Dunand, raised it to an art status. The procedure was slow and painstaking, and success could only be guaranteed by a deep love of the materials and a craftsman's pride in a job well done. This is how Maximilien Gauthier described the lacquering process in the magazine *L'Art Vivant* in 1925: "Twenty-two operations are needed to produce a piece of lacquered furniture. The first operation is to put a layer of natural lacquer (a special resin imported from Japan) on the wood panel, which has been previously rubbed down with pumice-stone. For the second, a tightly stretched cloth is applied to the panel; a mixture of natural lacquer and earth, also imported from Japan, serves as a fixative. The third to the tenth operations involve the application of layers of pure lacquer and earth, leaving

the article to harden in a humid room. The article is then polished, up to eight times in a row. The eleventh operation is to solidify the finish with another layer of natural lacquer. The twelfth to the seventeenth operations involve six layers of lacquer mixed with a very fine Japanese earth. The eighteenth operation is the first layer of black lacquer, or natural lacquer oxidized with iron. The nineteenth and twenti-

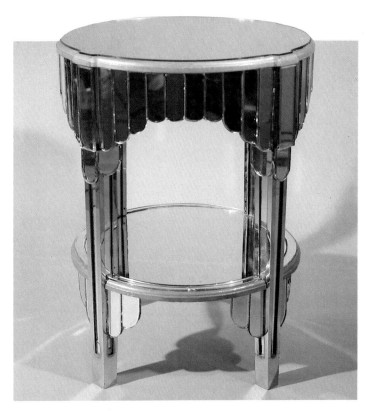

eth operations involve a further two layers, which are preceded and followed by thorough polishing. Finally, the twenty-first and twenty-second operations are decoration with encrustation of eggshell, mother-of-pearl, etc. and another two or three layers of lacquer" (in A. Duncan, *Art Deco Furniture. The French Designers*, London, 1984).

As may be seen, lacquering was a time-consuming process whose end result amply repaid the labour invested in achieving it. The lacquered surface was perfect. It might be smooth or delicately wrinkled; it was translucent, soft and velvety to the touch, creating a pleasure that was tactile and sensual as well as visual, as it responded deliciously to the caresses of its owners' fingers. The time and high cost involved in lacquering soon clashed, however, with the priorities of the age. The tech-

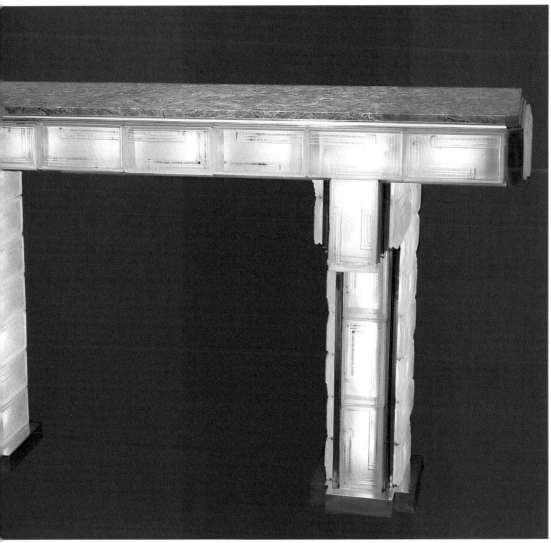

nique was exclusive, and quickly fell out of favour with a public that demanded modern, mass-oriented manufacturing procedures. Lacquering was replaced by synthetic industrial varnishes that coated wood and metal equally delightfully, at least to the eye and fingers of less discriminating consumers.

Organic materials and chrome-plate

Parchment had already been used to remarkable effect during the Art Nouveau period. To this, Art Deco added other "organic", animal-derived materials, particularly shagreen, the sharkskin known as *galuchat* in France after the M. Galuchat who had first introduced it in the 18th century. Shagreen, which was used to cover small items of furniture and ornaments, was obtained from a kind of sharkskin that was covered in small nodules. It was cut into sections of about 20 cm x 30 cm and left to soak in a chlorine-based solution to remove its natural colour.

Subsequently the skin was scrubbed smooth with a wire

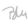

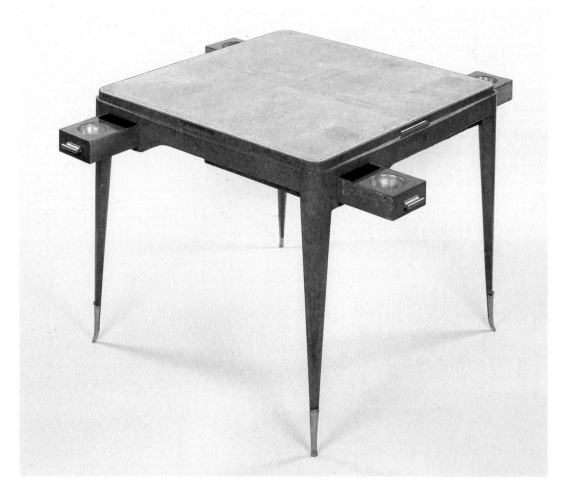

brush and then ironed, cut and glued on to furniture. The surface was generally painted green or blue to highlight the fine, irregular grain of its texture.

Another much sought-after material was snakeskin, which was highly prized for the decorative effects obtainable from its cell-based structure and chromatic subtlety. The less expensive pony skin was used by those who desired a more practical (and affordable) finish. Ivory came back into favour for inlays, or to embellish door and drawer handles, or to highlight profiles or underline the junctions of surfaces or volumes. There was renewed interest in forged iron, whose decorative potential had already been spotted by Émile Robert (see the ear-of-corn motif console table designed in 1908), Edgar Brandt's teacher and an artist. He was able, as Jean Locquin wrote in *Art et Décoration* in 1921, to dignify "the vilest of metals with the magic of the forge [...] showing once again that beauty is independent of materials and the true artist is privileged to elevate all that he touches."

In addition, the use of chromeplate deserves a separate mention. Chrome-plated steel, in particular, was to become, in the mid-Twenties, the special favourite of the Modernist wing of the Art Deco movement on the one hand and its bitterest enemies on the other. Steel, the raw material of manufacturing industry par excellence, could stand for the rejection of individuality in furniture-making, yet its very novelty was also able to signify the abandonment of all references to tradition. It could assume a polemical stance, breaking with, and transgressing, the rules that

governed a life of luxury and privilege.

That was the position of Le Corbusier and the "modern spirit" in the Twenties, when the aesthetics of technology and machinery found in steel a direct instrument of expression. But steel also found supporters among the less traditionalist adherents of Art Deco, and among designers who were more receptive to the requirements of the middle class.

Although the standard of living of the bourgeoisie had improved significantly since the end of the Great War, the cost of veneered wooden furniture was still

beyond the budgets of many families. Metal was a possible alternative solution for equal elegance of form at a greatly reduced cost. It was also more suitable for modern apartments, where central heating often ruined the veneer of furniture designed for more humid environments. Finally, metal could be used to obtain spectacular effects of cold, dazzling brilliance in combination with wood, mirrors or silver.

The ability of the artisan to "ennoble all that he touches" seems to have been a characteristic feature of Art Deco, whose aesthetic embraced the desire to

raise to the greatest possible heights of expression even materials which were generally held to be banal or contemptible.

A classic example of this is the console table in glass brick, one of the most "industrial" materials conceivable, by Marius Ernest Sabino, who transformed it into a deceptively unadorned piece of rarefied beauty that radiates a vibrantly pellucid light.

Jacques-Emile Ruhlmann

Unanimously considered by historians of Art Deco as one of the

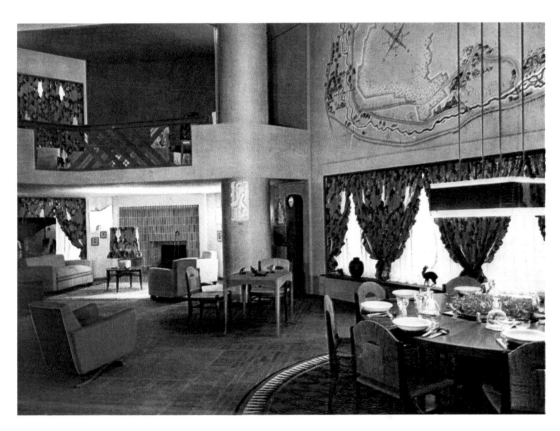

greatest furniture designers of the Twenties, Ruhlmann (1879–1933) began his career as an *ébéniste* by drawing, almost as a hobby, a few pieces of luxury furniture at his father's workshop. There he found both the means to execute his early projects and the opportunity to widen his knowledge of furniture-making techniques, from assembly to the art of inlay, and from weight distribution to door fixing and drawer insertion. Ruhlmann's outstanding technical preparation, which contributed to the supreme quality of his furniture, was coupled with a taste for refined objects whose virtues derived from purity of design, restraint in decoration and sensitivity for the aesthetic values that could be achieved by combining different materials or highlighting their intrinsic characteristics.

Exotic woods like amboina, amaranth, violetwood or macassar ebony were most effective when used in simple, discreetly elegant, forms enhanced with light inlays. In 1913, at the time of Ruhlmann's first exhibition at the Salon d'Automne, it had already been written of him that

"he asserted himself as the creator of luxury furniture" in accordance with an instinctive good taste that would never fail him and, indeed, would continue to grow surer and more discriminating with each passing year.

After the war, Ruhlmann took over his father's firm, which was thereafter called Ruhlmann et Laurent, increasing its manufacturing output in the applied arts by setting up carpentry and upholstery workshops and using

specialized workers in all sectors of furniture-making from mirror-grinding to veneering, inlay and the working of ivory, horn and mother-of-pearl.

Despite the company's commercial success, Ruhlmann's furniture continued to be exclusive. Its distinguishing features are instantly recognizable: the sense of proportion of the volumes, the carefully judged balance of spaces and filled sections both in the elaboration of the design and in the form of the supports. Slim, tapering legs, with ends often covered in ivory, hold up the less solid furniture, whose graceful configuration makes explicit reference to traditional designs. Good examples are the writing desks and secretaires with long, slender ivory-trimmed legs, as is the red-lacquer cabinet with its

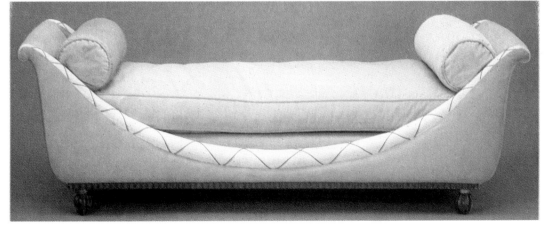

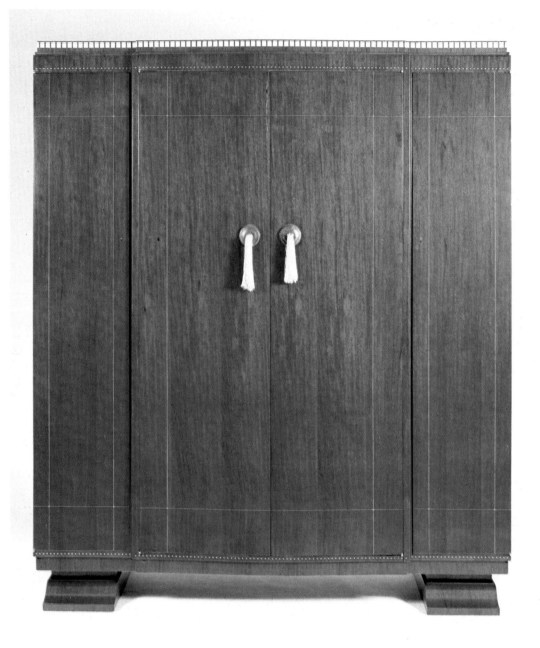

barely rounded profile supported on long legs that are slightly splayed and tipped with patinated bronze.

For his more geometrical, more robust furniture, Ruhlmann looked for ways of "hanging" it in mid-air by interposing between the base and the main body of the piece a low central support that reduced its volume and at the same time enhanced it by suggesting a valuable object exhibited on a pedestal. In certain cases, the furniture was mounted on an unremarkable, velvet-covered base almost as if it were being presented in a casket, with little concern for functionality. As the critic Charles Henri Besnard pointed out in 1924 in the magazine *Art et Decoration*: "What purpose do these solutions serve? If the aim is ease of access to the lower parts of the piece, then the platform is unnecessary. The article could simply have been mounted on longer legs. If there is a legitimate desire to protect the precious wood from the brush of an over-zealous maid, we can see no advantage in this system of raising the piece off the floor because a duster will do just as much damage as a sweeping brush."

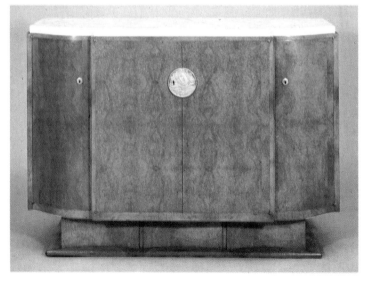

Furniture by Jacques-Emile Ruhlmann. FACING PAGE, ABOVE: a four-door wardrobe in rosewood with delicate ivory encrustations that highlight its geometrical shape. The "tassel" handles are in silver-plated bronze and silk. BELOW: an amboina *commode à vantaux* cabinet with gilded bronze fitments and a white marble top. THIS PAGE, LEFT: a slightly *bombé*, or convex, red lacquer cabinet (c. 1925) on long, slender, slightly splayed legs with patinated bronze tips by Jean Dunand. Antiques trade. RIGHT: small macassar ebony cabinet with tortoiseshell and ivory inlays. The tapering legs "rest" on the corners of the rectangular main body to emphasize its profile. Félix Marcilhac Collection, Paris.

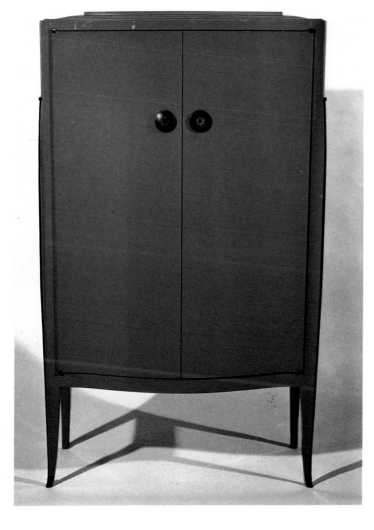

Ruhlmann's furniture-making technique

The concern with the formal result and final image created by the interpretation of the object's aesthetic and symbolic values meant that Ruhlmann's furniture came to be characterized by a manufacturing technique that completely masked the way in which it was constructed. Most components were made from very thick hardwood, generally oak, which was then covered with thin strips of wood whose grain ran in the opposite direction to that of the support.

The strips were planed and covered in turn with more reversed grain strips in a series of criss-crossing reinforcing layers that would prevent the cracking that had become commonplace with the introduction of domestic central heating and the relative scarcity of properly seasoned wood. The final "skin" was therefore applied, like real skin, over a complex multi-layered base hiding – its skeleton, joints and muscles.

The rarest and most costly woods, ranging from those with pronounced veining and well marked figures to the virtually plain, were cut and assembled in

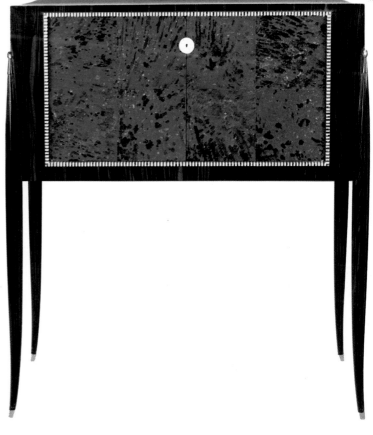

In fact Ruhlmann's platforms had no functional justification. Their purpose was subjective and aesthetic, for they created an effect of "distance" from the object, indicating that it was not just a cabinet, chest of drawers or sofa but a true work of art to be used yet also to be contemplated and admired for its formal values. In his upholstered furniture, Ruhlmann strove to create comfortable pieces, designing snug chairs and day beds whose soft but clearly defined lines drew on the Empire style and were upholstered in beige velvet edged with gold-trimmed white silk. According to Ruhlmann himself, such refined comfort should conform to its context, transmitting in its form and design the most appropriate sensations: "A living room chair should not be conceived in the same way as an office chair, which in turn must be very different from a smoking room chair. The first should be inviting, the second comfortable and the third voluptuous. Each should have its own strength, and it is the furniture-maker's primary task to identify that strength."

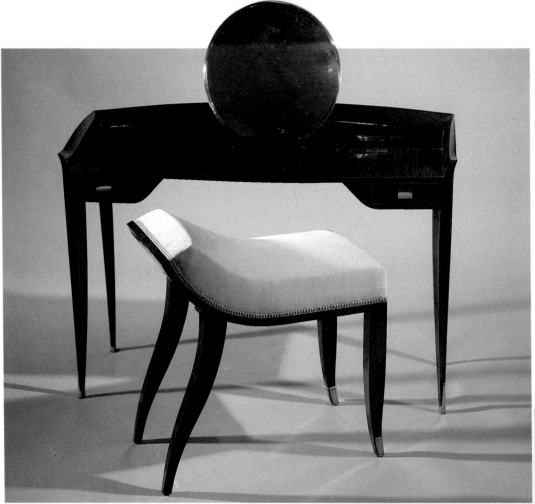

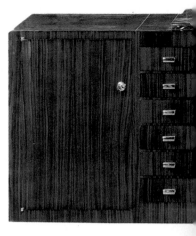

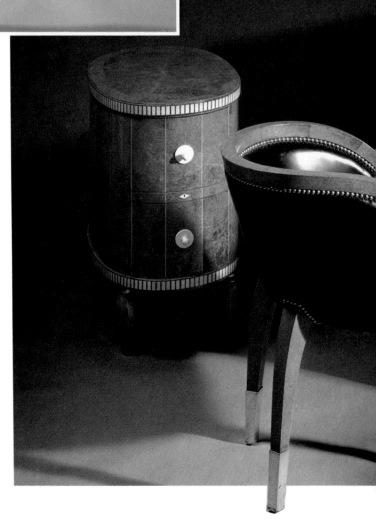

broad panels which often hid the joints entirely from view, giving the impression that the piece had been carved like a sculpture from a single piece of solid wood. Following on from this principle, the joints that could actually be seen on the surface were mainly for decoration and bore no relation to the true structural configuration of the object.

Ruhlmann usually combined exotic, expensive wood with ivory, to highlight profiles or for marquetry and inlays, or with embossed metal plaques, often placed in the centre of otherwise smooth pieces of furniture. Some examples were superbly lacquered by Jean Dunand (1877–1942), who was the undisputed master of that craft during the Twenties.

Ruhlmann's deluxe furniture was made for an elite clientèle, and the prices it commanded were extremely high. A fine selection was on show at the 1925 Paris exhibition in the memorable Hôtel d'un collectionneur pavilion, in which each object was the last word in exclusive luxury: "It would have been surprising," wrote Léon Deshairs in 1926, "if Ruhlmann had proposed interiors for a working class house and exhibited inexpensive

More Ruhlmann furniture. ABOVE LEFT: an elegantly curved macassar ebony tabouret, or stuffed stool (c. 1925), and dressing table featuring suspended side drawers with silver-plated bronze handles. FACING PAGE, ABOVE RIGHT: an *argentier*, or silverware cabinet (c. 1931), in macassar ebony with chrome-plated bronze trim and a marble surface above the central doors. Antiques trade. CENTRE: a cabinet, chair and writing table (1918–28) in amboina with ivory trim and encrustations. The writing table has a shagreen insert. Metropolitan Museum of Art, New York.

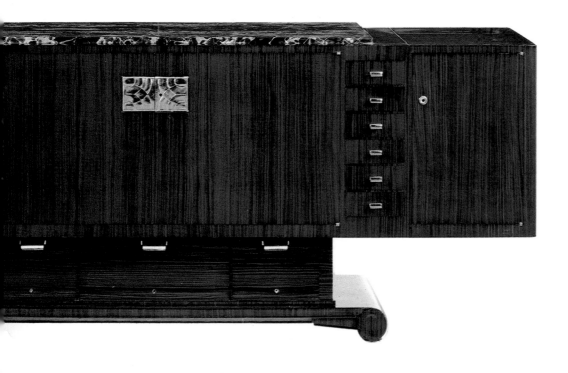

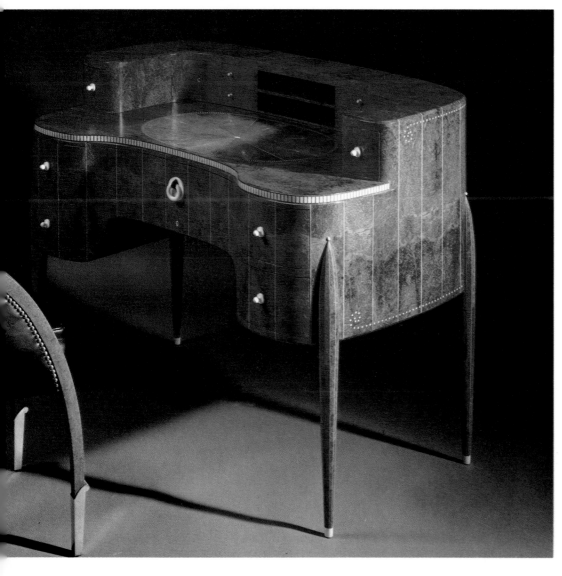

furniture. Not that he is incapable of perceiving the social significance of these themes for the applied arts, nor is he unaware that the simplest object and the most ordinary material can be ennobled by intelligence and creative talent. But other interests drive him [...]

Furniture born of his own researches, together with pieces by the colleagues he admires, and the works of art of all kinds with which he loves to, or would like to, surround himself are what Ruhlmann has decided to exhibit in the house of a rich collector, who resembles the designer himself like a sibling."

The trend towards sophisticated, expensive decoration began to draw a certain amount of criticism in the late Twenties. Ruhlmann himself attempted to ward it off by designing less exclusive, more "modern" pieces, giving up rare, expensive woods and substituting ivory, for example, with chrome-plated metal.

But as Edoardo Persico was to write in the magazine *Casabella* when Ruhlmann died, the designer's major contribution was his unwaveringly coherent interpretation of luxury and refinement, tempered by a profound sense of balance and control: "An artist with such a grasp of every trick of style, who was so ambitious, and so in love with his work, should not be mistaken for a consummate courtesan [...] 'Fashion is not generated from below,' he used to say, 'and creativity costs. To start with inexpensive furniture is heresy because the deluxe item becomes the model for mass production.' But Ruhlmann was a luxury artist with a sense of proportion who

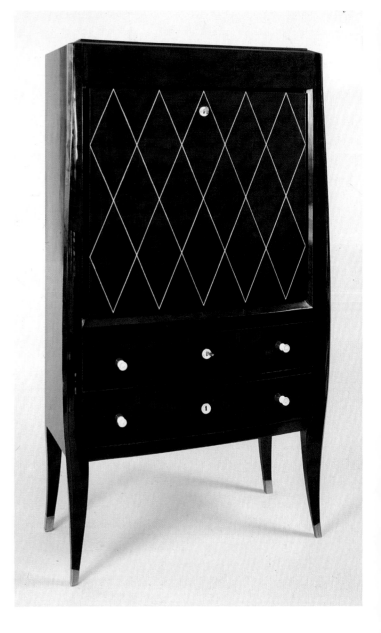

Süe and Mare

The architect and painter Louis Süe (1875–1968) and the artist André Mare (1887–1968) formed a partnership that was just as important as Ruhlmann in shaping the decorative tastes of the Twenties.

In 1919, the pair founded the Compagnie des Arts Français to make furnishings, having already been active individually for about a decade since the period in which Süe had set up a workshop for the applied arts called the Atelier Français. Mare, too, had come to the notice of both the

public and critics when he exhibited a Cubist house at the 1912 Salon d'Automne, although the avant-garde influence was restricted to the inclusion, in relatively traditional interiors, of paintings by Fernand Léger, Albert Grieze and Jean Metzinger.

The Compagnie went into decline in 1925, finally closing in 1928, but before then it turned out pieces whose "modernity" was extremely understated, often being restricted to the decorative motifs. All due attention was also paid to the national heritage, in an attempt to establish a uniquely French route to the renewal of taste. Süe and Mare's friend and collaborator André Véra wrote: "For furniture, we shall accept no advice from the British or the Dutch but shall continue the French tradition, ensuring that the new style will be a continuation of the last internationally successful style we had, that of Louis Philippe."

Like Ruhlmann, Süe and Mare re-interpreted the Neo-

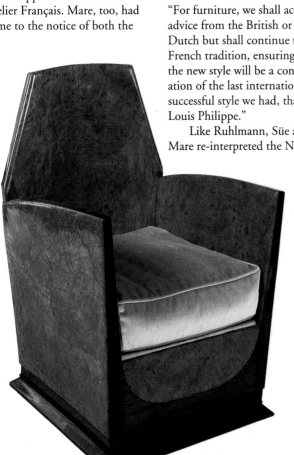

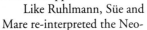

Two items made by the firm of Ruhlmann et Laurent about 1930. The structures of the armchair (left) and cabinet (above) display some of the main features of Ruhlmann's work, such as the armchair's curving base and profile, and the cabinet's slightly convex line, outwardly splayed, metal-tipped feet and ivory inlays. Antiques trade.

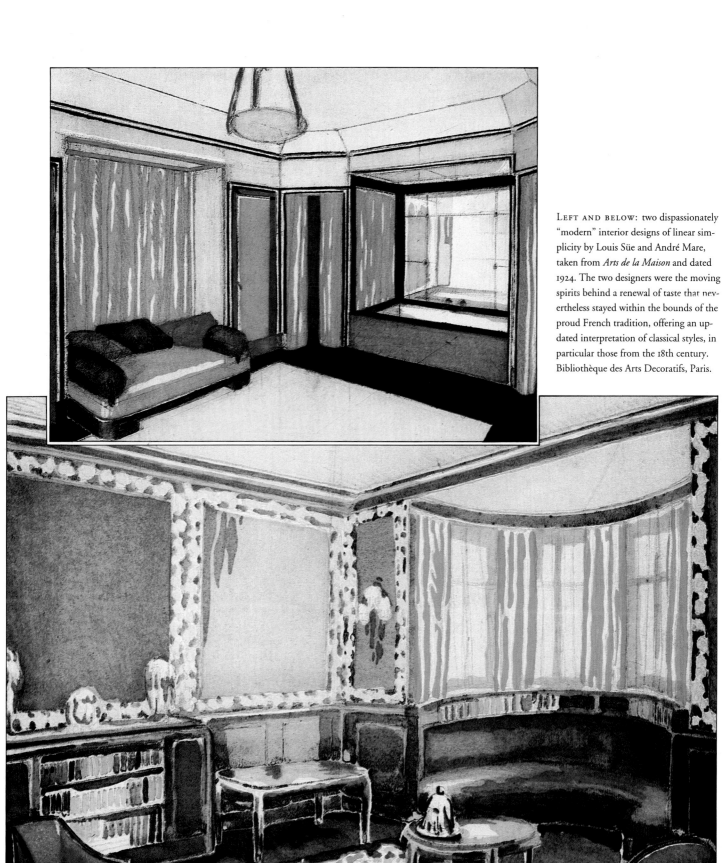

LEFT AND BELOW: two dispassionately "modern" interior designs of linear simplicity by Louis Süe and André Mare, taken from *Arts de la Maison* and dated 1924. The two designers were the moving spirits behind a renewal of taste that nevertheless stayed within the bounds of the proud French tradition, offering an updated interpretation of classical styles, in particular those from the 18th century. Bibliothèque des Arts Decoratifs, Paris.

BELOW: ebony cabinet by Süe and Mare with a mother-of-pearl bouquet-motif inlay on the front. FACING PAGE, ABOVE: a small, curved-outline cabinet (1925–30) whose combination of straight and wavy lines is emphasized by the metal cornice and base; in green lacquered wood, by Jean Dunand and Eugène Printz. Antiques trade. BELOW: a *commode à l'anglais* (1922) made to a design by Jean Goulden in Dunand's workshop. The lacquering is in the most highly prized colours: brown, ochre and black. Félix Marcilhac Collection, Paris.

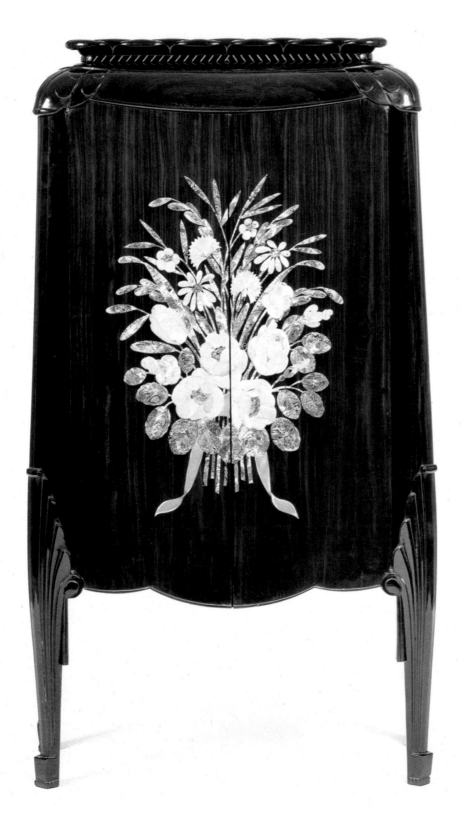

Classical mode but in a more substantial manner. Their furniture often featured heavy decoration and showy inlays. A further distinguishing feature of the Süe and Mare production was the design of support elements, most of which, whether they are in wood, or bronze or other metals, protrude from the main body as if they had been added on at a later stage of manufacture.

The Compagnie des Arts Français aimed to provide a complete range of furnishings, and used the services of many outside collaborators, who supplied ceramics, metal goods, wallpaper, glassware, lamps and carpets plus furniture and upholstery in coordinated colour schemes and patterns.

The designers set out to create welcoming, attractively elegant ambiences, and won commissions for the main reception rooms at the French embassies in Washington and Warsaw as well as for the residences of tycoons and stylists like Jean Patou. Süe and Mare's most spectacular creations, however, were the luxury ballrooms they designed for ocean liners such as the *Paris* or the *Île-de-France*.

The Compagnie won admirers for its ability to combine a traditional design with highly effective, startling details that had no structural importance but still managed to attract the observer's attention and set the tone of the entire piece. Their "exhibition" furniture often had large or unusual proportions, beautifully executed inlays such as the mother-of-pearl bouquet in the middle of an otherwise plain cabinet, attractive veining patterns or a dazzlingly polished finish, and it enjoyed great success thanks to

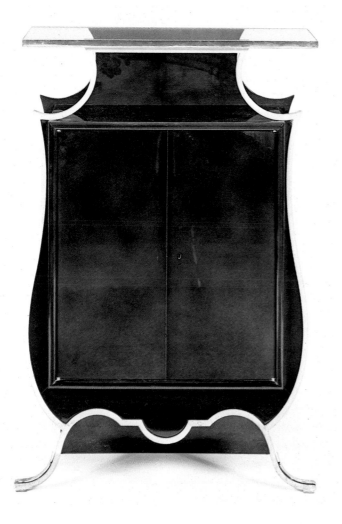

and in 1912 began to experiment with various techniques of lacquering and working in bronze and other metals.

In 1919, Dunand opened a workshop where he concentrated on various ways of lacquering, adding depth with the so-called *laque arrachée* technique, enriching the mixture with tiny fragments of eggshell to create surprising dotted effects on his translucent surfaces.

Dunand often worked for other artists – Ruhlmann was one outstanding example – but he also made a considerable range of articles himself, including furniture, screens, lacquered panels and jewellery. His superb lacquers were often resplendent with abstract geometrical motifs or stylized figures of oriental inspiration, their surfaces at times re-

vealing slight protrusions or fitting perfectly flush into lustrous, polished tops that are deliciously soft to the touch.

One example is a bed whose gently rounded lines are completely covered in a dark lacquer that features characteristically eastern decorative motifs: Japanese goldfish float as if suspended in an aquarium, and groups of water lilies drift on the translucent surface. But Dunand's art is shown to best effect in the pieces that have no decoration such as his red lacquer reading table, or the essential lines of his "gold-leaf" screen with its frieze of leaves and flowers at the top.

In some cases, such as for example his dressing table from the late Twenties, Dunand's art also emerges in the design. The dressing table has a geometric config-

the image of charm and novelty that it projected.

Süe and Mare's undoubted creativity in turning out eye-catching furniture was not matched by their technique, which fell short of Ruhlmann's perfection, and much of the Compagnie's furniture had only a brief useful life. This was especially true of the finishing and lacquering, for which the partners employed a fast, cheap method using cellulose-based products that deteriorated in a very short time.

Dunand's lacquer effects

The master of the art of lacquering and the man who revived the splendours of 18th-century *vernis Martin* was Jean Dunand, who, after training as a sculptor, moved over to the applied arts

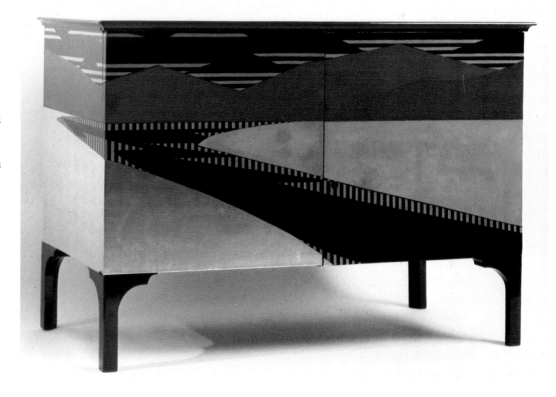

A "classical" designer:
Ruhlmann, the "20th-century Riesener"

To simplify and stylize the language of the great French tradition seems to have been the mission that inspired Jacques-Émile Ruhlmann, one of the world's most influential designers and makers of furniture between 1910 and the Thirties. Ruhlmann kept up to date with the experiments of the avant-garde, but he was also aware of the work done in the recent past. Without ever betraying the principles of comfort and functionality, he created furniture whose slender, whistle-clean lines were constructed with consummate precision. His production was characterized by the tapering legs of his writing desks and tables, dressing tables, small cabinets, commodes and chairs, which often "leaned" on the outside of corners to function as a decorative element, or might be slightly curved in a more agile version of the classic Louis V style. It was deluxe furniture for a sophisticated clientele made from the most valuable exotic woods such as macassar ebony, amboina and amaranth, whose veined or dappled surfaces were varied with ivory or tortoiseshell inlays, inserts in morocco leather or shagreen and ornaments in silver or gilded or silver-plated bronze, materials that Ruhlmann brought together with supreme good taste. Decoration is based on the graphical and artistic trends of the period, with stylized baskets of flowers, garlands and geometrical motifs featuring heavily. Ruhlmann's "classical", understated furniture was very distant from the wildest extremes of Art Deco and slipped comfortably into the urbane traditions of furniture for the elite, so much so that some critics called him the "20th-century Reisener", after the great French *ébéniste* of the second half of the 18th century.

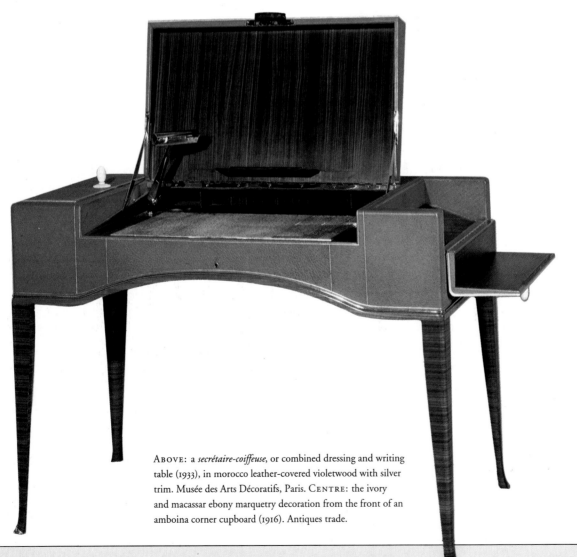

ABOVE: a *secrétaire-coiffeuse*, or combined dressing and writing table (1933), in morocco leather-covered violetwood with silver trim. Musée des Arts Décoratifs, Paris. CENTRE: the ivory and macassar ebony marquetry decoration from the front of an amboina corner cupboard (1916). Antiques trade.

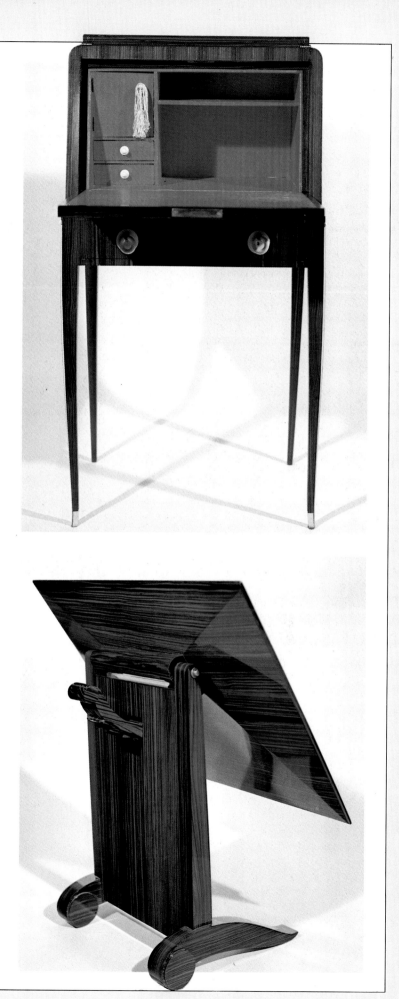

ABOVE RIGHT: a ladies' macassar ebony *bureau à abattant* (c. 1923)
with a red leather interior and long, tapering ivory legs. BELOW RIGHT:
a macassar ebony tilting top table (c. 1925). The rectangular top is
adjustable and mounted on a rectangular support with feet in the shape
of stylized scrolls. Antiques trade.

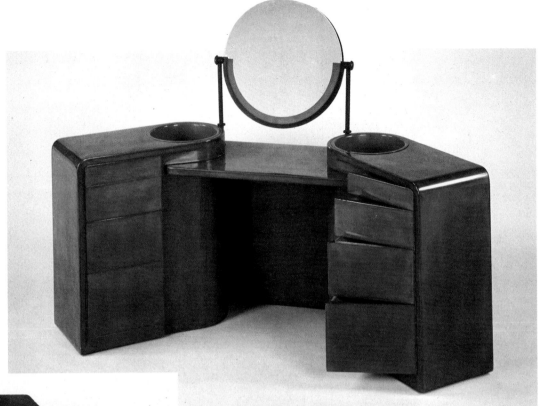

Two pieces designed by the celebrated lacquerer Jean Dunand. BELOW: a red lacquer reading table with adjustable bookstand on long, tapering, curved and slightly splayed legs. It is stamped "Jean Dunand Laqueur". RIGHT: a Cubism-inspired dressing table in red-brown lacquer with rotating pull-out drawers. Both antiques trade.

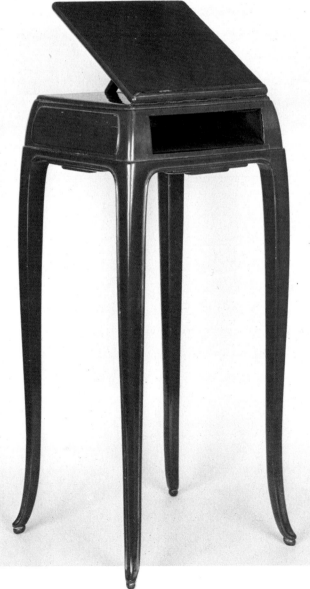

uration that is mitigated by a rounding of the corners echoed in the perfect circle of the mirror, the cylindrical red lacquer *cache-pots* or vase holders, lying snug against the mirror stand, and the rotating movement of the drawers that open to the sides.

André Groult and Paul Iribe

Whereas Jean Dunand's production was concentrated on individual pieces of furniture featuring his special lacquer finishing technique, André Groult (1884–1967) aimed for an integrated ambience, designing complete interiors in which shapes, colours, functional content and symbolism all interacted.

Groult was active from about 1910 and soon developed his own distinctive style, characterized by comfortably ample forms co-ordinated by their harmony of design and colour scheme. In 1925, he took part in the Paris exhibition, designing furnishings for the Fontaine, Christofle and Baccarat pavilions, the musical in-

strument section of the Grand Palais, the gardening section and the *chambre de Madame* in a pavilion representing a fictitious French Embassy. The last of these was without doubt Groult's most important contribution. It was conceived as a luxuriously sensual retreat, and many of its pieces survive today.

The critic Georges Le Fèvre wrote of it in the magazine *L'Art Vivant* in 1925: "Shagreen, lapis lazuli, amazonite, ivory, ebony, horn and pink quartz are the selected materials. Groult supervises the installation of his creations with small gestures. He is a phlegmatic man with a high forehead, slanting eyes and an Englishman's smile as he sensuously strokes the curving lines of a chest of drawers decorated with shagreen and ivory inserts."

The stunning *chambre de Madame* was a feast of *bureaux*, chairs, commodes and *bergères* in costly green shagreen arranged in segments in a sunburst effect around a central hub, rich pink satin upholstery, ivory trim and generously soft feminine curves that alluded directly to the room's intended purpose. For

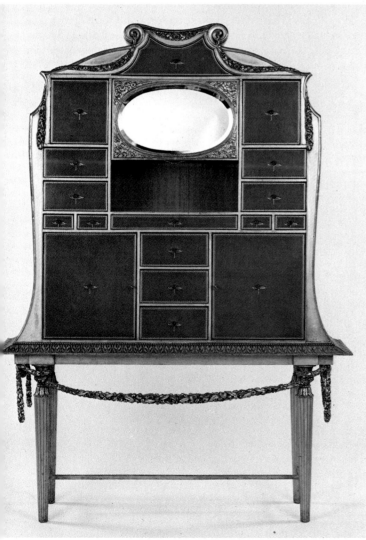

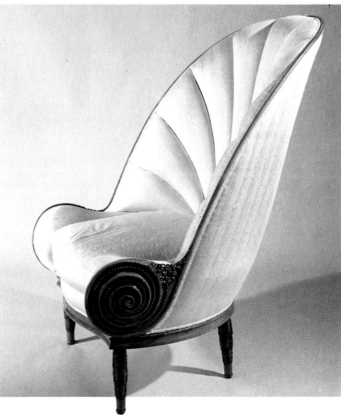

LEFT: a mahogany and gilded wood cabinet (1913) with leather-covered doors and drawers that bears the stamp of Paul Iribe. The tapering legs and stylized festoons recall 18th-century tradition. ABOVE: armchair, designed by Iribe (c. 1913), in rosewood, carved on the sides with a spiral motif that can be seen in the detail. Antiques trade.

BELOW LEFT: a small drawer unit (c. 1912) designed by Paul Iribe for Jacques Doucet. It is in light-coloured mahogany covered in shagreen with ebony trim and a black marble surface. The festoons and stylized basket of flowers anticipate the decorative tastes of the Twenties. Musée des Arts Décoratifs, Paris. CENTRE: *bureau plat* in green-dyed shagreen and chair with a pink satin cushion (1925) by André Groult.

FACING PAGE: two-piece display cabinet (1925) by Groult in green shagreen. The *galuchat* forms a decorative motif on the doors of the lower cabinet, while the upper section features a glass-fronted display cabinet and drawers. Galerie J.-J. Dutko, Paris.

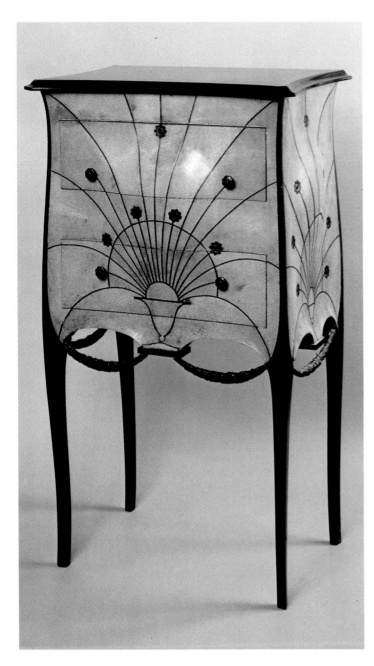

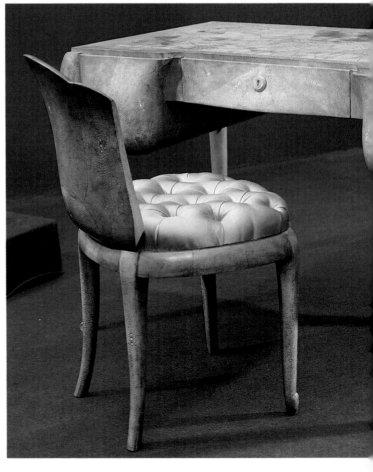

bued profiles, colours and materials with unexpected powers of evocation that border on the surreal. Nevertheless, there was in Groult's production an ever-present consciousness of the 18th-century tradition, which can be observed in even his most audacious pieces, where the soft lines and pot-bellied design are a stylized celebration of the Louis V idiom.

The furniture of Paul Iribe (1883–1935) was equally graceful, contributing to the formation of Art Deco taste in the years preceding the First World War. Iribe had been a painter and satirical artist before concentrating on in-

teriors, and had begun his career designing fabrics and wallpaper for André Groult (who, being the brother-in-law of Poiret, was active at the Atelier Martine). Then in 1912–13, a commission to furnish the apartment belonging to the couturier Jacques Doucet led Iribe into the field of interior design.

Iribe's designs for Doucet are a remarkable anticipation of the tastes of the Twenties. This is clear from his mahogany cabinet with its oval mirror and drawers highlighted in gilded wood and leather, or his small drawer unit, balancing delicately on slim, tapering legs. The 18th-century-in-

other interiors such as his smoking rooms, Groult designed furniture that would "suggest manly camaraderie", and for his dining rooms he sought forms that would encourage "conviviality and stimulate the appetite". As we have seen, the "most genteel

and comfortable pieces" were reserved for ladies' bedrooms, incorporating curves that were, as Groult himself claimed, "at the limit of decency". This attitude, although ironically detached, overloaded the interior with psychological significance, and im-

spired design evinces a slightly ironic stylization, and the "voluptuous" use of expensive materials heralds a distinctive feature of the following period. Festoons are suspended in mid air, and a barely hinted-at basket of flowers extending over the whole of the front surface is combined with mahogany and sharkskin drawers that are delicately veined with the ebony ornamental motif. The Doucet apartment also gave Iribe the opportunity to demonstrate his scenographic skills and sensitivity by creating a prestigious ambience with widespread appeal. It was no coincidence that he left France in 1914 to go to the

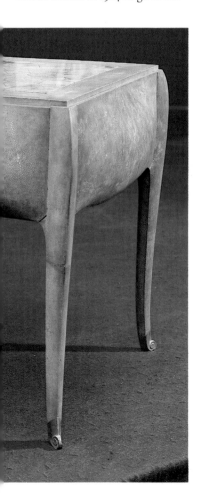

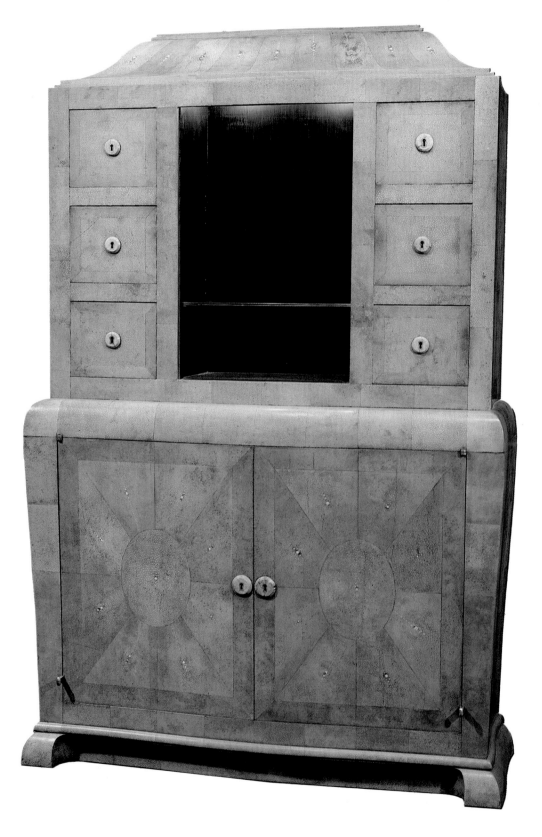

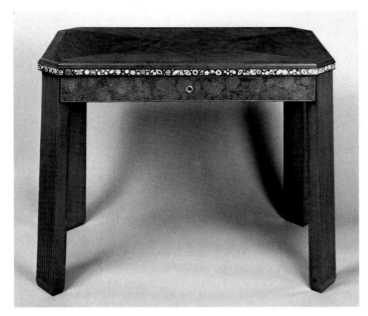

United States, where he found fame and fortune as a designer of theatre and cinema sets for Broadway shows and Hollywood spectaculars.

The other traditionalists

Other major traditionalist decorators were active in France at this time. One such was Clément Mère, born in 1870, who had begun his career in the Art Nouveau climate of Julius Meier Graefe's Maison Moderne. Mère was a creator of exquisite small objects such as boxes, paper-knives and bottles in leather, ivory and wood.

He had a special talent for detailed, intricate work in exotic woods and engraved, dyed or carved finishes of various kinds, ranging from ivory to lacquer and leather. Evidence of this can be found in his 1923 range of furni-

ture, where the plain design of straight lines and bold corners is offset by the richly decorated flower-motif leather finish. Mère's predilection for highly detailed calligraphic ornamentation reveals one of Art Deco's main characteristics: the stylization of nature.

In contrast to Art Nouveau's substantially naturalistic decoration, which made explicit reference to the natural structures of plants, flowers and animals, there was a shift in the opposite direction during the Twenties as nature took on an artificially dilated or pulverized appearance, as was the case with Mère's flowers.

The festoons, garlands, baskets and bunches of flowers that adorn Art Deco objects are destructured to make a world of cut flowers, leaves detached from plants or natural elements projected on to a plane and squeezed together into frames or bundled

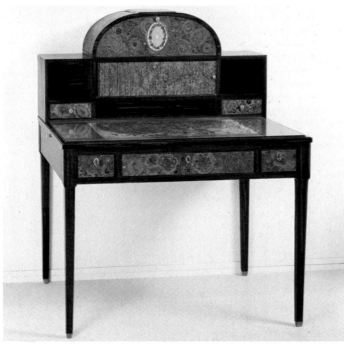

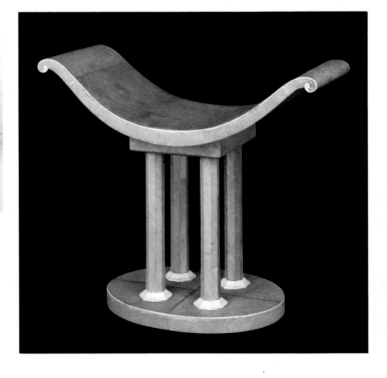

ABOVE: two macassar ebony pieces (c. 1923) by Clément Mère, whose decoration in ivory and dyed and embossed leather show the designer's taste for calligraphic detail. The upper illustrations show the table and a detail of the drawer and the front edge of the top. The lower illustration shows a writing table. Musée des Arts Décoratifs, Paris.

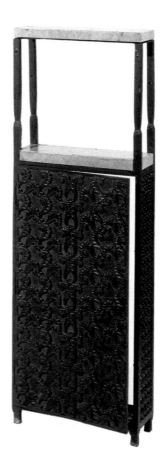

CENTRE AND RIGHT: dressing table and small side table with raised upper section, dating from 1925. The patinated bronze and marble top are typical of Rateau, who interpreted tradition both in the precious materials he used and in his classically-inspired approach, which was however stylized according to Art Deco tastes. Félix Marcilhac Collection, Paris.

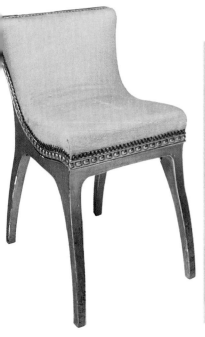

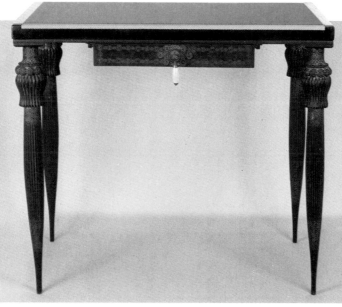

into skilfully composed heaps, in accordance with the rules of symmetry.

The eminently classical furniture of Jules Leleu (1883–1961) can be traced back to traditional models. Leleu was one of the most sophisticated *ébénistes* of the Art Deco period, preferring to decorate his beautifully poised pieces with sober floral decorations, often in ivory, using bronze for details and sharkskin for his finishes. Leleu's aristocratic taste was also evident in the interiors he designed for ships, which made a major contribution to his reputation.

Armand-Albert Rateau (1882–1938), another French furniture-maker who boasted couturiers and other prestigious customers among his clientele, had as his preferred materials patinated bronze, and occasionally lacquer, together with oak but more often richly veined marble. His best-known work includes the furniture he made in Paris between 1920 and 1922 for the fashion designer Jeanine Lavin, whose private residence and atelier Rateau designed. The low chairs, dressing tables and a wide range of bronze and marble furniture reveal a clear Graeco-Roman influence in which the traditional decorative repertoire of lion's paws, griffins, sphinxes and other animals was re-interpreted in the stylized idiom imposed by the new artistic climate.

Accentuated profiles, carefully framed decorations and the enhancement of line through the use of different materials were all characteristic of the relatively rare pieces of furniture made by the French industrial designer Clément Rousseau (1872–1950). Most of his work was done for

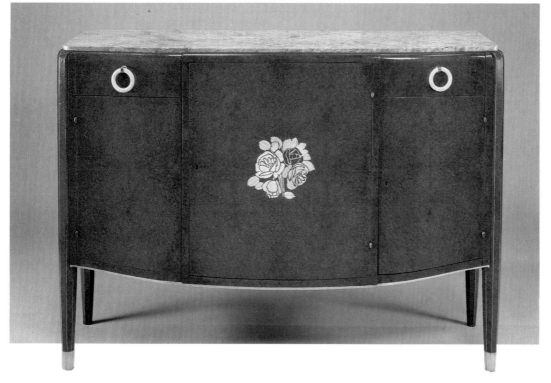

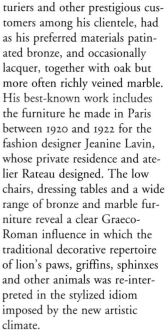

ART DECO FURNITURE · 743

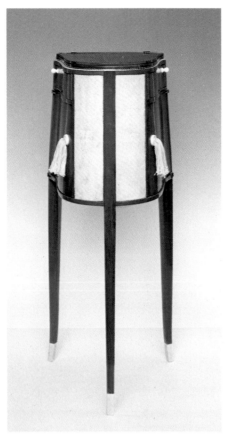

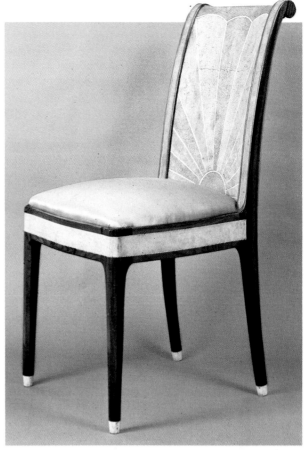

RIGHT: jewellery stand (c. 1922) by Théodore Chanut in amaranth with shagreen inserts on the front. Antiques trade. FAR RIGHT: ebony curved-back chair (1921) by Clément Rousseau. The strip underneath the seat is covered in shagreen. The thin ivory lines crossing the leather trace out a sunburst pattern. Musée des Arts Decoratifs, Paris. BELOW: the study of the Le Confortable store in a watercolour by Libis, presented by Léon Bouchet at the 1925 Paris exhibition. Bibliothèque des Arts Dècoratifs, Paris. FACING PAGE: a *chaise longue* (c. 1925) by Pierre Legrain in black lacquered beechwood with gold stripes and mother-of-pearl encrustations. Musée des Arts Decoratifs, Paris.

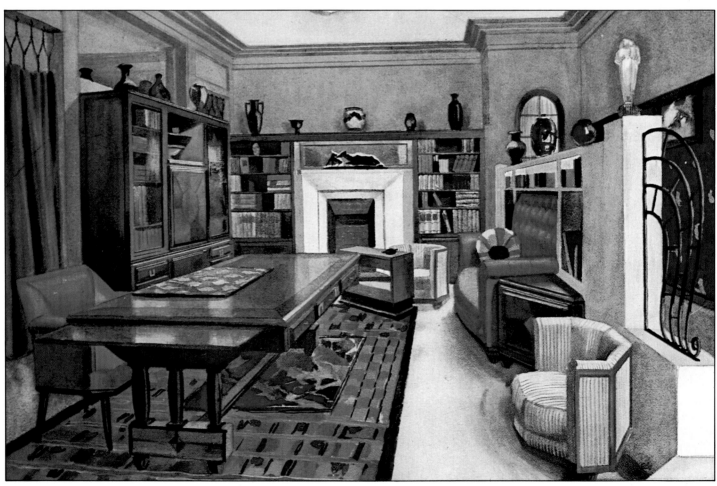

exclusive private customers such as the Rothschild family, and one item of particular interest, both in terms of design and of materials, was an ebony chair entirely covered in sharkskin dyed green, pink and white with a sunburst motif on the chair back and a blue silk upholstered seat. The rich materials, superb workmanship, carefully contrived colours and contrast between the smooth surface of the ebony and the attractive roughness of the sharkskin combine to make this one of the most significant examples of Art Deco taste. It testifies to the search for new tactile and visual sensations within a framework that rests firmly on the models of tradition, in this case that of the Directoire style, from which both the chair's form and its decorative elegance derive.

Léon Bouchet, who was born in 1880, also took traditional elegance as his starting point. Bouchet moved into furniture after beginning his career with a solid training as an *ébéniste*. Until 1925, his furniture was distinctly reminiscent of Louis Seize but he shifted direction decisively for the Paris exhibition, at which his contributions included a study for the Le Confortable store, featuring broken profiles, understated designs and a welcoming yet serious atmosphere suggested by the warm red shades of the upholstery.

Bouchet was also an interior designer who was capable of learning quickly. By the early Thirties, the design quality of his production had improved considerably, in many cases espousing the modern style.

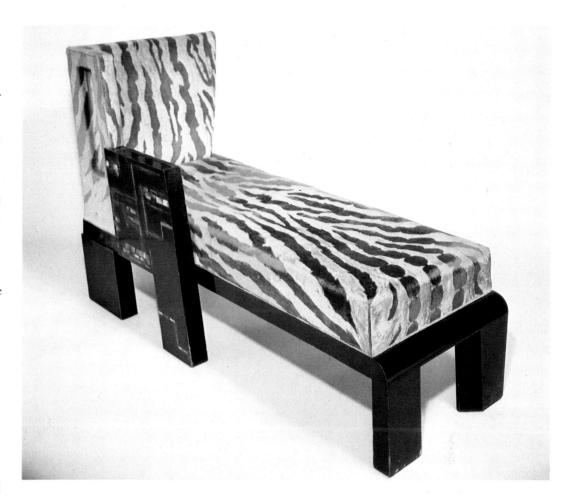

New shapes – Pierre Legrain

Pierre Legrain's (1889–1929) inspiration ran counter to that of the traditionalists, with an output markedly influenced by contemporary avant-garde artistic movements.

Legrain's development as a furniture designer was significantly shaped by Jacques Doucet, a passionate collector and patron of the modern style. Initially a keen collector of 18th-century art, Doucet had moved on to contemporary works, concentrating his attention on Matisse, Picasso and Brâncuşi and collecting ex-

amples of African and primitive art. He also re-discovered the great talents of the painter Henri Rousseau (1844–1910), with his intriguing fantastic figurations and bright colours.

It was to create a suitable home for these works that Doucet commissioned Legrain in 1925 to design the interior of a new villa at Neuilly, which soon came to be thought of by the observers of the time as emblematic of modern taste.

Legrain had a group of prestigious collaborators, including Marcel Coard, André Groult, Eileen Gray and Rose Adler, and was able to give vent to his muse

in the design of furniture that was often aggressive and unconventional in form.

Encouraged by his client, Legrain re-interpreted the strong, irregular features of primitive art and the seductive power of its crude sculptural quality, combining an apparent lack of sophistication with supreme elegance of design and execution. A series of sharkskin-covered chairs, inspired by the ritual stalls of the Ashanti and with wooden parts that were lacquered or veneered with ebony and inlaid in mother-of-pearl, "tamed" the "savage" element and adapted the object to an elegant, sophisticated context. Play-

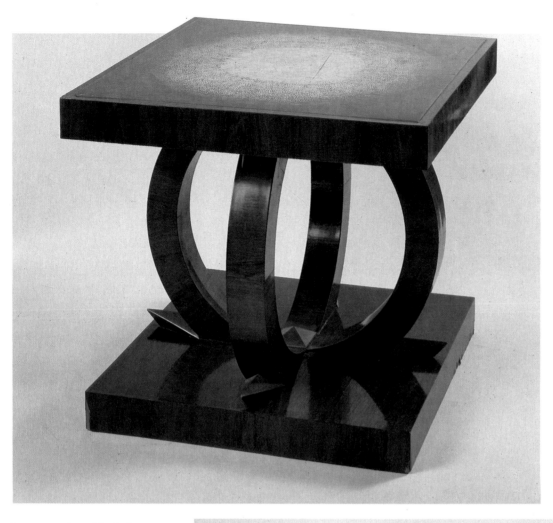

THESE PAGES: characteristic pieces by
Pierre Legrain which exemplify the de-
signer's highly personal style, in perfect
harmony with the contemporary artistic
avant-garde, and with Cubism in par-
ticular. LEFT: a *guéridon* stand (c. 1923)
with a segmented, arched support on a
square base and a painted top. BELOW:
two-door cabinet (c. 1929) featuring a
central "pillar" decorated with a motif
inspired by black African art. Musée des
Arts Décoratifs, Paris. FACING PAGE:
three pieces from a set of dining room
furniture (c. 1927) in natural and brown
lacquered sycamore with chrome-plate
and mirror inserts. Note the strong, inci-
sive, "modern-style" design: above is the
large sideboard, in the centre the dining
table, and below one of the six dining
chairs. Antiques trade.

ing two such antithetical compo-
nents against each other was a
difficult balancing act but one
that Legrain brought off with
skill and panache.

Some of Legrain's pieces,
such as his rectangular *chaise
longue* in black lacquered beech-
wood with irregular mosaic
mother-of-pearl encrustations
and a seat covered in zebra-stripe
velvet, or his other equally re-
markable dining room pieces in
sycamore, lacquered wood, mir-
rors and chrome plate, achieved
new heights of expression, under-
lining the effect with their bold
combinations of contrasting
materials.

Legrain's furniture for the
dining room, in which the dining
chairs stand out for their deliber-
ately "graceless" form, betrays
signs of the iconography of Art
Deco's most extreme avant-garde,
such as the geometrical sections
and the interlinking solids, par-
ticularly evident in the table and

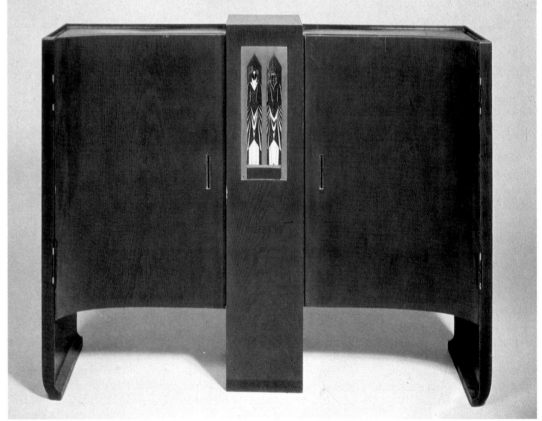

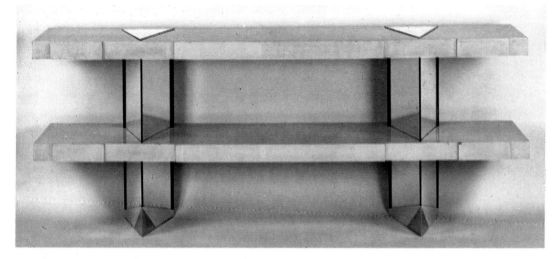

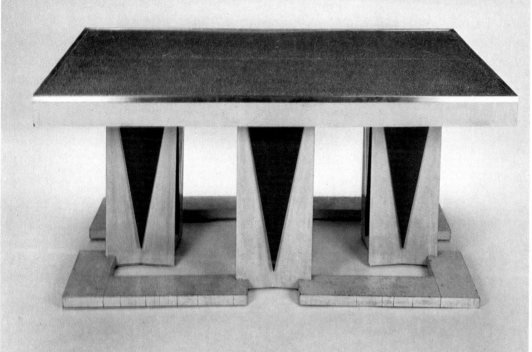

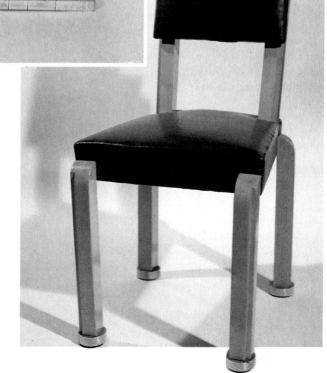

need to produce well-made furniture at a price the general public could afford. Consequently, it was necessary to forgo the precious materials and costly craft skills that had made Art Deco substantially the preserve of a moneyed élite.

Chareau's studies and production in kitchen furnishings, bathrooms and children's rooms were ground-breaking. These were functional, "non-reception" areas of the domestic environment that were best suited to the application of his theories. Here, Chareau had no hesitation in employing traditional materials provided they were the best available for the job.

His straight or curved profile wicker chairs are examples, for

sideboard. These are characterized by broken triangular-section elements creating interrupted structures in an irregular profile that draws on the Cubist doctrine of deconstruction and observation by squaring the outlines of the object under scrutiny.

Pierre Chareau's wicker furniture

Some of the same tendencies, together with a deeper sense of construction, could be observed in the furniture of Pierre Chareau

(1883–1950), an architect and decorator whose work is in a certain sense equidistant from Art Deco and the Rationalist trends of the late Twenties. Chareau was brought up in a shipbuilding family and acquired both sound professional experience and a special concern for the functional aspect of his design.

He approached his projects as exercises in structural engineering in which each component had to have a rational justification. In this perspective, the cost of the object became a limiting factor, leading Chareau to theorize the

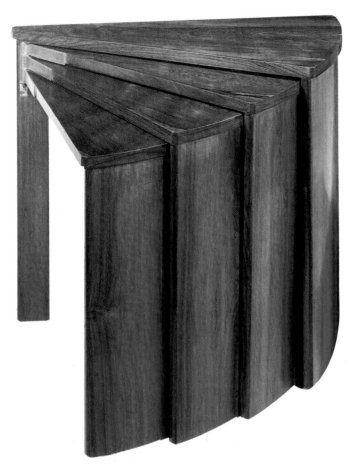

Some furniture by Pierre Chareau: LEFT AND BELOW: The *table gigogne* and the desk of macassar ebony with sloping planes were built to exact functional specifications. Both come from a set of furniture designed for a hypothetical French Embassy, shown at the 1925 Paris exhibition. Collection Felix Marcilhac and the Musée des Arts Décoratifs. FACING PAGE, ABOVE: round table with a spiral wicker base. BELOW: wicker chair, part of a omplete set of wicker furniture for a living room, 1928. Antiques trade.

riot. Wooden pieces are generally in palmwood, a material that is both hard and soft at the same time, and very challenging to work." Palmwood shelves ran along all the walls, despite the difficulty of making them for a circular room. They could be hidden with panels of the same material but could also be left on view to provide a framework for Chareau's extremely sophisticated ambience and its fascinating furniture.

The surviving examples include a macassar ebony desk whose angled surfaces and interlocking volumes are strongly reminiscent of the Cubist aesthetic (it has some features in common with the desk by the Czech designer, Antonín Procháska) besides offering an original figurative approach that corresponded to a precise functional purpose: that of preventing piles of papers and other objects from accumulating on the worktop.

The design was intended to create an orderly, systematic working environment, for it included drawers and containers for every requirement, but in fact it also enhanced the desk's value as an object of sculpture. The reflections of the lustrous dark wood served to intensify the contrasts

they are constructed to exploit the material's flexibility and axes of greatest strength. Wicker was proposed as a model for lightweight, informal pieces that could be subjected to heavy use or even replaced, as was appropriate in the case of furniture for a child's room.

Chareau's theories were partially contradicted by his displays at the 1925 Paris exhibition, for which he furnished a circular study-library for a hypothetical French Embassy. At the time, he affirmed: "I was given the job of designing a room, a sort of private study-cum-library, in a French Embassy.

"Contrary to what might have been expected from me, I used extremely precious woods that are almost impossible to find, and gave full rein to a sort of creative rapture that led to the creation of a real folly. But when you think that even plain deal would have been beyond the pockets of poorer customers [...] then for once you can let your imagination run

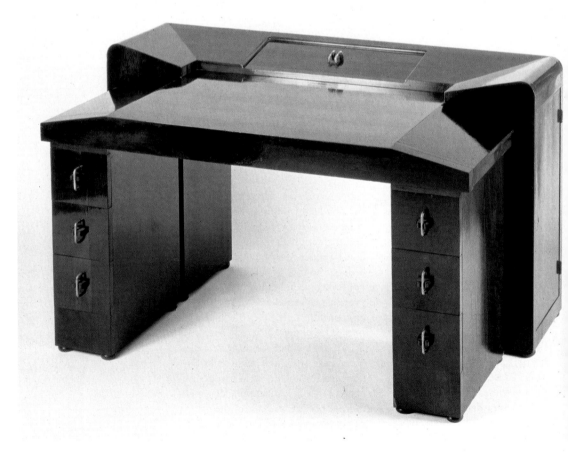

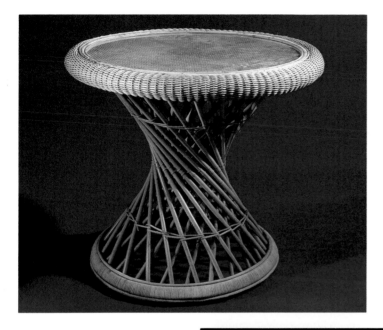

clients such as Madame Mathieu Lévy, whose Paris residence features an astonishing lacquered canoe day bed.

In this period, Gray became increasingly committed to the reduction of ornamentation, achieving a formal simplicity that can be seen in her minor pieces, such as the 1920 dressing table in which the wood is treated as if it were a single flexible slab from which trays and triangular swivel drawers emerge in unexpected places. The simplifying tendency was to become steadily more marked, drawing inspiration from the aesthetic of De Stijl, and later being underpinned by an interest in Rationalist-influenced furniture design. Gray was actually one of the few exponents of Art Deco who managed to pass without a hitch from designing luxury furniture made with costly materials to producing modern pieces. Indeed, her creativity was greatly stimulated by the aesthetic of manufacturing industry and the machine, which allowed her to combine perforated metal with celluloid or tubular steel while leaving the intensity of expression and artistic content of her work undiminished.

and interconnections of its surfaces and volumes.

Eileen Gray

One of the most noteworthy of the artists working for Jean Doucet, whom we have already mentioned in connection with Pierre Legrain, was Eileen Gray (1879–1976), an Irish architect who moved to Paris in 1902 where she stayed until her death. Gray was an extraordinarily interesting figure with a superb technical background, and her highly individual work never risked becoming banal.

Her Paris career began in lacquering, a skill whose secrets she learned so well that she was able to apply them to a series of daringly innovative works that combined technical skill with exceptional artistic sensitivity.

From 1914 until the mid-Twenties, Gray was active mainly in the field of luxury interior design, working for prestigious

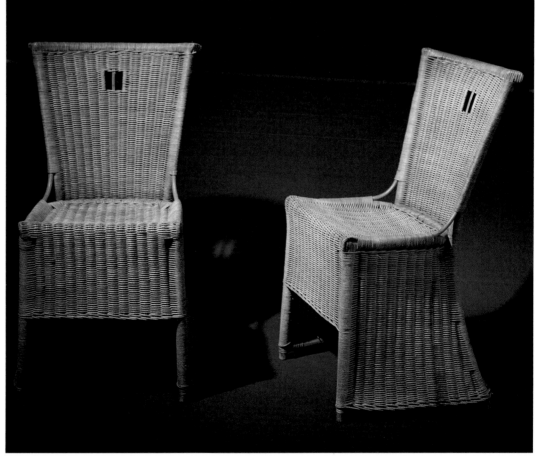

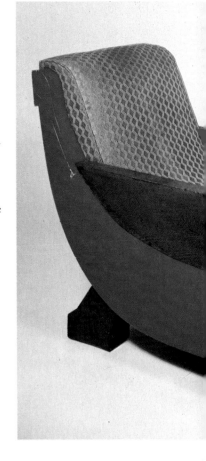

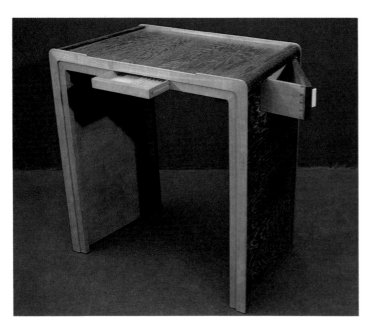

Marcel Coard and Dominique furniture

Marcel Coard's (1889–1975) output traces a line that oscillates between traditionalism and the new trends. Organized on an efficient commercial basis, it had a celebrated showcase in Coard's retail store on the Boulevard Haussmann in Paris. The store offered a wide range, from period furniture to interiors in the classical idiom and simpler yet nonetheless interesting items that revealed the influence of the avant-garde, suiting the tastes of a variety of customers.

Another typical feature of the Art Deco era, and indeed of the preceding Art Nouveau period, was the organization of artists into more or less market-oriented enterprises. One of the most important of these, in terms of both critical and commercial success, was the Dominique decoration workshop founded in 1922 by the self-taught artist André Domin

(1883–?) and the architect Marcel Genévrière (1885–?).

Dominique furniture incorporated every technique and every formal trend of the period. It was designed as luxury, but not necessarily exclusive, furniture for wealthy individuals, shop interiors, large hotels and even ocean liners and cruise ships. The focus was on innovation in the sense of the continuous renewal of forms and materials.

Dominique craftsmen were able to handle with equal skill the most expensive and the most humdrum woods, silks as well as synthetics, and lacquer or plate glass – often black – for the finishing details. In general terms, ornamentation was played down and the geometry of the piece more rigorously underlined.

Furniture for the average consumer

The above designers made individual pieces of furniture for a very exclusive, easily identified clientele, but in the same period Art Deco also offered ranges that were more accessible to the middle market.

DIM ("Decoration Intérieure Moderne") was founded immediately after the First World War by René Joubert and the theatre designer Mouveau, who was replaced in 1921 by Philippe Petit.

BELOW: Eileen Gray's *Transat* armchair (1927), comprising a natural varnished oak structure with horizontally quilted, jute-and-cotton fabric, headrest and seat. Made by Pallucco.

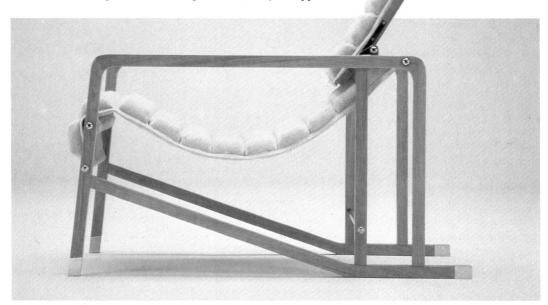

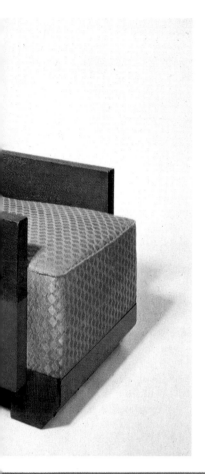

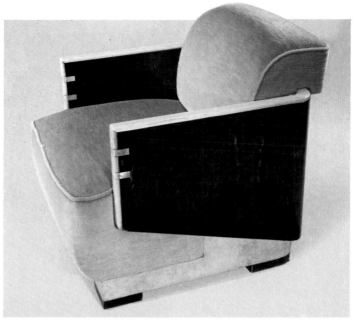

Its aim was to produce expensive furniture with exotic veneers, carvings and inlays, plus shop-ready mid-range items and accessories, including carpets, ceramics, light fittings and wallpaper.

DIM offered complete or near-complete interiors, in an attempt to educate the taste of a heterogeneous, fickle public towards the simpler canons of the new trends.

But no matter how large and influential the shops that sold Art Deco merchandise were, it was the department stores that were crucial for increasing the movement's popularity through their furnishing sections, which were managed by well-known artists.

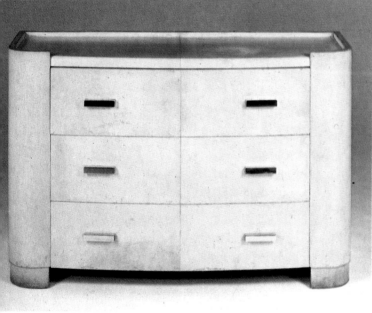

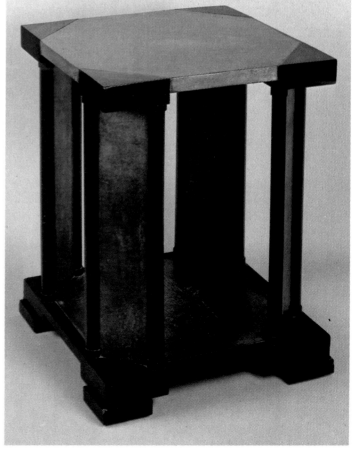

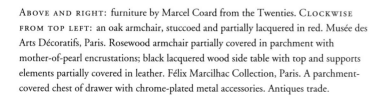

ABOVE AND RIGHT: furniture by Marcel Coard from the Twenties. CLOCKWISE FROM TOP LEFT: an oak armchair, stuccoed and partially lacquered in red. Musée des Arts Décoratifs, Paris. Rosewood armchair partially covered in parchment with mother-of-pearl encrustations; black lacquered wood side table with top and supports elements partially covered in leather. Félix Marcilhac Collection, Paris. A parchment-covered chest of drawer with chrome-plated metal accessories. Antiques trade.

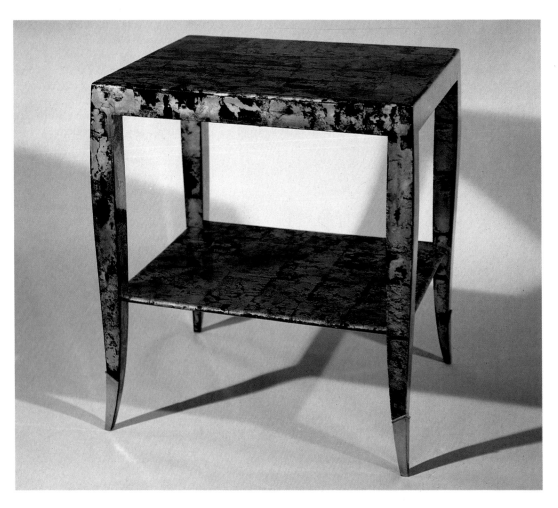

BELOW: a *guéridon* table attributed to Dominique. It is lacquered in black and gold, with two rectangular surfaces and square legs, slightly convex at the top and tapering towards the feet, which are sheathed in gilded bronze *sabots*. Antiques trade. FACING PAGE, ABOVE: chair (1913) by Paul Follot. The oval back frames a carved decorative motif of a basket of fruit. The front legs are topped by fluted capitals. BELOW: a colour drawing of a Follot interior for Pomone, the furnishings section of the Bon Marché department stores. Musée des Arts Décoratifs, Paris.

to the use of metal, which he began to utilize with great skill in the late Twenties, along with other materials such as leather or rubberized fabric. He was not just interested in the formal possibilities of metal, either as tubes or flat strips, as he also harboured a special passion for new materials. This was evident in his contribution to the 1932 Salon des Artistes Modernes, where he presented a series of dining room chairs in moulded and lacquered non-flammable plastic.

Apart from these fundamentally experimental episodes, it is beyond dispute that the department stores played a major in popularizing Art Deco tastes. It was there, in stores that were visited by hundreds of people day after day, that well-made furniture could be offered at a competitive price.

No money was wasted on extravagant detail, and the designs, while embodying the new decorative language, were easy to introduce into an ordinary metropolitan apartment, the average size of which was growing smaller as cities expanded.

Among these was the previously mentioned Maurice Dufrêne, who from 1921 ran the La Maîtrise workshop at the Galeries Lafayette; Paul Follot, manager of Pomone at the Bon Marché stores, where he designed furniture and fabrics; and Etienne Kohlmann, Max Vibert and Djo-Bourgeois for Studium Louvre at the Louvres stores. Djo-Bourgeois's (1898–1937) creations and designs were explicitly modern, incorporating new materials and developing a refined aesthetic that was described in 1929 as "simplicity taken to the *n*th degree or perhaps even beyond, you

might say, if you remember the concrete bed set into the wall! [There is] a harmony of spaces and forms, and an agreeable, almost monk-like, austerity revitalized by colour and the patterns of the carpets and fabrics that re-awaken the emotions" (T. and L. Bonney, *Acheter du mobilier ancien et moderne à Paris*, Paris, 1929).

The demands of modern life seemed to impose a purification of design and ornament, a more geometrical form and greater balance. These elements were also highlighted by Louis Sognot (1892–1970), who was active with

René Guillère in the furniture department of the Printemps department stores. His work is noteworthy for its clarity and lack of affectation – characteristics that were certainly reinforced by his collaboration with a major sales organization, but which also reflected his own personal preferences.

A good example is his design for a bedroom commissioned by Madame Callet, in which unadorned straight lines are combined with bright, fresh colours ranging from white to blue and are set off by warm wooden profiles. Sognot's name is also linked

Francis Jourdain

The needs of a public for whom ebony, sharkskin, ivory and shagreen were mere exotic details, evoking impossibly expensive interiors, were particularly close to the heart of Francis Jourdain (1876–1958), one of the few Art Deco artists to reject luxury in toto. Francis was the son of Frantz Jourdain, who it will be remembered played a leading role in organizing the Salon d'Automne, and won recognition for his own personal interpretation

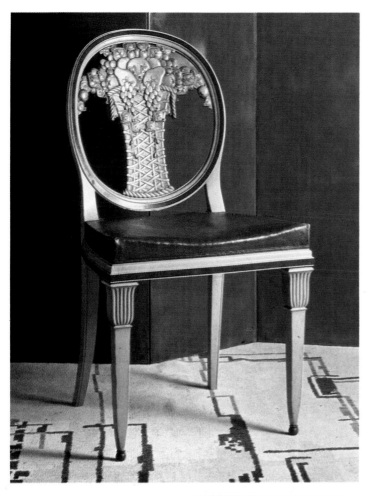

"Today we buy a table or a chest of drawers," he wrote in 1922 in *Art et Decoration*, "less for the utility it can offer than for the pleasing effect it produces when we are decorating an interior. This is a regrettable mistake. A room can be decorated much more elegantly and attractively by emptying it rather than by furnishing it."

England – the furniture of reason

As well as the production of the Omega Workshop, which was the most immediate link with the artistic avant-garde active in the years following the Great War, the teachings of William Morris and the Arts and Crafts movement continued to thrive in England after their revitalization of the applied arts in the second half of the 19th century.

The movement had recovered the quality and professional ethics of the craft tradition, and promoted local artistic idioms and techniques by adapting them to satisfy the demands of the contemporary market. The quality of the everyday environment, as one of art's civil obligations, could be achieved by the intervention of the creative artist, who had the task of contributing with his or her work to a greater plan of improving society. This principle imposed an approach to design in

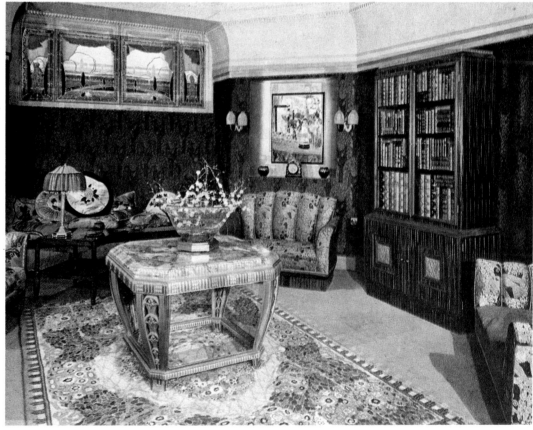

of Functionalism. Without being polemically Rationalist, the philosophy nevertheless imbued his work with a distinctive quality that set it apart from the furniture of his contemporaries.

Jourdain's work displayed an artistic language of extreme simplicity, moderated by decorative touches that would be integrated into a piece without dominating its design. Jourdain designed standardized items, many of which were modular, in non-precious wood, straw or wicker, with distinctly Viennese-inspired geometrical decorations, adapting them for mass production at his own factory, which was called Ateliers Modernes.

Even though Jourdain's furniture could in no way be described as Rationalist, his methods and aims were anticipatory of the future developments of the modern style and the new aesthetic canons.

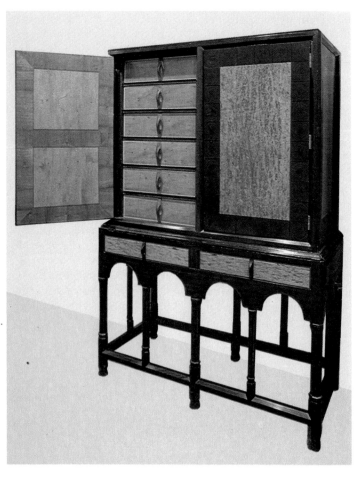

Gordon Russel

The designer who perhaps most perfectly embodied "reasonableness" combined with the high quality of much of English production at the time was Gordon Russel. Born in 1892, Russel inherited a small workshop for repairing the antique furniture that was to furnish a country pub that his father had acquired in 1904.

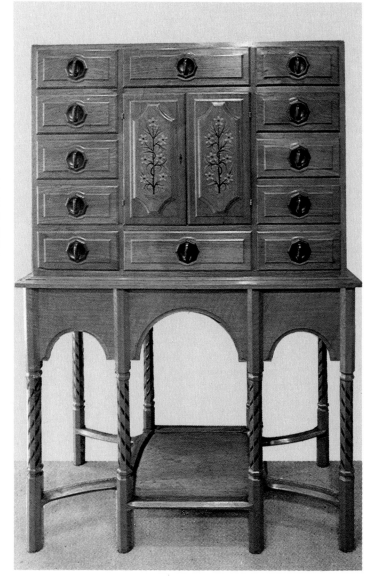

whose qualities could be enhanced without recourse to unnecessary artifices, so it would be decorated with light graffiti or carved motifs which, according to J.C. Rogers, author of *Modern English Furniture* (London, 1930) should not hide the wood's intrinsic qualities but emphasize them so they took on an explicit "oaky nature".

which expression became concrete and found practical, functional applications, rejecting " designer-label" manifestations of extravagant individualism.

The work of the architects Charles Francis Annesley Voysey (1857–1941) and Robert Ashbee (1863–1942) in the late 19th century provided the most significant model for an approach to interior design that, having shed its Art Nouveau overtones, continued along the path of progressive adaptation to contemporary trends without compromising its very high standards of quality.

Respect for the materials used, rigorous design and the elimination of every decorative whimsy were the distinguishing characteristics of such pieces, whose "reasoned" approach could also be applied to work intended for a wider public.

The furniture made by Ambrose Heal's company was in this spirit. Heal who had been active since 1904, produced convincing interpretations of Arts and Crafts principles on a semi-industrial scale for a middle-class clientele. His catalogues, published regularly from 1921 onwards, contain examples of complete interiors or individual items defined as "reasonable furniture". Wood, invariably of local origin, was the protagonist. Often that wood was oak, a solid, long-lasting material

Russel was familiar from childhood with the simple cottage furniture of rural tradition. His first-hand knowledge of locally available woods such as oak, walnut and chestnut, played a major part in developing his outstanding feeling for materials, manual craft techniques and the timeless forms that sprang from the need for authentic functionality and decoration in the domestic environment. In the following decade, Russel's workshop expanded to employ about thirty workers engaged in the manufacture of new furniture for special commissions.

An example of Russel's work was presented at the 1925 Paris exhibition, where it won a gold medal for a simplicity and decorative honesty that must have contrasted vividly with the exclusive luxury of many of the other interiors at the show. Russel exhibited a cabinet, the mainstay of his workshop's production throughout the Twenties, in which the reference to Georgian tradition in the overall design is tempered by a distinct lack of affectation and extravagance, brought out in the plain walnut finish and the soberly modest decoration in ivory, boxwood and ebony.

In the early Thirties, Russel's son R.D. Russel, who had trained as an architect at the Architectural Association in London, navigated the company through a sea change in both style and organization. Modern machinery was introduced, and only individual components for special purposes were handmade by artisans. Gordon Russel Limited focused on furniture for the mass market by simplifying its designs and making them more geometrical.

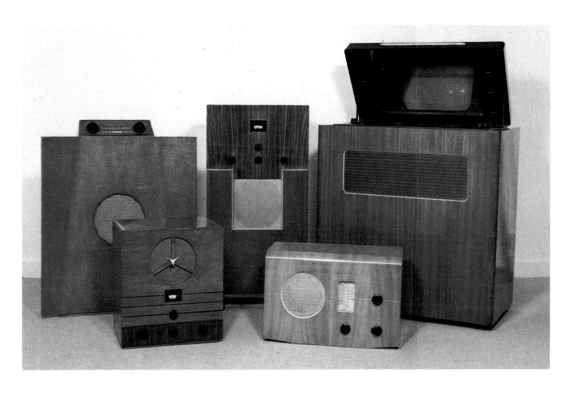

Quite naturally, they began to take on a more modern aspect.

A significant example of this shift is the series of radio cabinets made for the Frank Murphy company. These make no attempt at camouflage, unlike others from the period which often hid the radio inside door-fronted cabinets in a wide range of stylistic idioms. The Russel cabinets state their purpose clearly without forgoing either traditional materials or elegance of design.

Italy – an uncertain start

After the wind of change brought by Art Nouveau, which reached its maximum intensity at the Esposizione Internazionale di Arti Decorative in Turin in 1902, Italian furniture-making in the first decade of the new century presented a stylistic uncertainty and

a fragmentation of taste. This embodied both an extremist but ill-defined modernity which in the best examples drew on the Wiener Werkstätte, and a desire to return to the past as a way of ensuring continuity and artistic quality.

It was the latter attitude that prevailed at two exhibitions held simultaneously in 1911 to celebrate the fiftieth anniversary of Italy's unification. At Turin, the first capital of the new Kingdom of Italy, a mammoth international exhibition of industry and work was organized at great expense to commemorate the successful industrialization of the country and to take stock of the progress that had been made. That progress was celebrated in very traditional imagery.

Exhibits were housed in 17th-century-style pavilions, while the innovative contributions of man-

ufacturing industry (apart from the exhibition of highly efficient, state-of-the-art machinery), paradoxically largely comprised products that clearly drew on the heritage of the past. A rich tradition might well be embarrassingly intrusive, but it was also a guarantee, an easily identifiable benchmark and a source of – unfounded – pride in contemporary Italian virtues.

The critic Enrico Thovez, who had already proved himself to be an insightful observer during the Art Nouveau period, disconsolately pointed out this ultra-conservatism when he wrote: "Furniture-makers continue to supply the *nouveaux riches* with mock Renaissance furniture for their dining rooms, mock Louis Seize for their bedrooms and mock Empire for their reception rooms. Manufacturers of low-cost furniture keep going back to the

Duilio Cambellotti and regional furniture

Duilio Cambellotti was educated at the school of the Museo di Arti Industriali in Rome. Initially, he was attracted by Art Nouveau, illustrating Dante's *La Divina Commedia* for the Florence-based publisher Alinari, contributing to the magazine *Novissima* as a graphic artist and designing posters for the Argentina theatre. He moved closer to the simpler forms of the German Jugendstil in his lamp designs for the Berlin-based Schulze company. Cambellotti was active in all areas of the applied arts with an essentially individualistic, "artisan" vision that was often rather intellectualizing. It took on a more focused, personal tone after 1910 when the designer began to develop a language deriving from his study of the farming communities in the countryside around Rome. This provided him with inspiration for his decorative motifs, such as ears of corn, sheep or detailed country scenes but it also suggested some of the structural elements we find in his furniture such as the plough, which often appears as a support element for tables or chairs. Cambellotti rediscovered the rural, regional world, which he recreated in squat, old-fashioned benches and kitchen cupboards, and roughly cut surfaces in natural wood that were pointedly and deliberately very different from the aesthetic tendencies of the late Art Nouveau style. The most coherent examples of Cambellotti's work were presented at the first International Exhibition of Decorative Arts held at Monza in 1923, where he was elected president of the Rome section and at which he was awarded a certificate of merit. Cambellotti was active in other areas as well, however. His wide range of interests included theatrical design in particular. He supervised stage design for productions of Shakespeare's *Julius Caesar* and *King Lear* and D'Annunzio's *La Nave*. From 1914 to 1948, Cambellotti also designed sets for open-air performances of classical works at Ostia, Taormina and Siracusa.

ABOVE: a rigorously geometrical walnut kitchen cupboard (c. 1925) with ivory and ebony inlays on the front representing sheep huddled together, a motif much loved by Cambellotti. The piece, the first sketches for which date from 1923, was presented at the Second Monza Biennale. Private collection.

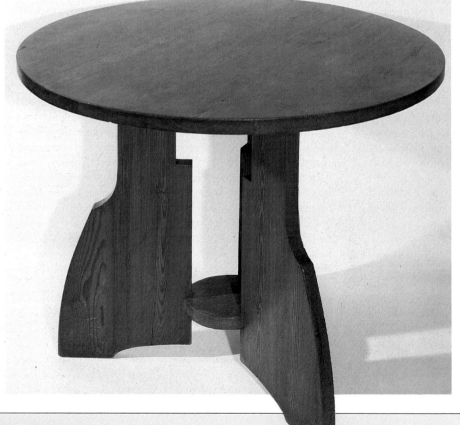

LEFT: pitch-pine table (c. 1912) with a round top on a support made of rudder-shaped elements. FACING PAGE, ABOVE RIGHT: the rudder motif can also be observed in the oak bench (c. 1908). FACING PAGE, BELOW: a small wall-mounted cupboard in pitch pine. The figures on the glass doors are in stove enamel.

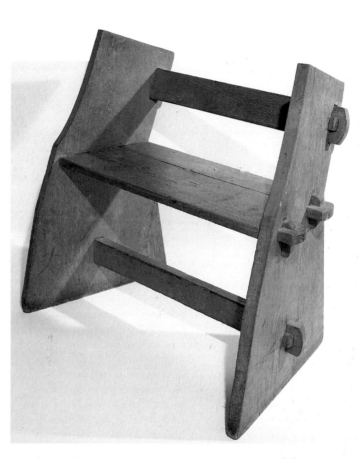

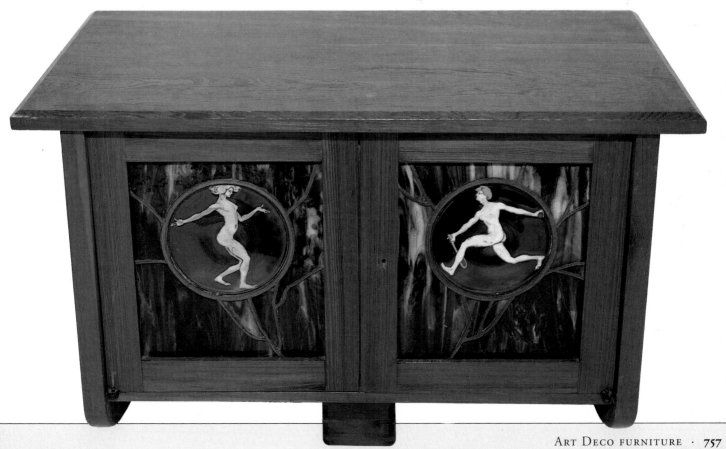

ineffable fantasy style that committed the most unpardonable of its many, never-to-be-forgotten crimes in the latter half of the last century." (E. Thovez, "L'Esposizione internazionale di Torino", in *La Stampa*, 10 July 1911) Some of the responsibility for this involution of style, which drew freely on the great heritage of *ébénisterie* and the latter stages of eclecticism, must go to exponents of Modernism active at the turn of the century, when Art Nouveau encouraged "artists rather than artificers" and "over-sophisticated painters and sculptors who were not obliged to produce commercially viable works". Over-elaborate ornamentation and freedom of imagination, excessive individualism and a self-indulgent tendency to produce works of art rather than utilitarian objects had alienated most of the public. Disoriented by eccentricities, inca-

pable of appreciating creativity and unable to afford the increasingly high cost of furniture, consumers began to demand reassurance and longevity rather than novelty at all cost. Quality could be sacrificed if pieces were more affordable and represented a guaranteed, uniform, rock-solid taste backed up by the example of tradition.

There were, however, a few exceptions among the followers of Art Nouveau at the time. These designers perceived in the new style an element that could free ornament, in the sense of liberating it from the burden of the past. This would help it to develop greater rigour of composition and construction along the lines of the English Arts and Crafts movement or Austria's Wiener Werkstätte.

They included Giambattista Gianotti (1873–1928), Luigi Maria

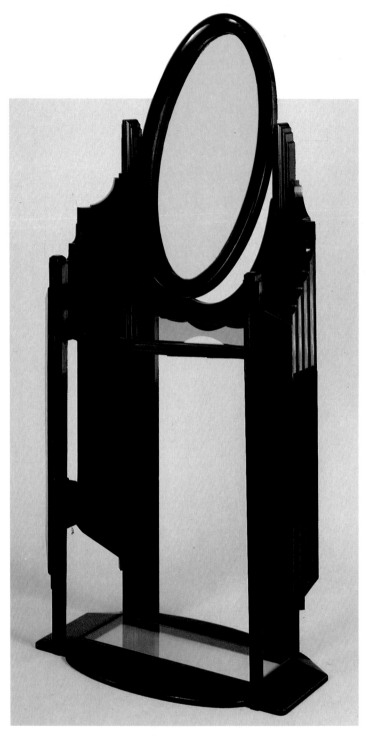

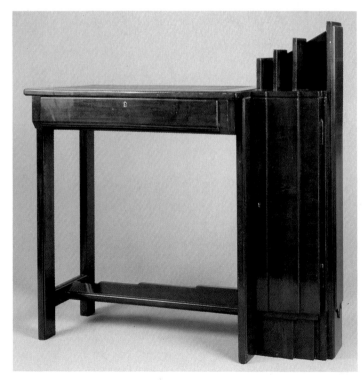

Two pieces by Giacomo Cometti. ABOVE: dressing table (c. 1920). LEFT: writing table in aniline green-dyed wood made to a design by Felice Casorati. FACING PAGE: mahogany sideboard (1910–15) in three convex-front sections, with wood and metal geometrical-motif inlaid decoration, by Giulio Ulisse Arata. The two upper side cupboards have coloured glass doors. Antiques trade.

Brunelli (1878–1966), Giacomo Cometti (1863–1938) and the Quarti company, which was run by Mario Quarti, son of the better-known Eugenio (1867–1929), all of whom continued to make high-quality furniture in the modern idiom, seeking new modes of expression (see, for example, the sideboard by the architect, Giulio Ulisse Arata, 1883–1962), preferring geometrical to naturalistic motifs and producing designs in compact forms that frequently involved interlocking volumes.

The re-discovery of country-style furniture

In Rome too, the fiftieth anniversary of Italy's unification was solemnly commemorated in 1911 with an exhibition of fine arts. Regional exhibitions in special pavilions were also put on to glorify the image of national unity through the promotion of local artistic traditions.

It was in this context that regional furniture was re-discovered, and there was a general re-appraisal of the most authentic vernacular pieces, especially in those regions that had been least affected by industrialization. In addition to its commemorative function, the 1911 exhibition also marked the growing interest in the undeniably significant local artistic heritages. In some cases, these traditions would give rise to work of indisputably good quality.

Such was the case with designs by Duilio Cambellotti (1876–1960). In partnership with the Futurist Giacomo Balla, whose interest in rural craft skills we have already mentioned, he exhibited in

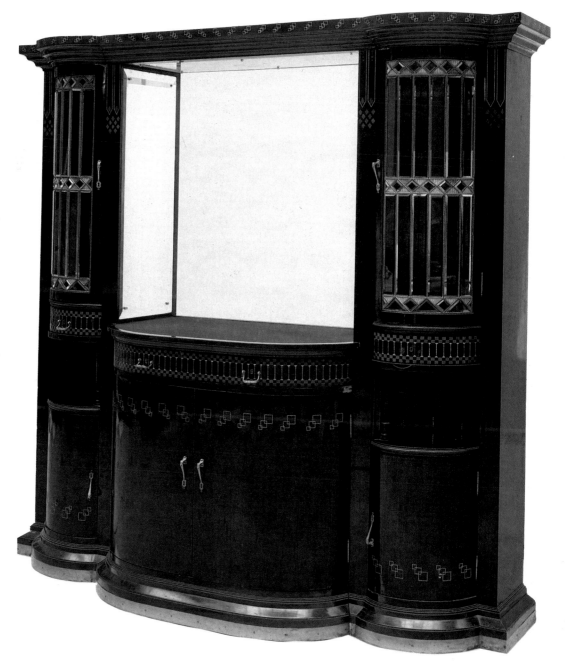

the Agro Romano pavilion a range of unpretentious furniture for schools as well as teaching materials, utensils and tools.

Cambellotti was a sculptor, painter and stage designer, active

in all areas of the applied arts. He had moved on from an initial interest in the Munich-based Jugendstil to the world of the Roman countryside, taking his cue from simple everyday furniture

such as kitchen cupboards, benches and chairs of an unaffected functionality whose beauty derived from the manual craftsmanship that had gone into their making. The square, old-fash-

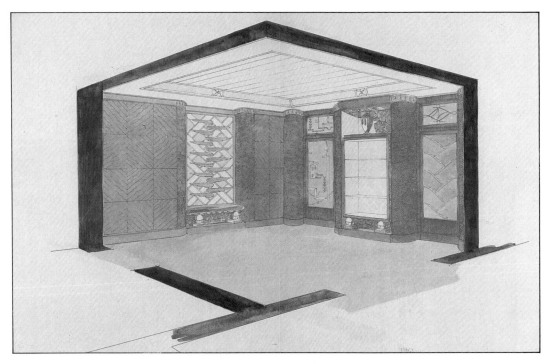

Two designs by Mario Quarti, who was active in his father Eugenio's company after 1920. LEFT: a sketch (1930) for the Nicky shop opened by the Chini company in Milan. BELOW: watercolour (1939–1940) for a living room in the Royal Palace of Tirana. Civica Raccolta di Stampe Bertarelli, Milan. FACING PAGE: wooden screen painted in tempera and gold with a galleon motif by Vittorio Zecchin (1878–1947), designed for the 1922 Biennale in Venice. The artist's monogram is on the back of the

ioned shapes, created using simple techniques that were appropriate to the materials, became in Cambellotti's hands highly distinctive objects with a personality of their own. The wood was left unfinished and its natural texture was embellished with stylized decorative motifs based on scenes from country life. There was, too, an intense social and humanitarian commitment behind Cambellotti's furniture. It had the merit of highlighting the plight of agricultural workers while supporting the fight to eradicate illiteracy and offering improved living conditions in the domestic environment.

Cambellotti was elected president of the Rome section at the 1923 Monza Biennale, the first exhibition under the aegis of the Monza school, which had been founded in 1922 to educate workers, artists and artisans through technical and artistic training. Cambellotti presented a number of examples of his work at Monza in a single large room, for which he was awarded a certificate of honour.

Here he brought together solid, vigorously designed furniture including tables, reading stands, chairs and oak chests, decorated with maple inlays and

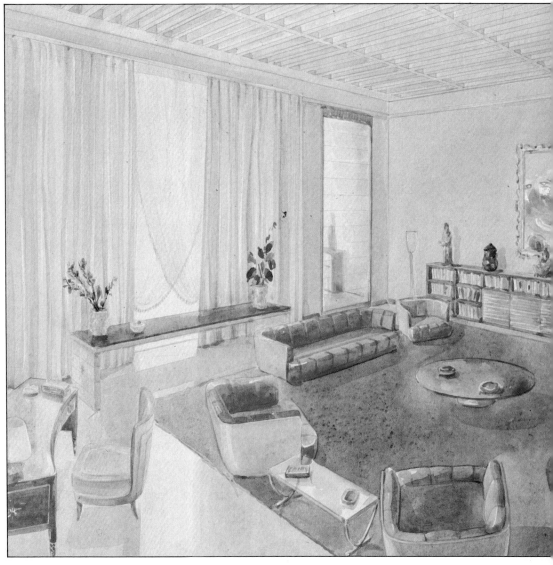

screen. Zecchin was an artist and decorator who specialized in designing tapestries. These were then completed in wool and silk by embroiderers in a workshop at San Donato on the island of Murano, employing a stitch that Zecchin himself had created and which was based on the Burano lacemaking tradition. Zecchin was also a noted glassworker, a material he found particularly congenial, producing much appreciated work in the "classic" idiom of Italian Art Deco.

wrought-iron mounts as well as decorative motifs with country scenes. Quite apart from any personal interpretation, his pieces made a more general comment that put forward an independent review of interior design without stylistic compromises.

During the same period, Melkiorre Melis (1889–1982) and Ettore Zaccari (1877–1922) were also influenced by regionalism and folk tradition, in the sense of refined craft skills. Zaccari created a kind of elaborate, richly engraved, beautifully finished rustic style that caught the imagination of better-off consumers, especially those who wanted to furnish country homes and villas. Benches and box-settles, those most typically Italian pieces, tables and kitchen cupboards, often embellished with Latin mottoes and transformed into living-room accessories, writing desks and sideboards took rustic furniture to new heights of sophistication that contrasted starkly with the style's origins. Nevertheless, the trend fitted perfectly into an overall programme of promotion of the national artistic heritage.

Refinement and vernacular tones were also mingled together in the work of Vittorio Zecchin (1878–1947). The son of a master glassmaker from Venice, Zecchin was a versatile artist whose interests ranged from painting to designing glassware, tapestries, mosaics and furniture.

The regional and popular content of his work is evident in uncomplicated basic designs, while a more illustrious craft heritage is evoked in his intricate, sophisticated decoration. "On profiles and surfaces of a primordial simplicity," wrote Roberto Papini, "he embroiders his exquisite patterns (golden arabesques, often on a black background) of carved and gilded lines" (R. Papini, *Le arti a Monza nel 1923*, Bergamo, 1923).

The Monza Biennale exhibitions

For Cambellotti, regionalism signified a conceptual, rather than formal, adherence to the meaningful content of an unjustly neglected culture and for the "furniture artists" like Zaccari and Zecchin it became the recovery and re-introduction of refined craft techniques. In many other cases, however, regionalism was mere folklore, underpinned by a widespread but sterile parochialism.

That tendency was very much in evidence at the first biennial exhibitions of decorative art at Monza (these were to become triennial in 1930 and, from 1933, the new "Triennale" moved to Milan, where it was held in the exhibition building of the same name).

The 1923 Biennale was organized into regional exhibition

halls, and the subsequent edition in 1925 underlined the national element in the products on show, proclaiming that it would feature "one of the most picturesque sectors [...] that of local art and folklore", including some "noble testimonies of the rustic expression that has in the past emerged from the naive, gentle soul of the humblest strata of the population". The programme continued to say that it would accept work inspired by the past while "granting citizenship to traditional styles only insofar as they were the irrepressible, undeniable sources of inspiration for new, original forms" (A. Pansera, *Storia e cronaca della Triennale*, Milan, 1978).

There were thus two clear trends dominating the applied arts in Italy at the time, as pointed out by Giulia Veronesi in *Stile 1925* (Florence, 1966). One was strictly nationalist and occupied a position that was somewhat old-fashioned with respect to comparable developments in other countries, concentrating on the "Italic" content of the picturesque and rural art. The other trend aimed for a moderate, prudent renewal founded on traditional models.

The Futurist contributions to these early exhibitions, described above, were therefore extraordinary. The regionalist connotations, which were present for example in the work of Fortunato Depero, were transmuted into free expression throbbing with energy, becoming a cue for subversion and the development of an aesthetic of "healthy transgression".

Furniture based on "traditional styles" as "sources of inspiration for new, original forms"

included what we might call the "identikit of Art Deco" in Italy – a portrait of a relatively fragile style, lacking depth of vision and unable to establish a clear image of the period, yet clearly recognizable from the incorporation of the key motifs adopted all over Europe at the time.

Those motifs were "the rose, the corbeille or basket of flowers, the palmette, the fountain and the curlicue, all of which have symmetrical, schematic, well-spaced lines. Then there were highly simplified versions of *Secessionstil* themes in certain star-shaped or chequered or zig-zag motifs. Also, we find anthropomorphic – particularly female – decorations with long legs, slim arms and smooth ovoid heads as well as lithe, sleek animals like roe deer and greyhounds.

It was the classic repertoire superficially rewritten as an exercise in calligraphy." (R. Bossaglia, "Arti decorative e Deco", in *La metafisica: gli Anni Venti*, Bologna, 1980, vol. II) The above stylistic features were common to all forms of applied arts and could be found in furniture, ceramics or glassware. They shared a very tenuous common theme while at the same time being very different both in form and in conception.

The new architects

In the mid-Twenties, decorative art had to face the problem of a market that required stimulation and expansion, so the debate turned once again to methods of design and manufacture. Some upheld the validity of artisan manufacture and, in the last analysis, the value of an item created by the skill of a single craftsman as the most authentic expression of "Italian-ness".

But there was also a new interest in the creation of prototypes rather than individual pieces, that is to say models that could stimulate mass production. A new generation of interior and furniture designers was emerging. These young professionals were already strongly in evidence at the 1927 Monza Biennale, when folklore-oriented and ultra-conservative period decorative styles were no longer the focus of attention. Nevertheless, the newcomers were not necessarily revolutionaries, indeed tradition was still an important inspiration, serving as an example of sobriety and design precision rather than for historical reference or stylistic citations.

This trend had already made itself felt in the figurative arts, where it produced the *Novecento Italiano*, a group of artists and sculptors who shared a respect for the classical tradition. The most important adherents included Ardengo Soffici (1879–1964), Ottone Rosai (1895–1957), Mario Sironi (1885–1961), Filippo De Pisis (1896–1956) and Felice Casorati (1886–1963).

More than by any similarity of expression, they were united by an attitude that rejected the formal and theoretical content of the avant-garde. The so-called Neo-Classical or *Novecento* architects, mainly based in Milan and Lombardy, shared the same spirit, maintaining that the architecture and decorative arts of the early 19th century comprised the last stylistic contribution to European culture that the arts in Italy had made. They therefore envisioned a return to the same historical

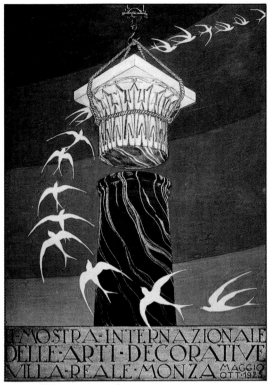

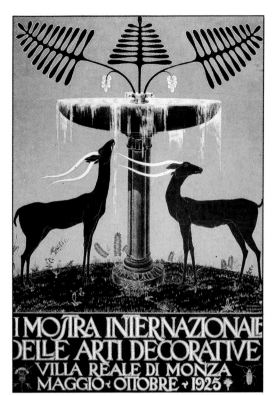

Left: two posters for the International Exhibition of the Decorative Arts at Monza. Below: the vestibule of the Rome section's exhibition at the 1923 Monza event, designed by Limongelli with furniture by Duilio Cambellotti, the Roman furniture-maker who championed a return to the rustic style. Organized initially as a series of regional halls, the Monza Biennale (which became a Triennale in 1930 and in 1933 moved to Milan) took on in its second guise a more specifically "Italian" flavour, contributing to a wider awareness of new trends in the applied arts, especially the avant-garde.

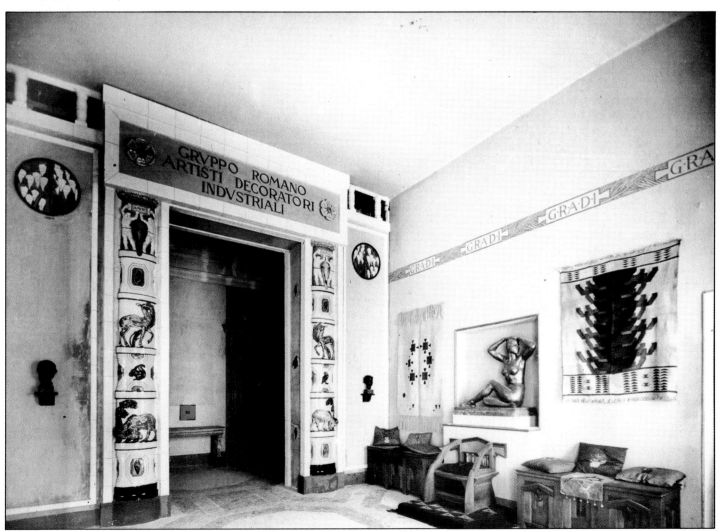

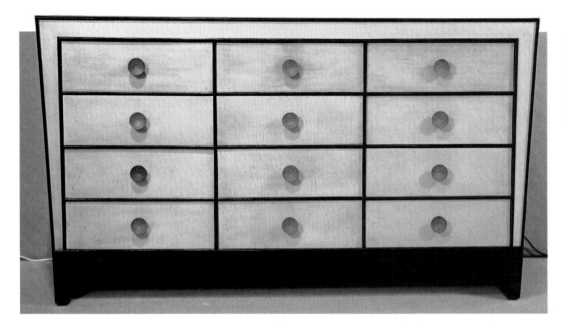

LEFT: chest of drawers (c. 1930) designed by Gió Ponti. The dark mahogany highlights the geometrical structure, which is further enhanced on the front by the rigid, regular pattern of the drawers. The finish is parchment.

style, within the bounds set by contemporary expression, often adding a seal of modernity with a hint of "Viennese elegance" in the manner of Josef Hoffmann.

It is in the work of architects like Piero Portaluppi (1888–1967) and Giovanni Muzio (1893–1983), and especially of Gió Ponti (1897–1979), Emilio Lancia (1890–1973) and Tommaso Buzzi (b. 1900) that the most intriguing aspects of the Italian approach to Art Deco can be seen. There was a keen interest in the production of prototypes, a striving for greater functionality and an ability to marry Wiener Werkstätte-derived models with the elegance and refinement of Paris.

At the Monza Biennale in 1927, Gió Ponti and Emilio Lancia presented uncomplicated furniture with a textbook clarity of composition for the Domus Nova furniture department of the La Rinascente retail chain. This company had decided to organize an Italian version of the initiatives pioneered by Parisian department stores.

Domus Nova and Il Labirinto

Referred to as "furniture that is economical as well as aesthetically appealing", the Domus Nova pieces were intended to revitalize

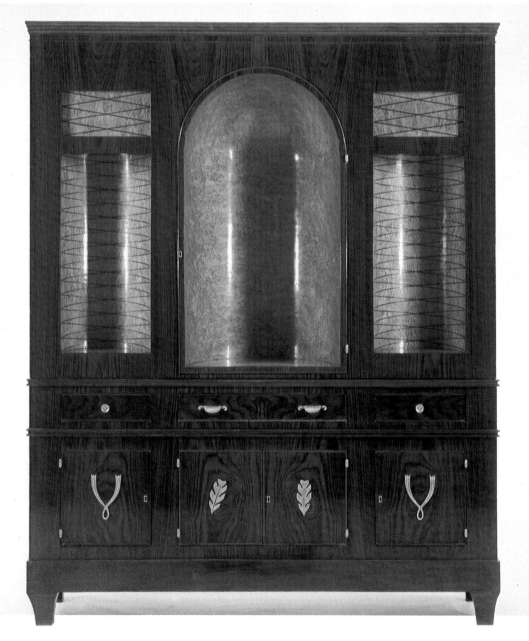

Facing page, below: a cabinet (c. 1935) made by the Arredamenti Moderni A. Canciani factory in Chiavari. Designed by Emanuele Rambaldi, it is in mahogany with light-coloured walnut veneer niches and bronze mounts. Below: writing table with a Neoclassical architectural raised centrepiece. It was made in gold-trimmed walnut in 1931 by Turri to a design by Gió Ponti. All Antiques trade.

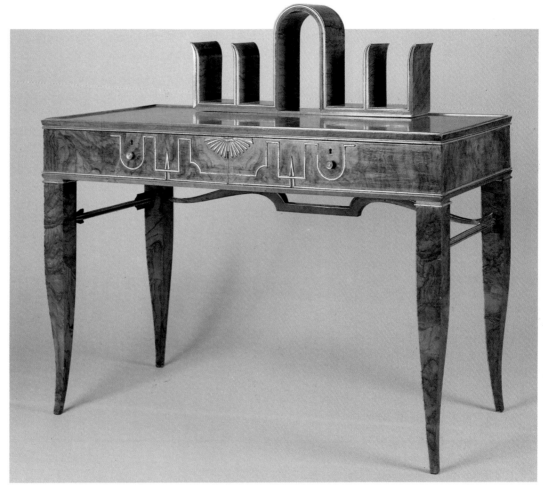

the concept of the middle class home with a formula of gracious, moderate decorum. The elimination of complicated carvings, projecting ornamentation and cornices, "niches and quivering leaves", as the critic Renato Giolli wrote in 1927, encouraged clean lines and functionality as well as promoting an aesthetic based on "architectural" design and the "pictorial" values of surfaces: "English furniture several decades ago destroyed all superfluous appurtenances [...] There are no caryatids, no cornices, no handles, no foliage, no bronzes and no reliefs. It is furniture that risks being no more than a drawer or a box. But there is no call for alarm. Form can be of very great interest even when unadorned. It is indeed spurred on to find its true nature as form and substance, as architecture and not mere decoration."

With reference to the furniture presented by Ponti, Lancia and Tommaso Buzzi for the Il Labirinto company, whose customers were more sophisticated and demanding than those who favoured Domus Nova, Giolli went on to write: "Furniture will always be able to find individuality through pictorial representation. That is the reason why in many artists, for example the Il Labirinto group, there has developed an acute awareness of the woods used in furniture-making, exploiting the warm, living colours of the material and utilizing it in the most rational ways. But these designers have not been content to let the smooth surfaces shine in the clear, bright shades of locally available wood; they have also savoured the other delights of more exotic timbers, bringing out their vibrant lustre in artistic arrangements." Rose-

wood, macassar ebony and mahogany, perhaps with lightly carved or relief trims or lozenges next to bronze handles and mounts, were distributed over the surface in equilibrium to bring out the symmetry of the composition.

In contrast to the French products of the period, and despite having an equally exclusive clientele with a similar taste for sophistication, Italian furniture shied away from explicitly flaunting luxury and extravagance, preferring instead to evoke the measured tones of a classical elegance re-interpreted in the modern idiom. Irony and wit were sometimes part of this re-interpretation and are in fact typical of cer-

tain pieces by Portaluppi. Citations were often urbane and free of "archaeological pretensions".

This quality derived from an intellectualizing spirit evident in the more sophisticated pieces, not necessarily made for an exclusive clientele. Allusions to the pediment of a classical temple or Renaissance palazzo, or a delight in "tympana, arches, pilasters and festoon-bedecked mouldings" hinted at refinement, intelligence and sensitivity of style.

Domus and *La Casa Bella*

The image of decorous propriety was reinforced by specialist maga-

zines, the most important of which were *Domus*, founded in 1928 by Gió Ponti, and its contemporary, *La Casa Bella*, two new monthly publications that dealt with interior design and the decorative and industrial applications of art. Their aim was to heighten public awareness of the problems concerning the house and objects currently made or designed in Italy.

Repeated attacks were directed against "antique-style" furnishings, and appeals were made to an Italian tradition that Ponti equated with "a spiritual measuredness of judgement and an effort to imbue the product with personality, free of foreign

Art Deco in the United States

Art Deco was a very effective decorative language in its most fashion-conscious versions, and from the mid-Twenties it began to gain popularity in the United States, where the 1925 Paris exhibition had been extremely influential. The Exposition Internationale became a symbol of the "spectacular" route to renovation, and an emblem of universally rec-

ognized economic leadership as well as of technological progress.

In fact the United States could boast a number of excellent home-grown designers, the most outstanding of whom was the architect Frank Lloyd Wright (1869–1959).

Wright's furniture was based on intersecting planes and volumes as early as the last years of the 19th century, so it already contained the seeds of what was to be known as the modern style. Moreover, it is to Wright that we owe the humanistic approach to the new architecture, based on the comfort of the ambience and respect for the materials used and the local culture. In this sense, his furniture was more than merely functional, comfortable and free of affectation. It had to blend organically with the architecture and help to define spatial relationships. Examples of this can be seen in Wright's various dining chair designs, in which the high, straight backs were conceived as screens, delimiting a zone within the ambience and a space with specific functions.

However Wright's original talent was an isolated phenomenon in a cultural panorama that remained, especially in the field of the decorative arts, largely in thrall to European models, whose authority rested on a long tradition. Art Deco was thus assimilated for its innovative characteristics where these were corroborated by precedents from the past.

French taste as the arbiter of fashion became more popular with the upper middle classes, thanks to a series of exhibitions that in 1926 presented in New York and other major cities the products that had been on show in Paris the previous year.

influences and the superficiality of fashion" (M.C. Tonelli, Michail, *Il design in Italia. 1925–1943*, Bari, 1987). In practice, the magazines presented furniture with trim, uncomplicated lines, with accompanying texts that offered advice or hints on interiors and the running of a household.

These two magazines were quick to notice the slightest change in the public's tastes, and perhaps for that reason have survived for an unusually long time (both titles are, in fact, still published).

They were also among the first to realize that the Italian version of Art Deco was in decline, a downfall that was signalled in the early Thirties when the scope of the Triennale exhibitions was broadened to include architectural and urban problems. The introduction of these more general topics with a greater social outlook directed the focus of the exhibition away from narrow "Italian-ness" into a European dimension, where interior design would find new inspiration and more modern points of reference.

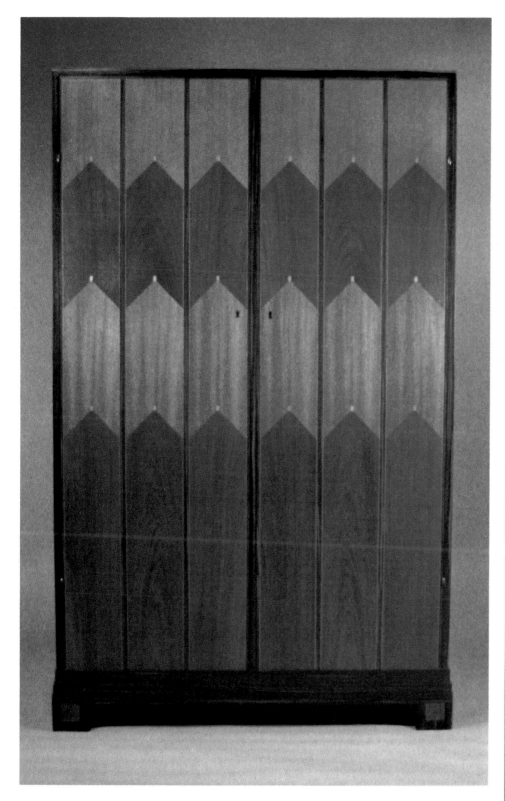

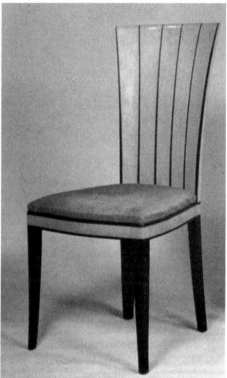

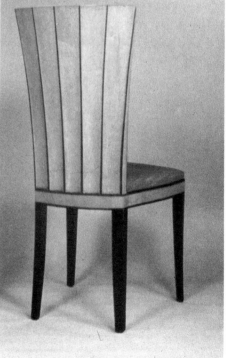

Facing page: two drawings by Gió Ponti. Above: for Villa Contini-Bonacossi (1933). Below: a Thirties writing table. Archivio Gió Ponti. This page, above: wardrobe and, right, two chairs by Eliel Saarinen. All three pieces feature natural wood in contrasting colours. Their severe, geometrical lines reveal the Finnish designer's adherence to the precepts of Art Deco. Cranbrook Academy of Art Museum, Bloomfield Hills.

The commercial potential of a decorative language that was based on the display of rich ornamentation acted as an incentive for a further series of exhibitions that led to the 1927 Art in Trade show, organized by the New York department store, Macy's, in collaboration with the Metropolitan Museum of Art. In 1929, the same museum made its own contribution to increasing awareness of the new style by canvassing for an American approach to interior design and encouraging projects of quality and distinction.

The exhibition entitled "The Architect and the International Arts" brought together the work of eight of the best-known architects of the day (Frank Lloyd Wright was not one of the eight), all of whom presented complete interiors. Organization of the show was entrusted to Eliel Saarinen (1873–1950), a Finn who in 1923 had moved to the United States, where he taught at Cranbrook Academy. He grafted his inclination towards romantic naturalism with a distinctly Nordic flavour on to the pioneer tradition of the American West.

Geometry and decoration

Part of Art Deco's success lay in the modern appeal of some of its geometrical decoration. This became the most appropriate form for America's big cities and the artificial landscape, in the sense of its abandonment of nature. In 1926, Claude Bragdon, referring to New York in *Ornament from Magic Square,* described the modern world as urban rather than bucolic. Manufactured articles were its flora and Ford cars its fauna.

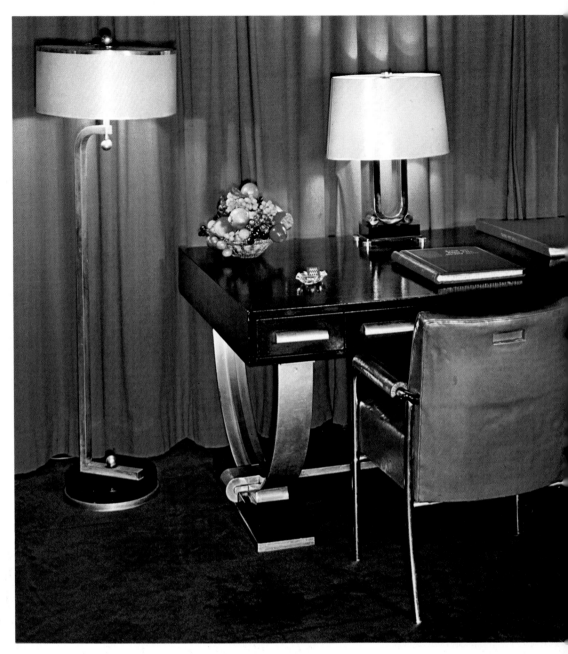

We may be alienated from nature but we have mathematics as a source of ornament. Since mathematics is the foundation of our society, according to Bragdon, we discover beautiful mathematical patterns wherever we look, in the reflection of a glass on a napkin or the shadows of a chandelier on a ceiling.

This approach led to the characteristic Art Deco motifs of geometric figures, in particular circles and triangles, which were juxtaposed, interlocked, shifted and recomposed in a pattern of concentric relationships.

Such figures were the favourite themes of Modernist American architects, and they found applications as decorative motifs on floors, as a shiny metal ornament on the door of a lift or on the angular, many-sided top of a skyscraper.

Skyscrapers were, of course, the symbol of money and modernity, and so they also became the hallmark of the city, its new personality, style of working and endless opportunities for having a good time.

Radio City Music Hall, located in the Rockefeller Center in

the heart of Manhattan, was the most explicit metaphor of an artificial world-view that incorporated all the possible scenic effects that modern technology could contrive. Radio City is an immense oval theatre for 6,200 spectators, over whose heads extend rays of plastic that cover the ceiling. The synthetic curtain shimmers with an extraordinary brilliance, producing surreal light effects that contribute to the impression of experiencing "another" nature. It is no surprise to find that some of the finest examples of American Deco furniture

LEFT: a group of furniture designed by Donald Deskey (1932) for Radio City Music Hall. Located in the Rockefeller Center in Manhattan, Radio City is one of the most complete, significant examples of American Art Deco, based on simplified forms and designs in ostentatious materials such as shiny metal and gloss lacquer. BELOW: windows by Frank Lloyd Wright. Metropolitan Museum of Art, New York.

are in Radio City Music Hall, among the wood, glass and aluminium pieces that grace the foyers and waiting rooms. The tables, chairs, armchairs, light fittings and mirrors designed by Donald Deskey abandoned the high craft tradition to seek a simplicity of form and ornament which is rendered spectacular by the dazzling sheen of metal, the interplay of reflections and the dramatic setting.

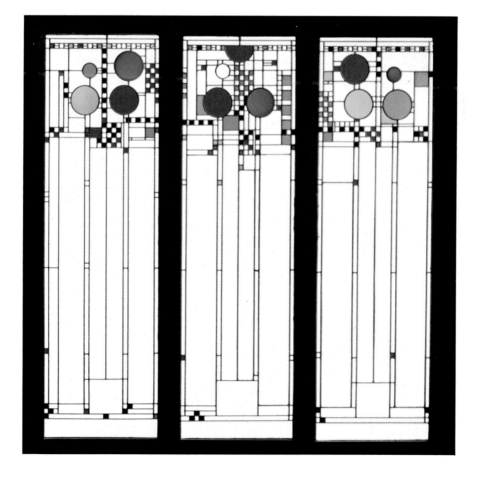

Appendix

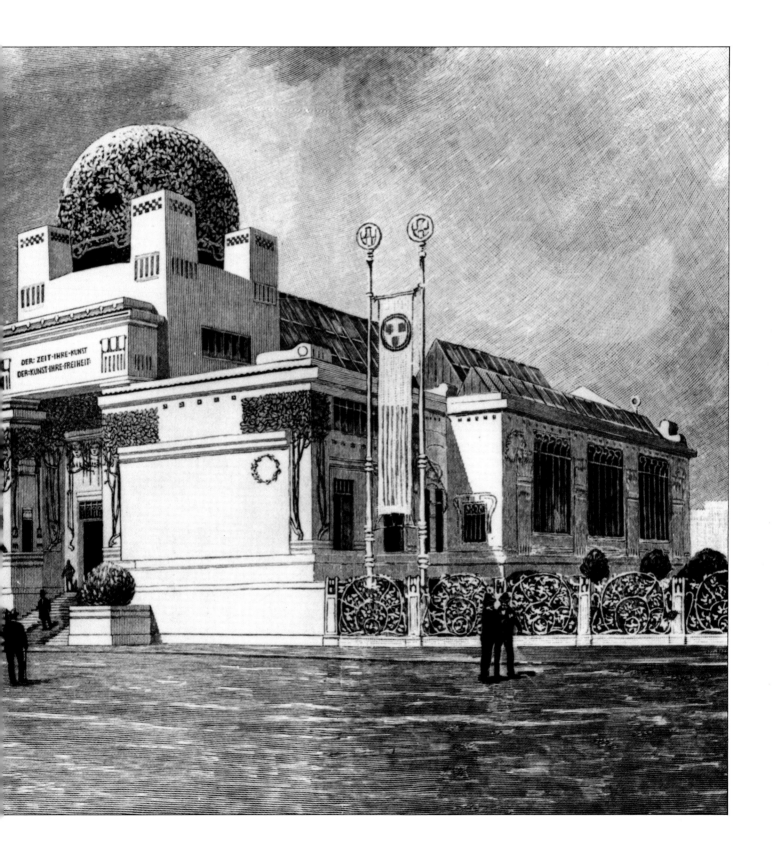

Glossary

ACANTHUS: a highly conventionalized classical ornament derived from the deeply lobed leaves of the acanthus plant, appearing repeatedly from the Renaissance into the 19th century. It forms the standard decoration of capitals of the Corinthian and Composite orders.

AEMILIA ARS: A workshop founded in 1898 in Bologna, strongly influenced by the English Arts and Crafts Movement.

AESTHETIC MOVEMENT: a hybrid decorative style combining Gothic and Queen Anne Revival with Oriental influences. Originating in England in the second half of the 19th century, it glorified the doctrine of *l'art pour l'art* (art for art's sake) put forward by Th. Gautier and C. Baudelaire in France and taken up by W. H. Pater, O. Wilde and A. Beardsley in England. The movement had a long-lasting influence on domestic interior decoration and the applied arts in general.

AGRIPPINA: daybed with a wide seat back continuing uninterrupted to one side to form an arm, typical of the late Neoclassical period. Its name derives from a seat used in a statue of a figure presumed to be Agrippina.

APPLIQUÉ: a method of decoration in which a motif is cut from a piece of material and attached, or 'applied'.

ARMADIO: large cupboard with two long doors or four shorter ones used for storing linen, developed in various forms and styles from the medieval prototype wall-cupboard and subsequent sacristy cupboards. A traditional Italian piece, its shape and decoration were originally inspired by the architecture of Renaissance palaces. It can be found in various guises throughout Europe, and became an indispensable feature of Dutch (the *kast*) and German (the *Schrank*) homes.

ARMCHAIR: typically Victorian piece of furniture. The "spoon-back" type was especially popular.

ARQUIMESA: architecturally constructed cabinet, evolved from the 17th-century *bargueño*, with the front divided into three sections, the outer sections with drawers, the central section recessed between small columns, framed by drawers or by compartments, which are either open or concealed by small doors.

ART DECO: A decorative style named after the exhibition Exposition Internationale des Arts Décoratifs et Industriels Modernes (Paris, 1925), which supplanted Art Nouveau. While retaining the ahistorical elements of the latter movement, it placed less emphasis on refinement of craftsmanship and naturalistic ornamentation, and set out to meet the challenges and exploit the opportunities presented by semi-industrial and industrial manufacture.

ART NOUVEAU: an exaggeratedly asymmetrical decorative style which spread throughout Europe in the last two decades of the 19th and the first decade of the 20th century. It makes use of undulating forms of all kinds, notably the whiplash curve of tendrils or plant stems, but also flames and waves and the flowing hair of stylized female figures. The chief importance of Art Nouveau is the rejection of 19th-century Historicism. The British designers H. M. Baillie Scott and C. R. Mackintosh developed an angular, puritanical style that harmonized with the stark simplicity of industrial design.

ARTS AND CRAFTS MOVEMENT: a movement arising out of the attempts of A. Pugin, J. Ruskin and W. Morris to reform the decorative arts, emphasizing the potential for social and moral influence. The endeavour to revive craftsmanship and reform design led to the forming of workshop collectives such as the Century Guild and the Art Workers Guild. The term "Arts and Crafts" was first coined in 1888 when members of the Art Workers Guild formed the Arts and Crafts Exhibition Society.

ATHÉNIENNE: small table consisting of a round or polygonal marble or wooden top supported on a tall, slender tripod; the legs might be of bronze, iron or wood, culminating at the top in sphinx or lion heads and at the bottom in hoof or claw feet. It could be used as a washstand, a perfume burner or a lampstand. First produced by Eberts in 1773, in imitation of a classical model, it is a typical Louis XVI or Empire piece.

BANQUETTE: small bench with an upholstered seat, similar in form to a long *tabouret* but supported by eight legs, used during Louis XIV's reign. It is called *banquette croisée* when placed in the splay of a window.

BARBIÈRE: tall, narrow shaving table. The upper part, supported by four columns, consists of a flat marble surface and a mirror.

BAS D'ARMOIRE: type of low credenza found in provincial France in the early 18th century as a substitute for the more costly commode. During the early part of Louis XVI's era it was usually one of a pair, with one or two doors. The version with two drawers set within a frieze is called a *buffet*.

BERGÈRE: low, deep upholstered armchair with integral rounded back and arms, appearing around 1725.

BIBLIOTHÈQUE: piece of furniture in the form of a cupboard with two doors made of glass or grills, with a shelved interior for books.

BIEDERMEIER: a term used to describe the Central European decorative arts of the period 1820–40, which put strong emphasis on unpretentious bourgeois comfort. The word derives from Gottlieb Biedermeier, a fictional character invented by the German satirical journal *Fliegende Blätter* to typify middle-class vulgarity. Biedermeier furniture is simple and well-proportioned. While avoiding the decorative exuberance of the Empire style, it was still influenced by the French *bois-clair* furniture of the Directoire and Empire periods. Its simplicity and clarity of line give Biedermeier furniture a distinctly modern appearance.

BOMBÉ: outwardly curving shape on two planes.

BONHEUR-DU-JOUR: lady's small writing-desk fitted with a low recess with drawers, made mainly in France and England after 1770. Secret compartments concealed in false bottoms were accessible through ingenious mechanical devices. It could also be used as a dressing-table.

BOOKCASE: piece of furniture which originated in the 18th century and changed little during the 19th century. Its division into two stages, with the lower cabinet usually projecting further than the upper, derived from the English bureau. The lower part had wider shelves for holding larger books. Both cabinets had glazed or panelled doors. In some models, the lower stage, supported on legs, was simply a chest of drawers, while others – known as low bookcases – consisted of a single cabinet with shelves, with or without doors. There was also a three-stage variant, with grilles rather than doors, known as a *chiffonier*, which was popular during the Regency period. Revolving bookcases could be square or circular with several shelves of decreasing size, or cylindrical; all rotated on their axes.

BORNE: large divan positioned in the centre of a room; circular in shape and generously upholstered, it was very popular during the Second Empire.

BOUDEUSE: type of seat, also known as a *dos-à-dos*, consisting of two armchairs set back to back. The name comes from the French verb *bouder*, meaning to sulk, because the person sitting on one side would inevitably be turning their back to the other.

BOULLE: Boulle marquetry is a furniture veneer of brass set in tortoiseshell. It is named after its most noted practitioner, A.-C. Boulle. The veneer was produced by fastening a sheet of brass and one of tortoiseshell firmly together, placing a paper pattern on top, then cutting with a fretsaw around the pattern and through the material below. The cut-out piece of brass then fitted perfectly into the space left in the tortoiseshell. Brass patterns were usually engraved with a design such as tendrils or shading to produce a three-dimensional effect, while the tortoiseshell was often coloured.

BUFFET: In England, the French word was used to indicate the presence of a shelving unit, either open or concealed behind doors, fitted into a niche in the wall and used for displaying china. See *bas d'armoire*.

BUREAU: writing table or desk whose French name, universally used, derives from *buré*, a coarse linen cloth, which, in the Middle Ages, was placed over the tables at which clerks wrote. The oldest version is the *bureau Mazarin*, the (incorrect) 19th-century term for a square desk supported on eight legs, with two or three drawers on each side of a knee-hole recess, above which is a single central drawer. The most common 18th-century form was the *bureau plat*, a flat-topped writing table with a leather- or velvet-covered top and drawers in the frieze. The *bureau à gradin* was similar, but had a superstructure of drawers arranged around the writing surface. During Louis XV's reign, the *bureau à dos d'âne,* with a sloping fall-front on both sides, was used; the version with a sloping fall-front on one side only was called a *bureau en pente.* The most famous 18th-century *bureau* was the *bureau* or *secrétaire à cylindre*, which was larger and was equipped with a quarter-cylinder roll-top, which, when lowered, covered both the drawer compartments and the writing surface. All these types of *bureau* survived into the 19th century. One 19th-century innovation was the *bureau-toilette*, which could serve as either writing-desk or *table de toilette*.

BUREAU-BOOKCASE: writing-table or desk surmounted by a bookcase, the lower section with ample shelves and compartments, the shallower upper section with glazed or panelled doors. If the lower part had drawers it was called a *bureau-cabinet*.

CABINET: Appearing in the early 17th century, this was considered a luxurious piece of furniture. In the Louis XVI era it was generally of symmetrical form with two doors, which opened to reveal a series of small drawers set around a cavity which had its own small door. The body was set on legs or on a detachable stand or table, enabling it to be seen as a single piece. It was elaborately decorated with marquetry, inlay, gilding, pietre dure, precious metals or lacquer. In 19th-century England, cabinets often held pride of place in a reception room. Deriving ultimately from Renaissance models, they could be of various sizes, freestanding or wall mounted, and fulfilled a range of functions.

CABRIOLE: a double-curved and tapering furniture leg, often ending in a stylized paw; a design deriving from the muscular hind legs of certain animals.

CABRIOLET: armchair with hollow, shaped back and open armrests.

CACHE-POT: ornamental container for a vase of flowers, fashionable in the 19th century, usually of lacquered metal or ceramics.

CANAPÉ: sofa. In early examples from the end of the 17th century, was formed of a bench with a triple backrest, two arms and eight legs; it later developed more harmonious shapes with undulated backs extending directly from the seats, side-splayed arms, and four, six or eight legs.

CANTERBURY: trolley, which came in many shapes and sizes. The most interesting was the supper *Canterbury*, a Regency item with four turned and fluted legs and a low gallery around the top, for moving crockery and cutlery.

CARREAUX: square cushions decorated in various ways, used by those members of the court who did not have the right to a *tabouret*.

CARTOUCHE: an ornamental motif, usually oval in shape, with curved or rolled edges resembling a scroll.

CASSETTONE: see *Commode*.

CAUSEUSE: two-seater sofa derived from the type of wide armchair which could seat two people side-by-side. One of Madame de Pompadour's favourite pieces of furniture, its name derives from the French verb *causer*, to chat, because it was ideal for holding a conversation.

CHAIR: English chairs fall into two main classes: occasional chairs and dining chairs. Some of the most common types are the typically Victorian balloon-back chair, the shield-back, the square-back popularized by T. Sheraton, and the wheel-back associated with G. Hepplewhite. Very common throughout the 18th century and into the 19th were Windsor chairs with their characteristic taper-turned "stick" backs. Rocking chairs were another popular item of "country" furniture.

CHAISE: The most common French types of chair in the period between the First and Second Empires were the *chaise en gondole*, with a rounded, body-hugging back, and the *chaise à crosse*, with a shepherd's-crook shape to the back- or the armrests. More closely associated with the Restoration period were the *chaise à consoles opposés* and the *chaise à chapeau de gendarme*.

CHAISE À LA REINE: see *Meublant*.

CHAISE-LONGUE: high-backed seat or armchair of extended form, allowing a person to recline. Given its function, it can be numbered among the *lits de repos*.

CHEST ON CHEST or **TALLBOY:** Deriving from the traditional chest of drawers, pieces consisting of one chest on top of another began to appear in the Queen-Anne period. The upper chest was narrower and less deep. Both were fitted with carrying handles. Furniture of this type was especially popular in America, as was the highboy, known in England as a chest on stand.

CHEST ON STAND: consisting of two parts, as the name suggests. The upper stage is similar to that of a tallboy, while the lower part – the stand – is a writing desk with a central knee-hole, supported by longish legs.

CHIFFONIÈRE: type of high, narrow, small cupboard with drawers, found towards the middle of the 18th century, generally used in bedrooms where it took on the function of a *commode;* when there were seven drawers, one for each day of the week, it became known as a *semainer*.

CHIFFONNIER: small work-table with two or three drawers beneath the top, usually fitted with a metal gallery rail and with a shelf enclosed between the long slim legs. The *table en chiffonnière* has a greater number of drawers.

CHINERO: Spanish two-sectional piece comprising a fall-fronted writing desk with drawers and an upper section with glass panelled doors, similar to the Italian *trumò*.

CHINOISERIE: the European style of decoration, occasionally fanciful, influenced by Chinese originals and extremely popular during the late 18th century.

CHIPPENDALE: English furniture in Rococo taste with much ornamental, openwork carving (e.g. in chair backs and cresting). It takes its

name from the designer and cabinet-maker Th. Chippendale, who produced a book of designs entitled *The Gentleman and Cabinet Maker's Director* (1754). The *Director* contained designs for household furniture. Most were in the Rococo style, while others employed Neo-Gothic elements and chinoiserie, the latter being categorized as *Chinese Chippendale*.

COFFER: a medieval chest, which came back into fashion as a result of the Gothic revival.

COIFFEUSE: small dressing table with hinged lid concealing an interior mirror and small drawers for toilet accessories; also known as a *poudreuse*, from the French word for powder.

COMMODE: chest with three large drawers extending the full width of the front, thus called since 1725. Corresponds to the Italian *cassettone*. The typically French *commode à vantaux* had drawers concealed behind doors. In the 19th century, the most common type had four drawers and stood on square, bun or bracket feet. The front tended to be designed as an architectural unit, with decoration applied to the corner pillars, the base and the frieze. In England, the term was used to describe a semi-circular or semi-oval piece of furniture supported by four or six legs, which came into use in the second half of the century.

COMMODE-CONSOLE: small wall-table with a single drawer and tall legs, found early in the second half of the 18th century.

CONFIDENT: During the 18th century the term referred to a type of very large armchair with an inward-curving back which enabled two people to sit next to each other, or an armchair whose wide outswept arms formed two small seats ideal for private conversation.

CONFORTABLE: type of *bergère* or wing chair with a higher than normal back forming two lateral wings. If it has a reclining back it is referred to as *de commodité* or *de malade*.

CONSOLE: a shelf or shelf-like table, evolving from the *table-console*, whose shaped top, often in marble, had a varyingly carved frieze and was supported by four or two legs. In the Louis XV era a popular version was the small wall-mounted *console* with two front supports converging to form a central carved or pierced decorative motif called a knot. In dining-rooms, the *console-desserte* was taller and was fitted with an upper shelf with compartments for china. As in the case of wall tables and *entrefenêtre* tables, only the visible parts were worked and decorated. When fixed to the wall on brackets, without front legs, it was known as a *console d'applique*. In the Empire and Restoration periods, console tables tended to be severely rectangular, with a marble top supported on a wooden frieze. The legs might be straightforward pilasters or columns, or carved with sphinx or caryatid motifs.

CONSULAT: a continuation of the Directoire style in the first years of Napoleon's rule (1799–c. 1804). It is often embellished with Egyptian motifs inspired by Napoleon's Egyptian campaign of 1798/99.

CRAPAUD: (French for "toad") type of low, generously upholstered armchair, popular in the second half of the 19th century.

CUPBOARD: Court cupboards, used for displaying and storing food and plates, were popular in the 17th century. Corner cupboards, introduced from Holland, were put to similar use in the 18th century, often mounted on the wall.

CURULE: type of chair with curved, crossed supports, similar to a faldstool, but with a back. It was modelled on the Roman *sella curulis* and was popular in the Directory and Empire periods.

DAVENPORT: small writing-desk (usually for a lady) of quadrangular form with drawers set in all sides of the body surmounted by a sloping, often hinged, writing surface. Slides were fitted on all four sides. Its name probably derives from a certain Captain Davenport who commissioned the piece from the Lancaster firm Gillows and Barton. Originating in the Georgian era, this form of writing desk remained popular during the Regency and in Victorian times.

DESSERTE: see *Console*.

DEUTSCHER WERKBUND: a German association whose founding body was made up of a dozen designers, including R. Riemerschmid, B. Paul, P. Behrens and J. Maria Olbrich, and a dozen established manufacturers, including P. Bruckmann & Söhne and Poeschel & Trepte, as well as design workshops such as the Wiener Werkstätte. Within a year its membership had increased to five hundred. Formed in 1907 in Munich with the aim of reconciling artistic endeavour with industrial mass-production, the Deutscher Werkbund made an important contribution to the design philosophy that later inspired the Bauhaus.

DIRECTOIRE: a simplified version of the Louis XVI style in French decorative art, popular c. 1795–99 under the Directory. An austere form of neo-classicism, it formed a bridge between the Louis XVI and Empire styles. The decorative motifs included neo-classical elements combined with republican emblems such as the fasces and the cap of liberty.

DORMEUSE: *chaise-longue*, also known as a *méridienne*, with upholstered arms of different heights at either end. First made in the 18th century and quite popular during the 19th, it was used as a day-bed.

DOS-À-DOS: see *Boudeuse*.

DRESSER: narrow cupboard with drawers and baluster legs, the 18th-century version evolving from a cupboard with open shelves for the display of china. Its name comes from the wall tables used in the Middle Ages for "dressing", or preparing, food. In the 19th century, dressers tended to be made in the Jacobean style.

DRESSING TABLE: English tables of two kinds: *toilette* and writing table. The former was a small closed table, similar to a tall chest with a central knee-hole recess and a mirror concealed beneath its hinged top. The hinged cover could be folded back to reveal an inner compartment and mirror. In other types, the mirror rested on the top.

DRESSOIR: a type of French cupboard made in two parts, the lower part fitted with doors and the upper section with shelves; used since the Middle Ages in kitchens for the preparation of food and in dining-rooms for the display of china.

DUCHESSE: extended version of the *chaise-longue* with a round padded back, much in use between 1745 and 1780.

DUCHESSE BRISÉE: *lit de repos* formed by a large, comfortable armchair, similar to a *bergère* (upholstered armchair of tub shape) and two stools, or by two armchairs joined by a stool.

DUMB WAITER: small item of furniture first produced in the 18th century, which became almost obligatory in Regency dining-rooms. An early form of supper trolley, it consisted of a series of revolving circular trays, decreasing in size towards the top, set on a central column with tripod base.

EMPIRE: a late version of neo-classicism popular in France during the first Napoleonic Empire, and particularly associated with the types of furniture and decoration ordered by the Emperor Napoleon for his residences. The designs of this period do not constitute any fundamental change of style. Protagonists of the Empire style were P.-F.-L. Fontaine and C. Percier, whose designs employed antique forms and ornamentation with Napoleonic and Egyptian motifs set off by lavish draperies.

ENCOIGNURE: corner cupboard found during the first half of the 18th century; the upper section, placed above a triangular one- or two-doored lower section, had a series of shallower open shelves.

ESTAMPILLE: mark bearing the name, initials or monogram of the *maître-ébéniste* responsible for a piece. In France, in 1741, it became obligatory to add this maker's mark – stamped onto or burnt into an out-of-the-way part of the item. *Commodes*, secretaires and *chiffonniers* tended to be stamped beneath the marble top; writing desks on the edge of a drawer; and side and armchairs on the underside of the back, inside the frame or behind the front seat rail. Really fragile pieces were signed in an oily type of ink. Some pieces also bear the mark of the upholsterer and subsequent restorers. In 1830, furniture-makers began affixing printed labels giving the manufacturer's details. Makers' marks were never a common or regulated phenomenon in Italy.

ETAGÈRE: an arrangement of open shelves, designed to display books and *bric-à-brac*.

FAUTEUIL: As with chairs, armchairs in France were divided into the categories of *fauteuils à la reine*, or *meublants*, with high rigid backs, or *fauteuils courants* or *en cabriolet,* which were much lighter versions with rounded and reclined backs. Different types of *cabriolet* armchair developed throughout the 18th century from *fauteuils en confessional* to *de cabinet* study chairs; from chairs for the preparation of one's toilette, *de toilette* and *à coiffer*, to the version similar to the *bergère* with large wings *(à oreilles)*, and the *fauteuil en gondole* with a deep rounded back, first produced in 1760 and common during the Empire and Restoration periods.

FUMEUSE: upholstered smoker's chair, commonly found in the second half of the 19th century. It had a high elbow rest, curiously affixed to the front legs, which concealed a box containing the smoker's equipment.

GEORGIAN STYLE: a style of architecture and decoration associated with the 'four Georges of England': George I, II, III and IV (1714–1810). It does not comprise a coherent entity, but combines Renaissance, Rococo and neo-classical elements, with predominantly classical forms. The first phase is dominated by a revival of Palladianism, manifested in furniture by the placing of classical pediments on cabinets. The late Italian Baroque style, which noblemen of the day would have encountered on the customary Grand Tour, was copied as fervently as the French *sécretaires à abattant*.

Gesso: a plaster-like compound applied to wooden furniture for modelled decoration, painting or gilding.

Gothic revival: a revival of Gothic architecture which took place, largely in England, in the late 18th and early 19th centuries. Gothic forms were used in mid-18th-century England in a spirit of playfulness and even mockery, e.g. Horace Walpole's villa at Strawberry Hill (Twickenham). From the beginning of the 19th century the Gothic style began to be taken more seriously, and was eventually applied to all types of public and private as well as ecclesiastical buildings. The Gothic revival spread across Europe towards the end of the 18th century, evolving in France into the so-called Troubadour Style.

Guéridon: small circular or shaped table, usually formed of a single pedestal, which could be carved in different forms, surmounted by a tray, originally used for holding a candelabrum. Louis XIV versions, also known as *guéridon-torchère* or *torchère,* were frequently carved in the form of a Blackamoor supporting a tray. The round or polygonal, wooden or marble top, often richly decorated, was supported by a tripod base.

Haricot: see *Kidney table*.

Harlequin Pembroke table: a multi-purpose piece of furniture, with hinged and sliding parts, of French inspiration (*harlequin* is the French term for adaptable furniture of this kind). It was popular in the late 18th and first half of the 19th centuries.

Indiscret: luxuriously upholstered divan consisting of three linked armchairs facing out from the centre.

Inlay: a decoration of contrasting colour or material set into wood or metal; most commonly used for furniture decoration.

Intarsia: wooden inlay creating an elaborate picture or design.

Jacobean style: a style of architecture and decoration prevalent in England during the reign of James I (1603–25). It combines Renaissance, Gothic and Palladian architectural motifs with strapwork and other decorative forms associated with Mannerism in northern Europe. The woodcarving, chiefly in dark brown oak, is highly elaborate and the form of the furniture somewhat heavy and complex.

Japanning: a European alternative to Oriental lacquerwork. The wood was covered with a skin of *gesso,* followed by many layers of gum lac, seed lac or shellac varnish to create a hard, smooth ground for polishing. A variety of background colours were produced, and the decorations frequently outlined in gold or silver.

Jardinière: an ornamental receptacle, pot or stand for the display of growing or cut flowers.

Kidney table: multi-purpose table with a kidney or bean-shaped top (hence the French name *haricot*), popular in England during the Regency period.

Knee-hole writing-desk: desk, in appearance like a chest of drawers, with a central recessed kneehole backed by a cupboard.

Library table: writing-table, originally consisting of a large top supported on two massive lateral structures containing drawers. During the Regency, the trend was towards pedestal tables, with drawers in the frieze.

Lit: The most popular of the 18th-century beds was the canopied version. The *lit à la duchesse* had an overhanging canopy attached to the wall by means of four square supports, while the *lit à la polonaise* had one side placed along the wall, with the headboard and foot board of equal height, often joined on the side against the wall, and was usually placed within an alcove, the canopy supported by curved iron supports. Both these types were used during the Louis XVI era. The traditionally Renaissance-style *lit d'apparat* had a canopy supported on four turned supports. Types adopted in the 19th century included the popular *lit en bateau*, with scrolled ends of the same height connected by sculptured sides emphasizing the curved boat shape; the *lit à pupitre*, with severely rectangular ends; the *lit à la turque*, which looked like a massive divan with rounded arms, very fashionable during the Second Empire; and the *lit à l'impériale*, also termed *à la grecque* or *à la romaine*, with a canopy and draperies attached to the wall against which it stood – popular in France during the First Empire and Restoration periods.

Lit de repos: type of bench or elongated armchair supported on short legs, which appeared in the 17th century and became extremely popular in the following century for reclining on during the day. Other versions are called *duchesse, duchesse brisée* and *méridienne*.

Louis XIV style: the rich, formal style of decoration in vogue under King Louis XIV of France. It combines elements of Italian Baroque with devices taken from the standard classical repertoire of ornament as well as innovations such as Boulle marquetry. The Sun King brought in craftsmen from all over Europe to transform his palaces, especially Versailles, into symbols of the wealth, power and grandeur of monarchy.

Louis XV style: the French version of Rococo, popular between 1720 and 1750. When the King died in 1774, it had long gone out of fashion. It's principal feature is with extensive use of asymmetry, with extensive use of abstract C-scrolls and rocaille and ormulu fittings. The style is brilliantly illustrated by the furniture of Meissoniers and Pinneaus.

Louis XVI style: early neo-classical style of decoration already popular when Louis XVI came to the throne in 1774, constituting a reaction to the frivolity and liberality of the Rococo era, and showing traces of the restrained Baroque style of Louis XIV. It was succeeded by the Directoire from c. 1795.

Louis-Philippe style: term used for a collection of styles found throughout in France during the reign of Louis-Philippe (1830–48), including variations of the Empire and Troubadour styles, together with more accurate versions of Gothic and Renaissance designs. One component of the style was a revival of the Rococo fashion of the mid-18th century.

Marquetry: shaped piece of wood or other material used as a veneer on furniture to create decorative mosaics, and floral, geometric or other patterns.

Marquise: upholstered armchair with wide seat, and a low rounded back that continues in an uninterrupted line to form the short down-scrolled arms. The same term is used for a sofa similar to the *confident* but with a lower back and without wings.

Méridienne: *lit de repos* used extensively during the half of the 18th century, with two lightly out-splayed arms and a seat back along the longer side. See *Dormeuse*.

Meublant: formal chair, also known as a *chaise à la reine*, with a flat upright back, sometimes upholstered; used to adorn reception rooms, where it was positioned against the wall and played a purely decorative role.

Moulding: a length of shaped wood applied to the surface of a piece of furniture. Frequently, the shape is of architectural origin.

Occasional table: table without a definite function, as opposed to a sofa table, tea table, gaming table, etc. Very common in Regency and Victorian interiors, occasional tables varied greatly in size and shape.

Omega workshop: workshops for the decorative arts set up by the painter-critic Roger Fry in London in 1913. His aim was to revive the art of mural painting and thereby bring employment to his friends in the Bloomsbury Group, some of the leading English artists of the time. They were joined by the Vorticist painters and the designer Edward McKnight Kauffer, and attempted to apply Fauvist and Cubist principles to the decoration of interiors and individual pieces of furniture. The workshops, never financially successful, closed in 1920.

Ormulu: a term derived from the French for ground gold. It refers to gilded bronze or brass furniture mounts.

Ottomane: Louis XV term for a small sofa built on an oval plan with a high seat back, curved in a similar fashion to the *veilleuse*.

Palladianism: a style of architecture inspired by the works and publications of the 16th-century Venetian architect Andrea Palladio. Brought to England in the 17th century by Inigo Jones, the style flourished in the 18th century, particularly under the patronage of R. Boyle, Earl of Burlington, and through the work of Burlington's protégé W. Kent. Although Palladio did not design any furniture himself, English furniture of the early 18th century clearly belongs in the interior of a Neo-Palladian house.

Paphose: type of *canapé* with bean-shaped seat and virtually no arms, in fashion during the reign of Louis XV.

Pedestal table: round table with central column or baluster support on a polygonal base, generally with three or four feet. If intended for the dining-room, it was often extendable, with folding legs to support the additional leaves.

Pembroke table: typically English table with two drop leaves to the side illustrated for the first time by G. Hepplewhite in the *Cabinet-Maker and Upholsterer's Guide* (1788).

Piqué à bouton: type of buttoned upholstery, very fashionable during the Second Empire.

Pliant: folding stool with X-shaped legs joined by a stretcher, the leather or fabric that formed the seat contributing to its stabil-

ity. It had already appeared in France towards the end of the 16th century and its primary use during the 18th century was as court seating.

POUDREUSE: dressing-table typical of the 18th century, especially used, as the name implies, for the powdering (*poudre* = powder) of one's wig or face; the top divided into three hinged compartments, the two lateral flaps opening outwards and the central panel, which enclosed a mirror, opening back.

POUF: a large, round stuffed cushion with a stable base, used as a low seat or footstool; fashionable during the Second Empire.

POZZETTO: typical 18th-century Venetian seat with wide, rounded seat back which continued without interruption to form the arms; with a loose cushion, similar in type to 15th-century seating.

PRIE-DIEU: seat similar to a *voyeuse*, with a low seat and tall sloping back, used especially as a prayer seat.

PSYCHÉ: a vertical mirror, of human height, generally oval or rectangular, that could be tilted on an easel-type support, also known as a cheval-glass; popular during the Second Empire.

QUEEN-ANNE STYLE: a style of furniture popular in England from c. 1700–20 and in America c. 1720–70, characterized by the use of unencumbered curves, walnut veneer and the cabriole leg. Ornate woodcarving and complicated varnishing procedures were abandoned in favour of purity of line and natural simplicity. The Queen-Anne style led the way to the Palladian designs of the early Georgian era.

RÉGENCE: the architectural and decorative style prevalent in France during the regency of Philippe D'Orléans (1715–1723). Régence furniture displays anti-classical elements of the early Rococo period while retaining a certain Baroque grandeur.

REGENCY: a style of furniture and decorative art popular in Britain during the regency of George IV (1811–20). The term is also used for the period of his reign (1820–30). A version of neo-classicism based on Greek rather than Roman prototypes, it also accommodates Egyptian, chinoiserie and Rococo influences. R. Adam, G. Hepplewhite and T. Sheraton are among the most famous exponents of this style.

RÉGULATEUR: clock which could be regulated, created in the 17th century. It has a tall case which can take many forms and often encloses a pendulum and weights.

ROCAILLE: *Rocaille* ornamentation first appeared in artificial grottos. The term *Rocaille* derives from the French words for rock *(roc)*, and shell *(coquille)*, and describes the mixture of mortar, gravel and shells used to decorate such grottos. In the context of furniture, it denotes one of the main, asymmetric motifs of Rococo ornamentation, the shell.

ROSEWOOD: a reddish-brown, black-streaked tropical hardwood.

SABRE LEGS: a furniture leg curved and tapered like the blade of a sabre.

SAUT-DE-LIT: classical-style tripod supporting a wash-basin and jug.

SCHRANK: German term for a cupboard; attached to other qualifying words, it describes various other pieces with the generic function of 'keeping in custody' or storing, hence *Kleiderschrank*, linen cupboard, *Kabinettschrank*, cabinet, *Überbauschrank, credenza* in two sections, and *Schreibschrank*, bureau-cabinet or bookcase, corresponding to the Italian *trumò*.

SCRIVANIA: writing-tables which in the 18th century were categorized as secrétaires, when placed against the wall, or *bureaux* when not.

SECRETAIRE: type of writing desk made up of two parts placed one above the other, the lower section with doors and the upper section with a hinged writing surface. Various popular versions existed from the second half of the 18th century. The *secrétaire à abattant* was tall and narrow and often designed *en suite* with the *chiffonier*. It stood against the wall and had a lower section with one or two doors and an upper section with a hinged fall-front writing surface, which opened to reveal an interior fitted with drawers and compartments. The *secrétaire à capucin* or *à la Bourgogne* had a series of levers and springs which raised and lowered a writing surface. This was hidden, when the piece was closed, behind a second surface which rotated 180°. The *secrétaire debout* or *bureau en pupître*, with its sloping book-rest and lower section with drawers, permitted the writer to remain standing, and developed into a more complicated 'mechanical' version called *à la Tronchin*. The *secrétaire cartonnier*, with a third sliding section above the hinged writing surface, was used for filing. Still fashionable during the 19th century, the *secrétaire à abattant* was also referred to as *en armoire* or *en tombeau*, and tended to be rigidly architectural in structure, with a fall-front writing surface and drawers or cupboards in the cabinet below. When

opened, the flap gave access to small drawers and compartments, often arranged to resemble an architectural setting.

SEMAINIER: a chest of seven drawers, one for each day of the week, in some ways similar to an English 'Wellington' chest of drawers.

SERVO MUTO: small stand with a number of tiers for serving dishes, corresponding to the English dumb waiter; it was very popular in the 18th century, especially in Italy and France.

SETTEE: English two-seater sofa, which although present in the second half of the 17th century, became more appealing in the Queen Anne period when its upholstered rounded back became more curved, almost to the extent of forming side wings, while the seat was embellished with loose cushions. During the 19th century it followed the shape of arm-chairs and would usually be *en suite*, i.e. designed to match a suite of chairs. The back is therefore constructed so as to suggest the backs of two or three chairs drawn close together. A larger settee is generally referred to as a sofa.

SETTLE: chest or bench with a high back, which became fashionable as a result of the Gothic revival. Early types were fixed to the wall (wall settle).

SEZESSION: name assumed by associations of German and Austrian artists who banded together to oppose staid Academic tradition and the restrictive power of the 'Salon' system in the last decade of the 19th century. The most famous of these was the Vienna Sezession, whose lead-ing members were active mainly in architecture and the fine arts. Furni-ture and textile design were, however, also represented.

SHAGREEN: untanned leather with a grainy surface made from the skin of sharks or animal hides resembling such skin.

SIDEBOARD: English wall furniture, first designed by Robert Adam in 1760 to complete dining-room furnishings, but made popular by George Hepplewhite; the most common version had a central section with drawers and two side sections, the whole on six legs, two placed against the wall and four front ones. Sideboards were a development of the long side tables previously used in the dining-room. They remained popular throughout the 19th century. An alternative was the *credenza*.

SILLA MALLORQUINA: cane-backed and bottomed Spanish chair with colourfully painted turned uprights and carved stretchers.

SOFA TABLE: a variant of the *Pembroke table*, generally tall and narrow with a rectangular top and lyre-shaped supports joined by a stretcher, or with a central column on a tripod base.

SOMNO: bed-side pedestal table of geometrical, truncated-pyramid or cylindrical shape, introduced into France in the early 19th century.

TABLE: There were many types of French 18th-century tables, whose styles became diffused throughout Europe while they retained their original French names. One of a special note is the *table-console*. This transitional piece, born around 1690 and evolving into the true *console*, was a wall table with a frieze carved on its three visible sides and on the front legs, which assumed greater importance while the back legs became simpler. The *table de chevet* or *de nuit*, a bedside table, with long, slim legs and doors, was in use from the middle of the 18th cen-tury. The *table en chiffonière* was a small lady's table with a hinged, often galleried, top, and compartments and small drawers set into the frieze. The *table d'en-cas*, a Louis-XVI-style small table with oval top and doors, had legs on casters, making it easy to move around. The *table de lit* or *d'accouchée* had an upper section with compartments for toilet accessories, mirror and book-rest standing on a lower table with four short feet, and was designed to straddle the bed of the patient or of a woman in childbed. Lastly, the *table servante*, popular in the second half of the century, had a cavity for bottles and glasses.

TABLE CIGOGNE: see *Trio* or *quartetto tables*.

TABOURET: stool originally shaped like a drum which, in the 18th cen-tury, became square-shaped with a padded seat. The term, however, applies to any stool with fixed upright legs, as distinct from the *pliant* versions with folding cross-legs. The right to be seated on a tabouret in the court of Louis XIV was considered a great honour and became a source of disputes between courtiers.

TALLBOY: see *Chest-on-chest*.

TÊTE-À-TÊTE: two-seater sofa normally placed beside a fireplace or in front of another similar piece of furniture, popular from the second half of the 18th century. In later versions, its highly curved ends made it similar to a *confident*.

TRAVAILLEUSE: elegant type of work table, round, oval or rectangular in shape, with a hinged lid. In examples typical of the French Restora-tion period, the compartment has lyre- or S-shaped supports terminat-ing in claw feet.

TRICOTEUSE: small, typically Louis-XVI work table fitted with a com-partment for balls of wool beneath the top, one side of which could be lowered.

TRIO or **QUARTETTO TABLES**: set of three or four occasional tables which fit under one another. Also known as *tables cigognes*, or a nest of tables.

TRUMEAU: typically Italian 18th-century piece, whose French name is often adapted to the Italian form *trumò*, in two parts, the lower section with drawers and a fall-front, and tall and shallow upper section with panelled or glass doors.

VEILLEUSE: type of small sofa which appeared during the reign of Louis XV, with padded sides of different heights joined by a sloping seat back.

VENEER: a very thin layer, normally of wood, affixed to the surface of a piece of furniture for decorative effect and to hide cheaper woods beneath.

VIDE-POCHE: small bedroom table, with galleried top, onto which a gentleman might empty the contents of his pockets before going to bed: money, keys, etc.

VOLTAIRE: comfortable armchair with high, upholstered back; the padded arms rest on wooden swan's-neck or scroll supports; fashionable after 1830.

VOYEUSE: gambler's chair popular in France from the middle of the 18th century, its tall padded back terminating in an elbow rest to lean on to observe the game; men would sit astride the seat but the feminine version had a low seat for ladies to kneel on. A variant is the *fauteuil voyeur* or *bergère voyeuse*, whose padded elbow rest at the top of the seat back enabled spectators to lean comfortably to observe games of chance.

WIENER WERKSTÄTTE: an association of designers and craftsmen established in Vienna in 1903 by J. Hoffmann and K. Moser; it was closely linked with the Vienna Sezession. Its main aim was to promote the principles behind the English Arts and Crafts movement in Central Europe, although its products also had affinities with French Art Nouveau and German Jugendstil. The workshop closed in 1932.

WINDOW STOOL: a bench with rigid arms designed to fit beneath a window.

WINE COOLER or **WINE CISTERN**: type of small, oval vat with a zinc lining, used in England in the 18th century for keeping bottles of wine cool.

WORK TABLE: a typical 19th-century piece of furniture, essentially similar in England, France and Italy. English models tend to have hinged flaps.

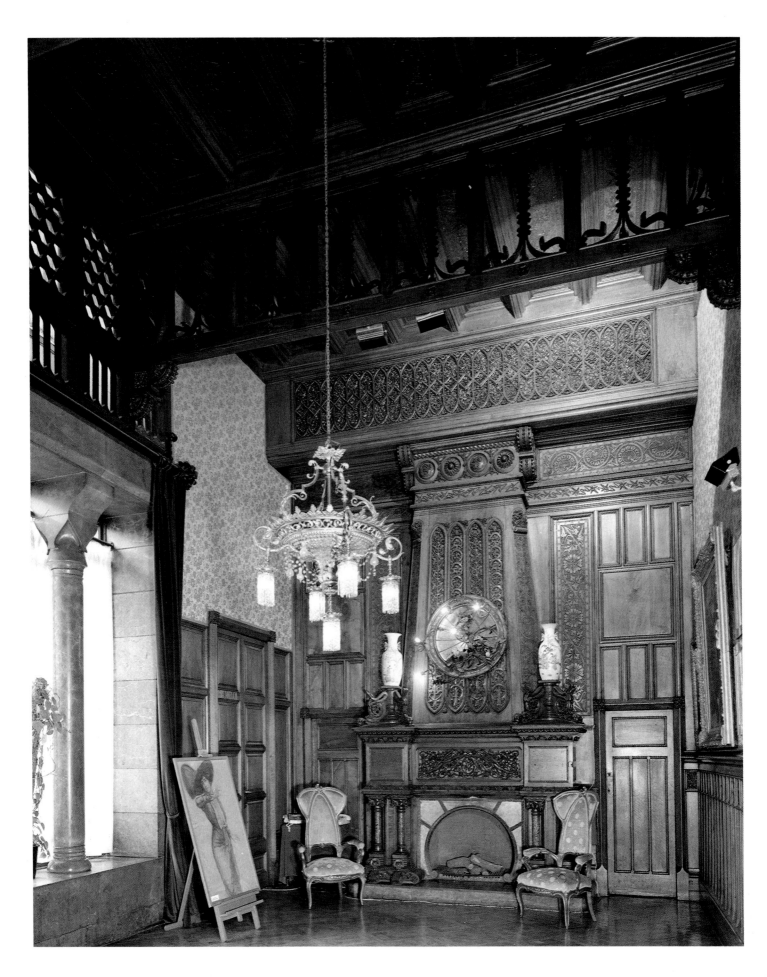

Wood and ornamentation

After the French Revolution, Paris continued to set the fashion for continental Europe. This was partly for cultural reasons and partly because, with the expansion of Napoleon's empire, French tastes and styles were exported to the many local courts dominated by his family and close associates. This historical background should be taken into account in any general examination of the materials and techniques used in 19th-century European furniture-making.

French cabinet-makers of the immediate post-revolutionary period tended to use inexpensive, home-grown woods such as elm, walnut, beech, citrus, and *bois fruitiers*. However, by the time of the Directoire, the use of solid mahogany or mahogany veneer was on the increase, especially for high-quality furniture, and this became the norm under the Empire. The technique of inlay, or rather of using veneers and other materials for stringing and delicate decorative work, survived through the Directoire and Consulate periods.

A distinguished exponent of this technique was Georges Jacob, whose workshop created sophisticated decorative effects using ebony and steel on chairs, stools and chests made of lighter woods. His technique differed from traditional inlay in being more superficial, and involving the use of an adhesive.

Where marquetry was concerned, in France there was a continuation of the 18th-century tradition, using rosewood, kingwood, holly, olivewood, mother-of-pearl and ivory. Italian cabinet-makers also produced some interesting pieces. Giuseppe Maggiolini, for instance, who did his best work between 1780 and 1796, achieved levels of technical perfection and decorative elegance that have never been surpassed. His marquetry panels were at least two millimetres thick and were so precisely cut as to resemble the most delicate of pen drawings. It is said that he used as many as 86 types of wood, with different grains, patterns and colours. He used stains only to achieve pink and light-blue effects, and obtained some shades by burying pieces of wood in red-hot sand.

Among the many followers of the Maggiolini style of marquetry, which persisted in Lombardy until the mid-century, Paolo Moschini is the most notable; his great achievement was to find a way of cutting elm and maple so as to resemble tortoiseshell. "Pollard the young elm tree where the side branches leave the main trunk to form the crown, and continue to cut them as others sprout from this point, so that a kind of table is formed. When this is eventually cut and cleaned, it will manifest a number of concentric patterns, which could never be found in the roots." (from the Milanese newspaper *L'Eco* of 14 December 1835)

With the culmination of Classicism in the Empire style, mahogany – both solid and as a veneer – was triumphant in all its sumptuous surface variations: flamed, swirled, bird's-eye and feather. Furniture tended to be rectangular, flush finished, without mouldings. In the case of *commodes*, secretaires and *psychés*, the ornamentation was strictly symmetrical, applied to the centre of flat surfaces and along the side pillars. Escutcheons and handles were embellished with rosettes or counterposed decorative motifs: human or animal figures, swans and lions, eagles and griffins; or vases with volutes of acanthus leaves. Quality furniture was decorated with delicately engraved bronze, which might be gilded and polished, or alternatively matt, opaque or burnished in imitation of classical bronze mounts.

The most sophisticated and expensive mounts – of the type manufactured by Pierre-Philippe Thomire or Pierre Gouthière – were gilded using the mercury process, i.e. bathed in an amalgam of gold and mercury, then heated in a low-temperature oven. Bronze mounts were sometimes combined with Sèvres porcelain plaques painted with classical subjects or in imitation of antique cameos.

The late Empire period saw a return to home-grown woods, when it became impossible to import mahogany from the Indies. Such woods had in any case always been used by regional craftsmen and for everyday furniture. Italian Empire furniture was often made of walnut or, in the Veneto region, of cherry. In northern Europe, light-coloured woods were more generally used, in particular birch and maple. They were chosen for reasons of economy, being available locally, and because they permitted lighter effects.

After 1815, during the Restauration, *bois clairs* – warm-hued, light-coloured woods with a prominent grain – became popular in France and regions under French influence. Maple, ash, plane, beech, poplar, olive, thuja, sycamore, orange, lemon and acacia were the woods most widely used, particularly burr wood cut from abnormal growths, and highly figured varieties. The decoration of Restauration furniture was extreme-

ly skilful, consisting of delicate inlays of darker woods, especially amaranth, but also ebony, on light backgrounds. The use of gilt-bronze mounts also continued, replaced by gilded brass and tinplate in everyday furniture.

Darker woods came to the fore again in the reign of Louis-Philippe, though rosewood was already in use during the Restauration, embellished with inlays of pewter and brass and lighter woods such as citrus and holly. The decorative features, always rigorously symmetrical, were still in the classical mould: rosettes and palmettes tended to predominate, together with medallions of various shapes based on the stylized acanthus-leaf motif; and there was still an abundance of swans, lyres and dolphins, both inlaid and carved.

The Louis-Philippe and Napoleon III periods saw a flood of new stylistic influences, and the gradual mechanization of furniture manufacture. During the first of these periods, and well into the second half of the century, comfort and convenience were prime considerations. As a result, seats tended to be rounded, shaped to the body, and generously upholstered. Chests of drawers, *secretaires*, tables and chairs were solid and harmonious, but designed for a middle-class family environment. Simplicity and solidity were accompanied by a return to darker woods, such as mahogany, rosewood, ebony, yew, walnut, oak, or ebonized woods, sometimes with attractive lighter inlays and stringing.

Carved or turned decorative features were also back in fashion. Ring, bobbin, baluster and spiral-twist turning was used to adorn the legs of chairs and tables, and to frame the fronts of chests and wardrobes. Light-coloured woods were used only for veneering the interiors of especially valuable pieces. Around 1840, the first virtuoso imitations of earlier styles and techniques began to appear, though, compared with the originals, there was something crudely mechanical about their design and execution.

The reign of Napoleon III saw the triumph of all styles and techniques, often combined in fantastic pastiches. There was a reappearance of *pietre dure* mosaics in the Renaissance and Baroque tradition, Boulle-style inlays, and 18th-century marquetry. High-quality furniture was heavily decorated with bronze mounts, porcelain plaques, coloured glass, ivory and tortoiseshell.

Walnut and other dark woods were lavishly carved and turned, in superlative imitations of Renaissance furniture. At the same time, new materials became popular: cast iron was used for both garden and indoor furniture, while *papier mâché* was painted and decorated with mother-of-pearl to create whimsical Neo-Rococo seats, stools and occasional furniture. Machine tools began to take over the work of traditional craftsmen, and structural components and decorative features were mass produced.

English furniture escaped the general French influence, in turn influencing those regions of Italy (Liguria, Tuscany and the Naples area) where there was a traditional British presence and where English cabinet-makers plied their trade. English 19th-century furniture was generally well constructed, using durable materials. Standards were high and, in the case of pieces made by the top firms for important clients or to the orders of well-known architects, technically near-perfect. This high standard can be accounted for largely by the quality of the woods: whereas "Indian" hardwoods were used for the veneers and visible parts, oak – a hard, strong, "national" wood, traditionally used for English furniture since Tudor times – served for the carcass and all the internal parts of the drawers.

Both the basic structure and the moving parts (doors, drawers, sliding surfaces) have therefore been perfectly preserved, despite constant use. On the continent, meanwhile, more easily worked softwoods were used for the internal components.

To the quality and hard compactness of the imported woods and domestic oak, the English added skilled workmanship in making and assembling the component parts, with a concern for both appearance and practicality. Particular care was taken with the joints of the drawers, which are mitred where the front meets the sides. Hinges, locks and escutcheon plates were almost exclusively made of brass, as were the castors fitted to chairs, divans, and tables of different kinds, to ensure ease of movement. Practicality was paramount.

Another reason for the high quality of 19th-century English furniture was the mechanization of production processes, which began early in the British Isles. There were hundreds of manufacturers specializing in a wide variety of techniques. Specialized workshops serving the furniture industry produced parts for subsequent assembly, such as chair legs and decorative components, lathe-turned items and bronze mounts. It is therefore possible to find identical decorative features in structurally very different pieces of furniture.

19th-century English furniture of all kinds, from Sheraton and Regency to the Victorian styles – with the exception of Neo-Medieval revival pieces, which reflected a return to working in the solid – was essentially veneered. In other words, the outer surface consisted of thin sheets of wood applied to the underlying carcass. The variety of the veneering was one of its characteristic features. For this purpose, imported hardwoods were almost always used: amboyna, rosewood, or Cuban mahogany, all of which were attractive in colour, figuring and markings. Around 1830, new machinery and techniques were introduced to perfect the processes used to make these veneers.

In earlier years, the relatively thick sheets of valuable hardwood were cut lengthways from the trunk in parallel sections. The largest sheets of veneer could therefore be no wider than the central section of the tree. In the 1830s, a steam-driven machine was developed which could "peel" the veneer from the trunk by making a spiral cut (the steam softened the fibres and made it possible to lay the veneer out flat). This yielded a continuous, extremely thin veneer of much greater surface area. Veneering therefore became quicker, easier and more economical, as less of the raw material was wasted.

However, from an aesthetic point of view, the surface veining of a

finished piece of furniture was now less varied and interesting. A characteristic of 19th-century English furniture is therefore the extreme thinness of the veneering, though it is perfectly executed and, in valuable pieces, extends to all the visible surfaces, for example the upper edges of drawers and doors.

Austrian furniture of the second half of the 19th century also shows the influence of industrial methods. Bentwood furniture, for instance, though stylistically derived from Biedermeier, depended technically on the development of machinery capable of steaming and bending wood. The inventor of this machine was a British engineer, Major Trew. The process was later perfected by Michael Thonet, who adapted it to produce his highly practical and popular style of furniture.

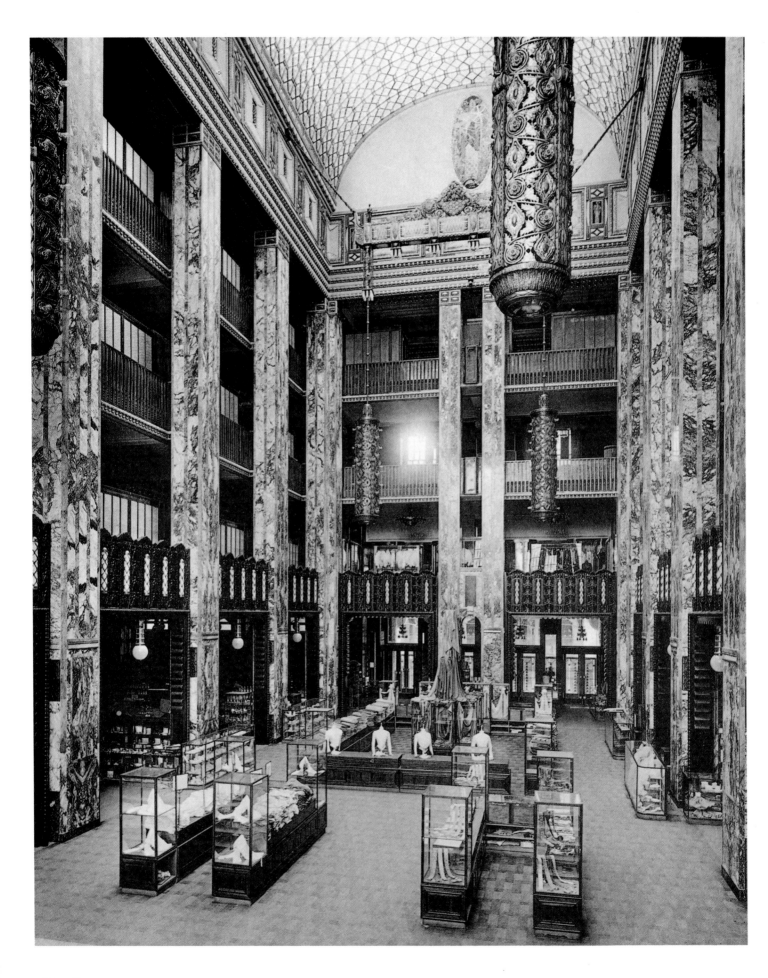

Bibliography

A

Adam, P., *Eileen Gray. Architect, Designer,* New York, 1987.

Adburgham, A., *Liberty's: A Biography of a Shop,* London, 1975.

Agius, P., *British Furniture 1880–1915,* Woodbridge, 1978.

Agius, P./Jones, S., *Ackermann's Regency Furniture and Interiors,* Woodbridge, 1984.

Ahlers-Hestermann, F., *Stilwende,* Berlin, 1956.

Airs, M., *The Buildings of Britain: Tudor and Jacobean,* London, 1982.

Alberici, G., *Il mobile lombardo,* Milan, 1969.

Alberici, G., *Il mobile veneto,* Milan, 1980.

Albertolli, G., *Corso elementare di ornamenti architettonici ideato e disegnato ad uso de' principianti,* Milan, 1805.

Albini, F., *La gommapiuma. Pirelli alla VI Triennale,* Milan, 1977.

Alcouffe, G./Baulez, D./Bellaigue, D. de/Ledoux-Lebard, D., *Il mobile francese dal Medioevo al 1925,* Milan, 1925.

Alison, F., *Charles Rennie Mackintosh as a Designer of Chairs,* London, 1978.

Alison, F., *Charles Rennie Mackintosh,* London, 1978.

Amaya, M., *Art Nouveau,* London, 1966.

Andrews, J., *Price Guide to Victorian, Edwardian and 1920s Furniture (1860–1930),* Woodbridge, 1980.

Anscombe, I., *Omega and After – Bloomsbury and the Decorative Arts,* London, 1987.

Antelling, M., "L'arte industriale nella esposizione Italiana di Torino, I mobili", in *Arte Italiana Decorativa e Industriale,* 1898.

Antonetto, R., *Minusieri ed ebanisti del Piemonte,* Turin, 1985.

Aprà, N., *Cos'è stile?,* Milan, 1962.

Aprà N., *Il mobile Impero,* Novara, 1970.

Aprà, N., *Il mobili Luigi XIV, Luigi XV, Luigi XVI,* Novara, 1970.

Argan, G. C., *Marcel Breuer, disegno industriale e architettura,* Milan, 1957.

Arwas, V., *Art Deco,* London, 1980.

Ashbee, C. R., *Craftmanship and Competitive Industry,* London, 1908.

Aslin, E., *19th-century Furniture,* London, 1986.

Aslin, E., *E. W. Goodwin: Furniture and Interiors,* London, 1986.

B

Baccheschi, E., *Mobili genovesi,* Milan, 1962.

Baccheschi, E., *Mobili intarsiati del Sei e del Settecento in Italia,* Milan, 1964.

Baccheschi, E., *Mobili spagnoli,* Milan, 1965.

Baccheschi, E., *Mobili Italiani del Meridione,* Milan, 1966.

Baccheschi, E., *Mobili tedeschi,* Milan, 1969.

Bachollet, R./Bordet, D./Lelieur, A.-C., *Paul Iribe,* Paris, 1982.

Bahnas, J., *Biedermeier-Möbel,* Munich, 1969.

Bahr, H., *Sezession,* Vienna, 1900.

Bangert, A., *Thonet-Möbel,* Munich, 1979.

Barilli, R., *Il Liberty,* Milan, 1966.

Baroni, D./D'Auria, A., *Josef Hoffmann e la Wiener Werkstätte,* Milan, 1981.

Battersby, M., *The Decorative Twenties,* London, 1969.

Battersby, M., *The Decorative Thirties,* London, 1970.

Baynes, K., *Gordon Russell,* London, 1981.

Beard, G., *The National Trust Book of English Furniture,* Harmondsworth, 1986.

Beard, G./Gilbert, C., *Dictionary of English Furniture Makers: 1640–1840,* Leeds, 1986.

Beard, G./Goodison, J., *English Furniture, 1500–1840,* Oxford, 1987.

Behrens, C. B. A., *The Ancien Régime,* London, 1967.

Beltrami, L., "La Mostra della Ditta Cerruti (Architetto Gaetano Moretti) all'Esposizione d'Arte Decorativa Moderna di Torino", in *L'Edilizia Moderna,* 1902.

Billcliffe, R., *Charles Rennie Mackintosh: The Complete Furniture, Furniture Drawings and Interiors,* London–New York, 1979.

Boeckhoff, H. et al., *Paläste, Schlösser, Residenzen: Zentren europäischer Geschichte,* Erlangen, 1983.

Boger, L. A./Batterson Boger, H., *Enciclopedia dell'antiquariato,* Florence, 1966.

Boito, C., *I principii e gli stili dell'ornamento,* Milan, 1882.

Borghini, V., *Mobili fiorentini,* Milan, 1808.

Borsato, G., *Opera ornamentale,* Venice, 1822/Milan, 1831.

Borsi, F., *Dall'Art Déco al Novecento,* Florence, 1983.

Bossaglia, R., *Il mobile Liberty,* Novara, 1971.

Bossaglia, R., *Il Liberty. Storia e fortuna del Liberty italiano,* Florence, 1974.

Bossaglia, R., *Il Déco italiano. Fisionomia dello stile 1925 in Italia,* Milan, 1975.

Bossaglia R., *Art Déco,* Bari, 1984.

Bossi Del Lago, G., *Un materiale nei secoli,* Udine, 1982.

Bouillon, J. P., *Journal de l'Art Nouveau,* Geneva, 1985.

Boulanger, G., *L'art de reconnaître les styles,* Paris, 1960.

Bragdon, C., *Ornament from Magic Squares,* New York, 1926.

Breicha, O./Fritsch, G. (eds.), *Finale und Auftakt, Vienna 1898–1914,* Salzburg, 1964.

Brosi, V., *Mobili dell'Ottocento*, Milan, 1964.

Brunhammer, Y., *The Art Deco Style*, London, 1983.

Brunhammer, Y., *Il mobile in Europa dal XVI al XIX secolo. Francia e Inghilterra*, Novara 1966.

Brunhammer, Y./De Fayet, M., *Meubles et Ensembles – Epoque Directoire et Empire*, Paris, 1955.

Brunhammer, Y./De Fayet, M., *Meubles et Ensembles – Epoque Restauration et Louis-Philippe*, Paris, 1966.

Buffet-Chaillé, L., *Art Nouveau Style*, London, 1982.

Burkhart, F./Lamarová, M., *Cubismo cecoslovacco. Architture e Interni*, Milan, 1982.

C

Cabanne, P., *Encyclopédie Art Déco*, Paris, 1986.

Calder, J., *The Victorian House*, London, 1977.

Camard, F., *Ruhlmann: Master of Art Déco*, London–New York, 1984.

Candilis, G., *Bugholzmöbel*, Stuttgart, 1980.

Canonero, L., *Barochetto genovese*, Milan, 1962.

Cantelli, G., *Il mobile umbro*, Milan, 1973.

Cattaneo, C., "Del Bello nelle arti ornamentali" in A. Bertani (ed.), *Scritti letterati, artistici e linguistici*, Florence, 1948.

Ceschinsky, H., *English Furniture. From Gothic to Sheraton*, New York, 1929.

Champigneulle, B., *L'Art Nouveau*, Paris, 1976.

Chiesa, G., *Il Settecento. Mobili, arti decorative, costume*, Milan, 1974.

Chippendale, T., *The Gentleman and Cabinet-Maker's Director (1762)*, reprint New York 1966.

Cirillo, G./Godi, G., *Il mobile a Parma fra Barocco e Romanticismo*, Parma, 1983.

Cito Filomarino, A. M., *L'Ottocento, i mobili del tempo dei nonni*, Milan, 1969.

Clementi, A., *Storia dell'arredamento*, Milan, 1952.

Collard, F., *Regency Furniture*, Woodbridge, 1985.

Collins, J., *The Omega Workshops*, London, 1983.

Comolli Sordelli, A., *Il mobile antico dal XIV al XVII secolo*, Milan, 1967.

Cooper, J., *Victorian and Edwardian Furniture and Interiors. From the Gothic Revival to Art Nouveau*, London, 1987.

Corkhill, T., *Glossary of Woods*, London, 1979.

Crawford, A., *C. R. Ashbee*, London, 1985.

Cremona, I., *Il tempo dell'Art Nouveau*, Florence, 1964.

Crispolti, E., *Ricostruzione futurista dell'universo*, Turin, 1980.

Curl, J. S., *Egyptomania*, Manchester, 1994.

D

Dabry, M., *The Islamic Perspective. An Aspect of British Architecture in the 19th Century*, London, 1983.

Dacier, E., *Le style Louis XVI*, Paris, 1939.

Dalisi, R., *Art Nouveau – Jugendstil*, Stuttgart, 1962.

De Fusco, R., *L'architettura dell'Ottocento*, Turin, 1980.

De Groer, L., *Les arts décoratifs de 1790 à 1850*, Paris, 1985.

De Reynies, N., *Le Mobilier Domestique: Vocabulaire Typologique*, 2 vols., Paris, 1987.

Delle Piane, L./Patrassi, A./Zanutti, G., *Carlo Bugatti*, Milan, 1924.

Denvier, B., *The Early Nineteenth Century. Arts, Design and Society 1789–1852*, London–New York, 1984.

Deutscher Werkbund, *Die Form ohne Ornament*, Stuttgart, 1925.

Disertori, A./Necchi Disertori, A. M., *Guida all'Antiquariato*, Milan, 1970, 1977, 1980.

Dresser, C., *Principles of Decorative Design*, London, 1873.

Duncan, A., *Art Deco Furniture. The French Designers*, London, 1984.

Duncan, A., *American Art Deco*, London, 1986.

E

Edwards, R., *The Shorter Dictionary of English Furniture: From the Middle Ages to the Late Georgian Period*, London, 1964.

Edwards, R., *The Dictionary of English Furniture: From the Middle Ages to the Late Georgian Period*, 3 vols., London, 1986.

Edwards, R./Jourdain, M., *Georgian Cabinet-Makers*, London, 1944.

Eisler, M., *Österreichische Werkkultur*, Vienna, 1916.

Eriksen, S., *Early Neo-Classicism in France*, London, 1964.

Exhibition catalogue, *Les années "25": Art Déco, Bauhaus, De Stijl, Esprit nouveau*, Paris, 1966.

Exhibition catalogue, *Jugendstil*, Vienna, 1969.

Exhibition catalogue, *Art and Design in Vienna, 1900–1930*, New York, 1972.

Exhibition catalogue, *Darmstadt 1901–1976. Ein Dokument Deutscher Kunst*, Darmstadt 1976.

Exhibition catalogue, *Frühes Industriedesign Wien 1900–1908. Wagner, Koloman Moser, Loos, Hoffmann, Olbrich, Ofner*, Vienna, 1977.

Exhibition catalogue, *C. F. A. Voysey, Architect and Designer*, London, 1978.

Exhibition catalogue, *L'art en France sous le Second Empire*, Paris, 1979.

Exhibition catalogue, *Architect-Designers: Pugin to Mackintosh*, London, 1981.

Exhibition catalogue, *Omega Workshop*, London, 1984.

Exhibition catalogue, *The Glasgow Style*, Glasgow, 1984.

Exhibition catalogue, *William Morris and the Middle Age*, Manchester, 1984.

Exhibition catalogue, *Rococo Art and Design in Hogarth's England*, London, 1984.

Exhibition catalogue, *Biedermeier – Glück und Ende. Die gestörte Idylle*, Munich, 1987.

Exhibition catalogue, *Il Progetto domestico. La casa dell'uomo: archetipi e prototipi, XVII Triennale*, 2 vols., Turin, 1988.

F

Fastnedge, R., *English Furniture Styles, 1550–1830*, London, 1955.

Fenz, W., *Koloman Moser*, Salzburg, 1976.

Feray, J., *Architecture Intérieure et Décoration en France*, Paris, 1988.

Fiell, P./Fiell, Ch., *Modern Chairs*, Cologne (Benedikt Taschen Verlag), 1993.

Fiell, P./Fiell, Ch., *1000 Chairs*, Cologne (Benedikt Taschen Verlag), 1997.

Fiell, P./Fiell, Ch., *Design of the 20th Century*, Cologne (Benedikt Taschen Verlag), 1999.

Fiell, P./Fiell, Ch., *Charles Rennie Mackintosh,* Cologne (Benedikt Taschen Verlag), 1995.

Fiell, P./Fiell, Ch., *William Morris,* Cologne (Benedikt Taschen Verlag), 1999.

Fleming, J., *Il mobile inglese,* Milan, 1981.

Fleming, J. et al., *Penguin Dictionary of Architecture,* Harmondsworth, 1980.

Fleming, J./Honour, H., *Penguin Dictionary of Decorative Arts,* Harmondsworth, 1977.

Fleres, U., "Lo stile nuovo", in *Rivista d'Italia,* 1902.

Focillon, H., *G. B. Piranesi,* Bologna, 1967.

Fossati, P., *Il design in Italia 1945–1972,* Turin, 1972.

Frey, G., *The Modern Chair: 1850 to Today,* London, 1970.

G

Gabrielli, B., *Il Museo dell'Arredamento,* Stupingi–Turin, 1966.

Garner, P., *Emile Gallé,* Milan, 1977.

Garner, P.(ed.), *Phaidon Encyclopaedia of Decorative Arts 1890–1940,* London, 1978.

Garner, P., *Möbel des zwanzigsten Jahrhunderts. Internationales Design vom Jugendstil bis zur Gegenwart,* Munich, 1980.

Giani, G., *94a Mostra Depero,* Trento, 1953.

Giedion, S., *Mechanization Takes Command,* Oxford, 1948.

Giovene, C., *Studio sul mobile napoletano,* 1930.

Girouard, M., *Life in the English Country House: A Social and Architectural History,* New Haven (Conn.), 1980.

Gloag, J., *A Short History of Furniture Design from 1300 BC to 1960 AD,* London, 1960.

Gmeiner, A./Pirhofer, G., *Der österreichische Werkbund. Alternative zur klassischen Moderne in Architektur, Raum- und Produktgestaltung,* Salzburg–Vienna, 1985.

Godoli, E., *Il futurismo,* Bari, 1973.

González-Palacios, A., *Dal Direttorio all' Impero,* Milan, 1966.

González-Palacios, A., *Il Mobile nei Secoli,* 10 vols., Milan, 1969.

González-Palacios, A., *Mobili d'arte,* Milan, 1973.

González-Palacios, A., *Il Mobilio francese dal Medioevo al 1925,* Milan, 1981.

González-Palacios, A., *Il Tempo del Gusto – Le arti decorative in Italia fra classicismo e barocco – Roma e il regno delle Due Sicilie,* 2 vols., Milan, 1984.

Grandjean, S., *Empire Furniture, 1800 to 1825,* London, 1966.

Greenberg, C., *Mid-Century Modern,* New York, 1984.

Gregori, M., *Mobili italiani dal XV al XX secolo,* Milan, 1966.

Guttry, I. de/Maino, M. P., *Il mobile Liberty italiano,* Bari, 1983.

H

Hall, J., *Dictionary of Subjects and Symbols in Art,* Harmondsworth, 1984.

Hammacher, A. M., *Die Welt Henry van de Veldes,* Otterlo, 1967.

Hanson, A. C., *The Futurist Imagination,* New Haven (Conn.), 1983.

Hardendorff-Burr, G., *Hispanic Furniture,* New York, 1964.

Harris, E., *The Furniture of Robert Adam,* London, 1963.

Harris, J., *The Palladians,* London, 1981.

Hautecœur, L., *Histoire de l'architecture classique en France,* vols. II, III and IV, Paris, 1948, 1950, 1952.

Havard, H., *Dictionnaire de l'ameublement et de la décoration depuis le XIIIᵉ siècle jusqu'à nos jours,* Paris, 1887/89.

Havasi, L., *Acht Jahre Sezession,* Vienna, 1906.

Hayward, H., *World Furniture: An Illustrated History,* London, 1965.

Hillier, B., *The World of Art Deco,* Minneapolis (Mass.), 1971.

Hillier, B., *Art Deco of the 20s and 30s,* London, 1985².

Himmelheber, G., *Klassizismus, Historismus, Jugendstil,* Munich, 1973.

Himmelheber, G., *Kleine Möbel,* Munich, 1979.

Holzhausen, W., *Lackkunst in Europa,* Brunswick, 1959.

Honour, H., *Chinoiserie: A Vision of Cathay,* London, 1961.

Honour, H./Fleming, J., *Dizionario delle arti minori e decorative,* Milan, 1980.

Howarth, T., *Charles Rennie Mackintosh and the Modern Movement,* London, 1952.

Hulten, P. (ed.), *Futurismo & futurismi,* Milan, 1986.

I

Impey, O./Macgregor, G., *The Origins of Museums: The Cabinet of Curiosities in Sixteenth and Seventeenth Century Europe,* Oxford, 1985.

J

Jackson-Stops, G. et al. (eds.), *The Fashioning and Functioning of the British Country House,* Washington (D. C.), 1989.

Jaffé, H. L. C., *De Stijl 1917–1931,* Milan, 1964.

Janneau, G., *Le mobilier français,* Paris, 1942.

Janneau, G., *Les styles du meuble italien,* Paris, 1973.

Jannelli, G., "Futurballa", in *Futurismo,* 1933.

Jarry, M., *Le Siège Français,* Fribourg, 1973.

Jervis, S., *The Penguin Dictionary of Design and Designers,* Harmondsworth, 1984.

Johnson, S., *Eileen Gray: Designer 1879–1976,* London, 1979.

Jones, O., *The Grammar of Ornament,* London, 1979.

Joyce, E. /Peter, A., *The Technique of Furniture Making,* Batsford, 1987⁴.

Junquera, J. J./Talbot Rice, T./Thornton, P., *Il mobile: Spagna, Portogallo, Paesi Scandinavi, Russia,* Milan, 1982.

Juyot, P., *Louis Majorelle: artiste décorateur, maître ébéniste,* Nancy, 1927.

K

Kenworth-Browne, J., *Il mobile inglese. L'età dei Chippendale,* Novara, 1971.

Kjelberg, P., *Le mobilier Français,* 2 vols., Paris, 1980.

Kjelberg, P., *Art Déco. Les maîtres du mobilier,* Paris, 1986².

Klein, D./ McClelland, N. A./ Haslam, M., *In the Deco Style,* London, 1987.

Kreisel, H., *Fränkische Rokokomöbel,* Darmstadt, 1956.

Kreisel, H./Himmelheber, G., *Die Kunst des deutschen Möbels,* vol. 3: *Klassizismus, Historismus, Jugendstil,* Munich, 1973.

Kreisel, H./Himmelheber, G., *Die Kunst des deutschen Möbels,* vol. 2: *Spätbarock und Rokoko,* Munich, 1983.

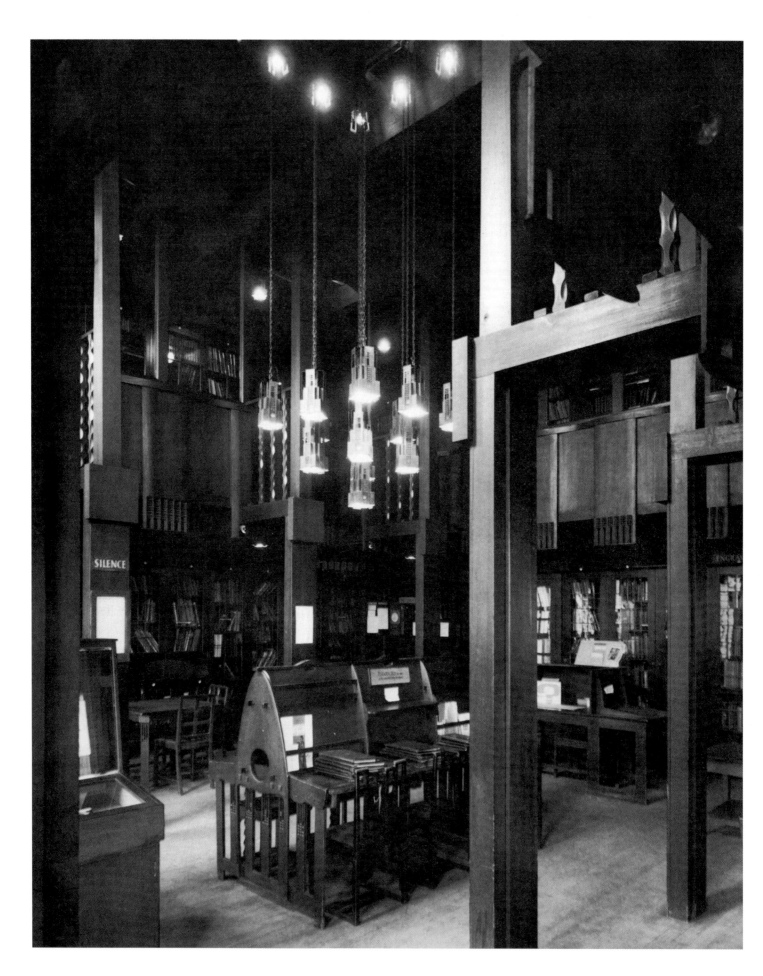

L

Lambert, S./Victoria and Albert Museum, London, *Patterns and Designs: Designs for the Decorative Arts, 1480–1980*, London, 1983.

Le Corbusier, *Arte decorativa e design*, Bari, 1972.

Ledoux-Lebard, D., *Les ébénistes parisiens. 1795–1870*, Paris, 1965.

Ledoux-Lebard, D., *Les ébénistes du XIXᵉ siècle. 1795–1889. Leurs œuvres et leurs marques*, Paris, 1984.

Lefuel, O., *Collection Connaissance des Arts – Le XIXᵉ siècle français*, Paris, 1957.

Lesieutre, A., *The Spirit and Splendour of Art Deco*, London, 1981.

Lever, J., *Architect's Design for Furniture*, London, 1982.

Levy, S., *Il mobile veneziano del Settecento*, Milan, 1964.

Lewis, P./Darley, G., *Dictionary of Ornament*, London, 1986.

List, C., *Alte Bauernschränke – Deutschland, Österreich, Schweiz*, Munich, 1981.

Lizzani, G., *Il mobile romano*, Milan, 1970.

Lucie-Smith, E., *Furniture. A Concise History*, London, 1979.

Lucie-Smith, E., *The Thames and Hudson Dictionary of Art Terms*, London, 1984.

M

Mackay, J., *Dictionary of the Turn of the Century Antiques*, London, 1974.

Madsen, S. T., *Jugendstil. Europäische Kunst der Jahrhundertwende*, Munich, 1967.

Maenz, P., *Art Deco. Formen zwischen zwei Kriegen*, Cologne, 1986.

Maland, D., *Culture and Society in 17th-century France*, London, 1970.

Mallé, L., *Le arti figurative in Piemonte*, Turin, 1961.

Mang, K., *Das Haus Thonet*, Frankenberg, 1969.

Mang, K., *Geschichte des modernen Möbels. Von der handwerklichen Fertigung zur industriellen Produktion*, Stuttgart, 1978.

Mannelli, V., *Il mobile regionale italiano*, Florence, 1964.

Marrangoni, G., *Storia dell'arredamento*, Milan, 1955.

Martinelli, C., *Antoni Gaudí*, Barcelona, 1975.

Masini, L. V., *Art Nouveau*, Florence, 1976.

Massobrio, G./Portoghesi, P., *Album del Liberty*, Bari, 1975.

Massobrio, G./Portoghesi, P., *Album degli anni Venti*, Bari, 1976.

Massobrio, G./Portoghesi, P., *Album degli anni Cinquanta*, Bari, 1977.

Massobrio, G./Portoghesi, P., *Casa Thonet – Storia dei mobili in legno curvato*, Bari, 1980.

Mazzariol, G., *Mobili italiani del Seicento e del Settecento*, Milan, 1963.

Meister, P. J./Jedding, H., *Das Schöne Möbel*, Munich, 1959.

Melani, A., *L'arte nell'industria*, vol. II, Milan, undated.

Menten, T., *The Art Deco Style*, New York, 1972.

Middleton, R./Watkin, D., *Architettura dell'Ottocento*, Milan, 1980.

Moglia, D., *Collezione di soggetti ornamentali ed architettonici inventati e disegnati da Domenico Moglia*, Milan, 1837.

Morrazoni, G., *Il mobile veneziano del Settecento*, Milan, 1927.

Morrazoni, G., *Il mobilio italiano*, Florence, 1940.

Morrazoni, G., *Il mobile genovese*, Milan, 1949.

Morrazoni, G., *Il Mobile Neoclassico Italiano*, Milan, 1955.

Morrice, R., *The Buildings of Britain. Stuart and Baroque: A Guide and Gazetteer*, London, 1982.

Müller, D., *Klassiker des modernen Möbeldesigns. Otto Wagner – Adolf Loos – Josef Hoffmann – Koloman Moser*, Munich, 1980.

Müller, M., *Die Verdrängung des Ornaments. Zum Verhältnis von Architektur und Lebenspraxis*, Frankfurt/M., 1977.

Muthesius, H., *Das englische Haus*, Berlin, 1904/05.

N

Naylor, G., *The Arts and Crafts Movement*, Cambridge (Mass.), 1971.

Nebehay, C. M., *Ver Sacrum*, Vienna, 1975.

Nerdinger, W., *Richard Riemerschmid. Vom Jugendstil zum Werkbund*, Munich, 1982.

Nicoletti, M., *Architettura Liberty in Italia*, Bari, 1978.

Norberg Schulz, C., *Casa Behrens*, Darmstadt – Rome, 1980.

O

Oliva, A. B., *Prampolini*, Modena, 1936.

Osborne, H., *The Oxford Companion to the Decorative Arts*, Oxford, 1975.

P

Pagano, G., *Tecnica dell'abitazione*, Milan, 1936.

Pansera, A., *Storia e cronaca della Triennale*, Milan, 1978.

Papini, R., *Le arti a Monza nel 1923*, Bergamo, 1923.

Papini, R., *Le arti d'oggi*, Milan, 1930.

Park, W., *The Idea of the Rococo*, Newark (Delaware), 1992.

Passamani, B., *Fortunato Depero*, Turin, 1974.

Passamani, B., *Depero*, Rovereto, 1981.

Patetta, L., *L'architettura dell'Eclettismo, fonti, teorie, modelli (1750–1900)*, Milan, 1975.

Payne, C. (ed.), *Sotheby's Concise Encyclopedia of Furniture*, London, 1989.

Persico, E., "Mobili metallici", in *La Casa Bella*, 1930.

Pevsner, N., *The Buildings of England*, 46 vols., Harmondsworth, 1951.

Pevsner, N., *Egyptian Revival*, London, 1956.

Pevsner, N., *Studies in Art, Architecture and Design, Victorian and After*, London, 1968.

Pfeiffer, B. B., *Frank Lloyd Wright*, Cologne (Benedikt Taschen Verlag), 1994.

Pica, V., *L'Arte Decorativa all'Esposizione di Torino*, Bergamo, 1902.

Pinto, P., *Il mobile italiano dal XV al XIX secolo*, Novara, 1962.

Piranesi, G. B., *Diverse maniere d'adornare i camini ed ogni altra parte degli edifici*, Rome, 1769.

Plumb, J. H./Weldon, H., *Royal Heritage: The Story of Britain's Royal Buildings and Collectors*, London, 1984.

Ponti, G., *La casa all'italiana*, Milan, 1933.

Ponti, G., "L'esito del concorso per un mobile-radiogrammofono", in *Domus*, 1933.

Ponti, G., "Insegnamento altrui e fantasia degli italiani", in *Domus*, 1951.

Pradere, A., *French Furniture Makers: The Art of the Ebéniste*

from Louis XIV to the Revolution, London, 1989.

Praz, M., *Gusto Neoclassico,* Milan, 1959.

Praz, M., *La casa della vita,* Milan, 1979.

Praz, M., *La filosofia dell'arredamento,* Milan, 1981².

Praz, M., *Studi e svaghi inglesi,* Milan, 1983.

Proudfoot, C./Walker, P., *Christie's Guide to Woodworking Tools,* Oxford, 1984.

Putaturo Muraro, A., *Il Mobile Napoletano del Settecento,* Naples, 1977.

Q

Quaglino, E., *Il Piemonte: mobili e ambienti dal XV all'inizio del XIX secolo,* Milan, 1966.

R

Rava, C. E., *Mobili d'ogni tempo. Cinque secoli di arredamento in Italia, Francia e Inghilterra,* Milan, 1947.

Rava, C. E., *Il mobile d'arte,* Milan, 1950.

Rheims, M., *The Flowering of Art Nouveau,* New York, undated.

Rogers, J. C., *Modern English Furniture,* London, 1930.

Rosa, G., "Mobili Lombardi del Settecento", in *Antichità Viva,* Florence, 1962.

Rosenblum, R., *Trasformazioni nell'arte. Iconografia e stile tra Neoclassicismo e Romanticismo,* Rome, 1984.

Roubo, A. J., *L'Art du Menuisier,* 3 vols., Paris, 1977.

Royal Academy of Arts et al., *The Age of Neo-classicism: The 14th Exhibition of the Council of Europe,* London, 1972.

Ruga, P., *Invenzioni diverse di mobili ed utensili sacri e profani per usi comuni della vita,* Milan, 1811.

Russel, F., *A Century of Chair Design,* London, 1980.

Ruta, A. M., *Arredi futuristi,* Palermo, 1985.

S

Salverte, C. de, *Les Ebénistes du XVIII Siècle,* Paris, 1975.

Scarlett, F./Towney, M., *Arts Décoratifs 1925,* London, 1975.

Schekler, E. F., *Josef Hoffmann,* Salzburg, 1982.

Schmidt, L./Müller, A., *Bauernmöbel im Alpenraum,* Innsbruck, 1982.

Schmitz, H., *Deutsche Möbel des Barock und Rokoko,* Stuttgart, 1923.

Schmitz, H., *Deutsche Möbel des Klassizismus,* Stuttgart, 1923.

Schmutzler, R., *Art Nouveau – Jugendstil,* Stuttgart, 1962.

Schommer, P., *Sièges et petits meubles anciens: XVIIIᵉ siècle et Empire,* Paris, 1920.

Schonberger, A./Soehner, H., *Il Rococò,* Milan, 1960.

Schweiger, W. J., *Wiener Werkstätte,* Vienna, 1980.

Schweiger, W. J., *Wiener Werkstätte. Art et Artisanat 1903–1932,* Brussels, 1986.

Segoura, M./Lemonnier, P., *Weisweiler,* Paris, 1983.

Selle, G., *Die Geschichte des Designs in Deutschland von 1870 bis heute,* Cologne, 1978.

Selvafolta, O. (ed.), "Il disegno del mobile razionale in Italia 1928–1948", in *Rassegna,* No. 4, 1980.

Sembach, K. J., *Stil 1930,* Tübingen, 1971.

Sembach, K. J., *Art Nouveau,* Cologne (Benedikt Taschen Verlag), 1999.

Sembach, K. J./Gössel, P./Leuthäuser, G., *Twentieth-Century Furniture Design,* Cologne (Benedikt Taschen Verlag), 1991.

Sessa, E./Pirrone, G., *Mobili e arredi di Ernesto Basile nella produzione Ducrot,* Palermo, 1987.

Sinisgalli, L., "Mobili moderni costruiti in serie", in *Domus,* 1936.

Smith, C. S., *18th-Century Decoration,* London, 1993.

Stamp, G., *The English House 1860 to 1914,* London, 1986.

Starobinski, J., *La scoperta della libertà, 1700–1789,* Milan, 1965.

T

Taylor, B. B., *Pierre Chareau,* Cologne (Benedikt Taschen Verlag), 1998.

Terni de Gregory, W., *Vecchi mobili italiani,* Milan, 1972.

Thornton, P., *Authentic Decor: The Domestic Interior 1620–1920,* London, 1985.

Tinti, M., *Il mobilio fiorentino,* Milan, 1928.

Tomlin, M., *English Furniture: An Illustrated Handbook,* London, 1972.

Tonelli Michail, M. C., *Il design in Italia 1925–1943,* Bari, 1987.

U

Uecker, W., *Art Deco. Die Kunst der zwanziger Jahre,* Munich, 1983⁴.

V

Van Herck, J., *Il mobile fiammingo,* Milan, 1972.

Van Voorst tot Voorts, J. M. W., *Meubles in Nederland,* Lochem, 1979.

Various authors, *The Connoisseur's Period Guide,* London, 1957.

Various authors, *The Complete Encyclopedia of Antiques,* London, 1962.

Various authors, *The Connoisseur's Handbook of Antique Collecting,* London, 1964.

Various authors, *World Furniture,* London, 1965.

Various authors, *Arredamento nei secoli,* Milan, 1966.

Various authors, *Sept siècles d'art du meuble en Belgique,* Tielt, 1977.

Various authors, *Ernesto Basile architetto,* Milan, 1980.

Various authors, *L'Italia Liberty,* Milan, 1980.

Various authors, *Il Liberty a Bologna e nell'Emilia Romagna,* Bologna, 1980.

Various authors, *Alfonso Rubbiani: i veri e i falsi storici,* Bologna, 1981.

Various authors, *Anni Trenta. Arte e cultura in Italia,* Milan, 1982.

Various authors, *Nineteenth-Century Furniture. Innovation, Revival and Reform,* New York, 1982.

Various authors, *Le arti a Vienna,* Milan, 1984.

Various authors, *Le Corbusier 1910–1965,* Bologna, 1987.

Various authors, *Le Corbusier: une encyclopédie,* Paris, 1987.

Vegesack, A. von, *Das Thonet-Buch,* Munich, 1987.

Venturini, C., *Il mobile italiano del secondo Ottocento: storicismo e movimento estetico,* Milan, 1986.

Vergo, P., *Art in Vienna,* London, 1975.

Verlet, P., *Le Style Louis XV,* Paris, 1942.

Verlet, P., *Le Mobilier Royal Français,* vol. I, Paris, 1945.

Verlet, P., *Le Mobilier Royal Français,* vol. II, Paris, 1955.

Verlet, P., *Les Meubles Français du XVIII^e siècle*, Paris, 1956.

Verlet, P., *L'art du meuble à Paris au XVIII^e siècle*, Paris, 1958.

Verlet, P., *Le Mobilier Royal Français*, vol. IV, Paris, 1958.

Verlet, P., *French Royal Furniture: An Historical Summary*, London, 1963.

Verlet, P., *Styles. Meubles, Décors du Moyen Age à nos jours*, 2 vols., Paris, 1972.

Verlet, P., *Les meubles français, du XVIII^e siècle*, Paris, 1982.

Veronesi, G., *Josef Hoffmann*, Milan, 1956.

Veronesi, G., *Stile 1925*, Florence, 1976.

Viaux, J., *Bibliographie du meuble (Mobilier civil français)*, Paris, 1966.

Viaux, J., *Bibliographie du meuble. Supplément 1965–1985*, Paris, 1988.

Victoria and Albert Museum, London/Edwards, R., *English chairs*, London, 1970.

Vinca Masini, L., *Art Nouveau*, Florence, 1976.

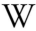

W

Wagner, O., *Moderne Architektur*, Vienna, 1975.

Waissenberger, R., *Die Wiener Sezession*, Vienna–Munich, 1971.

Waissenberger, R., *Wien 1870–1930: Traum und Wirklichkeit*, Salzburg–Vienna, 1984.

Waissenberger, R. (ed.), *Wien 1890–1920*, Vienna, 1984.

Walton, J. A., *Woodwork in Theory and Practice*, London, 1974⁵.

Wannenes, G., *Mobili d'Italia e di Francia. Il Settecento*, 2 vols., Milan, 1986.

Wannenes, G., *Mobili dell'Ottocento*, 2 vols., Milan, 1987.

Wannenes, G., *Mobili di Francia. L'Ottocento. Storia, stile, mercato*, Milan, 1987.

Watin, J. F., *L'Art du peintre doreur et vernisseur*, Paris, 1772.

Watkin, D., *Thomas Hope and the Neo-Classical Idea*, London, 1968.

Watson, F. et al., *The History of Furniture*, London, 1976.

White, P., *Poiret*, London, 1973.

Wiener Werkstätte. *Modernes Kunsthandwerk von 1903–1932*, Vienna, 1967.

Wilkie, A., *Biedermeier*, Milan, 1987.

Wills, G., *English Furniture 1760–1900*, Enfield (Middlesex), 1969.

Wills, G./Baroni, D./Chiarelli, B., *Il mobile, storia, progettisti, tipi e stili*, Milan, 1983.

Z

Zerbst, R., *Gaudí 1852–1926. Antoni Gaudí i Cornet – A Life Devoted to Architecture*, Cologne (Benedikt Taschen Verlag), 1985.

Zuckerkandl, B., *Zeitkunst, Wien 1901–1907*, Vienna, 1908.

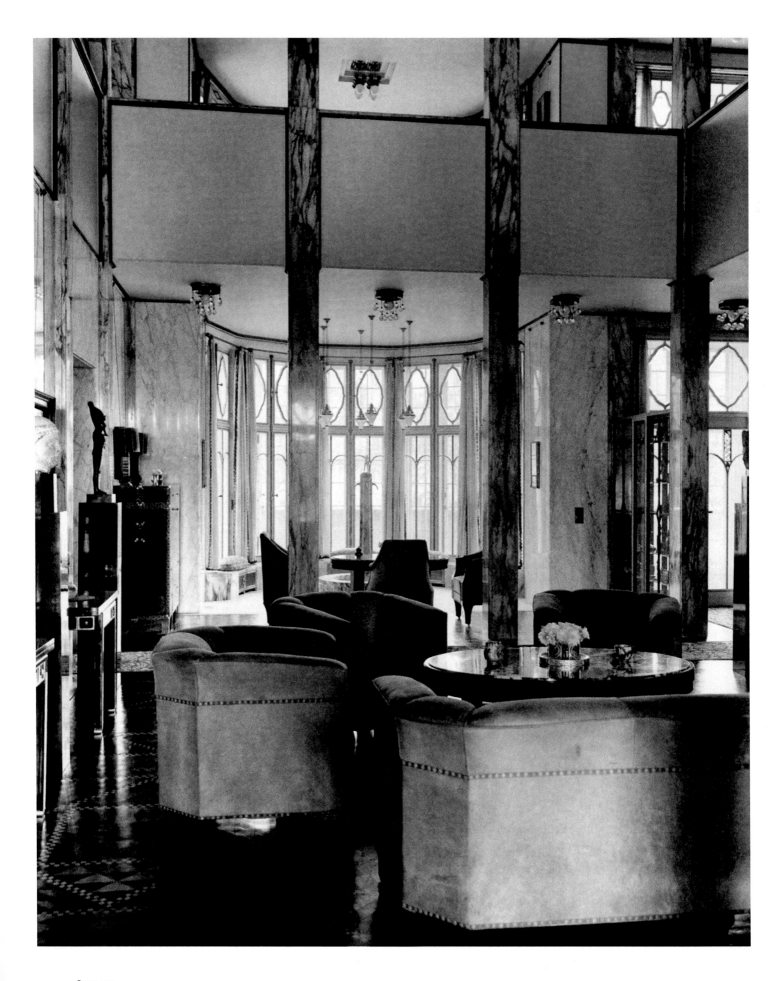

Index

Straight Roman numerals denote references to the text while numbers in italics refer to picture legends.

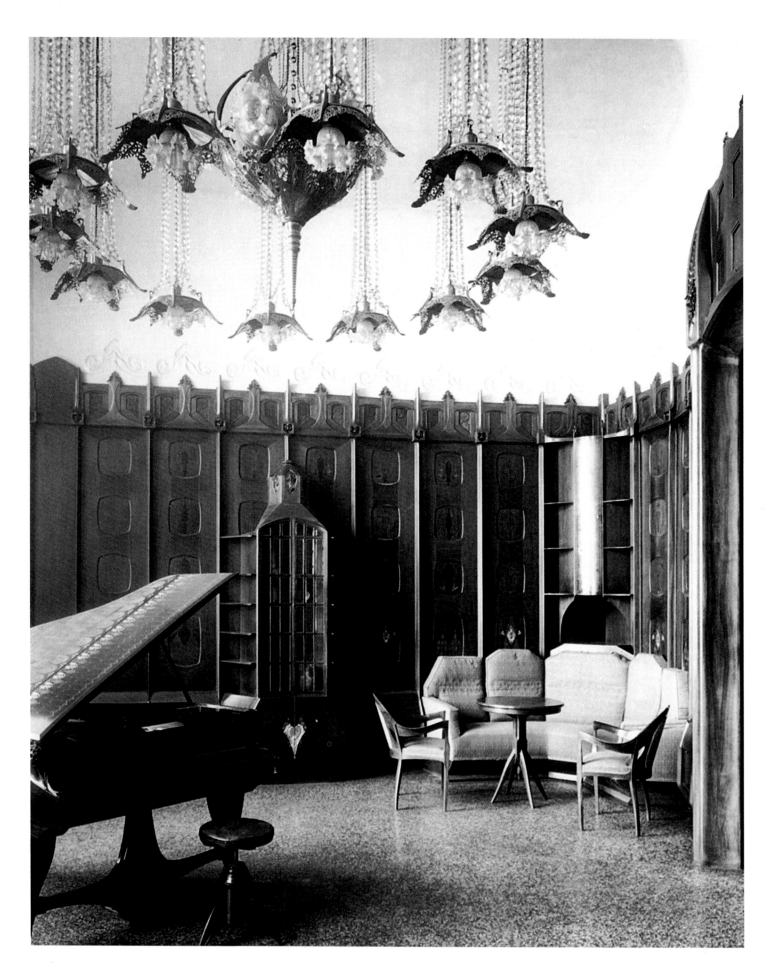

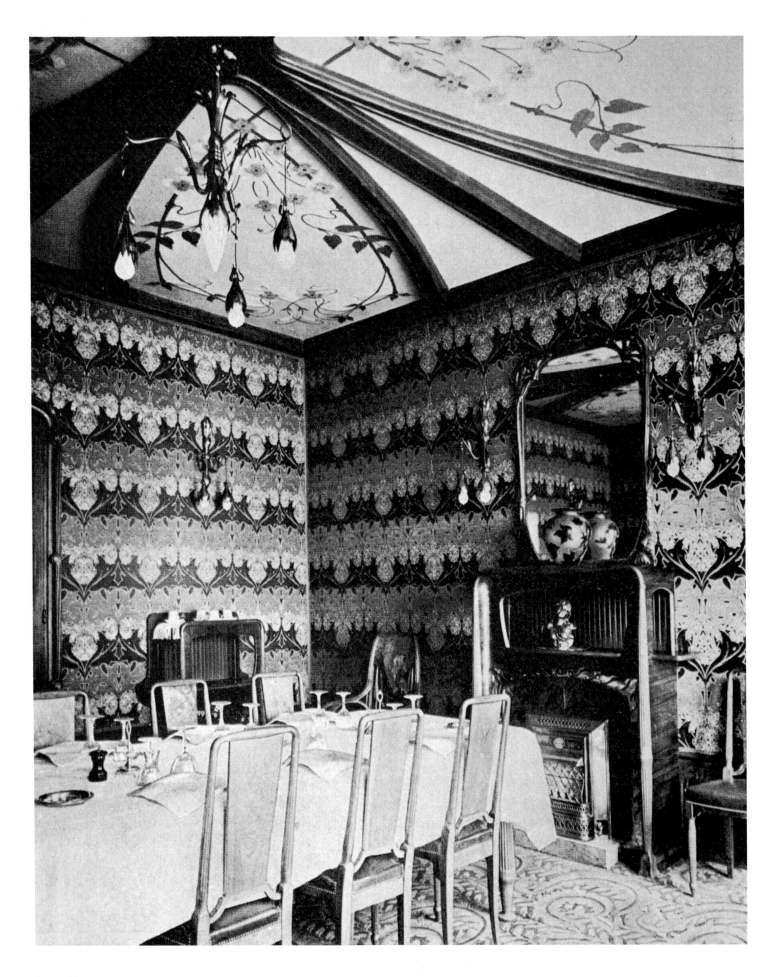

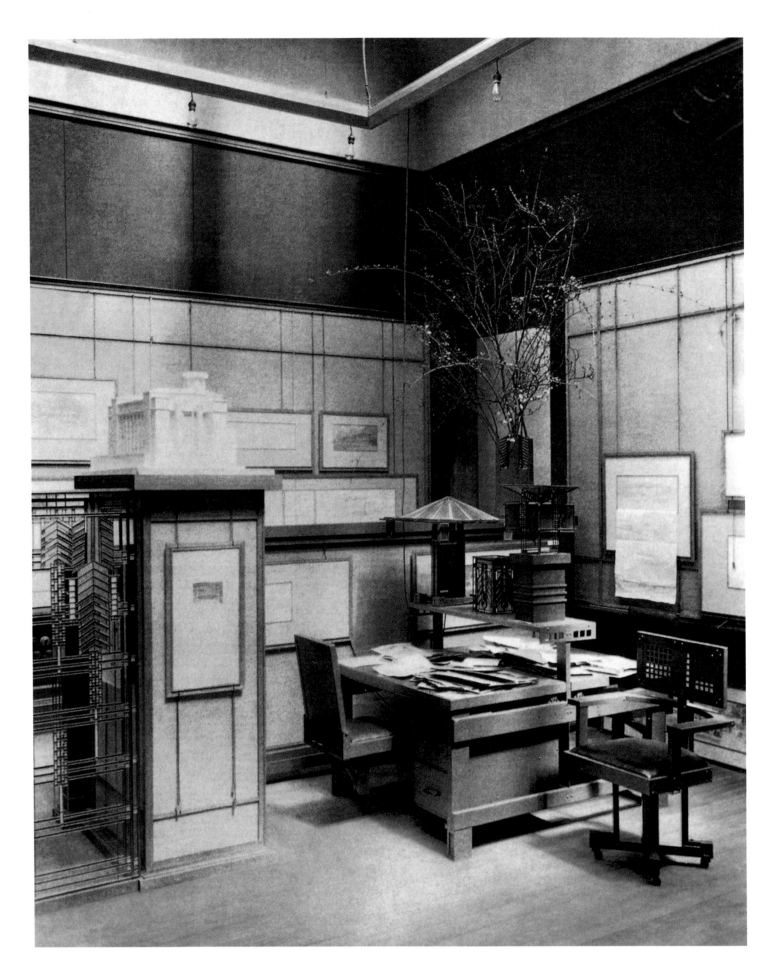

The authors

ADRIANA BOIDI SASSONE took a degree in modern languages at the University of Turin, and has undertaken research for the Italian National Research Council at the Institute of Art History in Turin, directed by Andreina Griseri. She has contributed to a number of specialist Italian publications, and to the *Grande Dizionario Enciclopedico Utet* and the *Dizionario Biografico degli Italiani*. She has also published several books: *Ville del Cuneese* (1980), *Art Nouveau a Cuneo: architettura e arti decorative* (1982), *Il palazzo della Cassa di Risparmio di Fossano* (1983), *Ville piemontesi: interni e decorazioni del XVIII e XIX secolo* (1986).

ELISABETTA COZZI graduated in architecture at Milan Polytechnic's Faculty of Architecture, where she now teaches. She has taken part in national and international competitions. She has a studio in Milan, where she is engaged in building and interior design.

ANDREA DISERTORI worked at the Milan *Politecnico*, after completing his studies, with the architect Giovanni Muzio. While there, he specialized in prefabrication methods and taught at the *Facoltà di Ingegneria* in Milan. He has also worked as an architect in film and television, and as a designer and book illustrator. He has published numerous books and articles in journals on architecture, furnishing, antiques of many eras and graphics.

MASSIMO GRIFFO, law graduate, journalist, novelist and antiquarian, serves on the national council of the Italian Federation of Art Dealers and is a member of the International Confederation of Art Dealers. He edited the Italian edition of *Falso o autentico?* for Istituto Geografico De Agostino (1987), and is a contributor to *Giornale* and the monthly magazine *Atlante*.

ANDREA GRISERI, Professor of Art History at the University of Turin, specializes in international Gothic art (*Jaquerio e il realismo gotivo*, 1965), linguistics (publications in the journal *Paragone*, edited by Roberto Longhi) and comparative analyses of the art of the 17th and 18th centuries (exhibition catalogues: *Il Settecento a Roma* [Rome, 1959], *Mostra del Barocco Piemontese* [Turin, 1963], *Rami incisi dell'Archivo di Corte* [Turin, 1981]. A summary of his analyses can be found in *Metamofosi del Barocco*, 1967, and in his later contributions to *Arcadia* or in *Storia dell'Arte Einaudi*, 1981.

ANNA MARIA NECCHI DISERTORI studied art in Milan and is now an art teacher herself. She has written numerous publications on architecture, furnishing, antiques of various eras and graphic art. She contributes to a number of journals and has also designed furniture herself, in wool and other materials.

ALESSANDRA PONTE studied at Venice University's Institute of Architecture and gained a doctorate in the history of architecture from the same university. Her particular interest is the history of residential architecture, and she was one of the organisers of the exhibition of domestic design at the Milan Triennale. She is a contributor to several Italian and foreign magazines.

GIANNI CARLO SCIOLLA holds a Bachelor of Arts degree from the University of Turin, where he now lectures in the history of art criticism. In addition to various studies of art-related literature and critical editions of texts in the field of 19th-century art criticism, he has also produced a number of publications on the Renaissance (*La scultura di Mono da Fiesole*, 1970; *La città ideale del Rinascimento*, 1974; *Ville Medicee*, 1986), the Baroque era (*Rembrandt: disegni*, 1976; *The Royal City of Turin, Princes, Artists and Works of Art in the Ancient Capital of a European Dukedom*, 1982; *Notizie preliminari circa la scultura degli antichi*, 1988); and the history of collecting antique drawings (*I disegni di maestri stranieri nella Biblioteca Reale di Torino*, catalogue, 1974; "I disegni" in *Le Collezione d'arte della Biblioteca Reale di Torino*, 1985).

ORNELLA SELVAFOLTA is Professor of the History of Architecture at the Polytechnic in Milan. Her main research interest is the architecture and design of the late 18th and early 19th centuries. She has worked on the editorial staff of *Casabella* magazine, as architectural editor for publishing house Electa, and contributed to many specialist exhibitions. Her publications include a monograph issue of the journal *Rassegna* (no. 4, 1980) on the design of Italian rationalist furniture, *Mobili come aforismi: 35 mobili del razionalismo italiano* (exhibition catalogue, 1988, 1990), *Il bello ritrovato; gusto, interni e mobili dell'Ottocento* (1990, with C. Paolini, A. Ponte), and *Mobili e arredi di Giuseppe Terragni* (in *Giuseppe Terragni, opera completa*, ed. G. Ciucci, 1996).

Photocredits

Aisa: 266, 267a-b-c, 269a-b-c, 292, 293, 294, 295, 552, 553a-b, 554a, 555a-b, 567a, 569, 570, 598–599

Jörg P. Anders: 230b, 231a, 235d-f, 507, 536c, 537a

Archivio Giò Ponti: 766b

Archivio I.G.D.A.: 13, 76b, 77a, 88–89, 124, 131a, 150, 153, 156–157, 186a-b-c, 208, 209, 216b-c, 217, 224, 225, 227, 229, 230a, 231b, 232a-b, 237a-c, 242, 244, 245, 246a, 247, 248a-c-d, 251a-b, 256a, 258, 259, 260, 268, 270, 316–317, 331, 353a-b, 366a-b, 378, 381, 382, 387, 388a, 399b, 428a-b, 442, 445, 448a-b-d, 456–457, 458, 490–491, 523, 544–545, 545, 549, 607, 610, 611, 613, 618, 625, 627, 640a-b, 641, 642b, 643, 644c, 646, 647, 665b, 671a, 682, 689, 690a-b, 691, 706, 714a, 730–731b, 743d, 750b

Artothek: 214b, 216a, 222–223, 223a-b, 236, 240, 243a-b, 504a, 520, 622, 668–669, 671c

C. Bevilacqua: 59

Bildarchiv Huber: 605a

Blauel: 671b

The Bridgeman Art Library: 114–115, 141b, 152, 159, 167a, 178a-b, 179a, 181, 182–183b, 187a-b, 189, 193, 226, 238b, 261a, 312a, 462a, 463a, 465, 475c, 485, 486b, 491b, 492b, 495, 497b, 576, 635a, 639, 660–661

Bulloz: 145, 287a, 440, 644a

G. Cappellani: 672, 673, 687

M. Carrieri: 662b, 663a-b-c-d, 664, 707

P. Cavallero: 601, 602a-b

A. Chadefaux: 444c, 450, 451b, 454a

J. L. Charmet: 416a, 436a

Christie's: 479

G. Cigolini: 271, 272, 273, 280–281, 281a-b-c, 282–283, 290, 291, 332a-b, 333, 345a, 350b, 358a, 365, 410, 459, 612, 642c, 657, 674–675, 675, 679c, 688a, 694b-c, 695, 696–697a, 697a, 698b-c, 699b, 700a-b, 758a, 765

G. Colliva: 43a

A. C. Cooper: 23a, 34a-b, 37a, 64a, 83b, 89, 93a, 94a, 97b, 98b, 101a-c, 102b, 106a-c, 107a-c, 110a-b, 111a, 116, 118a, 126a, 129, 133b-c, 134b, 139b, 148a-b, 151, 154, 158a-b, 160, 161a-b, 163a, 165, 166, 167b-c-d, 168a-b, 169, 170, 171, 174, 175a-b, 176, 177a-b-c, 178c, 180, 182, 184a-b-c-d, 185c, 188a-b, 194c, 195, 196, 197a-c-d, 198a, 200a-b, 201a-c, 202–203a-b, 203, 204a-c, 206, 207a-c, 221, 234a, 239, 241c, 246b, 248b, 250, 252, 253c, 261b, 262, 262–263, 263a-b,

264, 265, 312b, 334b-c-d, 408c, 409, 420d, 457, 461a-b, 468a-b, 469a-b-c, 470a, 470–471, 471, 472, 473b-d-e, 474a-b, 475a-c, 476a-b-c, 477a-b-c, 478a-b, 480a-c, 481b, 482b-c, 483a-b, 484, 486a-c-d, 487a-b-c, 488, 489, 491a, 493, 494, 514c, 516a, 519b, 534a-c, 554a-b, 608, 638, 649a, 650b, 651, 676–677, 721a-b-c, 726, 728a-b, 730–731a, 734, 735a, 738b, 739b, 742d, 747a-b, 751b

A. Dagli Orti: 14, 30b, 47a-b-c, 51a, 55d, 62, 62–63b, 65, 71a-b, 72a-b, 79a, 83c, 90, 91a-b, 93b, 96, 97a, 102–130a-b, 103, 108c, 109a-b, 111b, 113a-b, 142–143b, 146, 278, 288a, 298, 300, 305, 322, 326, 327, 336a-b-c, 336–337, 337, 339b-d, 342a-b, 343a-b-c, 344a-b, 345b-c, 346a-b-c-d-e, 347, 348a-b, 349, 352, 354, 355a-b, 356a-b-c, 357b-c, 359c-d, 361a-b, 363b, 373a-b-c, 374–375a, 380a-b, 384, 386, 388b, 389b, 425, 426b, 427a-b-c, 435a-b-d, 451a, 454–455, 512b-d, 513b, 517a, 519a, 529c, 534d, 566–567, 572–573, 574, 574–575, 578, 579, 581b, 582a-b, 583, 584–585, 586, 587, 588, 589b-c, 597, 636–637a-b, 637b, 656b, 668a, 677a, 679b, 681, 683a-b, 692, 693, 694a, 700c, 716a-b, 716–717, 717a-b, 718a-b-c, 719a-b, 764a

G. Dagli Orti: 15, 16, 17, 22b, 22–23, 24–25, 27b, 28a, 31a, 37b, 38, 39, 40a-b-c-e, 41b, 42, 42–43, 43b, 44a-b, 45a, 52, 53a-b-c, 55a-b, 56a-b, 58b, 61a-b-c-d, 69a, 70a-b, 73a-b-c, 77b-c, 99a-b, 104c, 105, 107b, 118b, 118–119, 127, 131a-b, 136b, 137a-b, 138a, 140a-b, 141a, 142, 142–143a, 144a-b, 147a-b, 149, 172, 173, 182–183a, 192, 194a-b, 197b, 198b, 199, 201b, 204b, 248, 274, 275, 287b, 289, 296–297, 299, 301, 302b, 304, 313, 334a, 340, 341, 350a, 351, 358b, 359a, 369a-b, 374, 400, 401, 403a-b, 404, 405a, 407, 410–411, 411a-b-c-d, 412, 413, 414a-b, 415, 416b, 416–417, 417a-b, 418a-b-c, 419, 420b-c, 421, 422b-c-d-e, 424a-b-c, 426a, 432a, 433, 434c, 466–467, 467a-b, 468c, 469a, 526a, 534b, 556, 558–559, 562a-b-c, 563, 564a-b, 565, 623, 626a-b, 629, 636a-b, 645, 652a-b-c-d, 653, 654a-b, 654–655, 656a, 665c, 676, 677b, 698a, 702, 708, 709, 715, 722, 723, 724, 724–725, 725, 729a, 730, 733a-b, 737a-b-c, 739a-c, 740–741, 741, 744c, 747c, 749a-b, 750a, 752, 761

C. Dani: 619, 684–685

A. De Gregorio: 18, 19a-b, 20, 285

The Design Council: 754a-b

Edimedia: 648b

Mary Evans Picture: 620

D. Ferry: 449b-f, 452a, 742a-b, 748a, 751a

Finarte: 45b, 49, 71c, 80a-b, 376, 377a-b, 379a-b, 383, 390a, 390–391a-b,

391a-b, 392, 393, 394a-b, 395, 396a-b, 397, 398, 399a, 678, 696, 696–697b, 697b, 699a, 701, 759

J. Freeman: 92b, 122, 123a-c, 130, 133a, 134a, 136a, 139a, 143, 634a-b, 650a

Giraudon: 443d, 449a, 598, 644b

A. Gold: 235a

J. Hiltmann: 669a-b

H. Holford: 635b

A. Hornak: 147c, 480b, 621, 632a-b, 633, 768–769

I. G. D. A./Meyer: 615

A. F. Kersting: 202, 205, 315, 318, 319

K. Kiemer: 218

Lalance: 609, 736, 753b

S. Licitra: 766a

Ingeborg Limmer: 228a-c

G. Mari: 325b, 358c-d, 359b, 368, 372, 373c, 532

A. A.W. Meine Jansen Grossel: 548a-b

Meyer: 278–279, 279, 306, 307, 308, 309, 667

G. Nimatallah: 23c, 48a-b, 51, 84b, 85, 87a-b-c, 92a, 93c, 94b, 95a-b-c, 97c, 98a, 100a-b-c, 101b, 102a, 104a-b, 106b, 108a-b, 112, 114, 116–117, 117, 123b-d, 126b, 132, 135, 138b, 210, 211, 212, 213a-b, 214a, 215, 219, 220a-b, 228b-d, 232c-d, 233, 234b-c, 235b-c, 237b, 238a, 241a, 246c, 284–285, 288–289, 302a, 303, 314, 330–331b-c, 335a, 361c, 362, 363a, 364a-b, 422a, 429a, 434a, 436b, 437a-b-c-d-e-f, 443c, 498, 499, 500, 501, 503b-c, 505, 508, 509, 510, 510–511, 511a-b, 512a-c, 513a, 516b, 521a-b, 522, 524a-b, 524–525, 525a, 526–527, 527a-b-c, 528a-b-c-d, 529a-b-d, 530a-b-c, 530–531, 531a-b, 533a-b-c, 535, 537b-c, 538, 539, 540, 541a-b, 542, 543, 550, 550–551, 557, 560–561, 580a-b, 580–581, 656–657, 704, 705, 710a, 711, 712a-b

Opdracht Foto: 551b

Al Pagani: 32, 46, 680b, 732a-b, 758b

Parvum Photo: 662a

Pealcini Snc: 589a

M. Perez: 642a

Photo Studio 9: 253a-b, 254a-b, 255a-b, 256–257, 257

V. Pirozzi: 286, 369c, 756, 756–757, 757a-b

Réunion des Musées Nationaux: 405b

Rheinländer: 235e

J. Riby: 430a-b, 431a-b-c, 434b, 435c-e, 436c-d, 438a-b-c-d, 439a-b-c-d, 441, 443a-b, 448, 449c-d-e

The Royal Collection: 162, 162–163, 163b, 190, 190–191, 191

Gordon Russell: 755

Salmer: 616, 616–617a-b, 617, 648a, 658a-b-c, 659a-b

Saporetti: 120, 121, 125, 686a-b, 760a-b

W. Schmidt: 536a-b,

Seemüller: 276–277

A. Spring: 590, 591

J. Stoel: 547

Studio Grand Augustins: 444a-b, 446a, 447b

Studio Image: 630, 631

L. Sully-Jaulmes: 432b, 447a, 637a, 655, 703, 740a, 742c, 743a, 744b, 745, 746a-b, 748b, 750–751, 753a

F. Tanasi: 78, 328, 329a-b, 370a-b, 371a-b

Tass: 567b

Ole Woldyle: 514a

Zuber: 446b, 447c, 450–451, 452b, 453, 596a-b

Acknowledgements

ALP, Antichità Cavour, Antichità A. Moretti, Arte Antica, M. Brucoli, De Contessini, Esagono Antichità, Finarte Spa, Galleria Camiciotti, Galleria Guelfa, Galleria Previtali, L. Galli, In Arte, La Porta Antica, La Roccia, Le Quinte di Via dell'Orso, L. Malinverni, Mallet & Son Antiques, Margua, G. Nestri, Pelgoron Antichità, G. Pratesi, G. Ricco, T. Russo, San Bassan Antichità, G. Scaccabarozzi, C. and Volker Silbernagl, A. Subert Jarach, Vecchia Europa Antiquariato, Venturi Spada, G. Wannenes